The Manual of Photography

The Manual of Photography

Tenth Edition

Edited by

Elizabeth Allen

Sophie Triantaphillidou

ELSEVIER

AMSTERDAM • BOSTON • HEIDELBERG • LONDON • NEW YORK • OXFORD
PARIS • SAN DIEGO • SAN FRANCISCO • SINGAPORE • SYDNEY • TOKYO

Focal Press is an imprint of Elsevier

Focal Press is an imprint of Elsevier
The Boulevard, Langford Lane, Kidlington, Oxford, OX5 1GB, UK
30 Corporate Drive, Suite 400, Burlington, MA 01803, USA

The Ilford Manual of Photography
First published 1890
Fifth edition 1958
Reprinted eight times

The Manual of Photography
Sixth edition 1970
Reprinted 1971, 1972, 1973, 1975
Seventh edition 1978
Reprinted 1978, 1981, 1983, 1987
Eighth edition 1988
Reprinted 1990, 1991, 1993, 1995 (twice), 1997, 1998
Ninth edition, 2000
Tenth edition, 2011

Notices

Knowledge and best practice in this field are constantly changing. As new research and experience broaden our understanding, changes in research methods, professional practices, or medical treatment may become necessary.

Practitioners and researchers must always rely on their own experience and knowledge in evaluating and using any information, methods, compounds, or experiments described herein. In using such information or methods they should be mindful of their own safety and the safety of others, including parties for whom they have a professional responsibility.

To the fullest extent of the law, neither the Publisher nor the authors, contributors, or editors, assume any liability for any injury and/or damage to persons or property as a matter of products liability, negligence or otherwise, or from any use or operation of any methods, products, instructions, or ideas contained in the material herein.

British Library Cataloguing in Publication Data
A catalogue record for this book is available from the British Library

Library of Congress Control Number: 2010933573

ISBN: 978-0-240-52037-7

For information on all Focal Press publications
visit our website at focalpress.com

Printed and bound in China

10 11 12 11 10 9 8 7 6 5 4 3 2 1

Contents

Contents

Contents

Contents

Contents

Contents

Preface

to the tenth edition

Although there are many textbooks, monographs and manuals that are available today dedicated to what has now become imaging, *The Manual of Photography* stands out as a significant and unique publication. It was first published in the very early days of photography in 1890 under the editorship of C.H. Bothamley at the request of the then Ilford Company as *The Ilford Manual of Photography*. The preface to this first edition has set the scene for all later editions:

> *… an endeavour has been made to state, in a simple way, sufficient of the principles to enable the reader to work intelligently, and to overcome most of the difficulties that he is likely to meet with …*

This firm foundation has persisted throughout all subsequent editions under the guidance of a number of editors leading to this tenth edition.

It has been revised and reprinted many times under only five editors during its 120-year period of publication. Forty years after its initial publication, George E. Brown provided a complete revision and started the tradition of using a number of specialist authors. This reflected the changes in photography that no longer could be fully understood and explained by a single author. The second edition appeared in 1942 under the editorship of James Mitchell, and the third and fourth editions rapidly followed in 1944 and 1949 respectively.

Alan Horder edited the fifth and sixth editions. The sixth edition of 1971 saw the move away from publication by Ilford Limited when it was acquired by the present publishers and the name Ilford was removed from the title. This edition also saw contributions for the first time by two of the contributors to this edition: Sidney Ray on the camera and Geoffrey Attridge on colour photography. In 1978 Ralph Jacobson became the editor for the seventh edition, followed by the eighth edition in 1988 and the ninth edition in 2000. He continued with the specialist contributions from these two authors and others at the then Polytechnic of Central London (now the University of Westminster). The ninth edition of 2000 and certainly this tenth edition must make it one of very few books to have a presence in three centuries. It has come to be valued by many generations of photographers for the straightforward account it provides of both the theory and practice of photography as the technology has evolved.

Sophie Triantaphillidou and Elizabeth Allen are the joint editors of this edition and under their guidance have ensured that the manual remains true to its traditions. In the 10 years since the last revisions were made to the manual there have been many significant technological developments. This edition remains absolutely up to date with explanations of the principles of modern imaging techniques. Like their predecessors they have enlisted the help of their colleagues with specialist knowledge that ensures that the explanations remain both accurate and authoritative.

The previous edition saw a move away from traditional chemical-based photography to the now widely practised electronically based imaging methods. This was in the era of hybrid imaging. Today this is even more apparent with digital camera sales outstripping conventional analogue cameras by around 100 to 1, excluding camera phones and one-shot single-use (recyclable) cameras. In order to provide a balanced basis of modern photographic practice and keep the size of the book within reasonable limits, the editors have been faced with difficult decisions on what to keep, what to discard and what to add. Fortunately much of the core information applies as much to modern electronic

systems as it does to analogue chemical systems. Optics and the basic physics of imaging are examples of core areas which also appeared in previous editions. These core areas have been considerably expanded to provide a sound basis for the understanding and practice of digital imaging. Surprisingly, explanations of colour photography were only introduced in 1971, but since then have become a significant topic in subsequent editions. This edition has four chapters devoted to this topic and aspects of colour are of course embedded in other chapters where appropriate.

The move to digital imaging is now virtually complete, with conventional analogue or film-based imaging now being practised by a relatively small number of photographers. This is reflected very much in the content of this edition and arguments on the relative merits of the two approaches are almost over as the quality obtainable by digital systems has exceeded all expectations. However, the traditional chemical image-forming processes still have a smaller but significant presence in this edition to cater for the needs of those dedicated users of this technology.

This edition is a completely revised book necessitated by the changes in imaging that have taken place in the last 10 years.

The measurement of image quality both by physical means and by perception by observers has been a key area for the development of all imaging systems. This is reflected in this edition by specialist chapters dedicated to image quality and system performance, and important physical aspects of image quality that include fundamental aspects of noise, sharpness, resolution and information content. These considerations also apply to all imaging systems. Information on aspects of modern digital imaging are extensively covered in specific chapters dedicated to sensors, cameras and scanners, output media, file formats, image compression and image processing, workflow and colour management systems.

The editorial team has made sure that this tenth edition remains true to the basic principles of their predecessors in providing accessible and authoritative information on most technical aspects of imaging.

Also, they have ensured that it remains of interest and value to anyone with an interest in imaging systems who has a need for explanations of the principles involved in their practical applications. Examples might include enthusiasts, students, professionals, technicians and computer users involved in imaging.

Ralph Jacobson
Emeritus Professor of Imaging Science,
University of Westminster,
June 2010

Editors' Acknowledgements

We are indebted to the previous editor of *The Manual of Photography*, our mentor and friend, Ralph Jacobson, for his encouragement to undertake the authorship and editing of the current edition, for his support during its production and his work as the technical editor. We would like to thank him and the other authors from the previous edition, Geoffrey Attridge, Wally Axford, and Sidney Ray, for allowing the use of parts of their text from the ninth edition. We are also grateful that two of these previous authors have continued their contribution in this tenth edition and we thank them and our new co-authors for their valuable input.

Thanks to Peter Burns for his contribution to technical editing; to Robert Hunt, Roy Berns, Mark Fairchild, Phil Green and Andy Finney for allowing the use of data/figures/images from their publications; to John Smith, Simon Brown and Andy Schonfelder for their assistance with research; and to the Focal Press team for supporting this publication.

Lastly, but importantly we would like to thank Olivier, Jason, Anja and our parents.

Elizabeth Allen and Sophie Triantaphillidou

Author Biographies

Elizabeth Allen is a principal lecturer in Imaging Science at the University of Westminster. She specialises in digital imaging systems and processes and image quality and has been the course leader of the BSc Photography and Digital Imaging since 2005. Her work has been presented at a number of symposia and has been published in related journals. She received the Selwyn Award from the Royal Photographic Society in 2005 and is currently working towards a PhD in imaging science. She is also a contributing author in the 7th and 8th editions of Langford's Advanced Photography.

Sophie Triantaphillidou is a principal lecturer and director of the Imaging Technology Research Group at the University of Westminster. She received the Selwyn Award from the Royal Photographic Society and her PhD in imaging science in 2001. She specialises in image quality, image archiving and colour imaging. She has been the chair of the Imaging Science Group of The Royal Photographic Society since 2007 and member of a number of conference programme committees related to imaging science. She has published numerous research papers and is a contributing author in the 7th and 8th editions of Langford's Advanced Photography.

Geoffrey Attridge has been an Emeritus Professor in Imaging Science at the University of Westminster, since retiring in 2004 from over 30 years of teaching. He originally studied chemistry, obtaining a PhD in chemical photography and during his early career worked at ILFORD laboratories. He is specialised in sensitometry, chemical photography and colour imaging. He has authored and co-authored prolifically, and has been a contributing author of the Manual of Photography since its 6th edition, published in 1971. He served as the Chair of the Imaging Science Group of The Royal Photographic Society between 2000 and 2006.

Efthimia Bilissi is a Senior Lecturer in imaging science at the University of Westminster, specialising in imaging systems and image quality. She was awarded the Selwyn Award from the Royal Photographic Society and gained her PhD in imaging science in 2004. Her work has been presented at many national and international symposia and has been published in related journals. She is assistant editor of the Imaging Science Journal and the editor and co-author of Langford's Advanced Photography, 7th and 8th editions.

Robin Jenkin works as a Senior Engineer for Aptina Imaging Corp. in San Jose, helping to develop image quality metrics by modelling, simulating and analysing imaging systems. He gained a PhD in imaging science from the University of Westminster in 2002 and has since worked as a university lecturer and researcher, publishing internationally in the field of image quality measurement. He received a Fenton Medal from the Royal Photographic Society in 2007 and is currently the Executive Editor of The Imaging Science Journal. Rob is additionally a Visiting Fellow in the field of Electro-Optics at Cranfield University and a keen practising photographer.

Sidney Ray was a Senior Lecturer at the University of Westminster from 1966 until retirement in 2004, specialising in applied photography and photographic optics. He contributed to the four previous editions of the Manual of Photography and has authored numerous books and papers on photographic topics. He has had numerous consultancies and roles in the professional practice of photography and imaging and is an Honorary Fellow of both the British Institute of Professional Photography and the Royal Photographic Society.

Chapter | 1 |

Introduction to the imaging process

Elizabeth Allen

All images © Elizabeth Allen unless indicated.

INTRODUCTION

The second half of the nineteenth century saw the progression from early experiments with light-sensitive compounds to the first cameras and photographic films becoming available to the general population. It developed from the minority use of the camera obscura as a painter's tool, through the first fleeting glimpse of a photographic image in a beaker containing silver compounds after light exposure, to the permanent rendering of the image, and then to the invention of the negative—positive photographic process used today to produce an archival image. A camera using roll film, the Kodak, was available to the public in 1887 and brought photographic media to the masses. By the beginning of the twentieth century, silver halide materials were produced that were sensitive to all visible wavelengths in the electromagnetic spectrum, producing tonally acceptable images, and this paved the way for practical colour imaging processes, beginning with the Autochrome plate in 1907, to be developed.

Since this period, the ability to capture, manipulate and view accurate images of the world around us has become something that we take for granted. There are few places in the world where images are not a part of daily life. We use them to record, express, represent, manipulate and communicate ideas and information. The diverse range of applications for imaging leads to a multitude of functions for the image: as a tool of coercion in advertising, a means to convey a visual language or an aesthetic in art, a method of visualization and analysis in science, to communicate and symbolize in journalism, or simply as a means to record and capture, and sometimes enhance, the experiences of everyday life. The manufacturing industries rely on images for a multitude of purposes, from visualization during the design and development of prototypes to the inspection of manufactured components as part of industrial control processes. Photography and applied imaging techniques using visible and non-visible radiation are fundamental to some fields: in medicine for diagnosis and monitoring of the progress of disease and treatment; and in forensic science, to provide objective records in legal proceedings and for subsequent analysis.

The art and science of photography and imaging has been developed through multiple disciplines, as a result of necessity, research and practice. The imaging process results in an image that will be observed; therefore consideration of the imaging chain, in practice or theory, must include the observer. But the numerous functions of images mean that the approach to and requirements from the imaging process are various. If involved in the practice of imaging, however, whatever the function of the image, it is impossible to avoid the need to acquire technical skills and some knowledge and understanding of the theory behind the imaging process.

Knowledge of factors affecting all stages of the imaging chain allows manipulation of the final image through informed selection of materials and processes. More in-depth study of the fundamental science of imaging, as well as being interesting and diverse, serves to enhance the practical imaging process, as understanding can be gained of the mechanisms involved, and processes and systems can be characterized and controlled to produce required and predictable results. Study of imaging science encompasses the nature of light, radiometry and photometry, vision science and visual perception, optics, colour science, chemistry, psychophysics, and much more besides. It provides methodologies for the assessment of imaging systems and tackles the complex issue of the evaluation of image quality.

DOI: 10.1016/B978-0-240-52037-7.10001-8

The greatest change in our approach to imaging since the development of the colour process has occurred in the last 25 years, with the burgeoning growth of digital imaging technologies. The first consumer electronic camera system was introduced to the public in 1981, but it took the development of the personal computer, and its leap to widespread use, before digital imaging became practical. The internet has caused and facilitated an exponential increase in image production and dissemination. Imaging has grown to embrace computer science and computer graphics in a symbiotic relationship in which each discipline uses elements of the others. Digital image processing finds application in many areas from the aesthetic enhancement of images to analysis in medical applications. The immediacy of digital imaging has raised our expectations; it is likely that this, along with the efficiency of the digital imaging process and the ease of manipulation of digital images which are, after all, just arrays of numbers, will mean that the traditional photographic process may eventually be entirely replaced.

Keeping up with the changes in technology hence requires the acquisition of different types of knowledge: technical skills in computing for example, and an understanding of the unique qualities of information represented by *discrete data*, in digital images, compared to the *continuous* representation of information, as used in analogue (silver halide) imaging. It is clear that the need for new practices and alternative approaches will continue as the technology develops further. It is important, however, in trying to understand the new technologies, not to forget where it all started. Although technology has changed the way in which we produce and view images, much of the core science upon which the foundations of photography were built remains important and relevant. Indeed, some of the science has become almost more important in our understanding of digital systems.

THE IMAGING PROCESS

The word 'photography' is etymologically derived from the phrase 'to draw with light'. Modern electronic imaging techniques are commonly classed under the umbrella term 'digital imaging' to distinguish between them and more traditional silver halide photography; however, both encompass the same core principle: the use of light to produce a response in a light-sensitive material, which may then be rendered permanent and viewed as an image of the original scene. Detailed comparisons will be drawn between the analogue and digital processes throughout this book. Thus, an overview is presented below.

During image capture, light from a scene is refracted by a lens and focused on to an image plane containing a light-sensitive material. *Refraction* is the deviation of a light ray as it passes from one material to another with different optical properties, and is a result of a change in its velocity as it moves between materials of different densities (see Chapters 2 and 6). The effects of refraction can be seen in the distortion of an object when viewed from behind a glass of water. Figure 1.1 illustrates the refraction of light rays through a simple positive lens to produce an inverted image in sharp focus on the image plane.

The amount of light falling on an image sensor is controlled at exposure by a combination of aperture (the area of the lens through which light may pass) and shutter speed (the amount of time that the shutter in front of the focal plane is open). This relationship is described by the reciprocity equation: $H = Et$, where E is the illuminance in lux, t is the time of exposure and H is the exposure in lux-seconds. At each exposure level, a range of possible aperture (f-number) and shutter speed combinations will produce the same overall exposure. Choice of a particular combination will affect the depth of field and sharpness/motion blur in the final image. Traditionally a single increment in the scale of possible values for both shutter speed and aperture is termed a 'stop' (although many cameras offer half-stop intervals). Each change of a single stop in either aperture or shutter speed scale represents a halving or doubling of the amount of light falling on the sensor. The photometry of image formation is dealt with in detail in Chapter 6 and exposure estimation is the subject of Chapter 12.

Image formation occurs when the material changes or produces a response in areas where exposed, which is in some way proportional to the amount of radiation falling

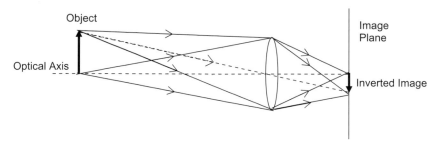

Figure 1.1 Image formation using a simple lens.

on it. In traditional photographic materials, exposed light-sensitive silver halide crystals (silver chloride, bromide or iodide) form a latent image (see Chapter 13). Latent in this context means 'not yet visible'. The latent image is actually a minute change on the surface of the exposed crystal, where a small number of silver ions have been converted to silver atoms, and is not visible to the naked eye. It is also not yet permanent. In an image sensor electromagnetic radiation falls on to pixels (a contraction of 'picture elements'), which are discrete light sensors arranged in a grid. Each pixel accumulates charge proportional to the amount of light falling on it.

After exposure, the image is processed. For simplicity we consider the monochrome process, as colour is discussed in more detail later in this chapter. In photographic chemical processing the latent image is developed (Table 1.1). During the development process silver halide crystals containing latent image are reduced to metallic silver. The silver forms tiny specks, known as photographic grains, and these appear as black in the final image. The full range of tones produced in a greyscale image is a result of different densities of clusters of grains, and the image density in any area is proportional to the amount of light that has fallen on it. The image tones at this stage will be negative compared to the original scene. After development time is completed the material is placed in a stop bath to prevent further development before the image is fixed.

In digital imaging, the processing will vary depending upon the type of sensor being used (see Chapter 9). In a charge-coupled device (CCD), the charge is transferred off the sensor ('charge coupling'), amplified and sent to an analogue-to-digital converter. There it is *sampled* at discrete intervals corresponding to individual pixels and *quantized*. Quantization means that it is allocated a discrete integer value, later to define its pixel value. The newer complementary metal oxide semiconductor (CMOS) image sensors perform this image processing on the chip and output digital values.

At this stage, the nature of the image represented by the two systems is quite different. In silver halide materials, the random arrangement of silver halide crystals in the photographic emulsion means that a *continuous* range of tones may be represented and silver halide methods are often referred to as *analogue* imaging. The digital image, however, is a grid of non-overlapping pixels, each of which is represented by an integer number that corresponds to its intensity. It cannot represent continuous tones in the same way as silver halide materials because the data are *discrete*. Various techniques, introduced later in this chapter, are therefore used to simulate the appearance of continuous tones.

The final step in the imaging process is image perpetuation, during which the image is rendered permanent. The silver halide image is made permanent by fixation, a process by which all remaining unexposed silver halide crystals are made soluble and washed away. A digital image is made permanent by saving it as a unique digital image file. The image is then output in some way for viewing, either as a print, a transparency or as a digital image on a computer screen. In silver halide processes this involves exposing the negative on to the print material and again processing and fixing the image. A comparison of the analogue and digital imaging processes is illustrated in Figure 1.2.

IMAGE CONTROL

By careful control of every stage of the imaging process, the photographer is able to manipulate the final image produced. Image control requires an understanding of the characteristics of imaging material and system, composition, the behaviour and manipulation of light, tone and colour, as well as the technical skill and ability to combine all of these factors for the required result. Such skills may be acquired by practice and experimentation, but having an understanding of the theory and the science behind systems and techniques allows true mastery of the process.

Control of image shape

When capturing an original scene, the photographer controls composition of the image to be projected on to the focal plane of the camera in a variety of ways. The *format* of the camera selected (the size of the image sensing area) will determine not only the design of the camera and therefore the capabilities of the system, but also the size, quality and aspect ratio of the final image. Large-format cameras (also known as *technical* or *view* cameras, with an image format of 5 × 4″) are designed to allow *camera movements*, physical manipulation of the two planes containing lens and imaging sensor separately, enabling the photographer to

Table 1.1 Monochrome photographic process	
PROCESS	**OUTCOME**
Exposure	Formation of latent image
Processing	
Development	Latent image amplified and made visible
Stop bath	Development stopped
Fixing	Unused silver halides converted into soluble compounds which dissolve in fixing agent
Washing	Soluble chemicals removed
Drying	Water removed

Original scene

EXPOSURE
IMAGE CAPTURE

SILVER HALIDE NEGATIVE-
POSITIVE PROCESS

CHARGE-COUPLED DEVICE

Exposed Film

IMAGE FORMATION

Invisible latent image -
containing both exposed
and unexposed silver
halide crystals

Exposed CCD

Charge accumulates
under pixels exposed to
light. No charge at
unexposed pixels

DEVELOPMENT

Film after Development

IMAGE PROCESSING

Developed image (silver
specks) and unchanged
silver salts

Digital Data

Response
proportional to light
exposure. Digital
values dependent
on bit depth of
system

CHARGE
TRANSFERRED OFF
CHIP, <u>AMPLIFIED</u>,
<u>SAMPLED</u> AND
<u>QUANTISED</u>

FIXATION

Film after Fixing Opaque

**IMAGE
PERPETUATION**

Developed image only -
a photographic
negative

Transparent

Pixel values in image file (8-bit)

Image file contains
header and digital
data (as a
minimum)
Examples: TIF,
JPEG, RAW, PSD

255	255	255	255	255
255	0	0	0	255
255	0	0	0	255
255	0	0	0	255
255	255	255	255	255
255	255	255	255	255

IMAGE OUTPUT

IMAGE PRINTED TO
PRODUCE POSITIVE

Image

PIXEL VALUES
CONVERTED TO
COLOUR VALUES IN
DESTINATION COLOUR
SPACE, TO BE USED BY
OUTPUT DEVICE FOR
COLOUR OUTPUT

Figure 1.2 Analogue and digital imaging processes.

change the size, magnification and perspective of elements on the plane of sharp focus. Image viewpoint is one of the key factors influencing composition, as this controls not only the positioning of different subjects and the perspective within the scene (the relationship between relative size and position of objects), but also whether the image is in portrait or landscape format (if using a rectangular image format). Chapter 11 covers camera movements and camera systems in detail.

Image shape is also controlled by the *focal length* of the lens being used. In a simple positive lens the focal length is the distance from the lens to the *rear principal focus*, defined

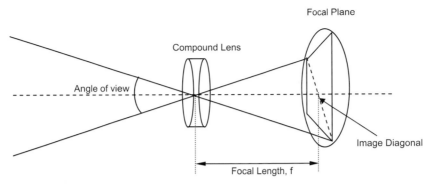

Figure 1.3 Angle of view of a lens.

as the point on the optical axis at which the lens brings a distant object to sharp focus. The focal length is determined by the curvature, thickness and *refractive indices* of optical components, and this in turn defines the angle by which light rays are deviated (*refracted*) as they pass through them. This determines the *field angle of view*, as illustrated in Figure 1.3. Geometric optics is the subject of Chapter 6.

The angle of view determines the amount of the original scene covered by the lens. Standard lenses for each format have an angle of view of around 50°. Wider angle lenses have shorter focal lengths and cover more of the original scene, hence often displaying distortion around the periphery of the image. Longer focal lengths cover a much smaller area of the original scene and may therefore show less off-axis curvilinear distortion.

Depth of field

Depending upon the lens focal length, there is a point of optimum focus in a scene that will be a particular distance away (depth) from the camera and will produce a sharp image exactly at the focal plane. There are also zones in front of and behind this point that will produce acceptably sharp images. This zone of sharp focus is referred to as depth of field and can be an important aspect of composition. A shallow depth of field will contain a small range of planes of sharp focus, all other planes being out of focus, hence isolating and emphasizing a subject of interest. Depth of field is influenced by lens focal length, distance to focused object, and also lens aperture.

Tone and contrast

As well as the position and size of scene elements, the photographer may also influence the composition by controlling the *tone* and *colour* of elements relative to each other. Tone in the original scene is defined by the intensity of light reflected from an object. The tone and contrast of the scene and reproduced image may be manipulated in a variety of ways, for aesthetic purposes, or to work within the limitations of a device or system.

Lighting control in the original scene

When white light reaches a surface, some wavelengths are absorbed and some are reflected or transmitted. Tone is controlled by the surface properties of the subject and the nature and intensity of the light source illuminating it. The *contrast* of the scene is the ratio between the brightest and darkest tones in the scene and the range of possible intensity levels in between, and may be controlled or manipulated at a number of stages in the imaging chain. Again, this is affected by the absorption characteristics of the surfaces being illuminated, but also by their position relative to the scene illuminants. Therefore the photographer can use lighting techniques to change image contrast. By adding light sources or changing the angle or distance of subjects relative to illuminants, the difference between highlight and shadow can be compressed or expanded.

The *tone reproduction* of a device or material describes how the range of intensities in the original scene is mapped to those in the final image (see Chapter 21). Tone reproduction is limited by many factors in the imaging chain, including the *dynamic range* of the image sensor – that is, its ability to record and represent a range of densities or intensities. Dynamic range in silver halide materials is also dependent upon exposure level. Selection of a particular type of film or image sensor will influence the range of possible tones at capture. Because both photographic and digital imaging processes involve an imaging chain containing multiple stages and devices, there are a number of points after image capture in which tone reproduction may be manipulated. Developing agents used in photographic processing, setting up and calibration of output devices, and selection of printing materials and processes all help to define the range of tones possible in the output image. Digital image processing software makes tonal adjustment simple and interactive through manipulation of image tonal curve or histogram.

Colour

Colour imaging involves an *analysis* stage in which the response of a sensor to narrow bands of wavelengths is recorded; it is followed by a *synthesis* stage, where the measured values are converted to a response in an output device, to produce a colour that matches to a certain degree the visual appearance of the original. The rendition of colour in an image, whether digital or analogue, is dependent upon a variety of factors. The complex mechanisms by which the human visual system perceives colour mean that no colour reproduction will be identical to the colours perceived in the original scene. The aim in colour reproduction is to produce consistent and acceptable colour, and is influenced by colour preference and 'memory colours', which are often quite different to the actual colour qualities of associated subjects. Fundamental colour science is introduced in Chapter 5. Colour reproduction is the subject of Chapters 22 and 23.

The colours recorded from an original scene are a combination of the wavelengths present in the illuminant (the spectral power distribution) and the spectral reflectance characteristics of the surface on which the light falls, coupled with the spectral responsivity of the sensor. Choice of light source and appropriate sensor are therefore important factors in determining final colour quality of the image. The wavelengths reaching the sensor can be altered by filtering the light sources using coloured 'gels' or using optical filters over the lens.

Colour reproduction through the imaging chain is managed by the selection of appropriate reproduction materials and devices. In photographic imaging, colour is manipulated by filtration at the capture stage (through the use of different colour-sensitive layers in emulsions) and also at the output stage (by filtration during printing). Digital image processing provides a powerful tool in the processing of colour in digital images, allowing simple manipulation of global colour balance, specific ranges of colours, or localized areas within the image. The many different stages in the digital imaging chain and the diverse range of devices and technologies available mean that colour translation between devices is complicated. The colour *gamuts* of input and output devices are highly device dependent, meaning that the same pixel value may produce different colours on different devices, depending upon their characteristics and age, and the way they are set up and calibrated.

This problem has led to the development of *colour management systems* (see Chapter 26), which manage the process of converting pixel values into the output colour values of different devices. To gain a proper understanding of digital colour management, a continually evolving discipline, requires some knowledge of colour science, the nature of light and the human visual system. Colour management relies on the absolute specification of colour as the human visual system perceives it. This specification (CIE colorimetry) is based upon experiments performed using human observers in 1931, many years before the extent of digital imaging today could be truly imagined. While colour management in a photographic system involves an understanding of colour filtration and the colour reproduction characteristics of a particular slide film or film/paper combination, digital colour management involves the careful calibration and characterization of all input and output devices coupled with an understanding of the different digital representation of colour through the imaging chain, and software to perform colour processing.

THE ORIGINS OF PHOTOGRAPHY

Camera obscura

Since the development of systematic schools of philosophy in Ancient Greece in around 500 years BC, man has found enduring fascination in attempting to understand the nature of light and its behaviour. In China at around this time, Mo Tzu, considered one of the first great Chinese philosophers, emphasized the importance of pragmatism in philosophical thought. His followers began measuring and observing the behaviour of light using flat and curved mirrors. It is believed that they also discovered the camera obscura, which was later further developed by Alhazen (AD965), a mathematician and physicist born in Basra, Iraq. The camera obscura produced the first projected images of the real world and may therefore be viewed as the starting point for photography. Camera obscura literally means 'dark chamber'. When light passes from outside a light-tight chamber or box through a pinhole, an inverted image is formed on the opposite surface. By the seventeenth century, the camera obscura had been adapted by placing a lens in front of the aperture and portable versions became a tool for painters, allowing them to accurately trace landscapes.

Early experiments

It was natural that the emphasis on developments in science and technology in Europe during the time of the Industrial Revolution (beginning in Britain in the latter part of the eighteenth century) would lead to attempts to try to 'capture' light and obtain a permanent image using the camera obscura. In 1727, Johann Heinrich Schulze, a German university professor, had discovered that light exposure caused silver nitrate to darken; this was an important step forward in the search for a light-sensitive material. In 1777, the Swedish chemist Karl Wilhelm Scheele observed the same effect using silver chloride. Thomas Wedgwood (1771—1805), son of Josiah, the famous potter, and Sir Humphrey Davy experimented with the use of paper soaked in silver nitrate placed in the camera

obscura. The images were not permanent, however, and a fixing agent was not found during Wedgwood's lifetime.

Towards the development process – the Daguerreotype

In 1822, a French physicist, Joseph Nicéphore Niépce, obtained the first permanent photographic image of a landscape. He was interested in trying to copy drawings on to transparent paper by producing a reproduction using some sort of light-sensitive material. He coated a pewter plate with asphaltum (a substance that hardens on exposure to light), exposed the plate, and then removed the remaining unexposed and unhardened asphalt in a solvent. Although crude, this was the first permanent photograph; he later used the same technique and then etched the pewter image using acid to produce a printing plate.

Niépce met Louis-Jacques-Mandé Daguerre in 1826. Daguerre was an artist, whose working life began as a theatre scenery painter, but he had progressed to painting large panoramic landscapes. He became interested in the blending of art and science in the experiments of Niépce. He had for some time been attempting to copy the images produced by the camera obscura and they now continued their investigations in partnership until Niépce died in 1833. Daguerre carried on with his experiments, but found the asphalt process slow, an image requiring an exposure of approximately 8 hours and he therefore concentrated again on using silver salts. With a coating of silver iodide on a silver backing, the exposure was reduced to as little as half an hour. This exposure produced an invisible *latent* image, which was then 'developed' over a tray of heated mercury before being fixed using common salt. He presented this process to a joint meeting of the Academy of Science and the Academy of Art in 1839 as the *Daguerreotype*, and it quickly became a commercial success. The process was further developed by the use of sodium hyposulphite, as a fixing agent. Sodium hyposulphite, which is the popular name for sodium thiosulphate, was discovered by Sir John Herschel in 1819 to be a solvent for silver halides and is still the basis of 'hypo' used today).

The length of exposure made the process more suited to still-life and landscape subjects; however, the earliest known photographic portrait was taken by an American, Samuel Morse, at around this time using Daguerre's technique. Despite the long exposures, portrait studios began opening throughout Europe and America, and the length of exposure was reduced to less than a minute by 1840 with the use of a new 'portrait' lens and a change from silver iodide to more sensitive silver bromoiodide.

The negative–positive process

During the same period, in England, William Henry Fox-Talbot was also experimenting with the camera obscura based on the work of Schulze, Davy and Wedgwood. Investigating both silver nitrate and silver chloride, he found that exposures could be dramatically reduced by using separate applications of silver nitrate and sodium chloride and exposing the paper while still wet. He called his methods *photogenic printing* and described them in a paper presented to the Royal Society shortly after Daguerre had unveiled the Daguerreotype in Paris. This was followed by the development of the *Calotype* process, which Fox-Talbot patented in 1840. The Calotype used paper sensitized in silver iodide and gallic acid to develop the image. This combination reduced the necessary exposure time to approximately a minute in bright sunlight. The key difference between this and the Daguerrotype was that where Daguerre had produced a positive image, Fox-Talbot produced the first paper negative, which was then contact printed to produce a positive. The images produced by this early negative–positive process, being from a paper negative, were not as sharp as the Daguerreotype and therefore did not gain the same commercial success in professional portraiture. The obvious advantage of a negative–positive process was that it became possible to obtain many reproductions from a single negative, and when compared to the 'one-shot' results of the Daguerrotype, meant that it quickly became the basis of modern photography.

Attempts were made to use the same technique using a transparent base to produce a sharper negative. Niépce de St Victor, also descended from Nicéphore, obtained good, but unreliable, results using albumen (egg white) to hold the silver halide on glass, but these were superseded by the development of the *wet-collodion* process by Frederick Scott Archer in 1851. Collodion, containing potassium bromide and potassium iodide, was coated on to a glass plate and allowed to set. The plate was then immersed in a silver nitrate solution in darkness, producing light-sensitive silver bromide and silver iodide. It was then placed in a holder, put in the camera and exposed. It was developed immediately following exposure using a solution of pyrogallol, vinegar and water, before being fixed in hypo, washed and dried. The technique relied on the collodion being wet and hence required the immediate processing of the plates before the solvents evaporated. This meant that location photography required a portable darkroom close to the camera and, with the weight of the glass plates, made photography a cumbersome process. Early wet-collodion negatives were printed on albumen paper, but collodion paper was soon produced before the first use of gelatin in printing paper in 1885.

Modern materials

The use of gelatin in photographic materials was first attempted in 1868, and by 1873 sensitized gelatin was available to photographers. Gelatin remains an important constituent of photographic materials today. As well as creating a fine suspension of silver halide crystals

throughout the emulsion, gelatin has certain special characteristics which enable and enhance the photographic process and to date no alternative has been found. Gelatin emulsions are made more light sensitive by heating, meaning that exposure time can be dramatically reduced. Additionally, the physical characteristics of gelatin mean that while it dissolves in warm water, making a solution easy to paint on to a backing such as a glass plate, it 'gels' as it cools, becoming hard if water is removed. The use of gelatin means that the sensitive material can be dry when exposed and need not be developed immediately if it is kept light-tight. Gelatin-based photographic materials quickly took over from the less convenient wet-collodion process, and indeed are still used in contemporary photography.

In 1885, Carbutt, of Philadelphia, produced the first sheet film using sheets of celluloid coated with the gelatin-based emulsion. Roll film quickly followed using a cast nitrocellulose base, developed by George Eastman and Henry Reichenbach, and alongside it a new camera, the Kodak, in 1888. This produced a circular image 2½ inches in diameter and 100 images. These two developments allowed photography to become not only more portable but also something that could appeal to the masses. Travel overseas was becoming a popular pursuit for those who could afford it and it was natural that these first tourists would want to record the diverse scenes they encountered.

These materials were the basis for modern materials, and their structures and properties have been refined rather than dramatically changed. Cellulose triacetate or acetate—butyrate is now commonly used as a film base, although some manufacturers use newer synthetic polymers, such as polyester. Film formats have changed as a result of developments in camera design, but the structure remains the same.

PHOTOGRAPHIC IMAGING TODAY

Modern photographic materials consist of an *emulsion* containing a suspension of light-sensitive silver halide crystals (chloride, bromide or iodide) in gelatin, coated on to a flexible and stable transparent plastic or paper backing (Figure 1.4). Control by the emulsion manufacturer of the physical characteristics of the material, such as the size, shape and surface area of the crystal, the nature of silver halides used, the arrangement and relative quantities of halides in a crystal, will affect the photographic properties of the emulsion in terms of contrast, speed, resolving power (resolution), sharpness and graininess. These subjects are dealt with in detail in later chapters; their influence on image quality and imaging system performance is the subject of Chapter 19.

Characteristics of photographic materials

The speed of a photographic material determines the exposure required to obtain a specific silver density, and is therefore necessary in exposure metering. Larger silver halide crystals have a higher probability of absorbing enough electromagnetic energy to form a latent image; therefore, higher speed films tend to have larger grain. A number of systems have been developed for the measurement of film speed; however, the one most commonly used is the International Organization for Standardization (ISO) standard system of arithmetic and logarithmic speeds. Black and white photographic materials are commonly available with arithmetic speeds from ISO 50 up to ISO 3200, with the increase in speed indicating higher sensitivity. Each time ISO speed is doubled, it represents a decrease of a single stop in required exposure. Monochrome film often contains two emulsion layers. Different silver halide crystals will be used in the two layers, the larger crystals reacting faster and therefore increasing the speed of the film. The finer crystals in the slower emulsion enhance the tonal range and are capable of recording finer detail. Speed and sensitivity are the subject of Chapter 20.

The image contrast describes the range and distribution of tones produced in the final image and will depend upon the original scene contrast ratio, but is also limited by the range of densities that the material can produce. A high-contrast material will produce an image containing mainly highlights and shadows with fewer mid-tones. A lower contrast material will record more information in the mid-tones and will have a smaller density range from minimum to maximum ('dynamic range'). The silver halide crystals in a single emulsion generally vary in size and distribution of sizes ('polydisperse'). The random dispersion of the crystals, and their number, size and shape, mean that a continuously varying range of tones can be produced, as

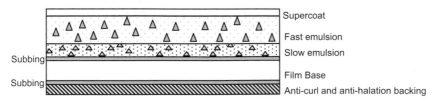

Figure 1.4 Structure of a monochrome photographic film.

different sized crystals will form latent images at different exposure levels. This will ultimately determine the contrast of the material. The material contrast can, however, be altered during photographic processing, by suitable selection of developing agents. Study of the tone reproduction characteristics of materials and systems are an important part of performance evaluation (see Chapter 21).

Developed silver specks in photographic emulsions tend to form random clumps as a result of their distribution and this leads to the visual effect of photographic grain. It causes a visual sensation of non-uniformity in an area of uniform tone similar to the effects of noise, and the subjective perception of this is referred to as 'graininess'. Graininess depends upon density level. At low densities, there is much less clumping and at high densities the visual system cannot distinguish between the individual grains; therefore, graininess is much more visible in mid-tones. The graininess of a negative is more important than that of a printing paper due to the enlargement required for printing. Granularity is an objective measure of the minute fluctuations of densities in an image. Factors during the development process such as developing agent and degree of development also affect image granularity.

The resolution of an imaging material determines its ability to represent fine detail. In practical terms it may be traditionally measured using *resolving power*. The resolving power of the entire system is affected by the characteristics of the imaging material and the optical limitations of the lens, and is measured in practice by imaging a test chart containing horizontal and vertical black and white closely spaced bars producing patterns of different frequencies. The smallest pattern that can be accurately resolved, i.e. where light and dark strips can still be differentiated, defines the highest *spatial frequency* that the sensor can represent and is often expressed in cycles per millimetre. The resolving power of the material is affected by the contrast, graininess and turbidity of the emulsion (the level and area of diffusion of light through a photographic emulsion as it is scattered by silver halide crystals). It is defined by the point spread function of the material, which describes the average size and shape of the dispersed image of a point of light in the emulsion.

Image sharpness refers to both the subjective impression produced by the image of an edge on an observer and an objective image measure. Fundamentally we judge the sharpness of an image at edges, which are localized areas of high contrast, containing a sudden decrease or increase in density. The turbidity of photographic emulsions, however, means that there is not an abrupt change but a gradual change as a result of light diffusion through the material. An objective measure that equates to sharpness is termed acutance and is evaluated by obtaining density profiles through the edge. Acutance depends upon the shape and spread of the edge. In photographic materials acutance is often enhanced as a result of chemical 'adjacency' effects at either side of the edge causing the dark side of the edge to be overdeveloped and the light side underdeveloped. Acutance is influenced by a number of factors, including type of developer, degree of development and type of emulsion.

A key difference between the first films developed towards the end of the nineteenth century and what is available today is their sensitivity to different wavelengths of radiation (spectral sensitivity). Silver halide materials have a natural sensitivity to the short wavelength end of the visual spectrum, including ultraviolet, violet and blue. These early photographic materials were therefore only capable of recording some of the light from the exposure and would not record longer green or red wavelengths. Images produced on these materials would represent blue objects as very light in tone and any objects containing green or red as very dark or black. Hermann Wilhelm Vogel, a chemist working with the collodion process in Berlin in 1873, discovered that by adding a minute amount of dye to the collodion, he could sensitize it to yellow light, producing better tonal rendition. These materials were known as *orthochromatic*. By 1905 *panchromatic* materials sensitive to the entire visible spectrum were available. Today, black and white materials sensitive to the far red and infrared regions of the electromagnetic spectrum are available.

Capturing colour

Isaac Newton first hypothesized that white light was made up of a mixture of wavelengths after observing, in 1664, the way in which a glass prism could split a beam of sunlight into a spectrum of coloured light. Using a second prism he found that he could recombine the dispersed light into a single beam of white light. He also discovered that it was possible to obtain light of a single colour by masking off the rest of the spectrum.

In 1802, Thomas Young showed that white light could be matched by an appropriate mixture of three lights containing a narrow band of wavelengths from the blue, green and red parts of the spectrum. He suggested that rather than the eye containing receptors for each hue, it contained only three different types of photoreceptors, each of which was sensitive to different wavelengths of light. His ideas were further extended by Hermann Von Helmholtz 50 years later, who showed, using colour matching experiments, that in people with normal colour vision, it was indeed possible to use only three wavelengths to create all other colours within the normal visible range. Helmholtz proposed that the receptors were sensitive to broad bands of short (blue), medium (green) and long (red) wavelengths. The combination of the responses of the three types of receptors would be interpreted by the brain as a single colour, the nature of which would be determined by the relative strength of response of each. This became known as the *Young–Helmholtz theory* of colour vision. The photoreceptors are known as *cone* receptors and

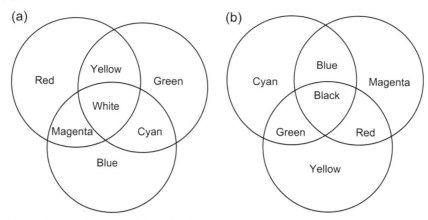

Figure 1.5 (a) Additive mixing of red, green and blue light. (b) Subtractive colour synthesis using cyan, magenta and yellow colorants.

are indeed sensitive to light from the three different parts of the visible spectrum as proposed (although this is a somewhat simplified version of the actual mechanism of colour vision, and is now recognized as only a single stage; see Chapter 5 for details of the *opponent theory of colour vision*). Red, green and blue are known as the *primaries*. The colour matching process is known as *trichromacy* and is the fundamental principle on which both photographic and digital colour imaging is based.

A Scotsman, James Clerk Maxwell, in 1861 demonstrated that this theory could be used as a basis for producing colour photographs. He produced three separate photographic images of some tartan ribbon by exposure through red, green and blue filters, which he then printed to produce positive lantern slides. Filters of the same colour as those used at image capture were then placed in front of their respective positives and when light was projected through them and the three images registered, produced a colour photograph of the original scene. This was an *additive* process of colour mixing, using the addition of light of the three primaries to produce all other colours. If equal amounts of the three primaries are added together then they will produce white light. Figure 1.5a illustrates the additive system of colour reproduction.

The three colours created by mixing any two of the primaries, cyan, magenta and yellow, are the complementary colours, sometimes called the secondaries, or subtractive primaries. Overlaying different amounts of these three colorants on paper is known as *subtractive* colour mixing. Subtractive methods are based upon the absorption of light, each secondary colour absorbing (or subtracting) light of the colour that is opposite to it in the diagram in Figure 1.5b, i.e. yellow absorbs blue, etc. When cyan, magenta and yellow are combined, they subtract all of the three additive primaries and black is produced.

After the development of panchromatic black and white film it was possible to produce emulsions sensitive to different wavelengths of light. It was proposed that

multilayer colour materials could be produced by adding substances to the emulsion that would produce coloured dyes on development. By adding an extra stage to the photographic process before fixation, in which the developed silver was bleached away, transparent coloured photographic layers were left. In 1935, Eastman-Kodak produced Kodakchrome, the first practical multilayer film, using this process.

Today the majority of both film and paper colour photographic materials are based upon the integral tripack structure, in which red-, green- and blue-sensitive silver halide emulsions produce layers of cyan, magenta and yellow dyes. These layers combine to subtract wavelengths of light from white light when it is projected through a piece of film, either when viewing a transparency or printing from a colour negative. In print materials the layers of complementary dyes subtract wavelengths from white light reflected off the white paper backing.

DIGITAL IMAGING

Early digital images

The first digital images were used in the newspaper industry. Pictures were sent by submarine cable across the Atlantic between London and New York in the 1920s, being reproduced at the other end using a specially adapted telegraph printer. They were digital in that the images were coded into discrete values and reconstructed using five levels of grey. The development of digital imaging into a process that can easily be used as an alternative to traditional photographic processes has, however, been reliant on the development of the computer. By the late 1970s cameras based upon the CCD as an image sensor had been developed to be used in research but they had not appeared in the public domain. The first electronic camera

available to the public was the Mavica, which was announced by Sony in August 1981.

The CCD was originally developed in 1934 as a shift register memory store in a computer. It is based upon the use of doped silicon, which is a *semiconductor*. At absolute zero (zero kelvin) it behaves as an insulator, but becomes an electrical conductor at room temperature if energy is applied to it. The CCD image sensor consists of metal oxide semiconductor (MOS) capacitors arranged in a grid, each corresponding to a pixel position. On light exposure an electrode on top of the capacitor causes an electric charge proportional to the light intensity to be collected in the silicon substrate underneath. Charge coupling occurs after exposure: the charge at a pixel position is transferred from one pixel to the next and transferred off the chip. The signal is then amplified, sampled, quantized and encoded to become a stream of digital data.

The development of digital computers began in the 1940s with ideas that would later be incorporated into the design of the central processing unit (CPU). Progressive developments of transistor, high-level programming languages, the integrated circuit, operating systems and the microprocessor led to the introduction of the first personal computer in 1981 (IBM). Developments in hardware and software have meant that now a large percentage of the population in Western countries have access to a computer, and are able to capture, view, manipulate and transmit images digitally.

Parallel to developments in computer technology, resulting in smaller components and more streamlined, sophisticated but user-friendly systems, digital cameras have become smaller and single area arrays have become larger. Image sensors were initially smaller than a full frame of the 'equivalent' photographic format, as they were expensive and difficult to manufacture in larger sizes. An early issue was therefore resolution, which was limited by pixel size but also by the size of CCD area arrays. However, the manufacturing process has improved dramatically, allowing full-frame equivalents to film formats in the last few years. In the consumer market, the smaller image format has meant that the image diagonal is reduced, and lenses can be placed closer to the sensor, resulting in camera bodies that have become progressively more compact. As electronic components have become more miniaturized, the processing on the camera has become more complex, allowing the user to select specific zones within the image to meter from, different metering modes, ISO speed ratings, white balance of neutrals, resolution, file format and compression. Less complex but even smaller digital cameras are now automatic features of most mobile phones.

The CMOS sensor

In recent years a new class of image sensor has been developed. Although still silicon-based technology, CMOS sensors differ from CCDs in that the charge is amplified and analogue-to-digital (AD) converted at the pixel site.

Digital data are then transported off the chip. The advantage of this is that each pixel can be read off the chip individually. CMOS sensors are also cheaper than CCDs to manufacture, less likely to contain defects and consume less power, which is of particular importance in a digital camera in terms of shutter lag and refresh time.

Because of the extra circuitry at each pixel site, the image sensing area of the pixel is smaller than the area of an equivalent CCD pixel. This means that the ratio of image signal to the noise generated by the electronic components is lower, and therefore images from early CMOS sensors were noisier and of lower quality than CCDs. Until a few years ago, CMOS image sensors were common in mobile phones but used less in digital cameras. Improvements in the technology and the use of advanced image-processing techniques on the sensor have meant that CMOS is now the choice in a number of high-end professional cameras, with full-frame area arrays equivalent to the 35 mm film format (for example, the Canon EOS 1DS Mark III, which has a 24×36 mm sensor containing approximately 21.1 million effective pixels).

Colour digital capture

Early digital cameras produced monochrome digital images, the sensor sampling intensities from the original scene. Trichromacy was used to produce colour in digital cameras using additive capture of three separate images corresponding to the red, green and blue content of an original scene. This was achieved by placing dichroic filters in front of three separate sensors that were exposed using a beamsplitter. This gave red, green and blue pixel values, which were then combined to represent the colour in the scene. Cameras based on this system are bulky however, as the camera body needs enough space to house the beamsplitter and three sensors. This system has been virtually replaced in the majority of digital cameras by the use of a single sensor on which coloured filters are overlaid. They are commonly arranged in a *Bayer* pattern, illustrated in Figure 1.6, and are each sensitive to a band of wavelengths of red, green or blue light.

After capture of a single value at each pixel site, values for the other two colour channels are created by interpolating between the values for each channel from surrounding pixels. The interpolation process produces estimates of the values that would have been produced if they were actually sampled; this does not improve resolution and as interpolation is an averaging and therefore a blurring process, (see Chapters 14, 24, 27) can result in a loss in image quality. A point to note in the Bayer array is that there are twice the numbers of green-sensitive pixels to those of red or blue. This feature is partly due to the fact that the peak sensitivity of the human visual system is to green light, at around 554 nanometres in normal daylight conditions, meaning that errors in the green channel are more noticeable to us than in the blue or red channels.

R	G	R	G	R	G	R
G	B	G	B	G	B	G
R	G	R	G	R	G	R
G	B	G	B	G	B	G
R	G	R	G	R	G	R
G	B	G	B	G	B	G
R	G	R	G	R	G	R

Figure 1.6 Arrangement of RGB sensors in a Bayer colour filter array.

A recent development in colour capture technology happened in the last ten years with the invention of the Foveon™ sensor, which in 2002 became available in the Sigma SD9 camera. The Foveon™ sensor has an arrangement much closer to that of integral tripack silver halide materials, making use of the fact that red, green and blue wavelengths of light penetrate to different depths in a silicon substrate. Values are captured for all three channels at every pixel site, meaning that it produces high-quality full-resolution colour images.

Other digital devices

The digital imaging chain consists of a number of devices other than the digital camera. The individual technologies and alternatives available in each stage of the imaging chain will be considered in more detail in later chapters. So far we have considered the digital camera as capture device; however, an alternative device for digital capture is the scanner, used to digitize photographic images. Flat-bed scanners were originally developed for the reflection scanning of print materials, although many now incorporate a transparency hood for scanning film materials. Dedicated film scanners provide higher quality scans from transparent media, as they are designed to record image data with a greater dynamic range (range of densities from shadow to highlight) than that encountered in print materials. Scanning film will always produce a better quality scan than scanning print, as the print is a second generation reproduction of the original scene. Drum scanners are at the professional end of the market, with the highest resolution and dynamic range. Like the digital camera, scanners use an RGB additive system of colour representation, with individual image sensors filtered for red, green and blue wavelengths of light.

A key device in the imaging chain is the computer monitor. Until recently it was based on cathode ray tube (CRT) technology developed from television systems, in which pixels are produced by different combined intensities of red, green and blue phospors. Today CRT displays have been largely replaced by alternative technologies, of which currently the most common is Liquid Crystal Display (LCD) technology. In LCD devices the image is formed from the combination of RGB filtered pixels illuminated by a backlight. The monitor is an output device and, like the digital camera and scanner, represents colour using the additive combination of RGB pixel values. Each pixel on screen is made up of a group of the three colours, sometimes termed a triad. Because the monitor is used for the viewing and editing of images, it is vital that it is set up and calibrated to produce accurate and repeatable colour.

The technologies available for digital print production are diverse; however, all use a subtractive system of colour reproduction, combining different amounts of cyan, magenta and yellow colorants deposited at pixel locations. In many, a black colorant is also used to produce accurate tones, rather than neutrals being created by maximum amounts of the other three colours. In recent years the range of possible colours capable of being printed (the colour gamut) has been extended by using extra inks, usually lighter versions of the other inks, as used, for example, in the six-colour Hexachrome™ process.

Image display devices and digital printers are the subjects of Chapters 15 and 16.

DIGITAL IMAGE REPRESENTATION

Finding methods to describe and evaluate images and image characteristics is at the heart of image science. We have thus considered the development of and differences in the analogue and digital imaging processes. To understand the implications of these differences, it is necessary to look at the way in which the two types of images are represented. The original scene may be described by a two-dimensional function $f(x,y)$, in which the (x,y) coordinates describe spatial position within the image frame and the function value is proportional to the intensity in that position in the original scene.

In a photographic imaging process the values of $f(x,y)$ may be represented by measured values of the density of silver at any location in the image. The position of measurement may be taken from anywhere in the image, and the density values also change continuously. This continuous range of represented tones is a result of the random distribution through the depth of the emulsion of tiny photographic grains overlaying each other. For this reason photographic images are referred to as *continuous-tone* images.

In a digital image, the image is represented by a grid of distinct non-overlapping pixels. Each individual pixel is addressed by its spatial coordinates in terms of rows and columns. The image function $f(x,y)$ is often replaced by the function $p(i,j)$, where i and j are the row and column

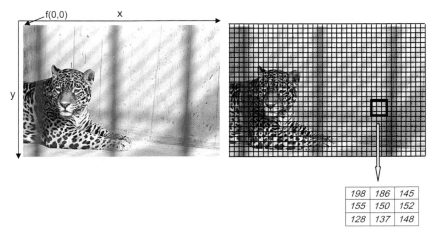

Figure 1.7 Analogue and digital image representation.
Original image from Master Kodak PhotoCD.

number and p is the pixel value. The pixels can only take particular values and are usually represented as a scale of integers. A colour image will have several values (usually a triplet such as RGB) representing each colour as a combination of the intensities of three channels. The pixel value means different things to different devices, for example the intensity of RGB coloured phosphors on a CRT, or the amount of CMYK coloured inks laid down by an inkjet printer. Figure 1.7 demonstrates this difference in representation between photographic and digital methods.

If a small area of smoothly changing tone in an image is represented by a function in which the *x*-axis represents spatial location across one dimension of the image and the *y* axis represents density, as if a cross-sectional slice had

been taken through it, a continuous-tone image function might look like the one in Figure 1.8a, whereas a discrete function might look like that in Figure 1.8b.

Note that the tones are inverted on the right-hand side compared to the discrete representation next to it, as high values in density relate to dark areas in the image, while high pixel values in a digital image indicate lighter values. The discrete spacing of image samples in the digital image produces a single tone at each pixel location and these values are also at discrete levels. The effect has been exaggerated by the low number of grey levels represented. The discrete spatial position and tonal values define two characteristics of the digital image, *spatial resolution* and *bit depth or grey level resolution*.

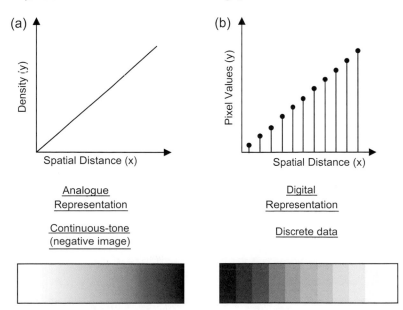

Figure 1.8 Continuous and discrete image functions.

Spatial resolution

In digital images, spatial resolution is a complex issue. The ability to represent fine detail is a combination of the number of pixels and the size of the pixels relative to the size of the imaging area. The resolution of the image is the number of pixels horizontally and vertically, and is defined at the beginning of the imaging process by the number of pixels on the original capture device, but it may be changed by up-sampling (interpolating) or down-sampling to resize the image. As well as the inherent resolution of the image, each digital device has its own resolution. Again, the input or output resolution in printers and scanners can be changed by interpolation. The resolution of input and output devices is commonly described in pixels per inch (ppi) or an equivalent measure such as dots per inch (dpi). The ppi of input devices is one factor limiting their ability to reproduce fine detail or high spatial frequencies.

Required output resolution depends upon the device being used. If an image is displayed on a computer monitor with groups of RGB phosphors representing each pixel at a spatial resolution of 72 ppi or above, then the eye perceives a continuous-tone image. For printed images higher resolutions are necessary. In many printing technologies 'half-tones' or 'digital half-tones' are used to create the illusion of continuous tone, by using groups of ink dots to represent a single pixel; this is described later in the book. In this case the actual number of pixels printed per inch may be defined in 'lines per inch', a line being a group of ink dots corresponding to a single pixel, terminology which has come from the press industry. The required printing resolution for the print industry is usually quoted as 300 dpi. It has been found that a resolution of around 240 dpi is adequate in printing using desktop inkjet printers. This subject is covered in more detail in chapters 16 and 25.

Spatial resolution has long been considered one of the major limitations of digital imaging compared to analogue processes; however, as the sensor technology is improving, pixel size is moving closer to that of photographic image point and digital sensor resolution is now considered adequate for many professional photographic applications.

Bit depth

A digital image is encoded as binary data, with a string of binary digits representing a single pixel. A binary digit (bit) can only take a value of 0 or 1 and the arrangement of digits will define the pixel value. The number of binary digits used for each pixel will define how many unique codes can be created and therefore how many different pixel values can be represented. For example, exactly 2 bits can produce the following four unique codes and no more – 00, 01, 10 and 11 – and can therefore be used to represent four values.

The visual importance of an adequate number of grey levels in a digital image can be clearly seen in Figure 1.9.

The image in Figure 1.9a, showing a 21-step grey scale, illustrates an interesting visual phenomenon. At the top of the grey scale, the greys change continuously, providing smooth gradation of tone from black to white. The bottom half of the grey scale shows a series of steps in tonal value, the visual differences between each pair all appearing equal. These steps have been produced from a digital image and the pixel values in each step in the middle and bottom strip of the grey scale are equal. In the horizontal region in the middle of the image the steps of single value have no white boundary between them. Yet the image appears 'scalloped' as if edges are between each step, with the area on the darker side of the edge appearing darker than the rest of its step and the area on the right-hand, lighter side appearing lighter than its step. This is believed to be caused by a 'sharpening' process carried out during the processing of the visual signal by the brain and the visual effect is known as *Mach banding*. In Figure 1.9b, which is represented by 5 bits per pixel (bpp), the noticeable jumps appear as contours over the whole of the image. Because the human visual system is so sensitive to jumps in tone, particularly in relatively uniform areas, the image values must be quantized to a fine enough level to produce the appearance of continuous tone (Chapter 21).

The number of different levels or pixel values that may be represented is defined by the expression Levels $= 2^b$, where b is the number of bits allocated per pixel. The maximum number of levels of intensity that can be differentiated by the human visual system at a particular luminance level has been approximated to 180; therefore, a greyscale digital

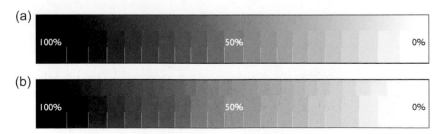

Figure 1.9 Bit depth and tone reproduction in digital images. (a) Eight-bit image = 256 grey levels. (b) Five-bit image = 32 grey levels.

image needs a minimum of this number of individual tonal values to appear as if it is continuous tone. An 8-bit pixel may take $2^8 = 256$ different values and this leaves some extra levels available for tonal manipulation and therefore an 8-bit image is the minimum standard used to produce photographic quality. The pixels in an 8-bit image are commonly displayed in image-processing applications in a range from 0 (black) to 255 (white). Modern capture devices often allow 16 bits per pixel for improved tonal rendition; however, the use of these may be limited by the functions available in image-processing software and the range of image file formats that will encode 16-bit images.

Colour representation

Colour images are represented by separate channels, each of which is allocated the same number of bits as the equivalent greyscale image. An RGB image can hence represent $256 \times 256 \times 256$ levels, which is approximately 16.7 million individual colours, using a total of 24 bits per pixel. RGB can also be represented by 16 bits per channel. Colour images can exist in a variety of colour spaces other than RGB, including CMY for printing. Colour spaces that are slightly more intuitive and easy to understand represent pixels in terms of hue, saturation and intensity (tone/intensity), and other variations of the same theme. The colour discrimination of the human visual system is not as sensitive as tonal discrimination and hence in certain applications it may be useful to separate tonal information from colour. Colour spaces such as the CIELAB colour space represent the image using three channels, in which a pixel has one coordinate for luminance and two relating to chroma, which represent red–green and blue–yellow opponent channels. Colour spaces and colour management between devices are dealt with in Chapters 23 and 26.

File size and file formats

The file size of a digital image is a function of the number of pixels and the number of bits allocated to each pixel. It is important to distinguish between the actual file size of the uncompressed raw data and the file size when the image is saved to a particular file *format*, which may be smaller or larger, depending upon which compression method is used and what other information the file contains, such as header, exif data, layers or alpha channels.

File size in bits = Number of pixels

× Number of bits per pixel

Dividing this figure by 8 converts the output to bytes; to convert to megabytes, divide by (1024×1024). The number of pixels depends upon required resolution, but to produce an image approximately equivalent to that of 35 mm film requires around 3072×2048 pixels. If this is a 24-bit RGB image then the file size = $3072 \times 2048 \times 24 = 18$ MB.

The size of digital image files has important implications in the imaging chain in terms of speed of transmission, image processing and storage. If the image is to be displayed on the internet, image file size is even more important in terms of the speed at which it must be transmitted. A reduction in either spatial resolution or bit depth will reduce file size with an associated reduction in image quality. A balance must be achieved between requirements to limit file size and optimum image quality. File size is, however, less of an issue than it used to be, as advances in computer technology mean that cheaper hard drives are now available with larger storage capabilities, small enough to be portable, parallel to developments of other portable storage media such as USB memory sticks. The widespread use of broadband to access the internet means that transmission of images is also quicker.

The different image file formats available have different qualities, which will be dealt with later in the book. The most useful formats are standardized, meaning that an image file can be opened in different applications and across platforms. Examples of commonly used standard or de facto standard storage formats include Tagged Image File Format (TIFF), Joint Photographic Experts Group (JPEG), Graphic Interchange Format (GIF), Photoshop format (PSD), and JPEG2000. They may be broadly divided into those that compress losslessly, such as TIFF, and those that apply lossy compression, giving a smaller file size with a loss in quality, such as JPEG. Compression is achieved by the removal of redundancy (unnecessary data or information) from the image, either by organizing it more efficiently or by the removal of less visually important information.

An important development in file formats has been the introduction of the RAW file. This is a file containing data that has undergone minimal processing before ADC. This is as close as possible to the data 'as seen' by the image sensor and can then be opened up in an image-processing software for more accurate processing before being converted to a standard format such as TIFF. Currently the RAW files captured by digital cameras are proprietary and different in structure and content; for example Canon uses CRW, Nikon uses NEF and Fujifilm, RAF. Individual conversion software is supplied with the camera to convert them, but it is likely that a standardized format will be used in future years and recent versions of Adobe Photoshop contain a plug-in converter, Camera RAW, which can convert the majority of different RAW formats.

Chapter 17 describes commonly used image file formats; image compression is the subject of Chapter 29.

IMAGING CHAINS

The imaging chain describes the stages, in terms of devices or processes, involved from original scene to final output.

ANALOGUE		DIGITAL
Camera + Film	IMAGE CAPTURE	Digital Camera or Scanner
Developed Film	PROCESSING	Amplification and conversion to digital data
Fixed Film	STORAGE	Digital image file written on magnetic or optical storage media
Optical Printing	MANIPULATION	Software
Mail / Courier	TRANSMISSION	Email, transport of storage media
Photographic Print / Slide	OUTPUT	CRT, LCD, Digital Print (various)
	VIEW	

Figure 1.10 Imaging chains.

The methods available to record, manipulate, store and transmit images are diverse and may be entirely based on traditional silver halide-based materials (here referred to as 'photographic') and techniques, or electronic processes using digital image sensors and devices. Inevitably, comparisons are made between the two types of system and the images produced, but to truly understand them is to realize that they are very different in nature and that sometimes direct comparisons are misleading. 'Hybrid' imaging chains contain aspects of both and can therefore combine some of the advantages of both. The concept of analogue and digital imaging chains is illustrated in Figure 1.10.

An example of a hybrid imaging chain acquires images on photographic film, which are then digitized in a film scanner, before being processed and output using an inkjet printer. This combines the initial quality of the film image, with the convenience of having a digital record of the image to process. An image on photographic material has a shelf-life based entirely on the physical properties of the material and the way in which it is stored. A digital image is simply an array of numbers and theoretically can be stored forever, as long as copies are archived. With the improvements in digital capture technology, it is likely that eventually an entirely digital route will become the most commonly used. However, alongside the move towards digital imaging chains the imaging process has turned full circle with high-end printing devices, such as the Fuji Pictrography™, having been developed, which 'write' digital images on to silver halide-based materials. As the colour layers are semi-transparent, the image has the colour and archival properties of photographic materials, but has been obtained and processed by the more immediate and versatile digital route.

In evaluating the merits of the two imaging chains, it is necessary to consider the different nature of image representation, alongside the processes involved. Photographic technologies are a known quantity, and photographic science is a well-established discipline in which a variety of performance measures have been developed, to allow evaluation of systems and materials. Photographic images are high quality and continuous tone, and the achievable

results are known and repeatable. However, chemical processing is messy, time-consuming, expensive and bad for the environment. It is likely that this will be a key factor in the eventual demise of the use of photographic materials and processes.

The discrete nature of digital data results in a trade-off between file size and image quality. Certain artefacts are inherent in digital data, as a result of its discrete nature. Artefacts may also be created as the image moves through the devices in the imaging chain, especially if lossy compression is used. The discrete nature of the data is also its strength, however, as the representation of the image by an array of numbers means that image processing is achieved by numerical manipulation. Consider this alongside the explosion in the use of the internet in the last 10 years. We are more and more accustomed to the immediacy of digital imaging, the ability to view images as soon as they are captured, real-time image processing on screen and fast transmission to the other side of the world over the internet. With each new development to improve image quality, digital imaging is set to take over from analogue in all but the minority of applications.

EVALUATING IMAGE QUALITY

Image quality is the subject of Chapter 19, hence only a brief introduction is given here. Image quality has been defined by Engeldrum (2000) as the 'integrated set of perceptions of the overall degree of excellence of an image'. Perceived image quality is the result of a complex interaction of the responses of the human visual system to a variety of image attributes. These attributes are not independent of each other; an increase in one attribute may serve to enhance or suppress the visual response to another and therefore it is logical to consider them as a whole. There are a number of physical attributes of images which may be measured and used as benchmarks for image quality and these are summarized in Table 1.2. It is

important to recognize that measurement of a single attribute provides a limited correlation with actual perceived image quality. A number of image quality metrics have hence been developed which take into account the combined effects of multiple variables.

Digital imaging has led to differences in approach to the measurement of image quality. This is partly because of the input of different disciplines in the development and evaluation of digital technologies and processes. The process of sampling means that there is a loss of information from the original scene simply because the image is digital. At all stages in the imaging chain, image data is manipulated and processed, causing artefacts and errors in the final result. Lossy compression also results in differences in the output image. A simple approach to the evaluation of an image or a process is to measure the difference between the original and the output image. A variety of measures of numerical differences such as mean absolute error, root mean square error and peak signal-to-noise ratio have been developed and applied in the evaluation of compression algorithms. These are generally termed *distortion metrics*.

Simple objective measures of image attributes do not always correlate well with subjective image quality. The weakness in such a straightforward approach is that the measures evaluate the imaging chain without the observer. A true measure of image quality must define the quality of the image as it appears to the observer. The quantification of subjective perception is termed psychophysics, which measures and describes the relationships between physical stimuli and subjective response. In psychophysical experiments, image quality is quantified by the responses of observers to changes in images, providing scales of values on which images are ranked, differences in the scale relating to perceived differences. Such experiments may investigate the effects of changing one or a multitude of image attributes, or the effect of changing the viewing conditions or environment, or may provide a scale of overall perceived image quality. Studies may be conducted to identify the point at which a change in an image is noticeable (just-noticeable difference) and relate it to

Table 1.2 Physical measures of image quality	
ATTRIBUTE	**PHYSICAL MEASURE**
Tone (contrast)	Tone reproduction curve, characteristic curve, density, density histogram, pixel values
Colour	Chromaticity, colour difference, colour appearance models
Resolution (detail)	Resolving power (cycles per mm, dpi, ppi, lpi)
Sharpness (edges)	Acutance, PSF, LSF, MTF
Noise (graininess)	Granularity, noise power spectrum, autocorrelation function, standard deviation, RMSE
Other	DQE, information capacity, file size, life expectancy (years)

changes in physical attributes. This is the measurement of *image fidelity*. The study of overall image quality involves observers identifying *preferred* image quality.

It is impractical for manufacturers to rely entirely on the results from psychophysical experiments alone, however, as they are time-consuming to set up, perform and analyse. Image quality metrics have therefore been developed to attempt to model the predicted response of human observers. By modelling the various responses of the human visual system and including such models in combination with other physical measures of image attributes in mathematical models, metrics can be used to measure image fidelity or image quality without the inconvenience of psychophysical experiments. Such metrics are tested against data from psychophysical experiments to see how much they correlate with perceived quality. Often a variety of metrics will be evaluated over the duration of an image quality study.

BIBLIOGRAPHY

Dainty, J.C., Shaw, R., 1974. Image Science. Academic Press, London, UK.

Engeldrum, P.G., 2000. Psychometric Scaling. Imcotek Press, Winchester, USA.

Gonzales, R.C., Woods, R.E., 2002. Digital Image Processing. Prentice-Hall, New Jersey, USA.

Graham, R., 1998. Digital Imaging. Whittles Publishing, Scotland, UK.

Hunt, R.W.G., 1994. The Reproduction of Colour. Fountain Press, Kingston-upon-Thames, UK.

Jacobson, R.E.J., Ray, S.F.R., Attridge, G.G., Axford, N.R., 2000. The Manual of Photography, ninth ed. Focal Press, Oxford, UK.

Keelan, B.W., 2002. Handbook of Image Quality: Characterization and Prediction. Marcel Decker, New York, USA.

Langford, M.L., Bilissi, E.B., 2007. Advanced Photography. Focal Press, Oxford, UK.

Neblette, C.B., 1970. Fundamentals of Photography. Litton Educational Publishing, New York, USA.

Chapter | 2 |

Light theory

Elizabeth Allen, Sophie Triantaphillidou

All images © Elizabeth Allen, Sophie Triantaphillidou unless indicated.

INTRODUCTION

The study of imaging must begin necessarily with an investigation into light. An understanding of light in the context of imaging includes its function and interactions throughout the imaging chain: its emission from a light source, reflection and absorption by surfaces within a scene, detection and transformation by an image sensor (which may be the human eye) and finally its interpretation. Alongside physics, a number of other scientific disciplines are involved, including biology, physiology, chemistry and psychology, each of which has contributed to the various theories that have developed in the history of light theory.

This chapter, introduces optics, the branch of physics describing the behaviour and properties of light. Optics can describe light in terms of how it is emitted and how it interacts with other matter, for example its deviation when moving from air into a more dense transparent medium such as the glass of a lens, how it behaves when moving through a small aperture or round the edge of an object, or how it is scattered by the earth's atmosphere. It also explains how light energy may be transformed into other forms of energy, such as electrical or chemical energy, when it hits an image sensor. Further optics is the subject of Chapter 6.

A BRIEF HISTORY OF LIGHT THEORY

Understanding the nature of light has played an important role in the history of science. The following chronology is incomplete, but summarizes some of the key ideas that have led to modern scientific understanding of light:

- Around 500 BC the ideas of a number of the great Greek philosophers fell broadly into two main schools of thought. They were more related to the mechanism of vision, and the relationship between light, observed objects and the eye. *Tactile theory*, suggested by Empedocles and further developed by Plato, modelled light as something emitted from the eyeball capable of touching things too far away to be physically touched by the observer. *Emission theory*, proposed by Pythagoras among others, postulated that light was a stream of particles emitted from all objects which bombarded and caused pressure on the eye. At the time emission theory was not widely accepted, but led later to the theories of the 'atomists', who believed that everything was made up of minute indivisible particles — atoms. For over a thousand years, tactile theory was widely accepted, despite its inability to explain certain phenomena, such as the reason that some bright bodies were able to light up neighbouring bodies.
- Around AD1000, Alhazen, a scholar and astronomer from Basra, established that light was external to the eye, and the tactile theory was finally rejected. Alhazen studied optics, and the behaviour of light moving in a straight line, establishing the Law of Reflection (page 104).
- A revised interest in the study of optics in Europe after the thirteenth century led to the development of the refracting telescope. In 1621 Willebrord Snell developed the Law of Refraction, also known as Snell's Law (page 104). Descartes independently derived the same law in 1637.
- Isaac Newton (1642—1727) considered light to be a stream of moving particles and this became known as *corpuscular theory*. The theory suggested that the particles travelled in straight lines, providing an explanation for

DOI: 10.1016/B978-0-240-52037-7.10002-X

both reflection and the casting of shadows. Famously, Newton also used a prism to *disperse* white light and concluded correctly that white light is made of a mixture of colours.

- Francesco Grimaldi (1618—1663) observed that shadows were slightly smaller than predicted due to 'fringing' at the edges (*diffraction* effects).
- Robert Hooke (1635—1703) proposed that light travelled in the form of a wave rather than a particle, which allowed diffraction effects to be explained as a result of constructive and destructive interference of the waves.
- Christian Huygens (1629—1695) further developed the idea that light was a wave in a universal medium, the 'aether'.
- Thomas Young (1773—1829) experimented with shining coherent light through a pair of closely spaced slits in a screen to produce a diffraction pattern of bright and dark fringes. The results could not be easily explained by particle (corpuscular) theory and led him to further develop the wave theory of light, with the Principle of Interference. He was able to explain Newton's results with dispersion of white light through a prism in terms of wave theory and even determined wavelengths for the colours.
- Michael Faraday (1791—1867) first established a relationship between light and electromagnetism. James Clerk Maxwell proved theoretically that electric and magnetic fields could continually propagate one another, travelling as a wave at a specific speed, close to experimentally determined values for the speed of light. This was a huge advance — enough to allow the theory that light was an electromagnetic wave to replace Newton's corpuscular theory.
- In 1900 Max Planck, investigating black body radiation (page 38), proposed that light energy was always emitted in multiples of certain energy units, or *quanta* (a quantum in physics refers to an indivisible unit of energy), although he maintained his belief that light was a continuous wave of electromagnetic radiation.
- In 1905 Einstein, following his work on the *photoelectric effect* (page 39), went further, suggesting that light was emitted in the form of localized particle-like packets of energy, later called *photons*.

WAVE—PARTICLE DUALITY

As is evident from the chronology, the issue of whether light is a wave or a particle has been an ongoing theme in the study of the nature of light. Although wave theory was generally accepted as a result of the work of Maxwell, there remained questions in terms of light's behaviour under certain circumstances that wave theory could not easily explain. It became clear that the concepts of light as particles and waves, which had seemed mutually exclusive, must both be considered when viewing the world at a submicroscopic level.

The work of Planck and Einstein initiated the development of quantum theory and quantum mechanics in physics, which centre around the fundamental idea that energy is not continuous but exists in discrete quantities. It is now accepted that a complete understanding of the nature of light must recognize both wave and particle theories as valid. This is termed *wave—particle duality* and is extended in current scientific theory to all matter at a quantum level: the idea that any object existing in the form of particles must also exhibit wave-like behaviour.

THE NATURE OF LIGHT

Light is a form of *electromagnetic radiation* (or *radiant flux*), which is emitted from various sources, most obviously the sun. Electromagnetic radiation is a *self-propagating* wave of energy which travels through empty space at a particular speed and consists of oscillations in electric and magnetic fields. As established by Maxwell, all electromagnetic radiation travels at the same speed in *vacuum*,[†] that is approximately $2.998 \times 10^8 \mathrm{~m~s}^{-1}$.

When electric charges move, they are accompanied by a magnetic field. If the charges accelerate or decelerate, then disturbances occur in both the electric and magnetic fields and radiation is emitted in a wave motion, carrying energy away from the disturbed charges. The fields oscillate at right angles to each other. They are also at right angles to the direction in which the wave is moving. Furthermore, electromagnetic waves exhibit rectilinear propagation — that is, a single point on a wave, if unimpeded, is propagated in a straight line.

Electromagnetic radiation exists at a wide range of wavelengths or frequencies and these are collectively termed the *electromagnetic spectrum* (see page 35). In general, in photography and digital imaging we are more correctly referring to the *visible spectrum* — that is, the range of wavelengths of electromagnetic radiation that are detectable by the human visual system. However, there is a range of imaging processes, more commonly employed in scientific imaging, that use non-visible electromagnetic radiation, such as ultraviolet or infrared radiation and X-rays, all of which have wavelengths outside the visible range.

Upon examining the behaviour of electromagnetic radiation in its interactions at a subatomic level, the wave model is no longer adequate, as it implies that radiation is continuous. As originally proposed by Planck, energy can

[†] The speed of light is defined in a perfect or absolute vacuum. Absolute vacuum does not exist in reality. The speed of light in a vacuum is therefore a theoretical concept.

only be transferred in discrete amounts or quanta. Electromagnetic radiation may thus also be represented as a stream of individual quanta of energy or photons. A beam of light may be envisaged as a huge quantity of photons of energy travelling at the speed of light. The energy associated with a photon is related to the frequency of the electromagnetic radiation (see page 40). Photons may be scattered if they collide with other particles; they may also be *emitted* or *absorbed* by charged particles such as electrons. We cannot see individual photons but we may observe the results of absorption or emission.

RADIOMETRY AND PHOTOMETRY

Radiometry and photometry are scientific disciplines concerned with the measurement of electromagnetic radiation. Radiometry involves the measurement of quantities of radiation from any part of the electromagnetic spectrum and therefore includes the ultraviolet, visible and infrared regions of the spectrum. Photometry, by contrast, deals with the measurement of radiation as it is perceived by the human visual system and therefore only deals with visible light, wavelengths 360–770 nm. This is achieved by weighting the radiant power at each wavelength by the average response of the human visual system to light of different wavelengths.

Radiometric and photometric measures usually quantify one of the following:

- *Energy*, which is a property possessed by a system that allows it to do work.
- *Power* or *flux*, which is the rate at which work is done or energy is converted.

Radiometric definitions

Radiometric definitions and units are summarized in Table 2.1.

Photometric definitions

Photometry takes into account the unequal response of the human visual system to different wavelengths. This process is accomplished by multiplying the measured values by the relevant value of a standard function, $V(\lambda)$, wavelength by wavelength. $V(\lambda)$ is the CIE *spectral luminous efficiency function for photopic vision* (see Chapter 4), which is a plot of the average relative response of the human visual system against wavelength. The $V(\lambda)$ function is used as a spectral weighting function to convert radiometric quantities to photometric quantities via spectral integration:

$$\Phi_v = \int_\lambda \Phi(\lambda) V(\lambda) d\lambda \qquad (2.1)$$

where Φ_v is the photometric quantity defined by the corresponding radiometric quantity in the calculation.

The equivalent photometric definitions to those given in Table 2.1 are summarized in Table 2.2.

See also Chapter 3 for further definition of luminance, luminous intensity and luminous flux.

OPTICS

The study of the behaviour and properties of light and the way in which it interacts with matter is termed optics. The

Table 2.1 Radiometric definitions and units		
QUANTITY	**DEFINITION**	**SI UNITS**
Radiant energy	The amount of energy transferred in the form of electromagnetic radiation	Joules (J)
Radiant flux	The rate of flow of energy per unit time. This is sometimes called *optical power* or *radiant power*	Watts (W)
Radiant flux density	The radiant flux per unit area on a surface. There are two cases: **Irradiance** – the radiant flux *incident* on the surface per unit area **Radiant exitance** – the radiant flux exiting from a unit area on the surface in all directions. *Radiant emittance* and *radiosity* are older terms (no longer used) for radiant exitance	Watts per square metre (W m^{-2})
Radiant intensity	The radiant power emitted from a point source per unit solid angle	Watts per steradian (W sr^{-1})
Radiance	The radiant power per unit solid angle per unit projected source area	Watts per steradian per square metre (W sr^{-1} m^{-2})

Table 2.2 Photometric definitions and units

QUANTITY	DEFINITION	SI UNITS
Luminous energy	The amount of electromagnetic energy that is part of the visible spectrum	Lumen second (lm s)
Luminous flux	The rate of flow of energy (weighted for visible wavelengths only) per unit time, emitted by a source in all directions. Also called *luminous power*	Lumen (lm)
Luminous flux density	The photometrically weighted radiant flux per unit area on a surface. There are two cases: **Illuminance** — the total amount of visible light *incident* on a point on the surface per unit area. *Illumination* is an older term (no longer used) for illuminance **Luminous exitance** — the visible light exiting from a unit area on the surface in all directions. *Luminous emittance* is an older term (no longer used) for luminous exitance	Lux (lx) (lumens per square metre, lm m^{-2})
Luminous intensity	The luminous flux emitted from a point source per unit solid angle in a particular direction	Candela (cd), also expressed as lumen per steradian (lm sr^{-1})
Luminance	The luminous power per unit solid angle per unit projected source area	Candela per square metre (cd m^{-2})

various areas of optics may be broadly classed according to the different models used to explain the particular properties.

Physical or wave optics models the propagation of light through an optical system as a complex wavefront. When a wavefront reaches an obstacle it may change direction, resulting in interference between different wavefronts.

Geometrical optics discounts the wave nature of light and studies its propagation in terms of rays. The path of any single point on the wavefront referred to above is a straight line with direction perpendicular to the wavefront. Hence we say that light travels in straight lines, in rays. The concept of light rays is helpful in studying the formation of an image by a lens.

Both are branches of classical optics and use approximations to model the behaviour of light. Physical optics successfully explains the diffraction, interference and polarization of light. Geometrical optics models the path of a ray of light as it moves through an optical system and may be used to describe reflection and refraction, which form the basis of imaging by lenses and are fully described in Chapter 10.

Quantum optics considers radiation in terms of quanta of energy. The effects of this are only evident at an atomic or subatomic level with the emission or absorption of light energy by matter, for example by a photographic emulsion or silicon in a digital sensor.

Aspects of wave theory, physical optics and quantum optics are covered in more detail in the remainder of this chapter.

WAVE THEORY

Many of the properties of light can be described by the fact that it takes the form of a wave, i.e. a disturbance that propagates in space. The family of waves that propagate in the same fashion as light waves are termed electromagnetic waves; therefore, the wave nature of light is described here in the context of electromagnetic theory. Where sound waves propagate in a mechanical fashion through matter — for example, air, rock and water — electromagnetic waves are self-propagating, waves travelling freely in empty space (the so-called vacuum) with a maximum velocity, c, of approximately 2.998×10^8 metres per second (or 300,000 kilometres per second). In media denser than a vacuum, electromagnetic waves slow down. In air the velocity is nearly the same as in a vacuum, but in water or glass it is reduced to about two-thirds of its value in a vacuum.

Sound waves are longitudinal, i.e. they oscillate along the direction of propagation of the wave; electromagnetic waves, however, are transverse waves, and oscillate in a direction perpendicular to the direction of propagation. According to Maxwell, at the speed of light electromagnetic waves oscillate in two planes, the electric field and the magnetic field planes, at right angles to each other and to the direction of propagation. The oscillation is generally described as sinusoidal (see below). Figure 2.1 shows an electromagnetic wave *at a fixed instance of time*, with the direction of propagation x, the electric field vibrating in

Electric field

Magnetic field

Distance

Amplitude

Figure 2.1 An electromagnetic wave at a fixed moment of time.

direction y and the magnetic field vibrating in direction z. The maximum displacement from the normal x, which corresponds to the crest or trough of the wave, is termed the *amplitude* of the wave, a. At any given time, the amplitudes of the two fields are proportional and their oscillations are always *in phase* (see below). In practice we cannot observe the oscillations as they occur far too fast. We observe the power transmitted by the light beam, averaged over a long time (millions of oscillations). This average power is the light intensity measured by light detectors. The amplitude of the light waves is related to the intensity of the radiation; in light waves it is related to the intensity of light.

Simple harmonic motion

The simplest regular waveform is known as *simple harmonic* or *sinusoidal motion*; it follows the profile of a cosine or a sine curve. Any complex waveform can be constructed by a superposition of harmonic waves (see Chapter 7). The regular oscillatory movement of simple harmonic motion generates a sinusoidal waveform and is that of the projected motion, S_y, of a point, S, rotating at constant (angular) speed in a circle. Figure 2.2 shows the point S moving around the circle, its path projected on segment

AB and the generated waveform as a function of time, t. The radius of the circle gives the amplitude, a. The time of completion of one rotation (i.e. an angle of 2π radians) is the wave's *temporal period*, T.

To visualize the generation of a sinusoidal waveform, consider the point of initial oscillation is affixed to a flexible cord (see Figure 2.3). The up and down movements transmit the signal to each point on the cord, and energy moves along, forming the waveform. During the motion from O to A, back to O, to B and back to O, one complete oscillation occurs. During the time required for such an oscillation, (the temporal period, T) the wave is propagated along axis x and travels a distance equal to the *wavelength* (or *spatial period*) of the wave. The wavelength is denoted by the Greek letter λ (lambda). Points on the cord separated by a distance equal to (or any multiple of) λ, such as S_1 and S_2 in Figure 2.3, will have the same displacement. These points are *in phase*. The customary unit of λ in light waves is the nanometre, where $1 \text{ nm} = 10^{-9}$ m, but the micron ($1 \text{ μm} = 10^{-6}$ m) and the older angstrom ($1 \text{ Å} = 10^{-10}$ m) are also used.

The distance the wave travels during T depends on the velocity of the wave in the particular medium. The velocity V and the wavelength λ are connected by the fundamental equation of wave motion:

$$\lambda = VT \qquad (2.2)$$

For electromagnetic waves in a vacuum, $V = c$ (i.e. the speed of light) and thus Eqn 2.2 becomes:

$$\lambda = cT \qquad (2.3)$$

The number of complete oscillations per unit time, usually per second, is the *temporal frequency*, usually denoted by the Greek letter v (nu),[‡] and measured in hertz (Hz; the SI unit of frequency), after the German physicist Heinrich Hertz. It is equal to:

$$v = c/\lambda \qquad (2.4)$$

which indicates that the speed of light equals the frequency times the wavelength.

A true sine wave is infinite in space and time. From this ideal, one can then consider a frozen episode in time (e.g. in Figure 2.1) or a fixed position in space (e.g. Figure 2.3).

Another quantity related to harmonic waves is the spatial frequency, f, which describes the number of waves (or cycles) per unit length:

$$f = 1/\lambda \qquad (2.5)$$

The spatial frequency, f, for space is the equivalent of temporal frequency, v, for time.

Now let t in Figure 2.2 be the time required for the rotation of S from S_0 (the origin of the circle) and S_0OS the

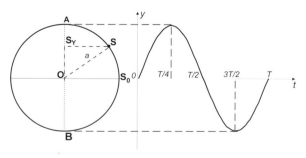

Figure 2.2 Simple harmonic motion as a function of time, t.

[‡] This should not be confused with the English character v, which is used as a symbol of *phase velocity* introduced later in this chapter.

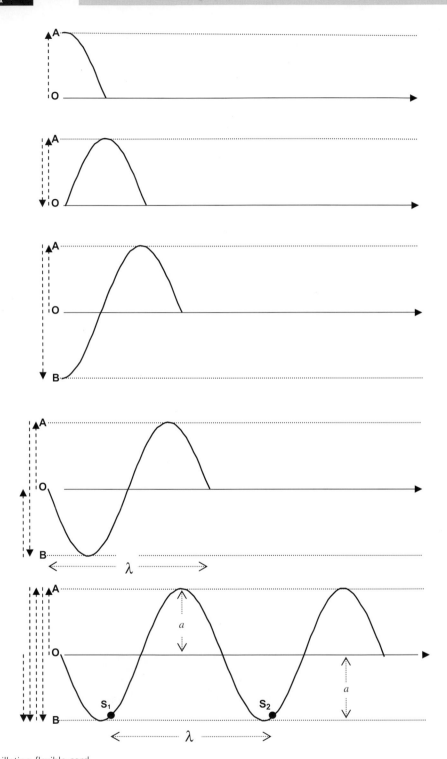

Figure 2.3 Oscillating flexible cord.

angle covered during t. The related harmonic wave is expressed by:

$$y = a \sin(S_0OS) \quad (2.6)$$

or by:

$$y = a \sin(\omega t) = a \sin\left(\frac{2\pi t}{T}\right) = a \cos\left(\omega t - \frac{\pi}{2}\right) \quad (2.7)$$

where a is the amplitude of the wave, t is time and ω is the *angular temporal frequency* (often referred to as *angular speed* and measured in radians per second). ω is given by:

$$\omega \equiv 2\pi/T = 2\pi v \quad (2.8)$$

Equation 2.7 indicates that a cosine wave has a *phase difference*, ε, equal to $\pi/2$ radians from a sine wave.

If the wave in Eqn 2.7 is expressed as a function of space rather than time, then:

$$y = a \sin(kx) = a \sin\left(\frac{2\pi x}{\lambda}\right) = a \cos\left(kx - \frac{\pi}{2}\right) \quad (2.9)$$

where k is a positive constant known as the *propagation number* (equivalent to ω) and is measured in radians per metre. The propagation number for any waveform is obtained by:

$$k = 2\pi/\lambda \quad (2.10)$$

Figure 2.4 shows the harmonic function described as a function of space, x, and of phase, ϕ. One wavelength therefore corresponds to a change in phase ϕ of 2π radians (rad) or one cycle.

The wave in Eqn 2.7 can be transformed to a *progressive wave*, travelling with a velocity V in the positive direction x. At a distance x from its source the time difference will be x/V seconds (since $V = tx$); therefore, replacing t by $t - (x/V)$ transforms Eqn 2.7 to:

$$y(x, t) = a \sin\left(\frac{2\pi}{T}\right)\left(t - \frac{x}{V}\right) \quad (2.11)$$

The wave is then periodic in both space (x) and time (t). The spatial period is the wavelength, λ, and T is the temporal period, corresponding to the amount of time taken for one complete wave to pass a stationary observer. Holding either t or x fixed results in a sinusoidal disturbance.

Definitions of the variables associated with harmonic waves are summarized in Appendix A. There are a number of alternative equivalent expressions that can be used for travelling harmonic waves; these are also summarized in Appendix A.

Simple harmonic waves have a single constant frequency (and single wavelength) and are therefore *monochromatic*, the *monochromatic wave equation* being given by any of the expressions above. For example:

$$\Psi(x, t) = a \cos 2\pi\left(vt - \frac{x}{\lambda}\right) \quad (2.12)$$

$\Psi(x, t)$ can be thought of as the *electric field strength*. The frequency is v so that $c = \lambda v$. As t increases, the whole wave moves to the right with velocity $c = \lambda v$.

In reality, electromagnetic waves are never monochromatic, instead consisting of a band of frequencies. Even 'perfect' sinusoidal generators emit waves encompassing a narrow band of frequencies and are said to be *quasimonochromatic*.

Principle of superposition

When two (or more) separate waves travelling in the same medium and at the same time meet, they will overlap and simply add or subtract from one another, then move away from this location unaffected by the encounter. The resulting disturbance at each point in the overlapping region is the algebraic sum of the separate disturbances at this location. This is known as the *principle of superposition*, given by:

$$y = y_1 + y_2 \quad (2.13)$$

where y is the resultant wave and y_1 and y_2 the two interacting waves. Figure 2.5 illustrates examples of the superposition of sinusoidal waves.

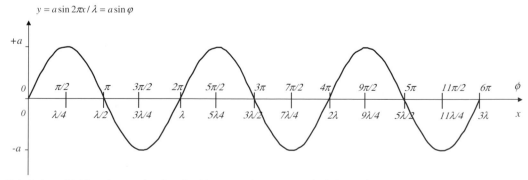

Figure 2.4 A sinusoidal function can be described in terms of space, x, and of phase, ϕ.

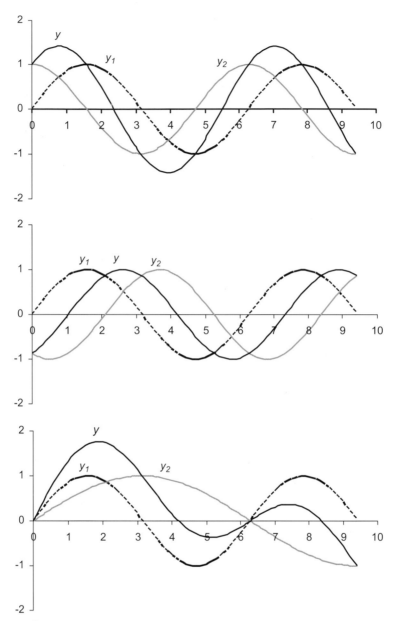

Figure 2.5 Superposition of waves, $y = y_1 + y_2$. Top: the superposition of two waves with the same wavelength, the same amplitude and a phase difference of $\pi/2$. Middle: the superposition of two different waves with the same wavelength, the same amplitude and a phase difference of $2\pi/3$. Bottom: the superposition of two waves of different wavelengths and the same amplitude.

In electromagnetic theory, light is described as a super-position of waves of different wavelength and polarization (see later) moving in different directions. The principle holds for waves travelling in *non-dispersive* media, i.e. a vacuum, where all frequencies travel with the same speed. If the medium was dispersive then their shape would change after the encounter. The superposition principle is also valid when the amplitudes involved are relatively small — linear superposition — and do not affect the medium in a non-linear fashion, as for example in the case of extremely high intensity light sources. Most optical phenomena, such as *interference*, *diffraction* and *polarization*, involve wave superposition in one way or another.

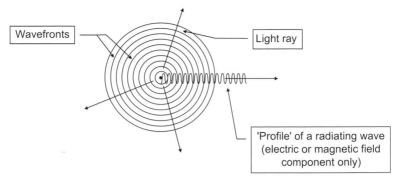

Figure 2.6 Point source in the centre and waves radiating outwards like waves on a pond. Wavefronts are planes with separation equal to one (or multiples of a) wavelength.

Plane waves

Up to this point wave motion has been considered as a one-dimensional vibration. Real light waves travelling in an isotropic homogeneous medium spread out at the same speed in all directions. Thus we need to consider light waves propagating out from a point source in three dimensions, similar to water waves moving out from a co-central point in a pond. At any given time, the surfaces on which the disturbance has *constant phase* (e.g. peaks of the co-sinusoidal oscillations) form a set of planes in space. The planes are referred to as *wavefronts* (see Figure 2.6).

According to Huygens, every point on a wavefront is considered to be a new point source, from which secondary 'wavelets' spread out in a forward direction. The surface which envelops all these wavelets forms a new wavefront, as illustrated in Figure 2.7. The advancing wave as a whole may be regarded as the sum of all the secondary waves arising from points in the medium. This continues as long as the medium remains *isotropic* (i.e. has the same properties in all directions) and *homogeneous* (i.e. has the same properties throughout its mass), both of which are true for most optical media. The straight line of propagation or of 'energy flow', which is always perpendicular to the wavefront, is considered as a light *ray* and many optical effects assume light as rays (as in geometric optics).

The plane wave is the simplest representation of a three-dimensional wave (Figure 2.8a), where wavefronts are parallel to each other and perpendicular to the direction of propagation. Light propagating in plane wavefronts is referred to as *collimated light*. Far enough from the source a small area of a spherical wavefront − described above − resembles a part of a plane wave, as illustrated in Figure 2.8b.

The mathematical description of a monochromatic (i.e. single constant frequency) plane wave is the vector equivalent of the expressions describing the simple harmonic motion (see definition in Appendix A).

Light intensity

In practice, the wave oscillations are not usually observed, as their frequency is too high. We observe the power transmitted by the light beam, averaged over some millions of oscillations. The instantaneous light power is proportional to $\Psi^2(x, t)$:

$$\Psi^2(x, t) = a^2 \cos^2 2\pi\left(vt - \frac{x}{\lambda}\right) \qquad (2.14)$$

The average of this over a long time is equal to the light intensity, or *irradiance*, I, which is proportional to the square of the amplitude, a, of the electric field:

$$I = \frac{1}{2}a^2 \qquad (2.15)$$

This is the quantity measured by light detectors.

Refraction and dispersion

As mentioned in the introduction to wave theory, electromagnetic waves slow down when travelling through media denser than vacuum. A measure of this reduction in speed

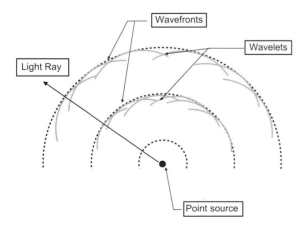

Figure 2.7 Propagation of light as wavefronts and wavelets.

(a) 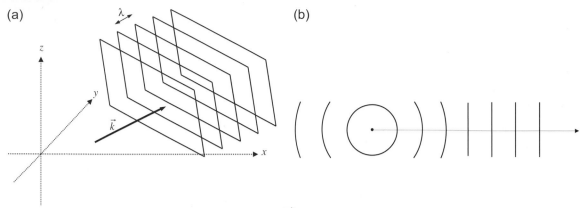 (b)

Figure 2.8 (a) The progression of a plane wavefront. The vector \vec{k} denotes the direction of the plane wave. (b) Far away from a point source a portion of a spherical wave is described as a plane wave.

in transmitting materials such as air, glass and water is the *refractive index n*, which increases with the density of the medium. It is given by:

$$n = \frac{c}{v} \qquad (2.16)$$

where v is the *phase velocity* of radiation of a specific frequency and is equal to:

$$v = \frac{\omega}{k} \qquad (2.17)$$

ω and k are as before. The refractive indices at a wavelength of 598 nm for vacuum, air and crown glass are 1.0, 1.0029 and 1.52 respectively.

When light waves travel between transmitting media with different refractive indices, their speed changes at the

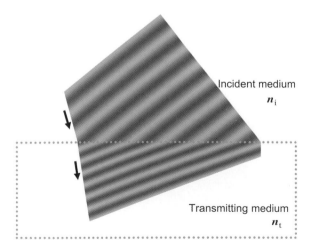

Figure 2.9 The refraction of waves. Here the refractive index of the transmitting medium, n_t, is greater than the refractive index of the incident medium, n_i. The travelling wavefront bends at the boundary because of the change of speed.

Incident medium
n_i

Transmitting medium
n_t

boundary and the waves entering the new medium change direction. This is *refraction* and is illustrated in Figure 2.9 (see also Chapter 6 for the *Law of Refraction*). The frequency of the waves does not change when the waves pass from one medium to another, but the wavelength increases or decreases (since $V = v\lambda$). The refractive index is therefore wavelength dependent and the speed of propagation in media other than a vacuum is frequency dependent. In general, n varies inversely with wavelength; it is greater for shorter wavelengths. This causes light in denser media to be refracted by different amounts, depending on wavelength. Refraction is therefore responsible for the splitting of the white light by a prism into different wavelengths, which are perceived as different hues. Because the refractive index of glass is higher than that of air, the different frequencies travelling with different speeds are refracted at different angles. This separation of electromagnetic waves consisting of multiple frequencies into components of different wavelengths is the phenomenon of *dispersion* (see Figure 2.26).

Polarization

So far we have considered electromagnetic wave propagation but not the direction of wave oscillations. *Polarization* in electromagnetic waves describes the direction of oscillation (or disturbance) of the electric field in a plane perpendicular to the direction of propagation – the *plane of polarization*. In polarization we describe the electric field only, since the magnetic field is perpendicular to it and their amplitudes are proportional. With natural light, which arises from a very large number of randomly oriented atomic emitters, the direction of wave oscillations is changing constantly and randomly. So light in its natural form is considered as randomly polarized, or *unpolarized* (see Figure 2.10).

To illustrate, it is useful to visualize a plane harmonic wave with electric field \vec{E}, split into two component waves

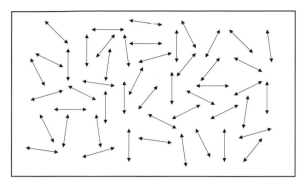

Figure 2.10 A head-on view of an approaching wavefront of unpolarized light at a fixed instant in time. At each position the direction of vibration in the plane of polarization is randomly aligned.

with perpendicular electric fields, \vec{E}_x and \vec{E}_y, with orientations x and y respectively, and with z the direction of propagation. The two component waves will have the same frequency but their amplitudes and phases may differ. The *state of polarization* of the wave is obtained by examining the shape outlined by the electric vector, \vec{E}, in the plane of polarization as the wave progresses, which depends on the amplitudes and phase difference of the two component waves.

In *linear polarization* or *plane polarization* the two orthogonal components are in phase (or have a phase difference of an odd integer multiple of π — i.e. opposite phase) but their amplitude may differ. A *linearly polarized* wave has (a) a fixed amplitude and (b) a constant direction of the electric field (although it may vary in magnitude and

sign with time). That is, the tip of the wave vector outlines a single line in the plane of polarization, as illustrated in the right corner of Figure 2.11. One completed line corresponds to one complete cycle as the wave advances one wavelength.

This process is equally valid in reverse. It is possible to examine the direction of oscillation (i.e. the state of polarization) of a wave resulting from the superposition of two linearly polarized light waves of the same frequency and with electric field vectors perpendicular to each other and to the direction of propagation.

So far we have illustrated only harmonic waves in which the orientation of the electric field is constant, i.e. plane polarized or linearly polarized light waves (e.g. Figure 2.1). Light can be converted from an unpolarized form to a linearly polarized form by passing it through a linear polarizer (e.g. polarizing sunglasses or filters). A polarizer has a transmission axis such that only incident oscillations parallel to this axis are transmitted, as illustrated in Figure 2.12.

In *circular polarization* the two constituent waves have equal amplitude and a phase difference of $\pi/2$, or exact multiples of it. That is, when one component is zero the other component is at maximum or minimum amplitude. In this case the wave is *circularly polarized*. It has (a) a constant amplitude and (b) the direction of the electric field is time varying and it is not restricted to one plane (Figure 2.13). The wave's electric field vector traces out a helix along the direction of wave propagation. After one complete oscillation the vector makes one complete rotation and outlines a circle in the plane of polarization. The direction of rotation depends on the phase difference of the two constituent waves. If the wave is moving towards an observer, in *right circular polarization* (where the phase

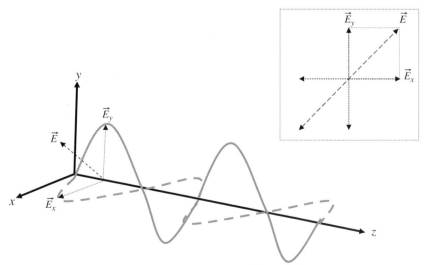

Figure 2.11 Linear light. The two wave components with electric fields \vec{E}_x and \vec{E}_y are in phase. The wave's electric field, \vec{E}, is linearly polarized in the first and third quadrants.

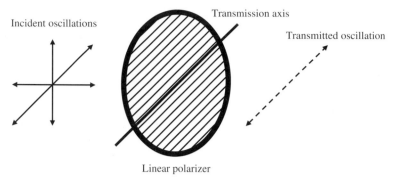

Figure 2.12 Transmission through a linear polarizer.

difference is equal to ..., $-\pi/2$, $3\pi/2$, $7\pi/2$, ..., and so on) the wave's electric field vector appears to rotate clockwise, whereas in *left circular polarization* (phase difference equal to $\pi/2$, $5\pi/2$, $9\pi/2$, ..., etc.) it appears to rotate anticlockwise. A linearly polarized wave can be composed of two opposite polarized waves of the same amplitude.

In all other cases, if the two orthogonal components are not in phase, or out of phase by exactly $\pi/2$ or multiples of

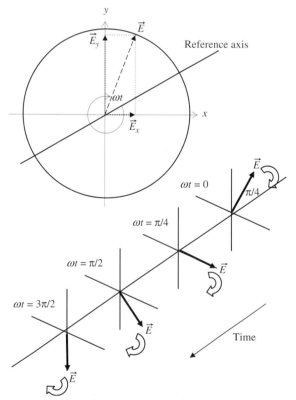

Figure 2.13 Rotation of the electric field vector in a right circular wave.
Adapted from Hecht (2002).

it — and don't have the same amplitude; the vector outlines an ellipse in the plane of polarization as it advances a wavelength, and the polarization is called *elliptical polarization*. Both linear and circular polarizations are special cases of elliptical polarization. Figure 2.14 illustrates various polarization configurations.

Plate retarders (such as photographic filters used with auto-focus lenses for light polarization) are crystals that retard the phase of wave vibrations in one direction relative to the direction at right angles. A *quarter-wave plate*, for example, will retard one direction by $\pi/2$ relative to the other direction.

Generally light, whether natural or artificial, is neither completely polarized nor unpolarized. Commonly, the electric field vector varies in a way which is neither totally regular nor totally irregular. We refer to this light as being *partially polarized*. It is often useful to imagine this as the superposition of specific amounts of natural and polarized light.

Interference

Interference occurs when two or more light wavefronts are superposed, resulting in a new wave pattern. According to the Principle of Superposition the resulting disturbance in the overlapping region is the algebraic sum of the separate disturbances. For simplicity, when we describe the effect of the superposition — that is the interference effect — we use coherent wavefronts (i.e. monochromatic waves of the same frequency), which interfere *constructively* or *destructively*. If two wave crests meet at a specific point in space then they interfere *constructively* and the resulting amplitude, a, is greater than either of the individual amplitudes a_1 and a_2 (i.e. $a = a_1 + a_2$). If a crest of a wave meets a trough of another wave then they interfere *destructively*, and the overall amplitude is decreased (i.e. $a = |a_1 - a_2|$). Figure 2.15a illustrates an example of *constructive interference* of two monochromatic waves in phase, where the amplitude of the combined wave is equal to the sum of the constituent amplitudes. Figure 2.15b illustrates an example of *destructive interference*, where the two waves are π radians

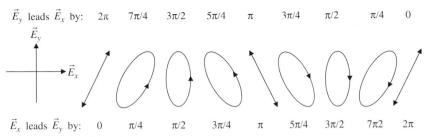

Figure 2.14 Various polarization configurations.
Adapted from Hecht (2002)

(a)

(b)

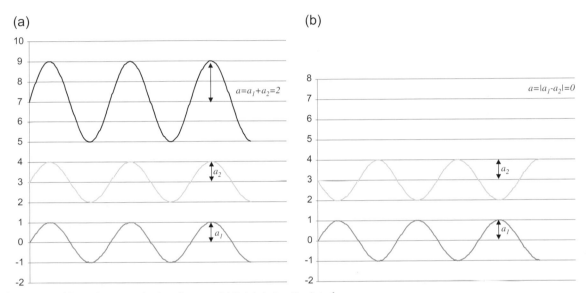

Figure 2.15 (a) Total constructive interference. (b) Total destructive interference.

out of phase. In this case one wave's crest coincides with the other wave's trough and the amplitudes totally cancel out.

Consider two coherent point sources, S_1 and S_2, emitting light in a homogeneous medium, having separation d. In a point P far away from the sources the overlapping wavefronts from the sources will be almost planar, as illustrated in Figure 2.16. The irradiance, I, at point P is equal to:

$$I = I_1 + I_2 + (2\sqrt{I_1 I_2}\cos(\delta)) \qquad (2.18)$$

where δ is the phase difference arising from the *combined path length* and the *initial phase differences* in the emitted waves.

At various points in space the irradiance can be greater, equal to or less than $I_1 + I_2$, depending on δ:

- The maximum irradiance is obtained when $\cos(\delta) = 1$ ($\delta = 0,\ \pm 2\pi,\ \pm 4\pi,\ \dots$, etc.). This is the case of *total constructive interference* (as in Figure 2.15a), where the phase difference, δ, is integer multiples of 2π:

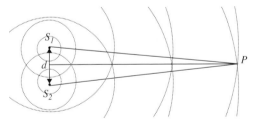

Figure 2.16 Waves from two point sources overlapping in space.
Adapted from Hecht (2002).

$$I_{max} = I_1 + I_2 + 2\sqrt{I_1 I_2} \qquad (2.19)$$

- When $0 < \cos(\delta) < 1$ the waves are out of phase and $I_1 + I_2 < 1 < I_{max}$, but the result is still constructive interference.
- When $\cos(\delta) = 0$, at $\delta = \pi/2$ the waves are a quarter of a circle out of phase and $I = I_1 + I_2$.

- When $0 > \cos(\delta) > -1$ we have destructive interference and $I_1 + I_2 > 1 > I_{min}$.
- The minimum irradiance occurs when $\cos(\delta) = -1$ ($\delta = \pm\pi,\ \pm 3\pi,\ \pm 5\pi,\ \dots$, etc.). This is the case of *total destructive interference* (as in Figure 2.15b), where δ is odd multiples of π:

$$I_{min} = I_1 + I_2 - 2\sqrt{I_1 I_2} \qquad (2.20)$$

When the amplitudes of the interfering waves reaching P are equal, denoted here as I_0 (i.e. $I_1 = I_2 = I_0$), Eqn 2.17 becomes:

$$I = 2I_0[1 + \cos(\delta)] = 4I_0 \cos^2\left(\frac{\delta}{2}\right) \qquad (2.21)$$

Thus, $I_{min} = 0$ and $I_{max} = 4I_0$.

Interference finds practical applications in single- or multi-layer anti-reflection coatings on lenses and as interference or dichroic filters for selective filtration of broad or narrow spectral bands.

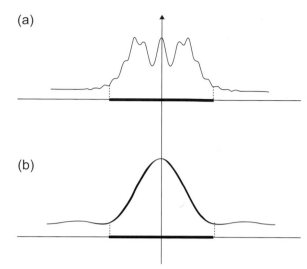

Figure 2.17 Diffraction patterns from a single slit. (a) Fresnel diffraction. (b) Fraunhofer diffraction.

Diffraction

Diffraction effects are general characteristics of wave phenomena whenever a portion of the otherwise infinite wavefront is removed by an obstacle. Light 'bends' around the edge of the obstacle producing a spreading of the image beyond the area expected. A shadow of a solid object when lit by a point source shows fringes near its edges due to diffraction effects. Diffraction also occurs when all but part of the wavefront is removed by an aperture or stop. The importance of diffraction depends on the size of the obstacle or aperture relative to the wavelength. It is most noticeable when the wavelength is close to the size of the diffracting obstacles or apertures. The complex patterns in the intensity of a diffracted wave are a result of interference between different parts of the wave reaching the observer by different paths. The halo seen around stars or around the sun are effects occurring due to the diffraction of light by particles in the atmosphere.

Different types of diffraction are observed, depending on the distance of the diffracting object to the plane of observation and the type and position of the light source. If an aperture is illuminated by plane monochromatic waves coming from a distance source and its image projected on to a screen parallel to the plane of the aperture, then *Fresnel* or *near-field diffraction* is the phenomenon observed when the plane of observation — in this case the screen — is near enough to the aperture. The projected image of the aperture appears structured with prominent fringes (Figure 2.17a). This is the more general case of diffraction; it is very complex to describe mathematically. When the screen is at a large distance from the diffracting object (i.e. so that planar or almost planar wavefronts hit the screen), or a lens is inserted between the object and the screen, focusing the

image at infinity on to the screen, the result is *Fraunhofer diffraction* or *far-field diffraction*. In this case the projected image of the aperture is considerably spread out (Figure 2.17b). Both the incoming and outgoing waves are planar, or nearly planar — differing therefore by a small fraction of wavelength. Generally, Fraunhofer diffraction occurs at an aperture (or obstacle) of width d, or smaller, when:

$$R > d^2/\lambda \qquad (2.22)$$

where R is the smaller of the following distances: (i) the distance from the point source to the aperture plane, or (ii) the distance from the aperture plane to the plane of observation. Equation 2.22 indicates that aperture width, wavelength and the distance R are parameters for Fraunhofer diffraction to occur. Fraunhofer diffraction is a special case of Fresnel diffraction but is more commonly examined because of its inherent mathematical simplicity.

Diffraction of a circular aperture and a single slit

Fraunhofer diffraction is observed when plane waves pass through a small circular aperture. Instead of producing a bright spot on a distant screen, the consequent far-field diffraction will produce a diffuse circular disc, known as an *Airy disc*, surrounded by much fainter concentric circular dark and bright rings, as shown in the examples in Figure 2.18. This example of diffraction is very important because the eye, cameras, telescopes and many other optical instruments have circular apertures.

(a)

(b)

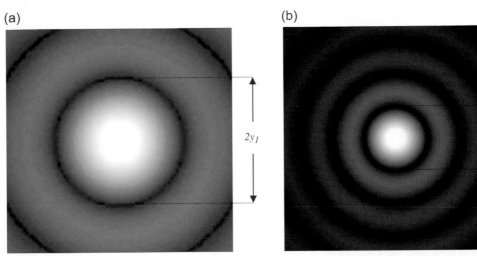

Figure 2.18 Computer-generated Airy discs for apertures with: (a) diameter d; (b) diameter $2d$.

The radius, y_1, from the centre of the Airy disc to the first dark ring, the *first minimum* or *first zero*, is given by:

$$y_1 = 1.22 \frac{R\lambda}{d} \qquad (2.23)$$

where λ is the wavelength, d the aperture diameter and R the distance from the aperture's centre to the first minimum of the Airy disc on the screen (see Figure 2.19). As R is very large compared to the radius of the disc, it is often represented as approximately the distance from the aperture plane to the screen plane. The distance between each dark ring is equal to y_1, and thus the distances between the centre of the Airy disc and the second, third, …, nth dark ring (i.e. the second, third, …, nth minimum) are multiples of y_1.

Note that, if a lens is focusing on the distant screen, the lens's focal length, f, is approximately equal to R and thus f is replacing R in Eqn 2.23. The diameter of the Airy disc, i.e. $2y_1$, in the visible spectrum is roughly equal to f/N, where N is the f-number or relative aperture of the lens (see Chapter 6). For light of wavelength (λ) 400 nm, D is approximately $N/1000$, i.e. 0.008 mm (8 μm) for an $f/8$ lens. In the most usual notation $N = f/d$ and thus the first minimum according to Eqn 2.23 occurs at $y_1 = 1.22\lambda N$. As shown in Figure 2.18, the diameter of the Airy disc increases as the aperture diameter decreases. The Airy disc is the diameter (D) of the first dark ring of the pattern given by $D = 2.44\lambda N$, where N is the f-number.

An optical system is *diffraction limited* if its resolution is only limited by diffraction and not by the system's spreading or degradation. Diffraction limited optical systems are very high quality systems, free of optical aberrations (see Chapter 10), which otherwise mask the diffraction effect. Most non-specialist lenses are aberration-limited as residual aberrations are greater than the diffraction effects, certainly at larger apertures. The Airy disc of a diffraction-limited optical system is considered as the image of a point formed by the system and represents the distribution of light at the focus point. Instead of just a point, the complex amplitude is distributed according to a *Bessel function* (i.e. a rather complicated mathematical expression). This represents the *point spread function* of the system (see also Chapter 7).

The one-dimensional approximation of the Airy disc is similar to the Fraunhofer diffraction pattern from a single long slit (see Figure 2.20). The one-dimensional analysis represents the behaviour of a lens aperture invariant in one

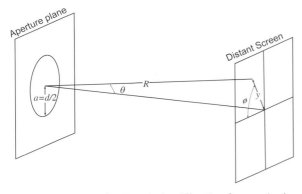

Figure 2.19 Set-up for Fraunhofer diffraction from a circular aperture producing an Airy pattern on screen.

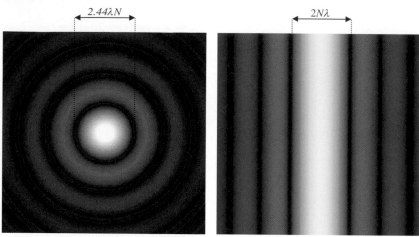

Figure 2.20 Fraunhofer diffraction of a circular aperture (left) and of a thin slit (right).

direction (a long slit) when imaging a one-dimensional point (a line). The amplitude of the diffracted pattern is given (instead of a Bessel function) by a *sinc function*,[§] while the intensity (or irradiance) is the square of it:

$$I(x) = I(0)\frac{\sin^2\left(\frac{\pi dy}{R\lambda}\right)}{\left(\frac{\pi dy}{R\lambda}\right)^2} = I(0)\,\text{sinc}^2\left(\frac{\pi dy}{R\lambda}\right) \qquad (2.24)$$

where d is the width of the slit, y is any point in the diffracted pattern, R approximately the distance between the slit and the screen, and λ the wavelength.

Hence, the sinc^2 function obtained in Eqn 2.24 represents the distribution of intensity of the image of a line. It is the so-called *line spread function* of the optical system, illustrated in Figure 2.21.

Notice the shape of the functions. There is a maximum value (i.e. representing the maximum intensity $I(0)$) when $y = 0$ and the function drops to zero at:

$$|y| = \frac{\lambda R}{d} \qquad (2.25)$$

and then again at $2(\lambda R/d)$, $3(\lambda R/d)$. These correspond to the \pm first, second, third, ..., etc. minima of the intensity profile. Similarly to the case in the circular apertures, the width of the central bright line varies with the width of the slit, d, while R represents the slit to screen distance — and for a lens its focal length, f.

Rayleigh criterion

Consider a diffraction-limited lens system imaging two incoherent point sources, such as two closely distanced stars. The images formed by the system will consist of two Airy distributions partially overlapping. According to the *Rayleigh criterion*, the minimum resolvable angular separation $\Delta\theta$, or *angular limit of resolution*, is:

$$\Delta\theta = \frac{1.22\lambda}{d} \qquad (2.26)$$

where d is the aperture diameter, λ the wavelength, and θ the angle between the optical axis and the axis from the centre of the aperture to the first minimum on the distant screen (Figure 2.19).

If Δl is the centre-to-centre separation of the two Airy discs, the *spatial limit of resolution* is given by:

$$\Delta l_{min} = \frac{1.22f\lambda}{d}\text{or } 1.22N\lambda \qquad (2.27)$$

where f is the focal length of the lens and N the numerical aperture (see Figure 2.22). Δl_{min} in Eqn 2.27 is essentially y in Eqn 2.23, which is often quoted as the *just resolvable separation* or *resolution limit* of the optical system for two

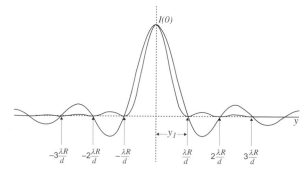

Figure 2.21 Amplitude (thin line) and intensity (thick line) distributions for Fraunhofer diffraction from a thin slit. The latter also represents the line spread function of a diffraction limited optical system, with value $I(0)$ at $y = 0$.

[§] The sinc(x) function is defined as sin(x)/x.

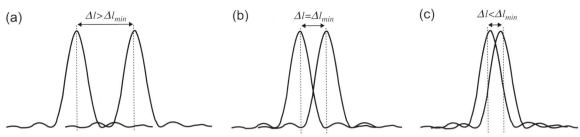

Figure 2.22 Intensity profiles of two overlapping images. (a) Well resolved. (b) Just resolved — the centre of the one Airy disc coincides with the first minimum of the other. (c) Not resolved.

incoherent point sources. Note that for square apertures it is equal to $N\lambda$. The *resolving power* (see Chapter 24) for the lens system is defined as $1/\Delta\phi_{min}$ or $1/\Delta l_{min}$.

THE ELECTROMAGNETIC SPECTRUM

As mentioned earlier in the chapter, there are other waves consisting of alternating electric and magnetic fields and travelling with the speed of light, but with shorter or longer wavelengths than light. The complete series of waves, arranged in order of wavelengths (or of frequency), is referred to as the *electromagnetic spectrum*. This is illustrated in Figure 2.23. There is no clear-cut line between one wave band and another, or between one type of radiation and another; the series of waves is continuous.

Radio waves, discovered by H. Hertz in 1887, have very long wavelengths (from 0.3 metres to many kilometres). Their frequency range is very large and extends to about 10^9 Hz. Radio waves have no effect on the body, i.e. they cannot be seen or felt, although they can readily be detected by radio and television receivers. Radio frequencies are used in astronomy and are captured by radio antennas. Otherwise radio waves are used for transmitting telephone communications, guiding aeroplanes, in speeding radars and in remote sensing. Moving along the spectrum to shorter wavelengths, the *microwave* region extends to about 3×10^{11} Hz. Water molecules are heated by the absorption of microwave radiation, hence its use in microwave ovens.

Infrared radiation, or *IR*, covers the region of frequencies before those seen as light, i.e. the visible spectrum. IR was first detected by the English astronomer Sir William Herschel in 1800. Heat emission from all molecules from temperatures above absolute zero ($0°$K or $-273°$C) is accompanied by IR radiation, with hotter bodies emitting more. IR is emitted from all light sources and naturally the sun, which produces almost half of its electromagnetic energy in IR. The IR spectrum extends roughly from 3×10^{11} Hz to 4×10^{14} Hz and is divided into four regions: the *near IR*, nearest to the visible spectrum, from 720 nm to 3000 nm; the *intermediate IR*, from 3000 to 6000 nm; the *far IR*, from 6000 to 15,000 nm; and the *extreme IR*, from

15,000 nm to 1 mm. Specially sensitized photographic films and digital camera sensors respond to a part of the near IR part (<1500 nm). The landscape in Figure 2.24 is photographed in the near IR, showing foliage (tree leaves, grass) strongly reflecting IR in the same way that snow reflects light. Far IR is used in thermal imaging, where IR detectors capture small differences in temperatures of objects which are further described as an image, often referred to as a 'heat map' or a thermograph — often used for diagnostic purposes and for 'night vision'. IR is widely used in astronomical, remote sensing and forensic applications. In biometrical and museum imaging IR is also very valuable due to its penetrating properties, allowing imaging beneath layers of objects.

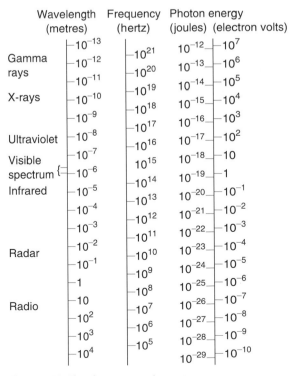

Figure 2.23 The electromagnetic spectrum.

Figure 2.24 Infrared photograph captured digitally using Sony DSC F828 camera and Hoya R72 filter.
© *Andy Finney, www.invisiblelight.co.uk*

The *visible spectrum* occupies a minute part of the total range of electromagnetic radiation, comprising frequencies between approximately 4.15×10^{14} Hz and 7.85×10^{14} Hz (380 and 720 nm). Within these limits, the human eye sees changes of wavelength as changes of hue (see more on perception of light and colors in Chapters 4 and 5). The change from one *perceived* hue to another depends on many variables influencing the human visual system, but the spectrum may be divided up roughly as shown in Figure 2.25. More than 300 years ago, Newton discovered that white light was a mixture of hues by allowing it to pass through a triangular glass prism. A narrow beam of sunlight was *dispersed* into a band showing the hues of the rainbow. These represent the visible spectrum. Newton's experiment is illustrated in Figure 2.26. It was later found that the dispersed light could be recombined using a second prism, producing white light once again.

Just beyond the visible in the electromagnetic spectrum is the *ultraviolet*, or *UV*, region with frequencies from 4.15×10^{14} to 8×10^{14} Hz. UV radiation is also subdivided into near, intermediate, far and extreme or *vacuum UV*. Much of UV radiation is harmful to humans, causing sunburn as well as other damage to the skin and the eyes. Fortunately, ozone (O_3) in the atmosphere absorbs most of the harmful UV coming from the sun, but considerable amounts are found at sea level due to scattering. UV is not as penetrative as infrared, although long-wave UV radiation penetrates

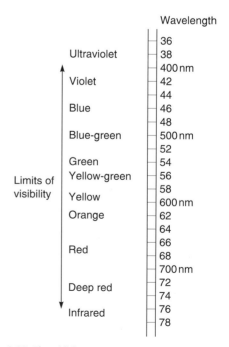

Figure 2.25 The visible spectrum.

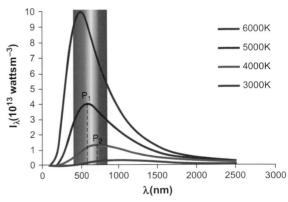

Figure 2.26 Dispersion of white light by a prism.

deeper into the skin than visible light. UVA is the part of the UV spectrum with the longest wavelength; it is known as *black light*. Black light artificial sources (also known as Wood's lamps) are used in UV reflectance and UV fluorescence photography. UVB is medium wavelength and UVC is short wavelength UV radiation. The UVB and UVC radiation are partially responsible for the generation of the ozone layer and cause sunburn to the human skin. A positive effect of UVB exposure nevertheless is that it induces the production of vitamin D in the skin. Humans cannot see UV because the eye's cornea absorbs it, but a number of insects — such as honey bees — and other animals create images from UV reflected from various objects. UV is also used to excite some types of molecules, for example in flowers' pollen, which in turn emit other (usually higher) wavelengths (a phenomenon known as *luminescence*). Similarly to IR, UV is widely used in astronomical imaging and in biomedical and forensic applications.

X-rays were discovered by Wilhelm Conrad Röntgen in 1890. X-radiation ranges roughly from 2.4×10^{14} to 5×10^{14} Hz and has extremely small wavelengths, most of them smaller than the size of atoms. X-rays are very energetic and penetrate the human body and several centimetres in metals. Medical applications of X-rays include medical film, digital radiography and computed axial tomography. X-ray microscopes and telescopes produce images of the invisible of a huge range of spatial scales. Finally, *gamma-radiation* is the most energetic radiation in the spectrum and is also very penetrative. Both X-radiation and gamma-radiation, unless properly controlled, are harmful to human beings.

BLACK-BODY RADIATION

A black-body radiator is a theoretical surface, which absorbs all radiation that is incident on it (therefore appearing perfectly black) and also behaves as a perfect emitter of radiation.

Black-body radiation theory began with the work of Gustav Robert Kirchhoff in 1859, studying the electromagnetic radiation emitted from bodies in thermal equilibrium. All objects at non-zero temperatures emit electromagnetic energy. Kirchhoff proposed that different surfaces would absorb and emit different amounts characterized by two coefficients, α_λ and ε_λ. The *absorption coefficient*, α_λ, is the *fraction* of incident energy of wavelength λ absorbed per unit area per unit time in a tiny band of wavelengths around λ and the *emission coefficient*, ε_λ, is the energy emitted per unit area per unit time for the same tiny band of wavelengths. The coefficients are specific to the material, depending on its surface properties, and wavelength dependent, i.e. a body may emit or absorb well at some wavelengths but not others.

Kirchhoff suggested that for a surface in the wall of an isolated cavity at thermal equilibrium in which all radiation was absorbed and emitted by the walls, the total amount of energy absorbed at all wavelengths must equal that emitted, or the temperature would change. He defined a wavelength distribution function $I_\lambda(\lambda)$, independent of the material, but dependent only on T, the absolute temperature of the cavity.

The energy absorbed at wavelength λ (for any material) will be $\alpha_\lambda I_\lambda$, which will be equal to the energy emitted, ε_λ. *Kirchhoff's Radiation Law* can be expressed as:

$$I_\lambda = \frac{\varepsilon_\lambda}{\alpha_\lambda} \qquad (2.28)$$

If Kirchhoff's law is applied to a black-body radiator, then by definition it will absorb 100% of the incident radiation; α_λ will become 1, and:

$$I_\lambda = \varepsilon_\lambda \qquad (2.29)$$

In other words, the radiation emitted from a black body heated to a particular temperature is equivalent to I_λ at that temperature. I_λ is commonly called a black-body radiation curve and is illustrated in Figure 2.27.

From Kirchhoff's work, the scientific community began to try to obtain I_λ for different temperatures, theoretically and from experimentation, but experienced difficulty in finding suitable sources approximating black-body

Figure 2.27 Black-body radiation curves (I_λ) at different temperatures.

radiation. From some experimental results, Jozef Stefan in 1879 realized that the *total* energy radiated per unit surface area per unit time (its *power*) was proportional to T^4. T is the temperature measured in Kelvin. The Kelvin scale is an absolute temperature scale where 0 K is absolute zero (which corresponds to $-273.15°C$). Ludwig Boltzmann, in 1884, used laws of thermodynamics to provide a theoretical basis for Stefan's findings and together their results were expressed as the *Stefan–Boltzmann Law*:

$$\frac{P}{A} = \sigma T^4 \qquad (2.30)$$

where P is the total radiant energy at all wavelengths, A is the radiating surface area, T is the absolute temperature and σ is a universal constant $= 5.67033 \times 10^{-8}$ W m^{-2} K^{-4}; P/A is equivalent to the area under the I_λ curve at that temperature.

Wien's Displacement Law

A further development in black-body radiation came with the work of German physicist Wilhelm Wien, who in 1893 used thermodynamics to derive a law describing the way in which the peak wavelength of a black-body radiation curve (the wavelength at which most energy is radiated) shifted as the temperature changed. The peak wavelength defines the dominant colour of the radiation. *Wien's Displacement Law* defines the peak wavelength as *inversely proportional* to the temperature:

$$\lambda_{max} T = \text{constant} \qquad (2.31)$$

where λ_{max} is the peak wavelength in nanometres (nm), T is the temperature in kelvin (K) and the constant is *Wien's displacement constant* $= 2.8977685(51) \times 10^6$ nm K.

Because the two variables are inversely proportional, as the temperature increases, the peak wavelength gets shorter. A black body, when heated from cold, will begin to radiate electromagnetic energy, with the dominant energy emitted first in the infrared long wavelength regions, and as it gets hotter will begin to emit visible radiation, glowing red, then yellow and eventually blue–white (a similar effect can be visualized by considering a piece of metal being heated in a furnace). The change in peak wavelength is illustrated by P_1 and P_2 in Figure 2.27, which are 580 and 724 nm respectively.

Wien's Displacement Law has particular relevance in photography in the characterization of light sources in terms of *colour temperature*. Colour temperature is a measure that may be used to describe the spectral characteristics of a light source and is derived from black-body theory. The measurement of colour temperature plays an important part in trying to match the spectral response of the sensitive material to the light source to ensure correct or adequate colour reproduction. The measurement of colour temperature and characterization of light sources is dealt with in Chapter 3.

The practical problem of an appropriate source of black-body radiation was solved at the end of the nineteenth century: The radiation from a black body will be the same as that for an isolated cavity in thermal equilibrium at the same temperature; therefore, it may be approximated by that emerging from a small opening in the wall of a furnace at the same temperature. This meant that actual data could be obtained to produce experimental curves for I_λ. It became clear, however, that the theoretical approaches used so far were not adequate; they did not produce curves that fitted the data. Until this point, the expressions derived were obtained by applying classical wave theory, the assumption being that the electromagnetic waves in the cavity travelled as a continuous flow of energy. It was possible to use the expressions to obtain curves that would fit the practical results, but only for some parts of the electromagnetic spectrum, either fitting the experimental curves at short wavelengths but deviating from them wildly at longer wavelengths, or vice versa. It was clear, finally, that wave theory alone could not adequately describe electromagnetic radiation.

Planck's Law

As already stated, all objects emit electromagnetic energy and this is the result of the constituent atoms moving randomly. The atoms in the walls of the cavity in the experimental set-up to determine black-body radiation are in constant motion, and are continuously emitting and absorbing radiation. Overall, the atoms must also be in an equilibrium state, i.e. the amount of absorption and emission is the same, to maintain a constant temperature. In attempting to derive an expression to predict the measured I_λ at a particular temperature, classical wave theory modelled the radiation in the cavity as *standing waves*, assuming that radiation could be absorbed or emitted in any quantity, however small. It was therefore assumed to be a *continuous* quantity.

Max Planck, in 1900, turned to the work of Maxwell and Boltzmann, which used statistical analysis to predict the behaviour of gas molecules enclosed in a chamber at constant temperature. This led him to an expression which successfully fitted the experimental data for black bodies, but only if he made an important assumption: that the energy exchanges of the atoms in the wall of the cavity were in *discrete quantities* only. His hypothesis was that the amount of energy released was dependent on the frequency of radiation, and he defined the relationship between energy and frequency in a relationship now known as *Planck's Law*:

$$E = h\nu \qquad (2.32)$$

where E is the energy, ν is the frequency and h is a universal constant, known as *Planck's constant*, with a value of 6.626×10^{-34} joule seconds. Planck's assumption led him to an expression which could predict black-body radiation

where others had failed; however, he held on to the classical wave picture of light, not yet realizing that light itself came in quantum amounts.

THE PHOTOELECTRIC EFFECT

It had been observed in the 1890s that when certain metals were bathed in either ultraviolet radiation or visible wavelengths of light, electrons were released from the metal surface (Figure 2.28). This phenomenon was known as the *photoelectric effect*. The photoelectric effect occurs as a result of electrons gaining enough energy to escape the ionic attractions in the metal's surface by absorbing the incident electromagnetic energy. For each metal it was found that there was a maximum wavelength (or minimum frequency) of radiation that would produce this effect and above this no further electrons would be emitted (for example, a metal might emit under short-wavelengths but not under long).

Classical wave theory predicts that the energy in an electromagnetic wave is continuous and evenly spread across the entire wavefront. If this were true, then electrons would gradually gain energy from the incident wave and be able to escape from the surface. The intensity of the incident light would be proportional to the amount of energy it carried. This theory could not explain, however, why a minimum threshold frequency of light was required for each metal, below which electrons would not be emitted, regardless of the light intensity. Additionally, it was observed that the electrons were emitted immediately that the surface was irradiated, which should not happen if

there was a slow cumulative gain of energy over time. It was also established that the electrons had various kinetic energies from zero up to a certain maximum energy and this maximum was independent of the light intensity, again unexplained by classical theory.

Albert Einstein, in 1905, published a different approach to the mechanism of the photoelectric effect by assuming that there was a *work function* for the metal surface. The work function represents the minimum amount of work required to give the electron enough energy to escape the ionic attractions at the metal's surface. Using Planck's hypothesis, Einstein concluded that if the electrons in the surface were irradiated with light of frequency v, they would receive energy only in quantities of hv, called *photons*.

If the quantity hv was less than the work function, then the energy gained would be lost immediately in collision with neighbouring atoms and the electrons would not escape. There was no intermediate state of 'partial escape'. This meant that electrons could not be gaining energy cumulatively: they must do so in a single step. Such an assumption explains why light intensity has no influence on whether electrons are emitted; an increase in intensity would only result in more energy 'packets' of the same size, not an increase in the amount of energy that a single electron could receive.

If hv was greater than the work function of the material, then the electron would have enough energy to escape the surface and any additional photon energy would be converted to kinetic energy in the electron. The escaping electrons might lose some energy during the escape, due to collisions with other atoms, meaning that they would emerge with a range of kinetic energies up to a maximum,

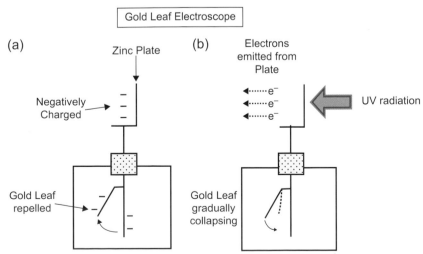

Figure 2.28 Demonstration of the photoelectric effect. A zinc plate is placed on a gold leaf electroscope and negatively charged. In (a), the gold leaf is repelled as a result of the negative charge. (b), When the zinc plate is bathed in UV radiation the gold leaf gradually collapses due to the emission of electrons.

which was related to the frequency of the radiation. This is summarized in *Einstein's photoelectric equation*:

$$h\nu = \text{k.e.}_{max} + \Psi_0 \qquad (2.33)$$

where k.e.$_{max}$ is the maximum kinetic energy of the escaping electrons and Ψ_0 is the work function of the material.

The existence of a threshold frequency for each metal can be explained by the work function of the material; the minimum photon energy capable of causing the photoelectric effect will eject the electron with zero kinetic energy. The photoelectric equation becomes:

$$h\nu_0 = \Psi_0 \qquad (2.34)$$

where ν_0 is the threshold frequency.

The existence of light in quantities called photons provided solutions to the problems raised by the photoelectric effect that classical wave theory had failed to explain. Einstein's work was a theoretical treatment and caused much controversy at the time, appearing as it did to contradict the wave theory of light based upon Maxwell's equations for electromagnetic waves and, perhaps more fundamentally, the idea that energy was not something that could be divided into infinitely small units, i.e. continuous in nature.

It was not until 1915, with the work of Robert Andrews Millikan, that Einstein's theory was shown to be correct: Einstein had predicted that the energy of the ejected electrons would increase linearly with the frequency of the radiating light and Millikan was able to demonstrate this linear relationship experimentally. The work on the photoelectric effect had turned the world of physics on its head, resulting in the introduction of the concept of the duality of light: that it exhibited the characteristics of both waves and particles in different circumstances. Wave–particle duality would eventually be extended to other elementary particles such as the electron.

THE PHOTON

A photon is a single quantum of energy that can only exist at the speed of light. It is the fundamental element carrying all electromagnetic radiation. It is indivisible, it cannot be split into smaller units, and is a stable, elementary particle. Photons differ from other elementary particles such as electrons in that they have zero mass or electric charge and consist purely of energy. When many photons are present, for example in a light beam, their numbers are so large that the inherent discontinuity or *granularity* of the light beam disappears and it appears as a continuous phenomenon. The photon can exhibit wave-like behaviour, resulting in phenomena such as refraction or diffraction, described earlier in this chapter. It also behaves as a particle when interacting with matter at a subatomic level, exchanging

energy in discrete amounts. The amount of energy E (from Planck's Law) exchanged during such an interaction is dependent on the frequency of light, and is known as the *photon energy*. This relationship may be rewritten in terms of the wavelength of the light:

$$E = h\nu = \frac{hc}{\lambda} \qquad (2.35)$$

where c is the speed of light, h is Planck's constant, ν is the frequency and λ is the wavelength. This means that shorter wavelengths of light will have higher photon energy (see Figure 2.23, which shows the electromagnetic spectrum in terms of wavelength, frequency and photon energy). This becomes important later on, in understanding why imaging materials are sensitive to some wavelengths of light and not others (spectral sensitivity).

BOHR MODEL OF THE ATOM

In the early twentieth century, the commonly accepted model of the atom was the planetary model of Rutherford in 1911 (Figure 2.29), which consisted of a small densely packed positively charged nucleus, made up of protons and neutrons, about which clouds of negative electrons orbited, like planets around the sun. Rutherford's model assumed that some outer electrons were loosely bound to the nucleus and could therefore be easily removed by applying energy.

There is a problem with this model, however, as follows: the negative charge of the nucleus and the positive charge of the electrons mean that there is an *electrostatic attraction* between them. The electrons must have a certain amount of energy to allow them to orbit at a distance away from the nucleus. The orbiting electrons are constantly changing direction; therefore they are accelerating. Classical laws of electromagnetism state that accelerating charges must radiate energy. A charge oscillating with frequency n (the frequency of its circular orbit) will radiate energy of frequency n and if the electron is radiating energy, it is losing energy. The radius r of the orbit must decrease, leading the electron to fall into the nucleus, which would indicate that all matter was inherently unstable. As the

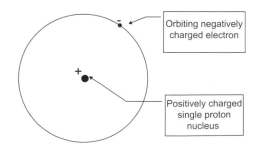

Figure 2.29 Rutherford model of the hydrogen atom.

orbit of the electron decreases, the frequency of emitted radiation should also change, continuously. Emission spectrum experiments with electric discharges through low-pressure gases show, however, that atoms will only emit electromagnetic radiation of specific discrete frequencies.

Niels Bohr, in 1913, used quantum theory to propose a modification of the Rutherford model. He postulated three fundamental laws:

1. Electrons can only travel in orbits at certain quantized speeds; therefore, they can only possess certain discrete energies. While in a state corresponding to these discrete energies (a *stationary* state), the electrons will not emit radiation. The energy of a particular orbit will define the distance of the electron from the nucleus.

2. Rather than continuously emitting energy as they accelerate, electrons only emit (or absorb) energy when they move between different orbits.

3. The electron will absorb or emit a single photon of light during a jump between orbits. The photon will have energy equal to the energy difference between the two orbits. If E_2 and E_1 are the energy levels of the two orbits, then using Planck's Law, $\Delta E = h\nu = E_2 - E_1$; therefore, the frequency of radiated energy will be $(E_2 - E_1)/h$.

Fundamentally Bohr's model led to the idea that at the subatomic level, the laws of classical mechanics did not apply and quantum mechanics must be used to describe the behaviour of electrons around a nucleus.

Bohr initially developed his model for the hydrogen atom, but later extended it to apply to atoms containing more electrons (to balance out the heavier nucleus as a result of more protons). He suggested that each electron orbit, corresponding to a stationary state, could contain a certain number of electrons. Once the maximum had been reached for the orbit, the next energy level would have to be used. These levels became known as *shells*, each one corresponding to a particular orbit and energy level. The shell model of the atom was able to explain many of the properties of elements in the periodic table. It eventually led to a more complex but accurate model of the atom using quantum mechanics to describe the behaviour of electrons in atomic orbitals, but the shell model is often used as an introduction to quantum theory.

Many of the chemical properties of elements are determined by the outer (valence) shell of the atom. If the atom has a full outer shell, it will tend to be very stable, and will not tend to form chemical bonds. The inert (noble) gases, e.g. helium or neon, are examples. Elements with outer shells containing single electrons, i.e. with spaces to fill, will tend to be highly reactive. Atoms of the elements silver (Ag) and the *halide* family (chlorine (Cl), bromine (Br) and iodine (I)) are of particular importance in photography as together they form the sensitive material in photographic emulsions. Of note is the fact that silver has a single electron in its outer shell, while chlorine has seven electrons in

an outer shell that can contain eight; essentially it has a space for one more electron. This is covered in more detail in Chapter 13.

THE EMISSION OF ELECTROMAGNETIC RADIATION IN ATOMS

The Bohr model has now been superseded by more complex models; however, the fundamental idea remains. The major mechanism for the generation of electromagnetic radiation is generally accepted as the emission of a photon that occurs when an electron drops from a higher energy level to a lower one.

An atom is said to be in its *ground* state when all its electrons are in the lowest possible energy states available to them. The lowest energy level that an electron may occupy, i.e. the one closest to the nucleus, is termed the normal level and may be taken as the zero energy state (as there are no lower levels to which an electron may drop). If any of the electrons occupies a higher energy level than its ground state, it is said to be *excited* (these stationary states are also called *radiating*, *critical* or *resonance* states), and such states are unstable and temporary. The energy level at which an electron can escape the pull of the nucleus completely is called the *ionization level* (at this point the electron is no longer in a stationary state and is promoted into the *conduction* band).

To excite or ionize an atom, it must be supplied with energy, either through electron impact, for example as a result of heating, which leads to atomic collisions (for example, in the walls of the heated cavity in a black-body radiation experiment), or as the result of photon impact when the atom is radiated (this is the mechanism responsible for the photoelectric effect). During an atomic collision, if the incident electron has enough energy, it will be able to transfer this to elevate one of the valence electrons to a higher energy level, either an excited or an ionized state, with any additional energy retained by the incident electron as kinetic energy. In the case of photon impact, to create an excited state, the incident photon energy must correspond exactly to the difference between two energy states for the photon to be absorbed. Alternatively, if the photon contains more energy than the difference between the valence shell energy level and the ionization level, then the atom will be ionized.

Whatever the mechanism for absorption of energy, an atom will generally only remain in an *excited* state for approximately 10^{-8} or 10^{-9} seconds before returning to its ground state. It loses the excitation energy in this process, either by conversion to thermal energy or by emission of electromagnetic energy. In the latter case, the excited electron will usually return to its ground state in a single step,

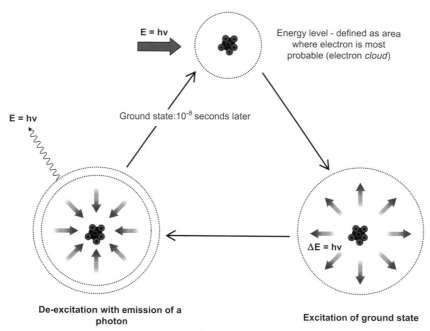

Figure 2.30 Absorption and emission of electromagnetic radiation in an atom.

with the emission of a photon of energy equal to the difference between the two states. The entire mechanism is illustrated in Figure 2.30. In some special cases it may return to ground state in several steps, emitting photons of lower energy at each. This is the mechanism of *fluorescence* or *luminescence*, which usually occurs when certain materials are irradiated with ultraviolet wavelengths and then emit visible radiation of longer blue or green wavelengths.

BIBLIOGRAPHY

Ball, J., Moore, A.D., 1997. Essential Physics for Radiographers, third ed. Blackwell, Oxford, UK.

Freeman, M.H., Hull, C.C., 2003. Optics, eleventh ed. Butterworth-Heinemann, London, UK.

Halliday, D., Resnick, R., Walker, J., 2001. Fundamentals of Physics, sixth ed. John Wiley, New York, USA.

Hecht, E., 2002. Optics, fourth ed. Addison-Wesley, San Fransisco, CA, USA.

Jacobson, R.E., Ray, S.F., Attridge, G.G., Axford, N.R., 2000. The Manual of Photography, ninth ed. Focal Press, Oxford, UK.

Jenkins, F.A., White, H.E., 1976. Fundamentals of Optics, fourth ed. McGraw-Hill International Editions, London, UK.

Chapter | 3 |

Photographic light sources

Sidney Ray

All images © Sidney Ray unless indicated.

INTRODUCTION

Photographs are taken by the agency of light travelling from the subject to the photoplane in the camera. This light usually originates at a source outside the picture area and is reflected by the subject. Light comes from both natural and artificial sources. Natural sources include the sun, clear sky and clouds. Artificial sources are classified by the method used to produce the light, including burning, heating, electric sparks, arcs or discharges and luminescence. Light sources differ in many ways, and the selection of a suitable source is based on a number of significant characteristics.

CHARACTERISTICS OF LIGHT SOURCES

Spectral quality

As discussed in Chapter 2, light is a specific region of the electromagnetic spectrum and is a form of radiant energy. The radiation from most sources is a mixture of light of various wavelengths. The *hue* (see Chapter 5 for CIE definition of hue) of the light from a source, or its *spectral quality*, may vary depending on the distribution of energy at each wavelength in its spectrum. Most of the sources used for photography emit what is usually termed *white light*. This is a vague term, describing light that is not visibly deficient in any particular band of wavelengths, but not implying any very definite colour quality. Most white-light sources vary considerably among themselves and from daylight. Because of the perceptual phenomenon of *colour constancy* (see Chapter 5), these differences matter little in everyday life, but they can be very important in photography, especially when using colour materials or where there is 'mixed' lighting. Light quality is described in precise terms. Colour quality may be defined in terms of the *spectral power distribution* (SPD), which is a plot of power versus wavelength throughout the spectrum. There are several ways this can be expressed, with varying degrees of precision. Each method has its own advantages, but not all methods are applicable to every light source.

Spectral power distribution curve

Using a *spectroradiometer*, the *spectral power distribution* of light energy can be measured and displayed as the SPD curve. Absolute SPD is given in absolute radiometric units (see Chapter 2), whereas relative SPD is the normalized power with respect to the power at $\lambda = 560$ nm. Curves of this type are shown in Figure 3.1 for various sources. Such data clearly show small differences between various forms of light. For example, the light sources in Figure 3.1 seen separately would, owing to colour constancy effects, probably be described as 'white', yet the curves are different. Light from a clear blue sky has a high blue content, while light from a tungsten lamp has a high red content. Although not obvious to the eye, such differences can be clearly shown by colour reversal film, which is balanced for a particular form of lighting.

Three general types of spectrum are emitted by light sources. Some have *continuous spectra*, with energy present at all wavelengths in the region measured. Many sources, including all incandescent-filament lamps, have this type of spectrum. Other sources emit energy in a few narrow spectral regions. At these wavelengths the energy is high, but elsewhere it is almost nil. This second type is called a *discontinuous* or *line spectrum*, given by low-pressure

DOI: 10.1016/B978-0-240-52037-7.10003-1

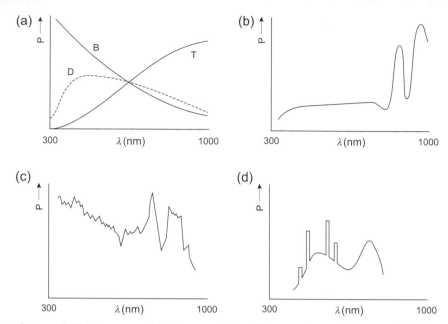

Figure 3.1 Spectral power distribution curves of light sources. Typical SPD curve shapes of photographic light sources. P, relative power output. (a) Continuous sources. B, blue sky; D, mean noon daylight; T, incandescent tungsten filament lamp. Discharge sources. (b) Pulsed xenon lamp. (c) Xenon flash tube. (d) Fluorescent lamp.

discharge lamps such as sodium- and mercury-vapour lamps.

A third type has broad bands of energy with a continuous background spectrum or *continuum* of varying magnitude, and is given by discharge sources by increasing the internal pressure of the discharge tube, e.g. a high-pressure mercury-vapour lamp. Alternatively, the inside of a discharge tube may be coated with phosphors which fluoresce, i.e. emit light at longer wavelengths than the spectral lines that stimulate them. Another method is to include gases in the tubes such as xenon or argon, and metal halide vapour.

Colour temperature

For photographic purposes a simple method of quantifying the light quality of an incandescent source is by means of its *colour temperature*. This is defined in terms of what is called a *Planckian radiator*, a *full radiator* or simply a *black-body radiator*. As described in Chapter 2, this is a source emitting radiation whose SPD depends only on its temperature and not on the material or nature of the source (Figure 3.2).

The colour temperature (CT) of a light source is the temperature of a full radiator that would emit radiation of substantially the same spectral distribution in the visible region as the radiation from the light source. Colour temperatures are measured on the *thermodynamic* or *Kelvin* scale, which has a unit of temperature interval identical to

that of the Celsius scale, but with its zero at $-273.15°C$ (absolute zero).

Luminous sources of low colour temperature have an SPD relatively rich in red radiation. With progression up the colour scale the emission of energy is more balanced and the light becomes 'whiter'. At high values the SPD is rich in blue radiation. It is unfortunate that reddish light has been traditionally known as 'warm' and bluish light as

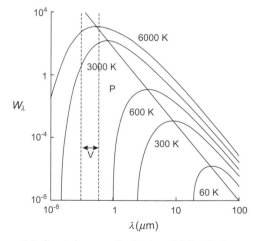

Figure 3.2 Spectral power distribution of full radiating sources (black-body radiation). P, locus of peak emission; V, visible spectrum; W_λ, spectral irradiance.

'cold', as the actual temperatures associated with these colours are the other way round.

Colour temperature applies to sources with continuous spectra, but in practice is extended to others with an SPD approximating to that of a full radiator, termed a *quasi-Planckian source*, such as a tungsten filament lamp. The term is, however, often applied incorrectly to fluorescent lamps, whose spectra and photographic effects can be very different from those of full radiators. The preferred term describing such sources is *correlated colour temperature*, which indicates a visual similarity to a value on the colour-temperature scale but with an unpredictable photographic effect, particularly with colour reversal film.

In black-and-white photography, the colour quality of light is of limited practical importance. In colour photography, however, it is vitally important, because colour materials and *focal plane arrays* (FPAs) are balanced to give 'correct' rendering with an illuminant of a particular colour temperature. Consequently, the measurement and control of colour temperature must be considered for such work, or the response of the sensor adjusted, usually termed 'white balance'. The latter may be done automatically in a digital camera or using a preset value chosen from a menu (see Chapter 14).

Colour rendering

With fluorescent lamps, which vary greatly in spectral power distribution, covering a wide range of correlated colour temperatures, the results given by two lamps of nominally the same properties may be quite different if used for visual colour matching or for colour photography. Various objective methods have been devised to give a numerical value to the colour rendering given by such sources as compared with a corresponding full radiator, or with visual perception. A *colour rendering index* (CRI) or value is defined based on the measurement of luminance in some six or eight spectral bands and compared with the total luminance, coupled with weighting factors, a value of 100 indicating ideal performance. Typical values vary from 50 for a 'warm-white' type to greater than 90 for a 'colour-matching' version.

Percentage content of primary hues

For many photographic purposes, the visible spectrum can be considered as consisting of three main bands: blue, green and red. The quality of light from a source with a continuous spectrum can be approximately expressed in terms of the percentages in which light of these three hues is present. The method is imprecise, but it is the basis of some *colour temperature meters*, where the ratios of blue—green and red—green content are compared to indicate an approximate CT. The same principles are used to specify

the colour rendering given by a lens, as preferential absorption of light at the blue end of the spectrum is common in optical glass.

Measurement and control of colour temperature

In colour photography, the CT of the light emitted by all the separate sources illuminating a subject should agree in balance with that for which the process is being used. The tolerance permissible depends on the process and to some extent on the subject. A departure of 100 K from the specified value by all the sources (which may arise from a 10% variation in supply voltage) is probably the maximum tolerable for colour reversal material balanced for a colour temperature of around 3200 K. Colour negative material (depending on how it is CT balanced) may allow a greater departure than this, because a certain amount of colour correction is possible at the printing stage.

A particular problem is that of *mixed lighting*, where part of the subject may be unavoidably illuminated by a light source of markedly different colour quality from the others. A localized *colour imbalance* may then appear in the photograph. Another example is the use of tungsten lamps fitted with blue filters to match daylight for fill-in purposes, where some mismatch can occur. Electronic flash is suitable as a fill-in source when daylight is the main illuminant. A visual comparison of the colour quality of two light sources is possible by viewing the independently illuminated halves of a folded sheet of white paper with its apex pointing towards the observer. Any visually observable difference in colour would be recorded in a photograph, so must be corrected by filtration. A colour-temperature meter incorporates filtered photocells to sample spectral zones such as red, green and blue. A direct readout of CT is given, together with recommendations as to the type of *light-balancing* or *colour-correction* filters needed for a particular type of film.

A *matrix array* of several hundred CCD photocells filtered to blue, green and red light, together with scene classification data, can also be used in-camera to measure the colour temperature of a scene (see Chapter 14).

The CT balance of colour films to illuminants are specified by their manufacturers. The effective CT of a source may be affected by the reflector and optics used; it also changes with variations in the power supply and with the age of a lamp. To obtain light of the correct quality, lamps must be operated at the specified voltage, and any reflectors, diffusers and lenses must be as near to neutral in colour as possible. The life of filament lamps can be extended by switching on at reduced voltage and arranging the subject lighting, then using the correct full voltage only for the actual exposure. To raise or lower the CT by small amounts, *light-balancing filters* may be used over the lamps.

Pale blue filters raise CT while pale yellow or amber ones lower it.

Because digital cameras have a fixed image sensor, it is necessary to adapt the response of the sensor to the colour temperature of the scene using *white balance* settings. This may be achieved in a number of ways, but results in the relative responses of the three channels (usually, but not always, from filtered pixels) being altered to match the illumination white point (refer to Chapter 14).

As conventional tungsten filament lamps age, the inner side of the envelope darkens from a deposit of tungsten evaporated from the filament, decreasing both light output and colour temperature. Tungsten–halogen lamps maintain a more constant output throughout an extended life, compared to ordinary filament lamps.

To compensate for the wide variations encountered in daylight conditions for colour photography, camera filtration is possible using light balancing filters of known *mired shift value*, as defined below. To use colour film in lighting conditions for which it is not balanced, *colour conversion (CC) filters* with large mired shift values are available.

The mired scale

The colour balance of an incandescent source is given by the *mired scale*, an acronym derived from *micro-reciprocal degree*. The relationship between *mired value* (MV) and colour temperature (*T*) in kelvins is:

$$MV = 10^6/T \qquad (3.1)$$

Note that as colour temperature increases the mired value decreases and vice versa.

The main advantage of the mired scale, apart from the smaller numbers involved, is that equal variations correspond to approximately equal visual variations in colour. Consequently, a light-balancing filter can be given a mired shift value (MSV) that indicates the change in colour quality given, regardless of the source being used. Yellowish or amber filters, for raising the mired value of the light, i.e. lowering its colour temperature in kelvins, are given positive mired shift values; bluish filters, for lowering the mired value, i.e. raising the colour temperature in kelvins, are given negative values. Thus, a bluish light-balancing filter with a mired shift value of −18 is suitable for converting tungsten light at 3000 K (333 mireds) to approximately 3200 K (312 mireds). It is also suitable for converting daylight at 5000 K (200 mireds) to 5500 K (182 mireds). Most filters of this type are given values in decamireds, i.e. mired shift value divided by 10. Thus, a blue daylight-to-tungsten filter of value −120 mireds is designated B12. A suitable equation for calculating the necessary MSV to convert a CT of T1 to one of T2 is:

$$MSV = (1/T_2 - 1/T_1)10^6 \qquad (3.2)$$

LIGHT OUTPUT

Units

A source can emit energy in a wide spectral band from the ultraviolet to the infrared regions; indeed, most of the output of incandescent sources is in the infrared. For most photography only visible light is of importance. Three related photometric units define light output: luminous intensity, luminance and luminous flux.

Luminous intensity is expressed numerically in terms of the fundamental SI unit, the candela (cd). One candela is the luminous intensity in the direction of the normal to the surface of a full radiator of surface area 1/600,000 of a square metre, at the temperature of solidification of platinum. Luminous intensity is not necessarily uniform in all directions, so a mean spherical value, i.e. the mean value of luminous intensity in all directions, is used. Luminous intensity was originally called 'candle-power'.

Luminance is defined as luminous intensity per square metre. The unit of luminance is the candela per square metre (cd m^{-2}). An obsolescent unit sometimes encountered is the apostilb (asb), which is one lumen per square metre (lm m^{-2}) and refers specifically to light reflected from a surface rather than emitted by it. The luminance of a source, like its luminous intensity, is not necessarily the same in all directions. The term luminance is applicable equally to light sources and illuminated surfaces. In photography, subject luminances are recorded by a film as analogue optical densities of silver or coloured dyes.

Luminous flux is a measure of the amount of light emitted into space, defined in terms of unit solid angle or *steradian*, which is the angle subtended at the centre of a sphere of unit radius by a surface of unit area on the sphere. Thus, an area of 1 square metre on the surface of a sphere of 1 metre radius subtends at its centre a solid angle of 1 steradian. The luminous flux emitted into unit solid angle by a point source having a luminous intensity of 1 candela in all directions within the angle is 1 *lumen* (lm). Since a sphere subtends 4π steradians at its centre (the area of the surface of a sphere is 4πr^2), a light source of luminous intensity of 1 candela radiating uniformly in all directions emits a total of 4π lumens, approximately 12.5 lm (this conversion is only approximately applicable to practical light sources, which do not radiate uniformly in all directions). The lumen provides a useful measure when considering the output of a source in a reflector or other luminaire or the amount of light passing through an optical system.

Illumination laws

The term *illumination* refers to incident light and depends on the luminous flux falling on a surface and its area. The quantitative term is *illuminance* or incident *luminous flux* per

unit area of surface. The unit is the lux (lx): 1 lux is an illuminance of 1 lumen per square metre. The relationship between the various photometric units of luminous intensity, luminous flux and illumination is shown in Figure 3.3. The illumination E on a surface at a distance d from a point source of light depends on the output of the source, its distance and the inclination of the surface to the source. The relationship between illumination and distance from the source is known as the *inverse square law of illumination*. Light emitted into the cone to illuminate base area A at distance d_1 with illumination E_1 is dispersed over area B at distance d_2 to give illumination E_2. By geometry, if d_2 is twice d_1, then B is four times A, i.e. illumination is inversely proportional to the square of the distance d. Hence:

$$E_1/E_2 = (d_2)^2/(d_1)^2 \qquad (3.3)$$

From the definition of the lumen, the illumination in lux from a source at distance d is given by dividing the luminous intensity by the square of the distance in metres. So the illumination on a surface 5 metres from a source of 100 candelas is $100/(5)^2 = 4$ lx. Recommended values of illumination for different areas range from 100 lx for a domestic lounge to at least 400 lx for a working office.

The reduced amount of illumination on a tilted surface is given by Lambert's *cosine law of illumination*, which states that the illumination on an inclined surface is proportional to the cosine of the angle of incidence of the light rays falling on the surface. For a source of luminous intensity I at a distance d from a surface inclined at an angle θ, the illuminance E on the surface is given by:

$$E = I \cos \theta / d^2 \qquad (3.4)$$

The inverse square law strictly applies only to point sources. It is approximately true for any source that is small in proportion to its distance from the subject. The law is generally applicable to lamps used in shallow reflectors, but not deep reflectors. It is not applicable to the illumination provided by a spotlight due to the optical system used to direct the light beam.

Reflectors and luminaires

Most light sources are used with a *reflector*, which may be an integral part of the lamp or a separate item. A reflector affects the properties of the lighting unit as regards distribution and uniformity of illumination. The source, reflector and housing form a 'luminaire'. Reflectors vary in size, shape and nature of surface, and can be flat or shallow, or deeply curved in spherical or paraboloidal form. The surface can be highly polished, smooth matt or even lenticular. Some intermediate arrangement is usually favoured to give a mixture of direct and diffuse illumination. The light distribution from a luminaire is given by graphing the luminous intensity in each direction in a given horizontal plane through the source as a curve in polar coordinates, termed a *polar distribution curve* (see Figure 3.4). The source is at the origin (0°) and the length of the radius from the centre to any point on the curve gives the luminous intensity in candelas in that particular direction.

A reflector has a *reflector factor*, which is the ratio of the illuminance on the subject by a light source in a reflector to that provided by the bare source. A flashgun reflector may have a reflector factor from 2 to 6 to make efficient use of

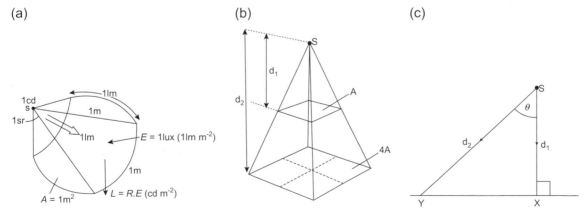

Figure 3.3 Photometric units and laws of illumination. (a) Photometric units derived from source S with intensity I of 1 candela (cd) at centre of sphere of radius 1 m. Flux emitted into 1 steradian (sr) is 1 lumen (lm). Area A is 1 m^2 with illumination E of 1 lux (lx) and luminance L in cd m^{-2} with reflectance R. (b) Inverse square law of illumination. Point source L gives illumination E_1 and E_2 at distances d_1 and d_2, where $E_1/E_2 = (d_2)^2/(d_1)^2$. (c) Lambert's cosine law of illumination. Illumination E_X at point X from source S of intensity I is $E_X = I/(d_1)^2$. At point Y, $E_Y = I \cos \theta/(d_2)^2$, where θ is obliquity.

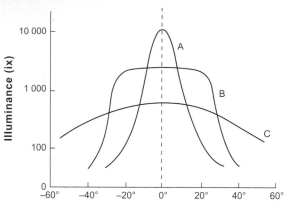

Figure 3.4 Distribution of illumination. Illumination levels at 5 m distance from a light source. (A) A 2 kW spotlight in 'spot' mode. (B) In 'flood' mode. (C) A 2.5 kW 'fill-in' light.

the light output, which is directed into a shaped beam with very little illumination outside the primary area.

Flashguns are often used with a large reflector of shallow box- or umbrella-like design and construction, called 'softboxes' and 'brollies'. Various surface finishes and diameters are used to convert the flashgun from a small source giving hard shadows when used direct, to a large, diffuse source offering softer lighting when used as the sole illuminant, albeit with considerable loss of efficiency. The *bare-bulb technique*, where the flash source is used without reflector or diffuser, is sometimes used for its particular lighting quality.

A *spotlight* gives a high level of illumination over a relatively small area, and as a rule gives shadows with hard edges. The illumination at the edges of the illuminated area falls off quite steeply. The use of diffusers gives softer shadows, and 'snoots' give well-defined edges. A spotlight consists of a small incandescent or flash source with a filament or flashtube at the centre of curvature of a concave reflector, together with a condenser lens, usually of *Fresnel lens* construction to reduce weight (Figure 3.5). By varying the distance between source and condenser, the diameter of the beam of light may be varied. For a near-parallel beam, the source is positioned at the focus of the condenser lens. With compact light sources, such as tungsten–halogen lamps, where it is possible to reduce the physical size of spotlights and floodlights, the optical quality of reflectors and condensers needs to be high to ensure even illumination.

Small electronic flash units can vary the distance of the flashtube from the Fresnel lens to provide a narrower beam that will concentrate the light output into the field of view of lenses of differing focal lengths. This 'zoom flash' action can be motorized and controlled from the camera to change automatically to match the lens attached to the camera, or when a zoom lens is used.

Constancy of output

Constant light output and quality are necessary characteristics of photographic light sources, especially for colour work. Daylight, although an intense and cheap form of lighting, is by no means constant: its intensity and quality vary with the season, time of day and weather. Artificial light sources are more reliable, but much effort can go into arranging lighting set-ups to simulate the desirable directional qualities of sunlight and diffuse daylight.

Electric light sources need a reliable power supply in order to maintain a constant output. If the frequency and/or voltage of the mains supply fluctuate, variation in light intensity and quality may result. Incandescent lamps inevitably darken with age, lowering both output and colour temperature. Tungsten–halogen lamps largely circumvent these problems. Fluorescent lamps have a long life, but also gradually decrease in light output with age.

Electronic flash has reliable light output and quality. Acceptably constant output requires adequate recharging time between successive flashes. The ready-light indicators fitted to many units glow when about 80% of the charging voltage is reached, but the energy available for the flash is only some two-thirds of full charge. Further time must be allowed to elapse before discharge, to ensure full capacity is available.

Efficiency

The efficiency of a light source for photographic use is related to factors determining its usefulness and economy in particular circumstances. These include control circuitry utilizing design techniques to give a low power consumption and choice of reflector to concentrate light output in a particular direction. Electronic flash units are examples of efficient reflector design, with little of the luminous output wasted.

The photographic effectiveness of a light source relative to a reference source is called its *actinity*, and takes into account the SPD of the source and the spectral response of the sensitized material or photosensor array. The *efficacy* is the ratio of luminous flux emitted to the power consumed by the source, and is expressed in lumens per watt. A theoretically perfect light source emitting white light of daylight quality would have an efficacy of about 220 lumens per watt. Values obtained in practice are lower.

DAYLIGHT

Daylight typically includes direct light from the sun, plus scattered light from the sky and clouds. It has a continuous spectrum and colour temperature gives an approximation of its quality, which varies through the day. Colour temperature is low at dawn, in the region of 2000 K if the sun is unobscured. It then rises to a maximum, and remains fairly constant through the middle of the day, to tail off

Figure 3.5 Effects of moving the light source in a luminaire. (a) Principle of the spotlight. When light source L is in 'spot' position S at the focus of spherical mirror M and Fresnel lens FL, a narrow beam of some 40° results. At 'flood' position F, a broader beam of some 85° results. (b) A 'zoom' flash system. The flash tube and reflector assembly R move behind the diffuser D to increase light coverage from telephoto T to wide-angle W setting of a camera lens.

slowly through the afternoon and finally fall rapidly at sunset to a value again below that of a tungsten filament lamp. The quality of daylight also varies from place to place according to whether the sun is shining in a clear sky or is obscured by cloud. The reddening of daylight at sunrise and at sunset is due to the absorption and scattering of sunlight by the atmosphere. These are greatest when the sun is low, because the path of the light through the earth's atmosphere is then longest. As the degree of scattering is more marked at short wavelengths, the unscattered transmitted light contains a preponderance of longer wavelengths and appears reddish, while the scattered light (skylight) becomes more blue towards sunrise and sunset.

These fluctuations prohibit the use of natural daylight for *sensitometric evaluation* of photographic materials (see Chapter 8). Light sources of fixed colour quality are essential. For many photographic purposes, especially in *sensitometry*, the average quality of sunlight is used as a standard (skylight is excluded). This is referred to as *mean noon sunlight*, and approximates to light at a colour temperature of 5400 K. Light of similar quality, but with a CT of 5500 K, is termed 'photographic daylight'. It is achieved in the laboratory by operating a tungsten lamp under controlled conditions to emit light of the required colour temperature, by modifying its output with a *Davis—Gibson liquid filter*.

Near noon, combined light from the sun, sky and clouds has a CT in the region of 6000–6500 K. An overcast (cloudy) sky has a higher value, and a blue sky may be as high as 12,000–18,000 K. The CT of the light from the sky and the clouds is of interest because it is this *skylight* alone that illuminates shadows, giving them a colour balance different to a sunlit area.

TUNGSTEN FILAMENT LAMPS

An incandescent photographic lamp produces light by the heating action of electric current through a filament of tungsten metal, with melting point 3650 K. The envelope is filled with a mixture of argon and nitrogen gas to allow operation at temperatures up to 3200 K. A further increase, to 3400 K, gives increased efficacy but a decrease in lamp life. A *tungsten filament lamp* is designed to operate at a specific voltage, and performance is affected by fluctuations in supply voltage. A 1% increase causes a 4% increase in luminous flux, a 2% increase in efficacy, a 12% decrease in life and a 10 K increase in colour temperature for a lamp operating in the range 3200–3400 K. Tungsten filament lamps include:

- *General-service lamps* used for domestic purposes in sizes from 15 to 200 W with clear, pearl or opal envelopes. The CT ranges from about 2760 to 2960 K, with a life of about 1000 hours.
- *Photographic lamps* are made for photographic use as reflector spotlights and floodlights. Their CT is nominally 3200 K, with a life of approximately 100 hours and power rating of 500 W. These have been superseded by more efficient, smaller tungsten—halogen lamps with greater output and longer life.
- *Photoflood lamps* produce higher luminous output and more actinic light by operating at 3400 K. A rating of 275 W gives a life of 2–3 h and 500 W a life of 6–20 h. Those with internal silvering in a shaped bulb do not need an external reflector.

TUNGSTEN—HALOGEN LAMPS

The *tungsten—halogen lamp* has a quantity of a halogen added to the filling gas. During operation a regenerative cycle is set up whereby evaporated tungsten combines with the halogen in the cooler region near the envelope wall, and when returned by convection currents to the much hotter filament region the compound decomposes, returning tungsten to the filament and freeing the halogen for further reaction. The effect is that evaporated tungsten

does not deposit on the bulb wall and this prevents blackening with age. Filament life is also extended due to the returned tungsten, but eventually the filament breaks as the redeposition is not uniform. The complex tungsten–halogen cycle functions only when the temperature of the envelope exceeds 250°C, achieved by using a small-diameter envelope of borosilicate glass or quartz (silica). The gas filling is used at several atmospheres pressure to inhibit the evaporation of tungsten and helps increase the life of such lamps as compared with that of conventional tungsten lamps of equivalent rating. The small size of tungsten–halogen lamps has resulted in lighter, more efficient luminaires.

Early designs used iodine as the halogen and the lamps were known as 'quartz–iodine' (QI) lamps. Other halogens and their derivatives are now used. Tungsten–halogen lamps are available as small bulbs and in tubular form, supplied in a range of sizes from 50 to 5000 W with CT from 2700 to 3400 K. A 200-hour life is usual with near-constant colour temperature. By operating at low voltages (12 or 24 V), a more compact filament can be used.

FLUORESCENT LAMPS

A *fluorescent lamp* is a low-pressure mercury-vapour discharge lamp with the envelope coated internally with a mixture of fluorescent materials or *phosphors*. These absorb and convert emitted short-wave UV radiation into visible light, the colour of which depends on the mixture of phosphors used, but can be made a close visual match to continuous-spectrum lighting.

Fluorescent lamps emit a line spectrum with a strong continuous background; their light quality can be expressed approximately as a *correlated colour temperature*. The *colour rendering index* (CRI) may also be quoted. There are many subjective descriptive names for fluorescent lamps such as 'daylight', 'warm white' and 'natural'. Lamps are classified as 'high efficiency' and 'de-luxe'. The former group have approximately twice the light output of the latter for a given wattage, but are deficient in red. They include 'daylight' lamps of approximately 4000 K and 'warm white' lamps of approximately 3000 K, a rough match to domestic tungsten lighting. The de-luxe group gives good colour rendering by virtue of the use of lanthanide (rare-earth element) phosphors, and includes colour matching types at equivalent colour temperatures of 3000, 4000, 5000 and 6000 K. The life of a fluorescent tube is usually of the order of 7000–8000 h, and the output is insensitive to small voltage fluctuations.

Colour images recorded using fluorescent lamps, even if only present as background lighting, may result in unpleasant green or blue colour bias, especially on colour-reversal film, needing corrective filtration by means of suitable *colour-compensating* filters over the camera lens.

METAL-HALIDE LAMPS

Originally the only metals used in discharge lamps were mercury and sodium, as the vapour pressures of other metals tend to be too low. However, the halides of most metals have higher vapour pressures than the metals themselves. In particular, the halides of lanthanide elements readily dissociate into metals and halides within the arc of a discharge tube. The ionized metal vapour emits light with a multi-line spectrum and a strong continuous background, giving virtually a continuous spectrum. The metals and halides recombine in cooler parts of the envelope. Compounds used include mixtures of the iodides of sodium, thallium and gallium, and halides of dysprosium, thulium and holmium in trace amounts. The discharge lamp is a very small ellipsoidal quartz envelope with tungsten electrodes and molybdenum seals. Oxidation of these seals limits lamp life to about 200 h, but by enclosing the tube in an outer casing and reflector with an inert gas filling, life can be increased to 1000 h.

The small size of this lamp has given rise to the term *compact-source iodide* (CSI) lamp. Light output is very high, with an efficacy of 85–100 lumens per watt. The *hydrargyrum metal iodide* (HMI) lamp uses mercury and argon gases with iodides of dysprosium, thulium and holmium to give a daylight matching spectrum of precisely 5600 K and CRI of 90 with a high UV output also.

When operated on an AC supply, light output fluctuates at twice the supply frequency. The resulting variation in intensity is some 60–80%. This can cause problems when used for short exposure durations in photography, unless a three-phase supply or special ballast control gear is used. Ratings of up to 5 kW are available.

PULSED XENON LAMPS

Pulsed xenon lamps are a continuously operating form of electronic flash device. By suitable circuit design a quartz tube filled with xenon gas at low pressure discharges at twice the mains frequency, i.e. 100 Hz for a 50 Hz supply, so that although pulsed the light output appears continuous to the eye. The spectral emission is virtually continuous, with a colour temperature of approximately 5600 K (plus significant amounts of ultraviolet and infrared radiation). Lamp dimensions are small, and they have replaced traditional carbon-arc lamps. Power ratings up to 8 kW are available, and lamp life is 300–1000 h depending on type.

EXPENDABLE FLASHBULBS

The traditional flashbulb is now obsolescent and used only occasionally such as for lighting very large interiors or for

high-speed recording where a series of bulbs fired in a 'ripple' give an intense compact source for a short time.

Flashbulbs contain fine metal ribbons of hafnium, zirconium or magnesium–aluminium alloy in an atmosphere of oxygen at low pressure, enclosed in a glass envelope with a lacquer coating to prevent shattering when fired. On electrical ignition, a bright flash of light is emitted as the metal burns, of about 0.01–0.02 s duration. The emission spectrum is continuous, with a CT of about 3800 K. A transparent blue lacquer coating converts this CT to 5500 K.

Trigger voltage from about 3 to 30 volts is from a *battery-capacitor circuit*. A battery charges a capacitor through a high resistance and the discharge of the capacitor then fires the bulb. Such a circuit may be used to fire several flashbulbs simultaneously in a multiple-flash set-up. Alternatively, *slave units* are connected to the individual extension flashguns so one flashbulb is triggered from the camera shutter contacts, and the light emitted by it operates *photocell switches* installed in the slave units to give near-simultaneous firing.

To avoid the necessity for batteries, alternative methods were used for firing arrays of bulbs in units intended primarily for simple cameras. Methods included a torsion spring striking a primer and a piezo-electric crystal and striker to give a firing pulse.

Flash performance is shown as a graph of emitted luminous flux emitted plotted against time, as in Figure 3.6a. *Effective flash duration* is a measure of the motion-stopping power and is the time interval between half-peak points. The camera shutter must be fully open at the point of peak output. The total light output (in lumen seconds) is given by the area under the curve.

A *guide number* or *flash factor* can be used to calculate camera exposure. A guide number (G) is the product of the f-number (N) of the camera lens and the subject distance (d) in metres for film of speed 100 ISO:

$$G = dN \qquad (3.5)$$

Guide numbers are subject to modification to suit the particular conditions of use, being influenced by the reflective properties of the surroundings of the subject.

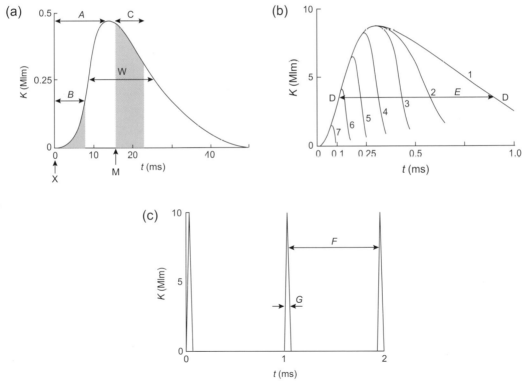

Figure 3.6 Characteristics of flash sources. (a) Flash bulb. *A*, time to peak; *B*, useful output for 1/125 s shutter speed, 'X' synchronization; *C*, output for 1.125 s with 'M' synchronization and 15 ms delay – total output is area under curve; *K*, light output in megalumens (Mlm); *t*, time; *W*, effective flash duration between half-peaks. (b) Automatic electronic flash. *E*, effective flash duration measured between one-third peak power points D (≈ 1 ms); *1*, full output; *2–7*, quenched output to reduce output and duration. For 7, *t* ≈ 1/20,000 s. (c) Stroboscope. Flashing rate of 1 kHz. *F*, inter-flash interval of 1 ms; *G*, flash duration of 20 µs (0.05 ms).

Guide numbers are estimated from the following formula:

$$G = \sqrt{(0.004LtRS)} \qquad (3.6)$$

where L is the maximum light flux in lumens, t is the exposure duration in seconds, R is the reflector factor and S is the arithmetic film speed. A modification necessary for units with built-in reflectors such as Flashcubes is:

$$G = \sqrt{(0.05EtS)} \qquad (3.7)$$

where E is the *effective beam intensity* of the bulb. This quantity is measured by an integrating light meter across the entire angle of coverage of the reflector and is not influenced by hot spots. It replaces the alternative *beam candle power* (BCP) measured at the centre of the beam only, but could be misleading.

Flash synchronization with the shutter is discussed in Chapter 11.

ELECTRONIC FLASH

Flash circuitry

In an electronic flashtube, an electrical discharge from a capacitor through a gas such as xenon, krypton or argon causes emission of a brief, intense flash of light. The gas is not consumed by this operation and the tube may be flashed repeatedly, with a life expectancy of many thousands of flashes.

The circuitry uses a capacitor charged from a DC supply of the order of 350–500 V, through a current-limiting resistor. This resistor allows a high-power output from a low-current-rated supply with a charging time of several seconds. The gas becomes deionized and the flash is extinguished after the discharge. The high internal resistance of the gas in the flashtube normally prevents any flow of current from the main capacitor, but by applying a triggering voltage (typically a short pulse of 5–15 kV) by means of an external electrode, the gas is ionized to become conducting, allowing the capacitor to discharge rapidly through it, causing a brief flash of light. This triggering voltage is linked to shutter contacts in the camera but a spark coil arrangement ensures only very low voltages pass though the contacts for safety. The trigger electrode may be in the form of fine wire around the flashtube or a transparent conductive coating.

The SPD of the flash discharge is basically the line spectrum characteristic of xenon, superimposed on a very strong continuous background. The light emitted has a correlated colour temperature of about 6000 K. The characteristic bluish cast given by electronic flash with some colour-reversal materials may be corrected either by a light-balancing filter with a low positive mired shift value, or by a pale yellow colour-compensating filter. Often the flashtube or reflector is tinted yellow or yellow–green as a means of compensation. The flashtube may be of borosilicate glass or quartz, the former giving a cut-off at 300 nm, the latter at 180 nm. Both transmit wavelengths up to 1500 nm in the infrared region. By suitable design of control circuitry, ultraviolet or infrared output can be enhanced, so an electronic flashgun can be a useful source of these radiations as well as visible light.

Flash output and power

The power output is altered by using additional capacitors, or the current may be divided between two tubes or separate heads or by thyristor control. The output can be 'symmetrical' or 'asymmetrical', e.g. 1000 W s^{-1} divided either into 2×500 or 4×250, or into 500 plus 2×250 W s^{-1} respectively. Alternative low-power settings typically offer alternative outputs from one-half to one-sixty-fourth of full power in halving steps. Extension heads may be used for multiple flash arrangements and each head may have its own capacitor. If the extension head shares the main capacitor output the connecting lead must be substantial, to reduce resistance losses. For greatest efficiency the connection between capacitor and flashtube must be as short and low resistance as possible. One-piece or 'monobloc' studio flash units are examples of this type. The use of slave units for synchronization facilitates multiple-head flash operation. Computerized control of outputs may be used.

The *energy input* E_i per flash in watt-seconds (W s^{-1}), often still called 'joules' (J), not all of which is available as output, is given by:

$$E_i = CV^2/2 \qquad (3.8)$$

where C is the capacitance in microfarads and V is the voltage in kilovolts. The *energy output* E_o is estimated by a formula for flash energy conversion such as:

$$E_o = E_i K_1 K_2 K_3 K_4 \qquad (3.9)$$

where K_1 is the conversion efficiency (some 50–60%), K_2 is the percentage of spectral bandwidth used, K_3 is the percentage of the emitted light directed at the subject by the optical system and K_4 is an empirical factor.

Camera integral units are rated at 5–20 W s^{-1} (joules), hand-held units for on-camera use are 20–200 W s^{-1}, while large studio flash units are available with ratings of 200–5000 W s^{-1}. The state of charge of the capacitor, i.e. readiness for discharge, is indicated by a neon light or beeping sound circuit, which is usually set to strike at about 80% of maximum voltage, i.e. at about two-thirds full charge. Several seconds must be allowed to elapse after this to ensure full charge. If the flash is not then triggered, various forms of monitoring circuitry may be used to switch the charging circuitry on and off to maintain full charge ('top-up') with minimum use of the power supply while conserving battery power. Some units may be equipped with monitoring circuitry that switches it off if

not used within a set period. The stored energy is 'dumped' as a safety measure.

Changes to flash circuitry allow a flashtube to be operated in *strobe mode*, i.e. emit a series of short flashes as well as a longer single flash. This allows a series of 'pre-flashes' to be emitted for red-eye reduction or for scene analysis, or during shutter operation to give a multiple exposure strobe effect, or to allow high shutter speeds to be used.

Flash duration and exposure

The characteristics of an electronic flash discharge are shown in Figure 3.6b. The *effective flash duration* (t) is usually measured between one-third peak power points, and the area under the curve between these points represents approximately 90% of the light emitted, measured in lumen-seconds or effective beam-candela-seconds. The flash duration t, as defined above, in a circuit whose total tube and circuit resistance is R with a capacitor of capacitance C, is given approximately by:

$$t = RC/2 \qquad (3.10)$$

So, for a 1 ms duration flash, the requirements are for high capacitance, low voltage and a tube of high internal resistance. The flash duration is usually in the range 0.02–2 ms. Units may have a variable output, controlled either by switching in or out of additional capacitors or by automatic 'quenching' controlled by monitoring of scene or image luminance (see later), giving a suitable variation in either intensity or flash duration. For example, a studio flash unit on full power may have a flash duration of 2 ms, changing to 1 ms and 0.5 ms when half- and quarter-power respectively are selected. Special strobe and *microflash* units may have outputs whose duration is of the order of 1 ms but with only about 1 W s^{-1} of energy. The output efficacy (P) of a flashtube is defined as being:

$$P = Lt/JE_i \qquad (3.11)$$

where L is the peak output (in lumens). The guide number of a flash unit with reflector factor R used with a film of arithmetic speed rating S is given by:

$$G = \sqrt{(0.005RSPE_i)} \qquad (3.12)$$

The flash guide number for distance in metres for ISO 100 film is usually incorporated in the designation number of the unit, e.g. '45' means $G = 45$.

The silvered reflectors used are highly efficient and direct the emitted light into a well-defined rectangular area with sharp cut-off, approximating to the coverage of a semi-wide-angle lens on a camera. Coverage may be altered to greater or lesser areas to correspond with the coverage of other lenses or a zoom lens by the addition of clip-on diffusers or by moving a Fresnel-type condenser lens in front of the flashtube to an alternative position. A moving tube 'zoom' feature may even be controlled automatically by the camera itself as a zoom lens is operated.

The use of diffusers and 'bounce' or indirect flash severely reduces the illumination on the subject and often needs corrective filtration with colour materials owing to the nature and colour of the reflective surface. This can be used to advantage, as when a golden-surfaced umbrella reflector is used to modify the slight blue cast given by some flash units, which may have colour temperatures of 6000 K or more. The main result of 'bounce' lighting is to produce softer, more even illumination. An umbrella-type reflector of roughly paraboloidal shape, made of translucent or opaque material, with white or metallic silver or gold finish, is a widely used accessory item, as are translucent umbrellas and 'soft boxes' to diffuse the light.

Portable units

A portable flash unit is attached to a camera via a hotshoe connection, or to a side bracket. The power supply is normally batteries, preferably alkaline-manganese. Alternatively, rechargeable types may be used such as nickel metal hydride and lithium-ion batteries. An LED display may show the state of charge or discharge of a set of batteries.

A range of accessories is available. The reflectors may be interchangeable from 'bare-bulb' to a deep paraboloid to give different beam shapes and lighting effects. Various modes of use include direct flash at full power, tilting reflectors for bounce flash, fractional output for close-up work or fill-in flash in sunlight, automatic exposure mode, programmed mode or stroboscopic mode. A data display panel gives a comprehensive readout of the operational mode in use.

Studio flash

A *studio flash unit* is usually used indoors but is transportable. Output is from 250 to 5000 W s^{-1}. The power supply is from the mains or a generator for location work, or even a large battery pack. The discharge tube may be in a linear or helical shape or possibly circular to give a 'ring flash'. Studio units have the convenience of a 'modelling lamp' positioned near the discharge tube to give a preview of the proposed lighting effect. The modelling lamp may be a tungsten or tungsten–halogen lamp, often with fan-assisted cooling, and its output may be variable, related to the flash output selected so as to facilitate visual judgement of lighting balance. The flash output may be selected manually by switches or by remote control, or by a cordless infrared programming unit used in the hand from the camera position. Output may be set within limits as precisely as one-tenth of a stop, a great convenience in balancing lighting rather than by shifting lights about, and allowing a smaller studio to be used.

The determination of the appropriate lens aperture setting is by the use of a hand-held integrating *flash meter*. Automatic in-camera methods use photocells to monitor the scene luminance or the image luminance on the film

surface by reflected light to a photocell in the camera body during the flash discharge. This is termed *off-the-film* (OTF) flash metering. As a confirmation and to give confidence in the outcome, a sheet of self-developing film may be exposed to evaluate exposure and lighting, as well as to check that everything is operating satisfactorily. Digital cameras give a preview of the result from the photosensor array.

Automatic flash exposure

The automation of camera exposure determination using electronic flash utilizes rapid-acting devices called *thyristor* switches and has power-saving advantages.

A silicon photodiode monitors the subject luminance when being illuminated by the flash discharge, and the resultant output signal is integrated by circuitry until it reaches a preset level. The flash discharge can then be abruptly terminated by a thyristor switch to give the correct exposure, subject to some limitations. The switch-off level depends on film speed and lens aperture.

The discharging flash capacitor may have its residual energy diverted into an alternative 'quench' tube, which is a low-resistance discharge tube connected in parallel with the main tube, and activated only when the main tube has ignited so as to prevent effects from other flashguns in use in the vicinity. There is no light output from the quench tube and the dumped energy is lost. The effective flash duration, dependent on subject distance, reflectance and film speed, may be as short as 0.02 ms, with concomitant motion-stopping ability. A preferred arrangement saves the residual charge in the capacitor and thereby reduces recharging time per successive flash and also increases the total number of flashes available from a set of batteries. This *energy-saving circuitry* has the thyristor switch positioned between the main capacitor and the flashtube. The thyristor is closed when the flash is initiated, and then opened almost instantaneously on receiving a pulse from the light-monitoring circuit to terminate the flow of current sustaining the flash. Full flash discharge is possible in manual mode by taking the monitoring photocell out of circuit so that the 'open' pulse is never given. To allow for the use of different film speeds and lens apertures the photocell may be biased electrically or mechanically. Flash duration reduces as the flash is quenched more rapidly over a range of usually 30 or 50 to 1, i.e. from 1 ms at full power to 0.02 ms at minimum power. This is useful for capturing motion of a subject. Flash colour temperature may also change with output duration, tending to rise as duration reduces.

The photocell can be in a small hotshoe-mounted housing attached to the flash unit by a flying lead, which allows monitoring of scene luminance irrespective of the flash-head position, and allows the use of bounce flash. It is desirable with flashguns having an integral photocell that this is positioned to face the subject irrespective of the direction in which a rotatable or swivelling flashtube assembly may be pointed. Two or more automatic flashguns can be combined for multiple flash use with either connecting leads or 'cordless' infrared or radio triggering systems. The hotshoe on the camera has a single central 'X' flash synchronization connection and, depending on the camera system, other connections to interface the flashgun with the camera for features such as automatic selection of a shutter speed for correct synchronization when the flash is attached, a 'thunderbolt' readylight indication in the viewfinder, use of a short 'pre-flash' for autofocus use or exposure determination and control of a zoom flash feature. The flash synchronization may be selectable to be *first blind* or *second blind* type where it is triggered either by the first blind uncovering the film gate or by the second blind just before it starts to cover up the gate. This latter feature is useful for combined flash and short time exposures with moving subjects to give an enhanced impression of motion. The problems of flash synchronization to the camera shutter are dealt with in Chapter 11.

Control can be by a photocell inside the camera which monitors the luminance of the image of the scene actually on the photoplane while the camera shutter is fully open at the flash synchronization speed when the photoplane is fully uncovered. A segmented photocell provides a weighted analysis of the tonal range and distribution in the scene, termed 'matrix flash'. For use in ambient light to provide fill-in by 'synchro-sunlight' techniques, this scene analysis can provide the right amount of supplementary flash to give a more pleasing image. An automatic flashgun may only operate fully with a particular camera, when it is called a 'dedicated' flashgun. The firmware of an automatic flash can be updated via downloads from a computer. A flow diagram for dedicated-flash operation is shown in Figure 3.7.

Integral flash units

Most cameras have an *integral flash* unit with a small but useful output. This can be just a fixed value as in single-use cameras or a system with a range of modes. In compact cameras the flash is automatically activated when the light level is too low for an ambient-light exposure. The flash output can be a single full discharge with the necessary lens aperture set to the required GN value by using subject distance information from the autofocus system used in the camera. This is a 'flashmatic' system. In other cameras of the SLR type, the flashgun is often fully automated with a photocell for through-the-lens and off-the-film operation. The output from a photosensor array may also be used. A menu of flash modes includes 'automatic', i.e. selected according to subject luminance, 'off' when no flash fires, 'on' when the flash fires irrespective of light conditions and always at full power, or 'red-eye reduction' to alleviate this disturbing effect.

Figure 3.7 Flow diagram of dedicated flashgun operation. The major stages of operational sequences and the features offered by such flashguns are shown.

Red-eye avoidance

An unfortunate optical consequence of an integral flash is that the flashtube is close to the lens so that the light is directed essentially along the optical axis. This direct *axial lighting* can be a problem with reflective subjects when a glare spot is given in the picture, but even more so when a subject is looking at the camera. Light enters the eye via the pupil, usually fully dilated in the dim light conditions requiring the use of flash, and illuminates the retina at the back of the eye, which is rich in red blood vessels. The result is a characteristic bright red pupil. This *red-eye effect* can be reduced in various ways. The ambient light can be increased to cause the pupil to contract, or a small projector in the camera or flashgun can direct a pencil beam of light at the face to the same effect or the flashgun can emit a number of short pre-flashes before the main exposure, when hopefully the pupil will have reacted. The subject can look away from the camera lens, but the best method is to move the flashtube away from the camera lens. This influences camera design and the integral flash unit may be on a short extension of the camera body for use. Portable

flash units should be used if possible but on an extension cable. The choice and disposition of lighting to suit the 'treatment' of the subject is beyond the scope of this book.

The various forms of flash synchronization and output, whether full, quenched or pulsed, are shown and compared in Figure 3.8.

OTHER SOURCES

Other light and radiation sources find use in photography and digital imaging, for both image capture and illumination systems.

Light-emitting diodes

The *light-emitting diode* or LED is a very small solid-state device encapsulated in a housing with integral lens to direct and shape the emitted beam. Operation is by electroluminescence using forward biasing of a p–n junction in materials such as gallium arsenide or gallium

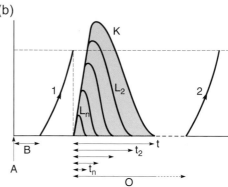

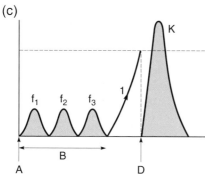

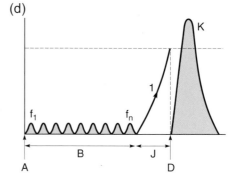

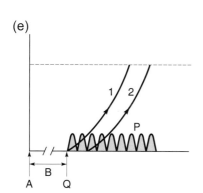

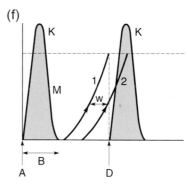

Figure 3.8 Flash modes and shutter synchronization. (a) First and second blind synchronization. 1, first (leading) blind; 2, second (trailing) blind; A, shutter triggered; B, reflex mirror time; C, blind travel time; D, flash triggered by first blind (X synchronization); E, flash triggered by second blind; O, film gate fully uncovered (flash synchronization speed); L, flash output; T, elapsed time; t, flash duration (nominal); K, main flash; Q, start of blind travel. (b) Quenched electronic flash. L_2, reduced flash output; t_2, reduced flash duration. (c) Red-eye reduction by bright pre-flashes. f_1, f_2, f_3, pre-flashes. (d) Matrix metering of scene using faint pre-flashes. f_1 to f_n, weak pre-flashes; J, data processing. (e) Flash with high shutter speeds, e.g. to 1/12,000 second, using high-frequency strobe flashes. P, pulsed strobe flash. (f) Flash synchronization errors. M, incorrect use of M instead of X synchronization setting; W, shutter speed too short for synchronization; a travelling slit is formed.

phosphide. Light output is monochromatic and, typically, red (649 nm), green (570 nm) or infrared (850 nm). The LED can be mains or battery powered and has very modest power consumption, but can still be a significant drain on the limited capacity of the battery in a camera. It has a principal use as an indicator light for equipment

operational conditions or modes. The small source can be used alone or behind a patterned mask to give an alpha-numerical or symbolic display, as in a viewfinder or flashgun data readout. The usual states are off, on, pulsing or dimmed (given by altering a flashing rate from a pulsed supply).

To provide a more intense beam suitable for illumination purposes, LEDs are used in arrays of multiple sources, e.g. emitting in the near infrared as used for covert work to illuminate a scene for recording by a suitable infrared system. An illuminator operating from a 12 V supply can illuminate a scene up to 25 m distant. Illuminators can be rectangular, linear or annular in shape to suit the illumination task. A pulse rate up to 150 Hz is typical. The red monochromatic emission also finds use in the darkroom as a bright safelight for room illumination or as a portable unit for hand-held local illumination.

Diode lasers

The *diode laser* or 'microlaser' is a semiconductor crystal derived from gallium arsenide that emits intense coherent light at a few wavelengths by stimulated emission, as compared to the spontaneous emission of an LED that produces incoherent light with a wider spectral range. The astigmatic shape of the output beam requires optical correction to a circular form. The devices can be assembled in rectangular array, linear (bar) or single source form. Laser wavelengths of 750—780 nm are typically used in optical disc (compact disc, CD) reader systems with a single source. Wavelengths of 670 and 780 nm are suited to printing plate technology using digital data direct from computer image files.

These devices can have an intense monochromatic output suited to three-colour (red, green, blue) exposure systems in various forms of printer to provide a hard-copy output from digital files and may even use three different infrared wavelengths to expose the three-colour forming image layers. Display systems may use red (656 nm), green (532 nm) and blue (457 nm) modulated microlaser beams to form a direct write display.

BIBLIOGRAPHY

Carlson, V., Carlson, S., 1991. Professional Lighting Handbook, second ed. Focal Press, Boston, USA.

Cayless, M., Marsden, A. (Eds.), 1983. Lamps and Lighting, third ed. Edward Arnold, London, UK.

Edgerton, E., 1970. Electronic Flash, Strobe. McGraw-Hill, New York, USA.

Fitt, B., Thornley, J., 1997. Lighting Technology. Focal Press, Oxford, UK.

Jacobson, R.E.J., Ray, S.F.R., Attridge, G.G., Axford, N.R., 2000. The Manual of Photography, ninth ed. Focal Press, Oxford, UK.

Minnaert, M., 1993. Light and Colour in the Outdoors. Springer-Verlag, New York, USA.

Ray, S., 1999. Scientific Photography and Applied Imaging. Focal Press, Oxford, UK.

Ray, S., 2002. Applied Photographic Optics, third ed. Focal Press, Oxford, UK.

Chapter | 4 |

The human visual system

Robin Jenkin

All images © Robin Jenkin unless indicated.

INTRODUCTION

Vision is perhaps the most remarkable of the senses. The human eye has been likened to a camera in many descriptions and indeed, superficially, this is true. As may be seen in Figure 4.1, it is a light-tight sphere with a lens system positioned with which to focus light on to a photosensitive layer, the *retina*, located at the back of the eyeball. Beyond this basic description, the structure and operation of the *human visual system* (HVS) is much more complicated than the most sophisticated cameras available at present. On examination, it may be seen that it is proficient in refined control of focusing, exposure, and white balance, capable of compression, is a scanning system and can respond to lighting conditions that can vary

by up to six orders of magnitude. Furthermore, it can competently provide information on the three-dimensional world around us.

Generally, the HVS works so reliably on a daily basis that its complexity is forgotten, as are the myriad of processes that lead to our perception of the world about us. The sophisticated processing that takes place within the HVS, and predominantly within the *visual cortex*, leads us to perceive images approximately one- to two-tenths of a second after they occur. Understanding the basic functioning of the eye leads to better design and operation of imaging systems, whether it be matching the exit pupil of a pair of binoculars to that of the eye or designing a compression system to be perceptually lossless. The visual systems of animals display incredible variation in complexity, operation and performance. Appreciation of this wide biological diversity, from the compound eye of the bee to the polarized vision of cephalopods, inspires many further advances in numerous areas.

THE PHYSICAL STRUCTURE OF THE HUMAN EYE

In brief, the eye is a light-tight sphere, approximately 24 mm in diameter, whose shape is predominantly maintained by the *sclera*, the white part of the eye, and the *vitreous humour* (Figure 4.1). It has a lens system positioned at the front to focus light on to a photosensitive layer, the retina, which lines the rear of the eye, to form an inverted image. The lens system consists of the *cornea* and a *crystalline lens*. It is the function of the retina to convert the incoming light to electrical signals which then travel to the visual cortex and other structures via the optic nerve at

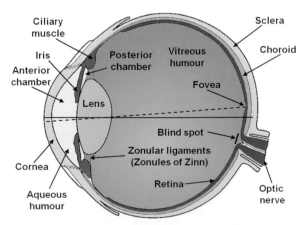

Figure 4.1 Cross-section through the human eyeball.
Adapted from McDonald (1987)

DOI: 10.1016/B978-0-240-52037-7.10004-3

the rear of the eyeball. Processing of images, their meaning and the context within which they appear is distributed throughout various parts of the brain and not presently fully understood. The visual cortex, however, is primarily responsible for perception of patterns and shapes encoded by the retina. The coloured portion of the eye, the *iris*, controls the amount of light entering the visual system by changing the size of the *pupil*, the dark centre, in a similar manner to a lens aperture. When combined with chemical changes in the retina this accounts for the eye's ability to respond to varying lighting conditions. Considerable detail is omitted from the above overview and the remainder of this chapter is dedicated to describing the structure and processes of the human visual system at greater leisure.

Tunics

The eye may be considered as comprising three *tunics*, or layers, identified as the fibrous, vascular and nervous tunics. These approximately correspond to the outer, middle and inner layers of the wall of the eye. The fibrous tunic, or the outer layer of the eye, consists of the sclera and cornea. The sclera, also known as the sclerotic coat, is the 'white' of the eye, an opaque tough fibrous material made of collagen and elastic tissues. Protecting the rear three-quarters of the eyeball, it generally 'yellows' as it ages.

The middle, vascular tunic consists of the iris, ciliary body and choroid. Sometimes referred to as the uveal tunic, the primary function of this layer is to provide the eye with the oxygenated blood that it needs to operate. This is principally undertaken by the choroid, a network of blood vessels which lie in the posterior region of the eye below the sclera. The vascular tunic is pigmented with a deep purple colour, often referred to as 'visual purple', which absorbs scattered light in a similar manner to the matte-black coating often seen inside cameras. The inner, nervous tunic is the sensory layer containing the retina and upon which images are focused. The function of the layer is to detect light and encode the signal for transmission via the optic nerve to the visual cortex.

Cornea

Though its shape is fixed, the cornea provides approximately three-quarters of the optical power necessary to focus light on to the retina. It is a clear, avascular dome, approximately 12 mm in diameter and up to 1.2 mm thick, which covers the front part of the eye, the iris and the lens. A reasonable estimate of the refractive index of the cornea is of the order of 1.376. It is, however, constructed of many layers of fibrous tissue and, as such, its refractive index varies with each layer, hydration and the wavelength of light considered. Light passing through the cornea enters into the *anterior chamber* formed between its posterior surface and the iris. It is filled with *aqueous*

humour which, necessarily, due to the avascular nature of the cornea, provides it with the nutrients it needs via diffusion.

The aqueous humour has a refractive index (see Chapter 2) of around 1.336 and, as such, the cornea—aqueous boundary provides no significant optical power. The majority of the optical power of the eye is therefore derived at the air—cornea interface. This is one of the reasons that when swimming underwater without a face mask or goggles human vision is blurred. The refractive index of water is approximately 1.335 at a wavelength of 550 nm as opposed to practically 1 for air. The reduction in the difference of the refractive indices at the boundary makes it virtually impossible for the average eye to focus a sharp image on to the retina. In a similar manner to the sclera, the cornea 'yellows' as it ages.

Conjunctiva

Beginning at the edge of the cornea, the *conjunctiva* is a membrane that covers the outer part of the sclera and inner surfaces of the eyelids. It serves to prevent dust and other objects from entering the eye and to reduce friction between the eyelids and eyeball by helping to keep it moist. Conjunctivitis, sometimes known as 'pink eye', is inflammation or irritation of the conjunctiva.

Iris and pupil

A coloured, muscular, disc-shaped structure, the iris is positioned just in front of the crystalline lens (Figure 4.2). It has a hole in the centre, the pupil, and muscles which run radially and tangentially in a ring around it. When looking in a mirror, it is the coloured portion of the eye that we see. The colour of the iris is determined by, among other things, the amount and ratio of different types of *melanin* contained within it, either darker brown—black eumelanins or lighter, red—yellow pheomelanins. Melanin is also found

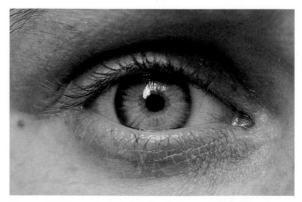

Figure 4.2 External photography of the human eye.

in the skin and hair and, in a similar manner, the ratio determines our skin or hair colour. The iris is considered part of the anterior vascular tunic and its rear surface is pigmented, as previously mentioned, a deep purple colour.

The iris controls the amount of light entering the eye which, when fully open, has a diameter of approximately 8 mm in low light levels and around 2 mm in bright conditions. It creates effective apertures from $f/11$ to $f/2$, but this only partially accounts for the large range of the lighting conditions under which the eye can operate. Controlled by the central nervous system, the iris has a sphincter muscle about 1 mm thick near the pupil, which constricts it in bright conditions. As light levels drop, radial muscles act to dilate the iris. Testing the reaction of the iris to light and its evenness in both eyes is often used as a basic test for brain function.

The iris is the dividing point for the anterior and posterior chambers located in the front of the eye. The posterior chamber is formed between the rear surface of the iris and the anterior surface of the crystalline lens. It is also filled with aqueous humour, which helps to nourish the crystalline lens.

The texture and patterns exhibited by the iris are believed to be unique and have been exploited in recent years for use in security systems. Though a full description is inappropriate here, most systems rely on a wavelet-based frequency analysis of the patterns and this is covered in more detail in Chapter 28.

Crystalline lens

Known as *accommodation*, the fine focusing necessary to produce a sharp image is undertaken by the crystalline lens. Constructed primarily of proteins, it is many layered and has a varying refractive index, from approximately 1.40 in the centre to 1.38 in outer layers. Flexible in nature, the diameter of the lens is approximately 9 mm in adults and up to 5 mm thick. The lens is suspended in its own corpuscular bag by zonular fibres behind the iris and is attached to the ciliary body.

The lens is biconvex with approximate radii of curvature of 9 and −6 mm for the anterior and posterior surfaces respectively when relaxed. Therefore, the lens contributes some optical power even when looking at distant objects, but primarily aids focusing of objects closer than about 20 ft. The effective focal length of the combined cornea−eye lens system is approximately 16 mm which, given the overall diameter of the eyeball at 24 mm, some may find surprising. The aqueous and vitreous humours, however, effectively lengthen the optical path between the lens system and the focal plane by reducing refraction at the lens boundaries internal to the eye. The optical power of the lens contributes around a quarter of the total power of the eye. Focusing, or accommodation as it is known, is considered in further detail later in this chapter.

Ciliary body

The *ciliary body* is a doughnut-shaped piece of tissue that lies at the outer edge of the iris and to which the crystalline lens is attached via the *zonular ligaments*. Somewhat like the iris, the ciliary body contains radial and tangential muscles which are responsible for adjusting the shape of the lens. The ciliary body is also thought to produce aqueous humour, which diffuses through zonular fibres into the posterior chamber of the eye, through the pupil and into the anterior chamber.

Vitreous cavity and vitreous humour

The *vitreous cavity* is the main space behind the crystalline lens and in front of the retina. It is filled with vitreous humour, a fluid much the same consistency as egg white, and helps to maintain the shape of the main body of the eyeball. The vitreous humour is predominantly water with a small amount of protein, which imparts its viscous nature and has a refractive index of around 1.337. It is attached to parts of the retina, though ageing generally causes it to liquefy, allowing it to move about. The liquefaction of the vitreous humour and further discontinuities in it may generally be seen as *floaters*, small spots or lines which move about the visual field as the position of gaze is changed. These are most easily seen on light-diffuse uniform backgrounds. More serious disruption of the vitreous humour can cause tension on the retina and a sensation of flashing lights. If this occurs, or the number of floaters seen increases, it is important to seek professional medical attention as soon as possible to avoid further damage to the retina. Generally, the light-sensitive cells in the retina do not cause pain in response to stimuli. Thus, flashing lights may be the only indication of a problem.

Retina and choroid

The inner surface of the eye starting behind the ciliary body is coated with the retina. The retina is a layer, about 0.5 mm thick, of photosensitive and nerve cells whose task it is to encode the incoming light into electrical signals for the brain. Coating about two-thirds of the inside of the eye, the retina lies on top of the *choroid*. As previously mentioned, the choroid is considered part of the posterior vascular tunic and primarily provides the blood supply to the retina. Directly above the choroid lies *Bruch's membrane*, which separates the retina from the vascular network. Between Bruch's membrane and the photosensitive cells of the retina lies the *retinal pigmented epithelium*. This layer helps to exchange waste products and nutrients between the choroid and the photosensitive cells of the retina and further absorb stray light. The posterior surface of the choroid is known as the *tapetum* and may appear iridescent.

Figure 4.3 A demonstration to find the blind spot. By covering your right eye and looking at the picture of the dog from approximately 20 cm, its owner should disappear. Alternatively, covering the left eye and looking at the owner, the dog will disappear. You may have to adjust the distance that you are to the page.

The detailed structure of the retina is considered later in this chapter.

Optic nerve

The signals generated by the cells in the retina travel towards a light-coloured spot on the retina, known as the *optic disc*. This is the point at which the *optic nerve* connects and is located at about 10° from the optical axis on the nasal side. It is additionally known as the *blind spot* due to the lack of photoreceptors at this point. Approximately 1 million nerve fibres commence their journey from the retina to the visual cortex here, though the pathway from the retina is not direct, as will be examined later. The optic nerve also carries the retinal artery and vein, transporting blood both towards and away from the eye.

Demonstration that the blind spot is insensitive to light is readily achieved. By covering your right eye and looking at the picture of the dog in Figure 4.3 from approximately 20 cm, its owner should disappear. Alternatively, covering the left eye and looking at the owner, the dog will disappear. You may have to adjust the distance that you are to the page.

Structure of the retina

The retina is a light-sensitive layered structure coating the inside of the eye and is considered as part of the nervous, or inner, tunic. It begins at, and is continuous with, the optic nerve and ends just behind the ciliary body at the *ora serrata*, so named because of its appearance as an irregular margin. A thin, non-imaging, layer continues beyond this point to cover the back of the ciliary body and iris. The retina is considered part of the central nervous system as it derives from the same material as the brain in embryonic development. Five main layers may be identified in the human retina: *the receptor, outer plexiform, inner nuclear, inner plexiform* and *ganglion cell layers*. More detailed descriptions, however, often divide the retina into 10 layers, or even more. Figure 4.4 presents a schematic of the basic retinal layers. The first interesting thing to note is that the light-sensitive receptor layer is nearest the choroid. Light must traverse the remaining layers before being detected by two types of cells that exist in the sensitive layer, *rods* and *cones*. The rods and cones convert incoming light into electrical

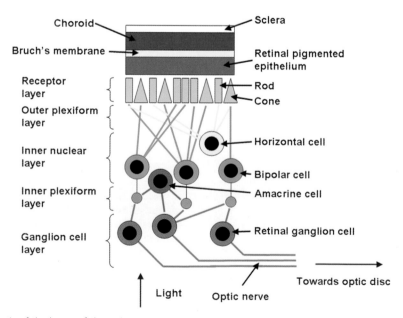

Figure 4.4 A schematic of the layers of the retina.

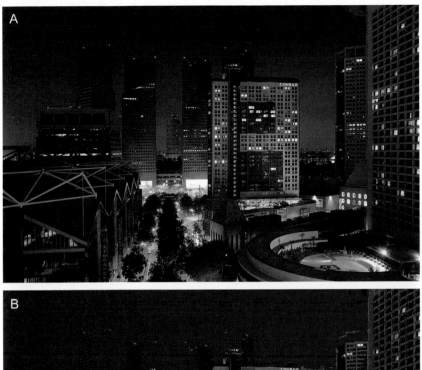

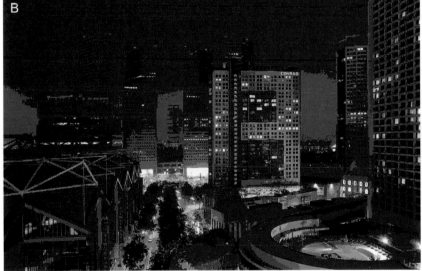

Figure 4.5 (A) An image of the centre of Singapore at night. (B) The same image compressed to 96:1 using JPEG compression.

signals which then traverse the layers until being transmitted by the axons of the *ganglion cells* that form the optic nerve. There are approximately 125 million photoreceptors in the retina; however, there are only about 1 million ganglion cells. This may be interpreted as representing compression of the image in the order of 125:1. The significance of this level of compression may be illustrated by comparing an image that has been compressed to a level of 96:1 to its original using the commonly available Joint Photographic Experts Group (JPEG) format (Figure 4.5). Whilst it may be argued that at the time of writing there are better performing compression systems available, JPEG is by far the most common. It should also be noted that

higher compression ratios may also be easily achieved by exploiting *temporal correlation*. Temporal correlation may be thought of as similarity between two or more successive images. Imagine a newsreader in a studio; only the newsreader moves and the background stays the same. Therefore, the background areas exhibit temporal correlation and this information need not be transmitted again.

The interaction of the layers in the retina is highly complex and the detailed mechanisms of vision, which involve the organization of the receptors and the way in which signals are generated, organized, processed and transmitted to the visual cortex, are beyond the scope of this book. However, they give rise to a number of visual

phenomena which have been extensively studied and have consequences in our understanding and evaluation of imaging systems. In addition there are a number of strong psychovisual effects due to interpretation and processing of the images in the visual cortex and other areas of the brain. Furthermore, upbringing has also been shown to influence the way in which images are understood. A number of generalized effects are given in the following pages and more detailed descriptions are given on colour vision (Chapter 5). For an in-depth description the reader is invited to consult some of the works listed in the Bibliography.

Rods and cones

The primary layer of light-sensitive cells is also known as *Jacob's membrane*. Named due to their shape, photosensitive rods and cones are not uniformly distributed throughout the retina and perform synergistic, but differing, functions. Rods are highly sensitive and provide monochromatic vision at low light levels: *scotopic vision*. Less sensitive by

a factor of hundreds, three variations of cones provide colour vision in more abundant levels of light: *photopic vision*. *Mesopic vision* occurs when light levels are such that both rods and cones are being used. Scotopic vision exists because cones cannot operate at low light levels and is generally considered to function in an illumination range of approximately 10^{-6} to 10^{-2} cd m^{-2}. The lower figure is the threshold at which rods operate and the upper figure that at which cones begin to operate. Because scotopic vision relies mainly on rods it displays poor acuity. Mesopic vision relies on both rod and cone vision from approximately 0.034 to 3.4 cd m^{-2}, or moonlight to twilight. Because cones are not operating optimally it gives poor colour discrimination though slightly better acuity than scotopic vision. For illumination levels above approximately 3.4 cd m^{-2}, cones function optimally and the best colour and acuity vision is rendered.

Figure 4.6 shows the distribution of the rods and cones throughout the retina. It may be seen that there is a very high density of cones at a point on the retina, named the *fovea*, and relatively few distributed throughout the

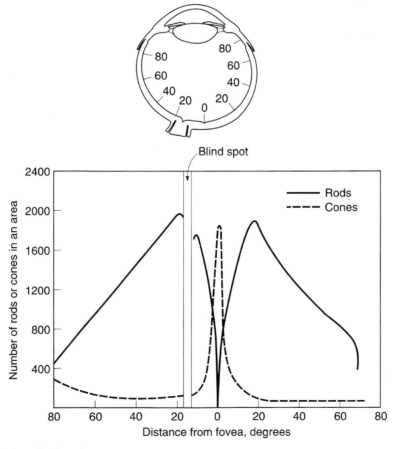

Figure 4.6 The distribution of rods and cones.

remainder of the area. Conversely, it may be seen that rods are extremely sparse at the fovea, numbering higher elsewhere in the retina and then dwindling in number towards the periphery of vision. At the blindspot neither rods nor cones exist.

The fovea is a point on the optical axis of the eye approximately 0.5−1 mm in diameter (about 2° of the visual field) into which is packed in excess of 50,000 cones in a hexagonal pattern. It appears as a small dip within a yellow circle known as the *macula*. Rods and cones have sizes in the range of microns, though the cones are slightly thinner in this area and generally have a near one-to-one correspondence with optic nerve fibres at the centre of the fovea. The fovea therefore provides high acuity colour vision in good lighting: photopic vision. The yellow pigment of the macula is know as *macula lutea* and is thought to reduce chromatic aberration of the eye by absorption of blue light. Acuity drops dramatically towards the periphery of vision and, as a consequence, light must fall on the central 15° or so to provide quality vision. A direct effect of this is that the human visual system scans to build a picture of its environment by constantly changing its position of gaze. These movements are known as saccades and are discussed in more detail later in this chapter.

Though rods outnumber cones by about 20 to 1, approximately 120 million as opposed to 6 million, they provide lower acuity vision in the remainder of the visual field. *Spatial resolution* is sacrificed increasingly toward the periphery of vision due to increased numbers of rods being 'wired together' in order to increase sensitivity and the perception of movement or temporal resolution. Triggering a turn of the head towards the stimulus, the detection of movement in the periphery of the visual field is thought to be important to ready the body for a 'flight or fight' response from a would-be predator.

The basic structure of rods and cones is shown in Figure 4.7. Rods, as their name suggests, are approximately cylindrical in shape. The outer light-sensitive part of the rod cell contains hundreds of discs, *lamellae*, containing the light-sensitive purple pigment *rhodopsin*, also known as visual purple. On exposure to light the rhodopsin is bleached or broken down, producing an electrical potential and chemical by-products. The electrical potential is the basic building block of the signal that is eventually processed and sent to the brain. Rods are many hundreds of times more sensitive to light than are cones, and this is further enhanced by their being combined in increasingly large clusters, or *receptive fields*, towards the periphery of the field of view. Therefore, to express it in modern terms, it is not useful to think of a rod or a cone as a single 'pixel' in an image. Rather, as will be seen later, the receptive fields to which a number of rods or cones contribute should be thought of as a basic picture element − larger, more sensitive pixels at the edge of the field of view and smaller, higher resolution, but less sensitive pixels at the centre. The increased sensitivity of the rods at the periphery of the field of vision is important to astronomers. The lack of rods at the fovea leads to very poor night vision on the optical axis, so looking directly at an object can often cause it to 'disappear'. By looking off-axis and using the more light-sensitive part of the retina is it possible to detect objects that are many times fainter.

The *spectral sensitivity* of the rods may be seen in Figure 4.8. The spectral sensitivity of a system may be thought of as how sensitive a detector is to each wavelength of light considered. If, for example, the sensitivity of a system to green light (550 nm) is 1 and to blue light (450 nm) is 0.5, it will take twice as much blue light to produce the same response as the green, as the system is only half as sensitive. If the spectral sensitivity of a system is zero, it cannot detect that wavelength of light. A related term, *spectral responsivity*, is the electrical output of a detector compared to the light falling on it with respect to wavelength. Whilst spectral sensitivity may often be

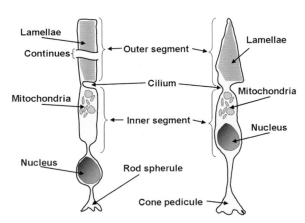

Figure 4.7 The structure of rods and cones.

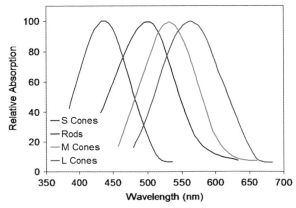

Figure 4.8 The spectral sensitivity of rods and cones.
Adapted from Dowling (1987)

expressed as a relative fraction and may be unitless, spectral responsivity is an absolute value with units such as $VJ^{-1}cm^{-2}$.

It is reasonable to expect that because of the rods' higher sensitivity, they would have a broader spectral sensitivity curve than that of any of the individual cone cells. This, however, is seen not to be the case and the curve for the rods is similar in width to that of any of the cones with a peak response at about 500 nm. This would suggest that the increase in sensitivity is achieved by some other means than simple spectral integration of light. The rods connect to a number of *horizontal* and *bipolar cells* contained within the outer plexiform layer of the retina.

Whilst there is only one type of rod, there are three types of cone that have been identified in the human retina, the distribution of which dominates the fovea. In other species these numbers can vary and the proportion of rods to cones, as well as type, can be reflective of an animal's typical behaviour and habitat. Often denoted short (S), medium (M) and long (L) wavelength cones, they are by no means found in equal numbers. Whilst 'blue'-sensitive S-cones have the highest sensitivity, they are generally not found in the central fovea and number only 1−2% of the cone total. 'Red'-sensitive L-cones can outnumber 'green' M-cones by as much as 2:1, yielding approximately 64% and 32% respectively. As may be seen in Figure 4.8, red, green and blue are terms that should be used with some caution as the cones' spectral sensitivities are not narrow-cut and idealized. Rather, they have broad-based curves which overlap greatly and therefore 'greenish-blueish' may be a more appropriate name for an M-cone, for example. The peak sensitivities of the S, M and L cones can be seen to be approximately 420, 534 and 564 nm respectively. The integrated peak sensitivity of the cones is close to 555 nm, which corresponds closely to the peak output of the sun.

In Figure 4.7 it can be seen that the structure of the cones is similar to that of the rods, with lamellae contained in the outer segment. Rather than being discs as in the rods, the lamellae are formed as a continuously folded sheet. The lamellae employ three variants of *iodopsin* − *cyanolabe*, *chlorolabe* and *erythrolabe* − in the S, M and L cones as the photosensitive chemical and are similar to rhodopsin found in the rods. Vitamin A is important in the synthesis and regeneration of photopsins in both rods and cones, and a deficiency can lead to defective vision. Though the cones have a lower absolute sensitivity to light than do the rods, their response time is quicker, and some studies have suggested that under identical stimulus, the signal from a cone can arrive up to a tenth of a second faster than that from a rod. At the most basic level, it is the detection in the differences of the ratios of the signals from the three cones that leads to the sensation of colour. As for rods, cones also connect to horizontal and bipolar cells in the outer plexiform layer.

For cones, however, especially in the foveal region, one photoreceptor often connects to one nerve cell, leading to better acuity.

To reiterate, it is wrong to think of the rods and cones as being a single element in an image. There are complex interconnections between the cells formed by other layers in the retina that modify and enhance these fundamental responses to light. A basic description of the remainder of these layers and the cells is given here and the reader is encouraged to also examine the work of some notable authors listed in the Bibliography.

'Non-imaging' cell layers

Synapses from the photoreceptors, bipolar cells and connections from horizontal cells are contained within the outer plexiform layer, whereas the inner nuclear layer contains the cell bodies of horizontal, bipolar and *amacrine cells*. Horizontal cells are large, connecting photoreceptors and bipolar cells that may be some distance apart. Lateral connections in the retina can cause a spread of the signal generated by photoreceptors of up to 1 mm. Horizontal cells alone, however, do not account for this total and are thought to possibly feed information back to the photoreceptors themselves.

Bipolar cells receive signals from rods and cones, in some cases as above via horizontal cells, and in turn they connect to *ganglion cells*. They may receive signals from several rods, though a cone is more often connected to a single cell. These cells and their inputs are arranged to have 'on' and 'off centre' receptive fields, which are discussed later in more detail. All photoreceptor signals that are eventually transmitted to ganglion cells are mediated by bipolar cells regardless of the path taken. The receptive field of a bipolar cell is generated by connections to a group of photoreceptors. It is thought that the surround is constructed via connections with horizontal cells.

The inner plexiform layer contains connections between bipolar, amacrine and ganglion cells. Amacrine cells link bipolar cells and ganglion cells; however, they do not connect with photoreceptors directly and carry information laterally across the inner plexiform layer. There are thought to be many dozens of different types, connecting signals from differing areas of the retina. Because of this, amacrine cells are thought to be responsible for some of the more complex processing that occurs in the retina, such as primitive motion detection. Exact functioning of the cells is a topic of current research in the field.

The ganglion cell layer contains the bodies of the ganglion cells and some amacrine cells. The retinal ganglion cells form the outermost layer. Their axons extend across the face of the retina and collect at the optic disc to form the optic nerve, which accounts for approximately a third of all the nerves entering the brain.

Receptive fields

The signal received by a retinal ganglion cell undergoes horizontal spreading and processing by each of the intermediate layers of the retina. Therefore, it may be influenced by any number of photoreceptors in an area around it on the face of the retina, named a receptive field. The receptive fields of retinal ganglion cells generally increase in size towards the periphery of vision, overlap and have complex interactions. Detailed behaviour is beyond the scope of this book and an introductory description of the topic is given here.

On-centre and *off-centre* form the two fundamental types of receptive field (Figure 4.9). In diffuse lighting conditions a ganglion cell will maintain a steady firing rate of anywhere up to 20 pulses per second. The frequency of the pulses increases for an on-centre receptive field when light strikes the centre portion and decreases when it hits the surround. Therefore, the maximum response for the cell is not achieved when the receptive field is illuminated strongly and evenly, but rather when the centre is illuminated and the surround dark. For an off-centre field the reverse is true, the maximum response being achieved when the surround is illuminated and the centre dark. Therefore, the difference between the signal from the centre and surround is of more importance than the absolute levels themselves. This mechanism within the retina is of great significance as, within reasonable limits, it dictates that the eye responds more readily to changes in contrast than it does to absolute illumination level (see later). This

in turn aids its ability to cope with a great range of illumination conditions. Plotting the ideal stimuli for the on- and off-centre fields (Figure 4.9), they may be seen to be very similar to a *Laplacian* (and a number of other) convolution filters designed to detect edges in digital images. An edge may be thought of as a change in contrast and similarities may be identified between the two cases. Edge detection is discussed further in later chapters.

On- and off-centre receptive fields are equally distributed throughout the field of view. The receptive field of a retinal ganglion cell may be as large as 1 mm. However, this changes markedly over the surface of the retina and significantly in the fovea. As previously indicated, photoreceptors can feed the inputs of a number of bipolar and horizontal cells, which in turn can feed a number of amacrine and, finally, ganglion cells. Within the fovea it is more likely that a single cone will stimulate a single bipolar cell, which in turn will stimulate a single ganglion cell. Towards the edge of the field of view more photoreceptors are connected to each bipolar cell and consequently stimulate ganglion cells in larger numbers. Because of the overlap of the receptive fields it is possible that a single photoreceptor can stimulate a number of ganglion cells and contribute to an on- and off-centre field, even creating *inhibitory* and *stimulatory* responses simultaneously.

The size of the receptive field dictates the range of spatial frequencies that it is interested in. Small receptive fields correspond to high spatial frequencies and large receptive fields to lower spatial frequencies. Receptive fields also exist that respond more strongly to select distances in binocular

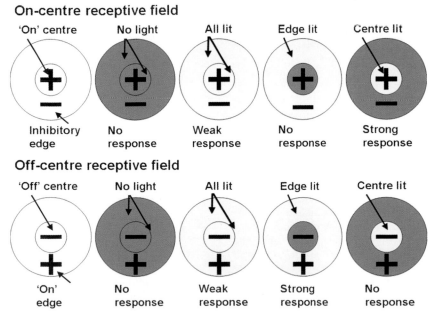

Figure 4.9 On- and off-centre receptive fields.

vision. A number of differing retinal ganglion cells have been identified with vastly differing shapes and sizes, and may be shown to connect to differing numbers of photo-receptors, and have differing speeds of response and function. Some cells help to control saccades or the size of the pupil and others exhibit colour preference. Rare, giant photosensitive ganglion cells, numbering only a few thousand, have also been recently identified. These are thought to assist setting of circadian rhythms within the body.

DARK ADAPTATION

The eye is expected to cope with an incredible range of illumination conditions, up to 12 orders of magnitude, from around 10^{-6} to 10^6 cd m^{-2}, yet the retina has an instantaneous *contrast* range of about 100:1. Contrast may be thought of as the difference or ratio of brightness of two objects. Therefore, in the above, the brightest object that may be seen is 100 times that of the darkest. The eye is much more dependent upon changes in contrast than in absolute illumination level, as seen above, and this very much aids our perception of the world. Imagine being outside on a bright day. The average illumination may be 10,000 lux, yet under the shade of a tree 100 lux, yet we can see perfectly well in either case. Indoors we may look at a television picture, about 100 lux, or underneath a desk, maybe 1 lux, and we can still see perfectly clearly. In both cases, the ratio of the darkest to brightest thing is 100 and it is the eye that has shifted the scale and adapted to the overall brightness. If the eye did not adapt in the above example and was only dependent on the absolute levels of light, when we arrived indoors we would not be able to see, as nothing would be as bright as our darkest object outside.

Change in size of the iris accounts for some fast and temporary adaptation. It is the adjustment of the chemistry, however, particularly the concentration of unbleached photopsins, that yields the full range over which the eye can operate. When one moves from a brightly lit environment to a dark or dimly lit room, it immediately appears to be dark. After 30 minutes the eye adjusts to the conditions. Chemical adaptation of the eye is well documented and plotting luminance level versus time, as shown in Figure 4.10, exhibits a distorted curve shape. The initial increase in sensitivity is due to cones adapting until the point at which they cannot adjust any further, causing a reduction in the gradient of the adaptation curve. After this point the increase in sensitivity is due only to the rods. There is a further influence on this process by neural effects. A large proportion of dark adaptation takes place within the first 30 minutes, though a slight improvement beyond this can be detected for over an hour. Poor health may also affect the ability of the eye to adapt. Light adaptation is the

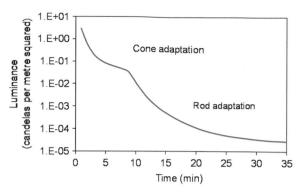

Figure 4.10 Dark adaptation of rods and cones.

reverse process with the same mechanism, but is generally accomplished within approximately 5 minutes.

The integrated peak sensitivity of cones is close to 555 nm, which corresponds to the peak output of the sun, whereas that of rods is 500 nm (Figure 4.8). This difference causes a shift towards the blue end of the spectrum when using scotopic vision, the Purkinje shift, and an associated decrease in red sensitivity (Figure 4.11). This can cause the brightness of colours with a high red content to appear darker than might be expected when using night vision. This effect should not be confused with metamerism, which is discussed in Chapter 5. Because of the length of time it takes to become fully dark adapted, the reduction in red sensitivity is exploited by those who wish to maintain their night vision, such as astronomers. By making illumination, display panels or other controls red it is possible to read information using the foveal red-sensitive L-cones, whilst causing only a partial reduction in night vision, if at all. Excessive exposure to a bright stimulus will cause desensitization of that area of the retina in the field of view, due to localized bleaching of photopsins. When the

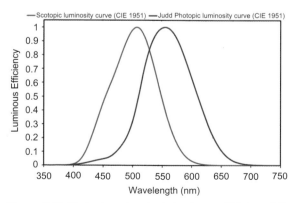

Figure 4.11 Photopic and scotopic luminous efficiency of the human eye. The Purkinje shift is seen as the shift in wavelength of the peak sensitivity.

stimulus is removed an after-image remains as the retina is no longer sensitive to low light levels. The after-image remains until the local sensitivity is returned to normal. Confirmation that after-images are a retinal, rather than a neural, effect is readily available as it is possible to create them in a single eye by closing the other. When the other eye is used to view the scene the after-image disappears.

ELEMENTARY COLOUR VISION

Young—Helmholtz theory of colour vision

As detailed in Chapter 1, the splitting and subsequent recombination of light suggested that the human eye might possess three types of colour sensitivity, to blue, green and red light respectively. This triple-sensitivity theory is called the Young—Helmholtz theory of colour vision. It provides a fairly simple explanation for the production of any colour from appropriate proportions of these primaries. This type of colour mixing is applied in cathode ray tube displays which have red, green and blue light-emitting phosphors in their faceplates, whereas subtractive colour mixtures are applied in most colour photographic materials, colour hard-copy output devices and liquid crystal displays. Subtractive colour mixing involves the overlaying of cyan, magenta and yellow colorants.

Opponent theory of colour vision

The trichromatic theory of colour vision cannot account for some observations. We do not see blueish-yellows nor do we see reddish-greens. Further if we look at the after-image of a red object it is often green and if we look at the after-image of a blue object it is often yellow. This premise formed the basis of the opponent theory of colour vision: that the neural processing in the visual pathway exhibited red versus green, blue versus yellow and black versus white opponency. Electrophysiological studies appear to support the theory with the discovery of red—green and blue—yellow ganglion cells. Refer to Chapter 5 for more detail on the subject.

COLOUR ANOMALOUS VISION

Colour anomalous vision, or *colour blindness* as it is commonly known, is brought about by not being able to detect the ratios of the proportions of the spectrum sufficiently well and usually results in the inability to distinguish certain groups of colours, rather than monochromatic vision as the name suggests. It generally occurs when one of the photopsins cannot be synthesized. Most colour blindness is

hereditary, carried by the X chromosomes, and therefore affects many more males than females. Up to 8% of males are affected in some populations whereas less than 0.5% of females are affected. Completely monochromatic vision, *achromatopsia*, occurs in less than 1% of cases. There are no treatments for colour blindness and it can cause some difficulties such as reading maps with colour legends, traffic lights, colour-based chemical tests, looking at the ripeness of food, selecting clothes or interpretation of coloured graphs. A difficulty distinguishing red and green colours is by far the most common symptom of colour blindness, occurring in 99% of cases, consisting of *protans* who are red weak and *deutans* who are green weak.

People with regular colour vision are known as trichromats and their vision as trichromacy (Chapter 5). *Anomalous trichromacy* occurs when one of the three types of cone does not operate as expected but still functions to some degree. A more severe condition occurs when one of the cone types ceases to function at all, *dichromacy*.

Anomalous trichromacy may be divided into *protanomaly* and *deuteranomaly*. Protanomaly is red-weak vision and the colour's saturation and brightness suffers as a result. Considering opponent theory, this in turn affects the hue, saturation and brightness of all colours that may be thought of as containing a proportion of red—green opponency: reds, oranges, yellows, greens, purples. Protanomaly affects approximately 1% of males. Deuteranomaly is green-weak vision and causes similar discrimination problems as protanomaly in approximately 5% of cases, again affecting colours with red—green opponency, though with greens appearing pale and unsaturated.

Dichromacy affects about 2% of males and can be further divided into *protanopia* and *deuteranopia*. Whilst anomalous trichromats can readily function, these conditions are usually more severe. Rather than having a slight effect on reds or greens they can generally see no difference between the hues. Protanopia, a severe red deficiency, affects 1% of males. Reds, oranges and yellows appear dark and cannot be distinguished from greens. Deuteranopia, severe green deficiency, also affecting around 1% of males, is similar but does not cause abnormal dimming. Blue—yellow colour blindness also exists, though is very rare.

Tests for colour blindness are readily available and easily administered. For diagnostic purposes lighting conditions should be arranged so that they simulate daylight at a comfortable level of illumination. If other lighting arrangements are used results will generally only be valid for those conditions. The Farnsworth—Munsell 100 hue test consists of four trays with a total of 85 caps exhibiting slight changes of hue. Users attempt to arrange the caps in the order of their hue. Errors in the cap positions are logged and used to diagnose the quality of the subject's colour vision. The Farnsworth—Munsell 100 hue test can detect all types of colour vision and the 85 hues form a perfect hue circle.

A *pseudo-isochromatic plate* appears as an image containing random dots of differing colour. Hidden within the plate is a number or pathway of a slightly different hue. People with colour anomalous vision are unable to read the hidden information. An example of this is the Ishihara plate test, the full version containing 38 plates and commonly used for detecting red—green blindness. American Optical Plates may further be used to grade severity of colour blindness. Modified plate tests employing pictures rather than numbers may be used to test people who have difficultly communicating or reading, such as preschool children.

MOVEMENT AND FOCUSING

Focusing and correction of eyesight

Focusing of the eye is known as *accommodation*. The crystalline lens is suspended behind the iris by the *zonules of Zinn* (Figure 4.1). The zonules are ligaments, made of collagen, which attach to the circular ciliary muscle. An out-of-focus retinal image triggers the *parasympathetic system*, which contracts and relaxes the ciliary muscle. As the ciliary muscle is relaxed the zonules become taught, placing tension on the crystalline lens and it is flattened. When the ciliary muscle tightens the zonules relax and the lens becomes rounded. To maintain focus on distance objects, the curvature of the lens is reduced, the lens is flattened and the focal length is increased. Conversely, to focus on close objects, the curvature is increased, the lens fattened and the focal length reduced (Figure 4.12). Focusing in other animals can include moving the lens rather than changing its optical power in the manner above. As the eye ages the crystalline lens becomes thicker and stiffer because its proteins continue to grow. This causes it to harden, diminishing its ability to change shape and therefore focus. Known as *presbyopia*, this generally starts to occur after age 40 and makes it more difficult to focus at a near distances. Weakening of the ciliary muscle adds to the effects of the condition.

If the cornea has too little curvature (flatter than it needs to be) the optical power of the crystalline lens is unable to compensate for this and images are brought to a focus behind the retina. *Hyperopia*, or far-sightedness as it is commonly known, occurs in approximately 1 in 4 people and causes near objects to be out of focus. The condition may also occur if the eyeball is too short. Adding a positive

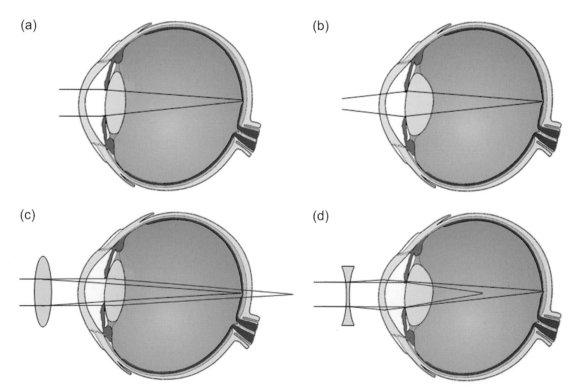

(a) (b)

(c) (d)

Figure 4.12 (a) Focusing on a distance object, the lens flattens. (b) The lens becomes more rounded when focusing on near objects. (c) *Hyperopia*, or commonly far-sightedness, may be corrected by adding a positive power lens in front of the eye. (d) *Myopia*, or near-sightedness as it is known, may be corrected by the addition of a negative power lens to the front of the eye.

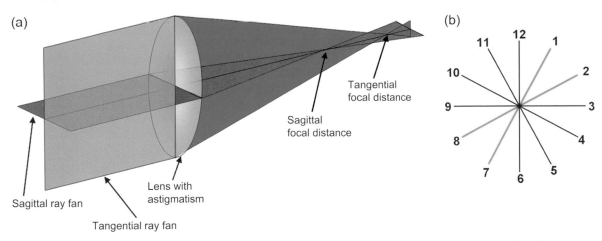

Figure 4.13 (a) The effect of astigmatism of the focal length of the lens in tangential and sagittal planes. (b) The effect of astigmatism on vision. The bars become blurred at a range of angles.

power lens in front of the eye can correct this (Figure 4.12a). *Myopia*, or near-sightedness as it is known, is the complementary condition, again affecting approximately 1 in 4 people. Images are focused in front of the retina either because the power of the cornea is too great or because the eyeball is too long (*axial myopia*). The addition of a negative power lens to the front of the eye may correct this.

Astigmatism is an unsymmetrical curvature of the cornea or crystalline lens. The affected surface curves more in one direction than another, somewhat similar to a rugby ball. If a number of cross-sections are taken each will exhibit a different optical power or focal length (Figure 4.13a). The effect of this on focusing is interesting and causes those affected to be able to focus on a structure in a single direction more strongly. For example, it is possible that somebody may be able to focus on horizontal lines but not vertical lines at the same time (Figure 4.13b). Astigmatism, occurring in isolation, may be corrected using a cylindrical lens.

Movement

Because of the change in resolution across the field of view of the eye, movement and scanning are very important to build up a picture of the scene around us and proper perception of the world. Though it is generally not noticed, the eye is moving constantly to direct the small, high acuity area of the fovea to objects of interest. Additionally, the eye needs to be able to compensate for movement of the head in order to be able to maintain direction of gaze and to follow objects that would otherwise move too quickly across the retina. The maximum speed is just a few degrees per second before the brain fails to recognize moving images. Each eye is controlled by six muscles, which are attached to the sclera.

Eye movements may be divided into a number of differing types: *smooth pursuit, saccades, vestibular-ocular*

reflex, opto-kinetic reflex and *vergence*. Smooth pursuit occurs when an object is followed at speeds of up to 100° per second, whereas a saccade is a rapid movement of the eye to a different part of a scene. Saccades may reach speeds of up to 1000° per second and are ballistic: they may be initiated voluntarily but cannot be changed once started. They are used primarily for fixation but imaging is suppressed during movement, as is the perception of the movement (*saccadic masking*). A *micro-saccade* is an involuntary movement similar in nature to a saccade but occurring over a much smaller visual angle, approximately 0.2°. Their exact purpose is still a topic of research, though it has been suggested that because the eye is continually looking for contrast they may be used to refresh the retinal image or to stimulate different receptive fields. Direction of gaze, as the head is moved, is maintained by the vestibular-ocular reflex and the balance organs in the ears are used as a feedback mechanism. The effectiveness of this method may be demonstrated when reading a book. Moving one's head from side to side it is possible to continue reading a motionless book, whereas keeping one's head still and moving the book it is not possible to continue reading beyond the most modest of speeds. Saccades and smooth pursuit are combined by the opto-kinetic reflex. The eyes follow the direction of movement of an object and a saccade returns the eye to the starting position. This is commonly experienced as a passenger in a car or on a fairground ride. Human vision is a binocular system and if the images from each eye did not overlap double vision would occur. For an object to be brought to the centre of the field of view of both eyes, it is necessary to turn the eyes inwards slightly. This is known as vergence and without it binocular vision would be substandard. It is also possible to roll the eyes about the optical axis and this is generally dependent on the angle of the head.

THE VISUAL PATHWAY

The response of the human visual system to stimulus is generally so good that we do not consider it on a regular basis. Yet the process and the brain are incredibly complex. The brain has approximately 10^{12} cells. The *visual pathway* starts with the signals generated in the 125 million or so photoreceptors that line the back of the eye and concludes with a perception of that scene, further comprising all interconnecting points. Brain function is an active area of research and a great deal of its workings are unknown; however, considerable efforts have been devoted to the visual pathway.

The visual pathway may be considered as largely serial, although there are some parallel branches (Figure 4.14). The signal from photoreceptor cells is subject to processing by each of the retinal layers as described previously. The result is transmitted by axons of ganglion cells which form the optic nerve, containing approximately 1 million fibres, and travels to the optic chiasm.

Each half of the visual field is generally referred to as the *temporal* and *nasal fields* respectively. Each eye generates largely overlapping information. Fibres from the nasal field in each eye cross at the *optic chiasm*, causing the left and right halves of the scene to be joined. The optic chiasm then continues in two pathways known as *optic tracts*. The right visual field heads towards the left brain and the left visual field heads towards the right brain. The overlapping visual fields are important for stereo vision and the optic chiasm is therefore crucial to facilitate this.

The optic tracts head towards two peanut-sized areas within the thalamus known as the *lateral geniculate nucleus*

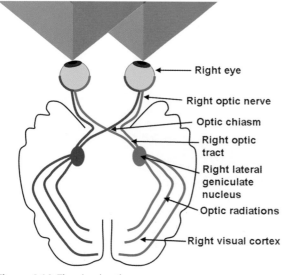

Figure 4.14 The visual pathway.

Right eye
Right optic nerve
Optic chiasm
Right optic tract
Right lateral geniculate nucleus
Optic radiations
Right visual cortex

(LGN). The exact functioning of the LGN is not fully known. It is a layered structure and has six layers of cell bodies, some of which interconnect, as well as others sending pulses directly to the visual cortex. It is shown to have receptive fields as in the retina and is thought to pre-process information and introduce coding efficiencies by cancelling redundancy. It may also help to coordinate the attention of the visual system to important events from other sensory stimuli. For example, a sound from the right may draw the gaze of the eyes. LGN axons fan out through the white matter of the brain via the *optic radiations* and ultimately travel to the *primary visual cortex*. It is also known that the LGN has feedback connections from the primary visual cortex. Signals are not only distributed by the optic nerve and chiasm to the LGN; information is also distributed to additional areas of the brain to control processes such as the convergence of the eyes or generate saccadic movements.

Visual cortex

The visual cortex, one of the largest brain structures, is located at the rear of the head. It consists of the primary visual cortex, also known as the *striate cortex*, and *extrastriate cortex*. The term striate derives from its layered appearance and structure. The primary visual cortex is further designated area V1, and the extrastriate cortical areas V2, V3, V4 and V5.

The primary visual cortex receives information directly from the lateral geniculate nucleus, after which there are thought to be two main processing pathways, the *ventral* and *dorsal streams*. Though still a subject of current research, these are often referred to as the 'what' and 'where' or 'how' pathways respectively. The ventral stream is thought to be responsible for recognition and memory, traversing areas V1, V2 and V4. From V4, information travels to the inferior temporal lobe. The dorsal stream is thought to be associated with the position and movement of objects and travels towards the inferior parietal lobe after traversing V1, V2, V3 and V5.

The field of view is mapped to the area of V1, preserving spatial information. *Cortical magnification*, however, maps the central portion, namely the fovea, to a much larger proportion, approximately half. Receptive fields have been shown to exist throughout the visual cortex, as in the lateral geniculate nucleus and the retina, though are more sophisticated than in either.

BINOCULAR VISION

The perception of depth is incredibly useful for performing many everyday tasks — driving, walking, picking up objects. It enables the judgement of distances and the relative

speeds of things moving towards or away from us. The primary mechanism of depth perception is *stereopsis*. Images from both eyes show slightly different views of the same scene as they are taken from different angles. The brain is able to interpret this as a single view through analysis of the images. To be able to accomplish this, the field of view from each eye must overlap.

Besides stereopsis, there are many other effects that give binocular clues to the visual system. Overlapping objects suggest that one may be behind another. Also, if size remains constant they will appear larger as they approach the eye. Because of perspective, it is generally also expected that stimuli will appear higher in the scene and subtend a smaller visual angle. Colour will also affect apparent depth as atmospheric haze tends to desaturate and lowers contrast. Desaturation may be thought of as a loss of colour intensity. More subtly, textures also repeat with increasing frequency. The angle that the eye needs to turn in to bring an object to the centre of the field of view in each eye, convergence, decreases with distance. Finally, if movement is involved, *movement parallax* may be utilized. This appears as closer objects moving more quickly than those further away. This is because the extent of a scene included in the field of view increases with range for a constant visual angle. Conversely, moving the head will cause objects that are near to apparently move more. Measuring parallax, by recording the associated position in the image as an observer's point of view is changed, allows distance to be calculated by triangulation. The technique may be used for rangefinding or measuring the distance of stars, for example.

The use of two eyes introduces other effects. Because of binocular summation, the threshold for detecting a stimulus using both eyes is lower than that for one. Interaction of the eyes leads pupil diameters to be the same in both, even if one is closed and, further, if the open eye is focused on an object, the accommodation of the other will be the same.

Depth from stereopsis arises from a form of parallax. Rather than changing the point of the view, the parallax is generated by the eyes being separated by a distance. The slight difference in positions of the image on each retina generates *retinal disparity*, the depth clue. Retinal disparity may also be called *horizontal disparity* or *binocular disparity*. To be able to detect retinal disparity the same point in both retinal images needs to be matched, or *correlated*. This leads to a *correspondence problem* — any point in one retinal image can potentially be matched with a number of points in the other. It is thought that the visual system overcomes this by placing receptive fields at slightly different horizontal positions throughout the visual cortex. This essentially configures matching left and right eye receptive fields to respond more strongly when stimuli exhibiting the correct horizontal disparity are presented. *Fusion* of images from both eyes to provide a single scene is considered separate to depth perception. This is known via disorders of the visual system that may destroy stereopsis but spare fusion. Predatory animals often favour stereo vision over a large field of view to be able to locate and chase prey by placing the eyes for large overlapping fields. Prey, conversely, often favour a larger total field of regard and thus avoid being caught. The behaviour of the human visual system is not completely encoded by the genes; a proportion of it is learnt through experience as infants. A lack of visual stimulus during development can lead to poor depth perception.

PERFORMANCE OF THE EYE

Luminance discrimination

Discrimination of *luminance* (changes in luminosity — lightness of an object or brightness of a light source) is governed by the level. As luminance increases, larger changes in luminance are needed to perceive a just noticeable difference, as shown in Figure 4.15. This is known as the *Weber–Fechner Law* and over a fairly large luminance range the ratio of the change in luminance (ΔL) to the luminance (L) is a constant of around 0.01 under optimum viewing conditions:

$$\frac{\Delta L}{L} = c \qquad (4.1)$$

The ratio of light intensities is the significant feature of our perception. Figure 4.16 gives a visual indication of reflected light intensities in which each step increases approximately by an equal ratio of 1, 2, 4, 8, i.e. a logarithmic scale. Stellar magnitudes are expressed logarithmically for this reason. Hipparchus ranked the brightness of the stars that he could see from 1, the brightest, to 6, the faintest, in ancient Greece in about 150 BC. The system,

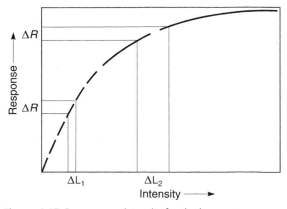

Figure 4.15 Response vs. intensity for the human eye.

Figure 4.16 Equal steps in lightness, each step differing by an equal ratio.

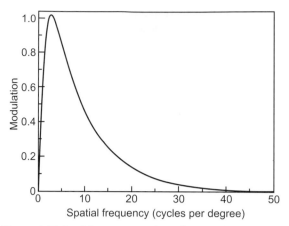

Figure 4.17 Spatial contrast sensitivity function for the human visual system.

though extended and formalized, is used to the present day. The logarithmic response of the eye creates the need for gamma correction in a number of imaging systems, as is discussed in later chapters.

Contrast sensitivity function

The human visual system's ability to discriminate fine detail has been determined in terms of its contrast sensitivity function (CSF). The CSF is defined as the threshold response to contrast where contrast (or modulation) is the difference between the minimum (L_{min}) and maximum (L_{max}) luminances of the stimulus divided by their sum:

$$\text{Contrast} = (L_{max} - L_{min})/(L_{max} + L_{min}) \qquad (4.2)$$

A typical CSF for luminance shown by the HVS is shown in Figure 4.17. It is usually measured by presenting sine waves of various frequencies to the user and varying the contrast until the pattern can just be detected. Because of the distribution of rods and cones in the retina the CSFs for the colour channels (see Chapter 5) are different from those shown in Figure 4.17, with lower peaks and cut-off frequencies. For luminance the HVS has a peak spatial

contrast sensitivity at around 5 cycles per visual degree and tends to zero at around 50 cycles per visual degree. Because of the lower acuity exhibited by rods in scotopic vision, it would be expected that the CSF curve would change with respect to illumination. Indeed, this is the case and overall performance drops as a function of illumination. Further models of the performance of the eye may be found in Chapter 5.

Visual acuity

Whilst the CSF for the eye expresses its ability to resolve individual spatial frequencies it gives no intuitive information about its ability to perform basic tasks or performance against the average population. Visual acuity is an indication of the resolving power of the eye. The height of a test chart letter is arranged to subtend an angle of 5 minutes when viewed at a distance of 20 ft. This equates to a height of approximately 8.9 mm and normal vision. The height of the letter is chosen according to the Raleigh Criterion (Chapter 2), such that each line of a capital letter 'E' should be resolved correctly. The distance is chosen so that the eye is at optical infinity. Visual acuity is then written as a fraction with the numerator being the distance of the test and the denominator an indication of the quality of vision. Normal vision is therefore written as 20/20. Good vision may be written as 20/10; the subject can read a letter at 20 ft that a normal person can only read at 10 ft. An example of poor vision may be 20/30, where the chart could be read at 30 ft by somebody with regular vision.

ANIMAL VISION

The vision of animals exhibits some remarkable variation and the diversity inspires many ideas in imaging. Most of

their visual systems have evolved to best cope with their environment and behaviour. Nocturnal animals, for example, usually have highly dilated pupils to let in as much light as possible as well as proportionally larger corneas. As mentioned previously, predators often have large forward-facing eyes and utilize stereopsis. Some of the simplest eyes, *ocelli*, are found in animals such as snails and only have the ability to distinguish between light and dark.

A number of common misconceptions exist regarding the vision of various animals, and the often misquoted monochrome vision of the dog is an example of this. Whilst the canine retina is comprised mostly of rods, two types of cone do exist in low numbers, making them dichromates, with 10–20% cones in the central retina. The cones have peak sensitivity at approximately 429 and 555 nm.

The predominance of rods leads the canine eye to respond well in low light and this is further enhanced by a large cornea and the tapetum lucidum, a reflective layer that exists in the choroid, reflecting any unabsorbed light back towards the photoreceptors. The tapetum can shift the wavelength of light, via fluorescence, towards the peak sensitivies of the rods. Instead of a fovea, the canine retina contains an elongated area named the visual streak. Parallel to the ground, it is located above the optic nerve. Canine visual acuity is around a third that of a human, typically from 20/50 to 20/100, and the optic nerve reflects this,

consisting of less than 170,000 fibres. The feline visual system is also adapted to low light vision, though weakly trichromatic, and a lower visual acuity, approximately 20/100. The tapetum can appear iridescent in both species, lending its name to the retro-reflectors marking the centre of roads, 'cats'-eyes'. The feline tapetum can reflect over 100 times more light than a human eye. Both canine and feline eyes have elliptical pupils, allowing them to close almost completely.

It is the air–cornea interface that provides the majority of the optical power in the human eye and it is the reduction in the difference of the refractive indices that renders the eye unable to focus when underwater. To overcome this problem some animals, such as crocodiles, have additional refractive eyelids in order to be able to see both in and out of the water. The optical power of the eye of some diving birds can change by up to 50 dioptres as opposed to around 16 for a human. Avian eyes exhibit further remarkable diversity. The hawk relies upon eyesight for hunting and this is reflected in the performance, with visual acuity being estimated at 20/2. It is thought that it can detect prey from a height of about a mile. Raptor eyes contain rods just like humans but can have up to five types of cones enhancing colour discrimination, and more tightly packed photoreceptors. Oil droplets in the cones act as filters to select appropriate wavelengths. A large majority of avian eyes, and many animals, also contain nictitating membranes, an extra

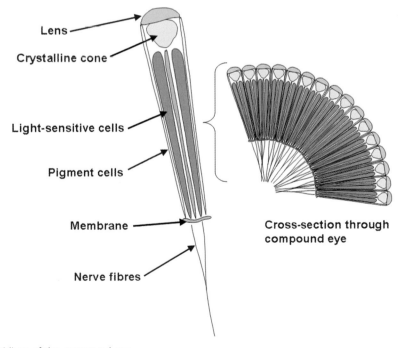

Lens

Crystalline cone

Light-sensitive cells

Pigment cells

Membrane

Nerve fibres

Cross-section through compound eye

Figure 4.18 Ommatidium of the compound eye.

eyelid which is used to wipe dust and dirt from the eye regularly. Unlike the outer eyelid these generally move horizontally.

When looking at the sky light is partially polarized (see Chapter 2) and this is reflected in the recently discovered ability of pigeons to be able to detect the plane of polarization. Whilst in pigeons the ability may aid homing, in cephalopods polarization has been developed for hunting. Giant squid, for example, operate in the low light levels of the deeper ocean and as a result their eyes have developed very large apertures of around 10 inches and better than f/1. It is thought that polarization helps them to see transparent or semi-transparent prey. Their visual acuity is estimated as being twice that of humans, though many believe that they are also colour blind as most only have a single visual pigment. Some cephalopods can also display polarized patterns on their bodies using iridophores, such as cuttlefish. Because seawater heavily filters light, discrimination of colour becomes more difficult at even modest depths; however, polarization remains unaffected.

Insects generally rely on compound eyes, which consist of many repeating units, *ommatidium* (see Figure 4.18). Ommatidia typically number thousands, with each one directed towards a narrow field of view. Each has an individual lens focusing light on to photoreceptors. Acuity varies amongst insects, though it is thought to be approximately one-sixtieth that of humans for a honeybee. The compound eye has a wide field of view, is relatively simple and is thought to be excellent for detecting motion. It has been observed that insects respond more readily to moving objects. Some compound eyes are able to distinguish colour. The bee, for example, has photosensitive cells with peak absorptions of 344, 436 and 544 nm. Flowers often exhibit patterns in the ultra-violet region of the spectrum which are invisible to the human eye and this is thought to explain the sensitivity range.

BIBLIOGRAPHY

Barten, P.G.J., 2000. Contrast Sensitivity of the Human Eye and Its Effects on Image Quality. SPIE Press, USA.

Bruce, V., Green, P.R., Georgeson, M.A., 1996. Visual Perception: Physiology, Psychology and Ecology. Psychology Press, Hove, UK.

Dowling, J.E., 1987. The Retina: An Approachable Part of the Brain. Belknap Press of the Harvard University Press, Cambridge, MA, USA.

Falk, D., Stork, D., 1986. Seeing the Light: Optics in Nature, Photography, Color Vision and Holography. Harper & Row, New York, USA.

Gordon, S., 2000. The Aging Eye. Simon & Schuster, New York, USA.

Hubel, D.H., 1989. Eye, Brain and Vision. Scientific American Library, New York, USA.

Jackson, R., MacDonald, L., Freeman, K., 1994. Computer Generated Colour. Wiley, Chichester, UK.

Marr, D., 1982. Vision: A Computational Investigation into the Human Representation and Processing of Visual Information. W.H. Freeman, San Francisco, UK.

McDonald, R. (Ed.), 1987. Colour Physics for Industry. Society of Dyers and Colorists, Bradford, UK.

Ray, S., 1994. Applied Photographic Optics, second ed. Focal Press, London, UK.

Weizer, J.S., Fekrat, S. (Eds.), 2006. All About Your Eyes. Duke University Press, Durham, USA.

Chapter | 5 |

Introduction to colour science

Sophie Triantaphillidou

All images © Sophie Triantaphillidou unless indicated.

INTRODUCTION

This chapter is an introduction to the fundamentals of colour description, measurement, evaluation and appearance. Knowledge of theories and current practices related to these topics is paramount in comprehending how colour is recorded, reproduced and managed in imaging media, subjects that will be introduced in later chapters. Colour is evaluated in different ways. Physicists describe variations in the intensities of wavelengths of visible radiation. Colorimetrists describe the amounts of reference primaries which, when additively mixed, match a particular reference light. Sensory scientists describe an observer's response as a result of stimulating their visual sensory mechanism. There is no single meaning or definition attached to the word 'colour'. Although the word is understood by everyone, if we are asked to define colour, the answer is not so obvious. Further, if asked to describe a particular colour, for instance 'blue', it is difficult to do so without using an example, such as 'blue is the colour of the sea'.

Regardless of how we interpret the word, colour exists because of the way our visual system interprets light of different wavelengths. It is not merely a physical phenomenon but a *psychophysical* phenomenon (i.e. a sensory response resulting from a physical stimulus) or simply an aspect of visual perception. Working with colour imaging has made the classification of colour and its description in terms of numbers essential. Several systems have been devised over the years for the purpose. The Commission Internationale de l'Éclairage (CIE, or International Commission of Illumination) methods are widely adopted and will be the main focus of this chapter. The CIE has, since its inception in 1913, developed standards and

procedures of metrology in the fields of lighting, vision, colour and, more recently, imaging.

THE PHYSICS OF COLOUR

We have already seen, in Chapter 2, that white light can be dispersed by means of a prism into light of different hues — violet, indigo, blue, green, yellow, orange and red, 'all the colours of the rainbow' — and that these hues correspond to different wavelengths. The wavelengths of visible electromagnetic radiation range from approximately 380 to 780 nm. In practice, light is never made of a single wavelength but of a narrow band or a large combination of wavelengths. Light consisting of a single wavelength — or a narrow band of wavelengths — is highly saturated in colour. These colours are referred to as *spectral colours*, or *spectral hues*. This is an opportunity for us to note that 'hue' and 'colour' are not the same thing, as we will see next, although the terms are frequently used interchangeably.

While Newton identified the seven spectral hues listed above, his descriptions were slightly different from those understood today. In particular he described what we would call 'blue' as 'indigo' and a 'blue—green' (or 'cyan'), as blue.

A revised set of names is shown in Figure 5.1, which indicates the spectral hues and the corresponding wavelength bands.

COLOUR TERMINOLOGY

In this section we provide some important colour terminology that is used throughout this book. The

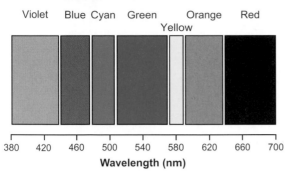

Violet Blue Cyan Green Orange Red
 Yellow

380 420 460 500 540 580 620 660 700
Wavelength (nm)

Figure 5.1 Seven hues identified in the visible spectrum, together with their approximate wavelength ranges.

definitions presented are based on definitions from the *CIE International Lightning Vocabulary* and from R.W.G. Hunt's publications (see Bibliography).

It is widely accepted that colours have three main *perceptual attributes*, relating to the response of the observer to a colour, and this is why colour is often referred to as being three-dimensional:

- The term *hue* refers to the appearance of a colour being defined as similar to one of the perceptual primary colours, red, yellow, green and blue, or to a combination of two of them. *Achromatic colours* are perceived colours devoid of hue (i.e. neutrals) and *chromatic colours* are perceived colours possessing a hue.
- *Colourfulness* denotes the extent to which the hue is apparent. Colourfulness is therefore zero for achromatic colours, low for pastel colours, high for oil paints and very high for spectral colours. For most luminance levels, the perceived colourfulness increases with increased luminance.
- *Brightness* (in the past referred to as *luminosity*) denotes the extent to which a colour appears to exhibit more or less light. It is very high for light sources, high for whites, medium for greys and browns, and low for blacks. Colours viewed in high levels of illumination generally look brighter than when viewed in low levels of illumination. For example, your coloured T-shirt appears more colourful under bright sunlight than on a dull day.

Colours may be seen and judged in relation to other colours (known as *related colours*), or in isolation (*unrelated colours*), and perceptual attributes may be defined according to each situation.

A real-life example of unrelated colours is traffic lights seen at night. Most imaging applications deal with related colours, since colours in images are intermingled and are judged in relation to one another.

Hue, colourfulness and brightness are attributes of both related and unrelated colours; they all refer to the absolute level of perception. In contrast, the perceptual attributes of *chroma* and *lightness* are defined only for related colours and

they refer to relative levels of perception, or more specifically the judgements are relative to 'similarly illuminated areas':

- *Chroma* is defined as the colourfulness of an area judged in proportion to the brightness of a similarly illuminated area that appears to be white (or highly transmitting). Chroma is therefore a relative colourfulness, i.e. relative to white.
- *Lightness* is defined as the brightness of an area judged in proportion to the brightness of a similarly illuminated area that appears to be white (or highly transmitting). Lightness is therefore a relative brightness, i.e. relative to white.

The adjectives *bright* and *dim* are used in connection with brightness, *light* and *dark* in connection with lightness, and *strong* and *weak* in connection with chroma.

Another perceptual attribute that relates to colourfulness is *saturation*, defined as the colourfulness of an area judged in proportion to its own brightness (rather than that of white). Saturation is also a relative attribute, but it is relative to another attribute of the object itself, and hence it can be used for both related and unrelated colours.

Figure 5.2 provides an example of the perceptual colour attributes introduced in this section. The same scene is presented under two different illumination conditions: on the left the scene is lit by bright direct sunlight and on the right by diffuse light on a dull winter day. The colours in the scenes will have the same lightness and chroma under both viewing conditions, since both lightness and chroma are relative attributes; they are judged with respect to the white in the scene. They will also have the same saturation, since saturation is judged with respect to the area's own brightness. In contrast, the brightness and the colourfulness of the colours will be higher on the bright sunny day than on the dull day, since these two attributes refer to absolute levels of perception.

In colour we deal with the perceptual nature of the stimulus and we employ objective measures to communicate the subjective impression. It is therefore essential to distinguish between perceptual, or subjective, and objective aspects of colour and the relevant subjective and objective terms. All terms mentioned up to this point in the section are subjective terms. Common relevant objective terms are listed in Table 5.1. Some of these will be introduced in detail later in this chapter.

THE COLOUR OF OBJECTS

Objects are visible because of the light they reflect or transmit. Coloured objects appear coloured because they absorb some wavelengths incident upon them and further reflect or transmit others. A red roof illuminated by white light, for example, appears red because it reflects more wavelengths that correspond to red hues than wavelengths

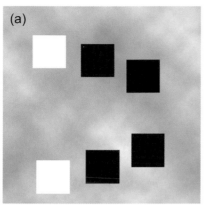 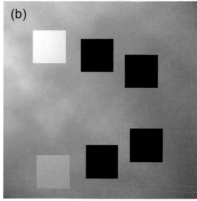

Figure 5.2 Computer images simulating colours seen on a bright sunny day (a) and on a cloudy day (b). Lightness, chroma and saturation will be the same in both conditions, whereas brightness and colourfulness will be higher on the bright sunny day.

SUBJECTIVE TERM	OBJECTIVE TERM	OBJECTIVE SYMBOL
Hue	CIE 1976 hue angle	h^*_{uv}, h^*_{ab}
	Dominant wavelength	λ_d
Brightness	CIECAM02 brightness	Q
Colourfulness	CIECAM02 colourfulness	M
Lightness	CIE 1976 lightness	L^*
	CIECAM02 lightness	J
Chroma	CIE 1976 chroma	C^*_{uv}, C^*_{ab}
	CIECAM02 chroma	C
Saturation	CIE 1976 saturation	s_{uv}
	CIECAM02 saturation	s
	Purity	p_{uv}
Hue and saturation	Chromaticity	x, y, u', v'

Table 5.1 Perceptual colour attributes and relevant objective measures

that correspond to blue or green hues — which are absorbed by the roof's material.

Thus, the colour of objects exists because of the interaction of three components: (1) the spectral quality of the light source illuminating the object; (2) the physical and chemical properties of the object, which modulate the electromagnetic energy coming from the source; and (3) the human visual system. The modulated electromagnetic energy coming from the object is imaged by the eye, detected by the photoreceptors and processed by neural mechanisms to produce the perception of colour. These components, according to Fairchild (2004) form the 'triangle of colour', shown in Figure 5.3. It is important to note that the light source itself not only interacts with the object but also with the human visual system, as the spectral output and intensity of the light source play a vital role in the colour appearance of objects through *adaptation* (see Chapter 4 and later in this chapter).

Spectral absorptance, reflectance and transmittance

Absorption, reflection and transmission are physical phenomena occurring when light interacts with matter. The radiant energy absorbed, reflected or transmitted by an object can be described by a graph in which the absolute or

Figure 5.3 The triangle of colour.
Adapted from Fairchild (2004)

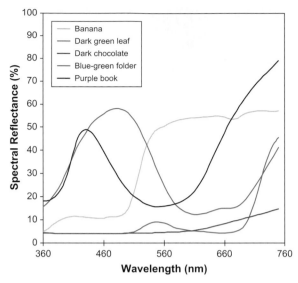

Figure 5.5 Spectral reflectances of common objects.

relative absorptance, reflectance or transmittance is plotted versus wavelength (the *spectral* absorptance, reflectance or transmittance), as shown in Figure 5.4. This representation, often referred to as the *object spectrum*, is the equivalent for the object of the relative spectral power distribution for self-luminous emitting media, such as light sources (see Chapter 3). The amounts of absorbed, reflected and transmitted radiant power must sum to the radiant energy incident on an object:

$$\Phi(\lambda) = A(\lambda) + R(\lambda) + T(\lambda) \qquad (5.1)$$

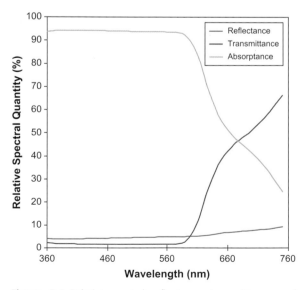

Figure 5.4 Relative spectral reflectance, transmittance and absorptance of a photographic slide exposed to red light.

where $\Phi(\lambda)$ is the incident radiant energy in radiant flux, $A(\lambda)$ is the absorbed flux, $R(\lambda)$ is the reflected flux and $T(\lambda)$ is the transmitted flux. Since the last three quantities sum to the incident energy, they are typically measured and presented in relative terms, such as the ratios of absorbed, transmitted or reflected flux to the incident flux, or as percentages (i.e. ratio \times 100). Note that ratio measurements are the subject of spectrophotometry, which is the measurement of ratios of radiometric quantities (see Chapter 2). The spectral reflectances of some common coloured objects are illustrated in Figure 5.5.

The interaction of electromagnetic energy with objects is not merely a spectral phenomenon but depends also on the viewing angle of the observer (or the measuring instrument) with respect to the object, as well as the illumination angle − the illumination and geometry. A classical example is that of gloss versus matte photographic paper. Due to the geometrical characteristics of the surface of gloss paper, light is reflected specularly (see Chapter 6) and colours appear more vivid or saturated compared to colours on the matte paper, from which light is reflected in a diffuse way.

CIE STANDARD ILLUMINATING AND VIEWING GEOMETRIES

Illumination and viewing geometries are significant when the colour of objects and material is measured. The CIE has established two pairs of standard illumination and

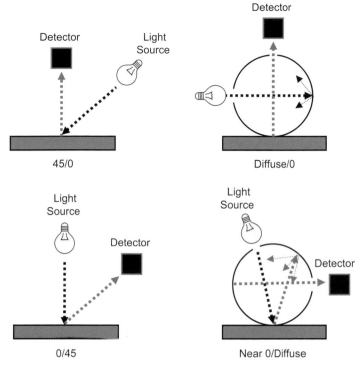

Figure 5.6 Standard viewing geometries.

viewing geometries for measuring the reflectance of objects, illustrated in Figure 5.6. These are:

1. *Diffuse/normal (d/0) and normal/diffuse (0/d).* In the diffuse/normal geometry the object is illuminated in a diffuse way, that is from all angles, and measured from an angle normal (i.e. perpendicular) to the object's surface. An integrating sphere is used to provide diffuse illumination; the measuring device is set perpendicular to the measuring surface. In the normal/diffuse geometry the object is illuminated at an angle normal to its surface and measured using an integrating sphere. Measurements made with these two reverse geometrical arrangements normally produce the same result. They are measurements of total reflectance and are used to provide the reflectance of objects, defined previously as the ratio of reflected over incident light energy.

2. *45/normal (45/0) and normal/45 (0/45).* In the 45/normal geometry the object is illuminated with beams of light incident at an angle of 45° from the normal and is measured from the normal. In the opposite arrangement, normal/45, the object is illuminated at an angle normal to its surface and the measurements are made using beams at a 45° angle from the normal. These two geometrical arrangements are used in applications where colour objects may have various

degrees of gloss, for example photographic papers. In measurements obtained by these arrangements, the ratio of reflected over incident light energy is very small, since only a small fraction of the reflected beam is recorded. They are usually employed when the reflectance factor (see later) of a colour is the objective. In this case the reflectance of the object is compared to the perfect diffuser, a theoretical medium that is both a *perfect reflector* (i.e. has 100% reflectance) and a *perfect Lambertian emitter* (i.e. produces equal flux in all directions).

Diffuse measurements are the norm these days; 45/0 or 0/45 give problems with directional surface textures, for example photographic prints with textures such as matte, pearl, etc.

CIE STANDARD ILLUMINANTS AND SOURCES

The CIE also recommends a number of spectral power distributions (see Chapter 3), the *CIE standard illuminants*, for use in colour measurements (see examples in Figure 5.7). Some of these illuminants correspond to 'real light sources' whereas some others represent 'aim'

distributions. It is important to distinguish between 'source' and 'illuminant': a source represents a physical light source with a given spectral power distribution whereas an illuminant is an aim spectral power distribution, purposely defined to serve colour measurements with spectral data specified by the CIE. The most commonly employed CIE illuminants are:

1. *CIE illuminant A*. This represents light from a Planckian radiator (see Chapter 2) at a temperature of 2856 K. It is used when incandescent illumination is of interest.
2. *CIE illuminant C*. This represents a phase of daylight (i.e. sunlight plus skylight) with a correlated colour temperature (CCT) of 6774 K.
3. *CIE daylight series*. Illuminants that have been statistically defined from a large number of measurements of real daylight. The most commonly used are: D_{65}, with a CCT of 6504 K, the recommended illuminant when daylight measurements are of interest, commonly used in photographic and imaging applications; D_{55}, with a CCT of 5500 K, known as the sensitometric daylight, for which daylight colour films are balanced; D_{50}, with a CCT of 5000 K, often used in graphic arts applications.
4. *CIE fluorescent series*. There are 12 in total, representing spectral power distributions for various fluorescent sources.
5. *CIE illuminant E*. This so-called equal energy illuminant, or equi-energy spectrum, is defined as a source whose relative spectral power is equal to 100.0 at all wavelengths. There is no physical source that emits equal power at all wavelengths in the visible spectrum. This illuminant is of interest for mathematical use in *colorimetry* (see later).

MODELS OF COLOUR VISION

The last component in the triangle of colour is the human observer. The CIE has defined two so-called *standard observers*. But before we introduce them, it is worth revisiting the models of human colour vision.

The *trichromatic theory of colour vision* is based on Young–Helmholtz theory and on the experimental work of Maxwell (see Chapters 1, 2 and 4), and states that all possible colours can potentially be matched by superimposing combinations of three light stimuli of different wavelengths. This so-called *additive matching* is possible because of the spectral responsivities of the three cone types found in the human retina, often noted as $L(\lambda)$, $M(\lambda)$ and $S(\lambda) - L$ standing for long wavelength, M standing for middle wavelength and S standing for short wavelength (see Chapter 4). Figure 5.8 illustrates the spectral responsivities of the L, M and S cones.

In parallel with the development of the trichromatic theory, a theory based on opponent colour signals, light–dark, red–green and yellow–blue, was proposed by Hering (a German physiologist born in 1834 who did research into colour vision and spatial perception) and was supported by subjective observations on colour appearance. Hering, who among other visual phenomena observed that reddish-greenish or yellowish-bluish hues cannot be perceived simultaneously, proposed that there are three types of visual receptors with bipolar responses to light–dark, red–green and yellow–blue.

Today, the contemporary colour vision theory, known as *stage theory*, involves two stages. The first stage is

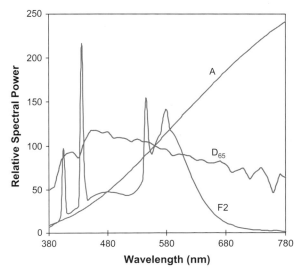

Figure 5.7 Relative spectral power distributions of CIE standard illuminants A, D_{65} and F2.

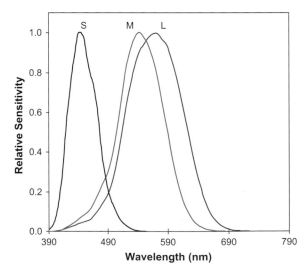

Figure 5.8 Spectral responsivities of the L, M and S retinal cones.

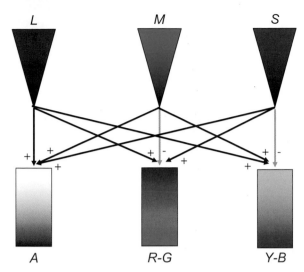

Figure 5.9 Schematic illustration of L, M and S cone signals into achromatic (A), red—green (R-G) and yellow—blue (Y-B) opponent colour signals.
Adapted from Fairchild (2004)

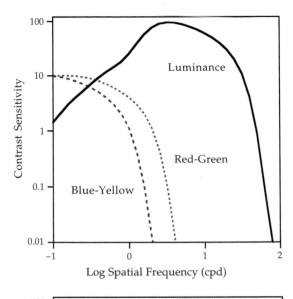

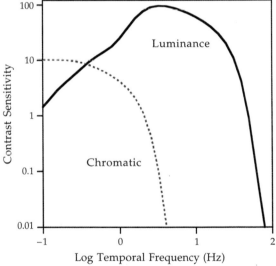

Figure 5.10 Typical spatial and temporal contrast sensitivity functions for the luminance and the two chromatic visual channels. Top: spatial contrast sensitivities. Bottom: temporal contrast sensitivities.
From Fairchild (2004); reproduced with permission of Wiley-Blackwell

trichromatic, as described by Young—Helmholtz theory. The three colour-separated images, however, are not transmitted directly to the brain. Instead, the neurons of the retina encode the colours into opponent signals. In the second stage the output of the three cones are summed $(L + M + S)$ to produce an achromatic response that matches the CIE $V(\lambda)$ distribution (see Chapter 4). The separation of the cone signals also permits the construction of the red—green $(L - M + S)$ and yellow—blue $(L + M - S)$ opponent signals. The transformation from L, M, S to opponent signals serves to disassociate luminance and colour information. An illustration of the encoding of cone signals into opponent signals is shown in Figure 5.9.

The three opponent pathways have individual spatial characteristics. This can be seen in Figure 5.10, which shows representative contrast sensitivity functions (CSFs; see also Chapter 4) for the luminance (i.e. achromatic), red—green and yellow—blue (i.e. chromatic) visual channels. The luminance spatial CSF typically peaks between 3 and 5 cycles per visual degree, and approaches zero at 0 cycles per visual degree and then at approximately 50 cycles per degree. The two chromatic spatial CSFs are of a low-pass nature (i.e. only maintain lower spatial frequencies) and have significantly lower cut-off frequencies. Clearly, the visual system is more sensitive to small spatial changes in luminance contrast compared to small changes in chromatic contrast.

The achromatic and chromatic pathways also have individual temporal characteristics, with the luminance pathway having higher overall contrast sensitivity and sensitivity that extends to higher temporal frequencies.

Note that the temporal contrast sensitivity is mostly relevant to moving (i.e. time-varying) images such as digital video, which can be delivered at different frame rates. The disassociation of luminance and colour information can be seen as an advantage in compression, encoding and transmission of imaging information, in that chromatic information can be compressed to a higher degree than luminance information without that compression being noticeable (see example in Figure 5.11).

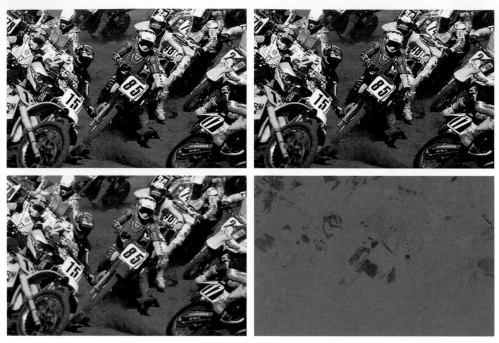

Figure 5.11 Top left: original image. Top right: reconstructed image with a full-resolution luminance channel and chrominance channels compressed at a ratio of 10:1. Bottom left: luminance channel. Bottom right: red—green and yellow—blue chrominance channels.
Original image from Kodak Master PhotoCD

THE BASICS OF COLORIMETRY

Colorimetry deals with methods of specifying, measuring and evaluating colour. When we speak about colour we generally refer, as we saw earlier, to a visual experience. When we refer to the colour of objects, we generally use subjective terms, such as dark or light, white, grey or black; we use names of hues such as red, yellow, green or blue, or we refer to rich or pale colours. It is therefore essential to specify and measure colour in relation to these subjective attributes as seen by a typical observer. Such an observer is defined by the CIE.

One of the roles of CIE colorimetry is to describe with a set of values — usually three — any given colour stimulus from its spectral power distribution, while taking into account a 'standard' human observer. The values defining the colour stimulus are the mathematical coordinates of a corresponding *colour space*. The latter is defined as an n-dimensional — usually three-dimensional — geometrical model, where colours are specified by their *vector coordinates* or *colour components*. An example of two different colour spaces is illustrated in Figure 5.12, with the same colour being defined by its colour coordinates in each space.

Note that spectral power distribution here is referring to different things for different types of stimuli. For

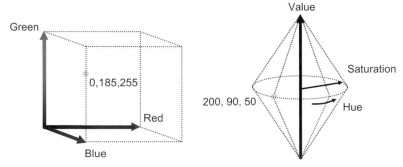

Figure 5.12 The same colour is represented by different colour coordinates in two different colour spaces.

Figure 5.13 Trichromatic matching set-up and the bipartite visual field used in colour matching experiments.

self-luminous stimuli, light sources, displays, etc., it is the spectral radiance or the relative spectral power distribution, $P(\lambda)$. For reflecting or transmitting stimuli, i.e. objects, it is the product of the spectral reflectance or transmittance of the object, $R(\lambda)$ (the object spectrum) and the spectral radiance or the relative spectral power distribution of the light source or illuminant of interest, $P(\lambda)$ (i.e. the product $P(\lambda)R(\lambda)$).

The CIE methods of colorimetry are based on rules of matching colours using additive colour mixtures. The rules of additive colour mixture, known as *Grassmann's laws*, involve the combination of a number of light *stimuli* (i.e. light sources) reaching the eye's retina simultaneously to match the sensation produced by a monochromatic light stimulus (Figure 5.13). The three laws state:

1. Three independent variables are necessary and sufficient for specifying a colour mixture. Mathematically this principle of the so-called trichromacy can be expressed by:

$$\mathbf{C} = X(\mathbf{X}) + Y(\mathbf{Y}) + Z(\mathbf{Z}) \qquad (5.2)$$

where X, Y, Z are the so-called *tristimulus values* of the colour stimulus, \mathbf{C}, and \mathbf{X}, \mathbf{Y} and \mathbf{Z} are units of the reference stimuli, called *primaries*, used in the colour mixture. According to trichromacy, any colour can be matched by certain amounts of three primaries, thus the amounts (i.e. tristimulus values) and the primaries (i.e. reference stimuli) allow the specification of colour.

2. Stimuli evoking the same colour appearance produce identical results in additive colour mixture, regardless of their spectral compositions. Take two colour stimuli \mathbf{C}_1 and \mathbf{C}_2 with specifications:

$$\mathbf{C}_1 = X_1(\mathbf{X}_1) + Y_1(\mathbf{Y}_1) + Z_1(\mathbf{Z}_1)$$
$$\mathbf{C}_2 = X_2(\mathbf{X}_2) + Y_2(\mathbf{Y}_2) + Z_2(\mathbf{Z}_2)$$

If:

$$\mathbf{C}_1 = \mathbf{C}_2$$

then:

$$X_1(\mathbf{X}_1) + Y_1(\mathbf{Y}_1) + Z_1(\mathbf{Z}_1) = X_2(\mathbf{X}_2) + Y_2(\mathbf{Y}_2) + Z_2(\mathbf{Z}_2) \qquad (5.3)$$

This principle implies that stimuli with different spectral characteristics (i.e. spectral power distributions, spectral reflectance or spectral transmittance) may produce the same colour match. This phenomenon is referred to as *metamerism* and the stimuli that evoke the same match are called *metamers* (see later for types of metamerism).

3. If one component of a colour mixture changes, the colour of the mixture changes in a corresponding manner. This third law establishes the proportionality (Eqn 5.4) and additivity (Eqn 5.5) of the stimulus metric for colour mixing. If Eqn 5.2 is true then according to the third law the following are also true:

$$\mathbf{kC} = kX(\mathbf{X}) + kY(\mathbf{Y}) + kZ(\mathbf{Z}) \qquad (5.4)$$

where k is a constant factor by which the radiant power of the colour stimulus is increased or decreased, while

its relative spectral power distribution/reflectance/transmittance remains the same.

If:

$$C_1 = C_2 \text{ and } C_3 = C_4 \text{ then } C_1 + C_3 = C_2 + C_4 \tag{5.5a}$$

Also, if:

$$C_1 = C_2 \text{ and } C_1 + C_3 = C_2 + C_4 \text{ then } C_3 = C_4 \tag{5.5b}$$

where C_1, C_2, C_3 and C_4 are four different colour stimuli. The symbol '+' in this context indicates additive colour mixture.

Colour matching functions and the CIE standard observers

According to Grassmann's first law, by means of additive mixtures of three stimuli it is possible to match all the colours of the spectrum (i.e. the spectral colours). When this is done the result is presented by three curves, referred to as *colour matching functions*, generally denoted as $\bar{r}(\lambda)$, $\bar{g}(\lambda)$ and $\bar{b}(\lambda)$ (Figure 5.14). These are curves of radiant power of three primary lights — e.g. **R**, **G** and **B** — per wavelength λ, required to produce by additive mixture a colour sensation equal to a unit power of monochromatic light of wavelength λ. Mathematically, this is expressed by:

$$1.0(\lambda) = \bar{r}(\lambda)(\mathbf{R}) + \bar{g}(\lambda)(\mathbf{G}) + \bar{b}(\lambda)(\mathbf{B}) \tag{5.6}$$

where **R**, **G**, **B** are the primaries and $\bar{r}(\lambda)$, $\bar{g}(\lambda)$ and $\bar{b}(\lambda)$ the amounts of the respective primaries, i.e. *they are the tristimulus values for the spectral colours produced with the specific primaries.*

The units of the radiant power of the three stimuli are not physical quantities but are chosen arbitrarily. They are chosen so that *the mixture (i.e. the addition) of one unit of each of the three primary stimuli matches a specific white*, the equal-energy white, with equal radiant power at all 'visible' wavelengths. This hypothetical white, denoted as $\mathbf{S_E}$, is very important in colorimetry. If a different white or units were chosen, the curves would have different relative heights but not a different shape. If different primaries were chosen the shapes of the functions would differ.

The first CIE colour matching functions were defined in 1931 (Figure 5.14) and were referred to as the *RGB colour matching functions*, $\bar{r}(\lambda)$, $\bar{g}(\lambda)$ and $\bar{b}(\lambda)$, or the *CIE standard observer*. They were derived by averaging the (similar looking) responses from a relatively small number of non-defective colour observers, who took part in two separate trichromatic matching experiments and used a 2° visual field for the purpose (see Figure 5.13). It is important to note here that, before the 1980s, it was not possible to measure the cone responses (shown in Figure 5.8) and thus trichromatic matching, although it did not give the cone response functions themselves, gave the colour matching functions which are *linear combinations of them*[†] and which are suitable for the specification of colour. These standard observer data consist of colour matching functions for the following three primary stimuli: **R** (i.e. red), **G** (i.e. green) and **B** (i.e. blue), of wavelengths 700, 546.1 and 435.8 nm respectively. The units of the primaries were so defined that equal amounts of the three stimuli were required to match light from the equal-energy illuminant, $\mathbf{S_E}$. The luminances of these stimuli, $\mathbf{L_R}$, $\mathbf{L_G}$ and $\mathbf{L_B}$ at colorimetric unity, were in the ratios 0.17697 to 0.81240 to 0.01063.

Soon after the definition of the RGB colour matching function, the CIE decided to transform the **RGB** to another set of primaries, the **XYZ** primaries, the ones that are still used today in modern colorimetry. This transformation was intended to eliminate the negative values in the RGB colour matching functions (that indicate negative radiant powers — an impossibility) and to force one of the colour matching functions to equal the CIE photopic luminous efficiency function, $V(\lambda)$, which was defined by the CIE in 1924 (see Chapter 4). The negative values were removed by selecting by a straightforward mathematical transformation defining a set of *imaginary primaries* that could be used to match all physically possible colour stimuli (see Figure 5.18). The resulting $\bar{x}(\lambda)$, $\bar{y}(\lambda)$ and $\bar{z}(\lambda)$ functions are related to the $\bar{r}(\lambda)$, $\bar{g}(\lambda)$ and $\bar{b}(\lambda)$ functions by:

$$\bar{x}(\lambda) = 0.49\bar{r}(\lambda) + 0.31\bar{g}(\lambda) + 0.20\bar{b}(\lambda) \tag{5.7a}$$

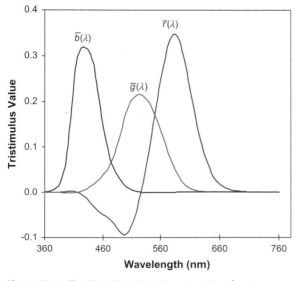

Figure 5.14 The CIE 1931 RGB colour matching functions.

[†] The relationship between the two is defined by a 3 × 3 linear matrix transformation as described in Chapter 23.

$$\overline{y}(\lambda) = 0.17697\,\overline{r}(\lambda) + 0.81240\overline{g}(\lambda) + 0.01063\overline{b}(\lambda)$$

$$(5.7b)$$

$$\overline{z}(\lambda) = 0.00\overline{r}(\lambda) + 0.01\overline{g}(\lambda) + 0.99\overline{b}(\lambda) \qquad (5.7c)$$

Setting one of the colour matching functions equal to $V(\lambda)$ served the purpose of incorporating photometry (see Chapter 2) into CIE colorimetry. The projected transformation made the respective colour matching functions $\overline{x}(\lambda)$, $\overline{y}(\lambda)$ and $\overline{z}(\lambda)$ positive across the visible spectrum and $\overline{y}(\lambda) = V(\lambda)$. The CIE 1931 colour matching functions for the **XYZ** primaries represent the *CIE 1931 2° standard colorimetric observer*; they are illustrated in Figure 5.15. Another colorimetric observer was recommended by the CIE in 1964, the *10° standard colorimetric observer* that is often employed for defining colour using wider visual fields – also illustrated in Figure 5.15. It is related to the X_{10}, Y_{10} and Z_{10} primaries which are only slightly different from the **XYZ** primaries.

Calculating tristimulus values from spectral data

Once the tristimulus values of all spectral colours are defined, the next step in colorimetry is to derive tristimulus values for any given colour. The tristimulus specification for any set of primaries is built on Grassmanns's law of additivity and proportionality, and uses (1) the spectral information of the light source or illuminant, (2) the spectral information of the object and (3) the corresponding set of colour matching functions – i.e. a standard observer. Remember: the triangle of colour!

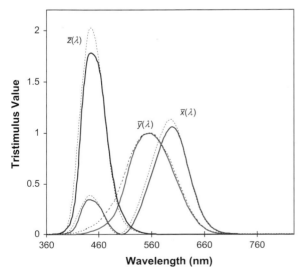

Figure 5.15 The CIE 1931 2° (thick line) and CIE 1964 10° (thin line) standard colorimetric observers.

Thus, for the CIEXYZ system, each of the *XYZ tristimulus values* is mathematically obtained by integrating over the range of visible wavelengths – for example, λ from to 400 to 700 nm – the product of the spectra of the source or illuminant, $P(\lambda)$, the object $R(\lambda)$, and one of the CIE 1931 colour matching functions (see also Figure 5.16):

$$X = k \int_{\lambda} P(\lambda)R(\lambda)\overline{x}(\lambda)\mathrm{d}\lambda \cong k \sum P(\lambda_i)R(\lambda_i)\overline{x}(\lambda_i)\Delta\lambda$$

$$(5.8a)$$

$$Y = k \int_{\lambda} P(\lambda)R(\lambda)\overline{y}(\lambda)\mathrm{d}\lambda \cong k \sum P(\lambda_i)R(\lambda_i)\overline{y}(\lambda_i)\Delta\lambda$$

$$(5.8b)$$

$$Z = k \int_{\lambda} P(\lambda)R(\lambda)\overline{z}(\lambda)\mathrm{d}\lambda \cong k \sum P(\lambda_i)R(\lambda_i)\overline{z}(\lambda_i)\Delta\lambda,$$

$$(5.8c)$$

where k is a normalizing constant which is defined differently for relative and absolute colorimetry, and $\Delta\lambda$ in the summations represents the interval over which the spectra and CMFs are sampled. Naturally, the object spectrum, $R(\lambda)$, is excluded in the integrals in Eqn 5.8 in the case of self-luminous stimuli.

In *absolute colorimetry*, used mostly for self-luminous stimuli, k is set at 683 lumens W^{-1}, which is the maximum spectral luminous efficiency, and the illuminant spectra, $P(\lambda)$, must be in radiometric units (i.e. $W\,m^{-2}\,str^{-1}\,nm^{-1}$ – see Chapter 2), corresponding to the photometric units required. In this case the tristimulus Y becomes equal to the luminance of the stimulus L and colorimetry is made compatible with photometry. In *relative colorimetry*, k is defined by:

$$k = \frac{100}{\int_{\lambda} P(\lambda)\overline{y}(\lambda)\mathrm{d}\lambda} \cong \frac{100}{[\sum P(\lambda)\overline{y}(\lambda)\Delta\lambda]} \qquad (5.9)$$

This normalization in relative colorimetry results in tristimulus values that are in the range $0-100$. k is chosen so that $Y = 100$ for the light source, or for objects with a reflectance, or transmittance spectrum, $R(\lambda)$, is equal to 1.0 for all wavelengths. The Y tristimulus value of the object then gives the *luminance factor* of the object (i.e. how luminous it is with respect to the perfect diffuser), expressed as a percentage.

In some cases, for example in graphic arts and colour reproduction industries or in gamut mapping techniques, the Y tristimulus value is set to 100 for the white of the paper rather than the light source (see Chapter 23). This is the practice of *normalized colorimetry* and should be

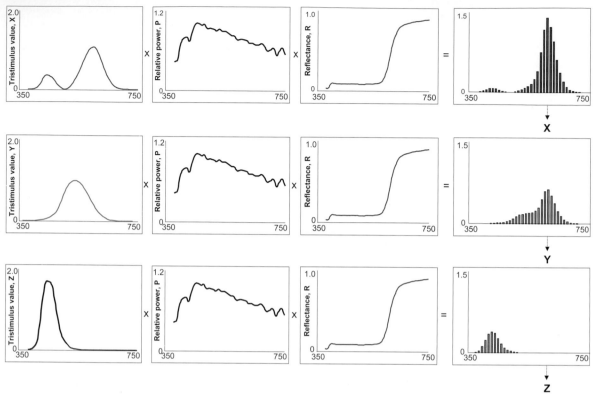

Figure 5.16 Graphical representation of the derivation of CIEXYZ tristimulus values for a surface colour with spectral reflectance R, using an illuminant with relative spectral power distribution P and the CIE 2° colorimetric observer.

differentiated from relative colorimetry, which deals with colour measurements.

CIE specifies that the range of summation in Eqns 5.8 and 5.9 is essential in the tristimulus specification. It recommends that the summations are performed at a sampling interval $\Delta\lambda$ of 5 nm over a range from 380 to 780 nm, resulting in 81 samples. However, many instruments, such as commercial spectrophotometers used to measure spectral data, use a $\Delta\lambda$ of 10 nm over a range from 400 to 700 nm, resulting in 31 samples.

The definition of colour by the three tristimulus values could be represented by plotting each of the tristimulus components along orthogonal axes in the 'tristimulus colour space', which is perceptually a *non-uniform space*, meaning that perceptual distances between colours are not uniformly distributed within the space.

Example relative CIEXYZ tristimulus values for the Gretag Macbeth Color Checker Chart for CIE illuminant C are shown in Figure 5.17.

Chromaticity diagrams

In order to provide a method of representation of colours in a more convenient two-dimensional diagram instead of a rather 'unreadable' three-dimensional space, *chromaticity diagrams* were developed. The colour of the stimulus is represented by its *chromaticity coordinates*, which are derived through a normalization of the tristimulus values of the stimulus *that removes luminance information*. Chromaticity coordinates for the CIEXYZ 1931 system are defined by:

$$x = \frac{X}{X + Y + Z} \tag{5.10a}$$

$$y = \frac{Y}{X + Y + Z} \tag{5.10b}$$

$$z = \frac{Z}{X + Y + Z} \tag{5.10c}$$

where x, y and z are the chromaticity coordinates of a colour stimulus with tristimulus values equal to X, Y and Z. Since x, y and z represent normalized quantities (i.e. $x + y + z = 1$), only two (usually x and y) are necessary to define the colour:

$$z = 1 - y + z \tag{5.10d}$$

X: 11.5 Y: 10.1 Z: 7.2	X: 39.1 Y: 35.8 Z: 28.8	X: 19.6 Y: 13.3 Z: 38.6	X: 10.6 Y: 13.3 Z: 7.6	X: 26.8 Y: 24.3 Z: 50.1	X: 32.8 Y: 43.1 Z: 49.8
X: 37.4 Y: 30.1 Z: 6.4	X: 14.5 Y: 12.0 Z: 42.1	X: 29.3 Y: 19.8 Z: 15.6	X: 9.3 Y: 6.6 Z: 16.8	X: 34.4 Y: 44.3 Z: 11.9	X: 46.5 Y: 43.1 Z: 8.8
X: 8.8 Y: 6.1 Z: 32.3	X: 14.9 Y: 23.4 Z: 10.6	X: 20.7 Y: 12.0 Z: 5.7	X: 56.3 Y: 59.1 Z: 10.3	X: 32.3 Y: 19.8 Z: 36.7	X: 15.4 Y: 19.8 Z: 43.4
X: 88.3 Y: 90.0 Z: 106.5	X: 58.0 Y: 59.1 Z: 69.9	X: 35.5 Y: 36.2 Z: 42.8	X: 19.4 Y: 19.8 Z: 23.4	X: 8.8 Y: 9.0 Z: 10.7	X: 3.0 Y: 3.1 Z: 3.7

© 2002 GretagMacbeth

Figure 5.17 Relative CIEXYZ tristimulus values for the Gretag Macbeth Color Checker Chart for CIE illuminant C.

Be aware that chromaticity coordinates represent a three-dimensional phenomenon with only two variables. Thus, to fully specify a colour one of the tristimulus values also has to be reported. Usually this is the Y tristimulus, which relates to the luminance (in absolute colorimetry) or the reflectance/transmittance factor (in relative colorimetry) of the colour, and the colour is then specified by the triplet x, y, Y. It is possible to recover X and Z from chromaticities and luminance by:

$$X = \frac{xY}{y} \qquad (5.11a)$$

$$Z = \frac{zY}{y} \qquad (5.11b)$$

The CIE 1931 x, y diagram lacks uniformity in that perceptual differences between colours do not correspond to equal distances in the diagram. The CIE currently recommends the CIE 1976 uniform chromaticity scales (UCS) diagram, with the u', v' chromaticities defined by:

$$u' = \frac{4X}{X + 15Y + 3Z} = 4x/(-2x + 12y + 3) \quad (5.12a)$$

$$v' = \frac{9Y}{X + 15Y + 3Z} = 9y/(-2x + 12y + 3) \quad (5.12b)$$

The third chromaticity coordinate, w', is equal to $1 - u' - v'$.

Both x, y and u', v' chromaticity diagrams are shown in Figure 5.19. The outer curved boundary in the diagrams is called the *spectral locus*, and is defined by the chromaticity coordinates of the spectral colours. The corresponding

wavelengths are shown around the locus line. All visible colours are represented in the area between the spectral locus and the *purple boundary*, the straight line connecting the two ends of the spectral locus, where there are no corresponding spectral colours since 'purples' are only produced by mixing red and blue light. Colours nearer the spectral locus are more *saturated* than colours located in the

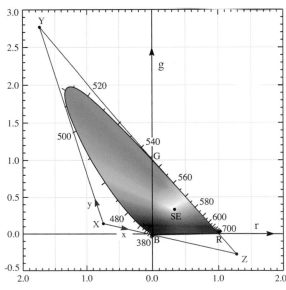

Figure 5.18 The derivation of **XYZ** primaries with respect to the RGB 1931 chromaticity diagram.

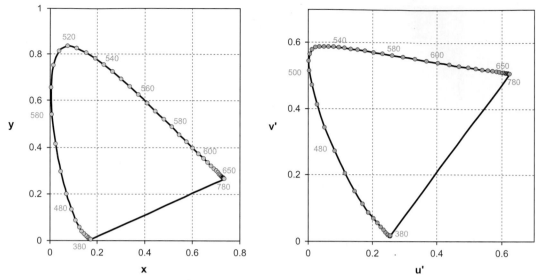

Figure 5.19 The spectral loci on x, y and u', v'.

central areas of the diagrams, which tend to zero saturation (i.e. lack of hue — neutrals or achromatic colours). The chromaticity coordinates of the *white point*, i.e. of the light source illuminating the colour objects of interest or of the illuminant used in the measurements, should be plotted along with the chromaticity coordinates of the colours. A change of white point will alter the position of all colours in a chromaticity diagram, except the spectral colours

(which are derived with respect to S_E), since the source or illuminant is taken into account in the calculation of the tristimulus values of all colour stimuli (Eqn 5.10).

The colour spacing provided by the CIE 1976 UCS chromaticity diagram is nearly uniform, with maximum difference in perceptual lines between colours up to only 4:1, as shown in Figure 5.20, a large improvement when comparing the same differences on the x, y diagram, in

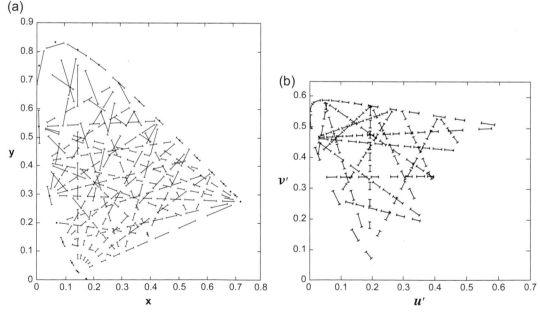

Figure 5.20 Visually equal chromaticity steps at constant luminance on the CIE x, y and u', v' chromaticity diagrams.
From Hunt (2004); reproduced with permission of Wiley-Blackwell

which maximum differences can be as high as 20:1. Unfortunately, the CIE *x*, *y* diagram is still widely employed, especially in the digital imaging literature and in software representing colour gamuts of imaging systems (see Chapter 23). Its use often leads to very wrong inter-pretations, such as in the example illustrated in Figure 5.21, which shows **RGB** primaries of two RGB colour spaces (see Chapter 23) in both CIE *x*, *y* and *u'*, *v'* diagrams. It is interesting to note that the position of the respective primaries does not differ greatly, as shown in the uniform *u'*, *v'* chromaticity diagram. However, in the *x*, *y* diagram, the green primary of colour space B is positioned much further from the green primary of colour space A, resulting in a false impression of a much greater colour gamut for colour space B. In general, the comparison of gamuts of imaging systems in chromaticity diagrams can be misleading due to the lack of the 'third dimension'; thus they should be interpreted with caution.

CIE uniform colour spaces and colour differences

In 1976 the CIE proposed two colour spaces, the CIELUV and the CIELAB spaces, that unlike the CIEXYZ system extend tristimulus colorimetry to three-dimensional spaces with dimensions that correlate with perceived hue, light-ness and chroma (i.e. three main perceptual attributes of colour). This was accomplished by incorporating elements to account for visual chromatic adaptation (see later in the chapter) and for the non-linear visual response to light energy (see Chapter 4). Accounting for the non-linear visual response provided visual uniformity to the colour spaces and allowed the measurement of visually mean-ingful colour differences between two colour stimuli, by taking Euclidean differences between two points in these spaces.

The derivation of the colour coordinates of CIELUV and CIELAB spaces is not dissimilar. Both spaces employ a common uniform lightness scale, *L**, which, when combined with two colour coordinates (*u** and *v** for CIELUV, or *a** and *b** for CIELAB), provides a three-dimensional colour space. Here we will present only the CIELAB space, which is the predominant CIE colour space used in colour imaging applications.

The CIE 1976 (*L**, *a**, *b**) colour space, referred to as CIELAB, is defined by normalizing the tristimulus values, *X*, *Y* and *Z*, of the colour to the white of the source or illuminant, X_n, Y_n and Z_n and then subjecting them to a cube root. This represents the relationship between physical energy measurements and perceptual responses for all levels of illumination but very low levels where the relationship is linear:

$$L^* = 116f\left(\frac{Y}{Y_n}\right) - 16 \tag{5.13a}$$

$$a^* = 500\left[f\left(\frac{X}{X_n}\right) - f\left(\frac{Y}{Y_n}\right)\right] \tag{5.13b}$$

$$b^* = 200\left[f\left(\frac{Y}{Y_n}\right) - f\left(\frac{Z}{Z_n}\right)\right] \tag{5.13c}$$

where *f(x)* is defined differently for very low and for normal and high ratios:

$$\text{For } x > 0.008856, \text{ then: } f(x) - (x)^{1/3} \tag{5.13d}$$

$$\text{For } x \leq 0.008856, \text{ then: } f(x) = 7.7871(x) + \frac{16}{116} \tag{5.13e}$$

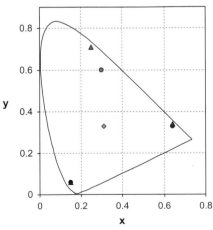
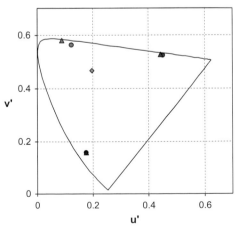

Figure 5.21 RGB primaries for two different RGB spaces, A (primaries represented by circles) and B (primaries represented by triangles), in both *x*, *y* and *u'*, *v'* chromaticity diagrams. The diamond represents the white point, D₆₅.

The ratios X/X_n, Y/Y_n and Z/Z_n are rarely smaller than 0.01 in imaging applications and therefore the function 5.13d is mostly employed in Eqns 5.13a, b and c.

The measure L^* is a correlate for perceived lightness; it ranges from 0.0 for black to 100.0 for a diffuse white and can be higher than 100.0 only in cases of specular highlights. Measures a^* and b^* are approximate perceptions of red—greenness and yellow—blueness respectively and take both positive (a^* for red, b^* for yellow) and negative (a^* for green, b^* for blue) values, while they both have value of 0.0 for *achromatic stimuli* (i.e. neutrals). L^*, a^*, b^* colour dimensions can be considered as the Cartesian coordinates of a three-dimentional colour space, where highly chromatic colours are located in the extremities of the space and less chromatic colours toward the centre, near the L^* axis.

From a^* and b^*, predictors for perceived chroma, C^*_{ab}, and hue angle in degrees, h_{ab}, are derived, in which case the colour space can be represented in terms of cylindrical coordinates, as illustrated in Figure 5.22:

$$C^*_{ab} = \left(a^2 + b^2\right)^{1/2} \qquad (5.13f)$$

$$h_{ab} = \tan^{-1}\left(\frac{b}{a}\right) \qquad (5.13g)$$

Achromatic stimuli have C^*_{ab} equal to 0.0. h_{ab} ranges from 0° (located on the positive a^*) to 360°.

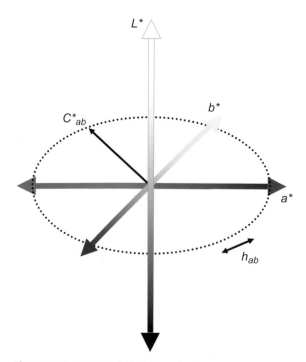

Figure 5.22 CIELAB cylindrical coordinates.

It is important to note that the location of all colours in the CIELAB space, including spectral colours, depends on the white of the illuminant (i.e. due to the normalization of the tristimulus values of the colour to the white of the source or illuminant). Also, the location of the perceptual *unique hues* (i.e. red, yellow, green and blue) do not align directly with the a^* and b^* axes. Under daylight illumination they are located at hue angles of 24° (red), 90° (yellow), 162° (green) and 246° (blue), but under different illuminants they lie at slightly different hue angles.

Colour differences between pairs of colour stimuli, ΔE^*_{ab}, in perceptual units are measured as the Euclidian distances between the Cartesian coordinates of two colour stimuli (Eqn 5.14a), or they can be expressed in terms of lightness, chroma and hue differences (Eqns 5.14b and c):

$$\Delta E^*_{ab} = \left((\Delta L^*)^2 + (\Delta a^*)^2 + (\Delta b^*)^2\right)^{1/2} \qquad (5.14a)$$

$$\Delta E^*_{ab} = \left((\Delta L^*)^2 + (\Delta C^*_{ab})^2 + (\Delta H^*_{ab})^2\right)^{1/2} \qquad (5.14b)$$

$$\Delta H^*_{ab} = \left((\Delta E^*)^2 - (\Delta L^*)^2 - (\Delta C^*_{ab})^2\right)^{1/2} \qquad (5.14c)$$

Typical perceptibility tolerances (i.e. just perceptible differences) for uniform colour patches are as low as approximately 1.0 ΔE^*_{ab}, but for complex scenes (such as complex images, where colours are intermingled) they usually range between 2.5 and 4.0 ΔE^*_{ab}, depending on the medium and the levels of luminance.

The CIELAB space was designed so that colour differences are perceptually uniform throughout the colour space, i.e. equal perceptual differences between pairs of stimuli correspond to equal magnitudes in the space. This is not entirely true. Research examinations in recent decades have illustrated discrepancies between observed and measured differences. An example of this is illustrated in lines of constant perceived hue plotted in a CIELAB a^*, b^* plane, as shown in Figure 5.23. These lines are shown to be curved, particularly for the blue and red hues. In an effort to compensate for these non-uniformities, the CIE has published two newer systems for colour difference measurements, the CIE94 and the CIE DE2000. The latter, which is the current CIE recommendation, is described in Appendix B.

Metamerism and types of metameric matches

According to Grassmann's second law, stimuli with different spectral characteristics may produce the same

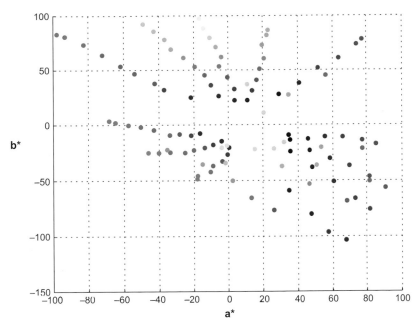

Figure 5.23 Lines of constant perceived hue plotted in the CIELAB $a*$, $b*$ plane.
Adapted from Hung and Berns (1995); reproduced with permission of R.S. Berns

colour match. Stimuli that match in colour appearance but differ in spectral composition are known as *metamers*. The phenomenon is referred to as *metamerism* and the match between two colours a *metameric match*. Metamers have the same colorimetry for a given illuminant and observer. Metamerism is an essential element in colorimetry. It is what makes colorimetry possible: the colour matching functions defining the human observer derive from the fact that many colours can be matched by additive mixtures of three selected primaries. Metamers of spectral colours are unattainable, because they possess the highest intensity. However, the problem can be solved by adding a primary to the monochromatic stimulus (i.e. the reference side of the match) to lower the intensity so that the mixture (i.e. test side of the match) can match. Mathematically, a metameric match can be described for the CIEXYZ system by:

$$\int_\lambda s_1(\lambda)\bar{x}(\lambda)\mathrm{d}\lambda = \int_\lambda s_2(\lambda)\bar{x}(\lambda)\mathrm{d}\lambda = X \quad (5.15a)$$

$$\int_\lambda s_1(\lambda)\bar{y}(\lambda)\mathrm{d}\lambda = \int_\lambda s_2(\lambda)\bar{y}(\lambda)\mathrm{d}\lambda = Y \quad (5.15b)$$

$$\int_\lambda s_1(\lambda)\bar{z}(\lambda)\mathrm{d}\lambda = \int_\lambda s_2(\lambda)\bar{z}(\lambda)\mathrm{d}\lambda = Z \quad (5.15c)$$

where X, Y and Z are the CIE 1931 tristimulus values. Note that constant k in the definition of the tristimulus values (see Eqn 5.8) is dropped here, or, rather, incorporated in the stimulus functions, $s_1(\lambda)$ and $s_2(\lambda)$, of the two stimuli. The functions $s_1(\lambda)$ and $s_2(\lambda)$ may represent:

- For emissive stimuli, the spectral power distributions, $P_1(\lambda)$ and $P_2(\lambda)$, of two different sources or illuminants (i.e. $s_1(\lambda) = P_1(\lambda)$ and $s_2(\lambda) = P_2(\lambda)$). This is the case where two different sources have the same tristimulus values and appear to have the same colour. Typically, one source will have a continuous spectrum and the second a selective narrowband spectral power distribution. Note that, if the two sources illuminate a spectrally selective object, the object will not generally appear the same.
- For objects, the product of the spectral reflectance or transmittance of two objects, $R_1(\lambda)$ and $R_2(\lambda)$, and the spectral radiance distribution (or the relative spectral power distribution) of the light source or illuminant that illuminates them, $P(\lambda)$ (i.e. $s_1(\lambda) = P(\lambda)R_1(\lambda)$ and $s_2(\lambda) = P(\lambda)R_2(\lambda)$). In this case, if a different illuminant is used the colours of the objects will probably not match.
- For objects, the product of the spectral reflectance or transmittance of two objects, $R_1(\lambda)$ and $R_2(\lambda)$, and the spectral radiance distribution (or the relative spectral power distributions) of two different light sources or illuminants, $P_1(\lambda)$ and $P_2(\lambda)$, (i.e. $s_1(\lambda) = P_1(\lambda)R_1(\lambda)$ and $s_2(\lambda) = P_2(\lambda)R_2(\lambda)$). This is the rare case, where different coloured objects illuminated by different illuminants match in appearance.

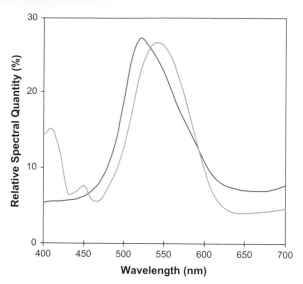

Figure 5.24 Spectral reflectances of a metameric pair under illuminant D_{50}. The spectral curves of metameric spectra cross each other at least three times.

In most cases, a metameric match is particular to one illuminant, i.e. *illuminant metamerism*, and one observer, i.e. *observer metamerism*. When either the illuminant or the observer is replaced, the match ceases to exist. Hence, if in Eqns 5.15 the CIEXYZ colour matching functions are replaced with another set, the matches will break down. Usually, a metameric match may hold for a second illuminant, if peak spectral reflectances or transmittances of the two stimuli are equal at three or more wavelengths. Observer metamerism cannot be eliminated in practical situations but the CIE $2°$ colorimetric observer represents satisfactorily real, non-colour-defective observers. Figure 5.24 presents a metameric pair of reflective spectra under illuminant D_{50}.

In 1953 Wyszecki indicated that the spectral power distribution of stimuli, $s(\lambda)$, consist of a fundamental function, $s_o(\lambda)$, which is inherently associated with the tristimulus values, and a function, $\kappa(\lambda)$, called the *metameric black*, unique to each metamer with tristimulus values (0,0,0) having no contribution to the colour specification. The metameric black is invisible to the eye and when it is added to any spectral power distribution $s_o(\lambda)$, the resulting spectra $s(\lambda) = s_o(\lambda) + \kappa(\lambda)$ will be a metamer of $s_o(\lambda)$.

THE APPEARANCE OF COLOURS

While having spent a large part of this chapter on CIE colorimetry, it is now time to appreciate that the appearance of colours is affected by the conditions under which they are viewed (i.e. *the viewing conditions* — see later in the chapter), such as the illumination level and colour, the background colours, the degree of visual adaptation, and the extent to which the illuminant is discounted, as well as the spatial structure of the stimuli. While the CIE system of colorimetry is extremely useful, it does not account for the viewing conditions. Two stimuli with identical CIEXYZ tristimulus values will only match under very specific viewing conditions. For instance, it is not usually appropriate to represent colours on a reflection print by the same tristimulus values as on an LCD. In this section, we introduce a number of visual mechanisms and visual phenomena that somehow invalidate colorimetry and show that the use of simple tristimulus values requires further treatment for successful colour match.

Visual adaptation and related mechanisms

We show in Chapter 4 that the full range of luminance to which our visual system is sensitive is roughly 13 orders of magnitude (from approximately 10^{-6} to 10^{6} cd m^{-2}). However, not all these levels can be perceived simultaneously. The human visual system is capable of decreasing or increasing its visual sensitivity according to the mean level of illumination, i.e. *light* and *dark adaptation*. It is due to light adaptation that we do not see the stars during the day, although they are present in the sky. The mean level of luminance in daytime is several orders of magnitude higher than in night-time and we simply cannot perceive them. In opposition, it is due to dark adaptation that, although we cannot see existing objects in a dark room when we first come in from a well-lit place, we can start distinguishing them after several minutes.

The processes of light and dark adaptation have a considerable impact on the perceived colour of objects, but a third type of adaptation is far more important: *chromatic adaptation*, the ability of the visual system to adjust — to a large extent — its colour sensitivity according to the colour of the illumination. This can be thought of as the visual system's ability to keep the white point in a scene more or less consistently white, independently of the colour of the illuminating light source, and shift all the colours in the scene relative to it. It generally applies to the range of black-body illuminants.

When reading a novel we always consider the pages of the book as being white, independently of whether we read in our bedroom, most often lit by incandescent illumination, which is predominantly yellow, or in the park under daylight, which is predominantly blue. Further, when we look for a familiar garment in our house, we can often identify it despite the changes in the colour of the illumination. The amount of reflected light from the objects as well as their tristimulus values under different sources is quite different. For example, the Z tristimulus value changes by a factor of 3 when the illuminant changes from

A to D for a sample that looks white under both sources. Figure 5.25 illustrates a book illuminated by daylight and by incandescent light, as seen by a system incapable of chromatic adaptation.

The examples above indicate that chromatic adaptation is important in *maintaining the perceived colour of objects despite changes in illuminant*. This phenomenon is known as *colour constancy*, which is also assisted by two other mechanisms: *memory colour* (i.e. ability to recognize objects due to having a 'typical' colour associated with them) and *discounting the illuminant* (i.e. ability to perceive the colour of objects after interpreting the illuminant colour and discounting it), all having a considerable influence in the appearance of the colour of objects.

Another situation where chromatic adaptation is evident is in (negative) *after-images*, which occur when the eye's cones are over-stimulated by a constant stimulus and as a result they adapt, i.e. decrease, their sensitivity. After-images are a result of independent changes in the sensitivity of cones and are manifested as colours complementary to the original stimulus. Therefore, a cyan after-image will be produced when the eye is over-stimulated by a red stimulus which tires out the red photoreceptors and as a result their sensitivity decreases and produces a weaker signal. After-images are 'seen' when the eyes, after over-stimulation, are diverted to a relatively neutral colour, such as a white area. The lack of red stimulus in the white area will produce the cyan after-image. Similar explanations will hold for all observed after-images. Figure 5.26 illustrates an example of after-images.

The equivalent of visual light and dark adaptation in photographic and digital imaging systems is automatic exposure. Instead of the photographer deciding aperture and shutter speed settings, in 'automatic exposure' setting the camera's software sets these, after having used a light sensor to measure the mean light intensity in the image plane (see Chapters 11, 12 and 14). Further, the equivalent of colour adaptation is the automatic white balance, available in digital cameras only. Colour films are balanced for specified lighting and colour temperatures, i.e. they

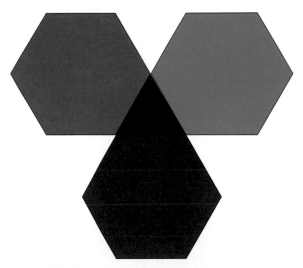

Figure 5.26 Illustration of after-images. Fix your eye on the black triangle in the middle for 30 seconds and then look at white paper. What colour are the after-images?

cannot 'adapt' their sensitivity to the colour of the illumination. Any mismatch can be compensated with suitable colour-balancing filters, typically placed over the lens or over the light source (see Chapter 3). Automatic white balance in digital cameras is achieved by the camera's software but it is not always effective (see Chapter 14). Unsuccessful white balance can create unpleasant blue, orange or green colour casts, which are particularly damaging in portraits – correct rendering of skin tones is of great importance in image quality. White balance in digital imaging is achieved via *white point conversion* or a *chromatic adaptation transformation*, introduced later in the chapter.

The adaptation mechanisms mentioned in this section are all parts of the general mechanisms that make us less sensitive to a visual stimulus (or indeed most physical stimuli) when the physical intensity of the stimulus is increased. Visual adaptation is very important in imaging

Figure 5.25 A book illuminated by daylight (a) and incandescent light (b) as recorded by an imaging system incapable of chromatic adaptation.
Original image taken from a Kodak PhotoCD

(a) (b)

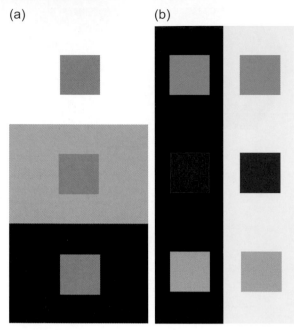

Figure 5.27 Examples of simultaneous contrast. (a) The grey patches in the centre of each square are physically identical, but appear lighter as the background becomes darker. (b) The pairs of green, red and grey patches are physically identical but appear yellower and darker on the blue background compared to a bluer and lighter appearance on the yellow background.

applications because images are viewed under a range of different illuminations, with luminance and colour characteristics often different from those in the original scene.

Other colour appearance phenomena

In this section we discuss briefly some more important visual phenomena that are due to changes in the viewing conditions. More details and a more extensive list can be found in Fairchild (2004).

Simultaneous contrast causes a stimulus to shift in colour appearance when the colour of the background is changed (Figure 5.27). The shift in appearance follows the opponent colour theory of colour vision. Hence, a light background will cause a stimulus to appear darker, a green background will cause a stimulus to appear redder, a blue background will cause a stimulus to appear yellower, etc. *Crispening* is the increased perceived magnitude of colour differences between two stimuli of similar hue, when the background on which the two stimuli are viewed is similar in hue to the stimuli themselves (Figure 5.28). *Spreading* is the apparent mixture of a colour stimulus with its surround at the point of spatial fusion, i.e. where the stimulus and the background are no longer viewed individually but they blend together. Examples of spreading are the half-tone dots and the CRT coloured phosphors, which cannot be resolved beyond a specific viewing distance despite the fact that they are individual colour points. In all these phenomena, which are directly related to the spatial structure of the stimuli, the colorimetry of the colour stimuli is invariable but their appearance differs.

The *Bezold–Brücke hue shift* is the phenomenon in which the hue of a monochromatic stimulus changes with its luminance. Although it is widely assumed that the hue is merely specified by wavelength this is not true; the hue does not remain constant with changes in luminance levels. Another phenomenon which is related to hue changes is the *Abney effect*, in which hue changes with colorimetric purity. It has been demonstrated that, when white light is added to a monochromatic stimulus, its perceived hue shifts. The *Helson and Judd effect* states that under higher chromatic illuminants bright objects appear to have the same hue as the illuminant, whereas dark objects appear opposite in hue.

In CIE colorimetry the Y tristimulus defines the luminance, or the luminance factor, of a stimulus and it is assumed that perceived brightness is only a function of Y. The *Helmholtz–Kohlrausch effect* invalidates this assumption. It is the phenomenon in which at constant luminance

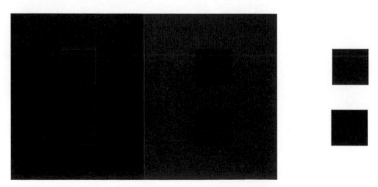

Figure 5.28 An example of crispening. The pairs of red patches are identical on all backgrounds.

the perceived brightness of a stimulus is shown to increase with increasing saturation, and therefore makes brightness not only dependent on luminance, but also on the chromaticity of the stimulus.

Further, the *Hunt* and *Stevens effects* describe phenomena where the colourfulness and the contrast of stimuli increase with luminance. This is apparent on bright sunny days, when colours appear vivid and of high contrast. Likewise, Bartleson and Breneman in the 1960s observed that the perceived contrast in images varied with luminance level and surround (see example in Figure 5.29). *Stevens* and *Bartleson–Breneman* effects are taken into account in many imaging applications. For example, because the perceived contrast decreases with luminance, motion picture films and colour slides, viewed in dark environments, are designed to have high physical, sensitometric contrast for compensation. The same is true for images transmitted for television, which are usually viewed in dim environments (see Chapter 21).

AN INTRODUCTION TO CATs AND CAMs

Colour appearance models (CAMs) aim to extend basic colorimetry by specifying the perceived colour of stimuli in a wide range of viewing conditions. They provide mathematical formulae to transform physical measurements of the stimulus and viewing environment into correlates of perceptual attributes of colour, such as lightness, chroma and hue.

The most important step in colour appearance modelling is accounting for visual chromatic adaptation. This is achieved using chromatic adaptation transformations (CATs) (also called chromatic adaptation models). CAT is the computation (or modelling) of the *corresponding colours* under a *reference illuminant* for a stimulus defined under a test illuminant. Corresponding colours are stimuli that maintain their appearance when viewed under different viewing conditions. For example, a colour with $(XYZ)_1$ tristimulus values in one set of viewing conditions might appear the same as another colour, specified with $(XYZ)_2$ tristimulus values in another set of viewing conditions. $(XYZ)_1$, $(XYZ)_2$ and the respective viewing conditions represent a pair of corresponding colours.

A generalized CAT

Most chromatic adaptation models are based on the hypothesis of Johannes von Kries (1902), which postulates that the cones adjust their individual sensitivities independently and in a linear fashion. For example, under a red light the cones become less sensitive only to longer wavelengths. Von Kries provided a specific set of equations which represent today what is referred to as a von Kries transformation. A generalized CAT is presented below.

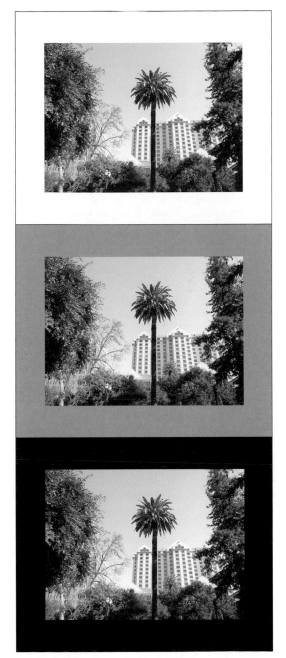

Figure 5.29 The perceived lightness and contrast of the black-and-white photograph changes with the background luminance.

Readers should refer to Fairchild (2004), Kang (2006), Westland (2004) and other relevant publications for detailed descriptions of several modern models, such as Nayatani's, Hunt's, Fairchild's, the Retinex theory and the BDF transform.

Based on the von Kries hypothesis, the tristimulus values of a stimulus for two different illuminants, a source and a destination illuminant, are related by a linear transformation:

$$\begin{bmatrix} X_2 \\ Y_2 \\ Z_2 \end{bmatrix} = \mathbf{T} \begin{bmatrix} X_1 \\ Y_1 \\ Z_1 \end{bmatrix} \qquad (5.16)$$

where \mathbf{T} represents the transformation, X_1, Y_1 and Z_1 are the tristimulus values of the stimulus under the source illuminant and X_2, Y_2 and Z_2 those under the destination illuminant. To model accurately the physiological mechanisms of chromatic adaptation, the stimulus needs to be expressed in terms of cone responsivities, L, M and S, instead of the CIEXYZ tristimulus values. Cone responsivities can be approximated by a linear transformation of the CIEXYZ tristimulus and thus the conversion matrix \mathbf{T} takes the form:

$$\mathbf{T} = M_{\mathrm{CAT}}^{-1} D M_{\mathrm{CAT}} \qquad (5.17)$$

where matrix M_{CAT} converts the sample tristimulus into cone responsivities. Then the diagonal transformation, D, is applied for transforming the cone responsivities under the source illuminant (L_1, M_1, S_1), to the cone responsivities under the destination illuminant (L_2, M_2, S_2). Finally, a second linear transformation, M_{CAT}^{-1} converts them back to tristimulus space. The diagonal transformation matrix, D, has non-zeros only in the diagonal, which contains the destination-to-source ratios of the cone responsivities:

$$D = \begin{bmatrix} L_2/L_1 & 0 & 0 \\ 0 & M_2/M_1 & 0 \\ 0 & 0 & S_2/S_1 \end{bmatrix} \qquad (5.18)$$

The matrix M_{CAT} is specific to each model. In the current CIE colour appearance model it converts the sample tristimulus into *sharpened cone responsivities*, which are similar to cone responsivities. Difference in various CATs are also due to the elements of the diagonal transformation, D, in which viewing conditions are taken into account. The generalized transformation can therefore be expressed by:

$$\begin{bmatrix} X_2 \\ Y_2 \\ Z_2 \end{bmatrix} = M_{\mathrm{CAT}}^{-1} D M_{\mathrm{CAT}} \begin{bmatrix} X_1 \\ Y_1 \\ Z_1 \end{bmatrix} \qquad (5.19)$$

Colour appearance models (CAMs)

Although CATs extend tristimulus colorimetry towards prediction of colour appearance they cannot be used to describe the actual appearance of a stimulus. Appearance attributes have been defined in Table 5.1 as brightness, colourfulness and hue (i.e. absolute), and lightness, chroma, saturation and hue (i.e. relative).

According the CIE Technical Committee (TC1-34): 'A colour appearance model (CAM) is any model that includes predictors of at least the relative colour appearance attributes of lightness, chroma and hue. For a model to include reasonable predictors of these attributes, it must include some form of chromatic adaptation transform. Models must be more complex to include predictors of brightness, colourfulness or to model luminance dependent effects such as the Stevens or the Hunt effects.' This definition allows the CIELAB and CIELUV colour spaces to be considered as CAMs, since both these colour spaces include a form of chromatic adaptation (i.e. the normalization of the tristimulus with the white) and have predictors for lightness, chroma and hue. However, they do not have the sophistication to predict luminance-dependent effects, background and surround effects, and they do not include correlates for brightness and colourfulness.

The first colour appearance model was introduced by Hunt (1982, 1985) and almost in parallel one was introduced by Nayatani (1986). CIECAM97s (1997) was the first CAM recommended by the CIE and was an interim model. It was a great success and led to progress in colour appearance modelling. The currently recommended CIE-CAM02 (2002) is simpler and more effective than the previous CIE model. Table 5.2 presents the input and output data for the CIECAM02. CAMs are very computationally intense. They are of great importance for cross-media image renditions. Readers should refer to references mentioned earlier in this section for extended reading on CAMs.

COLOUR REPRODUCTION

The colour reproduction of various photographic and imaging media is introduced in separate chapters, dedicated to specific processes and media. In general, colours can be reproduced either in self-emitting media (such as displays) or by using reflected or transmitted light (such as in prints and slides). As we saw in Chapter 1, there are two types of colour reproduction: *additive* and *subtractive colour reproduction*. A brief reminder: *additive colour systems* use additive mixing of chosen primaries to produce all colours, in a similar fashion to what is done in the colour matching experiments. For example in an LCD display, red, green and blue filtered sub-pixels are used to reproduce all possible colours for each displayed pixel (see Chapter 15). Since sub-pixels are very small they are visually unresolved at a typical viewing distance and the light from the LCD light source which is transmitted through them is additively mixed in our retina. When reflected-light is used, colour reproduction is predominantly achieved by subtracting light energy from the source spectrum illuminating the medium. One example of a *subtractive colour system* is the photographic print that uses a cyan dye that absorbs (i. e. subtracts) long wavelengths corresponding to reddish

Table 5.2 Input and output data for the CIECAM02 (c, N_c, F_{LL} and F are all constants provided for different viewing conditions)

INPUT DATA	OUTPUT DATA (APPEARANCE CORRELATES)
X, Y, Z: Relative tristimulus values of color stimulus in the *source* conditions	J: Lightness
L_A: Luminance of the adapting field (cd m^{-2})	Q: Brightness
X_w, Y_w, Z_w: Relative tristimulus values of white	C: Chroma
Y_b: Relative luminance of the background	s: Saturation
c: Impact of surround	M: Colourfulness
N_c: Chromatic induction factor	h: hue angle
F_{LL}: Lightness contrast factor	H: hue composition
F: Degree of adaptation factor	a_M, b_M: Cartesian colour coordinates derived from colourfulness and hue
	a_C, b_C: Cartesian colour coordinates derived from chroma and hue
	a_s, b_s: Cartesian colour coordinates derived from saturation and hue

hues, a magenta dye that absorbs middle wavelengths corresponding to greenish hues, and a yellow dye that absorbs short wavelengths corresponding to bluish hues.

The aim in the reproduction of colours in many imaging applications is a 'faithful' reproduction in colour appearance. Faithful may mean different things in different applications and in some cases it may be impossible. For example, it is very difficult to achieve in a printed image the high luminance range of an outdoor scene on a bright sunny day, since the photographic paper has only limited dynamic range (see Chapters 21 and 22). Similarly, it is impossible to reproduce the gamut of all surface colours on a computer monitor since the physical primaries of the monitor are a limiting factor. Furthermore, a faithful reproduction might not be the preferred reproduction by most viewers.

Objectives of colour reproduction

R.G.W. Hunt in the early 1970s defined six different objectives of colour reproduction that are introduced in this section. The decision on which reproduction is appropriate depends on various criteria, including the purpose of the reproduction, restrictions imposed by the physics of imaging systems, illumination and viewing constraints.

Spectral colour reproduction refers to the reproduction where the spectral reflectance curves of the reproductions are the same as those of the original colour object. In this case the colour matching is independent of the illuminant or observer (i.e. no metameric matches are involved). Colours are matched under daylight, tungsten, fluorescent and other illuminations, and appear the same to all observers, independently of their colour vision. Spectral colour reproduction is desirable for colours in mail-order catalogues, for example, where the appearance of colours needs to be maintained for all viewing conditions; another example is the reproduction of garment colours. In traditional film photography, the cyan, magenta and yellow dyes used cannot achieve spectral colour reproduction. In image displays, such as computer and television displays, the spectral emission curves of the phosphors in cathode ray tubes, as well as the spectral transmittances of the colour filters of liquid crystal displays (see Chapter 15) are such that the relative spectral power distributions of the displayed colours are markedly different from those of the originals.

Colorimetric colour reproduction is defined as reproduction in which the colours have CIE chromaticities and relative luminances equal to those of the original, but the spectral power distributions may differ. In the case of photographic reflection prints, original and reproduction illuminants should have the same chromaticities. The colorimetry is usually carried out relative to a well-lit reference white in the original and relative to its reproduction in the picture to assure equal relative luminances. The same is valid for images displayed on electronic displays. Colorimetric colour reproduction is therefore useful in imaging, but we need to bear in mind that the appearance of colours can be affected, sometimes markedly, by the intensity of the

illuminant (as well as other factors mentioned earlier) and thus colorimetric colour reproduction does not necessarily imply equality in the appearance of colours in the original and in the image.

In *exact colour reproduction*, the chromaticities, the relative luminances and the absolute luminances of the colours are equal in the original and the reproduction. Thus, differences in the luminance intensity existing in the colorimetric colour reproduction are eliminated here. This type of reproduction is also referred to as *absolute colorimetric colour reproduction*. In practice, the observer will rarely see the same colours in an exact colour reproduction and in the original. The appearance differences will be mainly due to viewing environment (surround, angle of subtense — see later), glare, visual adaptation state and spectral power distributions of the illuminants not being identical.

If a television studio is lit by tungsten light and the scene is reproduced with colorimetric accuracy in a viewing situation where the ambient light is daylight, the result will look too yellow to the viewers. *Equivalent colour reproduction* may be the appropriate type of reproduction in this example. It is defined as reproduction where the chromaticities and the relative and absolute luminances of the colours are such that, when seen in the picture-viewing conditions, they have the same appearance as in the original scene. Similarly, in *corresponding colour reproduction* the chromaticities and the relative luminances of the colours are such that, when viewed in the picture-viewing conditions, they have the same appearance as the colours in the original would have, if they had been illuminated to produce the same average luminance levels as those of the reproduction. The corresponding colour reproduction is related to the equivalent colour reproduction in the same manner that the colorimetric colour reproduction is to the exact colour reproduction. Both equivalent and corresponding colour reproductions are referred to as *appearance colour reproductions*.

Finally, *preferred colour reproduction* is defined as the reproduction where the colours depart from equality in appearance between original and reproduction in order to give a more pleasing reproduction, while the absolute or relative white in the original is maintained. There is considerable evidence that many commonly encountered colours, such as skin colours, the colours of grass, blue sky, blue water and others are preferred differently than real-life colours (see also Chapter 19). Preferred colour reproduction may be the aim in many photographic applications, such as advertising photography, but the objective is rather difficult to achieve using automated reproduction procedures. In consumer digital imaging, imaging system manufacturers provide colour profiles optimized to produce 'pleasing' reproductions, which are built to satisfy observer/consumer opinion on the reproductions of commonly photographed subjects (details in Chapter 26).

According to H. Che-Li (2005), it is useful to divide any colour reproduction into three main categories: (1) *subjective colour reproduction* that specifies what a desired reproduction should be according to the visual impression; (2) *psychophysical colour reproduction* that converts the subjective criteria specified in (1) into physically quantifiable criteria; and (3) *objective colour reproduction* that deals with calibrating and controlling imaging devices to desired reproduction in terms of physical quantities.

INSTRUMENTS USED IN COLOUR MEASUREMENT

There are three types of measurements in colour imaging: spectral, colorimetric and density measurements. In this section we introduce instruments used for spectral and colorimetric measurements. *Densitometers*, employed to measure densities from photographic prints and films and other hard-copy output, are discussed in Chapter 8.

The most complete description of a colour stimulus is its *absolute spectral power distribution*, which is a description of optical radiation (spectral radiance or spectral irradiance) as a function of wavelength. A *spectroradiometer* is used for the purpose (Figure 5.30). A spectroradiometer consists of a set of collecting optics that collimate the light coming from the stimulus forming an image beam that reaches a monochromator. A diffraction grating (or an optical prism) is used inside the monochromator to disperse the light into its spectral components. Selected narrow-bands (or ideally single wavelengths) from the incident light are focused on a single or multiple detectors, sampled and recorded. Modern spectroradiometers use charge-coupled-device (CCD) arrays for recording because of their nearly linear input-to-output characteristics. A lamp with known, calibrated spectral output is used for calibration of the instrument. It is possible to equip a spectrophotometer with a telescopic type of imaging lens, in which case the spectral radiant power can be measured — through

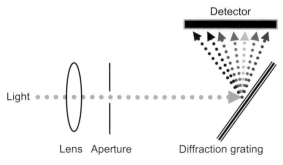

Figure 5.30 Spectroradiometer.

a narrow aperture — from a very small area in the scene. This is a useful feature when stimuli are complex scenes, also useful for display point measurements — i.e. *tele-spectroradiometry*. Spectroradiometers typically measure over the range of 380—780 nm, at a spectral resolution of 1—10 nm. The CIE indicates that for most spectral measurements a 2-nm sampling interval is sufficient. Spectroradiometers are employed for measuring both emissive and reflective spectra. For reflective spectra, an appropriate light source (white, with a smooth spectrum) is used to illuminate the subject.

For many imaging applications only the *relative spectral power distributions* of the stimuli are necessary. These can be measured using a *spectrophotometer*, an instrument that measures *relative light flux* with respect to the human luminous efficiency (see Chapter 2 — radiometry versus photometry). A spectrophotometer is a similar instrument to the spectroradiometer but has its own light source. It is not used to measure emissive stimuli but only spectral reflectances or transmittances from objects. Spectrophotometers are employed to measure spectra from prints and film targets for calibrating printers and scanners, but are not used for displays. The measurement geometries for the sensor/illumination arrangement (see earlier in the chapter) may vary with application. Calibration targets are provided with the instrument, which consist of white and mid-grey tiles and a light trap for setting up the black point (i.e. noise level).

Direct colorimetric measurements can be obtained with *colorimeters* that measure tristimulus values (CIEXYZ) and report these, or luminance and chromaticity (Y, x, y), or values from related colour spaces such as CIELAB, without having to measure spectral power distributions. Colorimeters use special colour filters in front of a light detector, which allow a device sensitivity that approximately matches the CIE 1931 colour matching functions and therefore have a relative response similar to that of the CIE 2° standard observer. Colorimeters are less expensive than spectroradiometers or spectrophotometers and can take faster measurements. Some colorimeters have an internal light source for measuring colour from reflective objects, but most measure only emissive stimuli or externally illuminated objects. Tristimulus values for samples under different illuminants might be an available function. Most colorimeters are hand-held instruments, such as those used for CRT measurements. Larger, more expensive devices are also available that employ telescopic optics and small apertures, such as those used for LCD measurements (Chapters 15 and 23).

VIEWING CONDITIONS

Colour perception is heavily affected by the environment in which the colour stimulus is viewed. Thus, when

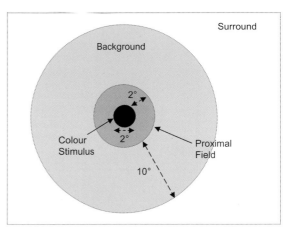

Figure 5.31 The viewing environment in related colours.

considering related colour stimuli (i.e. colours that are not viewed in isolation), or colour scenes and images, it is essential to describe appropriately the *viewing environment* or *viewing conditions*. The vocabulary used to describe the individual visual fields that comprise the overall viewing conditions is specified in Figure 5.31. This vocabulary is an essential component of colour appearance modelling:

- *Colour stimulus.* The colour element of interest. It is considered as a uniform colour patch of 2° angular subtense. In imaging of spatially complex scenes it is difficult to say whether the stimulus is a pixel, a cluster of pixels or the entire image. The latter is sometimes assumed, but it is a simplification. At present, there is no universally agreed definition of the stimulus for complex scenes. When using the currently CIE recommended CIECAM02 — designed for colour management and imaging applications — most applications assume that each pixel can be treated as a separate stimulus.
- *Proximal field.* The intermediate environment of the colour stimulus, extending typically for about 2° from its edge in most or all directions. Again, in imaging it is very difficult to separate the stimulus from its proximal field. In most applications, the proximal field is assumed to be the same as the image background.
- *Background.* The visual field extending 10° from the edge of the proximal field, in most or all directions. When the proximal field is considered part of the background, the latter is regarded as extending from the edge of the colour stimulus. In imaging, the background is usually considered as the area extending 10° from the entire image. The specification of background is very important in colour and image appearance, as illustrated in Figure 5.29.

- *Surround*. The field surrounding anything outside the background. It is considered as the entire environment in which the stimulus is viewed. In imaging applications, the surround often falls into one out of the three following categories: dark, dim and average.

The viewing environment, as described here, is used in colour and image appearance modelling. Although it is a simplification of the total environment in which related stimuli and images are viewed, it includes the most important factors affecting colour appearance.

BIBLIOGRAPHY

Che-Li, H., 2005. Introduction to Colour Imaging Science. Cambridge University Press, UK.

Fairchild, M.D., 2004. Color Appearance Models, second ed. Wiley, USA.

Grum, F.C., Bartleson, C.J., 1984. Optical Radiation Measurements. Academic Press, USA.

Hung, P.C., Berns, R.S., 1995. Determination of constant hue loci for a CRT gamut and their predictions using color appearance spaces. Color Research and Application 20, 285—295.

Hunt, R.W.G., 1998. Measuring Colour, third rev. ed. Fountain Press, UK.

Hunt, R.W.G., 2004. The Reproduction of Colour, sixth ed. Wiley, Chichester, UK.

Jacobson, R.E., Ray, S.F., Attridge, G.G., Axford, N.R., 2000. The Manual of Photography, ninth ed. Focal Press, Oxford, UK.

Kang, H.R., 2006. Computational Color Technology. SPIE Press, USA.

Reinhard, E., Khan, E.A., Akyüz, A.O., Johnson, G., 2008. Color Imaging Fundamentals and Applications. A.K. Peters, USA.

Westland, S., Ripamonti, C., 2004. Computational Colour Science using MATLAB. Wiley, USA.

Wright, W.D., 1969. The Measurement of Colour, fourth ed. Hilger, London, UK.

Photographic and geometrical optics

Sidney Ray

All images © Sidney Ray unless indicated.

INTRODUCTION

In Chapter 2 we were acquainted with the behaviour of light, mainly in terms of its wave and particle nature, which are the subjects of *physical* and *quantum optics* respectively. This chapter is largely concerned with *geometrical optics*, the part of optics dealing with light's propagation in terms of rays, i.e. how it travels in straight lines, also known as *rectilinear propagation*. The concept of light rays is helpful in studying the formation of images by lenses. Further, in many light-related phenomena, such as reflection, refraction and transmission, the properties of light are altered according to different physical properties of the optical media with which they interact. This is the subject of *photographic optics* in this chapter. Finally, the *photometry of image formation* will be discussed at the end of the chapter.

PHOTOGRAPHIC OPTICS

Optical materials

Optical elements are made from various transparent and reflective materials, particularly glasses, plastics and crystals. Optical glass is used for photographic lenses, being highly transparent with suitable refractive properties. Early glasses were of the crown and flint varieties, but pioneering work by Abbe, Schott and Zeiss in the 1880s gave many other types by adding elements such as barium, boron, phosphorus, lanthanum and tantalum. Lenses use glasses of both low and high refractive index and low and high dispersion (see Chapter 2). Glasses are characterized by their refractive index (n) and dispersion measured as the Abbe number, V, and location on a 'glass map', a graph of n against V. Additional properties are important such as resistance to staining and density. Glass is manufactured by melting the raw materials in platinum crucibles to avoid contamination, and then casting or pressing in moulds to approximate shapes or 'blanks'. It is essential that glass is homogeneous in its properties. Optical glass should ideally be spectrally non-selective as regards absorption but lower grade glass as may be used for condenser lenses absorbs slightly in the red and blue, giving a greenish tinge to the element. This may not matter in an illumination system. Addition of suitable minerals gives 'dyed-in-the-mass' coloured glass suitable for absorption filters.

Plastics (polymers) include transparent types for imaging systems, translucent and coloured types for filters and diffusers, and opaque varieties for constructional purposes. The first plastic lens of 1934 was of thermoplastic *polymethylmethacrylate* (PMMA) and shaped by moulding. Other varieties are used to provide chromatic correction, e.g. PMMA and polystyrene. Plastics can be moulded and extruded in complex shapes, including fibres and aspheric surfaces as well as in large sizes. They can be surface coated and used in hybrid glass–plastic lenses. Disadvantages include low refractive index, birefringence, poor scratch resistance and focus shifts due to thermal effects. One material, *allyl diglycol carbonate* (coded as CR-39), is used as an 'optical resin' for accessories such as filters, using dyes to produce uniform or graduated tones and colours. Constructional plastics have properties of low friction and dimensional accuracy suitable for moulded devices such as lens barrels, focusing mounts and camera bodies. Materials such as *polycarbonate* may be made opaque by addition of graphite. Thin films of gelatin, collodion and nitrocellulose are used for flexible 'gel' filters and *pellicle beamsplitters*.

DOI: 10.1016/B978-0-240-52037-7.10006-7

Crystalline materials have optical uses. Iceland spar and herapathite were used for polarizing optics until replaced by polymeric colloids. Natural mica is used for quarter-wave plates (see Chapter 2). Natural and synthetic quartz are useful for heat-resistant elements such as condensers and for UV optics. Fluorite or calcium fluoride grown as large crystals has useful properties for chromatic correction and UV lenses.

Reflection

Light interacts with materials in various ways, many of which are introduced in Chapter 2. When light encounters an opaque surface, *specular* and *diffuse* reflections occur (Figure 6.1). A perfectly diffuse surface reflects the incident light equally in all directions so that its brightness is seen as constant, irrespective of viewpoint. Few surfaces have such properties and there is usually a slight sheen depending on the degree of gloss. Most surfaces have a reflectance, R, in the range 0.02–0.9 (2–90%) represented by matt black paint and a typical white paper respectively. A glossy surface gives little scattering and a specular reflection of the light source is seen. The incident light is reflected at an angle equal to the angle of incidence, both measured from the normal to the surface. Suppression of reflections may be possible using the properties of polarized light (see Chapter 2, Light polarization).

Refraction

In Chapter 2 we saw the refraction of light travelling between transmitting media with different refractive indices. For a specific wavelength, λ, the ratio of velocities in a vacuum and the medium gives the *refractive index*, n_λ,

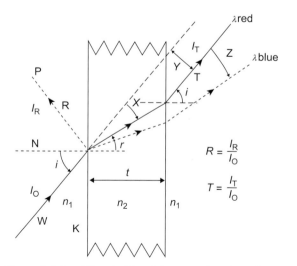

Figure 6.1 An oblique incident light ray undergoing refraction when passing from air to glass.

of the medium. A decrease in velocity causes the light ray to be deviated towards the normal and vice versa. The relationship between the angle of incidence, i, angle of refraction, r (Figure 6.1), and the refractive indices n_1 and n_2 of the two media is given by *Snell's Law* (also known as the *Law of Refraction*):

$$n_1 \sin i = n_2 \sin r \qquad (6.1)$$

Refractive index varies with wavelength, producing chromatic aberrations. The usual value is quoted for the d-line in the helium spectrum at 587 nm, denoted n_d. Gases and liquids change in density with variations in temperature or pressure, causing refraction changes.

A plane parallel-sided block of optical glass does not deviate an incident oblique ray but the emergent ray is laterally displaced. This can cause image aberrations or a focus shift in the case of glass filters. Refraction of a ray emerging from a dense medium increases as i increases until a critical value is reached, when the ray does not emerge as it has undergone *total internal reflection* (TIR). This property is used in mirror prisms and fibre-optic devices.

Transmission

The energy budget of light for a lens is $R + A + T = 1$, where R, A and T are surface reflectance, absorption by the medium and transmittance respectively. To maximize T, both R and A must be minimized.

Surface reflections are reduced by thin coatings of material applied by vacuum deposition and other methods. The principle for a single anti-reflection layer is that reflections from the air–layer and layer–medium interfaces interfere destructively to enhance transmission. The condition is that the coating has thickness of $\lambda/4$ and index \sqrt{n}. In practice, magnesium fluoride is used for a single hard coating, giving a characteristic purple appearance to the surface by reflected light. Reflectance is reduced to under 2%. A double layer gives less than 1% (Figure 6.2), while multiple layer 'stacks' of coatings with layers of differing thicknesses and refractive indices can reduce values to much less than 1%. Some 7–15 layers may be used as needed.

Multiple coatings can also be used to enhance reflectance as in mirrors for SLR cameras, or can be spectrally very selective and reflect (or transmit) very narrow spectral bands with sharp cut-off. These are termed interference filters and find use in applications such as multi-spectral photography and colour printing. Multi-layer coatings can also be used to make infrared transmitting or reflecting filters, often called 'cold' or 'hot' mirrors respectively.

Transmittance, T, of an optical system depends also on the aperture stop, which is important in determining precise exposures. It is usually measured as the f-number, N, which is defined geometrically (see later in the chapter, also Chapter 2), but the true f-number may be significantly different.

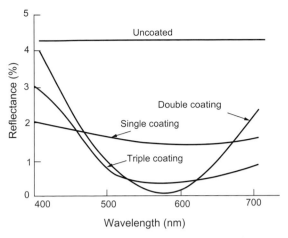

Figure 6.2 The changes in surface reflection using various types of anti-reflection coatings as compared with uncoated glass (for a single lens surface at normal incidence).

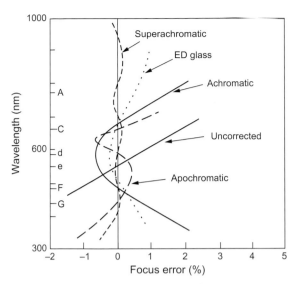

Figure 6.3 Types of chromatic correction for lenses. The letters on the vertical axis represent the wavelengths of the Fraunhofer spectral lines used for standardization purposes. Residual aberration is shown as a percentage change in focal length.

Dispersion

We saw in Chapter 2 that refraction of light decreases with increase in wavelength (dispersion), but it does so in a non-linear fashion. A variety of glasses are needed in lens design for compensation. Dispersion by simple glass lenses causes two distinct forms of *chromatic* or *colour aberrations*. Due to axial or *longitudinal chromatic aberration* (LCA), the focal length, f, increases with wavelength, λ (f_λ), and is corrected by combining two suitable positive and negative lenses of different glasses, to equalize f for two wavelengths such as the Fraunhofer F and C lines for the visible spectrum, giving an *achromatic lens*. This achromatic doublet has a residual uncorrected secondary spectrum, illustrated in Figure 6.3, further reduced by using three glasses and optimized for three wavelengths, termed *apochromatic*, although this may just mean a reduced secondary spectrum by the use of special anomalous (extraordinary) dispersion glasses, termed ED glasses. Chromatic correction does not usually include the IR and UV regions, and a focus correction must be made after visual focusing to allow for f_λ in these regions. The focusing scale may have an infrared focusing index. A special form of correction, *superachromatic*, extends correction from 400 to 1000 nm.

By contrast, *transverse chromatic aberration* (TCA), or lateral colour, illustrated in Figure 6.4, is dispersion of obliquely incident rays and the 'colour fringing' effects observed worsen rapidly as the image point moves off-axis. It is a difficult aberration to correct, but for general-purpose lenses, symmetrical construction is effective. Lateral colour sets the performance limits to long focus refracting lenses, but fluorite and ED glass elements give effective correction.

Reflecting elements such as full or partial mirrors do not disperse light and mirror lenses can be used for long-focus lenses as well as for UV and IR work and microscopy.

Pure mirror designs are called *catoptric* and are seldom suitable for photography. Additional refracting elements are needed for full aberration correction, giving catadioptric lenses.

Polarization

In Chapter 2 we explained the physical mechanisms and types of light polarization. In photographic applications linear or plane polarized light can be converted into circularly polarized light by means of a quarter-wave plate, which is a birefringent material of specific thickness that splits the plane polarized light into two equal perpendicular components with a phase difference of $\lambda/4$. The emergent beam proceeds with a circular helical motion. Left- and right-handed circular polarization is possible. Circularly polarizing filters have a specialized photographic application with some SLR cameras which use metal film beamsplitters to sample the light from the lens for exposure determination or for an autofocus system, as illustrated in Figure 6.5. The beamsplitter varies its percentage split of an incident beam depending on its amount of linear polarization, which in turn can affect exposure determination or light reaching the autofocus module. Circularly polarized light is unaffected. A linear polarizing filter is very useful in controlling surface reflections that become partly or wholly polarized from dielectric materials — that is, most materials except metals. Colour saturation can be improved. Blue skies may be darkened as scattered light is polarized relative to the sun's position.

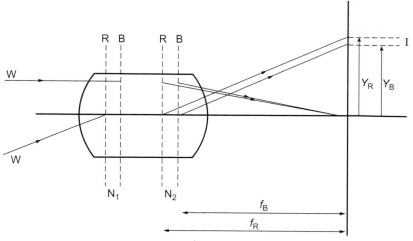

Figure 6.4 Lateral (or transverse) chromatic aberration (TCA) for off-axis points in a lens that has been corrected for longitudinal chromatic aberration (LCA) only. The effect is a variation in image point distance *y* from the axis for red and blue light.

Figure 6.5 Polarized light and beamsplitters. (a) With natural light (N) a beamsplitter (B) reflects light to the viewfinder (V) and transmits to a photocell or autofocus module (C) in ratio 3:1. (b) With linear polarizing filter (L) in 45° position, the ratio is 62:38. (c) With linear polarizing filter in 135° position, the ratio is 88:12. (d) With circular polarizing filter made by addition of quarterwave plate Q, the ratio is constant at 3:1 for all positions.

Simple lens

A *simple lens* consists of a single element with two surfaces. One surface may be flat. A curved surface may be concave, convex or possibly aspheric. The *focal length, f,* and *power, P,* of a lens with refractive index n_d are given by the *lens makers' formula*:

$$P = 1/f = (n_d - 1)(1/r_1 - 1/r_2) \qquad (6.2)$$

where r_1 and r_2 are the radii of curvature of the surfaces, being positive measured to the right of the vertex of the surface and negative measured to the left. Depending on the values for r_1 and r_2, focal length can be positive or negative. In terms of image formation, a *positive* or *converging lens* refracts parallel incident light to deviate it from its original path and direct it towards the optical axis and form a *real image* that can be focused or projected on a screen. A *negative* or *diverging lens* deviates parallel light away from the axis and a *virtual image* is formed, which can be seen or can act as a virtual object for another lens but cannot itself be focused on a screen. The location, size and orientation of the image may be determined by simple calculations. The *object* and *image distances* from the lens are termed *conjugate distances* and commonly denoted by the letters *u* and *v* respectively; see Figure 6.6.

Cardinal planes

A simple thin lens is normally unsuitable as a photographic lens due to aberrations. A practical lens consists of a number of separated elements or groups of

(a)

(b)

(c)

(d)

Figure 6.6 Image formation by a positive lens (a, b) and a negative lens (c, d). (a) For a distant subject. F is the rear principal focal plane. (b) For a near subject. Focusing extension $E = (v - f)$; I is an inverted image. (c) For a distant subject 'O:F' is the front principal focal plane. 'I' is virtual, upright image. (d) For a near subject.

and second *nodal planes* (N_1 and N_2) (Figure 6.7). An oblique ray incident at N_1 emerges undeviated on a parallel path from N_2. The terms *principal* and *nodal* are used interchangeably but when the surrounding optical medium is different for object and image spaces, such as an underwater lens with water in contact with its front element, then the two pairs of planes are not coincident. Focal length is measured from the rear nodal point. For a symmetrical lens, the nodal planes are located approximately one-third of the way in from the front and rear surfaces. Depending on lens design and configuration they may or may not be crossed over or even located in front of or behind the lens. The location of nodal planes can be used to classify major types of lenses (see Figure 6.8).

The third pair of these *cardinal* or *Gaussian planes* are the front and rear focal planes through the front and rear principal foci on the axis. *Gaussian* or *paraxial optics* are calculations involving subjects located close to the optical axis and small angles of incidence. Detailed information about the image and its aberrations is not given; instead, ray path traces using Snell's Law at each surface are necessary. The focal 'plane' is curved slightly even in highly corrected lenses and is only approximately planar close to the optical axis.

Focal length

A thin, positive lens converges parallel incident light to the *rear principal focus*, F_2, on axis. The distance from this point to the optical centre of the lens is the focal length, f. For a thick lens, focal length is measured from N_2. Parallel light from off-axis points is also brought to an off-axis focus at the rear principal focal plane. As light is reversible in an optical system there is also a *front principal focus*, F_1. The closest to a lens an image can be formed is at F_2. An object inside F_1 gives a *virtual image*, as formed by a simple microscope, magnifier or *loupe*. As *u* decreases from infinity

elements, the physical length of which is a significant fraction of its focal length. This is a *compound, thick* or *complex* lens. The term *equivalent focal length* (EFL) is often used to denote the composite focal length of such a system. For two thin lenses of focal lengths f_1 and f_2, the EFL, f, is given by:

$$1/f = 1/f_1 + 1/f_2 - d/f_1f_2 \qquad (6.3)$$

where d is their axial separation.

Thin lens formulae can be used with thick lenses if conjugate measurements are made from two specific planes perpendicular to the optical axis. These are the first and second *principal planes* that are planes of unit transverse magnification. For thin lenses in air the two planes are coincident. For thick lenses in air the principal planes are separated and coincident with two other planes, the first

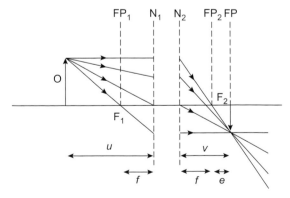

Figure 6.7 Image formation by a compound lens. F_1, F_2, front and rear principal foci; FP, image focal plane; FP_1, FP_2, first and second principal focal planes; N_1, N_2, first and second nodal planes (also principal planes).

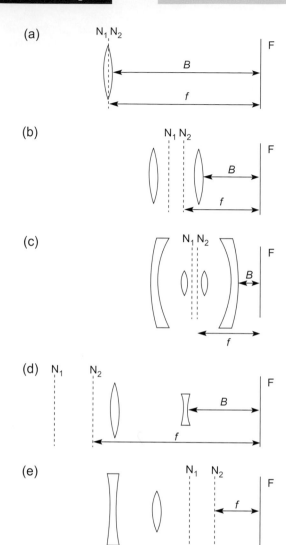

Figure 6.8 Nodal planes and lens configurations. *B*, back focal distance; *f*, focal length; F, photoplane; N_1, N_2, first and second nodal planes. (a) Simple or long focus lens, $B \approx f$. (b) Short focus symmetrical lens, $B < f$. (c) Quasi-symmetrical wide-angle lens, $B << f$. (d) Telephoto lens, $B < f$. (e) Retrofocus wide-angle lens, $B > f$.

the focus recedes from the lens so, in practical terms, the lens is shifted away from the film plane to focus on close objects. Parameters *u*, *v* and *f* are related by the *lens conjugate equation*:

$$1/u + 1/v = 1/f \qquad (6.4)$$

A Cartesian sign convention is often suitable with the lens taken as the origin so distances measured to the right are positive and to the left are negative. Alternatively,

a useful convention is that 'real is positive and virtual is negative', and useful derived equations include:

$$u = vf/(v - f) \qquad (6.5)$$

$$v = uf/(u - f) \qquad (6.6)$$

$$u = f(1 + 1/m) \qquad (6.7)$$

$$v = f(1 + m) \qquad (6.8)$$

where *image magnification*, *m*, is defined as:

$$m = v/u \qquad (6.9)$$

For large values of *u*, $v \approx f$, hence $m \approx f/u$. So focal length in relation to a film format determines the size of the image.

Focal length can be specified also as dioptric power, *P*, of the lens, where, for *f* in millimetres:

$$P = 1000/f \text{ dioptres (D)} \qquad (6.10)$$

Normal sign convention is applicable. A photographic lens of focal length 100 mm has a power of +10 D and one of 50 mm a power of +20 D. This term is used in *optometry* (measurement of visual performance in humans) and also to specify a *close-up lens* (see Chapter 10), although other numbering systems may be used. Powers are additive, so two thin lenses of powers +1 and +2 D placed in contact give a combined power of +3 D.

Image magnification

Magnification gives the image size relative to object size. Since in most practical photography the image is very much smaller than the subject, the magnification is less than unity, except in *photomacrography* (close-up photography — see Chapter 10), where the image is unity or greater. The term *ratio of reproduction* is often preferred, giving a quantity such as 1:50 instead of magnification 1/50 or 0.02. For *afocal* systems such as lens attachments and telescopes, either *magnifying power* or *angular magnification* is used instead.

From imaging geometry, three types of magnification are definable: *lateral* or *transverse*, *m*, *longitudinal*, *L*, and angular, *A*, with the relationship $AL = m$. As defined, $m = I/O = v/u$ (see Eqn 6.9) and $L = m^2$. Transverse magnification, *m*, is mostly used in photography. Note that for $m = 0.02$, *L* is 0.0002, so that if *depth of field* is 3 m, *depth of focus* will be 1.2 mm — definitions for depth of field and depth of focus are given later in this chapter.

An ideal lens gives a constant magnification in a given perpendicular image plane, but radial variations cause both *barrel* and *pincushion* distortion (see Chapter 10), while variation with λ causes lateral colour. Magnification can be determined by direct measurement of object and image dimensions or by use of a scaled focusing screen or a scale on the focusing mount of the lens. Measurements derived from conjugates are more difficult as the exact

location of the nodal planes may not be known. Alternatively if m is known, the values of u and v can be calculated from derived equations. For $m \geq 0.1$, exposure corrections are usually necessary to the values indicated by hand-held light meters.

Mirrors

Plane, spherical, aspherical, faceted and compound mirrors are used as optical elements in various imaging and illumination systems. A *plane (flat) mirror* gives an image that is virtual, upright, diminished and laterally reversed, located at the same distance behind the mirror as the subject is in front. Plane mirrors deviate the direction of the incident light and have a refractive index of -2 for optical calculations. A series of angled mirrors can be used to invert or laterally correct an image. A mirror can be surface silvered, or be immersed, as with the internal surface of a prism. Rotation of a mirror through an angle K rotates an incident beam through an angle $2K$.

Spherical mirrors may be concave or convex and have different imaging properties. Convex mirrors have a negative power and give an erect, minified, virtual image. Paraxial imaging behaviour is given by the mirror formula.

$$P = 1/f = 1/u + 1/v = -2/r \qquad (6.11)$$

where r is the *radius of curvature* and $f = r/2$.

Aspherical mirrors with ellipsoidal or paraboloidal shapes are useful in imaging systems by virtue of the way they focus light. For large r, a spherical mirror approximates to a paraboloid for paraxial imagery.

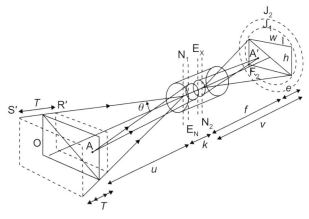

Figure 6.9 Imaging geometry of a photographic lens. A, object point; A′, conjugate image point; e, focusing extension; E_N, entrance pupil; E_X, exit pupil; h, w, format height and width; J_1, image circle; J_2, extra covering power; I, conjugate image plane; N_1, N_2, nodal planes; O, focused object plane; T, depth of field from planes S′ to R′; θ, semi-field angle of view.

OPTICAL CALCULATIONS

Parameters

The various parameters involved in the geometry of imaging by a photographic lens are shown in Figure 6.9. Information about an image or its optical parameters may be calculated using equations derived from Gaussian or paraxial optics. Special calculators may be used if available. It is assumed that no aberrations are present. Conjugate distances are measured from the first and second principal or nodal planes (points) as appropriate. The symbols used for the optical parameters are defined in Table 6.1.

Equations

The fundamental equation is the lens conjugate equation 6.4 and, assuming real is positive and virtual is negative, various rearrangements are often more convenient to use.

1. *Focal length* is calculated from:

$$f = uv/(u+v) = u/(1+R) = Rv/(1+R)$$
$$= mu/(1+m) = v/(1+m) = DR/(1+R)^2$$
$$= Dm/(1+m)^2 \qquad (6.12)$$

2. *Object conjugate* distance is calculated from:

$$u = vf/(v-f) = f(1+R) = f(1+m)/m$$
$$= DR/(1+R) = D/(1+m) \qquad (6.13)$$

3. *Image conjugate* distance is calculated from:

$$v = uf/(u-f) = f(1+R)/R = f(1+m)$$
$$= D/(1+R) = Dm/(1+m) \qquad (6.14)$$

4. *Magnification* and *reduction ratio* are calculated from:

$$m = I/O = v/u = (v-f)/f = v/(D-v)$$
$$= f/(u-f) = (D-u)/u \qquad (6.15)$$

$$R = O/I = u/v = f/(v-f) = (D-v)/v$$
$$= (u-f)/f = u/(D-u) \qquad (6.16)$$

5. *Conjugate sum* $(u+v)$ is calculated from:

$$D = f(1+m)^2/m = f(1+R)^2/R = v(1+m)/m$$
$$= v(1+R) = u(1+m) = u(1+R)/R = (u+v) \qquad (6.17)$$

6. *Object size* is calculated from:

$$O = IR = I/m = If/(v-f) = I(D-v)/v$$
$$= I(u-f)/f = Iu/(d-u) = Iu/v \qquad (6.18)$$

Table 6.1 Symbols used for optical parameters

SYMBOL	OPTICAL PARAMETER
f	Focal length
f_1	Focal length of component 1 in a multi-element system, etc.
F	Effective focal length (EFL) of a system with several components
s	Axial separation of two optical components in a system
P	Optical power of a lens in dioptres
u	Object conjugate distance
u_p	Object distance measured from the focal plane
u_s	Object distance for lens focused at distance u, with a supplementary lens
v	Image conjugate distance
D	Separation between object and image, i.e. sum of conjugates $(u + v)$, ignoring internodal space K
K	Internodal or nodal space
O	Linear size of object
I	Linear size of image
m	Optical (image) magnification $= I/O = v/u = 1/R$
M	Print magnification, i.e. degree of enlargement
R	Reduction ratio $= 1/m = O/I = u/v$
d	Effective clear diameter of a lens
N	Relative aperture or f-number
N'	Effective aperture or effective f-number
C	Diameter of circle of confusion
H	Hyperfocal distance
e	Movement of lens along axis, i.e. focusing extension
t	Depth of focus
T	Total depth of field $= S' - R'$
S'	Far limit of depth of field
R'	Near limit of depth of field

7. *Image size* is calculated from:

$$I = O/R = Om = Ov/u = O(v - f)/f$$
$$= Ov/(D - v) = Of/(u - f) = O(D - u)/u \quad (6.19)$$

8. *Effective focal length* of two lenses combined:

$$F = f_1 f_2 / (f_1 + f_2 - s) \quad (6.20)$$

9. Focal length of one component:

$$f_1 = F(f_2 - s)/(f_2 - F) \quad (6.21)$$

$$f_2 = F(f_1 - s)/(f_1 - F) \quad (6.22)$$

(f_1 and f_2 are positive when F is positive). If f_1 is known in dioptres (e.g. a supplementary lens), then:

$$f_1 = F(1000/P - s)/(1000/P - F) \text{ mm} \quad (6.23)$$

10. *Axial separation.* Necessary separation for required F is:

$$s = f_1 + f_2 - f_1 f_2 / F \quad (6.24)$$

11. For near contact to give a small s, approximations are:

$$F = f_1 f_2 / (f_1 + f_2) \quad (6.25)$$

$$f_1 = F f_2 / (f_2 - F) \quad (6.26)$$

12. Object distance with supplementary lenses. When the camera lens is focused on infinity, and a supplementary lens f_2 is added, then:

$$u = f_2 \quad (6.27)$$

The distance is independent of f_1 or F or S. If the camera is focused on nearer objects this does not apply and the combination has to be calculated.

Focusing movements

The forward movement of a lens to focus sharply a near object can be defined in terms of u and f. This distance e is measured from the infinity focus position. Object distance can be determined from f and e. Different formulae apply when object distance is measured from the focal plane and not the front node.

13. For u measured from front node:

$$e = f^2 / (u - f) = fI/O = fv/u \quad (6.28)$$

$$u = f(f + e)/e \quad (6.29)$$

14. For u measured from the focal plane:

$$e = [u_p - 2f - (u_p^2 - 4fu_p)^{1/2}]/2 \quad (6.30)$$

$$u_p = (f + e)^2 / e \quad (6.31)$$

15. Magnification and camera extension:

$$m = e/f \quad (6.32)$$

$$e = fm \quad (6.33)$$

16. Focusing movement with supplementary lenses. If F is computed as above, then this can substitute for f in the equations listed. For a camera lens fitted with supplementary lens f_2, and focused not on infinity but a near distance u, then the object distance u_s is given by the approximate formula:

$$u_s = uf_2/(u + f_2) \quad (6.34)$$

Depth of field and depth of focus

Relevant equations are based on the premise that some degradation of the image is permissible for objects not sharply in focus. The criterion of permissible unsharpness is the diameter, C, of the *circle of confusion*. *Depth of focus, t,* is the permissible tolerance in the distance between a lens and the sensitized material:

$$t = 2CN \quad (6.35)$$

For near objects, this becomes:

$$t = 2CN' = 2Cf/v \quad (6.36)$$

Depth of field, T, is given as the distance between the near and far points in acceptably sharp focus when the lens is focused on a subject distance that is not infinity:

$$S' = uf^2/(f^2 - NCu) \quad (6.37)$$

$$R' = uf^2/(f^2 + NCu) \quad (6.38)$$

$$T = S' - R' = 2f^2u^2NC/(f^4 - N^2C^2u^2) \quad (6.39)$$

For practical purposes with distant scenes the second term in the denominator may be disregarded, so to a first approximation:

$$T = 2u^2NC/f^2 \quad (6.40)$$

Figure 6.10 shows the effect of focal length, focused distance and f-number on practical depth of field.

Hyperfocal distance, H, is the focus setting, u, which gives S' as infinity. Use of H simplifies depth of field equations:

$$H = f^2/NC \quad (6.41)$$

$$R' = Hu/(H + u) \quad (6.42)$$

$$S' = Hu/(H - u) \quad (6.43)$$

$$T = 2Hu^2/(H^2 - u^2) \quad (6.44)$$

Close-up depth of field

When the lens is focused at close distances the depth of field is small and it is sufficient to calculate the total depth of field between the near and far limits rather than each separately:

$$T = 2CN(1 + m)/m^2 = 2CNR(1 + R) \quad (6.45)$$

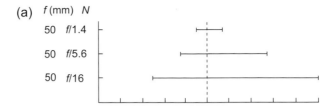

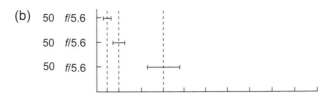

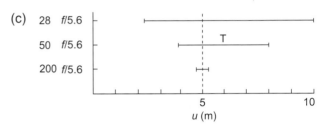

Figure 6.10 Depth of field (J). Effect of the variables of focal length (f), f-number (N) and focused distance (u) at a constant value for the circle of confusion. (a) Lens aperture varying from $f/1.4$ to $f/16$ with a 50 mm lens focused at 5 m. (b) Focused distance varying from 0.5 to 3 m with 50 mm lens at $f/5.6$. (c) Focal length varying from 28 to 200 mm at $f/5.6$ focused on 5 m.

THE PHOTOMETRY OF IMAGE FORMATION

The light-transmitting ability of a photographic lens, which principally determines the illuminance of the image at the film plane, is usually referred to as the *speed of the lens*. Together with the effective emulsion 'speed' or photosensor sensitivity and the subject luminance, this determines the exposure duration necessary to give a correctly exposed result.

Stops and pupils

An optical system such as a camera and lens normally has two 'stops' located within its configuration. The term *stop* originates from its original construction of a hole in an opaque plate perpendicular to the optical axis. The *field stop*, which is the film gate or photosensor array, determines the extent of the image in the focal plane and also the effective field of view of the lens. The *aperture stop* is located within the lens or close to it, and controls the transmission

111

of light by the lens. It also influences depth of field and lens performance, in terms of the accuracy of drawing and resolution in the image (its ability in reproducing detailed information in the original scene).

In a simple lens the aperture stop may either be fixed, or only have one or two alternative settings. A compound lens is usually fitted with a variable-aperture stop called an *iris diaphragm*. This is continuously adjustable between its maximum and minimum aperture sizes using five or more movable blades, providing a more or less circular opening. The aperture control ring may have click settings at whole and intermediate *f*-number values. In photography the maximum aperture as well as the aperture range is important, as aperture choice is a creative control in picture making.

In a compound lens with an iris diaphragm located within its elements, the apparent diameter of the iris diaphragm when viewed from the object point is called the entrance pupil, E_N. Similarly, the apparent diameter of the iris diaphragm when viewed from the image point is called the exit pupil, E_X. These two are virtual images of the iris diaphragm, and their diameter is seldom equal to its actual diameter. To indicate this difference the term *pupil factor* or *pupil magnification*, *p*, is used. This is defined as the ratio of the diameter of the exit pupil to that of the entrance pupil:

$$p = E_X/E_N \qquad (6.46)$$

Symmetrical lenses have a pupil factor of approximately 1, but telephoto and retrofocus lenses have values that are respectively less than and greater than unity. Pupil magnification influences image illuminance. The pupils are not usually coincident with the principal planes of a lens; indeed, for *telecentric* lenses the exit pupil can be at infinity.

Aperture

The light-transmitting ability of a lens, usually referred to as *aperture* (due to the control exercised by the iris diaphragm) is defined and quantified in various ways. Lenses are usually fitted with iris diaphragms calibrated in units of *relative aperture*, a number N, which is defined as the equivalent focal length *f* of the lens divided by the diameter *d* of the entrance pupil ($N = f/d$) for infinity focus (see also Chapter 2), so a lens with an entrance pupil 25 mm in diameter and a focal length of 50 mm has a relative aperture of 50/25, i.e. 2. The numerical value of relative aperture is usually prefixed by the italic letter *f* and an oblique stroke, e.g. *f*/2, which serves as a reminder of its derivation. The denominator of the expression used alone is usually referred to as the *f-number* of the lens. Aperture value on many lenses appears as a simple ratio, so the aperture of an *f*/2 lens is shown as '1:2'.

The relative aperture of a lens is commonly referred to simply as its 'aperture' or even as the 'f-stop'. The maximum aperture is the relative aperture corresponding to the largest diaphragm opening that can be used with it.

To simplify exposure calculations, *f*-numbers are selected from a standard series of numbers, each of which is related to the next in the series by a constant factor calculated so that the amount of light passed by the lens when set to one number is half that passed by the lens when set to the previous number, as the iris diaphragm is progressively closed. As the *amount of light passed* by a lens is inversely proportional to the *square of the f-number*, the numbers in the series increase by a factor of $\sqrt{2}$, i.e. 1.4 (to two figures). The standard series of *f*-numbers is *f*/1, 1.4, 2, 2.8, 4, 5.6, 8, 11, 16, 22, 32, 45 and 64. Smaller or larger values are seldom encountered. The maximum aperture of a lens may lie between two of the standard *f*-numbers above, and will be marked with a number not in the standard series.

Other series of numbers have been used in the past and may be encountered on older lenses and exposure meters. In cameras offering shutter priority and program modes, the aperture setting may be unknown. A change in exposure by a factor of 2 either larger or smaller is referred to as a change of 'one stop' or *exposure value* (EV). Additional exposure by alteration of 'one-third of a stop', 'half a stop' and 'two stops' refer to exposure factors of 1.26, 1.4 and 4 respectively. When the lens opening is made smaller, i.e. the *f*-number is made numerically larger, the operation is referred to as 'stopping down'. The converse is called 'opening up'.

The aperture of a lens is defined in terms of a distant axial object point. However, lenses are used to produce images of extended subjects, so that a point on an object may be well away from the optical axis of the lens, depending on the field of view. Obstruction may occur because of the type and design of the lens, its axial length and position of the aperture stop, and the mechanical construction of the lens barrel. The effect is to reduce the amount of light reaching the focal plane, termed *mechanical vignetting* or 'cut-off' or 'shading', which increases as field angle increases causing darkening at the edges of images, and is one factor determining image illuminance as a function of field angle and hence the circle of illumination. Mechanical vignetting must not be confused with the natural fall-off of light due to the geometry of image formation (see later), although both effects occur together. Vignetting may be reduced by designing lenses with oversize front and rear elements, and by careful engineering of the lens barrel. The use of an unsuitable lens hood or two filters in tandem, especially with a wide-angle lens, also causes cut-off and increases peripheral darkening. Vignetting is measured of a decrease in EV with respect to the axial EV and is a particular problem for photosensors.

Image luminance and illumination

A camera lens projects an image formed as the base of a cone of light whose apex is at the centre of the exit pupil (centre of projection). It is possible to derive an expression for the illumination or *illuminance* at any point in the image

of a distant, extended object. The flux F emitted by a small area S of a uniformly diffusing surface (i.e. one that appears equally bright in all directions) of luminance L into a cone of semi-angle ω is given by the equation:

$$F = \pi L S \sin^2 \omega \qquad (6.47)$$

Note that the flux emitted is independent of the distance of the source. For an object and an image that are both uniformly diffuse, and whose luminances are L and L' respectively, with an 'ideal' lens of transmittance T, then $L' = TL$. So the image luminance of an aerial image is the same as the object luminance apart from a small reduction factor due to the transmittance of the lens, within the cone of semi-angle ω. Viewing the aerial image directly gives a bright image, but this cannot easily be used for focusing, except by passive focusing devices or no-parallax methods. Instead, the image has to be formed on a diffuse surface such as a ground glass screen and viewed by scattering of the light. The processes of illumination cause this image to be much less bright than the direct aerial image.

Image illuminance

The projected image formed at the photoplane suffers light losses from various causes, so the image illumination or illuminance, E, is reduced accordingly. It can be shown that the axis is given by:

$$E = TLA \cos^4 \theta / v^2 \qquad (6.48)$$

Equation 6.48 shows the factors influencing image illuminance and exposure. The value of E is independent of u, the subject distance, although the value of v is related to u by the lens equation. The axial value of illuminance is given when $\theta = 0$; then $\cos \theta = 1$ and $\cos^4 \theta = 1$. Hence $E = TLA/v^2$. Now lens area A is given by:

$$A = \pi d^2 / 4 \qquad (6.49)$$

so that:

$$E = \pi L T d^2 / 4 v^2 \qquad (6.50)$$

For the subject at infinity, $v = f$. By definition, the relative aperture N is given by $N = f/d$. By substitution we thus have:

$$E = \pi T L / 4 N^2 \qquad (6.51)$$

This shows that, for a distant subject, on the optical axis in the focal plane, E is inversely proportional to N^2. Hence image illuminance is inversely proportional to the square of the f-number. For two different f-numbers N_1 and N_2, the ratio of corresponding image illuminances is given by:

$$E_1/E_2 = N_2^2/N_1^2 \qquad (6.52)$$

So it is possible to calculate that the image illuminance at $f/4$ is one-quarter of the value at $f/2$.

The *exposure H* received by a film or a digital sensor during exposure duration t is given by:

$$H = Et \qquad (6.53)$$

and so for a fixed exposure time, as H is proportional to E, then:

$$H_1/H_2 = N_2^2/N_1^2 \qquad (6.54)$$

Also, as E is inversely proportional to t, so:

$$E_1/E_2 = t_2/t_1 \qquad (6.55)$$

hence the exposure times t_1 and t_2 required to produce equal exposures at f-numbers N_1 and N_2 respectively are given by:

$$t_1/t_2 = N_2^2/N_1^2 \qquad (6.56)$$

Also, E is inversely proportional to d^2. In other words, image illuminance is proportional to the square of the lens diameter, or effective diameter of the entrance pupil. Thus, by doubling the value of d, image illuminance is increased fourfold. Values may be calculated from:

$$E_1/E_2 = d_1^2/d_2 \qquad (6.57)$$

To give a doubling series of stop numbers, the value of d is altered by a factor of $\sqrt{2}$, giving the standard f-number series.

An interesting result also follows from Eqn 6.51. By suitable choice of photometric units, such as by taking E in lux (lumen m^{-2}) and L in apostilbs (l/π cd m^{-2}), we have:

$$E = TL/4N^2 \qquad (6.58)$$

So for a lens with perfect transmittance, i.e. $T = 1$, the maximum possible value of the relative aperture N is $f/0.5$, so that $E = L$. Values close to $f/0.5$ have been achieved in special lens designs.

When the object distance u is not large, i.e. in close-up photography or photomacrography, then the effective aperture $N' = N(1 + m)$, so:

$$E = \pi LT/4(N')^2 \qquad (6.59)$$

Usually it is preferable to work with f-number, N, which is marked on the aperture control of the lens, and magnification, m, which is often known or set. In addition for photomacrography, when non-symmetrical lenses and, particularly, retrofocus lenses may be used in reverse mode, the pupil factor $p = E_X/E_N$ must also be taken into account for the effective aperture. The relationship is that $N' = N(1 + m/p)$ and is due to the non-correspondence of the principal planes from which u and v are measured and the pupil positions from which the image photometry is derived. By substitution:

$$E = \pi TL/4N^2(1 + m/P)^2 \qquad (6.60)$$

For image illumination off-axis, θ is not equal to 0. Then $\cos^4 \theta$ has a value less than unity, rapidly tending to zero as

113

θ approaches 90°. Also, a *vignetting factor*, V, is needed to allow for vignetting effects by the lens with increase in field angle. So the equation for image illuminance, allowing for all factors, is now:

$$E = V\pi TL \cos^4 \theta / 4N^2 (1 + m/p)^2 \qquad (6.61)$$

From Eqn 6.61, E is proportional to $\cos^4 \theta$. This is the *$\cos^4 \theta$ law of illumination*, or 'natural vignetting' or 'shading', due to the combined effects of the geometry of the imaging system, the inverse square law of illumination and Lambert's cosine law of illumination. The effects of this law are that even a standard lens with a semi-angle of view of 26° has a level of image illuminance at the edge of the image of only two-thirds of the axial value. For an extreme wide-angle lens with a semi-angle of view of 60°, peripheral illuminance is reduced to 0.06 of its axial value.

For wide-angle lens designs, corrective measures are necessary to obtain more uniform illumination over the image area. A mechanical method is a *graduated neutral density filter* or *spot filter*, in which density decreases non-linearly from a maximum value at the optical centre to near zero at the periphery. This can provide a fairly precise match for illumination fall-off. Such filters are widely used with wide-angle lenses of symmetrical configuration. There is a penalty in the form of a +2EV exposure correction factor. Oversize front and rear elements are also used to minimize mechanical vignetting. Illumination fall-off can be reduced if the lens has outermost elements that are negative and of large diameter. Lens designs such as quasi-symmetrical lenses with short back foci, and also retrofocus lenses, both benefit from this technique. The overall effect is to reduce the '$\cos^4 \theta$ effect' to roughly $\cos^3 \theta$. The theoretical consideration of image illuminance applies only to well-corrected lenses that are free from distortion. If distortion correction (which becomes increasingly difficult to achieve as angle of field increases) is abandoned, and the lens design deliberately retains barrel distortion so that the light flux is distributed over proportionally smaller areas towards the periphery, then fairly uniform illuminance is possible even up to angles of view of 180° or more. *Fisheye* lenses are examples of the application of this principle. The relationship between the distance y of an image point from the optical axis changes from the usual:

$$y = f \tan \theta \qquad (6.62)$$

of an orthoscopic lens to:

$$y = f\theta \qquad (6.63)$$

for this type of imagery (θ is given in radians).

Exposure compensation for close-up photography

The definition of relative aperture, N, assumes that the object is at infinity, so that the image conjugate v can be taken as equal to the focal length f. When the object is closer this assumption no longer applies, and instead of f in the equation $N = f/d$, we need to use v, the lens extension. Then N' is defined as equal to v/d, where N' is the *effective f-number* or *effective aperture*.

Camera exposure compensation may be necessary when the object is within about 10 focal lengths from the lens. Various methods are possible, using the values of f and v (if known), or magnification m, if this can be measured. Mathematically, it is easier to use a known magnification in the determination of the correction factor for either the effective f-number N' or the corrected exposure duration t'. The required relationships are, respectively:

$$t'/t = (N')^2 / N^2 \qquad (6.64)$$

or

$$t' = t(1 + m)^2 \qquad (6.65)$$

and

$$N' = N(v/f) \qquad (6.66)$$

i.e.

$$N' = N(1 + m) \qquad (6.67)$$

The exposure correction factor increases rapidly as magnification increases. For example, at unit magnification the exposure factor is ×4 (i.e. +2EV), so that the original estimated exposure time must be multiplied by four or the lens aperture opened up by two whole stops.

The use of cameras with through-the-lens (TTL) metering systems is a great convenience in close-up photography, as compensation for change in magnification is automatically taken into account, especially with lenses using internal focusing and for zoom lenses with variable aperture due to mechanical compensation, as the effective aperture may not vary strictly according to theory since focal length changes with alteration of focus too.

Lens flare

Some of the light incident on a lens is lost by reflection at the air–glass interfaces and a little is lost by absorption. The remainder is transmitted to form the image. So the value of transmittance T is always less than unity. Any light losses depend on the number of surfaces and composition of the glasses used. An average figure for the loss due to reflection might be 5% for each air–glass interface. If k (taken as 0.95) is a typical transmittance at such an interface, then as the losses at successive interfaces are multiplied, for n interfaces with identical transmittance, the total transmittance is:

$$T = k^n \qquad (6.68)$$

This means that an uncoated four-element lens with eight air–glass interfaces would have reflection losses

amounting to some $(0.95)^8 = 35\%$ of the incident light, i.e. a transmittance of 0.65.

Some of the light reflected at the lens surfaces passes out of the front of the lens and causes no trouble other than loss to the system, but a proportion is re-reflected from other surfaces and may ultimately reach the photoplane. Some of this stray diffuse non-image-forming light is spread uniformly over the surface of the image sensor, and is referred to as *lens flare* or *veiling glare*. Its effects are greater in the shadow areas of the image and cause a reduction in the image illuminance range (contrast). The flare light may not be spread uniformly; some may form out-of-focus images of the iris diaphragm (flare spots) or of bright objects in the subject field (ghost images). Such flare effects can be minimized by anti-reflection coatings, baffles inside the lens and use of an efficient lens hood. Light reflected from the inside of the camera body, e.g. from the bellows of a technical camera, and from the surface of the camera sensor, produces what is known as *camera flare*. This effect can be especially noticeable in a technical camera when the field covered by the lens gives an image circle appreciably greater than the film format. Such flare can often be effectively reduced by use of an efficient lens hood.

The number obtained by dividing the subject luminance range, SLR, by the image illuminance range, IIR, is termed the flare factor, FF, so:

$$FF = SLR/IIR \qquad (6.69)$$

Flare factor is a somewhat indeterminate quantity, since it depends not only on the lens and camera, but also on the distribution of light within and around the subject area. The value for an average lens and camera considered together may vary from about 2 to 10 for average subject matter. The usual value is from 2 to 4 depending on the age of the camera and lens design. A high flare factor is characteristic of subjects having high luminance ratio, such as back-lit subjects.

In the camera, flare affects shadow detail in a negative more than it does highlight detail; in the enlarger (i.e. in photographic printing), flare affects highlight detail more than shadow detail. In practice, provided the negative edges are properly masked in the enlarger, flare is seldom serious. This is partly because the density range of the average negative is lower than the log-luminance range of the average subject, and partly because the negative is not surrounded by bright objects, as may happen in the subject matter. In colour photography, flare is likely to lead to a desaturation of colours, as flare light is usually a mixture approximating to white. Flare may also lead to colour casts caused by coloured objects outside the subject area. Uncorrected flare may be predominantly in the infrared region and can seriously affect photosensor arrays with their extended spectral sensitivity. Suitable suppressive coatings are required on the rear surface of the lens.

T-numbers

Since lens transmission is never 100%, relative aperture or f-number N (as defined by the geometry of the system) does not give the light-transmitting capability of a lens. Two lenses of the same f-number may have different transmittances, and thus different speeds, depending on the type of construction, number of components and type of lens coatings. The use of lens coatings to reduce reflection losses markedly improves transmission, and there is a need in some fields of application for a more accurate measure of the transmittance of a lens. Where such accuracy is necessary, *T-numbers*, which are photometrically determined values taking into account both imaging geometry and transmittance, may be used instead of f-numbers. The T-number of any aperture of a lens is defined as the f-number of a perfectly transmitting lens which gives the same axial image illuminance as the actual lens at this aperture. For a lens of transmittance T and a circular aperture:

$$T\text{-number} = N/\sqrt{T} = NT^{-1/2} \qquad (6.70)$$

Thus, a $T/8$ lens is one which passes as much light as a theoretically perfect $f/8$ lens. The relative aperture of the $T/8$ lens may be about $f/6.3$. The concept of T-numbers is of chief interest in cinematography and television, and where exposure latitude is small. It is implicit in the T-number system that every lens should be individually calibrated.

Depth of field calculations still use f-numbers as the equations used have been derived from the geometry of image formation.

Anti-reflection coatings

An effective practical method of increasing the transmission is by applying thin coatings of refractive material to the air–glass interfaces or lens surfaces. The effect of single anti-reflection coating is to increase transmittance from about 0.95 to 0.99 or more. For a lens with, say, eight such interfaces of average transmittance 0.95, the lens total transmittance increases from $(0.95)^8$ to $(0.99)^8$, representing an increase in transmittance from 0.65 to 0.92, or approximately one-third of a stop, for a given f-number. In the case of a zoom lens, which may have 20 such surfaces, the transmittance may be increased from 0.36 to 0.82, i.e. more than doubled. Lens flare is reduced, giving an image of improved contrast.

The effect of a surface coating depends on two principles. First, the surface reflectance R, the ratio of reflected flux to incident flux, depends on the refractive indices n_1 and n_2 of the two media forming the interface. In simplified form (from Fresnel's equations) this is given by:

$$R = (n_2 - n_1)^2/(n_2 + n_1)^2 \qquad (6.71)$$

In the case of a lens surface, n_1 is the refractive index of air and is approximately equal to 1, and n_2 is the refractive

115

index of the glass, typically approximately equal to 1.51. Reflectance increases rapidly with increase in the value of n_2. In modern lenses, using glasses of high refractive index (typically 1.7–1.9), such losses would be severe without coating.

Secondly, in a thin coating there is interference between the light wavefronts reflected from the first and second surfaces of the coating. With a coating of thickness t and refractive index n_3 applied to a lens surface (Figure 6.11), the interaction is between the two reflected beams R_1 and R_2 from the surface of the lens and from the surface of the coating respectively. The condition for R_1 and R_2 to interfere destructively and cancel out is given by:

$$2n_3 t \cos r = \lambda/2 \qquad (6.72)$$

where r is the angle of refraction and λ the wavelength of the light. Note that the light energy lost to reflection is transmitted instead. For light at normal incidence this expression simplifies to:

$$2n_3 t = \lambda/2 \qquad (6.73)$$

To satisfy this condition the 'optical thickness' of the coating, which is the product of refractive index and thickness, must be $\lambda/4$, i.e. one-quarter of the wavelength of the incident light within the coating. This type of coating is termed 'quarter-wave coating'. As the thickness of such a coating can be correct for only one wavelength it is usually optimized for the middle of the visible spectrum (green light) and hence looks magenta (white light minus green) in appearance. By applying similar coatings on other lens surfaces, but matched to other wavelengths, it is possible to balance lens transmission for the whole visible spectrum and ensure that the range of lenses available for a given camera produce similar colour renderings on colour reversal film, irrespective of their type of construction.

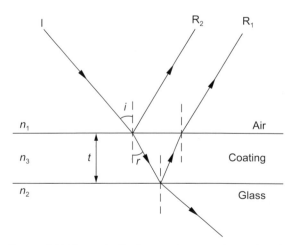

Figure 6.11 An anti-reflection coating on glass using the principle of destructive interference of light between reflections R_1 and R_2.

The optimum value of n_3 for the coating is also obtained from the conditions for the two reflected wavefronts to interfere destructively and cancel (see Chapter 2). For this to happen the magnitudes of R_1 and R_2 need to be the same. From Eqn 6.71 we can obtain expressions for R_1 and R_2:

$$R_1 = (n_2 - n_3)^2/(n_2 + n_3)^2 \text{ and}$$
$$R_2 = (n_3 - n_1)^2/(n_3 + n_1)^2 \qquad (6.74)$$

By equating $R_1 = R_2$ and taking $n_1 = 1$, then $n_3 = \sqrt{n_2}$.

So the optimum refractive index of the coating should have a value corresponding to the square root of the refractive index of the glass used.

For a glass of refractive index 1.51, the coating should ideally have a value of about 1.23. In practice the material nearest to meeting the requirements is magnesium fluoride, which has a refractive index of 1.38. A quarter-wave coating of this material results in an increase in transmittance at an air–glass interface from about 0.95 to about 0.98 as the light energy involved in the destructive interference process is not lost but is transmitted.

Types of coating

- *Evaporation*. The original method of applying a coating to a lens surface is by placing the lens in a vacuum chamber in which is a small container of the coating material. This is electrically heated and evaporates, being deposited on the lens surface. The deposition is continued until the coating thickness is the required value. This technique is limited to materials that will evaporate at sufficiently low temperatures.

- *Electron beam coating*. An alternative technique to evaporative coating is to direct an electron beam at the coating substance in a vacuum chamber. This high-intensity beam evaporates materials even with high melting points which are unsuitable for the evaporation technique. Typical materials used in this manner are silicon dioxide ($n = 1.46$) and aluminium oxide ($n = 1.62$). The chief merit of the materials used in electron beam coating is their extreme hardness. They are also used to protect aluminized and soft optical glass surfaces.

- *Multiple coatings*. Controlled surface treatment is routinely applied to a range of other optical products. With the advent of improved coating machinery and a wider range of coating materials, together with the aid of digital computers to carry out the necessary calculations, it is economically feasible to extend coating techniques by using several separate coatings on each air–glass interface. A stack of 25 or more coatings may be used to give the necessary spectral transmittance properties to *interference filters*, as used in colour enlargers and specialized applications such as

spectroscopy and microscopy. By suitable choice of the number, order, thicknesses and refractive indices of individual coatings the spectral transmittance of an optical component may be selectively enhanced to a value greater than 0.99 for any selected portion of the visible spectrum (see Figure 6.2).

The use of double and triple coatings in modern photographic lenses is now almost universal and even greater numbers are routinely used, making available a number of advanced lens designs that would otherwise have been unusable because of flare and low transmittance.

BIBLIOGRAPHY

Freeman, M., 1990. Optics, tenth ed. Butterworths, London, UK.

Hecht, E., 2002. Optics, fourth ed. Addison-Wesley, San Francisco, CA, USA.

Jacobson, R.E., Ray, S.F., Attridge, G.G., Axford, N.R., 2000. The Manual of Photography, ninth ed. Focal Press, Oxford, UK.

Jenkins, F., White, H., 1981. Fundamentals of Optics, fourth ed. McGraw-Hill, London, UK.

Kingslake, R., 1992. Optics in Photography. SPIE, Bellingham, WA, USA.

Ray, S., 2002. Applied Photographic Optics, third ed. Focal Press, Oxford, UK.

Chapter | 7 |

Images and image formation

Robin Jenkin

All images © Robin Jenkin unless indicated.

INTRODUCTION

How might the image shown in Figure 7.1 be described? Clearly a number of objects can be recognized. Enthusiasts may recognize the breed of dog. Comments on such attributes as lighting, colour and composition could also be made. These aspects of visual perception are a consequence of the subtle processes of physiology and psychology operating when the two-dimensional luminance pattern contained in the image is viewed by a human observer. The processes involved are the subject of much current research and are not covered in this work.

When asked to comment on the quality of the image, the same complex processes are involved and what is known as a *subjective judgement* is made. The processes operate on identifiable physical properties of the image, such as the structure of edges and the distribution of tones. The measurement of these physical properties forms the basis of *objective image evaluation* (see Chapter 19).

The purpose of this chapter is to introduce and develop the *Fourier theory of image formation*. This theory allows many objective measures of image quality to be unified and the evaluation and comparison of different imaging systems in a meaningful way. Most textbooks covering this subject require some familiarity with physics and mathematics. The presentation here includes a liberal sprinkling of important mathematical expressions but it is not necessary to understand their manipulation in order to understand the ideas of the chapter.

Figure 7.1 A typical image that could be made by any number of camera systems.

DOI: 10.1016/B978-0-240-52037-7.10007-9

In most cases the mathematics is included as an illustration of, and a link to, the more thorough treatments found elsewhere.

Returning to Figure 7.1, the image may be usefully described as a large array of small, closely spaced image elements (pixels) of different luminances and colours. If the pixels are sufficiently small, they are not noticed. All that is seen is a continuous luminance pattern. The way adjacent pixels vary in luminance over a small region determines image qualities such as sharpness, resolution and the appearance of noise, or in the case of photographic processes, *graininess* (see Chapter 24).

The idea may be extended to scenes in general. What lies in front of the camera lens when an image is captured is a continuous luminance pattern, which can be considered as an infinite array of infinitesimal points of varying luminance. The manner in which the imaging process translates these scene points (the input) into the image elements (the output) is then a fundamental physical process contributing to the quality of the image.

The physical relationship between input and output clearly depends on the technology of the particular imaging process. For example, the basic image element from a photographic film is best described as a localized group of developed silver grains, referred to as the *point spread function*. A charge-coupled device (CCD) or complementary metal oxide semiconductor (CMOS) imaging array produces more recognizable discrete cells (pixels) related to the parameters of the detector.

Despite these technological differences, the Fourier theory of image formation can be applied, with certain conditions, to all imaging systems. It enables the modelling of the relationship of the input to output in a general manner. It supplies an important tool, the *modulation transfer function* (MTF), with which important aspects of imaging performance can be assessed. The theory can be applied quite generally to colour images by treating individual channels independently. From this point forward we will consider the theory as applied to a luminance channel only.

To understand the Fourier theory of image formation requires a special treatment of images and their structure. The luminance pattern is decomposed, not into points or image elements, but into waves (see Chapter 2) or, more specifically, to *spatial frequencies*.

SINUSOIDAL WAVES

In Chapter 2 we discussed in-depth simple harmonic motion, so reference to that chapter may be useful in understanding the properties of sinusoidal waves. Figure 7.2a shows an amplified sine wave plotted as a function of distance, x. It exhibits the characteristic periodic behaviour where the number of repetitions (cycles) in unit distance is known as the spatial frequency, u, usually

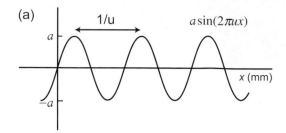

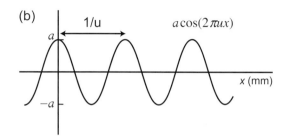

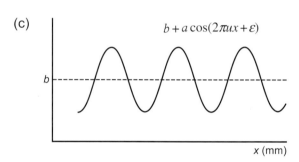

Figure 7.2 Sine (a) and cosine (b) waves.

measured in cycles per mm (mm^{-1}). The amplitude of the wave is a. The function is derived from the familiar trigonometric ratio by setting the angle equal to $2\pi ux$ radians and multiplying the resulting ratio by the required amplitude.

Figure 7.2a also shows a cosine wave of the same spatial frequency and amplitude. The two waves differ only in their positions on the x-axis. If the cosine wave is shifted a distance $\pi/2$ in the positive x direction it becomes a sine wave.

A sine or cosine wave, shifted an arbitrary distance along the x-axis, is termed a *phase-shifted* sine wave.

If we add a constant to a phase-shifted sine wave to produce an all-positive result, we obtain what will be referred to in this work as a sinusoidal wave (Figure 7.2b). This is appropriate for our work where the varying quantity is, for example, luminance.

For much of the work in image formation, phase is unimportant; however, when considering the analysis and measurement of sampled systems in particular, it can have an effect on results.

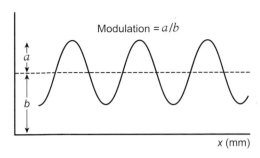

Figure 7.3 The modulation of a wave.

Modulation

The *modulation* of a sinusoidal wave is a formal measure of contrast. It is defined in Eqn 7.1 and shown in Figure 7.3. The modulation of a wave must lie between the two limits, zero and one. A modulation of zero implies the wave does not exist; a modulation of one is the maximum possible without invoking negative luminance and *a* will be equal to *b*.

$$M(u) = \frac{a}{b} \tag{7.1}$$

where $M(u)$ is the modulation of the sinusoidal wave with spatial frequency u, a is the amplitude and b is the mean signal level.

Images and sine waves

Figure 7.4a shows a sinusoidal luminance pattern. It is characterized by a particular spatial frequency, a direction of variation (x direction) and a modulation. Figure 7.4b shows the same information plotted as a three-dimensional figure. The luminance value of the image at any point is plotted vertically. Figure 7.4c is an end-on view. It shows the profile and clearly illustrates the sinusoidal character.

Figure 7.5 shows a second sinusoidal luminance pattern, of a lower spatial frequency and a lower modulation. Adding these two sinusoidal patterns together, Figure 7.6 is obtained. The result is no longer sinusoidal. The profile shows a slightly more complicated pattern.

This process may be continued by adding many more sinusoidal patterns of varying modulation and frequency. Figure 7.7 shows an image containing 30 harmonics, all of which vary in the x direction but have different frequencies and modulations. The profile is now very complicated and does not appear to be periodic, unlike the individual sinusoidal components. Note that in all of the above cases the images are invariant in the y direction (i.e they vary only in the x direction). They are described as functions of x only.

Figure 7.8 shows the result of adding more sinusoidal patterns, but this time their direction of variation is vertical (y direction). Finally, some sinusoidal patterns that vary in directions other than the horizontal or vertical may be added. Figure 7.9 shows two examples, and the result of adding them to the image. A complicated image is now created that varies in both the x and y directions.

This demonstration could be continued to include many more sinusoidal components. Some very complicated patterns could be created. With a large enough variety of components, it may be argued that *any* pattern could be created. In other words, any image can in principle be built

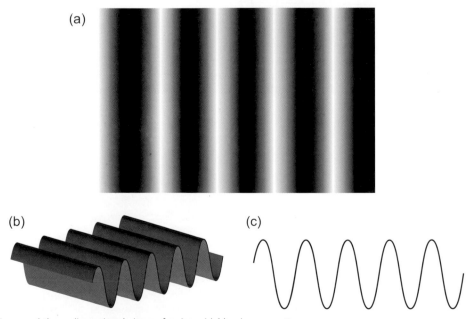

Figure 7.4 Two- and three-dimensional views of a sinusoidal luminance pattern.

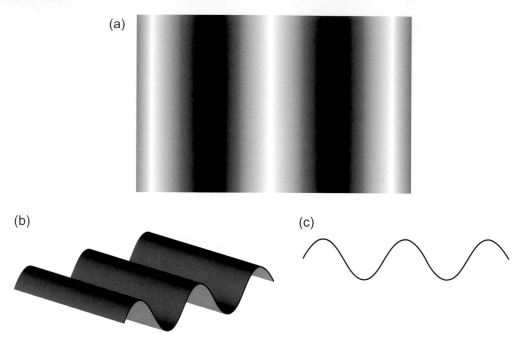

Figure 7.5 A sinusoidal pattern with a lower spatial frequency and modulation than that shown in Figure 7.4.

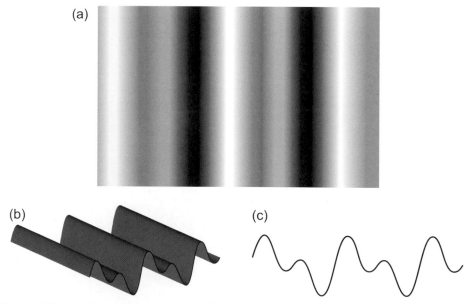

Figure 7.6 The sum of the two sinusoidal patterns shown in Figures 7.4 and 7.5.

up (or synthesized) from sine and cosine wave compo-nents. Waves of many different frequencies, amplitudes, orientations and phases would need to be included. The French mathematician Jean Baptiste Joseph Fourier (1768–1830) first demonstrated this principle, although he dealt with functions of one variable rather than two.

It follows from the discussion that real scenes can, in principle, be decomposed into sets of sinusoidal compo-nents of varying frequencies and modulations. The basis of Fourier theory of image formation is that if the perfor-mance of the imaging system to different sinusoidal inputs is known, *the principle of superposition* (adding together – see

(a)

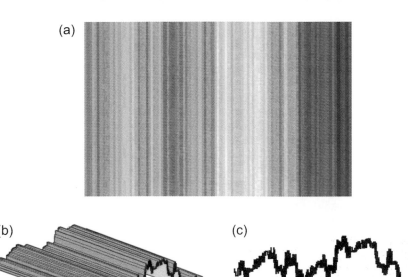

(b) (c)

Figure 7.7 The sum of 30 sinusoidal patterns.

Figure 7.8 The result of further adding sinusoidal components varying in the *y* direction to those shown in Figure 7.7.

Chapter 2) may then be utilized to determine the performance for a real scene.

The mathematical process known as the *Fourier transform* supplies the means of decomposing arbitrary functions into their sinusoidal components. This is a mathematical transformation of a function of space (or time), $f(x)$ into a different form, $F(u)$, a function of spatial (or temporal) frequency that represents the amplitudes of the contained frequencies u. The term Fourier transform is commonly used to represent both the process and the resulting function $F(u)$.

Imaging sinusoidal patterns

Consider an image of a sinusoidal pattern made using an 'ideal' imaging system. Imagining the wave to be made up of an infinite number of infinitesimally small points, then an ideal imaging system is one that is capable of reproducing every point faithfully. The image will then be an exact copy. Furthermore, we would know that each region in the image, no matter how small, corresponds to an identical region in the original.

Now, as was suggested at the beginning of this chapter, real imaging processes are not ideal. Points in the original are not reproduced as points in the image. Depending on the particular imaging process an *object point* may appear in the image as a fuzzy circular patch of varying density (photographic film), small concentric rings of light (a diffraction-limited lens – see Chapters 2, 6 and 10), a uniform rectangular pixel (digital system), etc. These examples are illustrated in Figure 7.10a–c. It is customary to refer to these basic image elements as *point spread functions* (PSFs). The designers of imaging systems (photographic emulsion chemists, optical engineers and solid-state physicists) are constantly striving to reduce the size of the PSFs for their systems.

Of major importance is the fact that images are formed from the summation of an infinite number of overlapping PSFs. This is fairly easy to visualize for the photographic and optical systems. In the case of the typical digital process a sampling mechanism (see later in the chapter) confuses the process, although overlapping PSFs are still effectively at work. This mechanism of image formation (summation of overlapping PSFs) is an example of a very important process known as *convolution* (explained later in the chapter). The image is essentially a convolution of the luminance distribution present in the original scene with the PSF of the imaging system.

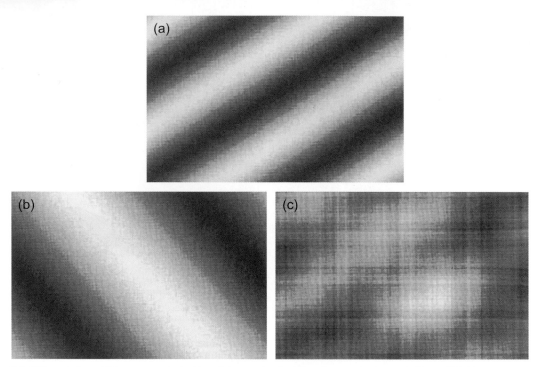

Figure 7.9 Different sinusoidal components (a, b) and the result of adding them to the image in Figure 7.8 (c).

This process results in images that are blurred when compared with the original scene.

A remarkable fact when imaging a sinusoidal pattern is that the result retains its sinusoidal form, even though the convolution process has blurred it. There will generally be a change (usually a reduction) in modulation, and there may be a phase shift (see Figure 7.12). The reduction in modulation depends on the spatial frequency of the luminance pattern and the size of the PSF. An important consequence of this is that the reproduction of sinusoidal patterns can be described very simply. Usually the reduction in modulation is all that is required. Furthermore, the results can be presented in clear graphical form (the *modulation transfer function*) and imaging systems can be meaningfully and usefully compared.

FOURIER THEORY OF IMAGE FORMATION

In order to use the theory, the imaging system must be *linear* and *spatially invariant*.

Linear, spatially invariant systems

Suppose a general input I_1 causes an output O_1 at a particular position in the image, and a different input I_2

causes an output O_2 at the same position. If an input $k_1I_1 + k_2I_2$ causes an output $k_1O_1 + k_2O_2$ where k_1 and k_2 are any arbitrary constants, the system is said to be *linear*. A consequence of linearity is that the output vs. input characteristic will be a straight line, i.e. input is proportional to output.

If the only change caused to an image by shifting the input an arbitrary distance is an equivalent shift in the image, then the system is said to be *spatially invariant* (or *stationary*).

In practice, most imaging systems violate both of these conditions. The photographic process is notoriously non-linear, with well-known characteristic curves (see Chapter 8) linking the output density with the input exposure. It is worth noting, though, that as long as the subject exposure falls on the straight-line portion of the characteristic curve, the photographic process can be considered to be linear. CCD and CMOS arrays are not spatially invariant. On a micro scale, moving a point source across a single detector will not change the detector output. The sampling process (see later), a feature of these arrays, acts as a special kind of non-linearity generating new spatial frequencies in the image. Lenses will not be stationary if they contain aberrations, which is generally the case.

In spite of these violations, most imaging systems can be treated as quasi-linear and stationary over a restricted operating region to take advantage of the wealth of tools available in Fourier theory.

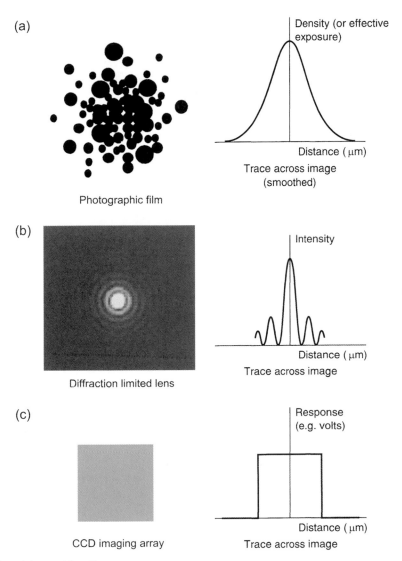

(a)

Density (or effective exposure)

Distance (μm)

Trace across image (smoothed)

Photographic film

(b)

Intensity

Distance (μm)

Trace across image

Diffraction limited lens

(c)

Response (e.g. volts)

Distance (μm)

CCD imaging array

Trace across image

Figure 7.10 Example point spread functions.

Spread functions

Spread functions arise from important fundamental physical processes acting in real imaging systems. A few of these are described in the following paragraphs.

Lens systems are limited by light diffraction (Chapter 2) and often suffer from aberrations (Chapters 6 and 10). These effects spread the light laterally in the image. Even in the case of a 'perfect' lens (one with no aberrations), the wave nature of light causes a point to appear as a disc surrounded by fainter rings (the Airy disc).

A photographic emulsion causes light passing into it to be diffused. It is said to be *turbid*. This diffusion arises as a result of reflection, refraction, diffraction and scattering by the silver halide crystals, and depends on such factors as

the mean crystal size, ratio of silver halide to gelatin and the opacity of the emulsion to actinic light.

A CCD or CMOS imaging array integrates the light falling over the area of a single detector element. Light is effectively spread over a rectangular area defined by the dimensions of the element. In some cases this is modified by the addition of filters designed to increase the light-gathering ability of the elements or reduce *aliasing* (see later in this chapter). Further spreading can occur as a result of charge diffusion, charge transfer inefficiencies and other electrical processing operating within the device.

Cathode ray tube (CRT) displays can be considered to exhibit a point spread function in the form of a display dot generated by the scanning electron beams. The profile of

the dot is usually Gaussian and in colour systems is sampled by a shadow mask. The spread function of liquid crystal displays (LCDs) is defined largely by the size of the liquid crystal polarizing filters used to contribute the red, green and blue components of the display signal to each discrete pixel.

Image processing and compression systems contribute significantly to modern imaging systems, particularly in the areas of digital stills cameras (DSCs), digital video, digital versatile discs (DVDs), high definition (HD) television and many others. In many cases these processing algorithms can significantly modify the point spread function that would otherwise be exhibited by the imaging hardware in isolation. Therefore, these software components may also be thought of as contributing a point spread function to the system and their effects should be considered when evaluating imaging devices.

It has already been noted that point spread functions are the 'building blocks' of real images and will be responsible for the degradations in image quality (sharpness, resolution, etc.) that occur in imaging systems. It has also been seen that degradation in image quality can be explained by reduction in modulation of sinusoidal components, summarized by the modulation transfer function. As we shall see, it is another remarkable fact of Fourier theory that these two quite different views of image formation are intimately connected. In particular, the point spread function and the modulation transfer function are related by the Fourier transform.

The point spread function (PSF)

The image of a point of intensity in a linear, stationary imaging system is the *point spread function* (PSF). It is a function of two orthogonal variables (x, y), usually taken in the same directions as the image plane variables x_p and y_p. If the system is *isotropic* (i.e. it has the same physical properties in all directions), the PSF will be rotationally symmetrical. It can thus be represented by a function of one variable, r say, where $r^2 = x^2 + y^2$.

Notation: $I(x,y)$ general representation, suitable for optical systems, CCDs, CMOS, monitor screens, scanners, algorithms, etc.
$I(r)$ for isotropic systems, e.g. photographic emulsions, lenses, CRTs.

Units: Light intensity (optical systems). Voltage, equivalent to effective exposure (CCD and CMOS devices). Luminance (monitor screens). Effective exposure (photographic emulsions).

Generally, no specific units are referred to here. Intensity is used here as a generic term for luminance, density, pixel value, etc. It is assumed that output units are linear with input units. Care must be taken when examining any system involving digital values (alternatively named integers, counts or pixel values) as input or output. Digital values must be mapped to an input or output as part of the *quantization process* and this can be highly non-linear. Without this information, digital values do not relate to any real (physical) quantities. Also, the significance of the values for two devices can be markedly different. Put another way, a pixel value of 255 from an 8-bit digital camera may be 'white' with an optical density of 0.02, whereas from another 16-bit camera it could very well be 'dark grey' with an optical density of 2.5. A pixel value means nothing until that value is put into context.

The shape of the PSF (in particular its extent in the x and y directions) determines the sharpness and resolution aspects of image quality produced. If the PSF is very narrow in the x and y directions, the image sharpness and resolution may be expected to be good (a hypothetical perfect system would have a PSF of zero width — i.e. a point). A system with a PSF extending over a large area (very wide) would produce very poor images.

The line spread function (LSF)

The intensity profile of the image of a line (a function of just one variable, or one orientation) is the *line spread function* (LSF). It is formed from the summation of a line of overlapping point spread functions. The LSF of a system is thus obtained by integrating the PSF in one direction (one dimension). If the system is not isotropic the LSF will depend on the orientation of the line. If the system is isotropic, the LSF is independent of orientation. In this case the LSF contains all the information that the PSF does. Since the LSF is much easier to measure and use than the PSF, imaging is nearly always studied using the LSF of the system.

Figure 7.11 shows the relationship between the LSF and the PSF for a typical diffusion-type imaging process (for example, a photographic emulsion). It should be noted, however, that the diagram applies to all linear, stationary imaging systems. Only the shapes of the spread functions will differ.

The edge spread function (ESF)

The intensity profile of the image of an edge (i.e. one-dimensional cross-section of the edge) is the *edge spread function* (ESF). It can be considered as formed from a set of parallel line spread functions finishing at the position of the edge. The value of the ESF at any point is thus given by the integral of a single LSF up to that point. Since the reverse relationship must apply, it is found that the first derivative of the ESF gives the LSF. In other words, the slope of the edge profile at any point is the value of the LSF at that point. Imaging an edge is therefore a very important method of obtaining the LSF of a system.

'Line' input
(row of infinite number of
infinitely small 'points',
shown as vertical arrows)

y_p

x_p

y_p

Process reproduces
each 'point' as an
'impulse response', or
'point spread function'

x_p

Image of line is the
infinite sum of point
spread functions in one
direction

y_p

x_p

$L(x)$

x

The normal section of the line image, i.e.
the function $L(x)$, is called the 'line spread
function'
Note: This is *not* a section of the
point spread function

Figure 7.11 Point and line spread functions.

The imaging equation (from input to output)

It has been seen that the input to an imaging system can be thought of as a two-dimensional array of very close points of varying intensity. Provided the system is linear and stationary the image may be considered to be formed from the addition of overlapping, scaled PSFs in the x and y directions. The image would be expected to be less detailed than the original input distribution and the amount of degradation will depend on the width of the PSF of the system.

The input scene may be denoted as $Q(x_p, y_p)$, the output image as $Q'(x_p, y_p)$ and the PSF as $I(x, y)$. Mathematically, the relationship between them is given by *the imaging equation*:

$$Q'(x_p, y_p) = \int_{-\infty}^{\infty} \int_{-\infty}^{\infty} Q(x, y) I(x_p - x, y_p - y) \, dx \, dy \quad (7.2)$$

This is a two-dimensional convolution integral. It represents the previously described process of adding up the scaled PSFs over the surface of the image. The integrals

127

represent the summation process when the individual PSFs are infinitesimally close together.

It is often written as:

$$Q'(x,y) = Q(x,y) \otimes I(x,y) \qquad (7.3)$$

or even just:

$$Q' = Q \otimes I \qquad (7.4)$$

where \otimes denotes convolution. Note also the dropping of subscripts on x and y. In all that follows, subscripts will be dropped if there is no danger of ambiguity.

The imaging equation in one dimension

Using the LSF instead of the PSF allows us to write a one-dimensional simplification:

$$Q'(x_p) = \int_{-\infty}^{\infty} Q(x)L(x_p - x)dx \qquad (7.5)$$

where $L(x)$ is the line spread function, $Q(x)$ is the one-dimensional input and $Q'(x)$ is the one-dimensional output. In this case, input scenes of the form illustrated in Figure 7.7 are considered as an infinitesimally close set of lines. The image is formed from the addition of overlapping weighted line spread functions.

This may also be written as:

$$Q'(x) = Q(x) \otimes L(x) \qquad (7.6)$$

or as:

$$Q' = Q \otimes L \qquad (7.7)$$

The modulation transfer function (MTF)

In an earlier section we highlighted an important property of linear, stationary systems. If the input is sinusoidal in form, then the output is also sinusoidal in form. It will have a different modulation (Eqn 7.1 — usually reduced) and may be shifted along the x-axis. The image will have the same frequency as the input. This is illustrated in Figure 7.12.

The degree of modulation reduction depends on the spatial frequency. Low frequencies (corresponding to coarse detail in the original) suffer only a minor reduction in modulation (if at all). High frequencies suffer much greater loss of modulation. If the frequency is high enough, it will not be reproduced at all (i.e. it is not resolved).

The reduction in modulation of a particular spatial frequency, u, is known as the modulation transfer factor. A plot of the modulation transfer factor against spatial frequency, u, gives the modulation transfer function (MTF). Some typical MTF curves for black-and-white photographic films are illustrated in Figure 7.13a and for typical CCD or CMOS devices in Figure 7.13b with a 9 μm pixel.

The MTF describes the reduction in modulation, or contrast, occurring in a particular imaging system, as a function of spatial frequency. Note that it does not include information about any 'phase shift', i.e. if any frequencies undergo a shift on imaging owing to an asymmetric spread function, this will not be shown by the MTF.

In Figure 7.13a, the curve for the fast panchromatic film shows an initial rise above unity at low spatial frequencies. This is evidence of development adjacency effects and represents a non-linearity of the system. Accordingly the MTF curve is not unique. It is of limited value as it does not represent the behaviour of the film for all input exposure distributions. Similarly, the curve for the typical commercial digital stills camera in Figure 7.13b exhibits a rise above unity at low spatial frequencies. In this case it is due to sharpening filters present in the system. Again, this renders the MTF curve dependent on the input, as typically the degree to which sharpening is applied is linked to the 'strength' of the edge presented to the system. Therefore, there is not a unique MTF curve for this system. Sharpening filters are discussed in more detail in Chapters 24, 27 and 28.

In order to complete this introduction to the Fourier theory of image formation, an introduction to the main tools for decomposing functions into their component spatial frequencies is needed, the Fourier series and Fourier transform.

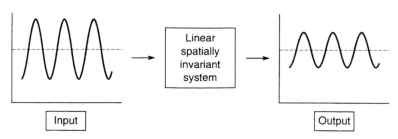

Figure 7.12 Imaging a sinusoidal exposure.

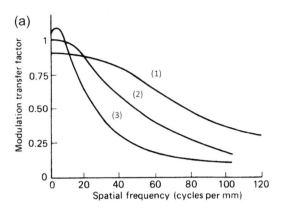

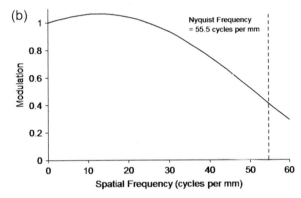

It has been shown that the addition of enough sine and cosine waves of various frequencies, modulation (or amplitude) and phase will enable the reproduction of any signal desired. Extending this argument, taking any signal it should be possible to decompose it into its component sine and cosine waves. This is attractive because, as has been shown earlier, it is easier to understand the effect of a system on simple functions like sine waves rather than complex signals like a real scene.

Consider the waveform shown in Figure 7.14a. It is composed of the waves $\sin(ux)$, $\sin(2ux)$ and $\sin(3ux)$ and is periodic (it repeats itself) (Figure 7.14b–d). The frequency of the first sine wave is u. The frequencies of the two additional sine waves are integer multiples of it. The amplitudes of the sine waves are 0.5, 0.4 and 0.3 respectively. The function for this may be written:

$$f(x) = a_1 \sin(ux) + a_2 \sin(2ux) + a_3 \sin(3ux) \quad (7.8)$$

where $u = 2$, $a_1 = 0.5$, $a_2 = 0.4$ and $a_3 = 0.3$. The frequency of the first sine wave is the lowest and is known as the fundamental frequency. Because the frequencies of the second and third sine waves are multiples of the first, they are known as harmonics. The method above is a perfectly acceptable way of describing the signal shown in Figure 7.14a. In reality, however, signals are far more complex than in the example and can contain many component sine waves, hundreds if not thousands. Using the above method to describe the signal is inefficient and tedious, and therefore Eqn 7.8 may be rewritten:

$$f(x) = \sum_{n=1}^{\infty} a_n \sin(nux) \quad (7.9)$$

Figure 7.13 (a) MTFs for fine grain film (1), medium speed film (2) and fast panchromatic film (3). (b) MTFs for a typical digital CCD or CMOS camera with a 9 μm pixel.

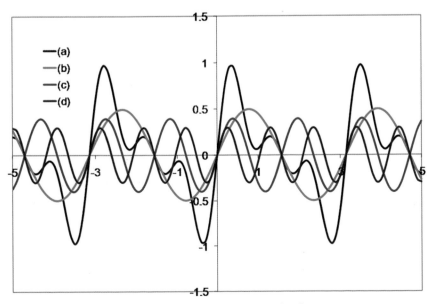

Figure 7.14 Composition of a periodic signal (a) from sinusoidal components (b–d).

where $u = 2$, $a_1 = 0.5$, $a_2 = 0.4$, $a_3 = 0.3$ and $a_{n>3} = 0$. Though this is a nice compact form, there is no way to alter the phase and a constant offset is also needed to make the result positive as before. The phase may be changed by adding differing ratios of cosine and sine waves for each frequency. To add phase and a constant offset we may rewrite the above as:

$$f(x) = a_0 + \sum_{n=1}^{\infty} a_n \cos(nux) + b_n \sin(nux) \qquad (7.10)$$

This is the Fourier series. Unique sets of coefficients a_0, a_n and b_n will describe unique periodic signals. Using Euler's formula it is possible to rewrite the addition of sine and cosine:

$$e^{inux} = \cos(nux) + i \sin(nux) \qquad (7.11)$$

where i is the imaginary unity (i $= \sqrt{-1}$, i.e. complex numbers theory).

Therefore, it is possible to rewrite Eqn 7.10 in the complex form:

$$f(x) = \sum_{n=-\infty}^{\infty} c_n e^{inux} \qquad (7.12)$$

where c_n is a coefficient, related to a_n and b_n via: $a_n = c_n + c - n$ and $b_n = i(c_n - c - n)$.

It is important that the less mathematically inclined reader see Eqn 7.12 only as representing the addition of sinusoidal waves written with mathematical shorthand rather than anything more complicated.

For a non-periodic function $f(x)$, the Fourier transform $F(u)$ is defined as:

$$F(u) = \int_{-\infty}^{\infty} f(x)e^{-2\pi iux} \, dx \qquad (7.13)$$

$F(u)$ represents the amount of frequency u present in the non-periodic $f(x)$. Equation 7.13 can be interpreted as follows. To establish the amount of a frequency to present, the function $f(x)$ is multiplied by a sine or cosine of that frequency. The area of the result (denoted by the integral) yields the required amount in terms of amplitudes.

$F(u)$ is called the Fourier spectrum (or sometimes just the spectrum) of $f(x)$. $F(u)$ is generally a continuous frequency spectrum.

The units of the variable u are the reciprocal of those of x. $f(x)$ is a function of distance (e.g. x in mm) and therefore $F(u)$ is a function of spatial frequency (mm^{-1}), i.e. cycles per mm.

The function $F(u)$ is in general a complex function. This means it has two distinct components at each frequency, u: the real component $R(u)$ represents the amplitude of the cosine component and the imaginary component $I(u)$ represents the amplitude of the sine component. Using the notation of complex mathematics, this is written:

$$F(u) = R(u) + iI(u) \qquad (7.14)$$

The total amplitude of the frequency u is given by the modulus of the Fourier transform:

$$|F(u)| = \sqrt{R^2(u) + I^2(u)} \qquad (7.15)$$

SPECIAL FOURIER TRANSFORM PAIRS

The rectangular function

One of the most important functions for which we need the Fourier transform is also one of the simplest functions, namely:

$$f(x) = \text{rect}(x/a) \qquad (7.16)$$

where 'rect' stands for rectangular and a is a constant representing the width of the rectangle. The function is thus a rectangular 'pulse' of width a and height 1. Its importance lies in the fact that it is used to represent many important imaging apertures (the width of a scanning slit, the one-dimensional transmittance profile of a lens, a single detector element of a CCD or CMOS imaging array, etc.). When the Fourier transform expression is evaluated for this function, the following result is obtained:

$$F(u) = \frac{\sin(\pi au)}{\pi u} = \frac{a \sin(\pi au)}{a\pi u} = a \, \text{sinc}(\pi au) \quad (7.17)$$

where the function sinc(x) function (see also Chapter 2) is defined as:

$$\text{sinc}(x) = \frac{\sin(\pi x)}{\pi x} \text{ or in some texts sinc}(x) = \frac{\sin(x)}{x} \qquad (7.18)$$

This Fourier transform pair is illustrated in Figure 7.15. As a further example, a rectangular function of width 5 units is presented together with its Fourier transform in Figure 7.16. In both of these cases the rectangular functions are symmetrical about the origin (even function). This means that they contain only cosine waves. The Fourier transforms therefore represent the amplitudes of the cosine components present in the rectangular functions.

The Dirac delta function

The Dirac delta function, $\delta(x)$, is a special function in Fourier mathematics. It is widely used in signal processing and has a particular significance in image science.

The Dirac delta function is defined with two statements:

$$\delta(x) = 0, \quad x \neq 0 \quad \text{and} \quad \int_{-\infty}^{\infty} \delta(x)dx = 1 \qquad (7.19)$$

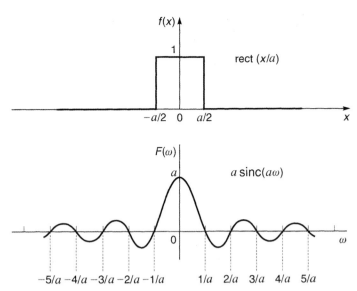

Figure 7.15 The rectangular function and its Fourier transform.

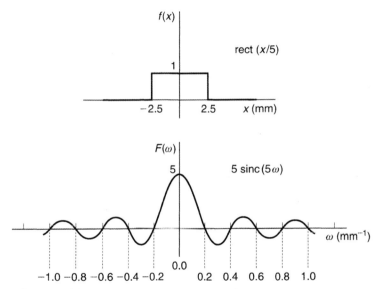

Figure 7.16 A rectangular function of five units wide and its Fourier transform.

The first statement says that $\delta(x)$ is zero everywhere except at the origin. The second statement says that $\delta(x)$ has an area of unity. The only reasonable interpretation of this definition is to suppose that $\delta(x)$ has infinitesimal width but infinite height, so that its width times height $= 1$.

The function is usually interpreted as representing an impulse of unit energy. It is shown graphically as a vertical arrow of unit height situated at the origin. The height of the arrow represents the energy (or area) of the impulse.

Properties of $\delta(x)$

(a) Its Fourier transform is 1

This means an infinitely brief pulse of energy contains an infinite range of frequencies, all of the same amplitude. In imaging terms it implies that a perfect point image contains an infinite range of frequencies of constant amplitude. $\delta(x)$ and its transform are illustrated in Figure 7.17.

131

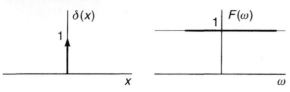

Figure 7.17 The Dirac function and its Fourier transform.

(b) The sifting property of the Dirac delta function

The convolution of any function $f(x)$ with $\delta(x)$ yields $f(x)$, i.e.

$$\int_{-\infty}^{\infty} f(x_1)\delta(x-x_1)dx_1 = \int_{-\infty}^{\infty} f(x-x_1)\delta(x_1)dx_1 = f(x)$$

$$(7.20)$$

Importance of $\delta(x)$

- $\delta(x)$ is used to represent a 'point' of unit magnitude input to a system. The image of the point is the point spread function (PSF). In spatial frequency terms, the input is a flat (or 'white') spectrum; the output is the MTF.
- If a hypothetical system has a perfect response, its PSF is identical to $\delta(x)$. Output images will then be identical to the input exposure (the sifting property).
- The process of sampling a continuous function uses a row, or comb, of delta functions to represent the sampling function. Sampled data values are obtained by multiplying the continuous function by the sampling function. Digital images are obtained using a two-dimensional sampling function.

The Gaussian function

For a quick analytical approximation of point and line spread functions, a Gaussian may be used of the form:

$$f(x) = e^{-\frac{1}{2}x^2\sigma^{-2}} \qquad (7.21)$$

where σ determines the width of the function. Its usefulness is not only because the function is included as standard in a lot of curve-fitting packages, but that its Fourier transform is another Gaussian, termed a *reciprocal function*:

$$f(x) = e^{-\frac{1}{2}x^2\sigma^{-2}} \overset{FT}{\Leftrightarrow} F(u) = \sqrt{2\pi}\sigma e^{-\frac{1}{2}u^2\sigma^2} \qquad (7.22)$$

Therefore, if the line spread function of the system under measurement lends itself easily to description using a Gaussian, the MTF may readily be approximated. The Fourier transform pair is shown in Figure 7.18.

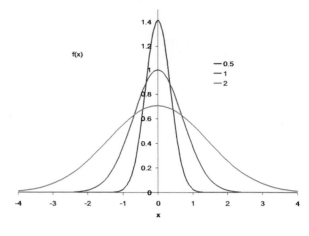

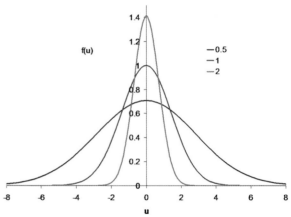

Figure 7.18 The Gaussian function and its Fourier transform.

THE MODULATION TRANSFER FUNCTION REVISITED

Starting with the imaging equation in one dimension:

$$Q'(x_p) = \int_{-\infty}^{\infty} Q(x)L(x_p - x)dx \qquad (7.23)$$

the image of a one-dimensional sinusoidal wave of frequency u is obtained as follows:

Let

$$Q(x) = b + a\cos(2\pi ux) \qquad (7.24)$$

This is a sinusoidal function with a modulation equal to a/b. The imaging equation can be developed to arrive at:

$$Q'(x) = b + a\left|\int_{-\infty}^{\infty} L(x)e^{-2\pi iux}\,dx\right|\cos(2\pi ux + \varepsilon) \quad (7.25)$$

$$Q'(x) = b + aM(u)\cos(2\pi ux + \varepsilon) \qquad (7.26)$$

This says that the output is also a one-dimensional sinusoidal wave, of the same frequency u but different modulation, namely $aM(u)/b$. The symbol ε represents a phase shift (this will be zero if the line spread function is symmetrical). The modulation transfer factor, $M(u)$, for frequency u is given by:

$$M(u) = \frac{M(u)_{\text{Out}}}{M(u)_{\text{In}}} = \frac{\frac{aM(u)}{b}}{\frac{a}{b}} \qquad (7.27)$$

where $M(u)_{\text{Out}}$ is output modulation and $M(u)_{\text{In}}$ is input modulation. A plot of $M(u)$ against u is the MTF. From Eqns 7.25 and 7.26 the important result below is found:

$$M(u) = \left| \int_{-\infty}^{\infty} L(x)e^{-2\pi iux}dx \right| = |T(u)| \qquad (7.28)$$

where $T(u)$ is called the *optical transfer function* (OTF), i.e. the modulation transfer function is the modulus of the Fourier transform of the line spread function.

Fourier theory is thus seen to unify two apparently independent image models: the array of points and the sum of sinusoidal components. This and other important relationships are presented in Figures 7.19 and 7.20.

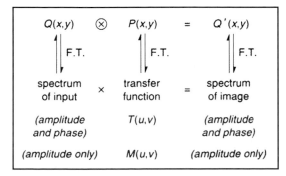

Figure 7.19 Relationships between one- and two-dimensional spread functions and their corresponding MTFs.

Figure 7.20 The imaging equation (convolution) and the spatial frequency equivalent.

Cascading of MTFs

A system comprising a chain of linear processes, each with its own MTF, has a system MTF, $M_s(u)$, given by:

$$M_s(u) = M_1(u) \cdot M_2(u) \cdot M_3(u) \cdot \text{K} \qquad (7.29)$$

where $M_n(u)$ is the MTF of the nth process. In other words, the individual MTFs for the components of an imaging chain combine by simple multiplication to yield the system MTF. This result follows directly from a consideration of the 'image of an image'.

CONVOLUTION REVISITED

A geometric interpretation of convolution

Convolution is such an important process in linear systems theory that it is useful to be familiar with the following geometrical interpretation. The convolution of two functions $f(x)$ and $g(x)$ yields a third function $h(x)$, where:

$$h(x) = \int_{-\infty}^{\infty} f(\xi)g(x - \xi)d\xi \qquad (7.30)$$

where ξ is the 'dummy' variable of the integration.

It can be considered an averaging process between the two functions f and g. Given the two functions f and g shown in Figure 7.21, the convolution process involves flipping g left to right as shown to form $g(-\xi)$ and then sliding $g(-\xi)$ across $f(\xi)$. At each position, x, the two functions are multiplied together. The area of the result is the value of the convolution at this position x. As we have seen, the two-dimensional version of this process is the basis of imaging in a linear, stationary imaging system.

The convolution theorem

The Fourier transform of a convolution of two functions is the product of the Fourier transforms of those two functions, i.e. if $F(u)$ is the Fourier transform of $f(x)$, $G(u)$ is the Fourier transform of $g(x)$, and $H(u)$ is the Fourier transform of $h(x)$, a function obtained by the convolution of $f(x)$ with $g(x)$, then:

$$H(u) = F(u) \times G(u) \qquad (7.31)$$

The convolution of two functions has a Fourier transform given by the product of the separate transforms of the two functions. This is a very important result and is the basis of all system analyses using frequency–response curves.

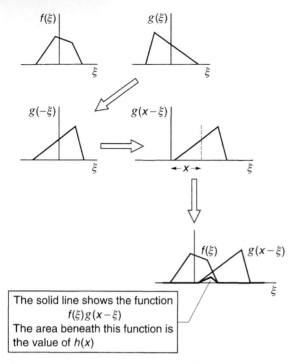

The solid line shows the function
$$f(\xi)g(x-\xi)$$
The area beneath this function is
the value of $h(x)$

Figure 7.21 Geometrical interpretation of convolution.

DISCRETE TRANSFORMS AND SAMPLING

In the previous sections it has been seen how important Fourier theory is in understanding the formation and properties of images formed in imaging systems. For example, the modulation transfer function (MTF), describing the attenuation of amplitude as a function of spatial frequency, can be obtained by taking the Fourier transform of the line spread function. Fourier space multiplication (corresponding to real space convolution) forms the basis of many established techniques in image processing (see Chapter 28).

In most cases the functions we wish to transform are not available in an analytical form, so the integral definition of the Fourier transform cannot be applied. Instead, we generally have some experimentally determined function $f(x)$ that is *sampled* at regular spatial intervals of x (i.e. δx), to yield a finite set of numbers (f_i say) that represent the function. The Fourier transform is taken of this discrete set of values (using a *discrete Fourier transform* or *DFT*). The result is another finite set of numbers (F_j) that represents the required Fourier transform $F(u)$ at regular intervals along the spatial frequency axis.

Correct *sampling* is essential if the digital values are to properly represent the continuous functions they are derived from. The set f_i must obviously be taken at an interval δx small enough to resolve all the detail in $f(x)$. Note the wording here. It is necessary to resolve all the detail present, even if we are not interested in the fine structure. The reason for this will become clear shortly.

In a similar manner, the set F_j must be determined by the DFT at frequency intervals of δu sufficiently close to display the details of the function $F(u)$.

Conditions for correct sampling are embodied in the well-known *sampling theorem*. If we choose our sampling interval δx according to the sampling theorem, then the results will be as accurate as the measurement noise will allow. If we *undersample* (i.e. with too large a sampling interval), the results will be wrong. The unwanted process of *aliasing* will have occurred.

The rest of this section deals with the *sampling theorem* and aliasing. The topic is introduced by first considering the process of undersampling a cosine wave. We then define the sampling function and apply the convolution theorem to derive the sampling theorem and to explain the phenomenon of aliasing.

Undersampling a cosine wave

Figure 7.22 illustrates the consequence of sampling a waveform using a sampling interval that is too great. Curve (a) shows the original cosine wave being sampled. This has a spatial frequency of 40 cycles per mm. The sampling interval is 30 μm and the sample points are shown as spikes. The resulting set of sampled values appears to come from a much lower frequency, as shown by curve (b). This is the reconstructed frequency and in this case has a value of 6.67 cycles per mm.

This process of reconstructing a lower frequency than the one that was sampled (the input frequency) is known as aliasing. It occurs to a greater or lesser extent in all digital systems and means that a digitized image will not be a true record of the original analogue (continuous) image. The next two sections investigate aliasing and its relation to the sampling conditions in more detail.

The Dirac comb (the sampling function)

An infinitely extending row of impulses (regularly displaced Dirac delta functions) is represented by:

$$\text{III}\left(\frac{x}{\delta x}\right) \tag{7.32}$$

This is known as a *Dirac comb*, or *Shah* function, and in our application represents the *sampling function*. The impulses are of unit energy and are spaced a distance δx (i.e. the sampling interval is δx). The Fourier transform of a Dirac comb is another Dirac comb with inverse scaling (interval equal to $1/\delta x$).

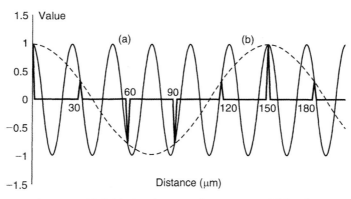

Figure 7.22 Undersampling a cosine wave. (a) Original cosine wave, frequency $u = 0.04$ cycles per μm. (b) Reconstructed cosine wave, frequency $u = 0.00667$ cycles per μm.

(a)

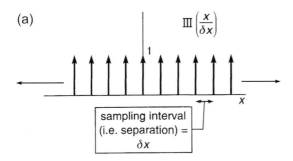

(b)

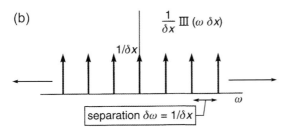

Figure 7.23 The sampling function (a) and its Fourier transform (b).

The sampling function and its Fourier transform are shown in Figure 7.23.

The process of sampling

The process of sampling a continuous function $f(x)$ is represented by the multiplication of the function $f(x)$ by a Dirac comb. By the convolution theorem, multiplication in distance space is equivalent to convolution in frequency space. $F(u)$ is replicated at intervals $1/\delta x$. The separate repetitions are known as *aliases*. The DFT will evaluate the quantity $F(u) \otimes III(u\delta x)$ over just one period (usually between $u = 0$ and $u = 1/\delta x$). The result is correct (i.e. equivalent to $F(u)$) provided the individual aliases do not overlap. However, if δx is not fine enough, overlap will occur, as shown in Figure 7.24. The DFT gives the sum of the aliases and in this case the result is incorrect as shown by the dashed line. Aliasing is said to have occurred.

In order to avoid aliasing, the function $f(x)$ must be sampled at an interval δx such that:

$$\frac{1}{2\delta x} > u_c \qquad (7.33)$$

where u_c is the maximum significant frequency contained by $f(x)$. The frequency, u_N, defined as:

$$u_N = \frac{1}{2\delta x} \qquad (7.34)$$

is known as the *Nyquist frequency*. It represents the highest frequency in the original function (i.e. signal) that can be faithfully reconstructed.

The *sampling theorem* states that all input frequencies below the Nyquist frequency can be unambiguously recovered, while input frequencies above the Nyquist frequency will be aliased. Such aliased frequencies are reconstructed in the frequency range $0-u_N$, their amplitudes being added to the true signal in that range.

A formal enunciation of the sampling theorem is: a function $f(x)$ whose Fourier transform is zero for $|u| > u_c$ is fully specified by values spaced at equal intervals δx not exceeding $1/2u_c$.

Note that $f(x)$ is assumed to be *band limited*, i.e. there is an upper limit to the range of frequencies contained by $f(x)$.

The sampling theorem implies that it is possible to recover the intervening values of $f(x)$ with full accuracy! In practice, the DFT will evaluate (i.e. sample) the quantity $F(u) \otimes III(u\delta x)$ at intervals δu, which is itself determined from the sampling theorem, i.e. $\delta u = 1/S$, where S is the total extent, in units of x, of the function $f(x)$. It is equivalent to replicating the sampled function $f(x)III(x/\delta x)$ at intervals S, although only actually one period is handled. This is illustrated in Figure 7.25.

135

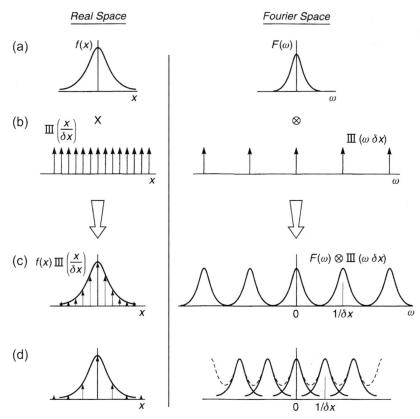

Figure 7.24 The mechanism of aliasing in undersampled functions. (a) A function $f(x)$ and its transform. (b) Sampling function of interval δx and its transform. (c) Sampled version of $f(x)$ and its transform. (d) Sampled version of $f(x)$ and its transform when δx is not small enough.

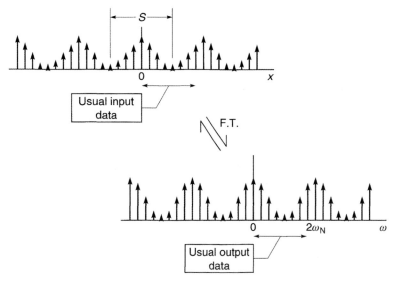

Figure 7.25 Sampled data and the result of a discrete Fourier transform.

Suppose $f(x)$ is sampled correctly, at intervals δx, over the range S. N data values will be produced, where $N = S/\delta x$. The DFT will produce N_1 values, representing one alias of the Fourier transform sampled at intervals $\delta\omega$:

$$N_1 = 2u_N/\delta u = 2(1/2\delta x)/(1/S) = S/\delta x = N \quad (7.35)$$

i.e. N input values to the DFT will yield N output values.

Finally, note that DFTs are often calculated using a so-called 'fast Fourier transform' or FFT method. It is essential that N be a power of 2 (16, 32, 64, etc.). If necessary, digitized functions of x must have sufficient zeroes added to the ends to satisfy this requirement (*zero padding*).

The MTF for a CCD imaging array

One important example of the correct use of the sampling theorem occurs in the slanted edge method for determining the MTF of CCD image arrays. Figure 7.26 shows a schematic representation of such an array. The detector

elements have a width a in the x direction. The centre-to-centre separation (the sampling interval) is δx.

The MTF in the horizontal direction will be determined mainly by the element width a. In fact, the line spread function for this aspect is given by:

$$\frac{1}{a}\,\text{rect}\left(\frac{x}{a}\right) \quad (7.36)$$

and the corresponding MTF is sinc(au). Other degradations, such as charge diffusion, will contribute to the MTF in a less significant manner.

A study of the sinc function reveals that spatial frequencies up to $1/a$ and beyond are capable of being recorded. The sampling interval δx will generally be greater than a, depending on the structure of the device (individual detector elements cannot physically overlap). This means that the Nyquist frequency cannot be higher than $1/2a$. We therefore have a situation of undersampling and the potential for much aliasing of the higher image frequencies. Readers may be familiar with *moiré patterns* visible in images formed with CCD or CMOS systems. These are the consequence of aliasing of fine periodic structure. Many CCD-type imaging systems (for example, film scanners) have anti-aliasing mechanisms built in. One of the simplest is to ensure that the preceding imaging lens has an MTF that will filter out frequencies above the Nyquist frequency of the detector.

To measure the horizontal MTF without aliasing corrupting the result we use the *slanted-edge method*, introduced and detailed in Chapter 24.

The non-stationary nature of sampled devices can cause further errors when evaluating MTF despite an absence of aliasing. The relationship of the phase of the signal to each sample will cause the recorded modulation to vary (Figure 7.27). The consequence of this is that, unless using a method such as above, MTF will vary with small changes

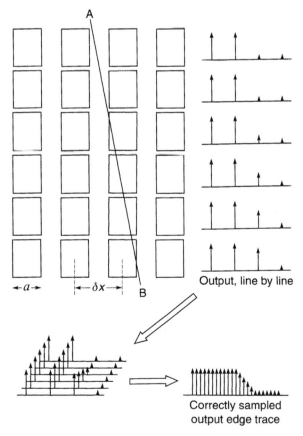

Output, line by line

Correctly sampled output edge trace

Figure 7.26 Schematic of a CCD or CMOS detector array and illustration of the principle of the slanted-edge method for edge analysis.

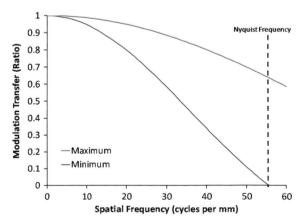

Figure 7.27 MTF variation with respect to phase difference between the sampling comb and the signal for a pixel of aperture and pitch 9 μm.

in the position of the test target used. It can be shown that the upper bounds of the MTF will be given by the sinc function described earlier and the lower bounds may be estimated by:

$$M(u)_{\text{Min}} = \frac{\cos\,(\pi up)\,\sin\,(\pi ua)}{\pi ua} \qquad (7.37)$$

where p represents the pixel pitch. This corresponds to a line spread function equivalent to two neighbouring pixels.

An in-depth account of MTF measurements of imaging systems and how the MTF summarizes image quality attributes that contribute to such subjective impressions as *sharpness* and *resolution* are given in Chapter 24.

BIBLIOGRAPHY

Bracewell, R.N., 1999. The Fourier Transform and its Applications, third ed. McGraw-Hill, New York, USA.

Castleman, K.R., 1996. Digital Image Processing. Prentice-Hall, Englewood Cliffs, NJ, USA.

Gleason, A., (translator), et al., 1995. Who Is Fourier? A Mathematical Adventure. Transnational College of LEX Blackwell Science, Oxford, UK.

Gonzalez, R.C., Woods, R.E., Eddins, S.L., 2004. Digital Image Processing Using MATLAB. Pearson Prentice-Hall, New Jersey, USA.

Goodman, J.W., 1996. Introduction to Fourier Optics (Electrical and Computer Engineering), second ed. McGraw-Hill, New York, USA.

Hecht, E., 1987. Optics, second ed. Addison-Wesley, Reading, MA, USA.

Jacobson, R.E., Ray, S.F., Attridge, G.G., Axford, N.R., 2000. The Manual of Photography, ninth ed. Focal Press, Oxford, UK.

Proudfoot, C.N., 1997. Handbook of Photographic Science and Engineering, second ed. IS&T, Springfield, VA, USA.

Chapter | 8 |

Sensitometry

Geoffrey Attridge

All images © Geoffrey Attridge unless indicated.

INTRODUCTION

The objective study of the response of imaging systems to light or other radiation is called *sensitometry*. It is concerned with the measurement of the exposure that a material has received and the amount of the resultant image. Sensitometry in silver-based photography which is the subject of this chapter is assessed by the amount of blackening, silver image formation, which takes place. In digital imaging sensors it is assessed by the output voltage, or the output pixel value and will be discussed in detail in Chapters 14 and 21. It is possible to produce photographs without any knowledge of sensitometry, but to obtain the best performance from photographic systems, under all conditions, an understanding of the principles governing the response of imaging systems is invaluable.

As sensitometry is concerned with the measurement of the performance of photographic materials and other light-sensitive systems, it is necessary to use precise terminology in defining the quantities that are measured. The impression that a photograph makes on us depends on physiological and psychological as well as physical factors, and for this reason the success of such an image cannot be determined from a simple series of measurements. This simply means that there are limitations to the help that sensitometry can give us.

THE SUBJECT

As far as the camera is concerned, a subject consists of a number of areas of varying luminance and colour. In the same way, a photographic print consists of areas of varying luminance and sometimes colour (luminance is measured in candelas per square metre). The variations of luminance in a subject are due to the reflection characteristics of different areas, and to the differing angles at which they are viewed. There may also be a significant variation in the illumination that the subject receives. The ratio of the maximum to the minimum luminance in a subject is defined as the *subject luminance range*.

It may surprise us at first to realize that a sunset, or the rippling of wind over water, can be reduced to areas of varying luminance. Yet it is so in the camera, and in the eye viewing a black-and-white print too, with the difference that the mind draws not only on the visual impression, but also on past experience. Thus, on viewing a picture of an apple, for example, we see more than just light and shade. Our past experience comes to the aid of the eyes in presenting to the mind a picture of an apple.

Our final goal in sensitometry is to relate the luminances of the print to the luminances of the subject. This involves the study, first, of the response of the negative material, then of the response of the positive material, and finally of the relation between the two. We shall consider each of these in turn. We refer to the light areas of a subject as the highlights and the dark areas as the shadows. To avoid confusion, the same terms should be applied to corresponding areas both in the negative and in the print, even though in the negative highlights are dense and shadows clear.

EXPOSURE

When a photograph is taken, light from the various areas of the subject falls on corresponding areas of the film. The photographic exposure, H (the effect produced on the

DOI: 10.1016/B978-0-240-52037-7.10008-0

emulsion), is, within limits, proportional to the product of the illuminance E and the exposure time t. We express this by the equation:

$$H = Et \tag{8.1}$$

Before international standardization of symbols, the equation was written as $E = It$ (E was exposure, I was illuminance) and this usage is still sometimes found.

The SI unit for illuminance is the lux (lx). Hence the exposure is measured in lux seconds (lx s). It should be noted that the lux is defined in terms of the human observer, who cannot see radiation in either ultraviolet or infrared regions of the spectrum. Inclusion of either of these bands in the imaging exposure may therefore yield erroneous results with some imaging systems.

As the subject luminance varies from area to area, it follows that the illuminance on the emulsion varies similarly, so that the film receives not one exposure over the entire surface but a varying amount of light energy, i.e. a range of exposures. As a general rule the exposure duration is constant for all areas of the film, variation in exposure over the film being due solely to variation in the illumination that it receives.

It should be noted that the use of the word 'exposure' as we use it here is quite different from such everyday use as: 'I gave an exposure of 1/60 second at f/8.' We can avoid confusion by designating the latter *camera exposure*.

DENSITY AND OTHER RELEVANT MEASURES

When a film has been processed, areas of the image that have received different values of illumination are seen to have differing degrees of darkening, corresponding to the amount of developed silver, or image dye, formed. The blackness of a negative, i.e. its light-stopping power, can be expressed numerically in several different ways. The following ways are of interest.

Transmittance

The transmittance, τ, of an area of a negative is defined as the ratio of the light transmitted I_t to the light incident upon the negative I_i. This can be expressed mathematically as:

$$\tau = \frac{I_t}{I_i} \tag{8.2}$$

Transmittance is always less than 1, unless expressed as a percentage. Thus, if 10 units of light fall on a negative and 5 are transmitted, the negative has a transmittance of $5/10 = 0.5$, or 50%. Unfortunately transmittance is not the most useful concept in sensitometry because it decreases as blackness increases, and equal changes in transmittance do not appear as equal changes in blackness.

Opacity

Opacity, O, is defined as the ratio of the light incident on the negative, I_i, to the light transmitted, I_t. That is simply the reciprocal of transmission and can be expressed:

$$O = \frac{I_i}{I_t} = \frac{1}{\tau} \tag{8.3}$$

Opacity is always greater than 1 and increases with increasing blackness. From this point of view, it is a more logical unit to use in sensitometry than transmittance, but equal changes in opacity still do not represent equal changes in perceived blackness.

Density

Transmission density, D_T, is defined as the logarithm to base 10 of the opacity. Hence:

$$D_T = \log_{10}\left(\frac{1}{\tau}\right) = \log_{10}\left(\frac{I_i}{I_t}\right) \tag{8.4}$$

Density is the unit of blackening employed almost exclusively in sensitometry. Like opacity it increases with increasing blackness, but has the following practical advantages:

1. The measured density is approximately linearly related to the amount of silver or image dye present; e.g. if the amount present in an image of density 1.0 is doubled, the density is increased to 2.0. The opacity, however, increases from 10 to 100, i.e. tenfold.
2. The final aim in sensitometry is to relate the tones of an image to those of the subject. Blackness in a reproduction depends on the way the eye assesses it, and is essentially physiological. The law relating the visual effect to stimulation is not simple, but over a wide range of viewing conditions the response of the eye is approximately logarithmic. If we view a number of patches in which density increases by equal steps, the eye accepts the steps as of equal increases in blackness. In this respect, therefore, a logarithmic unit is a satisfactory measure of blackening. Table 8.1 relates transmission density, opacity and transmittance. Densities of images on transparent and opaque bases are referred to as transmission and reflection densities respectively.

EFFECT OF LIGHT SCATTER IN A NEGATIVE

When light passes through a photographic image it is partially scattered. One result of this is that the numerical value of density depends on the spatial distribution of the incident light, and on the method adopted for the measurement of both this and the transmitted light. Three types of density have been defined according to the cone

Table 8.1 Density, opacity and transmittance

DENSITY	OPACITY	TRANSMITTANCE (%)	DENSITY	OPACITY	TRANSMITTANCE (%)
0.0	1.00	100.00	1.2	15.85	6.31
0.1	1.26	79.43	1.4	25.12	3.98
0.2	1.58	63.10	1.6	39.81	2.51
0.3	2.00	50.12	1.8	63.10	1.58
0.4	2.51	39.81	2.0	100.00	1.00
0.5	3.16	31.62	2.2	158.49	0.63
0.6	3.98	25.12	2.4	251.19	0.40
0.7	5.01	19.95	2.6	398.11	0.25
0.8	6.31	15.85	2.8	630.96	0.16
0.9	7.94	12.59	3.0	1000.00	0.10
1.0	10.00	10.00	4.0	10,000.00	0.01

angles of illumination and light collection; these are illustrated in Figure 8.1 and described in Table 8.2.

1. *Direct or specular density.* This is determined by using *parallel* illumination, *normal* to the sample, and measuring only *normal* emergence, the straight-through rays, parallel to the axis.
2. *Diffuse density.* This may be determined in either of two ways:
 a. By using parallel illumination, *normal* (i.e. at 90°) to the sample, and measuring *total* emergence (whether normal or scattered), or
 b. By using *diffuse* illumination and measuring only *normal* emergence.
 The numerical value of diffuse density is the same with either method of measurement.
3. *Doubly diffuse density (or double-diffuse density).* This is determined by using *diffuse* illumination and measuring *total* emergence.

Practical measurements of any of these types of density are based on the ratio of a reading made by a photocell when the sample is not in place (taken as I_i) to the reading on the same

Figure 8.1 The geometry of density measurement.

Table 8.2 The geometry of density measurement

α	β	TYPE OF DENSITY
0	0	Specular or direct
0	180	Diffuse
180	0	Diffuse
180	180	Doubly diffuse

photocell when the sample is in place (I_t). The difference between diffuse density and doubly diffuse density is usually quite small, but specular density is always greater than either.

Callier coefficient

The ratio of *specular* density to *diffuse* density is termed the *Callier coefficient*, or *Callier Q factor*, and can be expressed as:

$$Q = \frac{\text{Specular density}}{\text{Diffuse density}} \qquad (8.5)$$

This ratio, which is never less than 1.0, varies with grain size, the form of the developed silver and the amount of the deposit. As far as the grain is concerned, the finer it is, the lower the resultant scattering and the nearer to unity is the Callier coefficient.

The factors above, which influence the value of Q, vary markedly with the degree and type of development used. Consequently the Callier coefficient varies with density and contrast in a complicated way. At low degrees of

development, with one particular combination of film and developer, the value of Q was approximately constant at densities above about 0.3; for more complete development, however, there was no single value of Q that could be adopted.

One result of the variation of the Callier coefficient with density is that the tone distribution in a print produced with a condenser enlarger is likely to be different from that in a print produced using a diffuser enlarger. Colour photographic images, however, are essentially non-scattering, so that they possess Callier coefficients close to unity. Thus, in printing colour negatives there is seldom any measurable difference between the results from diffuser or condenser enlargers.

DENSITY IN PRACTICE

The types of density related to photographic practice are shown in Table 8.3.

Some kinds of illumination present an intermediate type of density, as, for example, when an opal bulb or a diffusing screen is used in a condenser enlarger. Apart from the true condenser enlarger and projectors, the effective density in all the examples quoted is either diffuse or doubly diffuse. Since the difference between the latter forms of density is slight, densities of negatives are expressed simply as diffuse densities.

If the image in a negative or print is not neutral in tone, its measured density will depend not only on the optics employed to measure it, but also on the *colour* of the light employed and the response to colour of the device employed to measure it. Considering these last two factors, we may consider density as being of four main kinds according to the spectral specifications involved:

1. *Density at any specific wavelength, spectral density* — determined by illuminating the specimen with monochromatic (of a narrow band of wavelengths — see Chapter 2) radiation.
2. *Visual density* — determined by measuring the illuminated specimen with a receiver having a spectral response similar to that of the normal *photopic* human eye, the eye functioning in bright lighting (see Chapters 4 and 5). This type of density is standardized as Status V and is used in the study of tone reproduction by both monochrome and colour materials.
3. *Printing density* — determined by illuminating the specimen with tungsten light and employing a receiver with a spectral response similar to that of photographic papers.
4. *Arbitrary density* — determined by illuminating the specimen with tungsten light and employing an unfiltered, or even filtered, commercial photo-sensor as the detector, the combination possessing an arbitrary and sometimes unspecified spectral sensitivity.

This classification applies equally to all three main types of density: specular, diffuse and doubly diffuse. For most monochrome photographic purposes *diffuse visual density* is employed.

Colour densities are also usually measured using diffuse densitometers. Colour images are composed of three dyes, each controlling one of the primary colours of light: red, green or blue. In practice, therefore, colour images are described in terms of their densities to red, green and blue light, the densitometer being equipped with filters to select each primary colour in turn.

The colour filters chosen for a densitometer usually select red, reen and blue spectral bands and measure the integrated effects of all three dye absorptions within those bands. Densities measured in this way are called *arbitrary integral densities* and are most commonly used in simple

Table 8.3 Effective density in different photographic activities	
APPLICATION	**EFFECTIVE DENSITY**
Contact printing	
(a) In a box, with diffuse source	Doubly diffuse
(b) In a frame, using a clear bulb or an enlarger as illuminant	Diffuse (parallel illumination total collection)
Enlarging	
(a) Condenser enlarger (point source, no diffuser)	Specular
(b) Diffuse enlarger (particularly *cold-cathode* types)	Diffuse (diffuse illumination, normal (0° collection))
Still or motion-picture projection	
All types	Specular

quality control measurements. For more useful results the densitometer filters and cell sensitivities are carefully chosen so that the densities measured represent the effect of the image either on the eye or on colour printing paper. Such measurements correspond to density categories (2) and (3) for black-and-white images, and are referred to as *colorimetric* and *printing densities* respectively. In practice, colorimetric densities are seldom measured because suitably specified (Status A) three-filter densities can usefully describe the response of the eye to visual neutral and near-neutral tones. This is all that is usually required. Printing (Status M) three-filter densities are, however, widely applied in the assessment of colour negatives for printing purposes, although measurements of this type can usually refer only to some defined 'typical' system. They are also generally specified for the control of colour negative processing and for the assessment of colour negatives for printing.

THE CHARACTERISTIC (H AND D) CURVE

If density is plotted against exposure, a response curve for a film can be obtained. Although a curve of this type may occasionally be of value, a far more useful curve for most purposes is obtained by plotting density against the common logarithm (logarithm to base 10) of the exposure. This gives a curve of the shape shown in Figure 8.2 (together with a few important features), the type of response curve typical of ordinary photography. It is referred to as the *characteristic curve* or *H and D curve*, after F. Hurter and V.C. Driffield, who established curves of this type. The H and D curve is a diagram that shows the effect on an emulsion of every degree of exposure from gross underexposure to gross overexposure for any single development time and any particular developer. These variables have to be specified because the characteristic curve varies with processing conditions and even, to a smaller extent, with exposure intensity and duration. A similar form of characteristic curve may be obtained for a digital camera by plotting log output pixel value against log exposure (see Chapter 21).

The use of $\log_{10}H$ instead of H as the unit for the horizontal axis of the response curve of a photographic material offers several advantages:

1. In practice, we consider changes in camera exposure in terms of the factor by which it is altered; the natural progression of exposure is geometric, not arithmetic. (When increasing an exposure time from 1/60 to 1/30 second, for example, we speak of doubling the exposure, not of increasing it by 1/60 second.) A logarithmic curve therefore gives the most reasonable representation of how density increases when exposure is changed. The series of camera exposure times 1/500,

1/250, 1/125, etc. is a logarithmic series, as is that of the printing exposure times 2, 4, 8, 16 s.

2. A D vs. log H curve shows, on a far larger scale than a density–exposure curve, the portion of the curve corresponding to just-perceptible blackening, i.e. with small values of exposure. The speed of a film is usually judged in terms of the exposure needed to produce quite small values of density.

3. The use of logarithmic units for both horizontal and vertical axes enables values of density in the photographic negative to be transferred readily to the log exposure axis of the characteristic curve of the print. This simplifies the task of relating the brightnesses of the original scene, the transmission densities of the negative and the reflection densities of the print.

Main regions of the negative characteristic curve

The characteristic curve of a negative material may be divided into four main regions: the toe or foot, an approximately linear portion, the shoulder and the region of solarization, as shown in Figure 8.2.

It is only on the linear portion that density differences in the negative are directly proportional to visual differences in the scene. For this reason the linear portion was at one time referred to as the region of correct exposure, the toe as the region of underexposure and the shoulder as the region of overexposure. As we shall see later in this chapter, however, such descriptions are misleading. The value of density reached at the top of the shoulder of the curve is referred to as D_{max}, the maximum density obtainable under the given conditions of development.

Provided the horizontal and vertical axes are equally scaled, the numerical value of the tangent of the angle which the linear portion of the curve makes with the log H axis is termed gamma (γ). Thus, when that angle = 45°, $\gamma = 1$.

Gamma may be defined more rigorously in terms of the values of density and log exposure corresponding to any two points lying on the straight-line portion of the curve. In Figure 8.2:

$$\gamma = \frac{BC}{AC} = \frac{(D_2 - D_1)}{(\log H_2 - \log H_1)} \quad (8.6)$$

This definition of γ does not depend on a characteristic curve at all, merely on the quantities: log exposure, which is known, and density, which is measured. The data required *must*, however, correspond to points on the linear part of the characteristic curve.

Gamma measures *sensitometric contrast*, i.e. the rate at which density increases as log exposure increases in the linear portion of the curve. It should be noted, however, that gamma gives information only about the linear portion; it tells us nothing about the other portions. Further, as will be seen later, the contrast of a negative is

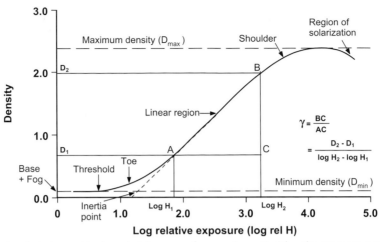

Figure 8.2 The conventional photographic characteristic curve of a negative material — the response curve obtained by plotting density against log exposure.

not determined by gamma alone: other factors play an important part, and with modern emulsions no portion of the curve may be strictly linear. In the case where there is no linear portion, the calculation of γ reduces to determining the maximum value of the gradient, technically at the point of inflection.

The term 'γ' is also used in the evaluation of transfer functions of digital systems and their components. The characteristics of digital imaging systems are described in detail in Chapter 21, which includes a consideration of the tone reproduction requirements of a variety of imaging systems. These are often characterized by 'γ', a parameter derived from the opto-electronic conversion functions (OECFs) of the devices involved.

Sensitometric contrast is an important aspect of performance and, with experience, is readily appreciated from a superficial examination of the H and D curve (provided the abscissa and ordinate axes have been equally scaled). The region of *solarization*, or reversal, was of interest when first observed with rather simple emulsions. Modern emulsions require very large exposures to show this effect — commonly of the order of 1000 times greater than the maximum normal exposure. In general, the more efficient a material is at forming a latent image, the less likely is solarization to occur.

Below the toe, the curve becomes parallel to the log H axis, at a *minimum density* or D_{min}. The value of density in this region is the sum of densities due to the film or paper base supporting the emulsion, the gelatin of the emulsion, any silver developed from unexposed emulsion grains, 'fog', and any residual chemical stain present after manufacture and processing of the film. This, usually small, density is sometimes misleadingly termed *base density*. The most generally used description is *fog level*, although D_{min} is the more accurate. It is the minimum density obtainable with the process employed. Base density is strictly the

density of the film or paper support while fog results from development of unexposed silver halide. The point corresponding to the first perceptible density above D_{min} is called the *threshold*.

The intersection of the extrapolated straight-line portion of the curve with the D_{min} is the *inertia point*, and the value of exposure at this point is the *inertia*. On published characteristic curves the log exposure axis may be marked 'Relative log exposure', often abbreviated to 'Rel log H' or, more properly, 'Log relative exposure', abbreviated to 'Log rel H'. Use of a relative instead of an absolute log H scale does not affect the shape of the curve, but absolute values of emulsion speed cannot be determined directly from the curve.

Variation of the characteristic curve with the material

The characteristic curves of individual materials differ in their shapes and in their positions relative to the log H axis. The position of the curve against the log H axis depends upon the sensitivity or *speed* of the material. The faster the material, the further to the left the curve is situated. The threshold density occurs at the lowest exposures with fast emulsions. Film speed itself is dealt with in Chapter 20. The main variations in the shape of the characteristic curve are the length of the linear portion and its slope (gamma).

Photographic materials differ both in the maximum slope that can be achieved and in the rate at which the value of the slope increases. Modern negative materials are usually made to yield a gamma of 0.7 or so with normal development. The toe is long and the straight line may be short or even non-existent. Some fast materials have a bent-leg or dog-leg curve, which has in effect two straight-line portions of different slopes. The lower part of the curve is

fairly steep, but at a higher density the slope becomes lower. This curve shape may have advantages when photographing subjects with intense highlights, e.g. night scenes.

Materials for copying are usually designed to have a short toe, which merges into the linear portion at a low density, and a long linear portion, the slope of which depends on the application for which the material is intended. Materials capable of yielding gammas from below 1 to 10, or more, are available.

In the duplication of negatives it is necessary to use a material possessing a long linear portion, the slope of which can readily be controlled in processing. The exposure should be confined to the linear portion, and it is advantageous to develop to a gamma of unity. Characteristic curves for specific materials are published by the film manufacturers.

Gamma–time curve

The characteristic curve is not a fixed function of an emulsion, but alters in shape with the conditions of exposure, e.g. the colour and intensity of the light source, and with the conditions of processing; in particular, the contrast is markedly affected by the development time. By plotting gamma as ordinate against development time as abscissa we obtain a curve, the general shape of which is illustrated in Figure 8.3.

Sensitometric contrast, gamma, increases very rapidly as development begins, and then at a more gradual rate until a point is reached where increased development produces no further increase in gamma. The value of gamma at this point is termed *gamma infinity* (γ_∞). This varies from emulsion to emulsion and depends to some extent on the developing solution used. A material capable of yielding a high value of γ_∞ is said to be a *high-contrast material*. It is

rarely desirable to develop to gamma infinity, as prolonged development increases fog and graininess, either or both of which may become unacceptable before gamma infinity is achieved. Owing to *chemical fog* (development of unexposed emulsion grains) gamma may decrease with development prolonged beyond gamma infinity, as the effect of fog density is greater on low densities than high.

A gamma–time curve shows the value of gamma infinity obtainable with a given material and developer. It also shows the development time required to reach this or any lower value of gamma. We have seen that it is rarely desirable to employ the very top part of the gamma–time curve. It is also usually unwise to employ the very bottom part, where a small increase in development time gives a large increase in gamma, because in this region any slight inequalities in the degree of development across the film will be accentuated, with the likelihood of uneven density or mottle.

Figure 8.3 shows gamma–time curves for a film in two differing developers. Curve A was produced in an MQ carbonate developer and curve B in an MQ–borax developer. Comparison of such curves assists in the choice of a suitable developer when the desired gamma is known. For example, if a gamma of 0.5 were desired the MQ–borax developer would be preferable to the other, since, with the latter, contrast changes rapidly with development time at the gamma required. But, to achieve a gamma of 1.1, the MQ–carbonate developer would be more suitable, the other requiring an excessively long development time to reach this value.

Gamma–time curves for individual materials under stated conditions of development are published by film manufacturers. Such curves can be of considerable assistance in the selection of a material and developer for a given task. Working conditions may, however, vary from those specified and in order to be of the greatest value, gamma–time curves for any given material should be determined by the user under the particular working conditions.

When plotting parameters such as D_{min}, speed or contrast against development time, it is often useful to adopt a logarithmic scale for development time. This compresses the region of long development times and sometimes enables the more interesting results to approximate a straight-line graph. This is easier to draw and to use than a curve.

Variation of gamma with wavelength

Besides being dependent on development, gamma also depends to some extent on the colour of the exposing light. The variation within the visible spectrum is not great, but it becomes considerable in the ultraviolet region. The general tendency is for gamma to be lower as wavelength decreases. This variation of gamma can be largely ignored in ordinary

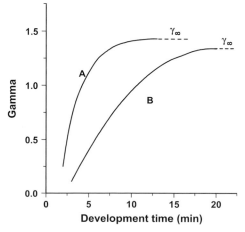

Figure 8.3 Gamma–time curves for the same material in two different developers.

photography, but must be taken into account when directly imaging by ultraviolet radiation (without assistance from visible fluorescence).

PLACING THE SUBJECT ON THE CHARACTERISTIC CURVE

A characteristic curve shows the response of a material under a wide range of exposures. Only part of this curve is used in any single negative. The extent of the portion used depends on the subject luminance ratio; its position depends on the actual luminances in the scene and on the camera exposure employed. Strictly, it is the illuminance ratio of the image on the film that concerns us here and, if flare is present, the illuminance ratio will be less than the subject luminance ratio. In the present context we shall assume that flare is absent.

We have observed (Figure 8.2) that the characteristic curves of negative materials possess a long toe. The part of the curve used by a 'correctly exposed' negative includes part of this toe and the lower part of the straight-line portion. This is illustrated in Figure 8.4.

Consider photographing the cube shown in Figure 8.5, in which S_1 is the darkest area in the subject, S_2 the next darkest, H_1 the highest highlight and H_2 the next highest. On a normally exposed, normally developed negative, the

exposures and densities corresponding to these areas will be approximately as shown in Figure 8.4.

Effect of variation of exposure of the negative

Figure 8.4 shows the positioning of tones, illustrated in Figure 8.5, on the characteristic curve of the correctly exposed and processed negative. If too little exposure is given, all tones will be recorded lower on the curve and S_1 and S_2 will possess a much lower density separation on the negative, and in the print, shadow detail will have been lost. Highlight tones H_1 and H_2 will, however, lie on the near-linear part of the characteristic curve, and highlight tones will be well distinguished. Moderate underexposure of the negative may be compensated for by using a high grade of printing paper, but if S_1 and S_2 have identical densities in the negative, there can be no separation of shadow tones in the print. In a moderately overexposed negative, given normal development, the selected shadow and highlight tones will all record on the high-contrast part of the characteristic curve. The overall density of the negative is higher than normal and the density range is expanded. In particular, tone separation in the shadows is increased. In the rare case of gross overexposure, the shoulder of the characteristic curve may be reached, the density range of the negative will be reduced and highlight detail compressed or totally lost.

AVERAGE GRADIENT AND \overline{G}

Since a negative usually occupies part of the toe of the curve as well as part of the straight line, gamma alone gives an incomplete picture of the contrast of an emulsion. A better measure is obtained by taking the slope of the line joining the two limiting points of the portion of the characteristic curve employed (Figure 8.6). This is referred to as the *average gradient*. It is always lower than gamma. Several

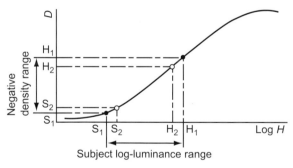

Figure 8.4 The portion of the characteristic curve employed by a 'correctly exposed' and 'correctly developed' negative, lies between S_1 and H_1.

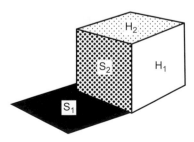

Figure 8.5 Subject tones.

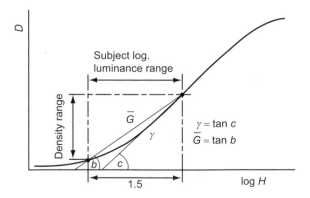

Figure 8.6 Average gradient.

limiting points on the curve are specified in standards concerning special photographic materials. For normal negative films the quantity \overline{G} (G-bar) was defined by Ilford Ltd as the slope of a line joining the point at a density of 0.1 above D_{min} with a point on the characteristic curve 1.5 units log H in the direction of greater exposure.

CONTRAST INDEX

A measure of contrast devised by Kodak is the *contrast index*, which, like \overline{G}, takes into account the toe of the characteristic curve. The determination involves using a rather complicated transparent scale overlaid on the characteristic curve, although an approximate method is to draw an arc of 2.0 units cutting the characteristic curve and centred on a point 0.1 units above D_{min}. This requires equally scaled log exposure and density axes. The slope of the straight line joining these two points is the contrast index. Characteristic curves of materials may differ in gamma but possess identical contrast index, or indeed \overline{G}. Negatives of identical contrast index or \overline{G} can be expected to produce acceptable prints using the same grade of printing paper.

EFFECT OF VARIATION IN DEVELOPMENT ON THE NEGATIVE

The negative represented by the curve in Figure 8.6 was given normal development. If we make two other identical exposures of the same subject, and give more development to one and less development to the other, we shall obtain two further curves such as those, together with the 'normally developed' curve (Figure 8.7). The camera exposure is the same in all three cases, so that the parts of the curves used, measured against the log H axis, are the same for all three.

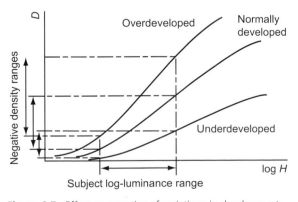

Figure 8.7 Effect on negative of variations in development.

It will be seen that overdevelopment increases the density of the negative in the shadows to a small extent and in the highlights to a large extent. As a result, the overdeveloped negative as a whole is denser and, more important, its *density range* is increased. Underdevelopment has the reverse effect. It decreases density in both shadows and highlights, in the highlights to a greater extent than in the shadows, and the density range of the negative is reduced, as is its overall density. Thus, the major effect of variation in the degree of development is on the density range, often described as the *contrast* of the negative.

EXPOSURE LATITUDE

Exposure latitude is the factor by which the minimum camera exposure required to give a negative with adequate shadow detail may be multiplied, without loss of highlight detail.

We may call the distance along the log H axis between the lowest and highest usable points on the curve the *useful exposure range*. This depends principally upon the emulsion and the degree of development. These two factors also govern latitude, but this is also dependent upon the log luminance range of the subject. In practice, loss of highlight detail (setting the upper limit to exposure) often results from loss of resolution due to graininess and irradiation, before the shoulder is reached. As the required resolution usually depends upon the negative size and the consequent degree of enlargement in making the print, we may add 'negative format' to the practical factors governing useful exposure range and latitude. In general there is less exposure latitude with a small format than with a larger one.

The log luminance range of the average subject is less than the useful log exposure range of the film, and there is usually considerable latitude in exposure. If, however, we have a subject with a log luminance range equal to the useful log exposure range of the film, only one exposure level is permissible. With the exceptional subject having a luminance range *greater* than the useful exposure range of the film, no exposure level yields a perfect result; either shadow or highlight detail or both will be lost. This most commonly arises with high-contrast materials, such as colour reversal (slide) films, when shadow detail is usually sacrificed to preserve highlight information.

If the subject range is below average we have extra latitude. In practice, however, this is limited on the underexposure side by the fact that an exposure too near the minimum will be located entirely on the toe and may result in an unprintably soft negative. It is usually preferable to locate the subject on the characteristic curve such that at least part is on the linear portion. In this way better negative contrast and more satisfactory print quality are achieved.

THE RESPONSE CURVE OF A PHOTOGRAPHIC PAPER

The characteristic curve of a paper is obtained in the same way as that of a film, by plotting density against log exposure. Density in this case is *reflection density* and is defined by the equation:

$$D_R = \log_{10}\left(\frac{1}{\rho}\right) = \log_{10}\left(\frac{I_i}{I_r}\right) \qquad (8.7)$$

where ρ (the Greek letter rho) represents the *reflectance*, which is the ratio of the light reflected by the image to the light reflected by the base or some specified 'standard' white. This definition is analogous to that of *transmission density*.

Figure 8.8 illustrates the general shape of the characteristic curve of a paper. This curve, like that of a negative material, can be divided into four main regions: toe, straight line (or linear region), shoulder and region of solarization, though the latter is seldom encountered in practice. The main differences between the curve of a paper and that of a film are:

1. The shoulder is reached at a lower density and turns over sharply, the curve becoming parallel to the log H axis at a value of D_{max} rarely exceeding a value of 2.1.
2. The toe extends to a fairly high density.
3. The straight-line portion is short and, in some papers, non-existent.
4. The slope of the linear portion is generally steeper than that of a camera film emulsion.
5. Fog (under normal development conditions with correct safe light) is almost absent, although the minimum density may slightly exceed that of the paper base material alone, owing to stain acquired in processing.

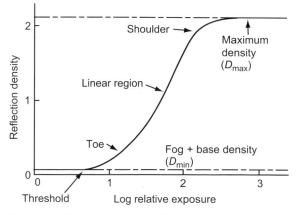

Figure 8.8 The 'geography' of the characteristic curve of a photographic printing paper.

Differences (2) and (4) arise from the fact that when a silver image on an opaque diffusing base is viewed by reflected (as opposed to transmitted) light its effective density is increased, because at moderate densities, light must pass through the image at least twice.

Maximum black

The practical consequence of (1) above is that the maximum density obtainable on any paper is limited, however long the exposure or the development. The highest value of density that can be obtained for a particular paper, with full exposure and development, is called the *maximum black* of the paper. The maximum density obtained on any given paper depends principally on the type of surface. Light incident on a print undergoes three types of reflection:

1. Part is reflected by the surface of the gelatin layer in which the silver grains are embedded.
2. Part is reflected by the silver grains themselves.
3. The remainder is reflected by the baryta or resin coating on the paper base.

The sum of these reflections determines the reflectance and hence the density of the print. By increasing the exposure received by a paper, and thus the amount of silver in the developed image, we can eliminate entirely the reflection from the paper base, but reflections from the gelatin surface of the emulsion and from the individual grains themselves cannot be reduced in this way. These reflections limit the maximum black obtainable.

Reflection from the emulsion surface depends upon the nature of this surface. A print will normally be viewed in such a way that direct, *specular*, reflection from its surface does not enter the eye. We are therefore concerned only with diffuse reflection. Now, the reflection from the surface of a glossy paper is almost entirely direct, so the amount of light reflected from the surface of such a paper, which enters the eye when viewing a print, is very small. In these circumstances, the limit to the maximum density is governed, principally, by the light reflected by the silver image itself. This is usually a little less than 1%, corresponding to a maximum density of just over 2.0. Reflection from the surface of a matt paper, however, is almost completely diffuse, so that an appreciable amount of light (say 4%) from the surface of the paper reaches the eye, in addition to light reflected from the silver image. (There may also be light reflected from particulate material, included in the emulsion of many matt papers.) The maximum black of matt papers is therefore relatively low. Semi-matt and 'stipple' papers have values of maximum black intermediate between those of matt and glossy papers. Table 8.4 shows typical values of maximum black obtainable on papers of three main types of surface.

Resin-coated printing papers are not glazed after processing but possess a high natural gloss and may achieve

Table 8.4 The maximum black of printing papers with different surfaces

SURFACE	REFLECTION DENSITY (MAXIMUM)
Glossy, glazed	2.10
Glossy, unglazed	1.85
Semi-matt	1.65
Matt	1.30

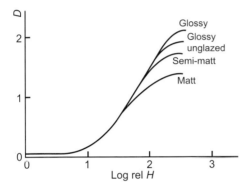

Figure 8.9 Characteristics of printing papers with different surfaces.

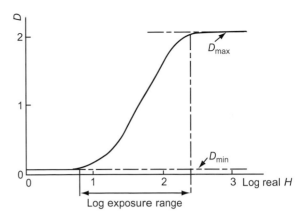

Figure 8.10 Exposure range of a printing paper.

a D_{max} of over 2.0 without glazing. Glossy colour prints possess little reflecting material other than the paper base, and values as high as 2.5 are not uncommon. The effect of variation in maximum black on the characteristic curve is confined largely to the shoulder of the curve, as shown in Figure 8.9.

Exposure range of a paper

The ratio of exposures corresponding to the highest and lowest points on the curve employed in a normal print is termed the exposure range of the paper (Figure 8.10) and is expressed either in exposure units or log exposure units. It represents the usable exposure range of the paper and corresponds to the greatest negative density range, which can be fully accommodated.

Variation of the print characteristic curve with the type of emulsion

Photographic papers employ emulsions containing various proportions of silver chloride and silver bromide. Slow emulsions intended for contact printing have traditionally contained a high proportion of silver chloride, while enlarging papers contain a greater proportion of silver

bromide. The names 'chlorobromide' and 'bromide' papers indicate different proportions of silver bromide present and the characteristic curves of these papers differ somewhat in shape. The practical effect of differing curve shapes is to alter the tonal relationships within the print, a matter of some subjective importance. Such subtle differences give additional control at printing.

Variation of the print characteristic curve with development

With papers the characteristic curve varies with development, but rather differently from that of negative film. Figure 8.11 shows a family of curves for a bromide paper. The normally recommended development time for this paper (in the developer employed) is 2 minutes at 20°C. With more modern printing papers, development normally requires a minimum of about 1 minute. At longer development times the curve may be displaced to lower exposure levels but, unlike the curve of a chloride paper, the

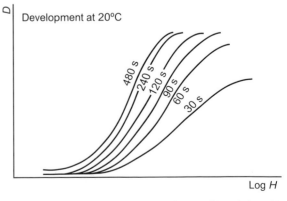

Figure 8.11 Characteristic curves of a traditional bromide printing paper for different development times.

149

slope may increase slightly. In other words, both speed and contrast of a bromide paper may increase on prolonged development. The increase in contrast is usually not very great, but can be of practical value. The major effect of variation of development time on papers of all types is on the effective development speed of the paper.

The situation may be complicated by the composition of 'bromide' paper, which may contain a significant proportion of silver chloride. This modifies the development behaviour so that there is no detectable contrast increase once maximum black has been reached.

With papers of all types, there is *development latitude* between the two extremes of under-and overdevelopment. With the paper shown in Figure 8.11, this extends from about 1.5 to 4 minutes. Between these times maximum black is achieved with no increase in fog. The ratio of exposure times required at the shortest and longest acceptable times of development is referred to as the *printing exposure latitude*. Development latitude and exposure latitude are interrelated — both cannot be used at the same time. Thus, once an exposure has been made there is only one development time that will give a print of the required density. In dish processing the development latitude may be reduced in modern printing papers by extended green sensitivity, which may make the emulsions liable to *actinic exposure*, exposure generating latent image, by yellow or orange safe lights. The effect may be visible, at low levels, as a reduction in tonal contrast of the prints made. There may be no increase in fog level, but a reduction of contrast may be observed.

REQUIREMENTS IN A PRINT

It is generally agreed that, in a print:

1. All the important negative tones should appear in the print.
2. The print should span the full range of tones, from black to white, that is capable of being produced on the paper used. (Even in high-key and low-key photographs it is usually desirable that the print should show *some* white and *some* black, however small these areas may be.)

In printing, the exposure of the paper in any area is governed by the negative density in the corresponding area: the greater the density of any negative area, the less the exposure, and vice versa. In order, then, to meet the requirements above, the exposure through the highlight (darkest) areas of the negative must correspond with the toe of the curve of the printing paper, and the exposure through the shadow (lightest) areas of the negative must correspond with the shoulder of this curve. Expressed sensitometrically, this means that the log exposure range of the paper must equal the density range of the negative.

Now, not all negatives have the same density range, which varies with the log luminance range of the subject, the emulsion used, the exposure and the degree of development. Therefore, no single paper will suit all negatives because, as we have seen, the log exposure range of a paper is a more or less fixed characteristic, affected only slightly (if at all) by development. A single paper with a sufficiently long log exposure range would enable requirement (1) to be met in all cases, but not requirement (2). Printing papers are therefore produced in a series of differing *contrast grades* or *usable exposure ranges*.

Paper contrast

In Figure 8.12 are shown the characteristic curves of a series of bromide papers. These papers all have the same surface and differ only in their contrasts, or usable exposure ranges, described as soft, normal and hard respectively. These are usually designated by grades ranging from 0 at very low contrast to 5 at very high contrast. All three papers have been developed for the same time. It will be noted that the three curves show the same maximum black, but that the steepness of the curve increases, and the exposure range decreases, as we progress from the 'soft' to the 'hard' paper. The soft paper with long log exposure range is intended for use with negatives of high density range. Conversely, the 'hard' paper, with short log exposure range, is intended for use with negatives of low density range.

Variable contrast papers comprise two emulsions of differing contrasts and possessing differing spectral sensitivities. The contrast is varied by suitably filtering the enlarger at exposure; typically, the highest grades are achieved using a grade 5 filter, which is magenta, and the lowest by using a grade 0 filter, which is yellow. Intermediate contrasts are achieved using either a set of appropriately designed colour filters, or by the use of a special enlarger head to vary the spectral distribution of the

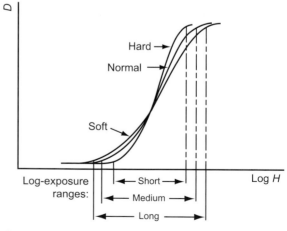

Figure 8.12 Paper contrast.

printing illuminant. The sensitometry of such papers will require similar filtration plus, usually, a correction filter to raise the colour temperature to that of a typical enlarger if a 2856 K source is used in the sensitometer. The characteristic curves corresponding to contrast grades will approximate those found for traditionally graded papers.

If negatives of the same subject, differing only in contrast, are each printed on papers of the appropriate exposure range, the prints will be practically identical. If, however, an attempt is made to print on a paper with too short a log exposure range, and exposure is adjusted to give correct density in, say, the highlights, then the shadows will be overexposed, shadow detail will be lost in areas of maximum black, and the result will appear too contrasty. If, on the other hand, a paper of too long a log exposure range is used (i.e. too soft a grade) and exposure is again adjusted for the highlights, the shadow areas of the print will be underexposed and the result will appear 'flat'.

The softer the grade of paper, i.e. the longer its log exposure range, the greater is the exposure latitude (as defined earlier) in printing. It is, however, generally unwise to aim at producing negatives suited to the softest available paper because one then has nothing to fall back upon if, for some reason, a negative proves to be exceptionally contrasty. It is therefore generally best to aim at the production of negatives suitable for printing on a middle grade of paper.

A simple, if approximate, check on the exposure range of a paper can be made by giving to a strip of it a series of progressively increasing exposures. The exposure ratio is the ratio of the exposure time required to yield the deepest black that the paper will give, to that required to produce a just perceptible density. A typical set of exposure times, using an enlarger set up for normal use, can be achieved by a geometric series: 1, 2, 4, 8, 16, 32, 64, 128, 256 seconds. An opaque card may be advanced across the paper surface by one division after each exposure step — the exposures suggested will result in an overall series from 1 to 512 seconds. If necessary the lens aperture can be adjusted to ensure that all the exposed steps, from white to black, are obtained.

Some skilled monochrome printers use an interesting method for the control of tone reproduction. They use a brief uniform, non-image, pre-exposure or *pre-flash* to modify the characteristic curve shape of the printing paper. Generally speaking, the higher the intensity of the pre-flash, the lower is the contrast obtained. There may be some increase in the minimum density if a large reduction in contrast is attempted, but this may be acceptable.

RECIPROCITY LAW FAILURE

The reciprocity law, enunciated by Bunsen and Roscoe in 1862, states that for any given light-sensitive material, the

photochemical effects are directly proportional to the incident light energy, i.e. the product of illuminance and exposure duration. For a photographic emulsion this means that the same density will be obtained if either illuminance or exposure duration is varied, provided that the other factor is also varied so as to keep constant the product H in Eqn 8.1.

Abney first drew attention to the fact that the photographic effect depends on the actual values of H and t, and not solely on their product. This so-called *reciprocity failure* arises because the effect of exposure on a photographic material depends on the *rate* at which the energy is supplied. All emulsions exhibit reciprocity failure to some extent, but it is usually serious only at very high or low levels of illumination, and for much general photography the reciprocity law can be considered to hold. In the sensitometric laboratory, however, the effects of reciprocity failure cannot and should not be ignored, or in certain practical applications of photography.

If sensitometry is to be a useful guide to the performance of photographic materials under their typical conditions of use, we have to approximate those conditions in the sensitometric laboratory. In practice it is very helpful to know and understand the behaviour of films within our own methods and conditions.

Practical effects of reciprocity failure

Reciprocity failure is encountered in practice as a loss of speed and increase in contrast at low levels of illumination, i.e at long exposure times. The degree of the fall-off in speed and the region at which maximum speed is obtained vary from material to material. The effects of reciprocity failure are illustrated in Figure 8.13, which

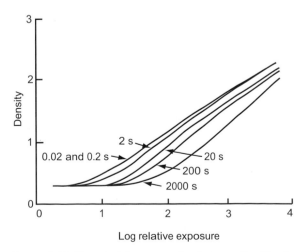

Figure 8.13 Characteristic curves of a fast negative film for different exposure durations.

illustrates the behaviour of a fast negative film at a range of exposure durations. With no reciprocity failure, all the curves would be identical and coincide with that for 0.02 and 0.2 s exposure time. A major effective speed loss, however, occurs at longer exposures, together with some contrast gain.

As a result of reciprocity failure, a series of graded exposures made using a time scale yields a result different from a set made using an intensity scale. Consequently, in sensitometry, a scale appropriate to the conditions in use must be chosen if the resulting curves are to bear a true relation to practice. For the same reason, filter factors depend on whether the increase in exposure of the filtered negative is obtained by increasing the intensity or the exposure duration. Two types of filter factor are therefore sometimes quoted: 'intensity-scale' and 'time-scale' factors.

The variation of speed and contrast with differing exposure duration is usually different for each of the three emulsion layers present in colour materials. Consequently, departures from recommended exposing conditions may lead to unacceptable changes in colour balance for which no compensation may be possible. Fortunately, the manufacturers of colour films for professional use make films in two classes: one for short daylight, or electronic flash, exposures and the second for long, studio-lit exposures.

It should be noted that although the mechanisms underlying anomalous reciprocity effects are dependent on the illuminance on the emulsion and can be adequately explained on that basis, it is the *duration of the exposure* that is critical in determining the importance of reciprocity failure to the practical photographer.

Intermittency effect

An exposure given as a series of instalments does not usually lead to the same result as a continuous exposure of the same total duration. This variation is known as the *intermittency effect*. It is associated with reciprocity failure, and its magnitude varies with the material. In practical photography the intermittency effect is not usually important except, possibly, in the making of test strips on printing paper for determining correct printing exposures. If a series of separate exposures is used to make a test strip, the suggested time may not be appropriate for a single continuous printing exposure. In sensitometry, this effect cannot be ignored and a single, continuous, exposure is used.

SENSITOMETERS

A *sensitometer* is an instrument for exposing a photographic material in a graded series of steps, the values

of which are accurately known. The essentials of a sensitometer are:

1. *A light source of known standard intensity and colour quality.* Many sources have been proposed and used at various times. The light source adopted as standard in recent years has been a gas-filled tungsten lamp operating at a colour temperature of 2856 K. The lamp is used with a selectively absorbing filter to yield a spectral distribution corresponding to daylight of 5500 K, modified by a typical camera lens. The filter used is made of a suitable glass. 5500 K corresponds to daylight with the sun at a height typical of temperate zones during the hours recommended for colour photography and is suitable for the exposure of colour and monochrome films designed for daylight use. Any sensitometric light source must be stabilized in terms of both luminous intensity and, particularly when used for colour materials, colour temperature. Fluctuations in mains voltage can alter both quantities, and are generally compensated by sophisticated voltage stabilizers. In most cases a DC supply to the lamp is used to avoid AC modulation of the exposure, which may be significant at short exposure times.

2. *Modulation of the light intensity.* To produce the graded series of exposures, it is possible to alter the illuminance to obtain sensitometric data, which will correctly reflect the behaviour of the material under the in-camera conditions of use. The exposure time and intensities should be comparable with those for which the material is designed.

A series of exposures in which the scale is obtained by varying the intensity — referred to as an *intensity scale* — can conveniently be achieved by use of a neutral 'step wedge'. A sensitometer is designed so that the exposures increase logarithmically along the length of the strip. The log exposure increments are usually 0.30, 0.15 or 0.10. If, for any reason, it is desired to interrupt the exposure, this must be done in such a way that the intermittency effect does not affect the results.

DENSITOMETERS

The name *densitometer* is given to special forms of photometer designed to measure photographic densities. Instruments designed to measure the densities of films and plates are described as *transmission densitometers*, while those designed to measure papers are termed *reflection densitometers*. Some instruments are designed to enable both transmission and reflection densities to be measured, usually employing separate sensor heads for the two tasks. Densitometers are generally *single-beam* instruments as shown in Figure 8.14 and the use of solid-state detectors, such as photodiodes, is now almost universal.

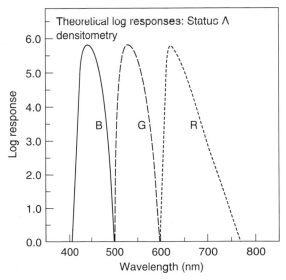

Figure 8.14 A single-beam, direct-reading densitometer.

The commonest type of transmission densitometer uses a light-sensitive detector illuminated by a beam of light into which the sample to be measured is placed. The response of the detector is displayed as optical density. The typical features illustrated in Figure 8.14 constitute a single-beam, direct-reading densitometer. Such instruments are usually set up by adjusting the density reading to zero when no sample is present in the beam. This operation may be followed by a high density setting, using some calibration standard, or even an opaque shutter for zero illumination. Once set up, the instrument is used for direct measurements of the density of samples placed in the beam.

Stability of light output, of any electronics used and of performance by the detector are required for accurate density determination. In practice, checks of the instrument zero may be required to eliminate drift. A further requirement of the direct-reading instrument is linearity of response to changes of illuminance.

Microdensitometers

These instruments are used to examine density changes over very small areas of the image. Such microstructural details are measured for the assessment of granularity, acutance and modulation transfer function — all important determinants of image quality (see Chapters 19, 20, 24). To measure the density of a very small area it is usual to adopt a typical microscope system, replacing the human eye by an electronic sensor. Microdensitometers are very precise instruments, with measuring intervals of a few micrometers — the output may be displayed using the monitor of a controlling computer and appropriate parameters may be directly determined by the same computer.

Colour densitometers

In addition to monochrome silver images, it is often necessary to make sensitometric measurements of colour images. These are generally composed of just three dyes absorbing red, green and blue light respectively. It is therefore possible to assess colour images by making density measurements in these three spectral regions.

Colour densitometers are therefore similar to monochrome instruments but are equipped with three primary colour filters. These red, green and blue filters combine with the sensor characteristics to give three separate response bands, in red, green and blue spectral regions respectively (Figure 8.15).

The behaviour of a dye image can be assessed most effectively when the densitometer measures only within the spectral absorption band of the dye, so colour densitometers are usually equipped with narrow-band filters. In view of the spectral imperfections of image dyes it will be appreciated that a single colour density measurement (red, green or blue) represents the sum of contributions from all the dyes present. Such combined densities are described as integral densities. The measured densities depend on the spectral bands sampled, which are in turn dictated by the material to be examined.

Colour negatives are designed for printing on colour paper, and are assessed using an instrument possessing ISO Status M spectral responses appropriate to colour printing. The purpose of this exercise is to use a densitometer to assess colour negatives and hence to predict the printing conditions required to yield a good colour print. Instruments set up according to an ISO Standard for the measurement of masked negatives are said to give Status M densitometry. Images designed for viewing are measured using ISO Status A densities, which accurately assess neutral images as viewed by the human observer. Colorimetric densities, which would assess colour densities in terms of human colour vision, have only found application

Figure 8.15 Blue, green and red response bands for ISO Status A colour densitometry, used for the examination of colour reversal film and positive prints designed for the human observer.

in research laboratories, and are not necessary for the quality control of either colour negative or positive materials.

The spectral responses of instruments for Status A and M densitometry are tightly specified. It may not, however, be necessary to establish a system meeting such specifications because arbitrary integral densities are often satisfactory for such purposes as quality control. As with black-and-white densitometers, the commonest type is the direct-reading single-beam instrument.

BIBLIOGRAPHY

Eggleston, J., 1984. Sensitometry for Photographers. Focal Press, London, UK.

James, T.H., 1977. The Theory of the Photographic Process, fourth ed. Macmillan, New York, USA.

Proudfoot, C.N. (Ed.), 1997. Handbook of Photographic Science and Engineering. IS&T Springfield, VA, USA.

SMPTE, 1963. Principles of Colour Sensitometry. Society of Motion Picture and Television Engineers, New York, USA.

Thomas, W. (Ed.), 1973. SPSE Handbook of Photographic Science and Engineering. Wiley, New York, USA.

Todd, H.N., Zakia, R.D., 1974. Photographic Sensitometry. Morgan & Morgan, Hastings-on-Hudson second ed., New York, NY, USA.

Chapter | 9 |

Image sensors

Robin Jenkin

All images © Robin Jenkin unless indicated.

INTRODUCTION

Photography has a long and well-documented history. The ability to record images in this manner has existed for more than 150 years. Less well known is that the electronic detection of light has also been possible for over a century and that images have been transmitted in this manner since the early 1900s. The growth of the digital imaging industry, therefore, should be attributed to something other than the use of electronics to form images.

Imagine using a simple *photodiode* to detect light. It is possible to arrange hundreds, or even thousands, of these in a grid to be able to record an image. However, the complexity of the wiring and the size of the photodiode (even if it were modest) make the proposition impractical (Figure 9.1). The invention of the integrated circuit and the process of large-scale integration addressed these wiring and organization problems by allowing the formation of many electronic components on a small area of silicon. It is this that facilitated modern digital imaging technology.

This chapter examines predominant electronic imaging sensors, the *charge-coupled device* (CCD) and *complementary metal oxide semiconductor* (CMOS) device, and their properties. Many differing types of electronic imaging sensors are available, far too many to include here. Therefore, those that principally detect visible light are concentrated upon and it is not considered appropriate to discuss thermal or high-energy detectors here.

MATERIALS AND DETECTION OF LIGHT

Imaging sensors rely heavily upon the properties of the materials of which they are comprised. The materials generally influence detection mechanisms, spectral sensitivity, noise characteristics and construction of a device. It is therefore useful to understand these fundamental mechanisms and their contribution.

Figure 9.1 An array of photodiodes can be arranged to record an image.

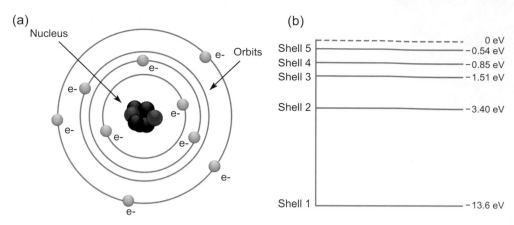

Figure 9.2 The Rutherford–Bohr model of the atom (a) and an energy level diagram (b).

Conductors, insulators and semiconductors

Over time, many models of the construction of atoms have been proposed. In 1913, Niels Bohr proposed that atoms consisted of a positive *nucleus* surrounded by negative *electrons* that could only occupy discrete *orbits* (Figure 9.2a). This was an improvement on an earlier model proposed by Rutherford in 1911 and is sometimes known as the Rutherford–Bohr model. Only a limited number of electrons may exist on each orbit and electrons may not exist at any orbits in between those for the atom. The number and position of the orbits depends on the element.

As has been mentioned in Chapter 2, electrons orbiting further from the nucleus have more energy. We may therefore imagine cutting a slice of Figure 9.2b to create an energy diagram, where the lower orbits have less energy and are 'closer' to the nucleus and those that are higher have more energy. To move between orbits, an electron must either lose energy to drop or gain energy to rise. If an orbit is full, electrons would not be able to join that orbit, and generally lower orbits fill first. An orbit may also be known as a shell or level.

Electrons will produce photons as they release energy, as has been seen in Chapter 2, and the wavelength of the light produced depends on the amount of energy released. If there is a large energy gap between two orbits, the electron will have to lose more energy and therefore the photon of light produced will have a shorter wavelength. If there are a discrete number of orbits for a given atom, it follows that only certain wavelengths of light will be produced. This is precisely the motivation behind Bohr's model: to explain the *line spectra* produced by certain gases.

The *valence band* describes the orbit with the most energy that is normally occupied by electrons at absolute zero. These electrons generally have low energy levels. The empty band above the valence is known as the *conduction band* and contains *free electrons* which may conduct electricity as they are not tightly bound with the nucleus.

The energy difference between the valence and conduction band may differ for different types of atoms. If an electron does not gain sufficient energy to move from the valence band to the conduction band it will not become a free electron able to contribute to conducting electricity. The region between the valence and conduction band is sometimes referred to as the *forbidden gap*.

All materials may be classed as *conductors* or *insulators*, either allowing electricity to pass through them or not. Materials that have a high number of free electrons, those in the conduction band of a material, are generally good conductors, whilst insulators have few or no electrons that are able to escape the valence band. The electronic properties of elements, the manner in which they combine to form molecules and external application of energy or force influence the number of free electrons in a material and their mobility. Generally an insulator has a larger forbidden gap between the valence and conduction bands.

A *semiconductor* is a material that has conductivity in between an insulator and a conductor. Its conductivity is closer to that of an insulator in a natural state and few electrons gain enough energy to reach the conduction band. By applying energy, it is possible to excite increasing numbers of electrons into the conduction band and increase the conductivity of the material. Energy may be applied by heating, or by applying light or non-visible radiation and in some cases mechanical forces. Silicon and germanium are common semiconductors, though a large number of other materials and compounds are used, such as silicon germanium, gallium arsenide and indium phosphide.

Being able to modify the conductivity of a semiconductor has made them immensely important in the technology industries and they have had a tremendous impact on the world. Integrated circuits (computer chips),

light-emitting diodes (LEDs), diodes, transistors and a host of other devices all rely on the use of semiconductors. It is very difficult in modern society to find a device that doesn't have a semiconductor in it.

Doping

The four outermost electrons in silicon and germanium may form *covalent bonds* with four neighbouring atoms to form a perfect crystal lattice. Because all of these electrons are involved with forming the crystal structure, they cannot conduct electricity. In their natural state, therefore, silicon and germanium do not conduct electricity well. The electronic properties of silicon and other semiconductors, however, may be modified using a process termed *doping*. Doping is the introduction of varying quantities of impurities into the semiconductor to change the conductivity.

A doped semiconductor is commonly referred to as an *extrinsic semiconductor*.

There are essentially two types of doping: *N-type* and *P-type*. Both permanently increase the conductivity of the semiconductor, though not by very much and using slightly different methods.

To understand the role of a *dopant*, the properties of both the dopant and the base material must be considered (Figure 9.3). Dopants are usually classified as either *acceptors* or *donors*. Donor dopants, or N-type dopants, donate weakly bound electrons to the valence band when incorporated into the otherwise pure crystal lattice. These electrons may be excited into the conduction band very easily, enabling the conductivity to increase. The majority carrier of the electricity is therefore negative electrons, hence the name N-type. Arsenic, antimony and phosphorus may all be used as N-type dopants. Each has five electrons in the valence band and

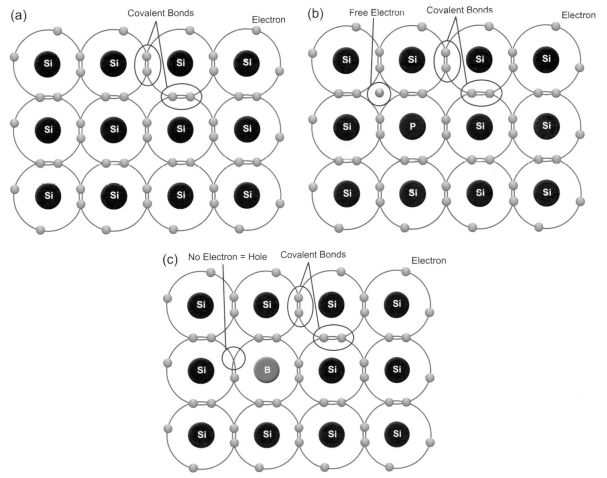

Figure 9.3 Silicon (a), N-type (b) and P-type (c) silicon electron diagrams. The silicon forms covalent bonds to form a perfect lattice. The addition of phosphorus produces a free electron, the addition of boron a hole.

therefore has an electron left over when bound to the *valence four* silicon.

Acceptor donors produce *positive holes* as majority carriers. Valence three materials, such as boron, are added and, once incorporated into the semiconductor lattice, accept electrons easily. The valence four silicon can form only three bonds with the acceptor material and therefore an electron is missing in the lattice. We can think of this missing electron as a positive hole. Electrons from other atoms can fill this hole, but that in turn creates a hole somewhere else. We can think of the hole as being able to move throughout the material, conducting electricity as it does so. Just like electrons, holes may be attracted or repelled by opposite or like charges.

If large amounts of impurities are added the semiconductors will become good conductors and may be used as the replacement for wires in some integrated circuits. Electric fields are created at the junctions between N- and P-type semiconductors, causing electrons and holes to migrate away from them. It is the utilization of this effect that allows the production of transistors, diodes and many other electronic components (Figure 9.4).

Photoemission and photoabsorption

When electrons move from one energy level to another in a material they may only do so by the absorption or release of energy (see Chapter 2). An electron moving from the conduction band of a material to the valence band needs to lose energy and, as a consequence, often produces quanta of energy. If the amount of energy released is sufficient, this will be seen as a photon of visible light. The equation governing the relationship of energy released is given by Eqn 2.35 in Chapter 2. It is this principle that governs light-emitting diodes and solid-state lasers. Conversely, if

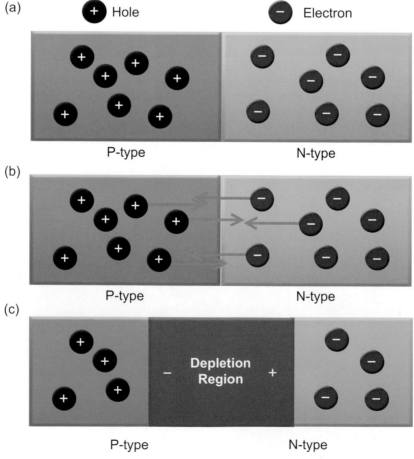

Figure 9.4 A P–N junction (a) and its depletion region formed as holes and electrons diffuse across the junction (b), to produce an electric field (c).

light of sufficient energy is absorbed by a semiconductor it may excite an electron from the valence band into the conduction band, consequently leaving a positive hole, a process known as electron–hole pair generation.

Diodes

A diode allows electrical current to flow in one direction but not the other and is one of the simplest devices that may be constructed from semiconductors. Amongst other things, they may be used to protect electronics from electricity with the wrong polarity. A diode is formed from the junction between N- and P-type semiconductors (Figure 9.4a). At the junction, the weakly bound electrons from the N-type material migrate to fill the holes in the P-type (Figure 9.4b). As electrons have moved from the N-type to the P-type material, the N-type becomes slightly positively charged and the P-type negatively charged in the region about the junction. This is known as the *depletion region* because there remain very few electrons and holes (Figure 9.4c).

The size of the depletion region may be influenced by applying a voltage. Operated in *reverse bias*, applying a positive voltage to the N-type and negative to the P-type, the depletion region increases and the net conductivity across the junction decreases. Applying a *forward bias*, i.e. a positive voltage, to the P-type and negative to the N-type, the depletion region decreases and the conductivity across the junction increases. Diodes are generally not perfect and a small current is generally conducted in the reverse bias mode. In forward bias mode, a small positive voltage is needed (≈ 0.7 volts) before the diode will conduct a useful current.

Transistors

Transistors are a natural extension of diodes. Using three layers of silicon, a PNP or NPN sandwich may be created. In either case, two P–N junctions are effectively created, blocking current from flowing in any direction. Applying a small voltage to the central portion can then control the current flow through the device, turning it on and off. The switching current may be many times less than the current it controls. A switch is a fundamental component of any computer and is a building block of logic and *Boolean* operations. Using *photolithography*, it is possible to fit millions of transistors on to a piece of silicon, thereby creating the tiny, complex circuitry that modern devices rely upon.

CCD and CMOS sensors

Charge-coupled device (CCD) and complementary metal oxide semiconductor (CMOS) sensors are similar in their architecture and function. They both utilize semiconductor technology to collect an image focused by a lens on to them. Some of the differences between the technologies will be detailed as we progress through this chapter, but the majority of concepts may be applied to both technologies.

Trying to conceive of a new type of memory for computers, CCDs were invented, almost by accident, by Willard Boyle and George Smith at Bell Laboratories in 1969. CCDs therefore precede CMOS devices and are a more mature technology. CMOS devices initially suffered from high noise and therefore low image quality, though these arguments are not as valid in the present day. CCD sensors are generally used for higher quality imaging and scientific applications, such as astronomy, whereas CMOS technology is used in many devices from cellphones and 'webcams' to prosumer digital single-lens reflex (ProDSLR) cameras and security devices. The pricing of the devices has fallen considerably as the technologies have matured and digital devices have become extremely common. The sales of digital cameras have surpassed those of film cameras since the last edition of this book.

Both CMOS and CCD imaging sensors are constructed from the same material, silicon, and this gives them fundamentally similar properties of sensitivity in the visible and near-IR spectrum. Sensors are formed on silicon wafers and cut apart, generally with a diamond saw, to produce individual sensors or *die*. CCD and CMOS sensors can support a variety of *photoelements*, though the fundamentals are primarily concentrated upon here.

MOS capacitor

At the heart of the CCD is the *metal oxide semiconductor* (MOS) (Figure 9.5). It is comprised of silicon doped with impurities, such as aluminium, to produce a P-type semiconductor, formed on a silicon substrate. Above the P-type semiconductor is formed a *gate* from *polysilicon*, which is held at a positive bias and produces a depletion region in the semiconductor. Generally, three or four such *photogates* are used in a single pixel to enable *charge transfer* (see later).

Silicon has a band gap of 1.1 eV; this is the energy required to promote one of its valence electrons to its conduction band (Figure 9.6). Using the relationship expressed in Eqn 2.35 it is therefore found that it has an inherent sensitivity up to approximately 1100 nm. While this may be an advantage for recording in the IR region of the spectrum for security and other applications, it is a disadvantage for imaging within the visible region of the spectrum and results in incorrect tone and colour balance. Image sensors to be used in the visible region of the spectrum have an IR filter to restrict their response to the visible region below approximately 670 nm.

The positive voltage to the gate (V_{gate}) causes mobile positive holes to migrate to the ground electrode, creating a depletion region. When light of sufficient energy (greater than 1.1 eV) is absorbed in the depletion region an electron–hole pair is produced. The electron remains in the depletion region whilst the positive holes migrate to the ground electrode. If the positive voltage was not applied,

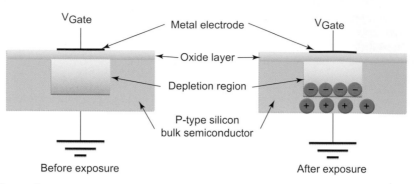

Figure 9.5 An MOS capacitor.

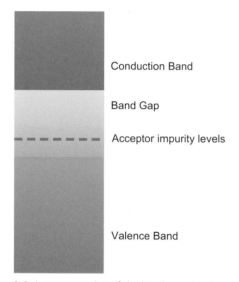

Figure 9.6 A representation of the band gaps in silicon.

the hole and the electron would recombine and release energy in the form of heat.

The number of electrons that can be retained in the depletion region is the *well capacity*, which depends on the physical sizes of the oxide layer and the gate electrode area, as well as the applied voltage.

Photodiodes

CMOS sensors employ *photodiodes* in a variety of configurations as opposed to MOS capacitors. The photodiode is formed by creating a layer of N-type silicon in contact with the P-type. This creates the depletion region, rather than employing a bias provided by a polysilicon gate.

As for the MOS capacitor, a photon may be absorbed in the depletion region to create an electron–hole pair and the device is subject to the same constraints of well capacity. To increase the sensitivity of the photodiode, a layer of intrinsic semiconductor may be placed between

the P–N junction to create a P–I–N diode or pinned photodiode. The layer of intrinsic semiconductor effectively increases the full-well capacity of the photodiode.

Variations in CMOS pixel architecture relate additionally to readout and amplification mechanisms and are discussed later.

In reality, CCD and CMOS architectures may use photodiodes and photogates interchangeably and mechanisms to read out the image formed remain the main distinguishing feature between the two technologies.

Pixels

In order to record images the sensor contains a large number of *elements (pixels)* in the form of a two-dimensional array for most CCD and CMOS cameras and a linear array for scanning devices and some types of large-format studio cameras. Generally, the individual pixels are separated from each other by infusing the substrate with boron or a similar element to create channels in a grid pattern on the substrate. Sensor sizes, numbers of picture elements and the bit depth (i.e. number of possible grey levels) are all increasing rapidly as technologies develop and this is commented upon later, though 12 million pixels (megapixels or Mp) are readily available at a reasonable cost for consumer cameras at the time of writing. A common pixel size is currently 1.75 μm, with 1.4 μm being introduced. At least one company at the time of writing has announced pictures that have been generated with a 1.1 μm pixel sensor prototype.

As will be seen later, a number of other layers may exist on top of the basic sensor, including a Bayer array, *microlenses* and *infrared reflecting filters*.

CCD AND CMOS IMAGE READOUT

A fundamental difference between CCD and CMOS technologies is the manner in which the signal is read from the pixels on the sensor. The CCD gets its name

from the method of moving the stored image across the sensor (*charge coupling*) and reading it out at one corner, whereas each pixel in a CMOS device contains several components and may be read individually in most architectures.

CCD readout

Exact architectures may vary, though generally each pixel in a CCD is subdivided with three photogates. The charge may be thought of as gathering under the photogate to which the highest potential is applied. Adjustments of the gate voltages then allow transfer of electrons from well to well

as a function of time. Figure 9.7 shows the way in which charges are transferred between neighbouring wells (1). After exposure to light, the charge in well one is shown in (2). If a voltage is applied to gate 2, electrons flow from well 1 to well 2 (3) until equilibrium is reached (4). If the voltage to gate 1 is reduced, electrons begin to be completely transferred to well 2 (5 and 6); complete transfer is shown. Thus, charges are transferred in a time-dependent way if one considers a complete array of image elements and their gates. The clocking sequence for a *three-phase device* is shown in Figure 9.8. It may be seen that only one-third of the pixel area is available as the well capacity (three gates). Both two- and four-phase readout

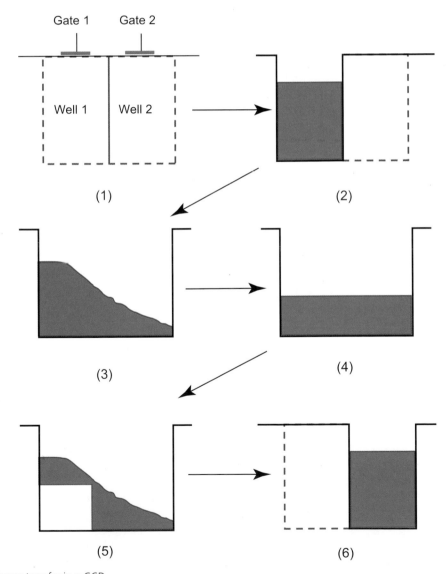

Figure 9.7 Charge transfer in a CCD.

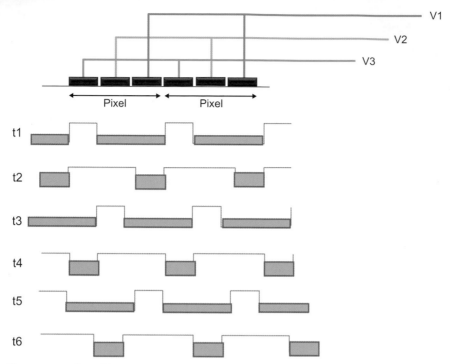

Figure 9.8 Clocking sequence for a CCD.

architectures also exist. By repeating the above procedure it is possible to shift the charge as many times as desired.

By combining corresponding electrodes of complete rows the individual charges for the whole image may be shifted down by a row at the same time (Figure 9.9). The charges at the bottom of the sensor are transferred into a *serial readout register*. The serial readout register works in a manner similar to the CCD itself and is able to shift the charge in each pixel towards the amplification and analogue-to-digital converter (ADC) circuitry. The ingenious method of charge transfer in the CCD may also be considered a disadvantage as it is essentially rendered a serial device. The ADC becomes a bottleneck, only able to digitize one value at a time, albeit very quickly.

During each shift of the stored charge, a small number of electrons may be left in the potential well. The efficiency at

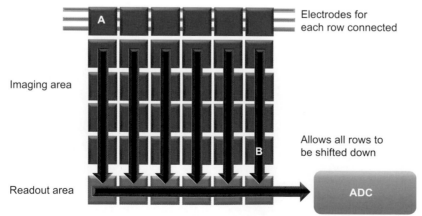

Figure 9.9 Basic architecture for transferring a full-frame image from a CCD.

which this process may be completed is known as the *charge transfer efficiency*. Charge transfer efficiency is generally very high (>99.999%) and is usually dependent upon the speed at which the transfer is completed. Faster transfers tend to leave little time for straggling electrons. The effect is also cumulative; the charge packets at point A in Figure 9.9 have more transfers to complete than those at B and are therefore more susceptible to the effects of charge transfer.

There are a number of different ways in which CCDs may be configured for different readout architectures, each with its own advantages and disadvantages. Some different architectures are given in Figure 9.10, including *full frame*, *frame transfer* and *interline transfer*.

The full-frame configuration shown in Figure 9.10a is generally the simplest and most sensitive, as it devotes the most area to image capture. If nothing is done to shield the CCD from light during the readout phase, charge will continue to accumulate on the device and *smearing* of the

image will occur. Therefore, these devices may only realistically be used with an external mechanical shutter to shield the sensor during readout. Due to their high sensitivity and use of a shutter these devices are most appropriate for DSLRs and similar cameras.

Frame transfer CCDs overcome the issues of mechanical shuttering by providing a 'storage' area on chip which is shielded from light. Whilst they still suffer from smear, the transfer of the image can be completed very quickly as the constraint of the serial readout has been changed. Once the image is in the storage area it may be clocked out during the exposure of the next frame. This increases the duty cycle of the sensor as more time may be devoted to collecting light. In addition, the frame rate is higher than that of a mechanically shuttered CCD and issues associated with mechanical wear and vibration are reduced. These sensors are more expensive as the area of silicon needed to produce them is double that of the full frame.

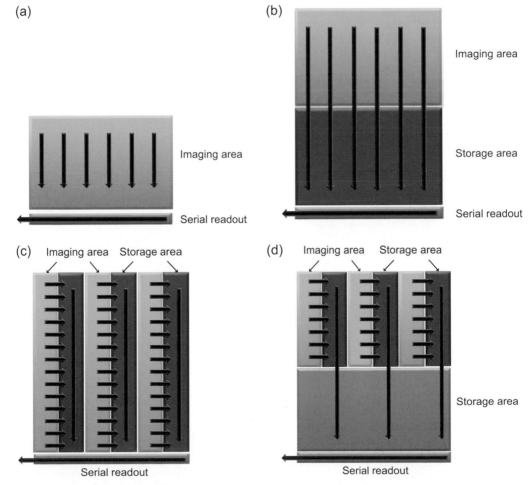

Figure 9.10 Readout architectures for CCDs. (a) Full frame, usually used with a mechanical shutter. (b) Frame transfer. (c) Interline transfer. (d) A hybrid interline transfer device with a storage area.

Interline transfer devices have shield strips between light-sensitive ones to reduce the effect of smear even further, also increasing duty cycle and frame rate. The addition of the shielded strips lowers the fill factor of the sensor and a microlens array is generally added to compensate for this. In addition, the MTF of the sensor may be different in the vertical and horizontal directions (Chapter 7). The complexity of the sensor can lead to increased costs.

CMOS readout

The architecture of CMOS sensors differs significantly from that of CCDs in terms of the manner in which the signal is read. Dependent upon the architecture, each pixel in a CMOS sensor has its own set of transistors to perform amplification and to assist with readout and reset. By including circuitry to select columns and rows, entire columns or rows can be read out simultaneously. Figure 9.11 shows an early passive pixel architecture. The readout transistor for each pixel in combination with the horizontal and vertical readout circuits allows each pixel to be individually addressed. Adding amplification to each pixel allows readout noise to be overcome, creating the *active pixel sensor* (Figure 9.12).

As separate amplifier and reset transistors are used for each pixel, CMOS sensors tend to have increased levels of noise over CCDs, as matching these components is a challenge and the photodiode resets to a slightly different value each time. The sophistication of a photodiode-based pixel is related to the number of transistors that can be incorporated into each pixel. The predominant architecture as of writing is three transistor designs (3T) consisting of the photodiode, reset, addressing and source-following components. A number of 4T, 5T and 6T designs exist, reducing read out and reset noise.

Advances in technology over the past decade have significantly reduced the gap with CMOS as the predominant sensor in the consumer market.

Because of the extra area needed to accommodate the circuitry for each pixel, the fill factor and the sensitivity of the CMOS device suffer. CMOS sensors may be made using

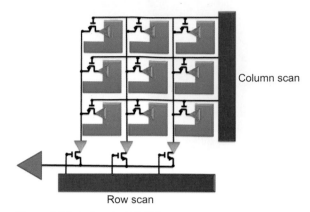

Figure 9.12 Active pixel CMOS sensor.

similar silicon foundry technology to computer memory and other integrated circuits and, hence, they may accommodate image processing and other circuitry that traditionally gets put into supporting chips for CCD devices. This allows for the production of sophisticated devices and full 'camera-on-chip' imagers are regularly seen at the time of writing. However, this extra complexity can increase design time and updates to the sensor's on-chip functions may often require revision of the chip design.

Though the CMOS sensor requires less off-chip support it uses a larger area of silicon for the supporting processing, and the cost benefits of using the same or older depreciated foundries for production have not been as large as expected. CCDs, by comparison, require dedicated foundries and little, if anything else at all, can be produced. Because a CCD uses a single amplifier and ADC, the uniformity of these processes is very good.

The method of reading the CMOS sensor allows for *windowing* of the image, selecting a reduced portion of the device from which to read an image. This, in turn, allows frame rates to increase as only part of the available data is read. In addition, control of the imaging parameters can be performed on a frame-by-frame basis, making the device highly configurable.

CMOS sensors generally consume less power than CCDs, which need accurate timing circuitry. CMOS sensors are therefore a preferred choice for consumer goods where battery life is important, e.g. small cellphones and cameras. As with many commercial products, the choice between the sensors is a compromise between cost, performance, efficiency and suitability for purpose.

AMPLIFICATION AND ANALOGUE-TO-DIGITAL CONVERSION

The voltage formed at each photosite is tiny, of the order of femtovolts, and requires amplification before it can be

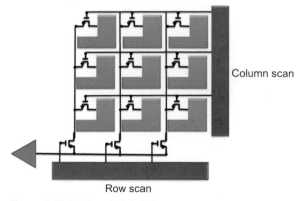

Figure 9.11 Passive pixel CMOS sensor.

converted into a digital number and subsequent use in a computer. As has been seen, where the amplification occurs is a difference between CCD and CMOS devices.

Because of the inherent spectral sensitivity of the materials from which the device is made, the total charge collected for each wavelength of light will be different even if presenting a spectrally uniform test target to the sensor. Therefore, if a colour image is produced by collecting red, green and blue light with one of the methods mentioned in the later sections, it will display a colour bias. This colour bias is further compounded by the relative transmittance of each of the filters used to divide the spectrum into its colour constituents. As is seen in other chapters, alternatives to red, green and blue may be used.

The amplification of the signal from each of the colour channels may be used to correct for the difference in the relative sensitivity of each. By amplifying the less sensitive channels more, the amplitude of the signals from each may be matched. Further, as with photographic emulsions, a colour shift may be seen when different illumination is used (see Chapter 3). Generally, incandescent lights appear 'warmer' and daylight appears 'cooler'. Using processing within the digital camera, the illuminant type may be detected. This information may then be used to adjust the analogue gain to correct the white balance of the sensor. The advantage of using this method is that no 'rounding errors' occur, as would be the case when applying amplification using integer maths after the signal is digitized. Some digital amplification may exist in cameras in addition to analogue amplification to enable other tasks.

Noise in the sensor is related in part to the signal level detected on the sensor. Therefore, it should be noted that for those channels in which the sensitivity is lower and the subsequent amplification higher, the noise in those channels will also be amplified and will be higher. Therefore, it is necessary when testing colour digital sensors to characterize the noise and signal characteristics of each channel.

After amplification, the signal is converted into a digital number using an analogue-to-digital converter (ADC). There are two basic methods of digitizing a signal: *dual slope integration* and *successive approximation*. Dual slope integration is slower, though less noisy than successive approximation. Successive approximation sequentially generates 'guess' voltages and compares them to the signal being digitized. The first 'guess' represents the first bit and is exactly half of the ADC input range. If the signal to be digitized is higher the bit is set to 1 and lower it is set to 0. The next voltage is a quarter of the input range and added to the result of the first guess. Again, if the signal is higher the next bit is set to 1 and if it is lower, to 0. The third guess is one-eighth of the input range and so on until a guess is made for each bit corresponding to the bit depth of the ADC. A slope integration ADC integrates (collects) the input voltage and times how long it takes to reach a reference voltage. The time is proportional to the input voltage. This method, however, is subject to manufacturing tolerances of the components. A dual slope integration ADC integrates the input as in the first case for a known amount of time, then times a discharge with respect to a known voltage. The time of discharge is proportional to the input voltage. As the same components are used to integrate and discharge the signal, the result is not subject to error caused by component tolerances.

The *readout rate*, the time in which an image has to be 'read' from the sensor, determines the time for which each pixel has to be read from the chip and digitized. Generally, the less time that a pixel has to be read from the sensor, the more noise is introduced into the measurement.

The scale that an ADC has to work with depends upon the number of *bits* available to store the signal. A bit is the most basic digital representation available, known as binary, and may take the value 0 or 1. The total number of levels that can be represented is given by 2^b, where b is the number of bits. Therefore, an 8-bit ADC can create 2^8 or 256 levels. Conventionally, these levels start at 0 and go to $2^b - 1$, or 0 to 255 in this example. The significance, or importance, of each bit when written in binary varies with its position and the proportion of the signal it represents (Figure 9.13). The digit on the right is known as the least significant bit (LSB) as it represents the smallest component the ADC can convey. The left-hand digit is known as the most significant bit (MSB).

The task of the ADC is to choose the value that most closely matches the input signal. Say the input signal lies between 0 and 3 volts and the ADC is 8 bits. Zero volts will be assigned a digital value of 0, 3 volts will be assigned a value of 255, 1.5 volts would be assigned to 127, etc. This may be represented as a graph (Figure 9.14).

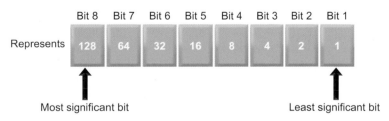

Figure 9.13 Binary number representation.

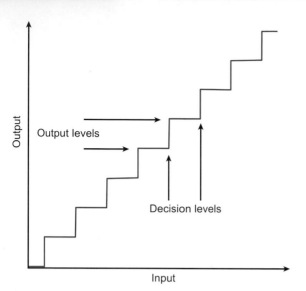

Figure 9.14 Decision levels for an analogue-to-digital converter.

The range of the ADC is divided into *decision levels* and *output levels* and shows how the input signal is assigned to the output.

When digitizing a signal, error occurs because of the resolution of the ADC. If the signal has a value halfway between two output levels, the ADC has to digitize it to either the value above or below it. This creates an error of 0.5LSB. As the number of bits with which to represent the signal increases, the relative size of the LSB becomes smaller. For an 8-bit ADC the LSB represents 1/256th of the input; for 10-bit ADC the LSB represents 1/1024th of the input signal. Therefore, using higher *bit depths* results in smaller errors when digitizing an image.

In addition to ADC error, there exists ADC noise (see Chapter 24). Using the 0–3 volt signal and 8-bit ADC as before, a value of 1.5 volts should be digitized as 127. However, sometimes the ADC will give 126, or 125, maybe 128 or 129. This is a random component that depends upon the quality of the ADC and the time available to digitize the value. Generally, the noise in an ADC will be quoted as a fraction of the LSB, e.g. 8 bits ± 0.25LSB. A fraction of an LSB may be used as this is the average error over a large number of measurements.

Because of these errors, information is lost at the point at which an image is digitized and some noise is introduced.

The image digitized from the sensor is used as input into an image-processing pipeline consisting of many stages designed to enhance the quality of the image before it is available for the user. The image-processing pipeline is discussed in more detail in the section on digital cameras in Chapter 14. Such processing could include colour correction, gamma correction, demosaicing, noise reduction, defect masking and a number of others. Performing mathematics on integer numbers, however, produces rounding errors. As digitization of the image on an image sensor is the first in many image-processing stages, it is generally digitized to a much higher bit depth than will be required for final output to a computer in order to reduce these errors. An image-processing pipeline within a digital camera may operate at 12–20 bits for a final output of 8–10 bits.

The number of intensity levels that can actually be resolved in the final image depends largely upon the noise in the sensor and the mode of operation. Because an image may be digitized at 10 bits, distinguishing 1024 distinct levels may not be possible (refer to Chapter 24 for further information). Generally, low light, high ISO, high frame rate, multispectral and poor *f*-number will be the type of factors that can increase image noise. The aperture, or *f*-number, of a lens is given by the ratio of the focal length to the aperture diameter (Chapters 6 and 10). A poor *f*-number (i.e a large *f*-number) lens will produce a darker image and larger Airy disc, increasing the exposure time and decreasing resolution. Further aspects of amplification and digitization are discussed in the following section.

SCANNING METHODS

Sensors may be deployed in a large variety of sizes from tens of pixels in devices such as optical mice to large linear arrays for scanners and studio cameras. The exact size depends upon the format of the device and the application. There are three basic scanning methods to utilize sensors in the most economical way: point scanning, line scanning and area scanning (Figure 9.15).

Point scanning uses a single pixel array and scans this throughout the full field of view. In practice the scanning is usually achieved optically, using a faceted mirror or fast and slow scan mirrors. Whilst the output from the device is generally very uniform because a single imager is used, it can often suffer from mechanical defects in the scan mechanisms. Linear arrays are often used in flatbed scanning, consisting of a strip of pixels, generally a few pixels deep and a number of thousands wide. By scanning this along its short direction it is possible to quickly build an image of a document. Some large-format studio cameras also use this technique. The scanning mechanics are simpler and the registration issues are reduced in one direction. Colour may be generated in a number of ways, as is shown later. Both of the above methods may only be used on static subjects, as any movement will cause image smear. Area scanning usually refers to a staring array, so called because it has no moving parts. The lack of scanning means that higher frame rates and relative sensitivities can be achieved.

(a) (b) (c)

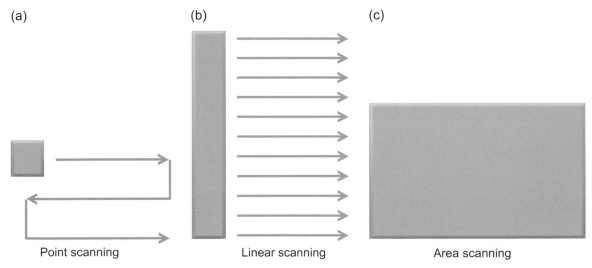

Point scanning Linear scanning Area scanning

Figure 9.15 Point (a), line (b) and area scanning (c) approaches.

IMAGING PERFORMANCE

Performance trade-offs

Many of the performance characteristics of a sensor are linked. Inevitably, if one measure increases another will often decrease. Common terms for sensor performance measures are given in Table 9.1. These are expanded upon in this and later chapters. Silicon wafers are technologically expensive to produce but the abundance of digital cameras has made them a commodity, driving prices down. The useful area upon each silicon wafer is expensive. As sensor sizes are reduced, each wafer can produce more. If sensor size is halved, wafers can produce four times as many. Therefore, pixel size, sensor size and cost are important factors, which in turn have an effect on image quality.

Common sensor sizes range from $1/10''$ to $4/3''$ and are specified as the length of the diagonal. The aspect ratio is commonly 4:3, though the recent introduction and proliferation of high definition television (HDTV) has seen an increase in the use of 16:9. A few high-quality image sensors exist that have 35 mm and square aspect ratios.

The size of the image sensor affects the apparent focal length of the lens used with the system. Many photographers familiar with the 35 mm format understand that a 'standard lens' has a focal length of 50 mm, a standard lens being a focal length that gives a field of view approximately similar to that of the eye. A practitioner of medium-format photography will likewise exclaim that a standard lens is 80 mm. If a smaller sensor than those commonly employed in film camera formats is used, it has the effect of cropping the image and, if the resultant image is displayed at the same size, will increase the apparent focal length of the lens.

The effect that this has on users of DSLR cameras is that the focal length of a lens should be multiplied by a factor to find its 35 mm equivalent (often termed the 'effective focal length'). The diagonal of a 35 mm frame is approximately 43 mm. Using a $1''$ imager will result in a crop factor of $\times 1.7$. Thus, a 100 mm lens will have an apparent focal length of 170 mm. Producing smaller sensors generally reduces the size and weight of the optical systems that are needed to accompany them because of the above scaling. However, lens placement and tolerancing become increasingly critical as the resolution requirements of the system generally become higher.

The size of the sensor and the number of pixels contained on that sensor specifies the physical limitations on the size of an individual pixel. As each pixel gets smaller, the number of electrons that it can trap, known as the *full well*, decreases and is related to its area. Thus, the full well of a 2 µm pixel will be a quarter of the size of a 4 µm. The full well and the various sources of noise in the sensor will define the dynamic range of the device. This is generally given as:

$$d = 20.\log \frac{f}{n_{RMS}} \text{ decibels} \qquad (9.1)$$

where f is the number of electrons in the full well and n_{RMS} is the root mean squared noise of the device in the dark. Thus, a device with a full well of 21,000 and RMS noise of seven electrons respectively would have dynamic range of 3000:1 or 69.5 dB (see Chapter 24 for various sources of noise).

The response of a CCD or CMOS device is generally highly linear (Chapter 24). However, as the full well approaches capacity, its ability to store more charge

167

Table 9.1 Common performance terminology for digital sensors

CHARACTERISTIC	COMMENT
Detector size	Dimensions of sensor area (mm × mm)
Pixel size	Physical dimensions of pixels expressed as μm × μm for each pixel, or as numbers of vertical and horizontal pixels for whole sensor area
Fill factor	Fraction of the pixel area which is sensitive to light (%). This is often the *effective fill factor* as it includes the effect of adding microlenses
Full-well capacity	Maximum charge (or signal) which the sensor can hold ($J\,cm^{-2}$, or number of electrons). The *linear full well* is the capacity at which the pixel still maintains a largely linear response to exposing light
Noise	Many sources: *shot* noise accompanies generation of photoelectrons and *dark current* electrons; *pattern* noise due to pixel to pixel variations; *reset* noise when reading the charge and added to by the amplifier; *quantization* noise arising from analogue-to-digital conversions. Expressed as RMS electrons or RMS volts
Dark current	Due to thermal generation of current (number of electrons or $nA\,cm^{-2}$). As a rough rule of thumb, dark current generally doubles for each 10°C increase in temperature
Dynamic range	Ratio of full-well or linear full-well capacity to noise (dB). It is good practice to specify the full-well measurement and formula for dynamic range used, as these may vary between engineering fields
Scanning mode	Interlaced or progressive
Resolution	Relates to detector size, pixel size and fill factor (see Chapter 24) expressed as line per mm, dpi, cycles per mm. Often expressed as number of pixels or file size. Applies to the imaging system output
Quantum efficiency	Ratio of number of electron–hole pairs produced to number of photons absorbed (maximum value unity)
Spectral response	Plots of quantum efficiency against wavelength
Architecture	Structure and readout modes of detector arrays

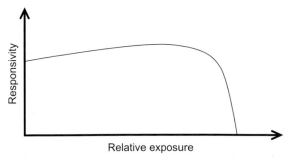

Figure 9.16 A generalized responsivity curve for a CCD or CMOS device.

diminishes until the point at which it becomes saturated. Therefore, when plotting a graph of relative responsivity versus exposure (Figure 9.16), one finds that as a pixel approaches saturation its sensitivity decreases and then drops dramatically. The linear full well is usually chosen to represent the linear portion of the output of the device and is a trade-off between the non-linearity that can be tolerated maximizing the dynamic range of the sensor. Amplification of the signal must also be taken into consideration as it will lower the dynamic range of the signal, increasing the levels of noise.

As discussed in Chapter 2, a lens has a diffraction limit associated with it. So whilst reducing pixel size may aid resolution, setting it below this will not add any information to the image. It may be argued that there are some benefits using this method to reduce aliasing, though this approach could be considered expensive when compared to the alternatives, such as adding an anti-aliasing filter. For information on aliasing, see Chapter 7. Information on resolution may be found in Chapters 7 and 24.

Fill factor, the ratio of the light-collecting portion to the total size of the pixel, affects relative sensor sensitivity, as described previously. The source of this is readily apparent for interline CCDs and CMOS sensors; however, further

electronics placed on the sensor surfaces can reduce this further. When a full well saturates, electrons are split from the saturated pixel to surrounding areas, causing corruption of those signals, known as *blooming*. To overcome this problem an *antibloom drain* is added to each pixel, dumping excess charge for highly illuminated areas. Though many different types exist, commonly a lateral overflow drain may be constructed adjacent to the photosite. This is essentially a reverse-biased diode that can draw off excess charge above a chosen level. These structures, however, are not sensitive to light and effectively reduce the fill factor.

Microlens arrays

Microlens arrays are added as a layer to the upper surface of the sensor to increase the effective fill factor of the pixel. A microlens, as the name implies, is a tiny lens formed to focus light into the pixel (Figure 9.17a). These arrays can increase the fill factors of some devices by 30—70%. The placement of microlenses has to take into account the variation in the chief ray angle (CRA) of the light hitting the pixel. Telecentric lenses are designed such that the light strikes the sensor orthogonally at all positions on the sensor, allowing it to be focused on to the correct pixel (Figure 9.17a). Most lenses, however, are not telecentric and the CRA varies with position in the field of view. This variation can cause the microlens to focus the light on to the adjacent pixel, causing colour shifts or optical crosstalk (Figure 9.17b). To overcome this problem, the lens must be designed such that its CRA, with respect to field of view, matches that specified by the sensor manufacturer for the particular sensor (Figure 9.17c).

Sensitivity

The fundamental spectral sensitivity of CCD and CMOS sensors is determined to a large extent by the silicon itself, modified by interference effects within the thin overlying layers forming part of the chip construction. The spectral sensitivity of a typical monochrome sensor is shown in Figure 9.18, from which it is seen that there is rather a low blue sensitivity and considerable sensitivity extending into the near-infrared region. In most sensors the infrared sensitivity is restricted by an infrared reflection or absorption filter on the face of the sensor, but in special purpose cameras a separate filter may be attached to the camera lens.

The use of a thin-film reflective infrared filter can introduce artefacts into colour images as the cut-off wavelength of the filter depends upon the angle of the arriving light. Towards the edge of the field of view where the CRA of the lens is greater, the filter cut-off is shifted towards the blue wavelengths, effectively cutting out more red light than at the centre of the field of view. This, in turn, causes a drop in red sensitivity towards the edge of the field of view of the sensor and a shift in the colour balance. Known as *lens shading*, algorithms in the image-processing pipeline can

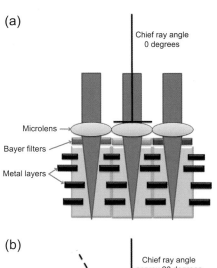

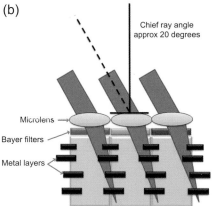

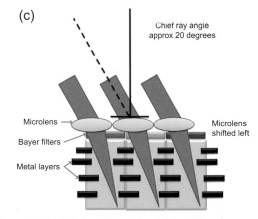

Figure 9.17 (a) If the CRA of the light striking the sensor is 0° the microlens will focus it into the sensitive region of the pixel. (b) The CRA varies with position in the field of view, causing the microlens to focus the light on to the adjacent pixel, creating colour shifts or optical crosstalk. (c) Shifting the microlenses may overcome this problem.

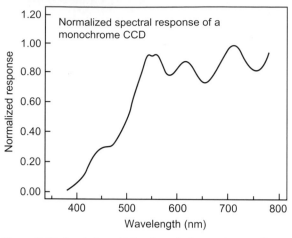

Figure 9.18 Spectral sensitivity of a typical monochrome silicon-based CCD or CMOS device.

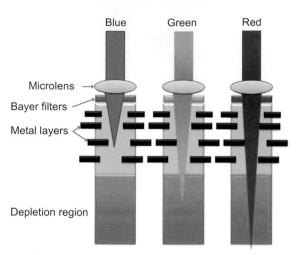

Figure 9.19 A representation of wavelength penetration in silicon devices.

correct for this colour artefact by digitally amplifying those parts of the image where the red signal falls off.

Sensitivity for an image sensor can usefully be expressed as the ratio of incident photons to detected photons with respect to wavelength, or *quantum efficiency* (QE) as it is known. This topic is covered in more detail in Chapter 24. Responsivity, mentioned previously, is also covered in Chapter 24.

Alternatively, photometric units may be used to relate incident light to a 'standard observer' given a global figure of sensitivity. Calculating the number of lux necessary for the sensor to produce a signal that is discernible above the noise floor of the device is possible by relating the image illuminance necessary to produce the desired signal-to-noise ratio to the scene illuminance, presented in Chapter 24.

Spectral sensitivities for CCD and CMOS sensors are generally lower than those for bare silicon because of the effect of the polysilicon surface components. The poly-silicon structure becomes less transparent at approximately 400 nm, attenuating blue light. A further problem is that the depth of penetration of the light is related to the wavelength, with red light travelling further into the photodiode than the blue. If the light does not reach the depletion region an electron–hole pair will not be generated and the quanta will not be detected (Figure 9.19). Due to the combination of these effects, CCD and CMOS sensors generally have lower sensitivity in the blue region of the spectrum. If a red quantum of light travels through the depletion region it will also not be detected and this is potentially a problem as the size of pixels falls and the corresponding size of the depletion region shrinks.

A typical sensor will have a DQE of approximately 30–40% (Chapter 24). By focusing an image on the back of the sensor and acid etching superfluous silicon substrate away, it is possible to increase the DQE of CCDs to beyond

80%. In addition, light does not have to traverse the poly-silicon layers as above. So-called *back thinning*, until recently, has resulted in expensive delicate sensors suitable only for controlled environments where sensitivity is paramount. Modern manufacturing development, however, has resulted in a number of manufacturers pursuing back-side illumination (BSI) technology for the commercial market. DQE may also be increased by the use of anti-reflection coatings and the application of fluorescent dyes which absorb in the UV region of the spectrum and emit in the green–blue.

Exposure control

Reduction of the effects of overexposure may be achieved in sensors by the use of electronic shutters. An electronic shutter can drain the charge from a pixel for a specific period of time and using this technique effective exposures down to 1 ms are readily achieved. The advantage of this technique is that a constant frame rate can be maintained despite varying levels of illumination and lack of mechanical shutter.

CMOS sensors more typically use rolling shutters. A rolling shutter uses pointers to enable the exposure of one portion of the sensor whilst reading out another. These pointers 'roll' throughout the lines on each frame, indicating when to read out, reset and expose. Whilst the technique increases the duty cycle of the sensor to near maximum, artefacts can be introduced into images if the camera or subject moves. This is because each part of the frame is exposed at a slightly different time (Figure 9.20). By extending or decreasing the time between the pointers the exposure time may be changed.

Extended shuttering allows capturing of scenes with large dynamic ranges. This may be thought of as the

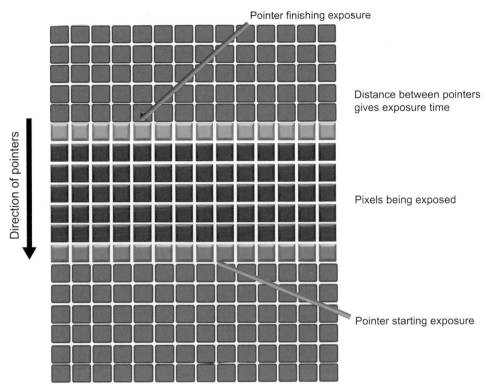

Figure 9.20 Rolling shutters as used in CMOS devices.

mathematical combination of different exposures made at different shutter speeds. By making successively shorter exposures, it is possible to capture very bright detail without saturation of the pixel. Using this technique, it is possible to record scenes with in excess of 90 dB dynamic range.

ISO settings in digital cameras essentially allow the user to trade noise for sensitivity. By increasing the ISO sensitivity, the camera shortens the exposure time and compensates this by increasing the levels of analogue and digital gain applied to the image. This increases the noise levels in the image.

Sensor imperfections

All sensors exhibit blemishes and manufacturers will generally set a threshold on each type of defect, above which it is discarded. The number of blemishes is proportional to the area of the sensor silicon and thus the manufacturing of devices is subject to a square law. In order to double the resolution of a device for a fixed pixel size, the area of silicon occupied quadruples. The likelihood of a sensor being discarded increases and the number of sensors per wafer falls. Hence to purchase a device with double the resolution the price is likely to more than double.

Dark pixels are those that have a lower response than the majority of those about them. They can be corrected for by

a number of methods, including interpolation of surrounding values or by taking a flat-field reference image. Hot pixels generally saturate easily and generate a large amount of thermal noise (see Chapter 24). Again, these may be corrected using interpolation or a flat-field image. A flat-field image may be created by imaging a uniform source of light. From this the relative gains of each pixel may be determined and accounted for in the final image. Columns and rows may be affected in a similar manner depending upon the architecture of the device. Generally these effects are more serious and difficult to correct for. In the case of CCDs, pixels can act as traps or inefficient charge transfer sites. The image can therefore be smeared and affected throughout a column where these occur. Most CCDs and CMOS devices include defect correction in their image-processing pipeline and a user is unlikely to be aware of defects in the sensor. It is possible to buy sensors that have been sorted with respect to the numbers of defects exhibited. These generally cost disproportionately more and are primarily useful for scientific applications.

Generating colour

So far we have only considered arrays that respond to light intensity and in order to generate colour a number of methods are used. Colour is examined extensively in

Chapters 5 and 23, and therefore only the physical aspects of generating colour are looked at here. Colour recording methods in digital cameras are also discussed in Chapter 14. One method is to successively record each image through red, green and blue filters and to additively record colour. Known as *sequential colour*, this method may be used for scanning colour originals and in some studio cameras where only static subjects are recorded as the time needed to change filters is generally large when compared to other methods. An advantage is that a larger number of filters may be used, giving very good colour fidelity. In addition, aliasing and demosaicing artefacts associated with the use of a Bayer array are avoided. This type of technique is advantageous for recording artwork where quality is paramount.

A second and by far the most predominant method used in consumer cameras today is to place a colour filter array (CFA) over the CCD. Although many configurations of the CFA have been developed (see Chapter 14), the most common is the *Bayer pattern* (Figure 9.21). There are generally twice as many green pixels present in a CFA array as this most closely corresponds to the peak sensitivity of the eye and the luminance component of images as perceived by humans. It is important to note that CFAs reduce the effective resolution of the camera sensor, since data has to be interpolated to provide the missing information at each pixel. If a red area is being recorded, it can be seen from Figure 9.21 that there will be pixels that will

not have been activated. As the sampling pitch of each colour channel is different from that of a monochrome sensor, further artefacts may be introduced and readers are referred to the generation of aliasing artefacts or moiré patterns (see Chapters 7 and 19).

The third method involves the use of a beamsplitter to divide the input into three separate channels which separately record red, green and blue signals (or other appropriate combinations) on three CCD detectors. Whilst this is an expensive solution to the recording of colour, it allows higher resolution recording than is possible using CFAs.

A more recent technique has been developed by Foveon Inc., and exploits the wavelength-dependent penetration of light into silicon. It employs three vertically stacked photodiodes for each pixel and detects blue, green and red light with each. As it does not require interpolation, colour artefacts are reduced when compared with the use of a CFA array.

It is worth noting with all colour systems that the amount of light used for a particular colour channel is approximately a third of that for a monochrome camera and the light is necessarily filtered in order to be able to detect the relative colour components. This generally results in colour systems having lower effective sensitivities than their monochrome counterparts. Therefore, it is common to see monochrome sensors used for very-high-speed applications or those where the reduction of noise is critical.

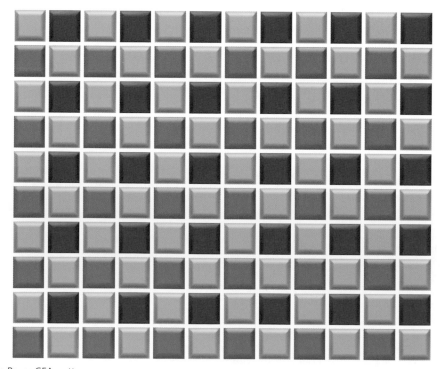

Figure 9.21 The Bayer CFA pattern.

As mentioned previously, CCD and CMOS sensors have a highly linear response. The eye, however, has a logarithmic response. This needs to be taken into account when generating images for viewing to achieve acceptable tone reproduction. Therefore, in addition to colour interpolation and correction via a colour correction matrix (CCM), the signal will also be gamma corrected as detailed in Chapter 21.

BIBLIOGRAPHY

Blouke, M.M., Sampat, N., Canosa, J., 2002. Sensors and camera systems for scientific, industrial, and digital photography applications II. Proceedings of SPIE. SPIE Optical Engineering Press, Bellingham, WA, USA.

Castleman, K.R., 1996. Digital Image Processing. Prentice-Hall, Englewood Cliffs, NJ, USA.

Dainty, J.C., Shaw, R., 1974. Image Science. Academic Press, New York, USA.

Gonzalez, R.C., Woods, R.E., 2007. Digital Image Processing, third ed. Addison-Wesley, Reading, MA, USA.

Gonzalez, R.C., Woods, R.E., Eddins, L.C., 2003. Digital Image Processing Using MATLAB®. Prentice-Hall, Englewood Cliffs, NJ, USA.

Holst, G.C., 1998. CCD Arrays, Cameras and Displays, second ed. SPIE Optical Engineering Press, Bellingham, WA, USA.

Jacobson, R.E., Ray, S.F., Attridge, G.G., Axford, N.R., 2000. The Manual of Photography, ninth ed. Focal Press, Oxford, UK.

Nakamura, J. (Ed.), 2006. Image Sensors and Signal Processing for Digital Still Cameras. CRC Press, Boca Raton, FL, USA.

Proudfoot, C.N. (Ed.), 1997. Handbook of Photographic Science and Engineering, second ed. IS&T, Springfield, VA, USA.

Chapter | 10 |

Camera lenses

Sidney Ray

All images © Sidney Ray unless indicated.

LENS ABERRATIONS

Introduction

An understanding of residual aberrations (errors) is useful in describing the types, merits and imaging limitations of camera lenses. An 'ideal' lens forms geometrically accurate images but actual lenses, especially simple ones, do not since the refractive index of glass varies with wavelength, lens surfaces are usually spherical in shape and because of the wave nature of light (see Chapter 2). These cause respectively *chromatic aberrations*, *spherical aberrations* and *diffraction effects*. The degrading effects usually increase with both aperture and angle of field.

There are seven primary chromatic and spherical aberrations. Two *direct errors* or *axial aberrations* affect all parts of the image field as well as the central zone, known as *axial chromatic aberration* and *spherical aberration*. The other five errors affect only rays passing obliquely through the lens and do not affect the central zone. The effects of these *oblique errors*, or *off-axis aberrations*, increase with the distance of an image point from the lens axis. They are called *transverse* (or *lateral*) *chromatic aberration* (often called 'lateral colour'), *coma*, *curvature of field*, *astigmatism* and (curvilinear) *distortion* (see also Chapter 6). Their degrading effects appear in that order as the *angular field of view* increases.

Axial and lateral chromatic aberrations are chromatic effects; spherical aberration, coma, curvature of field, astigmatism and distortion are spherical effects. The latter are also called *Seidel aberrations* after L. Seidel, who in 1856 gave a mathematical treatment of their effects. They are also known as *third-order aberrations*, from their mathematical

formulation. Modern highly corrected lenses have only residual traces of these primary aberrations.

Axial chromatic aberration

For transparent media, shorter wavelengths are refracted more than longer wavelengths, causing *spectral dispersion* and *dispersive power*. Focal length varies with the colour of light (see Figure 10.1); the focus for blue light is closer to the lens than the focus for red, giving *axial chromatic aberration*.

Using two elements of different optical glass, the chromatic aberrations in one can be made to effectively cancel out those in the other. Typically, a combination of positive 'crown' glass and negative 'flint' glass elements was used. The two elements may be separated or cemented together. A *cemented achromatic doublet* lens made in this way is shown in Figure 10.2. Other errors may be simultaneously corrected giving satisfactory results over a narrow field at a small aperture.

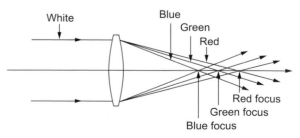

Figure 10.1 The dispersive effects of chromatic aberration in a simple lens.

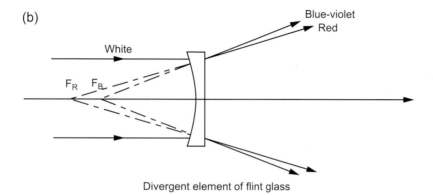

(a)

White

F_B F_R

Blue-violet

Red

Convergent element of crown glass

(b)

Blue-violet

Red

White

F_R F_B

Divergent element of flint glass

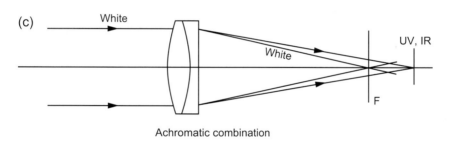

(c)

White

White

UV, IR

F

Achromatic combination

Figure 10.2 The principle of an achromatic doublet lens combination.

The chromatic performance of a lens is usually shown by a graph of wavelength against focal length, as shown previously in Figure 6.3. The variation of focus with wavelength for an uncorrected lens is an approximately straight line; that of an achromatic lens is approximately a parabola. The latter curve indicates the presence of a residual uncorrected *secondary spectrum*. The two wavelengths chosen to have the same focus positions are usually in the red and blue regions of the spectrum, for example the C and F Fraunhöfer lines. A lens corrected to bring three colour foci into coincidence is said to be *apochromatic*. This term is also used for those lenses that are corrected fully for two wavelengths, but use special low-dispersion glasses to give a much-reduced secondary spectrum. It is also possible to bring four wavelengths to a common focus, giving a *superachromat*. The wavelengths chosen are in the blue, green, red and infrared regions, so that no focus correction is needed between 400 and 1000 nm. Using materials such as silica and fluorite, an achromatic lens

may be made for UV recording, needing no focus correction after visual focusing.

Other optical materials require chromatic correction. Plastics (polymers) are used in photographic lenses either as individual elements or as hybrid glass—plastic aspheric combinations. It is possible to design an achromatic combination using plastics alone.

The use of reflecting surfaces that do not disperse light, in the form of 'mirror lenses', offers another solution, but most mirror designs are for long-focus lenses only. Most of these, too, are *catadioptric lenses* with some refracting elements and these still require some colour correction.

Lateral chromatic aberration

Lateral or *transverse chromatic aberration*, also called either *lateral colour* or *chromatic difference of magnification*, appears in the form of dispersed colour fringes at the edges of the

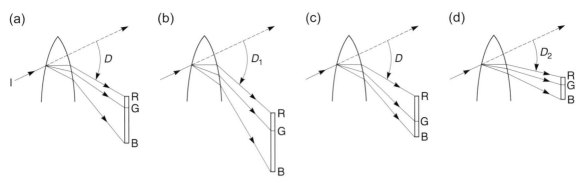

Figure 10.3 Refraction and dispersion by optical materials. The refractive power of a material is shown by the deviation angle D of incident light I. Dispersion by refraction is indicated by the length of spectrum RGB. Relative partial dispersion is indicated by the ratio of lengths RG and GB. (a) Conventional optical glass: dispersion is greater at short wavelengths. (b) High index glass: deviation increases but so does dispersion, $D_1 > D$. (c) ED glass: anomalous low dispersion at short wavelengths. (d) Fluorite: low deviation and anomalous dispersion, $D_2 < D$.

image (see Figure 6.4). It is an off-axis aberration, i.e. it is zero at the centre of the focal plane but increases as the angle of field increases. Whereas axial chromatic aberration concerns the focused distance from the lens at which the image is formed, lateral chromatic aberration concerns the size of the image. It is not easy to correct: its effects worsen with an increase in focal length, and are not reduced by closing down the lens aperture. It can be minimized by a symmetrical lens configuration and at least three types of optical glass. Almost full correction is achieved by use of special optical materials (Figure 10.3). These include optical glass of anomalous or *extra-low dispersion* (ED), which may be used in long lenses, at increased cost. Another material with very low dispersion characteristics is *fluorite* (calcium fluoride), grown as large crystals for photographic use. Unfortunately, fluorite is attacked by the atmosphere, so it must be protected by outer elements in the lens construction. Also, the focal length of fluorite lenses varies with temperature so infinity focus may vary. The cost of lenses using fluorite elements is significantly higher than that of equivalent conventional designs.

Spherical aberration

The amount of refraction depends on the angles of incidence made with the lens surfaces and the refractive index of the elements. Surfaces are usually spherical, being easy to manufacture. However, a single lens element with one or two spherical surfaces does not bring all paraxial (near axial) rays to a common focus. The exact point of focus depends on the annular region or *zone* of the lens surface under consideration. Rays from outer ('marginal') zones come to a focus nearer to the lens than those through the central zone (Figure 10.4). Consequently, a subject point source does not produce a true image point. The resultant unsharpness is called *spherical aberration* (SA). In a simple lens, SA is reduced by using a small aperture. As aperture is reduced the plane of best focus may shift, a phenomenon characteristic of this aberration. Spherical aberration in a simple lens is usually minimized by a suitable choice of radii of curvature of the two surfaces of the lens, termed 'lens bending'.

Correction of SA is by choice of a suitable pair of positive and negative elements whose spherical aberrations are equal and opposite. This correction is combined with that for CA and coma (see below) to give an *aplanatic lens*. Full correction is difficult and limits the maximum useful aperture of some designs, for example to $f/5.6$ for symmetrical lenses. The *double-Gauss* configuration, with five or more elements, allows apertures of $f/2$ and greater.

An *aspheric surface* can give a larger useful aperture, or alternatively allow fewer elements necessary for a given aperture. Optical production technology now provides aspheric surfaces at reasonable cost and they find a variety of uses. Another alternative is to use optical glasses of very high refractive index, which then need lower curvatures for a given refractive power, with a consequent reduction in spherical aberration.

Spherical aberration varies with focused distance. A lens computed to give full correction when focused on infinity might perform less well when focused close up. One solution uses a group of elements moving axially for correction purposes as the lens is focused and coupled to the focusing control, termed a *floating element*. Most 'macro' lenses for close-up photography incorporate such a system.

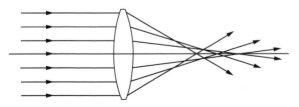

Figure 10.4 Spherical aberration in a simple lens.

Leaving a controllable amount of residual uncorrected SA gives a noticeable 'soft-focus' effect, particularly useful for portraiture. The Rodenstock Imagon lens was a well-known example. The degree of softness is controlled either by specially shaped and perforated aperture stops to select particular zones of the lens, or by progressive separation of two of the elements of the lens.

Coma

In an uncorrected simple lens, oblique (off-axis) rays passing through different annular zones of the lens intersect the film at different distances from the axis, instead of being superimposed. The central zone forms a point image that is in the correct geometrical position. The next zone forms an image that is not a point but a small circle that is displaced radially outwards from the geometric image. Successive zones form larger circles that are further displaced, the whole array adding together to give a V-shaped blur known as a *coma patch*, from its resemblance to a comet. Coma is significantly reduced by stopping down the lens and can be reduced in a simple lens by placing the aperture stop so that it restricts the area of the lens over which oblique rays are incident. In compound lenses coma is reduced by balancing the error in one element by an equal and opposite error in another. In particular, symmetrical construction is beneficial. Coma is particularly troublesome in wide-aperture lenses.

Curvature of field

From the basic lens conjugate equation, the locus of sharp focus for a planar object is the so-called *Gaussian plane*. In a simple lens, however, this focal surface is in practice not flat but spherical, called the *Petzval surface*, centred approximately at the rear nodal point of the lens (Chapter 6). It is impossible to obtain a sharp image all over the field: when the centre is sharp the corners are blurred, and vice versa. Some large-aperture camera lenses are designed with sufficient residual curvature of field to match the image surface or 'shell' of sharp focus to the natural curvature of the film in the gate; a number of slide-projector lenses have been designed in this way. Double-Gauss-derived lenses give a particularly flat image surface, e.g. the Zeiss Planar series of lenses. Given the planar nature of focal plane arrays of imaging elements, it is essential that a lens for digital cameras has a near-flat image surface.

Astigmatism

The image surface is the locus of true point images only in the absence of the aberration called *astigmatism*. This gives two additional curved *astigmatic surfaces* close to the focal or Petzval surface. The term 'astigmatic' comes from a Greek expression meaning 'not a point', and the two surfaces are the loci of images of points in the object plane that appear in one case as short lines radial from the optical axis, and in the other as short lines tangential to circles drawn round the optical axis. Figure 10.5a shows the geometry of the system, and the occurrence of astigmatism. When light from an off-axis point passes through a lens obliquely, the tangential and radial (sagittal) components are brought to different foci, forming two image 'shells' (see Figure 10.5b). On one surface all images of off-axis points appear as short lines radial from the optical axis, and on the other as tangential lines. The surface which approximately bisects the space between the two astigmatic surfaces contains images which are minimum discs of confusion and may represent the best focus compromise. Astigmatism mainly affects the margins of the field, and is therefore a more serious problem with lenses that have a large angle of view.

Both astigmatism and curvature of field are reduced by stopping down. Although curvature of field can be completely corrected by the choice and distribution of the powers of individual elements, astigmatism cannot, and it remained a problem in camera lenses until the 1880s, when new types of glass were made available from Schott based on work by Abbe, in which low refractive index was combined with high dispersion and vice versa, so as to reduce astigmatism without affecting other corrections. Such lenses were called *anastigmats*. Early anastigmat lenses were usually based on symmetrical designs, which gave a substantially flat field with limited distortion.

Curvilinear distortion

The aperture stop should be located so that it transmits the bundle of rays that surround the primary ray (i.e. the ray that passes through the centre of the lens undeviated). Image distortion occurs when a stop is used to control aberrations such as coma. If positioned in front of the lens or behind it, the bundle of rays selected does not pass through the centre of the lens, but through a more peripheral region, where it is deviated either inwards, for a stop on the object side of the lens ('barrel distortion'), or outwards, for a stop on the image side of the lens ('pincushion distortion') (see Figure 10.6). These names represent the shapes into which the images of rectangles centred on the optical axis are distorted. Because the aberration produces curved images of straight lines it is correctly called *curvilinear distortion*, to distinguish it from other distortions such as *geometrical distortion* and the *perceptual distortion* consequent on viewing photographs taken with a wide-angle lens from an inappropriate distance.

As distortion results from stop position, it cannot be reduced by stopping down. It can be minimized by making the lens symmetrical in configuration, or nearly symmetrical ('quasi-symmetrical'). An early symmetrical lens, the 'Rapid Rectilinear', took its name from the fact that it produced distortion-free images and was of reasonable

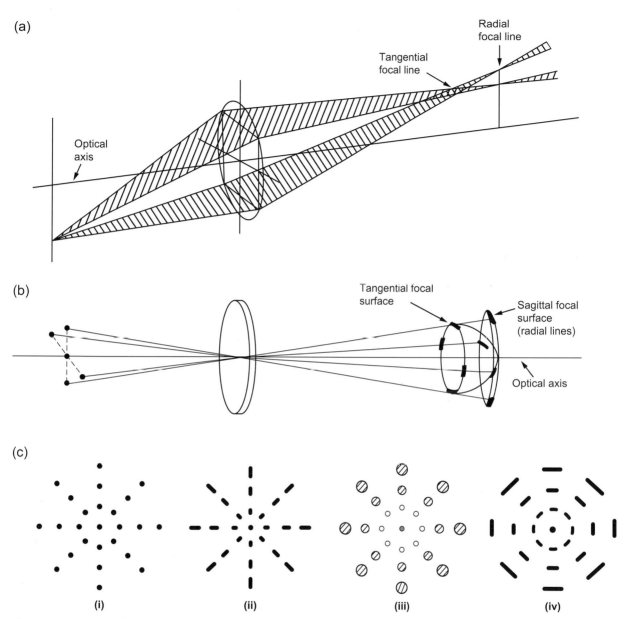

(a)

Radial focal line

Tangential focal line

Optical axis

(b)

Tangential focal surface

Sagittal focal surface (radial lines)

Optical axis

(c)

(i) (ii) (iii) (iv)

Figure 10.5 Astigmatism and its effects. (a) Geometry of an astigmatic image-forming system such as a simple lens. (b) Astigmatic surfaces for radial and tangential foci. (c) Appearance of images of point objects on the astigmatic surfaces: (i) object plane; (ii) sagittal focal surface; (iii) surface containing discs of least confusion; (iv) tangential focal surface.

aperture ('rapidity'). A truly distortion-free lens is termed *orthoscopic*. The geometrical accuracy of the image given by a lens is sometimes referred to as its 'drawing'.

Lenses of highly asymmetrical configuration, such as *telephoto* and *retrofocus* lenses, are prone to residual distortions; telephoto lenses may show pincushion distortion and retrofocus lenses barrel distortion. The effect is more serious in the latter case, as these are used for wide-angle work, where distortion is more noticeable. Zoom lenses tend to show pincushion distortion at long-focus settings and barrel distortion at short-focus settings, but individual performance must be determined by the user. General-purpose lenses usually have about 1% distortion measured as a displacement error, acceptable in practice. Wide-angle lenses for architectural work must have less than this. The use of aspheric lens surfaces may help reduce distortion.

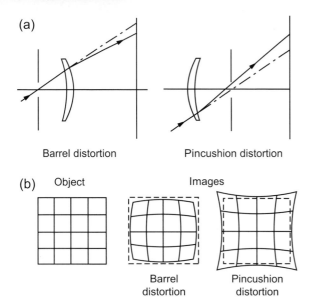

Figure 10.6 The effects of curvilinear distortion. (a) The selection of a geometrically incorrect ray bundle by asymmetric location of the aperture stop. (b) Image shape changes caused by barrel and pincushion distortion.

Lens aperture and performance

As the aperture is progressively closed down, residual aberrations (except for lateral chromatic aberration and distortion) are reduced, but the effects of diffraction (see Chapters 2 and 6) are increased. At large apertures the effects of diffraction are small, but uncorrected higher aberrations reduce the theoretical performance. The balance between the decreasing aberrations and the increasing diffraction effects on stopping down (see Chapter 2) the lens means that such *aberration-limited lenses* have an *optimum aperture* for best results, often about three stops closed down from maximum aperture. Most lenses, especially those of large aperture, do not stop down very far, $f/16$ or $f/22$ being the usual minimum values, and diffraction effects may not be noticed; the only practical effect observed may be the increase in depth of field. With wide-angle lenses in particular, a variation in performance at different apertures is to be expected, owing to the effect of residual oblique aberrations. Here it may be an advantage to use a small stop (similarly for zoom lenses). For close-up photography, photomacrography and enlarging, the value of $N' = v/d$ (Chapter 6) is much greater than the f-number of the lens, and the effects of diffraction are correspondingly greater than when the same lens is used for distant subjects. In these circumstances the lens should therefore be used at the largest aperture that will give an overall sharp image.

PHOTOGRAPHIC LENSES

Photography uses a variety of general-purpose and specialist lenses whose primary function is to form an image of sufficient image illumination, resolution and accuracy suited to the camera format and application. Selection of a suitable lens is facilitated by knowledge of imaging requirements and lens limitations related to catalogued properties.

Many lenses are adaptable for a variety of uses; some have restraints on their operating conditions and others are application specific. Photographic lenses are multi-element types and this *optical unit* is usually in a focusing mount or uses internal focusing, often integrated with an autofocus system. An automated iris diaphragm is incorporated and often a leaf shutter too. A checklist of relevant properties includes the following:

- *Focal length.* The (effective) focal length (EFL) (f) of the lens determines the image size from a given viewpoint and also the physical size of the lens. The EFL may be fixed as in a *prime lens*, or variable as in a *zoom* or *varifocal lens* (including internal focusing types). The marked EFL is nominal and exact values are determined by calibration.

- *Aperture.* Light transmission by a lens depends upon the *aperture stop* and is calibrated either as an *f-number* (N) or a *T-number* (*T-no*) or perhaps as *numerical aperture* (NA). For a lens with entrance pupil diameter E_N and transmittance T, we have:

$$N = (\text{EFL})/E_N \qquad (10.1)$$

$$T - \text{no} = N/\sqrt{T} \qquad (10.2)$$

$$N \approx 1/2(\text{NA}) \qquad (10.3)$$

Maximum aperture is of some importance, but values better than $f/2$ or $f/2.8$ depending on EFL are achieved at considerable cost and even then may be a compromise as imagery degrades, being aberration limited rather than theoretical diffraction limited. Zoom lenses have modest maximum apertures. Minimum aperture may be important for considerations such as *depth of field* (DOF). Aperture range is used to control exposure and is usually more limited than shutter speed range. Choice of *optimum aperture* is a compromise between optical performance and DOF obtained.

- *Angular field of view* (FOV). The *film gate* or active sensor dimensions in a camera act as the *field stop* and together with EFL or image conjugate (v) determine the FOV obtained, which provides an unambiguous method of classifying the lens for this format into a type such as wide-angle, standard or long-focus. Taking a format

dimension K (horizontal, vertical or diagonal distance) and semi-field angle θ:

$$\text{FOV} = 2\theta = 2\tan^{-1}(K/2f) \qquad (10.4)$$

For marketing purposes, the diagonal FOV is quoted, being the largest value, but the *horizontal FOV* is of more practical use. Note that a lens of EFL 50 mm related to format and FOV may be either a wide-angle or standard or even long-focus category. A standard lens has EFL $\approx K$ (diagonal) or $\approx 2K$ for cine and video.

- *Covering power.* Irrespective of aperture stop shape, a lens gives an *image circle* containing detail. The diameter of this circle or *covering power* is determined by lens design and any vignetting from optical and mechanical causes. Normally the diameter must circumscribe or be greater than the format diagonal, otherwise vignetting occurs. For use of camera movements, *extra covering power* is needed. Covering power is minimum at infinity focus and maximum aperture, but increases at reduced aperture and close focus.

- *Focusing range.* The focusing range of mounted lenses is usually from infinity to a subject distance (u) giving a magnification of 0.1−0.2. Optical performance usually deteriorates with decrease in u, unless it is a macro type with suitable correction. Fixed focus lenses are used for simplicity with focus set on the hyperfocal distance.

- *Spectral transmission.* Most lenses have broad-band transmission in the visible and IR regions and little in the UV, depending on the optical materials and lens coatings used. Families of lenses have matched transmissions to give a constant colour rendering irrespective of lens configuration. Colour filters may be used either to 'fine-tune' results or isolate transmission bands or improve resolving power (RP, Chapter 24). Lenses for use in the UV or IR use materials such as silica and fluorite or germanium respectively.

- *Chromatic correction.* Lenses may have residual amounts of lateral and transverse chromatic aberration depending upon the type and level of chromatic correction. Residual lateral chromatic aberration or *secondary spectrum* is illustrated by a graph of focus shift against wavelength (see Chapter 6). Achromatizing a lens is for two chosen wavelengths and depends on application. Visual and photographic corrections use the C and F spectral lines. A reduced *tertiary spectrum* is given by use of ED glasses and fluorite elements in apochromatic lenses or by high-index glasses in *ultra-achromatic lenses*. Special lenses to give high RP are best used with monochromatic light.

- *Residual curvilinear distortion.* Two varieties, termed *barrel* and *pincushion*, are detectable as shape changes in images otherwise highly corrected to be sharp, stigmatic and planar. Stopping down the lens to its optimum aperture has no effect. Distortion worsens off-axis and with focused distance. The prime cause is the position of the aperture stop and a symmetrical lens configuration greatly reduces distortion. A fish-eye lens is exceptional in that it deliberately retains excessive barrel distortion to improve peripheral illumination (Chapter 6).

- *Image contrast.* Apart from the inherent value of image contrast that varies with spatial frequency as a consequence of lens design, residual aberrations and diffraction, a lens may suffer reduced contrast due to its construction, the presence of flare and inefficiency of anti-reflection coatings as well as environmental factors.

- *Lens type.* Lenses may be classified by their type of configuration as well as FOV and EFL. Alternative configurations of the additional elements used downstream from the first one for aberration correction also give useful properties such as compactness, a long back focal distance (BFD) or freedom from distortion.

PHOTOGRAPHIC LENS TYPES

Simple lenses

A *simple lens*, i.e. a one-element type with spherical surfaces, has all of the primary aberrations. Chromatic aberrations, spherical aberration, coma, astigmatism and curvature of field all combine to give poor image quality, while distortion leads to misshapen images. Image quality is decidedly poor. But aberrations can be partially reduced by choice of suitable curvatures for the two surfaces and by location of an aperture stop. If, in addition, the subject field covered is restricted, it is possible to obtain image quality that is acceptable for some purposes, especially for *simple cameras* and *single-use cameras*.

A simple, positive, biconvex lens is shown in Figure 10.7. Performance is improved by modification to give *derivatives* by alteration of curvatures, the use of other glasses and adding corrective elements. This *compounding* and *splitting* distributes the power and correction among more elements.

Compound lenses

The performance of a single-element lens is limited by the available number of *optical variables* or *degrees of freedom*. In particular, there are only two surfaces. Using two elements to give a *doublet lens* provides three or four surfaces instead of two over which to spread the total refraction. Different types of glass can be used for the elements, their spacing can be varied or they can be cemented in contact. More elements increase the possibilities. A *triplet lens* of three air-spaced elements can satisfactorily be corrected for the seven primary aberrations for a modest aperture and field of view.

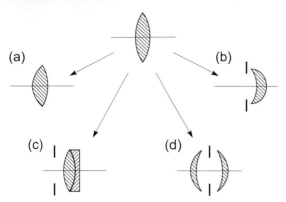

Figure 10.7 Derivatives from a simple biconvex lens to give improved performance. (a) Aspheric front surface. (b) Changing to meniscus shape and positioning a stop in front. (c) 'Compounding' with another element of a different glass into an achromatic doublet. (d) 'Splitting' to give a doublet symmetrical lens.

Five to eight elements give highly corrected, large-aperture lenses. Zoom lenses require more elements to give a suitable performance, and up to a dozen or more may be used.

Such *compound lenses*, i.e. multi-element, were progressively developed to give better image quality, larger apertures and greater covering power than those of simple lenses. The general principle is to balance aberrations from one element with equal but opposite values in another element 'downstream' in the configuration. Full correction is not usually feasible, just reduction to acceptable levels. Compromises have to be made with a lens intended for general-purpose use. If, however, maximum correction is desired in a lens designed with one particular use in mind, and which will therefore be employed only under a fixed set of conditions (say, always at full aperture, or at one magnification, or with monochromatic light), then improved performance is possible under these conditions at the expense of performance under other conditions for which the lens is not intended.

Photographic lenses use a few basic types of *configuration* or arrangements of individual elements, as shown in Figure 10.8. Only the simplest form of each is shown. Practical designs usually have many more elements for the control of aberrations.

Development of the photographic lens

Lenses are categorized related to nineteenth-century lens design. By the beginning of the twentieth century, lenses were available (albeit of modest aperture and field angle) which were virtually fully corrected for all the primary lens aberrations. The configurations of some early lenses are shown in Figure 10.9. By convention in such diagrams, light enters from the left. Recent progress has largely been dependent on the availability of improved optical materials, lens-coating techniques, computer-assisted calculations, advances in lens production technology, and more appropriate means of lens testing and evaluation.

Simple lenses and achromats

The year 1839 marked the beginning of practical photography. The use of lenses prior to this date was for for spectacles, telescopes, microscopes and the camera obscura. The *landscape lens* as used in the camera obscura was adapted for use in early cameras in meniscus form with a front stop. Wollaston had shown in 1812 that a flatter field plus reduced coma and astigmatism were given by this arrangement. Such lenses were used in box cameras and now in single-use cameras. In 1757 Dollond produced an achromatic doublet telescope lens and this was later adopted for landscape lenses for photography. Because of uncorrected off-axis aberrations, such lenses could only be used at small apertures and fields. Maximum apertures seldom exceeded $f/14$.

The Petzval lens

Simple lenses were inconveniently slow for portraiture with the insensitive plates of the period, and active efforts were made to design a lens of large aperture; the principles were already well understood, but lack of suitable optical glasses was a problem. In 1840 J. Petzval designed a lens of aperture $f/3.7$ using two separated, dissimilar achromatic doublets. This was the first lens to be computed specifically for photography. It had about 15 times the transmission of other contemporary designs. Some residual uncorrected aberrations, particularly astigmatism, caused poor peripheral definition, but this was found particularly pleasing for portraiture, giving a characteristic softness and vignetting. The restricted field of good sharpness needed a longer focal length than normal to cover a given format. The consequent need for a more distant viewpoint helped improve perspective in portraiture. This design is still the basis of many long-focus, large-aperture systems, especially projection lenses.

Symmetrical doublets

Landscape lenses did not improve until the 1860s, when lenses of good definition, flat field and moderate aperture became available as in the Steinheil Periskop lens of 1865, which used two meniscus components placed symmetrically about a central stop. The significance of symmetrical or near-symmetrical construction is that it permits almost complete correction of coma, lateral chromatic aberration and distortion. This non-achromatic

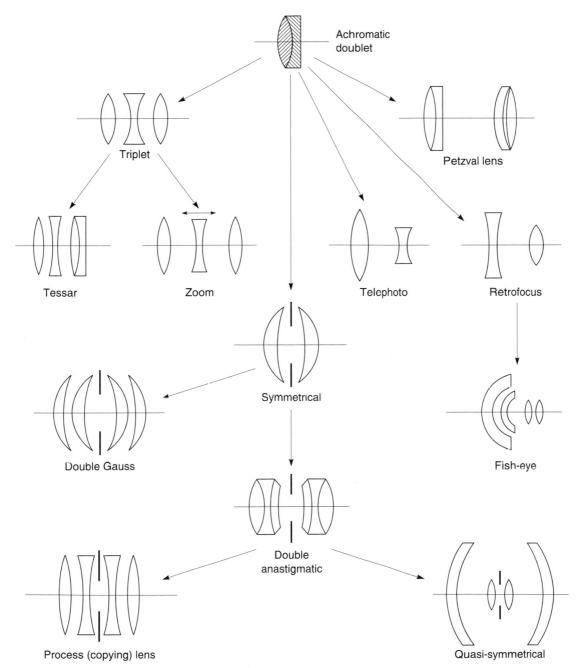

Figure 10.8 The basic achromatic doublet lens may be further split and compounded in various ways to provide the basic types of photographic lenses.

lens was soon superseded in 1866 by the introduction of two independent designs: the Rapid Rectilinear by Dallmeyer and the Aplanat of Steinheil, in which the meniscus lenses were replaced by achromatic combinations. Maximum aperture was around $f/8$, but astigmatism was still uncorrected.

Anastigmats

Originally, astigmatism and field curvature could not be corrected together with other aberrations, as the dispersion of available glasses increased more or less proportionally with refractive index. However, pioneer work by Abbe and

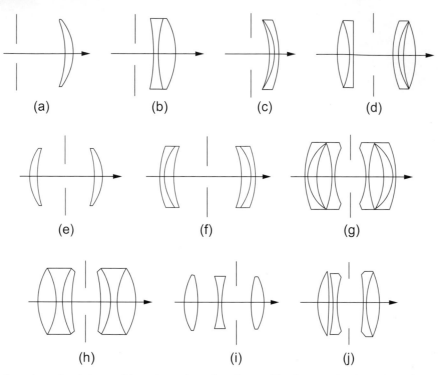

Figure 10.9 Configurations of early lenses. (a) Landscape lens of Wollaston. (b) Achromatic landscape lens of Chevalier. (c) Grubb's landscape lens. (d) Petzval portrait lens. (e) Steinheil's Periskop lens. (f) Rapid Rectilinear lens. (g) Zeiss Double Protar lens. (h) Goerz Dagor lens. (i) Cooke triplet lens. (j) Zeiss Tessar lens.

Schott in the 1880s produced new types of optical glass. Use of these resulted in the first *anastigmatic lenses*. Symmetrical construction was used, with components using a multiple cemented combination of old and new glass types, with maximum aperture up to about $f/6.8$.

Triplets

The complexity of early anastigmat lenses meant high manufacturing costs. In 1893 the Cooke Triplet lens was introduced. This used only three single separated elements having simplicity of construction, while giving sufficient variables for full correction. Then by splitting and/or compounding the three elements, various *triplet derivatives* were produced. The Zeiss Tessar lens of 1902, and in production ever since, is one of the best known of these.

Double-Gauss lenses

A major disadvantage of symmetrical construction is the inability to correct additional aberrations, particularly higher-order spherical aberration; this limits maximum apertures to about $f/5.6$. Triplet construction has a limit of about $f/2.8$. To obtain useful maximum apertures of $f/2$ or better, a derivative of a symmetrical design was adopted

based on an achromatic telescope doublet due to Gauss. This doublet was air-spaced with deeply curved surfaces concave to the subject. Two such doublets, both concave to a central stop, give the *double-Gauss* form of lens. Derivatives with up to seven elements have useful apertures up to $f/1.2$.

MODERN CAMERA LENSES

Camera lenses of fixed focal length ('prime' lenses) are based on triplet designs for the lower priced, moderate aperture varieties and double-Gauss designs for larger apertures. Symmetrical design is used for lenses for large-format cameras, for copying lenses and for some types of wide-angle lens. Complex and highly asymmetric designs are used for zoom, telephoto, retrofocus and 'fish-eye' lenses. A selection of typical configurations is shown in Figure 10.10. Different in concept, and used only for long-focus lenses, the 'mirror lens' employs reflecting surfaces both as the primary means of image formation and to fold the light path for compactness.

The *standard lens* for a camera is one whose (fixed) focal length approximates to the length of the diagonal of the image format or photoplane. Such lenses are highly

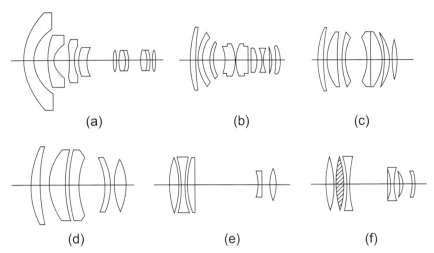

Figure 10.10 Configurations of representative lenses. (a) 8 mm fish-eye. (b) 24 mm retrofocus wide-angle. (c) 50 mm $f/1.4$ double-Gauss derivative. (d) 105 mm $f/1.8$ double-Gauss derivative. (e) 200 mm $f/4$ telephoto. (f) 400 mm $f/2.8$ super-telephoto with ED glass element (hatched).

developed, with large usable apertures and excellent performance over their field. However, they cannot meet all needs, particularly for large angular fields in cramped surroundings, or long-distance shots of inaccessible subjects. Then the use of wide-angle or long-focus lenses respectively is necessary. Also, where there is a need for a big close-up of a subject, a 'macro' lens is preferable. These alternative lenses also have a number of distinct design types, the results of intensive development work, aided by a number of interrelated advances in optical production technology such as aspheric and floating elements and anti-reflection coatings. Groups of moving elements were first used in zoom lenses to change focal length, and now 'floating elements' that move axially can correct for spherical aberration and retain performance at close object distances. This feature is particularly useful in macro lenses and wide-angle lenses of large aperture. The technique is commonly used for 'internal focusing' in a range of lenses from auto-focus (AF) types to super-telephotos, giving a means of rapid focus change with little mechanical movement and allowing the lens barrel to be sealed against the environment.

An example of improvements in just one class of lens is given by the wide-angle lens. The old problems of poor covering power, low marginal resolution, small usable apertures and flare have been overcome. Typically, for the 24×36 mm film or sensor format, 15 mm $f/3.5$, 24 mm $f/2$, 24 mm $f/3.5$ perspective-control and 35 mm $f/1.4$ lenses are commonly available, all in retrofocus configurations. The 60×60 mm film format has available lenses of 30–50 mm focal length and aperture $f/4$ to $f/2.8$. Large formats also have wide-angle lenses with usable apertures of $f/5.6$ to $f/4$ and sufficient covering power to permit limited use of camera movements.

By far the most popular type of lens, the *zoom lens*, has been much improved with many interesting design variants. Short-range zoom lenses have largely replaced the 'standard' lens for general-purpose cameras.

The *macro lens*, which is specifically designed and corrected for close-up work, now has an excellent all-round performance and a maximum aperture of $f/2$, its versatility making it a contender to the traditional standard lens.

WIDE-ANGLE LENSES

Wide-angle lenses, i.e. lenses where the focal length is less than the diagonal of the 35 mm film format, originate from early symmetrical film types. These were limited in practice by severely restricted covering power, owing to the $\cos^4\theta$ law, fall-off in marginal resolution, and small useful apertures (typically about $f/22$). Today, with digital sensor sizes often smaller than the 35 mm film frame, they come with even shorter focal lengths than wide angle lenses built for SLR 35 mm cameras.

Symmetrical-derivative lenses

Forms of quasi-symmetrical or near-symmetrical configuration give improved evenness of illumination and better image quality, as well as larger apertures up to about $f/2.8$. The symmetry means that correction for curvilinear distortion is particularly good. These symmetrical derivatives use very large negative meniscus lenses either side of the small central positive groups, giving the lens a characteristic 'wasp-waisted' appearance and increasing its bulk.

Such lenses, used on technical cameras, allow full use of camera movements, depending on focal length and covering power. The ability to use the rising-front movement is particularly valued. Unfortunately, just like the simpler symmetrical form, such lenses have a very short *back focal distance* (BFD) with the rear element very close to the film plane, so any form of reflex viewing and focusing is impossible; when this is necessary, lenses of *retrofocus* configuration must be used instead. Note that for compact cameras, a 'telephoto wide-angle configuration' is used to give as short a BFD as possible.

Retrofocus lenses

Departing from the symmetrical form of construction by using a front divergent (negative) group with a rear convergent (positive) group of elements results in a lens that has a short focal length in relation to its BFD, caused by a shift in the positions of the nodal planes (Figure 10.11). As this arrangement is the opposite of the telephoto construction, it is often described as a *reverse* or *inverted telephoto* configuration.

The asymmetry of this design can cause some barrel distortion. The long BFD allows devices such as reflex mirrors, shutters and beamsplitters to be located between the lens and film plane. The disadvantages are increased complexity of construction and the associated extra cost, bulk and weight.

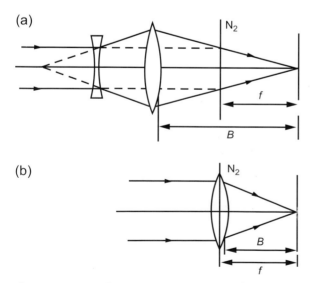

Figure 10.11 Retrofocus construction. (a) A retrofocus combination of front negative lens and rear positive lens resulting in back focal distance *B* being much greater than focal length *f*. (b) An equivalent short-focus lens where *B* and *f* are similar.

Fish-eye lenses

The geometry of image formation and image photometry limit the field of view of a distortion-free lens to about $120°$. However, if barrel distortion is permissible, a lens covering angles of view of $180°$ and even more is possible. Retrofocus configuration allows use of such lens systems in single-lens reflex cameras. These lenses are called *fish-eye lenses*, and are available in two versions. The *quasi-fish-eye lens* has a circle of illumination that circumscribes the film format and gives a $180°$ angle of view across the diagonal. The *true fish-eye lens* has its circular image wholly within the film frame, thus recording more of the scene. The diameter of the image circle depends on the focal length of the lens.

A different form of image projection is used for image formation. A conventional photographic lens of focal length f and semi-field angle θ forms images by *central projection*, where the distance (y) of an image point from the optical axis of the lens is given by the relationship $y = f\tan\theta$. Most fish-eye lenses use *equidistant projection*, where $y = f\theta$ when θ is measured in radians. Such lenses have many technical applications.

LONG-FOCUS LENSES

Long-focus designs

A long-focus lens is a lens whose focal length is greater than the diagonal of the format in use. As image size is proportional to focal length, an increase in focal length gives a bigger image. Lens configurations of achromat, Petzval, symmetrical and double-Gauss have all been used, depending on the maximum aperture and focal length required. Very-long-focus lenses of small aperture can be of simple construction, possibly just achromatic doublets. There are practical problems associated with long-focus lenses. Conventional refracting (dioptric) lens design is limited by the diameter of available glass blanks (some 150 mm) and by the degrading effects of lateral chromatic aberration as focal length increases. Also, the length and weight of such lens systems pose problems in design and handling. Internal reflections from the long lens barrel may cause flare. The use of telephoto construction and mirror optics reduces some of the problems of excessive length and lateral chromatic aberration. Refracting elements made from fluorite or special extra-low-dispersion glass can greatly improve colour correction.

Telephoto lenses

By placing a negative lens group behind a positive one, the transmitted light is made less convergent, as though it had been formed by a lens of much greater focal length; the nodal planes are now in front of the lens (Figure 10.12).

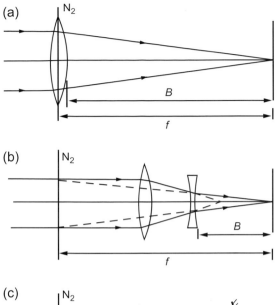

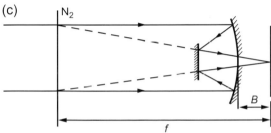

Figure 10.12 Telephoto construction. (a) A long-focus lens where the back focal distance B is similar to the focal length f as measured from the rear nodal point N_2 to film plane F. (b) An equivalent design using a front positive lens and a rear negative lens in a telephoto combination so that B is much less than f. (c) Another equivalent design using two optical reflecting surfaces to give a mirror lens, where B is very much less than f.

The length of the lens barrel can be much less than is needed for a conventional lens of similar long focal length.

Using this idea, early *telephoto attachments*, the precursors of the modern *teleconverter*, were placed behind normal lenses to give a variety of increased focal lengths with relatively short camera extensions. The resultant combinations had small apertures, and performance was poor. Such systems were replaced by *telephoto lenses*, which are fully corrected and can have large apertures. Any residual pincushion distortion is due to the asymmetric construction.

Cameras using telephoto lenses are easier to handle, and less prone to camera shake, than those equipped with a long-focus lens of conventional design, as the camera is better balanced and lighter. The use of optical materials such as extra-low-dispersion (ED) glass and fluorite give a class of lens called *super-telephoto*. These have focal lengths of 200–1200 mm with the exceptionally large apertures of $f/2$ to $f/2.8$ in the shorter focal lengths and $f/4$ to $f/5.6$ in the longer focal lengths. Such lenses are state-of-the-art designs using multi-coatings, internal focusing and anti-flare construction. They are costly but are exceptionally easy to use hand held, with applications in sport, natural history and surveillance work. Apart from the ease of focusing and the capability of using slower films/ISO setting or short exposure times, an advantage of the large aperture is that the use of suitably matched teleconverters gives very-long-focus lenses that still have a usefully large aperture. For example, a 300 mm $f/2.8$ camera lens can be converted into a 450 mm $f/4$ or a 600 mm $f/5.6$ lens by the use of ×1.5 and ×2 teleconverters respectively.

Catadioptric lenses ('mirror lenses')

The advantage of real image formation using a concave mirror rather than a convex lens is that there is no chromatic dispersion. The Cassegrainian double-mirror system is preferred that uses a secondary mirror to reflect the image out through a hole in the primary mirror. For photographic purposes a paraboloid mirror is not suitable due to cost and small field angles. A spherical mirror gives a larger field but the image suffers from both SA and curvature of field.

Residual SA is corrected using different optical modifications (Figure 10.13). An aspheric *Schmidt corrector plate* at the centre of curvature of the spherical mirror is used for large-aperture, wide-field astronomical cameras, but is very expensive to manufacture. Cheaper alternatives for photography are to use either a *Mangin mirror*, which has the reflecting surface coated on to the rear surface of a thin refracting correcting element, or alternatively to use large, thick refracting elements that are concentric with the spherical prime mirror. This latter approach was pioneered independently by Bouwers in Holland and Maksutov in Russia during World War II. The introduction of refracting elements constitutes a *cataioptric design*. A *dioptric system* is a system consisting of transmitting and refracting elements, i.e. lenses, whereas a *catoptric system* consists only of reflective elements, i.e. optical mirrors. The refracting elements need to be achromatized and their power chosen so as to give a flat field. They are positioned to seal the barrel and provide a support for the secondary mirror. Flare is a serious problem, so baffling and other anti-flare measures are essential.

Because of the central obstruction caused by the secondary mirror, the transmission of the lens cannot be controlled by an iris diaphragm. Mirror lenses are available with focal lengths in the range of 300 mm to more than 2000 mm and with apertures from $f/5.6$ to $f/11$. The compact design with its short length and large diameter compares favourably with equivalent long-focus or telephoto constructions. A useful feature of mirror lenses is their ability to focus close. Typically, an axial movement of

Figure 10.13 Mirror lens designs. (a) Simple spherical mirror with spherical aberration at the focus. (b) Cassegrainian construction with secondary reflector. (c) Bouwers–Maksutov design. (d) Mangin mirror design.

a few millimetres of the secondary mirror will focus a 500 mm lens from infinity to a magnification of some 0.25. A characteristic feature of a mirror lens is the 'ring doughnut' shape of out-of-focus highlights due to the annular shape of the entrance pupil.

ZOOM AND VARIFOCAL LENSES

Zoom lenses

A *zoom lens* is one whose focal length can be varied continuously between fixed limits while the image stays in acceptably sharp focus. The visual effect in the viewfinder is that of a smaller or a larger image as the focal length is decreased or increased respectively. The *zoom ratio* is the ratio of the longest to the shortest focal length — for example, a 70–210 mm zoom lens has a zoom ratio of 3:1. For 35 mm still photography, zoom ratios of about 2:1 up to 10:1 are available. For digital photography, where formats are much smaller, zoom ratios of 10:1 or 20:1 are common, further increased by digital methods to perhaps 100:1 with concomitant loss of image quality (see Chapter 14).

The EFL of a multi-element lens depends on the focal lengths of individual elements and their axial separations. An axial movement of one element will therefore change the focal length of the combination. This gives a primitive *zoom lens* or strictly a *varifocal lens*, as is used for a slide projector. The simplest possible arrangement is a front negative lens plus rear positive lens; reducing their separation increases the equivalent focal length.

A simple zoom lens has an aberrated image and does not retain sharp focus while being 'zoomed'. Both problems require additional lens elements and in practice any number between four and 20 may be needed. A sharply focused image is retained while zooming by a process of *compensation*, provided, for example, by another element moving in conjunction with the zoom element. Two types of compensation are used: *optical*, where the moving elements or groups are coupled and move together; and *mechanical*, where the groups move independently at different rates, sometimes in different directions (Figure 10.14). Optical compensation was used originally but mechanical compensation is preferred as higher levels of correction are possible. The moving groups can follow non-linear paths, so that as the zoom control is operated the elements may advance and recede at different rates. Some zoom lenses use three to five moving groups, with a mixture of both optical and mechanical compensation.

The classic design of zoom lens used an arrangement of four groups of elements. Two linked movable zoom groups are located between a movable front group (used to focus the lens) and a fixed rear group that also contains the iris

Aspherical lens

Focus

Figure 10.14 Configuration of a wide-angle zoom lens design (17−35 mm f/2.8−4) with mechanical compensation using three moving groups. Two aspherical elements and internal focusing are incorporated.

diaphragm. This rear group is positive and acts as a relay lens to produce an image in the film plane from the zoom groups, which behave as an afocal telescope of variable power. This system also keeps the f-number constant as focal length is altered, by controlling the size and location of the exit pupil of the system. This 'fixed-group' feature means that a separate mechanical control to adjust the iris according to focal length is not required. Close focusing (i.e. nearer than 1−2 metres) is also possible. For example, a separate *macro-zoom control* uses and rearranges the zoom groups so that for a particular focal length one group is moved to give a form of internal focusing over a limited close-up range with the prime focus control set at infinity focus. (In practice, there may be a gap between normal close focus and the far point of the close-up range so an achromatic close-up lens is required.) An advantage of this system is that the f-number stays almost constant over the close-up range, which is not the case with a conventional macro lens.

Not all 'macro' zoom lenses offer a genuine 1:1 image scale; the term 'macro' has become devalued and is often just used to mean a close-focus capability. A *tele-zoom lens* may now be no larger than an equivalent fixed-focal-length lens of the longest focal length it replaces. The use of ED glass elements and aspheric surfaces provides even more correction and compactness.

Zoom lenses include wide-angle-to-standard lenses for SLR cameras with 35 mm film or sensor format, such as 20−35, 24−70 and 28−85 mm, and their equivalents for digital cameras with smaller sensors. Continuous close focusing is possible with a single focus control, by movement of all or part of the lens groups, making separate macro modes obsolescent. The internal focusing may be under the control of an in-camera autofocus system, and the lens contains suitable electronics to relay data back into the central processing unit of the camera.

A penalty of mechanical compensation is that the f-number changes with focal length, typically giving a loss of one-half to one full stop from minimum to maximum focal length. This may be acceptable in order to keep the size of a zoom lens to within reasonable limits. Some lenses do have additional mechanical control of the iris to keep the f-number approximately constant while zooming. Today all cameras now have through-the-lens (TTL) metering, which will correct for changes in effective f-number. The modern zoom lens is very much a viewfinder-oriented lens in that it carries little information on its controls as to focus setting, focal length and depth of field. The distortion correction of zoom lenses is now also much improved, and image quality may approach that of a fixed-focal-length lens.

The trend is to use a zoom lens as a replacement for a set of fixed-focal-length (prime) lenses. Cameras with zoom lenses but no reflex viewing system use a complex coupled direct viewfinder system which is also a miniature zoom lens corrected for visual use. Only an approximate indication of the subject area is given with total reliance upon an autofocus system. Digital cameras can use similar systems but also may provide useful direct viewing of focus and field of view by means of an LCD viewing screen.

For general-purpose photography, the zoom lens is a very useful tool. One lens, say of 28−105 mm and f/2.8−4 specifications with close-focus capability to an image magnification of 0.25, can perform adequately for most purposes, especially if medium apertures can be used. Zoom lenses are still of modest maximum aperture, some f/2.8 at most, and the double-Gauss type of lens with aperture f/2 to f/1.4 is still useful for some low-light photographic tasks, as is the super-telephoto lens. A selection of zoom lens configurations is shown in Figure 10.15.

In a *varifocal lens* there is no attempt to hold the focus constant when the focal length is changed. This makes for a simpler and cheaper design, especially where a constant focal plane has little or no advantage, as in slide and movie projectors. To offset the slight inconvenience of having to refocus the lens when the focal length (i.e. the projected

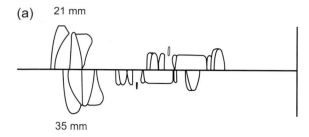

(a) 21 mm

35 mm

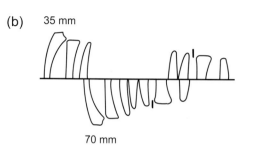

(b) 35 mm

70 mm

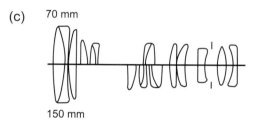

(c) 70 mm

150 mm

Figure 10.15 Typical zoom lens configurations. The various groups of elements alter their relative positions in various ways to change focal length. (a) All the elements in three groups move between the extremes shown to give 21−35 mm. The iris also shifts. (b) All the elements move in two groups with the iris to give 35−70 mm. (c) Two groups move to give 70−150 mm, the iris remaining static. In focusing, the whole lens is moved axially.

image size) is changed, it is possible to produce very good correction with comparatively few glass elements. This type is especially useful in autofocus cameras, where the focus is monitored and adjusted as necessary.

Zoom lenses for compact and digital cameras

Compact cameras use both the 135 and APS formats, while digital cameras use focal plane arrays of much smaller formats, typically from 2/3 to 1/4 inch diagonal. Apart from small formats, most of these cameras do not use reflex viewfinders but rely instead on separate optical viewfinders or LCD screens. Both factors influence lens design in that the rear element can be very close to the focal plane, and that a useful zoom range is possible with only a few

elements, especially if the maximum aperture is modest, perhaps *f*/4 at the most. The lens must also telescope down into the camera body for storage, to help keep the size of the camera small. For the 135 format, long-range zoom lenses of 38−200 mm are used, although the aperture reduces to some *f*/11 at the long-focus setting. The lenses are non-interchangeable and the collapsible telescoping barrel may cause some optical misalignment.

The basis of such compact designs was the Zeiss Biogon wide-angle lens, which has a very short *back focal distance* (BFD). From this was derived a *'telephoto wide-angle' lens* (see Figure 10.16a), a short-focus lens using both telephoto configuration to reduce its physical length and internal focusing to keep its external size constant. This led to compact zoom lenses by using a moving element or group to alter focal length (Figure 10.16b) and moving the lens to give unit focusing under autofocus control. By use of technology such as plastic elements and aspheric lens surfaces, as few as four elements could be used for a satisfactory zoom or varifocal lens with a 2:1 zoom ratio. The lenses may suffer from noticeable curvilinear distortion at

(a)

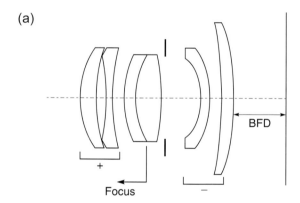

BFD

+

Focus

−

(b)

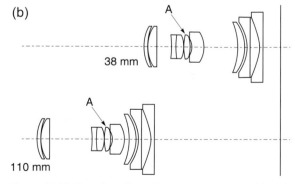

A

38 mm

A

110 mm

Figure 10.16 Zoom lens design for compact cameras. (a) Wide-angle telephoto configuration (35 mm *f*/2.8) as precursor to a zoom lens. (b) A 38−110 mm zoom design. Glass element A is aspherical.

both ends of the zoom range and possibly some vignetting. The modest apertures available limit the useful range of an integral flash and low-light-level use may cause camera shake due to the slow shutter speeds needed, unless a fast film of 400–800 ISO is habitually used. The lenses usually lack a filter thread to take accessories such as lens hoods, filters and converters.

Many digital cameras offer a 'digital zoom' feature. This is not an optical zoom using a lens, but uses a digital image processing routine to magnify a selected portion of the image frame stored as digital data (see Chapter 14). A bigger image is given by pixel interpolation (see Chapters 14 and 27) and too much 'zooming' causes unpleasant pixellation of the image.

MACRO LENSES

Design of a lens with good aberration correction requires the object conjugate distance to be specified. Most photography is of subjects at least 200 focal lengths away, so for convenience in design the object conjugate is taken as infinity. General-purpose lenses are therefore designed to give their best performance for distant subjects. The performance of such a lens will be less satisfactory when focused on a short distance, as in close-up work or photomacrography. Design features such as floating elements and aspheric surfaces may help in some cases, as can lens reversal rings, but it is preferable to use a lens optimized to produce a high-quality result when used for close-up work. Such a lens is known as a *macro lens*.

A macro lens has an extended focusing mount using a double helicoid arrangement. This gives enough extension to provide a magnification of 0.5, though many do give actual-size reproduction with $m = 1$ or more. A range from infinity to half-life-size is usually sufficient in practice, at least in the 24 × 36 mm format, and this keeps the focusing mount to a reasonable size. For the magnification range from 0.5 to 1.0, an extension tube can be added. Such a lens has full automation of the iris, and full aperture metering. Correction is optimized for a magnification of 0.1 (not infinity as discussed above) and the corrections hold well down through the close-up range to unit magnification. Thereafter, the lens is best used reversed, with possible consequent loss of the automatic features. The lens barrel may be engraved with scales of magnification and exposure correction factors: these are more useful when using manual electronic flash, as TTL metering systems automatically correct exposure at long extensions.

Macro lenses use a double-Gauss design computed to give a flat field and a distortion-free image essential for copying work. The maximum aperture can be $f/2$. For optimum results with distant subjects it is advisable to close down about two stops from maximum. Macro lenses often have focal lengths that are longer than normal; they are typically in the range 55–200 mm for a 24 × 36 mm format. Some are obtainable as just a *lens head*, an optical unit for attachment directly to an extension bellows so as to give an extended focusing range. Others have very short focal lengths of 12.5–50 mm to allow greater magnification with a modest bellows extension.

Autofocus macro lenses use complex arrangements of internal adjustments of elements to provide both focus and aberration correction. The use of ED glass, aspheric surfaces and floating elements is common, and a typical design may have 10 or more elements. A long-focus macro lens is a specialist lens but is favoured for the improved perspective it gives by virtue of its more distant viewpoint and the increased working distance from front element to subject. Internal focusing is convenient in a macro lens as there is then no need for a complex double-helical lens barrel extension system, but the effective focal length also changes continuously over a short range, so an indication of magnification to help calculate depth of field is useful. Internal focusing also means that the lens barrel does not rotate during focusing, useful with direction-sensitive devices such as polarizing filters.

OPTICAL ATTACHMENTS

A variety of optical attachments can be used in front of a camera lens. Like filters (see below), these are produced in a range of fittings and sizes, and are attached in a similar manner. Materials used range from high-quality anti-reflection coated optical glass to moulded plastics. Dependent on its function, the device may be transparent and non-selective, or it may absorb some wavelengths selectively.

Afocal converter lenses

These multiple-element optical systems are fitted in front of the lens and are generally used with non-interchangeable lenses to alter effective focal length. The term 'afocal' indicates that they have no focal length of their own, i.e. parallel light incident on the unit emerges parallel. Optically, they are related to the Galilean telescope, used either normally or in reverse mode in front of a camera lens. However, when such a converter is used with a camera lens, the effective focal length of the combination may be greater or less than that of the camera lens alone, depending on the orientation of the converter (Figure 10.17). The *telephoto converter* increases the focal length of the camera lens by factors of from ×1.5 to ×3 or even more, and the *wide-angle converter* decreases it by a factor of about ×0.7 ('wide-angle') or even ×0.5 to give a 'fish-eye converter'. Afocal converters were originally used with twin-lens reflex cameras but are now available for any types of camera that lack interchangeable lenses, particularly digital cameras.

191

(a)

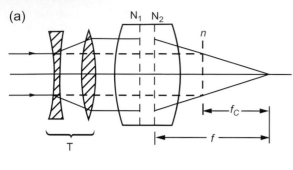

(b)

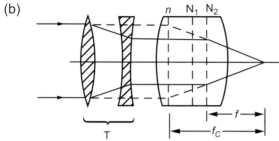

Figure 10.17 Afocal attachments. (a) Wide-angle attachment T. (b) Telephoto attachment T. Key: n, rear nodal plane of combination of focal length f_C; N_1 and N_2, nodal planes of prime lens of focal length f.

(a)

(b)

(c)

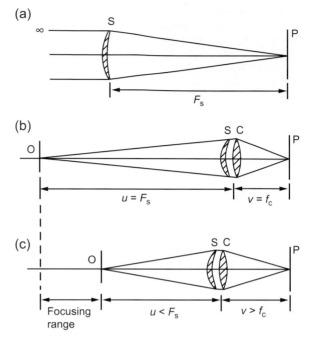

Figure 10.18 The close-up lens. (a) Positive meniscus close-up lens of focal length F_S. (b) Used with a camera lens C of focal length f_C, nearest close focus is at distance F_S. (c) Using the focusing extension of the camera lens to give a close-up focusing range.

Unless the converters are of high optical quality the results can be disappointing. Large apertures give poor resolution and small apertures produce vignetting. No change in the marked apertures of the camera lens is necessary and no exposure compensation is needed. Screen focusing is essential. With the telephoto converter the near focusing range is lost. Within their capabilities they are useful devices to give a modest change in focal length of a prime lens and consequent change in field of view.

Close-up (supplementary) lenses

Single-element lenses added in front of a camera lens will alter its focal length, a positive supplementary lens giving a reduction in focal length and a negative lens an increase. However, the most valuable use of such *supplementary lenses* is for close focusing, especially with cameras having a limited focusing capability. Focusing on a subject at a given (close) distance is possible by using a positive supplementary lens of focal length equal to the subject distance, irrespective of the focal length of the camera lens. The camera lens is then focused for infinity; the path of the rays is shown in Figure 10.18. This is the basis of *close-up* or *portrait attachments*. The focusing movement of the prime camera lens then provides a useful close-up focusing range.

Supplementary lenses are specified by their *power* in dioptres rather than focal length. The relationship between power (K) and focal length (f) is that a focal length of 1000 mm is a power of one dioptre (1 D), so $f = 1000/K$

(Chapter 6). The power of a convergent supplementary lens is positive and that of a divergent lens is negative. Specification of lenses by their power is convenient because in a combination the powers of the lenses are simply added to obtain the power of the combination.

Close-up lenses are available in a range of +0.25 to +10 dioptres. The weaker powers of 0.25 and 0.5 dioptres are used chiefly with long-focus lenses to improve their close-focusing capability. They do not seriously affect the corrections of the camera lens. Supplementary lenses are usually meniscus singlets which have only a small detrimental effect, especially at medium apertures. Some supplementary lenses are coated achromatic doublets, ideally designed for use with a specific camera lens, such as long-focus and long-range zoom types to provide an essential close-focus capability in the range from 0.5 to 2 metres, where often there is a 'focus gap'. The reduction in effective focal length and little change to the entrance pupil diameter mean that the effective aperture of the combination conveniently compensates for any necessary exposure increase for the change in magnification.

Other attachments

The use of a properly designed *lens hood* or *sunshade* with any lens will contribute significantly to image quality. The

lens is shielded from light outside the subject area, and flare is reduced, especially in back-lit and side-lit conditions. The usual shape is a truncated cone or box shape, allowing maximum depth for shading without causing vignetting. The internal finish is ridged and painted matt black. Owing to the danger of vignetting ('cut-off') by a lens hood, especially if a filter is also in use, many wide-angle lenses are not expected to be fitted with them; many such lenses are constructed with a recessed front component so that the front rim acts as a vestigial type of lens hood. Alternatively, a hood of cut-out 'petal' shape is used. As focal length increases, the need for an efficient hood becomes greater. Many long-focus lenses are supplied with an integral retractable hood. In the case of zoom lenses, the hood can only be of depth sufficient to avoid vignetting at the minimum focal length setting, even though the greatest need for a lens hood is at the maximum setting. Again, a hood can be of petal or flower shape to give some protection.

Various optical attachments and devices are available for effects produced in-camera rather than by later image manipulation, although most of the optical effects can be duplicated by digital image processing beginning with a 'straight' image. An optical *soft-focus effect* is given by the spreading of the highlights of a subject into adjacent areas. Special *portrait lenses* are available using controllable residual spherical aberration to give this effect, but these are expensive and limited in application. A *soft-focus attachment* is a cheap alternative for use with any lens. Two basic types of device are available, one having a number of concentric grooves in plain glass and the other having small regular or irregular deposits of refractive material about 1 μm thick, randomly scattered over a flat glass disc. The former type gives diffusion effects that depend on the aperture in use: the larger the aperture, the greater the diffusion. The latter type operates independently of lens aperture. The softening of the image results from the effects of scattering and refraction due to the presence of the attachment. Various degrees of diffusion are available and devices can be used in tandem or combination. Other devices use black or white netting of various mesh sizes encapsulated or laminated between clear plastic plates. These types give softening of the image and controllable reduction in image contrast with no effect on colour balance. Experimentation is necessary to obtain practical familiarity with predictable effects. Also available are devices termed 'haze effect' and 'fog effect' filters, which find particular application in landscape photography. This type of 'haze' filter is not to be confused with the UV-absorbing variety.

Teleconverters

These optical accessories are not photographic lenses since they do not form a real optical image on their own, only a virtual one as they are negative in refractive power.

However, these optical devices are in common use with interchangeable lenses. The astronomer Barlow reported in 1834 that placing a secondary negative lens *behind* a primary positive lens would increase effective focal length; indeed, this is the principle of the telephoto lens. These *teleconverter* or *multiplier lenses* use typically four to eight elements with a net negative effect, housed in a short extension tube fitted between the camera lens and body (Figure 10.19); linkages transmit the functions of automatic iris and focus and metering information. The effect of a teleconverter is typically to double or triple the focal length of the prime lens, forming a telephoto combination of short physical length. As the size of the entrance pupil is unaffected, this doubling or tripling means that the maximum aperture is reduced by two or three whole stops, turning, for example, a 100 mm $f/2.8$ lens into a 200 mm $f/5.6$ or a 300 mm $f/8$. Where these losses are unacceptable, a ×1.4 converter with only one stop loss may be preferred, especially where a long-focus lens is already in use. A highly corrected apochromatic *matched multiplier* may be supplied with a prime lens for this purpose.

The change to the marked apertures is usually automatically corrected for by the TTL metering system used in most

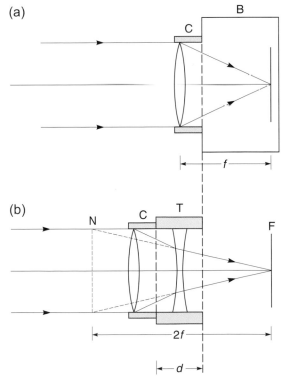

Figure 10.19 The teleconverter principle. (a) Camera lens C of focal length *f* in body B focuses light on to film F. (b) Addition of teleconverter T of thickness *d* gives rear nodal plane N and combined focal length 2*f*.

cameras, but must be remembered for use with manual, automatic and non-off-the-film electronic flash. The modest cost, small size and excellent results make tele-converters useful accessories. The minimum focusing distance of the camera lens is retained, with image magnification increased. Thus, a 90 mm $f/2.8$ macro lens focusing unaided to give 0.5 magnification, when used with a specially designed converter, will give a combination 180 mm $f/5.6$ lens focusing which gives unit magnification. Some manufacturers produce highly corrected converters designed especially for a particular lens or range of focal lengths; in such cases the performance is excellent. In general, teleconverters do not perform well with wide-angle lenses, as aberration correction may be affected adversely. It is pointless to convert a 24 mm lens into a 48 mm lens of mediocre performance when a good 50 mm standard lens may be available; on the other hand it is useful to be able to convert a 200 mm lens to 400 mm to save buying a heavy and expensive lens that may seldom be needed.

OPTICAL FILTERS

Absorption filters

An optical filter can be either a passive *absorption type* or an *interference type*. Their role is that of frequency filtering to remove unwanted spectral bands or lines otherwise transmitted by the optical system. Colour depends on the transmitted wavelengths and for absorption types is independent of orientation and angle of incidence. Filters are

characterized by their spectral transmission properties, presented in various ways (see Figure 10.20). Absorption filters tend to have broad-band characteristics, but 'narrow-cut' versions have reduced bandwidths. Any additional absorption in the UV or IR may be important. The designating alphanumerics of a filter often give an indication of the short-wavelength cut-off region, e.g. R64 and Y52 are red and yellow filters that transmit beyond 640 and 520 nm respectively.

For properly exposed results when using a filter, an increased camera exposure compensates for light absorption. The ratio of the filtered exposure to the unfiltered exposure is called the *filter factor* or *exposure factor*, expressed as a multiplying factor such as ×4 or as a negative EV such as −2EV. Filter factors depend on spectral absorption, spectral response of the detector and the exposure duration if film reciprocity law failure effects are significant. Cameras incorporating TTL exposure metering may compensate for certain filters such as pale coloured ones and neutral density (ND) types. Polarizing filters can also give problems for exposure metering if a beamsplitter is used in the TTL system; a circular polarizing filter is preferable (see Chapter 6).

The optical quality of a filter must be high if used in an imaging system, so as not to degrade performance, but can be of lesser quality if used in an illumination system. Optical quality is measured as flatness and parallelism of the filter surfaces. Multi-layer anti-reflection coating is desirable. Various forms of filter are available, including gelatin, cellulose acetate, polyester, solid glass, cemented types and interference types. The solid glass type offers only a restricted range of colours. Some filters, such as

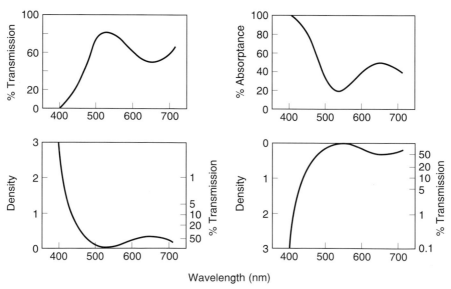

Figure 10.20 Methods of showing spectral absorption data for a colour filter. The four graphs show the same data for a pale green filter plotted in different ways to show the variations in curve shape given.

heat-absorbing and UV-transmitting types, are available only in glass form. Filters can be used in tandem such as for overall colour correction and local ND effects.

Gelatin filters are imbibition dyed and some 0.1 mm thick, giving almost no detectable degradation to optical systems, but are easily damaged. Polymer materials give intermediate optical quality and lightweight, unbreakable filters. A thickness of 2 mm is typical. The *optical resin* types are made from allyl diglycol carbonate. Filters should be anti-reflection coated where possible to reduce light losses.

Full discussions of the range and application of colour filters are given in the Bibliography below. For black-and-white photography, tonal reproduction may be altered by use of *correction filters* and *contrast filters*. The former are used to record subject colours in their true luminosities by partial absorption of spectral regions of the illuminant to suit the non-uniform spectral sensitization of panchromatic film materials. The latter control the tonal contrast in a print arising from colour contrast in the subject. An empirical rule is that a filter lightens subject colours of its own colour and darkens those of complementary colour. Haze penetration in telephotography is improved by orange or red filters, restricting photography to longer wavelengths which are scattered less.

Colour photography uses a wide range of filters to retain acceptable colour reproduction with variations of illuminant and exposure conditions. Colour materials are commonly balanced for illuminants of *colour temperature* (CT) 3200, 3400 or 5500 K, termed *white balance* in digital photography. For quasi-Plackian sources, *light-balancing* and *colour conversion filters* partially absorb specific spectral regions to match the illuminant to the photographic material. Their spectral effect is quantified by the *micro reciprocal degree* (mired) scale, where the mired value (MV) of an illuminant of colour temperature T in kelvin is given by:

$$MV = 10^6/T \qquad (10.5)$$

The mired shift value (MSV) of the filter required to convert a CT of T_1 into a value T_2 is given by:

$$MSV = (1/T_1 - 1/T_2) \times 10^6 \qquad (10.6)$$

Light-balancing filters are for small changes, while colour conversion ones are for large shifts. They are used mainly in film photography and are substituted by white balancing processes in digital cameras (Chapters 14 and 23). Another group, *colour-compensating filters*, have selective absorption in specific spectral regions and are used as *trimming filters* to offset colour imbalances such as those from optical systems, local colour effects and film reciprocity law failure behaviour.

UV and IR filters

Other filters have special or distinct functions. Some are colourless as their absorption lies outside the visible

spectrum; others are visually opaque, as their transmission lies outside the visible spectrum.

The sensitivity of photographic materials to scattered UV radiation and blue light causes a loss of contrast, and a blue cast with colour materials, increasing with increasing subject distance. In addition, the spectral transmission of different lenses, especially older designs, may vary for the UV region and give different colour balances in terms of 'warmth' of image. Use of *UV-absorbing* or *haze* filters gives a better match between lenses. An additional use is as a 'skylight filter' to reduce the effect of excessive scattered light from a blue sky. Such filters are usually colourless or a very pale pink or straw colour, depending on their cut-off for short wavelengths. Often the digits in a filter code number indicate this point, e.g. 39 denotes 390 nm. The use of a good-quality UV filter for mechanical protection of the lens surface is always useful.

For some specialist applications of photography, UV radiation is used as the illuminant. However, UV sources also emit visible light. Special opaque glass filters which transmit only in the near-UV region are used to block all visible radiation. Due to uncorrected 'chromatic' aberration between the UV and visible regions, a lens focus correction is usually needed unless a specially computed lens made with quartz and fluorite elements is used.

As well as visible light, all thermal sources emit much of their energy in the form of IR radiation. In an enclosed optical system such as an enlarger or slide projector, the negative or transparency in the gate must be protected from this unwanted radiation. Colour-print materials are sensitive to IR radiation, and its elimination from the image-forming light is therefore essential for correct colour reproduction. Colourless glass filters ('heat-absorbing glasses'), which transmit visible radiation but block IR radiation, are used for these purposes. They do not need to be of optical quality if they are mounted in the illumination system of an enlarger or projector. A mounting to hold the filter loosely is necessary to avoid cracking due to thermal expansion. Interference-type filters are also used. Usually such a filter transmits IR radiation and reflects visible light. Termed a *cold mirror*, the filter may usefully form an integral reflector of ellipsoidal shape for a tungsten—halogen light source.

Silicon, the photosensitive layer on CCD and CMOS sensors in digital cameras, has also an inherent sensitivity to IR. Digital cameras are equipped with IR blocking filters placed in front of the sensor to preserve colour rendition. Removing the IR filter is a possibility in some SLR cameras to allow IR photography. Infrared-sensitive film materials have an extended spectral response to some 950 nm as well as the usual sensitivity to visible light and UV radiation. Consequently, their use needs a special *infrared filter* opaque to both UV and visible radiation but transmitting in the IR region. Any filter factor must be determined empirically. These filters, which are almost opaque to visible light, are available in either gelatin or glass. Once more, due to uncorrected 'chromatic' aberration between the IR

and visible regions, a lens focus correction is usually needed unless a suitably corrected lens is used. This may be an apochromatic or superachromatic lens. Usually, the focus shift correction is by means of a supplementary index mark on the focusing scale of the lens, and the visually focused distance is transferred to this IR index. The lens is seldom chromatically corrected for the IR and the image may be characteristically 'soft' and 'hazy' due to this. Foliage appears very light in tone due to the high reflection of IR from chlorophyll in leaves.

Neutral-density filters

Neutral-density (ND) filters absorb all visible wavelengths to a more or less equal extent. They may be scattering or non-scattering. A filter for use in front of the camera lens must be non-scattering, but for other applications such as the attenuation of a beam of light, the scattering type can be used. Optical quality ND filters are made by dispersing colloidal carbon in gelatin. The addition of dyes with the necessary spectral absorption properties, combined with the brown colour due to the carbon, give the necessary neutral characteristics. ND filters are also available in graduated form, to give continuous light control over a given range of attenuation, or to give attentuation to part of the scene only, e.g. the sky region but not the foreground.

ND filters for camera use are calibrated in terms of their optical density and filter factor, e.g. a 0.3 ND filter with filter factor ×4 (+2EV). They can be used with monochrome, colour films and digital sensors (although rarely needed in digital photography), as they have no effect on colour balance. Their uses range from a means of avoiding overexposure with a fast film in very bright conditions to a way of using large apertures for selective focus in well-lit conditions. Mirror lenses use ND filters in lieu of aperture stops to enable selection of a different shutter speed.

Graduated filters are tinted over about half their area, with a gradual transition between the grey or coloured and the clear areas to give selective filtration to parts of the subject. A graduated yellow filter may be used with black-and-white film to filter the sky in a landscape picture, leaving the foreground unfiltered, the horizon approximately coinciding with the transition zone. Pairs of differently coloured graduated filters can be used in tandem in rotated opposition to give selective filtration to different zones of the scene. In colour photography, graduated colour filters can provide either a colour accent to part of a scene or correct the colour balance likewise, or give a strong colour effect. A graduated grey ND filter will reduce exposure to a selected area of the scene to help balance excessive luminance ratio, as in a landscape with a brilliant sky area. A *radially graduated ND filter* or 'spot' filter compensates for the loss of illumination at the edges of extreme wide-angle lenses, with need for an exposure increase of +1EV or +2EV.

Polarizing filters

As discussed in Chapters 2 and 6, light can be considered as a transverse wave motion, i.e. with vibrations orthogonal to the direction of propagation. The direction of vibration is completely randomized, giving unpolarized light. If the vibrations are restricted to one particular plane called the *plane of polarization*, the light is then *linearly polarized*, or *plane polarized* (or simply *polarized*). Such light can be produced, controlled and attenuated by a *polarizing filter*.

A polarizing filter is a sheet of polymeric material containing a layer of transparent polymer molecules whose axes are aligned in one direction during manufacture. They are *optically active*, so that light waves vibrating in one plane are transmitted, but light waves vibrating at right angles to this plane are blocked. Light waves vibrating in intermediate directions are partially transmitted. Such a linearly polarizing filter can be used to select light for transmission if some of it is polarized. Light coming from different parts of a scene may be in various states of complete or incomplete polarization.

Polarizing filters have several distinct applications. The light from any point in a clear blue sky is partially polarized by scattering, the direction of polarization being at right angles to the line joining it to the sun. The polarization is strongest over the arc of the sky that is 90° from the sun, and is weakest at 0° (i.e. close to the sun itself) and 180° (opposite the sun). Clear blue sky can thus be rendered darker by use of a polarizing filter over the camera lens, the amount being controlled by rotation of the filter. A polarizing filter does not otherwise affect colour rendering, and so is used in colour photography to control the depth of colour of a blue sky.

Unwanted surface reflections may also be reduced and even eliminated. Light that is specularly reflected from the surface of a non-metal at a certain angle is almost totally polarized in a plane perpendicular to the plane in which the incident and reflected rays lie. This is called *s-polarization*. Note that polarization at right angles to this plane, i.e. in the plane containing the incident and reflected rays, is known as *p-polarization*. The light that is transmitted is partly p-polarized. Total s-polarization occurs when the angle of incidence is such that the reflected and refracted rays are orthogonal, i.e. the tangent of the angle of incidence is equal to the refractive index (Brewster's law). For material with a refractive index of about 1.5 (i.e. most polishes, gloss paints, plastics and glass), the angle of maximum polarization (the *Brewster angle*) is about 56°. For water with a refractive index of 1.33 it is about 53°. Light reflected from a wide range of substances at approximately this angle is largely polarized. Polarizing filters may therefore be used for the control of reflections from nonmetallic materials, for example glass, wood, paint, oil, polish, varnish, paper and any wet surface. Practical applications include removal of *glare spots* from painted walls, wood panelling, furniture and glass, provided

a suitable viewpoint can be used. In colour photography, the presence of surface reflections reduces colour saturation, degrading the picture quality.

In copying applications, a polarizing filter over the lens offers little control of reflections, but full control is possible if the light source itself is plane polarized, the method being to place polarizing filters over both the lens and the lamps, the direction of polarization of the lens filter being orthogonal to that of the lamp filters. In this technique, the diffusely reflected light forming the image is depolarized, whereas the unwanted, directly reflected light remains polarized, and does not pass through the filter on the lens. In the same way, reflections from metal objects can be controlled by placing polarizing filters over the light sources as well as over the camera lens. Large sheets of polarizing material are needed for use over light sources, and they must not be permitted to overheat.

The ideal polarizing filter works equally well for all wavelengths and has no effect on colour. Due to the absorption of both polarized light and transmitted light by the materials of the filters, the filter factor is usually about $\times 3.5$ (+1.6EV) rather than the theoretical $\times 2$ (+1EV), but a TTL metering system will usually take such variations into consideration (with the qualification below). The filter factor is independent of the sensitive material and illuminant.

A practical problem arises when a linear polarizing filter is used with a camera that has an optical system with a beamsplitter device to sample the incoming light for exposure determination, or to direct part of the image to an array of photosensors in an autofocusing module set in the well of the camera. The beamsplitter divides the incident light into two beams that are orthogonally polarized. Consequently, when a plane polarizing filter is rotated over the camera lens, the beamsplitter does not divide this partially polarized beam in the correct proportions for viewing and light measurement, or transmit enough light to the autofocus module for this to operate satisfactorily. The effects depend on the orientation of the filter over the lens (see Chapter 6). If, however, a *circularly polarizing filter* is used instead of a linear type, the properties of the beamsplitter are unaffected so light measurement errors and inoperative autofocus systems are avoided. The filter uses in its construction an additional thin layer of optically active material behind the polarizing material. This is known as a *quarter-wave plate*, and its effect is to displace the relative phases of the electric and magnetic components of the propagated wave so that the plane of polarization rotates through a complete circle with every wavecrest (see Chapter 2).

BIBLIOGRAPHY

Goldberg, N., 1992. Camera Technology. Academic Press, San Diego, CA, USA.

Hirschfield, G., 1993. Image Control. Focal Press, Boston, MA, USA.

Kingslake, R., 1978. Lens Design Fundamentals. Academic Press, London, UK.

Kingslake, R., 1989. A History of the Photographic Lens. Academic Press, San Diego, CA, USA.

Kingslake, R., 1992. Optics in Photography. SPIE, Bellingham, WA, USA.

Ray, S., 1992. The Photographic Lens, second ed. Focal Press, Oxford, UK.

Ray, S. (Ed.), 1994. Photographic Lenses and Optics. Focal Press, Oxford, UK.

Ray, S., 2002. Applied Photographic Optics, third ed. Focal Press, Oxford, UK.

Smith, W., 1990. Modern Optical Engineering, second ed. McGraw-Hill, Maidenhead, UK.

Walker, B., 1994. Optical Engineering Fundamentals. McGraw-Hill, Maidenhead, UK.

Chapter | 11 |

Photographic camera systems

Sidney Ray

All images © Sidney Ray unless indicated.

INTRODUCTION

A *camera* is essentially a light-tight box with a lens at one end to form an optical image and a fixture to hold light-sensitive material at the other to record this image. Most cameras have some means of focusing the image sharply at the *photoplane* for subjects at different distances. The duration of exposure to light is controlled by a *shutter system*, either mechanical or electronic. During the exposure the image illuminance on the film is controlled by an *iris diaphragm*, the aperture diameter of which can be varied. The optimum settings of the shutter and iris diaphragm are linked to an *exposure determination system* using light metering, usually measuring through the lens. Finally, the camera has a *viewfinder system* by which the subject area to be included in the image may be determined. Essential features are some means of changing the exposed film in the gate for the next frame, and *flash synchronization* of the shutter. A data display panel may be needed for camera control. Both film and digital cameras share all or most of these features.

IMAGE FORMAT

The *format* of an image as recorded in the camera is the dimensions of the *film gate* in the *photoplane* or the *photosensor* area. Originally, photographs were taken on glass plates followed by contact printing. Plate sizes up to 305×381 mm (12×15 inches) were used. Improvements in lenses, emulsions and illuminants made projection printing practicable and a decrease in format with later enlargement possible. Roll film speeded this process and currently the 24×36 mm (135) format is the popular size.

The relative areas of various film formats are shown in Figure 11.1.

The 120 roll film size, using film of 62 mm width or 'gauge' and a backing paper, provides medium formats such as 60×60 mm. Adaptors can provide alternative smaller formats, e.g. roll-film backs for technical cameras and 35 mm film adaptors for 120 size roll-film cameras.

Sheet film was once considered an inferior alternative to plates but polymeric base materials such as polyester, with improved dimensional stability, have replaced these. Large-format work is standardized on 102×127 mm (4×5 inch) and 203×254 mm (8×10 inch) sheet film sizes.

CAMERA TYPES

Many types of camera have been produced both for general applications and for specialized purposes in conjunction with a range of accessories. Well-defined types include simple, compact, rangefinder, twin-lens reflex, single-lens reflex, technical, and specialized designs (see Figure 11.2).

Simple cameras

A 'simple camera' is made for ease of operation, with little choice of control settings. The primitive *box camera* has a single meniscus or doublet lens of aperture $f/14$. Smaller apertures are selected by 'weather' symbols on an aperture control. The lens is fixed-focus, set at the hyperfocal distance to give reasonably sharp focus from 2 m to infinity. A 'portrait' supplementary lens reduces the sharp focus to about 1 metre. Alternatively, a *three-point symbol* focusing system gives sharpness zones of 1–2 m (portrait), 2–8 m

Figure 11.1 Relative areas of nominal formats for film cameras. Medium and small formats are shown relative to the 4 × 5 inch large-format size.

(group) and 3 m to infinity (landscape). An 'everset' shutter offers two settings of 'I' for 'instantaneous' (about 1/40 s) and 'B' for time exposures. The viewfinder is either a direct optical one or a brilliant (reflex) type. Formats vary from 60 × 90 mm (eight exposures on 120 film) down to 30 × 40 mm (16 on 127 film), as well as 28 × 28 mm (126 cartridge), 11 × 17 mm (110 cartridge) and 8 × 10 mm (disc film cassette).

The *single-use camera* (SUC) or 'film-with-lens' camera is the current embodiment of the simple camera, intended to be used and then sent away complete for processing, when the camera components are largely recycled for reloading and further use. The plastic body shell with modest fixed-focus lens and a single speed shutter (1/100 s) contains pre-loaded film in cassette (135 format) or cartridge (APS format). The pre-advanced film is rewound into the cassette after each exposure. The shutter is inoperative after the last exposure. Fast film of ISO 400 or 800 speed is loaded to allow use in a range of conditions, taking advantage of the exposure latitude of colour negative material. Cameras are available with or without an integral flash, with output suited to the modest lens aperture. The popularity of these cameras is

due to their small size, light weight, modest cost and disposability. A variety of alternatives are available, including underwater versions, and long-focus and wide-angle (panoramic) types.

Compact cameras

A *compact camera* is intermediate to simple cameras and single-lens reflex (SLR) types, with a non-interchangeable lens and useful specifications and considerable automation, in a body of modest dimensions, using standard 135 or APS type cassettes. A coupled rangefinder, large-aperture lens, bright-line finder and choice of shutter- or aperture-priority automation may be provided. Other features are an integral electronic flash unit and autofocus using a phase detection system.

A fixed (non-zoom) lens has a typical maximum aperture of $f/2.8$ and a focal length of 35–40 mm. A silicon photodiode (SPD) monitors subject luminance and operates an exposure program with a between-lens shutter offering a range of some 1/20 to 1/500 s and an aperture range of $f/2.8$ to $f/16$. Flash exposure automation is by alteration of lens aperture in accordance with distance data

Figure 11.2 A selection of camera types. (a) A compact camera for 24 × 36 mm format with telescoping 38–135 mm zoom lens. (b) Single-lens reflex camera with integral finder for APS formats. (c) Single-lens reflex camera for 24 × 36 mm format. (d) 45 × 60 mm medium-format SLR camera with attachable motor drive grip. (e) 45 × 60 mm medium-format autofocus camera with zoom lens. (f) 4 × 5 inch large-format monorail camera with L-shaped standards.

from the autofocus system (the flashmatic system). Film speed is set by the *DX coding system* on the film cassette. A *backlight control* provides one to two stops exposure increase for high-contrast scenes. The flash can be used for fill-in purposes too, or a matrix-type metering system may combine flash with the ambient light exposure.

A zoom lens typically has a range of 35–70 mm focal length with the viewfinder frame altering to match. Other zoom ranges are available, such as 38–140 mm. To keep such lenses compact enough to telescope back into the camera body, maximum aperture decreases with increase in focal length, possibly to as little as *f*/11, from some *f*/4 at the short-focus end. Film loading is semi-automatic with advancement to the first frame on closing the camera back. Film advance is motorized, as is rewind of the exposed film. An alternative *panoramic format* of 13 × 36 mm is given by selecting masking blades for the film gate. The viewfinder is of complex optical design but kept small to fit within the

camera body. Usually *real-image* types are used, based on Kepler telescopes.

The APS type (which is no longer a supported camera format by the majority of manufacturers) offered additional features, apart from very small camera bodies. There was a selectable choice of three alternative formats, labelled C (classic), H (HDTV) and P (panoramic), giving aspect ratios of 1:1.5, 1:1.77 and 1:3 respectively, obtained by selective enlargement of areas of the film frame area. The film cartridge is easy to load, with film advance and rewind completely automatic. Mid-roll film interchange was possible to allow switching of film types. A range of 'intelligent' features provide a range of user options, especially at the printing stage, when multiple prints or different sizes and backprinting of data may be made individually for each exposed frame. The film base was coated with an additional transparent layer of material for magnetic encoding of data.

Rangefinder cameras

These cameras use a coincidence-type rangefinder system, coupled to the focusing mechanism of the lens to ensure sharp focus at the subject distance. This method is essential for accurate focusing of large-aperture lenses. Combined rangefinder–viewfinders have sets of bright-line frames. Interchangeable lenses are limited as the fixed base-length of the rangefinder means that focusing accuracy decreases with increase in focal length. A rangefinder camera is compact and capable of accurately focusing large-aperture lenses in low-light-level conditions. The viewfinder is complex with alternative bright-line frames, parallax correction linked to focusing and exposure metering systems by *through-the-finder* (TTF) methods.

Twin-lens reflex (TLR) cameras

Twin-lens reflex cameras are essentially two cameras mounted one above the other, the upper for reflex viewing and focusing, and the lower for exposing the film. Both lenses have the same focal length and are mounted on the same panel, which is moved bodily to provide continuous viewing and focusing. The reflex mirror gives an upright, laterally reversed image on a ground-glass screen. The screen is shielded for focusing by a collapsible hood with a flip-up magnifier. The hood may be interchangeable with a *pentaprism viewfinder* for eye-level viewing and focusing. The focusing screen incorporates a Fresnel lens, split-image rangefinder or microprism array to assist focusing. The viewing lens is always used at full aperture. Film transport and shutter setting is normally by means of a folding crank device. Cameras used the 60 × 60 mm format on 120/220 film. Interchangeable lenses are uncommon with these cameras. There is *parallax error* in the viewfinder screen image because of the separation between viewing and taking lenses. For close-up photography a wedge-shaped prism can be fitted to the viewing lens when supplementary lenses are used. Few TLR cameras are now in use.

Single-lens reflex (SLR) cameras

The principle of the SLR camera is illustrated in Figure 11.3. A plane front-surfaced mirror at 45° to the optical axis diverts the image from the camera lens to a screen for focusing and composition. For exposure the mirror is lifted out of the way before the camera shutter operates and returns to the viewing position after exposure. Design advantages are the ease of viewing and focusing, and freedom from parallax error. The depth of field at the pre-selected aperture can also be estimated.

Some designs use rectangular formats, and a *rotating back* may be provided so that upright ('portrait') or horizontal ('landscape') pictures can be composed.

SLR design has been fully developed for 135 and 120 film formats using focal-plane shutters and a spring-

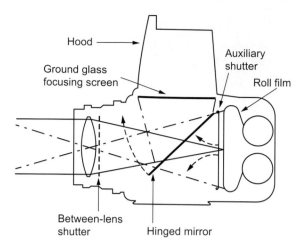

Figure 11.3 Principle of the single-lens reflex camera (Hasselblad).

operated mirror. An *instant return mirror*, giving uninterrupted viewing (except during the time the shutter is open), is now standard in most SLR cameras. For wide-angle lenses, the depth of the mirror box in the camera requires lenses with a long back focal distance, i.e. the retrofocus type.

A rectangular format is less convenient when vertical framing is required for a picture, as turning the camera sideways causes the image on the viewing screen to be inverted. A square format allows the camera to be held in the same way for all photographs. The pentaprism viewfinder (Figure 11.4) permits eye-level viewing and focusing with the image erect and laterally correct for both horizontal and vertical formats. The erect but laterally reversed image on the focusing screen undergoes three reflections inside the *roof prism* to appear correctly oriented. The necessary precision of the angles of the prism requires it to be made of glass, so it is weighty and expensive, but hollow prism versions using mirrors reduce both. The iris diaphragm, which was normally stopped down manually just before exposure, evolved into the *fully automatic diaphragm* mechanism (FAD). Improved viewfinder focusing screens use *passive focusing aids* in the form of microprism arrays and split-image rangefinders, with alternative screens for specialized purposes. Manual focusing has been superseded by autofocus systems (see below).

Available lenses range from fish-eye to extreme long-focus types. Fully interchangeable *magazine backs* allow for changing of film type in mid-roll, or rapid reloading. Exposure determination uses *through-the-lens* (TTL) metering.

The SLR design is the basic unit for a wide range of accessories. The medium-format SLR camera can replace a technical camera for many applications not requiring a large format or extensive use of camera movements.

(a)

(b)

(c)

(d)

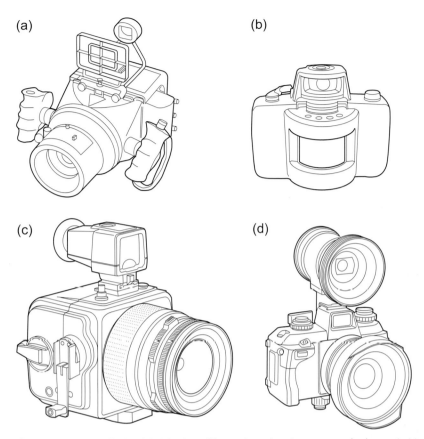

Figure 11.4 Action of a pentaprism viewfinder. (a) Side view. (b) Top view, showing crossover in the angled 'roof' of the prism.

Technical cameras

The terms *technical camera* or *view camera* cover two types of camera. The first is the *monorail* type (Figure 11.2f), based on the optical-bench principle to offer the widest possible range of camera movements. Focusing and composition are done using a ground-glass screen, and the camera needs a tripod. The second type is the *folding-baseboard* variety, and may have a coupled rangefinder and optical finder as well as a ground-glass screen. It can also be used hand held.

Early wood and brass *studio* and *field cameras* were adequate for large-format work but were slow in operation. Improvements in lenses and smaller formats needed greater precision in manufacture. So metal was substituted for wood, giving rigidity at the expense of weight. Some standardization was achieved in the sizes of items such as lens panels, filmholders and camera backs. Technical cameras can use medium formats such as 60×70 mm to 60×120 mm, but monorail cameras in these formats are less common. The term 'large format' covers film sizes of 102×127 mm (4×5 in) and 203×254 mm

(8×10 in). Cameras feature *reducing backs* and *format changing* for alternative formats.

As a 'system' camera the basic body can be fitted with alternatives for almost every component. Monorail designs are produced on modular principles so that rails, front and rear standards, bellows, focusing screens, lenses and shutters are interchangeable to adapt for a range of formats or types of work.

The folding-baseboard camera may use a high-precision rangefinder with coupling to alternative lenses. Viewing is by means of a multiple-frame, bright-line viewfinder. Sheet film, roll film, self-developing material and even plates can be used. It has a more limited range of movements than the monorail type. The ground-glass screen must be used for close-up work or camera movements. The bellows is of 'triple-extension' type, allowing a magnification of $\times 2$ with a standard lens for the format.

Innovations in technical camera design include: forms of through-the-lens exposure determination using a probe in the focal plane; preset mechanisms for shutter speeds and

aperture settings; electronic shutters; extreme wide-angle lenses of large useful aperture; computer coupled and indicated camera movements; and binocular viewing and focusing aids.

SPECIAL-PURPOSE CAMERAS

Cameras for self-developing materials

Special cameras use *self-developing* (instant print) materials manufactured by the Polaroid Corporation and others. These are available in roll-film, sheet-film and film-pack forms and formats up to 8 × 10 inches and even 20 × 24 inches. Both colour and black-and-white materials are available. Cameras range from simple types with minimal control of functions to sophisticated models equipped with electronic shutters, TTL exposure metering, autofocusing and automatic ejection of the exposed film frame. The geometry of image formation, and the sequence of the layers in the particular film type, may require use of a mirror system in the camera body in order to obtain a laterally correct image in the print. This gives a bulky, inconvenient shape or requires considerable design ingenuity to permit folding down to a compact size for carrying. Various adaptor backs permit the use of self-developing materials in other cameras for image preview purposes. Such camera and film combinations are often very convenient to use, and still have useful applications.

Aerial cameras

Most aerial cameras are rigid, remotely controlled fixtures in an aircraft, but for hand-held oblique aerial photography specialized types are used that are simplified versions of technical cameras without movements and with rigid bodies and lenses focused permanently on infinity. A fixture for filters, a simple direct-vision metal viewfinder and ample hand-grips with incorporated shutter release complete the requirements. If roll film is used (normally 70 mm), film advance may be by lever wind or may be electrically driven. To give the short exposures necessary to offset vibration and subject movement, a *sector shutter* may be used. This is a form of focal-plane shutter in which an opaque wheel with a cut-out radial sector is rotated at high speed in front of the film gate to make the exposure. Data imprinting can record positional and other information at the moment of exposure. These data may be taken directly from the navigational system of the aircraft.

Underwater cameras

For underwater use, cameras can be housed in a pressure-resistant container with either an optically *flat window* or a spherical *dome port*. The housing may be an accessory for the camera. Underwater housings are available for 35 mm, digital SLRs or compact camera formats and use rods attached to the main camera controls, which pass through the casing to oversize knobs on the outside and access the controls inside. Such housings can be expensive but may be safe down to depths of around 40 metres. They also have connectors to attach external flash units. Dome ports are used for wide-angle lenses and the curvature of the dome is ideally matched to the lens's focal length. The lens focuses on a virtual image created by the dome. Often a dioptric supplementary lens is required on the camera to facilitate this. Dome ports do not introduce problems associated with refraction, radial distortion and axial chromatic aberrations. Flat windows are used with long lenses for close-ups or shots that start or end above the water and don't require a dioptre. However, they are unable to correct for the distortion produced by the differences between the refractive indices of air and water, and introduce refraction, distortion and chromatic aberration problems when used underwater. In some cases the housings are made with other additional optics to make the apparent angle of view wider. This is particularly useful to some digital cameras with small sensors that do not achieve wide angles of view with the conventional lenses. Both wide-angle and close-up supplementary lenses are available, often as 'wet lenses' that can be added or removed underwater.

A few cameras have a pressure-resistant, water-tight body and interchangeable lenses to make them directly usable to specific depths. They are also useful in adverse conditions on land where water, mud or sand would ruin an unprotected camera. These cameras usually have a simple direct-vision or optical finder and manually set focusing controls, but SLR versions have been made. The lenses are interchangeable and have suitable seals, but changing must be done out of the water. A short-focus lens may be fitted as standard to compensate for the optical magnification effect that occurs due to the change in apparent subject distance caused by the refractive index of the water in the object space. A field of view similar to that of a standard lens on a conventional camera is then obtained. Special lenses corrected for underwater use, i.e. with water actually in contact with the front element, are also available. Some compact cameras are specially sealed to allow underwater use to depths such as 3 metres and will withstand adverse weather conditions.

Ultrawide-angle cameras

When a sufficiently large angle of view cannot be obtained from the usual range of lenses available for a camera, and when distortion considerations rule out the use of a fisheye lens, then an ultrawide-angle camera may be used. This may be a camera body of shallow depth with a lens (usually non-interchangeable) with a large angle of view,

e.g. some 110° on the diagonal, as obtained by the use of a 65 mm lens with a 4 × 5 inch format. Focusing of such a lens is usually by scale, and the viewfinder may be a simple direct-vision or optical type, preferably incorporating a spirit level as an essential aid in aligning the camera. Limited shift movements may be provided, such as rising front. Medium-format versions find special use as precision *shift cameras* for architectural work.

Panoramic cameras

It is possible to obtain *single-frame panoramas* using film cameras with *rotating* (or *swing*) *lenses*. The lens rotates around its rear nodal point − from which the back focal length is measured − while a vertical slit exposes a strip of film which is aligned with the optical axis of the lens. Lens and slit scan horizontally across the panoramic scene. Typically, the shots encompass a 110−140° field of view horizontally and 60° vertically; therefore the horizontal image size will commonly take up one and a half to two and half times the length of a common 35 mm frame. Unfortunately most swing lenses come with a fixed focal length and cannot focus well at a distance of less than 10 metres. Capturing subjects at a smaller distance requires use of a small aperture to provide a large depth of field. Additionally, the number of available shutter speeds is limited, causing problems for subjects at low light levels.

Rotating panoramic cameras function similarly, but in this case the camera body rotates around the front nodal point of a static lens. A mechanism rotates the camera continuously while the film, in a curved film gate with a centre of curvature at the rear nodal point of the lens, is transported in the opposite direction. The speed of movement of the film matches the speed of image movement across the image plane. The film is exposed through a thin slit producing a sharp image throughout; therefore, such cameras are also referred to as *slit* or *scanning cameras*. The horizontal panoramic coverage can be up to (sometimes more than) 360°.

The use of swing lenses or panoramic cameras does not result in the same extreme distortions of lines often seen in ultra wide-angle lenses; however, image perspective is unique. The camera must be correctly levelled, parallel to the subject plane, to prevent the introduction of other distortions, such as the curvature of horizontal lines near the bottom or top of the frame if the camera is tilted up or down. If a subject is at a close distance, horizontal lines will converge in the centre at the edge of the frame, even if the camera is parallel to the subject plane. On the other hand, a curved subject − such as a long group of people sitting around a concave row of chairs − will be reproduced as a straight line. Tilting the camera also causes convergence of vertical lines at the top or bottom of the frame.

In other cameras, known as *wide-angle* or *wide-field* camera systems, a high-aspect-ratio format (from 2:1 to 4:1) is used with a flat film gate and a very wide-angle lens, usually needing *a centre spot filter* to improve image illumination at the edges and eliminate optical vignetting. This reduces exposure of the film at the edges of the frame, but at the expense of approximately 2EV. These are the most common panoramic cameras, available in various image formats, and may vary significantly in quality and price. The image produced by true wide-field cameras is relatively distortion free but the panoramic coverage is restricted when compared to swing lenses or to rotating cameras. Nevertheless, they are popular for shooting architectural panoramas as they do not cause lines to curve or produce perspective distortions. Another great advantage of this type is the instantaneous exposure of the frame as opposed to the longer, sweeping exposures of other types of panoramic cameras, meaning that the use of flash is not restricted, as often happens with cameras which only expose one part of the image at a time using a slit or scanning mechanism. Typically, the maximum angle of view with a flat film camera is about 90°, although lenses with up to 150° can be used. Formats from 60 × 120 mm to 60 × 170 mm or even 60 × 240 mm are used.

A selection of types of special-purpose camera is shown in Figure 11.5.

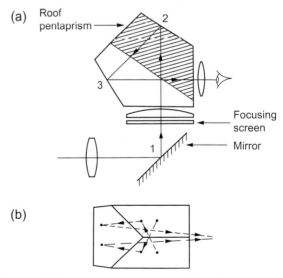

Figure 11.5 Special-purpose cameras. (a) Electrically operated hand-held aerial camera for 4 × 5 inch format. (b) Rotating lens panoramic camera for a format of 24 × 56 mm on 35 mm film. (c) Superwide-angle camera for a 60 × 60 mm format, the 38 mm lens giving a picture angle of 90°. (d) Underwater camera for 24 × 36 mm format equipped with a 15 mm fish-eye lens and accessory viewfinder.

AUTOMATIC CAMERAS

Most cameras are 'automatic' in that there is some form of digital control using solid-state micro-electronics. Functions previously operated by mechanical, electrical or electromagnetic devices are controlled by electronic circuitry. This replacement of gears, rods and levers varies from primitive controls, through electronic 'enrichment' to fully digital operation. Functions such as shutter operation and metering are controlled by a *central processing unit* (CPU) that makes logical decisions based on the *input* of digital data. Subsequent control commands or output can be carried out by the camera to give *full automation*, or with the aid of the user to change settings as appropriate, to give *semi-automatic operation*.

Analogue systems

The operation of all-mechanical cameras depends on the film advance mechanism to tension actuating springs and the shutter timing depends on escapement devices and gear trains. An electronically controlled shutter uses a resistor–capacitor circuit for exposure timing and automation is possible when the exposure metering photocell output is used to control the timing circuitry. The exposure-determination circuitry of the camera uses the exposure equation relating shutter speed (t), aperture (N), subject luminance (L) and the film speed (S), involving the meter constant (K) for reflected light where:

$$LSt = KN^2 \qquad (11.1)$$

Analogue converter devices set appropriate resistance values for these variables into a primitive computing device such as a Wheatstone bridge arrangement. The shutter-speed setting control, film-speed setting and exposure-compensation controls all use forms of fixed and variable resistors. The control circuitry uses only a few components such as transistors, resistors and capacitors. A silicon photodiode with its very fast reaction time and freedom from unwanted 'memory' allows metering to be carried out in 'real time' in the short interval between depression of the release button and the mirror rising or the shutter operating, or, better, during the shutter operation itself by metering from the actual film surface. The photodiode requires additional circuitry such as operational amplifiers, and draws current from a battery which also powers the shutter and viewfinder display. A meter needle is replaced by LED displays, still as an analogue arrangement. Increasing demands are made on simple analogue circuitry, especially with multi-mode metering systems and the short time available to carry out the necessary operations for each exposure, in particular with a motor drive operating at several frames per second. The possibility of overload is real. Most of these limitations are overcome by use of digital control.

Digital control

Digital control refers to the use of data and control commands in digital form. An early digitally controlled system was a viewfinder display using either alphanumeric characters formed from seven-segment LEDs or a liquid crystal display (LCD), where letters and symbols can be formed as well as numbers. Power-consuming LED displays can be replaced or complemented by large LCD panels that give a comprehensive readout of the current status of the camera (such as exposure mode, film frame number, film speed in use) (see Figure 11.6). Such displays require more complex control circuitry than a simple LED display, where the LED is either lit up or not. Activation is from the CPU via devices called decoders and multiplexers. A multiplexer is a circuit which selects with the aid of a clock circuit from a number of inputs and outputs in turn. The clock timing is provided by an oscillator circuit using quartz or lithium niobate crystals.

The CPU uses additional devices such as analogue-to-digital (A/D) converters and both random access memory (RAM) and read-only memory (ROM). A clock circuit monitors the sequence of operations and all are connected by buses for data flow.

(a)

(b)

Figure 11.6 Examples of external LCD data panels on the top plate of a camera.

Some systems need a 6-volt supply, others only 3 volts, determining battery needs and space for them. Devices may be sensitive to voltage changes, so a constant-voltage supply circuit is needed. Others are sensitive to temperature, so another compensating circuit is needed.

Various types of CPU are used, depending on needs. All have large numbers of circuit elements per unit area, given by large-scale integrated circuits. The high packing density is given by metal oxide semiconductor (MOS) circuitry. These are sensitive to voltage and temperature, and are not easy to interface with other devices in the camera. The alternative transistor–transistor logic (or TTL; not to be confused with 'TTL' metering) costs more, and uses more power, but needs less precise control. Processing speed is higher than with the simple MOS type. An intermediate choice is integrated-injection logic or I2L type, which has the packing density of the MOS type but is slower than the TTL type. Operation requires a *read-only memory* or ROM device to store a fixed program of operational steps in the correct sequence to guide the CPU through its calculations in the correct order. The ROM is static, and data does not disappear when the camera is switched off; the program ('firmware') can be added to or modified subsequently.

The clock circuit acts as a reference for the order of events. A *quartz oscillator* gives 32,768 beats per second or hertz (Hz). These pulses are counted by appropriate circuitry, and can also be used to control shutter speeds, self-timer delays, meter 'on' timing controls and intervalometers. An exposure of $1/1000$ s is timed as 33 pulses, to an error of less than 1%. The counting circuit delays travel of the second blind until sufficient pulses have elapsed. An alternative *ceramic oscillator* device gives 4,194,000 Hz for even greater accuracy and for control of complex data displays.

Digital control means that the data and calculations are handled in discrete form and not as a variable electrical quantity in their analogue form. The circuitry is basically an array of transistor switches, each of which can be in only one of two states, either 'off' or 'on', to shunt the current flow through logic gates of the 'if/then' and 'and/or' configurations. The decimal system of 10 digits from 0 to 9 is replaced by the binary system using the two digits 0 and 1, corresponding to the two alternative states of a switch. The 'number-crunching' power of a digital processing system, plus its speed and error-free operation, more than offsets the additional circuitry needed compared with analogue systems.

All input data must be coded into binary form and then the output commands decoded for implementation. The analogue data from *transducers* such as potentiometers in the film speed setting control is changed into binary data by an analogue-to-digital (A/D) converter, and the reverse operation by a *digital-to-analogue* (D/A) circuit. This conversion is doubly difficult in the case of data from the silicon photodiode photocell. This gives subject luminance data in analogue form, and covers an enormous dynamic range: a 20EV metering range corresponds to a light level range of 1,048,576:1. This range is compressed by converting values to their logarithmic equivalents before conversion to digital form, using a *logarithmic compression circuit*. Data encoding by a *transducer* may be by movement of a wiper arm over a patterned resistor or by an optical device, the output being a string of pulses corresponding to the required 0 and 1 values. To guard against encoding inaccuracies, the strict binary code may be replaced by, for example, the *Gray code*, which permits the checking of values by 'truth tables', so that impossible values cannot be sent to the CPU. Other components of the camera such as flash units, power drives and multifunction backs can transduce and transform their data as necessary. By means of the *DX film coding* system in binary form on a 35 mm film cassette, the film speed, exposure latitude and number of exposures may be encoded directly into the CPU by means of an array of contact pins in the cassette compartment.

The CPU performs various actions on its output. Values for the viewfinder display are 'rounded off' to conventional values or to two decimal places. The display can be updated every half-second or faster and alter its intensity in accordance with the photocell output by the simple means of altering the pulsing rate of each segment (the intensity of an LED cannot be varied by other means). A 'bleeper' can operate to warn of camera shake or inadequate light, generate an error signal, and so on.

A separate CPU may be used for the complex signal processing operations required with the data from arrays of sequentially scanned charge-coupled devices (CCDs) used in autofocus systems. Accessories such as flashguns may also have LCD digital displays to supplement the main display on the camera body or in the viewfinder.

Other *interfaces* in the form of arrays of electrical contacts are used in the lens mount, film gate, viewfinder well and hot shoe to allow the flow of data and commands from an autofocus lens with its own ROM and transducers, with a multi-function back, an accessory automatic metering viewfinder system and various forms of dedicated flashgun respectively. A generalized picture of the flow of data and control signals in an automatic camera under digital control is shown in Figure 11.7.

CAMERA FEATURES

Shutter systems

The camera *shutter* controls the duration (t) of the total exposure (H) given to the sensor. Image illumination (E_i) is controlled principally by the aperture stop according to the law of reciprocity:

$$H = E_i t \qquad (11.2)$$

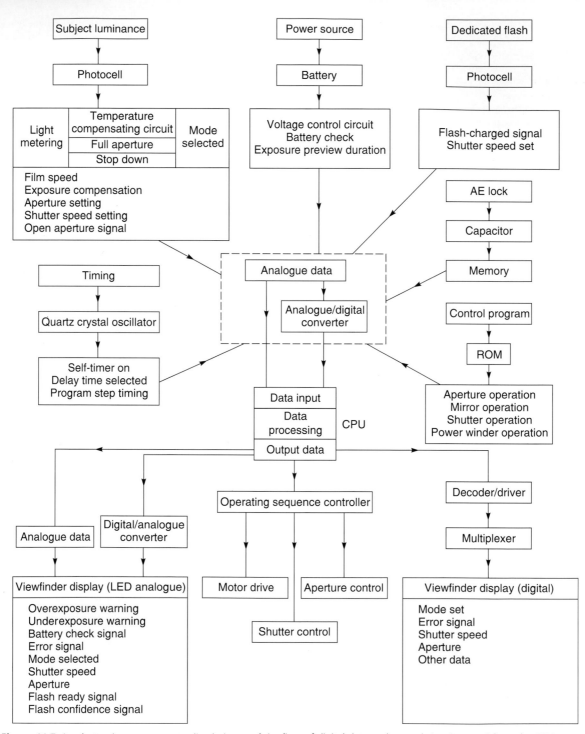

Figure 11.7 An electronic camera: generalized picture of the flow of digital data and control signals to and from the CPU.

Quantity t is called the *shutter speed*, and both E_i and t are in a simple reciprocal relationship in that to keep H constant, as either E_i or t increases, the other must decrease (see also Chapter 8, Eqn 8.1). For exposure control, the shutter speed range is usually greater than the aperture range, e.g. a 14-stop range from 8 s to 1/2000 s is 16,000:1, but a 50 mm f/1.4 lens stopping down to f/16 has only a seven-stop range giving 128:1. A shutter speed range from 1/12,000 s to 30 s is typical. The shutter is located either in front of, within or behind the lens (a leaf or diaphragm shutter) or close to the film plane (focal plane (FP) shutter).

Shutter speed also determines the amount of *subject movement* (blur) discernible in the image and is used to 'freeze' motion by short exposures. Long exposures can be used deliberately to give blur to provide information about subject movement or for creative effect. For a subject moving with velocity V orthogonal to the optical axis (parallel to the film plane) and distance u from the lens of EFL f, the image velocity V_i is given by:

$$V_i = Vf/u \qquad (11.3)$$

When u is large, magnification $m \approx f/u$, then:

$$V_i = mV \qquad (11.4)$$

The image distance (blur) B moved in time t is given by $B = V_i t$ and must be less than or equal to the local value for the circle of confusion (C), so $B = C$. By substitution, the necessary exposure time (maximum) for sharp images is given by:

$$t_e = uC/fV = C/mV \qquad (11.5)$$

So for a static camera and subject 5 m away moving at 1 m s^{-1}, for a 50 mm lens with $C = 0.05$ mm, t_e must be 1/200 s or less. If the camera is moving, the relative velocity of camera and subject is used. If the subject velocity is at an angle θ to the film plane, then $V\cos\theta$ replaces V in the above equations, i.e.

$$t_e = C/mV \cos\theta \qquad (11.6)$$

Another cause of image blur is *camera shake* where the camera is inadvertently moved during exposure due to user tremor, vibration of the camera platform and other environmental effects. Blur worsens with increase in lens EFL (in mm) and an empirical rule is that:

$$t_e \leq 1/(\text{EFL}) \text{ seconds} \qquad (11.7)$$

so for a 2000 mm lens t_e needs to be 1/2000 s or less. Some cameras give an audible or visible warning if shake is anticipated with the lens and shutter speed combination selected. A tripod or image stabilization system (see below) is needed to improve sharpness. Electronic flash can provide the short exposure needed to arrest motion, but in high ambient light levels, depending on shutter synchronization speed (usually from 1/30 to 1/250 s, but 1/1000 s is possible with leaf shutters) a secondary blurred image may be overlaid.

Shutters primarily use mechanical actuation systems to move the blades or blinds by the action of springs, levers, electromagnets or linear motors. These open/close systems require a timing arrangement to delay closure and provide a range of exposure times. Mechanical timers such as clockwork escapements were replaced by analogue electronic timers, then by digital circuitry using a quartz (32,768 Hz), ceramic (524,288 kHz) or lithium niobate (4,000,000 Hz) oscillator. Shutter speeds of 1/1000 and 1/15 s require counting of 33 and 2185 pulses respectively using a quartz oscillator.

Leaf shutters have multiple leaves or blades pivoting about one end to uncover and recover the lens aperture. Top speed is about 1/500 s. Shutter blade activation can be by spring, lever, electromagnet or linear motor. A 'cocking' or resetting action is necessary unless the shutter mechanism is self-cocking. The shutter may have a complex operation when used in SLR cameras, as it must normally be open for reflex viewing. There is a *time lag* before shutter operation of some 8–600 ms. A value of 120 ms is typical for a 35 mm SLR camera. Shutter blades use blackened steel 0.05 mm thick and the tips can reach velocities of 60 km h^{-1} (16.7 m s^{-1}) in use. Between one and seven blades can be used. Advantages include reliability, ease of flash synchronization, electronic timing, a clear aperture with 100% transmission, no distortion of the image and usability with all formats. Leaf shutter characteristics are shown in Figure 11.8.

The traditional design of *a focal plane shutter* uses a slit of width W formed between the trailing and leading edges of two successive 'blinds' travelling at velocity V_s across the film gate close to the photoplane. The effective exposure duration (t_e) is the time required for the slit to move its own width, so $t_e = W/V_s$.

The blinds can be rubberized cloth, thin metal structures or multiple overlapping blades. Materials include patterned titanium and carbon fibre/epoxy composite materials. Usually exposure is varied by altering W for a nominal constant velocity, but W may increase during travel to compensate for acceleration during travel. Slit velocity can be as high as 6.7 m s^{-1}. The slit can travel in four alternative directions across the gate, dependent on camera design. Shutter blinds may be patterned for use with off-the-film (OTF) automatic exposure systems. Timing mechanisms are mechanical or electronic as for leaf shutters, but shorter exposure times are possible, currently some 1/12,000 s. Shutter characteristics are shown in Figure 11.9.

Flash synchronization

Early flash photography used the camera on a tripod, an open shutter on the 'B' setting, a manually ignited tray of magnesium powder, then closure of the shutter. Later, flashbulb firing was synchronized with shutter opening, allowing a hand-held 'instantaneous' exposure. A separate

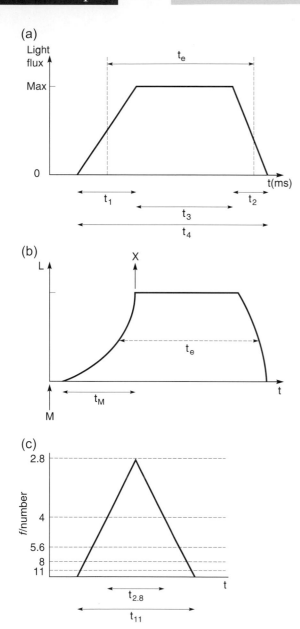

Figure 11.8 Characteristics of a leaf shutter. Leaf shutter properties are shown by a graph of light flux transmitted against time. (a) An ideal shutter: t_1, time taken for blades to open; t_2, time taken for blades to close; t_3, total open time; t_4, total operating time; t_e, effective exposure duration. (b) Typical characteristics; note blade behaviour. X-synchronization and M-synchronization are made at points shown. The value of t_M is 15−17 ms. (c) The effect of lens aperture on effective exposure time. Small apertures give more exposure than large ones due to the travel time of the blades.

synchronizer device was replaced by flash contacts incorporated in the shutter mechanism.

Flash synchronization of leaf and focal-plane shutters presents different problems. With the former, the aim is to arrange for the peak of the flash to coincide with the period over which the shutter blades are fully open. There is a short delay between the moment of release and when the blades first start to open (approximately 2−5 ms), and a further slight delay before the blades are fully open. Flashbulbs have a delay after firing before combustion occurs and light is produced. By comparison electronic flash reaches full output virtually instantaneously.

Two types of synchronization are used, called respectively *X-* and *M-synchronization*. With X-synchronization, electrical contact is made at the instant the shutter blades become fully open so this type can be used with electronic flash *at all shutter speeds*. Compact cameras with an integral electronic flash unit are X-synchronized only, as are hot-shoe connections. With the obsolescent M-synchronization the shutter blades are timed to be fully open approximately 17 milliseconds after electrical contact is made. This was to allow flashbulbs time to reach full luminous output when the shutter was fully open, requiring a delay mechanism in the shutter. M-synchronization allows synchronization of flashbulbs at all shutter speeds. It is not suitable for electronic flash, which would be over before the shutter even began to open, hence no image. This form of synchronization is now obsolete and only X-synchronization is usually provided. The exceptions are lenses with leaf shutters intended for large-format and some medium-format cameras. Some shutters manufactured have a lever marked 'V-X-M'. The 'V' in this case is a delayed-action ('self-timer') setting, which is synchronized to electronic flash only.

Synchronization of focal-plane shutters presents a particular problem. Exposures with electronic flash can be made only at slower shutter speeds, where the shutter slit is the same size as the film gate, so that the whole film frame area can be exposed simultaneously by the flash. When large flashbulbs had to be synchronized with fast shutter speeds up to 1/1000 s, a special slow-burning flashbulb (class FP), now obsolete, was available. This bulb gave a near-constant output for the whole transit time of the shutter blind. The modern electronic flash counterpart has a rapidly pulsed or *strobed* output that permits the use of flash even at 1/12,000 s.

Unlike a fully synchronized between-lens shutter, which has only one flash connection and a two-position switch to select 'X' or 'M' synchronization, some focal-plane shutters had one, two or even three flash connections in the form of PC (coaxial) sockets, hot shoes and special-fitting sockets. If only one, unmarked, outlet is fitted to the camera, such as a simple hot-shoe or PC cable socket, the shutter is X-synchronized only. Some older cameras have a separate control linked to this sole outlet, able to select different forms of delay, but this too is now obsolete. A pair of

(a)

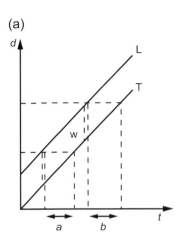

(b)

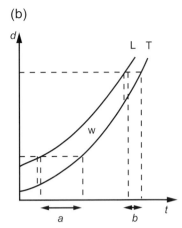

(c)

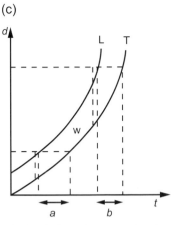

Figure 11.9 Characteristics of a focal-plane shutter. The behaviour of the two blinds of a focal-plane shutter can be shown by a graph of distance (*d*) across the film plane against elapsed time (*t*) for the leading edge of the slit (L) and the trailing edge (T). (a) Ideal behaviour. At any point during its travel the slit, whose width is the vertical interval LT, gives uniform exposure, so durations *a* and *b* are equal. (b) Typical behaviour where the blind accelerates during its travel so exposure *a* is greater than *b*, giving uneven exposure across the frame. (c) By having the two blinds form a slit and releasing one after the other, the slit width varies (increases) during travel and compensates for acceleration, so exposure *a* equals *b*.

outlets may be X and M, or perhaps X and FP. Use of the appropriate one of these with a suitable shutter speed automatically gives correct synchronization. The extension of exposure automation to the use of electronic flash has resulted in most cameras now giving automatic setting of the electronically controlled shutter to the correct X-synchronization speed, when a suitable dedicated flashgun is attached. This reverts to an alternative setting for ambient light exposure while the flash is recharging.

In X-type synchronization, electrical contact is made when the first shutter blind has fully uncovered the film gate, and before the second blind has begun to move. Depending on the design of the shutter, X-synchronization may be possible up to a shutter speed of 1/300 s. Medium-format cameras have synchronization restricted to a maximum shutter speed of typically 1/30 to 1/125 s. Due to these comparatively long shutter-open times in relation to the brief duration of an electronic flash unit, the effect of the ambient light can be a problem, and an electronic flash exposure meter that also takes into account the shutter speed in use is helpful. A comparison of shutter operation and flash source characteristics is shown in Figure 11.10.

The alternatives *rear curtain synchronizations* is when the flash is triggered just before the second blind starts its travel. This is useful for longer shutter speeds to give a better visual effect when there is a mix of time exposure and flash exposure.

The interface between the electronic flash and camera shutter is by means of an electrical connection in the form of a PC socket, hot shoe or special connection (such as by a pulse of infrared radiation to allow cordless operation in off-camera use). A PC (for Prontor-Compur) connection is a 3 mm co-axial plug-in socket. The *hot shoe* is a more reliable single-contact outlet, utilizing the original accessory shoe as used for viewfinders, rangefinders and simple flashguns. The centre contact provides X-synchronization. Other contacts provide additional features with 'dedicated' flashguns.

Many cameras now have integral flash units or use small units which clip on, both of which place the flash close to the camera lens. The result is near-axial lighting along the optical axis of the lens, which can give 'red-eye' where the light illuminates the retina of the eye that is red with blood vessels (see Chapter 3). The result is undesirable and unattractive. The best remedy is to remove the flash unit from near the lens, e.g. on an extension cable or by use of a slave unit. Alternative bounce or indirect flash can be used, or a flash diffuser may help. There is a loss of effective output. For direct flash, multiple pre-flashes may help to reduce the pupil size, an intense beam of light may be directed from the camera to the eye, the subject may be able to look away from the camera, or the ambient light may be increased.

The iris diaphragm

The intensity of the light transmitted by a photographic lens is controlled by the *iris diaphragm* or *stop*, which is usually an approximately circular aperture. In some simple cameras the aperture is fixed in size, in others the diaphragm consists of a rotatable disc bearing several circular apertures so that one of them may be brought in line with the lens. Such fixed apertures are known as *Waterhouse stops* and are used, for example, in some fish-eye lenses. This arrangement is limited in scope. Most lenses use an iris diaphragm, the leaves of which move to form an

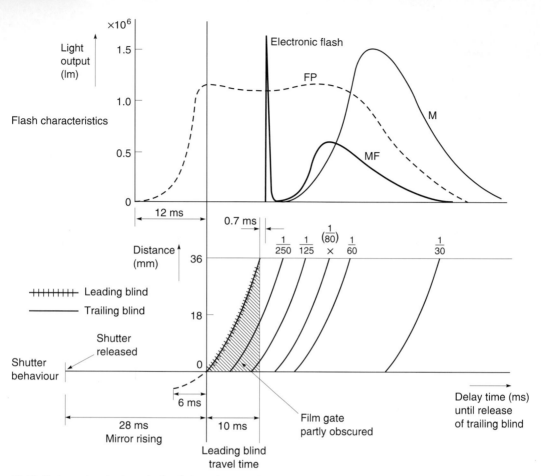

Figure 11.10 Flash synchronization of a focal-plane shutter. The lower part of the diagram shows the horizontal movement of the leading and trailing blinds across the film gate of width 36 mm. The leading blind is released some 6 ms before the end of the 28 ms taken for the reflex mirror to rise, and it takes some 10 ms to open fully. The trailing blind is released after a suitable delay time, also taking some 10 ms for its full travel. At exposure durations of less than 1/80 s (the X-synchronization value here), the film gate is still partially obscured, as the trailing blind is released before the leading blind has completed its travel. The leading blind fires the electronic flash after a delay of less than 1 ms and the flash discharge time is 1 ms or less. The full flash output of a small flashbulb of the MF type is obtained with X-synchronization and a shutter speed of 1/30 s or more, likewise for the larger 'M' type of bulb. To use the shorter shutter speeds of 1/80 to 1/2000 s, the long-burning 'FP' bulb (now obsolete) was triggered some 12 ms before the leading blind started to move. The upper part of the diagram shows the flash characteristics.

approximately circular aperture of continuously variable diameter. When the camera shutter is of the between-lens type the diaphragm is part of the shutter assembly. It is operated by a rotating ring, usually with click settings at half-stop intervals, and calibrated in the standard series of *f*-numbers. The interval between marked values will be constant if the diaphragm blades are designed to give such a scale; in older lenses with multi-bladed diaphragms the scale may be non-linear and the smaller apertures cramped together (Figure 11.11).

The maximum aperture of a lens may not be in the conventional *f*-number series, but can be an intermediate value, e.g. *f*/3.5. The minimum aperture of lenses for small-

format cameras is seldom less than *f*/16 or *f*/22, but for lenses on large-format cameras, minimum values of *f*/32 to *f*/64 are typical. An SLR camera requires automatic stopping down to the chosen aperture immediately before exposure, in order to permit viewing and focusing at full aperture up to the moment the shutter is released.

In early SLR cameras, the lens was stopped down manually by reference to the aperture scale. The use of click-stop settings assisted this process. Next a *pre-setting device* was introduced which, by means of a twist on the aperture ring, stopped the lens down to the preset value and no further. This arrangement is still occasionally used, for example, on perspective control (PC) lenses. The next

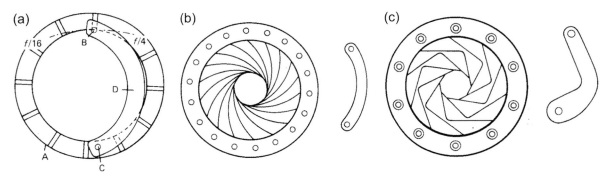

Figure 11.11 The iris diaphragm. (a) Principle of the iris diaphragm. Ring A contains a number of slots. An iris leaf D has a fixed hinge C at one end and a pin B at the other which moves in a slot in the rotating ring A. As ring A is rotated, pin B moves so that the leaf moves in an arc. The action of several overlapping leaves is to give a larger or smaller central aperture. (b) Multi-bladed iris using a simple radiused shape for each leaf. This gives a circular aperture but an unevenly spaced aperture scale. (c) Another multi-blade design, where the more complex blade shape gives an aperture scale with equidistant spacings suitable for automation or servo control.

step was to introduce a spring mechanism into this type of diaphragm, triggered by the shutter release. The sequence was thus speeded up, but the spring needed resetting after each exposure and the diaphragm then reopened to its maximum value. This was known as the *semi-automatic diaphragm*. Finally, with the advent of the instant-return mirror came the *fully automatic diaphragm* (FAD). In this system an actuating lever or similar device in the camera, operated by the shutter release, closes the diaphragm down during the shutter operation. On completion of the exposure the diaphragm reopens and the mirror returns to permit full-aperture viewing again. A manual override may be fitted to allow depth-of-field estimation with the lens stopped down. Cameras with a shutter-priority mode have an additional setting on the lens aperture scale, usually marked 'A', where the necessary *f*-number is determined by the camera and set just before exposure, the user having selected an appropriate shutter speed. The aperture set may be in smaller increments than the usual half-stop increments, possibly to 1/10 stop if motorized and under digital control.

In most exposure modes the TTL metering requires the maximum aperture of the lens in use to be set into the metering system to allow full-aperture metering with increased sensitivity. Lenses fitted to large-format technical cameras are usually manually operated. Some lenses have fixed apertures such as mirror lenses and those used in simple cameras.

Viewfinder systems

The functions of the viewfinder are: to indicate the limits of the field of view of the camera lens in use; to enable the user to select and compose the picture; to provide a data display; and to assist in focus or exposure determination. The viewfinder also acts as a 'control centre' and has a data display system primarily for the exposure measurement system, with a variety of indices, needles, icons, alpha-numerics, lights and camera settings visible around or within the focusing screen area. There may even be either an 'eye-start' function where putting an eye to the view-finder switches on the camera functions, or an interactive viewfinder where the direction of gaze activates different autofocus zones.

A versatile *simple finder* for use at eye level is the *frame finder*. A metal open frame, with the same proportions as the film format, is viewed through a small peep-sight to define the subject area. It is used with technical, aerial and underwater cameras.

A *direct-vision optical finder* uses a reversed Galilean telescope, giving a small bright erect virtual image. An improvement, the *van Albada finder*, uses a white-line format mask and a partially reflecting rear surface on the front negative lens so the lines are seen superimposed on the virtual image. The view extends beyond the frame lines so that objects outside the scene can be seen. A separate mask with selectable frame lines for different lenses can be superimposed on the field of view by a beamsplitter in the optical finder. The frame lines are separately illuminated. This type of finder usually incorporates a central image from a coupled rangefinder (Figure 11.12). Other refinements may include compensation for viewfinder parallax error by movement of the frame line with the focusing mechanism, and a reduction in the frame area when focusing at closer distances. A through-the-viewfinder (TTF) exposure metering system can also be incorporated. As seen in such finders, the image size is usually around ×0.7 to ×0.9 life-size.

The reversed Galilean type of finder gives a bright, upright, unreversed and virtual image. It is not easy to make this finder very compact or to provide a zoom mode. Instead, another type of telescope is adapted, the Kepler telescope used in reverse mode. This gives a real image but it is inverted and laterally reversed, so requires additional

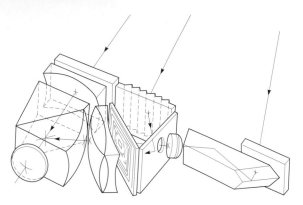

Figure 11.12 The optical configuration of a complex reversed Galilean coupled range and viewfinder with alternative frames (Leica data).

(a)

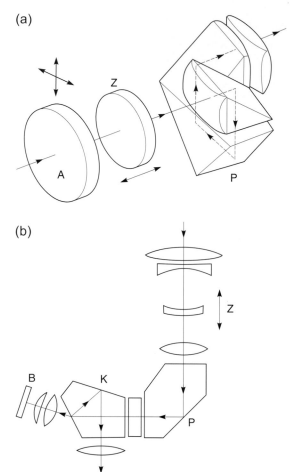

(b)

Figure 11.13 Real image finders. The optical path of the Kepler telescopic system is folded and corrected by prism systems. (a) Zoom finder. A, objective lens, movable for parallax correction; P, porroprism system with field frame; Z, zoom group. (b) Zoom finder (38—110 mm) using pentaprism P and pentagonal prism K. Light is sampled for exposure metering. B, photocell; Z, zoom element.

optics in the form of a prism erector system (Figure 11.13). The light path can be folded optically to fit inside a compact camera body. A very bright image is given and an intermediate lens gives a zoom action coupled to a zoom lens. An LCD plate in the system can display format lines and data. Aspherical plastic elements reduce distortion and a beamsplitter can sample light for through-the-finder (TTF) exposure metering.

Early cameras used a plain *ground-glass screen* giving a real image for composing and focusing, as is still used in technical cameras. The advantages of exact assessment of the subject area covered by the lens, accurate focusing and appraisal of the effects of camera movements offset any inconvenience in viewing an image that is dim, inverted and reversed.

A reflex system, with a front-surface mirror inclined at 45° to the optical axis, gives an image on a ground-glass screen in an *equivalent focal plane*. The image is the same size as it will be recorded on film, and erect but laterally reversed. In a TLR camera, viewing and taking are by separate lenses; in an SLR camera, viewing and taking are by the same lens using an instant return mirror.

A plain ground-glass screen indicates correct focus, but gives a rather dim image, with a rapid fall-off in illumination towards the corners. Evenness of illumination is improved if the screen is etched on the flat base of a plano-convex lens, or if an accessory Fresnel screen is used as a field-brightening element.

A supplementary focusing aid can be incorporated in the centre of the screen. This is a 'passive' device, i.e. it has no moving parts. It is usually in the form of a *split-image rangefinder* or a *microprism array*. The reflex mirror may be multi-coated to improve reflectance and give a brighter viewfinder image. Some of the incident light may be transmitted to a photocell for exposure metering or to a photosensor array for autofocusing, usually via a 'piggy-back' mirror hinged to the reverse side.

Lateral reversal of the reflex image is troublesome, especially in action photography, but addition of a *pentaprism viewfinder* gives an erect, laterally correct and magnified screen image for focusing. There is provision for *eyepiece correction lenses* or *dioptric adjustment* for users who would otherwise need spectacles for viewing. The viewfinder prism may incorporate a through-the-lens exposure metering system for measurements from the screen image.

Focusing systems

Lenses can be used as *fixed-focus* objectives, using small apertures, depth of field and distant subjects to give

adequate image sharpness, but this is not feasible with lenses of large aperture or long focal length, or for close-up work. To ensure that the most important part of the subject is in sharp focus it is necessary to have some form of *focusing system*, as well as a visual indication of the state of focus. Current focusing systems use a variety of mechanical, optical and opto-electronic arrangements (Figure 11.14). Focusing satisfies the lens conjugate equation (see Chapter 6), where a change in subject distance (u) requires a corresponding change in image distance (v) for focal length (f).

The simplest method is by movement of the entire lens or optical unit (Figure 11.14a). This is called 'unit focusing', as used in technical cameras. Monorail types are focused by moving either the lens or the back of the camera. Rear focusing alters the focus only, whereas front focusing alters the size of the image as well as the focus. Other cameras have the lens unit installed in a *lens barrel* or *focusing mount*. Rotation of a ring on the lens barrel moves

the lens in an axial direction. A *helical* focusing mount causes the lens to rotate during focusing, whereas a *rectilinear* mount does not. A *double-helicoid* arrangement provides macro lenses with the extended movement necessary for continuous focus to magnifications of 0.5 or more. The focusing action may be coupled to a rangefinder or to an autofocus system, or it may be viewed on a screen. The subject distance may also be set by a scale.

Focusing is possible by varying the focal length of the lens and not varying the lens-to-film distance. This is done by moving the front element to alter the separation of the front element from the other groups (Figure 11.14b). A slight increase in this separation causes an appreciable decrease in focal length, giving a useful focusing range. Close focusing to less than 1 metre is not satisfactory due to lens aberrations. Zoom lenses may use a (well-corrected) movable front group for focusing. Rotation of the front element is a nuisance with the use of polarizing filters and other direction-sensitive attachments such as graduated filters.

A positive supplementary lens can be fitted in front of almost any lens (see Chapter 10) to give a fixed close-up focusing range (Figure 11.14c). If the subject is positioned at the front focus of the supplementary lens, the camera lens receives parallel light, so it gives a sharp image at its infinity focus setting. By varying the focus setting on the camera lens, a limited close-up range is given. The design of the supplementary lens is important, as the curvatures of its surfaces determine its effect upon the aberration correction of the prime lens. Usually a positive meniscus shape is used, with its convex side to the subject. This simple lens may be perfectly adequate when used at small apertures, but an achromatic cemented doublet design with anti-reflection coatings is preferable for improved performance. A $+1$ dioptre lens has focal length 1000 mm, and if of diameter 50 mm has an aperture of $f/20$, which allows a doublet design to give excellent correction.

With *internal focusing* (Figure 11.14d), the focusing control moves an internal group of elements along the optical axis, thereby altering focal length but not the external dimensions of the lens. The front of the lens does not rotate either. An extensive focusing range is possible with only a small movement. The lens is not extended physically, and the whole unit can be sealed against the ingress of dust and water. The focusing movement can also incorporate the correction for lens aberrations that increase as the focused distance is decreased. Internal focusing is particularly suitable for autofocus lenses and the drive motor can be located either in the camera body or in the lens housing. Internal focusing is used for a variety of lenses, including zoom, macro and super-telephoto types. Close focusing is provided, with retention of image quality.

Many lenses can only be focused close enough to provide a magnification of about 0.1 or less. Most standard lenses have a minimum focusing distance of 0.3–1.0 metres. If the lens is removable, the use of *extension tubes* and *bellows*

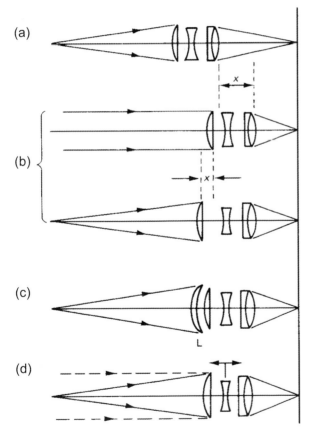

Figure 11.14 Focusing a lens. There are four principal methods of focusing: (a) by extending the whole lens by a distance x; (b) by front-cell focusing — a smaller extension is needed; (c) by adding a close-up lens L — no extension is needed; (d) by internal focusing — no extension is needed.

extensions between the lens and camera body provide the additional lens-to-image distance needed to give greater magnification. (Non-interchangeable lenses are limited to use of a supplementary close-up lens.) An extension tube has fittings for attaching the lens to one end and the camera body to the other. Tubes of various lengths are available for use singly or in combination. For SLR cameras, automatic extension tubes have the necessary mechanical or electrical linkages to retain the operation of the iris diaphragm and TTL metering systems.

Where magnification is greater than 1.0, the optical performance of a lens may be impaired, as corrections are normally computed for work at infinity, and macro settings reverse the usual proportions of conjugate distances (i.e. $v \gg u$). A *lens reversing ring*, to mount the lens with its rear element facing the subject, reduces this problem.

Lenses are usually focused without reference to *focusing scales* when a rangefinder, focusing screen or autofocus system is provided. Scales are useful for use with electronic flash, so that the aperture may be set according to a flash guide number, and to check if the subject is within the operating distance range of an automatic flash exposure system. Also, the distance values can give an estimate of the depth of field by reference to the appropriate scales on the mount, or to tables. The focusing scale may also carry a separate index for infrared use usually denoted by a red dot or letter 'R', and the distance value first set visually or by autofocus is then transferred manually to the IR index.

The traditional *ground-glass screen* or *focusing screen* is a most adaptable and versatile focusing system, giving a positive indication of sharp focus and allowing depth of field to be estimated. The screen can focus any lens or optical system, but accuracy depends on screen image luminance, subject contrast and the visual acuity of the user. Supplementary aids such as a screen magnifier or loupe and a focusing hood or cloth are essential, especially when trying to focus systems of small effective aperture in poor light. The plain screen has evolved into a complex optical subsystem, incorporating *passive focusing aids* (see below) and a Fresnel lens to improve screen brightness. The screen can be a plate of fused optical fibres or have a laser-etched finish to provide a detailed, contrasty, bright image. No single type of screen is suitable for all focusing tasks and many cameras have interchangeable focusing screens with different properties. Precise visual focusing is aided by accurate adjustment of the dioptric value of the eyepiece magnifier to suit the vision of the user.

A *coincidence-type rangefinder* uses two windows a short distance apart, through each of which an image of the subject is seen. The two images are viewed superimposed, one directly and the other after deviation by an optical system (Figure 11.15a). For a subject at infinity the beamsplitter M_1 and rotatable mirror M_2 are parallel, and the two images coincide. For a subject at a finite distance u the two images coincide only when mirror M_2 has been rotated through an angle $x/2$. The angle x is therefore

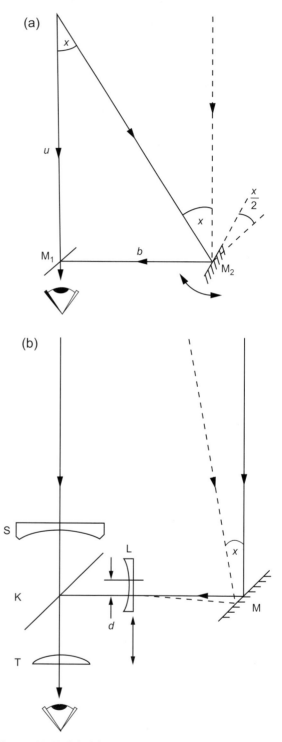

Figure 11.15 Coincidence rangefinder. (a) Rotating mirror type. (b) Sliding-lens type incorporated into a viewfinder. S and T are viewfinder elements, K a beamsplitter and L a sliding lens moving a distance *d* coupled to lens focusing.

a measure of u (subject distance) by the geometry of the system, and may be calibrated in terms of subject distance. By coupling the mirror rotation to the focusing mount of the lens in use, the lens is automatically in focus on the subject when the rangefinder images coincide. The accuracy of this *coupled rangefinder* system using *triangulation* is a function of subject distance u, the base length b between the two mirrors and the angle x subtended at the subject by the base length. Mechanical and optical limitations make this system of focusing unsuitable for lenses of more than about two and a half times the standard focal length for the film format, e.g. 135 mm for the 24 × 36 mm format. The method is unsurpassed in accuracy for the focusing of wide-angle lenses, particularly with a long-base rangefinder and in poor light conditions. Alternative systems use a fixed mirror and beamsplitter, obtaining the necessary deviation by a lens element which slides across the light path between them (Figure 11.15b). The rangefinder images are usually incorporated into a bright-line frame viewfinder.

A *split-image rangefinder* is a 'passive' focusing aid in that it has no moving parts, unlike the coincidence-type rangefinder. It is a small device, consisting basically of two semicircular glass prisms inserted in opposite senses in the plane of the focusing screen. Any image that is not exactly in focus on the central area of the screen appears as two displaced halves. These move together to join up as the image is brought into focus, in a similar way to the two images of the field in a coincidence-type rangefinder. The aerial image is always bright and in focus, even in poor light conditions. Because focusing accuracy by the user depends on the ability of the eye to recognize the displacement of a line, rather than on the resolving power of the eye, which is of a lower order, the device is very sensitive, especially with wide-angle lenses at larger or moderate apertures. The inherent accuracy of this rangefinder depends on the diameter of the entrance pupil of the lens in use, so large apertures improve performance. Unfortunately, the geometry of the system is such that for effective apertures of less than about $f/5.6$, the diameter of its exit pupil is very small, and the user's eye needs to be very accurately located. Slight movements of the eye from this critical position cause one or other half of the split field to black out. Consequently, long-focus lenses or close-up photography result in a loss of function of the rangefinder facility and produce an irritating blemish in the viewfinder image.

The same principle is used in the *microprism grid* array where a large number of small facets in the shape of pyramids are embossed into the focusing screen surface. An image from the camera lens that is not precisely in focus on the screen undergoes multiple refraction by these facets so that the image appears broken up into tiny fragmentary areas with a characteristic 'shimmering' effect. At correct focus this image snaps back into its correct appearance, giving a very positive indication of the point of focus. The pyramids are small enough (<0.1 mm diameter) to be

below the resolving power of the eye. The disadvantage of the microprism is the same as that of the split-image rangefinder, the microprism array blacking out at effective apertures less than about $f/5.6$.

Autofocus systems

Visual focusing can be slow, inaccurate and tiring. Methods of obtaining or retaining focus automatically are helpful and such *autofocus systems* can operate in various *modes*. Autofocus can be linked to the shutter release and may be blocked until focus is achieved. The focus may then lock at this setting or it can search continuously for focus as the camera or subject move. An 'active' type of autofocus scans a beam of infrared radiation across the scene; the reflection is measured and triangulation is used, similar to the coupled rangefinder. A 'passive' type uses no moving parts and a pair of images are compared using the output from a CCD array, similar to a split-image rangefinder.

A *focus indication mode* or *assisted focusing mode* is a form of electronic rangefinder that is an analogue of an optical rangefinder or focusing screen. An LED display lights up in the viewfinder to indicate correct focus when the lens is focused manually; the direction of focusing movement required is indicated if the focus is incorrect. A *predictive autofocus mode* anticipates the position of a moving subject after the time delay due to the mirror rise time and will 'drive' the lens to this focus setting in compensation. An automatic *depth-of-field mode* is where the lens is focused automatically on the near and far points of the scene to be rendered in focus; the necessary intermediate focus is set and the automatic exposure determination system then chooses the appropriate aperture to give the correct depth of field, given an input of data from the lens as to its focal length. Another type is a *motion-detection mode*, or *focus-trap mode*, where the camera is autofocused at a suitable distance; when a moving subject enters this zone, the camera automatically fires the shutter. A *focus maintenance mode* retains sharp focus once this has been set visually. Autofocus systems should be rapid-acting, function at low light levels and give accuracy comparable to visual methods. Different systems are in use.

One autofocus method uses direct measurement of the subject distance by an active ranging method using pulses of ultrasound, as introduced by Polaroid in cameras for self-developing film. A *piezo-electric ceramic vibrator* (PECV) emits a 'chirp' of ultrasonic frequencies and elapsed time for the return journey to the subject is proportional to subject distance. This system operates even in the dark, but cannot penetrate glass.

Other 'active' systems involve scans across the subject area. *Electronic distance measurement* (EDM) uses an infrared-emitting diode moving behind an aspheric projection lens to scan a narrow beam across the scene. Reflection from a defined subject area is detected by

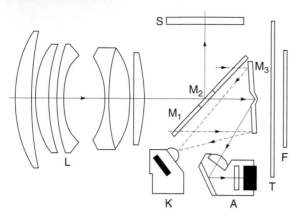

Figure 11.16 Location of autofocus and metering modules. A, autofocus module; F, film in gate; K, metering module, spot or centre-weighted; L, camera lens; M_1, reflex mirror with 30% transmission; M_2, central region with 50% transmission; M_3, secondary mirror with two focusing regions; S, focusing screen.

a photodiode, and controls the synchronous focusing movement of the camera lens. This is the electronic analogue of a coupled rangefinder. Infrared beams can operate in darkness and through glass, but can be fooled by unusual reflection of the radiation from various materials such as dark cloth.

Phase detection autofocus is a passive system using one or more linear CCD arrays and no moving parts. The CCD array is located in the mirror chamber (Figure 11.16) beyond an equivalent focal plane and behind a pair of small lenses that act in a similar manner to a prismatic split-image rangefinder, as in Figure 11.17. Divergent pencils of rays beyond the correct focus position are refracted to refocus upon the array, and the separation (or 'phase') of these focus positions relative to a reference signal is a measure of the focus condition of the camera lens. The phase information operates a motorized focus control in the lens. Very rapid focusing is possible, even in continuous-focus mode. The system will even focus in the dark, using the emission of infrared radiation from a source in a dedicated flashgun. The autofocus zone or zones are shown in the viewfinder and can be selectively located on subject detail to be in focus. The focused distance data may be used in exposure calculations or in the operation of dedicated flash systems. Accuracy of operation is dependent upon using a lens aperture of $f/5.6$ or larger and also a reasonable light level. Low-light performance is given by an EV scale of values, similar to that used for exposure metering systems. A dedicated flashgun fitted to the camera may emit a small pre-flash with a striped pattern to fall on the subject and assist autofocus in dim light. Alternatively, a continuous beam of deep red light or even infrared may be used.

An SLR autofocus system involves a beamsplitter mirror, whose effect is altered by linearly polarized light, so errors

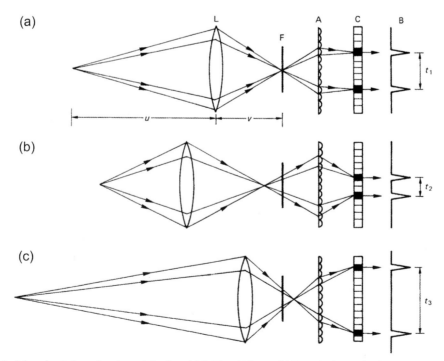

Figure 11.17 Principles of autofocus by phase detection. (a) Subject in focus. (b) Focus in front of subject. (c) Focus beyond subject. Key: A, lenslet array; B, output signals with time delay t_1, etc.; C, CCD linear array; F, equivalent focal plane; L, camera lens.

may occur if a linear polarizing filter is used over the camera lens. A circular polarizing filter is needed.

EXPOSURE METERING SYSTEMS

Most cameras incorporate some form of exposure metering system. The meter with a calibration constant (K) measures the luminance (L) of the subject by reflected light, and given a film speed (S) the exposure equation $t = KN^2/LS$ is solved by an integral calculator to display the various combinations of shutter speed (t) and f-number (N) required. The value of film speed may be automatically input by a DX coding system. The values of N and t may be selected automatically by a selected *program mode*. Various forms of photocell have been used in light-metering systems, including *selenium cell* and *cadmium sulphide cell* types, now effectively replaced by the silicon photodiode. Incident light on this photovoltaic device generates a very small current. This output is amplified and converted to a voltage which is linearly proportional to the incident light. Response is good even at very low light levels, and the linearity is maintained over a wide range of illumination levels. The response time of a silicon photodiode is very short, in the order of microseconds, and cell area can be very small while retaining adequate sensitivity. Spectral sensitivity is from 300 to about 1200 nm, with a peak around 900 nm. For photometric use in a camera or light meter, filtration to remove much of this natural IR sensitivity is necessary to give a suitable response.

Automatic exposure

A light-metering system built into a camera body coupled to the camera controls can be used either for manual setting or for one of several alternative *automatic exposure* (AE) modes. The photocell(s) may be located in various positions, requiring different optical systems for each variant. In non-SLR cameras the metering system reads directly from the subject. The cell is placed behind an aperture located either on the camera body or near the camera lens. Metering sensitivity is high as light losses are low compared with TTL metering. A frame line in the viewfinder may indicate the measurement area. To provide allowance for film speed, a metal plate with a series of graded apertures, or a tapered slit, is located in front of the photocell and linked to the film speed setting control.

Through-the-lens (TTL) measurements have advantages in that only the imaged area is used, regardless of the lens fitted, and exposure compensation is automatic for bellows extension and optical attachments. Such compensation is important for zoom lenses, as the f-number usually changes as focal length is altered.

The best location for a photocell is in the true photoplane of the camera, as realized in some insertable metering systems for large-format cameras, but an *equivalent focal plane* can be used instead. Details of photocell locations and optics are given in Figure 11.18. Such TTL systems are normally limited to simple measurements of subject luminance. Uncertain accuracy with non-average scenes using a simple integrated measurement requires alternative metering sensitivity patterns to improve the proportion of acceptable exposures. Alternative patterns use approximate full-area integration with central bias, centre-weighted measurement (possibly with directional bias) and small-area measurement. Some may use spot metering of very small areas, or zone measurements by multiple zone or *segmented photocells* to provide scene categorization information (*matrix metering*).

An accurate form of TTL metering is that of *off-the-film* (OTF) metering, in which image luminance measurements are made using the light reflected from patterned shutter blinds or from the film surface itself during exposure, even with rapidly fluctuating light levels. For short exposure times, the patterned shutter blind simulates average image luminance over the obscured area of the film gate during travel of the slit. Flash metering uses the open gate full frame area.

In camera metering is normally used in semi-automatic or automatic mode. In the former, either shutter speed or aperture or both together are varied manually, until a readout indicates that correct exposure has been set. The camera can be used to scan and sample the scene in chosen areas, and a modified exposure given as judged necessary. Automatic exposure offers a choice of shutter priority, aperture priority and various program modes. Additionally, *metering pattern* may be altered, an *exposure compensation control* may be used or an *exposure memory lock* employed to improve the proportion of acceptable pictures from non-average scenes.

Metering sensitivity is dependent upon the effective maximum aperture of the lens in use. Measurement may have to be carried out in a *stopped-down mode* if a lens without automatic iris diaphragm operation or maximum-aperture indexing is used. Metering is of the light reflected from a subject, as the incident-light mode is not easily available to TTL metering systems. Metering sensitivity with an $f/1.4$ lens and ISO 100 film is generally of the order of 1EV, significantly less than that of a hand-held meter.

Programmed exposure modes

Multi-mode cameras offer a choice of user-selectable AE programs. The *programmed exposure mode* is the 'snapshot' form of setting and was the original form of automatic exposure. The principle of this '*P*' mode is that photocell output and the set film speed will give the necessary exposure for a scene in terms of *exposure value* (EV), which represents a wide range of equivalent combinations of lens aperture and shutter speed. Associated circuitry is

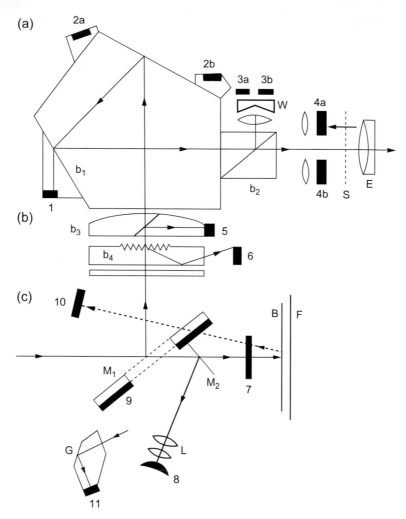

Figure 11.18 Photocell positions for in-camera TTL metering systems: a selection of systems and associated optics. (a) Screen luminance measurements. 1, integrated reading via beamsplitter b_1; 2a, 2b, photocells in series for weighted reading; 3a, 3b, segmented photocells reading via double wedge W and beamsplitter b_2; 4a, 4b, cells near eyepiece for integrated readings. Supplementary lenses give central bias. One cell may read stray light through the eyepiece for correction. E, eyepiece; S, eyepiece shutter. (b) Equivalent focal plane measurements: 5, small area reading via beamsplitter b_3; 6, small-area reading via diffraction-type beamsplitter b_4; 7, removable photocell on pivot; 8, photocell reading via semi-reflecting or perforated mirror M_1 and piggy-back mirror M_2, supplementary lens L added for bias; 9, photocell behind perforated mirror. (c) Measurement 'off the film' (OTF) or shutter blind B. 10, photocell for integrated reading; 11, photocell and light guide G. Cell 8 may also be used. The shutter blind may have a reflective zone.

programmed to give one particular combination according to the EV data fed in. Examples of such programs are shown in Figure 11.19, in which a program is given as a straight line with a chosen slope and one or more changes in direction to span the EV measuring range of the camera.

A horizontal or vertical line shows that one variable is kept constant while the other changes continuously; for example, shutter speed may change continuously over the range 8 to 1/8 s while the aperture is held constant at $f/1.4$.

A sloping line shows that both variables change continuously. A steeply sloping line shows that priority is given to the maintenance of short exposure durations, to minimize the risk of camera shake or to stop subject motion, while relying upon lens performance and accurate focusing at the corresponding large aperture. A required EV of (say) 12 for correct exposure is interpreted in various ways by programmed cameras. It could mean settings of 1/30 s at $f/11$ for one camera or 1/80 s at $f/7$, 1/125 s at $f/5.6$ or even 1/500 s at $f/2.8$ for other cameras. An electronically

Figure 11.19 Programmed exposure modes. The EV graph shows five possible program profiles over an exposure range from EV 1 to 20. These are D (depth), W (wide), N (normal), T (telephoto) and A (action). Both D and A may be selected manually while W, N and T are usually set by the focal length of the lens in use.

controlled shutter and fractional control of lens aperture setting allows non-standard exposure settings.

The user can decide whether shutter or aperture priority might be appropriate under different circumstances, such as moving subject matter, due to depth-of-field require ments, low light levels or long-focus lenses. So there is a choice of 'normal', 'action' and 'depth' AE programs. Additionally, the insertion of an alternative lens of different focal length may automatically select one of three shutter-biased program modes usually referred to as 'wide', 'stan-dard' and 'tele', with the turning point of the program line on the EV graph at the point where the minimum hand-held shutter speed may be used. The slope of the program line may increase progressively from 'wide' to 'tele'. A zoom lens may alter the program selected continuously as focal length is altered.

In any programmed AE mode the aperture value is selected by the camera in increments that may be as small as 0.1EV. When used with a metering-pattern system capable of some analysis of tonal distribution of the subject matter, programmed exposure modes are capable of producing a high proportion of acceptably exposed, sharp results.

Segmented photocell systems

Accurate determination of camera exposure, especially by in-camera TTL AE systems, is limited by variations in subject luminance ratio and non-typical subject tone distributions, which necessitate their recognition and classification by the user. Examples of such images include those containing large areas with very light tones or very dark tones; in these cases auto-exposure will often result in incorrect results, as the camera will be basing the exposure on an average of the scene, assuming that it should be a mid-grey. The use of spot metering, small-area and various weighted integrated readings can help, with intel-ligent use. A greater percentage of successful results is possible using a *segmented photocell* or *matrix metering* arrangement for scene classification. The viewfinder image is measured, assessed, compared to stored data on a large number of scene patterns and categorized for subject type. Adjustments are then made automatically to the basic camera exposure. For example, the screen area may be measured as five or six separate zones (with some overlap) by two symmetrically opposed segmented photodetector arrays, both with three independent measurement areas. Other arrays can provide spot, small-area and weighted readings as well (Figure 11.20). The weighted response data from the separate segments is classified by signal-process-ing techniques. Analysis of zonal luminance difference values and the total subject luminance value, plus the metering pattern, allows classification into a number of computer-simulated subject types and the exposure is based on stored data for several hundred subject types as determined from practical tests or evaluation of photo-graphs (see also Chapter 12).

(a)

(b)

(c)

(d)

Figure 11.20 Segmented photocell arrangements. (a) Canon, 16 segments. A, spot metering; A_1–A_4, movable spot metering and focus zones. Evaluative metering uses all segments. (b) Pentax, eight segments. A, spot metering. Other zones give centre-weighted and averaged metering. (c) Minolta, 13 segments. A simpler seven-segment inner group is also used. A, spot metering; A, B, C, centre-weighted. (d) Nikon, eight segments. A, spot metering.

The *tone distribution* may be determined as a comparison of central foreground to background luminance, and if a chosen difference value of EV is exceeded, then an integral flash unit may be charged automatically and used for fill-in purposes. The lens aperture and shutter speed are optimized separately for subject distance (using autofocus data) and flash synchronization. Additionally, separate segments may be switched out or used in different configurations to provide various alternative forms of metering sensitivity patterns (spot, small-area, centre-weighted).

An improvement in scene classification is to provide subject distance (u) information from the autofocus module and focus setting on the lens. The latter requires that the focusing control has a suitable transducer and data link with the microprocessor in the camera. From the *matrix* array of photocells used to divide the scene into segments, the scene can be classified using the three pieces of data, overall scene luminance (L), luminance range of the subject (LRS) and the subject distance (u), then subdivided into a series of scenes for which optimum exposure data is stored, based on extensive practical tests, especially for non-typical scenes. The scene is matched to one of these and the optimum exposure given. The defocus data from the AF system helps determine whether the subject is central or off-centre in the frame, as this can give emphasis to different segments of the matrix. By the additional use of 'fuzzy logic' procedures, the scene type boundaries are not sharply defined but overlap to some extent to avoid sudden changes in exposure, e.g. when using a motor drive, when small variations in an essentially constant scene may cause a noticeable change in exposure as the scene is inadvertently reclassified and exposure altered. The same principle can be applied in a simpler way to the use of fill-in flash to give a balanced exposure to subjects, especially of excessive contrast. A matrix array of CCD photocells filtered to blue, green and red light, together with scene classification data, can also be used in-camera to assess the colour temperature of a scene (see Chapter 14).

BATTERY POWER

Most cameras depend upon battery power for their functions, such as metering, autofocus, microprocessor operation, electronic shutter control, self-timer, viewfinder displays, and for motors to advance the film, rewind it and focus the lens. Accessories such as power winders, flashguns, data backs and remote controls all use batteries. Without functioning batteries the equipment is inoperative. An exception is a 'mechanical' setting of a shutter providing a single speed suitable for flash synchronization, given a failure of the battery operating the shutter timing circuitry.

For camera equipment only low direct current (DC) voltages are required, seldom more than 6 volts. Small batteries are favoured given space limitations, but have reduced capacities, especially given the number of functions to be powered. Batteries should be inserted correctly regarding polarities and may be in a removable holder or a shaped grip on the camera body. Performance is related to temperature and a cold weather adaptor kit may be available to allow the battery pack to be kept in a warm pocket and a long cable terminates in an adaptor to go into the camera compartment. A battery condition test and indication is vital. To conserve battery power a timing circuit may switch off the camera after a short time, varying from 30 seconds to several minutes. Slight pressure on the shutter release will keep power on. Other means of saving battery power include having mechanical latches on camera shutters for long exposure times using the 'B' setting. Electronic flashguns use very effective thyristor-controlled energy-saving circuitry to discharge the capacitor only as much as necessary; also, the unit may switch off if not used for a few minutes. Battery drain depends on circumstances, type of circuit and type of battery. Some metering or shutter control circuits are largely independent of the state of the battery; others such as silicon photodiode circuits require a stabilized voltage, so batteries are favoured that have a near constant output during their operation and life. Heavy-duty applications such as motor winders and flashguns need moderate voltage and short bursts of heavy current, supplied by clusters of alkaline–manganese or nickel metal hydride (NiMH) cells. Medium-format cameras with integral motor drives also have heavy-duty needs.

A battery uses cells in series and each electrochemical cell uses dissimilar electrodes and a suitable conducting electrolyte, which can be liquid, gaseous, viscous or near solid. Leakage of electrolyte can be disastrous and damage equipment severely, so batteries should be removed when equipment is not needed for a time. Chemical reactions cause a gradual loss of voltage from its initial value. Shelf life varies for unused batteries, but can be 5 years or more in the case of lithium types. A battery tester may be incorporated to check voltage before use. Batteries should be changed in sets, not just one discarded when found to be discharged. Batteries are either of the throwaway or rechargeable type. The first is disposed of when exhausted and it is very dangerous to attempt to recharge it as the gases formed may cause it to explode. The rechargeable cell uses a trickle DC current of low voltage to reform the chemical cell by inducing reverse reactions. With such cells, too rapid a discharge or charge must be avoided as internal damage and heating may occur. Types of rapid recharging batteries are available such as lithium-ion and nickel metal hydride types. Batteries should be inspected for corrosion before insertion and the terminals wiped with a cloth to remove any oxide film and improve contact.

A number of battery types are in use. The *carbon–zinc cell*, the oldest type, is cheap, has a short life and cannot deliver large amounts of current. It is best used only in an emergency if other varieties are unobtainable. Zinc chloride types give improved performance. The *alkaline cell*, or manganese–alkaline type, is similar to the carbon–zinc type but with a different electrolyte and near-leakproof construction. It has about 10 times the life and a wide operating temperature range. The *mercury button cell* is no longer available for safety reasons and has been largely replaced by the silver-oxide cell, which has a very stable output, but is costly so is frequently substituted by alkaline or lithium cells. The *lithium cell* uses lithium instead of zinc for its positive terminal. Combined with manganese dioxide, a long shelf life is given and a useful life in a camera. Low-temperature operation is possible to $-20°C$. The smallest voltage available is 3 volts so it can only replace two silver-oxide types used in series. Other types include lithium-ion and nickel metal hydride batteries, both of which are rechargeable and retain no memory of previous use.

CAMERA SHAKE AND IMAGE STABILIZATION

Image degradation and loss of resolution occur if the image moves across the photosensor area during exposure duration (t). This can be due to movement of the subject, the camera or both, referred to as *camera shake*. The subject velocity (V_s) and image velocity (V_i) are related by magnification (m) in that for motion parallel to the film plane $V_i = mV_s$. For motion in a direction inclined at angle θ to the optical axis:

$$V_i = m \cos \theta V_s \qquad (11.8)$$

In photography, blurring of an image point due to movement can be reduced to an acceptable level, such as to the value of C, the diameter of the circle of confusion, by a short exposure as given by shutter speed or flash duration, so:

$$C = tV_i = mtV_s \qquad (11.9)$$

The technique of *image motion compensation* (IMC) matches photosensor and image velocities during exposure to reduce blurring. For a fixed camera position and viewpoint, even the image of a static subject may move a distance exceeding C during exposure, due to camera shake. This is compounded by photography from a moving platform such as a car or helicopter. Taking $m = f/u$ as above, then:

$$t = uC/fV_s \qquad (11.10)$$

So t is proportional to $1/f$, hence for a lens with $f = 500$ mm, t must be 1/500 s or less for shake-free results.

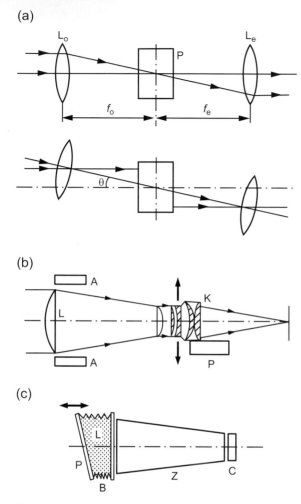

(a)

(b)

(c)

Figure 11.21 Optical image stabilization. (a) In prismatic binoculars, prism block P is rotated through angle θ to compensate for angular movement. L$_e$, eyepiece; L$_o$, objective. (b) Long-focus lens, 300 mm f/2.8 using optical compensation unit K. A, accelerometers; L, lens unit; P, actuator. (c) Liquid lens system for video camcorders. B, bellows; C, CCD sensor; L, liquid; P, movable plate; Z, zoom lens.

Personal limits for hand-held exposures can be determined using a test subject to compare results for tripod and hand-held exposures at different shutter speeds with different focal lengths. Cameras with auto-exposure systems interface with the lens to monitor focal length and give a visual or audible warning if the shutter speed exceeds a safe value. An autofocus module using a CCD array of cruciform shape can similarly be programmed to warn of camera shake by comparing phase information in both x and y directions to obtain a measure of image velocity. Camera performance is always improved by use of a suitable tripod

or other support. For hand-held use a method of offsetting the blurring effects of movement is to stabilize the image optically.

Methods used have included a *gyro-stabilizer* using a heavy flywheel rotated at high speed, when inertia reduces high-frequency oscillations or a body harness with balanced springs to allow movement to follow action smoothly without vibration by distribution of mass and balance. The effects of camera movement are reduced if the lens is supported at a position beneath its *rear nodal point*, as a lens can rotate about this point or *optical centre* without movement of the image. Such mounting can be difficult as the node can be in front of the lens if it is of telephoto design, or it can change position if it is a zoom lens.

Compensation is possible by additional refraction of incident light at an angle proportional and opposite to the camera motion angle using a *liquid lens* formed by a volume of liquid between two optical flats of the same refractive index. One flat is rotatable about two axes to produce a variable angle prism for compensation. This has little effect on lens properties. Contemporary methods use solid-state accelerometers to detect pitching and yawing movements in orthogonal axes and to operate piezo-electric actuators within 10 μs to adjust either a compensating lens group within the lens (see Figure 11.21), or a liquid-filled cell in front of the lens (used in camcorders).

Alternative non-optical methods use digital technology. The image is stored in a frame store, segmented into several areas and some 30 points in each area are compared to the next frame. The frame is cropped and reduced, rotated to align, and enlarged back again for display and recording. Alternatively, gyro sensors can adjust the timing of the CCD array to 'move' the image in a compensating direction.

CAMERA MOVEMENTS

For most photography it is usually sufficient to have the optical axis of the imaging lens orthogonal to the photoplane, intersecting it at (or near to) the point of intersection of the format diagonals, i.e. the image centre. This point is the *principal point (of autocollimation)* (P), not to be confused with the principal points of the lens, and its position is the origin of a Cartesian coordinate system for image points.

As well as axial focusing movements of the lens or photoplane, some camera designs offer the possibility of a range of *camera movements*, where the optical axis of the lens and the camera axis of symmetry are displaced (translated) and/or rotated relative to each other (see Figure 11.22a). The movements are usually called *shifts*, *swings* and *tilts*, and have distinct practical uses. They are

(a)

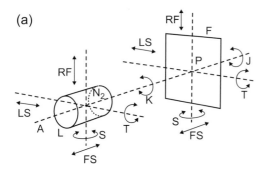

(b)

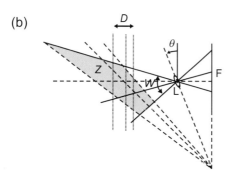

Figure 11.22 Camera movements. (a) Possible movements. A, camera axis (neutral); F, film plane; FS, focusing; J, rotating back; K, levelling; L, lens; LS, lateral shift; N_2 rear nodal point; P, image principal point; RF, rise or fall (shift); S, swing; T, tilt. (b) Example of lens tilt to reposition zone of sharpness by Scheimpflug's Rule. θ, lens tilt angle; D, depth of field without tilt; W, field of view; Z, sharp zone with tilt applied.

used to control focus distribution (image sharpness) and image shape ('perspective') by use of the lens or photo-plane movements respectively. Application of the *Scheimpflug Rule* (to give collinearity at the intersection of subject plane, lens rear principal plane and photoplane) gives optimum distribution of acceptable image sharpness within the volume of the subject space (Figure 11.22b). Some large-format cameras of the monorail type are equipped with transducers and sensors to measure swings and tilts, while a small on-board computer will indicate optimum settings to control sharpness as required from application of Scheimpflug.

A similar range of movements is provided in some enlargers for the restoration of image shape and scale when previously recorded by a tilted camera or without corrective movements.

A variety of movements find specific uses, including correction of verticals in architectural photography, lateral shifts by a 'perspective control' (PC) lens in panoramic photography and lens rotation in panoramic cameras, as well as lateral shifts and tilts for stereo photography, close focusing in photomacrography and the restoration of perspective from oblique views that include a subject reference grid.

Electronic imaging systems may offer the ability to restore or produce image shape changes by alternative means, such as the removal of *keystoning* (converging verticals when the camera is tilted up) in images for video projection. Digital image processing may use geometric transformations to restore image shape or distort images to conform to a particular form of image projection.

BIBLIOGRAPHY

Goldberg, N., 1992. Camera Technology. Academic Press, San Diego, CA, USA.

Harris, M., 1998. Professional Architectural Photography. Focal Press, Oxford, UK.

Jacobson, R.E., Ray, S.F., Attridge, G.G., Axford, N.R., 2000. The Manual of Photography, ninth ed. Focal Press, Oxford, UK.

Ray, S., 1983. Camera Systems. Focal Press, London, UK.

Ray, S., 1999. Scientific Photography and Applied Imaging. Focal Press, Oxford, UK.

Ray, S., 2002. Applied Photographic Optics, third ed. Focal Press, Oxford, UK.

Stroebel, L., 1993. View Camera Technique, sixth ed. Focal Press, Stoneham, MA, USA.

Chapter | 12 |

Exposure and image control

Efthimia Bilissi, Sophie Triantaphillidou and Elizabeth Allen

All images © Efthimia Bilissi, Sophie Triantaphillidou, Elizabeth Allen unless indicated.

CAMERA EXPOSURE

The term *exposure* in photography describes the total quantity of light energy incident on a sensitive material, which in general terms is the *photographic exposure*. It may alternatively describe the process of controlling the light energy reaching a sensitive material in a camera, which is more specifically the *camera exposure*.

As described in Chapters 1, 8 and 11, two parameters are used to control photographic exposure: the amount of light incident on the imaging sensor and the duration of the sensor's exposure. This is described by Eqn 8.1, the *reciprocity equation*:

$$H = Et \qquad (12.1)$$

where H is exposure, E is the subject illuminance and t is exposure duration.

As described in Chapter 11, in a camera, the amount of light, i.e. the subject illuminance (E), is controlled via the lens iris diaphragm. The iris diaphragm is calibrated in units of relative aperture (N) — see Chapter 2. The duration of exposure (t) is controlled by the shutter speed. Because of the reciprocal nature of Eqn 12.1, a range of different combinations of aperture and shutter speed (termed 'equivalent exposures') will provide the same quantity of incident radiation on the sensitive material.

A number of factors influence the optimum camera exposure for any imaging situation and the resulting quality of the image. Fundamentally, the results from any exposure are dependent upon the relationship between four factors: the radiation coming from the scene, the transmission of that radiation through the optical system, the exposure on the sensor, and the sensitivity and characteristic response

of the sensor to that radiation. We introduce the parameters influencing these aspects of exposure below, to be further elaborated later in the chapter.

In any given scene there will be a range of areas of different luminance which, as introduced in Chapter 8, may be characterized by the subject luminance ratio or the subject luminance range. These will provide a range of exposures to the sensor. Various aspects of the scene and the lighting conditions will influence the subject luminance range. Any scattered light results in a reduction in scene contrast. The luminance range is reduced by flare and, as a result, the tonal increments in the shadows are compressed. The colour of the subject and its surface reflection properties will affect the amount of light directed at the sensor. Additional factors include the type of light source(s), the direction and intensity of the light, and the distance between the light source and the subject, which follows the inverse square law (see Chapter 3). The greater the distance between subject and light source, the lower the intensity of the light that reaches the subject. Subjective preferences also influence the photographer's choices for optimum exposure.

As already described, the amount of light from the scene reaching the sensor is controlled by the aperture and shutter speed combination, but is also affected by other variables which are summarized by Eqn 6.61 in Chapter 6. This defines image illuminance as a result of the combined effects of subject luminance, transmittance (which includes lens transmittance, the effects of filters in front of the lens, and in digital systems, the transmittance of anti-aliasing filters, infrared filters and sensor microlenses), lens aperture, magnification and natural vignetting (see Chapter 6).

The sensitivity of the sensor (the ISO speed) is determined by the sensor type and characteristics, as well as subsequent processing: development conditions for film and subsequent

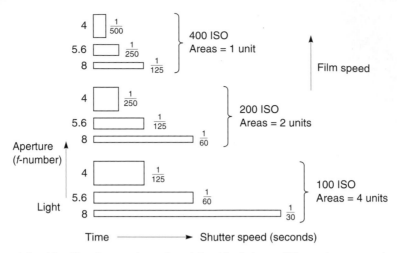

Figure 12.1 Exposure relationships. The diagram shows the relationships between ISO speed, exposure duration and aperture setting to give equivalent exposures (shown here as the areas of rectangles). A long exposure duration implies a reduced aperture and a low ISO speed setting, a larger rectangle, for a subject of given luminance.

analogue and digital processing of the signal from image sensors. Chapter 24 discusses speed and sensitivity of sensors in detail. The characteristics of the sensor, in terms of contrast reproduction and dynamic range, described by the characteristic curves of films and the transfer functions of image sensors, will ultimately define the relationship between the original scene luminances and their reproduction in the image. This is discussed later in the chapter and tone reproduction is also the subject of Chapter 21.

Subject luminance range, ISO speed, lens aperture and shutter speed are therefore the four essential quantities of camera exposure; they are also the ones which are, to a greater or lesser extent, the easiest to change (the other factors detailed above are often inherent properties of the system). The selection of a suitable combination of aperture and shutter speed at a given ISO speed is a primary creative control in photography and may be dictated by the subject itself or the treatment required (see Figure 12.1). Together they influence a number of important image attributes, such as depth of field, motion blur, image sharpness, contrast and noise. The ability to vary the illumination on the subject, where possible, provides more options for varying the other factors. Camera exposure may be determined by practical trial, e.g. by an estimate based on previous experience, followed by assessment of the resulting image, but measurement by some form of light meter is quicker and usually preferable.

EXPOSURE RELATIONSHIPS AND LOGARITHMS

As described in Chapter 4, the human visual system (HVS) has an approximately logarithmic response to light. This

means that light intensity must change by an approximate factor of 2 to be perceived by the HVS as a *just-noticeable difference* (JND) in brightness. This has been shown by both physiological and psychophysical studies on contrast perception. Psychophysical experiments led the German psychologist Ernst Heinrich Weber to the conclusion that just-noticeable differences in the perception of stimuli are constant fractions of the magnitudes of original stimuli. The German psychophysicist Gustav Theodor Fechner extended this work and described the mathematical relationship between the intensity of subjective sensation and the stimulus intensity. This relationship was shown to be logarithmic. Fechner named this as 'Weber's Law' but it was later renamed as the 'Weber–Fechner Law'.

Based on the Weber–Fechner Law, the following equation describes the HVS response:

$$S = C \log R \qquad (12.2)$$

where S is the magnitude of sensation, C is a constant and R is the magnitude of the stimulus.

Camera exposure is also controlled according to a logarithmic scale. Changes on the camera exposure scale are described in terms of *stops*. A change of one stop results in the doubling or the halving of the amount of light reaching the image plane. As a result, when the aperture is changed by one stop the aperture area is doubled or halved (see below), while when the shutter speed is changed by one stop the exposure time is doubled or halved. As described in Chapter 24, ISO speeds are also based upon a logarithmic (base 2) scale, with changes between consecutive ISOs approximately corresponding to an increase or decrease in sensor sensitivity by a factor of 2. This means that, for the same scene, the overall exposure required at 100 ISO will be twice that required at 200 ISO, a change of one stop.

Relative aperture

The aperture *f-stop* values represent relative apertures which are calculated from the focal length of the lens divided by the diameter of the entrance pupil for a lens focused on infinity:

$$N = \frac{f}{d} \qquad (12.3)$$

where N is the relative aperture, f is the focal length of the lens and d is the diameter of the entrance pupil (see also Eqn 2.23 in Chapter 2 for further explanations). The *f*-number, written as *f/*, is the value of N, and expresses the ratio of the focal length to the value of the diameter of the entrance pupil: an *f*-number of 5.6, for example, indicates that the focal length is 5.6 times the pupil diameter.

It can be seen from Eqn 12.3 that when the diameter of the entrance pupil increases for constant focal length, the *f-number* decreases. As previously mentioned, a change of one stop results in the doubling or halving of the amount of light that passes through the lens, because the area of the aperture is doubled or halved. To double the aperture area, the diameter must be increased by a factor of $\sqrt{2}$ (approximately 1.4). This results in a series of *f/*numbers with a one stop difference: *f/*1, *f/*1.4, *f/*2, *f/*2.8, *f/*4, *f*5.6, *f/*8, *f/*11, *f/*16, *f/*22, *f/*32, *f/*45, *f/*64, etc.

Shutter speed

The shutter speed is measured in fractions of a second (see Chapter 6). As described earlier, there is a range of combinations of *f*-number and shutter speeds that result in equivalent exposure at a given ISO speed (see Figure 12.1). Selection of a suitable combination depends on the specific scene and lighting conditions. For example, larger apertures allow faster shutter speeds, but result in reduced depth of field (see Chapter 6). Subject movement requires a minimum shutter speed, dictated by the speed of the subject, to produce a sharp image. A slow shutter speed, however, may be used in this case, if the effect of motion blur is desired in the final image. Slow shutter speeds may introduce blurring in the image due to camera shake, especially when using lenses with long focal length (see Chapter 11). In many cases, when a specific combination of *f*-number and shutter speed is desired, changes in the illumination may be necessary.

The choice of shutter speed is limited when using electronic flash with cameras which incorporate a focal-plane shutter. As described in Chapter 11, the shutter needs to be open for long enough for the entire image-sensing area to be exposed simultaneously by the flash. This limitation does not apply to cameras with leaf shutters, because the flash is fired when the shutter is fully open. The flash *synchronization speed* (the fastest shutter speed that can be used with flash) depends on the camera model. At the time of writing, high-quality SLR cameras provide flash synchronization speeds as fast as 1/250th of a second, while older cameras synchronize flash at lower shutter speeds, for example 1/60th of a second. It should be noted that when using slow shutter speeds the ambient light affects the exposure in addition to the illumination from the flash.

SUBJECT LUMINANCE RATIO

As introduced in Chapter 8, a primary classification of a scene is by its subject luminance ratio, sometimes called the subject luminance range. This is the ratio between the maximum and minimum luminances within the scene and is numerically equal to the product of the *subject reflectance ratio* (the ratio between maximum and minimum reflectances, dependent upon surface characteristics in the scene) and the *lighting ratio* (the ratio between the maximum and minimum illumination levels, dependent upon the characteristics and position of the light sources). Together, these define variations in subject luminance and therefore subject contrast.

For example, a subject whose lightest and darkest zones have reflectances of 0.9 and 0.09 respectively, i.e. a reflectance ratio of 10:1, when illuminated such that there is a lighting ratio of 5:1 between maximum and minimum illumination levels, has a subject luminance range of (10×5):1, i.e. 50:1. A high luminance ratio denotes a subject of high contrast. Luminance ratios from as low as 2:1 to 1,000,000:1 (10^6:1) may be encountered.

In practice, the luminance range is the difference in stops between the brightest highlights and the deepest shadows. The average luminance ratio based upon measurements from a large number of indoor and outdoor scenes is 160:1. The majority of normal scenes will have subject luminance ratios between 27:1 and 760:1. As each increment of one stop in exposure results in an increase in luminance by a factor of 2, this maximum corresponds to an exposure range from shadow to highlight of between 9 and 10 stops ($2^9 = 512$ and $2^{10} = 1024$).

Based upon appropriate scene measurements, it is usually assumed that an average outdoor subject has a luminance ratio of 128:1 or 2^7:1, corresponding to a seven-stop (or 7EV, exposure values − see later) range. Such a subject is also assumed to have an average reflectance of 18−20%.

Integration of individual luminance levels gives a value for the *average reflectance* of a scene, which depends on the subject luminance ratio and is used in reflected light measurements. As detailed later, there are a number of different reflected metering methods, using different areas of the scene. When using reflected light readings with hand-held exposure meters, however, whole scene integration to produce an average reflectance is a more common method. Most meters are calibrated to a mean reflectance of 18% grey, which can cause exposure problems for scenes with

very high or very low luminance ratios, as the mean reflectance of the scene will be significantly different from this value (illustrated later in Table 12.1). In such cases in-camera metering using one of the various specialized matrix metering modes, or spot metering from highlights and shadows and taking an average, both discussed later in the chapter, can prove more successful. Exposure correction factors, also described later, may be applied for particular types of subjects.

A more fundamental problem arises when the subject luminance range exceeds the dynamic range of the sensor (described in the next section). In this case, detail will be lost from the highlight or shadow regions of the image, depending on where the exposure is placed. The effect of this on image quality is dependent on various factors, such as how much of the image area is affected (detail lost from small specular highlights, for example, may not be a problem) and on the type of sensor (highlight clipping in digital images is generally much more noticeable than shadow clipping, or the loss of highlights in film). Strategies to alter the image contrast may be preferable, such as the reduction of the subject luminance ratio by the use of additional illumination.

DYNAMIC RANGE OF SENSORS

Several definitions of dynamic range exist. Most often dynamic range describes the ratio between the largest and smallest possible signal values of light intensity. Dynamic range can be either input-referred (ratio of scene light intensities, the scene or subject luminance range described above, with luminances measured in cd m^{-2}) or output-referred (ratio of the response signals delivered by an imaging sensor). The dynamic range of both silver halide and electronic imaging sensors (output-referred dynamic range) refers to the ratio of the highest to lowest level of radiation (in visible imaging light) sensed by the sensor. It generally relates to an imager's ability to record both bright and dark objects in a scene with the same exposure settings.

The dynamic range of still digital cameras incorporating CCD or CMOS sensors is defined as the ratio between the maximum charge that the sensor can collect and the minimum charge that is just above the sensor's noise level (see Chapters 9 and 14). Detection of the smallest possible light intensity is limited by the noise floor, as any signal below it is undetectable. The largest possible captured intensity is limited by saturation. Dynamic range is usually expressed in logarithmic units:

$$DR = \log\left(\frac{I_{max}}{I_{min}}\right) = \log\left(\frac{FWC}{NF}\right) \quad (12.4)$$

where I_{max} and I_{min} are the maximum and minimum intensities respectively; FWC and NF represent the full-well capacity and the noise floor respectively (see Chapter 9).

If the image sensor has a linear response curve, then only the saturation and the noise floor levels limit dynamic range. Extending the dynamic range requires the shifting of saturation to higher input signal levels by giving the sensor a non-linear response curve. In such a case the local slope of the response curve (called incremental gain) decreases so that saturation is reached at much higher luminance levels than for a linear imager (see Figure 12.2). However, lowering incremental gain will in turn decrease incremental signal-to-noise ratio (iSNR; defined as the ratio of the input luminance signal to the luminance-equivalent noise that is equal or greater to 1.0, also known as noise equivalent contrast, used as a criterion for detection), meaning that there is an incremental signal-to-noise trade-off when increasing dynamic range. A more general definition of dynamic range that is also valid for non-linear sensors is expressed as the luminance range between I_{max} and I_{min} in which incremental signal-to-noise satisfies the minimum threshold criterion of registerable signal intensity. In such cases dynamic range is given by Eqn 9.1, which expresses dynamic range in decibels (dB) and uses a scale factor of 20. The threshold criterion is application specific: 1.0 is the theoretical detection limit and 10 the requirement for 'acceptable' photographic image quality.

The output-referred definition of dynamic range of electronic sensors can lead to dynamic range numbers built merely on technical specifications, such as the bit depth of an analogue-to-digital (A/D) converter and has limited value in predicting dynamic range. The relationship between input and output signals is established by the imager's response curve (Chapters 9 and 21). Limited dynamic range and quantization in digital capturing devices thus lead to inadequate data representation and artefacts such as contouring and tone compression.

Scene luminance ranges are often greater than the dynamic range of imaging sensors and thus a single exposure often results in losses in the shadows or in the highlights. The part of the scene luminance range where the losses occur depends on the choice of exposure settings. Lower exposure (i.e. underexposure) allows the capture of

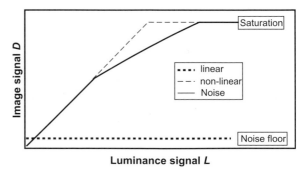

Figure 12.2 Extending dynamic range with a non-linear response curve.
Adapted from Hertel (2009).

highlights by avoiding sensor saturation but results in clipping the shadows and thus losing any shadow detail. On the other hand, higher exposure (i.e. overexposure) allows a good representation of shadows, but the highlights are clipped ('burnt'). Figure 12.3 shows slightly underexposed (a) and overexposed (b) images of a high (relative to the sensor) luminance range scene and the corresponding histograms, showing clipping of the shadows (a) and the highlights (b).

Digital images captured using a series of different exposure settings allow coverage of a wider scene luminance range, revealing more detail than would have been possible by a single shot. The process is the most common way to achieve *high-dynamic-range imaging* and is usually achieved by the following steps: (i) capture of multiple exposures of the same subject, (ii) camera response function estimation, (iii) high-dynamic-range construction by superimposing all subject exposures, and (iv) tone mapping to the display

or the print media. High dynamic range is briefly discussed later in this chapter and in Chapter 21.

The relationship between subject luminance range and film density, as well as different factors influencing the *exposure latitude* of silver-based media (defined as the minimum camera exposure required to produce adequate shadow detail without losses of highlight detail), is described in detail in Chapter 8.

OPTIMUM EXPOSURE AND THE TRANSFER FUNCTION

Figure 12.4 illustrates the response curves of a conventional black-and-white negative film (a) and that of a typical CCD, before encoding (b). In both media, 'correct' exposure of the subject luminance range should

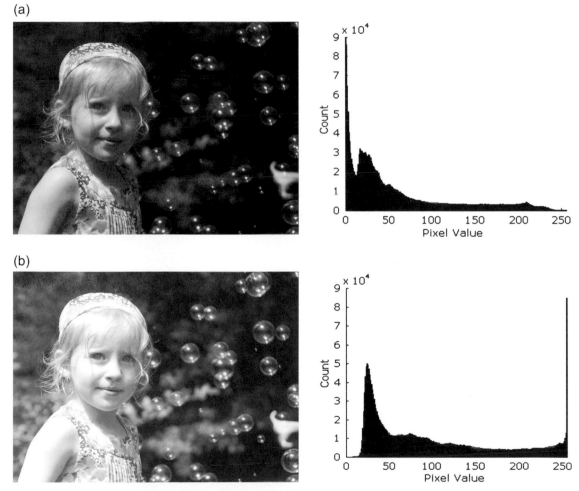

Figure 12.3 The effects of overexposure and underexposure on an image with a high luminance range. (a) Underexposed image and histogram. (b) Overexposed image and histogram.
Original image © Elizabeth Allen

record most of the scene luminances in the linear part of the response curve. However, the characteristic curve of negative material possesses a long toe. The part of the curve used by a 'correctly exposed' negative includes part of this toe and the lower part of the straight-line portion (see Chapter 8 for details). Further, because of the advantageous shape of the photographic film characteristic curve, the use of the shoulder in scene exposure on film is not as detrimental as with electronic sensors, since the slope of the curve at this point is relatively low, allowing a smoother gradation in the recording of highlights. Digital imaging sensor responses curves are often mapped (usually during encoding) to responses similar to those of film media for this very reason (see also Chapter 21).

Figure 12.5 shows the positioning of a typical scene luminance range on different parts of the CCD response curve, depending on exposure. Here again, the correctly exposed scene luminance range is fully falling on the linear part of the curve and thus it is reproduced without compression. Underexposure leads to clipping due to exposure falling at the noise floor, whereas overexposure leads to clipping due to sensor saturation. In both cases the reproduced luminance range is reduced, resulting in a reduction in image contrast — illustrated by the compacted output range in the figure.

EXPOSURE METERS

Exposure meters (or light meters) are devices which measure the reflected light from a subject, or incident light to a subject, and express its relationship to the sensitivity of the film or ISO sensor setting used, in terms of *f*-numbers and shutter speed settings.

Hand-held exposure meters allow the use of both incident and reflected light measurements and are still used to some extent in studio settings. Incident light measurements in particular can counteract the exposure problems caused by scenes containing large areas of bright or dark tones, which can produce anomalous reflected light measurements. However, partly because of the far greater range of digital sensor characteristics compared to those of film, and the many developments in complex in-camera metering systems, alongside the ability to immediately review images and adjust exposure, the use of external metering with digital systems is less widespread than it was when film predominated.

In-camera metering systems, although only able to measure reflected light, offer many sophisticated metering modes and directly relate the light reaching a sensor to its response; they have therefore found more widespread adoption in many types of digital imaging. It should also be noted that the use of the image histogram to establish correct exposure with digital cameras is common practice (see later in this chapter). This has led to a slight difference in the function of the exposure meter with a digital camera. Exposure metering often provides a starting point from which exposure is adjusted to produce a desired distribution of tones, rather than a final decision for shutter speed and aperture.

The structure and operation of hand-held exposure meters are described below. Chapter 11 covers in-camera metering systems in some detail, although the various metering modes are discussed later in this chapter.

Hand-held exposure meters

An exposure meter consists of a light-sensitive cell, some means of limiting its acceptance angle, an on—off switch and a range-change switch, a power source (as necessary), a scale in light values, a set of calculator dials or readout

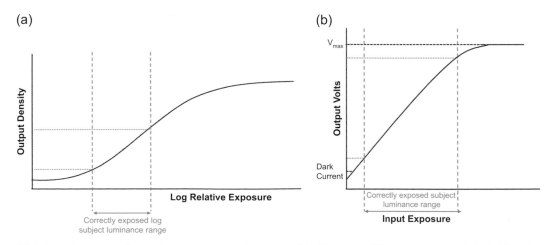

(a)

Output Density

Log Relative Exposure

Correctly exposed log subject luminance range

(b)

V_{max}

Output Volts

Dark Current

Correctly exposed subject luminance range

Input Exposure

Figure 12.4 Correct exposure of scene luminances results in the use of the linear part of the response curve in both (a) analogue and (b) electronic sensors.

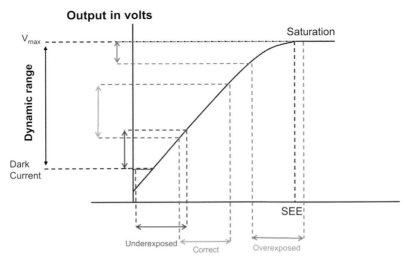

Figure 12.5 The effects of underexposure and overexposure on the positioning of the subject luminance range on the response curve of a CCD sensor.

of exposure data, which can be in matching pairs of *f*-numbers and shutters speeds or EVs, and a diffuser for incident light readings. The diffuser is domed and is placed over the photocell (see Figure 12.6).

A variety of types of photocell are in use, including the early selenium 'barrier-layer' photovoltaic cells, cadmium sulphide (CdS) photoresistors, silicon photodiodes (SPDs) and gallium arsenide phosphide photodiodes

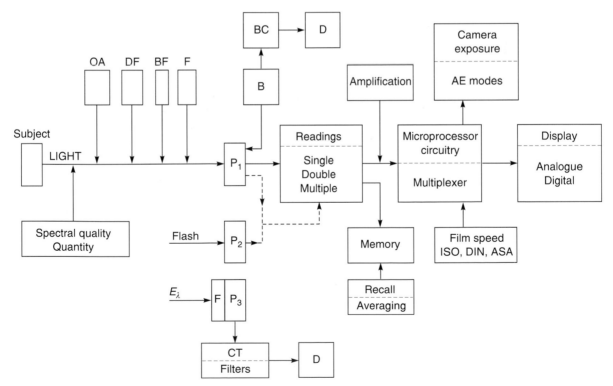

Figure 12.6 Block diagram of the principal components and features of an exposure meter. Ambient light, flash and colour temperature may all be measured. B, battery; BC, battery check; BF, baffle; CT, colour temperature; D, display; DF, diffusers; E_λ, spectral illumination; F, filter; OA, optical attachments; P_1, P_2, P_3, photocells.

(GPDs). The relevant properties of CdS and SPD types are listed in Table 12.1.

Selenium cells were the earliest cells to be used in exposure meters and are obsolete today. They do not require batteries but have a large cell area. The response of the selenium cell to light is dependent upon cell area. A plug-in booster cell can increase sensitivity by some 2EV. The battery-operated CdS was a newer type of cell, with higher sensitivity than the selenium cell. Higher sensitivity means that the size of the cell is reduced, an important factor for built-in camera exposure meters. A CdS photocell meter may have a resistor network to change its response range; alternatively it may use a neutral density filter or a small aperture in front of the cell. Its response may be affected by its previous exposure to bright light and it may take a few minutes for this 'memory' effect to disappear. Today the most common cells are SPDs. Some cameras incorporate GPD cells in their exposure metering system. Both SPDs and GPDs have a very fast response to light changes and for this reason they are also used in flash measuring devices.

The spectral sensitivity of the various types differs markedly (see Figure 12.7). The CdS and SPD types have high infrared (IR) sensitivity. The SPD is usually encapsulated with a blue filter to absorb IR to reduce this sensitivity and is referred to as 'silicon blue' cell. A selenium cell is also usually filtered to match its spectral response to that of the standard CIE photopic visual response curve (Chapters 4 and 5). GPD cells are not sensitive to IR radiation.

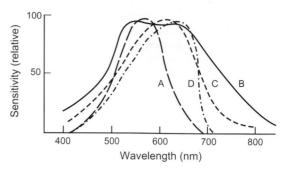

Figure 12.7 Spectral sensitivity of photocells. The graphs of relative spectral sensitivity against wavelength show the approximate spectral response or sensitivity of different photocells used in exposure metering systems. (A) Visual spectral sensitivity and a filtered selenium cell. (B) CdS photoresistor. (C) Silicon photodiode (SPD) fitted with a blue filter ('silicon blue' cell). (D) Gallium arsenide phosphide photodiode (GPD).

Acceptance angle

Both CdS and SpD photocells are small devices with a response that is independent of cell area, but require special optical arrangements when used in exposure meters. All photocells are non-imaging devices, which integrate the incident flux. The response is restricted to the subject area covered by the camera lens, or a smaller area. Alternative techniques of integrated, small area and spot readings are used.

Traditionally, the selenium cell meter was limited to have an acceptance angle of some 50°, corresponding to the field of view of the standard lens of a camera format, but with a much more rectangular aspect ratio, to reduce the effect of a bright sky area. The removal of the baffle increases the acceptance angle to some 75°, to assist sensitivity. The much smaller CdS and SPD cells may simply be located at the bottom of a cylindrical black-lined well or have a positive lens bonded to the receptor surface. These arrangements give acceptance angles of some 25–30°, allowing more selective readings of zones of the subject area. A small viewfinder may help to aim the meter cell at the desired area. Accessory devices may reduce this angle even further to 15° or even 5°. The *spot meter* is a specialist meter of acceptance angle 1° or less. Hand-held spot meters include a viewing system. Spot metering is often available in SLR cameras as one of two or three alternative means of selective image measurement (see later).

The measurement produced by an exposure meter is based on the assumption that the scene being measured integrates to a mid-grey. The grey value for which exposure meters are calibrated is the middle grey on a geometric scale from white to black (18% reflectance). The meter cannot therefore assess whether a subject is bright or dark, which can lead to errors in exposure readings for scenes containing

Table 12.1 Properties of photocells used in exposure determination systems

PHOTOCELL TYPE	CdS	SPD
Battery needed	Yes	Yes
Amplifier needed	No	Yes
Speed of response	Slow	Fast
Memory effects	Yes	No
Sensitivity	Medium to high	High to very high
Linear response	Poor	Yes
Spectral (colour) sensitivity	Red bias	Needs blue filter
Size	Small	Small
Range change device needed	Yes	No
Electrical property	Photoconductor or photoresistor	Photovoltaic

a substantial percentage of light or dark areas. Measurements returned by exposure meters are also based on the assumption that the distance between the lens and the focal plane is equal to the focal length of the lens. Correction of the exposure is therefore necessary when using extension bellows (see the later section on exposure factors).

There are two types of exposure meters depending on the method used to measure light: *incident light* and *reflected light* exposure meters. Hand-held exposure meters can measure both incident and reflected light. Built-in exposure meters in SLR cameras measure the intensity of the light reflected from the subject and pass *through the lens* (TTL). Non-SLR cameras have a photocell in front of the camera body or lens (see Chapter 11).

Exposure values

The exposure value (EV) system originated in Germany in the 1950s and was intended as an easily mastered substitute for the shutter speed/aperture combination, giving a single small number instead of two (one of which was fractional). The EV system is based on a geometric progression of common ratio 2, and is thus related to the doubling sequence of shutter and aperture scales. The relationship used is:

$$EV = \log_2\left(N^2/t\right) \quad (12.5)$$

where N is the relative aperture and t is the shutter speed.

Change of the base of the logarithm gives:

$$EV = \left(1/\log 2\right)\log\left(N^2/t\right) \quad (12.6)$$

or

$$EV = 3.32 \log N^2/t \quad (12.7)$$

For example, a combination of 1/125 second at *f*/11 from Eqn 12.6 gives an EV of 14. Similarly, all exposures equivalent to this pair will give an EV of 14.

Although no longer used for such purposes, the idea of the EV scale is useful in exposure measurement practice, remembering that an increment of 1 in the EV scale indicates a factor of 2 in exposure, or a change of one stop. A primary use is to give a quantitative measure of the *sensitivity* of a metering system by quoting the minimum EV that can be measured for an ISO speed of 100. For example, a hand-held exposure meter using an SPD cell may have a measuring sensitivity of between EV −2 and approximately EV 23. A sensitivity of EV −2 can allow metering in moonlight. The use of various attachments such as spot meter arrangements or fibre-optic probes reduces the sensitivity considerably; a high initial value is therefore needed for meters intended for such accessories.

In-camera meters are limited in their sensitivity by the light losses involved in their optical systems, and by the maximum aperture of the lens for full aperture TTL metering. For comparisons this aperture must be quoted: for an *f*/1.4 lens a sensitivity of EV 1 at ISO 100 is typical. The operating limit of an in-camera autofocus system is quoted similarly. Another use of the EV system is the *EV graph* (see Figure 12.8), where the scales on the rectangular axes are shutter speed and aperture. A series of diagonal lines connecting pairs of values of equivalent exposures represent the EV numbers. These EV loci may be extended to an adjacent graph of ISO speed and subject luminance. On such a graph it is possible to show the behaviour of a particular camera, for example in terms of the envelope of performance with the range of settings available. Additionally, in the case of an automatic camera the different exposure modes and forms of programmed exposure can be compared.

Finally, EV 'plus' and 'minus' scales are commonly used on the exposure compensation and autobracketing controls of automatic cameras, both film and digital SLR cameras, and to indicate filter factors and exposure compensation for interchangeable focusing screens.

Exposure factors

Exposure factors are the multiplying numbers used to correct exposure when using filters on the lens (filter factor), or bellows to extend the distance between the lens and the focal plane (bellows extension factor). They are used with non-TTL exposure meters. Exposure correction using the exposure factor is achieved by either multiplying the exposure time by the exposure factor, or by converting it into stops and correcting the *f*-number on the lens accordingly. Conversion of the exposure factor into stops is based on the fact that a change of one stop doubles or halves the exposure. So a factor of 1 means no change in exposure, a factor of 2 means a one stop change in exposure (as each stop doubles or halves the previous stop), a factor of 4 a change of two stops, and as a general rule:

$$2^n = CF \quad (12.8)$$

where CF is the correction factor and n is the number of stops.

The filter factor is recommended by the manufacturer and is used to compensate for any light losses which occur as it passes through the filter, before reaching the sensor. There are practical ways of determining the filter factor (see Chapter 3). The bellows extension factor compensates for any light losses occurring due to the increased distance between the lens and the focal plane. It is calculated as follows:

$$\text{Bellows extension factor} = \frac{2(\text{Bellows extension})}{(\text{Focal length})^2} \quad (12.9)$$

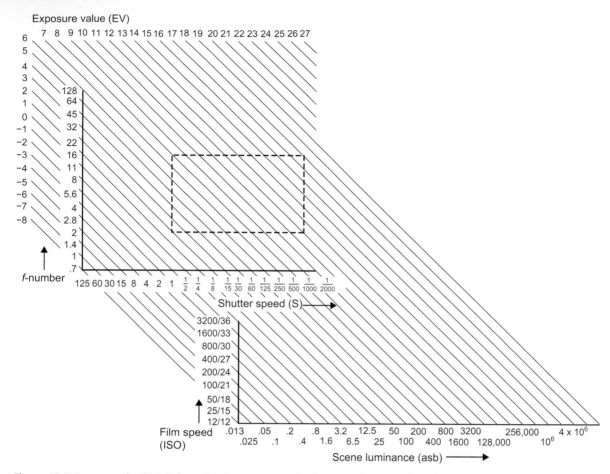

Figure 12.8 Exposure value (EV). Relationship between scene luminance and ISO speed can be expressed in terms of an exposure value, which is a combination of aperture and shutter speed. The rectangle indicates the typical operating range of a camera fitted with an *f/2* lens.

RECIPROCITY LAW FAILURE

The reciprocity law refers to photographic exposure and takes into account the amount of light that reaches the sensor and the duration of exposure (Eqn 12.1). With silver halide materials, there are cases, however, where the exposure relationship breaks down and the law no longer holds true. This is known as *reciprocity law failure* (RLF) and is described in detail in Chapter 8. Reciprocity law failure depends on the duration and intensity of the exposure. Two types of RLF therefore exist: *low-intensity RLF* and *high-intensity RLF*. Low-intensity RLF, which is the case most commonly encountered, occurs with exposures where the light intensity is low, requiring very long exposure times. The effective speed of the film is reduced at very low light levels, with a greater loss of speed in the shadow areas of the image compared to the highlights. This may be

explained because the low intensity of light results in photons reaching the sensitive material in much fewer numbers over a given period of time. According to the Gurney—Mott theory (see Chapter 13, Figure 13.4), below a certain number of absorbed photons, the latent image is unstable and there is a high probability of recombination of electrons into the silver halide lattice. Therefore, in the shadow areas of the image this probability of recombination is increased. The result is a decrease in the density in low-density areas of the film compared to the high-density areas. This results in higher contrast and a possible change in colour balance. The high contrast produced can be reduced by decreasing the development time.

High-intensity RLF occurs when the light intensity is very high, requiring very fast shutter speeds for correct exposure and lowering the effective film speed. A decrease in the high-density values results in a loss of contrast, which may be compensated for by increasing the development time.

Changes in colour balance may also appear because the layers of the colour film are affected differently. In both cases of RLF, these colour changes may be corrected with the use of filters.

Due to the different response of the film when used under very high or low light intensities, manufacturers design emulsions so that they have optimum performance at the light intensity normally used for that film. Astronomical plates are an example, with an emulsion specially designed for very long exposures at low light intensities.

TYPES OF LIGHT MEASUREMENT

Incident light measurement

As previously mentioned, hand-held exposure meters can provide both incident and reflected light measurements. In incident light measurement, the exposure meter measures the amount of light that illuminates the subject. The measurement is taken from the subject position, with the exposure meter's sensor pointing towards the camera. It is suitable for cases where the lighting is uniform or when controlled lighting is used. It is also useful when the background is dominant. When the subject is backlit correction may be needed on the exposure. With this type of measurement, however, the reflective properties of the subject are not taken into account. Another limitation is that, if it is to be used to determine exposure of a distant scene, the exposure meter should be suitably positioned so that the light falling on it is the same as the light falling on the scene. In the majority of cases this may not be practical.

Flash meters are incident light meters which are designed to have a very fast response time to changing light conditions. Incident light measurements are easy to make with a hand-held light meter but are not suitable for an in-camera metering system.

Reflected light measurement

Reflected light exposure meters measure the light that is reflected from the various different surfaces in the scene. When using hand-held meters, depending on the exposure meter, light measurement can be conducted using a *wide angle* (approximately 30°) or a *narrow angle*, also known as *spot* (approximately 1–2°). With reflected light exposure meters, the reading is from the camera position, at the lens axis, with the sensor towards the subject. Care must be taken to avoid any incident light on the exposure meter's cell because light scattering will affect the reading. Hand-held spot exposure meters include a viewer which is used to select a specific area of the subject or scene with precision. Reflected light measurement with wide-angle exposure meters is suitable for scenes with balanced highlights, middle tones and shadows because they average the luminances in the whole scene that is measured ('integrate to grey'). For this reason, scenes with dominant highlight or shadow areas may result in underexposure or overexposure respectively. The reflective properties of the subject may also have an effect on the measurement of the exposure meter. The measured area also plays a significant role in determining correct exposure, as described in the next section.

IN-CAMERA METERING MODES

Built-in camera exposure meters measure reflected light using a range of different metering modes. Their use is described below and the mechanisms of some of these modes are also described in Chapter 11.

Spot metering

As for a hand-held spot meter, an in-camera spot meter measures a narrow angle, corresponding to approximately 4% of the area of the scene. The measurement may be from the centre of the frame or from user-selected off-centre spots, with some models supporting multi-spot modes from different areas within the scene. Spot metering is useful in high-contrast and backlit scenes, where the subject of interest is significantly darker than the background, and allows the required area to be metered correctly, without the measurement being significantly influenced by the large brighter areas surrounding it, although highlight detail will be sacrificed. Spot metering is also useful when taking an average of highlights and shadows, described later.

Partial area metering

Partial area metering takes a measurement from a larger area than spot metering, of around 10–15% of the frame, which is usually at the centre of the frame, although as with in-camera spot metering, some models allow user selection of alternative off-centre AF points in the scene. As with spot metering, partial area metering can be useful for backlit subjects and can provide a better balance of exposure between foreground and background, which is particularly important when trying to avoid clipped highlights in exposure with digital cameras.

Centre-weighted average metering

Often a default method of in-camera exposure metering, centre-weighted average metering measures the entire scene, but weights a larger percentage of the measurement towards the centre of the scene, with the periphery having much less influence on the reading. Its widespread use is partly because it produces reasonable results when

237

dealing with scenes with a high luminance ratio such as a brightly lit sky above a darker landscape, without requiring significant exposure correction. This is the reason, in cameras, that centre-weighted average readings have entirely replaced whole-scene average metering, which is now obsolete in all but classic film cameras (see the later section on measurement of total scene luminance).

Matrix or multi-zone metering

Also called *segmented*, *honeycomb* or *evaluative* metering, as described in Chapter 11, these types of metering systems (of which there are many different types – see Figure 11.20) divide the scene into segments and take individual exposure readings from each of the different areas. The results are analysed in terms of average luminances and luminance differences between zones, as well as overall scene luminance, and compared to data from many different types of scenes pre-stored in the camera to decide on what type of scene is being photographed and establish optimum exposure. The zones are often weighted according to the selected autofocus point, to ensure that the region of interest is correctly exposed, but other factors may also be considered, such as subject distance, depth of field and back or peripheral lighting. Although the aim of such systems is to reduce the need for exposure compensation, and in general they are extremely successful at producing good results for the majority of scenes, results can be inconsistent for certain types of scenes, and are dependent on both the sophistication of the metering method from a particular manufacturer and on the autofocus point.

ELECTRONIC FLASH EXPOSURE

Exposure with an electronic flash can be a challenging task, especially due to the fact that the electronic flash does not incorporate modelling lights and therefore the pre-visualization of the final image is difficult. An advantage when using a digital camera with an electronic flash is that the image is almost immediately available for viewing. This enables the photographer to make suitable changes in the lighting if necessary. Still, due to the difficulties in pre-visualization, the photographer may have to take several photographs before achieving the desired result. This may be possible with still life, but with action scenes or scenes with moving subjects, it may not be possible to repeat the shot with different flash settings.

Electronic flash can be used in either manual or automatic mode. In manual mode the photographer sets the suitable *f*-number on the camera lens according to the distance between the flash and the subject and the *guide number* of the flash, which is described below in more detail. These settings also depend on the ISO setting on the camera. Note that the shutter speed is set to the flash synchronization speed for cameras with a focal-plane shutter. In automatic mode, the flash may incorporate a light sensor which measures the light reflected from the scene and interrupts the flash when the light reflected from the subject is adequate for correct exposure. Alternatively, the flash unit may use the information on scene luminance from the TTL measurement.

Lighting control with the use of additional light sources is often applied to alter the tonal range of a scene. If, for example, the contrast of the scene is high, introduction of fill-in lighting will make the shadows appear brighter and increase shadow detail. Fill-in lighting can also be introduced with the use of suitable reflectors opposite the main light source. High-dynamic-range scenes, for example when a subject is photographed indoors standing in front of a window, need the use of additional lighting to balance the foreground to the background and reduce the dynamic range of the scene, so that it more closely matches that of the sensor. A reading is taken from the background, the camera is set to correct exposure for the background and the flash is set to expose correctly for the subject.

Guide numbers

The light output and the required camera exposure for a given flash unit can conveniently be expressed by an *exposure guide number*, or *flash factor*. For ISO speed 100 and a subject distance d (in metres), the necessary *f*-number N is given from the guide number G by the relationship $G = Nd$.

This guide number is often included in the alphanumeric code designation of a flash unit. For example, inclusion of the number 45 would usually indicate a basic guide number of 45 in metres for ISO speed 100. The guide numbers are only guides, and practical tests are needed to establish their accuracy, which depends to some extent on the effects of the surroundings, ambient light level and the shutter speed used. The guide number also changes with *fractional power output* selection as offered by many units, some of which are able to select full, half, one-quarter, one-eighth and one-sixteenth power or less, or, when a camera motor-drive setting is selected, giving reduced power and rapid recycling. Likewise, an alteration in *flash covering power* to suit different lenses will also affect the guide number.

Guide numbers are devised on the assumption of a near-point source and are based on the *inverse square law*. A doubling of flash output or doubling of ISO speed used increases the guide number by a factor of 1.4. A quadrupling of output or ISO speed doubles the guide number. Doubling the distance between the flash source and the subject distance needs a change of +2EV in exposure (factor ×4).

While such calculations are reasonably simple to make for one flash source, it becomes increasingly difficult to do so for two or more sources, especially if they are at different distances and of differing powers. The positioning of flash-heads without the assistance of modelling lights is a task

requiring experience and skill. But as a guide a simple twin-head flash, using one flash off-camera as the main light and the other on-camera as fill-in light, the fill-in light should provide approximately one-quarter to one-half the output of the main light.

The guide number system has been replaced in automatic flash units by the use of *variable flash output* and hence duration as a means of controlling exposure, but it is still applicable in situations such as the use of *ring flash* units or in lenses where a guide may be set and linked to the focusing control to give a readout of the *f*-number necessary for a given subject distance. Similarly it is used in autofocus cameras where the flash output is fixed, and the appropriate *f*-number set by the distance setting from the autofocus system.

REFLECTED LIGHT MEASUREMENT TECHNIQUES

As described above, optimum exposure may be determined by measurement of the luminance of the subject (or zones of it) or, alternatively, by measuring the illumination on the subject (incident light), followed by location of the log luminance ratio in a suitable position on the characteristic curve of the material. Ideally, the luminance ratio itself should be determined, but this requires experience in locating suitable zones and is by no means easy to measure accurately. This method is usually too complicated for everyday use. Simpler methods are preferred in practice, even though they may, in theory, be less accurate.

Measurement of total scene luminance

This 'integration' method accepts all the light flux from the chosen area of the subject to be photographed. Such a *reflected light measurement* is simple to carry out and requires little selective judgement. It is used in hand-held

meters and in flash meters, but is now obsolete in in-camera metering systems, having been replaced by centre-weighted average metering. As described earlier, such a method will be accurate only for scenes with balanced highlights, mid-tones and shadows.

A correction is usually necessary to the indicated values of exposure settings for subjects of very high or very low contrast, as shown in Table 12.2, or for a subject of non-typical tone distribution, such as a high-key or low-key subject. Most cameras with an automatic exposure mode have an associated *exposure compensation control* which offers manually set increases or decreases of up to ±3EV or more in increments of 1/2 or 1/3 EV to cope with atypical subjects or luminance distributions.

Measuring a middle grey surface (key tone)

As mentioned previously, the exposure meter is calibrated to give a combination of aperture and shutter speed settings for a given ISO speed so that the surface measured will be reproduced in the print as middle grey. A light measurement technique, suitable for scenes with uniform lighting, is to select and measure a suitable area of the subject with middle luminance (*key tone*). A Caucasian flesh tone (about 25% reflectance) may be used as a key tone. This technique is similar to the incident light measurement. It is important to note, however, that it does not provide any information on the tonal range of the scene luminances.

In cases where the highlights and the shadows are out of the dynamic range of the image sensor or film, control of the scene illumination may be necessary to ensure that both highlights and shadows are suitably located on the characteristic curve (film) or the transfer function (image sensor). The middle luminance area of the subject can be substituted by a middle grey card (18% reflectance) such as the Kodak 18% reflectance neutral card, which is calibrated to the same middle grey value as the exposure meter. This card is used to conduct light measurements in scenes with

Table 12.2 Luminance range and exposure correction

SUBJECT LUMINANCE RATIO CLASSIFICATION	LUMINANCE RATIO	EV RANGE (STOPS)	MEAN REFLECTANCE (%)	APPROXIMATE EXPOSURE CORRECTION FACTOR
Very high	2048:1 (2^{11}:1)	11	11	+1EV
High	512:1 (2^9:1)	9	14	+0.5EV
Average	128:1 (2^7:1)	7	18	0EV
Low	32:1 (2^5:1)	5	25	−0.5EV
Very low	8:1 (2^3:1)	3	41	−1EV

variable luminances. The card is placed within the scene under the same incident light, so that it receives the same illumination as the subject. A measurement is taken with the exposure meter close enough so that the card fills the acceptance angle of the photocell. This ensures that the reading is not influenced by any variations in the scene luminances.

Many cameras offer an 'exposure memory lock' feature to allow the metering system to measure and set an exposure for a key or substitute tone, after which the picture is recomposed and the stored exposure given. This memory may be self-cancelling after exposure, or may require manual cancellation.

Measurement of luminance of the darkest shadow

This method locates this tone at a fixed point on the toe of the characteristic curve of the film, giving the correct density to the deepest shadow that is to be recorded. With digital photography, however, this technique may result in clipped highlights, so in most cases it is not used. Practical difficulties include the necessary metering sensitivity, the effects of flare light on measurements and the effects of highlights in the field of view of the meter.

Measurement of luminance of the lightest highlight

This method is similar to the *artificial highlight* method, which works well for colour slide material. With the artificial highlight method, an exposure measurement is taken from a matt white card, with approximately 90% reflectance. The indicated exposure on the exposure meter is then divided by 5 (90%/18%) to correctly reproduce the scene's tonal range. The method of measurement of luminance of the lightest highlight locates the highlight at a fixed point of the characteristic curve with the highlight detail and other tones as differing densities. The exposure on the exposure meter is then divided by 5. Shadow detail is usually adequately recorded, but a subject of average contrast may receive more exposure than necessary. Note that when using this method, measurements must not be made on specular highlights.

Averaging values

This method determines exposure by measuring the lightest and darkest areas in the scene that need to be recorded. The output combination of lens aperture and shutter speed for both measurements is then averaged. For this method a spot exposure meter is more suitable than a wide-angle exposure meter, which requires a wide area of approximately uniform luminance. It should be noted that an area that appears to have uniform luminance may appear to have variation in

luminances when it is observed or measured at a closer distance. Although this method gives information on the brightest and darkest areas in the scene and the difference in stops between them, it does not give information on how the intermediate tonal values are distributed.

EXPOSURE TECHNIQUES AND DIGITAL CAMERAS

As described in the previous section, some of the traditional exposure measurement techniques are equally applicable to digital capture; however, the characteristics of image sensors and the limitations imposed as a result of the process of analogue-to-digital (A/D) conversion mean that certain aspects require careful consideration and emphasis when establishing correct exposure. A fundamental concern is the combined dynamic range limitation of the sensor and subsequent A/D conversion. Additionally, clipping of highlights and the characteristics of digital noise in shadow regions of the image have a significantly detrimental effect on image quality. Further, if images are captured to the JPEG file format, then the dynamic range limitations are more pronounced, as the images are gamma corrected and quantized to 8 bits. Fortunately, image processing and the option to capture RAW images, along with the ability to view the image histogram at capture, provide opportunities to optimize the exposure. In-camera processing and RAW capture are covered in some detail in Chapter 14. Chapter 17 discusses digital file formats, and the characteristics and mechanisms of the JPEG compression algorithm are described in Chapters 23 and 29.

Using the image histogram

Digital capture has a fundamental advantage over capture on film: the ability to immediately review the image. This means that the exposure can be checked and, if incorrect, adjustments can be made for quick re-exposure. As with film, bracketing of exposures increases the chance of obtaining an optimum exposure.

However, one of the issues with reviewing images is that unless the camera is tethered to a computer and images are remotely captured to be displayed on a large and calibrated monitor, then assessment of the exposure must be achieved on a small LCD screen on the back of the camera. Although the size, resolution and colour reproduction of camera LCD displays continue to improve, image quality, lack of calibration and widely variable viewing conditions mean that judgement of optimum exposure is unreliable from the screen image alone.

Many digital cameras (almost all SLRs and many compacts) offer the option to display the image histogram alongside the image and this provides a much more accurate

assessment of exposure. Clipping of either highlights or shadows is immediately apparent (see Figure 12.3), and the position and spread of values in the histogram provide an assessment of overall exposure and contrast. A distribution of tones across most of the histogram indicates an image of high contrast. Over- or underexposure, as described earlier, will shift all values in the histogram to the right or left respectively and will reduce the spread of values, signifying decreased image contrast. Other options include the ability to display clipped areas of the image by overlaying the pixels with a saturated colour, which can help to determine how visually problematic the clipping will be and the display of separate red, green and blue channel histograms.

'Exposing to the right'

A fairly recent concept, the idea of *exposing to the right* is a technique used with RAW capture, to better distribute the levels available after quantization, while aiming to avoid clipped highlights and to reduce noise and contouring in the shadow areas of the image.

As described earlier, the image sensor has a linear response, meaning that there is a directly proportional relationship between the numbers of photons recorded at a photosite and the value produced. Tone mapping or gamma correction must be applied when the data is converted to an output-referred state for viewing. As described in Chapter 14, in most digital SLR cameras, the sensor data is commonly quantized to 10, 12 or 14 bits. Assuming 12-bit quantization, this equates to 4096 (2^{12}) discrete tonal levels. However, the usable dynamic range of the camera is commonly between five and nine stops of exposure, due to limitations from noise, signal amplification and various non-linear tonal mappings.

Because each change in exposure of one stop represents a log (base 2) change in recorded luminance, and the sensor is recording luminance increments linearly, this means that half of the available levels (2048) will be recorded for the brightest zone of the image (the highest exposure stop). For each stop down the scale of the recorded luminance range, the number of levels will be halved (1024 levels will be allocated to the next stop, 512 to the one after that, etc.). The shadow areas of the image will be allocated very few levels, which can result in visible contouring in these regions.

The term *expose to the right* refers to the selection of exposure settings such that the image histogram is skewed to the right (as a result of slight overexposure) but without blowing out the highlights; the scene is effectively exposed for the highlights. This shifts each image zone up the scale in terms of the number of levels each one is allocated (albeit compressing the range allocated to the brightest zones) and generally represents a more efficient distribution of the levels available.

The exposure is then adjusted during RAW conversion, to move the mid-tones and shadows to the left of the histogram. Therefore, these image regions are initially allocated

more levels than they would be at the normal exposure, reducing the possibility of contouring and better utilizing the range of levels of available. Additionally, the over-exposure increases the signal-to-noise ratio in the darker areas of the image (see Chapter 24). The amount of noise in the shadows is therefore lower using this method than it would be at the 'correct' exposure.

Care must be taken at exposure, remembering that the meter is usually calibrated to a mid grey; therefore, achieving the correct amount of overexposure will be a process of trial and error with careful assessment of the histogram. Further, the success of the method is very much dependent on the subject luminance range. A very-high-contrast scene may not allow much 'pushing' to the right of the histogram, or subsequent 'pulling out' of the shadows.

THE ZONE SYSTEM

The *zone system* was devised by the American landscape photographer Ansel Adams for black-and-white photography, although its principles are also applied for the exposure of colour films and digital sensors. This system allows the photographer to control the results accurately, according to personal working conditions and the needs of subject and interpretation. Tones can be expanded and contracted to result in specific controlled contrast.

In the zone system the tonal range of the image is controlled with exposure and film development, rather than by altering the contrast in the printing process. It was created for black-and-white photography using large-format sheet-film camera, where the negatives could be processed individually.

When using the zone system, it is essential to observe the subject and 'pre-visualize' how the tone values of colour subjects might be recorded on the final black-and-white print. The whole process, film exposure and development, is then implemented to achieve these results. The desired result depends on the imaging application and context. For example, it may be essential to reproduce a close representation of the tonal range of the subject, or to control the contrast to create a specific mood.

The zones

In the zone system, the series of pre-visualized subject brightnesses extend from the deepest shadows to the brightest highlights, and are then related to a set of zones which correspond to luminances on the print. These zones start from zone 0 through to zone X. Zone 0 represents total black (maximum black reproduced from the paper) and zone X represents total white (white of the paper). In these extreme zones of the scale, 0 and X, no detail is recorded. Detail appears from zone II and up to zone IIX. Middle grey, the value equivalent to 18% reflectance card, is

represented by zone V. A change of one zone corresponds to a change of one stop. For example, a part of the scene with illuminance half that of the illuminance corresponding to zone V would fall into zone IV. If the illuminance is twice as high it will fall in zone VI. When the exposure is changed by one stop all the subject illuminances are reallocated one zone up or down the scale. Pre-visualization of the final print allows the photographer to decide which areas of the subject are desired to be exposed as zone IV, zone V, zone VI, etc. The photographer, for example, may want a specific area of the subject to correspond to zone IV. After measuring the area with the exposure meter, the subject would then be underexposed by one stop.

The stop difference between the shadows and the highlights should also be taken into account. The subject luminance range covered by the 10 zones from I to IX is over 1:500. This, however, occurs in cases such as backlit subjects with a high-intensity light source which produces hard lighting. A typical luminance range is around 1:128 (seven stops difference) which covers a range of eight zones of the zone system. In addition, to record detail in both shadows and highlights the subject tonal range should lie between zones II and VIII. With black-and-white films, the tone is controlled with development so when using the zone system these films are exposed for the shadows and developed for the highlights. Use of the zone system with colour films is more limited, as the processing time cannot be altered to control contrast. In this case, only exposure is used to control the zones that will represent each tone on the print. Colour negative films are exposed for the shadows while colour transparencies are exposed for the highlights.

The zone system and digital cameras

As mentioned before, there are limitations in using the zone system with digital cameras. One of the reasons is the lower dynamic range of the digital image sensor compared to the dynamic range of film. In addition, overexposed highlights lose detail due to clipping. In the zone system this would correspond to highlights exceeding zone VIII. When clipping takes place, detail cannot be recovered and is permanently lost. To retain detail in the highlights, measurements are taken from the highlights and the exposure is set so that they fall into zone VII or VIII.

HIGH-DYNAMIC-RANGE (HDR) IMAGING

As mentioned earlier in the chapter, the subject luminance range often exceeds the dynamic range of the image sensors. In such cases a single capture results in clipping of either highlight or shadow regions in the scene. Solutions for HDR image capture have been introduced and have become very popular in the last decade. These include: (i) multiple exposures of the same scene using a digital camera with a low dynamic range capability and (ii) sensors with extended (higher than usual) dynamic range capture capability. The latter will not be discussed in this chapter.

Capture of multiple bracketed exposures of the same scene involves a number of different exposures of the subject, for appropriate capture of the shadows, mid-tones and highlights. Multiple exposures are then combined into a single image by a number of steps:

1. *Derivation of the opto-electronic conversion function* (OECF) is used to estimate how the camera sensor reacts to changes in exposure (see Chapter 21 for measuring OECFs of digital cameras).

2. *HDR image construction.* The HDR image is comprised of floating point values (stored in 32 bits per channel), which have higher tonal resolution than the usual low-dynamic-range data. The principle in this step is that each pixel in each separate image provides an estimate of the radiance value of the specific point in the scene. Different estimates are assembled by means of a weighted average and taking into account the reliability of the pixel itself. For example, very low pixel values coming from low exposures are often noisy and will be weighted less, whilst the same pixels are well exposed in images acquired with higher exposure settings and will be weighted more.

3. *Tone mapping to display or print media* (see Chapter 21 for more details). Output devices have a dynamic range which is lower than that of the HDR image, with the exception of the recent HDR displays. As a result, the image appears dark when displayed on typical low-dynamic-range displays. Reduction of the bit depth of the final image (to 8 or 16 bits per colour channel) is therefore carried out to map the dynamic range of the image to that of common output devices. Rendering to a lower bit depth is achieved by *tonal mapping*. Kuang et al. (2007) have given an overview of different HDR image-rendering algorithms. These include: a sigmoidal contrast enhancement function; histogram adjustment using local luminance adaptation levels; Retinex (an HVS model that simulates the eye local adaptation); a Retinex-based adaptive filter; iCAM (image appearance model which combines colour appearance with spatial vision metrics); modified iCAM (includes the Reinhard and Devlin tone mapping operator); a bilateral filtering technique (the image is decomposed into a base layer and a detail layer and the base layer's contrast is compressed); and local eye adaptation (compression of the luminance channel dynamic range by imitating the retina's photoreceptor responses). An HDR tonal mapping applied directly on the colour filter array (CFA) of the sensor instead of the image after demosaicing has also been proposed by Alleysson et al. (2006).

Figure 12.9 An HDR image created with three exposures.
©iStockphoto.com/photo75

Multiple-frame capture is achieved by varying the shutter speed rather than the aperture to ensure that depth of field remains constant in all exposures. With this method, it is important that the subject is static and that camera shake is prevented to avoid blurring of the subject; thus the use of a tripod is essential. Imaging software used for HDR image construction and tonal mapping to an output often provide features to minimize possible blurring due to camera shake by aligning the different exposures. Software used for HDR imaging provides options for implementation of tonal mapping using various different algorithms.

BIBLIOGRAPHY

Adams, A., 1981. The Negative. Little, Brown and Co., Boston, MA, USA.

Alleysson, D., Meylan, L., Süsstrunk, S., 2006. HDR CFA image rendering. Proc. EURASIP 14th European Signal Processing Conference, Florence, Italy, 4–8 September.

Hertel, D., 2009. Extended use of incremental signal-to-noise ratio as reliability criterion for multiple-slope wide dynamic range image capture. Journal of Electronic Imaging, Volume 19, Issue 1.

Jacobson, R., Ray, S., Attridge, G.G., Axford, N.R., 2000. The Manual of Photography. Focal Press, Oxford, UK.

Johnson, G.M., Fairchild, M.D., 2003. Rendering HDR images. Proc. IS&T/SID 11th Color Imaging Conference, Scottsdale, pp. 36–41.

Kuang, J., Yamaguchi, H., Liu, C., Johnson, G.M., Fairchild, M.D., 2007. Evaluating HDR rendering algorithms. ACM Transactions on Applied Perception, 4, Article 9.

Lukac, R., 2009. Single Sensor Imaging: Methods and Applications for Digital Cameras. CRC Press, Taylor & Francis Group, Boca Raton, FL, USA.

Meadhra, M., Lowrie, C.K., 2006. Exposure and Lighting for Digital Photographers Only. John Wiley, Indianapolis, Indiana, USA.

Peres, M.R., 2007. The Focal Encyclopedia of Photography, fourth ed. Focal Press, Oxford, UK.

Rand, G., 2008. Film and Digital Techniques for Zone System Photography. Amherst Media.

Reinhard, E., Ward, G., Pattanaik, S., Debevec, P., 2005. High Dynamic Range Imaging: Acquisition, Display, and Image-Based Lighting. Morgan Kaufmann, San Francisco, CA, USA.

Salvaggio, N.L., 2008. Basic Photographic Materials and Processes, third ed. Focal Press, Oxford, UK.

Saxby, G., 2001. The Science of Imaging: An Introduction. Taylor & Francis, Institute of Physics Publishing Bristol and Philadelphia.

Schaefer, J.P., 1999. The Ansel Adams Guide, Book 1: Basic Techniques of Photography. Little, Brown and Co., Boston, MA, USA.

Stone, H., Sidel, J.L., 2004. Sensory Evaluation Practices. Academic Press, Oxford, UK.

Stroebel, L.D., Current, I., Compton, J., Zakia, R.D., 2000. Basic Photographic Materials and Processes. Focal Press, Oxford, UK.

Chapter | 13 |

Image formation and the photographic process

Geoffrey Attridge

All images © Geoffrey Attridge unless indicated.

INTRODUCTION

The foundation of silver-based photography is the light sensitivity of silver salts named *silver halides*: the *chloride*, *bromide* and *iodide* salts. The latter is usually a very small percentage additive to silver bromide crystals. The discovery by Richard Leach Maddox in 1871 of a method of coating a gelatin dispersion of silver halide crystals on glass plates heralded the universal use of gelatin as a colloid in photographic *emulsions*.

Silver salts are usefully *light sensitive*, or can be made so by *spectral sensitization*. They are also *developable* to amplify the invisible effect of small exposures — the photographic *latent image*. An amplification factor of 10^9 to 10^{12} is achievable by photographic development — some 10^{10} (10,000 million) silver atoms are developed for each *photon* of light absorbed by an emulsion crystal.

Silver halide photography is shown diagrammatically in Figure 13.1. The immediate effect on the emulsion, at exposure, is the formation of a latent image. This is made visible by development. Light areas of the subject appear as dark developed silver, which appears black when finely divided — a negative image. Other areas contain unchanged silver salts, which would become dark over time if left in the gelatin. Residual silver salts are removed by *fixing* in a solution, which removes them as soluble complex salts. The fixing agent present is often *sodium thiosulphate*, the photographers' *hypo*. Another chemical commonly present in the solution is mildly acidic, to neutralize alkaline developer solution remaining on the negative. Once the negative is washed and dried it is printed through a similar negative-working process, to produce a positive. Print emulsions are usually coated on paper and viewed by reflection.

SILVER HALIDES

Silver halides are effectively insoluble in water and formed in photographic emulsions by preparing the salts in the presence of gelatin. This can be achieved by adding a solution of silver nitrate to soluble salts such as ammonium bromide or potassium chloride in a dilute solution of gelatin. Further treatments encourage crystals of the precipitated silver salts to grow into crystals of the required size and shape. Other treatments then achieve the required sensitometric speed, contrast and spectral sensitivity. Figure 13.2 illustrates spectral sensitivities of emulsions containing two pure silver salts, silver chloride and silver bromide, as well as technologically useful silver chlorobromide (silver chloride containing a percentage of silver bromide) and silver iodobromide (silver bromide with a small content of silver iodide). These blends result in mixed crystals, containing both silver salts in carefully controlled proportions. Silver bromide may be present in a wide range of concentrations in emulsion crystals, but silver iodide is usually present as a small proportion only. The silver halides used, and their relative proportions, differ considerably depending on the use of the materials concerned. Negative emulsions of camera speed usually contain silver iodobromide emulsions containing, as the name implies, crystals composed of silver bromide and of the order of 5% silver iodide *present in each crystal*. Such formulations can give high inherent emulsion speeds and are suitable for spectral sensitization to give panchromatic monochrome materials, or the selective sensitivities necessary in colour films. Negative emulsions of camera speed generally possess lowish contrast. They are subsequently printed on slower, high-contrast printing materials. They

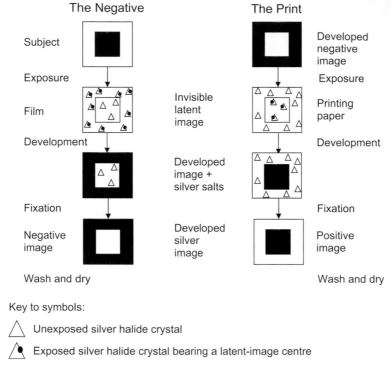

The Negative

Subject

Exposure

Film

Development

Fixation

Negative image

Wash and dry

The Print

Developed negative image

Exposure

Printing paper

Development

Fixation

Positive image

Wash and dry

Invisible latent image

Developed image + silver salts

Developed silver image

Key to symbols:

△ Unexposed silver halide crystal

△ Exposed silver halide crystal bearing a latent-image centre

Figure 13.1 Outline of the silver-based photographic process.

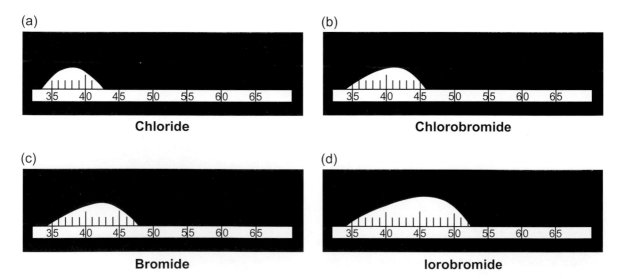

(a) **Chloride**

(b) **Chlorobromide**

(c) **Bromide**

(d) **Iorobromide**

Figure 13.2 Wedge spectrograms of silver chloride, chlorobromide and iodobromide emulsions — without spectral sensitization (to tungsten light at 2856 K).

have fine grain and may or may not need spectral sensitization. They are usually chlorobromide emulsions containing silver bromide and chloride present in each crystal (but no iodide), and are formulated to give high contrast, appropriate printing times with conventional enlargers, and minimal emulsion fog to give clear whites and the maximum tonal range in prints.

Silver chloride (AgCl) absorbs mostly in the *ultraviolet* region of the spectrum, while a small silver bromide (AgBr) content extends the spectral absorption further into the

blue. Silver bromide itself has much more absorption of blue light and this may be extended towards the green by a small content of silver iodide (AgI). Only light absorbed by an emulsion can make it developable, so increases in spectral absorption and its extension to more of the spectrum are important in determining the range of spectral sensitivities.

LATENT IMAGE FORMATION

The latent image is an exposure-induced change within a silver halide crystal that increases the probability of development from very low to very high. All emulsion crystals would eventually be reduced to silver if developed for long enough, but the rate of reduction is very much greater for those crystals bearing a latent image. The change produced by exposure is the formation at a site or sites on or within the crystal of an aggregate of silver atoms. Latent image sites are probably imperfections and impurities (e.g. silver sulphide specks) existing on the surface and within the bulk of the silver halide crystal. Light quanta, photons (see Chapter 2), are absorbed, releasing photoelectrons which combine with *interstitial* silver ions to produce atoms of silver. *Interstitial* silver ions are mobile, displaced from their normal positions in the crystal lattice, and are present in emulsion crystals prior to exposure. The general reaction can be represented by the equations:

$$\text{Br}:^- \xrightarrow{h\nu} \text{Br}\cdot + e^- \quad \text{and} \quad \text{Ag}^+ + e^- \rightarrow \text{Ag} \quad (13.1)$$

in which $h\nu$ is the energy of a photon, e^- is an electron and the dots represent important electrons associated with atoms.

Energy levels relevant to latent image formation are shown for a silver bromide crystal in Figure 13.3. Discounting thermal fluctuations, absorption of a quantum of energy greater than 2.5 eV (electron volts) is necessary so that a valence electron may be raised to the conduction band. The valence band is the highest, filled, band of energy in which the electrons exist. The conduction band comprises empty energy levels; electrons excited to this band are free to move and electrical conduction can take place. Between these two levels is a band gap in which electrons cannot exist. A quantum of energy of 2.5 eV is equivalent to a wavelength approximating 495 nm, and corresponds to the long wavelength sensitivity limit of silver bromide. Also shown in Figure 13.3 are the relevant energy levels of an adsorbed dye suitable for sensitizing silver bromide to longer wavelengths. A photon of energy less than 2.5 eV may, upon absorption by the dye, promote the molecule from its ground energy state to an excited state. If the excited electron can pass from the dye to the crystal, latent image formation may proceed. In this way silver halides can be sensitized to green, red and even infrared radiation.

Although several mechanisms have been suggested to explain latent image formation, considerable evidence supports the basic principle suggested by Gurney and Mott in 1938. The essential feature is that the latent image is formed from alternate arrivals of photoelectrons and interstitial silver ions at particular sites in the crystal. Figure 13.4 shows the important steps. The process is considered as occurring in two stages:

1. Nucleation of stable sub-developable specks.
2. Subsequent growth to just-developable size and beyond.

Broken arrows indicate decay of unstable species, an important characteristic. The first stable species is the two-atom centre, although the size of a just-developable speck is three to four atoms. Thus, a crystal must absorb at least three to four quanta in order to become developable, but throughout the sequence there are opportunities for inefficiency and, generally, more than this number are required. In modern emulsions an average exposure of 10 photons is required for developability of an emulsion crystal. Photon sensitivities may extend from three or four to 30 or 40. During most of the nucleation, species can decay and liberated electrons can recombine with halogen

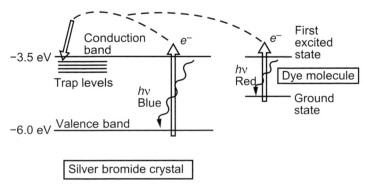

Figure 13.3 The energy levels relevant to latent image formation.

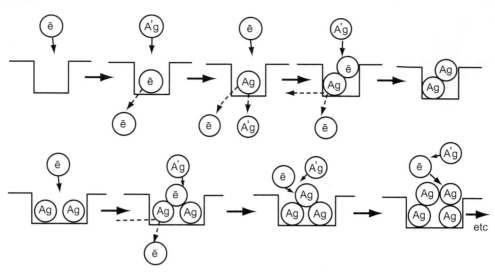

Figure 13.4 Latent image nucleation (top row) and initial growth (bottom row).

atoms formed at exposure. If this occurs, photographic effect is lost. The photo-equivalent surplus halogen atoms formed may also attack photolytically formed silver atoms, re-forming halide ions and silver ions. Gelatin is a halogen acceptor and should remove halogen atoms before such reactions can occur, but its capacity is limited and its efficiency drops with increasing exposure.

These considerations help to explain low-intensity and high-intensity reciprocity law failure (see Chapter 8). At low intensities, photoelectrons are produced at a low rate and the nucleation stage is prolonged. Consequently the probabilities of decay and recombination are relatively high. At high intensities, large numbers of electrons and halogen atoms are simultaneously present in the crystals. Such conditions yield high recombination losses. Nucleation may also occur at many sites in a single crystal, producing large numbers of very small, unstable silver specks.

SPECTRAL SENSITIVITY OF PHOTOGRAPHIC MATERIALS

The inherent light sensitivity of silver halide emulsions is confined to the range of wavelengths absorbed by the silver halides, illustrated in Figure 13.2. This includes blue and violet regions of the visible spectrum, the ultraviolet region and shorter wavelengths extending to X- and gamma-radiation. This applies to all types of emulsion — chloride, bromide, iodobromide — although the long-wavelength sensitivity cut-off varies with the type of emulsion, as shown. The amount of light absorbed in the inherent sensitive region, and hence the useful speed of an emulsion, depends on the volumes of the silver halide crystals present. Fast emulsions therefore give coarser-grained images than slower emulsions.

Response of photographic materials to short-wave radiation

Although silver halides have inherent sensitivity to all radiation of shorter wavelengths than the visible, the recording of such radiation involves special problems. Crystals of silver halide in emulsions significantly absorb radiation of shorter wavelength than about 400 nm. Consequently images produced by *ultraviolet* (UV) radiation lie near the emulsion surface, because the radiation cannot penetrate very far. At wavelengths shorter than about 330 nm, the radiation is also absorbed by glass, causing the short-wavelength cut-off seen in Figure 13.2. Recording beyond this region requires quartz or fluorite optics (see Chapter 10). At about 230 nm, absorption of radiation by gelatin becomes serious and conventional emulsions cannot be used. Fluorescence can, however, be employed to record in this region. Ordinary photographic films can be used, the emulsion being coated with petroleum jelly or mineral oil, which fluoresces during exposure giving a visible image, which the emulsion records. The jelly is removed using a solvent before processing.

X-ray or gamma-radiation is absorbed very little by emulsions, and it is necessary to coat very thick emulsion layers containing a large amount of silver halide to obtain an image. This is normally applied in two layers, one on each side of the film base. An alternative is to use fluorescent intensifying screens, placed in contact with each side of the X-ray film, which emit, under X-ray excitation,

blue or green light to which the film is very sensitive. Modern rare-earth salt intensifying screens considerably reduce the radiation dosage to patients receiving diagnostic X-ray exposures. For very short-wave X-rays and gamma rays, used in industrial radiography, lead screens can be used. Exposed to X-rays or gamma rays, these screens eject electrons which are absorbed by the photographic material, forming a latent image. Two major types of intensification of the effect of X-ray exposure are used, depending on the wavelength: *salt screens* and *lead screens*.

Ultraviolet radiation is present in daylight and, to a much lesser extent, in tungsten light. Ultraviolet radiation from 330 to 400 nm, referred to as the *near-UV region*, may affect ordinary photographs, increasing haze in distant landscapes and giving blue, hazy results in colour photographs of distant, high-altitude or sea scenes.

Response of photographic materials to visible radiation

Photographic materials relying on the unmodified sensitivity of the silver halides have been referred to as *blue sensitive*, *non-colour-sensitive*, *ordinary* or *colour-blind* materials. The most commonly used description is probably 'ordinary'. Materials used by the early photographers were of this type. Such materials lack sensitivity to green and red spectral regions, and cannot record colours correctly; reds and greens appear too dark (even black) and blues too light, the effect being greatest with saturated colours.

For some work this doesn't matter. Blue-sensitive or blue-and-green-sensitive emulsions are in general use for monochrome printing papers, and for negative materials used with black-and-white subjects in graphic arts applications. Even subjects with muted colours can be recorded with reasonable success on blue-sensitive materials. Many acceptable photographs have survived from the days when these were the only materials available. When colours are more saturated, blue-sensitive materials show their deficiencies markedly, and photographs in which many objects appear far darker than the observer sees them cannot be regarded as satisfactory.

SPECTRAL SENSITIZATION

Vogel, in 1873, discovered that silver halide emulsions could be rendered sensitive to green light in addition to blue by adding a suitable dye to the emulsion. Later, dyes capable of extending the sensitivity into the red and even the infrared region of the spectrum were discovered. This use of dyes is termed *dye sensitization*, or *spectral sensitization*. The dyes, termed *spectral sensitizers*, are added to the emulsion at the time of its manufacture. Sensitization follows from the dye becoming adsorbed to the emulsion grain surfaces. Dye that is not adsorbed does not confer spectral sensitization. The amount of dye required is extremely small, usually sufficient to provide a layer one molecule thick over only a fraction of the surface of the crystals. The quantity of dye added, and hence the sensitivity gained in the sensitized region, depends to a certain extent on the surface area and nature of the silver halide crystals.

The sensitivity conferred by dyes is additional to the sensitivity band of the undyed emulsion, and is added on the long-wavelength side. The extent to which an emulsion has been dye sensitized makes a considerable difference to the amount and quality of light that is permissible during manufacture and in processing.

Some classes of sensitizing dyes reduce the natural sensitivity of emulsions to blue light, while conferring sensitivity elsewhere in the spectrum. This may not be desirable in black-and-white emulsions but is often useful in colour materials.

For practical purposes, dye-sensitized black-and-white materials may be divided into four main classes:

1. Orthochromatic
2. Panchromatic
3. Extended sensitivity
4. Infrared sensitive.

The spectral sensitivities of emulsions of these classes are illustrated in Figure 13.5.

Orthochromatic materials

The term *orthochromatic* is applied generally to emulsions sensitive to both blue and green light. Orthochromatic materials are, in fact, not often used for general-purpose photography, although such sensitization is used in a few special-purpose monochrome materials. The tonal rendering of colours by orthochromatic films yields monochrome images in which blues and greens are recorded as much lighter than orange and red, which appear very dark.

Panchromatic materials

Materials sensitized to both the green and red regions of the spectrum, and thus sensitive to the whole of the visible spectrum, are termed panchromatic, i.e. sensitive to all colours. It was not until 1906 that the first commercial panchromatic plates were marketed. This advance enabled the manufacture of the first commercially available colour photographic plate, by the brothers Lumière.

Usually, the red sensitivity of panchromatic films extends up to 660—670 nm. They have two main advantages over the earlier types of material: they yield improved rendering of coloured objects, skies, etc. without the use of colour

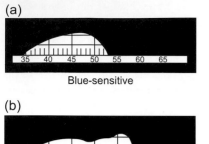

Blue-sensitive

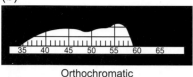

Orthochromatic

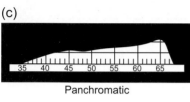

Panchromatic

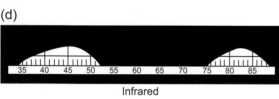

Infrared

Figure 13.5 Wedge spectrograms of typical materials of the principal classes of spectral sensitivity (to tungsten light at 2856 K).

filters, making possible the control of colour rendering by means of colour filters. When making a negative, and aiming to produce a correct monochrome rendering of a coloured subject, panchromatic emulsions must be used. If it is necessary to modify tonal relationships between different colours in the subject, full control requires the use of panchromatic materials in conjunction with filters.

Extended sensitivity materials

The sensitivity of the human eye is extremely low beyond 670 nm and an emulsion sensitive beyond this wavelength gives an *infrared effect*. Subjects that appear visually quite dark may reflect far-red and infrared radiation. This leads to a fairly light reproduction when recorded.

Panchromatic emulsions with sensitivity extended to about 750 nm are available for general photography and can be useful for haze penetration in landscapes, giving a light rendering of green foliage and a dark rendering of blue skies. The reproductions can be striking and account for the use of such materials.

Infrared materials

The colour-sensitized materials so far described meet the requirements of conventional photography. For special purposes emulsions sensitive to yet longer wavelengths can be made; these are *infrared materials*. These were not widely used until the 1930s. Since then, sensitivity has been extended to the region of 1200 nm. Infrared monochrome materials are normally used with an opaque filter over the camera lens or light source, to prevent visible or ultraviolet radiation entering the camera.

Infrared materials find use in aerial photography for haze penetration and for distinguishing between healthy and unhealthy vegetation, in medicine for the penetration of tissue, in scientific and technical photography for the differentiation of inks, fabrics, etc., which appear identical to the eye, and in general photography for pictorial effect. The penetration of haze depends on the reduced scattering exhibited by long-wavelength radiation. Other applications utilize the different reflectance and transmittance of objects to infrared and visible radiation.

Lenses are not usually corrected for infrared, so that using infrared emulsions requires a small increase in camera extension. This is because the focal length of an ordinary lens for infrared is greater than the focal length for visible radiation. This applies even when an achromatic or an apochromatic lens is used (see Chapter 10). Some cameras have a special infrared focusing index. With others, the correction necessary must be found by experiment, usually some 0.3–0.4% of the focal length.

Other uses of dye sensitization

Sensitizing dyes have other uses besides the improvement of the colour response of an emulsion. In particular, when a material is to be exposed to a light source that is rich in green or red and deficient in blue (such as a tungsten lamp), its speed may be increased by dye sensitization. Thus, some photographic papers are dye sensitized to obtain increased speed without affecting other characteristics of the material. Many modern monochrome printing papers use differences in spectral sensitization to define high- and low-contrast emulsion responses within the same material. Modification of the spectral quality at printing, by suitable filters, enables control of the print contrast. This eliminates the need for several contrast 'grades' of paper.

The most critical use of dye sensitization occurs in tripack colour materials in which emulsions with distinct blue, green and red spectral sensitivity bands are required. This has required narrow sensitization peaks, precisely positioned in the spectrum. Spectral sensitivities of a colour negative film are shown in Figure 13.6.

A useful balance of sensitivity is provided by dye-sensitized, tabular crystals. These are used in 'T-grain' or 'Delta' emulsions. The crystals have large surface area, are very

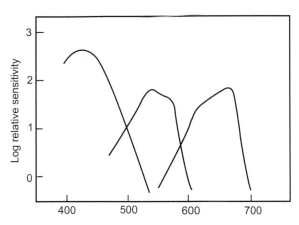

Figure 13.6 Spectral sensitivities of daylight-balanced colour negative film exposed to daylight.

thin, contain little silver halide, do not absorb much blue light, and hence have low blue sensitivity. They have a large surface area and relatively large quantities of sensitizing dyes can be adsorbed onto them. Such emulsions can be very sensitive to spectral bands outside the blue region, and have little blue sensitivity. They are well suited to use in colour materials and may eliminate the need for a yellow filter layer, used to restrict the inherent blue sensitivity of red- and green-sensitive emulsions.

STRUCTURE OF PHOTOGRAPHIC MATERIALS

Photographic materials are coated with suspensions of minute crystals (with diameters from 0.03 μm for high-resolution film to 1.5 μm for a fast medical X-ray film) of silver halide in a binding agent, almost invariably gelatin. These suspensions are called *emulsions*. The crystals are commonly termed grains. In materials designed for negative production, the halide is usually silver bromide, in which small quantities of iodide are also present. With papers and other positive materials, the halide may be silver bromide or silver chloride or a mixture of the two. The use of two silver halides in one emulsion results not in two kinds of crystal but in crystals in which both halides are present, although not necessarily in the same proportion in all crystals. Photographic materials containing both silver bromide and silver iodide are *iodobromide* materials, and those containing both silver chloride and silver bromide are *chlorobromide* materials.

Silver halides are uniquely useful in photography because they are *developable*, which means that the effect of light in producing an image can be amplified with a gain in image of about 1000 million times. The image produced when photographic materials are briefly exposed to light is invisible and termed the *latent image*.

Production of light-sensitive materials and sensors

The principal materials used in preparing a photographic emulsion, which is coated on a base to form the sensitive layer, are silver nitrate, alkali-metal halides and gelatin, and all must satisfy stringent purity tests. The gelatin is carefully chosen, and is a complex mixture of substances obtained from hides and bones of animals; although silver salts are the light-sensitive material, gelatin plays a very important part.

Essential steps involved in the preparation of photographic emulsions are:

1. Solutions of silver nitrate and halide salts are mixed in a *gelatin solution* under controlled conditions, where they react forming silver halide and a soluble nitrate. This is called *emulsification*.
2. This emulsion is heated under conditions in which silver halide is slightly soluble. The crystals of silver halide grow to sizes determining the characteristics of the emulsion: speed, contrast and graininess. This is the *first, physical* or *Ostwald ripening*.
3. The emulsion is washed to remove by-products of emulsification. Washing is achieved by causing the emulsion to precipitate by adding a coagulant to the warm solution. Unwanted liquid is then removed.
4. The emulsion is given a second heat treatment in the presence of a sulphur sensitizer. No grain growth should occur during this stage, but sensitivity specks of silver sulphide are formed on the grain surface and maximum speed is reached. This stage is *second ripening, digestion* or *chemical sensitization*.
5. Sensitizing dyes, stabilizing reagents, hardeners, wetting agents, etc. are now added.

Photographic manufacturers control all these stages and many other factors. They tailor-make emulsions, optimize them with respect to speed and granularity for specific applications, as well as maintaining appropriate tone and colour reproduction characteristics. Research and development work has led to colour negative films and papers of high sensitivity, low granularity and high image quality.

T-grains (flat tabular crystals) allow maximum sensitizing dye adsorption to the grain surface, encouraging efficient absorption of light, and possess other useful properties giving higher resolution and lower graininess than expected from large crystals. Double-structure crystals optimize both absorption of light and graininess. Monodisperse crystals can minimize light scatter, improving image resolution. Sophisticated technology, devised for colour materials, has been applied to modern black-and-white materials. Examples include Ilford XP-2, a monochrome film yielding a dye image developed in

251

colour-processing chemicals, Kodak 'T max' films using Kodak 'T-grain' technology, and Fuji Neopan films using 'high-efficiency' light-absorption grain technology.

The support

The finished emulsion is coated on a support, commonly film or paper base. Film base is usually a cellulose ester, triacetate or acetate-butyrate, although manufacturers also use newer polymers, such as polyethylene terephthalate, offering advantages, particularly dimensional stability. This makes them of special value in graphic arts and aerial survey. Polyethylene terephthalate has exceptionally high strength, much less moisture sensitivity than cellulose-derived films and an unusually small variation in size with temperature (Table 13.1), and is then stable throughout the temperature range encountered by photographic film.

Film base differs in thickness according to the product and type of base, most bases in general coming within the range of 0.08—0.25 mm. Roll films generally have 0.08 mm base, miniature films 0.13 mm base and sheet films 0.10—0.25 mm base. Polyethylene terephthalate can be somewhat thinner than cellulosic base because of its higher strength.

Glass plates have now been almost entirely replaced by films. They are still used occasionally in specialized fields, because of their dimensional stability and rigidity. An additional advantage of plates is that they lie flat in use. The advantages are, however, outweighed by high cost, fragility, weight, storage space requirements and loading difficulties.

Paper base used for photographic and digital hard copy must be particularly pure. Photographic base paper is therefore manufactured with the greatest care taken to ensure purity. Before photographic paper is coated with emulsion, it is usually coated with a paste of gelatin and a white pigment, baryta (barium sulphate), to provide a pure white foundation giving maximum reflection. Most modern paper bases are, however, not coated with baryta but coated on both sides with a layer of polyethylene and are known as PE or RC — polyethylene or resin-coated papers (Figure 13.7). The upper polyethylene layer contains titanium dioxide, as the white pigment, and optical whiteners. They are impermeable to water, which avoids paper base absorbing water and processing chemicals. This results in substantially shorter washing and drying times than are required by baryta-coated fibre-based papers.

Coating the photographic emulsion

Coating modern materials is a complex task and current coating methods are the subject of commercial secrecy. One of the earliest forms of coating flexible supports was 'dip' or 'trough' coating. Dip coating is slow because faster coating results in thicker emulsion layers which are difficult to dry, and may have undesirable photographic properties. In order to increase the coating speed this method was modified by the use of an air-knife, an accurately machined slot directing air downwards on to the coated layer, increasing the amount of emulsion running back into the coating trough (see Figure 13.8). This method enables the use of more concentrated emulsions, higher coating speeds and thinner coatings.

More modern coating employs accurately machined slots through which emulsion is pumped directly on to the support or to flow down a slab or over a weir on to the support (cascade coating). Such methods enable coating speeds to be far higher than were possible with traditional methods. This allows very high speeds, coating base material typically being 1.4 metres wide. Monochrome materials have more than one layer coated; colour materials may have as many as 14, while instant self-developing colour-print films have an even more complex structure. In modern technology, many layers are coated in a single pass through the coating machine, either by using multiple slots or a number of coating stations, or both. A non-stress supercoat is finally applied to reduce the effects of abrasion. The coating is then set by chilling, and dried under controlled conditions.

Table 13.1 Properties of supports

PROPERTY	SUPPORT MATERIAL			
	Glass	Paper	Cellulose triacetate	Polyethylene terephthalate
Thermal coefficient of expansion (%)	0.001		0.0055	<0.002
Humidity coefficient of expansion (% per % RH)	0.000	0.003—0.014	0.005—0.010	0.002—0.004
Water absorbed (% at 50% RH, 21°C)	0.0	7.0	1.5	0.5
Processing size change (%)	0.00	−0.2 to −0.8	<−0.1	±0.03
Tensile strength (N cm^{-2})	13,730	690	96.50	17,240

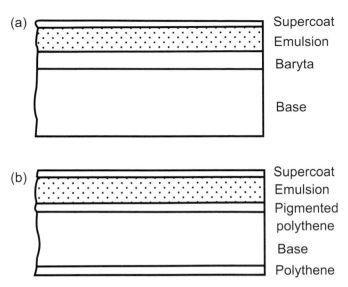

Figure 13.7 Construction of photographic papers: (a) baryta paper; (b) polyethylene- or resin-coated paper.

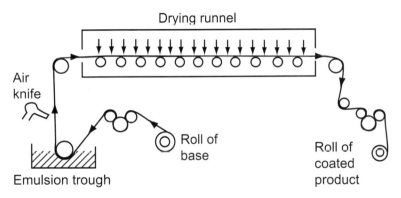

Figure 13.8 Schematic diagram of a coating machine.

With negative materials it is usually impossible to obtain the desired properties in any single emulsion. Two emulsions may then be prepared which, together, exhibit the desired characteristics. These may be mixed and coated as a single emulsion, or applied as two separate layers, an undercoat and a top coat. A supercoat is then added. For maximum speeds the top coat consists of a fast component while the undercoat is slower, allowing the control of speed, contrast and exposure latitude (see Chapter 8).

SIZES AND FORMATS OF PHOTOGRAPHIC MATERIALS

Photographic materials are supplied in many formats, some of which are shown in Table 13.2. Film sizes have to correspond to standard dimensions if they are to fit cameras in use but printing papers, except in automatic printers, are often trimmed after printing to suit the aesthetics of images, and standardized sizes are less vital. In practice, printing paper is available in a wide range of sizes, including the familiar metric dimensions A3, A4, A5 and A6, as well as Imperial sizes: 4×5, 6.5×8.5, 8×10, 10×12 and 16×20 inches.

SPEED OF PHOTOGRAPHIC MATERIALS

Two films differ in speed if the exposure required to produce a negative on one differs from the exposure required to produce a negative of similar quality on the other. The

Table 13.2 Sizes and formats of some photographic films

SIZE DESCRIPTOR	FILM WIDTH (MM)	NOMINAL IMAGE SIZE (MM)	NUMBER OF IMAGES	NOTES
APS	24	17 × 30	15/25/40	Advanced Photo System, various aspect ratios possible, data stored on magnetic strip, processed film returned in cartridge
135	35	24 × 36	12/20/24/36	Double perforations, cassette loaded
120	62	45 × 60 60 × 60 60 × 70 60 × 90	16/15 12 10 8	Roll film, unperforated, rolled in backing paper on spool
220	62	As for 120 but 2 × number of images		Unperforated film with leader and trailer
70 mm	70			Double perforations, cassette loaded
4 × 5 (inches)	102	97 × 122	1 per sheet	Sheet film, exposed in a dark slide, using a stand camera

material requiring lower exposure is said to have the higher speed. The speed of a material varies inversely with the exposure required, and we can express speed numerically by selecting a number related to exposure. The response of photographic emulsions is complex, and speed depends on many variables, the following being most important:

- Exposure
 - The colour of the illuminant, e.g. daylight or tungsten light.
 - Intensity of the exposing light. This is because of reciprocity law failure (see Chapter 8).
- Development
 - Composition of the developer, e.g. high or low activity.
 - The degree of development, indicated by the contrast achieved. This depends principally upon the development time, temperature and degree of agitation.

Strictly it is not possible to define the speed of a material completely by a single value. A speed number can, nevertheless, provide a good guide to the performance that may be expected from a material and can be determined for photographic materials provided all the variables are defined.

Speed systems and standards

The various standards adopted by the American, British and German national standards organizations were brought into line in all respects, except for the type of speed rating employed, in 1960–62, the American and British Standards specifying arithmetic numbers and the German Standard logarithmic ones. This followed work showing good correlation between speeds based on a *fixed density* of 0.1 above D_{min} (see Chapter 8) and the *fractional gradient* criterion, for a wide variety of materials when developed to normal contrast. Current ISO practice specifies a speed point at $D_{min} + 0.1$ and development conditions such that density increases by 0.80 over an exposure increment of 1.30 from the speed point (see Figure 13.9). Arithmetic and logarithmic speeds are calculated from the following formulae where exposure (H) values are in lux seconds:

$$\text{Arithmetic speed,} \quad S = \frac{0.80}{H_m} \qquad (13.2)$$

$$\text{Logarithmic speed,} \quad S^\circ = 1 + 10 \log_{10} \frac{0.80}{H_m} \qquad (13.3)$$

The quantity H_m is the exposure in lux seconds at the speed point specified above. Table 13.3 shows equivalents between arithmetic and logarithmic speeds. Doubling the arithmetic speed gives a logarithmic speed *increment* of 3 and a multiplication of the arithmetic speed by 10 gives an *increment* of 10 in logarithmic speed. With these notes, and the table, the corresponding equivalence for any standard logarithmic or arithmetic speed value may be calculated.

Table 13.3 Arithmetic and logarithmic ISO speed ratings compared

ARITHMETIC (S)	LOGARITHMIC (S)
10	11
20	14
25	15
32	16
40	17
50	18
64	19
80	20
100	21
1000	31

ISO speed ratings shown on boxes of films are daylight ratings, currently shown in both the following ways:

- ISO 200, arithmetic speed.
- ISO 64/19°, both arithmetic and logarithmic speeds.

These speed ratings are not necessarily true ISO speeds, but each is the manufacturer's recommendation indicating an appropriate setting for a camera, or exposure meter, in order to achieve optimal results under normal conditions of use.

ISO film speeds are not published for materials which are not commonly used for pictorial photography. In such cases useful speed values have to be found by 'trial and error' methods.

CHARACTERISTICS OF PHOTOGRAPHIC MATERIALS

Graininess and granularity

A grainy pattern may be detected in photographic negatives even though the individual crystals of a photographic emulsion cannot be seen by the unaided eye. These patterns may be detected at much lower magnifications in prints. Enlargement of the negative, subject matter, development and viewing conditions all contribute to the impression of *graininess* and these aspects are detailed more extensively in Chapter 24.

Granularity is an objective measure of the inhomogeneity of a photographic image and is determined with the aid of a *microdensitometer* making traces of the density fluctuations of uniformly exposed areas of emulsions. Interestingly, there is a simple relationship between the area of the scanning aperture used in the microdensitometer and the standard deviation measured from the noise trace that yields a constant value. Known as Selwyn granularity, G, this single number is a useful indication of the granularity of an emulsion or print material. Selwyn granularity may be affected by emulsion parameters, development and exposure. The relationship to these factors is also explored in Chapter 24.

Contrast

Contrast has two related but distinct applications. It is widely used to describe the appearance of a scene: a cross-lit bright sunny urban landscape, without clouds, may have a large difference between the luminance of shadow and highlight areas. It is a *high-contrast* subject, possessing a high *subject luminance range*. The same scene on a foggy

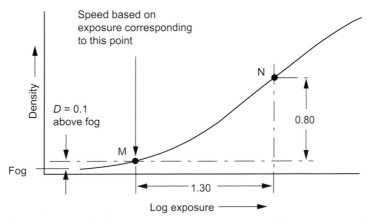

Figure 13.9 Principles of the method adopted for determining speed in the current ISO standard.

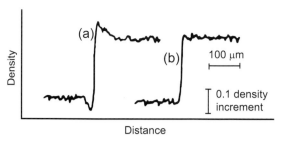

Figure 13.10 Microdensitometer traces of edge images for a medium-speed film developed in: (a) an 'acutance developer', giving edge effects; (b) a standard general-purpose developer, without edge effects.

day will be a *low-contrast* subject, with a low subject luminance range. An average outdoor subject, lit by the sun, and with some clouds, gives a subject luminance range of 160:1, a log subject luminance range of 2.2.

The second use describes how photographic materials reproduce the log exposure range presented to an emulsion in the camera, or at the printing stage. This is *sensitometric* contrast and its significance has been discussed in Chapter 8. The relationship between subject and image scales forms the study of tone reproduction described in Chapter 21.

Sharpness and acutance

Sharpness is a subjective term describing how sharply focused images appear. If an image looks out of focus, it will not be described as sharp. It also carries implications about the subject. An image can only appear sharp if the subject contains sharply defined material, such as an edge. Our judgement of sharpness depends heavily on edge detail. The objective correlate with sharpness is termed *acutance* and can be assessed. Certain photographic procedures that improve sharpness acquire a description using the term 'acutance' — *acutance developers* give high edge gradients and may show significant 'edge effects' — shown in Figure 13.10; *acutance dyes* added to emulsions absorb scattered light at exposure. Both give sharper results as described by observers. The reader should refer to Chapters 19 and 24 for extended reading on sharpness and its measurement.

CHEMISTRY OF THE PHOTOGRAPHIC PROCESS

Developers and development

Development forms a visible image corresponding to the invisible latent image. It continues the effect of light on the silver halide grain by converting exposed grains to black metallic silver (see Figure 13.1). The reaction may be described by the chemical equation:

$$\text{Exposed silver halide} + \text{Developing agent} \rightarrow \text{Metallic silver}$$
$$+ \text{Oxidized developing agent} + \text{Halide ion}$$

$$(13.4)$$

In *chemical development*, each emulsion crystal acts as a unit: it is either developable as a whole, or not. A second type, *physical development*, derives the image from silver salts contained in the developer. This is not normally used but *some* physical development occurs in most developers, because they contain *complexing* agents, which dissolve some silver halide giving silver compounds in the developer. The latent image exists mainly on the surfaces of emulsion crystals. With sufficient exposure, latent images of a developable size are formed and become development centres. On development, the crystals are attacked, at development centres, by the developing agent and those having received more than some minimum exposure are *reduced* to metallic silver.

Developing agents are classed chemically as reducing agents. Very few reducing agents are selective enough to distinguish between emulsion crystals with a latent image and those without. For those that are sufficiently selective, the action on exposed and unexposed (or insufficiently exposed) crystals is distinguished by its rate. It is not that unexposed silver halide crystals do not develop, but that exposed crystals develop very much more quickly. Latent image accelerates development, but cannot initiate a reaction that would not otherwise occur. Normally the proportion of unexposed crystals developed is small, but with very prolonged development practically all the emulsion crystals will develop. Density resulting from development of unexposed crystals is called *chemical fog*.

Composition of a developing solution

Developing agents are not used alone; a *developer* solution almost always contains other essential constituents. A developing solution usually comprises:

- *Developing agent (or agents)* — to reduce exposed silver halide emulsion crystals to silver metal.
- *Preservative* — to (a) prevent wasteful oxidation of developing agent(s), to (b) prevent discoloration of used developing solution and consequent staining of negatives or prints, and to (c) act as a silver halide solvent in certain fine-grain developers.
- *Alkali (or accelerator)* — to activate developing agent(s) and buffer the pH at a constant value.
- *Restrainer* — to increase selectivity of development and minimize fog by decreasing the development rate of unexposed grains compared to that of exposed grains.

- *Miscellaneous additions* — include wetting agents, water-softening agents, solvents for silver halides, anti-swelling agents for tropical processing, development accelerators, etc. In addition, there must be a solvent, nearly always water.

Developing agents

Almost all developing agents in use are organic compounds. Not all behave in exactly the same way and, for certain purposes, one agent may be preferred to another. Consequently, a number of different agents are in use, the characteristics of important examples being described below. Names of organic chemicals follow international rules but common usage means that there can be different names used for the same compound.

L-Ascorbic acid (vitamin C)

This is a reducing agent. Like hydroquinone, it is more active at higher alkalinities. It forms very active super-additive developers with phenidone or Metol.

Glycin (4-hydroxyphenylaminoacetic acid)

This is a white crystalline powder. Slightly soluble in water, it is freely soluble in alkaline solutions. Glycin developers are non-staining and have exceptionally good keeping properties, but are too slow in action for general use. It is used, with other developing agents, in some fine-grain developers.

Hydroquinone (quinol; 1,4-dihydroxybenzene)

This forms fine white crystals, fairly soluble in water. The dry substance is kept well stoppered, otherwise it tends to become discoloured. Hydroquinone is mainly used together with Metol or phenidone, forming superaddtive mixtures.

Metol (4-methylaminophenol sulphate)

This is readily soluble in water. Metol developers yield high emulsion speed, low contrast and fine grain, valuable when maximum shadow detail is required. Low-contrast developers may be made up using simply Metol and sulphite. In general, Metol is used with a second developing agent, hydroquinone, in a superaddtive combination. This is illustrated in Figure 13.11. Metol—hydroquinone formulations may be referred to as MQ developers, the letter Q representing quinol.

Paraphenylenediamine

Many fine-grain developers are based on para-phenylenediamine (*p*-phenylenediamine, 4-aminoaniline,

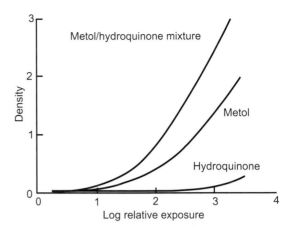

Figure 13.11 Superadditivity in a Metol—hydroquinone developer.

1,4-diaminobenzene). When used alone it requires very long development times. To shorten development, most paraphenylenediamine developers contain either glycin or Metol. Derivatives of 4-aminoaniline are present in modern colour developers.

Phenidone (1-phenyl-3-pyrazolidone)

This possesses most of the photographic properties of metol together with important advantages. It activates hydroquinone, so that a phenidone—hydroquinone (PQ) mixture forms a useful, very active developer. Used alone, phenidone gives high emulsion speed but low contrast, and has a tendency to fog. Mixed with hydroquinone, with various alkali concentrations, phenidone features in a wide range of developers. Much lower concentrations of pheni-done than Metol are required.

More stable derivatives of phenidone have been proposed, and used in concentrated liquid developers. These include phenidone Z (1-phenyl-4-methyl-3-pyr-azolidone) and dimezone (1-phenyl-4,4-dimethyl-3-pyrazolidone).

Of the developing agents above, only phenidone, Metol and hydroquinone are widely used today for monochrome development, while analogues of *p*-phenylenediamine (4-aminoaniline) are essential in colour developers. All developing agents should be regarded as hazardous by skin absorption, and rubber gloves should always be worn when preparing or using developers.

Preservatives

Sodium sulphite is commonly used as preservative in developing solutions, although potassium (or sodium) metabisulphite is sometimes used, either by itself or with sulphite. It is available in crystalline and anhydrous forms.

257

Anhydrous sodium sulphite is a white powder which dissolves readily in water. The crystals dissolve most easily in water at about 40°C, giving a weakly alkaline solution (pH approximately 8.5). The pH of a solution is an internationally agreed measure of its acidity or alkalinity. It is defined as:

$$pH = \log_{10}(1/\text{Hydrogen ion concentration}) \quad (13.5)$$

On this scale, pure water (a neutral solution) has a pH of 7. An acid solution has a pH < 7 and an alkaline solution a pH > 7. The greater the amount by which the pH of a solution differs from 7, the greater is its acidity or alkalinity. Since the pH scale is logarithmic, quite small changes in pH may indicate significant changes in the activity of a solution.

One advantage of using potassium metabisulphite rather than sodium sulphite is that it forms a slightly acidic solution (pH 4−5), which decreases aerial oxidation in concentrated two-solution developers, i.e. one solution containing the developing agent and preservative and the other containing the alkali. Alternatively sodium metabisulphite may be used.

A preservative is present to prevent aerial oxidation of the developing agent(s). Sulphite can be regarded as removing oxygen from air in the solution, or at the surface, before it can oxidize the developing agent. This is an oversimplification. The action of preservatives is not simply a preferential reaction between sulphite and oxygen; the rate of uptake of oxygen by a solution of sulphite and hydroquinone is many times smaller than that by either the sulphite or hydroquinone alone. Sulphite also reacts with developer oxidation products and prevents staining of the image by forming soluble sulphonates:

Silver halide

+ Developing agent → Oxidized developing agent

+ Metallic silver + Halide ion + Hydrogen ion (acid)

$$(13.6)$$

Oxidized developing agent + Sulphite ion

+ Water → Developing agent sulphonate

+ Hydroxyl ion (alkali) $\quad (13.7)$

In addition to being a preservative and stain preventer, sulphite has a third function. It is a silver halide solvent and promotes some physical development, leading to finer-grained images, if its concentration is sufficient.

Alkalis

By suitable choice of alkali, the pH of a developer can be adjusted to a required level and a range of varying activities can be achieved. One alkali commonly used is sodium carbonate. In some developer formulae, potassium carbonate is used as the alkali. It is supplied in anhydrous form and should be kept tightly sealed. Potassium salts have increased solubility, allowing them to be used at a higher concentration. In high-sulphite, low-energy fine-grain developers, borax (sodium tetraborate) is a common alkali.

Certain alkaline salts also act as buffers to maintain the pH value constant during development, on storage, or standing of the developer in a processing machine. A solution is *buffered* when it shows little or no change in pH on the addition of acid or alkali. Water is not buffered and its pH is greatly affected when only a little acid or alkali is added. Buffering of photographic solutions is commonly achieved by using relatively large amounts of a weak acid, e.g. boric acid, and the sodium salt of that acid, e.g. borax.

Restrainers (anti-foggants)

Two main types of restrainer are employed: inorganic and organic. The function of a restrainer is to reduce the development of unexposed silver halide crystals, preventing fog. Restrainers also reduce the development of minimally exposed crystals, i.e. at the foot of the characteristic curve, to some extent, and thus affect film speed. The effectiveness of a restrainer in minimizing fog, and its effect on film speed, vary from one developing agent to another and also depend on the pH of the solution.

Potassium bromide is the most widely used restrainer. Soluble bromide is produced as a by-product of the development process and affects the activity of the developer. Inclusion of bromide in the original developer helps to minimize the effect of this released bromide. Most developer formulae therefore use bromide as a restrainer, including those that contain organic restrainers. Developers for papers always include bromide because the smallest amount of fog is objectionable.

Organic restrainers, such as benzotriazole, are especially valuable in phenidone developers. The activity of most phenidone formulae is such that, to prevent fog with high-speed materials, the amount of bromide required as restrainer would be so great that there would be a risk of stain, bromide in excess being a mild silver halide solvent. Use of an organic restrainer avoids this risk. Some bromide is, however, usually included in phenidone formulae to keep developer activity constant with use.

Miscellaneous additions to developers

Besides the main ingredients − developing agent(s), alkali, preservative and restrainer − a developing solution sometimes contains other components for specific purposes. These may include wetting agents, silver halide solvents, anti-swelling agents for high-temperature processing,

calcium-sequestering agents (water-softening agents) and development accelerators.

SUPERADDITIVITY (SYNERGESIS)

Many combinations of two developing agents have been found to have a far greater effect than the sum of their individual effects. This phenomenon is called *superadditivity* or *synergesis*. Figure 13.11 illustrates this phenomenon for Metol and hydroquinone developing agents.

If a film is developed in an MQ–carbonate developer for the recommended time, an image of normal contrast showing both highlight and shadow detail is obtained. If, however, the film is developed in the same basic developer formulation for the same time but omitting Metol, only the brightest highlights are recorded. If the film is developed for the same time in the developer, omitting hydroquinone, an image is obtained containing both highlight and shadow detail but somewhat lacking in contrast. These results show that a developer containing both Metol and hydroquinone produces a photographic effect greater than a simple addition of the effects of both.

Development time

Development is not usually instantaneous, and control of both development time and temperature is required for reproducible results. The effect of development time variation for monochrome film is illustrated in Figure 8.7 and for paper in Figure 8.11. Recommended development conditions for photographic materials are customarily specified at 20°C for monochrome materials and at higher temperatures for colour materials. While development times for monochrome materials may be adjusted to compensate for different developer temperatures, this is not recommended for colour processing where accurate time, temperature and agitation control is essential.

PRINTING

Sensitometric properties of printing paper have been described in Chapter 8 and the construction has been reviewed in this chapter. It remains to comment briefly on the features of print materials in practical use. Referring to Figure 8.8, we note, particularly, the high contrast, low D_{min} and high D_{max}. These qualities combine to give prints on glossy paper bright whites and rich blacks with good shadow detail.

It is generally agreed that, in a good print, there should appear:

- All the important subject tones, *present in the negative.*
- The full range of tones between black and white that the paper can produce. (Even in high-key and low-key photographs it is usually desirable that the print should show *some* white and *some* black, however small these areas may be.)

The first criterion indicates the log exposure range required of the paper (Figure 8.10), which must accept the density range of the negative, and that the negative must have received sufficient exposure to record all required shadow tones. The second requires a correct printing exposure and a suitable contrast grade of paper. It is clear that there is very little exposure latitude in printing, although there is some development latitude (Figure 8.11), usable for small adjustments by visual inspection during safe-lit dish development. Contrast grades are so designated that a negative of an average subject, correctly exposed and developed, will usually print well on grade 2 or 3 paper depending on the enlarger used.

Modern *variable contrast* papers comprise two emulsions of differing contrasts and spectral sensitivities. The contrast is varied by suitably filtering at exposure; typically the highest grades require a magenta grade 5 filter, and the lowest a yellow grade 0 filter. Intermediate contrasts require a set of appropriately designed colour filters. The characteristic curves corresponding to contrast grades approximate those found for traditionally graded papers.

The ranges of surfaces and paper grades (Figures 8.9 and 8.12) give photographers the opportunity to vary the appearance of prints and to cater for differing tastes — but any surface texture lowers the maximum black. Observer preferences tend to favour less than maximum black in deep shadow only if the subject was, itself, clearly of low contrast — misty landscapes and diffusely lit portraits being examples.

Meeting the criteria for a good print does not therefore necessarily imply that the resulting print will be aesthetically pleasing. In practice, the print will usually be satisfactory if the subject luminance range is not high, but with high-contrast subjects results may appear 'flat' and visually uninteresting, even though the criteria have been met. This is because the log luminance range of a high-contrast subject is far greater than the maximum density range that can be obtained on printing paper. Two remedies are possible. The simplest is to print the negative on a harder grade of paper and to sacrifice detail at either the shadow or the highlight end of the scale. This, in effect, abandons the first criterion but is often satisfactory. A preferred remedy is to use a 'harder' printing paper but to isolate the various tone bands within the picture, and treat them individually by additionally *printing in* lighter tones. In this way we can obtain the contrast we require within the various tone bands of the picture without sacrificing detail at either end of the scale. For aesthetic reasons it may thus be

259

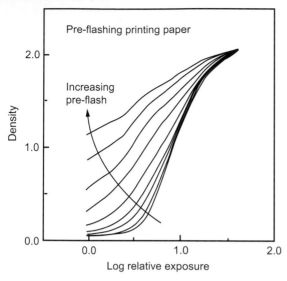

Figure 13.12 Control of print contrast by pre-flashing the printing paper.

appropriate to introduce a measure of distortion in the tones of the final print.

Some skilled monochrome printers use an additional method for controlling tone reproduction. A brief *uniform* pre-exposure, or *pre-flash*, is used to modify the characteristic curve of the printing paper. The higher the intensity of the uniform pre-flash the lower is the contrast obtained. There is usually some increase in the minimum density, although this may be acceptable if it is not too high. Results obtained with pre-flashes of increasing intensity are shown in Figure 13.12, which shows a large increase in useful exposure range. This method of controlling print contrast has, in fact, been successfully used in large-scale production using an automatic printer.

Darkroom work

Printing and development are carried out in a darkroom, using red or orange illumination to which black-and-white printing paper is not sensitive. Negative images are projected on to printing paper using an enlarger, which enables image magnification to be controlled, at a convenient lens aperture and exposure time. The former is usually set to give the highest sharpness in the image, at some aperture midway between minimum and maximum. The exposure time may be controlled manually, or by a suitable timer. Because a wide range of film and paper formats, as well as enlarging magnifications, may be encountered, the ISO speed of a printing paper is usually irrelevant. An initial stepped exposure is customarily used to determine printing exposures *from first principles* for a chosen negative. This guides both exposure time and choice of contrast grade, and the optimum print obtained is a guide for subsequent exposures from other negatives in the same printing session.

Development

Development may be manual using dishes or, for large-scale work, a processing machine can be used. In either case, reproducibility is vital. It is customarily achieved by a choice of development time sufficiently long for minor time variations to produce no perceptible image changes. Figure 8.11 illustrates the minimal effect of small development variations beyond 120 s for a particular set-up. Modern papers often require shorter development times to achieve a useful constancy of result. An acid fixer will both stop development immediately and fix the print after development. Complete fixing and washing are essential for print stability, and are followed by drying.

Critical inspection of the finished print under good lighting conditions is useful in deciding whether to improve the result by reprinting, with suitable modifications, and in developing the photographer's critical faculties.

BIBLIOGRAPHY

Allbright, G.S., 1991. Emulsion speed rating systems. Journal of Photographic Science 39, 95—99.

Coote, J.H., 1982. Monochrome Darkroom Practice. Focal Press, London, UK.

Diamond, A.S. (Ed.), 1991. Handbook of Imaging Materials. Marcel Dekker, New York, USA.

Eggleston, J., 1984. Sensitometry for Photographers. Focal Press, London, UK.

ISO 6:1993, 1993. Photography — Black-and-White Pictorial Still Camera Camera Negative Films/Process Systems — Determination of ISO Speed.

ISO 6846:1992, 1992. Photography — Black-and-White Continuous Tone

Papers — Determination of ISO Speed and ISO Range for Printing.

Jacobson, R.E., Jacobson, K.I., 1980. Developing, eighteenth ed. Focal Press, London, UK.

Jacobson, R.E., Ray, S.F., Attridge, G.G., Axford, N.R., 2000. The Manual of Photography, ninth ed. Focal Press, Oxford, UK.

James, T.H. (Ed.), 1977. The Theory of the Photographic Process, fourth ed. Macmillan, New York, USA.

Langford, M., Bilissi, E., 2008. Langford's Advanced Photography, seventh ed. Focal Press, Oxford, UK.

Proudfoot, C.N. (Ed.), 1997. Handbook of Photographic Science and Engineering, second ed. IS&T, Springfield, VA, USA.

Tani, T., 1995. Photographic Sensitivity. Oxford University Press, Oxford, UK.

Todd, H.N., Zakia, R.D., 1974. Photographic Sensitometry. Morgan & Morgan, New York, USA.

Walls, H.J., Attridge, G.G., 1977. Basic Photo Science. Focal Press, London, UK.

Chapter | 14 |

Digital cameras and scanners

Elizabeth Allen and Efthimia Bilissi

All images © Elizabeth Allen and Efthimia Bilissi unless indicated.

DIGITAL STILL CAMERAS

As we have seen in earlier chapters, conventional silver halide photographic systems produce images by the recording of a light intensity function as a latent image, which is a light-induced chemical change in the silver halide emulsion. The image is rendered visible and permanently stored as a result of film development and fixation; therefore, the image sensor in silver halide camera systems is also the storage medium. Each image requires a separate image sensor (film frame) and the characteristics of the imaging material may be changed from frame to frame by changing the photographic emulsion.

In an electronic camera system the image sensor converts a light intensity function to an electronic signal. The process differs fundamentally from that of a silver halide system in that the image sensor is a capture and conversion device only and is a permanently fixed component of the camera. The camera therefore requires a separate storage device in addition to the image sensor. As described in Chapter 1, the first prototype electronic still camera, the Mavica, was announced by Sony in August 1981. Such early electronic cameras were analogue devices, storing the image function as a video signal on some type of electromagnetic storage media. *Digital still cameras* (DSCs) similarly rely on a sensor which converts a light intensity function to an electronic signal, but they output a digital signal by passing it through an analogue-to-digital converter (ADC). The signal is then encoded and stored on some form of digital storage device. See Chapter 7 for information on image formation and Chapter 9 for further information on image sensors.

Because digital cameras have a fixed sensor, it is important to be able to change various characteristics of the sensor, such as its sensitivity (equivalent to ISO film speed) and its response to illuminants with different spectral characteristics (equivalent to the colour balance of film). This is achieved by manipulating the output signal either before or after analogue-to-digital conversion.

Many of the functions, features and architecture of digital still cameras are similar to those of conventional film cameras. They consist of a lens, shutter and viewfinder system, a means of determining exposure, focusing, automating features and data display. Many of these features are covered in detail in Chapter 11. Therefore, this chapter mainly concentrates on the aspects of digital cameras that differ from those of film cameras.

DIGITAL STILL CAMERA ARCHITECTURE

There is an enormous range of different types of digital camera. The main categories of camera designs, which may be broadly classified based on image format and camera features, are described later in the chapter. A block diagram of the generic architecture of a digital still camera is illustrated in Figure 14.1. Many of the mechanical and optical components of digital cameras may be similar to their analogue equivalents, especially in digital single-lens reflex cameras (SLRs). The characteristics of digital cameras are determined by a combination of the hardware (sensor, and optical and mechanical components), the camera *firmware*, the camera system controller and the

DOI: 10.1016/B978-0-240-52037-7.10014-6

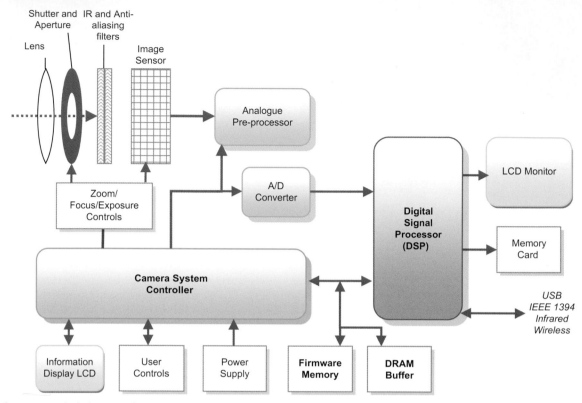

Figure 14.1 Block diagram of a generic digital still camera.

image-processing algorithms applied in the digital signal processor (DSP).

The software in the DSP tends to provide higher-level image processing, which may be affected by user settings, some of which may be bypassed if capturing RAW images. By contrast, the camera firmware is software embedded in the camera's read-only memory, which often provides lower-level processing, but which is essential to the basic functioning of the camera. Firmware programs control the microprocessors and circuits, which in turn control, for example, the LCD screen, autofocus function, sensor and buffers, hence the direct connection with the camera system controller in Figure 14.1. Firmware updates are often released by camera manufacturers to improve performance or add functionality.

The camera architecture may be broadly divided into three subsystems. The optical and mechanical subsystems define how the original scene is captured; these are often similar in structure to those in film-based camera systems, with some small differences. The analogue front-end consists of the image sensor, analogue pre-processor and ADC, which capture and process the analogue signal before converting it to a digital signal for further processing. The digital back-end consists of the DSP, camera system controller, LCD display and various other components. The digital circuits apply

various image processes and image compression if required, before storing the image in a suitable format (see Chapters 17 and 29 for information on file formats used in digital cameras and compression methods). Generally, the processed images will be stored on a removable memory card. They may also be downloaded directly to a computer via a universal serial bus (USB) or other interface.

Automatic exposure, autofocus (AF) and automatic white balance control are performed by the camera system controller based on image signals generated in the DSP when the shutter is depressed halfway. In compact digital cameras these signals have usually come from the image sensor. Digital SLRs may have separate sensors for AF and auto-exposure.

The camera controls available to the user will be dependent on the type of camera. Digital SLRs, for example, may be similar in the design and positioning of external controls to equivalent film SLRs by the same manufacturer. An information display LCD is used to apply many camera settings, including image resolution, compression method, capture colour space, white balance and features such as red-eye reduction.

Many DSCs have an electronic viewfinder in the form of a thin-film transistor LCD display as well as an optical viewfinder, although some cameras have an electronic

viewfinder only. For the purposes of framing and focusing, when the shutter is depressed halfway, a sub-sampled image is captured, processed and stored in a dynamic random access memory (DRAM) buffer and a thumbnail output to the LCD screen, for instant review.

In digital SLRs, however, the LCD display only plays back captured images and does not function as a viewfinder. The low resolution of the image and the fact that the image is often viewed in bright ambient lighting conditions can be a problem in evaluating the image exposure and colour reproduction, although the resolution and colour rendering of such LCD displays has improved in recent years. Many cameras have provision for the optional display of the image histogram alongside a reduced version of the captured image. This provides a much more accurate method of exposure evaluation and allows the user to identify clipped highlights or shadows and adjust the exposure to compensate. Additionally, some cameras allow the display of out-of-gamut colours or clipped highlight or shadow areas on the image itself (termed *gamut warning*; the pixels will usually be masked with a specific highly saturated colour).

IMAGING OPTICS

The imaging optics consist of the imaging lenses, an infrared (IR) cut filter and an optical low-pass filter.

The reader should refer to Chapter 6 to gain an understanding of geometrical optics, and to Chapter 10 for the design and characteristics of lenses. However, it is useful to summarize below a few important points about lenses for digital cameras.

Digital sensors are currently, in the majority of cases, smaller in dimensions than the main film formats. The lens focal length required to provide a 'standard' field of view (an angle of around 50°; see Chapter 6) corresponds approximately to the diagonal of the sensor and is therefore of a much shorter focal length than those for equivalent film formats. Aspheric lens elements and materials with high refractive indices are used to produce smaller lenses, particularly for compact cameras. Many digital cameras (almost all consumer digital cameras) make use of zoom lenses. In film compacts, the zoom lenses are normally *retrofocus* in design (see Chapter 10). Digital image sensors fitted with microlenses (see Chapter 9) require that the angle of light rays exiting the pupil is nearly parallel. For zoom lenses, this must apply across the full range of focal lengths. The configurations of groups of lens elements are reversed compared to retrofocus lenses; these are known as *telecentric* lenses.

The small sensors and shorter focal lengths result in a small depth of focus and much larger depth of field. This is particularly true for digital compacts, in which the sensor dimensions are smallest, meaning that it can be difficult to isolate subjects using a shallow depth of field.

In many cases the lenses used in film single-lens reflex cameras (SLRs) may be transferred across to digital SLRs. However, if the sensor size is smaller as described in Chapter 9, their effective focal length will be increased, as they image a smaller area from the centre of the image.

This change in focal length is often described as the 'effective focal length' or as the 'equivalent focal length' (relative to full-frame 35 mm cameras). The relationship may also be expressed as a 'crop factor' (sometimes termed the 'focal length multiplier'), which is used to multiply the lens focal length to find its equivalent focal length. The crop factor (CF) is most commonly calculated by: $CF = diagonal_{35\,mm}/diagonal_{sensor}$. The crop factor and equivalent focal lengths for a range of lenses for a 1.8 image sensor, typical of the type used in a number of currently available semi-professional digital SLR cameras, are given in Table 14.1.

It is clear from the table that what would be a 'standard' lens on a 35 mm frame (focal length 50 mm) becomes a telephoto lens with a 1.8 sensor, because it will only be imaging an area from the central area of the frame, and therefore the field angle of view is reduced. To achieve a field angle of view similarly to the standard lens with the sensor requires a much shorter focal length of between 24 and 35 mm, which is close to the diagonal dimension of the sensor.

This has some impact on the image: First, imaging from the centre of the lens may reduce some distortion effects as a result of lens aberrations, which are worse near the periphery. Secondly, the same desired image framing on both the full frame of film and the smaller image sensor may be achieved in two ways: either a shorter focal length lens can be used with the smaller image sensor, which will produce the same equivalent focal length; or if using the same lens on both, the camera with the smaller sensor will be further away from the subject. In either case, at the same aperture, the depth of field in the image will be greater for the image produced with the smaller sensor (see Figure 6.10).

Various surfaces in an optical system reflect light, producing a loss of contrast and *ghosting* artefacts, which are minimized by the use of anti-reflection coatings on lens elements. The problem is more pronounced in digital cameras, due to the highly reflective surface of the sensor and additional elements such as the IR filter (see below). Additionally, materials with high refractive indices used in the lens elements result in increased reflection. These factors necessitate better multi-layer anti-reflection coatings for digital lenses and mean that some reduction in image quality may be apparent when using a lens designed for a film camera.

As described in Chapter 9, the inherent IR sensitivity of the image sensor necessitates the use of an IR filter, which in the majority of cases is an absorption filter, although IR reflection filters and combined absorption and reflection filters are sometimes used. The IR filter is usually

Table 14.1 Equivalent focal lengths for lenses used with a sensor smaller than the 35 mm full-frame format (24 × 36 mm)

SENSOR FORMAT (see Table 14.2 for sensor dimensions)	35 MM FULL-FRAME DIAGONAL (MM)	SENSOR DIAGONAL (MM)	CROP FACTOR (focal length multiplier)	LENS FOCAL LENGTH (MM) (on 35 mm full frame)	EQUIVALENT FOCAL LENGTH (MM)
1.8	43.3	26.7	1.6	24	38.4
				35	56
				50	80
				105	168
				200	320

positioned behind the imaging lens, but may be attached directly to the lens. The filter is removable in a limited range of digital SLRs. This removal is a delicate procedure, during which care must be taken to avoid damage to the sensor and accumulation of dust in the camera body. Alongside the specialist high-end IR digital cameras developed for use in scientific applications, some of the larger mainstream camera manufacturers have also released versions of their digital SLRs without an IR filter for scientific and applied imaging applications.

The optical low-pass filter (OLPF), sometimes called an *anti-aliasing filter*, is used to attenuate frequencies beyond the Nyquist limit of the sensor, to prevent aliasing (see Chapter 7). It is positioned directly in front of the image sensor. The filter is most commonly constructed of a birefringent material, usually quartz, although calcite and lithium niobate are also used. Thin plates of the material are sandwiched together. Birefringent materials have two refractive indices, which are dependent upon the polarization and direction of travel of a ray of light through the material (see Chapter 2). When an incident ray enters the material, it is split into two rays, which are refracted by different amounts and therefore emerge with a small separation. As a result of this, a point of light is slightly blurred in one direction. Each thin plate will separate the rays in different directions. By combining several different plates, several images of the same point will be produced, blurring in different directions. The most common type is the *four-spot anti-aliasing filter*, which produces four separate images of a point. The separation between the spots is determined by the thickness of each plate. To prevent aliasing, a ray of light must be separated so that the two rays fall on consecutive pixels. If a sinusoid is imaged at the Nyquist frequency, every point will be blurred across two pixels, therefore producing a modulation of zero (Figure 14.2).

The combination of larger sensor sizes with very small pixel pitches now available requires lenses with higher

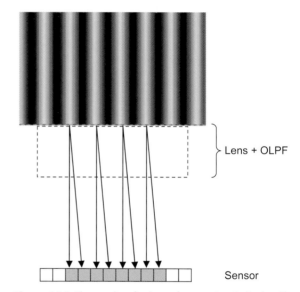

Figure 14.2 The results of using a four-spot anti-aliasing filter on the image of a sinusoid at the Nyquist frequency of the sensor. The luminance at each peak of the sinusoid is imaged at two consecutive pixels, meaning that every pixel receives the same amount of light, producing a modulation of zero.

resolving power than those required for film-based systems. This is particularly true for lenses to be used with larger-format digital backs. The modulation transfer function (MTF) (see Chapters 7, 19 and 24) of the imaging optics is the product of the MTF of the imaging lens and the MTF of the OLPF (also the MTFs of other imaging components such as sensor micro-lenses if they are used). The lens must be designed to ensure good performance at frequencies below and close to the Nyquist. This requires a reasonable MTF level at the range of frequencies up to 80% of the Nyquist frequency. A lens with high resolving power is required to achieve this; therefore, the lens MTF will normally have a higher cut-off frequency than the Nyquist frequency of the sensor.

IMAGE SENSOR

Both charge-coupled devices (CCDs) and complementary metal oxide semiconductor (CMOS) sensors are employed in digital still cameras. Chapter 9 covers the structure and characteristics of both types of sensor in detail. Until recently the CCD was predominant, but cameras with CMOS sensors are now becoming more widespread. There is much variation in sensor size, pixel pitch and numbers of pixels, leading to a diverse range of camera designs. Where film cameras are classified into three main types, which are based on common image formats, digital cameras of the same equivalent design may be very different in terms of sensor size and resolution. Table 14.2 provides some examples of the variation of sensor dimensions and types currently available in a range of digital still cameras.

The term *full-frame format* in the camera type description in Table 14.2 does not refer to the sensor readout architecture (see Chapter 9 and below for information on sensor architecture). In this case, it is a term which has found common use within the imaging community to describe cameras with a sensor that has the same dimensions as an equivalent film-based system. A few high-end digital SLRs and medium-format backs have this equivalent sensor size, whereas the majority of digital cameras rely on sensors that are smaller than the corresponding film format.

For compact cameras, small sensor dimensions are not really an issue. At the time of writing, there are pixel sizes available in consumer cameras of 1.4 µm or less, resulting in sensors containing 10–12 million pixels. The resolution of these cameras is more than adequate for images to be output to screen or print. A disadvantage to using smaller pixels, as described later in the chapter, is more noise, thus a lower signal-to-noise ratio (the *fill factor* of the pixel is

Table 14.2 Sensor dimensions and formats commonly employed in digital still cameras

SENSOR FORMAT	HORIZONTAL (MM)	VERTICAL (MM)	DIAGONAL (MM)	ASPECT RATIO	SENSOR TYPE	CAMERA TYPES
Digital sensors: consumer market						
1/5	2.6	1.9	3.2	4:3	CMOS	Mobile phone
1/2.7	5.4	4.0	6.7	4:3	CCD/CMOS	Compact
1/2	6.4	4.8	8.0	4:3	CCD/CMOS	Compact
1/1.8	7.2	5.3	8.9	4:3	CCD/CMOS	Compact
2/3	8.8	6.6	11.0	4:3	CCD/CMOS	Compact
1	12.8	9.6	16.0	4:3	CCD/CMOS	Compact
1.8	22.2	14.8	26.7	3:2	CMOS	SLR
1.8	23.7	15.7	28.4	3:2	CCD	SLR
Digital sensors: professional market						
35 mm	36.0	24.0	43.3	3:2	CMOS	SLR (full-frame format)
Medium/large-format back	36.9	36.9	52.2	1:1	CCD	Digital back (full-frame format)
Medium/large-format back	48.0	36.0	60.0	4:3	CCD	Digital back (full-frame format)
Medium/large-format back	49.0	36.9	61.0	4:3	Trilinear array CCD	Scanning back
Large-format back	96.0	72.0	120.0	4:3	Trilinear array CCD	Scanning back
Large-format back	100.0	84.0	130.6	4:3	Trilinear array CCD	Scanning back

lower) and reduced dynamic range compared to sensors employing larger pixels. Additionally, the higher noise levels require more noise reduction processing in the DSP, which often reduces sharpness in the final image. However, the small sensor allows the use of lenses with shorter focal lengths and therefore facilitates more compact camera designs. A 2/3 inch sensor, for example, with dimensions 6.6 × 8.8 mm, has a diagonal of only 11 mm, indicating a focal length of close to this value for a standard field of view of approximately 50°.

As described earlier, for cameras with removable lenses, there is a significant advantage in using a sensor size equivalent to the relevant film format, as the lenses used in film-based systems may then be transferred across to digital camera systems, and the focal length and depth-of-field characteristics will be the same for both systems. Of course, the other main advantage with a larger sensing area is the space for more pixels. The increase in the manufacturing cost of larger sensors means that full-frame cameras are therefore high-resolution professional systems at the top of the price range for each format.

SHUTTER SYSTEMS

The method used to control exposure time in DSCs is dependent on the type of sensor and the sensor readout architecture. The main difference is in the use of a mechanical (usually focal-plane) shutter or an electronic shutter.

As described in Chapter 9, several readout architectures are used in the CCD image sensor. *Full-frame* CCDs (Figure 9.10a) are the simplest in design, using the majority of the area of the chip for image sensing, after which the charge is read out line by line into a horizontal serial CCD register. *Frame-transfer* CCDs, depicted in Figure 9.10b, consist of an image-sensing area similar to a full-frame array, but have a charge storage area shielded from the light, where charge is stored before being read out. *Interline transfer* CCDs have shielded strips for vertical charge readout between strips of pixels (Figure 9.10d). The charge is read out into these strips after the integration period and read off line by line into the horizontal serial CCD register while the next image is being captured. The fourth method is a combination of two of the others, the *frame–interline* CCD.

In the case of the full-frame CCD, the photosensitive area must be completely shielded from light during the readout, otherwise light-generated charge carriers will continue to accumulate as the charge is being transferred off the sensor, resulting in smear artefacts. Therefore, a mechanical shutter must be used. Full-frame CCD sensors are typical of professional digital SLRs, which tend to be constructed similarly to their film-based equivalents and therefore include mechanical shutters of similar design (see Chapter 11 for details of mechanical shutter systems).

Many consumer cameras use interline transfer CCDs (ITCCDs). There are two methods for reading out the signal from these CCDs, by *progressive scan*, in which the entire charge is transferred into the vertical shift register simultaneously, or by *interlaced scan*, where odd and even horizontal lines are read out separately. In the case of interlace scanning, the integration period for all pixels begins at the same point, but the odd and even fields are read out sequentially after the integration period has ended. This requires the use of a mechanical shutter to shield the sensor from light during the readout period. An ITCCD reading out by progressive scan does not require shielding and may therefore use an electronic shutter. After exposure, a transfer gate pulse is applied to the vertical electrode and the signal is read out. The time difference between the start of integration and the point at which the transfer gate pulse is applied becomes the shutter speed. The use of an electronic shutter has several advantages: it does not suffer from wear and tear or the inaccuracies of a mechanical shutter and the shutter speed can be more precisely controlled. This allows the use of much higher shutter speeds (a super high-speed shutter of 1/10,000 second is possible) than achievable using a mechanical shutter. However, this must be balanced against the inefficiency in terms of image-sensing area of using an interline transfer CCD as opposed to a full-frame or frame-transfer CCD. The extra space required for the vertical charge readout area reduces the potential fill factor of the pixels.

There are also different possible readout architectures for CMOS image sensors. *Pixel serial readout* architecture selects pixels one at a time by row and column and reads them out and processes them sequentially, allowing full X—Y addressing. *Column parallel readout*, which is used in the majority of CMOS image sensors, reads pixels in a row out simultaneously and processes the entire row (for example, suppressing fixed pattern noise and applying ADC) in parallel. *Pixel parallel readout* performs the signal processing on each pixel in parallel using a processor element contained within the pixel, and then transfers the set of compressed signals for all pixels simultaneously. The configuration of the pixels in pixel parallel sensors is much more complex and the pixels larger. This method is therefore not used in the majority of digital still cameras, but is confined to specialist high-speed applications. CMOS sensors require a reset scan in which shutter pulses scan the pixel array before readout. The shutter pulse corresponds to the beginning of the exposure, which is completed when the pixel is read out. This is a form of electronic rolling shutter. Because this shifts the exposure time between pixels it is not suitable for capturing still images. Therefore, a mechanical shutter is generally used to control exposure in DSCs using CMOS sensors. In this case the reset pulses are completed in a relatively short time or simultaneously; then exposure begins and is completed when the mechanical shutter is closed.

DYNAMIC RANGE IN DIGITAL CAMERAS

As described in Chapter 12, the optimum exposure is dependent on the relationship between subject luminance range and the dynamic range of the camera. It is also dependent on scene content and the intentions of the photographer, to determine which areas of the scene are most important in the image and require optimal tone reproduction, possibly at the expense of other areas.

The dynamic range of the sensor, prior to analogue-to-digital conversion, is defined by the ratio between the full-well capacity of the pixel (the saturation level, or maximum number of electrons that the pixel can trap) and the noise floor (the minimum charge detectable above the sensor noise), given in Eqn 9.1. The full-well capacity is related to pixel size, meaning that sensors with larger pixels (for example, those in digital SLRs compared to those in compact cameras) will have a larger capacity and therefore a higher potential dynamic range. The noise floor depends upon the sensor type and is highly variable.

The coarseness of quantization in the analogue-to-digital conversion is a limiting factor in dynamic range. The precision of the converter defines the maximum number of levels that can be reproduced and therefore the theoretical maximum dynamic range without the limitations of noise. In an unrendered RAW file 10-, 12- or 14-bit linear quantization may be employed. As the number of levels that can be encoded is equal to 2 bits, then the maximum contrast ratio achievable by a 12-bit quantizer, for example, is 1:4096, which corresponds to 12 stops ($2^{12} = 4096$).

In linear quantization (which is most common in RAW files from digital cameras), however, each increase of luminance level by one stop corresponds to a doubling of light intensity and a doubling of the number of output levels allocated by the ADC. The minimum step level of quantization required to prevent visible contouring in the lowest intensity areas of the image (see Chapter 21) defines the minimum number of levels to be allocated to the lowest exposure zone. As the number of levels allocated to each subsequent stop/zone increases from the previous one by a factor of 2, the maximum number of stops represented and the usable dynamic range are lower than the bit depth of the quantizer in practice.

Additional factors influence the dynamic range of the camera when compared to that of the sensor. As described in Chapter 9, the process of analogue-to-digital conversion results in quantization noise due to rounding errors, raising the overall noise level. Subsequent processing further reduces the final usable dynamic range of the camera. Signal amplification, for example, when using an ISO speed other than the native ISO of the sensor, also amplifies noise; the application of non-linear mapping functions in gamma correction, or to mimic a film-like characteristic curve (to provide smoother gradation and detail in shadow areas and smoother gradation in highlights), while improving perceived contrast, may reduce the effective captured luminance range. The final dynamic range of the camera is likely to be closer to 5–9 stops (10 stops is possible for some medium-format cameras, assuming a higher precision ADC).

Since the dynamic range of many scenes will exceed that available to the camera, it is necessary to expose the scene so that the important information is correctly exposed, which may mean sacrificing some detail at either end of the tonal range. It should be noted that the dynamic range of the sensor will not be fully utilized in a rendered image. JPEG images, for example, are limited to 8 bits. Unrendered RAW data may retain more of the sensor dynamic range, allowing some adjustments to exposure at the post-processing stage before the image is rendered to 8 or 16 bits — this is discussed and illustrated in Chapter 25. 'Exposing to the right', as described in Chapter 12, is a technique used to optimize the tonal distribution in shadow areas in RAW files. This is achieved as a result of careful exposure and post-processing, without clipping the highlights, as highlight clipping is significantly more problematic visually than shadow clipping. Simple auto-exposure methods cannot determine what is important in terms of scene content. Thus, for certain types of scenes, spot metering of specific image zones or the use of sophisticated programmed exposure modes is critical to achieve satisfactory results.

High-dynamic-range imaging (HDR imaging) provides a potential solution to the problem of low-dynamic-range sensors. Described in Chapter 12, HDR imaging combines multiple images of the same scene bracketed at different exposures into a high-bit-depth file. Some of the tonal range of each image is used for the final image, which is then compressed into an 8- or 16-bit-depth image format. At a relatively early stage of development, there are limitations to its use, as it requires a static subject for bracketing and a reasonable degree of post-processing. At the time of writing, however, a number of compact cameras and one digital SLR have been recently released boasting built-in HDR imaging technology. The Fuji Super CCD SR described in the next section was a sensor using a very early adaptation of the principles of HDR imaging.

COLOUR CAPTURE

It is important to note that the sensor itself is a monochromatic device. It simply captures light and converts it to an electronic signal. As we have seen in previous chapters, capturing colours in photographic film requires that the incoming radiation is analysed into different spectral bands. This is achieved by sensitizing separate emulsion layers to bands of different wavelengths, which, upon processing, form layers of dyes to allow the generation of

(a) (b)

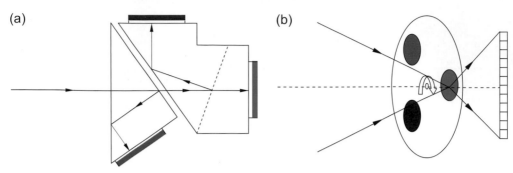

Figure 14.3 (a) Three-sensor camera. (b) Sequential colour camera.

a colour image. Similarly, digital image sensors require some mechanism for the separation of light into different wavelength bands. There are various methods employed in digital cameras to achieve colour separation, as introduced in Chapter 9 and summarized below.

Three-sensor cameras

These early digital cameras employ a beamsplitter, usually a dichroic prism, to separate the incoming light into three components (see Figure 14.3). These are directed to three separate sensors, filtered for red, green and blue wavelengths respectively. Each sensor produces a monochromatic record of the filtered light only, corresponding to one of the three channels of the image. The images from the three separate sensors require careful registration to produce the full colour image. Because each sensor produces a full-resolution record of the image, these cameras do not suffer from chromatic aliasing typical of cameras using Bayer arrays (see below). The use of three sensors, however, means that these cameras are both expensive and bulky.

Sequential colour cameras

These cameras capture successive red, green and blue filtered exposures, using a colour filter wheel or a tunable LCD filter to separate the light into the three components (see Figure 14.3b). The image is then formed by a combination of the three resulting images. As for three-sensor cameras, each channel is captured at the full resolution of the sensor, resulting in very-high-quality images. However, the colour sequential method is only suitable for static subjects, because the three channels are captured at slightly separate times and any misregistration of the subject will result in colour fringes at edges. An additional problem is that of illumination, which may vary during the successive exposures. Therefore, this approach is confined to a limited number of professional studio cameras.

Scanning backs for large-format cameras have similar limitations to colour sequential cameras. Most commonly they employ a trilinear CCD array, which scans across the image format. All three channels are captured at the same

time in this case, so misregistration of the three channels is not a problem, but subject movement may result in image distortion. Inconsistent illumination produces changes in exposure across the image plane.

Colour filter array (CFA) cameras

Nearly all commercially available digital cameras (other than those using a *Foveon* sensor, described in the next section) use a colour filter array positioned directly in front of a single sensor, capturing separate wavelength bands to individual pixels. Each pixel therefore contributes to only one of the colour channels and the values for the other two channels at that pixel must be interpolated. The process of interpolating colour values is known as *demosaicing*. If rendered images are being produced by the camera, which is most commonly the case, then demosaicing is performed by the camera digital signal processor. Alternatively, if RAW camera data are to be output (in *unrendered camera processing*), then demosaicing will usually be performed later during RAW conversion (see Chapters 17, 25 and 26).

A number of different CFA patterns have been developed, but the two most frequently employed are the *Bayer array* and the *complementary mosaic pattern*. These are shown in Figure 14.4a and b (see also Figure 9.21).

The Bayer array is the most common, consisting of red, green and blue filters, with twice the number of green to red and blue filtered pixels. As described in Chapter 9, the spectral sensitivity of the green filtered pixels most closely corresponds to the peak luminance sensitivity of the human visual system, hence the higher allocation, providing better luminance discrimination. This results in a higher Nyquist frequency for the green channel than that of the red and blue channels. Differing Nyquist frequencies produce different amounts of aliasing across the three channels, appearing as chromatic aliasing at high spatial frequencies. The effect, which is indicated by colour fringing, is counteracted by the use of the OLPF described earlier in this chapter.

The complementary mosaic pattern, used in some digital still cameras, consists of equal numbers of cyan, magenta, yellow and green filtered photosites. Because complementary filters absorb less light than primary filters, these CFAs

(a)

R	G	R	G
G	B	G	B
R	G	R	G
G	B	G	B

(b)

M	G	M	G
C	Y	C	Y
M	G	M	G
C	Y	C	Y

(c)

R	E	R	E
G	B	G	B
R	E	R	E
G	B	G	B

(d)

G	W	R	W
B	W	G	W
G	W	R	W
B	W	G	W

Figure 14.4 Colour filter arrays. (a) Bayer array. (b) Complementary mosaic pattern. (c) RGBE filter pattern (Sony). (d) Example RGBW filter pattern (Kodak).

are more sensitive to light than RGB filter patterns. However, more colour correction is required with complementary filters, leading to an increase in noise and reduced signal-to-noise ratio at higher illumination levels; therefore, RGB filter patterns are more common.

Other combinations of filters may also be used, for example the red, green, blue and 'emerald' pattern (RGBE), similar to the Bayer array, but with a blue—green 'emerald' filter replacing some of the green filters (Figure 14.4c), with the aim of more closely matching the spectral response of the sensor to that of the human visual system. RGBE arrays are used in some Sony cameras. Another fairly recent development is the RGBW (red, green, blue, white) pattern (an example is depicted in Figure 14.4d). Kodak announced several RGBW patterns in 2007, to be made available in some cameras in 2008. The 'white' filter elements are actually transparent, or panchromatic, transmitting all visible wavelengths and increasing the amount of light detected. The data from the remaining RGB filtered pixels is processed using a Bayer demosaicing algorithm.

The Super CCD™

The Super CCD was first announced by Fujifilm in 1999 and currently available Fuji compact and bridge cameras employ the eighth generation version of this proprietary sensor. A form of mosaic array, it is based on octagonal rather than rectangular pixels, which allows the pixels to be diagonally mapped (Figure 14.5), with smaller horizontal

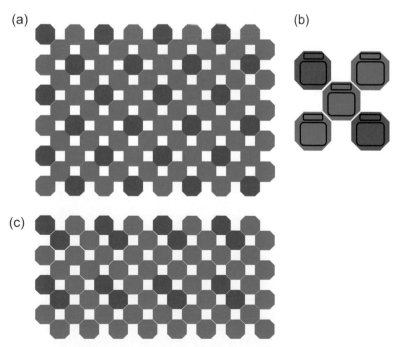

Figure 14.5 Fuji Super CCD™ sensors. (a) The Super CCD HR. (b) The Super CCD SR. (c) The Super CCD EXR.

and vertical pitches than traditional mosaic arrays with equivalent pixel numbers. The increase in horizontal and vertical resolution is at the expense of diagonal resolution (although this is less important to the human visual system and therefore the architecture still remains an improvement on conventional mosaic sensors). The fourth generation of these sensors, announced in 2003, diversified into the Super CCD HR ('high-resolution') sensor, as depicted in Figure 14.5a, and the Super CCD SR ('high-dynamic-range') sensor (Figure 14.5b). The latter sensor has two photodiodes per pixel, of different sizes and sensitivity. The larger 'primary' photodiode has high sensitivity but a relatively low dynamic range and caters for dark and medium intensities, while the smaller 'secondary' photodiode has low sensitivity but a very large dynamic range. Both photodiodes are exposed at the same time, but the two signals are read out consecutively, before being combined in the camera DSP into a high-dynamic-range image. The combined output of the two photodiodes is four times the dynamic range of a conventional photodiode. The fifth and sixth generations of the sensor improved upon performance at high ISOs. The very latest version, the Super CCD EXR, announced in September 2008, uses a new arrangement of colour filters to 'bin' the output from two consecutive pixels filtered with the same colour, producing effective double-sized pixels, to combine the advantages of both the earlier HR and SR technologies (Figure 14.5c).

The Foveon™ sensor

As mentioned in Chapter 9, there is another method of colour reproduction, developed by Foveon Inc, and currently used in a limited number of digital cameras. This approach is implemented through the design of the sensor itself rather than through the camera architecture, and is based upon absorbing different wavebands of light in different layers of the sensor, similarly to multi-layer colour film.

The Foveon X3 three-layer silicon image sensor was announced in 2002 and uses stacked silicon photodiodes, manufactured using a standard CMOS processing line. Different wavelengths of light penetrate to different depths in silicon; therefore, when light is absorbed by the sensor it produces electron−hole pairs proportional to the absorption coefficient (see Chapter 7). Short wavelengths will produce more electron−hole pairs near the sensor surface, while long wavelengths penetrate the deepest before producing charge carriers. By burying photodiodes at different depths in the silicon, different wavelengths are captured at these depths, therefore acquiring all three colour channels at every pixel. The spectral sensitivity of the sensor is determined by the depth of the photodiodes. Figure 14.6 illustrates the technology.

In CFA cameras using a Bayer array, only 50% of the pixels (the green-sensitive pixels) contribute to the luminance signal. However, there is luminance information in

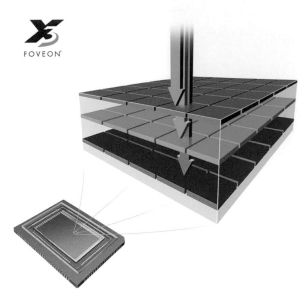

Figure 14.6 Foveon™ sensor technology.

the red channel and a smaller amount in the blue channel. In cameras using the Foveon X3 sensor, this information may be captured at every photosite across all three channels, and linearly combined to produce a very-high-quality luminance signal. Without the interpolation required by a CFA, the luminance image produced may be significantly sharper than that of a CFA camera of an equivalent number of pixels, and there is not the problem of chromatic aliasing characteristic of CFA cameras (although the use of the OLPF and improvements in demosaicing techniques mean that this is less of an issue with most current cameras using Bayer arrays). At the time of writing, the most recent camera releases using the Foveon X3 sensor include the Sigma SD14 (a digital SLR released in March 2007) and the Sigma DP1 (a compact camera launched in the spring of 2008).

RENDERED VERSUS UNRENDERED CAMERA PROCESSING

For the majority of imaging applications the requirement is for fully processed and colour rendered images to be output and stored in a standard file format. In this case the camera settings will be used to capture the raw data from the sensor. In a camera using a colour filter array for colour separation, the data will be demosaiced, white balance correction applied, and tone and colour rendering performed to provide an output-referred image. The image will then be sharpened, compressed and stored, most commonly in the Exif/JPEG file format using lossy compression, although some cameras also allow storage as

JPEG 2000 or uncompressed TIFF files. See Chapter 17 for details on file formats and Chapter 29 for information on image compression.

The option to output unrendered image data has been a more recent development in digital cameras. In this case the raw and relatively unprocessed data from the sensor is optionally losslessly compressed, stored and output in a usually proprietary RAW file format. The image data is then opened in RAW conversion software, and the processing that would be performed by the camera, such as white balancing, exposure adjustments, sharpening and even changes in resolution, is applied prior to or in conjunction with colour demosaicing to produce a final output-referred image (in most cases). This affords the user a high degree of control over the rendering of the image and allows fine-tuning of exposure using more of the available dynamic range from the sensor. See Chapter 25 for information about RAW capture workflow.

EXPOSURE DETERMINATION AND AUTO-EXPOSURE

The factors influencing the necessary exposure for a scene captured using a digital camera are the same as those for film-based systems: a combination of scene illumination levels and reflectances within the scene (subject luminance range) and the sensitivity of the sensor, which together define the required lens aperture and shutter speed.

The sensor will have a native sensitivity, or nominal speed. This may be specified using several different approaches, which are defined in ISO standard 12232:2006 and described in Chapter 20. However, the majority of digital cameras have a range of ISO speed settings which may be selected by the user, the lowest of which usually relates to the sensitivity of the sensor. As for a film camera, changing to a faster ISO speed setting will alter the range of shutter speed and aperture combinations specified by the camera system controller from an exposure reading, to reduce the exposure to the sensor. In the case of a digital sensor, however, the sensitivity of the sensor is not actually changed and the reduced exposure produces a reduced output signal. Instead, the analogue or digital gain is adjusted to amplify the signal, but with an associated amplification of the noise in the signal. Although noise-processing algorithms continue to develop, this is a limiting factor in the use of speed settings above ISO 400 in many digital cameras.

Once an ISO speed setting has been selected by the user, the camera must take exposure readings from the scene. As mentioned earlier, exposure readings in compact cameras usually come from the sensor itself, whereas for digital SLRs, a separate sensor may be used. The various different exposure metering modes used in cameras are discussed in

detail in Chapter 11 and types of exposure measurement are covered in Chapter 12.

During auto-exposure (AE) in DSCs, the image-sensing area or the separate AE sensor may be divided into non-overlapping segments, or *AE windows*. The signal from each AE window is converted into luminance values, which are passed to the AE signal-processing block. For each segment, the mean and peak luminance values (or sometimes the variance) are calculated, and these are passed to the camera system controller. An AE control application program evaluates all of these values to establish the optimum exposure and set the required shutter speed.

AUTOFOCUS CONTROL

There are a range of different systems used for focus control, including *electronic distance measurement*, which uses an infrared emitting diode, active range measurement using an ultrasound pulse transmitter and *phase detection autofocus*, all of which are described in Chapter 11.

A further method, used extensively in digital still cameras, uses focus adjustment to maximize the high-frequency components in an image. This approach uses an algorithm implemented in the digital signal processor on an image acquired from the sensor; therefore, the camera does not require an external autofocus sensor. It is based upon the assumption that high-frequency components in the image, which correspond to edges and fine details, will increase to a maximum when the image is in focus. A digital band-pass filter, which passes frequencies in a band while attenuating other frequencies (see Chapter 28 for information on filters implemented in the frequency domain), is applied to the acquired image and the output from the filter is integrated to produce an absolute value. The absolute value is used by the camera system controller to adjust the position of the lens until a peak output from

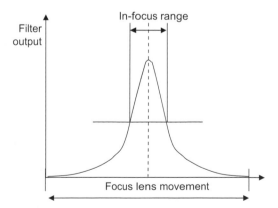

Figure 14.7 Digital integration focus value curve. The curve is obtained by integrating the output from the AF band-pass filter at each focus position and taking absolute values of the result.

the filter is achieved (see Figure 14.7). The *resonant* frequency (peak frequency) of the filter depends upon the lens system being used.

ANALOGUE PROCESSING

The analogue signals from the sensor are first processed in an analogue pre-processor, which performs various functions, depending upon the sensor. These may include *correlated double sampling* (CDS) to suppress reset noise and to reduce fixed pattern noise, automatic gain control, and generation of a reference black level for the reproduced images. The reference black is obtained from shaded pixels on the sensor, which produce a signal as a result of thermally generated dark current. This generated signal is then subtracted from the signals from the pixels in the sensing area of the array. Black level generation may be performed for each colour separately. Additionally, white balance may be performed on the analogue signal by using different gain settings for different colour channels, although this is most commonly performed on the digitized signal. The analogue front end may also control the operation of the image sensor by generating timing pulses. The signal is then digitized in the analogue-to-digital converter (ADC). Chapter 9 discusses amplification and analogue-to-digital conversion in detail.

DIGITAL PROCESSING

The digital signal output from the ADC consists of unrendered RAW data. To produce a rendered (and viewable) image, a significant amount of image processing must be performed to adjust and optimize the image. Additionally, some processes are applied in the digital circuits of the camera to adjust the camera response, for example autoexposure, autofocus and auto-white balance. As stated previously, the majority of digital still cameras currently available are single-sensor CFA cameras; therefore, the rest of the chapter refers to the processing typical of these cameras.

The image processing functions will depend upon the features of the camera, but may include:

- Demosaicing
- White balance and colour correction
- Tone and gamma correction
- Digital filtering (non-adaptive and adaptive, noise removal and sharpening)
- Zooming and resizing of images
- Digital stabilization
- Red-eye removal
- Face detection
- Image encryption

- Image compression
- Formatting and storage.

The order in which processes are performed varies. The particular algorithms selected will have an impact throughout the image-processing pipeline. Most image processes may be performed before or after demosaicing (red-eye removal and face detection are exceptions and are performed after colour interpolation). Because the CFA data is effectively greyscale prior to demosaicing, processes performed beforehand will be performed on only one channel as opposed to three, representing significant computational savings. Some processes will produce improved results once the data has been demosaiced however, although they may enhance other artefacts which must be further corrected. Even if unrendered RAW data is to be output, because RAW files are currently proprietary (see Chapter 17), the image processing applied to the RAW data, prior to colour interpolation, will vary significantly between manufacturers.

Further computational savings may be achieved by implementing processes together. Generally, this may be achieved if the individual processes are applied in a similar manner. Such an approach can improve the performance of the individual image-processing steps, suppress artefacts and enhance the resulting image quality. Examples of processes which may be applied jointly include image smoothing and sharpening, which are both filtering operations, or colour correction and white balancing. Additionally, processes such as denoising and resizing may be implemented together with the demosaicing process.

Many of the relevant image-processing algorithms are covered in detail in the last two chapters of this book; therefore, only brief descriptions are provided in this chapter.

Colour demosaicing

A range of demosaicing algorithms exist for various different CFA patterns, with varying levels of complexity. The simplest approach uses bilinear interpolation (see Chapters 23 and 25) in which a colour value is interpolated by taking averages from the four closest (two horizontal and two vertical) values of the same colour. This is computationally efficient, but reduces sharpness and increases the visibility of chromatic aliasing artefacts.

An alternative adaptive approach, *edge-sensing demosaicing*, can improve results. This method first calculates the green (luminance component), using the same neighbourhood as bilinear interpolation, the two closest horizontal and two vertical pixels of the missing green pixel, but first classifies the missing pixel according to whether it is part of an edge or a uniform area. This is achieved by evaluating the differences in the horizontal and vertical directions and comparing them to a threshold. If both horizontal and vertical differences are below the threshold, then the pixel is classified as uniform. If one or other of the

Figure 14.8 Pixel classification in edge-sensing demosaicing interpolation. (a) G4 − G2 < T, G3 − G1 > T, G5 = average (26,23) = 25. (b) G4 − G2 > T, G3 − G1 < T, G5 = average (47,46) = 47. (c) G4 − G2 < T, G3 − G1 < T, G5 = (average (119,107) + average (107,106))/2 = 110.

differences is above the threshold, then the pixel is classi-fied as part of an edge with a gradient in that direction (Figure 14.8). Pixels identified as uniform are calculated using bilinear interpolation of the four values. Those identified as part of a horizontal edge are calculated as an average of the two vertical values, and similarly those that are part of a vertical edge are averaged between the horizontal values. This ensures that values are not averaged across an edge, which would smooth the image. Once the luminance component has been calculated, it is used to calculate the missing red and green values. For a blue value, for example, the values of B/G on either side of it horizontally are calculated, and the value of B/G for the central missing value is taken as an average between them, from which the missing B value can be derived.

Many more advanced methods may be used, some based on adaptive approaches similar to those above, using a filtering operation. Other methods model demosaicing as a reconstruction process, creating a mathematical model based upon assumptions about a previous image or about the correlation between colour channels and providing a solution to the reconstruction problem based upon this model. Another approach, used by some algorithms, models the entire image formation process as a series of colour transformations which account for the effects of the CFA, lens distortions and noise. These algorithms then calculate the most likely output image from the measured CFA values.

Setting white balance

As described in Chapter 5, the human visual system performs *chromatic adaptation*, adjusting the sensitivity of the different types of cone receptors, to maintain *colour constancy*, ensuring that white objects will continue to appear white despite changes in the spectral quality of the illuminant. The equivalent process in digital cameras is *white balance*, to estimate the white point of the light source and adjust the image accordingly. Different approaches may be used. As described earlier, some cameras adjust the analogue gain of the channels, producing low signal values in the analogue pre-processor as they are read off the sensor. More commonly, however, white balance is applied to the signal after it has been digitized in the digital signal processor.

White balance may be implemented by the user in various ways. The white balance may be set manually, usually from a series of preset illuminants or colour temperatures in the menu settings. In this case the preset selected will define which chromatic adaptation trans-formation (CAT; see Chapter 5) is used by the camera during the rendering of the image. This approach may be adequate in a situation where the colour temperature of the illuminant reaching the camera can be measured externally and with accuracy. However, where preset illuminants are used it is important to note that the colour temperature of

some illuminants varies significantly from unit to unit and over time (see Chapter 3). Mixed illumination will further alter the spectral quality of the light reaching the sensor, meaning that the results may not be accurate.

Alternatively, a custom white balance may be used, in which an area of white or neutral, such as a grey test target, is included in a test shot of the same scene. This is then selected and used by the camera to adjust the white balance in subsequent images. This method may also be used to perform white balance during the processing of RAW files in a RAW conversion application. The success of the approach will depend upon the size and position of the neutral target in the frame.

The third approach is automatic white balancing by the camera. This may be achieved using separate RGB filtered photodiodes on the front of the camera, which measure the light source. A more commonly implemented (and often more accurate) approach is to estimate the white balance from the colour gamut of the scene using a captured image. The light source is estimated by measuring the colour distribution of the image and correlating it with entries in a colour gamut database created for typical scenes and light sources. The image is divided into segments (between 20 and 100) and average RGB values are calculated for each segment. These are then converted to colour difference signals for analysis against values produced by different light sources. Once the scene illuminant or white point is established, the RGB signals may be amplified by appropriate amounts to white balance the captured image.

After, or at the same time as, white balance correction, colour correction may be applied to compensate for cross-colour bleeding in the filter, using a 3×3 matrix to provide corrected RGB values. Additionally, the image may be converted to the YCbCr colour space, which is a necessary step if the image is to be output as a JPEG compressed file. Chapter 23 provides details of this transformation.

Digital zoom, resizing and cropping

Digital or electronic zoom is based on digital signal processing of the captured image, as opposed to optical zoom, which is achieved by shifting the position of lens elements to change the focal length of the lens. The image is magnified by interpolating new pixel values between the existing ones. The concept of interpolation was introduced earlier in this chapter in relation to the demosaicing process, which is a special case where missing colour values are calculated. Interpolation is more generally applied in digital zoom and various other *resampling* operations throughout the imaging chain, where the spatial dimensions of the image are altered, for example in enlargement, or in the correction of geometric distortion.

Where optical zoom magnifies the image and may reveal further fine detail, this is not the case with digital zoom. The optical zoom operates prior to image capture, therefore

increasing the Nyquist limit of the original image. The total number of pixels will not change, but a smaller area of the original scene will be captured by that number of pixels. Digital zoom, however, is applied after image capture. As with all interpolation processes, because they are based upon an averaging of existing pixels, the magnified image may appear blurred, and may display other interpolation artefacts. The three main methods of non-adaptive interpolation are *nearest neighbour*, *bilinear interpolation* and *bicubic interpolation*. In practice, the latter method is most commonly used as it produces fewer artefacts than the other two, but the computationally simpler bilinear interpolation may be used if speed is an issue. Interpolation methods and their associated artefacts are discussed in Chapter 25, and examples are illustrated in Figures 25.3 and 25.4. The reduction in image quality by digital zoom means that this method tends to be used in the lower-priced end of the consumer market, mainly for camera phones and compact cameras, although some mid-range cameras may offer both optical and digital zoom features.

The image may also be resized down, or an image of a lower resolution than the sensor may be output. This is a down-sampling process. The simplest approach to resizing down is simply to drop every other pixel, which will produce a lower resolution image of the same scene. However, this method is rather detrimental to image quality. A better approach is to *low-pass filter* the image prior to down-sampling. Low-pass filters, which are described in Chapters 27 and 28, effectively reduce high frequencies within the image, resulting in a blurred image compared to the original, but after down-sampling the blurring will not be noticeable. If the image is to be resized to a non-integer ratio, then an interpolation step will also be necessary. In this case the low-pass filtering may not be necessary in all cases, as the interpolation operation is also a blurring or low-pass operation, but the actual implementation will vary from manufacturer to manufacturer.

Noise reduction

There are a range of different causes of noise in a digital camera. Noise sources and their characteristics are described in Chapter 24. They may be broadly classified into noise associated with the quantum nature of the signal itself, fluctuations independent of the signal (for example, as a result of thermal generation, or the quantization process) and those as a result of defects in individual sensor elements.

The aim in designing the analogue front end of the camera must be to reduce noise in the signal as much as possible before CFA interpolation. False colour noise, and colour phase noise, which are generated when using a digital white balance and show up as colour shifts in dark areas of the image, may be reduced by increasing the resolution of the ADC, or using analogue white balance (described in the earlier section on analogue processing).

Cross-colour noise, which is characteristic of CCD sensors using CFAs, is caused by cross-colour bleeding between adjacent colour filters and may be corrected using a 3×3 matrix on the RGB values, as described earlier.

Another significant source of noise is as a result of the dark current variability across the sensor. Recall that the reference black-level calibration is performed by averaging the dark current signal from optical black or shaded pixels on the sensor and that this value will then be subtracted from the pixel signals. The dark current may vary across the sensor, however, as a result of thermal generation. In a CCD, the dark noise level gradually increases from the beginning to the end of sensor readout. In some cameras, the sensor will be cooled to reduce dark current and associated noise. Further, the pixel-to-pixel variations in dark level may be determined by the manufacturer and used as a mask to alter the subtracted offset value for the reference black across individual pixels early in the signal-processing pipeline.

Further noise reduction may be performed using digital filtering processes. As many of the image processes implemented in the DSP, such as tone and colour correction, amplify the signal, and consequently the noise, noise reduction is usually performed prior to these processes. Additionally, the presence of noise may reduce the accuracy of the interpolation algorithms used in demosaicing, particularly if an adaptive method such as the edge-sensing interpolation algorithm described above is being used. Better results may thus be obtained by noise reduction prior to CFA interpolation, using a greyscale filtering process. This is achieved by collecting together non-interpolated pixels from each filter colour and treating each channel as a grey-scale image. Low-pass (linear) filters or median (non-linear) filters are typically used. The operations and characteristics of both are discussed in Chapter 27

Sharpening

Sharpening is performed to counteract the blurring effects of the optical system and any interpolation processes. Blurring in the optical system is a combination of the optical limitations of the lenses and the deliberate blurring introduced by the anti-aliasing filter over the sensor. Sharpening is usually implemented using a variation of *unsharp masking*, known as *high-boost* filtering. Unsharp masking was originally a darkroom method used for sharpening images and involves the subtraction of a blurred version of the image from the original to enhance high frequencies. In high-boost filtering, an image containing only high frequencies, output from an edge detection filter, is added to an amplified version of the original. The sharpened image is usually obtained using a *Laplacian* second derivative edge detection filter, which is a two-dimensional linear convolution filter. The original image is amplified by multiplying it by a constant. Refer to Chapter 27 for details of all of these operations. The extent and design of the filter and the amplification factor will determine the degree of sharpening in the resulting image and the level of associated sharpening artefacts.

TONE/COLOUR RENDERING

The signal output from the image sensor is in a *sensor image state*, i.e. the values are entirely device dependent. Sensor image data are not viewable, fundamentally because the values have not yet been interpreted. The process of converting the data into a state in which they may be understood and reproduced as colour values by other devices such as displays or printers is known as *colour rendering*. Colour rendering converts the image to an *output-referred image state*, where its values are specified in terms of their reproduction on a real or virtual output device. The rendering may be implemented in the digital signal processor in the camera or, if unrendered RAW data are output, will be applied at RAW conversion. Colour rendering is a very complex procedure, involving multiple stages and is considered in detail in Chapter 23. It may also involve the use of colour profiles, if International Color Consortium (ICC) colour management is being implemented. This is the subject of Chapter 26. In terms of image processing, colour rendering will usually involve a tonal mapping stage, known as gamma correction (see Chapter 21). This is a process in which the (usually) linear output of the sensor is transformed using a non-linear function, which is most commonly implemented using a look-up table. The various stages in colour rendering may be performed using look-up tables or matrix transformations of the demosaiced RGB values from the sensor. White balancing and colour correction are implemented as part of the colour rendering process. The reader should refer to the relevant chapters identified above for more on these subjects.

CAMERA TYPES

Film-based camera system designs are mainly differentiated by image format, viewfinder system and complexity of camera components.

There are a diverse range of designs and price brackets for digital camera systems. The increased capabilities of desktop computers and the rapid growth in the use of the Internet have helped to stimulate the development of hardware and software for digital photography and to provide widespread application for digital images across a global network. The technology has evolved through the efforts of research and development from many different disciplines. Alongside the well-known manufacturers of photographic equipment, camera systems have been

produced by manufacturers new to the market, previously involved in other types of technology.

The wide variety of digital camera designs have evolved in response to (and initiated) different methods and applications of imaging. Consider the rapid development of digital cameras incorporated into mobile phones. Early camera phone models consisted of very-low-resolution CMOS sensors and rather basic features, but models available at the time of writing may be integrated into sophisticated communications devices, which incorporate features such as network connectivity, email capability, video streaming and large high-resolution touch screens. These cameras have sensor resolutions up to 8 megapixels, built-in flash, manual and automatic focusing systems and various other advanced features, such as face detection and video capture. Improvements in image quality as a result of higher pixel counts, better optics and advanced image processing mean that camera phones have found wide-spread application as an alternative to compact digital cameras. This is in part because consumers are more likely to carry a mobile phone than a separate camera with them, but also because many phones are now capable of communicating image data via Bluetooth technology or broadband networks.

There are a variety of digital camera designs used for many different applications. These range from low-cost 'toy' cameras used mainly for capturing images for websites, up to full-frame medium-format cameras and large-format scanning backs aimed at the professional photographer, with prices running into tens of thousands of pounds. The features of the main camera formats are summarized below and examples are illustrated in Figure 14.9.

Compact digital cameras

These are by far the most popular type of digital camera among consumers. They are designed to be small, portable and easy to use, with many automatic features. Some advanced models offer a limited range of interchangeable lenses and optical converters, although the majority of these cameras have non-interchangeable zoom lenses. The LCD monitor display commonly functions as a viewfinder, and an optical viewfinder may be omitted, to keep costs and size down.

Figure 14.9 Types of digital camera. (a) Ultracompact. (b) High-end compact. (c) Bridge. (d) Digital SLR. (e) Medium-format digital camera and digital back.
(a) ©iStockPhoto/bbee2000, (b) ©iStockPhoto/Ronen, (c) ©iStockPhoto/hayesphotography/Mark Hayes (d) ©iStockPhoto/Joss/Jostein Hauge,
(e) ©iStockPhoto/Nikada

The very smallest models are often marketed as *sub-compacts* or *ultra-compacts*. These tend to be the most automated, most without optical viewfinders. With dimensions of around 100 mm × 55 mm × 22 mm and weights between 100 and 200 g, they are truly pocket-sized. Sub-compacts or ultra-compacts commonly employ CCD image sensors; with some current models boasting over 10 million effective pixels, resolution is more than adequate for consumer applications. With fewer manual controls the emphasis is on automatic features, with many advanced shooting modes and preset scene modes. Many of these cameras have a range of automatic exposure modes and also allow manual exposure setting. Some models offer functions such as macro and movie modes, and stitch assist for the production of panoramic images. Although many sub-compacts will only output JPEG compressed images, some of the newer models also output RAW files.

High-end compact cameras are sometimes labelled as *prosumer compacts* (*professional* con*sumer*), indicating that they are marketed towards serious amateurs or professional photographers. Although small, they are bulkier than the majority of digital compacts and the external design is often more traditional, with black camera bodies and external controls for exposure and focusing more consistent with those of digital SLRs. They tend to have fewer automated features and an emphasis on improving image quality through more expensive optical components, often also incorporating image stabilization to reduce camera shake. With CCD or CMOS sensors containing up to 12 million megapixels, sensor resolution rivals that of many digital SLRs, although sensor sizes are usually significantly smaller . Some of these cameras have fixed rather than zoom lenses; alternatively, they may have very-high-ratio optical zooms.

Bridge digital cameras

The name for this class of digital camera originates from their design, which is meant to provide an intermediate step between compact cameras and digital SLRs. Like high-end digital compacts, they are often marketed as prosumer cameras. They are similar in dimensions, weight and body shape to digital SLRs, but without removable lenses or the single-lens reflex viewfinder, relying on live preview of images on the LCD display and either an optical or electronic view-finder. They have smaller sensors than digital SLRs, of dimensions more typical of compact cameras (a 1/2.5 inch sensor, with dimensions 5.8 × 4.3 mm, is typical). As a result of this, the lenses are smaller than those of digital SLRs, allowing them to incorporate a very wide range of focal lengths into the non-removable zoom lens. Recent models allow up to ×20 optical zoom, providing a range of focal lengths of around 20−500 mm (equivalent 35 mm focal lengths). For this reason some bridge cameras are classified as *superzoom* cameras. Sensor resolutions of around 10 million pixels are currently available and they include the same level of automated and advanced features as compacts alongside many of the manual controls of digital SLRs. Like compacts, many of the newer models output RAW files as well as compressed JPEGs. Some models also offer functions such as *high-speed burst* shooting modes, which allow the capture of many consecutive frames per second (13 frames per second, of images at a reduced resolution, is quoted for one current model), a feature less common in compacts. The future of this type of camera design is not certain, however, due to the development in advanced features in compact cameras and the significant reductions in the cost of digital SLRs, particularly of the semi-professional models (see below), compared to a few years ago.

Digital single-lens reflex (DSLR) cameras

These cameras are very similar in design to equivalent 35 mm film cameras and, as already mentioned, some manufacturers have maintained the positioning and design of external controls from their film cameras to ease the transition for photographers from film to digital imaging. As with conventional SLRs, they use a mechanical mirror system and a pentaprism to provide an image in an optical viewfinder, and they are aimed at the advanced amateur and professional photographer markets. The main difference from film SLRs is the use of a digital sensor and the LCD display which, unlike compact and bridge cameras, functions only as a playback device of captured images and not as a viewfinder. They incorporate the majority of features in terms of focus, exposure and exposure metering modes of film SLRs and have a similar range of accessories. They may also include many of the advanced features specific to digital cameras, such as the ability to apply custom or preset picture 'styles' to the image (e.g. to change saturation for the requirements of different types of scene content or to produce monochrome images). They do not, however, have the large range of automated functions characteristic of compact cameras.

Sensor dimensions are larger than those used in compact and bridge cameras (see Table 14.2), and CMOS sensors are more common, although this camera class is still dominated by CCDs. Sensor resolutions in recent models range from around 10 million up to 24.6 million pixels for some full-frame sensor formats which, as described earlier, are equivalent in dimensions to 35 mm film.

Digital SLRs fall into two broad classes. *Semi-professional* digital SLRs, aimed at the serious amateur, are significantly cheaper than *professional* digital SLRs (the majority of these are 35 mm equivalents, although there are some medium-format models available, described in the next section). In the UK at the time of writing, the former category are generally under £1000, whereas the cost of a professional SLR may run to several thousands of pounds for the camera body alone. The lower price of semi-professional DSLRs is indicated in smaller sensors, in the lower optical quality of the lenses that accompany them and in the build quality of

the camera body, which tends to be manufactured from cheaper and less resilient materials than the higher-end professional cameras. The smaller sensor size means that the effective focal length of lenses from film SLRs is increased. Other than that, they have similar features to their more expensive counterparts, but may have a wider range of automated features to appeal to the consumer market.

Digital cameras and camera backs for medium and large format

It is difficult and expensive to manufacture large-area digital sensors without significant imperfections. This has meant that the development of digital cameras for the production of images equivalent to those of medium- and large-format film cameras has been much slower than for smaller formats. This is also partly due to the fact that photographers using larger image formats occupy a relatively small section of the professional market. These camera systems are prohibitively expensive for all but the professional photographer, and in general are significantly more expensive than their film equivalents.

A number of different options are available for digital medium format. These include medium-format digital SLRs with interchangeable lenses, digital backs to be used with existing medium-format camera systems and digital medium-format camera systems with similar design and viewfinder arrangements to medium-format film cameras.

Medium-format digital SLRs have larger sensors than 35 mm equivalent digital SLRs and use medium-format lenses. They vary in design; some have a very similar camera body to smaller format digital SLRs, with a fixed pentaprism viewfinder on top of the camera body which houses the sensor and reflex mirror system. An example is the earliest model, Mamiya's ZD, which was announced at Photokina in 2004. Others look more like traditional medium-format camera systems and are modular in design, allowing the selection of different viewfinders, for example. Both types are relatively compact compared to other digital medium-format camera systems. They typically employ a 48 mm × 36 mm CCD sensor, with sensor resolutions up to 50 million pixels in models announced in 2008.

Medium-format camera systems have camera bodies based on the design of those in traditional medium-format camera systems, with interchangeable viewfinders (45°, 90° and waist level) and lens diaphragm shutter systems. The sensor is housed in a digital back, which in some cases is compatible with many different medium- and large-format cameras. Current models have CCD sensors which range from square format 36 × 36 mm, with 16 million effective pixels, up to true wide-frame sensors of 56 × 36 mm with 56 million effective pixels in recently announced models. As mentioned above, the digital backs may be sold separately for use with existing camera systems.

As already mentioned, some of the digital backs using area arrays for medium-format may also be used with large-format cameras. The other option for large format is the use of a *scan back*, which may be integrated into a camera system or may be modular for use with view cameras. Scan backs employ trilinear CCDs and operate by scanning across the image area. They are therefore only suited to still-life subjects and reproduction work. Resolutions of up to around 400 million pixels are available at the very top end of the market. Even at this resolution they do not fully cover the dimensions of 4 × 5 inch format film (102 × 127 mm), being closer to 3 × 4 inch (76 × 102 mm), but more than match the resolution required.

Specialist digital cameras

Cameras for industrial and scientific applications are offered by specialist manufacturers. These high-performance cameras are designed for specific purposes. The image quality requirements of the applications for which they are designed, using specific techniques under particular imaging conditions, determine the camera designs and are very different to the needs of standard consumer and commercial imaging applications. For example, in some cases the sensors used may not necessarily offer the same resolution as those used in consumer cameras, but the design and performance of the sensor under specific conditions will be optimal. Much emphasis is of course placed upon optical design, as many criteria will be the same as for film cameras and imaging devices for scientific applications.

Industrial cameras may be used for applications as diverse as automated optical inspection, metrology, flat-panel inspection, traffic management, biometrics, three-dimensional imaging and many others for different industries. *Original equipment manufacturer* (OEM) components are also available to be embedded in systems by other manufacturers (embedded OEM). Scientific cameras are designed for *extended vision* applications, such as digital microscopy, for use in medical and forensic imaging. Surveillance applications require specialist high-resolution cameras with superior performance under low light levels and may use specially designed sensor architecture and advanced image-processing techniques. In digital cameras for astrophotography, the emphasis is on fast frame rates and extremely low noise. As well as the advantages in terms of flexibility and speed offered by digital image sensors, many of these applications use digital image processing extensively to further expand the capabilities of the imaging systems.

IMAGE SCANNERS

Digitization of photographic originals, either on film or print, is carried out using image scanners. The first scanners

Figure 14.10 A flatbed scanner.
©iStockphoto.com/Hofpils

developed were the *Murray and Morse* scanner in 1941 and the *Hardy and Wurzburg* scanner in 1948, aiming to produce continuous-tone photographic plates.

There are several different types of scanner, the most common being: *drum* scanners, used for scanning film and transparencies; *flatbed* scanners (see Figure 14.10), used for scanning printed photographs, documents and, with some models, film; and dedicated *film* scanners. A more recent type of scanner technology, the *Flextight* scanner, combines some aspects of both drum scanners and film scanners. *All-in-one* devices consist of a flatbed scanner and printer combined in one unit.

When a material is scanned, it is illuminated by a suitable light source and the transmitted or reflected light from the scanned material is captured by a digital sensor. The sensor's voltages are converted to digital values by the analogue-to-digital (A/D) converter (see Figure 14.11).

Colour scanners usually have three rows of CCD sensor elements (i.e. three linear CCDs) covered with red, green and blue (RGB) filters, to separate the image into three colour channels. Colour separation may alternatively be achieved using an unfiltered linear CCD sensor and a light-emitting diode (LED) RGB array which provides a separate red, green and blue flash for each scanning line. An exception is the *multi-spectral scanner* described later in this chapter.

In scanners that employ three filtered rows of CCDs, the filters have narrowband characteristics and their red, green and blue peaks are selected to provide a reasonable match to the characteristics of the dyes of a range of hard-copy/film original media. For example, in scanners designed mainly for digitizing photographic images, the RGB peaks of the filters closely match the absorption of the subtractive cyan, magenta and yellow dyes typical of photographic paper. In practice, the effect of *metamerism* (see Chapter 5) may occur in some cases, where two colours that appear visually different in the hard-copy image result in the same RGB values in the digitized image.

The method of image capture, type of sensor and light source depends on the type of scanner. Temporal stability is an important characteristic of the light sources used in scanners and depends on the type of the source. Good stability for the duration of an image scan is essential; although any variations of the source can be adjusted either by correcting the reflectance or transmittance values of the scanned image, or by adjusting the power supply of the source, both will increase the cost of the scanner. The source's spectral power distribution is an important parameter in colour reproduction. In early scanners fluorescent lamps were used as light sources. They were later replaced by cold cathode fluorescent lamps (CCFLs) and more recently by xenon arc lamps and lasers. At the time of writing, white LED lamps have been introduced in some models, minimizing the required warm-up time.

Non-uniformity of the illumination produced by the light source, together with the variation in lens transmittance and variation in the sensitivity of individual elements in the digital sensor, may introduce spatial non-uniformity at a pixel level, which is very difficult to correct in the digital image. For this reason scanners are calibrated using targets specifically designed for the purpose and the results are used to calculate individual values of electronic

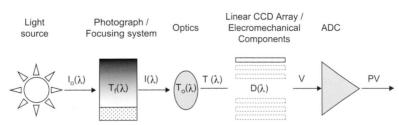

Figure 14.11 The basic components of a scanner, where $I_o(\lambda)$ is the spectral distribution of the scanner illumination, $T_f(\lambda)$ is the spectral transmittance (or reflectance) of the medium, $T_o(\lambda)$ is the spectral transmittance of the optical lenses, $D(\lambda)$ is the sensitivity of the imaging sensor, V are the image sensor voltages and PV are the converted digital values (or pixel values). *Adapted from Triantaphillidou (2001)*

gain for each pixel, i.e. the *analogue-to-digital units* (ADU) per electron. This information is stored in the memory of the scanner and is applied to the digital output image during the scanning process, ensuring that the response of all pixels is the same. Further variation in the scanned image may result from various other sources of noise present within the system (see Chapters 9 and 24).

It should be noted that scanners may be affected by extreme temperatures and humidity. A suitable location for the scanning device must therefore be selected to minimize the effect of environmental conditions. The use of a continuous power supply is also recommended because scanner components may be damaged by power surges. The scanner should therefore be attached to an *uninterruptible power supply* (UPS) device.

TYPES OF SCANNERS

Drum scanners

In a drum scanner the original material, transparent or reflective, is mounted around a clear drum and illuminated by a high-intensity xenon or tungsten—halogen lamp (Figure 14.12). When scanning transparent materials, the light source is located inside the drum, while for scanning reflective materials it is located outside the drum. The light is focused on the original material and rotation of the cylinder at high speed causes the focused light spot to move along the cylinder and progressively scan the original. The focused light that passes through (or is reflected from) the

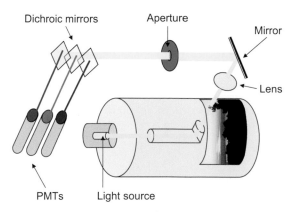

Figure 14.12 In drum scanners the original hard-copy material is mounted around a clear drum. The light is focused on the hard-copy material and the cylinder rotates. The focused light spot moves along the cylinder and progressively scans the original. Dichroic mirrors divide the light into red, green and blue components and divert it to a sensor unit with PMTs. The data from the PMTs are converted into a digital form by an analogue-to-digital (A/D or ADC) converter.

original material reaches a set of dichroic mirrors. These mirrors divide the light into red, green and blue (RGB) components via RGB filters and divert it to a sensor unit with *photomultiplier tubes* (PMTs). PMTs are devices which detect photons. They are sensitive to a range of wavelengths from the short ultraviolet (UV) wavelengths to the far infrared (IR). A current pulse produced by each detected photon results in an analogue signal produced by the PMTs. These data are converted into a digital form using an ADC. The number of quantized levels depends on the bit depth of the ADC (as described earlier in the chapter, the number of levels $= 2^b$, where b is the number of bits allocated per pixel). Cooling of the PMTs is essential to reduce dark current (see Chapter 9).

A limitation of drum scanners is the requirement that the original is flexible and can be mounted around the scanner's cylinder. However, for the majority of photographic materials this is not an issue. Bending the original allows very-high-resolution scanning; these scanners represent the professional end of the market in terms of both scanned image quality and cost.

Flatbed scanners

The original primary function of flatbed scanners was to scan reflective materials, but many currently available models also scan transparent materials. They employ either a CCD sensor or a *contact image sensor* (CIS) instead of photomultiplier tubes (see Chapter 9). A flatbed scanner with a CCD sensor contains a linear array of CCD elements.

Models that record colour information with three passes (for red, green and blue) contain a CCD sensor with a single row of elements. Each pass records one colour channel. The colour of the light is changed after each pass, either by switching RGB light sources or by using white light and switching RGB filters. One-pass image capture employing an unfiltered array has also been employed with the use of RGB lamps which flash sequentially during the scanning of each row. Models that record colour information with one pass use a trilinear CCD array (with three rows of elements). In this case the CCD elements in each row are filtered red, green and blue (Figure 14.13a).

It should be noted that there are variations in the CCD technology employed, for example high-resolution flatbed scanners may employ a *six-row CCD*, an array with double rows of CCD elements for each of the red, green and blue channels. In this case, high resolution is achieved by the overlapping of CCDs instead of employing CCD elements with very small dimensions, which helps to reduce the level of noise typically associated with small sensing elements. During scanning, each line of the original is scanned by both rows. The data of both rows is then combined for a single red, green and blue output for each line. An example of this technology is the Canon Hyper CCD (Figure 14.13b).

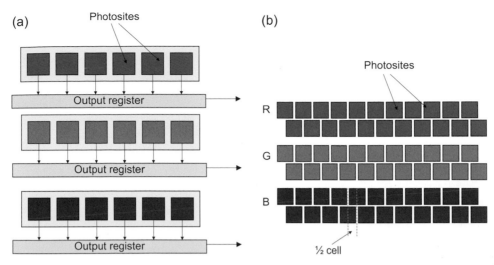

Figure 14.13 (a) A CCD trilinear array with RGB filtered elements. (b) A CCD array with double RGB rows of CCD elements.

When scanning reflective materials the hard copy is placed face down on the top glass plate (Figure 14.14). During the scanning process a linear light source, which can be a fluorescent tube or a halogen lamp, together with a mirror, moves down the length of the hard copy. The light is reflected by the hard-copy image and then by the mirror. With the aid of a second mirror it is directed on to the CCD array via a lens unit with a fixed magnification. The magnification depends on the size of the hard-copy image and the size of the sensor.

Because the original hard copy is placed on a glass plate, thorough removal of any dust or marks on the glass and the hard-copy surface is essential, otherwise they will appear on the digitized image. Although they can be removed later using imaging software, productivity may be adversely affected if a large number of images are scanned daily. Scratches on the print (or film) can be removed digitally or, in some scanners, they can be corrected using a scratch reduction feature described later in this chapter.

Flatbed scanners for reflective materials can be converted to scan transparent materials using a light-transmitting optical system which is embedded in the scanner cover. This system provides good-quality images when large-format transparencies (up to 200 × 250 mm) are scanned. For 35 mm film the *optical resolution* of the scanner should be greater than 2000 pixels per inch for good results. Optical resolution is discussed in more detail later in this chapter.

A flatbed scanner with a *contact image sensor* (CIS) is slimmer and lighter compared to a scanner with a CCD sensor. A CIS consists of red, green and blue *light-emitting diodes* (LEDs) which illuminate the image at a 45° angle, and a row of CCD or CMOS sensors which capture the reflected light via a lens array located above the sensors (see Figure 14.15). The width of the sensor row is equal to the width of the scanning area. With the use of CIS technology there is no need for an optical system, lamps or filters. For this reason the scanner has lower power consumption and reduced manufacturing costs. With a CIS, geometrical distortions of the scanned image, which may be introduced by the lens and mirrors in a CCD scanner, are eliminated. The colour gamut of a CIS scanner depends on the spectral output of the LEDs rather than the RGB filters.

Film scanners

Scanning of films is carried out by dedicated (*film/transparency transmission*) scanners, which also employ a CCD sensor. These scanners give higher quality images than the flatbed scanners described above, due to their higher dynamic range and resolution compared to a flatbed scanner. As with scanners for reflective materials, the CCD

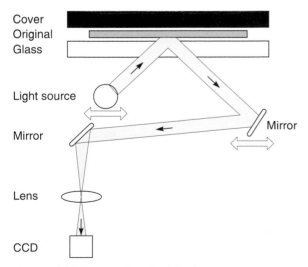

Figure 14.14 Cross-section of a flatbed scanner.

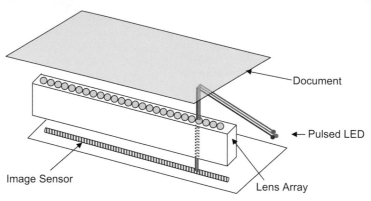

Figure 14.15 A scanner with CIS technology is based on a row of CCD or CMOS sensors equal to the width of the scanning area. They capture the light reflected by the original material via a lens array.

sensor is linear, comprising one row of unfiltered CCD elements (for capturing colour with three passes) or three filtered rows of CCD elements (for one pass). In most scanners the sensor is stationary and the film moves across the sensor. In the case where the scanner comprises an area CCD array, the image information is recorded with a series of exposures with red, green and blue light. It should be noted that when films are scanned, the emulsion should face the sensor to eliminate any diffusion of the image. Diffusion may occur as a result of light passing from the thicker film base after going through the emulsion. In addition, when the emulsion faces the sensor, the optics of the scanner are focused on the emulsion.

Flextight scanners

Flextight scanners are scanners that employ a CCD image sensor and a magnetic flexible holder which bends the original around a virtual drum. The bending of the original helps to improve the scanning resolution and there is no glass between the original and the sensor, which helps to improve the quality of the scanned image. The CCD array remains stationary while the original (which may be negative, positive or print media) is rotated. Illumination of the original is performed by a cold cathode light tube, which emits very low levels of IR radiation and therefore heat. The design of the scanner enables a simpler arrangement of the lens, without the use of mirrors. When different formats are scanned, the lens zooms accordingly to ensure that the CCD resolution corresponds to the width of the original. Another feature of the Flextight scanner is the change of the intensity of the light source depending on the density of the original. The maximum resolution of this type of scanners is, at the time of writing, 8000 ppi. For this reason, and because of the high dynamic range of these scanners, very-high-quality results may be achieved when scanning medium- and large-format films. These scanners are significantly more expensive than other types of desktop scanner and are therefore aimed at the professional

market, but provide an affordable alternative to drum scans.

Multi-spectral scanners

Image capture in three colour channels (RGB) has limitations when there is a need to derive colorimetric data from the digital image, because the RGB values of the image depend on the scanner characteristics. Solutions such as colour correction via scanner characterization (see Chapter 23) provide accurate results only for the specific media for which the scanner was characterized. For specialized applications where colour fidelity is crucial, multi-spectral imaging is proposed. It was initially developed for remote sensing applications, where the spectrum captured may exceed the visible spectrum.

In multi-spectral imaging colour is captured in more than three channels using suitable narrowband filters. It should be noted that the amount of data processed with this method is much larger than the data from scanners that capture an image in three channels and this has an effect on the processing time and image storage. Spectral data of images is captured in multiple channels depending on the system. The digitization of works of art is an example of one of the applications employing multi-spectral scanning, as its larger colour gamut provides more information on the characteristics of the original, often necessary for restoration purposes.

SCANNER CHARACTERISTICS

Sampling and resolution

When a hard-copy photographic image is scanned, its continuous tones are represented in the output digital image by an array of digital values. The value of each

element of the array represents a sample of the reflectance of the original at a corresponding discrete location of that image. The array, however, has a finite number of values, so sampling a spatially continuous-tone image means that some of its spatial detail may be lost. As described in previous chapters, determination of the sampling rate which avoids significant information loss is provided by the *Whittaker–Shannon sampling theorem*. According to that theorem, the spatial frequencies that can be fully recovered from the discrete samples are the ones that are below the Nyquist frequency (see Chapter 7). Frequencies above the Nyquist produce aliasing.

The resolution of a scanner is related to its sampling rate and is measured in *pixels per inch* (ppi) or *samples per inch* (spi). Resolution is sometimes, incorrectly, quoted in *dots per inch* (dpi). This term, however, more correctly refers to output resolution, such as the resolution of a printer or display. It should be noted here that there may be a difference between the *optical resolution* of a scanner and the resolution quoted by the scanner manufacturer. The optical resolution depends on the number of pixels in the scanner's sensor and the pixel pitch. The quoted resolution may be either the optical or an *interpolated resolution*. In this case, interpolation is used to increase the number of pixels in the image (see Chapter 25). However, because the data in the interpolated pixels is the result of a computation of data from neighbouring pixels, the image does not have any additional detail. As described in the earlier section on digital cameras, the quality of the image depends on the interpolation algorithm. The interpolation method used by the scanner driver may not be quoted by the manufacturer. If an image with a different resolution than the optical resolution of the scanner is required, it is usually preferable to scan the original with the optical resolution and then apply a suitable interpolation method using imaging software. This will provide better control over the quality of the final digital image. This approach is used in an image workflow where the main requirement is to obtain and maintain optimal image quality.

The optical resolution depends on the type of scanner. A dedicated film scanner has typical optical resolution in the range of 1000–4800 ppi and a drum scanner in the range of 8000–12,000 ppi. At the time of writing, the optical resolution of a flatbed scanner can be up 6400 ppi. In most cases, the optical resolution is quoted by manufacturers using two numbers, for example 1200×2000 ppi. The first number refers to the optical resolution of the linear array image sensor. The second number, which may be different to the first, is the resolution in the direction perpendicular to the linear array.

It is important to understand that the optimal resolution for scanning may also depend on the resolution of the output media as well as the image quality requirements of the workflow. If the requirement from the workflow is for efficiency and speed of processing for a particular output, then scanning at a resolution higher than that of the output

media will result in a large file size with information that will not be used by the output device. The large file size requires greater computational time during image processing and it occupies more space on the computer's hard disk. Although for a small number of images this may not appear to be significant, it may have an adverse effect on efficiency and productivity when large numbers of images are scanned, manipulated and stored daily. Calculation of the scanning resolution in this case is carried out by taking into account the physical dimensions of both the hard copy and the output image and the resolution of the output device:

$$R_s = R_o \times \frac{S_d}{S_o} \tag{14.1}$$

where R_s is the required scanning resolution, R_o is the output device resolution, S_o is the original size and S_d is the desired size.

Dynamic range

The dynamic range (or density range) of a scanner is dependent on its sensor and represents the range of density values that it can distinguish and capture. It is measured as the difference between the optical density of the darkest shadows (D_{max}) and the optical density of the brightest highlights (D_{min}). The dynamic range, DR, can be expressed as (see also Chapter 21):

$$DR = D_{max} - D_{min} \tag{14.2}$$

The values of the dynamic range are in a logarithmic scale and can range from 0 (D_{min}) to around 4.0 (D_{max}). Scanner technical specifications may include the D_{max} value instead of the dynamic range of the scanner. It should be noted, however, that there are losses due to the analogue-to-digital conversion which reduce the measured dynamic range of a scanner. Disparity between the dynamic range of the scanner and the original hard copy has an effect on the range of tones that will be represented in the digital image. When the original image has a higher dynamic range than the scanner, some of its tones will be clipped. Most reflective scanners nowadays have higher dynamic range than the printed material.

Some manufacturers relate the dynamic range of a scanner to the bit depth of the analogue-to-digital conversion. As seen earlier in the chapter, the computed dynamic range, DR_{comp}, relative to the bit depth, is given by the following equation:

$$DR_{comp} = \log(2^n) \tag{14.3}$$

where n is the bit depth of the A/D conversion. Using this equation, a high bit depth results in high computed dynamic range.

This number, however, represents the number of tones that the scanner is capable of reproducing. As for digital cameras, it does not take into account the dynamic range of the sensor, which may be higher or lower, and any effects

from the analogue components which may reduce the final dynamic range of the digital image. For this reason, a number of methods for measuring the dynamic range of a scanner have been developed. These methods employ the use of a test chart with greyscale patterns. The greyscale must have a density range similar to that of the scanned material. It should be noted that the dynamic range of the scanner's output image depends on the material that is scanned. Several ways of determining the D_{min} and D_{max} of the scanner for measuring its dynamic range have been proposed. The International Standards Organization (ISO) has published the standard ISO 21550:2004 on measuring the dynamic range of scanners. In this standard the D_{min} is defined as 'the minimum density where the output signal of the luminance opto-electronic conversion function (OECF) appears to be unclipped'. The D_{max} is defined as 'the density where the *signal-to-noise ratio* (SNR) is 1'. The OECF relates input values and output values of the scanner (see Chapter 21). The SNR is determined by the equation:

$$\frac{S}{N}\left(X_i\right) = \left(\frac{T_i g_i}{\sigma_i}\right) \qquad (14.4)$$

where σ_i is the standard deviation of the density patch, g_i is the incremental gain of patch i and T_i is the transmission level of patch i. The number of grey patches is i, with i_{min} as the lightest and i_{max} as the darkest patch.

Incremental gain is defined in the ISO standard as the rate of change in the output level divided by the rate of change in the input density. The dynamic range is calculated individually for the red, green and blue channels. To report a single value for dynamic range (DR) the individual values for the red, green and blue should be weighted as follows:

$$DR = 0.2125 \times DR_{(R)} + 0.7154 \times DR_{(G)} + 0.0721 \times DR_{(B)} \qquad (14.5)$$

where $DR_{(R)}$ is the dynamic range for the red, $DR_{(G)}$ is the dynamic range for the green and $DR_{(B)}$ is the dynamic range for the blue channel.

Bit depth

As previously mentioned, the analogue values from the image sensor are converted to discrete n bits per pixel digital values via the ADC. The bit depth (number of bits per pixel) defines the number of output grey levels per pixel (see Chapter 1). For a colour scanner, the bit depth defines the number of colours that can be reproduced. At present most models offer output bit depths up to 48 bits (16 bits per channel). Increase in the bit depth, however, results in additional quantization levels, increasing the file size. This requires more memory and results in increased processing time of the image. To prevent this, 48-bit images may be reduced to 24-bit colour output via the scanner software. The levels chosen are those which produce visually equal

changes in brightness. Depending on the application and the available storage space, it may be preferable to store digital images in 48-bit depth. This could provide more options for future processing of the image (see Chapter 25).

Scanning speed

Scanning speed is determined by the resolution of scanning in the direction perpendicular to the sensor array. A high resolution will result in a low scanning speed. The scanning speed may affect productivity when large numbers of images are scanned on a daily basis. It also varies between models. A flatbed scanner, for example, would need 14 seconds to scan an A4 colour print at 300 ppi and 25 seconds to scan the same print at 600 ppi. When scanning film there are also differences in speed between flatbed and dedicated film scanners. The flatbed scanner may need 35−50 seconds for a 35 mm film, positive or negative, while a film scanner may need around 20−50 seconds. The scanning speed may also be affected by the ADC. One additional parameter used to affect the scanning speed was the time needed to store the image. The faster speeds of data storage nowadays mean that this does not have a significant effect.

Image transfer

There are four methods by which a scanner can be connected to a computer: *parallel port*, *universal serial bus* (USB), *small computer system interface* (SCSI), and FireWire (also known as IEEE-1394). The first type of connection, parallel port, is rarely used today because, compared to the other alternatives, it is the slowest method as its transfer rate is 70 KB per second. The parallel connection has now been largely replaced by the faster USB connection. The latest version, USB 2.0, is capable of transfer speeds of up to 60 MB per second, much higher than the 1.5 MB per second of the older USB 1.1. It is the most common connection standard at present. The SCSI connection is a faster connection with very high data rates. For example, the Ultra SCSI standard provides data rates as high as 160 MB per second. It can be, however, complicated to configure because it requires either an SCSI controller or an SCSI card in the computer. An advantage of the SCSI connection is that multiple devices can be connected to a single SCSI port. For example, up to eight devices can be connected in SCSI 2.

FireWire is used by scanners that have very high output resolutions which need faster transfer rate due to the high volume of data. It is faster than USB 1.0 and is comparable to earlier SCSI and to USB 2.0.

Scanner drivers

Scanner manufacturers provide the user with *drivers*, programs which provide control over the settings of the

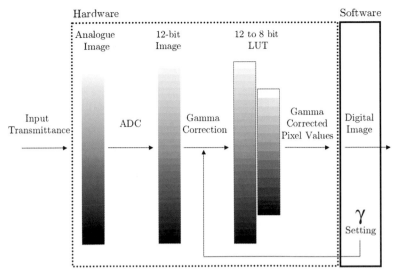

Figure 14.16 The process of acquisition, gamma correction and output performed during scanning.
Adapted from Triantaphillidou (2001)

device. An additional option provided by the manufacturer is the control of the scanner via a TWAIN driver (TWAIN is not an acronym), an interface between the scanner hardware and the imaging software. This enables communication between the scanner and different imaging software applications. Third-party scanning software is also available. In some cases, the scanner driver may give more flexibility compared to scanning via an imaging software application using the TWAIN driver.

Several options are available by the driver for setting the scanning parameters. These parameters may include sharpening, resolution, bit depth (colour, greyscale, black and white), colour balance, colour saturation, brightness, contrast and *gamma correction* (see Chapter 21). The option of adjusting gamma correction may be given by setting a gamma value (which is usually the inverse of the effective gamma applied in scanning) by adjusting the curves for the three RGB channels, individually or combined. Gamma correction is often applied to a 12-bit or a 16-bit signal which is then down-sampled to 8-bit (Figure 14.16). This is explained in more detail in Chapter 21.

The driver usually provides the option to use colour management and profiles. Some drivers allow the use of custom profiles. When films are scanned, setting of additional parameters is needed. These include the type of film (black and white, positive or negative) and format. Due to the fact that the characteristics of different photographic dyes vary, some scanners may allow the user to specify the brand of the film so that suitable profiles can be used. Additional features may also be included such as red-eye reduction, colour restoration or shadow correction. Another feature is the removal of artefacts on the digital image due to dust and scratches on the film. This is performed by first detecting the dust or scratch on the film, which is carried out by irradiating it with IR radiation. The artefact is then located and removed using image processing with combined information from the surrounding pixels obtained when the film is illuminated with white light. Selection of the output colour space (for example, sRGB, Adobe RGB – Chapter 23) may be available. The output digital RGB image can be saved via the driver as a TIFF, bitmap, JPEG or, in some scanners, as the PNG file format (see Chapter 17).

BIBLIOGRAPHY

Brown, D.S., 2008. Image Capture Beyond 24-Bit RGB. Available from the URL. http://www.imaging.org/resources/web_tutorials/Image_Capture/image_capture.cfm (accessed 15 August 2008).

Dougherty, E.R., 1999. Electronic Imaging Technology. SPIE Press, Bellingham, WA USA.

Gonzales, R.C., Woods, R.E., 2002. Digital Image Processing. Prentice-Hall, New Jersey.

Gunturk, B.K., Glotzbach, J., Altunbasak, Y., Schafer, R.W., Mersereau, R.M., 2005. Demosaicking: color filter array interpolation. IEEE Signal Processing Magazine, 44–54. January.

Hunt, R.W.G., 2004. The Reproduction of Colour, sixth ed. John Wiley, Chichester UK.

International Standards Organization (ISO) 21550:2004 2004. Photography — Electronic Scanners for Photographic Images — Dynamic Range Measurements.

Jacobson, R.E.J., Ray, S.F.R., Attridge, G.G., Axford, N.R., 2000. The Manual of Photography, ninth ed. Focal Press, Oxford UK.

Keys, R.G., 1981. Cubic convolution interpolation for digital image processing. IEEE Transactions in Acoustics, Speech, Signal Processing 29, 1153—1160.

Langford, M.L., Bilissi, E., 2007. Langford's Advanced Photography, seventh ed. Focal Press, Oxford UK.

Lee, J., Jung, Y., Kim, B., Ko, S., 2001. An advanced video camera system with robust AF, AE, and AWB control. IEEE Transactions on Consumer Electronics 47 (3), 694—699.

Lukac, R., 2008. Single-Sensor Imaging, Methods and Applications for Digital Cameras. CRC Press, Boca Raton, FL USA.

Nakamura, J., 2006. Image Sensors and Signal Processing for Digital Still Cameras. CRC Press, Boca Raton, FL USA.

Parulski, K., Rabbani, M., 2000. Continuing evolution of digital cameras and digital photography systems. IEEE International Symposium on Circuits and Systems, 28—31. May, Geneva, Switzerland.

Ramanath, R., Snyder, W.E., Yoo, Y., Drew, M.S., 2005. Color image processing pipeline: a general survey of digital still camera processing. IEEE Signal Processing Magazine, January, 40—44.

Sharma, G., 2003. Digital Color Imaging Handbook. CRC Press, Boca Raton, FL USA.

Stroebel, L.D., Current, I., Compton, J., Zakia, R.D., 2000. Basic Photographic Materials and Processes, second ed. Focal Press, Oxford UK.

Sturge, J.M., Walworth, V., Shepp, A. (Eds.), 1989. Imaging Processes and Materials — Neblette's, eighth ed. John Wiley, New York, USA.

Triantaphillidou, S., 2001. Aspects of Image Quality in the Digitisation of Photographic Collections. Ph.D. thesis, University of Westminster, Harrow, UK.

Vrhel, M., Saber, E., Trussell, H.J., 2005. Color image generation and display technologies, an overview of methods, devices, and research. IEEE Signal Processing Magazine, 23—33. January.

Wueller, D., 2002. Measuring scanner dynamic range. Society for Imaging. Science and Technology (IS&T) PICS Conference, Portland, OR, pp. 163—166.

Chapter | 15 |

Displays

Efthimia Bilissi

All images © Efthimia Bilissi unless indicated.

INTRODUCTION

Digital images are viewed, judged and manipulated using display systems. The display technology that has dominated up until now, the cathode ray tube display (CRT), has gradually been replaced by the liquid crystal display (LCD). This has enabled the use of displays in many devices such as portable computers, mobile phones and digital cameras. The two display types have significant technological differences which affect the perceived quality of the displayed images. Other technologies have also emerged, such as organic light-emitting diodes (OLEDs) and flexible displays.

IMAGE DISPLAY

Display of images on a computer monitor is performed via a *graphics card*. The image data in the computer is in the form of a stream of *binary digits* (bits). This data is converted by the graphics card into a form suitable for input to the display device. The graphics card communicates with the *central processing unit* (CPU) of the computer via the motherboard. The necessary power for the graphics card is provided either from the motherboard or from a connection to the power supply of the computer. The graphics card has its own processing unit, which performs the necessary operations for image display. It also has *random access memory* (RAM), which is used to store the image data. Part of the RAM is a *frame buffer* in which the whole image is stored before it is displayed on the computer monitor. The size of the frame buffer depends on the number of pixels that comprise an image and the number of bits that are associated with each pixel. The output signal values from the memory are converted via colour *look-up tables* (LUTs), to analogue signals. This is achieved by the *digital-to-analogue converter* (DAC). The LUT data range from 0 to $(2^N - 1)$ levels, where N is the number of DAC bits. Three analogue RGB video signals are formed and sent to the CRT display. The connection between the graphics card and the monitor is a *digital video interface* (DVI) for LCDs and *video graphics array* (VGA) for CRT displays.

CATHODE RAY TUBE (CRT) DISPLAYS

Cathode rays have been studied since the late nineteenth century. They were first investigated by Sir William Crookes, who developed the Crookes tube. Based on the Crookes tube, Professor Karl Ferdinand Braun in 1897 invented the first cathode ray tube where the bending (deflection) of the electron beam, the cathode rays, was controlled electromagnetically. He also used phosphors for light emission. The CRT display in some countries is called a Braun tube. The British physicist Joseph John Thompson also developed a CRT at the same time but the difference from the Braun tube was that it employed two deflection plates producing electrostatic deflection. Thompson had also experimented with other types of deflection.

A CRT display consists of an *electron gun*, a *focusing* system, a *deflection* system and a screen coated with *phosphors*, which emit light when excited by electrons. A beam of electrons with high velocity, a *cathode ray*, is produced by the electron gun and is focused on the screen, forming a small dot. The position of the dot on the screen is controlled by a deflection system (see Figure 15.1).

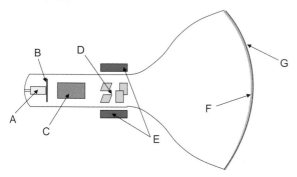

Figure 15.1 A CRT display system. A, cathode; B, modulator; C, focusing system; D, deflection plates (for electrostatic deflection); E, deflection yoke (for electromagnetic deflection); F, phosphor coating; G, faceplate.

The electron gun consists of the cathode, a cylinder with an insulated heating element (*filament*), a *control grid* and an *anode*, which accelerates the electrons. Current passing through the filament causes it to heat, resulting in the emission of electrons in an electron beam (cathode ray). The electron emission is increased by a calcium or strontium coating at one end of the cathode cylinder. There is a minimum time necessary for the filament to be heated and emit electrons. This is known as the *warm-up* time of the CRT display.

In a colour CRT display, colour is reproduced using the RGB additive system (see Chapter 5). Three electron guns, corresponding to the red, green and blue voltage signals, are focused on separate red-, green- and blue-emitting phosphors. There is no distinction between the three electron guns; each simply controls an electron beam for its corresponding colour. However, in the Trinitron CRT display technology developed by Sony (the first Trinitron colour television entered the Japanese market in 1968), only one electron gun is used for all three signals. The output of one electron gun and therefore the existence of one channel at a given pixel, however, may not be independent of the other channels at that pixel and this may affect the colours displayed on the screen. Research has shown that colour inaccuracies may occur due to limitations of the amplifier or the power supply and it depends on the luminance level. It has also been shown that the higher the luminance, the greater the effect.

The intensity of the electron beam is controlled by the *control grid* or *modulator*, from which the electron beam passes through to reach the phosphor coating of the screen. The amount of emitted light by a phosphor depends on the number of electrons that excite it. By varying the voltage of the, slightly negative, control grid the number of electrons (intensity of the electron beam) which excite the phosphors can be controlled, and consequently the luminance of the display. The electrons that exit the control grid pass through the anode cylinder. The anode has a positive potential, which accelerates the electrons.

An *electron lens* focuses the electron beam to the screen by applying different potentials. The electron lens has similar characteristics and limitations to the *optical lens*, such as spherical aberration (see Chapters 6 and 10). There are two focusing systems with an electron lens: an *electromagnetic* (EM) and an *electrostatic* (ES) system. In the electromagnetic system a magnetic focusing coil external to the CRT envelope is used to focus the electron beam. The resulting spot size is very small, smaller than the spot obtained with the electrostatic system. With the electrostatic system the focusing is achieved using an *electrostatic lens*, which is a built-in metal cylinder. This system is the most commonly used in commercial colour CRTs. Both focusing systems focus the beam in the centre of the screen. The CRT display screen has a curvature so the focusing distance is not the same for all the points of the screen's phosphor coating. For this reason it is necessary to use additional focusing systems.

The location of the focused spot on the screen is controlled by the deflection system and, again, there are both electromagnetic and electrostatic types of system. The electromagnetic system employs two pairs of *electromagnetic coils* and an *electromagnetic yoke*. The two pairs of coils provide horizontal and vertical deflection, which is controlled by varying the current that passes through them. Most CRT displays which are used to view images have electromagnetic deflection systems which provide higher luminance compared to the ones with electrostatic deflection systems and very small spot size (the effective diameter of the spot is defined by its diameter at half maximum of its intensity (FWHM)). CRT displays with electrostatic deflection systems have two pairs of deflection plates for horizontal and vertical deflection inside the cathode ray tube envelope. These systems provide higher speed of deflection but the deflection angle has to be smaller than the angle in the electromagnetic systems, otherwise the electron beam may be defocused. Of course the smaller deflection angle results in longer CRTs.

The screen on which the electron beam is focused is coated with phosphors, materials which *luminesce* when they are excited by electrons and *phosphoresce* (continue to glow) once the excitation stops. The afterglow fades slowly and this varies depending on the type of phosphor. There are three types of phosphors according to the duration of afterglow emission: *short persistence*, *medium persistence* and *long persistence*. The persistence of a phosphor is measured as the time it takes for its light emission to decrease to 1% of its maximum intensity. Long-persistence phosphors eliminate the effect of flickering. When the change of the displayed content is rapid, however, such as in that of moving images, an after-image effect is produced. Short-persistence phosphors eliminate this effect. Since in colour CRT displays there are three types of phosphors it is essential that they all have matching persistence. In most CRT displays the phosphor persistence is around 5 ms.

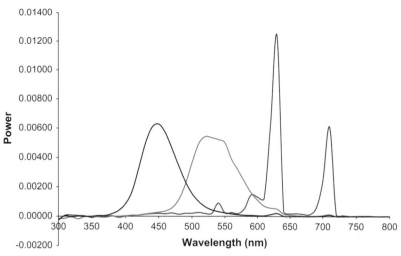

Figure 15.2 Typical spectral power distribution of P22 phosphors.

The maximum light output of the phosphor depends on the acceleration of the electrons of the beam and on the characteristics of the phosphor itself, meaning that different phosphors may emit different amounts of light, even if excited by the same number of electrons with the same acceleration. The age of the phosphor also affects the intensity of the emitted light due to physical degradation caused by the cumulative effect of many electron collisions. In addition, when an electromagnetic deflection system is used, degradation is also caused by ions striking the phosphor surface. The light output of the phosphors can be improved by coating the back of the phosphor surface with a metallic layer, mainly from aluminium or beryllium. The layer of the coating is very thin, around 0.127 mm. Screens which employ this method are called *metal-backed phosphor screens*.

Phosphors are designated with P values according to the Electronic Industries Association (EIA). A common type of phosphor for commercial colour CRT displays is the P22. This is a set of red (YVO$_4$:Eu — yttrium orthovanadate activated with europium), green (ZnS:Cu, Au, Al — zinc sulphide activated with copper, gold and aluminium) and blue (ZnS:Ag — zinc sulphide activated with silver) phosphors. The red P22 phosphors have their peak emission at 626 nm, the green at 535 nm and the blue at 450 nm (Figure 15.2).

The three phosphors are arranged in *triads*, with (theoretically) each triad forming a pixel. There are two different types of electron gun arrangement depending on the phosphor triad technology being used, the *'delta'* and the *'in-line'* arrangements (Figure 15.3). The magnetically deflected electron beams from the three electron guns with a 'delta' arrangement reach the phosphor surface through a steel mask, a *shadow mask* with *dot* geometry (Figure 15.3a). With the shadow mask, the beam from the electron gun reaches only the phosphors with the corresponding colour and the other phosphors remain in shadow. It should be noted that a large portion of the electron beam, around 70%, does not pass through the shadow mask holes. The distance between the phosphors is the same and phosphors of the same colour form an equilateral triangle. When the CRT display has an 'in-line'

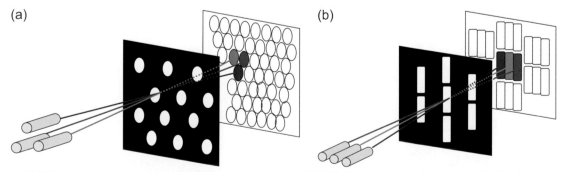

(a) (b)

Figure 15.3 Electron gun arrangements and shadow mask geometry. (a) 'Delta' arrangement and shadow mask with dot geometry. (b) 'In-line' arrangement and shadow mask with slot geometry.

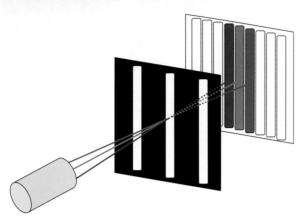

Figure 15.4 Trinitron technology with aperture grille.

electron gun arrangement a *slot mask* is used with three vertically aligned slots for each triad, as shown in Figure 15.3b. In this technology, used by NEC in the ChromaClear CRT displays and Panasonic in the PureFlat CRT displays, the red, green and blue phosphors are elongated and vertically aligned. In Trinitron technology an *aperture grille* is used (Figure 15.4), comprising thin vertical wires instead of a metal mask and corresponding phosphor stripes. In this case the screen is less curved compared to the screen of displays using a shadow mask or a slot mask.

The distance between two identically coloured phosphors is called the *pitch*. The smaller the distance, the sharper and brighter the image is. The measurement of pitch depends on the phosphor triad technology. In *dot triad* technology the pitch is measured diagonally between the centre of two nearest-neighbour, identically coloured phosphor dots (Figure 15.5a). The distance is often called *dot pitch* and is typically 0.27 mm or less. Due to the fact that CRT display screens have a curvature, the electron beam that passes through a hole in the centre of the shadow mask will form a circle on screen, while if it passes through a hole at the edge of the shadow mask it will form

an ellipse. Consequently the dot pitch in the centre of the screen will slightly differ from the dot pitch at its edges. For this reason manufacturers quote an average dot pitch or they may give two values, one for the centre and one for the edges of the screen. The term *mask pitch* is used to describe the distance between two holes in the shadow mask corresponding to two identically coloured phosphor dots; this has a slightly smaller value than the dot pitch. In displays with slot masks, the pitch is measured as the horizontal distance between two identically coloured phosphor stripes and is called *slot pitch* (Figure 15.5b). The distance between two phosphor stripes with identical colours in aperture grille technology is referred to as *stripe pitch* (Figure 15.5c).

Accurate convergence of the three electron beams is very important for a CRT display. Convergence, however, is not always perfect and this may have an effect on the quality of displayed images. The effect of *misconvergence* is more pronounced at the edges of the screen, while the best results appear in the central area. Research has shown that the central area is also the most uniform regarding luminance and chromaticity while the largest deviations usually occur at the edges of the screen. One of the reasons is the above-mentioned curvature of the CRT display screen, which results in variability in the distances for the electron beam to travel. Other reasons include non-uniform application of the phosphors on the screen, temperature and magnetic fields. Magnetic fields exist internally in the CRT displays that use electromagnetic deflection. External magnetic fields, however, may cause slight changes in the path of the electron beams but usually the result is not perceptible. Turning off and unplugging nearby electrical appliances can prevent the effect of magnetic fields. Regularly *degaussing* the monitor also minimizes the effect. In cases where there is a strong magnetic field an external shielding box for the CRT display can be used, or a shielded room. Taking into account the human visual system's contrast threshold to low spatial frequencies (see Chapter 4), however, the lack of uniformity for most displays is not perceived.

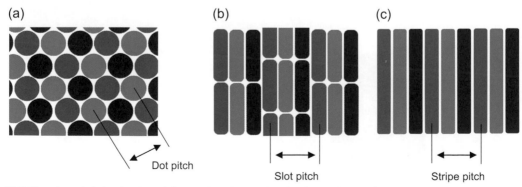

Figure 15.5 Phosphor pitch for the three different phosphor triad technologies: (a) dot pitch; (b) slot pitch; (c) stripe pitch.

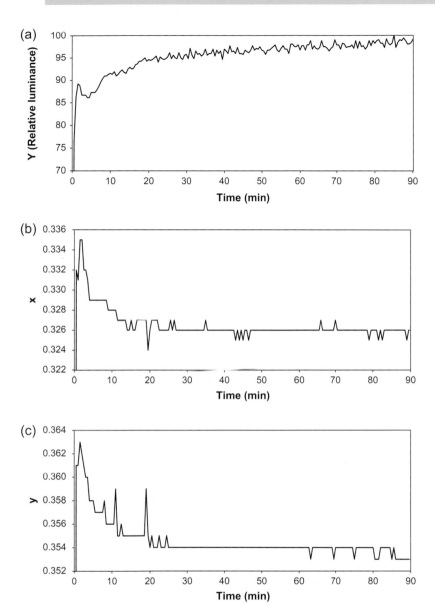

Figure 15.6 Variation of luminance and chromaticity during the warm-up time of a CRT display.

When viewing images on a CRT display it is essential to allow the display to warm up. This is usually for at least 30 minutes, so that it reaches its highest level of luminance. Warm-up time is also necessary for stabilized luminance and colour output, essential when viewing images. Figure 15.6 illustrates the variation in luminance and CIE *xy*-chromaticities of a CRT display which has been allowed to warm up for a period of time. Different types of CRT displays need different times to stabilize after being powered up and it has been estimated to be from 15 minutes to over 3 hours. The stabilization time for a specific device can be determined by repeated measurements of the display luminance and chromaticity over an extended but specified period of time.

LIQUID CRYSTAL DISPLAYS (LCDs)

The discovery of liquid crystals dates back to the late 1800s. It was not until much later, in the 1960s, however, that research by the Radio Corporation of America finally led to the development of the first LCDs. In 1888 the Austrian botanist Friedrich Reinitzer observed the properties of

cholesteryl benzoate, a material which changed state upon heating. The change of state occurred at two different temperature points: from solid to cloudy anisotropic liquid (*mesophase*) at temperature T_1 and from cloudy liquid to clear isotropic liquid at a higher temperature point T_2. Otto Lehmann, a professor of physics, observed that in meso-phase the material in liquid form showed characteristics of a crystal and for this reason he termed it *liquid crystal*. These types of liquid crystals are called *thermotropic* because their state changes with temperature (as opposed to liquid crystals, whose state changes on reaction with water, which are called *lyotropic* and are studied in fields such as biochemistry). The molecules of thermotropic liquid crystals have either a rod-like shape (*calamitic*) or a disc-like shape (*discotic*). In LCDs, liquid crystals with a rod-like shape (their length is approximately 2 nm) are used, but in recent years the discotic type has also been used for improving the *viewing angle*. Three types of thermotropic liquid crystals exist, known as *smectic, nematic* and *cholesteric* (Figure 15.7). Liquid crystals have *anisotropic* properties, meaning that they have physical properties that are directionally dependent. There are two forms of anisotropy in liquid crystals: *optical anisotropy*, which refers to the different magnitudes of refractive indices in different directions; and *dielectric anisotropy*, which refers to the dielectric constant, depending on the axis on which they are measured and specifically on the orientation of the liquid crystal's molecules.

Most current LCDs are based on the *twisted nematic* (TN) system, which was described in the early 1970s by Fergason and by Schadt and Helfrich. This system is based on nematic liquid crystals. The molecules of the nematic liquid crystals have parallel order and their favoured orientation is represented by the *director*, which is a vector *n*. As mentioned above, they are characterized by their optical and dielectric anisotropy. The optical anisotropy serves to adjust the polarized light in an orientation which is suitable for display. This is as a result of *double refraction* or *birefringence*. Dielectric anisotropy is exploited by applying an electric field to change the direction of the liquid crystal molecules; when the electric field is applied crystals with *positive dielectric anisotropy* will align parallel to the field, while crystals exhibiting *negative dielectric anisotropy* will align in a perpendicular orientation.

A thin layer (4–10 μm) of liquid crystals with positive dielectric anisotropy is used in the TN system. This layer is between two glass substrates which have conductive electrodes in their internal surfaces. The surfaces have *orienting* or *alignment layers*, which are organic or inorganic films used to provide the appropriate orientation of the molecules, resulting in a 90° twist of the director (Figure 15.8). Two cross linear polarizers (see Chapters 2 and 10), usually made of polyvinyl acetate (PVA) with iodine doping, are used to control the light entering and exiting the liquid crystal layer. As described in Chapter 2, light travels in the form of electromagnetic waves. When it passes through two

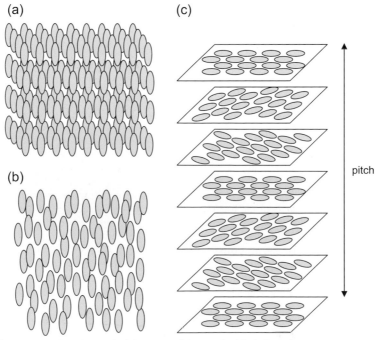

Figure 15.7 Types of thermotropic liquid crystals: (a) smectic; (b) nematic; (c) cholesteric.

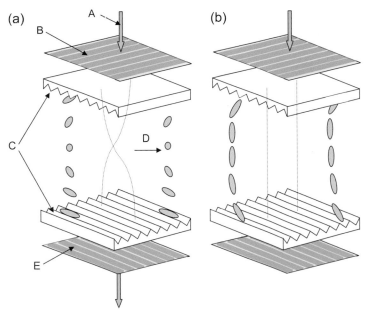

Figure 15.8 (a) The director is twisted by 90°, resulting in rotation of the polarization direction and light passes through the second polarizer (normally white case). (b) The orientation of the director changes when an electric field is applied. When it becomes perpendicular to the second polarizer's polarization direction no light can pass through the second polarizer. A, light; B, rear polarizer; C, orientation surfaces; D, liquid crystal molecules; F, front polarizer.

polarizers, the intensity I_t of the light transmitted through both polarizers depends on the angle θ, the mutual angle between the polarizing axes of the two (i.e. Malus' law):

$$I_t = I_i \cos^2 \theta \qquad (15.1)$$

where I_i is the incident light to the first polarizer. It should be noted that, in ideal polarizers, the light that passes through the first polarizer is 50% of the incident light. If the angle θ is equal to 0° then the light transmitted from the first polarizer will pass also through the second polarizer, so 50% of the incident light will be transmitted. If the angle θ is equal to 90° (i.e. *orthogonal polarizing axes*) no light will be transmitted through the second polarizer. In practice, however, there is some light absorption on the optical axis (dichroism) when the light passes through the polarizers and this has an effect on the contrast ratio of the LCD.

LCDs are backlit; white light first passes through a diffuser, which produces uniform illumination due to scattering, and it then enters the liquid crystal layer via the rear polarizer. As it enters, its polarization rotates with the liquid crystal molecules. If there is no electric field applied, when the light reaches the second (front) polarizer with polarization axis orthogonal to the first one, its polarization direction has rotated by 90° as a result of the twist of the director. It can therefore exit passing through the second polarizer, which is outside the second glass plate. This is known as the *normally white* mode. When an electric field is applied to the liquid crystals the orientation of the director changes and tends to have an orientation

angle greater than 0° with respect to the polarization direction of the second polarizer. In this case the amount of transmitted light is reduced. The light transmission can therefore be moderated by adjusting the applied voltage. When the voltage is sufficiently high the rotation of the liquid crystals can be reduced to 0°. In this case the light cannot pass through the second polarizer and is therefore blocked (Figure 15.8). If the polarizing axes of the two polarizers are parallel, the light exiting from the first polarizer is transmitted through the second polarizer when electric field is applied and is blocked when there is no voltage applied. This is known as the *normally black* mode.

The first TN LCDs were reflective-type displays, where the ambient light was necessary to read text or numbers. It was not possible to display large images because each pixel had to be individually connected to the addressing circuitry. This meant that for an image array of m rows and n columns, the interconnections would be $m \times n$. Other drawbacks were the parallax errors and difficulty in displaying colours. The display of images became possible with the development of matrix addressing of each pixel, where the number of interconnections was reduced to $m + n$. These were *passive matrix* displays, which improved over the years. They had limitations, however, regarding the response time, viewing angle and *contrast ratio*. A solution to this involved independent control of the voltage of each pixel. This was accomplished by adding a switch at each pixel in a matrix display. This was the *active matrix LCD* (AMLCD), which is the most common LCD technology today. The on/off

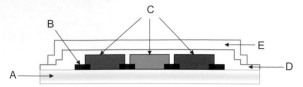

Figure 15.9 LCD colour filter structure. A, clear substrate; B, black matrix; C, colour filter layer; D, overcoat layer; E, ITO.

switches in the first AMLCDs were CdSe thin-film transistors (TFTs). The materials for TFTs changed through the years to polycrystalline silicon (poly-Si) materials and in the 1990s to amorphous silicone (a-Si) materials, which are used in displays for portable and desktop computers. Poly-Si TFT LCDs started being used again in the late 1990s for small displays. It should also be noted that, for better control of the cells' twist, nematic crystals are 'doped' with cholesteric crystals (see Figure 15.7c).

In current LCD technology the light sources are *cold cathode fluorescent lamps* (CCFLs), which have a phosphor coating. The colours of the phosphors are red, green and blue (RGB), resulting in white light emission with distinctive peaks for the three colours and luminance around 3000 cd m^{-2}. Colours are displayed by using a pixel array consisting of three subpixels with RGB filters (additive colour system − see Chapter 5). The filters have suitable surfaces to minimize dispersion of the light (Figure 15.9). In TFT LCDs the filter array is approximately 4−5 μm away from the TFT array (this is the thickness of the liquid crystal layer). The filters consist of a plastic or glass substrate, a black matrix between the colour filters, an RGB layer where the colours are pigments or dyes, a protective overcoat layer which also minimizes any variations in the filter's thickness, and a film of indium tin oxide (ITO). The black matrix, usually of chromium combined with chromium oxide, prevents leakage of light between the pixels and protects the TFTs from light exposure to ambient light. The spectral transmittance of the RGB filters closely matches the above-mentioned three peaks of the emitted white light from the CCFLs and is one of the parameters that affects the white point of the display. Another parameter is the colour purity of the filters. It is important that the filters have stability, especially during heating and exposure to light. Also, they should have chemical stability because they are exposed to chemical substances during the manufacture of the LCDs.

OTHER DISPLAY TECHNOLOGIES

Plasma display panels (PDPs)

Plasma displays are based on cells filled with gas at low pressure. The gas is neon (Ne) or helium (He) with added 5−15% xenon (Xe). The cells are between two glass plates. Each cell forms a pixel, with three subpixels with red, green and blue phosphors. The phosphors used are of the same type as the phosphors of the CRT displays and cover all the inner surfaces of the subpixels apart from the front. The difference is that in plasma displays the phosphors are excited by ionization of the gas (*plasma*). Xenon produces ultraviolet light, in a similar way to the neon tubes, with a wavelength of 147 or 173 nm. The ionization is achieved by applying a voltage via the grid of electrodes which address each pixel. The subpixels are isolated with *barrier ribs* to avoid the effect of *crosstalk* between them. The phosphors are also insulated by the data electrodes which are on the back glass plate, perpendicular to the scan, and sustained electrodes located on the front glass plate.

Because the pixels of plasma displays are neither 'on' nor 'off', the grey levels are controlled by adjusting the fraction of time for which a pixel will be 'on' and using eight subfields for addressing the frame.

The colour gamut (range of reproduced colours) of plasma displays is similar to that of the CRT displays. Due to their technology they are also thin and lightweight and are used for large TV sets. They have a very long lifetime, usually over 100,000 hours. However, as in CRT displays, the phosphors age; this affects the displayed luminance, which is reduced over time, and the display colour balance. Power consumption of plasma displays depends on the luminance of each pixel of the displayed images. Although if all pixels are driven with high luminance the power consumption will be very high compared to TFT LCDs, in practice the average pixel luminance is much lower, approximately 20% or less, so the plasma display consumes less energy.

Organic light-emitting displays (OLEDs)

OLEDs are electroluminescent (EL) displays and have two glass substrates, a thin organic layer, and electrodes created by metal and ITO films. Colour is produced by light emission by the OLED materials at different wavelengths. The light emission of an OLED is almost *Lambertian* (i.e. the radiance is directly proportional to the cosine of the angle, with respect to the direction of maximum radiance, from which the display is viewed) and for this reason the viewing angle is very wide, approximately 170%. With this technology the power consumption is low because it depends on the luminance level of the displayed images (as in plasma displays). Two types of OLEDs exist. These are *small-molecule OLEDs* and *polymer OLEDs* (or PLEDs). The PLED technology has received the most interest and development. This is due to limitations of the small-molecule OLED technology for depositing the organic material on large surfaces.

Depending on the way pixels are addressed there are passive matrix OLEDs and active matrix OLEDs

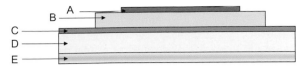

Figure 15.10 Structure of an AMOLED pixel. A, anti-reflection coating; B, cathode; C, organic layers; D, anode; E, glass substrate.

(AMOLEDs). Passive matrix OLEDs are not suitable for large-size displays because they are slow and an increase in resolution decreases the luminance to an insufficient level. In an AMOLED there are two TFTs per pixel and the pixels are controlled by adjusting the current (and not the voltage). The AMOLED pixel is illustrated in Figure 15.10. One of the limitations of the OLEDs is that the luminance of the display decreases over time and this also affects the display colours. So far OLEDs have been used as small screens on consumer products such as consumer cameras.

Flexible displays

Flexible display technology (or *electronic paper* or *e-paper*) has been developed to approach the appearance of paper. Flexible displays have low power consumption. Based on the thickness of the display, there are flexible displays that curve or very thin ones that can be rolled. This feature makes rollable displays suitable for several applications where easy storage and light weight are important factors. The technology of flexible displays was initially based on liquid crystals. Passive matrix and active matrix flexible displays have been developed, with the glass substrates replaced by flexible materials. As mentioned previously, however, the polarizers significantly reduce the transmitted light so these types of flexible display cannot closely approach the appearance of paper. A different technology, the *electrophoretic display*, uses microcapsules with white positively charged particles and black negatively charged particles in liquid. The capsules are deposited, with the method of printing, on a plastic film which has a grid of

circuits, forming an array of pixels. The black and white dots on the display appear by controlling the voltage. With positive voltage applied, the black particles move to the top of the microcapsule and the viewer sees a dark spot. With negative voltage applied, the viewer sees a white spot because the white particles move to the top of the capsule (Figure 15.11). The resulting white in this technology has reflectance of around 30–50%. The *interferometric modulator technology* (IMOD) by Qualcomm is based on the principle of constructive and destructive interference (see Chapter 2). In this technology, a thin-film stack and a reflective layer are on a transparent substrate. Incident light is reflected from both the film and the membrane. Depending on the distance between them, there is constructive or destructive interference of the light waves. Red, green and blue colours are produced by varying the distance so that constructive interference will occur only for the wavelengths that correspond to these colours (see Figure 15.12). Black is obtained by applying voltage to the film. This produces electrostatic force that causes the membrane to touch it. In this case the constructive interference is at the, invisible, ultraviolet wavelengths. Greyscale is obtained by spatial or temporal dithering or a combination of both. Flexible OLED is another technology that has been proposed.

CHARACTERISTICS OF DISPLAYS

Refresh rate and response time

Refresh rate refers to CRTs and is the rate (in Hz, i.e. times per second) at which a CRT monitor screen displays the data. Refreshing at a low rate may cause the effect of *flickering*, which is uncomfortable for the user and can lead to eye fatigue. The reason for flickering in CRTs is the phosphor decay. The electrons emitted by the electron gun excite the phosphors, which emit light. This light begins to decay until the phosphors are bombarded again by electrons. Flicker can be avoided by setting on the computer a refresh

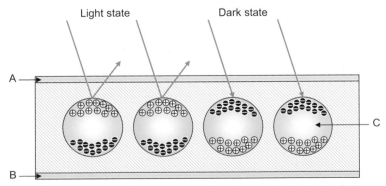

Figure 15.11 Electrophoretic display technology. A, top electrode; B, bottom electrode; C, clear fluid.

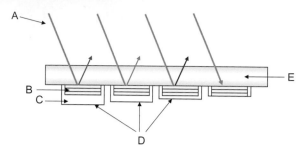

Figure 15.12 Interferometric modulator technology. A, ambient light; B, thin-film stack; C, air gap; D, deformable membrane; E, glass.

rate higher than the *critical fusion frequency* (CFF). CFF is the frequency higher than which flickering is not perceived. The CFF depends on ambient lighting and on the viewer. The setting at which most people do not perceive flickering is 70 Hz.

Due to the different technology employed, refresh rate does not apply to LCDs. The equivalent characteristic is *response time*. It expresses the time needed for the liquid crystals to pass from the aligned to the twisted position and back to the aligned position. Response time is defined as the time needed to change state from white (10% transmittance) to black (90% transmittance) and back to white (10% transmittance), and is usually around 10−50 ms. A long response time results in blurring when fast-moving images are displayed. There are, however, limitations when very short response times are used because they can cause flickering.

Resolution

In a display *device resolution* expresses the number of *pixels per inch* (ppi) or the number of pixels in the horizontal and vertical dimensions (e.g. 1024 × 768 pixels) it can display. In the latter case it is also important to know the physical dimensions of the display screen. *Addressability* expresses the number of points that can be addressed by the graphics card adaptor and in CRT displays it is independent of resolution. There are several factors that affect resolution in CRT displays. One of these factors is the spot size, which depends on the phosphor layer but also on the electron beam current and the optics of the display system. The ratio of resolution to addressability (RAR) can be calculated by taking into account the pixel pitch, p (display height divided by the number of addressed lines), and the spot size, s:

$$\text{RAR} = \frac{s}{p} \qquad (15.2)$$

The focusing and deflection systems used also affect *effective resolution* (see Chapters 19 and 24). The shadow mask is yet another factor. High luminance of the display is related to longer spot diameter, reducing the effective resolution. Due to the Gaussian profile of the light emitted by the phosphors, a CRT monitor can display multiple resolutions by adjustment of the electron beam. It should be noted, however, that changes of resolution have an effect on the refresh rate of the display. Some typical display resolutions are shown in Table 15.1. Reducing or increasing the resolution setting of a CRT display may have an effect on image quality. The effect is scene dependent and it may affect image areas with high frequency where detail may be lost at a lower resolution setting. Changing display resolution also alters the dimensions of the displayed images (at a higher resolution the image appears smaller and vice versa).

LCDs have a matrix of pixels on the screen and for this reason their resolution, which is referred to as *native resolution*, is the same as the addressability. Optimal image

Table 15.1 Typical display resolutions

RESOLUTION	NUMBER OF PIXELS
QCIF	144 × 173
QCIF+	220 × 176
CGA	200 × 320
QVGA	240 × 320
CIF	288 × 352
VGA	480 × 640
NTSC	480 × 720
WVGA	480 × 800
PAL	576 × 768
SVGA	600 × 800
WSVGA	600 × 1024
XGA	768 × 1024
WXGA	768 × 1280
SXGA	1024 × 1280
SXGA+	1050 × 1400
W-HDTV	1080 × 1920
UXGA	1200 × 1600
WUXGA	1200 × 1920
QXGA	1536 × 2048
WQXGA	1600 × 2560
QSXGA	2048 × 2560
QUXGA	2400 × 3200
WQUXGA	2400 × 3840

quality is obtained only when the display resolution of the LCD is set to its native resolution. Although the driver may allow alteration of the display resolution setting, in an LCD this may cause blurring of the image due to applied *interpolation* (see Chapters 23 and 27).

Perceived resolution decreases with viewing distance, i.e. displayed spatial frequencies in the visual field become higher and higher as the viewing distance increases. The required resolution for viewing images on a computer monitor where typical distance is approximately 50 cm is up to 180 ppi, and therefore different to that for television viewing at typical distance of 3 m. In that case the required resolution would be up to 30 ppi. Higher resolutions would not improve image quality, provided that distances are kept constant.

Luminance

The level of luminance set for a display depends on the ambient lighting conditions, so it may vary between displays which are viewed in different locations. Typical maximum luminance for a CRT display is around 100 cd m^{-2}. In TFT LCDs the luminance depends on the light intensity of the CCFLs, with typical luminance ranging from 150 to 300 cd m^{-2}. There is a significant reduction of luminance, around 90–95%, compared to the light output from the CCFLs. The reduction occurs due to losses when the light passes through the rear and front polarizers, the black matrix and the colour filters. Although the output luminance of an LCD can be increased by increasing the output of the backlight source, in practice this could result in higher temperature of the display and higher power consumption. Other methods which can be applied to increase the output luminance have been suggested. These include improvements on the light transmission of the colour filters (they transmit around 25% of the incident light), redesign and rearrangement of the colour filters so that they include a white filter, designing the black matrix with higher aperture ratio, and use of brightness enhancement films. In plasma displays the luminance is around 1000 cd m^{-2}.

Contrast ratio

Contrast ratio (CR) is the ratio between the maximum luminance (peak white), L_{max}, to the minimum luminance (black), L_{min}, that a display system can produce (see also Chapter 21):

$$CR = \frac{L_{max}}{L_{min}} \qquad (15.3)$$

There are two methods of assessing contrast ratio: small-area (pixel) and large-area (group of pixels) measurements. Contrast ratio, however, is affected by the ambient lighting conditions and the environmental conditions. It also depends on the screen's reflectance (screen glass and

phosphors for CRTs) or diffusion of the incident ambient light. Other parameters, for LCDs, are the viewing angle and the wavelength (depending on whether the LCD is in normally white or normally black mode). Measurements may be carried out for a range of viewing angles and the results plotted in an *isocontrast ratio diagram*. When measured in a totally darkened room the contrast ratio is called *intrinsic contrast ratio*. The contrast ratio may also be measured with the presence of ambient lighting (*extrinsic contrast ratio*). In that case it is essential to quote the measured ambient light illuminance and the angle of incident light in addition to the luminance values of the display. For CRTs the extrinsic contrast ratio can be expressed by the following equation:

$$CR = \frac{L_{max} + L_r \times r}{L_{min} + L_r \times r} \qquad (15.4)$$

where L_r is the reflected light from the glass and r is the phosphor reflectivity, typically 70%. A typical value for the intrinsic contrast ratio of a CRT display is around 100:1, while for an LCD it can be around 500:1. Plasma displays have a higher intrinsic contrast ratio, 5000:1. With ambient light present the contrast ratio of a CRT display is reduced and with typical lighting conditions is around 20:1. There are several different methods used for the measurement of contrast ratio by manufacturers, however, so the contrast ratio values quoted may not be comparable.

Viewing angle

The reproduced range of grey levels, the contrast ratio and the colour in LCDs depend on the viewing angle. The effect is more pronounced on the vertical angle, while the horizontal viewing angle is more symmetric. This is a result of the different orientation of the liquid crystals' director for positive and negative vertical angles. The liquid crystals are tilted when voltage is applied and their direction is different when the screen is viewed from an upper or lower angle. In the normally white mode an inverted image may be observed when the vertical viewing angle changes. This is more obvious in the lower viewing angles. The effect of the viewing angle can be significant when viewing and manipulating images using an LCD, and also when the display is viewed simultaneously by several viewers, or when a large display is viewed by a single user. The viewing angle should also be taken into account when conducting colorimetric or luminance measurements. A colorimeter specially designed for LCDs should be used, measuring at a very narrow angle (see Chapters 5 and 23).

In recent years several methods have been developed to improve viewing of LCDs from different angles. One of these methods is the *in-plane switching* (IPS) mode, introduced by Hitachi. The IPS mode is based on the normally black mode. Two orthogonal polarizers are used but the liquid crystals are aligned when there is no electric field applied and thus the light cannot pass through the

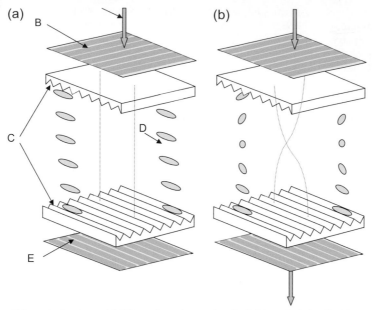

Figure 15.13 In-plane switching technology. (a) When there is no electric field applied the liquid crystals are aligned and no light passes through the second polarizer (normally black case). (b) When electric field is applied light is transmitted because the orientation of the director changes. A, light; B, rear polarizer; C, orientation surfaces; D, liquid crystal molecules; E, front polarizer.

second polarizer (Figure 15.13a). When an electric field is applied the orientation of the director changes and light is transmitted. Maximum light transmission occurs when the angle between the director and the polarizer is 45° (Figure 15.13b). The liquid crystals are parallel to the glass substrates so there is no variation in the orientation of the director. The response times of the IPS LCDs used to be slow in the early models, but this has been improved. The aperture ratio of the cell is also lower, resulting in the use of more powerful backlight sources. Recent improvements of this technology include the True White IPS by LG Philips and Super IPS (S-IPS) by Hitachi. An alternative is *vertical alignment* (VA), where the liquid crystals are at right angles to the glass substrate when there is no electric field (Figure 15.14). Another method for viewing angle improvement is the use of compensation films with discotic liquid crystals, developed by Fuji Corporation. With the compensation films the retardation of the light that passes through the liquid crystals does not depend on the viewing angle, thus improving the contrast ratio. CRT and plasma displays have a very wide viewing angle duo to the fact that phosphors have Lambertian light emission. Flexible displays also have a very wide viewing angle.

Colour

The colour gamut of a CRT display depends on the spectral characteristics and luminance of the RGB phosphors. The colour gamut produced by the P22 set of phosphors is illustrated in Figure 15.15.

In LCDs the colour gamut depends on the spectral transmittance of the RGB filters and on the spectral characteristics and luminance of the backlight source. Perceived colour also depends on the colour filter arrangement (Figure 15.16). Each arrangement has advantages and limitations. The vertical line arrangement is the most

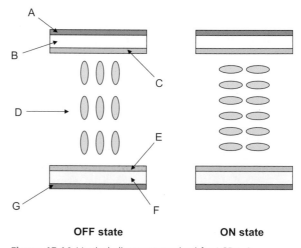

OFF state ON state

Figure 15.14 Vertical alignment method for LCDs. A, front polarizer; B, colour filter plate; C, ITO; D, liquid crystal molecules; E, ITO; F, TFT plate; G, rear polarizer.

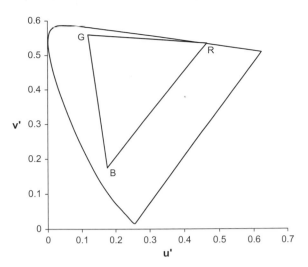

Figure 15.15 Colour gamut of the P22 phosphors.

popular for computer displays and is less complicated than the other two. Colour integration, however, is not as good as with the RGB diagonal or 'delta' arrangements.

The number of colours addressed by the graphics card is related to the number of bits (and therefore grey levels) that correspond to each pixel. For an 8-bit system, typical for a computer monitor, the grey levels are equal to 2^8 per colour while high definition LCDs employ a 10-bit system resulting in 2^{10} grey levels per colour. In general the number of colours in an LCD is 2^{3n}, where n is the number of bits. In an optimum situation, the number of colours the display is capable of reproducing should correspond to the number of addressable colours. However, the number of displayed colours depends on the contrast ratio of the display and the chromaticity of the display primaries. If the contrast ratio is high enough and the primaries are saturated enough, each addressable colour value can be displayed as a different chromaticity and/or luminance level. This is rarely the case. Generally, for a specific set of display primaries, smaller gamuts are reproduced when the contrast ratio is reduced.

Display artefacts

Artefacts depend on the display technology used. Flickering has already been mentioned for CRTs. It can also appear in LCDs due to the backlight. *Temporal aliasing* (a stroboscopic effect) can occur if the frame rate of the screen is slower than the rate the data change (moving images). Strobing may also occur if the refresh rate of the CRT display is set to the same rate that fluorescent lamps flicker. To avoid this effect the refresh rate should be higher. *Spatial aliasing* is an artefact related to the spatial resolution of the display and therefore its ability to display high frequencies, resulting in a *moiré effect* (see Chapter 7). The point spread function of the pixel is affected by the electron optics. Increase of the spot's diameter may cause image blurring. Image retention (burn-in) may occur in CRTs or plasma displays due to phosphor degradation when images or text are displayed unchanged for a long time. This results in a ghosting image effect. Image retention may occur in LCDs for different reasons. The DC components which are used to apply voltage to the liquid crystals may have an effect and cause

Figure 15.16 RGB colour filter arrangements for LCDs. (a) RGB stripe. (b) RGB diagonal. (c) RGB 'delta' or triad. (d) RGBW stripe. (e) RGBW quad.

short-term image retention. Long-term image retention may be caused by changes in the alignment layer or the current of the TFTs.

In LCDs additional artefacts include *mura*, cross-talk, pixel defects and motion blur. The term *mura* includes several artefacts caused by the process of LCD manufacturing. It includes the existence of larger or smaller than normal cells in some areas of the screen (causing brighter or darker areas respectively), inhomogeneity in the circuits that control the pixels, and differences in processing of the liquid crystal's alignment layer. The artefact of cross-talk, mainly in passive matrix LCDs, occurs when the output of one or more pixels is affected by the data of neighbouring pixels (they may be on the same column or row). Pixel defects are subdivided by the International Standards Organization into three categories: *hot pixels* (always on, resulting in a white spot), *dead pixels* (always off, resulting in a dark spot) and *stuck pixels* (one of the subpixels is always on or always off). Due to the response of the human visual system hot pixels in a dark background are easier to detect than dead pixels in a white background. *Motion blur* may be caused when a fast-moving object is displayed because the voltage applied on a pixel remains until the next refreshing of the data.

EFFECT OF VIEWING CONDITIONS

The viewing conditions have a significant role in the perceived quality of images viewed on displays. The level of ambient illumination and the colour temperature of the illuminant have an effect. As mentioned previously, the contrast ratio decreases with increase of the ambient light illumination due to flare. This makes the discrimination of figure—ground by the human visual system more difficult because when the ambient light is increased, it needs higher rather than lower contrast. Anti-reflection coatings can reduce the effect of flare. A hood can also be attached to some displays, isolating the screen from the ambient lighting. It also serves to isolate the screen from the surround and background, which influence the adaptation of the visual system. The gamma setting of the display is also related to the displayed image contrast (see Chapter 21).

Characterization and calibration of the display devices used for image viewing is essential for accurate colour reproduction of the displayed images. In many cases, however, and especially when images are viewed across the Internet, displays are used in different locations, with different brightness, contrast and white point settings, and under different ambient lighting. The sRGB standard has been developed to ensure accurate colour and tone reproduction of images when viewed on CRT displays under reference display and viewing conditions (see Chapter 23). These include parameters typical to most CRTs such as the white point (phosphor RGB chromaticities), the display luminance level and the ambient light illuminance. Visual adaptation (see Chapter 5) is an important factor in viewing of displayed images. Research has shown that when images were viewed on a CRT display the human visual system was approximately 40% adapted to the ambient light and approximately 60% to the monitor's white point.

BIBLIOGRAPHY

Collings, P.J., Hird, M., 1997. Introduction to Liquid Crystals — Chemistry and Physics. Taylor & Francis, London, UK.

Damjanovski, V., 2005. CCTV: Networking and Digital Technology, second ed. Elsevier Butterworth-Heinemann, Oxford, UK.

Den Boer, W., 2005. Active Matrix Liquid Crystal Displays — Fundamentals and Applications. Elsevier Newnes, Oxford, UK.

Dorf, R.C., 1997. The Electrical Engineering Handbook. CRC Press, Boca Raton, FL, USA.

Driggers, R. (Ed.), 2003, Encyclopedia of Optical Engineering, Vol. 2. Marcel Dekker, New York, USA.

Holst, G.C. 1996. CCD Arrays, Cameras and Displays. JCD Publishing, Winter Park, and SPIE Optical Engineering Press, Washington, DC, USA.

Hunt, R.W.G., 2004. The Reproduction of Colour, sixth ed. John Wiley, Chichester, UK.

Karim, M. (Ed.), 1992. Electro-Optical Displays. Marcel Dekker, New York, USA.

Kawamoto, H., 2002. The history of liquid-crystal displays. Proceedings of the IEEE Vol. 90 (No. 4) April.

Kelly, S.M., 2000. Flat Panel Displays — Advanced Organic Materials. The Royal Society of Chemistry, Cambridge, UK.

Li, Z., Meng, H., 2007. Organic Light-Emitting Materials and Devices. Taylor & Francis Group CRC Press, Boca Raton, FL, USA.

Chapter | 16 |

Digital printing and materials

Efthimia Bilissi

All images © Efthimia Bilissi unless indicated.

INTRODUCTION

Recent technological advances in digital printing have enabled the high-quality printing of digital images using non-silver-halide media, as well as some high-end printing methods which combine the use of laser technology with silver halide materials. Historically, there have been two main approaches in printing technologies *impact* methods and *non-impact* methods. With impact printing the print head comes into contact with the paper. An example of this is the dot-matrix printer, where characters and images are formed from a matrix of dots, however, this is now an obsolete technology. All modern printing technologies are non-impact, where, as the name suggests, there is no contact between paper and printer head. These methods include the ejection of ink through nozzles on to a coated substrate, the use of heat for dye transfer, and the combination of a light source and electrostatic charging to adhere toner particles, all allowing the formation of an image or text on paper. Each method has its advantages and possible limitations, as explained later in this chapter. The physical and chemical properties of the printing media play a significant role in the quality of the printed image as well as the device characteristics. Sound knowledge of the media characteristics, as well as practical experimentation, is important in controlling the printer's output. The choice of optimal resolution for the input image is also important to avoid large file sizes and slow printing speeds due to excess unnecessary information. Digital printing of images in large volumes as parts of books, brochures, magazines, etc. is carried out using printing presses, which are presented briefly at the end of this chapter.

PRINTING TECHNOLOGIES

Inkjet printers

A desktop inkjet printer is shown in Figure 16.1. Inkjet printing is based on a print head (carriage) with a large number of nozzles which eject ink on the paper. The print head moves at a velocity of over 1 m s^{-1} backwards and forwards across the width of the paper. The paper advances after each pass (*swath*), controlled by an encoder which ensures high precision. The diameter of the nozzles is very small, about 10 μm, and the velocity of the ejected ink is around $5-10 \text{ m s}^{-1}$. The method of ink ejection depends on the technology employed, described later in this chapter. The distance between the nozzles is referred to as *nozzle pitch* and is a parameter that affects the location of the dots on a page. Nozzle pitch is quoted in μm but some manufacturers, such as Canon, quote the nozzle pitch in dots per inch (dpi). This is often the value quoted as 'print resolution' and can lead to confusion, if the printer is employing *digital half-toning*, in which tones are simulated using clusters of dots to represent each pixel. The output resolution in pixels per inch will therefore be significantly lower than this value.

Inkjet printers are non-impact printers. There are several inkjet technologies, with the earliest, *electrostatic pull*, dating back to the 1960s, in which droplets of ink were drawn through the nozzles using an electrostatic field. Disadvantages of this method include the high voltage necessary to pull the ink and the large nozzles of the jets. Two technologies more commonly used today are *continuous inkjet* and *drop-on-demand inkjet*.

DOI: 10.1016/B978-0-240-52037-7.10016-X

Figure 16.1 An inkjet printer.
©iStockphoto.com/dennysb

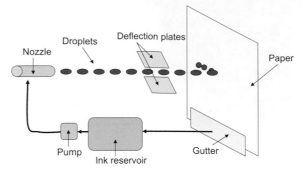

Figure 16.2 The process of printing with a continuous inkjet printer.

Continuous inkjet printers are used mainly for industrial applications. Examples include coding of products such as packages, cans, bottles or cables, and printing of logos. Their operation is based on the *Rayleigh instability*. The Rayleigh instability, named after Lord Rayleigh, who analysed it in the late 1800s, causes a stream of liquid to break into droplets. One of the methods that continuous inkjet printers employ is based on the *Sweet method*, developed by Dr Richard Sweet, of Stanford University in the 1960s, where the direction of the ink droplets is controlled by deflection. The Sweet method allows two different types of deflection: *binary* and *multilevel*. In binary deflection an array of jets is used for ejecting the ink droplets. When a voltage is applied each droplet is charged. An electrostatic field is then used to direct each droplet to the substrate. In multi-level deflection the horizontal movement of the head or the substrate provides the horizontal dimension of the characters. The vertical dimension is provided by deflecting the charged ink droplets vertically, using an electrostatic field. With this method a complete character can be printed by a single pass of the print head. The *Hertz method*, developed by Professor Hertz of the Lund Institute of Technology, in the late 1960s, is another method used in continuous inkjet printers, in which the density of colour is adjusted by controlling the number of droplets for each pixel (employing digital half-toning — see page 310) using electrostatic methods. Up to around 30 droplets can be ejected for each colour, resulting in an increased number of density levels per pixel. The speed of the ejected droplets in continuous inkjet printers is very high, 50,000—100,000 per second per nozzle, and the droplets are in the range of 15—400 μm, depending on the printer. The ink, however, needs to be recirculated and this demands complex hardware (Figure 16.2).

Drop-on-demand (DOD) inkjet printers mainly comprise two technologies: *piezo-electric* and *thermal* (also referred to as *bubblejet*). Piezo-electric technology utilizes piezo crystals in one of the walls of the ink chamber. Piezo crystals are crystals that produce voltage when pressure is applied to them. With the application of electric current these materials become distorted. This is known as the 'reverse piezo-electric effect'. The distortion causes pressure to build in the ink chamber and the ink is ejected from the nozzle (Figure 16.3). The type of distortion, elongation or bending, depends on the crystals and the magnitude of distortion depends on the electrical current. It can therefore be controlled, enabling variation of the size of the ink droplets. Two types of ejectors exist: *flat ejectors*, used in most commercial inkjet printers; and *cylindrical ejectors*, used for inkjet wide-format printers (Figure 16.4).

The ink used for piezo-electric printers is liquid and the droplets produced can be as small as approximately 1—1.5 picolitres (pl). This results in printed dots with a diameter of approximately 10 μm. Another type of piezo-electric printer uses *phase-change* (or *hot melt* or *solid*) ink, which is solid at room temperature. The printing device heats the ink to its melting point, at around 120—140°C, and the ink is then ready for ejection on to the substrate surface. When the ink comes into contact with the substrate, which is at room temperature, it becomes solid, without the need for drying time. An adequate warm-up time, around 10—15 minutes, is necessary before printing so that the ink is allowed to reach its melting point.

In inkjets based on thermal technology, each nozzle corresponds to one ink chamber which is connected to the

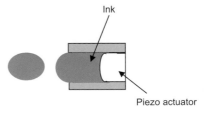

Figure 16.3 Drop-on-demand piezo-electric inkjet printing.

Figure 16.4 Wide-format inkjet printers (also known as *plotters*) can print large-scale images in a variety of substrates. They use roll paper and separate ink cartridges.
©iStockphoto.com/jamirae

ink reservoir. A heater resistor is positioned on a wall of the ink chamber (usually behind the nozzle, but this depends on the manufacturer). The chamber is filled with ink. When an electrical current is applied, for around 1 μs, the temperature of the ink that is closest to the resistor reaches around 300°C, causing vaporization of the ink. The bubble created applies pressure to the ink, which is then ejected from the nozzle (Figure 16.5). When the temperature drops, the bubble contracts and the ink returns to its previous state. This method is also based on studies made by Rayleigh on bubble creation and collapse. Inks used for thermal inkjet printers are therefore restricted to formulae which are not affected by heating and vaporization.

In inkjet printers the accuracy with which the ink dots are placed on the paper is controlled with an optical encoder. This is to ensure that any variations in the speed of the print head will not have an adverse effect on the quality of the print. A transparent plastic code strip, consisting of black stripes, is placed between a light-emitting diode (LED) and a photodetector on the moving head. The beam emitted from the LED passes through the code strip but not through the black stripes. The resulting beam is received by the photodetector, which sends a signal that controls the ink ejection.

As mentioned above, the ink nozzles have a very small diameter, therefore posing the possibility of clogging. To avoid clogging due to dried ink on the nozzle when the printer is not in operation, the nozzles are covered. During printing, however, some of the uncovered nozzles may not be used, which means that they will not eject ink (which nozzles eject ink depends on the image or text being printed). The problem is solved by ejecting ink from every nozzle at preset intervals, when the print head is not over the paper. Clogging can also be caused by substances in the ink itself or due to unstable dispersion of ink particles in pigment-based dyes. Filtering the ink during fabrication and in the printer eliminates the presence of these substances. Wiping of the nozzles is also applied in the printer to eliminate clogging. Advances in ink technology have considerably improved the dispersion of pigment-based inks.

Inkjet printing is based on the *subtractive* method (see Chapter 5) using cyan, magenta, yellow and black (CMYK) inks. With the use of black ink, the effect of any variations of the CMY ink colours on the printed image is reduced. In addition, the image has better contrast. It is also less expensive to print black using black ink instead of using CMY inks. The intensity of colours when printing with an inkjet printer is controlled using digital half-toning and *stochastic printing*, which are explained in more detail in the section 'Colour, resolution and output' later in this chapter. Current inkjet printers designed for printing photographic images use more than the four colours, cyan, magenta, yellow and black, to produce smooth colour tones in the print and to expand the colour gamut obtained by using four inks only. At the time of writing, inkjet printers may use up to 12 inks, depending on the manufacturer. As an example, inks may include 'light cyan', 'light magenta', 'light black', 'light light black', 'photo cyan' and 'photo magenta'. More than one black ink is used for high-quality printing of greyscale images, where only the black inks are used. Some printers incorporate red, green and blue inks in addition to the subtractive ones. Inks may also be customized depending on the printing paper. For example, the eight colour printers of one manufacturer (Epson) include a 'photo black' ink for printing on glossy paper and a 'matt black' ink for printing on matt paper.

Electrophotographic printers

Electrophotographic (EPG) printers are also non-impact printers (see Figures 16.6 and 16.7). Light amplification by stimulated emission of radiation (laser) is the most common light source for EPG printers, but there are other light sources that have been used by manufacturers, as will be described later in this chapter. The introduction of EPG printers that used plain paper instead of the necessary special-purpose paper for earlier EPG printers dates back to the 1970s.

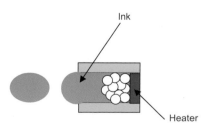

Figure 16.5 Drop-on-demand thermal inkjet printing.

Figure 16.6 An electrophotographic laser printer.
©*iStockphoto.com/jaroon*

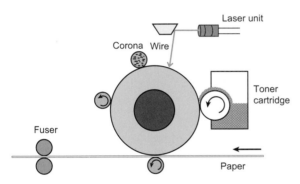

Figure 16.7 Process of printing in an EPG laser printer.

Electrophotographic printers consist of a *photoconductor* (a surface sensitive to light), which is usually organic or silicon. Early photoconductors were made of cadmium, arsenic or selenium, which had very long life span (over 100,000 pages) but were toxic. Organic photoconductors have a shorter life span (up to 100,000 pages) but are regarded as non-toxic. Silicon photoconductors have a much higher life span, up to 1,000,000 pages. The substrate of the photoreceptor is either an aluminium metal cylinder or a flexible web. The photoconductor surface is uniformly electrostatically negatively charged by corona charging. It is then exposed to an optical image using a light source. The light source can be laser or light-emitting diode (LED) arrays. Other methods include liquid crystal (LC) shutters, which have not been widely used, and optical fibre faceplate cathode ray tubes (CRTs) in early printers. Early laser printers used gas lasers, initially cadmium or argon and later helium–neon. Solid-state laser diodes, which can be controlled directly

by the drive current, were introduced in the 1980s, and this reduced the cost for commercial printers. It is important to mention that the spectrum of the laser should match the spectral sensitivity of the photoconductor. The image data, stored in the buffer memory, is converted bit by bit into on/off signals which modulate the laser beam. The light passes through a lens, which focuses the beam to a spot of approximately 42 μm on a rotating polygon mirror. The rotations per minute (rpm) of the mirror depend on the print speed, the printer's resolution and the number of facets of the mirror, and it is in the range of 30,000 rpm. Rotation of the mirror is also affected by heat, ambient or generated by the printer, resistance from the air when the mirror turns, vibrations, and any discrepancies in the manufacture of the mirror. The mirror reflects the light and directs it through a lens, which corrects any effects of the above-mentioned parameters, to the photoconductor. It should be noted that there is a limitation on the maximum paper width that can be used in a laser printer. This is due to the fact that the laser beam becomes more slanted when its angle with the photoconductor is increased.

The areas of the photoconductor surface which are exposed in consecutive rows to light are discharged and a latent image is created. *Development* of the latent image is conducted with the use of dry *toner*. Toner is a polymer mixed with carbon black at approximately 10%. The size of the toner particles is approximately 12 μm. Smaller particles can be produced either mechanically (around 7 μm) or chemically (around 3–5 μm). Although very small toner particles can be produced, there are problems associated with them (see later in this chapter). For this reason there are limitations on the smallest size of particles that can be used in practice.

Positive charge is applied to the toner particles. The toner particles then adhere, with the aid of a material with 3–50 times larger particles, known as a *carrier*, to the latent image on the photoconductor. This is achieved either by magnetic or by electrostatic forces. The developed image is then *transferred* from the photoconductor on to paper and *fused*, usually with a heated roll and high pressure. Another method, cold pressure fusing, is used in some printers. Finally, the excess toner is removed from the photoconductor so that it is ready for the next cycle.

EPG printers that use LED arrays as a light source work on the same principles as the laser printers described above. Instead of a laser beam and a rotating mirror, they employ an array of LEDs, where each LED provides a spot across the width of the printable area. The number of LEDs in the array is related to the horizontal resolution of the printer and the width of the print line. An array of 600 LEDs per inch, for example, is needed for a 600 dpi printer. For a print line with 8 inches width, the total number of LEDs in that printer would be 4800. Colour LED arrays have four rows of LEDs for cyan, magenta, yellow and black. Although the LED printers have fewer mechanical parts and

are therefore less complicated, there is a limitation on how many LEDs can be built into the array because of the technical difficulty of fabricating very small LEDs.

EPG printers use CMY or CMYK toner for colour printing and employ digital half-toning to reproduce continuous tone images. Due to the use of toner particles, however, the dots overlap each other instead of forming distinct half-tone screens. As a result the subtle colours are not well defined or distinguishable from each other.

Thermography

Thermography, printing using application of heat, is divided into two categories: *direct thermography* and *transfer thermography*. Direct thermography is used mainly in applications such as printing labels. The substrate has a special coating which, with the application of heat, changes colour. For the scope of this book the second category, transfer thermography, is presented in detail. Transfer thermography is subdivided into two categories: *thermal transfer* printing (Figure 16.8) and *dye diffusion thermal transfer* printing (D_2T_2). Thermal transfer printing, also known as *thermal mass transfer*, is based on trans-ferring ink (wax or resin) from a donor to a substrate with the application of heat. The ink donor is positioned between a head consisting of heating resistors and a substrate. The donor, usually a sheet or ribbon with thickness of approximately 10 μm, has a layer of cyan, magenta and yellow dyes and a protective layer for the substrate. The arrangement of the dye areas depends on the donor. When a web material is used, the dyes are arranged behind each other so that the image can be printed with one pass of the substrate. With donors using a sheet, several passes of the substrate are necessary for full colour printing. Because the substrate is printed for each colour separately, any slight misregistration will cause a visible effect on the image. The resolution of the printer is determined by the number of resistors. When the resistors are turned on, the ink from the donor is trans-ferred to the substrate with which it is in direct contact. The amount of dyes per pixel deposited on the substrate is modulated by controlling the heating of the resistors. The dot size can therefore vary. Printing with the thermal

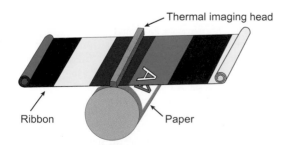

Figure 16.8 Method of thermal transfer printing.

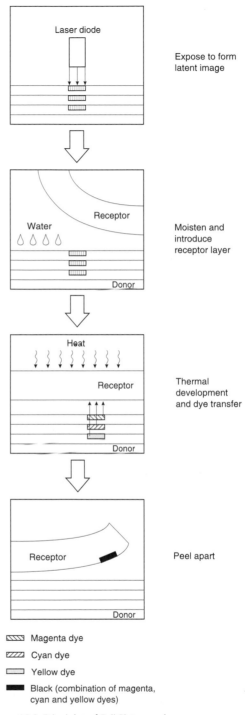

Expose to form latent image

Moisten and introduce receptor layer

Thermal development and dye transfer

Peel apart

Magenta dye
Cyan dye
Yellow dye
Black (combination of magenta, cyan and yellow dyes)

Figure 16.9 Principles of Fuji Pictrography.

Table 16.1 Digital printing technologies and the principles employed

PRINTING TECHNOLOGY	METHOD
Inkjet	Ink injection
Electrophotographic (EPG)	Electrostatic toner transfer
Thermography — Thermal Transfer	Thermal transfer of ink from a donor to a subtrate
Thermography — Dye Sublimation	Thermal transfer of ink from a donor to a subtrate — ink sublimation
Dye sublimation inkjet	Dye sublimation ink injection — heat application
Pictrography	Thermal development and Dye transfer

transfer method is a binary process and *half-toning* is employed for reproducing continuous tones (varying dot size to reproduce different tones is sometimes called *true half-toning*, as opposed to digital half-toning, which uses different arrangements of clusters of dots). The quality of the printed images with this method is lower than the quality from the dye diffusion transfer method.

Dye diffusion thermal transfer printers, also known as *dye sublimation* printers, are based on the *sublimation* of the ink (the ink is converted from solid to vapour without passing through a liquid stage) and employ the same arrangement as thermal transfer printers. When heat is applied to the donor, the ink evaporates. It then penetrates the substrate by diffusion and becomes solid. A special coating on the substrate is necessary. While in thermal transfer printing the dot size can vary, with dye diffusion thermal transfer printing the ink density can change but the diameter of the dot remains almost the same. With this technology 256 levels can be obtained for each colour, resulting in high-quality prints. The printing speed is slower with thermal transfer printers compared to electrophotographic and inkjet printers. Because the dyes are spread through the coating, the image has very smooth continuous tones. The spreading, however, in combination with the low resolution, results in loss of sharpness in the printed image compared to a photographic print. This is shown more in edges rather than large areas with uniform colour. The longevity of dye sublimation prints is affected by humidity and temperature.

Because both thermal transfer and dye sublimation printers work on the same principle (dyes are transferred to the substrate by a donor with the application of heat), systems can be designed to operate multifunctionally — that is, to operate for both thermal transfer and dye sublimation printing. Suitable donors and inks are necessary for this purpose.

Dye sublimation inkjet printers combine inkjet and dye sublimation technologies. These are large-format printers used to print on flexible or rigid substrates such as fabrics and gadgets. The image is printed with the inkjet technology but these printers use special dye sublimation inks. Heating is applied to the substrate so that the gas

inks penetrate it and become solidified. The substrate, however, has to be fully or a high proportion polyester due to the properties of this material with the application of heating. Cotton fabrics cannot be used with this technology.

Pictrography

Fuji Pictrography is a method based on exposing a donor material to light using solid-state laser diodes and silver halide materials (*thermal development and dye transfer technology*). The latent image is created on the donor, which is in contact with the receiving photographic paper. With the application of heat and a small amount of water, a positive image is created on the paper and then donor and receiving paper are peeled apart (Figure 16.9). Further developments of the system have resulted in materials that combine the donor and receiver. Pictrography does not require inks or chemicals, only water. These high-end printers reproduce images with 256 tonal levels for cyan, magenta and yellow. The printing resolution is standard, 400 dpi. The paper is provided by the manufacturer in different types (glossy, matt, OHP). A list of digital printing technologies is presented in Table 16.1.

PRINTING MEDIA AND THEIR PROPERTIES

The properties of the equipment and materials used for digital printing introduce several factors that can have an effect on the quality of the final prints. These factors include deviations during manufacturing of printer components, and properties of the toner or ink and substrate used for printing the images.

Manufacturers have devised methods to improve the hardware and the printing methods, but also the properties and fabrication of toners, inks and substrates to optimize image quality. It is important to note, however, any physical limitations on improvement to hardware and materials, as is shown later in this section.

In an inkjet printer, for example, a variation in the diameter of nozzles which print the same colour may cause *banding* in the printed image. High precision in manufacturing the nozzles that will eject ink of the same colour is essential to obtain uniform density of each colour in the print. Usually all the nozzles of one colour are fabricated in one step. In some inkjet printers the density of the printed colour may be modified by varying the size of the ink droplet. The size of the droplet depends on the amount of ink ejected by the nozzle. It can be controlled either by the pulse in piezo-electric printers or by heating in thermal printers. Another method to create large droplets is by ejecting several small droplets in a fast sequence. With this method printers can print several grey levels per pixel by altering the number of droplets, improving the quality of continuous-tone photographic prints. It should be noted that the size of a printed spot on the paper also depends on the properties of the paper, such as its absorption, as described later.

Paper for inkjet printing

High-quality document printing with inkjet printers can be carried out on plain paper without any special coating. For optimal quality when printing photographs, however, coated paper should be used. The coating of the paper is developed taking account of several factors that include the volume of droplets, the thickness of the coating, the rate at which the ink penetrates the paper, and the absorption of the paper, to name a few (Figure 16.10).

Inkjet printers use mainly water, phase-change, solvent or oil inks and some use ultraviolet (UV)-curable or reactive-based inks. With water inks special paper coating is necessary, otherwise the ink is spread on the surface of

the paper and penetrates it. The ink spread has an adverse effect on the quality of the printed image due to the increased spot size, which causes loss of sharpness and desaturated colours. Short paper fibres and *sizing* (where the paper is coated during manufacture to reduce absorption of liquid when dry) are also used to minimize spread of the ink. The paper coating also adds fluorescence that makes the white surface appear brighter. Prints made with *phase-change* ink are not affected by ink spreading or paper absorption even when the substrate is plain paper or another suitable surface without special coating. The reason is that the ink, ejected as liquid by the nozzle, becomes solid when it comes into contact with the substrate surface, without spreading. This, however, means that the droplets retain a hemispherical shape, which results in light scattering. To eliminate this effect and to increase adhesion, the ink needs to be fused on the substrate. Oil-based inks are used for wide-format printers. UV-curable and solvent-based inks are used for printing on impermeable surfaces such as plastic, glass or metal, and for this reason they are mainly used for industrial applications.

Papers for inkjet printing are manufactured with different finishes (such as glossy, semi-matt or matt), colour (bright white, white), weights or surfaces. *Fillers* are used for this purpose such as titanium dioxide, for example, to create a bright white appearance. Colour saturation may be affected by these parameters. For this reason, the printer driver alters the amount of ink deposited on the paper according to the type of paper used, ensuring optimal results. The combination of ink and paper affects the longevity of the print. Differences in print quality may also be observed when using inks and paper from different manufacturers. With inkjet printers that do not use phase-change inks, the print must be allowed to dry before handling and storing it. For creative work, different non-inkjet types of paper, which are uncoated, may be used. In this case careful selection of papers suitable to be used and experimentation on the effects of the different media on image sharpness, colour saturation and contrast can give interesting results.

The lifetime of inkjet papers is affected by humidity, temperature, exposure to UV rays and acidity of the paper (see more on media stability in Chapter 18).

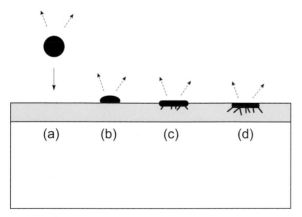

Figure 16.10 Diffusion, adhesion and evaporation in inkjet printing using a coated paper receptor. (a) In-flight droplet. (b) Poor diffusion and adhesion. (c) Good diffusion and adhesion. (d) Excessive diffusion but good adhesion. The dashed arrows represent evaporation.

Inks for inkjet printing

Inks used for inkjet printing are *dye based* or *pigment based*. In earlier systems, there were differences between the colour gamuts of dye-based and pigment-based inks. The colours of dye-based inks are more vivid than the colours of pigment-based inks. Recent improvements in technology, however, have reduced the gap between the two types of inks. Dye-based inks, however, have a faster rate of fading when exposed to weather conditions and light. Their different properties have led to some manufacturers using

both in inkjet printers, for different purposes. For example, dye-based inks may be used for cyan, magenta and yellow, and pigment-based inks for black. Absorption and dispersion of the ink particles on the substrate is another important factor. Dye-based inks are absorbed in the paper while pigment-based inks remain on the surface. Phase-change inks have different properties. They have large colour gamuts and vivid colours and are not affected by ambient humidity or high temperatures, an important property for many applications.

Toner materials

The toner materials used in electrophotographic printers have different properties to those of ink. One of the factors affecting image quality is the size of the toner particles. By application of pressure during fusing the particles are flattened out. When the particles are large, and possibly asymmetrical, the edge definition in an image is affected. Small particles are therefore expected to produce the best image quality. Very small toner particles, however, may also cause problems to the edges of an image, due to scattering. It is also very difficult to control very fine particles inside the printing device. In addition, very fine particles can be a health hazard if breathed in.

In EPG printers the processes of latent image creation, development, fusing and cleaning may cause variability in the results if a large number of prints of the same image is required. This is because the latent image is created and erased for every print. This is a general limitation when printing with non-impact printing technologies compared to press printers, which use a plate.

COLOUR, RESOLUTION AND OUTPUT

Printing photographic images with continuous tones requires around 90 tone levels per colour to minimize the effect of visible banding. Digital printers use a limited number of colour inks, depending on the specific system. Inkjet printers may use up to 12 inks depending on the model, while in EPG printers four colours (CMYK) are used and in transfer thermography three colours (CMY).

The colour gamut of printers is an important factor affecting image quality. The saturation and definition of colours depends on the printing technology. For example, as mentioned previously, saturated colours of an image reproduced by EPG printers are well defined, whereas subtle colours are not. When compared to photographic prints, the saturation of colours produced by a dye sublimation printer is lower and the colour gamut is therefore smaller. Inkjet printers have a wider colour gamut than other technologies such as pictrography. Their colour gamut, however, is affected by the printing media. It is wider, for example, when special photographic

quality paper is used compared to the gamut reproduced on plain paper. The gamut is also affected by the type of inks used. Dye-based inks provide wider gamut than pigment-based inks. There is therefore a wide variation in colour gamuts when a combination of different papers and dyes is used.

Half-toning and dithering

Different printing methods have been devised to represent continuous-tone levels per colour using a limited number of inks. Fundamentally, printing using dots of ink or toner is a binary process — in other words, the individual dots are 'on' or 'off'. The printers use various methods of *half-toning* to give the visual impression of continuous tone. In principle, a greyscale image printed using 'true' half-toning on white paper consists of printed black dots spaced at equal distances. The diameter of the dots varies, creating the impression of different levels of grey. This is due to the visual effect of *assimilation* where, from a suitable viewing distance, mixed black and white dots, for example, are perceived as grey. In digital printers, where the size of an individual ink dot cannot be varied, each pixel is instead printed using a group of dots; this is known as *digital half-toning*. The pixel is divided into subpixels and each subpixel either receives, or does not receive, ink or toner. This is known as a *dot screen*. The number of ink dots determines the size of the half-tone dot and therefore the grey level and colour of the pixel (Figure 16.11). Dark tones are reproduced with large half-tone dots which require more ink dots per pixel. Lighter tones with smaller half-tone dots require fewer ink dots per pixel. This method of half-toning, where the size of the half-tone dot varies depending on the grey level of the pixel, is known as *amplitude modulated* (AM) or *clustered dot* half-toning. AM half-toning has limitations in reproducing images with smooth tonal transition. Early printers which employed this half-toning method were limited in reproducing basic graphics and were unable to reproduce images with photographic quality.

In the 1970s, *frequency modulated* (FM) half-toning was introduced and about a decade later affordable colour

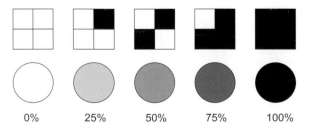

Figure 16.11 A half-tone pattern. From a suitable distance the image is viewed with a gradation of grey tones rather than black and white dots.

inkjet printers employing FM half-toning were produced. This method is also used in electrophotography. In FM half-toning the half-tone dot size is fixed while the frequency of the dots varies depending on the grey level of the pixel. This means that in darker tones the dots are in closer proximity than in lighter tones. Hybrid AM–FM half-tone systems are being developed today to overcome the limitations of the FM half-toning due to the high resolution (over 1200 dpi) of today's inkjet printers. With AM–FM half-tone systems both the size and the frequency of dots varies to represent a grey tone.

Inkjet printers today use *stochastic printing*, a form of FM half-toning, to produce smoother transition of tones. With stochastic printing the shape of the dots is irregular and their placement random (the distance between them is not equal). These systems may also combine a half-toning method with *dithering*. With dithering, a colour that does not exist in the colour palette of the device can be visually simulated by using information from the neighbouring pixels to mix dots of the existing colours that approximate it. Manufacturers use several different algorithms for dithering. One such example is *error diffusion*. An example of an error diffusion dithering algorithm is the algorithm created by Floyd and Steinberg. In this method, processing of one pixel depends on its neighbouring pixels; a pixel's output value is determined by a threshold. Figure 16.12 illustrates the steps of the Floyd–Steinberg algorithm.

The input pixel is referred to as *a* and the transformed pixel as *b*. The indices *i* and *j* refer to the row and column of the digital image matrix respectively. When the pixel value of the input pixel is below the threshold, a value of 0 is returned for the output pixel. When it is over the threshold, a value of 1 is returned for the output pixel. The introduced error is the difference between the values of the input and the corresponding output pixels. To obtain an output image with equivalent tonal scale to the input image the introduced error must be cancelled. This is achieved by using four neighbouring pixels with weights equal to 7/16, 1/16, 5/16 and 3/16 of the error (Figure 16.13). The sum of the error of the processed pixel and the error weights of the four neighbouring pixels should be equal to zero. When a photographic image is printed at high resolution using

X	X	X	X	X	X	X
X	X	X	X	X	X	X
X	X	X	P	7/16	0	0
0	0	3/16	5/16	1/16	0	0
0	0	0	0	0	0	0
0	0	0	0	0	0	0
0	0	0	0	0	0	0

Figure 16.13 The error weights in the neighboring pixels (Floyd–Steinberg error diffusion algorithm).

dithering it appears as a continuous-tone image when viewed from a suitable distance (Figure 16.14).

Resolution

Printing resolution affects the level of detail and tonal gradation that can be recorded in the final printed image. The *native* resolution of a printer refers to the maximum number of pixels per inch it is capable of printing. The native resolution of inkjet printers may vary depending on the manufacturer and the model, and is a factor that affects the choice of optimal input resolution, as described in more detail in Chapter 14. It is therefore advisable to follow the manufacturer's recommendation for the required spatial resolution of the input image for best printing results. A practical method to estimate the optimal spatial resolution of an image is described at the end of this section. The *addressable* resolution (or *printer resolution*) of a device refers to the total number of dots per inch and can be higher than the value of pixels per inch. It depends on the technology used. In inkjet printers the nozzle size, nozzle pitch, size of droplets and number of droplets are factors that affect the printer output. Small droplets improve the resolution of the printer but there is a practical limit on reducing their size. Below that limit accurate placement of the droplets on the substrate is very difficult due to the effect of aerodynamic forces. Small ink droplets demand higher speed of drop ejection per second compared to ejection of larger droplets to cover the same area. At the time of writing, addressable printer resolutions

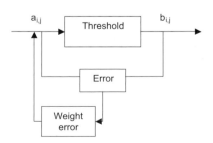

Figure 16.12 The Floyd–Steinberg error diffusion algorithm.

(a) (b)

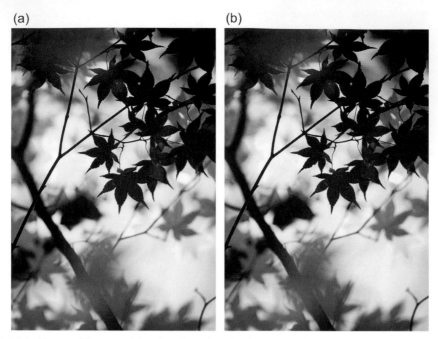

Figure 16.14 (a) Original image. (b) Image with reduced number of colours using Floyd—Steinberg error diffusion. ©*iStockphoto.com/ooyoo*

are in the range 1440—2880 dpi or higher. As mentioned before, however, EPG and inkjet printers are able to print more than one dot per pixel and these dots are overlapping.

Selecting the optimal input image spatial resolution for output is an important task. Lower resolution may result in printed images appearing 'pixelated' while higher resolution will include unnecessary information which will only increase the file size and printing time but will not be used by the printing device. This applies to bitmap images and not vector graphics, which can be enlarged in any dimension without the resolution affecting image quality. The optimal input resolution is described in more detail in Chapters 14 and 24.

In the early years of inkjet printers, their addressable resolution was around three times higher than the spatial resolution of the input image. The optimal spatial resolution of the input image was therefore calculated by dividing the printer's addressable resolution by 3. With the technological advances of recent years the addressable resolution of inkjet printers increased further, so dividing it by 3 results in images with very high spatial resolution that exceeds optimal resolution.

A general rule for estimating the optimal spatial resolution of an image aimed for printing is based on properties of the human visual system and specifically on the contrast sensitivity function of the human eye (see Chapter 4). It also depends on the viewing distance. The correct viewing distance for a print can be estimated by multiplying the

print's diagonal by 1.5. It has been found that for a viewing distance of 250 mm, which is a typical reading distance, the representative limit of resolution for continuous-tone images is 5 cycles per mm. This corresponds to about 250 ppi at the dimensions of the printed image. Due to the fact that a pixel may be affected by its neighboring pixels, a higher spatial resolution is recommended for printing, typically 300 ppi. However, the manufacturer-recommended printer resolution for printing photo quality images on a particular printer, which is based on the native resolution of the printer (if it has one), may not be 300 ppi, but is likely to be close to it.

Note that in dye diffusion thermal transfer printers, the spatial resolution of the input digital image should match the resolution of the printer. The reason is that this type of printer employs a different printing method without the use of digital half-toning and dithering. For this reason, the resolution of a dye sublimation printer is not comparable to that of an inkjet printer. Typical addressable resolution for this type of printer is 300 dpi, but this depends on the manufacturer and the model.

PRINTING PRESS

Reproduction of photographs in media such as books, brochures, newspapers, etc. is carried out using *printing*

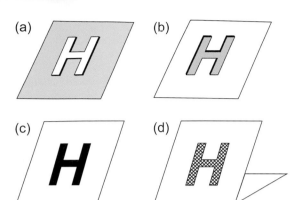

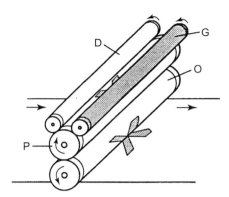

Figure 16.15 Categories of printing processes. (a) Relief printing. (b) Recess printing. (c) Planographic printing. (d) Through printing.

Figure 16.16 Principle of offset photolithography press. D, dampening roller; G, roller carrying greasy ink; O, large rubber offsetting roller transfers image ink to moving paper; P, printing plate with image.

presses. The main categories of printing processes which are carried out by printing presses are *relief printing, planographic printing, recess printing* and *through-printing* (Figure 16.15).

Relief printing

The principles of relief printing are based on the letterpress, a type of relief printing, invented by Johann Gutenberg in 1440, where characters are transferred, reversed, by the inked surface to paper or fabric by application of pressure (a form of impact printing). The inked surface is the raised area of the character. Application of the ink on that surface is carried out using rollers. A characteristic of this method is the effect on the edges of the printed area which appear raised with more ink. This is due to the pressure of the inked surface on the paper. The tonal range of an image is reproduced by applying different pressure to areas with highlights compared to shadows. Three types of printing presses exist in relief printing: *platen* and *flatbed cylinder*, where the plates are placed on a flat surface; and *rotary*, where the surface is a cylinder. Use of a web-rotary press with rubber or plastic plates is called *flexography*. It prints at high speeds and even on tough paper surfaces due to the properties of its plates.

Planographic printing (or lithography)

In lithography the surface of the lithographic plate is flat. It is treated so that the area with the image accepts a greasy ink while the rest of the plate surface accepts water. When a roll applies greasy ink on the surface, only the image area will hold the ink. Because the greasy ink and water do not mix, the image and non-image areas are well defined. Lithography is further divided into *direct lithography* and *offset lithography*. Offset lithography uses an intermediate stage; the image from the plate is transferred to a rubber blanket and then to the printing paper. In this case the printing is indirect, with no direct contact between the lith plate and the printed surface (Figure 16.16). Offset lithography is suitable for very large volumes of prints because of the low level of wearing of the plate. For this reason it is the main method used today for printing books, magazines, brochures, newspapers, etc. Also, the images and characters are not reversed.

Recess printing

In this technology the image or characters are engraved on the plate or cylinder. When the plate or cylinder is inked, the ink remains in the recessed areas. By application of pressure it is transferred to the paper. One of the best-known methods is *rotary photogravure* (or gravure). This method provides a rich tonal range and was used in art photography in the nineteenth and early twentieth centuries. In gravure the inks used are solvent based. Applications of gravure printing include art books and magazines. *Intaglio* is another method of recess printing, consisting of *line engraving*, which uses copperplate and steel engraving, and *artistic engraving* uses drypoint and mezzotint engraving.

Through printing

In *through printing* or *silk screen printing* a material such as silk is mounted on a frame. A stencil produced on the silk screen covers the areas that should not be printed. Ink is applied to the uncovered areas and by pressure it is transferred to the substrate. Four screens for cyan, magenta, yellow and black can be used for printing colour photographic images while one screen can be used for black-and-white images.

BIBLIOGRAPHY

Diamond, A.S., Weiss, D.S., 2002. Handbook of Imaging Materials, second ed. Marcel Dekker, New York, USA.

Floyd, R., Steinberg, L., 1975. An adaptive algorithm for spatial grey scale. SID Digest, pp. 36–37.

Hunt, R.W.G., 2004. The Reproduction of Colour, sixth ed. John Wiley, Chichester, UK.

Jacobson, R., Ray, S., Attridge, G.G., Axford, N.R., 2000. The Manual of Photography. Focal Press, Oxford, UK.

Johnson, H., 2004. Mastering Digital Printing, second ed. Thomson Course Technology, Boston, MA, USA.

Kipphan, H., 2001. Handbook of Print Media: Technologies and Manufacturing Processes. Springer, Berlin.

Lau, D.L., Arce, G.R., 2001. Modern Digital Halftoning. CRC Press, Boca Raton, FL, USA.

Lukac, R., Plataniotis, K.N., 2007. Color Image Processing: Methods and Applications. CRC Press, Boca Raton, FL, USA.

Norberg, O., Andersson, M., 2002. Characterization of printing situations. IS&T's NIP18: 2002 International Conference on Digital Printing Technologies, pp. 774–776.

Ohta, N., Rosen, M., 2006. Color Desktop Printer Technology. CRC Press, Boca Raton, FL, USA.

Ray, S.F., 1999. Scientific Photography and Applied Imaging. Focal Press, Oxford, UK.

Russ, J.C., 2007. The Image Processing Handbook. CRC Press, Boca Raton, FL, USA.

Webster, E., 2000. Print Unchained — A Saga to Invention and Enterprise. DRA, West Dover, VT, USA.

Zakia, R.D., 2007. Perception and Imaging, third ed. Focal Press/Elsevier, Burlington, MA, USA.

Chapter | 17 |

Digital image file formats

Sophie Triantaphillidou and Elizabeth Allen

All images © Sophie Triantaphillidou, Elizabeth Allen unless indicated.

INTRODUCTION

The issue of the storage of digital images is more complex than that of images on silver halide materials, where the sensor is also the storage medium. Thought must be given to much more than simply the physical conditions of storage. The image data must be encoded in some way in an image file; this must be stored in a file format, which is then saved to some form of hardware storage device. There are a range of factors to consider in selecting a particular image file format, which are fundamentally governed by the image properties, the way in which the image is being used and specific storage/file size requirements.

Digital images can be considered simply as arrays of pixel values; however, the image data must be converted to binary code to be processed, stored and transmitted. This code needs to be represented in an image file in a way that allows it to be interpreted as it moves through the imaging chain. The image file format determines how the image data are organized. It also defines the 'packaging' around the data: at the very least it will include a *header* which contains extra information necessary or useful for its interpretation, such as datatype, resolution, bit depth, colour space; it may also include *metadata* (defined as 'data about data') such as *Exif* (Exchangeable Image File Format) information from digital cameras.

There is a wealth of file formats available for the storage of images and many more that have been developed and have since become obsolete. Luckily, as digital imaging technology has progressed, the range of formats used within the imaging industries has decreased, converging to a collection which is now widely used for the majority of imaging applications. These formats encompass a range of image types, employ different approaches to store images efficiently and have various advantages and limitations; in some cases these allow them to be optimal for a particular aspect of imaging.

The majority of formats currently used in the imaging industries have something in common: they are, in most cases, imaging *standards*, meaning that they have gone through a fairly lengthy process of development and that they are widely available. They also tend to have enough flexibility to allow further development and improvement to adapt to the changing needs of the technology and systems. In some cases they are also *de facto standards*, meaning that they have become the dominant standard for a particular imaging task or application (note, however, that a de facto standard is not necessarily a standardized file format). This may be either as a result of widespread adoption by manufacturers, or because they have become the preference of the majority of users over other equivalent formats.

There are a number of important properties to consider when selecting a file format. These are briefly summarized below, before more detailed information about the most relevant formats is given.

Raster and vector graphics

Most fundamental in defining the nature of an image file, the type of imaging graphics relates to the structure of the image information across the image plane. In photographic imaging we are predominantly dealing with *raster graphics*, which are essentially defined by an array of discrete values, commonly known as a *bitmap*. The raster is the image grid

DOI: 10.1016/B978-0-240-52037-7.10017-1

of picture elements; nowadays we use raster displays, i.e. displays made up of pixels. The alternative type of image representation uses *vector graphics*. These are most commonly used in computer graphics applications and drawing programs, although one may well work with both types if using text with images or *selection paths*, which are defined using vector descriptions.

Vector images are described in terms of lines and shapes, which are represented by mathematical formulae. The vectors represent end points, directions and magnitudes of lines, for example, in an efficient way.

The difference between the two image types is shown in Figure 17.1. The bitmap has samples fixed at regular intervals, hence it suffers from the various artefacts, such as aliasing, which are characteristic of sampled images (see Chapter 7). It is also of a fixed resolution and if magnified enough the samples will be visible (i.e. pixelation).

The vector image has no fixed points — a line can have end points at any position within the image. Curves may be represented in various ways, most commonly using a parametric description. Bezier curves and splines are examples. Vector graphics provide a compact approach to describing shapes and lines, and these may be easily altered in size and shape using geometric transformations. Because the objects within a vector image are described by equations rather than sets of discrete samples, the image is resolution independent and resizing operations do not result in artefacts related to sample size and separation. It is more difficult, however, to represent filled shapes with vectors, and impossible to reproduce the many spatial, tonal and colour variations that occur at a minute level in natural scenes. Vector descriptions are therefore not so useful for representing photographic quality images; they tend to be used for computer-generated images and drawings.

To be displayed on a typical computer monitor, vector graphics must be *rasterized*, i.e. converted into an array of pixels.

There are a number of image file formats that use some form of vector representation. Many use vectors to describe text and graphics objects, but will have the capability to also contain bitmap information. In this chapter we will mainly concentrate on the bitmap formats, but include the *Portable Document Format* (PDF), which is an example of a vector-based format used widely nowadays for proofing documents that contain both graphics and bitmaps.

Bit-depth support and colour encoding

Bit-depth support defines the *image modes* that can be stored by a particular file format. The image mode relates to how many colour channels and how many bits per channel are stored for an individual pixel. The bit-depth support therefore limits the colour encoding (see Chapter 23). Many formats were developed at a time when imaging industries dealt with predominantly 8-bit (per channel) images, but it is becoming more common nowadays to work with 16 bits per channel. In many cases formats have been updated to provide support for 16-bit quantization. *Graphics Interchange Format* (GIF) is a special case, as GIF images contain up to 8 bits in just a single channel, whether the image is greyscale or colour. This is a *paletted* or *indexed* image, which means that a colour palette, or table, is included with the image data. Because each pixel may be represented by a maximum of 8 bits, it can take a maximum of 256 different values. However, the pixel values are actually indices into the colour palette and, for an RGB image, the index will point to a triplet of RGB values defining the colour.

Compression methods

The file format will define which types of compression algorithms are available and importantly whether the compression is *lossless* or *lossy*. Lossy compression is only suitable for applications where some loss in image quality can be tolerated. This is an immediate limiting factor in terms of the selection of certain file formats such as the *Joint Photographic Experts Group* (JPEG) format. This was designed as a lossy method and although it has a lossless version, this has not been widely adopted or supported. Compression is covered in more detail in Chapter 29.

Standardization of the format

If a format is a standard, then it has the advantage of being open source and widely available. Technical standards are a formalization of a method or process. A standard file

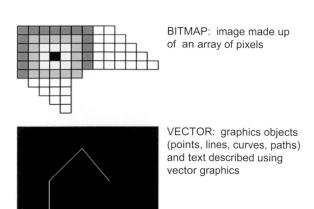

BITMAP: image made up of an array of pixels

VECTOR: graphics objects (points, lines, curves, paths) and text described using vector graphics

Figure 17.1 Bitmap versus vector graphics.

format will have certain aspects completely specified, such as the language used to store the data, the type of data stored and the structure of the file. This means that a standard file format will have the same or very similar structure, independently of implementation. Standards make it easier to ensure cross-platform compatibility.

Proprietary file formats are developed by individuals or companies who then 'own' them, meaning that they control the distribution and availability of the format, as well as the ability to make changes to it. This also means that they may charge for their use. An example of the problems associated with proprietary formats is that of the RAW format (or formats!). At the time of writing there is no standard RAW format. Most digital camera manufacturers have developed their own proprietary RAW format. The result is a set of formats, each using different methods to encode and interpret the data and, until recently, each requiring its own converter, i.e. software that opens the RAW images and allows them to be processed, converted and saved to other formats (see later RAW format).

De facto standards are those that have become standards as a result of widespread adoption. As mentioned earlier, they may also be formal standards, but not necessarily.

Metadata and Exif

The metadata contained within a file is extra information that is useful to include with the image data and assist the processing of the image within the imaging chain. Metadata may include capture information such as ISO rating, aperture and shutter speed, focal length, lighting conditions and the average colour temperature of the scene. Information about the scene content, for example keyword descriptions, may also be included. Exchangeable Image File Format (Exif) is one of a number of specifications for the storage of camera metadata, used in a range of different file formats. Exif data are embedded in the image file format.

Colour management

The file format will specify what methods of colour representation are available and more specifically which colour space encodings are supported. A format may allow for the use of image profiles, allowing the image to be colour managed by International Color Consortium (ICC) colour management (see Chapter 26). If colour space support is limited by a file format, information may be lost when the image is saved in this format and into a particular colour space.

Additional features

These are many and various and are usually extra capabilities that make a file format suitable for a particular application. Examples include *progressive display*, which allows the image to be partially displayed as it is being transmitted, important for web applications; support for transparency and layers, important in composite images and for formats to be useful as an interim during image editing; and multi-resolution support, meaning that the image can be saved at a high resolution, but opened at lower resolutions, cutting down the need to save multiple different-sized image files.

TAGGED IMAGE FILE FORMAT (TIFF)

Tagged Image File Format (TIFF; extension .tif or .tiff) is a tag-based image file format, developed for storing and interchanging bitmap images originating from scanner and desktop publishing applications. The first public version of the TIFF specifications was published by Aldus Corporation in 1987 in consultation with scanner manufacturers and software developers, who agreed on a common image file format to replace individual manufacturer proprietary formats. This first version was the third revision of TIFF (named TIFF Revision 3.0) and stored only greyscale images. Very soon after this, TIFF Revision 4.0 was published, supporting RGB images and a little later in August 1988 TIFF Revision 5.0 came out, adding the capability of storing indexed colour and supporting *Lempel-Ziv-Welch* (LZW) compression (see Chapter 29). The current TIFF Revision 6.0 was released in June 1992 by Adobe Systems (which merged with Aldus Corporation in 1994) and additionally supported CMYK, YC_bC_r and CIE $L*a*b*$ image encoding (see Chapter 23), and standard JPEG compression (see Chapter 29). Since then some extensions have been made to this current version, published in the form of technical notes.

Today TIFF is widely used and supported by most imaging and desktop publishing software. Although it has not been standardized, it is a de facto standard. Two different file format specifications that are based on TIFF have been standardized: the TIFF/EP (ISO 12234-2:2001) and the TIFF/IT (ISO 12639:2004) — seen later in the chapter. TIFF is considered to be the leading commercial and scientific image file format, because of its flexibility, power, extensible nature and many options. The fact that the source code of TIFF is easily accessible, alongside its stability and its easy access and retrieval across all platforms (PC, Mac, Unix, etc.), makes TIFF the most suitable format for image archiving purposes nowadays, along with JPEG 2000. The goal of Adobe when TIFF 6.0 was published was to update the format while maintaining compatibility 'so that TIFF will never become obsolete and should not have to be revised more frequently than absolutely necessary'.

TIFF is a highly adaptable file format that stores images and data in a single file by including a basic set of file header tags (see Figure 17.2) that indicate the basic

317

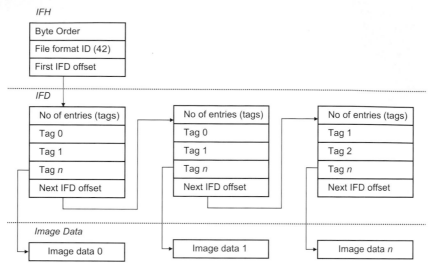

IFH

| Byte Order |
| File format ID (42) |
| First IFD offset |

Figure 17.2 The TIFF structure.
Adapted from Gosney et al. (1995)

properties of the image. Manufacturers can use private tags to enable them to include their own proprietary information inside a TIFF file without causing problems for file interchange. TIFF is ideal for most storage needs, allowing storage of multiple bitmap images of virtually any colour encoding and bit depth: 1 bit per pixel bi-tonal, 4- or 8-bit greyscale or palette colour, and up to 48- and 64-bit colour. The largest possible TIFF file is 2^{32} bytes in length, equal to 4 gigabytes. It is important to note that, although the TIFF 6.0 specification allows for up to 64-bit colour, many TIFF readers will only open a maximum of 24-bit RGB images or 32-bit CMYK images. Also, not all readers open multi-image TIFF files. TIFF supports the storage of uncompressed images – that is its most popular application. However, as mentioned earlier, lossless schemes such as LZW (compression of full colour images – Chapter 29) and ITU-T.6 (compression for bi-tonal images) are used for reducing file size without any information loss and JPEG lossy compression (see Chapter 29) is supported by TIFF. Other available TIFF options include multi-pages and layers and the support of ICC colour profiles. Because of multi-page support and the support of compression of bi-tonal images TIFF is being widely used for the storage of faxes, especially on fax servers.

On the downside, TIFF image files are generally large, mostly due to the versatility of the TIFF tags. Uncompressed TIFF files are approximately the same size in bytes as the image size in the computer memory. Because of its versatility and flexibility, TIFF was considered for many years as complicated and confusing, but not so any more. Tags that are contained with the data can sometimes cause incompatibility, but any imaging application will nowadays handle standard baseline TIFFs. A source of problems when opening compressed TIFF files can be the use of applications that do not support algorithms used to compress image data, but these are very rare nowadays.

The TIFF structure is illustrated in Figure 17.2. It contains an *image file header* (IFH) describing the byte order used in the file, the identification number 42 (a number providing the answer to the universe) that identifies the file as a TIFF and the offset position of the first *image file directory* (IFD). The IFD is a collection of information similar to the header used to describe the bitmap data to which it is attached, such as image height and width, bit depth, number of colour channels and type of compression used. The information is stored in one or more data structures, called *tags*. The IFD also contains the offset position of the next IFD. There may be more than one IFD in a TIFF file, but a baseline TIFF reader is not required to read any IFDs beyond the first one. The *image data* follow each IFD.

TIFF/EP

Tagged Image File Format for Electronic Photography (TIFF/EP; extensions .tif or .tiff) is an image file format based on a subset of the current revision of TIFF Version 6.0 and of the Exif standard. TIFF/EP was standardized by the International Organization for Standardization in 2001 (ISO 12234-2:2001). It is defined to be as compatible as possible with existing desktop software packages, to enable them to operate with images from electronic cameras. Several still-picture cameras use it as their native TIFF format. There are no major departures from the TIFF 6.0 standard structure (Figure 17.2) except that many of the existing TIFF tags are not used while there are a small number of new tabs. A TIFF/EP file is a valid TIFF file that contains the TIFF/EP format identifier and has

exactly the same header as the TIFF header. Unlike TIFF, in TIFF/EP there is a method for dealing with thumbnail images. The allowed colour space encodings are RGB, YC_bC_r and CFA (colour filter array) — see Chapter 23 — but not all TIFF/EP readers read CFA encoded files. The format supports uncompressed, JPEG lossless and lossy compression algorithms; however, TIFF/EP readers are only required to open uncompressed images.

TIFF/IT

Tagged Image File Format for Image Technology (TIFF/IT; extensions .tif or .tiff) is another file format based on TIFF Version 6.0 which has been standardized. Its current second edition is defined in the ISO 12639:2004 standard, which specifies media-independent means for prepress electronic data exchange. The TIFF/IT standard is intended to facilitate the interchange of rasterized images among electronic digital systems used in prepress image processing, graphic arts design and related document creation and production operations. It supports the encoding of continuous-tone images, colour line art, binary images and binary line art, screened data and images for composite final print pages. The current second edition of the standard specifies three levels of conformance: TIFF/IT (also referred to simply as TIFF/IT), TIFF/IT-P1 and TIFF/IT-P2. TIFF/IT-P1 provides a smaller set of options to permit simpler implementation and compatibility, where possible, with commonly available TIFF 6.0 readers and writers. TIFF/IT-P2 is also a subset which incorporates all of the options defined for TIFF/IT-P1 but provides wider image type support. The primary colour space for the TIFF/IT standard is CMYK since the intended output is a printed page. The 2004 edition of the standard added support for an expanded line-art palette (up to 65,535 colours) and support for up to 32 colour separations. Other colour spaces and the use of ICC profiles are supported, but the P1 profile is limited to CMYK. Many magazines and journals require that advertising materials are submitted as TIFF/IT.

JOINT PHOTOGRAPHIC EXPERTS GROUP (JPEG)

JPEG is a lossy compression standard and also the name of the related file format (file extension .jpg, .jpeg). The compression standard was developed by the Joint Photographic Experts Group, a joint ISO/CCITT committee, with the aim of producing an international standardized method for the compression of 'natural', continuous-tone, greyscale or RGB images. The specification was proposed in December 1991 and standardized as ISO/IEC IS 10918-1|ITU-T Recommendation T.81, in 1994. A file format, *JPEG Interchange Format* (JIF), was included in an annexe in the standard. This was quickly updated to the *JPEG File Interchange Format* (JFIF), which is described in the standard as 'a minimal format which enables JPEG bitstreams to be exchanged between a wide variety of platforms and applications … the only purpose of this format is to allow the exchange of JPEG compressed bitstreams'.

Two JPEG file formats are currently used today: JPEG/JFIF and JPEG/Exif. The files stored using both these formats are commonly referred to simply as 'JPEG' files. JPEG/JFIF is used most commonly for storing or transmitting files on the Internet and has now become a de facto standard. JPEG/Exif has gained widespread use in digital cameras. It should be noted that a lossless version of JPEG compression, JPEG-LS, was also released, but has never really been used; therefore, we will deal here only with the well-known lossy version, *baseline JPEG*.

The JFIF implementation is compatible with Mac, Windows or Linux operating systems. It provides support for up to 8-bit greyscale or 24-bit colour, but uses the YC_bC_r colour space, into which images to be saved as JPEGs are transformed in a pre-processing step before compression. If an RGB image is to be saved as a JPEG, its YC_bC_r components are calculated using a linear transformation. The compression method is the lossy JPEG compression algorithm, which is detailed in Chapter 29. More in-depth information about the colour encoding in JPEG can be found in Chapter 23.

JPEG files consist of a series of *markers*, specifying various properties which may be followed by *payload data*. The markers specify the type of JPEG implementation, the quantization tables used, the Huffman tables used in entropy coding (see Chapter 29), the start of the image data and the end of the file. Some markers are for description of specific data, such as Exif, and some are used for text comments. The payload data includes any data relating to the markers, for example the values within the tables and the entropy coded image data.

JPEG can achieve high levels of compression, up to 1:100 (with heavy penalties in image quality). Up to 1:10, it is generally considered to be *perceptually lossless*, meaning that the artefacts caused by the algorithm are virtually imperceptible. High compression rates, coupled with the fact that JPEG represents the appearance of continuous tone, have led to the format being one of the most widely used with images on the Internet, as well as a range of other imaging applications.

The JPEG/Exif format is based upon the JFIF implementation, but includes camera metadata in an Exif format, such as date, time and camera settings and an image thumbnail. JPEG/Exif files are supported by nearly all consumer digital cameras on the market and it is expected that this will continue. JPEG files are able to embed ICC colour profiles, such as sRGB and Adobe RGB 98, making them compatible with ICC colour management systems, although JPEG profiles are not always recognized by application software.

There are certain characteristic artefacts of JPEG at high compression levels, known as 'blocking' and 'ringing' artefacts (see Figure 29.15). These can be more bothersome in higher resolution printed images, where quality requirements are higher and images are likely to be more closely examined, but in such cases lossless formats are more commonly used. The quantization in the JPEG compression algorithm is achieved using visually weighted quantization tables, which are defined based upon a quality setting selected by the user. There is always a trade-off between the degree of compression and the image quality of JPEG images, but that is a problem with any lossy compression method. The global adoption of JPEG indicates that as a lossy format it is one of the best. One of the areas, however, where it is less successful is in the compression of images containing text. This has been one of the reasons behind the development of the latest standard, JPEG 2000.

JOINT PHOTOGRAPHIC EXPERTS GROUP 2000 (JPEG 2000)

The JPEG 2000 format (file extension .jp2) is a *wavelet*-based image compression standard, developed by the JPEG committee to address the evolving requirements of digital imaging technologies and to improve upon some of the limitations of the earlier JPEG format. As with JPEG, the standard specifies both compression method and file format. The compression method is covered in more detail in Chapter 29.

The call for proposals for the new compression standard went out in 1997. One of the committee's aims was to develop a standard which would be useful in some of the emerging digital imaging areas, such as medical imaging, digital image libraries and mobile applications. The format was required to support multiple bit depths and image types (bi-tonal, greyscale, colour), provide lossless and lossy compression, and support a range of imaging models, preferably in some unified system. Another key requirement was superior compression performance to existing standards, especially at low bit rates (corresponding to high compression levels): JPEG and other schemes performed well at high bit rates (low levels of compression) but suffered from severe distortions at low bit rates. This was relevant in many of the new areas of digital imaging, especially in multimedia, the Internet and mobile phones, where images needed to be heavily compressed.

The features in the resulting standard, ISO/IEC 15444, approved in 2001, are summarized in Chapter 29. Further versions of JPEG 2000 have since been approved, adding various new parts to the standard. Key to the JPEG 2000 format is that it produces a multiple resolution representation of the image. This is achieved because JPEG 2000 uses a *discrete wavelet transform* (DWT) instead of the DCT used in JPEG, to pre-process the data prior to optional quantization.

The ability of JPEG 2000 to support both lossless and lossy compression makes it suitable for imaging applications which require perfectly reconstructed images, such as medical imaging and image archiving, as well as the applications already supported by JPEG. The results from comparison studies with JPEG on the image quality of the

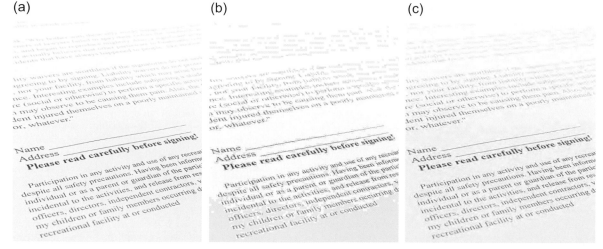

(a)　　　　(b)　　　　(c)

Figure 17.3 Comparison of the performance of JPEG and JPEG 2000 when compressing images containing text. (a) Original uncompressed image. (b) Image compressed using JPEG (compression ratio 1:94). The ringing and contouring artefacts are very obvious, and obscure the text in many areas. (c) Image compressed to the same compression ratio using JPEG 2000. Although artefacts are also obvious, they do not degrade the text by the same amount, and it is much more legible.
© iStockphoto/fotko

lossy compression are discussed in Chapter 29. One type of scene content successfully addressed by JPEG 2000 is an improvement on the poor performance of JPEG when compressing text (Figure 17.3).

JPEG 2000 provides for multiple colour spaces and image types. Images may be single channel or multiple channels, greyscale, bi-tonal or colour. In terms of colour space encoding support, it includes palettes, device-dependent RGB, sRGB, YC_bC_r and some ICC colour spaces. Because it is able to work with bi-tonal images and text in particular, it is suitable for layout applications. However, possibly as a result of the development and growth in the use of the PDF format, it has not been widely adopted for this purpose. In general, although JPEG 2000 addresses many of the areas of weakness in JPEG and provides many features useful in imaging applications today, it is still not widely used. This may be partly due to the lack of support by web browsers, although there are plug-ins available, but also because there are a number of other competing formats that possess some of the application-specific features. The same applies to digital cameras, where support for the format is inconsistent. However, there is much research going on in various specialist imaging application areas such as forensic imaging and image archiving into the suitability and performance of JPEG 2000, which is likely to ensure that it will eventually becomes a more widely available format.

RAW

RAW (the extension is variable – see Table 17.1) is not a single file format but is a generic term indicating proprietary image file formats that contain unprocessed (or minimally processed) digital image data originating from digital capturing devices. A RAW file is composed of two parts: the image data and the metadata. It is expected to contain a record of the image data as captured by the electronic sensor – the so-called *sensor data* – which has been sampled and quantized according to the specifications of the sensor and the analogue-to-digital converter (ADC) of the capturing device. In most commercial cameras some processing, such as dark noise reduction and the mapping out of 'dead' pixels, takes place on the sensor and thus the raw data are not totally unprocessed (see Chapter 14 for the image-processing pipeline in digital cameras). Also, non-linear quantization may be employed at capture, which allows distribution of the tonal information in a similar manner to the human visual system (HVS).

RAW image files are often compared to photographic negatives, for these are unrendered images containing image information from which one can generate different kinds of prints. In a similar fashion RAW files, sometimes called *digital negatives* (note, however, that there is also an Adobe RAW format called a digital negative – see below), can be rendered in different ways depending on the rendering settings chosen by the user, who can adjust a wide range of parameters, including white balance, tonal mapping, noise reduction, sharpening and others to achieve a preferred look (more details are given in Chapter 14). Processed images are then saved for display or print in a rendered image file format such as TIFF or JPEG, but the RAW data file remains unchanged, and can be 'archived' for future re-rendering.

In most commercial digital cameras, where colour filter arrays are overlaid on CCD or CMOS sensitive elements to filter the incoming light and separate colour information, the raw pixel values of the red, green and blue channels are of incomplete resolution (see Chapters 9 and 14). The resulting captured image has only one full channel of information in which some of the pixels represent (most commonly) red, some green and some blue pixel values (CFA colour space). To retrieve the full resolution three-channel RGB image from the raw file the mosaic data are interpolated and combined – a process known as *demosaicing*. RAW files from scanner sensors, or from full-colour camera sensors (such as the Foveon™ range of multi-layer image sensors – see Chapters 9 and 14), provide raw data which do not need demosaicing. Further, since electronic sensors are linear devices (they respond to light in a linear fashion, unlike the HVS and silver-based photographic media – see Chapters 4, 8, 9 and 21), the tone reproduction of RAW files is linear – provided that linear quantization has been employed. In exceptional cases, curve shaping may have taken place during or after ADC and the RAW file ends up with a gamma different from 1.0. Digital RAW files contain pixel values of high bit depth (often 12, 14 or 16 bits per pixel per colour channel) compared to typical 8-bit per channel renderings and thus can store greater tonal latitude

Table 17.1 Examples of extensions used by various manufacturers for their photo RAW files

FILE NAME EXTENSION	MANUFACTURER
.dng	Adobe
.crw, .ciff, .cr2	Canon
.raf	Fuji
.k25, .kdc, .dcr	Kodak
.nef	Nikon
.orf	Olympus
.cap, .tif, .iiq	Phase One
.srf, .sr2, .arw	Sony

and finer tonal and colour variations. Important image processes result in fewer artefacts when performed on high-bit-depth data, such as raw data (or high-bit-depth TIFF data), than when done on already typically rendered 8-bit per channel images. Applying tone modification, such as a typical gamma correction of 1/2.2 for example, on 8-bit per channel data, will result in a loss of almost 30% of the available intensity levels in the image due to rounding errors, compared to a loss of 3% when the same gamma correction is applied to 12-bit data which are then down-sampled to 8 bits for viewing (details in Chapter 21).

In addition to image pixel values, RAW files contain large amounts of metadata. Apart from Exif type metadata, further metadata are included in RAW files to be used by *RAW converters*; these are necessary to process the RAW files and render them for appropriate viewing.

While raw data provide great flexibility and choice of image rendering, RAW file formats are proprietary and their structure differs from manufacturer to manufacturer and even from one camera model to another. They are not standardized or documented. Often image information is compressed using lossless (or nearly lossless) data compression methods. The fact that different RAW formats are in use creates problems of support with software for conversion and guarantees no compatibility with future software.

Cameras that support RAW files provide proprietary RAW converters to render their RAW format. While other conversion programs, plug-ins and open source programs are available, they do not always deal with all proprietary RAW files. These other applications aim to provide a common interface for the conversion of many different RAW files. Adobe camera RAW is a generic converter which has gained widespread use within the commercial industry. Images are rendered differently by different RAW converters which employ different (proprietary) rendering algorithms. For example, as there is no standard algorithm for converting data from Bayer colour filter arrays into RGB, different RAW converters may produce different colours for the same digital file, even if the rendering settings chosen by the user are the same. Most RAW converters will perform the following operations:

- Demosaicing — involves interpolation (see Chapters 14 and 26) and is based on the information provided in the metadata regarding the arrangement of the colour filters on the sensor.
- Colour space mapping — involves mapping the camera colour space (see Chapter 23) to a device-independent space such as the CIEXYZ.
- Gamma correction/curve shaping — involves a non-linear conversion of the linear pixel values (with respect to input intensity) to achieve redistribution of the tonal information in the image, so that this matches best the HVS and is appropriate for viewing images on displays (see Chapter 21).

- White balance — involves white point conversion and is based on settings selected by the user during capture or during rendering (see also Chapters 14 and 23).
- Noise reduction, anti-aliasing and sharpening — these steps are commonly included in the camera processing pipeline to counteract the blurring and aliasing artefacts caused by sampling, imaging optics and demosaicing, and the noise from multiple sources inherent in digital capture devices. They are therefore also necessary steps in processing RAW images, although they may sometimes be applied with more precision after the RAW conversion process in an imaging software application instead (see Chapter 14).

DIGITAL NEGATIVE (DNG)

Digital Negative (DNG; extensions .dng or .tif) was introduced by Adobe in 2004 in an attempt to address the lack of a universal format for RAW files. It is a publicly available file format for RAW files generated by digital cameras. The specification of the latest DNG version 1.3.0.0 was published in June 2009. DNG conforms to TIFF/EP (see above), it is structured according to TIFF and thus permits significant use of metadata. Adobe aims to promote DNG as a universal RAW file format for archival purposes and is currently submitting it for standardization to the International Organization for Standardization. A number of camera manufacturers have introduced cameras that support DNG either as their native or as an alternative RAW format, while a number of digital imaging and desktop publishing applications provide conversion and writing DNG files. DNG files store uncompressed data and JPEG lossless compressed data in a linear non-white balanced colour space, which is usually the native RGB colour space of the camera. It enables data storage in either CFA form or in full-colour RGB.

It is possible (but not required) for a DNG file to simultaneously comply with both the DNG specification and the TIFF/EP standard. The format for storing image data in DNG files is based on the published TIFF/EP but not the metadata, which contains all the information that a converter needs to convert the RAW image data, even if the application was not designed for a specific camera. DNG 1.2.0.0 and later, allows for one or more 'camera profiles' to be embedded, as a set of tags that include information such as colour calibration matrices for conversion from/to CIEXYZ to/from the native camera colour space, linearization tables that map stored values into linear values, whether noise reduction has been applied to the raw data, etc. DNG specifies a required set of metadata but does not restrict additional, proprietary (not publicly documented) metadata to be included which can embed features chosen by camera manufacturers, stored in private tags. It enables

inclusion of TIFF/EP, Exif, IPTC and XMP formats for metadata tags.

In addition to the DNG specification, Adobe provides a free DNG converter that converts most camera-specific RAW format files, including of course DNG, but without obligatorily maintaining all of the original proprietary metadata because this information is not publicly documented. The converter is not an open source.

GRAPHICS INTERCHANGE FORMAT (GIF)

The GIF format (file extension .gif) was introduced by Compuserve Inc. in 1987 as a raster format, originally designed for easy transmission and viewing of image data, stored either locally or on remote computers. GIF is optimized for the storage of graphics and has since gained worldwide usage as a result of the high degree of compression it achieves, making it suitable for certain types of images on the worldwide web.

GIF images are paletted or indexed images and contain a maximum of 8 bits per pixel, whether greyscale or colour GIF files compress data using LZW coding, a lossless dictionary-based compression technique. This method is covered in detail in Chapter 29, but in summary it allocates sequences of pixel values single codes from a dictionary, meaning that an image with many repeating sequences (such as one containing lots of graphics) may be substantially compressed. The other key characteristic of the GIF format is the ability to store multiple images in the same file, which means that it is possible to store the frames of an animated sequence in a single file.

Compuserve Inc. released the first version of GIF, GIF87a, as a free open specification. It was superseded 2 years later by GIF89a, which added various additional features, including transparency support and storage of metadata for a specific application. During the next few years, it became a de facto standard for Internet imaging (at this point JPEG had only just been released). It emerged, however, in 1994 that the LZW compression algorithm used within GIF was a method that had been previously patented by Unisys. No mention of this had been made in the GIF specification, but it meant that Unisys could charge a licence fee to certain users, for example developers creating software to read or write GIF files. The issue eventually led to the development of the Portable Network Graphics (PNG) format as an alternative.

The colour palette used in GIF is the fundamental limitation in its suitability as a format for the majority of photographic imaging applications. It is commonly termed a lossless format, because LZW compression is a lossless compression method. However, the process of storing a 24-bit RGB image as a GIF involves the conversion of a range of over 16 million possible colours into one containing just 256 individual colours. Even if a local colour table is included, in which the colours are selected based on those in the image, it is a quantization process and is irreversible; therefore, image information will be lost, with an associated loss of image quality.

The effects of this are clearly shown in Figure 17.4, which depicts an original TIF image and the appearance of the image and its histogram, after it is saved as a GIF. Contouring or *posterization* artefacts are indicated on the histogram and are clearly visible in the image, particularly in areas of smoothly graduating tones. The significant degree of compression achieved is indicated by the file sizes at the bottom. The visibility of the artefacts means that GIF is only really suitable for photographic images that are small and/or being viewed as part of a quickly moving sequence, hence it is still sometimes used on web pages. However, the JPEG format can achieve significant compression without the same degree of quality loss on continuous-tone images; therefore it is now more commonly used for Internet images. The GIF format is much more successful for images containing graphics with solid colour or text.

Figure 17.4 A continuous-tone image saved as a GIF file displays visible contouring artefacts, noticeable in areas of gradually changing tone and colour, in this case in the sky background. (a) Original uncompressed image, 1.71 MB, image dimensions 945 × 627 pixels. (b) GIF image, same image dimensions, file size 236 KB.
© iStockphoto/philipdyer

323

All GIF files begin with a *header*, a *logical screen descriptor* and a *global colour table*. The header simply identifies the file as a GIF format; the logical screen descriptor provides colour and screen information necessary to correctly display the image, such as the minimum screen resolution required to display the image without scaling. The global colour table is an optional colour palette, which is used as the default table to index the colour data from the pixel values within the contained image file (or files). However, each image included in the file may use its own *local colour table*, which then overrides the use of the global colour table.

In GIF89a, *extension* information is included after this information and before the individual image information. This information is termed *control extension* information, as it controls the way in which the graphical data within the file, both bitmap and text, is rendered.

Following this, in both specifications, is the image information for one or multiple images. This is made up of a *logical image descriptor*, a *local colour table* and the image data. The logical image descriptor describes the position of the image on screen and the height and width in pixels, as well as information about whether a local colour table is attached to it, and how many bits are allocated to each local colour table indexed entry. The image data are the output from LZW compression and are organized in a series of data sub-blocks rather than a continuous stream. The GIF file ends with a *trailer*, which is a single byte of data, always the same value, marking the end of the file.

PORTABLE NETWORK GRAPHICS (PNG)

The PNG format (file extension .png) is a lossless raster format designed as an alternative to (and an improvement on) the GIF format and, most importantly, it is an *open specification* which is patent free. It was developed with two main applications in mind: as a storage format for images to be used on the worldwide web and as an intermediate storage format in image editing.

It has several advantages over the GIF format. It compresses images using the *'Deflate'* algorithm, a combination of *LZ77* and *Huffman coding* (see Chapter 29), which provides greater levels of lossless compression than the LZW compression in GIF, particularly on very small images. Additionally, it can be extended by software implementers to include *compression filters*, which filter the image data beforehand to improve the compression results. Perhaps most importantly, where GIF is limited to a maximum 8-bit colour palette, PNG provides extensive bit-depth support. As well as supporting 1-, 2-, 4- and 8-bit paletted images, it also supports up to 16-bit greyscale

images and up to 16-bit per channel RGB images. In addition to allowing transparency equivalent to that of GIF, PNG allows the inclusion of an alpha channel, which can provide 'variable transparency', such as that used in image masks, with 8- or 16-bit greyscale or RGB images, hence its suitability as an intermediate editing format. It does not, however, support CMYK images, as its main applications use images displayed on screen. It also does not provide multi-image support so cannot store animations.

PNG has a range of other useful extra features, such as the facility to include information for gamma correction to ensure the correct display of images across different browsers and platforms, and to embed text annotations in the image file, for copyright information, for example. The latest version supports ICC colour management. The format also supports *interlacing*, which is a method in which the image information is selected and transmitted in a number of different passes, taking some lines (or blocks) of pixels but not others at each pass until all have been selected. The image information can be filled in at the other end progressively from each pass. If the interlacing method is successful, then aspects of the image content will appear in a rough version when the image is first displayed in a web browser and the details will be filled in as each subsequent pass is received. GIF also supports interlacing, although using a slightly less sophisticated method than PNG. It should be noted here that this is mainly relevant for images being transmitted across a modem. The fact that broadband connections are now commonplace may be one of the reasons that the adoption of PNG has not been as widespread as was expected.

The history of the PNG format is interesting, as it is a demonstration of the influence of the Internet in the sharing and promulgation of information to a common end. The announcement that GIF was to be partially licensed as a result of the patent on the LZW compression method held by Unisys led to the formation in 1995 of an informal Internet working group, now known as the PNG Development Group, led by Thomas Boutell. He posted a draft format called the *Portable Bitmap Format* on a number of relevant newsgroup websites and the group was established from interested parties with the aim of developing a royalty-free alternative to GIF. The format was developed very much by consensus; within a few weeks most of its major features had been proposed, and within a few months seven new drafts of the format had been developed.

The PNG specification (version 0.92) was released by the World Wide Web Consortium in 1995 as a working draft, followed a few months later by version 0.95 as an Internet draft by the Internet Engineering Task Force (IETF). The update to version 1.1 in 1998 included new information for cross-platform colour correction using sRGB and a revision to the gamma correction method. This was followed by the current specification, version 1.2, in 1999 with some minor revisions. In 1997 PNG had been

formally adopted by the Virtual Reality Modelling Language (VRML) Architecture Group as one of the required image formats for conformance with VRML 2.0. This helped to progress it towards standardization. It became the joint ISO/IEC (International Electrotechnical Commission) standard 15948 in 2004.

Despite some of the advantages that PNG has over some equivalent formats, particularly in its use on the Internet, it has not yet been widely adopted by users instead of GIF and JPEG. This is partly due to the fact that it is not as widely supported in application software and web browsers as the other two. It may also be due to its inability to store animated sequences. It is quite clear that PNG is more successful than GIF for storing continuous-tone images but GIF does not tend to be widely used for such images unless they are very small. GIF is useful mainly for images containing graphics; it may be that the majority of users continue with it out of habit, because it is good enough for their requirements. By contrast, JPEG is a lossy format, resulting in much smaller file sizes than the PNG equivalent, as it is designed for continuous-tone images. The artefacts produced may not be problematic on low-resolution images on the Internet. It is possible, now that images are being transmitted across higher bandwidths, that PNG may come into its own as a lossless format for larger images; however, it also has competition from JPEG 2000, another format yet to be widely adopted.

A PNG file begins with a *PNG file signature*, which is a set of 8 bytes always containing the same decimal values, which signify that a PNG file follows. It is then made up of a series of *chunks*, each of which includes a length descriptor, a chunk type descriptor and the chunk data, among other things. The chunks are of two types: *critical* and *ancillary*.

The critical chunks include: a header chunk containing data about image dimensions, bit depth, colour type, compression and compression filtering methods and interlace method; an optional colour palette chunk (maximum 8 bits); an image data chunk, which is the output data from the compression algorithm; and an image trailer chunk marking the end of the PNG file. The ancillary chunks are optional chunks which allow developers to include other useful information in the file and fully utilize the potential features of the PNG format. They include, amongst other information, background colour, primary chromaticities and white point to enable colour management support, image gamma for gamma correction, the image histogram, image transparency and text chunks.

PHOTOSHOP DOCUMENT (PSD)

Photoshop Document (PSD; extension .psd) is a proprietary image file format. It is the native bitmap file format of

Adobe Photoshop — the most commonly used image-editing application — and although it is a de facto standard format for designers and photography professionals it is not considered a general-purpose interchange format, rather an intermediate editing format. Because PSD is an application-based format it is expected to change in the future. It is a complex format but its strength lies in the fact that it stores image layers, effects, paths and other Photoshop-specific elements. Photoshop and a few other editing and desktop publishing applications can write PSD files while a few additional ones can read them.

PSD provides good support for various colour schemes, storing binary, indexed colour, greyscale, half-tone, RGB, CMYK and $L*a*b*$ image data of up to 16 bits bit depth per channel. The maximum spatial resolution supported by the format is $30,000 \times 30,000$ pixels. Image data is stored uncompressed, or using the incorporated RLE lossless compression (a compression algorithm used by the Macintosh ROM and the TIFF standard), resulting in PSD files usually being very large.

The structure of PSD is illustrated in Figure 17.5. Files consist of a header, three informational sections followed by the image data. The header includes fields for the file identification number (signature), the number of channels in the image (from 1 to 24), image dimensions, bit depth and the colour mode of the file. The other sections are of variable length. Only indexed colour and duotone have colour mode data. For indexed colour images the colour data contains the colour table for the image. For duotone half-tone images, the colour data contains the duotone specification. Other than Photoshop applications that read PSD files, a duotone image is treated as a greyscale image. The Image Resources section consists of non-pixel data associated with the image; following are the Layer and Mask section, where each layer and mask is documented, and the image data.

Figure 17.5 The structure of PSD.

PHOTO CD (PCD)

Photo CD (PCD; extension .pcd) is a proprietary image file format, attached to the Photo CD system. The Photo CD was a commercial system introduced by Kodak in 1992 but was discontinued in the mid-2000s (Photo CD discs are still available from an independent vendor in the USA). It provided film (negative or slide) development, high-quality scanning and storage of the digital image files on a CD-ROM for access from Kodak CD players, other media players and computers with suitable software. Although the Photo CD system has now been replaced by other Kodak services it is worth explaining PCD, as it is considered a high standard file format.

PCD is still used by some professionals and supported by most of the graphics software applications. The Photo YCC encoding (one luminance, Y, and two chrominance, C_1 and C_2, channels — see Chapter 23) of the PCD format is suitable for archiving master image files in cases where the original colorimetry needs to be preserved, because it is an input-referred encoding system, i.e. the transformation from sensor encoding to input-referred encoding is known (see Chapter 23). This allows for PCD readers to convert the YCC data to device-independent colour spaces, such as the CIELAB. PCD images are often used by imaging researchers as test images, because of their high quality and calibrated colour.

Images on Photo CD were scanned using high-quality scanners at a spatial resolution of 2200 or 4400 dpi, the latter offered with the Pro Photo CD service. Thirty-five-millimetre frames produced sampled files of 3072 × 2048 pixels (or 6144 × 4096 pixels with the Pro Photo CD for 35 mm, which also offered scans from 120 and 4 × 5 film sizes), per red, green and blue channels, quantized to 8 bits per channel. RGB files were then converted to Photo YCC, an encoding that was primarily developed for the Photo CD system. They were compressed at a 'visually lossless' Kodak proprietary compression and stored as 2.0–6.0 megabyte files. Compression was carried out in Photo YCC colour space, where much of the chrominance information was averaged — by averaging colours of adjacent pixels — and subsampled to reduce image size significantly. After two subsampling phases, the original and compressed image data were compared and the differences between them — the so-called *residuals* — were saved as two separate files. The residuals were recombined later with the subsampled data to rebuild two high-resolution versions of the image. The compression of chrominance information in the Photo YCC encoding takes advantage of the fact that the human visual system is much more sensitive to luminance differences than to differences in colour (or hue; see Chapters 4 and 5). Without compression each image would occupy 18 MB (or 78 MB for the Pro version) of disc storage.

PCD is a multi-resolution image format. Images can be opened at five separate resolutions because the information is stored in a so-called *image pac*. The main advantage of multi-resolution formats is that lower resolutions, intended for Internet, TV and multimedia applications, can be viewed and downloaded quickly. The Base image resolution contains the original data, averaged and subsampled. There are two low-resolution versions (Base/4 and Base/16) and two high-resolution versions (4×Base and 16×Base). The high resolution versions contain the Base plus the first (4×Base) and second (16×Base) residuals. A Base/N image contains $1/N$ the number of pixels in the Base image and an N× Base contains N times as many pixels as the Base image.

The specifications of the PCD have been published and the format has been widely used by many libraries and archives. According to Kodak: 'The PCD file format was designed to reliably perform a specific function. However, the equipment and software required to scan an image from film and write it to a PCD file is expensive.' Thus, despite its advantages the PCD format's future is unclear.

POSTSCRIPT (PS) AND ENCAPSULATED POSTSCRIPT (EPS)

PostScript (PS; extension .ps) is a file format for files that are saved in the PostScript page description language (PDL). It is not an image file format. PostScript is a programming language that describes very accurately the appearance of a page, including vector graphics, high-quality bitmaps and text of various fonts for both print and display, and is used extensively in desktop publishing. The program code is processed by related software and hardware in printers (the *Raster Image Processor* — RIP) that support PostScript. The RIP interprets the PostScript code into a bitmap, producing graphical information (i.e. vector graphics and text are rasterized at a desired resolution). PostScript instructions can be rendered into a display for viewing instead of to paper, in which case an RIP is also used by the PS viewer. PostScript Level 1 was developed by Adobe in 1984 and has since gone through many revisions and updates. The current version is PostScript 3, introduced by Adobe in 1997.

One advantage of PostScript files is that they are rendered in exactly the same way from different PostScript-compatible printers and viewers, so they are device independent. The rich font system used the PS graphics primitives to draw *glyphs* (or characters) as line art, which can be rendered at any resolution. PS files are relatively small in size as they contain instructions in ASCII form to be sent to the printer, rather than bitmap information. This applies unless they incorporate bitmaps, in which case the results are large PS files.

PostScript used to be a de facto standard for printed output, but this is no longer the case. The evolution of PostScript led to the development of Adobe Acrobat, which creates Portable Document Format (PDF) documents (see later).

EPS

Encapsulated Postscript files (EPS; extension .eps) are PostScript format that includes a low-resolution 'preview' encapsulated in it so that it can be displayed as a preview without interpreting the associated PostScipt code. EPS is essentially an image file format that focuses mainly on output. It is suitable for high-end print workflows but can be rendered by any application that renders bitmaps. EPS files may contain as a minimum one command, describing the page containing the image described by the EPS file. Applications can use this information to lay out the page, even if they are unable to directly render the PostScript inside. In recent years, applications have ignored the 'preview' of an EPS file, but are able to display a preview by interpreting the PostScript to get their own preview.

PORTABLE DOCUMENT FORMAT (PDF)

The PDF format (file extension .pdf) was released by Adobe systems in 1993 and during the 1990s became the de facto standard for the storage and communication of documents. PDF was officially standardized and published by the International Organization for Standardization as ISO 32000-1:2008 in July 2008. It is not really an imaging format, rather it is a document format that allows the inclusion of images, providing support for both raster and vector data representation. A PDF file contains a fixed layout of a page and provides a complete description of the document, which includes graphics, images, text and fonts. The document is displayed as an image, which can be viewed or printed, making it particularly suitable for proofing composite images. Hence it was originally used mainly in desktop publishing applications. It has now found widespread use for images or documents which are to be printed from the web.

A PDF document is represented in a way that is independent of the system on which it is displayed, i.e. the application software, the operating system and the hardware. It is a collection of objects, describing the appearance of a page or pages and includes structural information about the page layout. The graphics, text and images in the page are contained in a *content stream* of graphics objects which is painted on to the page, the layout and formatting all defined by the application creating the file. The main graphics objects are: *path objects*, which are vector descriptions of graphical objects (points, lines, curves, which may be filled shapes); *text objects*, which are glyphs representing text characters (which are included in a separate font data structure); and *image objects*, which are rectangular arrays of sampled values, essentially bitmaps. The images are embedded in the PDF file using a PDF-specific image format, from which the original image format may not be determined. The images have up to 64-bit colour support in RGB, YC_bC_r and CMYK colour spaces. The images may be uncompressed, losslessly compressed using various algorithms including LZW, or compressed using lossy JPEG compression. This means that the degree of quality loss may be controlled for different types of documents.

Specific software (the Acrobat family of products from Adobe) is necessary to view or create PDF files. Initially, Adobe charged for this software, which may have contributed to the relatively slow uptake of the format; however, Acrobat Reader is now distributed at no cost, making it feasible for distribution of PDF documents on the Internet, resulting in its current status as a de facto standard. Early versions of PDF and Acrobat allowed only the viewing and printing of documents, but more recent developments have added the facility to extract specific selections of text and images. There have been eight versions of PDF and Acrobat, culminating in PDF version 1.7 and Adobe Extension 3/Acrobat 9.0 in 2008. This has now been published as an open standard, ISO 32000-1:2008.

PDF is an extremely useful format in imaging workflow as a means for the communication of information, layouts and the overall look of a document. It is also suitable as a format to provide documents containing images for downloading and printing from the Internet. It is not, however, comparable to the other formats designed specifically for images; it has a specific purpose in document communication and should be used in this context, with more suitable image formats selected for the storage of images.

BIBLIOGRAPHY

Adobe Photoshop Software Development Kit 2006. Adobe Systems Incorporated, USA.

Burns, P.D., Houchin, S., Parulski, K., Rabbani, M., 2002. Using JPEG 2000 in future digital cameras: advantages and challenges. Proc. ICIS'02 Conference, Tokyo, 371–372.

CIPA DC-008-2010: *Exchangeable Image File Format for Digital Still Cameras: Exif Version 2.3* Camera and Imaging Products Association (CIPA) and Japan Electronics and Information Technology Industry Association (JEITA).

Common Image File Formats 2008. http://www.library.cornell.edu/ preservation/tutorial.

Digital Negative (DNG) Specification 2008. Adobe Systems Incorporated, USA.

Encapsulated PostScript File Format Specification version 2.0 1996. Adobe Systems Incorporated, USA.

Fraser, B., 2004. Real World Camera Raw. Peachpit Press, Berkeley, CA, USA.

Gosney, M., et al., 1995. The Official Photo CD Handbook. Peachpit Press, Berkeley, CA, USA.

Graphics Interchange Format 87a Specification 1987. Compuserve Inc. Available from the World Wide Web Consortium website.

Graphics Interchange Format 89a Specification 1989. Compuserve Inc. Available online from the World Wide Web Consortium website.

Hamilton, E., 1992. JPEG File Interchange Format version 1.02 Specification. C-Cube Microsystems, available from the World Wide Web Consortium website.

ISO 12234-2:2001, 2001. Electronic Still-Picture Imaging — Removable Memory, Part 2: TIFF/EP Image Data Format. International Organization for Standardization.

ISO 12639:2004, 2004. Graphic Technology — Prepress Digital Data Exchange — TIFF/IT Tag Image File Format for Imaging Technology. International Organization for Standardization.

ISO 32000-1:2008, 2008. Document Management — Portable Document Format, Part 1: PDF 1.7. International Organization for Standardization.

Murray, D.J., vanRyper, W., 1996. Encyclopaedia of Graphics File Formats, second ed. O'Reilly & Associates, Cambridge, UK.

PDF Specification version 6, 2007. PDF Reference and related documentation.

Adobe Systems (updated October 2007).

PNG (Portable Network Graphics) Specification, version 1.2, 1999. Portable Network Graphics Development Group.

PostScript Printer Description File Format Specification version 4.3, 1992. Adobe Systems Incorporated, USA.

Rabbani, M., Joshi, R., 2002. An overview of the JPEG 2000 Still Image Compression Standard. Signal Processing: Image Communication 17, 3—48.

TIFF Revision 6, 1992. Adobe Systems Incorporated, USA.

Wallace, G.K., 1991. The JPEG Still Picture Compression Standard. IEEE Transactions on Consumer Electronics, December.

Chapter | 18 |

Image storage and archiving

Sophie Triantaphillidou

All images © Sophie Triantaphillidou unless indicated.

INTRODUCTION

In this chapter we will consider general aspects of *image storage* and *archival properties* or *life expectancy* of different imaging media. Prior to digital photography the term *archival* was used to describe materials with a *long life*, which is now taken to mean a minimum of 100 years. Nowadays the term *archival* is less commonly used and materials are described in terms of their *life expectancy* instead. This is because the newer electronic media related to imaging do not have proven archival properties. All materials degrade over time and differing imaging media are subject to many causes of degradation, many of which are not well understood. Steps may be taken to ensure that their life expectancy is as long as possible. As imaging systems advance and new systems evolve, the initial prime criterion is to provide a system that works and fulfils the needs of the consumer. In these initial stages of providing new products their longevity is not necessarily a high priority. This was the situation at the start of the negative–positive photographic process when W.H.F. Talbot experimented with various fixing methods to achieve a stable image and this approach continues to this day. However, as our knowledge advances, both manufacturers and users are more aware of the need for imaging media to have reasonably long life expectancies and much research is undertaken to achieve this. Today, this is becoming a useful strategy in marketing imaging products. A relatively recent example is in colour hard-copy output using inkjet or thermal dye-transfer systems in which the early products had very poor stability to light, as did colour photographic print materials before them. This problem has been researched thoroughly; more recent products have much improved light stability and predictions about their life expectancy are very optimistic.

Longevity in all imaging storage media depends on the stability of the medium, the storage conditions and handling. With digital technologies a number of other considerations concerning the life expectancy of the digital image information have to be taken into account in addition to degradations of the storage medium itself. Of particular concern is for how long the hardware and software reading and rendering of the image information will be available. With the rapid advances in both hardware and software, long-term preservation of digital information is only achieved by transferring from obsolete to newer systems. *Migration* is the periodic transfer of digital files from one hardware/software configuration to another. Ensuring image longevity presents various challenges. Some are common to both silver-based and digital media, whereas others are unique to one or the other. Storing photographic films, prints and digital storage media under controlled environmental conditions, handling them with care and migrating digital image files from old to newer media are all techniques which help to prolong the lifespan of photographs. The focus of this chapter will be on three main areas: (i) life expectancy and storage of traditional photographic media; (ii) life expectancy and storage of digital prints; and (iii) digital image storage and migration of digital information.

LIFE EXPECTANCY OF TRADITIONAL PHOTOGRAPHIC MEDIA

The longevity of silver-halide-based media depends on the *photographic medium* itself, the *chemical processing* and the *consequent storing conditions*. Black-and-white analogue materials have a number of advantages with respect to their

DOI: 10.1016/B978-0-240-52037-7.10018-3

life expectancy over any other media, including the fact that they are viewed with the unaided eye, there is no need for hardware or software to render the image data to viewable records, and history. We know that properly processed and stored black-and-white photographic records have a life expectancy of at least 150 years.

According to work published by the Image Permanence Institute (IPI) of the Rochester Institute of Technology (RIT) in the USA there are three categories of environmentally induced types of deterioration in photographic (and other image-related) media. *Biological decay* involves living organisms, such as mould and bacteria that damage films and prints. Mould, once present and if left untreated, eventually destroys all pictorial information. *Mechanical decay* is related to changes in the structure of the photographic image, such as its size and shape. Overabsorption of moisture from photographic media found in humid environments causes swelling; equally, lack of humidity and dryness in the atmosphere cause shrinking and cracks. Finally, *chemical decay* changes the chemistry of the photographic image. Incorrect processing – for example, leaving residual chemicals or final prints with an unfavourable pH value – causes fading of the colour dyes in colour materials.

Nine types of decay that are major threats to photographic and digital image collections are listed in Table 18.1. Some forms may affect one only media type; others may affect other types too. Proper environmental conditions minimize the risk of decay-related damage.

On the longevity of the photographic medium itself, generally fine-grain silver images are more susceptible to degradation than larger-grain images. Prints are more susceptible than negatives or slides. Fibre-based printing papers, especially silver-enriched premium weight types, provide better image stability than resin-coated material. Colour photographic media are more at risk than black-and-white. Furthermore, photographic materials have to be properly developed, fixed and washed to avoid later yellowing and fading on storage. In Chapter 13 attention was drawn to the importance of properly fixing and washing black-and-white films and prints to avoid fading and yellowing on storage. However, even if photographic materials are properly processed they may suffer from any of several forms of degradation in the

Table 18.1 The 9 types of decay, published by Peter Adelstein of the Imaging Permanence Institute in the USA, that are a major threat to photographic and digital image collections

TYPE OF DECAY	MEDIA	RECOMMENDED ENVIRONMENT
Silver image decay	Photographic glass plates Black-and-white film Black-and-white photographic prints	30–50% RH
Colour image decay	Colour film Colour photographic prints Inkjet prints	Low temperature 30–50% RH
Colour bleeding	Inkjet prints	30–50% RH
Yellowing, staining	Colour photographic prints Inkjet prints	Low temperature 30–50% RH
Binder degradation	Magnetic tapes	Low temperature (not frozen) 30–50% RH
Acetate decay	Acetate-based black and white film Acetate-based colour film Acetate-based magnetic tape	Low temperature 30–50% RH
Glass deterioration	Photographic glass plates	30–50% RH
Layer separation	Photographic glass plates CDs and DVDs	Minimal temperature and RH fluctuations 30–50% RH
Mould	All media	30–50% RH

RH stands for relative humidity.

Table 18.2 Some causes of deterioration in photographic materials

EFFECT	CAUSE
Overall yellow stain	Residual chemicals (thiosulphate, silver–thiosulphate complexes)
Image fading and yellowing	As above
Brown spots	Localized retention of above
Local or general damage	Bacterial or fungal attack on gelatin, degradation of gelatin and paper fibres by acidic atmospheric gases
Microspots (red/yellow)	Oxidizing atmospheric gases
Dye fading	Dark reactions and/or light-induced reactions of image dyes

long term. A summary of the types of degradation and their causes for both black-and-white and colour materials is given in Table 18.2.

All of the degradations listed in Table 18.2 can be avoided or at least minimized by eliminating their known causes as far as possible. A number of international standards exist for proper storage environments, display conditions and protective treatments of photographic media which, if followed, will prolong the life expectancy, as will following the recommended processing conditions. ISO 18909:2006 is an example, relating to dark storage and the light fading of colour prints.

Processing conditions

Development conditions as recommended by the manufacturer should be followed. Acidic stop baths can influence the keeping properties of silver images. Excess acetic acid in the stop bath may cause some papers to become brittle on drying and subsequent storage. Also, with carbonate-buffered developers excess acetic acid may cause bubbles of carbon dioxide gas to be formed in the paper fibres of prints. Thiosulphate and silver–thiosulphate complexes can become trapped in these bubbles and may not be readily washed out. This in turn can cause localized spots of silver sulphide to be formed on storage. The minimum permissible levels of thiosulphate ions for some photographic materials are specified in standards. For maximum stability of silver images it is usually recommended that all thiosulphate is removed by thorough washing or with the aid of a hypo eliminator when a short wash time is used. However, it has been suggested that for prolonged life expectancy it is better that the material contains a very small amount of thiosulphate, e.g. 0.03 g m^{-2} for microfilms. Archival keeping properties are greatly improved by the use of protective toning treatment (see later in this chapter), which is why it may be better to include a small residue of thiosulphate in the processed material to form a protective layer of silver sulphide on the silver grains.

Incorrect processing of colour materials, which may leave residual chemicals in the layers or provide a processed record with an unfavourable pH value, can lead to the destruction or fading of image dyes, known as *dark fading* as opposed to *light fading*.

Dark fading

The fading of dyes has two causes, categorized as dark fading and light fading. Different mechanisms for the destruction of the dyes are involved for these two types of fading. Dark fading involves chemical reactions that depend upon on the structure of the dye. These aspects will be considered separately. As with silver-based materials, the dark fading of image dyes is influenced by temperature, relative humidity (RH) and the chemistry of the environment. Common atmospheric gases that can cause dark fading of dyes are oxides of sulphur and of nitrogen, and ozone, but these are insignificant when compared with other causes. As with black-and-white images, dye images are affected by errors in processing. Dark fading is accelerated by the presence of residual thiosulphate ions. Inefficient washing of colour materials not only leads to incomplete removal of thiosulphate and other harmful chemicals, but also can leave the material with a low pH value, which has also been shown to accelerate dark fading. If correct processing procedures are adopted, the reduction in the keeping properties of materials associated with these causes is avoidable.

The main reactions responsible for dark fading in chromogenic materials are those involving hydrolysis and oxidation–reduction reactions, which cause the dye to be converted into a colourless form, or into forms that are different in colour from the original dye. Hydrolysis is decomposition by water and is accelerated by extremes in pH value as well as humidity and temperature. Yellow dyes are particularly susceptible to this form of destruction, whereas cyan dyes are susceptible to reduction to a colourless form by residual thiosulphate ions, ferrous ions or

other reducing agents present in the material or the environment. An understanding of the mechanisms involved has led to the present generation of chromogenic materials, which contain colour couplers that form image dyes with greater resistance to dark fading than earlier materials. The predictive tests for dark fading involve accelerated ageing tests carried out under a fixed RH (40%) at elevated temperatures for long periods of time.

This procedure is based on the classical Arrhenius equation (see ISO 18924 for more details), which is given below in a simplified form:

$$\log_e k \propto 1/T \qquad (18.1)$$

where k is a measure of the rate of dye fading and T is the thermodynamic temperature in kelvin. If a plot of $\log_e k$ against $1/T$ for a number of temperatures gives a straight line, then it is possible to extrapolate the straight line to other temperatures to predict the rate of fading. Also, it has been shown for dark fading that:

$$\log_e k \propto \log_e t_{10\%} \qquad (18.2)$$

where $t_{10\%}$ is the time required to fade 10% of the dye density from an original density of 1.0. Hence, from the simplified form of the Arrhenius equation:

$$\log_e t_{10\%} \propto 1/T \qquad (18.3)$$

In practice, $1/T$ may be plotted against $\log_{10} t_{10\%}$, as shown in the lower graph in Figure 18.1.

The application of this procedure for the dark fading of a magenta dye is shown in Figure 18.1 and its use for predicting dark fading, at a temperature at which fading would take too long to measure, is given below. Dark fading figures for temperatures ranging from 24 to 93°C at 40% RH are shown as the full curves in the top graph of green density DG against \log_{10} time (in days). A horizontal line is drawn at the 10% fade level criterion. Where this line crosses the actual fading curves, a vertical line is drawn to the lower graph where the temperature ($1/T$ in kelvin) is plotted against the log of the fading time ($\log_{10} t_{10\%}$). The linear relationship obtained is shown by the line joining the full circles. Extrapolation of this line to the required temperature of 24°C is shown as the broken line. Translation of this point vertically back to the top graph horizontal line labelled 10% gives the predicted value for the fading of the dye to the 10% level, from which it can be seen that this dye would fade 10% in antilog 4.1 days, i.e. 34 years. This procedure could be repeated for other fading levels and by this means a complete fading curve would be predicted.

All dyes fade and dye images cannot be considered to be of archival quality. However, manufacturers have paid considerable attention to minimizing dye fading, and modern colour photographic materials are capable of lasting for many decades if properly stored and processed. Manufacturers claim a 100-year dark storage capability for their colour print materials. However, the

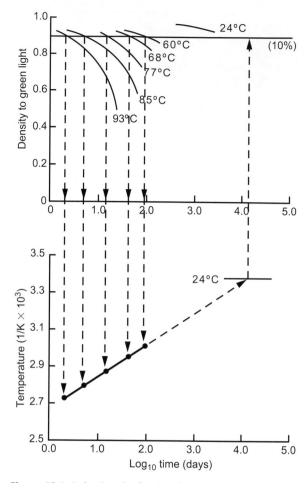

Figure 18.1 Arrhenius plot for dark fading of magenta dye.

only really effective method for achieving extended life expectancy of colour materials is to convert them to black-and-white records by making separation positives or negatives and to process and store these under the conditions discussed in the earlier sections. These black-and-white separations can then be reconstituted as full colour images as required, using appropriate photographic or digital imaging techniques.

Some dyes are inherently more stable than others. For example, those used in the photographic dye-transfer process, those present in silver–dye–bleach materials and metal-based dyes are generally more resistant to certain types of fading than those formed in chromogenically developed materials. For example, one of the most dark-fade-resistant colour photographic materials is Kodak's Kodachrome film.[†] Large studies on old photographic

[†] Kodak had stopped the processing of Kodakchrome by the time of the publication of this book. The film is currently processed only by a few independent laboratories in the world.

collections have indicated Kodachrome to be the only transparency film that remains totally free from yellow staining formation during long-term safe storage. The film's stability is largely due to its processing, which is very complex when compared to E6 processing used for all chromogenic slides. Unless stated otherwise, considerations of dye fading which follow have been applied to chromogenic materials.

A problem with colour materials is that image dyes fade at different rates; this results in a change in colour balance (see example of dark fading in Figure 18.4). Also, there is no universally agreed criterion by which fading is judged or of the degree of fading that can be tolerated. Originally manufacturers adopted a criterion of a reduction in density of 10% (i.e. 0.1 from an original density of 1.0), though it has been argued that greater changes than this may be acceptable to the average observer. This quantitative measure of dye fading, rather than one concerned with quality, has been termed a *just-noticeable difference*. It provides a useful criterion for the comparison between different products when treated in the same way for laboratory evaluations of dye stability. However, more recent standards use a 30% density loss from a density of 1.0 as the criterion for predictive aspects of dye fading. This 30% loss in density is regarded as the density change that becomes noticeable to the consumer. There may well be some confusion as to what represents a *just-noticeable difference* or a *minimum acceptable difference*. This is a controversial area of colour appearance which is dependent on the colour content of real scenes.

Predictive tests for dye fading are being undertaken by all manufacturers, but at present there is no guarantee that these tests will predict precisely what will happen under actual conditions of storage. A further difficulty is that many claims use different test conditions and criteria for acceptability of fading. This means that published data must be

interpreted and compared with care, especially if different test conditions have been used. This procedure provides a predictive technique for manufacturers and researchers, and typical fading results are shown in Figure 18.2.

From this it can be seen that in order to reduce dye fading to a minimum a low storage temperature should be used. If refrigerated storage conditions are used to minimize dark fading, the materials will have to be enclosed in suitable sealed containers and, because the RH increases as the temperature is lowered, the photographic materials must be preconditioned at low RH (25–30% at 20°C) before they are sealed in their containers. The practical conditions for storage given earlier also apply to colour materials and are relatively easy to achieve without the use of costly refrigeration facilities. Colour materials such as slides can be duplicated every few years and good colour fidelity maintained for generations; colour negatives can be reprinted.

Light fading

Light fading of the photographic dyes is the fading that results from exposure to light and ultraviolet (UV) radiation. Predictions from light fading tests carried out in the laboratory are less easily made than those from dark fading, which use the more reliable Arrhenius method. Light fading of dyes depends on the intensity, duration and spectral energy distribution of the radiation to which they are subjected. These vary considerably with the display conditions under which the materials are viewed. The fading of dyes is a photochemical reaction in which oxygen is involved, and leads to destruction of the dye. This photochemical fading is increased by high humidity.

Two laboratory methods are used for investigating light stability, relating to the viewing and display conditions for the particular material. Slides can be subjected to hundreds of projections in a slide projector and decreases in density for neutral and colour patches measured and plotted against the number of projections. Results for a reversal film neutral patch of original density 1.0 are shown in Figure 18.3. Most reversal films follow the trends shown in this figure, but there are variations between different products, and current films show less steep curves and better light stability.

Colour print materials are usually exposed to an intense xenon source at 5.4 klux, 40–50% RH at 22–23°C and the time taken for a fixed loss in density (10%, 15% or 30% as mentioned earlier under dark fading) is used as a measure of the light stability which is obtained from graphs of density against time. Extrapolations are made from 5.4 klux to 120 lux, which is regarded as a typical light level in the home environment where the pictures may be displayed. Chromogenic colour photographic papers have made substantial improvements in their light stability over the last 50 years. Current materials show considerable

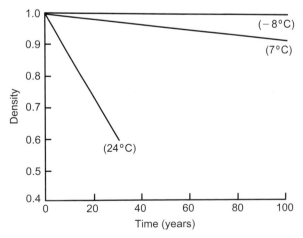

Figure 18.2 Dark fading of a cyan image dye at various temperatures.

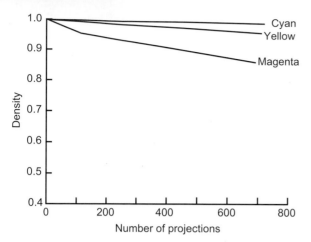

Figure 18.3 Light fading of a neutral patch imaged on a colour reversal film.

resistance to light fading. Colour photographic prints are now claimed to have a useful life of 150 years in typical home-display conditions of around 120 lux at 50% RH and 23°C. Improvements are being made by all manufacturers of chromogenic print materials; modern materials are almost as stable to light as are dye-transfer prints. The latter have been regarded as a standard with which other materials are compared. Silver–dye–bleach materials are particularly resistant to light fading.

As mentioned earlier, the instability of dye images is due to a combination of light absorption and dark storage effects, although the latter are often ignored when accelerated light fading is carried out. There exist many additional complicating factors which are involved in light fading. Examples of these include staining, the influence of UV radiation and UV absorbers, the presence of residual chemicals and colour couplers in chromogenic materials, anti-oxidants and stabilizers which may be included in modern materials, the influence of the substrate and environmental factors, such as temperature, humidity, pH and the presence of oxygen. Because of the possibility of reciprocity effects, all accelerated light-fading studies, which use high intensity and relatively short duration exposures, are subject to the criticism that the effects may not relate directly to longer exposures at lower intensities. It is possible that the conditions used for accelerated light fading may induce reactions that are not found for ambient conditions under which the materials are displayed. There is, however, little alternative if fading studies are to be carried out within reasonable periods of time and most investigations involve the use of high-intensity sources and an extrapolation to other conditions when predictions are being made.

An additional problem is in the choice of assumed typical ambient display conditions when predictive calculations are made for fading by a specified amount. One

manufacturer has used a value of 500 lux for 12 hours per day in such calculations. This was based on the assumption that in common domestic situations sunlight varies between 1000 lux during the day, decreasing to 300 lux in the evening, and an average value of 500 lux for 12 hours per day appears to be a reasonable estimate. Whilst others have adopted 450 lux for the same time period at a temperature of 24°C and 60% RH, yet others use 120 lux, as mentioned earlier. This further illustrates the difficulties and the caution that must be exercised in making comparisons between claims for the light stability of imaging materials.

Modern chromogenic printing papers have evolved over a period of at least 50 years and much research has been carried out to improve their stability. Particular attention has been concentrated on improvements in the intrinsic stability to light of magenta dyes, which are regarded as having the most noticeable fading and were the least stable of the image dyes. In addition, UV absorbers and other minor chemical components are included in modern materials to reduce their rates of fading. These are mature products, whereas materials for hard-copy output from electronic systems have evolved over a period of less than a decade and fade more rapidly than colour photographic materials.

Storage conditions

Most of the harmful effects summarized in Tables 18.1 and 18.2 are aggravated by high temperatures and high RH. In fact, subjecting processed photographic materials to such conditions is used as a test procedure for accelerated ageing techniques to find optimum processing and storage conditions and for research into the causes of deterioration. One International Standard specifies as an image stability test incubating the material for 30 days at $60 \pm 2°C$ and an RH of $70 \pm 2\%$, and states that: 'The film image shall show no degradation that would impair the film for its intended use.' When storing photographic materials the temperature should not exceed 21°C and the RH should be kept within the range of 30–50%. For archival storage, a lower temperature and RH is recommended (10–16°C and RH of 30–45%). This represents a practical compromise for air-conditioning. Also, the materials should be protected from harmful atmospheric gases (discussed in the next section). More recent recommendations are to keep photographic materials in sealed polypropylene bags containing a visible humidity indicator, in a controlled humidity environment at temperatures of −20°C. This provides the highest standard of conservation whilst achieving maximum chemical stability without harmful physical change. The main limitation is that rigorous warm-up procedures have to be adopted when removing material from cold storage to avoid condensation and physical changes due to thermal shock. Figure 18.5 shows the McCormick-Goodhart recommendations for storage of

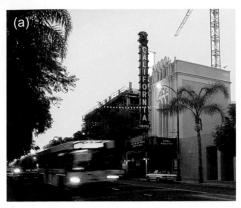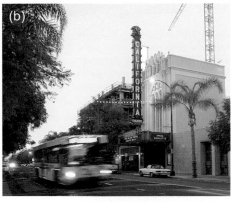

Figure 18.4 The pinkish cast in (b) is a simulation of the cyan dye fading faster than the magenta and yellow dyes in old photographic prints — pre 1974 — stored in the dark.

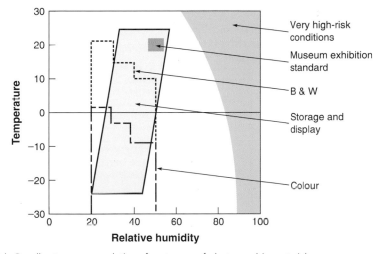

Figure 18.5 McCormick-Goodhart recommendations for storage of photographic materials.
Adapted from paper presented at 14th Annual Archive and Records Administration Preservation Conference: Alternative Archival Facilities, *Washington, DC, March 1999; reproduced by permission of M.H. McCormick-Goodhart*

photographic materials in terms of the interrelationships between temperature and RH.

Photographic materials should be protected from the light. Recent tests have shown that subjecting silver materials to high-intensity simulated daylight (5.4 klux or 5400 lumens per square metre) accelerates the yellowing of images in processed materials containing small amounts of thiosulphate ion.

The materials in which photographic records are stored, as well as the processing conditions and the storage environment, are also of the utmost importance. Suitable materials for the storage of processed photographic films, plates and papers are also specified in Standards. Generally, wood and wood products (plywood, chipboard, hardboard, etc.), formaldehyde-based plastics, polyvinyl and acrylic plastic containers should not be used. These materials may contain residual solvents, catalysts, plasticizers, etc. which are known to have harmful effects on photographic materials, as can many adhesives, inks and marking pens. Preferred storage containers are those made from anodized aluminium or stainless steel, or cardboard boxes made from acid-free high-alphacellulose fibres that are lignin free and sulphur free. The latter also applies to mounting boards for prints, envelopes for negatives, etc. Fortunately there are a number of specialist suppliers of archival storage materials for processed photographic records; these are able to supply 'archival' polypropylene or polythene sleeves and envelopes for the storage of negatives and slides, along with files and boxes of appropriate archival materials.

335

Atmospheric gases

There are many pollutants present in the environment which can have deleterious effects on photographic materials. These include oxidizing gases such as hydrogen peroxide, ozone, oxides of nitrogen, peroxides and peroxy radicals emitted by car exhausts, paints, plastics, acid rain and sulphur compounds. The general effects of oxidizing gases are to induce yellowing and fading of the image at the edges of the print or negative where the atmosphere has been able to penetrate most readily. This staining may be dichroic, appearing grey by reflected light and yellow by transmitted light. Low concentrations of oxidizing gases such as hydrogen peroxide can produce microspots. In prints these appear as yellow, orange or red spots depending on the size of the silver particles, and if clustered near the surface may appear as a silver mirror. The mechanism by which microspot formation occurs involves an initial oxidation by the gas, which converts silver metal to mobile silver ions. The silver ions migrate away from the silver filaments of the image and become reduced to metallic silver by the action of light, or are converted to silver sulphide by hydrogen sulphide present in the environment. This process forms microspots of approximately 60 µm or larger in diameter, comprising a concentric ring structure of particles of 5–10 nm to 0.5 µm in diameter. In laboratory experiments, using accelerated ageing techniques at 50°C and 80% RH, it has been shown that microspot formation occurs with a concentration of hydrogen peroxide of 500 ppm.

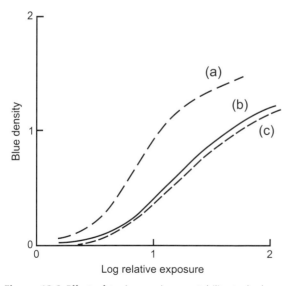

Figure 18.6 Effect of toning on image stability to hydrogen peroxide. (a) Untoned image after 3 hours, 5% hydrogen peroxide. (b) Original image, no treatment. (c) Toned image after 3 hours, 5% hydrogen peroxide.

Protection against attack by oxidizing gases can be given by selenium toning. Figure 18.6 shows the degree of protection that is possible with this toning treatment when the material is subjected to an extreme test using 5% hydrogen peroxide. From Figure 18.6 it can be seen that toning (curve c) leads to very little change in the characteristic curve after attack by hydrogen peroxide, whereas an untoned image (curve a) shows a considerable change. Acidic atmospheric gases, often present in the environment, can degrade gelatin and paper base materials and some form of protection from these in storage is necessary for archival permanence.

Toning

Certain toning processes are now known to increase the life expectancy of silver images. Originally toning was carried out to change the colour of a photographic image by means of chemical solutions. Toning is mainly applied to prints but may also be used to confer additional stability on films or plates, and most manufacturers offer proprietary toning solutions to enhance the life expectancy of their silver photographic products. The principle of obtaining enhanced stability of silver images through toning is to convert or coat the silver image into a silver compound that it is more inert, less finely divided and less soluble than the original silver image particles.

The silver image may be converted into silver sulphide (or silver selenide). Silver sulphide and silver selenide have brown and purple colours, much warmer than that of the usual silver image, so these processes are often referred to as sepia toning. Silver selenide toning provides a means of obtaining very stable images and is less expensive than gold toning, which provides the most stable images. However, selenium compounds are toxic, as are sulphides, and should be handled with caution. Indeed, all toning solutions should be handled carefully and discarded with caution. Sulphide toning is probably the most widely used form of toning, and properly carried out yields images of great permanence. Also, protective gold solutions have been proposed for the archival permanence of prints. They involve immersing the thoroughly washed print material in a mixture of dilute gold chloride and sodium thiocyanate (Kodak Gold Protective Solutions GP1 and GP2). They provide print protection while changing the image tones only slightly.

LIFE EXPECTANCY OF DIGITAL PRINTS

Preservation and conservation of digital prints is one of the major contemporary concerns of the imaging community, especially because longevity of digital image

files suffers from rapid changes of technologies and media obsolescence. A number of digital image preservation specialists suggest that the first and simplest way the most valuable digital images can be preserved is to make hard-copy prints and store them under optimum conditions. Technologies and media are relatively new while their evolution has been extremely rapid. Central to this evolution has been image quality and print permanence. The permanence of digital prints varies widely with printing technology, printing material and characteristics of the colorants used to produce them. It also varies with display and storage environments that should be considered separately when the longevity of the media is in question. Digital colour prints are produced in materials that differ in composition to conventional photographic materials and in their response to environmental factors that damage them. Unfortunately, at the present time there are no ANSI or ISO standards defining the longevity of digital prints. (The ISO 42 Technical Committee on Photographic Standards is − at the time of writing − working toward the development of such standards to support new technologies.) Prognostics on the life expectancy of digital media are made exclusively by using accelerated fading techniques, of which the conditions are not universally agreed. As with analogue media, it is often disputed that in accelerating ageing procedures manufacturers do not follow the same methodologies, thus the predicted fading rates are not comparable. Also, the majority of published life-expectancy predictions are based only on the results of light-exposure testing, which accounts for only one of the possible causes of print deterioration. *Until universal guidelines are published, storage recommendations should be similar to those specified for conventional colour prints.*

Printing technologies and media

Inkjet print technologies are the most commonly used technologies in the production of digital photographic quality prints, largely due to the fact that they allow a greater range of dyes and pigments than any other printing process. The structure of the inkjet print partially governs its future integrity. Inks may be made from dyes, similar to those used in traditional photographic prints, or pigments, which are also used in toner. Pigment-based inks provide better stability because pigments are less sensitive to water, humidity and high temperatures than dyes. From a permanence point of view pigment-based inks are better than dye-based inks in every respect. They are expected to typically achieve more than 100 years on display or 250 years in safe storage conditions; however, this depends largely on the printing surface. For many years the shortcomings of pigment-based media were related to image quality issues, including reduced colour gamut, differential gloss problems on glossy photo-papers, metamerism problems and others. Today, the image quality of pigment-based inks/media is rapidly approaching, and in some cases exceeding, that of dye-based inks. Dye-based inks, on the other hand, contain molecular colorants that penetrate the surface. Early generations of such inks had very poor display life (often less than 10 years) but, as printing technologies and dye chemistry advance rapidly, print display life has increased tenfold, while still preserving the rich colours inherent to dyes.

Inkjet prints are made on either uncoated or coated paper. Uncoated paper absorbs the ink better, but coated paper produces photographic quality prints (i.e. coating high-quality paper results in brighter, more saturated color and greater image resolution − see Chapter 16). Coated papers have similar supporting bases to traditional colour printing papers. Acid-free, lignin-free and buffered paper bases are generally recommended for longevity. Two main types are available for inkjet printing: *swellable* and *porous coating* papers. High-quality *swellable* papers encapsulate the inkjet dyes. They have a protective top layer, a layer that keeps the ink droplets in place and a layer that absorbs additional ink components. The paper base is placed between two polyethylene layers and backed by an anti-curl coating and an antistatic layer. Cheaper swellable papers do not always contain all these layers. Swellable polymer coated papers are better protected from degradation caused by atmospheric pollutants than porous papers with no protective polymer. The lack of a protective layer in porous papers makes the exposed colorants susceptible to pollutants, such as ozone, oxides of sulphur and nitrogen. Prints on porous papers, on the other hand, are more resistant to humidity and moisture, especially when used with pigment-based inks. Accelerated ageing tests, conducted by Wilhelm Imaging Research Inc., recently showed that dark storage stability of inkjet prints is limited by the thermal stability (yellowing) of the modern coated papers rather than the stability of the inks.

The use of *fluorescent brighteners* (also called *UV brighteners*), which are added to many inkjet papers (and to nearly all plain papers) to make them appear 'whiter' than they really are, is an issue regarding inkjet paper stability. Fluorescent brighteners lose activity, mainly when exposed to light and UV radiation, but also when subjected to high temperatures used in accelerated ageing techniques. With loss of brightness, the papers appear to have a slight yellow cast. It is therefore recommended that for long-term permanence papers with brighteners should be avoided.

Generally, more and more inkjet paper manufactures claim 'archival' properties of their papers, typically up to 200+ years. Yet, since there are no universal standard measures for inkjet print longevity, longevity claims vary with manufacturer and product. Independent research in inkjet print permanence has often shown that inkjet prints have considerably higher longevity when they are printed on the printer manufacturer's branded print media (i.e. papers and inks).

Little information is available on the life expectancy of digital prints by other than inkjet printing technologies. In thermal transfer (referred to also as dye diffusion or dye sublimation – see Chapter 16) print heat is used to transfer the dye from a donor on to the printing surface. Such prints often have a clear protective layer that prevents the image from smearing when it is rubbed. The media present problems with respect to accelerated ageing techniques (see below). In electrophotography, toner is transferred and fused in the paper base. The paper is usually uncoated and the images are reasonably stable, because toner is composed of pigment particles that are fused to the paper with a durable polymer binder material. This technology is not often used for photographic quality printing. Digital silver halide and silver–dye–bleach colour prints consist of layers with dye-forming couplers containing layers further comprising silver halide emulsions sensitive to visible light. In some cases the silver halide processes are combined with thermal development and dye transfer. The permanence characteristics of a digital silver halide colour print are the same as those of traditional photographic prints. They may last from 50 to more than 100 years in appropriate storage. The deterioration varies between manufacturer's products, the level of illumination and UV radiation to which the print has been exposed.

Permanence factors and test for digital prints

Exposure to light when displaying prints, high temperatures and humidity, atmospheric pollutants and mould, are common factors affecting image permanence in both conventional and digital prints, although not to the same degree. Due to lack of international standards on testing print permanence, many manufacturers consider Wilhelm Imaging Research Inc. as a reliable independent standard for digital print permanence predictions. For most types of digital prints light fading is the dominant factor of their permanence. Light-fading predictions from Wilhelm calculations are based upon relatively high lighting indoor conditions of 450 lux averaged for 12 hours, which surpass the conditions that some printing manufacturers use in their tests – for example, the published Kodak method that assumes 120 lux for 12 hours per day. Tests are conducted until a just-noticeable amount of fading has occurred, while 17 failure criteria are tracked. Traditionally, methods for evaluating light fading take into account fading in cyan, magenta and yellow patches, as well as fading and colour imbalances in the neutral patches at a single density of 1.0 (and for Wilhelm Imaging at 0.6 too). These methods do not address directly the imbalance on all types of colours, including skin tones, and this is why recently colorimetry rather than densitometry-based methods are proposed.

Slow-fade tests are also carried out in darker environments. Accelerated tests for dark fading require long-term tests at elevated temperatures, such as $50-70°C$. The results are extrapolated for common room-temperature predictions. Each type of print media has its own dark storage stability characteristics. Generally, inkjet prints do not suffer too much from dark fading, since inkjet dyes and pigments are very stable and typically can last 100+ years at room temperature, provided that they are laid on high-quality papers and kept relatively safe from harmful atmospheric pollutants. Thermal transfer prints cannot withstand elevated temperatures required by accelerated tests and therefore predictions on their long-term longevity are not made.

Digital prints stored in the dark suffer slow deterioration. This manifests as yellowing of the paper, image fading, changes in colour balance, cracking and delamination of the image layer. Rates of deterioration are influenced, as with photographic prints, by the levels of temperature and RH. High RH causes colorants to migrate, causing colour 'bleeding' and lack of edge sharpness, while it promotes microbial and fungal growth. Tests involve the exposure of prints to elevated humidity levels (e.g. 80%) for weeks and evaluation of the fastness of colour prints as a result of RH based upon changes in the colours. Electrophotographic and pigment-based inkjet prints are generally less sensitive to high temperature and humidity than traditional photographic images and dye-based inkjet prints, because they are made with pigments rather than dyes. The behaviour of inkjet materials varies widely under these conditions, depending upon whether the images are dyes or pigments and whether the paper is uncoated, swellable or porous. In humid conditions, inkjet images composed of dyes that have been printed on swellable coated paper can appear unsharp because of dye spreading. Water damage, cause by floods, etc., is a common damaging factor that affects dye-based inkjet prints more than any other print media. Rubbing the surface while it is wet worsens the condition of the print. Pigment-based prints are relatively water resistant, even when printed on plain paper.

Airborne gases and pollutants, primarily ozone, cause inkjet prints to fade. Accelerated tests involve exposure to a high level (>1 ppm)[‡] of ozone until fading is noticed. The years of ozone resistance are then calculated upon indoor average data – e.g. 40 ppm-hours of ozone is equivalent to one year under usual indoor conditions. Generally, inkjet prints made with swellable papers or with pigmented inks are resistant to air pollutants and ozone for several decades without any protection. On the contrary, dye-based inkjet prints on porous photographic papers, for example 'instant dry' papers, can suffer from noticeable air fade within months of exposure. Thermal

[‡] The abbreviation ppm stands for *parts per million*, which is a way of expressing very dilute concentrations of substances in water; 1 ppm is equivalent to 1 milligram of the substance per litre of water ($1\ mg\,l^{-1}$).

Table 18.3 Summary based on Wilhelm Research and HP Image Permanence Data

PRINT TECHNOLOGY	DISPLAYED (GLASS PROTECTED)	AIR FADING RESISTANCE	STORED
Digital silver halide	12–40 years depending on brand	Decades	100+ years with quality processing
Inkjet	100+ years for branded ink/paper prints, but significantly less for other combinations	Decades for pigments or dyes on encapsulating paper. Months for most dyes on porous paper	100–200 years depending on brand
Thermal transfer	Typically 4–8 years	Decades for most brands	Currently unknown

From Miller (2005).

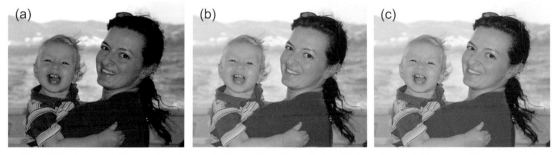

Figure 18.7 (a) An inkjet print in its original state. (b) Simulation of the effects of light fading on inkjet prints: the magenta dye fades faster than the cyan and yellow dyes when exposed to light, resulting in a green cast on the print. (c) Simulation of the effects of atmospheric pollutants: fading of cyan and magenta dyes result in a yellow cast in the print.
Original Image © Pygmalion Kalimeris

transfer print resistance to dark fading is less specific; it might range from one to several decades. Generally, ozone-related damage is minimized in digital prints when they are framed behind glass, laminated or stored in albums. Table 18.3 presents a summary of the life expectancy of different print technologies under display and storage that is based on data from Wilhelm Imaging Research and HP Image Permanence Laboratory. Figure 18.7 illustrates dye fading on inkjet prints due to exposure to high and to atmospheric pollutants.

DIGITAL IMAGE STORAGE AND LONGEVITY

At the start of this chapter we saw that electronic media have, in addition to potential physical and chemical degradation, the problem of obsolescence. Unfortunately, even if the best media and storage conditions are ensured, the success in securing the longevity of digital images is only partial, because it is impossible to rely upon the hardware and software used to store the digital images being available in the future. This fact has been realized for many years but the solution is neither simple nor obvious. One suggestion is that data should be transferred from the old storage media to the new media as it becomes available. This process is known as *data migration*. It is suggested that permanence of digital storage should be considered as a measure of the renewal period. There is no degradation in the migration process, since digital information, unlike any other form of information, has the advantage of duplication without loss. Depending on the amount of image data, migration might be very challenging. It is time-consuming and requires whole systems for data management. However, it is very unlikely that existing materials, formats and compression techniques are reliable for more than a couple of decades. As shown in Figure 18.8, digital media used as recently as 20 years ago are already incompatible with most of today's systems. This poses problems for artists who care about the longevity of their work, archivists who wish to preserve visual heritage and individuals who want to pass their photographs on to future generations. The migration of digital data from one medium and format to a newer one is therefore an essential requirement despite the difficulties.

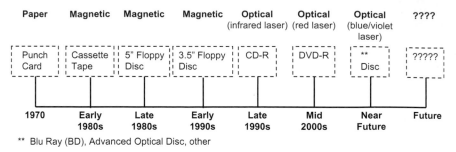

Figure 18.8 Timeline illustrating the developments in common removable digital storage media. *Adapted from Byers (2003)*

Modern storage media have two life expectancies: one refers to the physical and chemical lifetime and the other to the expected time of obsolescence. Rothenberg (1999) has summarized the problem:

> *There is as yet no viable long-term strategy to ensure that digital information will be readable in the future. Digital documents are vulnerable to loss via the decay and obsolescence of the media on which they are stored, and they become inaccessible and unreadable when the software needed to interpret them, or the hardware on which that software runs, becomes obsolete and is lost.*

Figure 18.9 gives an indication of these times for some commonly used storage media and further reinforces the view that data migration is essential. The figure also indicates that the migration must be carried out within the life span of the medium's chemical/physical life expectancy. Storage media have varying suitability according to the storage capacity required and preservation or access needed.

Magnetic storage

Magnetic storage media use magnetically coated surfaces to store information. They are rewritable media and

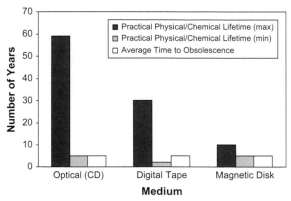

Figure 18.9 Life expectancies of common digital storage media. *Based on data from Rothenberg (1999)*

information is accessed — read and written — by magnetic heads. The most common magnetic image storage devices are hard disks (fixed or portable) and magnetic tapes (commonly in cartridges and cassettes). On a hard disk, digital information is accessed randomly and thus very rapidly; in magnetic tapes it is accessed sequentially. Although the reliability of magnetic media has improved substantially in recent years, their integrity has varied considerably from manufacturer to manufacturer. The very rapid increases in disk space and data access speeds for hard disks make them very suitable as 'working' storage media. Magnetic tapes, in contrast, are cheap, and have large data capacity (typically 20–40 GB) but a short life span. This is why they are recommended for keeping additional copies (back-ups) in image archiving (where rapid and frequent access is not required), provided that tapes are replaced annually.

The weakness of magnetic media is in the way they read and write information; thus, longevity is not one of their advantages. They suffer degradation from high-intensity magnetic fields. Hard disks require a certain range of air pressure to operate properly and very high levels of humidity can cause damage to the heads and corrosion. Normal use can eventually lead to failure of these rather fragile devices, so backing up images frequently is imperative. Magnetic tapes should be kept in cool conditions, good-quality air and at maximum 50% RH for best preservation. Binder degradation can cause uneven tape transport and layer separation. Tapes need to be handled with care because they are thin and fragile.

Optical disc storage

The most popular storage for digital images is *optical disc storage*, including types such as CD-ROM, CD-R, CD-RW, DVD, DVD-R and DVD-RW. Optical disc drives use laser diodes to illuminate the information engraved as *pits* on the disc's reflective layer (i.e. *the land*). In the case of a read-only CD-ROM the laser beam is reflected back from the reflective metallic surface (aluminum or gold), which is very close to the top of the disc, to a sensor that 'reads' the information; when a pit is encountered the beam is not

reflected back. Fast random access is the result of the continuous sequence of sectors on the spiral layout of the discs. The basic structures of a CD-ROM, a CD-R and a DVD-R are shown in Figure 18.10. The writable CD-R has a slightly different structure than the CD-ROM, as shown in Figure 18.10, in which pits are recorded in a dye layer in the guiding groove where the recording beam converts the dye to products that block reflection. Above the dye layer is a reflective metallic area and above that is a layer of protective lacquer. The types of data (i.e. read only, recordable or rewritable) and recording layers depend on the type of disc. Table 18.4 shows the relationship between the data types stored on various optical media, the metal layers and the disc type.

CD-ROM and DVD media are read-only storage media, CD-R, DVD-R and DVD+R are recordable once, and CD-RW, DVD-RW and DVD+RW can be used for re-recording digital information. They are removable media, which can be duplicated and handled quite easily. CD-Rs are preferred for image archiving because of their write-once capability, which provides high security from data erasure or modification.

CDs are subject to deterioration, and a lifetime of around 100 years is a reasonable estimate based on moderate storage conditions, which is indicated in Figure 18.9. Like other non-electronic media, they may be affected by poor storage conditions, handling, scratches, etc., although they are more tolerant to scratches than most other media. This is because the reading laser beam is focused on the pits (see Figure 18.10), some distance away from the surface of the disc where the scratches are located, and they are out of focus. Apart from the more obvious physical damage, CDs may deteriorate through oxidation of the reflective metallic

layer, which in early CDs was aluminium. In more recent CDs aluminium alloys are used, which are more resistant to oxidation, and gold is used in writable CDs, which does not oxidize readily. Similarly to hard-copy media, slow chemical changes will cause degradation of the data over long periods of time, such as dark and light fading of dyes in CD-R discs and the oxidation of metallic reflective layers in CD-ROMs.

Other problems that can occur in CDs and must be guarded against are:

- Diffusion of solvents from labels
- Peeling off of labels, which may cause localized delamination
- Diffusion of solvents from felt-tip pens for marking and identifying the discs
- Writing on discs with a ball-point pen or pencil
- Cleaning with solvents
- Exposure to sunlight
- Storage at temperatures greater than 25°C and RHs greater than 50%
- Sudden and rapid changes in temperature and humidity
- Exposure to dust and dirt
- Handling the surface.

Predictions of the life expectancy of CDs come from accelerated ageing tests very similar to those described previously for photographic and related media and extrapolation to storage conditions of 25°C at 40% RH. Life expectancy is based on readability errors in the data stored on the disc. It may be determined as *block error rates* (BLERs). The BLER is the number of errors detected in a 10-second period and can be expressed as $BLER_{max50}$, where

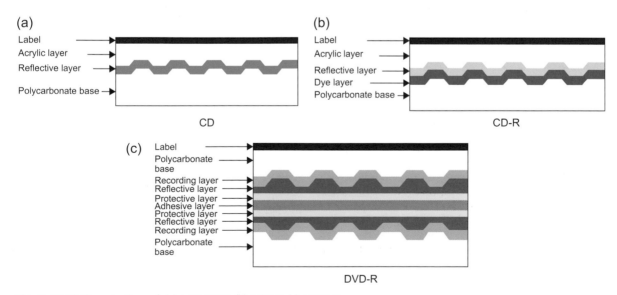

Figure 18.10 Cross-sections of: (a) a CD-ROM; (b) a CD-R; (c) a DVD-R.

Table 18.4 Disc type, read/record type, data layer and metal layer

CD	DVD	TYPE	DATA LAYER	METAL LAYER
CD-ROM	DVD-ROM	Read only	Moulded	Aluminum (also silicon, gold or silver in double-layered DVDs)
CD-R	DVD-R DVD+R	Recordable (write once only)	Organic dye	Gold, silver or silver alloy
CD-RW	DVD-RW DVD+RW DVD-RAM	Rewritable (write, erase and rewrite)	Phase-changing metal alloy film	Aluminium

Modified from Byers (2003).

max refers to the maximum BLER found on reading the disc and 50 refers to the end-life of 50 errors. This is the electronic data equivalent of a 10% fade value for a hard-copy material, for example. However, it has been pointed out that most discs are still readable with a $BLER_{max50}$ and that this test provides a pessimistic measure of life expectancy.

Like all materials that suffer chemical degradation over long periods of time, the life expectancy of CDs can be substantially prolonged by storage at a reduced temperature of $10°C$ and an RH within the range of 20–50%. This slows down the rate of any chemical reactions that may be taking place. Discs that are in daily use are likely to last less long than those that are back-up archival copies kept under consistent and controlled conditions.

The use of the ISO 9660 for recording on CD media is recommended, because it ensures access of the stored data from all current computer platforms and operating systems. The ISO 9660 is an international standard published in 1988, which defines a method of organizing computer files for CD-ROM media. An extension to ISO 9660, the Joliet system format, allows longer file names and non-ASCII character sets. DVDs may also use the ISO 9660 file system, although the Universal Disk Format (UDF), based on the ISO 13346:1995 standard, is more appropriate on DVDs. It has better support for the larger storage media and is more suitable to the needs of modern operating systems. CD and DVD writers are common and inexpensive nowadays. CD-type discs can store over 600 MB, a capacity which is rather limited for contemporary image sizes but they cost very little. DVDs are more recent optical storage media with capacity to store 4.7–18.0 GB.

Other digital image archiving issues

Other image storage media include *flash cards* and *solid-state disks* (SSDs) that have very fast data access and are used mostly as temporary storage devices in digital cameras. The

life expectancy of such media is difficult to obtain and has not being researched in any depth. Otherwise, *remote storage* — where digital image files are kept in large servers and their longevity is the responsibility of the provider of the service — is becoming more and more popular, especially from institutions that hold large amounts of digital information. One example of such a service is the Digital Repository Service (DRS) of the Harvard University Library in the USA, which is a preservation repository holding millions of digital objects under managed storage and intended for highly 'curated' digital assets.

It is best for the longevity of digital image data to store one copy of each image in a form as close as possible to the original capture. This enables the user to always be able to refer back to a 'master' copy, which is what the capturing device can produce best with minimum processing (i.e. using the native RGB space of the device and minimum image processing — see Chapters 14 and 23). In such a case the image might not be optimized for a specific output. Archiving only an optimized copy often produces a loss in quality, such as compression of the native colour gamut, but has the advantage of a ready-to-use image. If only one optimized version of the image file is saved, it is recommended that one of the standard RGB colour spaces be chosen for colour encoding — e.g. Adobe RGB 1998 for print and sRGB for display media.

The requirements of a file format for archiving are that it is an open standard, non-proprietary file format and preferably no compression is used — although lossless compression may be acceptable. Uncompressed Tagged Image File Format (TIFF) has been the most popular choice for archiving images. In 2004 Adobe proposed the Digital Negative (DNG) format as a non-proprietary file format for storing camera RAW files that can be used by a wide range of hardware and software vendors. Like most RAW file formats, the DNG file holds the RAW data in a TIFF-based format. DNG is quickly becoming a choice for image archiving purposes. The Portable Network Graphics (PNG) file format is an open-source image format working toward official standardization, and is considered as a possible

replacement for TIFF. Otherwise, JPEG 2000, which can be lossy or lossless depending on the compression algorithm (see Chapter 29), has recently been recommended for archiving images because of several advantages, such as the storage of several resolution levels, the allowance for *image metadata* to be built into the image file and bit-depth support to 48 bits. Chapter 17 provides extensive information on file formats.

Digital image files intended for preservation should be accompanied by *image metadata*. Preservation metadata is information supporting the digital preservation process. A number of metadata categories can be saved, including descriptive, administrative (including copyright and permissions), technical (including information on the tone and colour reproduction, resolution, etc. of the capturing device) and structural. Technical metadata are probably the most important in supporting preservation. The 2006 ANSI/NISO Z39.87 Standard on Technical Metadata for Still Images lays out a set of metadata elements to facilitate interoperability among systems, services and software, as well as to support continuing access and long-term management of digital image collections.

BIBLIOGRAPHY

ANSI/NISO Z39.87, 2006. Data Dictionary — Technical Metadata for Digital Still Images.

Byers, F., 2003. Care and Handling of CDs and DVDs: A Guide for Librarians and Archivists. Council on Library and Information Resources and National Institute of Standards and Technology, Washington, DC, USA.

Image Permanence Institute, 2004. A Consumer Guide to Traditional and Digital Print Stability. Image Permanence Institute, Rochester Institute of Technology, Rochester, NY, USA.

ISO/IEC 13346-1:1995, 1995. Information Technology — Volume and File Structure of Write-Once and Rewritable Media using Non-Sequential Recording for Information Interchange, Part 1: General.

ISO 9660:1988, 1998. Information Processing — Volume and File Structure of CD-ROM for Information Interchange.

ISO 18924:2000, 2000. Imaging Materials — Test Method for Arrhenius-Type Predictions.

ISO 18909:2006, 2006. Photography — Processed Photographic Colour Films and Paper Prints — Methods for Measuring Image Stability.

Jacobson, R.E., Attridge, G.G., McDermott, D., Mitchell, C., Tong, B., 1996. Light stability of colour hardcopy materials. Journal of Photographic Science 44, 27—30.

Jacobson, R.E., Ray, S.F., Attridge, G.G., Axford, N.R., 2000. The Manual of Photography, ninth ed. Focal Press, Oxford, UK.

McCormick-Goodhart, M.H., 1996. The allowable temperature and relative humidity range for the safe use and storage of photographic materials. Journal of the Society of Archivists 17 (1).

Miller, N., 2005. How long will your digital prints will last? Shutterbug March.

Rieger, O., 2008. Preservation in the Age of Large-Scale Digitisation. Council on Library and Information Resources, Washington, DC, USA.

Rothenberg, J. 1999. Ensuring the longevity of digital information, expanded version of the article 'Ensuring the Longevity of Digital Documents' published in Scientific American, January 1995, Vol. 272 (1) — http://www.clir.org/pubs/archives/ensuring.pdf

Ware, M., 1994. Mechanisms of Image Deterioration in Early Photographs. Science Museum and National Museum of Photography. Film and Television, London, UK.

White, G., 2007. Nash Editions: Photography and the Art of Digital Printing. New Riders, Berkeley, CA, USA.

Wilhelm, H. 2007. A survey of print permanence in the 4 × 6 consumer digital print market in 2004—2007. Proceedings IS&T's 2007 International Symposium on Technologies for Digital Fulfilment, Las Vegas, NV, USA.

Wilhelm, H., Brower, C., 1993. The Permanence and Care of Color Photographs: Traditional and Digital Color Prints, Color Negatives, Slides, and Motion Pictures. Preservation Pub. Co., USA.

Wilhelm Imaging Research, http://www.wilhelm-research.com.

Introduction to image quality and system performance

Sophie Triantaphillidou

All images © Sophie Triantaphillidou unless indicated.

INTRODUCTION

In this chapter we will review the *quantification of image quality*, as carried out by imaging scientists, designers and engineers, who are concerned with the design, implementation and manufacturing of imaging systems.

The quantification of image quality is often related to a number of *image quality attributes*, also referred to as *image quality dimensions*, which contribute to the overall impression of the quality of images. Many of these attributes have already been mentioned in previous chapters (e.g. resolution, sharpness). Here we will clearly identify them and list the most useful *objective imaging performance measures* employed in their quantification. In Chapters 20–24 we will discuss each of these extensively, their purpose and their individual measurement for both analogue and digital imaging systems.

Later in the chapter we will introduce qualitative methods such as *image psychophysics* and *psychometric scaling*. These methods are employed to quantify the quality of images, to derive *thresholds* of visibility of image defects or artefacts and *just-noticeable differences* between image stimuli. Lastly, there will be an introduction to *image quality metrics and models*, designed to predict the visual impression of image quality.

SUBJECTIVE AND OBJECTIVE IMAGE QUALITY

Figure 19.1 illustrates a typical imaging chain. Every component in the chain contributes to the overall quality of the image. In many cases, the purpose of image quality measurement is to quantify the relationship between the *scene* and the *image* (the input and the output in the imaging chain respectively). However, often the 'scene' is not at our disposal, or it is even irrelevant to the preferred reproduction, which might include purposeful distortion; thus we may simply quantify the quality of the produced image. At the end of the imaging chain there is the *observer*, who makes subjective judgements on the quality of the image.

Before we discuss methods employed in the evaluation of image quality, first let us define it: strictly speaking, image quality is the *subjective impression* of goodness that the image conveys. Amongst many well-known image scientists, Jacobson pointed out the fact that the perceived quality is very difficult to define. Engeldrum has defined image quality as '*the integrated set of perceptions of the overall degree of excellence of an image*' and Keelan as '*an impression of its (the image's) merit or excellence, as perceived by an*

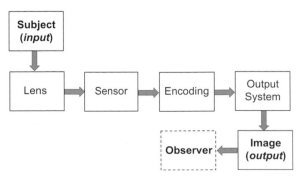

Figure 19.1 A typical imaging chain.

DOI: 10.1016/B978-0-240-52037-7.10019-5

observer neither associated with the act of photography, nor closely involved with the subject matter depicted'. All given definitions point to the fact that, ultimately, image quality is a subjective attribute that relates to human perception, memory, experience, etc. After all, it is the human observer that decides whether an image looks good. If we now revisit Figure 19.1 we establish that the objective relationship between the input and the output in the imaging chain has to correlate with the subjective (observer's) judgement of the image.

Image quality assessment

In order to produce reliable measurements it is necessary to understand the factors influencing image quality. The subjective assessment of image quality is a function of the *human visual system* (HVS), as well as the *quality criteria* of the observer. The HVS is highly dependent on the viewing conditions as well as the physical properties of the test stimuli, i.e. the test images used in the evaluation. The quality criteria of the observer are based on various cognitive factors, such as memory, influences, experience, expectations and many more, and result in a variation of assessments amongst individuals as well as temporal variations for any one individual. Different observers may prefer slightly different colour reproduction of the same subject, or the same observer may alter their preference over time because of, for example, contemporary trends in colour printing. The purpose and context in which the image is to be used also influences the subjective assessment of image quality. A photograph printed in a newspaper is usually of a 'good-enough' quality for illustrative purposes, but should the same relatively low-quality print be displayed in an exhibition, its quality would probably be judged as disappointing.

Measurements relating to image quality assume that there is a functional relationship between the subjective impression of image quality and some selected attributes of the observed stimuli (introduced later). This assumption is based on experience gained from *psychophysical experiments*, the purpose of which is to provide quantification of qualitative attributes (see later section on image psychophysics). Psychophysical tests are performed under controlled viewing conditions and measure *subjective image quality*, or attributes of it, using a panel of observers and statistical analysis to quantify the observers' responses. *Objective image quality*, on the other hand, employs *performance measurements*, carried out on images or imaging systems. Useful performance measurements are those which correlate successfully with the subjective impression of image quality. Further, computation and modelling is used to produce complex objective measures, such as *image quality models* and *metrics*. These often incorporate models of the HVS along with performance measurements taken from images or systems (see later section on image quality metrics/models).

Basic image quality attributes (or dimensions)

The appearance of images has traditionally been considered to be influenced by five basic *image quality attributes*: tone (or contrast), colour, resolution, sharpness and noise. These main attributes, also referred to as *image quality dimensions*, along with the associated visual descriptors, are summarized in Table 19.1. They are assessed using either subjective or objective measurements, collectively (i.e. assessments of the *overall image quality*) or individually. They are measured either purposefully by image quality evaluators, or considered unconsciously when we look at images. The individual subjective assessment of these attributes is a subject of debate, since many have argued that judgements of image attributes are unlikely to be independent from other attributes, while the relationship between them has been studied extensively. Figure 19.2 demonstrates an example of the interrelationship between resolution, sharpness and contrast in perceived image quality.

Tone reproduction is concerned with the reproduction of intensity[†] and intensity differences between the original and the image, i.e. objective tone reproduction, as well as with the observer's impression of these qualities, i.e. subjective tone reproduction. The reproduction of tones is the most important attribute of image quality, being a critical component of the subjective impression of both the excellence of an image and the fidelity of the reproduction. Its importance lays in the fact that the achromatic visual channel carries the majority of the visual information (see Chapters 4 and 5). Other image quality attributes, such as colour, resolution and sharpness, are governed by the contrast of the image and their measurement relies on optimum tone reproduction. As we saw in Chapter 8, the

Table 19.1 Image attributes examined in image quality assessments and associated perceptual attributes

IMAGE ATTRIBUTE	VISUAL DESCRIPTION
Tone	*Macroscopic contrast* or reproduction of *intensity*
Colour	Reproduction of *brightness* or *lightness*, *colourfulness* or *chroma* and *hue*
Resolution	Reproduction of *fine detail*
Sharpness	*Microscopic contrast* or reproduction of *edges*
Noise	Spurious information

[†] Intensity is used as a generic term for physical quantities such as luminance, illuminance, transmittance, reflectance, and density.

(a) (b)

Figure 19.2 Image (a) was photographed with a lens with poor resolution but has increased contrast. Image (b) was photographed with a lens with good resolution but has less contrast than (a). Image (b) may look sharper than (a) from reading distance, but once the viewing distance is increased, (a) will look sharper than (b) due to its increased contrast.
© Carl Zeiss

objective tone reproduction of silver-halide-based photographic media is evaluated sensitometrically from the characteristic curve. In a similar fashion, the relationship between input and output intensities is plotted for the evaluation of the tone reproduction of electronic devices. Such plots are referred to generally as *transfer functions*. Chapter 21 introduces the *theory of tone reproduction* and measures related to digital imaging.

The objective evaluation of *colour reproduction* is achieved via densitometry, spectral colour definition, colorimetry or colour appearance modelling. In Chapter 5, basic colour theory and the objectives of colour reproduction were introduced. Which objective is appropriate for a given application depends on various criteria, including the purpose of the reproduction, restrictions imposed by physical limitations of imaging systems, illumination and viewing constraints. Chapter 22 discusses extensively the colour reproduction of silver-based media. Digital colour imaging media function in their own intrinsic colour dimensions. These vary, from one type of medium to another (e.g. cathode ray tube (CRT) vs. liquid crystal display (LCD)), also from one device to another (e.g. LCD vs. digital camera), resulting in somewhat arbitrary colour reproduction, when colour characterization and management between devices and media is not involved in the image making. Chapter 23 deals with the colour reproduction of digital imaging devices and its evaluation, and Chapter 26 is dedicated to digital colour management.

Resolution is a spatial image attribute. It is concerned with the ability of a system to reproduce fine detail, i.e. high spatial frequency information in images. This ability is a function of the number of basic image points, or point spread functions (PSFs) per unit distance – in other words, a function of the size of a basic image point (see Chapter 7). Traditionally, resolution in photographic and optical systems is determined by measuring the *resolving power*, in line pairs per mm, using bar targets and visual estimates with the aid of a microscope. The estimation of resolving power is critically dependent on the contrast of the target and each stage in the evaluation (i.e. microscope, visual acutance and experience of the evaluator). Also, resolving power measurements cannot be cascaded though the imaging components of a chain. Other methods involve measuring the limiting resolution from the PSF of the system, or deriving it from the system's modulation transfer function (MTF) (see Chapter 24). It is worth noting that, in digital imaging systems, resolution often refers to the *number of available pixels* per unit distance, as in dots per inch (dpi or ppi) for input devices and printers, or to the *addressable resolution* (or *addressability*) in displays, i.e. the number of points that are addressed by the graphics card adaptor. This should not be confused with the system's 'true' resolution relating to the effective size of the smallest image point formed by the system.

Like resolution, *sharpness* is a spatial attribute concerned with definition, more specifically the definition of edges.

347

Objective measures of sharpness, however, take into account the microscopic image contrast and thus correlate with the subjective impression of definition, i.e. the impression received by an observer viewing well-resolved image elements. Although resolution and sharpness are very closely related, there are cases where images of low resolution may appear sharper than images of high resolution due to their increased contrast (see example in Figure 19.2). Traditionally, in photographic and optical systems, objective sharpness has been evaluated by measuring either the *acutance* or the system's MTF. Although acutance measurements produce a single figure of merit for assessing image sharpness, the MTF has been a far more successful measure, since it is a function describing the reproduction of micro-image contrast at all available spatial frequencies and falls to some threshold value, which is considered as the limiting system resolution. Today, MTF is the dominant measure in the evaluation of sharpness in all imaging devices. The theory of MTF is strictly applicable to linear and stationary systems, and allows the determination of the overall system MTF from the MTF of the individual imaging components (see Chapter 7). It is necessary to compensate for various non-linearities present in the system for its accurate evaluation. This can be achieved by correcting for input-to-output (transfer) non-linearities or restricting the test target to a very low contrast, i.e. an intensity range where the system is assumed to behave linearly. Chapter 24 discusses in detail objective methods for evaluating image sharpness and MTF measurements. Figure 19.3 demonstrates the fact that although the limiting resolution of two systems might be similar, their sharpness may differ greatly.

Image noise is defined as the intensity fluctuations around a mean signal which is introduced by the imaging system. Noise obscures image features, particularly fine detail, but it is more visible in uniform areas, i.e. areas of low frequencies. It is generally objectionable: as image noise increases, image quality decreases monotonically. It is inevitable in all imaging systems, including the HVS, due to the statistical nature of light. Theoretically, it is random and signal independent, but in real systems it is semi-random because it is often signal dependent; that means it is often controlled by the input intensity. There are various types of distortion referred to as non-random noise, such as pixel-to-pixel non-uniformities in an imaging sensor, or CRT spot misposition produced by inaccurate digital-to-analogue converters. In silver-based photographic media, noise is the result of the binary process of sensitization of silver grains, whilst sources of photographic noise include grain clusters resulting from the random distribution of grains, fog and development effects. In electronic sensors common sources are electronic, photoelectronic and quantization noise. The subjective impression of image non-uniformities due to noise is termed *graininess* or *noisiness*. The objective aspect in terms of spatial variations in the image is termed *granularity* (an expression that has its origins in traditional photographic media and is

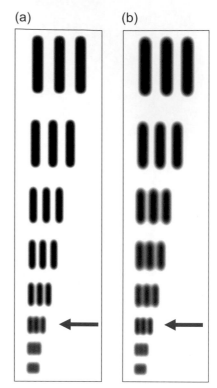

Figure 19.3 Systems a and b have approximately the same limiting resolution (indicated with the red arrows), but different image sharpness.
Adapted from Burns (2006)

not used to describe electronic noise) or simply noise. Noise can be objectively evaluated statistically, or in terms of its components at different spatial frequencies (see Chapter 24).

Imaging performance measures related to the attributes discussed above are presented in Table 19.2.

The image quality circle

To simplify the understanding of image quality, the relationship between the perception of image quality attributes and related objective or physical measures (or physical image parameters, examples in Table 19.2), technological imaging system parameters and observer's preference, Engeldrum (2000) has proposed a step-by-step approach called the *image quality circle* (IQC). According to this approach, the goal of an imaging designer is to relate the technological variables of the imaging system to the quality preference of the observer and, in the case of a commercial system, to the preference of the customer. The IQC, as illustrated in Figure 19.4, breaks the relationship down into a series of measurable steps. It contains four elements (shown in grey rectangles), which are linked to each other via models and algorithms (shown in white rectangles).

Table 19.2 Imaging performance measures relating to the objective evaluation of imaging systems

IMAGE ATTRIBUTE	MEASURES
Tone	Characteristic curve, density differences, transfer function and OECF, contrast, gamma, histogram, dynamic range
Colour	Spectral power distribution, CIE tristimulus values, colour appearance values, CIE colour differences
Resolution	Resolving power, imaging cell, limiting resolution
Sharpness	Acutance, ESF, PSF, LSF, MTF
Noise	Granularity, noise power spectrum, autocorrelation function, total variance (σ^2_{TOTAL})
Image content and efficiency	Information capacity, entropy, detective quantum efficiency

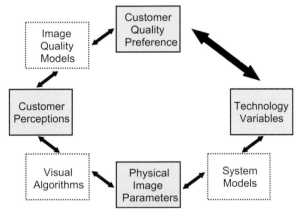

Figure 19.4 The image quality circle (IQC). The *key elements* are in grey rectangles and the *connecting links* in white rectangles.
Adapted from Engeldrum (2000)

The four elements of the IQC approach are:

- *Customer quality preference* is defined as the *overall image quality*, as judged or rated by observers.
- *Customer perceptions* are the *subjective perceptions* of the basic image quality attributes or dimensions introduced above. These are often called the 'ness' of the attribute, for example sharpness, graininess, etc.
- *Physical image parameters* are measurable system parameters we ascribe to image quality, such as the physical measures in Table 19.2.
- *Technology variables* are the parameters of the system that can affect image quality. These are governed by physical constraints. System designers and manufacturers manipulate them in the best possible way to change the quality of their systems. Examples include: the size of a pixel, which affects resolution; and the choice of camera colour filter arrays, which affects colour reproduction.

These four elements are linked to one another via models and algorithms as shown in Figure 19.4:

- *Image quality models* are empirical (statistical) models that link the customer perceptions (e.g. sharpness, graininess) to quality preferences or overall image quality.
- *Visual algorithms* are used to compute a value of the subjective perception, such as sharpness, from objective quality measures, i.e. imaging performance measures, such as the gradient of an edge. In the context of IQC, 'visual' implies that the spatial properties and the non-linear response aspects of the HVS are incorporated in the algorithm.
- *System models* are analytical models that predict the physical image parameters from the technology variables. One example might be the model of the system's point spread function developed by knowing technology variables such as the pixel aperture and the sampling interval.

Further image quality attributes

Apart from the five basic image quality attributes introduced earlier in this chapter, there are a large number of other attributes that are related either to the objective quantification of systems or the subjective quantification of images. Some frequently employed ones are discussed in this section.

One way to look at the objective quality of an image is in terms of the *amount of information* it contains. *Information theory* deals with the objective quantification of information and was originally applied to communication channels. It has been used extensively in quantifying information in images, or the information that imaging systems convey. Related measures, such as the *information capacity* and *entropy*, have been shown to correlate with quality and image usefulness.

Another physical attribute that relates to image sensors, in particular, is their effectiveness in recording light signals. The detector's *speed* is related to how fast the detector reacts to light, while *sensitivity* and *detective quantum efficiency* are related to how sensitive to light the detector is. Measures relating to these attributes are discussed in Chapters 20 and 24.

In addition to attributes introduced up to this point, which relate to physical quantities in systems and have objective measures associated with them, two *visuo-cognitive attributes* are commonly used - in the evaluation of image quality: *usefulness* and *naturalness*. These attributes relate to the 'successful interpretation' of the image, which is based on the idea that the interpretation process should result in a satisfactory match between visual representation and knowledge of reality. Usefulness is defined as the precision of the visual representation of the image. Naturalness is defined as the degree of correspondence between the visual representation and the knowledge of reality, as stored in memory. Thus, in this context a 'good-quality' image implies that the visual representation of the image should be sufficiently precise, and the correlation between the visual representation and knowledge of reality as stored in memory should be high. The usefulness and naturalness of images are only evaluated subjectively. Objective measures indicating good image sharpness, accurate tone reproduction or only small shifts in the reproduced hue have been shown to correlate successfully with both the usefulness and naturalness in images.

DIGITAL IMAGE ARTEFACTS

Digital images suffer from artefacts that, generally, cannot be classified in a conventional manner or quantified using

Table 19.3 Common digital image artefacts, their sources and image areas which are more susceptible to each artefact

IMAGE ARTEFACT	CAUSE OF ARTEFACT	SUSCEPTIBLE IMAGE AREAS
1. Contouring	Poor quantization	Uniform and slow varying areas
2. Jaggedness/pixelization	Insufficient spatial resolution	Slanted edges, slanted lines
3. Aliasing	Sampling	Areas with periodic high-frequency information (high-frequency lines)
4. Blocking	DCT compression	Affects: areas with high-frequency info More visible: uniform and slow varying areas
5. Smudging	DWT compression	Edges and lines
6. Colour bleeding	DWT compression	Adjacent colour areas
7. Ringing	Abrupt truncation of frequencies. Examples include *ideal filtering* in the frequency domain or DCT compression	Appears as an echo or a ripple around edges and lines
8. Halo artefact	Exaggerated 'overshoot' at edges caused by digital sharpening in the spatial domain	Appears as a halo around edges and lines. Can appear similar to the ringing artefact
9. Patterning	Dithering	Slow varying areas except for pure blacks and pure whites
10. Streaking	Pixel-to-pixel non-uniformity in linear arrays (mostly in digital printing devices)	Uniform areas, slow varying areas
11. Banding	Periodic variations in digital printing devices	Uniform areas, slow varying areas
12. Color misregistration	Optical images of different colour channels not geometrically identical	Small amounts: edges, lines, areas with high-frequency information Large amounts: all areas
13. Digital flare (also referred to as blooming in images from digital cameras)	Stray light from areas of high intensity	Dark areas surrounded by high-intensity areas

classical objective measures, as, for example, those listed in Table 19.2. Digital image artefacts can be considered as 'noise', since they are information originating from the system — they are not components of the signal — and are objectionable, i.e. their presence decreases image quality. The most common are listed in Table 19.3, along with their origins and image areas that are more susceptible to each artefact. Based on their origins they can broadly be classified as follows: artefacts 1–3 are due to the nature of the digitization process, which involves spatial sampling and quantization; artefacts 4–8 result from digital image processes, such as image compression and sharpening (Chapters 27–29); artefacts 9–11 are types of non-isotropic noise, often originating from errors in digital printing; artefacts 12 and 13 are also common to analogue systems.

There are a few objective measures dealing with the measurement of individual artefacts, such as the evaluation of colour misregistration in digital input devices via the *spatial frequency response* (SFR; Chapter 24), or several image quality metrics designed specifically to quantify the effect of compression artefacts. In the majority of cases, however, the impact of digital image artefacts is evaluated subjectively, by determining visual thresholds or by measuring the decrease in overall image quality due to their presence.

DISTORTION, FIDELITY AND QUALITY

Under the general expression 'image quality' three different aspects, all concerned with the assessment of images or imaging systems, may be referred to: *image distortion, image fidelity* and *image quality* (as defined earlier on page 345 in its true, narrower sense). Although they investigate different aspects of images, the terminology attached to them is often applied inconsistently in the literature. Figure 19.5 summarizes the components involved in the assessment of image distortion, image fidelity and image quality. It also illustrates the points in the imaging chain where related evaluation is carried out.

Image distortion

Image distortion simply assesses physical differences in images, for example differences in pixel values, densities or spectral power distributions. *It is only assessed objectively.* Distortion measures and metrics are most often applied to evaluate numerical differences between digital images and more specifically the effects of various image-processing algorithms, such as image compression (see examples in Chapter 29). These measures do not take into account the visual significance of the error and therefore results from distortion assessments do not often correlate with perceived image quality. An example can be seen in Figure 19.6, which illustrates an original image (a) and two distorted versions (b and c): (b) is created by simply adding a positive constant to the original and (c) by adding the same constant, but with a random sign. Images (b) and (c) have exactly the same measured distortion (calculated from the difference image) with respect to the original but their quality differs drastically. Image (b) is simply a lighter version of the original and can be a perfectly acceptable reproduction, but image (c) is a much 'noisier' version and consequently of much lower visual quality than (b).

Image fidelity

Image fidelity assesses whether an image is *visually distorted*. It is concerned with *relative thresholds*, i.e. minimum changes/differences in images that can be visually detected. Image fidelity involves the HVS. Its physiological and cognitive functions are employed when psychophysical tests are carried out to evaluate subjective image fidelity. These can be *threshold experiments* designed to determine the just-noticeable difference (JND) in a stimulus and matching techniques employed to determine whether two stimuli are perceptibly different (see section on psychophysics later in the chapter). Fidelity judgements may be related to the observer's mental prototype used to produce a match of a memorized colour; for example colours of

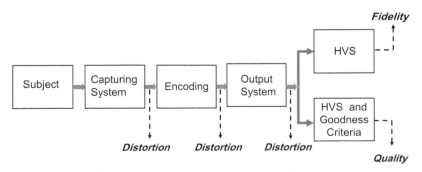

Figure 19.5 Image distortion, image fidelity and image quality, and points in the imaging chain where related evaluation is carried out.
Adapted from Ford (1997) and further from Triantaphillidou (2001)

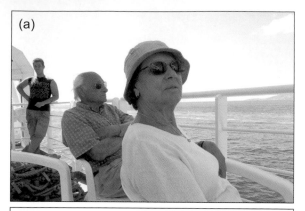

Figure 19.6 (a) Original image. (b) Distorted version created by adding a positive constant to each pixel value of the original. (c) Distorted version created by adding the same constant but with a random sign.

Although in the first instance we might think that an image of high fidelity is of a high quality too, it is known that image fidelity does not always correlate with the subjective impression of image quality, i.e. threshold judgements are unrelated to suprathreshold judgements. Observers may notice the difference between two images and yet prefer the distorted version to the original. In many applications accurate or faithful reproduction is not the ultimate goal. For example, a slightly blurred reproduction of a portrait might be assessed to be of a higher quality than the sharper original, since blurring provides a 'softer' appearance to skin. Similarly, a digitally sharpened reproduction of a photograph that includes a lot of fine detail may be more appealing than the original. In pictorial imaging, deliberate distortions are often introduced to match the *preferred reproduction* of some colours such as Caucasian skin, blue sky colours and green grass (see Chapter 5). In most consumer cameras, manufacturers aim to adjust their devices and algorithms so that customers find the resulting images pleasing, rather than faithful reproductions — which may be the aim of scientific imaging devices.

Image quality

Image quality is concerned with threshold points as well as suprathreshold magnitudes. The difference between image fidelity and image quality is often not clearly distinguished. It has been described as the difference between the ability to discriminate between two images and the preference of one image over another, or the difference between the visibility of a factor (such as an artefact) and the degree to which that factor is bothersome. Apart from the physiological and cognitive factors of the HVS, the subjective assessment of quality also involves the quality criteria of the observers, since it deals with the acceptability in the case of loss of fidelity and the measurement of the perceptual magnitudes of error. It is subjectively quantified by suprathreshold judgements, using preference, categorical or other scaling methods aiming to create subjective quality sales (see section on psychophysics). Objective quantification involves measurements of the system's performance or modelling of one or several system attributes. These are often combined with models of the HVS to produce models of image quality and image quality metrics (see later section on image quality models and metrics).

Some image attributes and/or characteristics have a stronger impact on observers than others. Thus, in objective quality assessments errors of similar magnitude may not be equally acceptable. In the reproduction of colours, for example, some colours are more important than others (greys, blue sky, foliage, skin); in colorimetric errors hue shifts are more serious than chroma differences. A distinction between the *perceptibility* (the just-noticeable difference) and the *acceptability* (the maximum colour deviation) of differences is essential.

skin, green grass and blue sky may be biased towards idealized prototypes of memory colours of the real objects. The fidelity of images is objectively quantified using models of the reproduction system/image along with models of the HVS describing the lower-order processing of the visual cortex, and in some cases psychophysical functions dealing with the probability of signal detection.

The use of a reference image

When measuring distortion or fidelity there is always the need for a *reference image* (or at least a 'model' of it) – that is, an original against which the distortion or fidelity of the reproduction is assessed. In image quality evaluations there may or may not be a reference original. Having a reference is not always possible but depends on the imaging application. In lossy image compression, for example, the distortion, fidelity or quality of the compressed image is readily quantified against the uncompressed original. However, when measuring the quality of an imaging device, such as a camera lens, a reference image does not exist in the first place. In such a case, quality is evaluated subjectively, simply by judgements of the resulting images, and objectively by measuring the lens's imaging performance using methods that involve test targets and related objective measures, such as those in Table 19.2.

TEST CHARTS AND TEST SCENES

Test charts

A wide range of *test charts* (also referred to as *test targets*), specifically designed to incorporate objects or image elements, are employed in the objective evaluation of the performance of imaging systems. They are usually designed to measure a specific image attribute, such as colour, tone or resolution. Test charts are *calibrated* in such a way that they have known and constant properties; these are often provided by the target manufacturer, or measured in the laboratory. They are considered as the input in the imaging system, i.e. 'the imaging signal'. The response of the system to this signal is used to quantify its imaging performance. A number of commonly employed test charts are illustrated in Figure 19.7. Details on the design and use of specific charts are provided in various relevant chapters in this

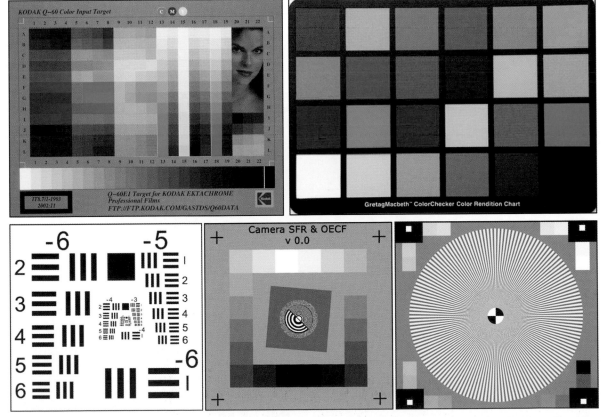

Figure 19.7 Commonly employed test charts for the evaluation of imaging performance. Top left: Kodak Q60 Target. Top right: GrettagMacbeth™ Color Checker Chart. Bottom left: 1951 USAF Resolution Test Chart. Bottom middle: test chart for digital camera SFR and OECF measurements, designed by Don Williams, Image Science Associates. Bottom right: star chart, designed by Imatest.

Figure 19.8 Top: two images from the ISO 12640:1997 set. Bottom: black-and-white version of 'Lena', a test image commonly employed for the evaluation of image-processing algorithms.

book. It is important to note that the response of the system is often signal dependent and thus results obtained by imaging a specific test chart may not always be representative of the system's overall performance.

Test scenes

In addition to test charts, real scenes, or images of them, can be used as the 'imaging signal' to evaluate distortion, fidelity or image quality. A variety of images representing scenes with different physical characteristics (for example, colours or spatial configurations) are often chosen carefully and purposefully by the experimenters. Various criteria have

been devised to help the selection of these scenes (see later in the chapter). Some test scenes are commonly employed and have been established as 'standard' test images within the imaging community. Examples include the ISO set (see Bibliography) and 'Lena', an image that is widely used in image-processing applications (see Figure 19.8).

IMAGE PSYCHOPHYSICS

The subjective evaluation of image quality uses *visual psychophysics*, which involves the study of visual stimulus

—response relationships. Psychophysics, when properly employed, has the capacity to produce accurate quantitative results from qualitative judgements. Human observers and statistical analysis of the resulting observations are the basis of psychophysics and *psychometric scaling*. The latter, with respect to image quality, deals with the measurement of human response to the continuum of image quality and/or its individual perceptual attributes, so-called 'nesses', e.g. sharpness, noisiness. As described by Engeldrum: *'these are called the "nesses" to emphasize the perceptual as opposed to the physical nature of these attributes'*. In particular, it deals with the creation of psychological rulers, or *psychometric scales*, against which subjective quality, or an image's 'ness', can be measured.

Psychometric scales

According to Engeldrum, the processes that must take place when developing *scale values* (i.e. numerical values obtained from the scaling study) are:

- Selection and preparation of samples
- Selection of observers
- Determination of observers' task or question
- Presentation of the samples to the observers and recording of their judgement
- Data analysis of the observers' responses and generation of the sample scale values.

Four types of psychometric scales were defined during the 1940s by Stanley S. Stevens, a renowned American psychophysicist who referred to measurement as 'the process of assigning numbers to objects or events by rules'. Since then, these scales have been the standard reference classification and measurement system in psychophysics. They are briefly described below and illustrated in Figure 19.9:

- *Nominal scale.* Samples or categories are identified solely by labels (numbers or names). A typical example

is images classified by categories, such as architectural, natural scenes, portraits.

- *Ordinal scale.* Samples or qualitative categories are ordered along the scale but there is no information about the distances along the scale. Category names or numbers in an ordinal scale simply represent the order of the events — for example, from 'best' to 'worst' quality or from 'least' to 'most'. The scale has greater than or less than properties.
- *Interval scale.* Numbers are used for measurement in these scales, which have the property of distance, as when using a ruler. Equal differences in scale values represent equal perceptual differences between the samples with respect to a 'ness' or overall image quality. Not all 'nesses' in an interval scale have a fixed zero point. Interval scales are usually floating scales (i.e. provide relative values), in that they are subject to linear transformations.
- *Ratio scale.* This is an interval scale with an origin equal to zero. The origin may not be experimentally measurable. Unlike the interval scales, ratio scales are fixed with respect to an origin of the scale.

The statistical analysis employed to derive each type of scale increases in complexity as the scales increase in sophistication, from nominal to ratio. The observer's skill and the amount of data also increase with increasing scale complexity.

The psychometric function

It is also possible to measure image fidelity using psychophysics, where observations are used to determine thresholds of visibility between an original and a reproduction (i.e. absolute thresholds), or determine just-noticeable differences (JNDs) in the psychological continuum of a 'ness'. The probability of 'seeing a difference' is the principle on which the concept of thresholds and JNDs is based. The observer is asked to respond with a 'yes' or 'no' to the question 'do you see the attribute?' or 'do you see a difference between stimuli?' and the responses are accumulated over a number of observers. The observers' responses are shown to vary even if the stimulus is constant! This variation is described statistically by a probability distribution, of which the cumulative distribution is referred to as the *psychometric function*. Such a typical function is illustrated in Figure 19.10. The absolute threshold is usually taken as the point where 50% of the observers can just see the attribute or 'ness', for example an artefact resulting from image compression. This corresponds to the 0.5 probability point on the psychometric curve. A stimulus's JND is the stimulus change required to produce a just-noticeable difference in the perception of the 'ness', for example a JND in the intensity of the artefacts. It is usually defined as the point where 75% of the observers see the 'ness' in the stimulus and corresponds to the 0.75 probability on

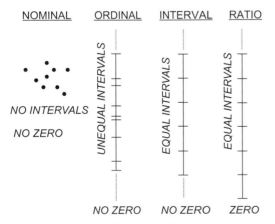

NOMINAL ORDINAL INTERVAL RATIO

NO INTERVALS

NO ZERO

UNEQUAL INTERVALS

EQUAL INTERVALS

EQUAL INTERVALS

NO ZERO NO ZERO ZERO

Figure 19.9 Stevens' psychometric scales.

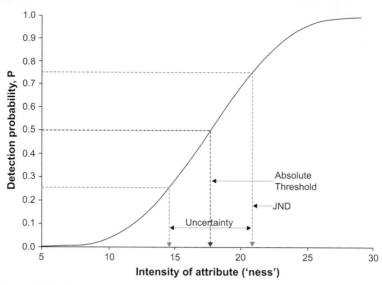

Figure 19.10 The psychometric function.
Adapted from Engeldrum (2000)

the psychometric function. The range of intensities that generates the range of probabilities between 0.25 and 0.75 is referred to as the *interval of uncertainty*, for which the judgements can go either way ('yes' or 'no'). In most derivations of the psychometric function, the curve is symmetrical about the threshold and thus the interval of uncertainly is twice a JND.

Scaling methods

There are various procedures for developing psychometric scales and, in some cases, different procedures give different measurements. The choice of scaling method depends mainly on (i) whether threshold or supra-threshold assessments are required and (ii) the type of scale to be derived. Other factors influencing the experimenter's choice of scaling method are the number of images to be presented to the observers (and thus the experimental time), the *sample set confusion* (i.e. whether adjacent sample images are easily distinguishable or not, a requirement for some methods) and the complexity of the statistical operations linked to each experimental method.

For the determination of thresholds and JNDs, the following scaling methods can be employed:

- *Method of limits*. Both absolute threshold and JNDs can be determined with this method. Closely spaced image stimuli of increasing or decreasing 'ness' are presented to the observer, who is asked whether he or she detects the 'ness', or a noticeable difference in the 'ness' — e.g. difference in image colourfulness.

- *Method of adjustments*. This is similar to the method of limits, except that it is the observer that adjusts the 'ness' in the image sample until it is just visible (for threshold determination), or until it matches a standard. This method can be easily implemented in computer displays, by employing a slider that 'modifies' the 'ness' in the sample.

- *Method of constant stimuli*. There are several variations of this method, used to determine both absolute thresholds and JNDs. In all a constant set of samples is selected by the experimenter who has previously defined by pilot experiments the range and closeness of the 'ness' of these samples.

- *Paired comparison method*. This is one of the most employed variations of the method of constant stimuli, where pairs of pre-selected image stimuli are presented to the observers who are asked to reply with a 'yes' or a 'no' to the question of whether there is a visual difference between the members of the presented pair. In a complete experiment all pairwise combinations, n^2, are presented, where n is the number of images. As the number of comparisons increases very rapidly with increasing number of image stimuli, usually $n(n-1)/2$ pairs are presented. In this most common case, image pair A–B is assumed to generate the same observer response as pair B–A, and in an image pair A–A comparison one sample is assumed to be selected over the other 50% of the time. A great advantage of this very popular method is that a psychometric function and thus the JND can be determined for each of the n samples used in the comparisons. It is used for both printed and displayed images.

The most common methods implemented in supra-thrshold experiments (in the creation of scale values of image 'ness' or overall quality) are:

- *Rank order method.* Here (a preferably small number of) images are ordered from best to worst (or the reverse) according to one physical attribute or 'ness', or their overall quality. While it is the simplest method to employ when printed images are evaluated, it is rather impractical for assessing displayed samples since monitors are not big enough and also generally fail to produce the necessary spatial uniformity for displaying more than two images simultaneously. Ordinal scales are generated with this method.

- *Paired comparison method.* Here all possible pairs of selected image samples are shown to the observer (see above), who is asked to select the preferred image in terms either of the selected attribute ('ness') or overall quality. This two-alternative forced choice method is based on the *law of comparative judgements*, which relates the proportion of times one stimulus is found greater than another stimulus. The proportions are used to generate ordinal scales but the real advantage of the method is that pair-comparison data can be transformed to interval and ratio scales by the application of z-deviates of the Gaussian function. A triplet comparison method that results in a reduction of assessment time is an alternative to the paired comparison method. It is described in ISO 20462-2:2005 for producing scales calibrated in JNDs.

- *Magnitude estimation, direct and indirect rating scales.* These require the assignment of numbers to represent the intensity of sensory experience. A reference image might be presented to the observer, who assigns a number to it (rates it according to its 'ness' or overall quality) and judges the other stimuli in terms of this reference. If a reference has not been used in the first place, then the images are assessed in the context of the entire test set. Interval and ratio scales can be generated with these methods. Many potential problems are associated with methods that assign numbers, because people use numbers in different ways and give them different meanings.

- *Categorical scaling method.* This is based on the *law of categorical judgements*, which relates the relative position of stimuli to a number of categories. The observers view one sample at a time and are asked to place it into a specific category according to the sample's 'ness' or overall quality. The number of categories usually range between five and nine; they may be labelled with names. Categorical scaling is a popular method because data collection is simple, scale meanings are easily understood and each judgement is quick to perform; thus, a large number of image samples can be used. Ordinal or interval scales can be created with this method. The latter requires not only the derivation of

Table 19.4 A five-category qualitative scale of image quality

QUALITY	ARTEFACT
Excellent	Imperceptible
Good	Perceptible but not annoying
Fair	Slightly annoying
Poor	Annoying
Bad	Very annoying

the sample scale value, but also the definition of category boundaries, which, although they are assumed to be perceptually equally distant, in reality rarely are. Table 19.4 lists the ITU 1995 five-point qualitative scale, which has been widely applied in the evaluation of the quality of television pictures and more generally in the imaging field, and provides an example of how it could be used to define the acceptability of an image artefact. Figure 19.11 illustrates an example of a relative interval scale, generated using categorical scaling, with unequally distant category boundaries (broken lines), where each image sample is placed on the scale according to its perceived quality scale value.

Table 19.5 lists the most common psychometric scaling methods and the types of results they may produce.

The statistical operations employed for the derivation of thresholds, JNDs and scale values are beyond the scope of this chapter. Amongst many, Boynton and Bartleson (1984) and Engeldrum (2000) are two classical textbooks that provide detailed guidelines. Further, the International Standards Organization Technical Committee 42 has produced a three-part standard for psychophysical experimental methods to estimate image quality (ISO 20462: 2005). It discusses specifications regarding observers, test stimuli, instructions, viewing conditions, data analysis and reporting of results. In addition, it describes two perceptual methods, the triplet comparison technique (see above) and the *quality ruler*, which yield results calibrated in JNDs.

SCENE DEPENDENCY IN IMAGE QUALITY

An unsurprising result that stems from the variations in original scene configuration of test scenes in image quality assessments is that, in many subjective investigations, image quality is found to be *scene dependent*. That is, the results are shown to vary with the content of the images used for the investigations. The following paragraphs

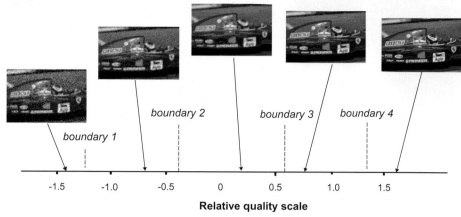

Figure 19.11 An interval scale with unequally distant category boundaries (broken lines). Each image is placed on the scale according to its perceived quality scale value.
Original image from Master Kodak PhotoCD

Table 19.5 The most common psychometric scaling methods

METHOD	THRESHOLD	JND	ORDINAL SCALE	INTERVAL SCALE	RATIO SCALE
Limits	X	X			
Adjustments	X	X			
Paired comparison and variations	X	X	X	X	
Rank order			X		
Categorical scaling			X	X	
Rating scaling				X	X
Magnitude estimation				X	X

differentiate between three major origins of scene dependency in image quality measurements.

1. *Scene dependency resulting from the observer's quality criteria.* It is well known that image classes and scene content exert an influence on the observer judgements of image quality. Psychophysical experiments that took place as early as the 1960s indicated that the sharpness of portraits is judged by observers differently than the sharpness of landscapes and architectural scenes. More specifically, in very-high-quality portraiture, subjective quality decreased as objective sharpness increased. This result confirmed what practical photographers had known for years: 'soft focus' renders the skin smoother and thus more pleasing. In the same way, it is widely known that observers' preference of critical colours, such as green grass, blue sky and skin colours, differs from the actual colours themselves.

 An example of this type of scene dependency, which originates from the observer's quality criteria, is illustrated in Figure 19.12. In this figure, two test scenes have been subjected to the same objective amount of sharpening (versions (a) and (c)) and blurring (versions (b) and (d)). Most observers have judged the blurred version of the portrait to be of a higher quality than the sharpened version, whereas the opposite preference was reported for the 'door' scene.

2. *Scene dependency due to the visibility of an artefact.* Noise and other artefacts are more or less visible in an image, depending on whether original scene features mask the artefact or reveal it. Scene dependency due to the visibility of an artefact is also known as *scene susceptibility*. Variations in scene susceptibility occur when the same objective amount of an artefact such as noise, striking or banding, for example, is present in images, but it is more or less evident in different types of scenes, or different areas with the same scene. For example, the digital artefact of striking is more evident in clear-sky image areas (i.e. relatively uniform, light

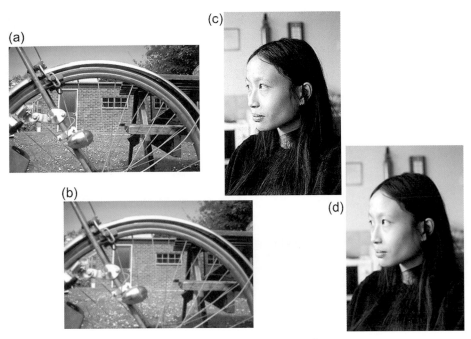

(a)
(c)
(b)
(d)

Figure 19.12 Sharperned (a, c) and blurred (b, d) versions of two images with different scene content. *Original image of (a), (b) from Master Kodak PhotoCD.*

areas) than in image areas of high-frequency signal and in extensive dark areas, which visually mask that striking. Similarly, for a given print granularity, graininess (i.e. the subjective measure of photographic granularity) usually decreases with print density and hence dark areas in prints are less visually susceptible to photographic noise.

Figure 19.13 provides a demonstration in scene susceptibility to noise in digital images. Images (b) and (d) are noisy versions of images (a) and (c) respectively. In image (b) most observers agree that noise reduces significantly the overall quality of the image, since it is largely evident due to low-frequency original image content. In image (d) the same amount of uniform noise has been digitally added but, due to the abundance of high-frequency information in the original, the noise is hardly visible and thus affects less the image quality.

The two types of scene dependency introduced so far are commonly seen in results from subjective experiments. They occur because of functions of the HVS, or they are due to the observers' quality criteria.

3. *Scene dependency of digital processes.* A digital image process may objectively change pixel values to a greater or lesser amount in a digital image, depending on the original scene features (colours, spatial properties, etc.). For example, image sharpening will modify more pixels in an image with many contours, lines and fine

detail than in one with mostly slow varying, or uniform areas. Thus, scene dependency of digital processes (or image-processing algorithms) has an objective nature; it may also have different visual consequences depending on the type of scene used for processing and its characteristics.

A classical case is that of image compression. Applying the same objective amount of compression (compression ratio) in two different images, one with mostly high- and the other with mostly low-frequency information, will discard different amounts of information, since most lossy compression algorithms discard mostly high spatial frequencies (see Chapter 29). Figure 19.14 illustrates the results of this effect, where both 'Motor race' and 'Boats' images have been compressed at a ratio of 60:1. With both JPEG and JPEG 2000 compression schemes, the objective damage introduced by the compression is more severe in the 'Motor race' image than in the 'Boats' image. However, the artefacts in the image 'Boats' might be more objectionable as they occur in flat image areas, whereas in 'Motor race' they are visually masked by the high frequencies that are abundant in this image.

Independently of the type of scene dependency, its main causes (variations in original test image characteristics) as well as the consequences are the same. Scene dependency makes the analysis of results and inter-laboratory comparisons problematic. It often

359

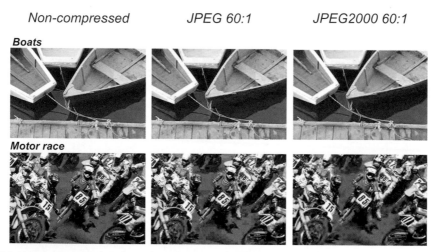

Figure 19.13 Original (a, c) and noisy (b, d) versions of two images with different scene content. *Original images from Master Kodak PhotoCD.*

Non-compressed JPEG 60:1 JPEG2000 60:1

Boats

Motor race

Figure 19.14 Original and compressed versions of two images with different scene content. *Original images from Master Kodak PhotoCD.*

biases mean ratings and this is why it is common use to exclude outlying results or the 'the odd scenes' in subjective quality measurements. Additionally, the evaluation of image quality models and metrics is complex and often incomplete due to scene dependency in the perceived quality.

Choice of test scenes

There are methods to overcome some of the problems caused by scene dependency in image quality evaluations.

Using a representative set of test stimuli (e.g. well-illuminated subjects, in focus) and excluding atypical stimuli (e.g. some objects out of focus, very high or very low dynamic range scenes) from the set of test stimuli is the most common. Nowadays many experimenters incorporate in their test sets images from the ISO test set, or other known test images (samples in Figure 19.8). A small number of standard test images, however, does not effectively represent the range and variety of different scenes that photographers, artists and consumers may wish to record and reproduce successfully. Furthermore, scenes that deviate in

content from representative test scenes may not be reproduced appropriately, since they are not in accordance with the 'average' reproduction derived from image quality results.

Bartleson, in an extensive study on psychophysical methods, suggested that the test stimuli should be chosen by a clearly defined set of procedures, and proposed five ways for choosing a sample of stimuli: (i) the random independent sample; (ii) the stratified sample; (iii) the contrast sample; (iv) the purposeful sample; and (v) the identical sample. In all cases apart from the randomly chosen samples, some decisions have to be made by the experimenter on the features and content of the test images. These are usually assessed by inspection and require the experimenter's intuition and judgement.

One way to identify scene features that play a significant role in image quality assessments is to look closely at the visual description of the image quality attributes (Table 19.1), as well as the susceptible image areas in various digital image artefacts (Table 19.3). Here is a summary of original scene features and characteristics in test scenes that influence image quality:

- Illumination and luminance contrast
- Hue, chroma and colour contrast
- Amount of contour lines and edges
- Amount of slow varying areas (low-frequency information)
- Busy areas with high amount of detail/texture (high-frequency information)
- Camera-to-subject distance
- Spatial distribution of subjects.

IMAGE QUALITY METRICS AND MODELS

Image quality metrics (IQMs) are objective measures designed to produce a single figure (or a set of values)

aiming to describe the overall quality of images. They often employ physical performance measures of various attributes of the imaging chain, combined with models of functions and properties of the HVS (Figure 19.15). True visual IMQs take into account the HVS; otherwise, they only measure distortion between an original and a reproduction (see Chapter 29) and rarely relate to perceived image quality. The performance of IQMs is tested by correlation between the metric value and ratings produced in subjective assessments.

There are a very large number of IQMs and models employed in imaging laboratories. Many metrics have their origins in photographic systems and are adapted for predicting the quality of digital imaging systems. Others are specifically designed to evaluate digital image quality. A number of metrics have been developed to measure spatial image quality and take into account contrast, sharpness and noise aspects, independently or in combination. Examples are Barten's SQRIn and Jacobson and Topher's PIC, which produce visually weighted signal-to-noise ratios. Another example of a spatial metric is Jenkin's EPIC, which was published in the mid-2000s and returns a value related to the perceived information capacity of images. All the above metrics employ a model of the contrast sensitivity function (see Chapter 4) to filter the frequency responses of the image/system and models of the eye's noise.

Metrics in colour appearance spaces have been used for evaluation of colour image quality. Although ΔE^*_{ab} is considered as a colour metric (see Chapter 5), the first true colour IQM was proposed by Pointer, referred to as the Colour Reproduction Index (CRI). It is based on the Hunt colour appearance model for colour vision. The first metric that included both colour and spatial image properties was Zhang and Wandell's sCIELAB, a spatial extension to CIE-LAB, which applies three pre-processing stages before computation of the modified colour difference metric ΔE^*. It was developed in the 1990s. Later, Johnson and Fairchild presented an extension of sCIELAB, a modular framework developed for calculating image differences and predicting

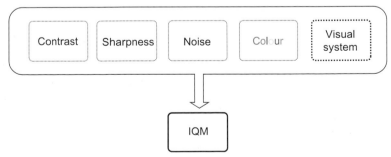

Figure 19.15 Measures or models describing the images', or the imaging systems' attributes and models of the HVS are used in IQMs.
Adapted from Jacobson and Triantaphillidou (2002)

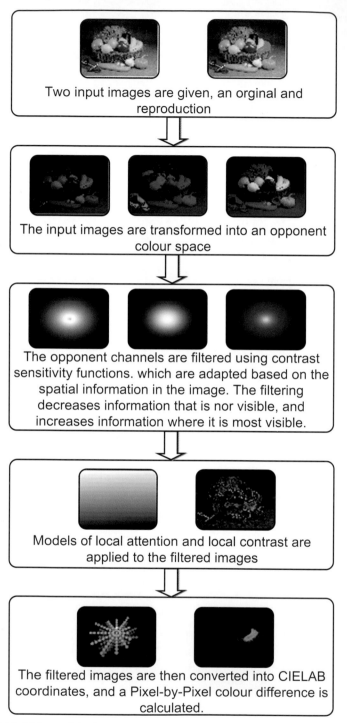

Figure 19.16 Johnson and Fairchild's modular framework for obtaining colour image differences. *From Johnson (2003).*

image quality. The framework was designed to be used with advanced colour difference formulae, such as the CIEDE2000, and performs spatial filtering in the frequency, rather than the spatial, domain. Further independent pre-processing modules are added for adaptation, spatial localization and local contrast detection, before performing pixel-by-pixel colour difference calculations (Figure 19.16).

There are a large number of IQMs that are intended for display assessment and image-processing applications and are designed to assess image fidelity. They involve frequency analysis (i.e. decomposing the image into several frequency channels, or sub-bands), models of the contrast sensitivity function, optical masking and an *error pooling* method (i.e. an error summing method, for example

Minkowski's method) to obtain a spatial map of perceptually weighted error. A widely known such metric is Daly's Visual Difference Predictor (VDP). Finally, several models have been produced specifically to measure the effects of image compression, which also include frequency decomposition, such as Watson's DCT-based metric and wavelet-based metrics.

In reality, there is no unique measure of image quality, because of its subjective and multidimensional nature, as well as the problems of scene dependency described earlier. The purpose of useful metrics is to provide overall, average ratings or figures that can be used to compare in a visually meaningful manner the performance of imaging systems. The reader is suggested to refer to the extended Bibliography on the subject.

BIBLIOGRAPHY

Barten, P.G.J., 1999. Contrast Sensitivity and its Effects on Image Quality. SPIE Optical Engineering Press, Bellingham, WA, USA.

Boynton, R.M., Bartleson, C.L., 1984. Optical Radiation Measurements, Volume 5, Visual Measurements, Part II, Chapters 7—9. Academic Press, New York, USA.

Burns, P.D., 2006. Evaluating digital camera and scanner imaging performance. Short course, RPS Digital Futures 2006 Conference, London, UK.

Engeldrum, P.G., 1995. A framework for image quality models. Journal of Imaging Science and Technology 39 (4), 259—270.

Engeldrum, P.G., 2000. Psychometric Scaling: A Toolkit for Imaging Systems Development. Imcotek Press, Winchester, MA, USA.

Ford, A.M., 1997. Relationship Between Image Quality and Image Compression. Ph.D. thesis, University of Westminster, London, UK.

Ford, A.M., 1999. Colour Imaging: Vision and Technology, Part 4: Quality Assessment. In: MacDonald, L.W., Luo, R.M. (Eds.), Wiley, Chichester, UK.

ISO 12640:1997, 1997. Graphic Technology: Prepress Digital Data Exchange — CMYK Standard Color Image Data (CMYK/SCID).

ISO 20462:2005, Parts 1, 2 and 3 2005. Photography: Psychophysical Experimental Methods for Estimating Image Quality.

Jacobson, R.E., 1995. An evaluation of image quality metrics. Journal of Photographic Science 43, 7—16.

Jacobson, R.E., Triantaphillidou, S., 2002. Colour Image Science: Exploiting Digital Media, Part 5: Image Quality. In: MacDonald, W.L., Luo, M.R. (Eds.), Wiley, Chichester, UK.

Janssen, T.J.W.M., Blommaert, F.J.J., 1997. Image quality semantics. Journal of Imaging Science and Technology 41 (5), 555—560.

Jenkin, R.B., Triantaphillidou, S., Richardson, M.A. 2007. Effective Pictorial Information Capacity (EPIC) as an image quality metric. Proc. SPIE/IS&T Electronic Imaging: Image Quality and System Performance IV, San Jose, CA, USA, pp. O1—O9.

Johnson, G.M., Fairchild, M.D., 2003. Measuring images: differences, quality and appearance. Proc. SPSPIE/IS&T

Electronic Imaging Conference, Santa Clara 5007, 51—60.

Keelan, W.B., 2002. Handbook of Image Quality: Characterization and Prediction. Marcel Dekker, New York, USA.

MacDonald, L.W., Jacobson, R.E., 2006. Digital Heritage: Applying Digital Imaging to Cultural Heritage, Chapter 13: Assessing Image Quality. In: MacDonald, L.W. (Ed.), Butterworth-Heinemann, Oxford, UK

Shaw, R. (Ed.), 1976. Selected Readings in Image Evaluation. SPIE Press, Bellingham, WA, USA.

Triantaphillidou, S., 2001. Image Quality in the Digitisation of Photographic Collections. Ph.D. thesis. University of Westminster, London, UK.

Triantaphillidou, S., Allen, E., Jacobson, R.E., 2007. Image quality of JPEG vs JPEG 2000 image compression schemes, Part 2: Scene analysis. Journal of Imaging Science and Technology 51 (3), 259—270.

Zhang, X., Wandell, B.A., 1997. A spatial extension of CIELAB for digital color-image reproduction. J. SID Digest 96, 61—63.

Chapter | 20 |

Speed and sensitivity

Robin Jenkin

All images © Robin Jenkin unless indicated.

SENSITIVITY OF IMAGING SYSTEMS

Spectral sensitivity describes a system's ability to detect light with respect to wavelength. As spectral sensitivity increases for a given wavelength, the probability of recording the light present at that wavelength increases (Figure 20.1). The vast majority of imaging systems are not equally sensitive to all wavelengths of light and the measure is important, as it will define the scope of use and performance of an imaging system, e.g. the ability to distinguish colour or its viability as a night vision system. Absolute radiometric spectral sensitivity is a primary objective imaging measure, from which many of the others described throughout this book may be derived.

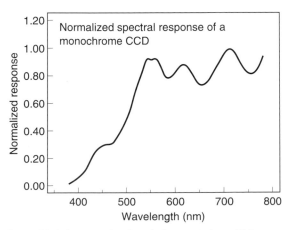

Figure 20.1 An example of a relative spectral sensitivity curve.

The spectral sensitivity of a system may be specified in many forms and it is useful to verify that equivalent methods are being used when comparing measurements. In all cases some measure of sensitivity is plotted against wavelength, as in Figure 20.1. Spectral curves may be presented as relative or absolute measures of sensitivity. In the case of relative sensitivity, the spectral curve is normalized to a unit area, or the peak spectral response to a value of 1. This is by far the most accessible type of curve and can provide a great deal of information. Measurement requires little more than a light source for which the relative spectral output is known and some method of division of the source into appropriate bands of wavelengths with which to expose the sensor, such as a *monochromator* or spectral wedge. Relative spectral curves are unitless because of the normalization and therefore care must be taken when comparing them. The relative curve represents the response of the system to a 'unit' of light; it does not specify what that unit is. Therefore, it is possible for systems to have identical relative spectral sensitivities, though overall one may be half as sensitive to light as the other. This would result in increased noise and a decreased response in the less sensitive system for equivalent exposures.

One may overcome the above problem by producing absolute spectral sensitivity curves. These relate input energy to output units (sometimes in a quite abstract form), from which the absolute sensitivity of the system at each wavelength is determined. Many of the measures detailed in Chapter 24, such as noise equivalent exposure (NEE), saturated equivalent exposure (SEE), responsivity or detective quantum efficiency (DQE) may be used to produce such curves if plotted with respect to wavelength. When comparing the imaging systems in the example above using such measures, it would be readily apparent if one was half as sensitive as the other.

DOI: 10.1016/B978-0-240-52037-7.10020-1

Spectral sensitivity curves may be produced using radiometric or photometric units. Radiometric units, as seen in Chapter 2, describe electromagnetic radiation in terms of its absolute energy using units such as joules or watts. These units are useful for describing imaging systems that do not necessarily use visible light, e.g. an infrared (IR) security camera or an X-ray machine. The absolute spectral sensitivity curve may be specified in a large variety of units depending upon the measure chosen to express the sensitivity and how appropriate it is for the system under consideration. For example, a radiometric calculation of noise equivalent exposure for a digital sensor may use units of $V\,W^{-1}\,nm^{-2}$. This may be translated as the number of volts produced by the sensor per watt of energy falling on a square micrometre of the detector surface per nanometre wavelength, when plotted as a curve.

Photometric units are much more applicable to systems utilizing visible light. Light is normalized with respect to the luminous efficiency of the eye (see $V(\lambda)$ curve in Chapters 2 and 5), and is described by units such as lux, lumens and candelas per unit area. Care must be taken, however, if the system or source under evaluation has any significant component outside of the 380–750 nm range used in normalization as the real response will deviate significantly from the normalized calculation. For example, the sensitivity of video cameras is often specified in terms of the lowest number of lux with which it is possible to make a recording. If the IR response of the camera is significant, the voltage measured per unit of light falling on the sensor will be significantly higher than that calculated using the photometric units.

As for many other aspects of imaging, multi-channel or colour systems may be evaluated by measuring each channel individually.

Spectral sensitivity of digital cameras

Many of the mechanisms which define the spectral sensitivity of charge-coupled device (CCD) and complementary metal oxide semiconductor (CMOS) cameras are detailed in Chapter 9. To summarize, the largest contribution to spectral sensitivity in digital cameras is that of the silicon substrate itself, modified by the effects of the overlying metal and polysilicon layers, which attenuate shorter wavelengths. The degree of attenuation of wavelengths below 400 nm is predominantly influenced by the choice of glass used for micro lenses. The depth of the depletion region can affect sensitivity, as penetration of photons is dependent on wavelength, with longer wavelengths travelling deeper into the substrate. The sensitivity of silicon extends to a wavelength of 1.1 μm and therefore an IR reflecting filter is regularly used in this region. The angle with which light strikes this thin-film reflecting filter changes the cut-off frequency and therefore it can create spectral

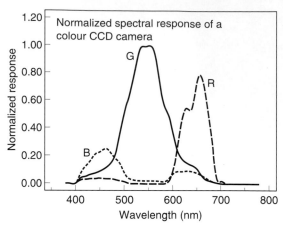

Figure 20.2 The spectral sensitivity of a typical digital sensor after colour filters have been added.

sensitivity variations across the field of view of a sensor (see Chapter 9). Also, as detailed in Chapter 9, in a single-sensor digital camera, colour discrimination is usually facilitated by the inclusion of a colour filter array (CFA) in front of the sensor, splitting the remaining signal into three broad bands of the spectrum (Figure 20.2; also see Chapter 23).

Measurement of the spectral sensitivity of digital cameras

ISO 17321 provides a standard methodology for the evaluation of the relative spectral sensitivity of digital stills cameras. A monochromator is used to evenly illuminate a surface which fills the field of view of the camera. The device filters light to yield a narrow wavelength band in a desired range (see Chapter 5). It is often controlled by computer to easily step through a large number of wavelengths automatically. Fall-off of illumination is limited so that the radiance at the edge of the field of view is at least 70% of that at the centre. The standard specifies that the surface should be an integrating sphere with a diffuser placed over the exit port.

Images of the surface are created between 360 and 830 nm in increments of less than 10 nm, though not smaller than the band-pass of the monochromator. Measurements to 1100 nm are encouraged where possible. The band-pass of the monochromator is recommended as being narrower than 5 nm. The procedure for setting up the camera is as for ISO 14524, which describes opto-electronic conversion function (OECF) evaluation (see Chapter 21). Fixed exposures are used, such that the maximum response falls between 50% and 90% for the full range of the camera. White balance and other automated functions of the camera are fixed. A radiance meter is used to capture the relative illumination of the target as a function of wavelength.

The camera OECF measured for each colour channel is used to linearize with respect to input luminance each colour plane of each image captured, after which the average of 64×64 pixel blocks are calculated at the centre of each image. This yields the linearized response of the camera for each wavelength. The relative spectral response may then be calculated for each by dividing the result by the surface radiance measured. The results are then normalized so that the area under the green channel sensitivity curve is 1. The camera OECF may then further be used to yield absolute spectral sensitivities if desired.

The ISO standard also describes a method for determining colorimetric response utilizing a reflective test target with tabulated patches.

Determination of the colour sensitivity of an unknown photographic emulsion

The spectral sensitivity of photographic materials (orthochromatic, panchromatic, IR, etc.) has been discussed extensively in Chapter 13. The colour sensitivity of an unknown emulsion can be most readily investigated in the studio by imaging a colour chart consisting of coloured patches with a reference scale of greys. In one such chart it has been arranged that the different steps of the neutral half have the same luminosities as the corresponding parts of the coloured half when viewed in daylight. If an image of the chart is made, the colour sensitivity of the emulsion being tested, relative to that of the human eye, is readily determined by comparing the tonal values of the image of the coloured half with those of the image of the neutral half. The value of the test is increased if a second exposure is made on a sensor of known colour sensitivity, to serve as a basis for comparison. Unexpectedly dark monochrome records of colours will indicate a low sensitivity in the spectral region concerned.

A more precise, yet still quite practical, method of assessing the colour sensitivity of a sensor is to determine the exposure factors of a selection of filters. A selection of three filters, tricolour blue, green and red, may be used. An unexpectedly large filter factor will reveal a spectral region, that passed by the filter concerned, to which the sensor is relatively insensitive. The properties of the filters used may be adjusted to approximate estimations of visual spectral sensitivity. In the laboratory, the spectral sensitivity of an emulsion may be determined as a wedge spectrogram.

Wedge spectrograms

The spectral response of a photographic material is most completely illustrated graphically by means of a curve known as a wedge spectrogram, and manufacturers usually supply such curves for various materials. A wedge spectrogram indicates relative sensitivity and is obtained by

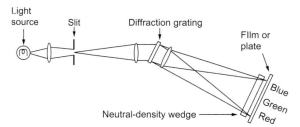

Figure 20.3 The optical arrangement for a wedge spectrograph.

exposing the material through a photographic wedge in an instrument known as a wedge spectrograph. The spectrograph produces an image in the form of a spectrum on the material, the wedge being placed between the light source and the emulsion. A typical optical arrangement is shown in Figure 20.3.

Examples of the results obtained in a wedge spectrograph are shown in Figure 13.5 in Chapter 13, which shows wedge spectrograms of typical materials of each of the principal classes of colour sensitivity. The outline of a wedge spectrogram forms a curve showing the relative log sensitivity of the material at any wavelength. Sensitivity is indicated on a logarithmic scale, the magnitude of which depends on the gradient of the wedge employed. All the spectrograms illustrated here were made using a continuous wedge, but step wedges are sometimes used. In Figure 13.5 the short-wave cut-off at the left of each curve is characteristic not of the material, but of the apparatus in which the spectrograms were produced, and arises because of ultraviolet absorption by glass. The curves of the spectrally sensitized materials are also seen to consist of a number of peaks; these correspond to the summed absorption bands of the dyes employed.

The shape of each curve depends not only on the sensitivity of the material, but also on the quality of the light employed. All the spectrograms shown in Figure 13.5 were made with a tungsten light source with a colour temperature of approximately 2856 K. Wedge spectrograms of the same materials, made with daylight, would show higher peaks in the blue region and lower peaks in the red.

The wedge spectrogram of the IR material in Figure 13.5 of Chapter 13 shows a gap in the green region of the spectrum. This permits the handling of the material by a green safe light. IR-sensitive materials do not necessarily have this green gap and furthermore may receive IR radiation transmitted by materials which appear opaque to light. Some black plastics and fabrics, such as camera bellows, may transmit IR radiation, as may the sheaths in dark slides used for the exposure of sheet film in technical cameras. Unexpected fogging of extended sensitivity emulsions or IR materials may occur and constructional materials may be implicated if this is found.

The colour material whose spectral sensitivity is shown in Figure 13.6 of Chapter 13 was designed for daylight exposure and was therefore exposed using a tungsten source of 2856 K and a suitable filter to convert the illumination to the quality of daylight. The omission of the conversion filter would have resulted in a relatively higher red sensitivity peak, at about 640 nm, and a lower blue peak, at about 450 nm.

The necessity to balance the exposing illuminant and the film sensitivity by the use of correction filters can be inconvenient, although generally accepted by professional photographers. The ill-effects of omitting correction filters can be substantially reduced by using a negative film specially designed for the purpose, termed *type G* or, sometimes, *universal* film. The sensitivity bands of the type G film are broad and less separated than those of the conventional film. The sensitivity characteristics of type G materials give an acceptable colour reproduction over a wide range of colour temperatures, though the optimum is still obtained with daylight exposure. This tolerance to lighting conditions is gained at the expense of some loss in colour saturation and other mechanisms may have to be used by the manufacturer to restore this to an appropriate level. Alternatively, very fast blue-sensitive emulsions of extra-large latitude may be used to provide a suitable image over a wide range of illuminant quality. Such a film will yield negatives of unusually high blue density when used in daylight and these may prove awkward to print using automatic printers.

Uses of wedge spectrograms

Although they are not suitable for accurate measurements, wedge spectrograms do provide a ready way of presenting information. They are commonly used:

1. To show the way in which the response of an emulsion is distributed through the spectrum.
2. To compare different emulsions. In this case, the same light source must be used for the two exposures. It is normal practice to employ as a source a filtered tungsten lamp giving light equivalent in quality to daylight (approx. 5500 K) or an unfiltered tungsten lamp operating at 2856 K, whichever is the more appropriate.
3. To compare the quality of light emitted by different sources. For this type of test, all exposures must be made on the same emulsion.

SPEED OF IMAGING SYSTEMS

Whilst the spectral sensitivity curves discussed above are useful in a large variety of applications, they do little to aid the photographer to correctly expose images quickly and

effectively under varying illumination levels and conditions. In practice an alternative method is needed to determine exposure readily 'in the field'.

The speed of an imaging system designates the relative amount of light needed to produce an image with a defined 'quality' and is expressed as a number which may be related to exposure. High speed numbers indicate a greater sensitivity to light and therefore lower total exposures are needed, i.e. shorter exposure times or smaller apertures. Conversely, lower speed numbers indicate that a larger total exposure is required, leading to longer exposure times and larger apertures. The 'quality' of the image may be any one of a number of parameters, as will be seen, such as noise levels, contrast or density (intensity) level.

Methods of expressing speed

The problem of allotting a speed number superficially appears simple. It would seem, for instance, that if we wish to compare the speeds of two systems, all we have to do is to make exposures on each to yield comparable images, and the ratio of the exposures will give us the ratio of the speeds. It is true that we can usefully compare speeds in this way, but the comparison may not be typical of the relation between the two systems under other conditions. Furthermore, it will tell us nothing about the absolute speed of the imaging systems; knowing that one is twice as fast as the other does not give an effective exposure. It is in trying to obtain absolute speed numbers for general application that difficulties arise.

One of the first problems in allotting speed numbers is connected with the variation in the speed of imaging systems with the conditions of use. This problem is generally overcome by agreeing upon standard conditions of exposure and handling for the speed determination. A further problem is concerned with the criterion of exposure to be used as the basis for the measurement of speed, i.e. the particular concept of speed which is to be adopted.

This problem arises from the fact that an image consists not of a single tone but of a range of tones. Consequently, it is not immediately apparent which tonal or pixel value or other attribute should be adopted. The characteristic curve − or the system's transfer function (see Chapters 8 and 21) − is useful here. Several different points related to this curve have been suggested as speed criteria. Most of these points were derived from the development of photographic imaging and from a historical perspective it is useful to discuss these first. Digital imaging adds unique issues to the definition of speed due to the amount of subsequent image processing that can occur in the system and further standards have been developed to account for these.

Many of the photographic speed points are related to the toe of the characteristic curve, i.e. to the shadow areas of the negative. These criteria can be divided into five main types,

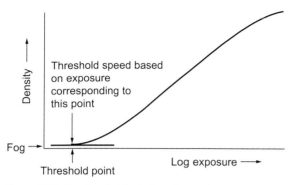

Figure 20.4 The threshold criterion of speed.

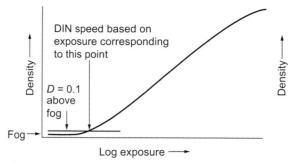

Figure 20.5 Fixed density criterion.

as follows: threshold, fixed density, inertia, minimum useful gradient and fractional gradient.

Threshold systems

The threshold is the point on the characteristic curve corresponding to a just-perceptible density above fog, i.e. the point where the toe begins. Under the heading 'threshold systems' are those systems in which speed is based on the exposure required to give such a density (Figure 20.4). The disadvantages of the threshold as a criterion of speed are that it is difficult to locate exactly and that it is not closely related to the part of the characteristic curve used in practice.

Fixed density

The exposure required to produce a given density above fog may be used as an effective speed point. For general-purpose films, a (diffuse visual) density of 0.1 or 0.2 above fog is frequently selected (Figure 20.5), which corresponds approximately to the density of the deepest shadow of an average negative. With high-contrast materials in which a dense background is required, a density of 1–2 is a more useful basis for speed determination, while for materials used in astronomy, a density of 0.6 has been suggested. It will be apparent that the exposure corresponding to a specified density can be more precisely located than the threshold. A fixed density criterion ($D = 0.1 +$ fog) was adopted in the first National Standard speed system, the DIN system, in 1934, and is now employed in all current systems.

Inertia

This was the basis selected by Hurter and Driffield for their pioneering work on quantifying the photographic process. The inertia point is where an extension of the linear portion of the characteristic curve crosses a line representing the

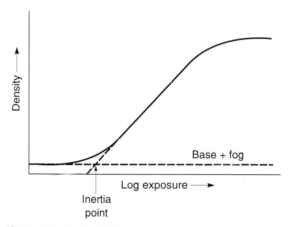

Figure 20.6 Inertia criterion.

base plus fog level (Figure 20.6). Under the processing conditions which were prevalent in Hurter and Driffield's time, inertia was independent of development and so offers a fixed point of reference. Further, the inertia point is related to the linear portion of the characteristic curve, i.e. the part of the curve in which objectively correct reproduction in the negative is obtained. With short-toe materials, as used by Hurter and Driffield, this would be an advantage. With modern materials, which have a long toe often with no linear region, the linear portion of the curve has little relevance.

Minimum useful gradient

Threshold speed systems work at the very bottom of the toe of the characteristic curve, while systems based on inertia ignore the toe completely. Neither system approximates very closely to actual practice, where a part (but only a part) of the toe is used. It was at one time suggested that a criterion more closely related to practice could be obtained from that point on the toe of the characteristic curve at which a certain minimum gradient is reached. A value of

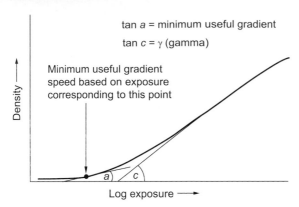

Figure 20.7 Minimum useful gradient criterion.

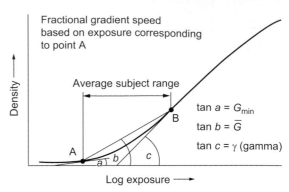

Figure 20.8 Fractional gradient criterion.

0.2 for tan *a* in Figure 20.7 was proposed. The minimum useful gradient criterion was based on the idea that loss of tone separation in the shadows (shadow detail) is the first sign of underexposure, and that this in turn is due to unacceptably low contrast in the portion of the characteristic curve occupied by the shadows. The minimum useful gradient criterion did not come into general use but is of interest because it led to the more fundamental fractional gradient criterion.

Fractional gradient

The main argument against the minimum useful gradient criterion is that the minimum value of contrast acceptable in the shadows is not a constant but depends upon the contrast grade of the paper on which the negative is to be printed. If the overall contrast of the negative is such that it needs a hard paper, the contrast of the negative in the shadows can be lower than with a negative requiring a soft paper. A hard paper is generally one that produces high image contrast, whereas a soft paper gives low contrast. In other words, the minimum contrast acceptable in the toe depends upon the contrast of the negative as a whole. Realization of this fact led to the conception of the fractional gradient criterion. The point chosen for this criterion is the point A in Figure 20.8, where the slope of the tangent to the curve at A equals a given fraction of the slope of AB, the line joining the points marking the ends of the portion of the curve employed. This is usually expressed by the equation:

$$G_{Min} = K \times \overline{G} \qquad (20.1)$$

where $G_{Min} = \tan a$, $\overline{G} = \tan b$ (provided the density and log exposure axes are equally scaled) and K is a constant determined empirically.

Practical tests by L.A. Jones showed that a value for K of 0.3 gave results corresponding very well with the minimum exposure required to give a negative from which an 'excellent' (as opposed to merely 'acceptable') print could be made. In Jones's work, the fractional gradient point A was located by the equation:

$$G_{Min} = 0.3 \times \overline{G}(1.5) \qquad (20.2)$$

where $\overline{G}(1.5)$ means the average gradient over a log exposure range of 1.5, a value which has been shown to be fairly typical for exterior scenes in daylight. When located in this way, point A is sometimes referred to as the 'Jones point'. This criterion was employed first by Eastman Kodak in 1939, and was later adopted by the then American Standards Association (in 1943) and the British Standards Institution (in 1947) as the basis for national standards.

Speed systems and standards

Table 20.1 outlines standards which were adopted by the various national standards organizations. Speed in all three American, British and German systems is currently determined with reference to the exposure required to produce a density of 0.1 above fog density, this criterion being simpler to use in practice than the fractional gradient criterion. American and British standards were further modified in 1972 and 1973 respectively. Both use the same speed criterion mentioned below but the developer solution and the illuminant specified are slightly different from those specified in the earlier standards. The common method adopted for determining speed in the three standards is illustrated in Figure 20.9. This procedure is used in the current International Organization for Standardization (ISO) standard.

The International Organization for Standardization (ISO) is an international federation of national standard (member) bodies. Its work is undertaken by various technical committees on which interested member bodies have representatives. Draft international standards are adopted when at least 75% of the member bodies have cast supporting votes. It is important to note that where ISO speed values are to be measured, reference must be made to all

Table 20.1 The principal methods of expressing film speed of negative monochrome materials adopted in early standards

SYSTEM	DATE OF INTRODUCTION	TYPE OF UNIT	SPEED CRITERION	DEVELOPMENT
H and D	1890	Arithmetic	Inertia	Developer to be bromide free; development time not important
Scheiner	1894	Logarithmic	Threshold	Not specified
DIN[†]	1934	Logarithmic	Fixed density (0.1 + fog)	To be continued until maximum speed is obtained (optimal development)
BS[†]	1941	Logarithmic	Fixed density (0.1 + fog)	To be under carefully controlled conditions giving a degree of development comparable with average photofinishing. See Figure 20.11 and accompanying text
ASA[†]	1943	Arithmetic	Fractional gradient	
BS and ASA	1947	Arithmetic and logarithmic	Fractional gradient	
DIN	1957	Logarithmic	Fixed density (0.1 + fog)	
ASA	1960, 1972	Arithmetic	Fixed density (0.1 + fog)	
DIN	1961	Logarithmic	Fixed density (0.1 + fog)	
BS	1962, 1973	Arithmetic	Fixed density (0.1 + fog)	
ISO[†]	1956, 1962		Fixed density (0.1 + fog)	

[†]DIN, ASA and BS stand respectively for Deutsche Industrie Normen, American Standards Association (now American National Standards Institution or ANSI) and British Standard. ISO stands for International Standards Organization.

the specifications, and definitions which can only be found by direct reference to the standard.

Figure 20.9 shows the basic principles now used for the determination of ISO speed of emulsions. The characteristic curve of a photographic material is plotted for the specified developing conditions. Two points are shown on the curve at M and N. Point N lies 1.3 log exposure units from point M in the direction of increasing exposure. The development time of the negative material is so chosen that point N has a density 0.80 greater than the density at point M. When this condition is satisfied, the exposure corresponding to point M represents the criterion from which speed is calculated. It is for the degree of development obtained that the correlation between the fixed density criterion and the fraction gradient criterion that was referred to above holds good. In the current standards speeds are determined from the following formulae:

Arithmetic speed

$$S = \frac{0.8}{H_{\mathrm{m}}} \quad (20.3)$$

Logarithmic speed

$$S^{\mathrm{o}} = 1 + 10 \log_{10} \frac{0.8}{H_{\mathrm{m}}} \quad (20.4)$$

where H_{m} is the exposure in lux-seconds corresponding to the point M in Figure 20.9. Table 13.3 in Chapter 13 shows equivalent arithmetic and logarithmic speed numbers. The range of exposure values for rounding to the particular speed value are provided in tables of the ISO Standard. In Table 20.1 and elsewhere in the text, reference has been made to arithmetic and logarithmic speed ratings. With arithmetic scales a doubling of film speed is represented by a doubling of speed number. With

Figure 20.9 Principles of the method adopted for determining speed in the current ISO standard.

logarithmic speed scales, distinguished by a degree (°) sign, the progression is based on the common logarithm (base 10 scale). The common logarithm of 2 is almost exactly 0.3, and logarithmic film speeds are scaled so that a doubling of film speed is represented by an increase of 3 in the speed index.

Speed ratings are not published for high-contrast materials, such as those used in the graphic arts or for micro-copying, or for special materials such as astronomical plates, holographic materials and recording films. As we have already seen, any system for expressing the speed of a photographic material must take into account exposure and development conditions, and must be related to some particular criterion of correct exposure. The systems in general use for ordinary photographic materials cannot be applied to high-contrast or special materials since the conditions of exposure and development are quite different. For these applications, speed points are often measured at fixed densities greater than 0.1.

ISO speed ratings for emulsions should not be confused with manufacturers' exposure indices, which are suggested values for use with exposure meters calibrated for ISO speeds and have been arrived at by manufacturers' testing procedures for determining camera settings. A speed rating preceded by the letters 'ISO' implies that this rating was obtained by exposing, processing and evaluating exactly in accordance with the ISO standard.

ISO SPEED RATINGS FOR COLOUR SILVER-BASED MATERIALS

Colour negative film

The principles of speed determination for colour negative (print) films follow those described previously for monochrome materials. However, speed determination is complicated by the fact that colour materials contain layers sensitive to blue, green and red light, and the standards involve averaging the speeds of the three sensitive layers. The ISO standard (ISO 5800:1987) uses fixed-density criteria for locating the speed points of the three layers, exposed in a defined manner and processed according to the manufacturer's recommendations after storage at $23 \pm 2°C$ for between 5 and 10 days, for general-purpose films. Blue, green and red densities are measured according to defined ISO measurement standards and the characteristic curves shown in Figure 20.10 are plotted.

The points B, G and R are located at densities of 0.15 above the minimum densities for the blue-, green- and red-sensitive layers. The log exposure values corresponding to these points are $\log H_B$, $\log H_G$ and $\log H_R$ respectively. The mean exposure, H_m, is then calculated from two of these

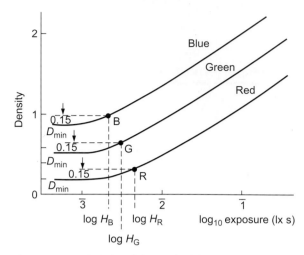

Figure 20.10 Principles of the method for determining speed of colour negative films (BS 1380, Part 3:1980, and used currently in ISO 5800:1987).

values (H_G and the slowest layer, usually the red-sensitive layer, H_R) according to the following formula:

$$\log_{10} H_m = \frac{\log_{10} H_G + \log_{10} H_R}{2} \qquad (20.5)$$

or

$$H_m = \sqrt{H_G \times H_R} \qquad (20.6)$$

The logarithmic speed is calculated as follows:

$$S° = 1 + 10 \log_{10} \frac{\sqrt{2}}{H_m} \qquad (20.7)$$

where all exposure values are in lux seconds. The speed values are then determined from a table of $\log_{10} H_m$ provided in the standard. The arithmetic speed may be calculated from the value of H_m by the formula:

$$S = \frac{\sqrt{2}}{H_m} \qquad (20.8)$$

Colour reversal film

The standard for colour reversal films involves measurement of diffuse visual density and the plotting of a single characteristic curve, shown in Figure 20.11. Films are exposed in a defined manner and processed according to the manufacturer's recommendations. For the determination of speed, two points (T and S) are located on the characteristic curve of Figure 20.11. Point T is 0.20 above the minimum density. Point S is that point on the curve at which the density is 2.0 above the minimum density. The log exposure values ($\log_{10} H_S$ and $\log_{10} H_T$) corresponding

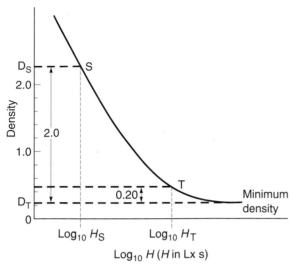

Figure 20.11 Principles of the method for determining the speed of colour reversal (slide) films used in ISO standard ISO 2240:1994(E).

to points S and T are read from the curve and their mean value (H_m) is calculated:

$$\log_{10} H_m = \frac{\log_{10} H_S + \log_{10} H_T}{2} \tag{20.9}$$

or:

$$H_m = \sqrt{H_S \times H_T} \tag{20.10}$$

from which the speeds may be calculated by analogous procedures to those used for the previously described ISO standards:

Arithmetic speed

$$S = \frac{10}{H_m} \tag{20.11}$$

Logarithmic speed

$$S^{\circ} = 1 + 10 \log_{10}\frac{10}{H_m} \tag{20.12}$$

All exposure values are in lux seconds.

SPEED OF DIGITAL SYSTEMS

Evaluation of the speed of digital systems poses particular problems as the degree to which they may be manipulated subsequent to exposure by mathematical processing such as data compression or analogue-to-digital conversion. Their ability to alter speed settings electronically by increasing electrical gain may also bias the result. However, there is also a need for speed ratings for digital systems due

to their proliferation in recent years and for the same reasons as for photographic materials. A number of ISO standards have been adopted for the evaluation of various parameters of digital systems.

ISO 12232 was first adopted to rate the speed of digital stills cameras in 1998 and has subsequently been updated in 2006 with the addition of recommended exposure index (REI) and standard output sensitivity (SOS). Similarly to standards for photographic media, those for digital systems specify conditions of illumination, temperature, relative humidity and exposure time. In addition, those variables specific to digital systems are specified. These include:

- Adjustment of white balance for the illumination used, as equal RGB signals according to ISO 14524, Chapter 21.
- Exposure time (photosite integration time) not longer than 1/30 s.
- IR-absorbing (blocking) filter should be used if required (ISO 14524, Chapter 21).
- If the device uses any form of lossy compression this must be disabled.
- If lossy compression systems cannot be disabled then noise-based values for ISO speed determination should not be reported.
- Factory defaults for other settings such as sharpness and contrast filtering, etc.

The standard (ISO 12232) provides four methods for the determination of speed and has as one of its aims a correlation between the ISO speed rating of an electronic camera and that for conventional photographic media. This means that a setting of ISO 200 on an electronic camera requires the same exposure time and aperture to that of a photographic film with an ISO speed of 200.

Speed based on saturation (S_{sat})

This is based on the user setting the camera exposure such that the highlights of the image are just below the maximum value (saturation) for the signal value, i.e. before they become clipped. For focal plane measurement of exposure this is defined as:

$$S_{sat} = \frac{78}{H_{sat}} \tag{20.13}$$

where H_{sat} is the minimum exposure level (lx s) that produces the maximum output signal with no clipping.

If exposure cannot be measured in the focal plane, H_{sat} is calculated as follows:

$$H_{sat} = \frac{65 L_a t}{100 A_{eff}^2} \tag{20.14}$$

where A_{eff} is the effective f-number of the lens, L_a is the arithmetic mean luminance of the scene expressed in candelas per square metre and t is the photosite integration time (s).

373

Speed based on noise (S_{noise})

This is based on the minimum exposure value before the onset of noise becomes objectionable. This depends on subjective assessments of images and their correlations with noise to decide on the acceptability of noise. Two noise-based speeds are used ($S_{noise10}$ and $S_{noise40}$), where 10 corresponds to the 'first acceptable' image and 40 to the 'first excellent' image, determined from psychophysical experiments. For focal plane measurement of exposure this is defined as:

$$S_{noisex} = \frac{10}{H_{S/Nx}} \qquad (20.15)$$

In the above equation, the exposure providing the camera signal-to-noise ratio which must satisfy a number of criteria specified in the standard, x, has the value of 10 or 40. The signal-to-noise criterion may be fulfilled by satisfying the condition:

$$D = x \times \sigma(D) \qquad (20.16)$$

where x takes the value 40 or 10 as before, D is linearized signal level and $\sigma(D)$ the standard deviation of the linearized signal for a 64×64 pixel patch. For colour cameras, weighted output of the R, G, B channels is used.

The standard again provides for the situation in which the focal plane exposure cannot be measured. The ISO standard (12232) includes weighting factors for summing luminances in single-exposure colour cameras in which the weighting factors are not known, from the individual channels according to ITU-R BT.709:

$$Y = \frac{2125}{10,000} R + \frac{7154}{10,000} G + \frac{721}{10,000} B \qquad (20.17)$$

The standard deviation is then calculated using the weighted formula:

$$\sigma(D) = \left\{ \sigma(Y)^2 + \left[\frac{279}{1000}\right]\sigma(R-Y)^2 \right.$$
$$\left. + \left[\frac{88}{1000}\right]\sigma(B-Y)^2 \right\}^{1/2} \qquad (20.18)$$

Standard output sensitivity (SOS)

To evaluate standard output sensitivity the sensor is exposed to produce a signal level of $461/1000 \, O_{MAX}$, where O_{MAX} is the maximum output value of the system. SOS is then given by:

$$I_{SOS} = \frac{10}{H_{SOS}} \qquad (20.19)$$

where H_{SOS} is the exposure required. H_{SOS} values are rounded using tables given in the standard before reporting and should give an indication as to the use of tungsten or daylight illumination.

Recommended Exposure Index (REI)

Recommended exposure index (REI) may be calculated using:

$$I_{REI} = \frac{10}{H_M} \qquad (20.20)$$

where H_M in this instance is an exposure that the camera or sensor manufacturer specifies. This method of speed rating can serve to account for instances where mathematical processing or the exposure regime of the camera is unconventional and cannot be specified using the recommended methods, e.g. multiple-exposure high-dynamic-range cameras. It can further account for when the camera is to be used for specific circumstances such as document imaging. The value should not be used for comparison of systems.

Digital camera ISO settings

On a wide variety of digital cameras, it is possible to *change* the ISO settings at will and as such it appears superficially that manufacturers have discovered a method for arbitrarily changing the sensitivities and thus speeds of their systems. A typical digital single-lens reflex (SLR) camera may have an ISO range of 50–6400. In practice all cameras have a nominal speed as defined by the ISO standards described above and this will generally be the slowest speed represented in the cameras' ISO range. When a user selects a higher ISO speed rating the camera sacrifices signal levels to allow the user to use shorter exposure times and subsequently adjusts the analogue and digital gains and image processing to produce the image. Therefore, as ISO speed ratings are increased, the noise levels in the image will rise. The facility is added for the convenience of users and purchasers should use the nominal speed rating of the camera for comparisons.

TYPICAL SENSITIVITIES OF FILM AND CCD DEVICES AND SPEED RATINGS IN PRACTICE

The only useful speed number in practice is one that adequately represents the speed of a material, or system, under the conditions in which it is likely to be used. Published speed values aim at providing exposures that will secure a printable negative, or an excellent result from a digital system under a wide range of conditions. The published rating for a given material or system cannot therefore be the best to use under all conditions of use. For critical use it is always best for the user to determine the appropriate exposure to suit the particular equipment and

conditions. Published exposure indices provide a valuable starting point, although if you have selected an exposure index that suits your needs you should remember that it is no more 'correct' than the published figure, except for your own conditions of working. Typically, emulsions range from ISO 64 for fine-grained colour reversal, through ISO 100 for fine-grained colour and black-and-white print films, ISO 200–400 for medium-grained emulsions, to ISO 800 for fast colour print films and even ISO 1000 for some black-and-white materials. There are a number of black-and-white emulsions that are marketed to be exposed at speeds of up to 3200. This, however, is a result of push processing and their ISO rating is typically lower. Digital cameras have nominal ratings of between ISO 100 and 400 in the consumer market, though they may be exposed up to ISO 25600. Typically, noise levels in digital images exposed beyond ISO 800 start to become objectionable.

For further sensitivity data for specific photographic products and CCD cameras, the reader is recommended to consult the websites of the manufacturers.

BIBLIOGRAPHY

Allbright, G.S., 1991. Emulsion speed rating systems. Journal of Photographic Science 39, 95–99.

Dainty, J.C., Shaw, R., 1974. Image Science. Academic Press, New York, USA.

Egglestone, J., 1984. Sensitometry for Photographers. Focal Press, London, UK.

Holst, G.C., 1998. CCD Arrays, Cameras and Displays, second ed. SPIE Optical Engineering Press, Bellingham, WA, USA.

ISO 2721:1982, 1982. Photography — Cameras — Automatic Controls of Exposure.

ISO 7589:1984, 1984. Photography — Illuminants for Sensitometry — Specifications for Daylight and Incandescent Tungsten.

ISO 5800:1987, 1987. Photography — Colour Negative Films for Still Photography — Determination of ISO Speed.

ISO 6846:1992, 1992. Photography — Black-and-White Continuous Tone Papers — Determination of ISO Speed and ISO Range for Printing.

ISO 6:1993, 1993. Photography — Black-and-White Pictorial Still Camera Negative Films/Process Systems — Determination of ISO Speed.

ISO 2240:1994, 1994. Photography — Colour Reversal Camera Films — Determination of ISO Speed.

ISO 14524:1999, 1999. Photography — Electronic Still Picture Cameras — Methods for Measuring Optoelectronic Conversion Functions (OECFs).

ISO 12232:2006, 2006. Photography — Digital Still Cameras — Determination of Exposure Index, ISO Speed Ratings, Standard Output Sensitivity and Recommended Exposure Index.

ISO 17321:2006, 2006. Graphic Technology and Photography — Colour Characterisation of Still Cameras (DSCs).

ITU-R BT.709:1993, 1993. Basic Parameter Values for the HDTV Standard for the Studio and for International Programme Exchange.

Jacobson, R.E., Ray, S.F., Attridge, G.G., Axford, N.R., 2000. The Manual of Photography, ninth ed. Focal Press, Oxford, UK.

James, T.H. (Ed.), 1977. The Theory of the Photographic Process, fourth ed. Macmillan, New York, USA.

Kriss, M.A., 1998. A model for equivalency ISO CCD camera speeds. Proceedings ICP5 '98, Antwerp, Belgium, Volume 2, pp. 341–347.

Nakamura, J. (Ed.), 2006. Image Sensors and Signal Processing for Digital Still Cameras. Taylor & Francis, New York, USA.

Todd, H.N., Zakia, R.D., 1974. Photographic Sensitometry. Morgan & Morgan, New York, USA.

Walls, H.J., Attridge, G.G., 1977. Basic Photo Science. Focal Press, London, UK.

Chapter | 21 |

Tone reproduction

Sophie Triantaphillidou

All images © Sophie Triantaphillidou unless indicated.

THEORY OF TONE REPRODUCTION

Tone reproduction is concerned with the reproduction of original intensities and intensity differences, as well as with the observer's impression of these quantities, i.e. brightness (or lightness) and contrast reproduction respectively. *Intensity* is used in this context as a generic term for physical quantities related to the imaging signal or output, such as luminance and illuminance, transmittance, reflectance and density, and pixel value. Tone reproduction is the most crucial dimension of image quality, being a critical component of the subjective impression of the excellence of an image and the fidelity of a reproduction. Other important aspects of image quality, such as colour and perceived sharpness, are greatly affected by the contrast of an image and their subjective evaluation relies on optimum tone reproduction.

The theory of tone reproduction was established by L.A. Jones (an American physicist specializing in sensitometry) in the 1920s and 1930s, who first distinguished between *objective* and *subjective tone reproduction*. The terms were later formalized by C.N. Nelson. Objective tone reproduction refers to the measured or modelled relationship between the input and output intensities of an individual imaging device or system, or an imaging chain consisting of a number of systems. Subjective tone reproduction is, of course, dependent on the objective tone reproduction but also takes into account the viewing conditions (luminance level, background luminance, flare, etc.) that greatly influence the perception of image tones.

Transfer functions and gamma

The relationship between input-to-output intensities in an imaging device or system is described by one or a set of transfer functions. The luminance–brightness relationship introduced in Chapter 4 (see Figure 4.16) can be considered as the transfer function of the human visual system (HVS). The photographic transfer function, known as the *characteristic curve*, describes the sigmoid relationship between the common logarithm of relative exposure and the reproduced density on film or photographic paper. Note that density is also a logarithmic quantity, defined as the \log_{10} of the reciprocal of the film transmittance or print reflectance (Eqns 8.4 and 8.7). Chapter 8 is dedicated to sensitometry and the characteristic curve. Later in this chapter we discuss in detail the transfer functions of input and output imaging devices employed in digital imaging as well as the transfer functions, such as the opto-electronic conversion function (OECF), of various encoding systems.

Transfer functions are commonly plotted in linear–linear, log–log or linear–log units (with respect to luminance). The photographic characteristic curve — the earliest ever imaging transfer function — is plotted in log–log units, as mentioned above. The slope (or gradient) of the straight-line portion of the characteristic curve is termed *gamma* (denoted by the Greek letter γ) and it is a descriptor of the contrast of the photographic material under a given set of development conditions. The transfer functions of digital image capturing devices and display systems are usually plotted in linear–linear units (for example, luminance vs. pixel value in displays), but not exclusively. As we will see later on, the input–output relationships of such systems are often described by *power transfer functions*, i.e. output = input$^{\text{exponent}}$, where the 'exponent' represents gamma, a descriptor of the imaging contrast with a similar meaning to the photographic gamma. It is important to note that a power relationship appears linear when plotted in \log_{10} vs. \log_{10} units. This implies that *the slope of the straight line of a transfer function represented in log–log units is*

DOI: 10.1016/B978-0-240-52037-7.10021-3

equal to the exponent of a transfer function represented in linear—linear units. Therefore, mathematically, gamma has the same meaning whether it is calculated from the slope of a transfer function plotted in log—log, or from the exponent of a transfer function plotted in linear—linear units. This concept is illustrated in Figure 21.1.

Overall transfer function and overall gamma

The relationship between original scene intensity and reproduced image intensity characterizes the tone reproduction of an imaging chain and is affected by the tonal characteristics of each component in the chain. The *overall transfer function* of an imaging chain consisting of more than one imaging component is the product of the individual transfer functions of the separate components, as illustrated in the example in Figure 21.2. This is true provided that all individual transfer functions are plotted in the same mathematical space (i.e. log—log, linear—linear) and expressed using relative intensities. The overall gamma of the imaging chain in this example may therefore be derived by calculating the product of the component gammas (Eqn 21.1), or equally by deriving the gamma from the overall transfer function.

$$\gamma_O = \gamma_P \times \gamma_S \times \gamma_C \times \gamma_D \qquad (21.1)$$

where the subscripts O, P, S and D refer to the overall system, the photographic print, the scanner and the display respectively. γ_C is the amount of gamma correction, which can be applied to adjust the overall gamma to a desired value. Gamma correction can be carried out in imaging software, applied during scanning or can be a built-in function in video and digital cameras.

The term gamma correction was instigated by the television industry and originally referred to the modification of the video camera signal required to compensate for the tonal distortion introduced by the non-linearity of cathode ray tube (CRT) display systems (see Chapter 15 for CRT

transfer characteristics and later in this chapter). In this particular case, gamma correction was achieved by applying the inverse (of the display) transfer function to the original signal for obtaining an overall system gamma equal to unity:

$$V' = V^{1/\gamma_D} \qquad (21.2)$$

where V' is the corrected video signal, V is the original video signal and γ_D is the exponent of the power function that models the transfer characteristics of the display.

Equation 21.2 is a simplification of the case of real systems, since it assumes that the CRT display is perfectly set up and thus can be modelled by a single power function — as we will see later on, strictly speaking this is not true. Additionally, the gamma for television signal transmission is greater than $1/\gamma_D$ and thus the overall gamma is greater than unity to compensate for the dim viewing environments common to television viewing (see section on subjective tone reproduction below). For example, if γ_D is 2.5 as in the case of High Definition television (HDTV) systems, the effective gamma correction is close to 0.5 (whereas $1/2.5 = 0.4$) and the overall gamma equal to 1.25.

As we will see later in the chapter, in reality imaging transfer functions are rarely perfectly linear or pure power functions. The effective gamma correction refers to the exponent of a power function that approximates the system's overall transfer function and is usually slightly different to the actual exponent applied in gamma correction.

Subjective tone reproduction, optimum gamma and viewing conditions

In objective tone reproduction, higher measured gamma values than 1.0 indicate higher contrast in the reproduction than that in the original scene; lower gamma values than 1.0 indicate lower than the original contrast; gamma equal to 1.0 indicates equal scene and reproduction contrast. While

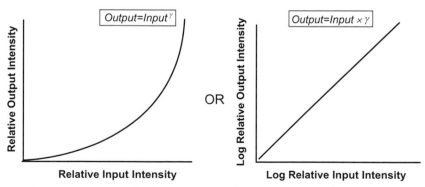

Figure 21.1 Gamma as the exponent in a transfer function plotted in linear—linear space (left) or as the slope of a transfer function plotted in log—log space (right).

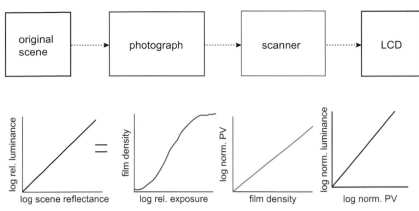

Figure 21.2 The tone reproduction of an imaging chain.

the aim of objective tone reproduction is a one-to-one reproduction of the relative input intensity, i.e. relative luminance reproduction, the aim of subjective tone reproduction is to have a linear reproduction of brightness relative to white, i.e. a linear lightness reproduction (lightness is the subjective perception of relative luminance – see Chapter 5). As we saw in Chapter 5, however, the perception of lightness is dependent on the relative intensity of the stimulus and the viewing conditions. More specifically, the perceived contrast decreases as the intensity of the stimulus, adapting background and surround decreases. Thus, the optimum tone reproduction can only be considered when the viewing conditions are known. Additionally, projection, printing or/and viewing flare lower image contrast (and thus the overall viewing gamma), especially in the dark image regions. To compensate for the 'flare effect' an ideal imaging system must have a gradually decreasing gamma at the light end of its transfer function.

Optimum gamma values for subjective tone reproduction vary between 1.0 and 1.5 (Figure 21.3). For example, reflection prints viewed typically in bright viewing conditions require an overall viewing gamma of approximately 1.0, but the overall objective gamma is close to 1.1 to compensate for flare. This is achieved by having, for example, a negative gamma close to 0.90 and a print gamma of 1.2. A gamma of approximately 1.25 is optimum for television and cut-sheet transparencies viewed in dim environments, whereas a gamma of approximately 1.5 is optimum for transparencies projected in dark and motion pictures. Thus, slide and motion picture films are designed to have high contrast – typically a gamma of 1.6 to compensate also for flare. Note that overall gamma values of 1.25 and 1.5 for dim and dark surrounds are optimum for fairly high imaging intensities – in the case of film and print densities. For lower densities slightly lower gamma values may be more appropriate. Computer images are viewed in brighter than television settings – office settings – and therefore the overall target gamma for viewing displayed digital images is between 1.1 and 1.15.

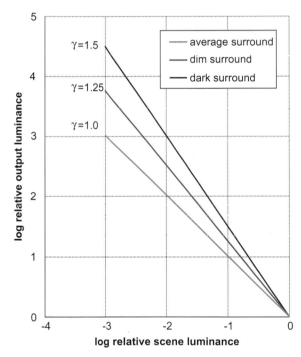

Figure 21.3 The relationship between log relative input and log relative output luminances required to achieve optimum tone reproduction.

Quadrant diagram

The viewing conditions can be modelled by a separate transfer function included in the imaging chain. This idea was first represented in the photographic *tone reproduction diagram* or *quadrant diagram*, introduced by L.A. Jones, which aims to model the tone reproduction of all stages in the imaging chain in a single diagram. The diagram consists of four quadrants, which are interrelated graphs

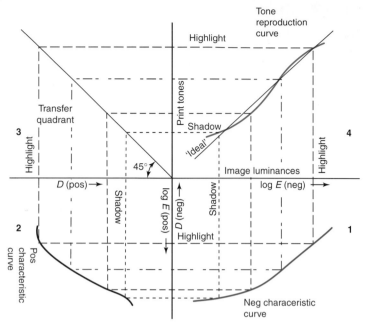

Figure 21.4 Quadrant diagram describing the tone reproduction of a film-based imaging chain.
From Bilissi (2003)

representing each stage of the photographic process, proceeding in a clockwise direction. The data output from the graph in the first quadrant is transferred as the input to the graph in the next quadrant, as illustrated in Figure 21.4. The representative graphs in the quadrants in the diagram are:

1. Characteristic curve of negative material and development
2. Characteristic curve of positive material
3. Transfer line
4. Overall tone reproduction characteristics achieved with steps 1, 2 and 3.

The *transfer line* in the third quadrant can be used to represent the viewing conditions. A simple straight line at 45° (slope = 1.0) can represent viewing of the print under conditions similar to those used when measuring the print with the reflection densitometer. Different viewing arrangements should produce a different line, depending on how the final print densities are viewed by the observer.

In the quadrant diagram, points from the first characteristic curve in the reproduction process are transferred from quadrant to quadrant via the characteristic curve of each stage in the process to produce the overall tone reproduction curve. Thus, the idea is essentially the same as that presented in Figure 21.2. Quadrant diagrams can also be used to represent the tonal characteristics of digital imaging chains (as illustrated in Figure 21.5), for example a camera/gamma correction/display system. To obtain a desired tone reproduction curve, the gamma correction

required for tonal compensation in the digital chain can be derived from the transfer line.

<div style="background:grey">

TONE REPRODUCTION OF IMAGING DEVICES AND IMAGE ENCODING SYSTEMS

</div>

CRT display transfer function

The evaluation of the tone reproduction of CRT display systems is based on the relationship between *input voltage* in mV (or *input pixel values* in the frame buffer, provided that they are linearly related to voltage) and *output luminance* in cd m^{-2} produced on the CRT faceplate. CRTs are inherently non-linear: the output luminance is a non-linear function of the input voltage. The CRT transfer function can be roughly described by a power function which obeys what physicists call the 5/2 power law (see Figure 21.6). Most CRTs have a numerical value of gamma — described by the exponent of the power function — close to 2.5.

Most commonly the CRT transfer function is described by the *gamma model* described below:

$$L = o + gV^{\gamma_{\mathrm{D}}} \tag{21.3}$$

where: L is the normalized luminance (obtained by calculating $(L_n - L_{min})/(L_{max} - L_{min})$, with L_n representing the

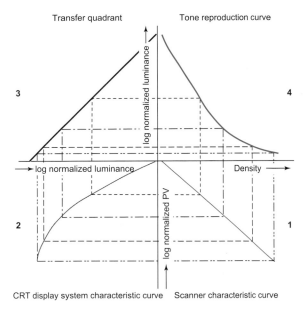

Figure 21.5 Quadrant diagram describing the tone reproduction of a digital imaging chain. *From Bilissi (2003)*

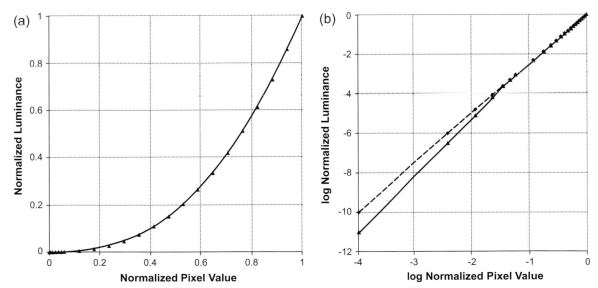

Figure 21.6 A measured transfer function of a CRT display in linear–linear (a) and log–log (b) space represented with solid lines. The broken line in (b) represents a transfer function with gamma = 2.5, offset = 0 and gain = 1.

nth luminance level); V is the normalized voltage (or normalized pixel values in the case digital systems); o is the system offset, controlled by the brightness setting on the display; g is the system gain, controlled by the contrast

setting on the display; and γ_D is the descriptor of the non-linearity in the contrast of the displayed image.

Theoretically, on a correctly adjusted display the offset and gain are set so that they have values of 0 and 1

381

respectively. This makes output luminance equal the input voltage raised to the power of γ_D, which in turn becomes the sole descriptor of the display tone reproduction.

In reality the offset is almost never exactly 0 and the gain never exactly equal to 1, so the measured display transfer function cannot be modelled solely by a straight power function. This is evident in Figure 21.6, where we notice in log–log space (where the very low luminances are better described) a deviation of the measured CRT response from a straight power curve.

What Poynton (2003) refers to as an 'amazing coincidence' is that the luminance–lightness function describing the human visual system's lightness sensitivity is nearly the inverse of the CRT transfer function: lightness is approximately luminance raised to the power of 0.33 (see Chapters 4 and 5). This coincidence has implications in imaging: the gamma-corrected functions implemented in video cameras, digital image encoding systems and digital input devices essentially mimic the visual transfer function. This is advantageous with respect to image quality, for to minimize the perceptibility of image noise (see Chapter 24) it is advisable to use a perceptually uniform code. (This is especially true when encoding is carried out in lower than 9 bits per pixel bit depths, as we will see later in the chapter.) The gamma-corrected video camera voltage (Eqn 21.2), as well as the corrected signal in most encoding systems (see later), is a perceptually uniform input.

More complicated models than the gamma function are used to describe the CRT non-linearity with more accuracy. Their implementation is generally more complex. One that is widely implemented is the GOG (gain, offset, gamma) model, described in Eqn 21.4 for the red channel, in which the CRT image is described in terms of its spectral radiance. Similar expressions describe the green and blue channels.

$$
L_{\lambda,r} = \begin{cases} L_{\lambda,r,max}\left(k_{g,r}\left(\dfrac{LUT_r(d_r)}{2^N-1}\right)+k_{o,r}\right)^{\gamma_r} \\[2ex] \left(k_{g,r}\left(\dfrac{LUT_r(d_r)}{2^N-1}\right)+k_{o,r}\right) \geq 0 \\[2ex] 0; \quad \left(k_{g,r}\left(\dfrac{LUT_r(d_r)}{2^N-1}\right)+k_{o,r}\right) < 0 \end{cases} \quad (21.4)
$$

$L_{\lambda,r,max}$ defines the maximum spectral radiance of the red channel (r) for a given CRT set-up, LUT represents the video look-up-table and N is the number of bits in the digital-to-analogue converter (DAC). Constants $k_{g,r}$ and $k_{o,r}$ are referred to as the system gain and offset respectively, and γ_r is the exponent describing the CRT inherent non-linearity between video voltages and electron beam currents hitting the faceplate. $L_{\lambda,r}$ is the spectral radiance produced on the CRT faceplate. Because the spectral radiance depends on both the graphics display controller

and the actual CRT, Eqn 21.4 includes common components to all computer-controlled CRT displays, such as the DAC and video LUTs, and thus characterizes the 'display system' as a whole.

Liquid crystal display (LCD) transfer function

Display technologies more modern than the CRT, including LCDs, have inherently different transfer functions to that of the CRT. They are intrinsically linear devices, i.e. the output luminance produced on the faceplate is linearly related to the input pixel value, at least for the largest part of the system's luminance range. The native transfer function of LCDs depends on the particular cell structure and the mode it operates in. Because of the 'amazing coincidence' described above, however, it is essential for image quality that the encoding of image data is carried out in a non-linear space. Therefore, LCDs incorporate some internal (local) correction to adapt their intrinsic transfer functions, often modelled by hyperbolic (i.e. sigmoid) functions, to transfer functions that have been standardized for video transmissions and image interchange. This signal remapping is achieved via a voltage modification or internal LUTs. Many modern LCDs have transfer functions that mimic that of the CRT and therefore the model described in Eqn 21.3 can be used to approximate the transfer characteristics of such displays; however, it does not describe them accurately.

Measuring display transfer functions

Display transfer functions are measured in total darkness, where the display is the only emissive device. The display needs to have been turned on a sufficient time before the measurement to ensure stabilization (see Chapter 15). CRTs need approximately 45 minutes to 1 hour to stabilize; LCDs stabilize in a maximum of 10 minutes. Photometers, spectrophotometers and colorimeters can be used to measure the display luminance (Y) output in candelas per square metre ($cd\,m^{-2}$) of the red, green and blue channels, as well as the monochrome display response. Spectroradiometers can also be used to record spectral radiance. When measuring LCDs, instruments with very small apertures are required; also, measurements are carried out from an axis exactly perpendicular to the display faceplate to avoid angle-of-view dependencies (see Chapter 15).

Measuring methods involve displaying uniform patches in the central 50% area of the display from which the luminance is measured (Figure 21.7). For CRT measurements, the display remaining area is often set to display either the complementary colour or an average display luminance, i.e. an average grey to avoid electron gun overload. For LCD measurements the remaining of the

Figure 21.7 Measuring and surrounding areas on the display faceplate.

display is set to black. Displayed patches range from the display black (input pixel value $d = 0$) to the maximum colour of each channel (input pixel value $d = 2^N - 1$, where N is the number of bits per pixel sent to the graphics card — usually 8), with equal steps in between. Seventeen to twenty-two steps per channel are usually enough to evaluate the display transfer characteristics. For measuring the greyscale response, set the input $d_r = d_g = d_b$, where d_r is the red, d_g the green and d_b the blue channel counts respectively. For varying a single-channel response, d is set to the desired input pixel value and the pixel values of the remaining two channels are set always to zero. Linear or non-linear interpolation between measured points can be used to estimate missing values and create LUTs that fairly

well represent the response of the system for all input digital counts.

In a perfectly additive display, the measured normalized red, green and blue channel responses should be matching. In reality, this is rarely the case. Any important deviation, however, represents problems with the *greyscale tracking* of the display, resulting in a colour cast in areas where the deviation occurs. Figure 21.8 shows measured red, green, blue and greyscale channel responses of an LCD system before (Figure 21.8a) and after (Figure 21.8b) normalization. The shape of the transfer function is similar to that of a CRT. In Figure 21.8a we notice that the neutral response is not identical to the sum of the three colour channel responses, an indication of lack of total additivity that is also seen in the slightly non-matching normalized blue channel response (see also Chapter 23).

In the evaluation of display transfer functions there is often a problem in numerical precision when measuring low-luminance colours — especially at zero digital input values. This results from either the low dynamic range of some displays, or the insufficient precision of measuring instruments at low luminance levels, or both.

Transfer functions of digital acquisition devices

The tonal characteristics of digital acquisition devices are commonly described by the relationship between the original scene luminance (often expressed by luminance ratios such as scene or print reflectance, or film transmittance) and the generated digital counts. Although charge-coupled device (CCD) and complementary metal

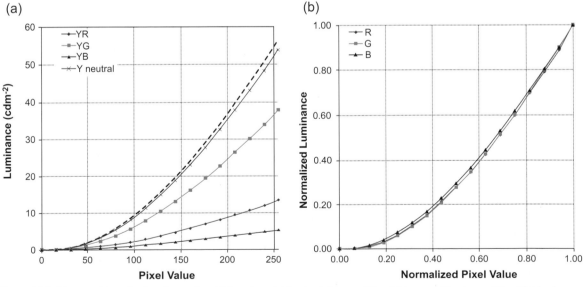

Figure 21.8 Measured transfer functions of an LCD system: (a) in absolute quantities; (b) in normalized quantities. The broken line in (a) indicates the sum of the three colour channel responses.

oxide semiconductor (CMOS) sensors incorporated in such systems generally respond in a linear fashion for the majority of input luminances (see Chapter 9), a non-linear mapping (gamma correction) of the output signal takes place in the system firmware or software to mimic the eye's response and at the same time accommodate for the display non-linearity and bring the overall system gamma close to unity. Note that digital RAW files (see Chapter 17), however, are reproduced with linear tone reproduction (gamma 1.0) − but also with high enough bit depths to compensate for the problems accompanying linear quantization (see later). The RAW converter applies gamma correction to redistribute the tonal information when images are displayed.

The transfer function of acquisition devices, also known as the *opto-electronic conversion function* (OECF), describes the overall transfer characteristics of a camera or a scanner system (i.e. sensor, firmware, software) and can be modelled roughly by the inverse of the CRT transfer function given in Eqn 21.3:

$$PV = o + gL^{\gamma_A} \tag{21.5}$$

PV is the generated pixel value, often normalized by the maximum count (i.e. $2^N - 1$, where N is the number of output bits/channel), L is the input luminance ratio, o is the system offset, g is the system gain and γ_A is the measure of digital image contrast.

An offset in the positive direction can be caused by either an electronic shift or stray light in the system. While the electronic offset can be set equal to zero and offset from uniform stray light can be adjusted out electronically, signals coming from flare light (i.e. stray light coming thought the lens) are often scene dependent.

In digital cameras the acquisition gamma, γ_A, is usually near $1/\gamma_D$ (i.e. the inverse of the display gamma, $\cong 1/2.2$ to $1/2.5$ or 0.45 to 0.40), or 1.0 − depending on the choice of output colour space (or encoding) and/or file format (see Chapter 17). When scanning, γ_A may be adjusted by the user via the scanning software so that a desired gamma correction is applied during digital image acquisition. When capturing using a chosen colour encoding such as sRGB, $\gamma_A = \gamma_E$, the gamma of the encoding system (see below and Chapter 23).

Measuring acquisition device transfer functions

The transfer functions of digital acquisition devices can be measured by averaging the response of the device to uniform transmittance or reflectance steps of conventional test charts (see Figure 21.9). Examples of such charts are: the ISO camera OECF test chart (ISO 14524:1999 method for measuring camera OECFs − see Bibliography), which includes 12 reflective uniform neutral grey patches with visual density increments which are equal with respect to

the cube root of the luminance illuminating the target; and the Kodak Q-13 greyscale, including 20 uniform grey steps in 0.10 density increments between almost 0.0 (white) and a practical printing black of 1.90 density. Visual densities in such charts are measured with conventional densitometers (see Chapter 8). Reflectance (or transmittance in transmissive targets) values can be calculated using the inverse of Eqn 8.4. Alternatively, for reflection-only charts and camera measurements, chart luminances can be measured with a telescopic photometer placed at the camera location, or chart relative luminances can be measured using a spectrophotometer. Strictly, the resulting curves from such measurements are average responses to the specific target, target positioning and illuminance. Various non-uniformities affect the response of the system, including the response of individual sensor elements in the camera/scanner sensor and lamp variations during illumination or scanning.

OECFs are often plotted in a linear−linear space (for example, (normalized) pixel value vs. scene relative luminance − or test chart reflectance, or transmittance) or a log−log space (for example, \log_{10} (normalized) pixel value vs. chart density). γ_A can be approximated by extracting the exponent of the power function in the former case, or the slope of the straight line in the latter case. The ISO 14524:1999 method suggests plotting the output pixel value, or \log_2 of the output pixel value, vs. the input log exposure or the input log luminance. Log luminance values are calculated from chart density measurements.

OECFs can also be constructed by extrapolating between closely measured points and creating LUTs that represent the response of the system at every pixel value. Figure 21.10 shows two example RGB OECFs plotted in linear−linear (a, c) and log−log (b, d) spaces. The overlapping functions in Figure 21.10a and b indicate good greyscale response, where $\gamma_{Ar} \cong \gamma_{Ag} \cong \gamma_{Ab}$ (the subscripts r, g and b denote red, green and blue). Notice that these responses are nearly the inverse of the CRT responses. However, when the OECFs are plotted in log−log space they do not appear linear but hyperbolic functions, similar to the photographic characteristic curve, where tones are compressed in the shoulder and toe regions (see Chapter 8). In fact, digital camera manufacturers often use S-shaped LUTs to emulate the response of silver halide materials, which are known to produce pleasant tone reproduction. In Figure 21.10c and d, the OECFs show poor greyscale response, with the blue channel response being different to that of the red and blue channels, indicating a colour cast in the mid and dark tones of the acquired image.

Image encoding: sRGB, Adobe RGB and JPEG transfer functions

sRGB (standard Red, Green, Blue) is a colour image encoding that is devised for personal computers and for

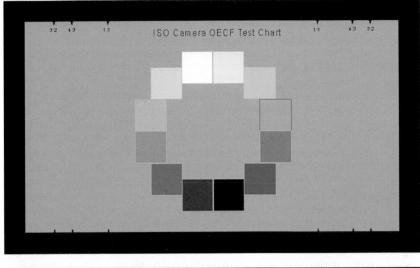

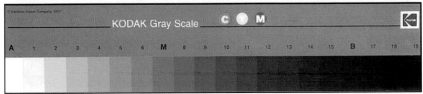

Figure 21.9 Two different test charts for measuring transfer functions of digital acquisition devices. Top: ISO camera OECF test chart. Bottom: Kodak Q-13 greyscale.

image exchange on the Internet. Most commercial digital cameras use sRGB as their standard output colour space, or at least give the option to choose sRGB encoding. The sRGB encoding space is discussed in detail in Chapter 23, but here we present its transfer function.

sRGB is calibrated colorimetrically for a reference display output, viewing conditions and observer. It assumes that the encoded signals will be outputted on a standard CRT display system with a nominal gamma value of 2.5. sRGB has an effective power function with gamma 1/2.2 (0.45), resulting in an overall system (encoding × display) gamma of 1.125, appropriate for dim illumination conditions and flare. The sRGB overall gamma is similar (but not identical) to the Rec. 709 standard encoding for HDTV. The encoding transfer function is given by:

$$sR'G'B'$$
$$= \begin{cases} 12.92 \times sRGB; & 0 \leq sRGB \leq 0.0031308 \\ 1.055 \times sRGB^{1/2.4} - 0.055; & 0.0031308 < sRGB \leq 1.0 \end{cases}$$
$$(21.6)$$

where $sR'G'B'$ is the gamma-corrected encoded signal (either red, green or blue – between 0 and 1.0) and sRGB is the linear input signal prior to the gamma correction (either red, green or blue – between 0 and 1.0).

Note that the sRGB transfer function is not a pure power function. At very low relative luminances the transfer function is linear (top part of Eqn 21.6). At relative luminances larger than 0.003130 the encoding gamma, γ_E, is equal to the exponent 1/2.4, offset is −0.055 and gain is 1.055. The effect of Eqn 21.6 is to closely fit a straightforward effective gamma 1/2.2 (0.45) curve, with $o = 0$ and $g = 1.0$. The gamma correction and the −0.055 offset is included to compensate for contrast ratios that occur when a value is at or near zero and for ambient light effects.

Another commonly employed image encoding is the Adobe RGB 1998 encoding system. It has a pure power transfer function similar to that described in Eqn 21.6 with a straightforward encoding gamma, γ_E, approximately equal to the exponent 1/2.2. As mentioned above, if we model the sRGB function as a pure power function the effective exponent is 1/2.2. This fact makes sRGB and Adobe encoding functions very similar to each other. Figure 21.11 illustrates the sRGB and Adobe RGB 1998 transfer functions.

In the JPEG encoding standard (see Chapter 29) there is no reference to a transfer function, but a non-linear transfer function, similar to video encoding or to a standard RGB colour encoding system (when such a system is used for image encoding), is embedded. Much lower quality results

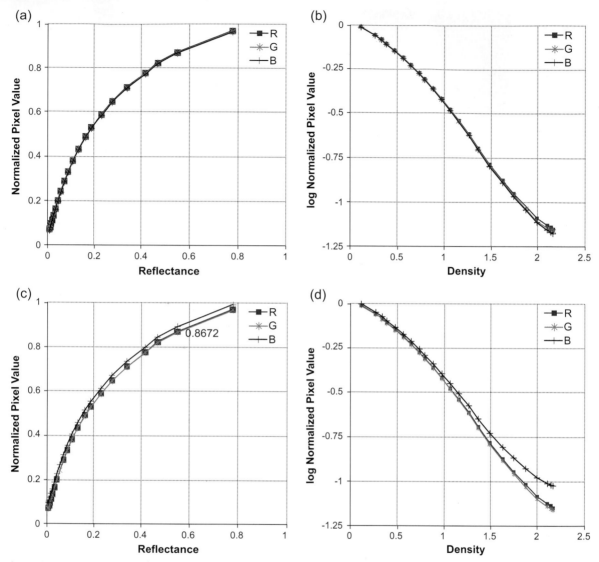

Figure 21.10 Camera OECFs plotted in linear–linear space (a, c) and in log–log space (b, d).

are obtained when JPEG is applied to linear data, due to the greater visibility of JPEG quantization artefacts.

Transfer functions of printers

The tonal characteristics of desktop printers are described by the relationship between input digital counts and the generated density (or reflectance) produced on the paper. The transfer functions of printers do not follow a specific model and depend on many variables, such as printer technology, dot size and dot gain setting, ink concentration, number of inks, printer driver and settings. To characterize this relationship a number of steps are printed from white to the maximum density for the neutral

(K) and for the colour channels of the printer (CMY, for example). Linear interpolation is used between measured points to obtain a curve that characterizes the response of the device for the specific ink set, paper and printer settings.

OTHER MEASURES RELATED TO TONE AND CONTRAST

Dynamic range and contrast ratio

Two other objective measures related to tone are the *dynamic range* and the *contrast ratio*. Several definitions of

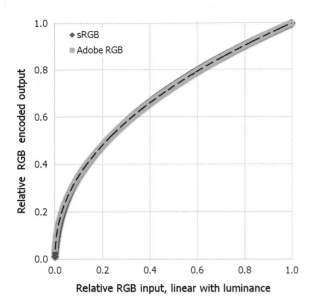

Figure 21.11 sRGB and Adobe RGB 1998 transfer functions. The black broken line indicates a pure power function with exponent 1/2.2.

Table 21.1 Typical contrast ratios of self-luminous devices in arithmetic units

DEVICE	CONTRAST RATIO
Liquid crystal computer displays	200:1 to 20,000:1
Cathode ray tube computer displays	300:1 to 1500:1
Digital data projectors	600:1 to 2000:1
Slide projectors	500:1 up to 1000:1

High contrast ratio is a desired feature of any device; higher ratios bring out subtle tonal and colour differences. The contrast ratios of devices are highly affected by the viewing conditions: the brighter the surrounds, the lower the effective contrast ratio. Typical contrast ratios are given in Table 21.1 and typical luminance ranges in Table 21.2.

A non-linear mapping of the input luminance (i.e. logarithmic or cubic root) mimicking the perceptual response is required to make the most of limited contrast ratios in imaging systems (see later in this chapter). Many factors, such as projection flare and backlighting on LCD devices, increase the luminance of the black and therefore lessen the contrast ratio in imaging systems, resulting in decreased image quality.

Due to their discrete nature, digital images allow some further direct measures related to tonal issues. One is the grey-level *histogram*, which summarizes the frequency of occurrence of the available intensity levels in an image. Histograms are discussed in detail in Chapter 27. Normalizing the grey-level histogram by dividing it by the number of pixels in the image produces the *probability density function* (PDF), also defined in Chapter 27. The PDFs of three different greyscale images are shown in Figure 21.12. Several image characteristics can be understood from its PDF, such as exposure and range, whether the image is low key (PDF skewing toward the lower pixel values) or high key (PDF skewing toward higher pixel values). Further, several statistical measures providing information relating to image tones can be calculated from image PDFs. Examples include the mean and median of the PDF, both relating to global image intensity, the standard deviation which relates to global image contrast (see below), and entropy which relates to the information content and random tonal changes in the image, etc. Some of these are discussed in later chapters.

dynamic range exist. Generally, it refers to the range of intensities in a scene (subject luminance range), a medium or a picture, i.e. the difference between the maximum and minimum intensities. Contrast ratio is the ratio of maximum to minimum signal, or output light intensities.

Dynamic range is often expressed in densities (which is measured on a base 10 log scale; thus the values represent the tens exponent of the relative density, for example $3.0D = 1000$ contrast ratio) or in photographic stops (see Chapter 12). Photographic flare might modify the subject luminance range. ISO 21550:2004 specifies methods for measuring and reporting the dynamic range of electronic scanners for continuous-tone photographic media. It applies to scanners for reflective and transmissive media.

The dynamic range in real scenes may range from direct sunlight to dark shadows and thus sometimes it happens to be much higher than that of imaging systems. High-dynamic-range (HDR) imaging is concerned with a set of techniques that allow the realistic reproduction of such high-dynamic-range scenes. It generally involves multiple captures of the same scene with a range of exposures and their combination to produce one image. An issue with HDR is in viewing the reproduced image. Typical methods of displaying and printing images have a limited dynamic range and thus various methods of converting HDR images into a viewable format have been developed. These are generally referred to as 'tonal mapping'. A number of tonal mapping algorithms exist but they are all scene dependent, meaning that not a single algorithm is appropriate for best rendering of all types of HDR scenes. More on HDR imaging can be found in Chapter 12.

Contrast in uniform areas, test targets and images

The two definitions that follow represent contrast as a ratio of luminance change to mean background luminance. They

Table 21.2 Typical dynamic ranges of scenes and imaging media in logarithmic units

MEDIUM/SCENE	DYNAMIC RANGE (LOG UNITS)
Outdoor scenes (luminance range)	1.25–1.50 typically, up to 3.3
Colour transparency film	3.0–3.7
Projected transparencies	2.1 (reduced to 1.4 perceivable scene luminance, due to dark surrounds that reduce apparent contrast)
Black-and-white negative film	2.1
Colour negative film	2.1
Black-and-white photographic paper	1.9
Colour photographic paper	2.4
Colour reflection prints, in ordinary room illumination conditions	2.1 (reduced to 1.25 perceivable, due to flare from topmost surface of print)
CCD and CMOS sensors in commercial cameras and scanners	2.5–3.6

are commonly used for measuring the contrast of simple uniform fields and test targets. One is the *Weber fraction* or Weber definition of contrast (see also Chapter 4), which is used to measure local contrast of an area with uniform luminance against a uniform background:

$$C = \frac{\Delta L}{L} \tag{21.7}$$

where ΔL is the increment or decrement in the area's luminance from the luminance of the uniform background.

The second, Michelson's formula, measures the contrast of a spatially periodic pattern, such as a single frequency sinusoidal grating:

$$C = \frac{L_{max} - L_{min}}{L_{max} + L_{min}} \tag{21.8}$$

where L_{max} and L_{min} are the maximum and minimum luminance values respectively in the grating (see also Chapter 24).

Equations 21.7 and 21.8 cannot be used to define contrast in digital images with complex scene content (i.e. non-uniform in luminance and complex in terms of spatial frequency content). Because of the difficulties in defining contrast in images many definitions of contrast can be found in the literature. A common way to define global contrast in an image so that the contrast of two different images can be compared is to measure the *root mean square* (rms) contrast, defined as the standard deviation of the pixel values (grey levels):

$$C_{rms} = \left[\frac{1}{N-1} \sum_{i=1}^{N} (x_i - \bar{x})^2 \right]^{1/2} \tag{21.9a}$$

where N is the total number of image pixels, x_i is a normalized grey level value of the digital image (ranging between 0 and 1) and \bar{x} is the normalized mean grey level, given by:

$$\bar{x} = \frac{1}{N} \sum_{i=1}^{N} (x_i) \tag{21.9b}$$

The rms contrast does not depend on the spatial frequency content of the image or the spatial distribution of the contrast in the image.

NON-LINEAR QUANTIZATION, BIT-DEPTH REQUIREMENTS AND GAMMA CORRECTION

We have seen in previous chapters that the human response to luminance is nearly logarithmic (or the cube root of the luminance), that the contrast ratio of the human vision at most levels of adaptation is about 100:1 and that the contrast ratio of two distinguishable levels of luminance is about 1% of luminance — for the majority of luminance levels. What happens when linear quantization is applied to the luminance signal (i.e. when output pixel values are proportional to input luminance) using 256 grey levels? Poynton (2003) points out that in an 8-bit quantized luminance signal the code value 100 is where the contrast ratio between adjacent luminance levels is approximately 1%, thus equal to the visual threshold. Adjacent luminance levels below code value 100 (in the

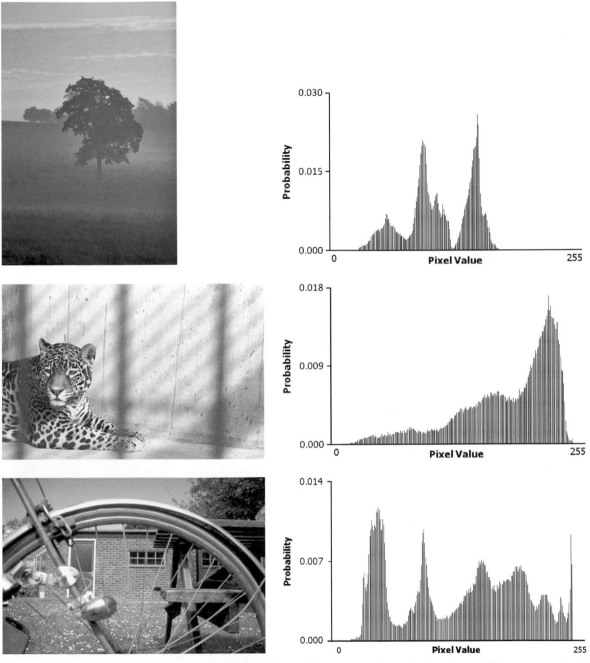

Figure 21.12 Greyscale normalized histograms (PDFs) of an image with narrow tonal range (top), an image with tones concentrated in the light part of the tonal scale (middle), and an image with a wide range of tones (bottom).
Original images from Kodak Master Photo CD.

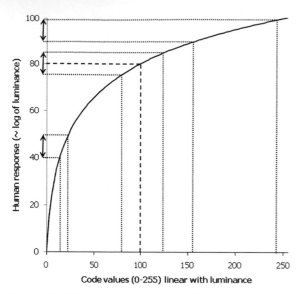

Figure 21.13 Human response versus a linearly quantized 8-bit signal.

Table 21.3 Original intensity levels in an 8-bit quantization space and modified levels by 1/2.2 gamma correction before and after rounding

ORIGINAL INTENSITY VALUE	GAMMA-CORRECTED INTENSITY BEFORE ROUNDING	GAMMA-CORRECTED INTENSITY AFTER ROUNDING
0	0.00	0
1	20.54	21
2	28.15	28
3	33.85	34
4	38.58	39
5	42.69	43
⋮	⋮	⋮
250	252.71	253
251	253.17	253
252	253.63	254
253	254.09	254
254	254.54	255
255	255.00	255

darkest image areas) become increasingly visible, whereas adjacent levels above this point become more and more indistinguishable from each other and thus many code values are being wasted. As a result, smoothly varying dark areas in images, where the contrast ratio is as high as 4%, suffer from *contouring*, an artefact that has the appearance of visible steps (or bands) in areas that otherwise would look continuous. Thus, linear quantization in 8 bits per channel is unsuitable. This is one of the reasons why the majority of digital acquisition devices that employ linear quantization use bit depths of higher than 8 bits. In fact, even if logarithic quantization is employed, a bit depth of 9 bits per pixel would be required to produce non-perceptible steps in the entire range of quantized lumi-nances. Figure 21.13 shows that in a perceptual scale from 1 to 100 which is logarithmically related to luminance, equal steps in visual response (represented by the double arrows on the *y*-axis) require different steps in a linearly quantized luminance signal. It also demonstrates that around the code value 100, the balance shifts from the need for fine quantization of the dark values to coarser quantization of the light values.

Another reason why digital acquisition devices quantize images at bit depths higher than 8 bits is to minimize the effects of the rounding errors caused during image modifications. The limited precision of the integer math-ematics used by digital imaging devices and computers presents problems at low bit depths. One example is gamma correction which, as described earlier, is applied to the acquisition signal to adjust the overall gamma in the imaging chain to an optimum value. The problem with tonal correction in discrete systems is that it introduces

a loss in the original number of the available intensity levels. In a gamma-corrected signal, the limits of the intensity range (pixel values representing black and white) remain the same as in the original discrete signal, but some of the original available intensity levels are lost whereas some others are repeated due to *rounding errors* (see example in Table 21.3). The losses appear more significant when the quantization levels are coarse and gamma correction in an 8-bit space may result in up to a 30% loss in the available intensity levels. The loss of intensity levels with gamma correction is illustrated in Figure 21.14, which presents a range of gamma corrections in an 8-bit per channel quantized signal. Missing grey levels in an image may lead to *posterization*, an artefact similar to contouring, mentioned above, where contin-uous gradation of image tones is replaced with visible steps of fewer tones.

A solution to this is to start with more available intensity levels, i.e. higher bit depths, so that the loss is not so significant. Performing tone modification in 12 or even 16 bits per channel and down-sampling the optimized signal to 8 bits per channel for output means that the remaining levels after gamma correction are enough to be mapped to 256 output code values. This is a very common imple-mentation in digital cameras and scanners. The subject of 8-bit versus 16-bit depth imaging is further dealt with in Chapter 28.

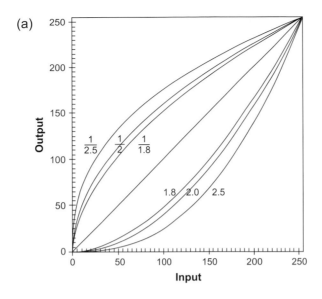

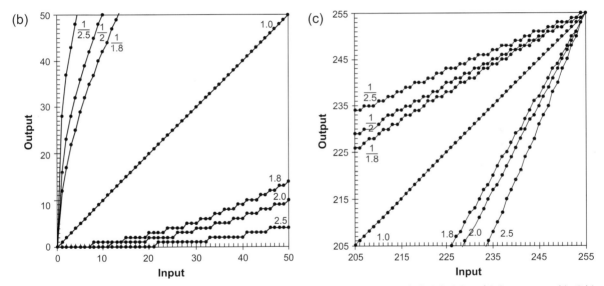

Figure 21.14 A range of transfer functions with gamma values equal to 1/2.5, 1/2.0, 1/1.8, 1.8, 2.0 and 2.5 represented in 8-bit space. (a) The entire functions. (b) Magnified, the lower region (shadows). (c) Magnified, the upper region (highlights) of the functions.

BIBLIOGRAPHY

Adobe RGB 1998 Color Image Encoding, version 2005-05, 2005. Adobe Systems Incorporated.

Berns, R.S., 1996. Characterization of a CRT display. Displays 16 (4), 173–182.

Bilissi, E., Langford, M., 2008. Langford's Advanced Photography, seventh ed. Focal Press, Oxford, UK.

Eggleston, J., 1984. Sensitometry for Photographers. Focal Press, Oxford, UK.

Gibson, J.E., Fairchild, M.D., 2000. Colorimetric Characterization of Three Computer Displays (LCD and CRT). Munsell Color Science Laboratory Technical Report.

Hunt, R.W.G., 2004. The Reproduction of Colour, sixth ed. Wiley, USA.

IEC 61966-2-1, 1998. Multimedia Systems and Equipment — Colour Measurement and Management, Part 2.1: Colour Management in Multimedia Systems — Default RGB Colour Space — sRGB. International Electrotechnical Commission.

ISO 14524:1999(E), 1999. Methods for Measuring Opto-Electronic Conversion Functions (OECFs). International Organization for Standardization.

ISO 21550:2004, 2004. Photography — Electronic Scanners for Photographic Images — Dynamic Range Measurements.

ISO 22028-1:2004, 2004. Photography and Graphic Technology — Extended Colour Encodings for Digital Image Storage, Manipulation and Interchange.

Jones, L.A., 1920. On the Theory of Tone Reproduction, with a Graphic Method for the Solution of Problems. Journal of the Franklin Institute 190 (1), 39—90.

Nelson, C.N., 1966. The Theory of Tone Reproduction, in the Theory of Photographic Process. In: Mees, C.E.K., James, T.H. (Eds.). The MacMillan Co., New York, USA.

Peli, E., 1990. Contrast in complex images. Journal of Optical Society of America 7 (10), 2032—2040.

Poynton, C., 2003. Digital Video and HDTV Algorithms and Interfaces. Morgan Kaufman, Elsevier Science, San Francisco.

Triantaphillidou, S., 2001. Image Quality in the Digitisation of Photographic Collections. Ph.D. thesis, University of Westminster, UK.

Chapter | 22 |

Photographic colour reproduction

Geoffrey Attridge

All images © Geoffrey Attridge unless indicated.

INTRODUCTION

If we are to obtain the optimum record of the appearance of coloured objects, for most purposes our aim in photography must be to reproduce them as the eye sees them in daylight. Unlike the eye, however, photographic materials do not adapt themselves to changes in the light source (see chromatic adaptation of the human visual system as described in Chapters 4 and 5). They faithfully record the effects of any such changes: if a photograph is not being taken by daylight, the difference in colour quality between daylight and the source employed must be taken into account if visually optimum colour rendering is to be obtained, and it will be necessary to use colour-compensating filters. These will not necessarily be effective in extreme lighting conditions: low-pressure sodium lighting is such an example.

In practice, a technically correct rendering is rarely required in black-and-white photography, and changes in the colour quality of the illuminant can usually be ignored. In colour photography, however, very small changes in the colour quality of the illuminant may produce significant changes in the result, and accurate control of the quality of the lighting is essential if optimal results are to be obtained.

Complementary Pairs of Colours

As described in previous chapters, when any one of the three sets of colour-sensitive receptors of the eye is stimulated on its own, the eye sees blue, green or red light respectively. These three colours are known to the photographer as the *primary colours*, already mentioned. The sensations obtained by mixing the primaries are called *secondary* or *complementary* colours and are obtained when

Table 22.1 Primary and complementary colours

PRIMARY COLOUR	COMPLEMENTARY COLOUR	ADDITIVE MIXTURE
Red	Cyan	= Blue + green
Green	Magenta	= Blue + red
Blue	Yellow	= Green + red

just two sets of receptors are stimulated. If all three sets of receptors are stimulated in equal proportions the colour perceived is neutral.

Any two coloured lights which when added together produce white are said to be of *complementary colours*. Thus, the secondary colours (cyan, magenta and yellow) are complementary to the primary colours (red, green and blue), as seen in Table 22.1. Some colour theorists in the field of aesthetics refer to such complementary pairs of colour as 'harmonious colours'.

COLOUR PHOTOGRAPHIC PROCESSES

We have already seen in Chapters 1 and 5 that two techniques of colour photography have been of practical importance, namely additive and subtractive methods. Of these, *additive* photography was the first successful process, but we shall review it only briefly as it has been overtaken by the more successful *subtractive* processes. Additive systems of colour reproduction do, however, continue to be successful in the field of digital capture and display.

DOI: 10.1016/B978-0-240-52037-7.10022-5

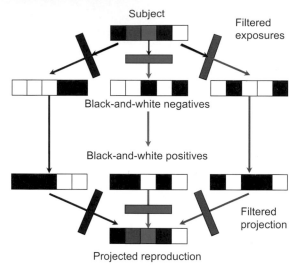

Figure 22.1 Maxwell's additive colour photographic process.

Subject

Filtered exposures

Black-and-white negatives

Black-and-white positives

Filtered projection

Projected reproduction

Additive colour photography

In James Clerk Maxwell's additive process, demonstrated in 1861 (shown diagrammatically in Figure 22.1), the selection of three spectral bands at the viewing stage was made by the original primary-colour filters used for making the negatives. The amount of each primary colour projected on the screen was controlled by the density of the silver image developed in the positive slide.

An interesting parallel between additive colour photography and digital displays is exemplified by early colour plates and, later, colour films using an integral or, sometimes, separate mosaic of red, green and blue filters, through which a panchromatic emulsion was exposed (see Figure 22.2). The exposed material was processed to yield a positive silver image. This neutral silver image effectively modulated the amount of light passing through each element of the filter mosaic, and hence controlled the image colour perceived at every point in the mosaic. Each of the filters used transmitted less than one-third of the visible spectrum and the reproductions appeared rather dark unless very powerful projectors were used.

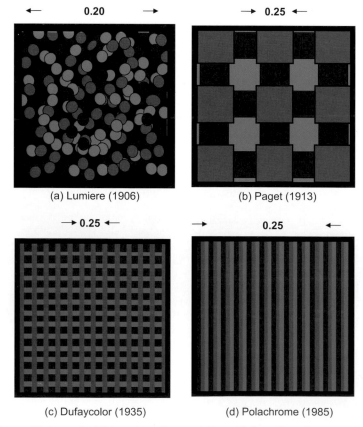

(a) Lumiere (1906)

(b) Paget (1913)

(c) Dufaycolor (1935)

(d) Polachrome (1985)

Figure 22.2 Filter mosaics used in integral additive colour plates and films. All dimensions shown are in mm.

An alternative and successful approach to the selection of spectral bands for colour reproduction is to utilize dyes of the complementary hues yellow, magenta and cyan to absorb, respectively, light of the three primary hues blue, green and red.

Subtractive processes

Subtractive systems use yellow, magenta and cyan image dyes in appropriate concentrations to control the amounts of blue, green and red light respectively transmitted or reflected by the reproduction. Thus, white is reproduced by the virtual absence of image dyes, grey by balanced moderate quantities of the three dyes, and black by a high concentration of all three dyes. Colours are reproduced by superimposed dye images of various concentrations. The effects of superimposing pairs of subtractive dyes are illustrated in Figure 22.3.

It is possible to prepare subtractive dye positives from blue, green and red separation negatives. Such dye positives can be used to superimpose the yellow, magenta and cyan images to obtain a reproduction that may be projected using one projector only, or viewed against a reflecting base. Two major processes that operated by this method were the Kodak Dye Transfer process for making reflection colour prints and the Technicolor method of preparing motion-picture release colour prints.

Integral tripacks

While subtractive images can be separately prepared and superimposed to form a colour reproduction, this method finds limited application. Most colour photographs are made using a type of material which makes blue, green and red records in discrete emulsion layers within one assembly. This specially designed emulsion assembly is called an *integral tripack*. Latent image records within the emulsion layers are processed in such a way that the appropriate dye images are generated in register, within the emulsion layers, by colour development. The processing chemistry is such that the blue, green and red records are made to generate complementary yellow, magenta and cyan images respectively.

The sensitivities of the emulsions of a typical camera-speed tripack are illustrated in Figure 22.4. All three layers possess blue sensitivity. Blue light must therefore be prevented from reaching the green- and red-recording layers. This may be achieved by coating a yellow (blue-absorbing) filter layer between the uppermost blue-sensitive assembly (Figure 22.5), and the green- and red-sensitive layers below, typically resulting in the sensitivities shown in Figure 13.5.

In practice the film is more complicated and an example is shown in Figure 22.11, with the blue-recording layer on top of the other two layers, and a yellow filter layer between the blue-recording and green-recording layers. The *supercoat* is added to protect the emulsions from damage. The filter layer absorbs blue light sufficiently to suppress the blue sensitivities of the underlying emulsions, and an interlayer is usually positioned between the lower emulsion layers. It is

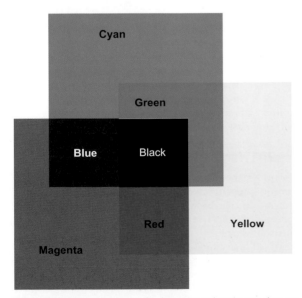

Figure 22.3 Combinations of subtractive colour image dyes on a viewing screen.

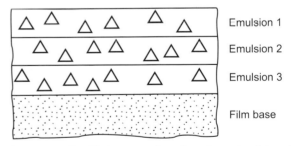

Figure 22.4 Simplified cross-section of an elementary integral tripack colour film. The symbol Δ denotes a silver halide emulsion grain.

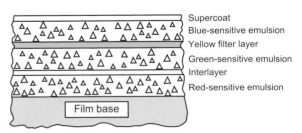

Figure 22.5 Construction of a simple integral tripack colour film.

395

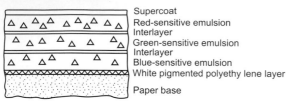

Supercoat
Red-sensitive emulsion
Interlayer
Green-sensitive emulsion
Interlayer
Blue-sensitive emulsion
White pigmented polyethy lene layer

Paper base

Figure 22.6 Cross-section of a tripack colour-printing paper. Compare the layer order with that in Figure 22.5, and note the absence of a yellow filter layer.

common for each individual sensitivity component to be coated as two adjacent layers, one fast and one slower, the faster component being located above, nearer the camera lens, than the slower.

A more elegant solution to the problem of inherent blue sensitivity of the green- and red-recording layers is to suppress it within the emulsion layers themselves. This may be achieved in materials for camera use by, for example, the use of tabular emulsion crystals of very high surface-area-to-volume ratio. The blue response depends on the amount of silver halide in each crystal, a volume effect, but the dye-sensitized response depends on the quantity of adsorbed dye, a surface-area effect. A high area-to-volume ratio therefore increases the sensitivity in the sensitized region compared with the inherent blue sensitivity, and with modern sensitization techniques this may be so low as to require no yellow filter layer.

In print materials it is often possible to reduce and confine the inherent sensitivity of red- and green-sensitized emulsions to the far blue and ultraviolet spectral regions, and to exclude these by a suitable filter during printing; no yellow filter layer is then required in the print material and the order of layers may be changed to suit other needs. A commonly employed order of layers in colour-printing materials is illustrated in Figure 22.6. The most important colours for the visual impression of sharpness are magenta and cyan. The red- and green-sensitive layers are therefore coated above the blue-sensitive emulsion so that the red and green optical images reach the appropriate layers without suffering prior blurring due to scatter in the blue-sensitive layer.

Formation of subtractive image dyes

Having analysed the camera image into blue, green and red components by means of the tripack film construction, it is then necessary to form the appropriate image dye in each layer. Conventionally this is achieved by the reaction of by-products of silver development with special chemicals called *colour couplers* or *colour formers*. Developing agents of the *p*-phenylenediamine type yield oxidation products which will achieve this:

1. Silver halide grains which have been rendered developable by exposure to light, or otherwise, are *reduced* to metallic silver and the developing agent is correspondingly *oxidized*:

Exposed silver bromide

+ Developing agent → Metallic silver

+ Developer oxidation products + Bromide ions

2. Developer oxidation products react with chemicals called colour formers or colour couplers to form dyes. Colour developing agents of the substituted *p*-phenylenediamine type are used in practice, and the colour of the developed dye depends mainly on the nature of the colour former:

Developer oxidation products + Colour former → Dye

Thus, to form a dye image alongside the developed silver image a special type of developer is required and a suitable colour coupler must be provided either by coating it in the emulsion or, less commonly, by including it in the developer solution.

The dyes formed in subtractive processes would ideally possess spectral absorptions similar to those illustrated in Figure 22.7 as 'ideal'. In practice they are not ideal and possess spectral deficiencies similar to those also shown in the figure. The consequences of these dye imperfections can be seen when the sensitometric performance of colour films is studied.

COLOUR SENSITOMETRY

Using sensitometric methods it is possible to investigate and illustrate important features of colour films in terms of both tone and colour reproduction. Tone reproduction properties are shown by neutral exposure — that is, exposure to light of the colour quality for which the film is designed, typically daylight at 5500 K or studio lighting at 3200 K. This exposure also gives information about the overall colour appearance of the photographic image. Colour exposures are used to show further colour reproduction properties not revealed by neutral exposure.

Negative–positive colour

Colour negative films and printing papers have tone reproduction properties not unlike those of black-and-white materials, except that colour negative emulsions are designed for exposure solely on the linear portion of the characteristic curve. The materials are integral tripacks and generate a dye image of the complementary hue in each of the three emulsion layers: yellow in the blue-recording, magenta in the green-recording and cyan in the red-recording layer.

The densities of colour images are measured using a densitometer (see Chapter 8) equipped with blue, green and red filters, to give a standard set of sensitivities chosen

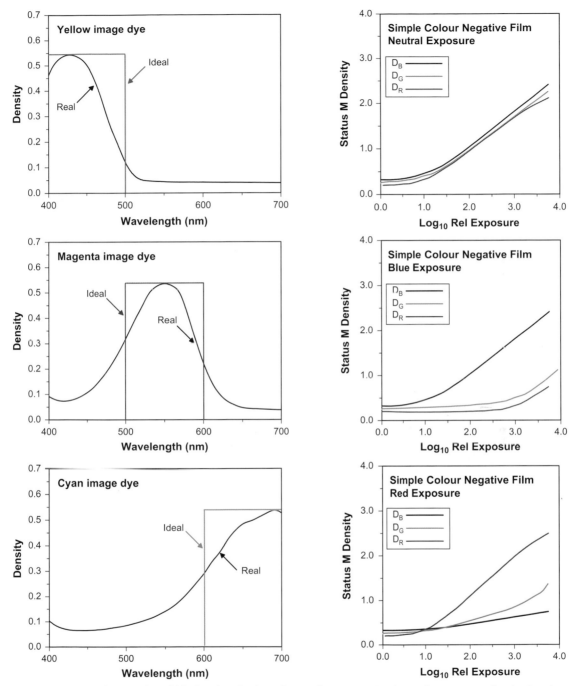

Figure 22.7 Spectral properties of ideal and real subtractive image dyes.

Figure 22.8 Sensitometric exposures of a simple colour negative film: neutral, blue and red.

with respect to the intended use of the images. All three colour characteristic curves are drawn on one set of axes for each individual sensitometric exposure. Typical negative characteristics obtained from a neutral exposure appear in

Figure 22.8, which shows that the three curves are of similar contrast, although of slightly different speeds and different density levels. The unequal negative densities have no adverse effect on the colour balance of the final print

397

because colour correction is carried out at the printing stage.

Neutral-exposure characteristic curves are informative about the contrast and sensitometric speed of a product and the presence or absence of contrast and speed balance, but those obtained from exposures to the primary colours can also be useful. Saturated primary-colour exposures could be expected to reveal the characteristics of individual emulsion layers. The results of two such exposures of a simple colour negative film are also shown in Figure 22.8. The characteristic curves show a number of departures from the ideal in which only one colour density would change with colour exposure. Two main effects typically accompany the expected increase of one density with log exposure. The first is the low-contrast increase of an unwanted density with similar threshold to the expected curve; the second is a high-contrast increase (similar to that of the neutral curves) of an unwanted density with a threshold at a considerably higher log exposure than the primary curve shown. The former effect is due to secondary, unwanted, density of the image dye; thus, the cyan image formed on red exposure shows low-contrast blue and green secondary absorptions. The second effect is due to the exposing primary colour filter passing a significant amount of radiation to which one or both of the other two layers are sensitive. The blue exposure has clearly affected both green- and red-sensitive layers at high exposure levels. In this case of blue exposure the separation of layer responses is largely determined by the blue density of the yellow filter layer in the tripack, at exposure, as all emulsion layers of the negative are blue sensitive. The results of red exposure show a combination of the two effects, revealing secondary blue and green absorptions of the cyan dye and the overlap of the red radiation band passed by the filter with the spectral sensitivity band of the green-sensitive emulsion.

Modern colour negative films yield characteristic curves, which differ from those shown in Figure 22.8 owing to methods adopted to improve colour reproduction. The most obvious of these is *colour masking*, which is designed to eliminate the printing effect of unwanted dye absorptions by making them constant throughout the exposure range of the negative. Important characteristics of a masked colour negative film are shown in Figure 22.9. The obvious visual difference between masked and unmasked colour negatives is the orange appearance of the former. This appears as high blue and green densities, even at D_{min}. The results of colour masking can clearly be seen in the case of the red exposure illustrated in Figure 22.9. Unwanted blue and green absorptions of the cyan image are corrected by this masking, which would ideally result in blue and green characteristic curves of zero gradient, i.e. constant blue and green densities at all red exposure levels. In this example, the green absorption is slightly under-corrected and the blue is over-corrected. The green density does rise a little with increased exposure, while the blue falls. Some degree of over-correction, or *over-masking*, may be deliberately

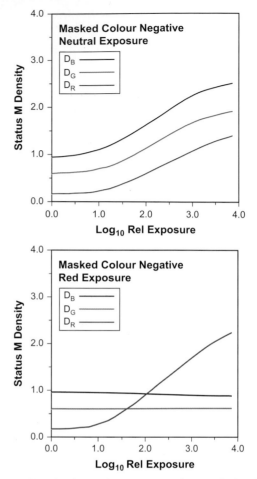

Figure 22.9 Sensitometric exposures of a masked colour negative film: neutral and red.

introduced by manufacturers in negative products designed to give very colourful prints.

A second method of colour correction is to make image development in one layer inhibit development in the other emulsion layers. If an emulsion has an appreciable developed density this may be reduced by development of another layer, giving a corrective effect similar to that of colour masking. Such *inter-image effects* are not always simply detected by measuring integral colour densities but they are sometimes detectable. Inter-image effects, for example, would appear to be operating in the negative film illustrated in Figure 22.8. Blue exposure results in development of the yellow image in the top layer of the tripack and this, in turn, inhibits development of the green- and red-sensitive layers so that the red minimum density, in particular, falls while the blue density increases. Such unexpectedly low image densities are often the only clue to the existence of inter-image effects to be found using integral densitometry.

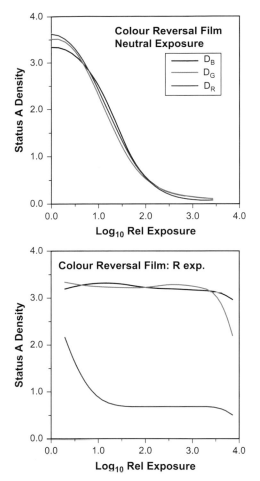

Figure 22.10 Neutral and red sensitometric exposures of colour reversal film.

Current colour negative films (see Figures 22.11 and 22.12) use both colour masking and inter-image effects, allowing excellent colour correction with relatively low mask densities. The mask density and its colour, however, remain far too great for this colour correction method to be used in materials such as reversal films, designed for viewing rather than printing. The consequences of dye deficiencies in such systems are, however, less important than in negative–positive systems, where two reproduction stages are involved, with a consequent reinforcement of colour degradation. Colour reversal films do, however, generally exhibit significant and beneficial inter-image effects.

Reversal colour

Colour reversal films are constructed similarly to integral tripack negative films, but without the colour masking components present in negative films. The positive nature of the image springs primarily from a major difference in the processing carried out, not from the emulsions used in the film. As in the negative, the dye image generated in each layer is complementary in colour to the sensitivity of the emulsion.

The results of neutral exposure are illustrated in Figure 22.10, and show typical positive characteristic curves. Unlike colour negative materials it is important that the results of a neutral exposure on reversal film should appear truly neutral: no simple correction can be carried out once the image has been developed. In the case illustrated, the curves show sufficiently similar densities for the result to be visually satisfactory. The major difference is at so high a density as to be imperceptible – there is rarely any perceived colour in regions of deep shadow.

Colour exposures show various departures from the ideal and are sometimes quite difficult to interpret. The two main effects are, however, as easily characterized as they were for colour negatives: the unexpected decrease of density with log exposure at low contrast and the decrease in a colour density other than that of the exposure at high contrast. The former effect is generally caused by the secondary absorption of an image dye, and the latter shows the overlap between the spectral region passed by the exposing filter and the sensitivity band of the emulsion concerned. Red exposure can yield characteristic curves showing the effects of both secondary absorptions and inter-image effects. The expected result of red exposure is a decrease in red density with increasing exposure. This is seen in Figure 22.10, but other results are also observed. The initial large decrease in the density of the cyan dye image with increased exposure is accompanied by a small decrease in the green density, caused by the correspondingly reduced unwanted secondary green absorption of the cyan image dye. An increase in blue density is observed over the same exposure range, and this indicates the existence of an inter-image effect in which the development of an image in the red-sensitive layer inhibits the development of an image in the blue-sensitive layer. This takes place during colour development, and represents a colour correction effect akin to masking. The apparently high minimum red density, in the case of red exposure, is due to unwanted red absorptions of the yellow and, particularly, magenta image dyes present in maximum concentration. At very high exposure levels, when the blue- and green-sensitive layers respond and the yellow and magenta dye concentrations fall, the red density is also reduced. The response of the blue- and green-sensitive layers to exposure through a red filter is due to the small but appreciable transmission of the red filter in the green and blue regions of the spectrum.

In essence, each primary-colour-exposed result for reversal films may be analysed in terms of three main regions. The first, at low exposure levels, shows one dye decreasing in concentration; its secondary densities are

399

revealed by low-contrast decreases in the other two densities. The second region, at intermediate exposure, shows no change in any of the three curves, but the level of the lowest is well above the minimum found on neutral exposure, owing to the unwanted absorptions of the two image dyes present. This is exemplified by the red exposure, shown in Figure 22.10 at a log relative exposure of 2.0. Lastly, at high exposures, a region exists where sufficient *actinic* exposure — that is, exposure to which the emulsion is sensitive — of the remaining two emulsions leads to a decrease in the concentration of the corresponding image dyes. The secondary absorptions of these two dyes are shown by a low-contrast decrease in the third curve, for example the blue density at log relative exposures of 1.5 or more. For reversal film, departures from this scheme are caused by inter-image effects, which appear as unexpected *increases* in density with *increased* exposure, or by overlap of filter pass bands with sensitivity bands of the emulsions. This last departure from the ideal results in a compression of the three regions with the possible loss of the middle one and overlap of the other two. The middle region is not necessarily evident on green or blue exposure owing to the sensitivity separations of the three emulsions being only as much as is needed for adequate colour reproduction. Only the red exposure has sensitivity separation to spare. Indeed, the extensive range of exposures, over which no change is seen in the image, may be the cause of poor reproduction of form and texture of vivid red subjects. Vivid red tulips or roses, for example, may simply appear as red blobs with no visible tonal quality or texture.

COLOUR PHOTOGRAPHIC MATERIALS

The dye-forming development reaction allows us to generate dyes of the required colours, yellow, magenta and cyan, to control blue, green and red light respectively. To take advantage of colour development it has been necessary to make special photographic materials of the integral tripack variety described. This means that light-sensitive emulsions are coated in three layers on a suitable support, the basic construction shown in Figure 22.4. The records of blue, green and red light are made independently in the three emulsion layers. The resulting layer sensitivities are illustrated in Figure 13.6. The demand for high film speeds and improved quality has led to important developments in the technology of colour film assembly. Some of these changes are revealed by obvious but microscopic structural changes, and one such departure from the conventional tripack is shown in Figure 22.11. In order to obtain the required exposure latitude, it is customary to include two separate emulsions, a fast and a slow component of similar spectral sensitization, in each layer of a tripack colour film. This arrangement gives the highest sensitivity when the fast component is coated above the slow in each double-layer

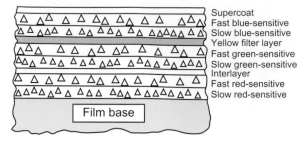

Figure 22.11 Cross-section of a modern colour negative film. Note the double-coated emulsion layers with fast components coated above the slow.

and therefore has the greatest possible access to the incoming radiation. Each sensitive layer of the elementary tripack construction is then coated as a double layer. This is preferable to blending fast and slow emulsions in a single layer, which reduces the overall speed by the absorption of light by smaller grains overlying the large at exposure. In addition, the colour-former-to-silver ratio in each component may be manipulated independently to optimize sensitometric and micro-image properties.

A further improvement in film speed has accompanied the structural change illustrated in Figure 22.12. In this cross-sectional diagram it will be seen that the logic, which positions the fast component above the slow in the emulsion double layers in Figure 22.11, has been extended. In this example the fast green- and red-sensitive components are adjacent and both lie above the two slow components, resulting in a partial inversion of layer order, with the fast red-sensitive layer above the slow green-sensitive layer. This structure is considerably more complex than that shown in Figure 22.11, but has been used to meet very stringent targets for speed and quality. The adoption of tabular-grain emulsions in the green- and red-sensitive layers of some products has made possible the omission of the customary yellow filter layer from the structure shown in Figure 22.11. This change, in itself, tends to reduce both the overall thickness of the coating and the scattering of input light, thus improving image sharpness.

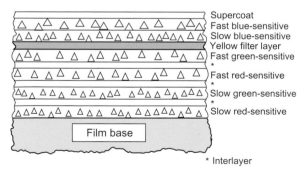

Figure 22.12 Cross-section of a modern high-speed colour negative film.

We have examined the methods used to obtain separate blue, green and red latent image records in an integral tripack. Now we shall consider how the colour developer oxidation products evolved in an emulsion layer are arranged to react with a colour former to yield the appropriate image dye. As the colour-developing agents are mobile in solution and diffuse rapidly through the swollen emulsion, we shall be concerned especially with the location of colour formers in *chromogenic*, or *colour-forming*, development.

Location of colour formers

It is required that the records of blue, green and red light shall be composed of yellow, magenta and cyan dyes respectively. This distribution of dyes is achieved by presenting colour formers to developer oxidation products in a selective manner, e.g. the oxidation products of development in the blue-recording emulsion are allowed to react only with a yellow-forming coupler. This coupler may be in solution in the colour developer, or it may be introduced into the emulsion during manufacture of the film.

Developer-soluble couplers can only be used when a single dye is to be formed in a colour development stage. Three colour developers are needed for a tripack and only one emulsion must be rendered developable before each colour development, if separation of the colour records is to be achieved. These conditions can be satisfied only in certain reversal processes of the Kodachrome type.

Couplers incorporated in the emulsions are used to form all image dyes in one colour development step. In this case only the appropriate dye-forming couplers may be permitted in an emulsion layer, if separation of the colour records is to be adequate. The colour formers therefore have to be immobilized to prevent diffusion of the couplers from layer to layer during manufacture, or later, and specially formulated interlayers are incorporated to prevent migration of oxidized colour-developing agent from layer to layer.

Two main methods of immobilizing couplers have been used. The method originally adopted by Agfa is to link the otherwise mobile coupler to a long, chemically inert chain. This chain interacts with gelatin in such a way that the molecule is effectively anchored in the layer. Such a coupler is described as being *substantive* to gelatin. Processes employing this type of immobilized coupler are often referred to as *substantive processes*. Those employing developer-soluble couplers are termed *non-substantive processes*.

A second immobilizing method is due to Eastman Kodak and employs shorter chemically inert chains linked to the otherwise mobile coupler. The inert chains are selected for oil solubility and render the entire molecule soluble only in oily solvents. A solution of such a coupler is made in an oily solvent and that solution dispersed as minute droplets in the emulsion, before coating. The coupler is very insoluble in water and the oily droplets are immobile in gelatin, so that the coupler is unable to diffuse out of the emulsion layer in which it is coated. Processes of the *oil-dispersed coupler* type are also sometimes loosely called 'substantive processes', although the couplers are not themselves anchored to the gelatin. The blanket term *coupler incorporated* may be applied to both *substantive* and *oil-dispersed* systems.

COLOUR PROCESSING

We have already encountered a number of chemical steps which are used in colour processing. Before examining the applications of such steps, we will summarize the functions of processing solutions commonly encountered in colour processes (Table 22.2).

The major differences between the processing of conventional black-and-white and of colour tripack films arise because of the need in the latter case to generate precisely the required amounts of the image dyes in all three layers (Figure 22.13). If this is not achieved,

Table 22.2 The primary functions of solutions commonly used in colour processes

SOLUTION	FUNCTION
Black-and-white developer	Develops a metallic silver image
Pre-bleach	Hardens the gelatin before entering the bleach
Bleach	Bleaches the silver image, usually by oxidation and rehalogenation to silver halide
Bleach—fix	Bleaches the silver image and fixes the silver salts formed. Leaves only the dye image required
Colour developer	Develops dye images together with metallic silver
Fix	Dissolves silver halide present after development and/or bleaching
Fogging bath	Replaces fogging exposure in modern reversal processes
Hardener	Hardens gelatin to resist damage in later processing stages
Stabilizer	Improves the stability of dye images, may also contain wetting agent and hardener
Stop-fix	Stops development as well as removing silver halide

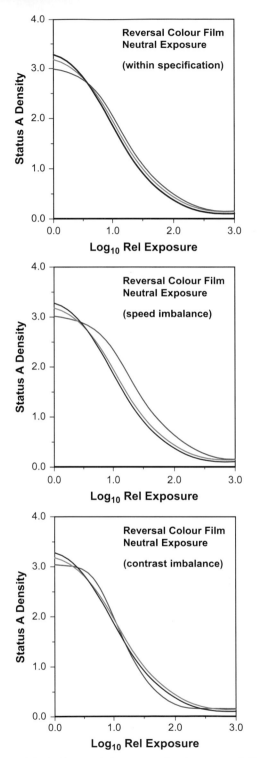

Figure 22.13 Characteristic curves of colour reversal films: within specification, with poor speed balance and with poor contrast balance.

objectionable colour effects can occur: they may be largely independent of density level, resulting in a uniform colour cast over most of the tone scale, or density dependent, showing a change in colour balance with density level. The former case corresponds to a speed imbalance of the three layers while the latter corresponds to a contrast mismatch, both cases also being illustrated in Figure 22.13.

The processing conditions under which a colour film will give correct values of speed and contrast for all the emulsion layers are very limited and are generally specified closely by the film manufacturer. The specifications usually include processing times and temperatures, as well as the method and timing of agitation in processing solutions. In addition, such factors as rate of flow of wash water may also be specified. It is important to realize that any departure from the exact processing specifications laid down by the film manufacturer is likely to lead to a lower-quality result. Where manufacturers suggest process variations in order to modify a property (speed, for instance), there is often a penalty in terms of some other property such as graininess or colour reproduction. We will now consider how solutions of the types shown in Table 22.2 are used in colour processes, starting with colour reversal processing.

Reversal process

Non-substantive

As already described, there are two main types of chromogenic colour reversal process, the developer–soluble coupler type and the type with couplers incorporated in the emulsions. The Kodachrome process is of the former (*non-substantive*) type, the couplers being present in the three separate colour developer solutions. This process is handled in very large laboratories (of which only one remains, in North America, at the time of writing), cannot be undertaken anywhere else, and lies outside the scope of this text. It has a following among photographers, to whom it yields a very high image quality.

Coupler-incorporated films

Reversal films incorporating couplers in the emulsion are simpler to process, and this may be carried out by the user, although the complexity is such that laboratory processing is more common. Such a reversal process is shown in Table 22.3, and commences with black-and-white development. After the first development the film is fogged with white light before colour development, or chemically before (or in) the colour developer. The fogged silver halide grains are colour-developed to yield positive dye images, together with metallic silver. The appropriate dye colours are ensured by the location of the yellow-forming coupler only within the blue-recording layer, the magenta-forming coupler only within the green-recording layer, and the cyan-forming coupler only within the red-recording layer.

Table 22.3 A process for coupler-incorporated colour reversal film

		TEMPERATURE (°C)	TIME (MIN)	PROCESSING STEP
1	Black-and-white developer	38 ± 0.3	6–7	6–7
2	Running water wash	38 ± 1.0	2	8–9
3	Reversal bath	38 ± 1.0	2	10–11
4	Colour developer	38 ± 1.0	4	14–15
5	Pre-bleach	35–40	2	16–17
6	Bleach	35–40	6	22–23
7	Fix(er)	35–40	4	26–27
8	Running water wash	35–40	4	30–31
9	Rinse	Ambient	1.0	31–32
10	Dry	20–60		

Steps 1–3 take place in total darkness, the remaining steps in normal room light. Recommendations for timings may vary according to the type of processing equipment employed.

Bleaching and fixing are then carried out in order to leave only the image dyes in the gelatin layers.

An advantage of the substantive reversal process lies in the ability to modify it to change the effective emulsion speed, usually with some loss of image quality. It is possible to make a limited correction for non-standard exposure by adjusting the first development time. Manufacturers usually publish such information in their data sheets or processing guides. Modifications to effective speed of more than ± one stop may visibly reduce image quality. Such manipulations of first development usually do involve the sacrifice of some quality and should be used only as an emergency measure, unless the known sacrifice is tolerable.

Negative–positive process

The negative–positive process is analogous to the conventional black-and-white process in that a negative record is made by camera exposure followed by processing. This record is not generally intended for viewing but is used to produce a usable positive by contact or projection printing on a colour print material. Since information about the blue, green and red light content of the camera image is to be available at the printing stage the blue-, green- and red-sensitive layers of the colour negative film generate yellow, magenta and cyan image dyes respectively. Metallic silver is, of course, generated at the same time, and is removed by subsequent bleaching and fixing operations. The remaining dye images form the colour negative record, the colours formed being complementary to those of the subject. The production of a colour negative record is illustrated in Figure 22.14. If integral masking is employed in the colour negative, then low-contrast positive masks are formed in the negative film at the development stage, if coloured couplers are used.

The colour negative is then the subject of the printing stage. In principle, the negative is printed on to a second integral tripack which is processed in similar fashion to a colour negative. The production of a positive print is also shown, in Figure 22.14, as the preparation of a reproduction of the subject. Certain differences of construction are shown in the positive.

Printing papers employ red- and green-sensitive emulsions whose natural blue sensitivity is very low and largely confined to wavelengths shorter than about 420 nm, a region normally filtered out in colour printing. Consequently no yellow filter layer is usually required to suppress unwanted blue sensitivity and the layer order can be selected on the basis of other criteria. It is found to be advantageous to form the image that is the most critical in determining print sharpness in the topmost layer. In most cases the cyan and magenta images are crucial for sharpness and the red-sensitive emulsion is coated uppermost, so that the red image is least affected by emulsion turbidity at exposure.

Colour print materials have characteristic curves similar to those of black-and-white print materials, as the tone reproduction requirements are quite similar. Thus, the colour negative film may have characteristic curves similar to those shown in Figure 22.15. Curves for a typical printing paper and a motion-picture release positive film are also shown. The negative illustrated is masked giving an

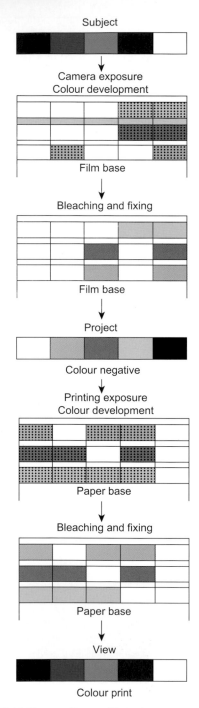

Figure 22.14 The negative–positive colour process.

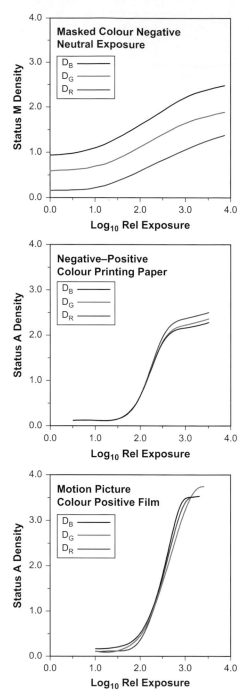

Figure 22.15 Neutral characteristics of negative–positive colour materials.

overall colour cast, and this results in vertical displacements of the blue and green density curves, compared with the red curve. Colour masks rarely possess significant red absorption.

The higher blue and green densities of colour negatives are compensated for by manufacturing colour print materials with blue and green sensitivities correspondingly higher than the red sensitivity. The printing operation

Table 22.4 A process for colour negative film

	STEP	TEMP. (°C)	TIME (MIN)	TOTAL TIME (MIN)
1	Developer	37.8 ± 0.15	3¼	3¼
2	Bleach	24–41	6½	9¾
3	Wash in running water	24–41	3¼	13
4	Fixer	24–41	6½	19½
5	Wash in running water	24–41	3¼	22¾
6	Stabilizer	24–41	1½	24¼
7	Dry	24–43	10–20	

Steps 1 and 2 of the colour negative film process take place in the dark, the remainder in the light. Agitation procedures suitable for the process are specified in instructions packed with the processing chemicals. Unlike the reversal processes, recommendations are not normally made for modification of development time to compensate for exposure errors.

Table 22.5 A process for negative colour papers

	STEP	TEMP. (°C)	TIME (SECONDS)	TOTAL TIME (MIN)
1	Developer	35.0	45	¾
2	Bleach–fix	35 ± 3.0	45	1½
3	Wash in running water	30–40	90	3
4	Dry	Not above 96	–	–

Steps 1 and 2 take place in the dark or specified safe lighting, the remaining steps in normal room light.

allows manipulation of the overall colour of the reproduction by modification of the quantities of blue, green and red light allowed to reach the print material from the negative. This may be achieved by separate additive exposures through blue, green and red filters (*tricolour printing*) or by making a single exposure through appropriate dilute subtractive filters, yellow, magenta or cyan (*white-light printing*). Thus, as control of colour balance is easy to achieve, it is not so important in negative and print materials to possess standard speed balances as it is in reversal materials. Little or no colour correction of a reversal transparency is usually possible after the taking stage, whereas in the negative–positive process, adjustment of colour balance at the printing stage is a common procedure. Modern materials are, however, so consistent that only minor printing adjustments are usually necessary to accommodate, for example, batch changes of photographic products.

Colour paper processes normally require only two or three solutions together with the necessary washes. The process is quick and simple, using a bleach–fix, or *blix*, solution and operating at a comparatively high temperature. Typical colour negative and colour paper processes are shown in Tables 22.4 and 22.5.

Prints from transparencies

The processes considered so far have relied on the formation of image dyes by colour development within the emulsions. There are, however, alternative approaches: one of these is to destroy dyes introduced into the emulsions at manufacture. In such processes the red exposure is arranged to lead to the destruction of a cyan dye, the green exposure leads to the destruction of a magenta dye, and blue exposure leads to the destruction of a yellow dye. Such photographic processes possess too low a sensitivity for other than specialized applications. They are, however, suitable for the production of colour prints from colour slides.

Commercial processes of this type have used the silver photographic image to bring about the chemical decomposition of dyes already coated in the emulsion layers. A current process that uses this mechanism is *Ilfochrome*, a process for the production of positive prints from positive transparencies. In systems of this type, the print material is an integral tripack: the uppermost, blue-sensitive emulsion contains a yellow dye, the green-sensitive layer contains a magenta dye, and the red-sensitive layer contains a cyan

405

dye. The *basic* construction is shown in Figure 22.16. Because the dyes present in the emulsions have high optical densities, together with emulsion desensitization by some of the dyes, it is necessary to use high-speed emulsions in order to achieve acceptably short printing exposures.

The processing of one modern silver−dye−bleach material follows the scheme shown in Table 22.6, illustrated diagrammatically in Figure 22.17. The initial step is black-and-white development of silver halide crystals rendered developable by the printing exposure. The silver image is then used, in a bleaching stage, to reduce the dyes present in the emulsions.

This reaction may be summarized:

$$Dye + Acid + Metallic\ silver \rightarrow Reduced\ dye\ fragments$$
$$+ Silver\ salts$$

It is arranged that the fragments resulting from the reduction of the dyes are colourless and/or soluble. Thus, in the silver−dye−bleach bath we have an image-wise reduction of the dyes by metallic silver, and corresponding oxidation of the silver. The reaction is extremely slow (owing mostly to the immobility of the reacting species), and a catalyst is necessary to obtain a satisfactory rate of bleaching. The catalyst has usually been incorporated in the silver−dye−bleach. It may, however, be carried over from solution in the black-and-white developer, within the emulsion layers.

Following the silver−dye−bleach, unwanted silver salts are removed in a fixing bath. In the process listed in Table 22.6 two fixing baths appear and there are two cascade washes which follow the fixing stage. The final result is the positive dye record retained within the gelatin, as shown in Figure 22.17.

Major advantages claimed for the silver−dye−bleach process follow from the freedom to use compounds classed as *azo dyes*. These possess better spectral properties than the dyes formed by chromogenic development, are markedly less fugitive to light and largely stable when stored in the dark. The better spectral properties improve the saturation and lightness of image colours, while the improved light-fastness gives a much greater life for displayed prints

Supercoat
Blue-sensitive emulsion + yellow dye
Yellow filter layer
Green-sensitive emulsion + magenta dye
Red-sensitive emulsion + cyan dye

Reflecting base

Figure 22.16 Cross-section of an elementary silver−dye−bleach material.

	Table 22.6 A silver−dye−bleach process for prints from transparencies			
	STEP	**TEMP. (°C)**	**TIME (SECONDS)**	**TOTAL TIME (SECONDS)**
1	Developer	36 ± 0.5	75	75
2	Wash 1	34 ± 2	22	97
3	Bleach	39 ± 1.0	75	172
4	Wash 2	36 ± 3	22	194
5	Fixer 1	36 ± 2	75	269
6	Fixer 2	36 ± 2	75	344
7	Wash 3	28−34	75	419
8	Wash 4	28−34	75	494
9	Drying	50 ± 10		
	Steps 1 and 2 take place in darkness, the remainder can be in normal lighting.			

Figure 22.17 The silver—dye—bleach process.

the sensitivity of the layer. There is no need for an interlayer between the two component emulsion layers, as the silver image in the fast emulsion is required to bleach the dye in the adjacent slow emulsion. This structure has been found to lead to a number of advantages in terms of emulsion speed, lower contrast and improved image sharpness.

In addition, silver—dye—bleach materials have been *colour masked* in various ways. Clearly, silver—dye—bleach print materials, whether viewed by transmission or reflection, cannot be masked in a similar way to colour negatives: whites have to be as light and neutral as possible. On the other hand, some form of inter-image effect can be used without adding to the minimum density and this, in essence, is what has been done in silver—dye—bleach materials.

In one such masking system the filter layer contains colloidal silver, i.e. very finely divided silver particles which are yellow in hue, and is an active player in promoting a favourable inter-image effect. The material is so formulated that, in correct processing conditions, *physical* development takes place *in the filter layer*, due to the presence of the colloidal silver, but *not* in the vicinity of images developed in the green- or red-sensitive emulsions. The physically developed silver is bleached by the silver—dye—bleach and this gives rise to bleaching of the adjacent yellow image dye in the blue-sensitive layer. Hence, wherever there is a significant amount of magenta or cyan dye in the image, there will be a corresponding reduction in the amount of yellow dye present. The yellow dye image will be at a maximum where there is no magenta or cyan present. The similarity between this and the colour masking of a negative film gives rise to 'masking' being used to describe the mechanism. A substantial degree of colour correction can be achieved, but without an increase in minimum density.

and the dark stability gives excellent archival properties. A further advantage is that the presence of the image dyes at exposure results in a decreased path length of light scattered within the emulsions. This improves the sharpness of the image to such an extent that it is higher than for any comparable chromogenic reflection print material. The sharpness is also improved by the use of low silver halide coating weights, made possible by the very high spectral absorptions of the azo dyes. Very little dye is therefore present to be bleached, and thus very little developed silver is required.

The basic structure, shown in Figure 22.16, for silver—dye—bleach materials has been improved over time. Each emulsion layer may now be a double-coated assembly comprising a fast component containing little or no image dye and a slow component which contains all the necessary image dye complementary in hue to

ENHANCEMENT OF COLOUR REPRODUCTION

Two methods of compensating for unwanted spectral absorptions of developed image dyes have been mentioned in this chapter: colour masking in negative—positive systems and the use of inter-image effects. The latter are employed in both negative-working systems and, because no coloured mask is involved, in reversal colour films and print materials. The advantages that accrue from the use of these methods are summarized in Table 22.7, as applied to the final image in a grey-balanced system (giving a neutral reproduction of a greyscale, at all density levels, by having identical contrasts in all three colour records and ensuring correct colour balance with the exposing illuminant).

Table 22.7 The effects of colour masking

IMAGE	EFFECTIVE CHANGE IN UNWANTED ABSORPTION			OBSERVED CHANGE IN COLOUR IMAGE					
Dye	D_R	D_G	D_B	Red	Green	Blue	Cyan	Magenta	Yellow
Cyan		↓		More red	Lighter	No effect	More green	More vivid	No effect
Cyan			↓	More orange	No effect	Lighter	Bluer	No effect	More saturated
Cyan		↓	↓	More saturated	Lighter	Lighter	Lighter, more saturated	More saturated	More saturated
Magenta			↓	No effect	Yellower	Lighter	No effect	Bluer	More saturated

COLORIMETRY OF PHOTOGRAPHIC IMAGES

The images formed using dye-forming or, indeed, dye destruction colour photographic systems may usefully be examined using colorimetric as well as sensitometric methods. By plotting the chromaticity coordinates of image dyes at a range of densities, from D_{min} to D_{max}, the range of available colours can be illustrated in a chromaticity diagram (see Chapter 5). The envelope of this range of colours is called the *colour gamut* of the process examined and is illustrated, for a reversal colour film, in Figure 22.18.

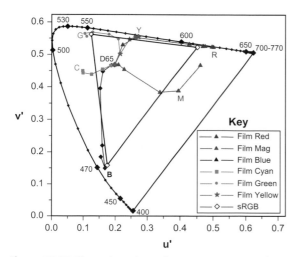

Figure 22.18 Film and monitor colour gamuts compared.

The measured samples were prepared by colour sensitometry and extend over a wide exposure range from under- to overexposure.

It will be seen that the images vary considerably over the exposure series examined in Figure 22.18. At zero density the reproductions lie close to the white point, D65, when viewed with that illuminant. As image densities increase, the purity of the record also increases — in some cases approaching 100% at the spectral locus. Yellow and red reproductions are good examples. With overexposed red subjects (see Figure 22.10) the recording is clearly quite yellow, and runs through orange to red at lesser exposures. Some variation of hue with image density can be seen for each reproduced colour.

Also shown in the figure are the colour emissions of displays operating according to sRGB specifications (see Chapter 23). The sRGB gamut is represented by the triangle linking phosphors positions in the CIE u', v' chromaticity diagram. If single red, green or blue pixel values lie between 1 and 255, the lightness alone changes and the chromaticity coordinates remain constant at the points shown. The addition of equal amounts of the other two primaries results in linear loci, from the points shown, to the white point of the sRGB reference display, at which all three pixel values lie at, or close to, 255. The subtractive hues, cyan, magenta and yellow, are synthesized on the monitor by combining pairs of the additive primary emissions: blue + green yielding *cyan*, green + red giving *yellow*, and red + blue forming *magenta*. It will be observed that, perhaps surprisingly, the dye image gamut is bigger than that of the reference sRGB display. In perceptual terms, however, this seeming advantage is, at least to some extent, counterbalanced by maximum purity reproductions on monitors being relatively lighter than those of

reversal film. This extra lightness advantage may give the appearance of greater saturation.

On the other hand, the sRGB reference viewing conditions include illumination of the monitor by ambient lighting, which inevitably involves some loss of colour saturation. Reversal film transparencies and motion-picture release prints of high density scales are customarily projected in conditions of very low ambient illumination, and hence substantially preserve the colour saturation, although the dark surround lowers the perceived contrast (see Chapter 21). Thus, reversal film, in correct viewing conditions, is capable of yielding the greater colour gamut. Even at the optimum, approximately 30% of the CIE u', v' diagram cannot be accurately reproduced. It is, however, true that most commonly encountered colours lie within the gamuts of both systems and are acceptably reproduced — a major technological triumph in each case.

BIBLIOGRAPHY

Eggleston, J., 1984. Sensitometry for Photographers. Focal Press, London, UK.

Evans, R.M., Hanson, W.T., Brewer, W.L., 1953. Principles of Colour Photography. Wiley, New York, USA.

Hunt, R.W.G., 2001. The Reproduction of Colour, sixth ed. Wiley, New York, USA.

Langford, M., Bilissi, E., 2008. Langford's Advanced Photography, seventh ed. Focal Press, Oxford, UK.

Proudfoot, C.N., 1997. Handbook of Photographic Science and Engineering, second ed. IS&T, Springfield, VA, USA.

Walls, H.J., Attridge, G.G., 1977. Basic Photo Science. Focal Press, London, UK.

Chapter | 23 |

Digital colour reproduction

Sophie Triantaphillidou

All images © Sophie Triantaphillidou unless indicated.

INTRODUCTION

There are numerous books and references entirely dedicated to digital colour imaging and reproduction; it is impossible to encompass all aspects of the subject in only one chapter. Relevant information on the subject of colour has been provided in various sections of the book up until this stage. Chapter 3 discusses light sources, Chapter 4 introduces basic colour vision and Chapter 5 is dedicated to an introduction to colour science. The latter chapter discusses colour terminology, models of colour vision, the basics of colorimetry and colour appearance modelling, as well as the objectives of colour reproduction and instruments used for colour measurement. Also, sections of Chapters 9, 14, 15 and 16 discuss how colour is formed in various imaging media, whilst Chapter 22 is dedicated to photographic colour reproduction. Later, in Chapter 25 we discuss how colour is communicated in various digital image workflows and in Chapter 26 how colour can be managed using International Color Consortium (ICC)-based colour management systems (CMS).

The reproduction of colour in digital imaging systems is a complex operation. Its understanding relies on knowledge of the underlying principles of physical and psychophysical phenomena related to colour perception, and colour measurement and definition, as well as knowledge of the physical principles, capabilities and limitations of image recording, storage, transmission and output systems.

Let's consider a 'colour scene' as a spatially varying spectral distribution. When the scene is imaged by a still digital acquisition device, the resulting digital colour image is made out of spatially and spectrally sampled distributions that have been integrated *over a number of spectral bands* and over a time interval. Each digitized spectrally weighted integral corresponds to a colour channel in the digital image:

$$f(i, j, t, \lambda) \rightarrow f'_n(x, y) \qquad (23.1)$$

where f is the spectral distribution of the two-dimensional focused plane in the scene, at a spatial location (i, j) and time interval t, and λ is the wavelength; f'_n is the encoded intensity of the nth channel in the image at the corresponding discrete location (x, y). The number of spectral bands over which the scene is integrated corresponds to the number of colour channels[†] and thus the same number of encoded intensities (i.e. pixel values) are used to describe the colour at the image location x, y.

The reproduction of the digital image from an output imaging device is essentially the physical rendering of the encoded intensities to produce a 'colour image'. The encoded image is thus converted back to a spatially varying spectral distribution: a spectral radiance/luminance distribution in a displayed image, or spectral reflectance distribution in a printed image.

The encoded image intensities represent the colour coordinates of the image in the colour space (see Chapter 5) in which it is colour encoded. The early sections in this chapter are concerned with the definition and specification of digital colour spaces and will introduce different colour space encodings that have been proposed, or standardized by various standards organizations in order to communicate digital colour images in a consistent and unambiguous manner. Transformation of an image from

[†] The number of spectral bands used to integrate the spatially varying spectral distributions in the scene may originally be more than the number of the colour channels in the digitally encoded image.

DOI: 10.1016/B978-0-240-52037-7.10023-7

one space and encoding to another requires knowledge of the colour space characteristics — for example, the colour space primaries, white point, transfer function — as well as the specification of the encoding method and range. If the colour space is device dependent (i.e. defined by the characteristics of a specific imaging device), then the characterization of the device is necessary to reveal such characteristics — that is, to relate the device-dependent colour coordinates to CIE colour space coordinates and to further achieve such a transformation. Therefore, several sections of the chapter will discuss device characterization of capturing, display and printing imaging systems.

The range of colours capable of being reproduced by a particular device and/or medium, or encompassed by a particular colour space, or occupied by a particular scene or image, is referred to as the colour gamut of the device, space, scene or image. Colour gamuts vary between systems and media and are strongly influenced by the viewing conditions, i.e. illumination, surround and background. For example, the appearance of some bright colours displayed on a computer monitor in a dark environment cannot be replicated in a printed magazine viewed in a typically dimly lit room in a home, because the gamuts of the media under these viewing conditions are very different. Such gamut mismatches are very common and unavoidable in image workflows. They are dealt with using gamut mapping techniques, which alter the original image colour coordinates to ones that a given medium can reproduce. The last sections of the chapter will introduce the principles behind some common gamut mapping techniques.

COLOUR SPACE AND COLOUR ENCODING

In Chapter 5 we defined *colour space* as an *n*-dimensional geometrical model, where colours are specified by their *vector coordinates* (i.e. colour coordinates). These coordinates describe the position of the colour within the specific colour space only (see Figure 5.12). According to the CIE, three dimensions are enough to describe colour; thus most colour spaces are three-dimensional. Examples of colour spaces include the CIEXYZ, CIELAB and CIELUV spaces, and continuous (i.e. not quantized) RGB spaces with a particular set of red, green and blue additive primaries. In digital imaging applications, the specification of a colour space provides information about its geometrical representation, i.e. the 'volume' and 'shape' of the space. However, it does not specify how the digital colour coordinates (pixel values) can be interpreted. For this reason, the colour spaces need to be encoded.

Colour space encoding is the digital encoding of a colour space. Specification of the colour space encoding includes information about the *digital encoding method* and the *encoding range* that the space covers. The digital encoding method specifies the relationship between continuous colour space values and the corresponding encoded (digital pixel) values. In most cases the digital encoded values are linearly related to the continuous colour space coordinates and are integer values — although non-linear encoding and/or floating-point digital encoding methods are used in some applications. The encoding range is essentially the range of digital code values that are available and relates directly to the bit-depth characteristics. Therefore for 8-bit encoding the encoding range is 0−255, for 12-bit encoding it is 0−4095 and for 16-bit encoding it is 0−65,535. It is important to note that multiple encodings for a single colour space may be defined. A particular additive RGB colour space, such as the sRGB colour space, which will be discussed later in the chapter, may have different colour space encodings — for example, 8-bit sRGB and 10-bit extended sRGB (e-sRGB).

Finally, a *colour image encoding* is the encoding of the colour values for a digital image. This includes the specification of a colour space encoding, i.e. the colour space and colour space encoding in which the image is represented, together with any further information to interpret the pixel values, such as the reference image viewing environment and reference imaging medium. Multiple colour image encodings can be related to one colour space encoding. According to the related standard ISO 22028-1:2004 *'it is important that the colour is specified by a complete colour image encoding, rather than simply defining a colour space encoding'*. The standard specifies what should be included in a colour image encoding definition in order to achieve unambiguous colour image representation. Readers should refer to it for further information.

In the following sections we will discuss the various types of digital colour spaces, introducing the characteristics of some colour spaces and colour space encodings that have been standardized from various organizations (i.e. *standard colour spaces*) to help the communication of colour information through imaging chains.

CLASSIFICATION OF COLOUR SPACES

There are a variety of colour spaces used in digital imaging, as different spaces are suitable for different applications. Figure 23.1 illustrates an example of an imaging chain, where various imaging components are related to different colour spaces. There are several ways of classifying them.

The *first classification* is concerned with the intrinsic nature of the colour space; specifically whether the colour space is based on *additive* or *subtractive* mixtures of its related primaries, or is derived from an additive or a subtractive colour space. According to this classification we can group colour spaces as follows.

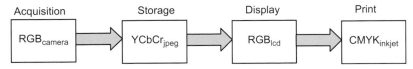

Figure 23.1 A typical imaging chain and related colour spaces.

RGB (red, green, blue)

These are additive-based spaces and relate directly to the trichromatic theory, i.e. the mixing of three primaries to obtain all possible colours (see Chapter 5). RGB spaces are very common since they are used by digital capturing devices, such as digital cameras and scanners, and soft displays, such as cathode ray tube (CRT) displays and liquid crystal displays (LCDs). The RGB primaries of such spaces are based on a real or hypothetical input or output device. RGB colour spaces are non-linearly related to visual perception (non-uniform), which means that equal steps within the colour space are not perceived as equal by the human visual system (HVS).

CMY(K) (cyan, magenta, yellow, black)

These are subtractive-based colour spaces; they are mainly used in printing and hard-copy output. They use three subtractive primaries, CMY (dyes at full saturation), to create all possible colours by absorbing (subtracting) various wavelengths. The fourth, black, component is included to improve the density range and thus image contrast, as well as the available colour gamut (see Chapter 16). The transformation between CMY(K) and RGB colour values is very complex. It is most often performed via an intermediate space, i.e. a CIE colour space (see later in the chapter). CMY(K) spaces are also non-linearly related to visual perception.

HSL (hue, saturation, lightness) — and similar

There are various colour spaces falling into this category, such as HSL (L standing for lightness), HSI (I standing for intensity) and HSV (V standing for value), and others. Most of these are linear transformations from RGB spaces and thus they are non-linear with respect to human vision. They are mainly used in computer graphics and image-processing applications because of one main advantage: they separate the three perceptual attributes of colour, i.e. hue, saturation and lightness (see Chapter 5), so that each one can potentially be treated individually.

YCC (luminance, chrominance 1, chrominance 2) — and similar

There are various colour spaces falling into this category, such as: Photo YCC, used in the (now obsolete) Kodak

PhotoCD file format (see Chapter 17); YC_bC_r, which is a digital standard used in the JPEG compression schemes; and YIQ and YUV, which are analogue-based spaces for NTSC and PAL TV respectively. They are linear transformations of RGB spaces and non-linear with human vision. Such spaces separate the luminance (Y) from the chrominance (C_1, C_2) components and are widely used in image transmission where compression is important, i.e. they allow the compression of the luminance channel to be treated separately from that of the chrominance channels. The chrominance channels are usually more compressed since this is more tolerated by the HVS than compression of the luminance channel (see Chapter 5).

CIE colour spaces

In Chapter 5 we introduced the CIEXYZ system, which in this context can be considered as a colour space. It is linearly related to a specific set of RGB primaries and is based on the 'standard colorimetric observer'. The CIEXYZ space is non-linear but defines colours by a set of coordinates that are meaningful to the HVS.

Two other CIE colorimetric spaces, CIELAB and CIELUV, are used in colour imaging, with CIELAB being the more commonly used by far. Both spaces are non-linear transformations of the CIEXYZ system and they are nearly linear with human perception. The latter feature is an asset, as their coordinates describe colour in a perceptual manner — provided the white point is known.

Finally, CIE colour appearance spaces, such as CIECAM97 and CIECAM02, specify colour using appearance coordinates (see Chapter 5). Colour image values for lightness, chroma and hue, for example (J, c and h respectively), are directly related to the visual appearance of the image. They are derived from colorimetric spaces but take into account additional parameters relating to the viewing environment such as surround and background illumination.

CIE colour spaces are not used by any digital imaging device, but as intermediate spaces connecting digital colour spaces which are *device dependent* (see below). They are also used for the definition of image coordinates in a device-independent, visually meaningful manner. They are used in colour management workflows (see Chapter 26, ICC colour management architecture) as *device connection spaces* (DCSs).

The *second classification* is concerned with whether the colour space is related to CIE specifications. According to this classification, digital colour spaces can be grouped as follows.

413

Colorimetric colour spaces

There is a specified relationship between colour space coordinates of these spaces and respective CIE colorimetric values and thus they are considered *device independent*. A known transformation allows conversion of device colour coordinates to and from a colorimetric CIE space. Standard CIE colorimetric colour spaces, such as CIEXYZ or CIELAB, fall into this category. Colour spaces other than the CIE spaces can also be classified as colorimetric, such as additive RGB or luminance—chrominance colour spaces, provided that their relationship with CIE colorimetry is specified. The information needed to define a colorimetric space is:

- CIE colour spaces:
 - name of colour space (e.g. CIEXYZ);
 - white point (e.g. D65).
- RGB colour spaces:
 - chromaticities of the RGB primaries;
 - white point;
 - transfer functions (e.g. gamma function — see Chapter 21).
- Luminance—chroma colour spaces:
 - relevant information about the additive colour space from which they are derived;
 - transformation matrix that relates YC_1C_2 to RGB coordinates.

Colour appearance spaces

As mentioned earlier, CIE colour appearance spaces specify colour using appearance coordinates, again in a device-independent manner. The definition of a colour appearance space includes the specification of the particular colour appearance model upon which the colour space is based, together with the colour coordinates of the image data.

Device dependent colour spaces

Most imaging devices produce colour in a device-dependent manner, since their output is related to the individual primaries of the device (see Chapters 14—16), as well as other device-specific parameters. Device-dependent colour spaces are therefore linked to the characteristics of a real, or an idealized, imaging device and have no defined relationship with CIE colorimetry. This means that the transformation between space colour coordinates and a CIE space is not specified. Some device-dependent colour spaces can be *characterized*, i.e. measurements may be used to define (or characterize) their relationship to CIE colorimetry. In such cases, they can be considered as *colorimetric colour spaces*.

There are two main classes of device-dependent colour spaces. *Input (or sensor) device-dependent colour spaces* are device-specific RGB colour spaces attached to the capturing device and capturing conditions. They can be specified by:

- spectral sensitivity of the camera/scanner (see later);
- transfer function;
- scene/original illumination.

Output device-dependent colour spaces are linked to a particular output device, a display or a printer. Display device-dependent RGB spaces are specified by:

- chromaticity of the RGB primaries;
- white point;
- transfer functions (e.g. gamma function — see Chapter 21).

Printer device-dependent colour spaces, such as a printer CMY(K), are specified by the relationship between the input encoded values and the corresponding output colour values.

IMAGE STATE

This section explains the *image state* in the context of particular digital imaging workflows. It indicates the colour image encoding (in a particular encoded colour space) within the workflow, and provides information about the rendering state of the image data. Figure 23.2 illustrates a generic diagram showing the relationship between different colour encodings.

As indicated in Figure 23.2, the image data can be represented in *sensor*, *scene-referred*, *original-referred* and *output-referred* colour encodings. The latter two states are also referred to as *image-referred* encodings.

Sensor colour encoding

When a scene (or an image) is captured by a digital camera (or scanner), the first image state is a sensor state, which is device dependent. That means that it is encoded to RGB device-specific coordinates which, as mentioned above, depend on the sensor characteristics (spectral sensitivities, transfer characteristics) and illumination. When images are archived, or progress though the imaging workflow in sensor colour encoding, the image data has no connection with the original scene colour representation, unless the capturing system is characterized so that sensor characteristics and illumination are known. There is no standardized RGB sensor encoding colour space, and it is unlikely that there will be one, since different manufacturers employ their proprietary filters and thus the sensor sensitivities differ. Also, with digital cameras, the illumination is scene dependent.

Scene-referred colour encoding

The image data originating from a scene capture can pass from a sensor colour encoding to a *scene-referred colour*

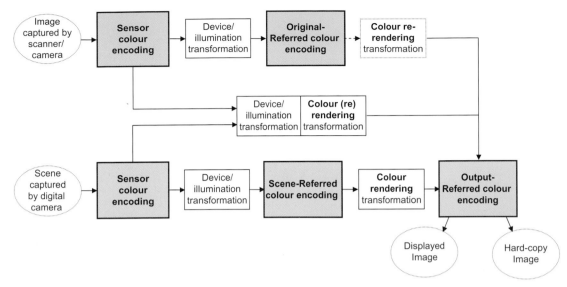

Figure 23.2 Image state flowchart showing relationships between various types of colour encodings.

encoding by employing a transformation that takes into account the sensor characterization, white balancing and exposure adjustments, i.e. it is device and/or image specific. Scene-referred colour encodings are representations of the estimated colorimetric coordinates of the objects in the original scene. The coordinates may be represented in many different ways, for example as encoded scene colour values in a CIE space or in terms of the response of an idealized capturing device having a specified relationship with a CIE space. An example of the latter is the standard RIMM RGB (see later on). Note that the image colorimetry of the scene-referred image data may contain some inaccuracies due to dynamic range limitations of the capturing device, noise, quantization and other sources of error, and also due to modifications employed on purpose to 'alter the scene' colorimetry (for example, simulating different scene lighting).

Scene-referred image data is not readily rendered by an output device and this is why the scene-referred colour space encodings are referred to as *unrendered*. The advantage of storing image data in such encodings is that data can potentially be rendered for any output device in a meaningful way, especially when it is encoded in high bit depths. Such encodings are used for archiving and transformation purposes.

Output-referred colour encoding

A colour rendering transformation, including tone mapping and gamut mapping based upon a rendering intent (see Chapter 26), is required to transform scene-referred image data to an *output-referred encoding*. Output

referred colour encodings are linked to a particular real, or virtual, output device and viewing conditions. Output-referred image data may be represented by a colour encoding derived from CIE colorimetry and produce the intended colour appearance when viewed in the reference viewing environment. Examples of ways that output-referred image data may be represented include encoding colour values using a CIE colorimetric space (in which case they are unrendered) or a standard rendered colour space encoding derived from CIE colorimetry (e.g. sRGB or ROMM RGB – see later), or by characterized device-dependent control signals for a particular soft-copy (RGB) or hard-copy output device (CMYK).

It is important to note that output-referred image data can be obtained directly by a transformation from sensor data, without passing via a scene-referred colour encoding, as illustrated in Figure 23.2. In such cases images are intended for a specific output device and viewing conditions. For example, sRGB standard output-referred image data is frequently stored by digital cameras to be readily displayed in the reference sRGB conditions. In the case of printing, the printing systems will generally perform a colour re-rendering transformation to transform the sRGB colour values to those appropriate for the particular output device and assumed viewing conditions.

Original-referred colour encoding

Images encoded to original-referred colour encoding have coordinates that are representative of colour coordinates of a two-dimensional hard-copy image (photographic print, slide or artwork). Thus, the source is not a scene but an

original image. The characteristics of the original-referred encoded image data are directly related to the characteristics of the original image colorimetry, in terms of a CIE colour space such as CIEXYZ or CIELAB, an idealized measurement device such as a Status A densitometer (see Chapter 23), or in terms of device-dependent control signals for a particular capturing device (camera or scanner).

Since the encoded image represents a two-dimensional hard-copy or soft-copy image, the resulting image data should be treated as original-referred image data rather than scene-referred image data. In this case, it is usually unnecessary to apply a colour-rendering transformation to the image data for purposes of determining output-referred image data since the original image has already been colour rendered. However, it may be desirable to apply a colour re-rendering transform to account for the differences between the media/viewing condition characteristics of the original image and the final output-referred image. As with the scene-referred colour encoding, images stored in original-referred colour encodings can be accessed for later use without needing to commit to a specific output.

STANDARD COLOUR SPACES AND COLOUR SPACE ENCODINGS

There are a number of colour space encodings which have been standardized by international organizations to facilitate the communication of images through imaging chains. Some of them are de facto rather than official standards, with their specification being available in the public domain. Standard colour space encodings have a specified relationship with CIE colorimetry (they can be transformed to/from CIE coordinates) and are based on real or idealized (hypothetical) input or output devices. The most widely known are introduced in the following sections. Figure 23.3 compares the u', v' chromaticity coordinates of their primaries, on the (nearly) uniform CIE u', v' chromaticity diagram.

sRGB (standard RGB) and sRGB-related colour space encodings

The standard RGB colour space encoding (sRGB) is an IEC standard (IEC 61966-2-1:1999). It was originally designed by HP and Microsoft as the default colour space encoding for the Internet during the mid-1990s. Since then, it has received wide adoption in the consumer imaging industry. sRGB is an output-referred colour space encoding, based on typical CRT display primaries (identical to ITU-R BT.709-3, used in High Definition (HD) TV monitors) and transfer function. The standard specifies a black digital code of 0 and a white of 255 for 24-bit (8 bits/channel) encoding. The strength of sRGB is its simplicity, the fact that it is based on a real device, and that it is inexpensive to implement and computationally efficient. It is available in most consumer digital cameras and also implemented in the majority of LCDs, which allow an sRGB setting to simulate a typical CRT output.

Table 23.1 presents the CIEXYZ chromaticities of the sRGB reference primaries and white point (D65), and Table 23.2 the sRGB reference display and reference viewing conditions. It is important to note that images encoded using sRGB colour space encoding maintain their colour appearance only under the reference display and viewing conditions.

The reference display transfer function is described by the equation below, where V'_{RGB} is the normalized digital count and V_{RGB} is the normalized output luminance (see also Chapter 21, Figure 21.11):

$$V_{RGB} = (V'_{RGB} + 0.0)^{2.2} \qquad (23.2)$$

The encoding transformation between 8-bit sRGB values and CIEXYZ involves the following steps (see

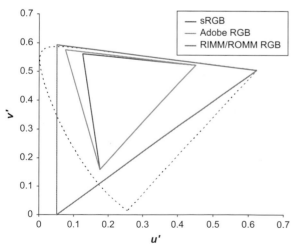

Figure 23.3 u', v' colour space representation of the family of sRGB colour spaces, the RIMM/ROMM RGB and the Adobe RGB 1998.

Table 23.1 CIE XYZ chromaticities of the sRGB primaries (ITU-R BT.709-3) and white point

	RED	GREEN	BLUE	WHITE (D65)
x	0.6400	0.3000	0.1500	0.3127
y	0.3300	0.6000	0.0600	0.3290
z	0.0300	0.1000	0.7900	0.3583

Table 23.2 sRGB reference display and viewing conditions

sRGB reference display	
Display luminance level	80 cd m^{-2}
Display white point	D65 ($x = 0.3127$, $y = 0.3290$)
Display model offset (R, G, B)	0.0
Display input/output characteristic (gamma; see Eqn 23.2)	2.2
Reference viewing conditions	
Reference background − part of the display surrounding the image	20% of the display luminance level (16 cd m^{-2}), D65
Reference surround − area surrounding the display	20% of the reference ambient level (4.1 cd m^{-2}), D50
Reference proximal field	20% of the display luminance level (16 cd m^{-2}), D65
Reference ambient illuminance level	64 lux
Reference ambient white point	D50 ($x = 0.3457$, $y = 0.3585$)
Reference veiling glare	0.2 cd m^{-2}
Reference observer	CIE 2° standard colorimetric observer

characterization of displays later in this chapter for further explanations):

1. Scaling of the sRGB pixel values to colour space values ranging from 0.0 to 1.0.
2. Linearization of the sRGB scaled values using the reference display transfer function.
3. Linear transformation from linear sRGB scaled values to CIE XYZ scaled values (ranging from 0.0 to 1.0) using the 3 × 3 sRGB matrix.

The inverse transformation is obtained by reversing steps 1−3, and using the inverse sRGB matrix (see later) for the linear transformation from CIE XYZ and linear sRGB values.

While sRGB is suitable for the needs of display and Internet colour imaging, the achievable colour gamut obtained by the sRGB primaries is rather narrow compared to the colour range of many non-CRT applications, such as digital printing and photofinishing. The native transfer characteristics of LCDs do not obey the power law and are normally incompatible with sRGB; also, some late LCDs work with a 12-bit encoded input. Further, the colour ranges produced by the sensors incorporated in modern digital cameras and scanners, i.e. sensor colour gamuts, usually exceed the sRGB gamut, and thus when sensor encoded data are colour rendered to sRGB the original gamut is reduced irreversibly. Figure 23.4 illustrates an example of a number of 'lost' colours of a typical colour test chart when sensor encoded values originating from a commercial slide scanner are transformed to sRGB.

Gamut limitations, as well as the restrictive 8-bit sRGB encoding, have led to various extensions of the sRGB encoding standard. Here is a brief summary of them:

- e-sRGB (an I3A standard, PIMA 7667:2002) is a family of output-referred colour encodings (e-sRGB10, e-sRGB12 and e-sRGB16, for 10, 12 and 16 bits per channel respectively), based on a *virtual* additive colour device with an *extended* RGB gamut. The sRGB set of primaries, transfer function and white point are used, but the standard allows for a larger colour space value range, extending from −0.53 to 1.68 (instead of 0.0 to 1.0), thus providing a gamut that is larger than the sRGB gamut, along with minimum 10 bits per channel quantization. The viewing conditions match those of sRGB. While both sRGB and e-sRGB are output referred, e-sRGB provides additional flexibility for high-quality printing compared to sRGB.
- bg-sRGB (IEC 61966-2-1, amendment 1) is similar to e-sRGB standardized by the IEC.
- scRGB (IEC 61966-2-2) is another extended gamut colour encoding based on the sRGB primaries. It is a scene-referred colour encoding, with linear transfer characteristics. Since it is scene referred, the white point luminance is based on the absolute white point luminance of the scene, i.e. it is scene dependent. The white point chromaticities correspond to D65. The digital code values are based on 16 bits per channel encoding. A non-linear version, the scRGB-nl, is also described in the same standard, with a power transfer function based on that of sRGB.

IT8 – Kodak Q60

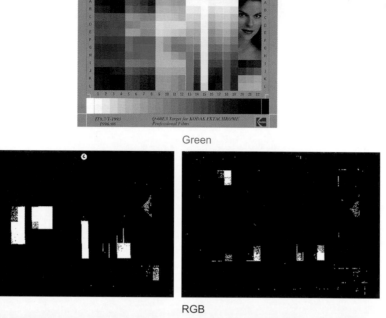

Red Green

Blue RGB

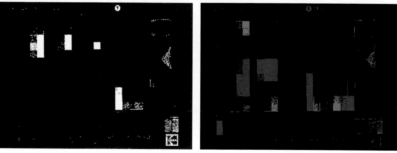

Figure 23.4 The Kodak Q60 colour test chart (top row) and colours in the red, green, blue channels and the combined RGB image (two bottom rows) that are lost during transformation from scanner sensor RGB to sRGB. Lost colours are indicated with white pixels on black on the individual channel images and with colour pixels in the combined RGB image.

sYCC and sYCC-related

The standard YCC encoding, sYCC (IEC 61966-2-1, amendment 1), is the standardized encoding of YC_bC_r colour space used in JPEG compression. It is based on the sRGB primaries and is also an output-referred encoding, but with a hypothetical extended (larger than the sRGB) colour gamut. sYCC code values are obtained from sRGB encoded images via a luma–chroma linear (3×3 matrix – see later) transformation. In JPEG compression the sRGB image data is converted to sYCC values prior to the actual discrete cosine transformation (DTC; see Chapter 29). Saturated colours that lie outside the sRGB gamut can be stored in a standard JPEG file by

directly encoding the image data as YCC, rather than first clipping/mapping the image to the sRGB gamut. Imaging applications that retain the extended gamut image data can enable output devices, such as inkjet printers, to make use of them.

sc-YCC-nl (IEC 61966-2-2) is based on the non-linear version of sc-RGB (sc-RGB-nl) and it is connected to it via a linear transformation (the same used to transform sRGB to sYCC). However, as with scRGB-nl, this is a scene-referred colour encoding with the absolute white point luminance being scene dependent. It is quantized to 12 bits per channel, thus the 16-bit RGB sc-RGB-nl data is down-sampled.

ROMM RGB and RIMM RGB

ROMM RGB (ISO 22028-2-2006) is an output-referred colour encoding. It achieves an extended gamut by using theoretical rather than physical primaries based on a hypothetical (print) output. Its transfer function is non-linear but differs from that of the sRGB encoding. There are three quantization options, at 8, 12 or 16 bits per channel. The reference medium white and black point chromaticities are those of D50 (suitable for print viewing and graphic arts) and the reference medium white and black point luminances are equal to 142 and 0.5 cd m^{-2} respectively. Linear transformation from ROMM RGB to CIE XYZ tristimulus values of the image is achieved via the ROMM RGB matrix.

RIMM RGB (ISO 22028-3-2006) is a scene-referred colour encoding, having the same primaries as ROMM RGB and also achieving an extended colour gamut. The colour space range is from 0.0 to 2.0 (instead of 0.0 to 1.0 for the ROMM RGB) and has a non-linear transfer function based on that of sRGB. The colour space white point is D50, with luminance of 15,000 cd m^{-2} to accommodate exterior scenes.

It is essential to note that colour space gamuts with extended primaries have the advantage of covering the colours reproduced by most devices, but they also lead to potential colour inaccuracy, as coded values may be wasted for reserving these to unnecessary colours. Additionally, they need to be quantized to large bit depths to avoid quantization effects such as contouring and posterization.

Adobe RGB 1998

The Adobe RGB colour space encoding was developed by Adobe Systems in 1998. It is a de facto standard, used widely by the photographic industry mainly because it is the native colour space of the Adobe Photoshop® image editing software. It is an output-referred 8 bits per channel colour encoding with primaries (the same as those used by NTSC — TV system used in the USA and other countries) and non-linear transfer characteristics based on a CRT output with a gamma of 2.2. The RGB primaries are not dissimilar to those of the sRGB (see Figure 23.3), although they encompass a slightly larger colour gamut, primarily in the cyan–green region. This dissimilarity is often accentuated by representing the RGB chromaticities on the non-uniform CIE x, y chromaticity diagram. The reference display white point corresponds to the illuminance D65 and the white point luminance is 160 cd m^{-2}. The reference viewing conditions are similar (but not exactly the same) to those of sRGB. The specification of Adobe RGB 1998, including the transformation from/to CIE XYZ coordinates, is available from Adobe Systems.

DEVICE COLOUR CHARACTERIZATION

Calibration and colour characterization of imaging devices are essential processes in ensuring consistent colour reproduction in digital imaging chains. *Calibration* is the process of setting and maintaining the imaging device to fixed settings, which correspond to known colour responses — for example, grey balancing scanner RGB responses, i.e. ensuring that equal RGB signals corresponds to neutral scanner responses ($R = G = B = f(Y)$), or setting the display white point to the illuminant D65, i.e. ensuring that the colour temperature of the display white point is approximately equal to 6504 K.

Colour characterization is concerned with defining the relationship between device-dependent colour coordinates and the corresponding device-independent, CIE colorimetric coordinates. Device characterization helps to transport colours between imaging devices in a meaningful manner. It is used to predict the colour output from specific input signals, or to predict the required input signal for obtaining a specific colour output. It is important to note that, once a device is calibrated to specific settings, the characterization is valid only for these settings.

The *characterization model* can be defined in two directions: the *forward* and the *inverse* models. For input devices, the forward model is a mapping from the original scene, or medium device-independent coordinates, to the corresponding device-dependent output signals. For output devices, it is a mapping from device-dependent input signals to the rendered device-independent colour that is produced by these signals. In both cases the inverse model is used to determine the required input in order to obtain a desired response.

A wide range of different models have been developed for the purpose of colour characterization, but none gives optimum results for all types of devices. Most models have been developed by first measuring a certain number of colours on the device/medium to be characterized and then defining a mathematical relationship that enables the transformation of any colour from the device space to a CIE colour space, or vice versa. These transformations are referred to as *colour transformations*.

We can broadly classify the types of models developed for device characterization as follows:

1. *Physical models*, which are based on various physical properties of the device, such as spectral sensitivity, absorbance, reflectance of the device or medium.
2. *Numerical models*, in which a set of coefficients is derived by regression, using a number of colour samples represented both in device-dependent and in device-independent coordinates.
3. *Look-up tables with interpolations*, connecting device-dependent colour coordinates to device-independent coordinates for a large number of colour samples. The

values are interpolated to create missing values for all intermediate colour coordinates.

4. *Neural networks*, where the device-dependent data for a number of colour samples is the input to the network and the device-independent data is the neural network's approximation of the device responses, or vice versa. Characterization methods based on neural networks will not be described in this chapter. Nevertheless, they have become more and more popular in recent years due to the computational speed of contemporary computer systems.

Colour transformations may involve elements from more than one of the above types. For example, entries on a colour look-up table used as the input to a colour display can be generated directly from measured data, or by employing a function derived from a numerical model.

Physical models

Physical models are often based on the spectral characteristics of the device. For example, in *input devices*, the spectral sensitivities of the camera's or scanner's sensor can be used to predict the response signals of the device. Spectral sensitivity functions of digital cameras can be measured by imaging monochromatic lights at different single wavelengths, or of narrow wavebands (using a monochromator — Chapter 5) and recording the linearized (i.e. gamma-corrected — Chapter 21) responses of each channel. These functions are usually normalized to their maximum values. Alternatively, they can be obtained from the manufacturer of the device. The latter are, however, generic and do not account for variations from device to device, or for temporal changes in the devices' characteristics.

Provided that the spectral sensitivity (or responsivity), $S_i(\lambda)$, of the ith channel (usually three, i.e. red, green and blue) is known, the channel's response signal, D_i, is given by:

$$D_i = k\left(\int_\lambda P(\lambda)R(\lambda)S_i(\lambda)d\lambda\right) + o \qquad (23.3)$$

where $P(\lambda)$ is the spectral radiance of the illuminant used during capture, $R(\lambda)$ is the spectral reflectance or spectral transmittance of the input colour stimulus, and k and o are scaling and offset parameters respectively. λ is the range of wavelengths to which the device is sensitive. In digital cameras, the spectral responsivity $S(\lambda)$ itself depends on various device-specific parameters, mainly on:

- the spectral sensitivity of the CCD or CMOS detector;
- the colour filters used for colour separation;
- the spectral transmittance of the infrared blocking filter that might be included in the camera;
- the spectral transmittance of the micro-optics of the sensor;
- noise.

In Chapter 5 we showed that the spectral distributions of the sample and the illuminant are related to colorimetric CIE XYZ values via a similar equation to Eqn 23.3 (see Eqn 5.8). The main difference is that the colorimetric value in Eqn 5.8 is obtained by using, instead of the channel sensitivity $S_i(\lambda)$, the corresponding colour matching function. Thus, it is important to note that, if the camera sensitivity functions are equal to (or a linear transformation of) the CIE colour matching functions describing the response of the standard colorimetric observer, the camera response will be colorimetric, and thus device independent. Devices that fulfil this so-called *Luther—Ives condition* are referred to as *colorimetric devices*. In such cases, and in the absence of noise, a *unique matrix*, **M**, can be derived that relates device-dependent signals D_1, D_2, D_3 (i.e. R, G, B) and device-independent signal CIE tristimulus values X, Y, Z:

$$\begin{bmatrix} X \\ Y \\ Z \end{bmatrix} = \mathbf{M} \begin{bmatrix} R \\ G \\ B \end{bmatrix} \text{ or } \begin{bmatrix} X \\ Y \\ Z \end{bmatrix} = \begin{bmatrix} a_{1,1} & a_{1,2} & a_{1,3} \\ a_{2,1} & a_{2,2} & a_{2,3} \\ a_{3,1} & a_{3,2} & a_{3,3} \end{bmatrix} \begin{bmatrix} R \\ G \\ B \end{bmatrix}$$

$$(23.4)$$

The coefficients $a_{1,1} \dots a_{3,3}$ of the matrix **M** are *constant* and can be used to transform all possible colour coordinates from one colour space to the other. Matrix **M** is obtained by:

$$\mathbf{M} = (\mathbf{S}^\mathrm{T}\mathbf{S})^{-1}\mathbf{S}^\mathrm{T}\mathbf{A} \qquad (23.5)$$

where **S** is a $3 \times n$ matrix containing three columns with the sampled spectral sensitivities of the device (of n number of samples, usually taken at 5—10 nm intervals) and **A** is a $3 \times n$ matrix containing the sampled CIE 1931 colour matching functions (plotted in Figure 5.15). T denotes the transpose of the matrix and -1 the inverse of the matrix.

$$\mathbf{S} = \begin{bmatrix} S_r(\lambda_1) & S_g(\lambda_1) & S_b(\lambda_1) \\ S_r(\lambda_2) & S_g(\lambda_2) & S_b(\lambda_2) \\ . & . & . \\ . & . & . \\ . & . & . \\ S_r(\lambda_n) & S_g(\lambda_n) & S_b(\lambda_n) \end{bmatrix} \text{ and}$$

$$(23.6)$$

$$\mathbf{A} = \begin{bmatrix} \bar{x}(\lambda_1) & \bar{y}(\lambda_1) & \bar{z}(\lambda_1) \\ \bar{x}(\lambda_2) & \bar{y}(\lambda_2) & \bar{z}(\lambda_2) \\ . & . & . \\ . & . & . \\ . & . & . \\ \bar{x}(\lambda_n) & \bar{y}(\lambda_n) & \bar{z}(\lambda_n) \end{bmatrix}$$

$\lambda_1 \dots \lambda_n$ denote the sample points of the spectral data.

Note that, in case the camera is characterized for specific lighting conditions, or the imaging device is a scanner with a fixed illuminant, **S** in Eqns 23.5 and 23.6 should be substituted by the product of the spectral

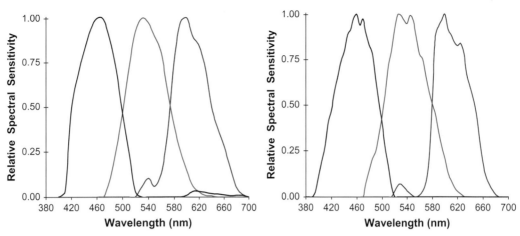

Figure 23.5 Relative spectral sensitivities of two commercial digital SRL cameras.
Adapted from Fairchild et al. (2008); reproduced with permission of M. D. Fairchild

sensitivities and the spectral reference illuminant (i.e. $S(\lambda) \times R(\lambda)$).

Although the design of colorimetric input devices has been explored, in practice it is very difficult to achieve since it requires large dynamic ranges and high signal-to-noise ratios, as well as very narrow-band filters. A potential problem with the use of narrow-band filters is metamerism, where stimuli that appear identical to the eye may result in different device responses, or vice versa. The spectral sensitivities of input devices are unlikely to be linear combinations of the CIE 1931 colour matching functions and therefore a different matrix $M_1, M_2, M_3, \ldots,$ M_n links each individual set of device coordinates to the corresponding colorimetric values. A single matrix, \widehat{M}, can be estimated with coefficients obtained by 'best fitting' the camera sensitivities to the colour matching functions[‡] (see 'Regression' section below). This is only an approximation, but for many applications it may be sufficient. Typical spectral sensitivities of commercial digital cameras are shown in Figure 23.5.

Physical characterization models of *additive emissive displays* use the spectral radiance output of each colour channel. The spectral radiance emitted by a display, $S_{rgb}(\lambda)$, is a function of the linearized input digital counts:

$$S_{rgb}(\lambda) = S_{r_max}(\lambda)R' + S_{g_max}(\lambda)G' + S_{b_max}(\lambda)B'$$
$$(23.7)$$

where $S_{r_max}(\lambda)$, $S_{g_max}(\lambda)$ and $S_{b_max}(\lambda)$ are the spectral radiances emitted from the display primaries (i.e. the red, green and blue channels respectively) and R', G', B' are the

[‡] Note that the mathematical symbol '\wedge' in the matrix \widehat{M} is used to denote 'an estimated' matrix **M**.

digital input counts for the red, green and blue channels respectively linearized with respect to luminance (see Chapter 21). Typical spectral radiances of CRT displays are illustrated in Figure 15.2. Spectral radiances can be measured using a spectroradiometer (see Chapter 5).

When the display characterization model is based on this relationship, there are three assumptions that are made:

- *Channel independence* – each of the display channels operates independently of the other two and thus there is a separate contribution of spectral radiance for each channel, i.e. no cross-talk.
- *Chromaticity constancy* – the chromaticity of the spectral radiance function is independent of the intensity of the input signal.
- *Spatial independence* – the output from one spatial location of the display does not affect another spatial location.

Although monitors adhere to the above assumptions to varying degrees, models based on the spectral properties of the displays are widely used for characterization.

In a properly set-up display, the output spectral radiance for each linearized R', G', B' digital input count, can be defined from the maximum spectral radiance of each channel by:

$$\begin{bmatrix} S_{rgb}(\lambda_1) \\ \cdot \\ \cdot \\ S_{rgb}(\lambda_n) \end{bmatrix} = \begin{bmatrix} S_{r_max}(\lambda_1) & S_{g_max}(\lambda_1) & S_{b_max}(\lambda_1) \\ \cdot & \cdot & \cdot \\ \cdot & \cdot & \cdot \\ S_{r_max}(\lambda_n) & S_{g_max}(\lambda_n) & S_{b_max}(\lambda_n) \end{bmatrix} \begin{bmatrix} R' \\ G' \\ B' \end{bmatrix}$$
$$(23.8)$$

$\lambda_1 \ldots \lambda_n$ denote the sample points of the spectral radiances.

Since the display is an additive device, the corresponding colorimetric values can be derived by employing a 3×3

transformation matrix, **M**, with coefficients equal to the CIE tristimulus values of the display primaries:

$$\begin{bmatrix} X \\ Y \\ Z \end{bmatrix} = \mathbf{M} \begin{bmatrix} R' \\ G' \\ B' \end{bmatrix} \text{ or } \begin{bmatrix} X \\ Y \\ Z \end{bmatrix} = \begin{bmatrix} X_{\text{r_max}} & X_{\text{g_max}} & X_{\text{b_max}} \\ Y_{\text{r_max}} & Y_{\text{g_max}} & Y_{\text{b_max}} \\ Z_{\text{r_max}} & Z_{\text{g_max}} & Z_{\text{b_max}} \end{bmatrix} \begin{bmatrix} R' \\ G' \\ B' \end{bmatrix}$$

(23.9)

The inverse transformation, used to predict required normalized R', G', B' linear in luminance RGB values for any given set of tristimulus values is obtained by:

$$\begin{bmatrix} R' \\ G' \\ B' \end{bmatrix} = \mathbf{M}^{-1} \begin{bmatrix} X \\ Y \\ Z \end{bmatrix}$$

(23.10)

where \mathbf{M}^{-1} is the inverse of matrix **M** described in Eqn 23.9.

An example of display characterization using a physical model is described later in the chapter.

There are a number of physical models developed to estimate the colorimetry of *printers*. Most of them are rather complicated and are based on modelling the interaction between light, colorants and printing medium at microscopic or macroscopic levels. Some well-known physical models used for printer characterization are:

- *Beer–Bouguer model* – used to predict the transmission of light though transparent colorants and media related to continuous-tone printing on reflection media. One of the drawbacks of this model is that it does not account for light scattering within the layers of the colorants.
- *Kubelka–Mung model* – not dissimilar to the Beer–Bouguer model, it is employed to predict the reflectance of translucent or opaque colorants and takes into account light scattering within the printing medium.
- *Neugebauer model* – used to model half-tone printing where each primary colorant in the half-tone process is a spatial array of dots (see Chapter 16).

Green and MacDonald (2002), Sharma (2003) and Kang (2006) – see Bibliography – provide information on the above physical models and examples of model-based characterization of printers.

Numerical models

The aim of the numerical models for device characterization is to define a matrix **M** used for colour transformation between device-dependent and device-independent colour values by measuring a number of colour samples in the device and recording their coordinates in both device-dependent and CIE spaces. For digital capturing devices, a number of colour patches with measured tristimulus values are employed as the input to the device and the corresponding device RGB values are recorded. For display and hard-copy devices, sample colour patches are created by inputting a range of device values and measuring the tristimulus coordinates of the

rendered colour, using a colorimeter, a spectrophotometer or other colour instruments (see Chapter 5).

Once the matrix is derived, the colour transformation is achieved by using Eqn 23.4. As mentioned above, if the spectral power distributions of the device and the CIE colour matching functions are linearly related, the coefficients of the non-singular matrix **M** are constant and can be used to transform accurately all possible colour coordinates from one colour space to the other. In such a case, the coefficient can be derived by measuring only *three* known colour samples and solving three simultaneous equations. By matrix algebra, the solution to the set of linear equations is given by (see 'Regression' section below):

$$\mathbf{M}_X = (\mathbf{D}^T \mathbf{D})^{-1} (\mathbf{D}^T \mathbf{X})$$
$$\mathbf{M}_Y = (\mathbf{D}^T \mathbf{D})^{-1} (\mathbf{D}^T \mathbf{Y}) \qquad (23.11)$$
$$\mathbf{M}_Z = (\mathbf{D}^T \mathbf{D})^{-1} (\mathbf{D}^T \mathbf{Z})$$

where **D** is a 3×3 matrix with the device-dependent code values (such as R, G and B) for the three samples:

$$\begin{bmatrix} R_1 & G_1 & B_1 \\ R_2 & G_2 & B_2 \\ R_3 & G_3 & B_3 \end{bmatrix}$$

X is a vector with the three corresponding X tristimulus values for the three samples:

$$\begin{bmatrix} X_1 \\ X_2 \\ X_3 \end{bmatrix}$$

Y is a vector with the three corresponding Y tristimulus values for the three samples:

$$\begin{bmatrix} Y_1 \\ Y_2 \\ Y_3 \end{bmatrix}$$

Z is a vector with the three corresponding Z tristimulus values for the three samples:

$$\begin{bmatrix} Z_1 \\ Z_2 \\ Z_3 \end{bmatrix}$$

Then, the transformation matrix **M** is given by:

$$\mathbf{M} = \begin{bmatrix} \mathbf{M}_X \\ \mathbf{M}_Y \\ \mathbf{M}_Z \end{bmatrix}$$

(23.12)

The inverse transformation of the transformation described by Eqn 23.4 is often required to predict the required code values which will render a colour having a set of known CIE XYZ tristimulus values. This is achieved by using the inverse of the matrix **M**:

$$\begin{bmatrix} R \\ G \\ B \end{bmatrix} = \mathbf{M}^{-1} \begin{bmatrix} X \\ Y \\ Z \end{bmatrix}$$

(23.13)

In most cases, the spectral power distribution of the device is not a linear combination of the CIE 1931 colour matching functions and therefore a matrix, \mathbf{M}, can be estimated using a regression method. Regression is used to correlate the *colour coordinates of the selected colour samples in both device and CIE colour spaces*.

The steps to derive a numerical model include:

- The selection of the *source* and the *destination* colour spaces used to describe the coordinates of the colour samples. For example, scanner RGB to CIE XYZ, or log RGB to log CIE XYZ.
- The selection of number and location (in terms of their lightness, hue and chroma) of *training* colour samples, i.e. the colour samples that will be used in the regression to estimate $\widehat{\mathbf{M}}$.
- The choice of the regression equation.
- The evaluation of the estimated results.

Regression

The most common method for estimating the coefficients of the transformation matrix $\widehat{\mathbf{M}}$ is the least squares method. The best fit in the least squares method is the estimated model for which the sum of squared *residuals* has its smallest value. A residual is the difference between the measured value and the value estimated by the model.

Regression is performed on a selected number of samples (*training samples*), n, with measured colour specifications both in the *source* (device) and *destination* (CIE) colour spaces. It is based on the assumption that the correlation between colour spaces can be approximated by a set of simultaneous equations. For a unique solution to the equations, *the number of colour samples, n, must be higher than the number of *terms*, m, in the regression ($n > m$)*. Once the coefficients in the equations are derived (i.e. the coefficients forming matrix $\widehat{\mathbf{M}}$), one can use the simultaneous equations with the source variables (e.g. RGB) to compute the destination coordinates (e.g. CIE XYZ). The device data are the *independent variables* in the regression and the tristimulus values are the *dependent variables*.

Regression can be linear or of a higher order, such as polynomial, the latter being an application of linear regression with m variables, where m is actually greater than the number of independent variables, i.e. three R, G and B, in the case of RGB systems.

The general form of the linear regression with m variables is given by:

$$d(q) = a_1 q_1 + a_2 q_2 + a_3 q_3 + \ldots + a_m q_m \qquad (23.14)$$

And in vector notation:

$$d = \mathbf{Q}\mathbf{A}^{\mathrm{T}} \text{ or } d = \mathbf{Q}^{\mathrm{T}}\mathbf{A} \qquad (23.15)$$

where d is the dependent variable. Vector \mathbf{Q} has m elements indicating the number of polynomial terms: each of these is an independent variable (R, G, B), or a product of independent variables (RG, GB, RB, R^2, R^2, G^2, RGB, etc.). \mathbf{A} is a vector with the corresponding coefficients. The number of coefficients is equal to the number of polynomial terms, m.

An example of applying polynomial regression to three independent variables corresponding to the device coordinates, R, G and B, with $m = 4$ polynomial terms, would be when $q_1 = R$, $q_2 = G$, $q_3 = G$ and $q_4 = RGB$. The q values are therefore derived directly from the three independent variables, i.e. from the measured device-dependent coordinates. The output-dependent variable d represents the corresponding colour value in the destination space (CIE X, Y or Z tristimulus value).

For the X tristimulus value and using n measured samples, Eqn 23.14 would be represented by:

$$X_1 = a_{x1}R_1 + a_{x2}G_1 + a_{x3}B_1 + a_{x4}RGB_1$$
$$X_2 = a_{x1}R_2 + a_{x2}G_2 + a_{x3}B_2 + a_{x4}RGB_2$$
$$\ldots$$
$$\ldots \qquad\qquad (23.16)$$
$$\ldots$$
$$X_n = a_{x1}R_n + a_{x2}G_n + a_{x3}B_n + a_{x4}RGB_n$$

In matrix form, Eqn 23.16 above becomes:

$$\begin{bmatrix} X_1 \\ X_2 \\ . \\ X_n \end{bmatrix} = \begin{bmatrix} R_1 & G_1 & B_1 & RGB \\ R_2 & G_2 & B_2 & RGB_2 \\ . & . & . & . \\ R_n & G_n & B_n & RGB_n \end{bmatrix} \begin{bmatrix} a_{X1} \\ a_{X2} \\ a_{X3} \\ a_{X4} \end{bmatrix} \qquad (23.17)$$

And in vector notation:

$$\mathbf{X} = \mathbf{Q}^{\mathrm{T}}\mathbf{A}_X \qquad (23.18)$$

where \mathbf{X} is a vector with the X tristimulus values for n samples, \mathbf{Q} is a $4 \times n$ matrix (four terms for n number of samples) and \mathbf{A}_X is a vector of the four corresponding coefficients.

If the number of X tristimulus values of the colour samples in vector \mathbf{X} is less than the number of unknowns in vector \mathbf{A}_X, there is no unique solution to the simultaneous equations. Thus, for this example the number of samples n has to be greater than or equal to 4.

In the case of the least squares fit, the error in finding the best-fitted function that returns the coefficients in matrix \mathbf{A}_X is minimized between the estimated and measured values of \mathbf{X}. If the number of samples is indeed greater (or equal) to the number of coefficients, the product of \mathbf{Q} with its transpose (i.e. $\mathbf{Q}\mathbf{Q}^{\mathrm{T}}$) can be inverted (it is non-singular), and the required coefficients can be obtained by:

$$\mathbf{A}_X = (\mathbf{Q}^{\mathrm{T}}\mathbf{Q})^{-1}(\mathbf{Q}^{\mathrm{T}}\mathbf{X}) \qquad (23.19)$$

Equation 23.19 is repeated for all three tristimulus values of the samples, X, Y and Z. Finally, the transformation matrix \widehat{M} is obtained by:

$$\widehat{\mathbf{M}} = \begin{bmatrix} \mathbf{A}_X \\ \mathbf{A}_Y \\ \mathbf{A}_Z \end{bmatrix} \qquad (23.20)$$

or:

$$\widehat{\mathbf{M}} = \begin{bmatrix} a_{X1} & a_{X2} & a_{X3} & a_{X4} \\ a_{Y1} & a_{Y2} & a_{Y3} & a_{Y4} \\ a_{Z1} & a_{Z2} & a_{Z3} & a_{Z4} \end{bmatrix} \qquad (23.21)$$

Note that Eqns 23.19 and 23.20 are analogous to Eqns 23.11 and 23.12. The transformation from device-dependent coordinates to CIE tristimulus values for the above example is achieved by:

$$\begin{bmatrix} X \\ Y \\ Z \end{bmatrix} \widehat{\mathbf{M}} \begin{bmatrix} R \\ G \\ B \\ RGB \end{bmatrix} \text{ or } \begin{bmatrix} X \\ Y \\ Z \end{bmatrix} = \begin{bmatrix} a_{X1} & a_{X2} & a_{X3} & a_{X4} \\ a_{Y1} & a_{Y2} & a_{Y3} & a_{Y4} \\ a_{Z1} & a_{Z2} & a_{Z3} & a_{Z4} \end{bmatrix} \begin{bmatrix} R \\ G \\ B \\ RGB \end{bmatrix}$$

$$(23.22)$$

Table 23.3 shows examples of equations used for colour space conversion. Generally, the accuracy of polynomial approximation improves as the number of polynomial terms increases. Higher order polynomials, however, might result in poor results in practice (see 'Scanner characterization' section below).

When the colour conversion needs to work inversely (i.e. CIE XYZ to RGB), the matrix of coefficients for the inverse transformation has to be sought. This is achieved via Eqns 23.16−23.22, by exchanging the position of the input and output data in the regression. That means that the regression is applied to the CIE tristimulus values, which now become the independent variables, and the RGB data, which are in this case the dependent variables.

An example of polynomial regression for input device characterization is given later in the chapter.

Look-up tables with interpolation

Colour space transformation can be achieved using multidimensional look-up-tables (LUTs) that map device-dependent to device-independent colour coordinates, and vice versa. Generally, a relatively large number of colour samples are measured (training samples) in both device-dependent and device-independent spaces. The measured

colours constitute a subset of the total number of colours available in the device to be characterized. For example, in an RGB device, the number of available colours at 8 bits per channel quantization is $2^8 \times 2^8 \times 2^8 = 16{,}777{,}216$. This is clearly too big a number of colours to be evaluated by direct manual measurement. To cover all possible colours, *interpolation* between the nearest measured points is used to cover all the colours that could be encountered in either colour space.

Various mathematical algorithms are used for interpolation. The purpose of such algorithms is to estimate the output colour coordinate for a corresponding known input coordinate, provided that two or more colour coordinates are known in both input and output colour spaces. The relative geometrical distances from the known points to the point to be determined are used as weights to estimate the value of the unknown coordinate. Thus, colour space coordinates are measured at regular intervals to create a lattice of points which are used to evaluate an interpolation function. The *interpolation error* is the distance between the coordinate calculated by the interpolation and the value of the interpolation function at that colour coordinate.

Since input as well as output colour spaces are usually three-dimensional (3D), interpolation methods are required that exploit various ways of subdividing a 3D space, such as the cube representing the input colour space. Examples of 3D interpolation methods used for device characterization include trilinear, prism, pyramid and tetrahedral interpolation. In trilinear interpolation the cube is not segmented, whereas in the latter three the cube is subdivided into two, three and four segments respectively.

Generally, 3D interpolation methods are an extension of linear (one-dimensional, 1D) and bilinear (2D) interpolation. In Figure 23.6, linear interpolation in one dimension is used to determine the y coordinate of a point with coordinates x, y from *two* points with known coordinates x_1, y_1 and x_2, y_2. The value of y, or $f(x)$, is given by:

$$f(x) = y = y_1 + (y_2 - y_1)\left(\frac{x - x_1}{x_2 - x_1}\right) \qquad (23.23)$$

Table 23.3 Examples of equations used for colour space conversion (*m* is the number of polynomial terms)

M	POLYNOMIAL	TYPE
3	$d(x, y, z) = a_1 x + a_2 y + a_3 z$	Linear
4	$d(x, y, z) = a_0 + a_1 x + a_2 y + a_3 z$	Linear
6	$d(x, y, z) = a_1 x + a_2 y + a_3 z + a_4 xy + a_5 xz + a_6 yz$	Polynomial
8	$d(x, y, z) = a_0 + a_1 x + a_2 y + a_3 z + a_4 xy + a_5 xz + a_6 yz + a_7 xyz$	Polynomial
9	$d(x, y, z) = a_1 x + a_2 y + a_3 z + a_4 xy + a_5 xz + a_6 yz + a_7 x^2 + a_8 y^2 + a_9 z^2$	Polynomial
14	$d(x, y, z) = a_0 + a_1 x + a_2 y + a_3 z + a_4 xy + a_5 xz + a_6 yz + a_7 x^2 + a_8 y^2 + a_9 z^2 + a_{10} x^3 + a_{11} y^3 + a_{12} z^3 + a_{13} xyz$	Polynomial

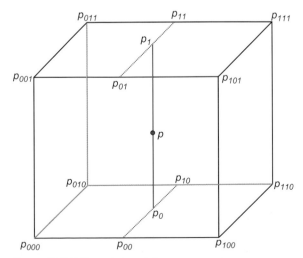

Figure 23.6 Linear interpolation.

The interpolation error is given by the distance between the value of y and the interpolated value y_i.

In bilinear interpolation performed in two dimensions, we have a function of two variables, $f(x,y)$, and we thus need four known points. Further, a trilinear interpolation is achieved by applying the linear interpolation seven times. It repeats the bilinear interpolation ($3 \times$ linear) twice to determine two points on two opposite sides of a cube and then performs it once more to determine the geometrical location of the unknown point on the line connecting these two points (Eqn 23.4). Figure 23.7 illustrates the application of trilinear interpolation to determine point p with coordinates x, y, z, from the eight available points of the cube: p_{000}, p_{001}, p_{010}, p_{011}, p_{100}, p_{101}, p_{110} and p_{111}. Refer to Kang (2006) for more details.

$$p = c_0 + c_1 \Delta x + c_2 \Delta y + c_3 D \Delta z + c_4 \Delta x \Delta y + c_5 \Delta y \Delta z$$
$$+ c_6 \Delta z \Delta x + c_7 \Delta x \Delta y \Delta z$$

$$(23.24a)$$

Figure 23.7 Trilinear interpolation.
Adapted from Kang (2006)

where:

$$\Delta x = (x - x_0)/(x_1 - x_0), \Delta y = (y - y_0)/(y_1 - y_0), \Delta z$$
$$= (z - z_0)/(z_1 - z_0)$$

$$(23.24b)$$

and

$$c_0 = (p_{000}), c_1 = (p_{100} - p_{000}), c_2 = (p_{010} - p_{000}),$$
$$c_3 = (p_{001} - p_{000}), c_4 = (p_{110} - p_{010} - p_{100} + p_{000}),$$
$$c_5 = (p_{011} - p_{001} - p_{010} + p_{000}),$$
$$c_6 = (p_{101} - p_{001} - p_{100} + p_{000}),$$
$$c_7 = (p_{111} - p_{011} - p_{101} - p_{110} + p_{100} + p_{001} + p_{010} - p_{000})$$

$$(23.24c)$$

The characterization of a device using LUTs with interpolation is carried out as follows. First, the lattice is created by subdividing the colour space. This is achieved by measuring the training colour samples at regular intervals in the input space and obtaining the corresponding output coordinates. The lattice essentially partitions the colour space into sub-volumes. When the colour transformation is performed, the input colour is located into a sub-volume and then the interpolation is executed to derive the output colour coordinate.

In characterization techniques using LUTs with interpolation it is important that the input colour space is represented and subdivided in a perceptually uniform manner prior to input into the LUT, to avoid perceptually important interpolations errors. This can be achieved by transforming the input data using a non-linear function which approximates the eye's response (e.g. logarithmic, or raised to the exponent of 1/3), or using directly gamma-corrected data. The number of samples measured during the characterization process may range from 120 to 500. A larger LUT will reduce the interpolation error at the transformation stage but requires more measurements (more colours have to be measured to create the lattice) and more computer memory during its implementation.

LUTs that describe characterization models of devices are commonly used by ICC colour profiles for colour transformation (see Chapter 26), since applying colour transformations via LUTs is usually faster than via a model function that has to run for every pixel of the image. However, a LUT is set and cannot be modified during run time.

Evaluation of the characterization model

Colour differences, such as CIELAB ΔE_{ab}, as well as CIE94 and CIEDE2000 (see Chapter 5 and Appendix B), are employed to evaluate the error in characterization model. The mean, median, maximum and 95th percentile colour differences are obtained, first for the training set of samples and also for a *testing set* of colour samples. The latter have not been used to build the model but are used to test it, so

425

normally they return a higher error than that returned from the training set of colours. The error measure selected to evaluate the model performance should be perceptually uniform, thus consideration needs to be given to the colour difference formula employed to estimate it.

Although the mean colour difference is often the first reported value, it can be misleading, since the error is usually not normally distributed throughout the samples. The median colour difference is a more appropriate metric to represent the 'average' model performance. Histograms of the frequency of the colour differences versus the magnitude of the difference are plotted to illustrate the distribution of the error (see example in Figure 23.8). Colorimetric errors are often reported in separate ΔL^*, ΔC^*_{ab} and ΔH^*_{ab} differences and plots such as ΔE^*_{ab} versus L^*, C^*, h^* or versus ΔL^*, ΔC^*_{ab} and ΔH^*_{ab} can reveal systematic tendencies in the distribution of the error. An example is illustrated in Figure 23.9. Based on this type of analysis, corrections to improve the characterization model are often implemented.

The performance of the characterization model is also often evaluated by using statistical error measures. For example, the performance of a colour transformation matrix derived by polynomial regression between device-dependent and CIE XYZ tristimulus values can be tested by calculating the correlation coefficient r of the regression by:

$$ r = \left[\frac{\sum (x_i - \bar{x})(y_i - \bar{y})}{n\sigma_x\sigma_y} \right]^{1/2} \quad i = 1, 2, 3, \ldots, n \quad (23.25) $$

where x_i and y_i are the individual estimated and original values respectively for each tristimulus value, \bar{x} and \bar{y} are the mean estimated and original values, n is the number of training colour samples, and σ_x and σ_y are the standard deviations of the estimated and original values. A separate coefficient is calculated for each tristimulus value. The problem with using the correlation coefficient to test such a characterization model is the non-uniformity of the CIE XYZ colour system. Also, the correlation coefficient does not give any account of the location or distribution of the error; it is only an estimator of the accuracy of the fitted function.

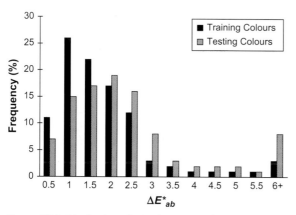

Figure 23.8 Distribution of ΔE^*_{ab} in scanner characterization.

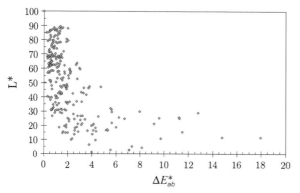

Figure 23.9 CIE L^* versus ΔE^*_{ab} for all training colours. Large colorimetric errors are associated with low lightness colours.

CHARACTERIZATION OF DISPLAYS

In CRT displays, excited phosphors modulated by three electron guns emit an additive mixture of red, green and blue lights. The assumptions mentioned earlier in the section 'Physical models', in addition to the assumption of temporal stability, must hold to use the following simple procedure to characterize the display.

The calibration and characterization of displays are performed in a dark environment with all ambient lights off. The display has to warm up for a period of 30−60 minutes to allow stabilization of luminance and chromaticity (see Chapter 15). Before the characterization starts, the desired correlated colour temperature must be selected. The brightness and contrast controls of the display have to then be set to a fixed value. The aim is to achieve the maximum contrast range, with the darkest possible black point and no loss in the available luminance levels. This is carried out visually, preferably by an observer with experience and with the aid of simple black-and-white test patches, or by displaying several typical pictorial images and trying to achieve pleasing tone reproduction.

The characterization of a display system is a two-step operation. These are:

- Evaluation of the transfer characteristics of the CRT display, i.e. definition of the relationship between input pixel values and output luminance, for the red, green and blue channels.
- Derivation of the matrix, **M**, of coefficients used for transforming R', G', B' linearized − with respect to display luminance − pixel values to CIE XYZ tristimulus values.

The evaluation of the R, G and B transfer functions of display systems is achieved by taking luminance measurements from a series of displayed ramps for each primary colour. This relationship is usually modelled by a function obeying the power law. Details on measuring CRT transfer characteristics, along with models used to describe the transfer relationship, are given in Chapter 21. A calibrated and warmed-up colorimeter can be used for the purpose.

The coefficients of the colour transformation matrix, **M**, are obtained by using the colorimeter and measuring each channel's peak output chromaticities, x, y and luminance, Y, from the central part of the display. The measurement set-up is illustrated in Figure 21.7, with the central part of the display faceplate displaying the colour of interest and the surrounding area set to display its complementary. The required coefficients are the tristimulus values of the display primaries described in Eqn 23.9. They are obtained by:

$$\mathbf{M} = \begin{bmatrix} X_{r_max} & X_{g_max} & X_{b_max} \\ Y_{r_max} & Y_{g_max} & Y_{b_max} \\ Z_{r_max} & Z_{g_max} & Z_{b_max} \end{bmatrix}$$

$$= \begin{bmatrix} (x_r/y_r) & (x_g/y_g) & (x_b/y_b) \\ 1 & 1 & 1 \\ (z_r/y_r) & (z_g/y_g) & (z_b/y_b) \end{bmatrix} \begin{bmatrix} L_{r_max} & 0 & 0 \\ 0 & L_{g_max} & 0 \\ 0 & 0 & L_{b_max} \end{bmatrix}$$

$$(23.26)$$

where x_r, y_r and z_r are the chromaticities of the red primary, x_g, y_g and z_g are the chromaticities of the green primary, z_b, y_b and z_b are the chromaticities of the blue primary and L_{r_max}, L_{g_max} and L_{b_max} are the maximum luminances of the red, green and blue channels respectively. The coefficients are normalized in the range 0.0–1.0, achieved by scaling so that Y values sum to 1.

The colorimetry of a set of RGB colour coordinates sent to the CRT is predicted by the forward model (Figure 23.10), involving:

- The application of the transfer function of the display to each of the R, G and B input digital counts to obtain linear in luminance R', G' and B' values. This can be achieved by applying the model display transfer function, or by creating three LUTs with the actual measured (and interpolated) channel responses.
- The tristimulus values of the display colours are then obtained by implementing Eqn 23.9.

The success of the characterization can be tested by converting a test set of colour patches with known CIE XYZ tristimulus values to display RGB through the inverse characterization model and measuring the displayed colours using a colorimeter. The inverse transformation (Figure 23.10) is achieved by reversing the steps listed above, i.e. applying the inverse matrix transformation described in Eqn 23.10 and then applying the inverse display transfer function to the linear in luminance R', G', B' values to obtain input R, G, B digital counts.

Finally, the discrepancy between original and measured displayed colour is calculated using a colour difference formula, as indicated earlier in this chapter. CRT characterization may result in average colour differences of magnitude as low as 1.0 CIE ΔE_{ab}, which is considered as the threshold of visibility in uniform colour patches. In imaging, this threshold rises for complex scenes, with the limit of visibility of displayed images being between 2.5 and $3.5\Delta E_{ab}$ and the limit of acceptability being around 5.0 or $6.0\Delta E_{ab}$.

In the characterization of LCD technologies most assumptions made with the CRT hold to a degree and thus a characterization model based on that of the CRT described above can be used. In backlit active matrix LCDs, linear polarizers and a liquid crystal substrate between them are employed to polarize light coming from a source on the back of the display. The polarized light passes though a set of RGB filters to create an additive colour mixture (see Chapter 15). A primary difference between CRT and LCD characteristics is that the LCD has a native transfer function which is sigmoid (hyperbolic). However, many LCDs have built-in correction tables to mimic the CRT response. It is thus best to obtain the display transfer characteristics by direct measurement

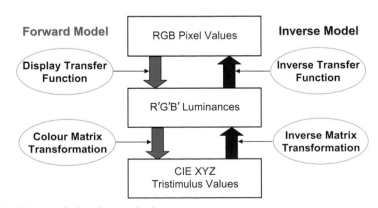

Figure 23.10 Forward and inverse display characterization.

rather than adapting a CRT model with no prior knowledge of the system. Another important difference is that the black point luminance (minimum luminance) is comparatively high, due to the backlight source. For this reason a more accurate transformation between linearized input pixel values and CIE tristimulus values is achieved when the tristimulus values of the black point of the display are taken into account. The transformation in Eqn 23.9 is replaced by:

$$
\begin{bmatrix} X \\ Y \\ Z \end{bmatrix} = \begin{bmatrix} X_{\text{r_max}} - X_{k_\text{min}} & X_{\text{g_max}} - X_{k_\text{min}} & X_{\text{b_max}} - X_{k_\text{min}} & X_{k_\text{min}} \\ Y_{\text{r_max}} - Y_{k_\text{min}} & Y_{\text{g_max}} - Y_{k_\text{min}} & Y_{\text{b_max}} - Y_{k_\text{min}} & Y_{k_\text{min}} \\ Z_{\text{r_max}} - Z_{k_\text{min}} & Z_{\text{g_max}} - Z_{k_\text{min}} & Z_{\text{b_max}} - Z_{k_\text{min}} & Z_{k_\text{min}} \end{bmatrix} \begin{bmatrix} R' \\ G' \\ B' \\ 1 \end{bmatrix} \tag{23.27}
$$

where $k_$min denotes the black point.

Another consideration when characterizing an LCD system is the viewing angle dependency of the display. Therefore, measurements are angle dependent − taken from an axis perpendicular to the display, but also for other angles separately − and have to be carried out with a colorimeter having a very small reading area (aperture). Such colorimeters are usually designed specifically for LCD measurements. Finally, the grey balance of the LCD for R = G = B inputs is relatively poor, as well as the display's chromaticity constancy. Models that compensate for the lack of chromaticity constancy introduce cross-terms in the non-linear transfer function to describe interactions between R, G and B channels.

CHARACTERIZATION OF DIGITAL INPUT DEVICES

Various methods can be employed for the characterization of input devices, such as desktop and film scanners. These include the use of linear or polynomial regression to derive a colour transformation matrix, the creation of LUTs with interpolation between measured points, dye concentration modelling and neural networks. In this section characterization using regression is discussed. This method requires relatively simple equipment and an input colour target. The scanner characterization using regression consists of:

- Grey balancing the red, green and blue scanner signals, i.e. by setting R = G = B = $f(Y)$ for the neutral patches; here Y is the patch relative luminance. This step is not compulsory.
- Deriving a 3 × m matrix through polynomial regression to selected samples with known colour specifications in both source (CIE XYZ) and destination colour spaces (grey balanced R', G', B' values). The matrix is implemented for the colour transformation between device responses and CIE coordinates.

The polynomial regression method for device characterization is constrained to a single set of dyes (best to characterize for specific film/print dyes), illuminant and observer. Thus, during characterization it is advisable to employ a test chart produced on the same photographic medium as the media to be scanned later on. As indicated earlier in the 'Numerical models' section, the number of training colour samples, n, must be equal to or greater than the number of polynomial terms, m.

Standard test targets such as the ANSI IT8.7 (Figure 23.11) can be used for the purpose. The target provides uniform mapping in the CIELAB colour space

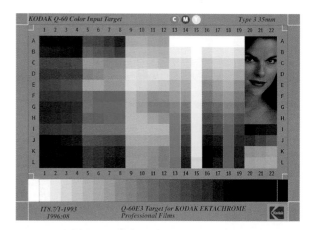

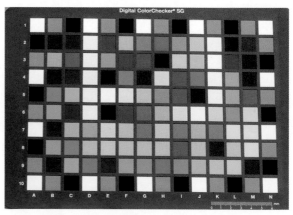

Figure 23.11 The Kodak Q60 target based on the design of the ANSI IT8.7 (top) and the Digital ColorChecker SD (bottom) used for scanner and digital camera characterization.

and includes a 24-step grey ramp. The number as well as the location of the training samples on the target are important in the characterization. The training set may consist of half of the total number of colour samples on the target; these should cover the CIELAB space of the scanning medium uniformly. Thus, the training set may consist of every other sample on the target. Measurements from the target are performed with a reflection spectrophotometer (or a transmission one for film targets) to obtain the original CIE XYZ tristimulus values for the training set of colours. Measurements are carried out for the standard illuminant and the CIE colorimetric observer of choice.

The target is scanned using selected working scanner settings (e.g. optical resolution, gamma = 1). Automatic selection of white and black point as well as automatic exposure should be avoided. These should be set manually when pre-scanning the target and kept constant during scanning.

Grey balanced RGB values (R', G', B') are obtained by:

1. Measuring the RGB scanner responses for the neutral patches of the target (see Chapter 21 for measuring the OECF of input devices). The relationship between relative input luminances and scanner responses can be used to build three LUTs used in the next step. This can be achieved using linear or spline interpolation.
2. Implementing the three LUTs to linearize — with respect to input luminance — the RGB scanner responses.

The grey balanced test target is then measured. R', G', B' values for the training set of samples are obtained by averaging a number of pixels from the central area of each sample.

The colour transformation matrix, $3 \times m$, can be derived by implementing Eqns 23.19 and 23.20. **Q** in Eqn 23.19 is the matrix of independent variables of size $n \times m$ (m is the number of polynomial terms, for n number of training samples; see example in Eqns 23.16–23.18 for $m = 4$). Examples of polynomials with different numbers of terms are given in Table 23.3. The terms x, y, z, etc. in the table represent the grey balanced pixel values (R', G', B') or/and their products (R', G'; R', B'; G', B'; R', G', B', etc.). **X** in Eqns 23.18 and 23.19 is the vector of size n of dependent variables (either X, Y or Z), which contains the corresponding tristimulus value for n training samples. Finally, A_X, A_Y and A_Z are the derived corresponding vectors of coefficients ($1 \times m$) used to build the $3 \times m$ colour correction matrix, **M** (see Eqns 23.20 and 23.21).

The implementation of the matrix is achieved using the equivalent of Eqn 23.22. In this equation a 3×4 transformation matrix has been derived using polynomial regression with $m = 4$.

The performance of the derived matrix can be assessed by examining the colour differences between original and estimated from the transformation CIELAB values, for the training set and a testing set of colour samples. The latter may be the colour patches in the test target which were not used in the regression. Figure 23.8 illustrates the distribution of ΔE^*_{ab} colour differences for a training and a testing set of colours, when implementing a 3×14 colour matrix to characterize the responses of a film scanner. Figure 23.9 shows how these colour differences vary according to the lightness of the individual colour samples.

The best polynomial used for characterizing an input device varies with the device characteristics and measurement accuracy. As mentioned earlier in the chapter, input device responses are usually not linearly related to CIE colorimetry; thus a higher than first order polynomial may be required in the regression to derive a suitable matrix for colour transformations. High-order transformation equations may return lower colorimetric errors for the training set of colour samples, but can lead to poor performance when applied to independent data — such as the testing set of colours — or the scanned image data. This is a result of fitting the noise present in the measurement in addition to the desired systematic trends.

For the inverse colour transformation, i.e. from CIE XYZ to scanner RGB, polynomial regression can be used to derive a new matrix of coefficients. The regression in this case is applied to the tristimulus data (independent variables) and (one at a time) to R, G, B values (dependent variables) to compute a new set of coefficients. The derived polynomial will not map the sample points to their exact original value.

The framework of characterization of digital still cameras is common to that of scanners. The characterization of cameras is, however, more ambiguous, mainly because the lighting conditions during capture are often uncontrolled and can vary widely. It is advisable to characterize the camera for a set of common illuminants, or characterize for one only and use the camera white balance settings to set the white point equal to that illuminant. Similar test charts to those employed for characterizing scanners can be used. Uniform illumination must be ensured during the recording of the target, setting a viewing/illuminating geometry of 0/45 (see Chapter 5). Since camera lenses do not transmit the light uniformly across the capturing frame, a grey card may be recorded prior to characterization for tracing any spatial non-uniformities, which can later be corrected. It is useful to sample the grey card densities at set distances, as the card itself might not be totally uniform.

GAMUT MAPPING

The range of reproducible colours of digital imaging systems varies between devices, media and viewing conditions. Therefore, *colour gamut mapping* is a necessary step of the imaging workflow. Gamut mapping deals with the adjustment of the colours of an input device, or an encoded image, to fit the colour range of the reproduction

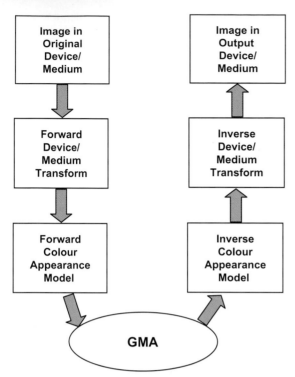

Figure 23.12 Gamut mapping in the imaging workflow.
Diagram adapted from Green and MacDonald (2002)

device and media. It is performed via gamut mapping algorithms (GMAs), the aims of which vary with application.

The main factors affecting the performance of GMAs are the characteristics of the original and reproduction systems, the colour space in which the gamut mapping is taking place and the characteristics of the image to be mapped.

Gamut mapping is performed in images originating and reproduced in devices which are characterized (or profiled – see Chapter 26). The success of the characterization is important, since characterization errors may be perpetuated further during mapping. Figure 23.12 illustrates where the gamut mapping takes place in the imaging workflow.

Gamut mapping aims

There are many possible ways to map colours from a system to another. The choice of method (and thus of GMA) is based on the *objective of colour reproduction* (see Chapter 5). A way to narrow these objectives is to split them into two broad categories: accurate and pleasing reproduction. The aim of accurate reproduction is to maintain the appearance of the colours and to render them as close as possible to the original image colours, whereas the aim of pleasing reproduction is to achieve an overall pleasing image regardless of the original. For the purpose of

ICC colour management systems four *rendering intents* have been defined: perceptual, saturation, media-relative colorimetric and ICC absolute colorimetric. For each, different gamut mapping techniques are employed. Details on these intents are provided in Chapter 26. Briefly, for the perceptual rendering intent, GMAs which preserve the contrast of the image are employed. This rendering intent is particularly applicable to pictorial images, where the overall pleasantness of the reproduction is more important that its colorimtric accuracy. The saturation rendering intent employs algorithms which preserve the vividness of the colours but do not obligatorily maintain their hue. In media-relative colorimetric rendering intent, gamut mapping aims to maintain the colorimetry of the original in-gamut colours but adapt them with regard to the white point of the reference medium. Finally, for absolute colorimetric intent the in-gamut colours at output are chromatically adapted with respect to the input and remain unchanged. The first two rendering intents can be classified as 'pleasing' whereas the second two are classified as 'accurate'.

Gamut mapping techniques

There are two possibilities for performing gamut mapping: *device-to-device*, which is an image-independent mapping between the gamuts of the original and reproduction devices; and *image-to-device*, which is an image-dependent mapping, resulting in the smallest possible distortions in the image.

Implementation of gamut mapping requires information on the gamuts of the original and reproduction systems. Thus, before implementation, it is necessary to compute first the *gamut boundary descriptor* (GBD). This can be achieved via the characterization models of the devices. Specific methods for defining image gamuts as well as media gamuts are available. Then, the intersection between the gamut boundary and a given line along which the mapping is to be carried out, *the line gamut boundary*, has to be identified.

The majority of GMAs are aimed to work with perceptual attributes of colour, such as lightness, chroma, colourfulness, saturation and hue (see Chapter 5). Most proposed algorithms work with CIELAB or CIELUV colour spaces and thus the mapping is carried out in those space dimensions. However, the representation of hue in these spaces does not always correlate well with perceived hue, especially in the blue region. More recently, CIE colour appearance spaces and their coordinates have been used for mapping.

GMAs can be broadly divided into two types: *gamut clipping* and *gamut compression*. Gamut clipping algorithms only change colours which are located outside the reproduction gamut (Figure 23.13). Gamut clipping may be carried out before or after *lightness compression* (see later). This method minimizes the colour shift and maintains (as much as possible) image saturation, but some details of the

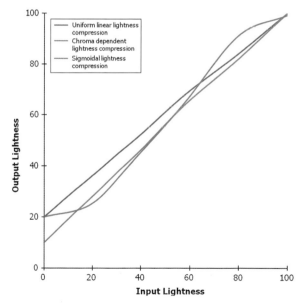

Figure 23.13 Gamut clipping vs. gamut compression.

image can be lost because many colours may be mapped to the same point on the reproduction boundary. Gamut compression algorithms change the position of all colours from the original gamut, so as to distribute the differences caused by gamut mismatches across the entire range of colours. This method aims to preserve the relative relationship between colours. Therefore, image details are not necessarily lost at the gamut boundary. Other unwanted artefacts can, however, be caused because of the changes in the in-gamut colours (e.g. unwanted decrease in saturation).

Most existing GMAs start with lightness mapping. A good reproduction should maintain the tones of the main regions in an image, whereas the tone of the less important parts should be compressed. There are various types of lightness mapping techniques, such as clipping, soft clipping, linear compression and the use of sigmoid functions (similar to the characteristic curve), which preserves not only overall contrast but also shadows in the dark image areas. Figure 23.14 shows different types of lightness compression.

Chroma mapping can be achieved via linear or non-linear functions (such as sigmoid and knee functions). A sigmoid non-linear scaling function maps chroma in three regions: for the lower chroma region the colorimetry and low-end contrast are preserved by setting the input value to output value directly; for the middle region, the chroma is increased to overcome the loss in chromatic contrast associated with the GMAs; for the high chromatic region, the out-of-gamut chroma is compressed into the destination gamut.

Figure 23.14 Different types of lightness compression. *Diagram adapted from Green and MacDonald (2002)*

Finally, as the tolerance of the human visual system to shifts in hue is very small, most GMAs aim to preserve the hue as much as possible, but there are some which prioritize the reduction of chroma losses.

The CIE (TC8-3) recommends guidelines that cover numerous aspects of GMA evaluation, including test

images, media, viewing conditions, measurement, gamut boundary calculation, colour spaces and experimental methods. Two GMAs are currently recommended by the CIE:

1. HPMDE (hue preserving minimum ΔE^*_{ab}) keeps colours on the intersection of the original and the reproduction gamuts unchanged and modifies original out-of-gamut colours by clipping them to a point in the reproduction gamut that results to the smallest ΔE^*_{ab} in a plane of constant hue angle.

2. SGCK is also hue preserving; it uses chroma-dependent sigmoid lightness compression and a piecewise linear compression toward the lightness cusp of the reproduction gamut.

Details on these algorithms can be found in Green and MacDonald (2002) and Sharma (2003).

BIBLIOGRAPHY

Adobe RGB 1998 Color Image Encoding, version 2005-05, 2005. Adobe Systems Inc.

Day, E.A., Taplin, L., Berns, R.S., 2004. Colorimetric characterization of a computer-controlled liquid crystal display. Color Research and Application 29 (5), 365–373.

Fairchild, M.D., Wyble, D.R., Johnson, G.M., 2008. Matching image color from different cameras. Proceedings of the SPIE/IS&T's Electronic Imaging 2008: Image Quality & System Performance Conference, Vol. 6808.

Green, P., MacDonald, L. (Eds.), 2002. Colour Engineering: Achieving Device Independent Colour. Wiley, Chichester, UK.

IEC 61966-2-1:1999, 1999. Multimedia Systems and Equipment – Colour Measurement and Management, Part 2-1: Colour Management – Default RGB Colour Space – sRGB.

IEC 61966-2-2:2003, 2003. Multimedia Systems and Equipment – Colour Measurement and Management, Part 2-2: Colour Management – Extended RGB Colour Space – scRGB.

IEC 61966-2-4:2006, 2006. Multimedia systems and equipment – Colour Measurement and Management, Parts 2–4: Colour Management – Extended-Gamut YCC Colour Space for Video Applications – xvYCC.

ISO 22028-1:2004, 2004. Photography and Graphic Technology – Extended Colour Encodings for Digital Image Storage, Manipulation and Interchange, Part 1: Architecture and Requirements.

ISO 17321-1:2006, 2006. Graphic Technology and Photography – Colour Characterisation of Digital Still Cameras (DSCs), Part 1: Stimuli,Mmetrology and Test Procedures.

ISO/TS 22028-2:2006, 2006. Photography and Graphic Technology – Extended Colour Encodings for Digital Image Storage, Manipulation and Interchange, Part 2: Reference Output Medium Metric RGB Colour Image Encoding (ROMM RGB).

ISO/TS 22028-3:2006, 2006. Photography and Graphic Technology – Extended Colour Encodings for Digital Image Storage, Manipulation and Interchange, Part 3: Reference Input Medium Metric RGB Colour Image Encoding (RIMM RGB).

Kang, H.R, 2006. Computational Color Technology. SPIE, WA, USA.

MacDonald, L.W., 1993. Gamut mapping in perceptual colour space. Proceedings of the IS&T/SID's 1st Color Imaging Conference, 193–196.

Sharma, G. (Ed.), 2003. Digital Color Imaging Handbook. CRC Press, Boca Raton, FL, USA.

Spaulding, K., 1999. Requirements for unambiguous specification of a color encoding: ISO 22028-1. Proceedings of the IS&T/SID's 10th Color Imaging Conference, 106–111.

Susstrunck, S., Buckley, R., Swen, S, 1999. Standard RGB color spaces. Proceedings of the IS&T/SID's 7th Color Imaging Conference, 127–134.

Triantaphillidou, S., 2001. Aspects of Image Quality in the Digitisation of Photographic Collections. Ph.D. thesis, University of Westminster, UK.

Chapter | 24 |

Noise, sharpness, resolution and information

Robin Jenkin

All images © Robin Jenkin unless indicated.

INTRODUCTION

Imaging systems transmit information and can be analysed using the procedures developed for other types of communication systems. In Chapter 7, the analysis of frequency response was introduced and developed as one of the most important of these procedures. In the context of images, this gives the means of assessing the progress of information carrying spatial signals through an imaging chain.

In common with other communication systems, this signal transfer proceeds against a background of noise. Indeed, the true effectiveness of a system for transmitting information can only be measured in terms of the signal-to-noise ratio. Most objective image quality metrics (see Chapter 19) involve some form of signal-to-noise component. In this chapter image noise and sharpness are further examined, and the ways in which these limit the usefulness of images and imaging systems as carriers of information. Fundamental measures, such as detective quantum efficiency (DQE) and information capacity, can then be defined without reference to the internal technology involved in the imaging system. The definitions use signal-to-noise (S/N) ratios, which in turn depend on the system modulation transfer function (MTF) and output noise power. These can all be measured from the output image. When applied to specific imaging systems and processes, these fundamental measures offer additional scope for modelling, which in turn allows a greater understanding of the limits of the various technologies.

IMAGE NOISE

Image noise is essentially the unwanted fluctuations of light intensity over the area of the image. It is a quantity

that usually varies over the image plane in some random way, although there are examples of image corruption from structured patterns such as sinusoidal interference patterns (sometimes referred to as coherent noise) and fixed pattern noise associated with charge-coupled devices (CCDs).

Figure 24.1 shows an image with and without noise. We usually consider the noise to be a random pattern added to (or superimposed upon) the true image signal. Although there is an intrinsic unpredictability, a random process can be defined statistically, for example by its mean value, variance or probability distribution. The spatial properties can be summarized by the *autocorrelation function* and the *power spectrum*.

Causes of noise in an image

1. Random partitioning of exposing light.
2. If an image is converted from a light intensity of exposure distribution to an electrical form, there will be photoelectric noise.
3. Electronic noise will occur in any system with electronic components.
4. Quantization noise occurs at the digitization stage in digital systems.
5. Poisson exposure noise means there is a randomness of photons in a nominally uniform exposure distribution.

The first of these is the cause of image noise in photographic systems where images exhibit noise due to the random grain structure of photographic negatives. The second and third cases are the main cause of image noise at the output of a CCD or complementary metal oxide semiconductor (CMOS) sensor. Case 4 occurs to a greater or lesser extent in all digital systems where a brightness value is quantized (or binned) into one of a finite number of values, as described in Chapter 9. Poisson exposure

Figure 24.1 (a) An image without perceptible noise. (b) The same image with increased noise.

noise is present in all images. It arises because the photons of light captured by the imaging system arrive randomly in space and time. The relative magnitude, and hence significance, of quantum noise will depend on the system and its use.

The best-known examples of noisy images occur with photographic systems. Anyone who has attempted an enlargement of more than about ×10 from a photographic negative will be familiar with the appearance of a grainy structure over the image. Photographic noise is well studied and the procedures for quantifying it are straightforward. A discussion of photographic noise is first presented with reference to the traditional black-and-white negative–positive process.

PHOTOGRAPHIC NOISE

Graininess

The individual crystals of a photographic emulsion are too small to be seen by the unaided eye, even the largest being only about 2 μm in diameter. A magnification of about

×50 is needed to reveal their structure. A grainy pattern can, however, usually be detected in photographic negatives at a much lower magnification, sometimes as low as only three or four diameters. There are two main reasons for this:

1. Because the grains are distributed at random, in depth as well as over an area, they appear to be clumped. This apparent clumping forms a random irregular pattern on a much larger scale than with the individual grain size.

2. Not only may the grains appear to be clumped because of the way in which they are distributed in the emulsion, but they may actually be clumped together (even in physical contact) as a result either of manufacture or of some processing operation.

The sensation of non-uniformity in the image produced in the consciousness of the observer when the image is viewed is termed *graininess*. It is a subjective quantity and must be measured using an appropriate psychophysical technique, such as the blending magnification procedure. The sample is viewed at various degrees of magnification and the observer selects the magnification at which the grainy structure just becomes (or ceases to be) visible. The reciprocal of this 'blending magnification factor' is one measure of graininess. Graininess varies with the mean density of the sample. For constant sample illumination, the relationship has the form illustrated in Figure 24.2. The maximum value, corresponding to a density level of about 0.3, is said to result from the fact that approximately half of the field is occupied by opaque silver grains and half is clear, as might intuitively be expected. At higher densities, the image area is more and more covered by agglomerations of grains and, because of the reduced acuity of the eye at the lower values of field luminance produced, graininess decreases.

We have so far referred only to the graininess of the negative material. The feature of interest in pictorial photography is likely to be the quality of a positive print made from that negative. If a moderate degree of enlargement is employed the grainy structure of the negative becomes visible in the print (the graininess of the paper emulsion itself is not visible because it is not enlarged). Prints in which the graininess of the negative is plainly visible are in general unacceptable in quality. Although measures of negative graininess have successfully been used as an index to the quality of prints made from the negative materials, the graininess of a print is not simply related to that of the negative, because of the reversal of tones involved. Despite the fact that the measured graininess of a negative sample decreases with increasing density beyond a density of about 0.3, the fluctuations of microdensity across the sample in general increase. This follows from the increase in grain number involved. As these fluctuations are responsible for the resulting print graininess, and as the denser parts of the negative correspond to the lighter parts of the print, we can expect relatively high print graininess in areas of light and middle tone (the graininess of the highlight area is minimal because of the low contrast of the print material in this tonal region). This result supplements the response introduced by variation of the observer's visual acuity with print luminance. Figure 24.3 shows the graininess relationship between negative and positive samples.

It is clear that print graininess is primarily a function of the fluctuations of microdensity, or *granularity*, of the negative. The graininess of the negative itself is of little relevance. Hence, when a considerable degree of enlargement is required, it is desirable to keep the granularity of the negative to a minimum.

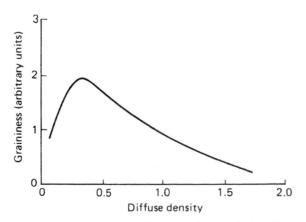

Figure 24.2 Graininess–density curves for a typical medium-speed film.

Figure 24.3 Graininess in negative and print. Left: enlargement of negative. Right: corresponding areas of print.

Factors affecting the graininess of prints

1. The granularity of the negative. As this increases, the graininess of the print increases. This is the most important single factor and is discussed in detail in the next section.
2. Degree of enlargement of the negative.
3. The optical system employed for printing and the contrast grade of paper chosen.
4. The sharpness of the negative. The sharper the image on the film, the greater the detail in the photograph and the less noticeable the graininess. It can be noted here that graininess is usually most apparent in large and uniform areas of middle tone where the eye tends to search for detail.
5. The conditions of viewing the print.

Granularity

This is defined as the objective measure of the inhomogeneity of the photographic image, and is determined from the spatial variation of density recorded with a microdensitometer (a densitometer with a very small aperture). A typical granularity trace is shown in Figure 24.4. In general, the distribution of a large number of readings from such a trace (taken at intervals greater than the aperture diameter) is approximately normal, so the standard deviation, σ (sigma), of the density deviations can be used to describe fully the amplitude characteristics of the granularity. The standard deviation varies with the aperture size (area A) used. For materials exposed to light, the relationship $\sigma\sqrt{2A} = S$ (a constant, termed the Selwyn granularity coefficient — see later) holds well and the parameter S can be used as a measure of granularity.

Factors affecting negative granularity

The following are the most important factors affecting the granularity of negatives:

1. Original emulsion employed. This is the most important single factor. A large average crystal size (i.e. a fast film) is generally associated with high granularity. A small average crystal size (i.e. a slow film) yields low granularity.
2. The developing solution employed. By using fine-grained developers it is possible to obtain an image in which the variation of density over microscopic areas is somewhat reduced.
3. The degree of development. Since granularity is the result of variations in density over small areas, its magnitude is greater in an image of high contrast than in one of low contrast. Nevertheless, although very soft negatives have lower granularity than equivalent

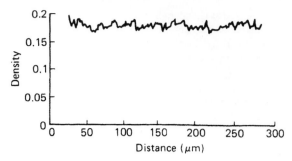

Figure 24.4 Granularity trace for a medium-speed film, using a scanning aperture of 50 μm.

negatives of normal contrast, they require harder papers to print on, and final prints from such negatives usually exhibit graininess similar to that of prints made from negatives of normal contrast.

4. The exposure level, i.e. the density level. In general, granularity increases with density level. Typical results are shown in Figure 24.5. This result leads to the conclusion that overexposed negatives yield prints of high granularity.

The first two factors are closely related, for just as use of a fast emulsion is usually accompanied by an increase in granularity, so use of a fine-grained developer often leads to some loss of emulsion speed. Consequently, it may be found that use of a fast film with a fine-grained developer offers no advantage in effective speed or granularity over a

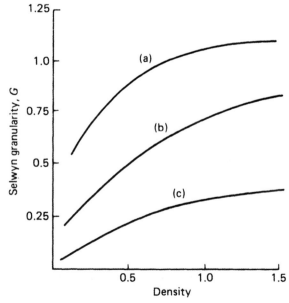

Figure 24.5 Granularity as a function of density for high- (a), medium- (b) and slow-speed (c) films.

slower, finer-grained film developed in a normal developer. In fact, in such a case, the film of finer grain will yield a better modulation transfer function and higher resolving power, and in consequence is to be preferred.

VARIATION OF GRANULARITY WITH DENSITY

Figure 24.2 shows the non-linear relation between graininess and image density for a typical silver image, while Figure 24.5 relates Selwyn granularity to density for monochrome films of differing speeds. In each case the images are silver, developed in a standard monochrome developer. In some commercial products, the monochrome emulsion contains colour couplers to yield a dye image in a colour developer, and the silver image is bleached away in the processing, leaving a dye image. This behaves differently from a silver image and is illustrated in Figure 24.6a and b. In Figure 24.6a the silver-image granularity is compared with that of the dye image, also generated by the *chromogenic*, dye-forming developer used. Both sets of granularity data are plotted against *visual density*. The dye image gives much lower granularity at high than at low densities, while the silver image possesses a slightly diminished granularity at high density. This product is normally treated in a combined bleach and fix bath after development, leaving only the dye image and giving the

dashed curve in Figure 24.6a. On the other hand, if the film is processed as a conventional monochrome film, a silver image alone is obtained and the granularity behaviour is more conventional (Figure 24.6b). This behaviour is important: conventional negative film gives grainier results on overexposure while chromogenic negative gives less grainy images. It means that chromogenic negative film can be overexposed considerably, i.e. rated at a lower ISO speed, giving the lower granularity associated with conventional negative films of that lower speed. Carefully formulated chromogenic negative film, using special colour couplers, can yield increased sharpness as well as decreased graininess, when rated at lower ISO speeds. The image density, however, will be higher than usual.

QUANTIFYING IMAGE NOISE

Methods for quantifying image noise are presented in the following sections in terms of the photographic imaging process, where noise fluctuations are measured in density units (denoted D). The methods can be applied quite generally to other imaging systems where the fluctuations might, for instance, be luminance or digital values.

Although we are dealing with two-dimensional images it is usual to confine noise analysis to one spatial dimension. This simplifies the methods and is entirely adequate for most forms of noise. We begin by assuming we have

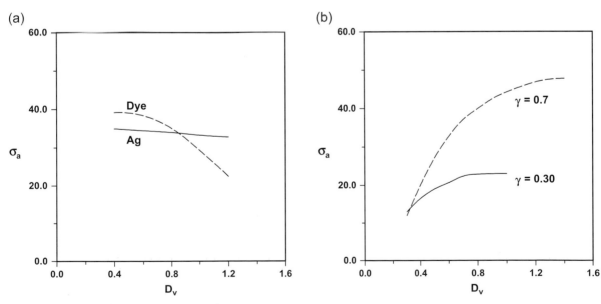

Figure 24.6 Granularity of chromogenic negative film, as a function of visual density, developed in: (a) colour developer for the recommended time and fixed, but with silver unbleached, silver and dye images being separately measured; (b) black-and-white developer at times giving the γ values shown.
© Geoffrey Attridge

a noise waveform $D(x)$ — the variation of output density in one direction across a nominally uniform sample image.

Variance

This is the mean square noise, or the total noise power, and is useful for summarizing the amplitude variation of the (Gaussian) random function. It is defined as:

$$\sigma^2 = \lim_{x \to \infty} \frac{1}{2x} \int_{-x}^{x} \Delta D^2(x) \mathrm{d}x \qquad (24.1)$$

where $\Delta D(x)$ is the deviation of $D(x)$ from the mean density.

Estimating σ^2

The expression for variance, σ^2, is replaced by a discrete version for the purpose of calculation:

$$\sigma^2 = \frac{1}{N-1} \sum_{i=1}^{n} \Delta D_i^2 \qquad (24.2)$$

ΔD_i is the ith measured value of the deviation. N values are recorded (where N is 'large', for example 1000) using a measuring aperture of area A. Note that this is simply the formula for sample variance found in textbooks on statistics.

Selwyn's law

Studies of photographic granularity show that, provided the scanning aperture area A is 'large' compared with the grain clump size, the product of σ_A^2 with A is a constant for a given sample of noise. This is known as Selwyn's law and means that $A\sigma_A^2$ is independent of the value of A. Hence $A\sigma_A^2$ can be used as a measure of image noise (granularity). Other measures include $\sigma\sqrt{A}$ and $\sigma\sqrt{2A}$. The latter expression is known as Selwyn granularity. This is often written as:

$$S = \sigma\sqrt{2A} \qquad (24.3)$$

where S is the measure of granularity.

Although σ or σ^2 can be used to describe the amplitude characteristics of photographic noise, a much more informative approach to noise analysis is possible using methods routinely used in communications theory. As well as amplitude information, these methods supply information about the spatial structure of the noise.

The autocorrelation function

Instead of evaluating the mean square density deviation of a noise trace, the mean of the product of density deviations at positions separated by a distance τ (tau) is measured for various values of τ. The result, plotted as a function of τ, is commonly known as the *autocorrelation function* $C(\tau)$. It is defined mathematically as:

$$C(\tau) = \lim_{x \to \infty} \frac{1}{2x} \int_{-x}^{x} \Delta D(x) \Delta D(x + \tau) \mathrm{d}x \qquad (24.4)$$

It includes a measure of the mean square density deviation ($\tau = 0$) but, equally important, contains information about the spatial structure of the granularity trace. Strictly, Eqn 24.4 gives the autocovariance of the signal and should be normalized by the variance to yield the autocorrelation function. The imaging field commonly uses the autocorrelation function and we will keep with this convention, but readers should be aware of the difference.

The importance of the function is illustrated in Figure 24.7, where a scan across two different (greatly enlarged) photographic images is shown. The granularity traces, produced using a long thin slit, have a characteristic that is clearly related to the average grain clump size in the image. The traces are random, however, so to extract this information the autocorrelation function is used. The two autocorrelation functions shown summarize the structure of the two traces, and can therefore be used to describe the underlying random structure of the image. Larger grain structures will generally produce autocorrelation functions that extend further, whereas finer grain will cause the autocorrelation function to fall more rapidly.

The noise power spectrum

The autocorrelation function is related mathematically (via the Fourier transform) to another function of great importance in noise analysis, the *Wiener* or *power spectrum*. This function can be obtained from a frequency analysis of the original granularity trace, and expresses the noise characteristics in terms of spatial frequency components.

A practical definition of the noise power spectrum is:

$$N(u) = \frac{1}{x} \left| \int_{0}^{x} \Delta D(x) \mathrm{e}^{-2\pi i u x} \mathrm{d}x \right|^2 \qquad (24.5)$$

It is essentially the squared modulus of the Fourier transform (see Chapter 7) of the density deviations, divided by the range of integration, x. Formally, the noise power spectrum represents the noise power per unit bandwidth plotted against spatial frequency. It is important to note that in practice Eqn 24.5 does not converge as longer data lengths are used. This is because the bandwidth of each measurement point becomes smaller and statistical error associated with measuring a random process (noise) remains. To overcome this problem data is generally divided into smaller lengths, Eqn 24.5 applied and the ensemble average of the results taken to yield an estimate

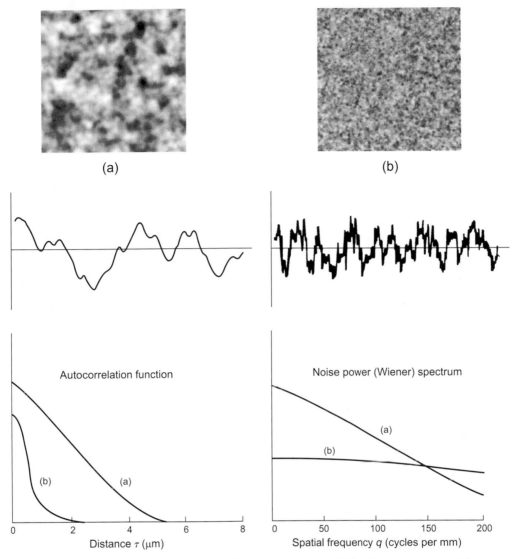

Figure 24.7 Autocorrelation functions and noise power (Wiener) spectra for two different image structures: (a) coarse grain; (b) fine grain.

of the noise power spectrum (see later comments in the section 'Direct Fourier transformation of noise samples').

The power spectra of the two granularity traces are also shown in Figure 24.7. It will be noticed that the trend in shape is opposite, or reciprocal, to that of the autocorrelation functions. The fine-grained image has a fairly flat spectrum, extending to quite high spatial frequencies. This reflects the fact that the granularity trace contains fluctuations that vary rapidly, as compared with the coarse-grained sample in which the fluctuations are mainly low in frequency.

Relationships between noise measures

For a given noise trace the three measures discussed above are related as follows:

$$\sigma^2 = \int_{-\infty}^{\infty} N(u)\,\mathrm{d}u \quad \text{and} \quad N(u) = \int_{-\infty}^{\infty} C(\tau)\mathrm{e}^{-2\pi iux}\,\mathrm{d}\tau$$

(24.6)

i.e.

- the variance is the area under the noise power spectrum;
- the noise power spectrum is the Fourier transform of the autocorrelation function.

Although the noise power spectrum and the autocorrelation function are closely related (one may be readily calculated from the other), they have very distinct roles in image evaluation. The autocorrelation function relates well to the causes of image noise while the power spectrum is important in assessing its effects.

In all the above, the equivalent two-dimensional versions of the definitions and relationships exist for the more general case of two-dimensional image noise 'fields'.

Practical considerations for the autocorrelation function and the noise power spectrum

In practice, image noise is sampled either intrinsically as in the case of digital systems or following some external scanning as in the evaluation of photographic images.

The expressions for the autocorrelation function and the power spectrum defined in the previous sections have discrete equivalents for the purpose of calculation. To use them, the sampling theorem must be obeyed for the results not to be distorted by aliasing.

The noise field (i.e. a two-dimensional image containing noise alone) is scanned and sampled using a long thin slit to produce a one-dimensional trace for analysis. In the case of photographic noise this is an optical scanning process and would typically use a slit of width 2–4 μm. The sampling interval δx must be selected to avoid aliasing (defined in Chapter 7), i.e.

$$\frac{1}{2\delta x} \geq u_c \qquad (24.7)$$

where u_c is the maximum significant frequency contained by the noise. In the photographic case u_c is likely to be determined by the MTF of the scanning slit (see Chapter 7). This means that the sampling interval δx may need to be as small as 1–2 μm.

For a digital imaging system, the philosophy is a little different. Whatever the source of noise in the digital image (see sources of electronic noise later in the chapter), it can only contain frequencies up to the Nyquist frequency (defined by the pixel separation). To evaluate the noise in the x direction and up to the Nyquist frequency for this virtual image, columns of data are averaged to produce a one-dimensional noise trace. To deal with noise in the y direction, rows of data are averaged.

The total number N of noise samples used must be large (e.g. 10,000) to obtain a reasonable degree of accuracy. In the photographic case a scan distance of 10–20 mm is required to achieve this. For a digital system, many frames containing noise will need to be evaluated.

Using the autocorrelation function

The first $(n/2 + 1)$ points of the autocorrelation function (this includes $\tau = 0$) are calculated using:

$$C'_j = \frac{1}{N-j}\sum_{i=1}^{N-j}\Delta D_i \Delta D_{i+j}, \quad j = 0,\ 1,\ 2...n/2 \qquad (24.8)$$

where n is selected using the sampling theorem:

$$\frac{1}{n\delta x} = \delta u \qquad (24.9)$$

where δu is the required bandwidth of the measurement (i.e. the interval along the spatial frequency axis at which the noise power spectrum values are required).

A Fourier transform of the n values of the (symmetrical) autocorrelation function gives the noise power spectrum. To ensure the values of the spectrum correctly represent the power in the original two-dimensional image, the function should be re-scaled as follows:

- Determine the variance, σ_A^2, when the noise field is scanned with a 'large' aperture of area A (i.e. large compared to the above slit width). In the photographic case this might be an aperture of size 50×50 μm². In the case of a digital image it will be an equivalent simulation.
- Form the quantity $A\sigma_A^2$. This is the required value of the noise power spectrum at the origin, i.e.

$$N(0) = A\sigma_A^2 \qquad (24.10)$$

Direct Fourier transformation of noise samples

The N values of noise are Fourier transformed directly. The squared modulus of the result is the noise power spectrum. Due to Eqn 24.9, this will have an extremely narrow bandwidth.

In other words, the spectrum is determined at very close intervals along the spatial frequency axis. Because noise is non-deterministic (averaging successive samples does not converge to a 'true' noise trace), each computed point in the spectrum is subject to high error, which does not reduce as the noise sample is lengthened. To get a reasonable estimate of the spectrum, blocks of adjacent spectrum values are averaged to increase the effective bandwidth and reduce the error per point (this is known as band averaging). The resulting noise power spectrum should be scaled as described in the previous paragraph.

Figure 24.8 shows noise power spectra for developed single-layer coatings of silver halide/cyan coupler with increasing concentrations of coupler DIR. The noise power spectra were measured with a microdensitometer fitted with a red filter. The sampling interval δx was 3 μm, giving a Nyquist frequency of 167 μm⁻¹. A slit of width 4 μm was used to supply optical low-pass filtration to avoid aliasing

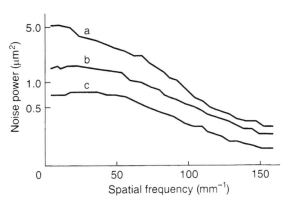

Figure 24.8 Noise power spectra for developed single-layer coatings of silver halide/cyan coupler with increasing concentrations of coupler DIR (a–c).

Curves redrawn from Graves, H.M., Saunders, A.E. (1984). The noise-power spectrum of colour negative film with incorporated couplers. Paper presented at the RPS Symposium on Photographic and Electronic Image Quality, Cambridge, September

Figure 24.9 (a) Image of a star (circular disc). (b) Trace across image, recorded with a scanning aperture the same size as the star.

of unwanted high frequencies into the region of interest. The sample size $N = 40{,}960$ gives a measurement bandwidth $\delta u = 8.14 \times 10^{-6} \ \mu m^{-1}$.

Blocks of approximately 600 points were averaged to give the final curves, which have an effective bandwidth of $5 \times 10^{-3} \ \mu m^{-1}$. It should be noted that some aliasing is likely to have occurred.

If the noise values are uncorrelated, the noise power spectrum will be constant at all frequencies ('white noise'). There is no point in evaluating the spectrum. All that is required is the value of $A\sigma_A^2$.

Signal-to-noise ratio

In communication theory, the signal-to-noise ratio (S/N) is the ratio of the information carrying signal to the noise that tends to obscure that signal. In the case of images, the signal is some measure of the amplitude, or contrast, of the wanted image structure. The noise is the equivalent measure of the unwanted, usually random, superimposed fluctuations.

The particular measures of signal and noise employed will depend on the type of image and the application. A simple example is obtained from the field of astronomical image recording. Figure 24.9a shows a star image in the form of a disc of area $A \ \mu m^2$ superimposed on a noisy background. If we imagine scanning across the image with an aperture of the same size as the star image, we would produce a trace of the form shown in Figure 24.9b. The maximum deflection, recorded when the aperture just sits on top of the star image, is shown as the signal strength, D_S. The standard deviation of the background fluctuations, σ_B, gives the corresponding measure of noise. The signal-to-noise ratio is defined as:

$$\frac{S}{N} = \frac{D_S}{\sigma_B} \qquad (24.11)$$

For more general images, particularly in digital form, a signal-to-noise ratio can be calculated by evaluating the total variance of the image σ_T^2 and the variance σ_N^2 of a nominally uniform portion of the image (the noise). The variance of the signal is then the difference $\sigma_T^2 - \sigma_N^2$ (assuming the noise is uncorrelated with the signal). The signal-to-noise ratio is then:

$$\frac{S}{N} = \frac{\sqrt{\sigma_T^2 - \sigma_N^2}}{\sigma_N} = \sqrt{\frac{\sigma_T^2}{\sigma_N^2} - 1} \qquad (24.12)$$

A more rigorous treatment of signal-to-noise is afforded by utilizing the ideas of Fourier theory. The signal is considered to be a set of spatial frequencies determined by the MTF of the image-forming system. The noise is represented by the image noise power spectrum. The signal-to-noise ratio is then dependent on the MTF of the system 'viewing' the image. Where the viewing system is the human observer the noise power spectrum is often presented in the form of a modulation threshold curve. This displays the minimum modulation necessary for a sinusoid

signal to be visible above the noise, as a function of spatial frequency. Expressions for perceived image quality can then be constructed.

ELECTRONIC SYSTEM NOISE

Noise is perhaps one of the most important limitations affecting any imaging system, and this is no different for CCD and CMOS sensors in digital cameras. There often exists a misconception that because the output is digital that it is more accurate, or not subject to noise in the same manner as in an analogue device. The measures and techniques described throughout this chapter are equally applicable to film and digital imaging sensors — the obvious difference being that working with photographic emulsions one has to digitize the response before analysis can take place.

In a similar manner to a photographic emulsion, digital imaging sensors have unique sources of noise, a number of which are described below.

Photon shot noise. A perfect detector will be subject to the limitations of the light falling on it. As mentioned previously, light randomly arrives at the sensor and at any one moment in time there will be a random deviation from the mean level. As given above, the variance of a nominally uniform patch containing N quanta will be given by \sqrt{N}. The signal-to-noise of the idealized exposure will then be:

$$\frac{S}{N} = \frac{N}{\sqrt{N}} = \sqrt{N} \qquad (24.13)$$

Thus, a perfect exposure of 7000 quanta will have an S/N or approximately $\sqrt{7000} \approx 84 : 1$.

Dark current or thermally generated noise. This is output that occurs without an input. It is caused by thermal generation of electron–hole pairs and diffusion of charge and can be reduced by cooling the device. Dark current exhibits fluctuations, similar to shot noise, so while the dark current average value can be subtracted from the output to provide the signal due to photoelectrons, the noise cannot. Termed dark current uniformity, the rate of dark current generation will also vary from pixel to pixel. A rule of thumb is that dark current approximately doubles for every 8°C increase in temperature. Therefore, cooling using liquid nitrogen or a Peltier device can reduce this significantly.

Readout noise. This occurs as the signal negotiates the readout circuitry necessary to convert it from an analogue signal to digitized values. This is sometimes combined with amplification and quantization noise. It should be noted, however, that even if amplification and quantization were perfect, some readout noise would exist. This is due to subtle variation in addressing circuits and wiring, and addition of unwanted random signals, and is not related to exposure level.

Amplification noise. This is a combination of two sources, white and flicker noise, and is dependent upon sample rate. White noise generally occurs at higher sample rates whereas flicker, sometimes know as $1/f$ noise, occurs at lower rates. As CMOS sensors generally have additional amplification on pixels, this can be a source or variation between pixels.

Reset noise. Before the integration of the charge for the next exposure, the photoelement is reset to a reference voltage. Each time the photodiode is reset there is a slight variation which is added into the signal.

Pixel response non-uniformity (PRNU). Each pixel will exhibit a slight variation in sensitivity to a uniform exposure. This is due to natural variation in the manufacturing process. Exposing the sensor to a uniform source will create a flat field which may be used to correct the image.

Defects. Whilst a working pixel may exhibit PRNU, defective pixels do not effectively detect a signal. Hot pixels saturate very quickly, generating maximum output regardless of the input signal. Dark or dead pixels do not respond to light. Most sensors incorporate defect detection and correction, replacing the defect value with one interpolated from the surrounding pixels. If the sensor has sufficient on-board memory, a defect map may be created to store the locations. In CCDs the defective pixels may also act as a trap and inhibit the transfer of the signal. More seriously, entire columns, rows and larger areas can be affected.

Fixed pattern noise. As the name suggests, this is noise that is consistent from frame to frame. This can include noise from a lot of effects and often defects are included in the description. Slight variations in Bayer filters, dust and manufacturing processes can all contribute to the effect (Figure 24.10).

Clock signals and other interference. Especially in the case of CCDs, reading the image so that it may be output from the sensor requires accurate timing. The signals generated from the clock may sometimes interfere with the image.

Figure 24.10 An enlarged example of fixed pattern noise and defective pixels from a commercial digital stills camera. Contrast has been enhanced to make the noise more apparent.

Interference from other electrical devices, such as motors, and static discharge can also affect the signal. This effect will be familiar with the users of electric drills.

It is worth noting that for a number of reasons noise does not have to be uniform across the field of view of a particular sensor. Charge transfer efficiency was mentioned in Chapter 9. Signals from those pixels that are furthest from the analogue-to-digital converter (ADC), thus requiring more transfers, will be subject to more charge transfer loss, therefore creating one source of asymmetry. In addition, Chapter 9 details the use of infrared filters, whose cut-off frequency is dependent on the angle in incoming light. This causes fall-off of the red channel towards the edge of the field of view. Lens vignetting and the \cos^4 law (Chapter 6) further cause the signal to be reduced for all channels (Figure 24.11). A common method for correcting this is to use flat-field correction. By exposing to a uniform light, the relative fall-off for each channel may be observed and corrected using the inverse. This will have the effect of amplifying the signal more at the edge of the field of view of the sensor, effectively increasing the noise and reducing the dynamic range in these areas.

Assuming noise sources to be uncorrelated, the total system noise σ_{SYS} can be obtained by adding together the individual noise powers. This requires that all noise sources be specified in equivalent output units (e.g. electrons or volts). For example:

$$\sigma_{SYS}^2 = \sigma_{DARK}^2 + \sigma_{PATTERN}^2 + \sigma_{READOUT}^2 + \sigma_{ADC}^2 \quad (24.14)$$

where $\sigma_{DARK}^2 =$ dark current, $\sigma_{PATTERN}^2 =$ fixed pattern noise, $\sigma_{READOUT}^2 =$ reset noise (from charge reading) and amplifier noise, and $\sigma_{ADC}^2 =$ quantization noise generated by the analogue-to-digital conversion, as detailed in Chapter 9.

In addition, the noise at the output, σ_{TOT}^2 will include a contribution from the input photon noise σ_q^2 so that:

$$\sigma_{TOT}^2 = \sigma_{SYS}^2 + \sigma_q^2 \text{ (expressed in output units)} \quad (24.15)$$

RESOLUTION, SHARPNESS AND MTF

Resolution, sharpness and MTF are all related to micro-image (spatial) properties of a system, but they are not equivalent and cannot be used interchangeably, as is often mistaken. Resolution describes the finest detail that may be recorded (or reproduced) by a system and depends on the basic imaging element (the point spread function, PSF), whereas sharpness essentially describes the recording of edges, or transitions, and depends on the ability of a system to reproduce contrast, especially at high spatial frequencies (see also Chapter 19). Figure 24.12a shows an image with high resolution but low sharpness and Figure 24.12b an image with low resolution and high sharpness.

When an image is presented to a viewer, the subjective impression of sharpness and resolution will depend largely on the viewing conditions and the context in which the image is shown. Therefore, whilst a high resolution or a sharp image may suggest more accurate recording of high spatial frequencies, the notion of high spatial frequency is relative. Additionally, depending on the level present, image noise may either mask, or in some cases enhance, the subjective impression of sharpness and detail.

Resolving power of photographic systems

A good example of a signal-to-noise-based decision is illustrated by the traditional measure of photographic resolving power. Generally, *resolving power* measures the detail-recording ability of systems, i.e. an objective measure of resolution. In silver-based photographic systems it is determined by photographing a test object containing a sequence of geometrically identical bar arrays of varying size, and the smallest size in the photographic negative, the orientation of which is recognizable by the eye under suitable magnification, is estimated. The spatial frequency of this bar array, in line pairs per millimetre, is the resolving power. Figure 24.13 shows some typical test objects.

The test object is imaged on to the film under test either by contact printing or, more usually, by use of an optical imaging apparatus containing a lens of very high quality. A microscope is used to examine the developed negative. The estimate of resolving power obtained is influenced by each stage of the complete lens/photographic/microscopic/visual system, and involves the problem of detecting particular types of signal in image noise. However,

Figure 24.11 An example of lens vignetting from a commercially available digital stills camera. Contrast has been increased to make the vignetting more apparent.

443

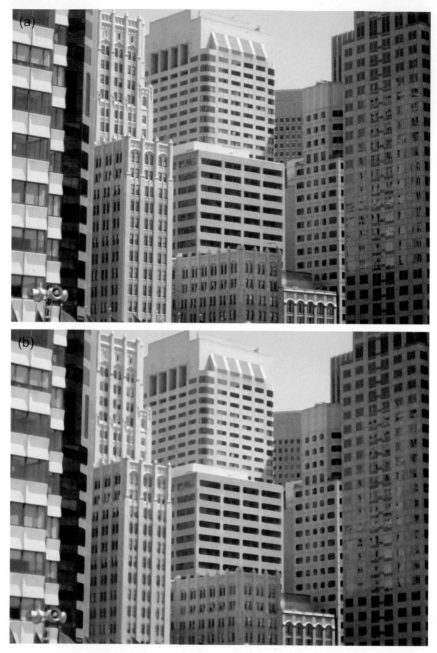

Figure 24.12 An image with high resolution but low sharpness (a), and low resolution and high sharpness (b).

provided the overall system is appropriately designed, the imaging properties of the photographic stage are by far the worst, and one is justified in characterizing this stage by the measure of resolving power obtained.

Because of the signal-to-noise nature of resolving power, its value for a particular film is a function of the turbidity of the sensitive layer, the contrast (luminance ratio) and design of the test object, and the gamma and graininess of the final negative. It is influenced by the type of developer, degree of development and colour of exposing light, and depends greatly on the exposure level. Figure 24.14 shows the influence of test object contrast and exposure level on the resolving power of a typical medium-speed negative material.

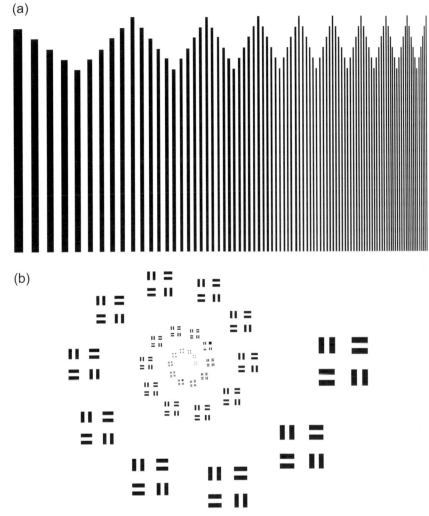

Figure 24.13 Typical resolving-power test charts. (a) Sayce chart. (b) Cobb chart.

The chief merit of resolving power as a criterion of spatial image quality lies in its conceptual simplicity, while taking account of several more fundamental properties of the system, including the MTF of the emulsion and optics, the noise power spectrum of the developed image, and the qualities and limitations of the human visual system. Very simple apparatus is required and the necessary readings are straightforward to obtain. Although it is not a measure of image quality, resolving power has been widely used as an indicator of the capabilities of photographic materials in reproducing fine image structure. It is important, however, to note that resolving power measurements, unlike MTF measurements (see Chapter 7 and later in this chapter), cannot be cascaded through the imaging components of a chain, i.e. the resolving power of the chain cannot be calculated from the resolving powers of the individual imaging components.

Measuring modulation transfer functions

The MTF, introduced in Chapter 7, when combined with noise power measurements, provides more information concerning the response of an imaging system than does resolving power alone. There is, however, an associated increase in the difficulty of implementation and interpretation of results. The sophistication of the experimental set-ups that are needed will generally be higher and more processing steps will need to be accomplished with higher

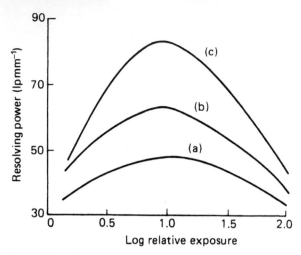

Figure 24.14 Variation of resolving power with exposure using test charts of increasing contrast (a–c).

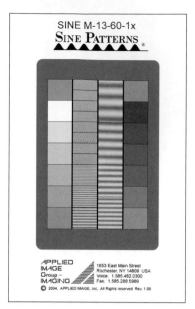

Figure 24.15 An example of a calibrated sine wave chart, M-13-60-1x, used to evaluate MTF.
Manufactured by, and courtesy of, Applied Imaging Inc., www. appliedimage.com. See bibliography for full information.

data volumes before results are available. Readers are encouraged to identify the final use of the derived information to help with the decision as to which imaging system evaluation methodology is best to use.

To evaluate MTF there are two main measurement classifications:

- Wave recording
- Edge methods.

Wave recording – sine-wave method

This is a fairly traditional approach for the analysis of optical and photographic systems. A chart containing a range of spatial frequencies (i.e. sinusoidal intensity patterns varying in one orientation) is recorded by the system under test. Figure 24.15 illustrates such a target. The dynamic range of the signal (i.e. the exposure range) is made low enough to ensure effective linearity, i.e. linear input-to-output intensity is required. Alternatively, the input-to-output non-linearity is first corrected (the inverse relationship is applied to linearize the ouput signal) before the image modulation is determined.

For each frequency the image modulation is determined from a scan of the image. This is divided by the corresponding input modulation to obtain the modulation transfer factor (see Chapter 7). A plot of modulation transfer factor versus spatial frequency is the MTF of the system. Note that the frequency quoted is usually specified in the plane of the detector. Therefore, magnification of the test target needs to be accounted for. Multiplying the test target frequency by the magnification gives the frequency in the plane of the detector (see Eqn 24.17).

In sampled (digital) systems it is increasingly difficult to produce results up to the Nyquist limit with the sine-wave method due to phase and noise issues. At high spatial frequencies, the sensor's elements are rarely perfectly aligned and in-phase with the target's periodic intensity patterns. Image noise worsens this problem.

Wave recording – square-wave methods

Because of the ease of production of accurate square-wave objects, so-called square-wave frequencies are often employed. Using the same steps as in the sine-wave method, the square-wave MTF, $M_{SQ}(u)$, is constructed. Fourier series theory gives the conversion to obtain the correct MTF as:

$$M(u) = \frac{\pi}{4}\left[M_{SQ}(u) + \frac{1}{3}\ M_{SQ}(3u) - \frac{1}{5}\ M_{SQ}(5u)\right.$$

$$\left. + \frac{1}{7}\ M_{SQ}(7u) - K\right] \tag{24.16}$$

where u is the spatial frequency of the square wave.

Edge input method

This method is important because it requires no special patterns for input. Theoretically, a 'perfect edge' contains an infinite number of frequencies and therefore it is the perfect input signal for testing the spatial frequency response of a system. Edges are commonplace objects in most scenes.

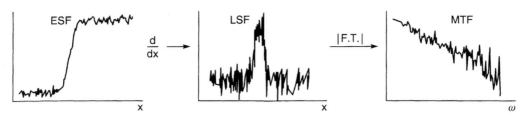

Figure 24.16 Derivation of an MTF from an edge spread function.

The main disadvantage of the method lies in its sensitivity to noise, because of the small area of image used. Again, the edge target needs to be of low contrast to ensure effective system linearity, or the recorded image needs to be corrected, as with the sine-wave method, before any calculations.

The method involves scanning the image of the edge to produce the edge spread function (ESF; see Chapter 7). This is differentiated to obtain the system's line spread function (LSF). The modulus of the Fourier transform of the LSF, normalized to unity at $u = 0$, is the required MTF. The procedure is illustrated in Figure 24.16. The measured MTF contains the spatial frequency content of the edge target. It can be corrected, if necessary, using the cascading property, described later.

It should be noted that noise will influence the highest frequencies the most, because of the differentiation stage. Even if the ESF is smoothed prior to differentiation, the uncertainty in the resulting MTF still remains and will generally cause the MTF to be overestimated at higher spatial frequencies.

The edge method, whilst useful, suffers from difficulties when applied to sampled (digital) systems. Relative alignment of the edge with the sensor array will cause variations in the result due to aliasing and phase effects. Any angular misalignment results in softening of the edge when column averaging is performed. Additionally, MTFs may only be calculated to the Nyquist frequency because of the sampling theorem.

Slanted edge method

As a response to the above difficulties in MTF evaluation of sampled systems, the slanted edge technique was developed and has since been adopted as an ISO standard (ISO 12233:1999).

The technique is illustrated in Figure 24.17. An edge (A—B) is projected on to the detector at a slight angle to the vertical. The output from any one row will be an under-sampled edge trace. However, if successive rows are combined in the correct interlaced order, we obtain a single edge trace that has been very closely sampled. This trace is then differentiated and the modulus of Fourier transform is taken to yield an accurate measure of the horizontal spatial frequency response (SFR), measured well beyond the practical Nyquist limit.

The above response is named SFR, as opposed to MTF, as it takes no account of the spatial frequency content of the edge target, or of attempts to separate system components. Practically, however, the target has little effect on the result if imaged at a low magnification (e.g. 1/50th). A standard target for the measurement is available. Standard test targets for measuring SFR are shown in Figure 24.18a and b. A typical digital camera SFR is illustrated in Figure 24.19. A number of commercial pieces of software have plug-ins available to calculate SFR. The method has become popular

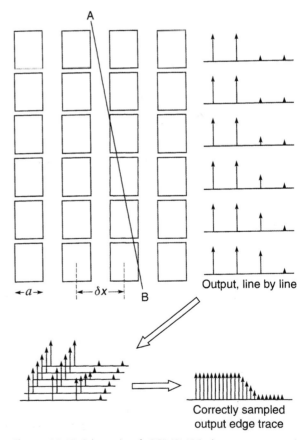

Figure 24.17 Schematic of CCD/CMOS detector array and illustration of the principle of the slanted edge method for SFR measurement.

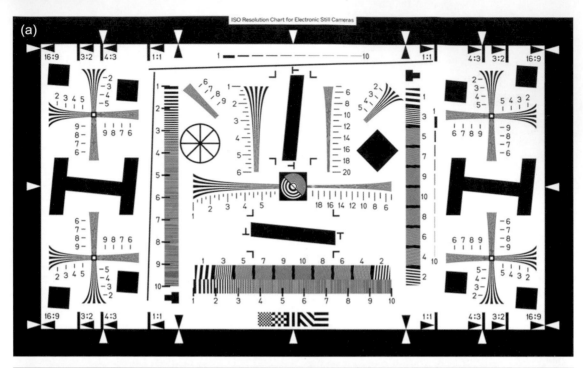

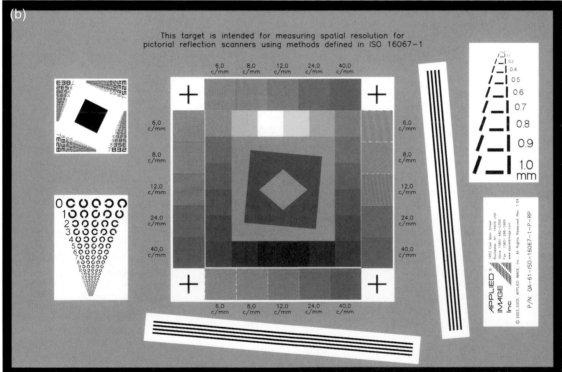

Figure 24.18 (a) The test chart used for ISO 12233 SFR measurement and (b) the test target specified for reflective scanners in ISO 16067-1. The test target shown in (b) has lower contrast and therefore some advantages for systems with non-linear components. *Permission to reproduce extracts from ISO 12233 and ISO 16067-1 is granted by BSI. Test target example in (b) manufactured by, and courtesy of, Applied Imaging Inc, www.appliedimage.com. See bibliography for full information.*

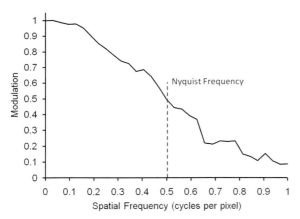

Figure 24.19 A typical SFR for a commercial digital camera with pixels of 9 μm in size. Also indicated is the Nyquist frequency, beyond which aliasing can occur if not controlled.

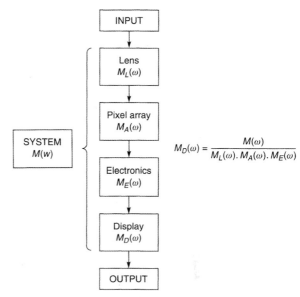

Figure 24.20 The relationship between the MTF of a display device and the complete imaging chain, assuming linearity.

because of its ease of use and the software tools available. SFR may be treated as MTF by correcting for the target using the cascading property below.

MTF/SFR provides useful measures for system design and analysis. Generally, the point at which the MTF/SFR drops to 10% will be measured as the resolution limit. Algorithm designers will also use the MTF/SFR to indicate where digital amplification of the signal may result in objectionable noise. MTF will often be used as a design criteria with respect to position in the field of view to specify lens designs.

MTF correction

With all the above methods, the measured MTF will generally be that for a system containing a chain of processes. For example, in the analysis of photographic film some form of scanning device is required to extract the spread function. When measuring the MTF of a CCD array, a lens will normally be included.

Each of these processes has its own MTF. The cascading property states that *these multiply together to produce the system MTF.* This is provided that the processes and the links between them are linear. Therefore, coherent optical systems will not cascade in this manner.

The effect of an individual process may therefore be removed from the overall measurement by dividing by that MTF (at least, up to the frequency at which noise dominates). Figure 24.20 illustrates this procedure for a digital acquisition and display chain.

It should be noted that the correction becomes unreliable in areas where any component MTF curve approaches zero or small values relative to the other components, as it forces the resultant curve towards infinity. A pragmatic approach is to estimate the error in the result as

proportional to the reciprocal of a lowest value in any component curve at each spatial frequency.

Resolving power and MTF for optical systems

It is sensible to test any optical system, usually to estimate the available maximum and minimum *resolving power* (RP; see Chapter 6) values and threshold contrast. A complete system can be evaluated together with any environmental effects such as vibration, different systems can be compared and a check kept on the maintenance of an agreed or necessary performance. Methods of testing can either be by *field testing* or be studio based.

Field testing is concerned with: actually taking pictures under typical user conditions to evaluate human and environmental factors; the type and quality/quantity of subject lighting; latent image effects for delayed processing; the effect of subject matter on image quality, and of subject distance or movement. Subjective judgements of the final image can be scaled on the basis of either a three-point Pass/Acceptable/Fail system or a quality scale from 1 to 5.

Field and studio testing can use a *collimator*, a compact optical instrument consisting of a well-corrected lens with a pinhole or illuminated test reticule at its rear focal plane. Viewing from the front gives the reticule at an artificial infinity. An *autocollimator* has a beamsplitter for direct viewing of a reticule in the focal plane, or on the film, photocathode or CCD array. It is possible to check focal length and focusing scale accuracy as well as misalignments

449

and aberrations. Field use allows quality control of a complete system of lens, mount and camera body.

Studio-based *resolution testing* is easy and cheap without specialist equipment. Limitations include use of finite conjugates, repeatability no better than ±10% and that no single *figure of merit* is given. The two basic methods are either to photograph with the lens under test a reduced image ($m = 0.02$) of a planar array of test patterns (targets) covering the field of view, or use the lens to project an enlarged image ($m = 50-500$) on to a screen of a precision micro-image array of targets on a plate placed in the focal plane of the lens. The former method gives a result for the composite performance of the system, including detector, focus, vibration and image motion.

Various designs of test target are used, including the *Sayce chart, Cobb chart* and *Siemens Star*. The *USAF (1951) target* is widely used, having a three 'bar' design with bar and space of widths d and length $5d$. Target elements have size decreasing by factor of $^6\sqrt{2}$, equivalent to a 12% spatial frequency (u) change, where $u = 1/2d$ and a *line pair = 2d*. The RP limit is the value of $1/2d$ for an image in both orthogonal azimuths that is *just resolved*. Target frequency u_o and image frequency u_i are related by magnification m:

$$u_o = u_i m \qquad (24.17)$$

Target contrasts used are 1.6:1, i.e. $\Delta D = 0.2$; 6.3:1, $\Delta D = 0.8$; and 100:1, $\Delta D = 2.0$, where ΔD is the reflection density.

Optical resolving power is also given in *line pairs per mm* (lp mm^{-1}, lpm or mm^{-1}) as $RP = 1/2d$. The results are influenced by exposure, focus, processing and visual evaluation. Imaging performance can be assessed from inspection of RP figures for a range of conditions of focus, aperture, etc.

MTF data for optical systems is very useful. A direct use is the determination of best focus setting by the maximum response obtained. Optical design software often uses models of MTF to optimize lens designs in the later stages. It is useful to remind the reader at this point that only incoherent component MTFs may be cascaded; the phase of the light must be random. Practically, this means that for a multi-element lens, the MTF of the lens as a whole *is not* the MTF of the individual elements multiplied together.

A single MTF curve does fully describe lens performance and many curves are needed for different apertures, in monochromatic and white light, and at different focus settings, conjugates and orientations. Lenses can be compared directly under similar conditions and characterized from their MTF data as being, say, 'high image contrast but limited RP' or 'moderate contrast but high RP'. Both types give distinctive images and are preferred for specific types of practical work, typically general-purpose recording by the former and copying by the latter. Separate assessments have to be made of other image characteristics such as distortion and flare.

Sharpness, MTF and image quality

It is seen throughout this book — particularly in Chapter 19 — that image quality involves psychophysical processes acting on various physical attributes of the image. The MTF summarizes those attributes that contribute to such subjective impressions as *sharpness* and *resolution*.

The term 'sharpness' refers to the subjective impression produced by an edge image on the visual perception of an observer, produced by either film or a digital sensor. The degree of sharpness depends on the shape and extent of the edge profile, but being subjective the relationships are complex and difficult to assess. Traditionally, an objective measure of photographic sharpness, known as *acutance*, can be calculated from the mean-square density gradient across the edge. This involves very careful microdensitometry for photographic-type processes and is subject to high error. The result only partly correlates with visual sharpness.

The density profile of a photographic edge depends on the turbidity of the emulsion and on the development process. When adjacency effects are significant, enhanced sharpness often results. This phenomenon is used to advantage in many developer formulations, and is illustrated in Figure 24.21a. The density in the immediate neighbourhood of the high-density side of the edge is increased by the diffusion of active developer from the low-density side. Development-inhibiting oxidation products diffusing from the high-density side reduce the density in the immediate neighbourhood of the low-density side of the edge. The luminance overshoots created at the edge boundaries in the final image produce the sensation of increased sharpness.

The same approach and phenomenon form the basis of analysing digital imaging sensors. An edge profile may be imaged, after which digital values may be inspected to form 'traces', as above. In a similar manner, image-sharpening procedures used in digital image processing (see Chapter 27), such as the *crispening* operator, based on the *Laplacian*, create the sensation of increased sharpness by producing similar overshoots in the grey levels of pixels close to edges.

It was noted earlier that the line spread function of a system can be obtained from the first derivative of the

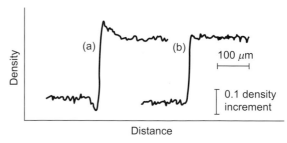

Figure 24.21 Edge traces for a typical medium-speed film in the presence (a) and absence (b) of edge effects.

Figure 24.22 The effect of blurring chrominance and luminance channels. (a) The original image. (b) Blurring only the chrominance information. (c) Blurring only the luminance information. The chrominance information is blurred using a Gaussian kernel 10 times wider than that of the luminance, yet the luminance degradation is more apparent.

edge profile. This suggests that there could be a relationship between sharpness and MTF.

In recent years much research has been conducted to establish models of image quality. In many cases MTF curves feature prominently in the derived expressions. The MTFs are for components of the imaging chain, including the human eye and visual system, and are weighted according to factors such as the type of image and the viewing conditions. As a simple example of this weighting process, consider an imaging system in which the luminance channel is separate from the colour channels. It is well known that the luminance MTF is more important than the colour MTFs as far as the perceived quality of the resulting images is concerned. In other words, provided that the greyscale image component is sharp, the final image can appear acceptable even if the colour component is blurred (Figure 24.22). Much recent research effort has been applied to the development of spatial-chrominance-based models of the human visual system, including the effects of visual masking, leading to better performing image quality metrics (see Chapter 19). This is only possible through the advancements in computing and numerical processing.

The value of quality metrics involving the use of MTF is that they can provide a very useful engineering link between the subjective human response and the need for hard engineering goals in the design of imaging products. It is becoming increasingly common for metrics to be used to estimate a *required* MTF to achieve a desired level of perceived image quality. The MTF may then be used as a design constraint in lens design software or for '*pixel engineering*'. Further, designing the MTF of lenses to match the CCD or CMOS sensor for which they are intended reduces aliasing and, in some cases, manufacturing cost. Because of its flexibility, MTF theory is considered to be one of the most important tools available to the image scientist.

DETECTIVE QUANTUM EFFICIENCY (DQE)

General considerations

Imaging systems work by detectors responding to light energy. The information contained in an exposure can in principle be measured in terms of the number and distribution of energy quanta in the exposure.

The efficiency of an imaging process in recording the individual quanta in an effective manner is therefore a valuable measure, particularly in applications such as astronomy, where exposure photons may be in short supply. Such a measure is *detective quantum efficiency* (DQE). Strictly it is a function of spatial frequency, involving the MTF and normalized noise power, together with a quantity $\varepsilon(0)$, which represents the effective fraction of quanta counted. These three parameters are responsible for degrading the image and thus lowering the information recording efficiency.

If we assume our exposures are low frequency, the MTF and normalized noise power are both unity, DQE becomes identical to the quantity $\varepsilon(0)$. This is defined in terms of signal-to-noise ratios as follows:

$$\mathrm{DQE} = \varepsilon(0) = \frac{\left(\frac{S}{N}\right)^2_{\mathrm{OUT}}}{\left(\frac{S}{N}\right)^2_{\mathrm{IN}}} \qquad (24.18)$$

where $(S/N)^2_{\mathrm{OUT}}$ is the squared signal-to-noise ratio of the image and $(S/N)^2_{\mathrm{IN}}$ is the squared signal-to-noise ratio of the exposure. $(S/N)^2_{\mathrm{OUT}}$ takes into account all the system inefficiencies associated with the effective recording of quanta (random partitioning of exposure, quantum efficiency of detector, random processes in amplification, etc.). It must be expressed in equivalent input exposure units. $(S/N)^2_{\mathrm{IN}}$ depends on the number of quanta in the exposure.

451

(a)

Star disc, area A μm^2 and intensity above background of I_S photons μm^{-2} s^{-1}

Background intensity I_B photons μm^{-2} s^{-1} on average

(b)

(c)

Figure 24.23 (a) Representation of a photon exposure pattern following an exposure time of T seconds. (b) Image where all photons are recorded but an MTF operates. (c) Typical image from real system where an MTF operates and only a fraction of the exposure photons are recorded.

An ideal imaging system would have DQE = 1 (100%). Real imaging systems have DQE < 1, e.g.:

TV camera (Orthocon) DQE ~ 0.1
CCD cooled DQE ~ 0.5
CCD uncooled DQE ~ 0.3
CCD Back thinned DQE ~ 0.8
Photographic emulsion DQE ~ 0.01
Human eye DQE ~ 0.03.

The concept of DQE can be illustrated with the help of Figure 24.23. In Figure 24.23a, a representation of an input photon pattern is shown. It comprises a disc of area A μm^2 and intensity above background of I_S photons μm^{-2} s^{-1}. The background intensity is I_B photons μm^{-2} s^{-1} on average. Suppose an exposure lasts for T seconds. The total number of photons contained in the disc (the signal strength) will be AI_ST. The mean number of photons present in an equivalent area A of the background is AI_BT. Because the distribution of photons follows Poisson statistics, the background is accompanied by a noise level of $\sqrt{AI_BT}$. The signal-to-noise ratio for this exposure is given by:

$$\left(\frac{S}{N}\right)^2_{IN} = \frac{AI_ST}{I_B} \qquad (24.19)$$

In other words, the signal-to-noise ratio increases as the square root of the exposure time. Since the background exposure level is just $q = I_BT$ photons μm^{-2} we can substitute for T in Eqn 24.19 to obtain:

$$\left(\frac{S}{N}\right)^2_{IN} = \frac{AI_S^2q}{I_B^2} = kq \qquad (24.20)$$

where k is a constant for the particular photon pattern, i.e. the squared input signal-to-noise ratio is proportional to the exposure level.

An 'ideal' imaging system would record the positions of each photon contained in this input pattern, and display an image identical in all respects. In other words, the image or output signal-to-noise, $(S/N)_{OUT}$, would equal $(S/N)_{IN}$.

Figure 24.23b shows an image of Figure 24.23a in which all quanta have been uniquely recorded, but the image elements corresponding to their detected positions have been moved, at random, a small distance to simulate light diffusion. This corresponds to an MTF that is not unity over the range of spatial frequencies contained. The disc is still visible although its edges are less well defined. In this example the signal-to-noise ratio is only slightly less than that for the exposure.

Figure 24.23c illustrates an image typical of a real process where only a fraction of the quanta is effectively recorded after light diffusion. The system amplifies the image elements to render the image visible. The image is now very noisy and the star is barely detectable. The signal-to-noise ratio for this image is very much less than that for the exposure. In terms of signal-to-noise, this image could be matched by an image from an 'ideal' system operating at a much lower background exposure level (q' say). In other words, although the actual exposure level is q, the result is only 'worth' the lower exposure level q'.

If the signal-to-noise ratio for this image is denoted $(S/N)_{OUT,REAL}$, we can write:

$$\left(\frac{S}{N}\right)^2_{OUT,REAL} = kq' \qquad (24.21)$$

Using Eqn 24.21, we can write the DQE for the real system as:

$$DQE = \frac{\left(\frac{S}{N}\right)^2_{OUT,REAL}}{\left(\frac{S}{N}\right)^2_{IN}} = \frac{q'}{q} \qquad (24.22)$$

Equation 24.22 indicates that the DQE of a real image recording process at an exposure level q is given by the ratio q'/q, where q' is the (lower) exposure level at which the hypothetical 'ideal' process would need to operate in order to produce an output of the same quality as that produced by the real process.

DQE for the photographic process

By expressing the signal-to-noise ratio of the photographic image in terms of sensitometric parameters, we can derive the following working expression for the DQE of a photographic emulsion:

$$DQE = \frac{\gamma^2 (\log_{10} e)^2}{qA\sigma^2} \qquad (24.23)$$

Here γ^2 represents the slope of the photographic characteristic curve at the exposure level q quanta μm^{-2}, $\log_{10} e$ is a constant and $A\sigma^2$ is the image granularity at the exposure level q.

Equation 24.23 is equivalent to writing:

$$DQE = \text{speed} \times \text{contrast}^2/\text{granularity} \qquad (24.24)$$

Such a relationship, happily, agrees with conclusions arrived at from a more intuitive commonsense approach to the problem of improving the quality of photographic images.

Figure 24.24 shows a DQE vs. log exposure curve for a typical photographic material. It can be seen that the function peaks around the toe of the characteristic curve and has a maximum value of only about 1% at best. Either side of the optimum exposure level, the DQE drops quite rapidly. This very low DQE is a characteristic of all photographic materials. They are not particularly efficient in utilizing exposure quanta. Fortunately, this is not significant in normal photography where exposure levels are high enough to ensure an adequately high output signal-to-noise ratio. In situations involving low light levels, however, such as may be encountered in astronomical photography, this low DQE is a severe limitation, and has led to the development of far more efficient image-recording systems to replace or supplement the photographic material.

DQE for a CCD or CMOS imaging array

CCD and CMOS imaging arrays are now the detector of choice in most imaging applications. So-called megapixel cameras are available that offer MTF characteristics comparable to those of photographic emulsions. They also exhibit significantly higher DQE than the photographic emulsion. In this section we introduce the processes that determine the DQE for such a device.

We begin by defining some necessary terms with reference to Figure 24.25, which shows the transfer function of a CCD array prior to analogue-to-digital conversion.

Responsivity, R. This is the slope of the straight-line section of the output–input transfer curve. Possible units are volts/joules cm^{-2}, volts/quanta μm^{-2}, etc. R depends on a number of factors (wavelength, temperature, pixel design) but can be broadly expressed as:

$$R = g\eta \qquad (24.25)$$

where g is the output gain (volts per electron) and η is the quantum efficiency.

Saturation equivalent exposure (SEE). This is the input exposure that saturates the charge well. If the dark current is considered negligible then we have (approximately):

$$SEE = V_{max}/R \qquad (24.26)$$

where V_{max} is the full-well capacity in volts and R is responsivity.

Noise equivalent exposure (NEE). This is the exposure level that produces a signal-to- noise ratio of 1. If the measured output noise is σ_{TOT} (rms) and if the dark current is considered negligible, then:

$$NEE = \sigma_{TOT}/R \qquad (24.27)$$

Sometimes the NEE is used as a measure of the sensitivity, S, of the detector.

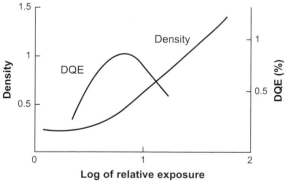

Figure 24.24 Detective quantum efficiency (DQE) as a function of exposure for a typical photographic material. The function peaks at an exposure level near the toe of the characteristic material.

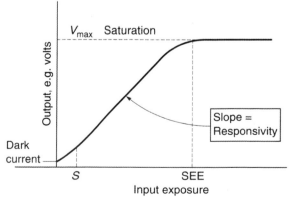

Figure 24.25 Characteristic curve of a CCD/CMOS array prior to analogue-to-digital conversion.

453

DQE and signal-to-noise ratio

Consider an exposure level q photons per unit area. The noise associated with this is $q^{1/2}$ photons per unit area (because photon arrival in space and time is governed by Poisson statistics).

Therefore, the signal-to-noise ratio of the exposure, $(S/N)_{IN}$, is:

$$(S/N)_{IN} = q/q^{1/2} = q^{1/2} \qquad (24.28)$$

so

$$(S/N)^2_{IN} = q \qquad (24.29)$$

This exposure will yield ηq photoelectrons per unit area and $g\eta q$ volts. The noise at the output due to these photoelectrons will be $\sigma_q = (\eta q)^{1/2}$ e$^-$ rms or $g(\eta q)^{1/2}$ volts rms. The variance is then $\sigma_q^2 = g^2 \eta q$ (using volts as the output unit).

The total output noise is therefore:

$$\sigma^2_{TOT} = \sigma^2_{SYS} + \sigma^2_q = \sigma^2_{SYS} + g^2 \eta q \qquad (24.30)$$

We must now express this output noise in terms of the input exposure units (i.e. we transfer the noise level back through the transfer curve):

Output noise, $\sigma_{EFF} = \dfrac{\sigma_{TOT}}{R}$, so that σ^2_{EFF}

$$= (\sigma^2_{SYS} + g^2 \eta q)/(\eta q)^2.$$

Hence:

$$(S/N)^2_{OUT} = q^2/\sigma^2_{EFF} = g^2 \eta^2 q^2/(\sigma^2_{SYS} + g^2 \eta q) \quad (24.31)$$

and

$$\varepsilon(0) = (S/N)^2_{OUT}/(S/N)^2_{IN} = q\eta^2 g^2/(\sigma^2_{SYS} + g^2 \eta q) \qquad (24.32)$$

Note that if there is no system noise, then the low-frequency DQE $\varepsilon(0) = \eta$.

Example

A photodetector has a quantum efficiency $\eta = 25\%$ and system noise σ_{SYS} equivalent to 20 electrons rms per unit area. What is the low-frequency DQE $\varepsilon(0)$ at an exposure level of (a) 1000 photons per unit area and (b) 10^5 photons per unit area?

Solution

Since output noise is given in terms of electrons per unit area, we can set $g = 1$ in Eqn 24.32:

$$\varepsilon(0) = (0.25)^2 1000/(0.25 \times 1000 + 20^2)$$
$$= 62.5/650 = 9.6\%$$

$$\varepsilon(0) = (0.25)^2 10^5/(0.25 \times 10^5 + 20^2 = 6250/25,400$$
$$= 24.6\%$$

The DQE function of Eqn 24.32, with the parameters of this example, is plotted in Figure 24.26. The curve is

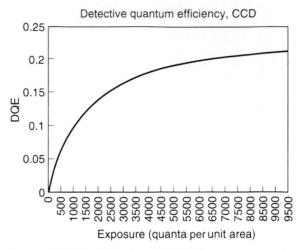

Detective quantum efficiency, CCD

Figure 24.26 The DQE of a CCD/CMOS imaging array. For high exposures (limited by the SEE) the DQE approaches the quantum efficiency, which in this example is 25%.

significantly higher than the peak DQE for typical photographic materials. For high exposure levels (up to the SEE), the DQE approaches the quantum efficiency of the device.

INFORMATION THEORY

Information theory supplies a mathematical framework within which the generation or transmission of information can be quantified in an intuitive manner. In other words, information can be measured precisely and unambiguously in a way easily understood and applied in practice. The reader is also directed to Chapter 29, where some of the background to the concepts described here (in particular the work of Claude Elwood Shannon, from which much of the theory originated) is further discussed.

The process of gaining information is equivalent to the removal of uncertainty. We speak of a *source* of information containing a number of possible *outcomes*. The uncertainty in the source depends on the probabilities of the individual outcomes. When a particular outcome is generated, that uncertainty has been removed. We have gained information. The uncertainty in a source is measured using the concept of *source entropy*. If a source has n possible outcomes, and the ith outcome occurs with probability p_i, then the source entropy is defined as:

$$H = \sum_{all\ i} p_i \log_2 \left(\frac{1}{p_i}\right) \text{ bits} \qquad (24.33)$$

where the unit, bit, takes the same definition as in Chapter 9. If the outcomes are all equally likely, the source entropy reduces to:

$$H = \log_2(n) \text{ bits} \qquad (24.34)$$

In a sequence of independent trials, where each trial generates an outcome, we gain H bits of information per outcome on average.

Information capacity of images

Suppose we have an image containing m independent pixels per unit area where each pixel can take on one of n different values (assumed equally likely). Each pixel can be considered as a source of information. According to Eqn 24.34 the entropy per pixel is given as $H = \log_2(n)$ bits. Regarding the image as an information channel, this means that each pixel is capable of carrying $\log_2(n)$ bits. We say that the *information capacity*, C, is $\log_2(n)$ bits per pixel or, more generally:

$$C = m \log_2(n) \text{ bits per unit area} \qquad (24.35)$$

As an example, consider a CCD image array comprising 1800 pixels horizontally by 1200 pixels vertically. If each pixel can independently take on one of 256 different levels, the information capacity of one frame is given as:

$$\begin{aligned} C &= 1800 \times 1200 \times \log_2(256) \\ &= 1800 \times 1200 \times 8 \\ &= 17{,}280{,}000 \text{ bits (over 2 megabytes)} \end{aligned}$$

The information capacity of a photographic emulsion is less easy to evaluate, since there is no readily identified pixel. The area of the point spread function at 10% has been used as an equivalent area. The number of recording levels, n, depends on the level of granularity. Such calculations yield values for the information capacity of camera speed materials of the order of 10^5 bits cm^{-2}. A 35 mm frame will therefore have a capacity of approximately 8.5×10^6 bits. It would appear that the digital system has overtaken the photographic process with respect to this measure of performance.

In practice the above information capacities are rarely achieved. To realize the idealized capacity in such a system, each pixel and intensity level in the system would be independent and noise free.

Correlation of neighbouring pixels occurs in images due to the subject being imaged. Therefore, the *information content* for a typical image will be much less than the information capacity, since for most meaningful images many neighbouring pixel values will be the same. We say there is redundancy.

Further correlation, not caused by the original signal, is also present and for digital devices may be attributed to the performance of the optics: Bayer-type colour array, interpolation, denoising algorithms, anti-aliasing filters and system electronics. This component may essentially be represented by the PSF of the imaging system as a whole and its width will indicate the extent to which correlation between neighbouring pixels exists. As the PSF widens, the number of independent imaging units within the image drops. Conversely, it may be imagined that if the combined PSF of all other components was smaller than a single pixel, the output would be ideal. Correlation amongst pixels in some digital devices can extend tens of pixels and thus the size of an imaging cell would be of that order.

Therefore, regardless of the number of pixels actually output by a given device, the PSF will more accurately represent the true number of independent imaging units or cells. This effect is important for purchasers of digital imaging equipment to consider. The reported number of pixels of the device will not necessarily relate to the final resolving power of the image. Certainly, if the pixel size is much smaller than the Airy disc of the accompanying lens, the value of the 'extra' pixels should be evaluated. A good 6 Mp digital camera can outperform a poor 10 Mp device.

The number of independent levels that an imaging unit may take is dictated by the noise present in the system. As noise in the image rises, it is increasingly difficult to predict with accuracy the original intensity of the subject. Thus, the number of independently measurable levels in the output falls. It should also be noted that a component of pixel correlation may be added by the effects of noise and may be assessed by evaluating the noise power spectrum of the device. Certainly, a more sophisticated treatment of information capacity as provided by Shannon defines the signal-to-noise as the ratio of signal-to-noise spectral powers at each spatial frequency, partially accounting for correlated noise effects.

Information capacity may be assessed for any system for which a reasonable estimate of the PSF and noise can be made. An important example of its application is in the context of image compression. Both information theory and compression are covered in more depth in Chapter 29; therefore, the following is mentioned briefly here as an illustration. Figure 24.27 shows the information capacity of

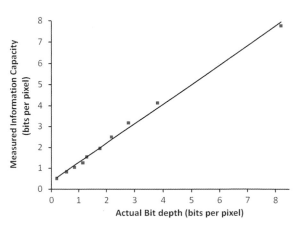

Figure 24.27 JPEG information capacity versus compressed file size.

JPEG 6b compressed images versus compressed file size. By treating blocking artefacts in JPEG compression as noise and evaluating the average PSF of the entire image using a comparison of pre- and post-compressed information, it is possible to calculate the information capacity at different quality factors. It may be seen that as information is discarded because of the compression of the image, the information content of the decompressed image also decreases.

Increasing interest in the information capacity of imaging systems exists, as it has been proposed that there is a degree of correlation between it and the perceived quality of images. In today's technology and socially networked society, we are looking to compression and processing techniques to intelligently handle and transmit images in systems such as cable TV, DVDs and the Internet. The use of information capacity allows these compression and processing techniques to be optimized, yielding the best possible image quality.

BIBLIOGRAPHY

Bolton, W., 1995. Fourier Series. Longman, London, UK.

Bracewell, R.N., 1999. The Fourier Transform and Its Applications, third ed. McGraw-Hill, New York, USA.

Castleman, K.R., 1996. Digital Image Processing. Prentice-Hall, Englewood Cliffs, NJ, USA.

Dainty, J.C., Shaw, R., 1974. Image Science. Academic Press, New York, USA.

Gleason, A. (translator), et al., 1995. Who Is Fourier? A Mathematical Adventure. Transnational College of LEX/Blackwell Science, Oxford, UK.

Gonzalez, R.C., Woods, R.E., 2008. Digital Image Processing, third ed. Addison-Wesley, Reading, MA, USA.

Gonzalez, R.C., Woods, R.E., Eddins, L.C., 2003. Digital Image Processing Using MATLAB®. Prentice-Hall, Englewood Cliffs, NJ, USA.

Goodman, J.W., 1996. Introduction to Fourier Optics (Electrical and Computer Engineering), second ed. McGraw-Hill, New York, USA.

Hecht, E., 1987. Optics, second ed. Addison-Wesley, Reading, MA, USA.

Holst, G.C., 1998. CCD Arrays, Cameras and Displays, second ed. SPIE Optical Engineering Press, Bellingham, WA, USA.

ISO/FDIS12233:1999(E) 1999. Photography – Electronic Still Picture Cameras – Resolution Measurements. International

Organization for Standardization, New York, USA.

James, J., 1995. A Student's Guide to Fourier Transforms with Applications in Physics and Engineering. Cambridge University Press, Cambridge, UK.

Proudfoot, C.N., 1997. Handbook of Photographic Science and Engineering, second ed. IS&T, Springfield, VA, USA.

Smith, E.G., Thomson, J.H., 1988. Optics, second ed. Wiley, Chichester, UK.

Permission to reproduce the M13-60-1x Sine Pattern test target in Figure 24.15, and the example ISO 16067-1 target in Figure 24.18b was granted by Applied Image Inc. Readers should note that an ISO 12232 target, as shown in Figure 24.18a with an extended spatial frequency range is also available. These and other targets are manufactured by Applied Image, Inc., 1653 East Main Street, Rochester, NY 14609, USA. Phone: +1 585 482 0300, Fax: +1 585 288 5989, E-mail: info@appliedimage.com website: www.appliedimage.com.

Permission to reproduce extracts from ISO 12233:2000 Photography—Electronic still-picture cameras—Resolution measurements, and ISO 16067-1:2003 Photography—Spatial resolution measurements of electronic scanners for photographic images—Part 1: Scanners for reflective media, for Figure 28.18, is granted by BSI. British Standards can be obtained in PDF or hard copy formats from the BSI online shop: www.bsigroup.com/Shop or by contacting BSI Customer Services for hard copies only: Phone: +44 (0)20 8996 9001, E-mail: cservices@bsigroup.com.

Chapter | 25 |

Digital image workflow

Elizabeth Allen

All images © Elizabeth Allen unless indicated.

IMAGING CHAINS AND IMAGE WORKFLOW

The management of digital images through an imaging chain is a complex operation. The huge range of options available in terms of hardware, software, file formats and image-processing techniques mean that there are many decisions to be made during the passage of the image from acquisition to output. These decisions affect the way the image is processed, which will ultimately define the number and visibility of artefacts produced, and therefore the overall image quality.

A generic digital imaging chain is illustrated in Figure 25.1. Input and output devices vary widely in technology and characteristics; therefore, the image must be manipulated in many ways as it passes through the chain. A *hybrid imaging chain* combines silver-halide-based processes with digital processes, for example scanning a photographic original which is then processed and output digitally.

Consideration of image workflow is an important aspect in the management of a digital imaging project. The workflow defines the sequence of operations to be performed and the order in which they occur. The main aim of a good workflow is to provide a framework which simplifies the decision-making process, allowing the user to work efficiently while producing optimum results for the particular imaging application.

The definition of a suitable workflow for a photographic project is dependent on various factors. Ideally, particularly for a large-scale digital project, workflow will be reflected upon prior to the purchase of equipment. More commonly, however, the workflow needs to be optimized within the constraints of the available equipment, software

and facilities. Obtaining and maintaining optimum image quality should be a primary concern, but must be balanced against the need for efficient processing, storage and cost. The requirements of the imaging application will ultimately determine the relative importance of these issues. If the image is to be processed for a specific output, then the workflow may be simplified. However, the future usage of the image is often more difficult to define and may be limited by this approach; this should also be a consideration in terms of decisions about both quality at capture and image archiving.

If the digital workflow is to adequately satisfy the needs of the application, then a thorough approach must be used, with thought given to the hardware settings to be used and the various image processes that may be applied in software. Technical aspects to be considered should include:

- the image resolution throughout the imaging chain;
- bit depth of the image;
- the necessity of interpolation (in resampling processes) and at what stage this should be performed;
- colour management and colour spaces to be used;
- where in the chain image adjustments or enhancements should be performed;
- whether automatic hardware settings may be an appropriate approach to speed up workflow;
- file formats to be used and whether lossy compression is possible or desirable.

This chapter aims to look at the implications of some of these issues. It is not meant to be a prescription for an ideal imaging workflow, rather a discussion serving to provide some background to the subject, enabling the user to consider technical aspects of the imaging chain in a coherent way when approaching their own digital imaging projects.

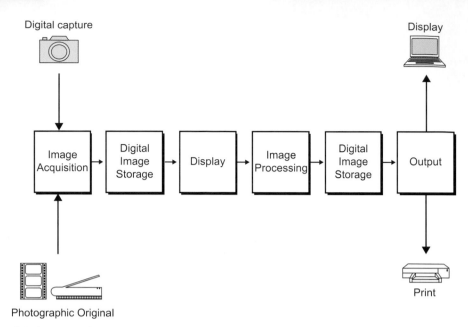

Figure 25.1 A digital imaging chain. Further stages may be included in the chain, for example an extra processing stage when capturing RAW files.

PRINCIPLES GUIDING EFFECTIVE WORKFLOW

The widely varying requirements of different imaging applications mean that it is impossible to determine a generic workflow suitable in all cases. It is possible, however, to establish a few general guidelines which may be applicable to multiple applications, as follows:

1. *Image quality at capture.* An overriding concern is image quality and key to this is optimal image quality at capture. One of the aims in the workflow should be to capture the image at the highest quality possible, within the limitations of the equipment and taking into account requirements for speed of processing.
2. *Image quality through the imaging chain.* Further to this, the workflow should endeavour to maintain image quality throughout the imaging chain, by minimizing the errors in the image introduced by various processes as it moves through the chain.
3. *Workflow approach based on image output.* Both the preceding guidelines must be balanced against the need for the image to be 'suitable for application'. This means that in some cases speed of processing and small output file size may be more important than maximum image quality.
4. *An efficient approach.* The workflow should be efficient, meaning that at all stages in the chain the aim should

be for a simplified approach if possible, with unnecessary processes being eliminated. The workflow must be flexible enough to allow for extra processing of individual images as required. Having a simple sequence of steps which will work for the majority of images will help to increase speed and minimize unnecessary quality loss.

5. *Repeatability.* An efficient approach will be repeatable, meaning that image processing is applied in an ordered and deliberate fashion where possible, rather than using an ad hoc approach which is much more difficult to replicate. It can also help to speed up image editing, as the processing steps become second nature to the user, and may facilitate automated (batch) processing.
6. *Interpolation.* Unnecessary interpolation should be avoided. If resampling processes are to be used, they should be kept to a minimum. Consideration should be given to the interpolation methods used and the point in the workflow where they will be applied.
7. *File formats.* The use of standard file formats ensures that results are predictable across different platforms, applications and imaging chains. File formats should be selected carefully in terms of their properties and suitability at a particular stage in the imaging chain (see Chapter 17 for more information on file formats). Thought should be given to the issue of image compression; lossy compression should only be applied if necessary (see Chapter 29).

8. *Colour management*. The aim of colour management is to ensure that tone and colour reproduction are controlled and produce predictable (and desired) results. This involves decisions about the colour space encodings to be used throughout the imaging chain and how and where colour conversions should occur. Unnecessary conversions between colour spaces should be avoided to minimize artefacts such as colour *banding* (a form of *posterization*, or colour contouring – see Chapter 19). In general, an 'open-loop' approach to colour management is desirable, allowing flexibility if further devices are added to the imaging chain. For the majority of projects, International Color Consortium (ICC; see Chapter 26) colour management provides an elegant solution and may be implemented with a greater or lesser degree of user input. It should be noted that an open-loop approach is not always required, for example in research applications, but these are a special case, in which colour is controlled by characterization and construction of transforms specific to the devices involved. In such cases, image workflow is defined entirely by and will be specific to the requirements of the project.

9. *Archiving data*. Image archiving requires decisions to be made in terms of suitable file formats, storage media and the way in which archived images are organized, managed and the image data will be migrated in the future. This subject is dealt with in detail in Chapter 18. Ideally, image data should be archived at several stages, before and after optimization.

10. *Data organization and retrieval*. The workflow should include a strategy for the cataloguing and retrieval of images, which requires a labelling system and keywords. Image database software and imaging workflow applications can assist in this process.

WORKFLOW APPROACH

It is important to consider image output and image quality requirements prior to workflow design. If the output is known and speed and efficiency are paramount, then the best approach may be to capture images specifically for that output, i.e. of sufficient resolution but no more. This may be termed a *production for output* workflow where the stages in the imaging chain are considered in terms of the requirements at output. The advantages of this approach are simplicity and speed. With size and required quality at output specified, the preceding steps are easy to define. Colour spaces that are optimum for mapping to the gamut of the output device may be selected during or after capture. It may be feasible to apply some image adjustments using batch processing. This type of workflow is suitable when dealing with high volumes of images in which the images need to be processed and delivered quickly, which are typical requirements of photojournalism and sports photography.

Producing images for a particular output may limit alternative usage, particularly if the images are of limited resolution, or if lossy compression has been applied. To maintain the widest possible range of options for image output in the future, a *production for optimum quality* approach may be used. In this case, images are captured at the optimum resolution of the capture device and remain at that resolution without resizing. Colour encodings are selected so that colour gamuts large enough to encompass the gamuts of a range of output devices and master copies are archived in an uncompressed file format. This approach is less efficient in terms of the necessary levels of image processing and storage. The same workflow requirements are typical of imaging applications dealing with low volumes of very-high-quality images, for example in high-end advertising, museum archives or editorial photography.

RESOLUTION AND THE DIGITAL IMAGING CHAIN

Resolution is an image attribute that has a significant effect on image quality, both in terms of the ability of the system to adequately represent scene content and also upon the subjective quality of the image as perceived by the viewer (see Chapters 19 and 24). Changes in pixel count in digital systems are predominantly achieved by interpolation (described below), which may introduce digital artefacts into the image. The impact of the image's pixel resolution and any changes in it must therefore be considered as a fundamental part of the image workflow.

The term resolution when discussed in relation to digital imaging systems can be confusing. As described in Chapters 19 and 24, the 'true' definition of resolution is as a measure of the detail-recording capability of a system. In digital imaging the term is applied in different ways. It is often used by camera manufacturers to describe the pixel count of a sensor. This is more correctly termed the pixel resolution and may be defined as the number of pixels horizontally and vertically, or as a combined figure in terms of *megapixels*, which describes the total number of pixels in millions of pixels. The spatial resolution of image sensors may alternatively be defined as described in Chapter 19 in terms of the number of available pixels per unit distance, commonly pixels per inch (ppi).

Pixel resolution is often quoted as a figure of merit when comparing different sensors. However, the actual detail-recording ability of the system, although related to this, is not defined by it. In comparing two sensors, the sensor

with a larger number of pixels will not automatically produce better image quality as many factors, including the sensor dimensions, will influence the size and shape of the point spread function.

The ability of the imaging chain to represent detail is not only dependent upon the capture resolution, but is also influenced by the resolution of any output device in the chain. As the image moves through the imaging chain, the number of pixels will remain the same unless cropping or resampling processes take place. However, these pixel numbers only become meaningful when considered in terms of device resolution, particularly that of the output device. Most devices in the chain will have a *native* pixel resolution, which may be defined as the maximum number of pixels that may be captured or reproduced without interpolation and is an inherent property of the system; this will frequently be described in pixels per inch (ppi). For output devices this will define the total number of pixels, and the maximum number of pixels per inch that can be reproduced without interpolation. Again, the effective spatial resolution of the output device will be defined by the size and shape of the point spread function (PSF) and various other factors (see Chapters 19 and 24). It should also be noted that a pixel displayed on a monitor may be represented by various different shapes and configurations of RGB triads (see Chapter 15). Furthermore, a printed pixel may actually consist of various configurations of groups of printed dots rather than

a single dot if digital half-toning is being used to represent continuous tone (see Chapter 16).

Interpolation

If the image has been captured at the native pixel resolution of the sensor and is to be displayed or printed at the native resolution of the output device, then each pixel from the input device will correspond exactly to a pixel in the output device. In this situation the spatial dimensions of the output image will be fixed by the number of pixels in the image. In many cases, however, the image will need resizing either up or down to achieve the required dimensions. The resizing of an image is a *resampling* process (sampling intervals are redefined), i.e. because there is no longer a 1:1 ratio between pixels at input and output, pixel values will be interpolated.

Because resampling to a lower resolution can produce aliasing of high frequencies within the image, better results may be produced by preceding the interpolation with a low-pass filtering stage, to remove the high frequencies. This process may be built in to specialized down-sampling algorithms and software.

Interpolation in the form of resampling may occur at multiple stages in the imaging chain. If the image is captured either by a scanner or a digital camera at a resolution other than the sensor's native resolution, then an interpolation algorithm is applied in the digital signal

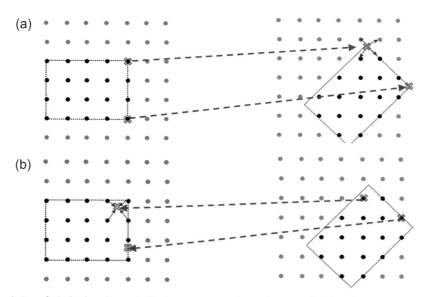

Figure 25.2 Interpolation of pixel values is required when rotating an image by an angle other than a multiple of 90°. This may be implemented in a forward mapping (a) in which the output position of every input pixel is calculated. In this case input pixel values falling between pixel positions will be split between the closest output pixels by interpolation. Note that one of the pixels has mapped to a position outside the image. The alternative is an inverse mapping (b), in which output pixel positions are mapped back to find their positions in the input image and their values are calculated as an interpolation between the input pixels closest to this position.

processor of the capturing device and, in the case of a digital camera, may be implemented prior to, in conjunction with or after colour demosaicing. Similarly, interpolation may be applied by the RAW conversion software (see Chapter 17). The default resolution identified for the image when it is opened in the RAW application interface is the actual number of pixels captured by the sensor and so corresponds to the native input resolution; anything else will be achieved by interpolation. Alternatively, resampling may be applied in an image-processing application. At output, images at resolutions other than the native resolution of the output device (if a printer) will usually be interpolated to that resolution by the device's software; hence, more predictable and theoretically optimum results will be achieved by sending the image to that device at that resolution to start with.

The resizing of an image is not the only operation involving interpolation. *Spatial* or *geometric transformations* of the image plane (such as rotation, translation, correction of geometric distortions and 'free transforms') involve the repositioning of all or some of the pixels within the image. These operations often result in pixels being mapped to positions between pixel coordinates (Figure 25.2), in which case the pixel values must be interpolated. They therefore represent a further potential compromise of image quality.

Interpolation methods and associated artefacts

The process of interpolation involves the estimation of new values from known values. In general, interpolation is an averaging process and therefore cannot provide an increase in the resolution of fine detail, i.e. new pixel values are generated, but new levels of detail are not resolved. *Non-adaptive* interpolation algorithms use the same interpolation method across the entire image plane. There are various approaches, which differ in terms of the size of the neighbourhood of pixels used in the calculation and the method of estimation used. The choice of a particular method is a balance between speed of processing, accuracy and resulting artefacts. More details on the bilinear algorithm mentioned below are given in Chapter 23.

The simplest approach to estimate new pixel values is *nearest neighbour* interpolation, which simply replicates image pixels, giving the new pixel the same value as its nearest neighbour (Figure 25.3a). This is the fastest method, but produces the greatest loss in quality, due to the artefacts incurred, and is used mainly for images containing illustrations with hard edges. Because pixel values are not averaged, but are copied, jagged artefacts will become particularly apparent on diagonal edges (see Figure 25.4b).

Bilinear interpolation estimates missing values by combining the values of the four closest pixels, fitting linear functions between adjacent points and then calculating the average value from these functions (Figure 25.3b). The

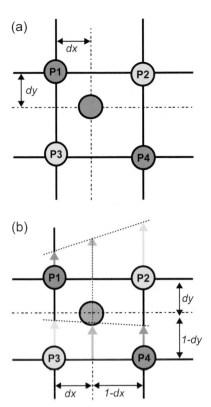

Figure 25.3 Non-adaptive interpolation methods. (a) Nearest neighbour sampling. (b) Bilinear interpolation. Note the difference in colour of the final pixel.

averaging process results in a slight blurring of the image (see Figure 25.4c). Bilinear interpolation is slower than nearest neighbour interpolation, but will produce fewer artefacts in continuous-tone images.

Bicubic interpolation is even more complex, using the values of 16 pixels and fitting a cubic surface function between them to provide an estimate of the new pixel value. The larger number of pixels used in the calculation and the complexity of the function mean that the estimation is more accurate compared to the previous two methods. This provides a significant improvement in image quality, with smoother results on diagonal edges but less overall image blurring (see Figure 25.4d).

Adaptive interpolation algorithms change their approach pixel by pixel for different types of image content to minimize the visibility of artefacts (see Chapter 14 for an example of an adaptive algorithm employed in digital cameras). Such algorithms may be implemented behind the scenes by a hardware signal processor to produce optimal results for that particular device. They may also be applied in proprietary software developed to manage specific imaging processes, such as image enlargement or printing. Many adaptive methods will apply a different

461

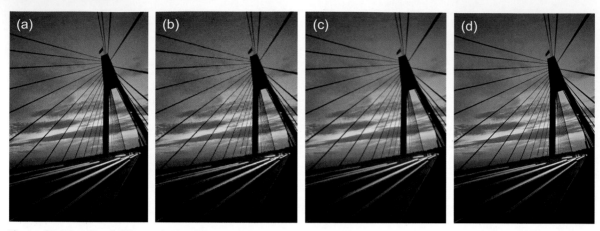

Figure 25.4 Results of different interpolation methods when resizing continuous-tone images. (a) Original image. (b) Nearest neighbour sampling results in severe pixelation and jagged artefacts on diagonals. (c) Bilinear interpolation produces improvement in jagged diagonals, but noticeable image blurring. (d) The best results are obtained using bicubic interpolation, which produces the fewest jagged artefacts and the sharpest images. The image has been resized to three times the size of the original.
Image 'Anzac Bridge at Night' © iStockphoto/TSKB/Tim Barrett

version of the algorithm at edges, as these are the image areas where interpolation artefacts are most visible. There are a number of adaptive methods now available in more recent versions of image-processing software which are optimized for specific resampling operations.

Interpolation and image workflow

Figure 25.4 illustrates the artefacts that may be introduced by interpolation algorithms used when resizing an image. Therefore, if these are to be minimized, interpolation should only be applied when absolutely necessary. As already described, the point at which interpolation is applied will be dependent upon the workflow approach.

For example, if the images are only to be used for a web page, then the maximum or native resolution of the sensor may be unnecessary. In this case, it may be perfectly adequate to capture images at a lower resolution, or to down-sample quite early on in the imaging chain. If the images need resizing, optimum results may be achieved using the adaptive interpolation algorithms automatically applied by the capture device. However, it may be that the results are better for the particular output using one of the algorithms available in proprietary RAW conversion software or image-processing software. It is important to note that the optimal approach can only be established by comparing images side by side using both methods.

Clearly, if the aim of the workflow is to provide optimum quality and the flexibility to output images to different media, then the image should not be resized until much later in the imaging chain. In particular, if the image is likely to undergo a significant amount of editing, then higher quality will be maintained by performing image adjustments on an image of higher resolution and then

downsizing. The most common approach is therefore to resize the image at the end of the image-processing pipeline when preparing it for output. The image may then be sharpened if necessary to counteract the smoothing effect of the interpolation.

Calculating required resolution for image output

When images are to be prepared for a specific output, it is important to calculate the required pixel resolution based upon the resolution of the output device and the required physical dimensions of the output image. Such a calculation is needed to ensure that captured images have a high enough pixel resolution for the output requirements and to establish whether interpolation will be necessary. As described in Chapter 14, scanners usually have flexibility in terms of the input resolution that may be set by the user. Equation 14.1 describes the relationship between input and output resolution in terms of the dimensions of the scanned original and the output image. When capturing images using a digital camera, the choice of input resolution will be limited and is unlikely to exactly match that of the output device (Table 25.1).

In general, if images are to be prepared for display on a monitor, they may be specified in terms of the number of pixels required. The required output image size can be determined by establishing how large the image is to be displayed on screen and basing the calculation on one of the screen dimensions given in Table 15.1. If the image is to be placed on a web page, the screen dimensions should be selected carefully to represent an 'average' monitor. Monitors of higher resolutions will simply display the image at a size covering a smaller proportion of the screen.

Table 25.1 Example required resolution for web output	
SYSTEM	**PIXEL DIMENSIONS (H × V)**
XGA monitor resolution	1024 × 768
Required resolution of an image to be displayed at three-quarters of screen size	768 × 576
Minimum capture resolution for a typical digital compact camera	640 × 480
Minimum capture resolution for a typical professional digital SLR	1936 × 1288

Images to be prepared for print must be considered in terms of the required output print size. Printer resolutions are variable. As already described, the highest quality will be achieved if the image is sent to the printer at its native resolution, maintaining a one-to-one correspondence between input and output pixels. However, not all printers have a native resolution. In some modern inkjet printers in particular, it is possible to vary both numbers and sizes of printed dots, producing a range of printed resolutions for different media. For 'photographic quality' images, inkjet printers commonly work with resolutions from 180 to 360 ppi. It is important to note that technical specifications for inkjet printer resolutions commonly refer to the maximum number of dots per inch. These values can be slightly misleading, as they do not correspond to printed pixels per inch, which are produced from groups of dots of different colours. The correct value for maximum ppi should therefore be established from the manufacturer. Continuous-tone printers may vary between 240 and 400 ppi (see Chapter 16 for further information on typical resolutions of different printing technologies). The standard resolution quoted for offset printing is 300 ppi, but the required resolution may be lower than this. Required pixel dimensions for the images can be calculated by multiplying the required resolution in ppi by the image dimensions in inches. For example, for an image printed at 300 dpi and 10 × 8 inches, 3000 × 2400 pixels are necessary.

BIT DEPTH: 8-BIT VERSUS 16-BIT IMAGING

As described in Chapter 9, analogue-to-digital conversion applied to the signal output from the image sensor may result in much higher bit depths than those in the captured image. This is prior to the many other image-processing stages that happen in the capturing device and allows a reduction in the rounding errors produced as a result of working with integer mathematics (see also Chapter 21). The image, once saved, will be in most cases either 8 or 16 bits per channel. The choice of bit depth is a balance between requirements in convenience of processing, file sizes and image quality.

The convention of working with 8-bit images is based on the need to provide enough individual levels to visually represent images as continuous tone. However, as images are processed through the imaging chain, particularly as tonal corrections are applied in either *levels* or *curves* adjustments (see Chapters 21 and 27), or as a gamma correction, many intensity levels (grey levels) may be quantized to the same integer value, resulting in a tonal range in which some grey levels are missing (termed posterization). Bit-depth requirements for gamma correction are discussed in Chapter 21 and the effects on the image output levels illustrated in Table 21.3. Figure 25.5 shows the effects of posterization on an 8 bit image and its histogram (note that this image has been very heavily processed to emphasize both effects).

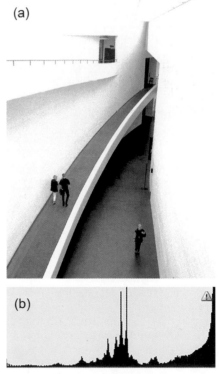

(a)

(b)

Figure 25.5 Posterization artefacts caused by image processing of an 8-bit image (a) appear as visible contours in smoothly changing tones in the image and result in a 'comb-like' histogram (b).

Working with 16-bit images means that there are many more levels available (65,536 instead of 256) per channel, reducing the effects of posterization, as illustrated in Figure 25.6. Thus, 16-bit quantization helps to maintain image quality but produces files twice the size of the equivalent 8-bit image. Sixteen-bit files are not supported by all file formats (currently, they are supported by RAW, TIFF, PSD, PNG and JPEG 2000 formats). Until recently, the level of 16-bit support in image-processing applications was limited, meaning that certain processes available for 8-bit images could not be performed on 16-bit images, although in current software versions this is less of an issue.

At the time of writing, a limited number of printers support the printing of 16-bit images with the aim of providing an extended printer gamut. This is useful when working with RAW files captured at 16 bits, using a large-gamut colour space such as ProPhoto RGB (see Chapter 23) and maintaining 16-bit workflow throughout. Whether the improvement in output gamut compared to the gamuts of 8-bit printers using eight or more inks is significant enough for 16-bit printing capability to become the standard is as yet unclear.

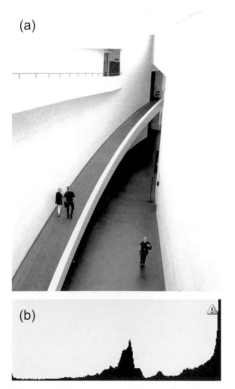

(a)

(b)

Figure 25.6 A 16-bit version of the image in Figure 25.5 processed in the same way (a) displays reduced contouring (noticeable in the central region of mid-tone and shadow) and a much smoother histogram (b).

COLOUR MANAGEMENT

The Universal Photographic Digital Imaging Guidelines (UPDIG), produced by the UPDIG coalition (see Bibliography), describe one of the aims of digital workflow as the preservation of image appearance as the image moves through and between imaging chains. This requires colour management of the imaging chain, with information necessary for the transformation of image colours between colour spaces to be included with, or embedded in, the image file. Chapter 23 describes digital colour spaces and provides information on the characterization of digital imaging devices. The implementation of these processes in ICC colour management architecture is the subject of Chapter 26, where colour management workflow is covered in more detail. Thus, here the subject is introduced in the context of more general imaging workflow.

In ICC colour management, the processes of calibration and characterization result in device *profiles*. These are data files containing information about the tone and colour reproduction of each device. Profiles are used by the colour management system (CMS) for the colour conversions between devices. They may be sent as a separate file with the image file or embedded in it. If an image with an embedded profile is transmitted between imaging chains, the colour appearance of the image should be preserved. This is assuming that the profiles are accurate, that the conditions to which the device was calibrated prior to profiling remain the same and that the destination imaging chain is also colour managed using ICC colour management. Ideally, all devices in the chain should be profiled.

Camera profiles are only useful if applied to image data in a *scene-referred image state* (see Chapter 23). The majority of cameras do not, however, render scene-referred image data, but instead use one of two alternative colour rendering options. *Intermediate reproduction description* rendering encodes the image directly into a standard output-referred RGB colour space such as sRGB or Adobe RGB 98 and is the most widely used approach. The standard colour space is chosen by the user in the camera settings. Alternatively, *manually deferred colour rendering* may be used, in which the data are output as a RAW file. In this case the image after RAW conversion is also (usually) encoded in a standard output-referred RGB colour space, again selected by the user. Therefore, the profile used with an image captured using a digital camera will usually be the colour space profile for the colour space in which the image is encoded. This subject is covered in more detail in Chapters 14 and 26.

The display profile is extremely important, as the display is used for image editing and soft-proofing of images. The display profile should ideally be a custom profile produced by taking measurements from the surface of the display. Ambient viewing conditions must be carefully controlled

by all image users to ensure that the display profile remains accurate. Scanners and printers are usually supplied with generic profiles from the manufacturer, but better results for both devices will be obtained from a custom profile. Generic scanner profiles do not generally compensate for the range of different settings that may be applied, although scanned images may be saved to a standard colour space to avoid the need for a custom profile. Custom profiles are also optimal for printers to ensure accurate soft-proofing and output colour rendition.

Colour workflow

Unless an input profile is being used, a typical aim in setting the colour space at acquisition is to select the standard RGB colour space encoding to most closely match the gamut for a particular output. If the output is unknown, then it is advisable to select a colour space which is large enough to encompass most or all of the gamuts of possible output devices. There are a range of standard RGB space encodings, each covering different gamuts, which most closely match different ranges of input and output devices; no one colour space will be ideal for all imaging situations. There are four currently specified in generic RAW conversion software, the details of which are covered in Chapters 23 and 26; therefore, they are described only briefly here.

sRGB (*Standard RGB colour space*) was originally designed as a default colour space for multimedia images; therefore, its gamut is optimized to most closely match reference cathode ray tube (CRT) display gamuts. sRGB has a relatively narrow gamut and it is also very mismatched with CMYK spaces, being unable to reproduce a large part of the cyan region which is available to printers (see Figure 25.7). These two factors make sRGB less suitable than some of the colour spaces described below, if images are to be output to print. However, if the workflow output is known to be for web or multimedia display, sRGB is the optimum choice; it is also commonly specified as the colour space to be embedded in images to be submitted to professional digital colour labs or consumer digital print vendors for the production of display prints. If images to be output in sRGB do not require colour or tonal correction, then the simplest approach is to capture into sRGB. However, in many cases better results may be obtained by capturing into a colour space with a wider gamut, performing image editing and then converting to sRGB.

Colormatch RGB was introduced by Radius™ for its Pressview range of professional graphics monitors. Its advantage was a tonal response that closely matched press output; therefore, it was used particularly for high-end pre-press work. It has a larger gamut than sRGB, although still clipping some cyan areas when compared to CMYK colour spaces, but is relatively small compared to the majority of other gamuts now available. Adobe RGB 98 has mainly superseded it as the RGB colour space of choice for printed output.

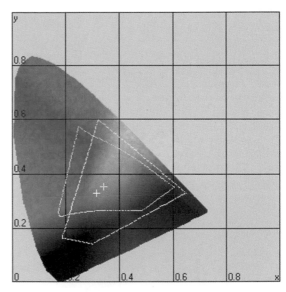

Figure 25.7 Example of gamut mismatch between sRGB and CMYK colour spaces illustrated on a CIE 1931 *x*, *y* chromaticity diagram. The smaller yellow boundary indicates the extent of the gamut for Euroscale-coated CMYK, while the white one is the extent of sRGB. The crosses indicate the white point for each. The image was created using Gretag Macbeth ProfileEditor Version 5.05b.
© LOGO, a Gretag Macbeth company

Adobe RGB 98 has a wider gamut than sRGB and Colormatch RGB. It encompasses most of the CMYK gamuts used in offset printing; therefore, it was initially used as a default working colour space for pre-press work. Currently, it is commonly used in two situations: (1) if future image usage is undefined − its wide gamut is most likely to encompass the gamuts of potential devices, both display and hard copy; images should be captured into and maintained in Adobe RGB 98; (2) when the image output is known to be via inkjet or dye-sublimation printing, therefore a wide gamut is also required. In these printers, the conversion from RGB to CMYK is performed internally by the device driver (rather than prior to the image being sent to print) and they require an RGB file as an input; therefore, the RGB colour space needs to match the CMYK space as closely as possible, and Adobe RGB 98 is a good choice.

Although sRGB and Adobe RGB 98 can fairly adequately match the gamuts of the majority of output devices currently available, neither colour space comes close to using the full extent of the colour space of the majority of image sensors. Capturing into these colour spaces fundamentally limits the range of saturated colours that can be reproduced by the sensor. *ProPhoto RGB* (developed by Kodak ProPhoto RGB as a version of ROMM RGB; see Chapter 23) is a colour space with an extremely wide

gamut; indeed, part of its gamut falls outside the gamut of the human visual system, illustrated in the CIE *x*, *y* chromaticity diagram in Figure 25.8.

The extent of ProPhoto RGB means that it is a much closer match to the gamuts of the majority of image sensors. Acquiring images into ProPhoto RGB therefore allows more of the gamut of the image sensor to be utilized. However, this approach should be used with caution; some of the colours available in ProPhoto RGB cannot be displayed on a monitor, meaning that there is no way of checking them during editing. The size of the gamut means that ProPhoto is only really practical when using a 16-bit workflow from input to output; if the gamut is represented using only the 256 levels per channel available in an 8-bit image, then posterization will be severe, as a result of the large colour differences between the different levels. In a 16-bit workflow, however, the wide gamut allows space for the extra levels that are available. With advances in both display and printing technologies, gamut sizes will increase in the future and images captured currently in a wide gamut may be output in the future to take advantage of this progression.

Image files for offset printing are finally output as CMYK files, the particular colour space being dependent on the press and paper type. The process of converting to CMYK is not a simple case of changing image colour mode in an image-processing application but requires, as for all conversions, source and destination profiles and rendering intents. Often, RGB files with embedded profiles will be supplied to the printer, who will perform the conversion. Alternatively, the photographer performs the conversion using a profile supplied by the printer. In this case, the point at which the RGB-to-CMYK conversion is carried out must be considered in terms of workflow. In the early days of colour management, it was common to convert to the relevant CMYK colour space as soon as possible after capture: an 'early-binding' workflow. This approach is simple and means that the way the image is processed is constrained within the output gamut from the very beginning. However, it is now much more common to operate using an RGB workflow until the image is to be output, described as a 'late-binding' workflow, therefore only limiting the gamut at the end of the workflow. Adobe RGB 98 is a good option in this case, for the reasons described above. Using an RGB workflow results in smaller file sizes through the earlier stages of the imaging chain and more available image-processing operations, and facilitates the potential for alternative output gamuts in the future. The implications of early or late binding are also briefly discussed in Chapter 26.

FILE FORMATS

An effective workflow relies on the use of file formats which are standardized, meaning that they can be recognized across imaging chains and platforms. The file formats that are now standards or de facto standards for imaging applications have various properties, meaning that they are most useful for different parts of image workflow. Important features are: (1) the use of lossless or lossy compression (see Chapter 29); (2) support for layers, paths and other image editing functionality; and (3) storage and processing requirements of the workflow. Often, different formats will be used at different stages in the workflow. Chapter 17 covers the properties of the more commonly used formats in detail. File formats for archiving are also discussed in Chapter 18.

Image acquisition

The still image file formats available in digital cameras are often limited to JPEG, RAW and in a few cases TIFF and/or JPEG 2000 files. Usually JPEG captured files will have a range of options for quality settings and sometimes an additional range of resolution settings, whereas RAW and TIFF files will be captured at the resolution of the image sensor. The range of formats available for scanned images is much greater.

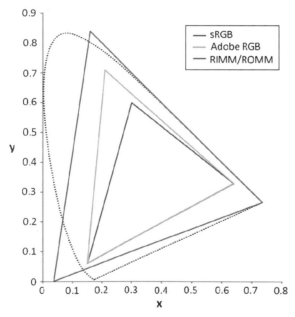

Figure 25.8 CIE 1931 *x*, *y* chromaticity diagram illustrating the gamuts of sRGB, Adobe RGB 98 and ProPhoto RGB. Note that ProPhoto RGB extends beyond the limits of colours discernible to the human visual system. (The gamuts of the same three colour spaces are also illustrated in Figure 23.3, represented in CIE *u'*, *v'* space. *u'*, *v'* chromaticity diagrams are more perceptually linear than *x*, *y* diagrams; however, within colour management, gamuts are more commonly represented in *x*, *y* space, hence their inclusion here.)

The workflow approach is the biggest factor influencing the selection of formats. In a 'production for quality' workflow, optimum quality will be achieved by capturing in a RAW format, which also has advantages for image archiving. In a 'production for output' workflow, particularly if the fast turnaround of a high volume of images is a requirement, then the extra processing involved in dealing with a RAW file (and the extra storage required on a memory card) may make it a less appropriate choice.

The lossy compression employed by JPEG will create visible artefacts at high compression rates, although the effects of this on perceived image quality will depend upon the imaging application, resolution of the image and the scene content (see Chapter 19 on image quality and Chapter 29 for examples of lossy compression artefacts). If the application requires high quality but a fast turnaround, then capturing to uncompressed TIFF files will allow the acquisition of images without compression artefacts, with an inevitable trade-off in terms of file size and versatility. TIFF files are larger than their RAW equivalents, without the level of control that RAW conversion affords the user.

For Internet publishing, JPEG files are generally the preferred option for continuous-tone images. Whether these have been captured as JPEG files or converted to JPEG for output will depend upon the type of work being done. JPEG files are often described as *perceptually lossless* at low compression rates, i.e. when captured at the high-quality JPEG setting in digital cameras (this equates to Q8 or above in the quality scale of 1−10 sometimes used) − see Figure 29.14. Although TIFF files are generally preferred as output files for printing, high-quality JPEGs may also be suitable for printed images for some applications, as long as they are at a high enough resolution.

Imaging applications such as sports photography and much of photojournalism commonly rely on JPEG capture. In these cases, large volumes of images are likely to be captured at one time; therefore, storage is limited to that available on the camera. Additionally the images need to be transmitted to news desks as quickly as possible, so image processing needs to be minimal and file sizes are limited by available bandwidths for transmission. In such cases, much of the image processing, such as tonal correction, white balance and sharpening, may be applied in the camera using auto or custom settings to generate images that are good enough for the required output.

RAW capture and workflow

Capturing RAW files represents a significant departure in imaging workflow. As described earlier in the chapter, RAW capture defers colour rendering and many other image processes to a later stage in the imaging chain, separate to acquisition. The properties of RAW file formats are described in detail in Chapter 17, and RAW image-processing workflow is discussed in Chapter 14, so are only summarized here. A RAW file is not a 'finalized' file in the same way as JPEG or TIFF files. RAW files consist of almost unprocessed data directly from the image sensor, prior to colour interpolation ('demosaicing'). This bypasses much of the processing that is automatically applied by the acquisition device when saving to other formats, such as white balance, gamma/tonal correction, colour space and even resolution settings. RAW workflow contains an extra image-processing stage immediately after capture, that of *RAW conversion*, which is carried out using either a plug-in such as 'Camera RAW' (see Figure 25.9) in Adobe Photoshop or an image management application such as Adobe Lightroom, or using proprietary RAW conversion software specific to the RAW format (as described in Chapter 17, RAW is a generic term for a group of proprietary formats based upon the same principle of manually deferred colour rendering; as yet there is no standard).

The acquisition stage in RAW workflow is therefore much simpler than when using other file formats. In general, the only settings in the camera that will influence the raw data captured are the ISO speed, determining the effective 'sensitivity' of the sensor (or rather the gain applied to the sensor signal), and the aperture/shutter speed combination selected from the resulting exposure reading. In many cases captured raw data will have linear tone reproduction, which allows gamma correction during processing. The method of 'exposing to the right' of the histogram (described in Chapter 12) may be used to expand the number of bits allocated to shadow detail within the image, which are reduced as a result of the linear output. In some devices a non-linear tone curve may also be optionally applied to the raw data at the point of capture. Although other variables such as bit depth, white balance and colour space may be set in the camera, they will not have an influence on the results, as they are adjustments that are applied after, or in conjunction with, demosaicing. For all other file formats, these settings define image processes which are performed by the capture device digital signal processor (DSP). In the case of RAW files the processes are instead applied during RAW conversion. The camera settings will be included with the data and may appear as the default settings in the RAW conversion software, but may be changed by the user.

Depending upon the software, RAW conversion generally includes options for limited resizing, fine-tuning of exposure and white balance, and setting of acquisition colour space as a minimum. Some versions allow complex tone and colour adjustments, for example to bring out shadow or highlight detail. These may be by the use of simple sliders or the more sophisticated editing afforded by *levels* or *curves* adjustments (see Chapter 27). Additionally, sharpening, noise removal and geometric corrections may be possible.

The range of RAW conversion software available and the differing degree and types of image processes available to the user can be problematic, especially if several cameras from different manufacturers are regularly used. Because

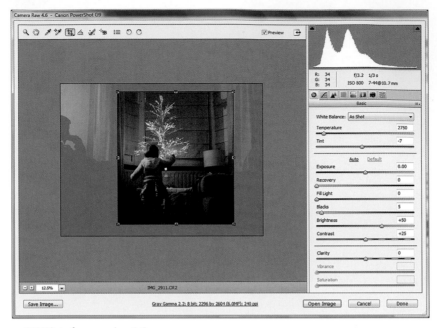

Figure 25.9 Camera RAW interface, version 4.6.

RAW formats are proprietary, and non-standardized, the arrangement of the data, the information included with it and the RAW conversion software interface vary between manufacturers. Adobe has progressed some way towards providing a solution to this with the Camera RAW plug-in, which can perform RAW conversion using the same interface for the majority of versions of RAW files. However, because this is a 'one-size-fits-all' approach, in some cases better results may be obtained using proprietary converters. Further to this, Adobe have also developed their own RAW format, the Digital Negative (.dng), which is promoted by Adobe as a universal RAW format and is currently submitted for standardization. Some camera manufacturers have included support for .dng files as an option in their digital cameras.

The obvious advantage to working with RAW files is the degree of control afforded to the user. The image processing that is applied automatically by the capture device when rendering to an intermediate reproduction description is instead performed interactively.

Most importantly, the editing is *non-destructive*. The results are viewed on a large (and preferably profiled) display, prior to being finalized. Colour interpolation and other image processes are only applied to the data at the point at which the image is saved to another format — the user simply sees a preview of the results on screen prior to this.

The implications in terms of image quality are most apparent when applying corrections to the tonal range. If an image is saved as another format, then its tonal range

and therefore its exposure level will be set across the range of values defined by the bit depth of the image file. As already discussed, applying image processes such as gamma correction to the range of values may result in posterization of the image, particularly in an 8-bit image. Changes in global brightness levels and image contrast are fundamentally limited — if the grey levels in the image fully cover the extent of the image histogram, then these changes may ultimately result in clipping of either highlights or shadows. With a RAW file, however, the full bit depth of the sensor is still available, meaning that the range of captured image values may be carefully adjusted to fit this range without clipping.

Figure 25.10a illustrates a slightly underexposed low-contrast image, which has been captured as an 8-bit JPEG file and a RAW file. Tonal adjustments to correct the exposure and contrast must be applied to the JPEG file in image-editing software (Figure 25.10b); for the RAW file the adjustments are applied during RAW conversion (Figure 25.10c). Although tonal adjustment has improved the exposure and contrast of the JPEG image in Figure 25.10b, there is some obvious clipping in the highlights. The adjusted RAW image in Figure 25.10c retains much more highlight detail, particularly noticeable in the hair and also in the pattern on the table. The histograms of all three images are displayed in Figures 25.10d—f. The last histogram, that of the adjusted RAW file, displays significantly less clipping than the one from the adjusted JPEG image, particularly in the highlights. It also displays less clipping than the original underexposed image,

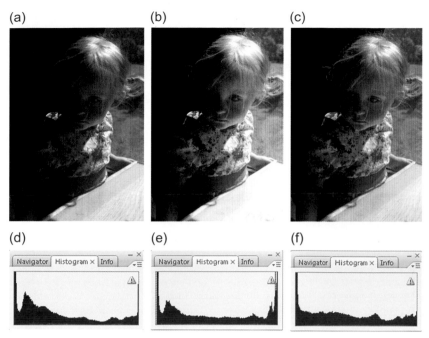

Figure 25.10 The results of tonal adjustments to an underexposed image applied to an 8-bit JPEG file and a RAW captured file. (a) Original image. (b) Results of contrast and brightness adjusted from JPEG capture. (c) Results of contrast and brightness adjusted during RAW conversion. (d) Original histogram. (e) JPEG adjusted histogram. (f) RAW adjusted histogram.

indicating that the actual exposure has effectively been changed, rather than the tonal range being redistributed between the same points. Furthermore, it is smoother, indicating a more even distribution of tones.

Using a RAW workflow has further advantages in terms of image archiving. The non-destructive nature of RAW conversion and the fact that the processed image is saved as a new format means that the RAW file is unchanged and can be repeatedly reprocessed.

The optimized RAW file can additionally be saved as a .dng file, maintaining the adjustments but allowing further editing. Assuming that the .dng format is standardized, it will become an ideal format for archiving images.

Image editing

Image editing is a fluid process, in which the image may be processed in a rather 'non-linear' manner. The user may apply processes and then return to previous edited image states, combine edited elements of the image, process only selected image areas, or fine-tune the degree to which a particular image process affects the image. Various functionalities in modern editing applications, such as an 'undoable' and optionally non-linear history palette, the use of layers, image masking, sophisticated selection tools, and the ability to convert selections to vector paths, facilitate this approach to image processing.

Image file formats used at the editing stage are most useful if they are able to support some or all of these functions, allowing the user to save and reopen the image at a particular stage in the editing and pick up where they left off. Adobe's Photoshop Document (PSD) format was developed for this purpose and most fully support these functions. TIFF and JPEG 2000 support unmerged layers. The PNG format does not support layers but allows for an extra alpha channel with variable transparency, of the type used in image masks. All of these formats are able to support 16 bits per pixel or per channel.

Additionally and importantly, all of these formats employ lossless compression (although JPEG 2000 also optionally employs lossy compression). Editing a lossy compressed image and then resaving it with lossy compression will inflict further errors on the image; each edit and save will cause further deterioration. Therefore, if an image is likely to require complex editing using the tools described above, then it should ideally be converted from a lossy format such as JPEG to a PSD or TIFF file, as an intermediate.

Image output

File formats for output are determined by the requirements of the particular imaging application. If the user is sending files directly to an output device then they are usually

optimized, and the same considerations, described in the previous section on image acquisition, apply. If the images are for the Internet, then saving them as JPEG files in the sRGB colour space is a common solution, providing small file sizes and optimal colour reproduction on screen. Images to be sent to desktop printers should generally be either high-quality JPEG files or TIFF files, although PSD files may be proof printed. Generally RAW files require conversion to another format before proof printing.

When files are being delivered for reproduction elsewhere, the required format will usually be specified. For imaging applications such as photojournalism, high-quality JPEGs with the appropriate ICC colour profile are often adequate for both web and printed outputs. International Press Telecommunications Council (IPCT) metadata describing the source of the image, photographer's details, copyright, captioning and keywords should ideally be embedded in the file, to ensure that all the required information is transmitted with the image.

In workflows producing higher quality printed media, images may be output as optimized TIFFs or high-quality JPEGs. Alternatively, proprietary RAW files may be delivered, allowing clients to perform the optimization themselves, although this is much less common and means that the photographer has no real influence over how the image is processed. A better option may be to deliver DNG files which have been adjusted, allowing the client to see the photographer's optimized version, but with the option to edit it themselves.

Image archiving

If capturing RAW files it makes sense to archive the original RAW file prior to any processing. This facilitates the possibility of optimizing the images several times for different types of output and means that a master copy will always be retained. Ideally, the adjusted file should also be archived. The format for this will depend on the workflow, but using a format that supports layers means that image adjustments can be changed in the future, as the image will not be finalized until the layers are merged or flattened. Finally, if images are being prepared for a specific output, then it is good practice to archive a copy of the finalized file, in case there are any problems with file transmission, or a client loses a file and requests a copy. The file format in this case will depend upon the output and may include lossy compression.

RGB *master files* are optimized files with a wide gamut of RGB colour space which are kept at the native resolution of the sensor, unsharpened and saved as PSD or TIFF files. These represent the highest quality version of the image after it has been optimized and finalized. Archiving RGB master files with RAW files means that a high-quality and optimized file can be repeatedly used, for example for different outputs, without having to go through the RAW conversion procedure. For very-high-quality output, such

as that required in high-end advertising, the RGB master file may be used to prepare several versions of the image for the client, each for a different output.

IMAGE OPTIMIZATION WORKFLOW

The production of an optimized image involves the application of a number of image adjustments, which are necessary to compensate for sensor characteristics and capture conditions. Optimization may involve cropping and resizing, tone and colour corrections, noise and dust removal, and a limited amount of sharpening. Corrections may be applied globally, but often there is the necessity for some local adjustments as well. Global adjustments are applied first, which may negate the need for further enhancements to specific areas of the image.

A high-volume, lower-quality workflow will be faster and more efficient if some of the adjustments can be automated at image capture. Examples include the application of an optimized-for-output custom tone curve in the capture device, or applying in-camera sharpening and noise suppression. In examples where JPEG images are being captured at the native resolution of the sensor, minimal global adjustments to tone and colour may be adequate for many images. Other processes such as resizing, geometric correction and further localized noise removal and sharpening may be necessary, but can be applied on an image-by-image basis in an image-editing application.

For high-end workflows more image adjustments may be required to optimize the quality of the final image. Fundamental in defining the order in which image adjustments are performed are the file formats and hence the types of software being used. If RAW files are being captured, then higher quality will be maintained by performing global adjustments to white balance, tone reproduction and colour in the RAW processing software. Global sharpening and noise removal may also be applied at this point. This is analogous to the in-camera processes mentioned above. Once these fundamental corrections have been applied, the image may be saved and opened in an image-editing application for further processing.

If RAW conversion is not part of the processing pipeline, then the majority of adjustments will be performed in a single editing application. There are exceptions to this, such as the use of third-party software and plug-ins developed to perform particular image-editing processes. Examples include applications developed specifically for resizing, noise removal or the sharpening of images, which use more sophisticated adaptive algorithms than those commonly available in image-editing applications.

When all image enhancements are being carried out in an editing application, geometric operations such as rotation, perspective correction and cropping should be performed at the beginning of the adjustment process.

Cropping unwanted image areas is particularly important, as the extra redundant pixels will otherwise be included in the image histogram and may affect tone and colour corrections using levels and curves. It is logical to perform global tone and colour adjustments as a next step. Levels adjustments to individual colour channels can improve tone reproduction, enhance overall contrast and correct neutrals. Curves adjustments have the added advantage of altering one part of the tonal range (or colour range, if applied to separate channels) without significantly altering other areas, but this requires some skill (see Chapter 27 for more details on these types of spatial processes). Both types of adjustments are best applied as *adjustment layers* rather than directly to the image values. Editing in this non-destructive manner allows results to be fine-tuned and helps to minimize clipping, colour banding and posterization.

Noise removal and sharpening may be applied at various stages in the imaging chain. It is important to note that the application of one operation may result in the need for the other, as global sharpening can enhance noise and noise removal may result in unwanted softening of edges. Under certain capture conditions, such as those using high ISO speed settings, or long low-light-level exposures, noise removal will be necessary and may be best performed in the capture device or the RAW processor.

Sharpening may be applied at several different stages. Although in theory sharpening should not be applied until the final stage, due to the possible enhancement of noise, in practice it is often useful to sharpen earlier in the imaging chain to ensure that image quality is satisfactory for the requirements of the workflow. Capture sharpening may be performed in-camera or in scanner software to compensate for the digitization process, or alternatively during RAW conversion. Sharpening may also be performed if the image is being edited, as a final processing stage to compensate for blurring introduced by other processes such as resizing. Finally, the image may also be sharpened for a specific output. Whether sharpening is applied at only one or all the different stages will be dependent on the workflow and output.

It is important not to over-sharpen, as this will result in obvious 'halo' artefacts (see Figure 27.22). Improved results may be achieved using adaptive algorithms, or by applying luminance sharpening only. Results can be fine-tuned by applying the sharpening using a layer. Additionally, if a master file is being sharpened, then the sharpening should be saved on a separate layer, so that the degree and method of sharpening may be altered for different outputs.

WORKFLOW EXAMPLES

Having discussed various aspects of image workflow, we complete this chapter with some case studies illustrating typical workflows currently used for different types of imaging. These are genuine examples, based on information provided by three different photographers.

1. Commercial photography

The images produced in this example cover a range of different types of high-end commercial photography, such as portraiture, fashion and architectural work. Important objectives of this workflow are the acquisition and maintenance of optimum image quality and flexibility, where the output media is not defined, or where several output images are required on different types of media (at different qualities).

Acquisition

Images are captured at the native resolution of the sensor (e.g. 29 megapixels), using a medium-format digital back. The camera is controlled using remote capture software and a laptop. RAW capture is the only option and, in this case, scene-referred image data are output, to be converted to an output-referred image state using an embedded camera profile. A large range of profiles for the sensor under different illumination conditions are supplied. Using a camera profile provides a much larger gamut than any of the standard RGB working spaces commonly available at RAW conversion. Images are captured at the full 16-bit depth of the sensor.

Image processing

The majority of image adjustments are applied during RAW conversion, using a workflow management application such as Adobe Lightroom. These include cropping, tone and colour corrections, all performed within the colour space of the sensor. If the image is being prepared directly for printed output, then it will be sharpened at the last stage.

If the image requires more localized adjustment, or is to be combined with other images, it is saved as a PSD file and imported into Adobe Photoshop. In this case sharpening is not performed during RAW conversion, but is applied using an *unsharp mask* (see Chapter 27) as a final editing stage in Photoshop.

Image quality is maintained by avoiding resampling processes where possible, applying the majority of image adjustments in a non-destructive manner (until the file is finalized), either during RAW conversion or using *layers* in Photoshop and working at 16 bits within the large gamut of the sensor colour space until the output stage.

Output and archiving

Following the adjustments applied during RAW conversion, the optimized RAW files are archived (note that the

adjustments are still non-destructive at this stage and simply illustrate the editing intentions of the photographer). If the images are further edited in Photoshop, then a working copy in PSD format, with adjustment layers still intact, will also be archived.

The final stages in preparing output files for print involve a colour space conversion to Adobe RGB 98, upsizing if a large print is required and conversion to 8-bit TIFF files. Images for Internet output are converted to sRGB, downsized and saved as 8-bit JPEG files.

2. Forensic imaging

A large area of forensic imaging is concerned with the capture and presentation of *evidential* images, described by the Home Office Scientific Development Branch (HOSDB UK): *'Evidence, in terms of a still image or video footage, is the presentation of visual facts about the crime or an individual that the prosecution presents to the court in support of their case.'* Such images require an audit trail, which may be written, electronic or both, describing the image source and capture conditions. The audit trail also includes details of any image processing carried out, to prove the authenticity of the image.

This example is concerned with the capture of fingerprint images. The fine detail contained within fingerprints requires high-quality and high-resolution images for analysis or comparison. The international standard for fingerprint capture, based on the HOSDB UK guidelines (see Bibliography), specifies that the output images should be at lifesize magnification with a resolution of 500 ppi.

Acquisition

Images are captured at the native resolution of the sensor using a digital single-lens reflex (SLR) camera. They are most commonly captured as TIFF files (as a non-proprietary format), although working practices vary. In some cases proprietary RAW files may be captured instead. Capture colour space is set to sRGB, either in the camera settings or during RAW conversion. Generally image sharpening (if an option in the camera) is turned off at the capture stage. Low ISO speeds are recommended to minimize noise, although some images may be shot in low light levels. Noise removal may be performed by filtering, or by averaging multiple images of the same subject (see *arithmetic processes* in Chapter 27).

Image processing

This stage varies depending upon how the image is going to be used, the local agency guidelines and the amount of processing applied at image capture in the camera settings. As a minimum, tonal correction is applied using levels and curves. Initial enhancements to tone and colour may be applied to RAW files in the RAW conversion software. The image is saved as a TIFF, copied and the copy is opened in another application for further processing. Following initial adjustments, the TIFF image is converted from RGB to an 8-bit greyscale image (using a 'channel mixer' to fine-tune the conversion, rather than a simple mode change), in accordance with the standard guidelines. Subsequent processing may include noise reduction, and background pattern removal, followed by local enhancements to selected areas of the image. The image may need to be resized to conform to the output resolution guidelines. This is usually performed at the end of the processing pipeline to minimize quality loss and may be followed by sharpening or blurring depending upon the image and how it is to be used. Finally, the image is saved as a TIFF 'working copy'.

Output and archiving

The images may be output to a high-end printer such as the Fuji Pictrography, or they might be saved to an image database for further analysis, possibly as JPEG files. The optimized TIFF file, after initial adjustment, is archived. The output working copy may also be archived.

3. Medical imaging

This example is based upon working practices for clinical photographers in UK hospitals. The emphasis in this workflow is on the need for speed in processing and delivery, with some sacrifice in quality, as relatively low-resolution images are required at output. The image types and uses may vary, but in general the majority of images will be output as 6 × 4 inch prints, to be appended to patients' records, or to be stored in an electronic database, and viewed on screen.

Acquisition

Required magnification varies and will be specified for each clinical department. Images are captured at the native resolution of the sensor using a digital SLR. Current practice is moving towards the use of full-frame sensors and RAW capture, although at the time of writing it is still quite common to use smaller sensors in semi-professional SLRs and capture high-quality JPEGs. Ideally, white balance is performed by measurement from a grey card. Images are captured into the sRGB colour space. If the recommendation to capture RAW files becomes standard practice, then it is likely that wider gamut colour spaces may be specified during RAW conversion for image editing.

Image processing

JPEG captured images are archived at capture prior to any adjustments being applied. If they are only being

downsized for output they may remain as JPEG files, but if further editing is required, they will be changed to a lossless format such as PSD or TIFF. Adjustments may include global tone and colour correction, dust removal and local colour corrections. The image is then resized, sharpened if for print output and resaved as a JPEG.

RAW files are initially renamed using a *unique patient identifier* and then resaved as RAW files. Following this, RAW conversion is normally performed in a generic RAW converter (such as Camera RAW). The majority of image adjustments are performed in this application, due to the non-destructive nature of the editing process, with Adobe Photoshop only being used for locally selected adjustments. Again, the image is resized at the last stage. If it is to be opened again for editing it may be saved as a TIFF, but in general output files are high-quality JPEGs.

Output and archiving

Output images may be printed to inkjet printers or delivered as electronic files to an image database. This is a central server-based database, which allows access across the UK National Health Service to clinicians for their particular patient group. All output files are archived, along with the original captured files (JPEG or RAW files prior to optimization).

ACKNOWLEDGEMENTS

Special thanks to Andrew Schonfelder, John Smith and Simon Brown for their input in this chapter.

BIBLIOGRAPHY

Anderson, R. (Ed.). Universal Photographic Digital Imaging Guidelines version 4.0. Published by the UPDIG coalition, available for download from www.updig.org

Cohen, N., Maclennan-Brown, K., 2007. Digital Imaging Procedure version 2.1. Home Office Scientific Development Branch.

Fraser, B., Murphy, C., Bunting, F., 2005. Real World Color Management, second ed. Peachpit Press, Berkeley, CA, USA.

Green, P., MacDonald, L., 2002. Colour Engineering: Achieving Device Independent Colour. Wiley, New York, USA.

Hunt, R.W.G. 1997. Bits, bytes and square meals in digital imaging. Proceedings of the IS & T/SID 5th Colour Imaging Conference.

International Standards Organization 2004. ISO 22028-1:2004. Photography and Graphic Technology — Extended Colour Encodings for Digital Image Storage, Manipulation and Interchange, Part 1: Architecture and Requirements. Available online from www.ISO.org

Lukac, R., 2008. Single-Sensor Imaging, Methods and Applications for Digital Cameras. CRC Press LLC, Boca Raton, FL, USA.

Sharma, A., 2004. Understanding Color Management. Delmar Learning, Thomson Learning, New York, USA.

Sharma, G. (Ed.), 2003. Color Imaging Handbook. CRC Press LLC, New York.

Süsstrunck, S., Buckley, R., Swen, S. 1999. Standard RGB color spaces. Proceedings of the IS & T/SID 7th Colour Imaging Conference.

Chapter | 26 |

Colour management systems

Elizabeth Allen

All images © Elizabeth Allen unless indicated.

INTRODUCTION

The advancement of digital imaging has led to the development of numerous different technologies and devices for the capture, display and output of image data. While this provides great flexibility and a wide variety of options in terms of the imaging chain and image workflow, it means that certain aspects of image control are much more complex than they are with silver halide imaging. The most obvious example is that of digital colour reproduction, which is dealt with in detail in Chapter 23. Because so many alternative methods are employed to capture and reproduce colour in digital devices, the image will pass through a range of different colour spaces and be limited by various colour gamuts as it moves through the imaging chain. Colour values must be interpreted and converted between colour spaces and decisions must be made about how to deal with out-of-gamut colours. For most imaging applications, this process is dealt with by a *colour management system*.

COLOUR MANAGEMENT TASKS

A colour management system (CMS) is a collection of software tools used to manage the processes of colour specification and communication through an imaging chain. The key objectives of such a system include the production of almost identical representations of the same scene from different types of input devices (achieved by device adjustment), and the production of almost identical images on different types of output device (achieved by processing of the image). The first of these objectives means that devices are controlled so that two different input devices will produce almost the same set of digital values in a device-independent colour space from the same scene or original image. In practice, of course, exact matching may not be possible; therefore, the aim is to achieve predictable results within the limitations of the devices. The second objective means that if an image in the form of a set of digital values in a device-independent colour space is sent to two different output devices, the image should be adjusted so that the colour appearance of the image appears identical (or as close as possible) in the two outputs.

There are a number of fundamental steps required to achieve the main objective of device-independent colour translation. These are covered in detail in Chapter 23, but are summarized here. The *calibration* of a device involves setting up and modifying its behaviour to a desired state (which may be a standard specification). This establishes a known starting point for the measurement of the device's colour reproduction. Ongoing colour management will involve recalibrating the device to this state. The *characterization* of the device is concerned with measuring the response of a device and describing it in a device-independent manner (i.e. in terms of CIE colorimetry). In the context of this chapter, the characterization process results in an image *profile* which may be *embedded* in or *assigned* to an image. It is important to note that the characterization will only be accurate for the device in the calibrated state in which it was measured, hence the need for ongoing calibration, to return the device to this state.

The CMS uses the characterization data in each device profile to implement colour *conversions* (or colour transformations) between colour spaces. The aim of conversion may be to reproduce colours with colorimetric accuracy, or to achieve a 'pleasing reproduction', i.e. producing an optimal reproduction in a particular context. Modern colour management systems are flexible enough to achieve

DOI: 10.1016/B978-0-240-52037-7.10026-2

both. The CMS must also deal with the mismatching of gamuts through the system. The approach used in the mapping of out-of-gamut colours needs to be flexible and should be defined with reference to the reproduction aims of various different imaging applications.

CLOSED-LOOP VERSUS OPEN-LOOP COLOUR MANAGEMENT

The management of colour reproduction in early digital imaging systems was simplified by dealing with very limited imaging chains, and used a similar approach to that used in high-end photographic colour reproduction systems. This was possible because the numbers of available input and output devices were far fewer than the wide variety available today. Additionally, digital imaging tended to be more commonly used in high-end professional workflows, as many early digital imaging devices were prohibitively expensive for the average consumer.

Working within the constraints of a small imaging chain meant that the issues of colour conversion and management were significantly less complicated than they are at the current advanced stage of the development of digital imaging systems. In general, the imaging chain would be based upon a single input and output device, with a skilled operator managing both through some form of software interface. Such an approach is known as *closed-loop* colour management. A typical example of such a workflow is the use of a drum scanner to digitize images, outputting to some form of digital printer. Early drum scanners would scan using RGB filtered photomultipliers, but would output CMYK values, which would be specific to and optimized for the particular output device. The system was typically managed by one operator, who would gain knowledge of the colour reproduction characteristics of the entire chain over time and would be able to fine-tune the devices or the output to compensate for colour drift.

A single *colour transformation* is required for such a system, translating colour values directly device to device between the two colour spaces. It is possible to achieve very-high-quality results using a closed-loop approach, which is, incidentally, still used in some high-end proprietary systems. However, in the majority of imaging applications today, the imaging chain is likely to consist of numerous possible input and output devices. The requirement, therefore, is for flexibility and interoperability between different workflows and imaging chains.

Figure 26.1 illustrates the problem that arises when trying to add devices to a closed-loop colour management system. For every new input device that is added, a device-to-device colour transformation must be defined between

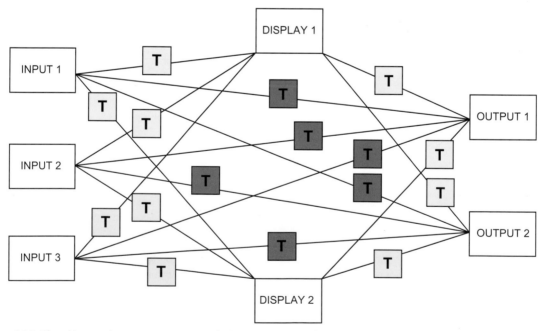

Figure 26.1 Closed-loop colour management. A device-to-device transform must be constructed between every source and destination device. In this diagram, display devices behave as source and destination devices. The total number of transforms required is $m \times n$ between the input and output devices only (in this case 3×2, marked in blue), and a further $(m + n) \times$ the number of display devices between the display devices and all other devices (in this case 5×2, marked in yellow), a total of 16 transforms for this imaging chain.

Figure 26.2 Open-loop colour management. An intermediate device-independent colour space is used as a 'hub'. Profiles provide transforms for each device into and out of this space only; there are no device-to-device transforms. The number of transforms required is now reduced to equal the total number of devices.

the new device and all other output devices in the system. The same applies to new output devices, which require transforms to be defined with all input devices. For m source devices and n destination devices, $m \times n$ transforms will be required. Every time a device is recalibrated or a new device added, a further m transforms (if it is an output device) or n transforms (if it is an input device) must be calculated. The situation is further complicated by the fact that display devices may behave as source or destination devices in terms of a colour management imaging chain. As more devices are added, a closed-loop approach quickly becomes impractical.

A solution to this problem is to use an intermediate standard colour space as a 'hub' through which all colour values are transformed, rather than transforming values directly from device to device. It is then only necessary to define the relationship between each device and this colour space, as illustrated in Figure 26.2. Such a colour space must be device independent and therefore able to specify colour values unambiguously. Conversions between devices are performed via the intermediate colour space and each device will require the specification of only one transform into or out of this colour space. The number of total transforms required is reduced to n transforms for n devices, and the recalibration of a device or addition of a new device will only require one additional transform. This is termed *open-loop colour management* and is the basis of the International Color Consortium (ICC) colour management architecture.

THE INTERNATIONAL COLOR CONSORTIUM (ICC)

This chapter deals with the subject of colour management within the framework specified by the ICC. The ICC architecture provides a standard method of implementing colour management in a profile-based system.

A number of companies developed colour management systems during the late 1980s and early 1990s, which defined *colour profiles* to provide device-to-device colour transforms and matching. However, these systems were proprietary and the lack of a standard profile format meant that the profiles could not be used by different colour management systems. The ICC was founded in 1993 by eight industry vendors, with the aim of providing a solution to this problem and developing a specification for a - colour management architecture based on a standard profile format. Today, the ICC has approximately 70 members from all areas of the imaging and computing industries. The ICC website states the consortium's purpose: '... to promote the use and adoption of open, vendor-neutral, cross-platform colour management systems.' To this end, a standard profile format specification has been developed. The profile is based upon the Apple ColorSync profile format.

The first version was released in 1994 and has been revised a number of times. The most recent major revisions resulted in the final version 2 specification, ICC.1:2001-04,

followed by the current version, ICC.1:2004-10 (profile version 4.2.0.0), which has become ISO standard 15076-1:2005. This latest version has been developed to address certain ambiguities in the version 2 specification. Both types of profile may be currently used, but the implementation of version 4 is becoming more widespread. In general, this chapter describes the version 4 specification. Part of the implementation is the same for version 2.

The definition of a standard format for colour profiles allows the user to work within the same colour management architecture with profiles created by different vendors. This means that the architecture itself can be incorporated into widely used image-editing applications, and provides a framework to facilitate the communication of colour between different imaging chains, operating systems and applications.

ICC COLOUR MANAGEMENT ARCHITECTURE

An ICC colour management system is an embedded extension of the operating system, providing a common framework for colour management, which may be accessed by different applications. A CMS has two main functions. The first is the *interpretation* of device-specific colour values, and their specification in an unambiguous colour model. The system also manages the *conversion* of colour values between different colour space encodings and image encodings, maintaining colour consistency through the imaging chain. To achieve this, an ICC colour management system has four key components. These are:

- The *profile connection space* (PCS), which is the standard intermediate space that all profiles convert into and out of.
- The *colour management module* (CMM), which is a software 'engine' embedded in the operating system, and performs all the colour conversions.
- The ICC profiles, which are of various different types and follow the ICC standard format. They contain the

information necessary for the colour conversions into and out of the PCS.
- *Rendering intents*, currently four being specified, which provide different approaches to dealing with out-of-gamut colours, each one prioritizing certain qualities of the image at the expense of others and each optimized for the colour reproduction goals of particular imaging applications.

Each ICC profile contains the information necessary for transformation between a colour space and the profile connection space. The process of colour conversion is illustrated in Figure 26.3. Each colour conversion between two colour spaces requires a *source* and a *destination* profile. The CMM connects the two profiles, producing a transformation between them. The information contained within the source profile is used to convert values into the PCS, where colour values are specified as CIEXYZ values or derived CIELAB values. The destination profile provides the transform from the PCS to the output colour space. The values produced from the profiles, particularly if based on a look-up table model, will require interpolation (see Chapter 23) and this is also calculated by the CMM.

The rendering intent is specified at the point of conversion and further defines the relationship between the source and destination gamuts in terms of how colours are rendered from input gamut to output gamut. It is quite common to find some areas of gamut mismatch between the gamuts of the devices, and sometimes between the device gamuts and the gamut of the PCS. This means that some colours available from an input device may not be reproducible at output and, equally, colours that can be produced by the output device may not be captured by an input device. Two main approaches are used to deal with out-of-gamut colours: *gamut compression* reduces the overall source gamut to fit into the destination space, whereas *gamut clipping* only adjusts the out-of-gamut colours, clipping them to the gamut boundary.

The description of the role of these components given above is that of the standard default implementation of the architecture. There is capability within the ICC.1-2004 specification for the CMM to be adapted to perform more

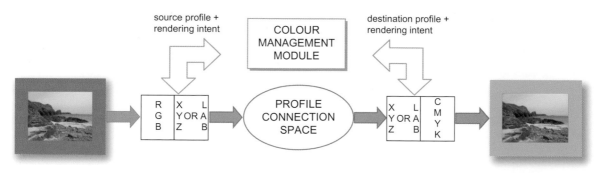

Figure 26.3 ICC colour conversion.

complex functions, such as the calculation of optimized transforms for specific images, a possibility for third-party vendors of CMMs.

THE PROFILE CONNECTION SPACE (PCS)

The architecture is based around a reference colour space using the colour specification method defined by the CIE. Values in the profile connection space are encoded as 16-bit XYZ or 8- or 16-bit CIELAB values, depending on the profile type and implementation. Because the PCS is intended to be used as an interchange space to connect source and destination profiles, it has a large enough gamut to encompass the gamuts of the majority of input and output devices and media. A degree of restriction is applied in determining the PCS however, to ensure that it remains unambiguous for all imaging applications. The CIE specifications define colour values for two standard observers, two measurement geometries for reflecting media and a range of different illuminants. The PCS is strictly specified for the 2° standard observer (CIE 1931 standard colorimetric observer — Chapter 5) relative to the CIE daylight D50 illuminant, although it is possible to provide values using other illuminants with a chromatic adaptation transform between the illuminant and D50. Values are measured for reflected media using specified measuring geometry ($0°/45°$ or $45°/0°$) and measurement procedures are specified for transmitting media (refer to Chapter 5 for further details on measurement procedures and definitions in CIE colorimetry).

When a sample is measured, the illumination level and any surrounding stimuli will affect image appearance. The CIE system does not accommodate either of these effects. The PCS must necessarily incorporate corrections for such image appearance variables. This is achieved by using the PCS to render images in two different ways to accommodate different reproduction criteria. The distinctions between the two are fundamentally to do with *image state*.

As described in Chapter 23, the image state describes the rendering state of the image data. Colour image encodings may be broadly classed into two different image states. Data in a *scene-referred* image state represent estimates of the colour space coordinates of an original scene (which may be real, modified or computer generated) without reference to an output, i.e. prior to colour rendering. Because such data have not been colour rendered, they are not in a viewable state. Data in a *picture-referred* image state represent colour space coordinates of a hard-copy or soft-copy image, where the values have been produced via a colour rendering (or re-rendering) transform for a specific real or virtual imaging medium under specified viewing conditions. Picture-referred image states include images that have been scanned from originals, termed *original*

referred, which have characteristics tightly coupled to the characteristics of the input device, and images that have been rendered for a particular output device under specific viewing conditions, which are *output referred*.

For *colorimetric rendering*, the PCS describes the colorimetry of the originals and their reproductions, relating the source code values to colorimetric code values without adapting the image appearance to a possible output. Data being rendered into the PCS may be in an input-referred or output-referred state. There will be no change in the image state, but a change in image encoding with chromatic adaptation to D50 if appropriate. Colorimetric rendering from the PCS to an output device again will also change the image encoding but not the image state, i.e. the image appearance will not be optimized to produce a 'pleasing' appearance on the output medium.

The alternative use of the PCS, *perceptual rendering*, involves *colour rendering* or *re-rendering* to or from a defined output to provide accurate (or optimal) colour appearance. Colour rendering may be defined as the mapping of scene-referred image data to picture-referred image data, e.g. producing a viewable image from a raw data capture. Colour re-rendering is the mapping of picture-referred image data for one set of output conditions to picture-referred data for another output. When the PCS is used for perceptual rendering, the colorimetry of the original is changed to colorimetric values that better suit the reproduction medium. In this case the colorimetric values in the PCS represent the image colours rendered to a standard reference medium (the *ICC PCS perceptual intent reference medium*, described in version 4 of the ICC specification and below) under a specified viewing condition (see Figure 26.4). Images rendered into the PCS using perceptual rendering will be rendered to the reference medium. Images rendered from the PCS to an output device using perceptual rendering will assume that the image is already output referred to the standard reference medium and will re-render the data to the required alternative output medium.

To summarize, then, the PCS operating in colorimetric rendering mode will not change the image state, but will simply describe the colorimetry of the image. In the perceptual rendering mode, the image state will be changed and the image colorimetry will be described as rendered to a standard reference medium under particular viewing conditions. The reference medium limits the gamut and dynamic range of images rendered using the perceptual intent, whereas there are no limits on those produced by colorimetric rendering.

RENDERING INTENTS

The specifics of the rendering method used, in terms of how colours are dealt with in-gamut and out-of-gamut, are defined by the rendering intent, which is selected at the

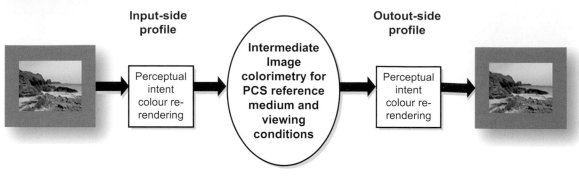

Figure 26.4 Perceptual rendering path.
Based upon a figure from ICC white paper 4 (2004)

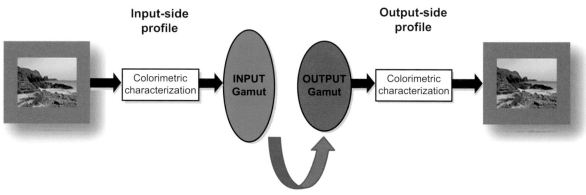

Figure 26.5 Colorimetric rendering path.
Based upon a figure from ICC white paper 4 (2004)

point of conversion between profiles. Four different rendering intents are specified in the ICC.1 version 4 architecture. Each of the rendering intents is defined by a different transformation; the transforms for three of them are included in the profile (they may be separate profiles, or a single profile with several rendering intents) and the fourth is derived from one of the others (see 'Absolute colorimetric intent' below). Their purpose is to accommodate the various different objectives of colour reproduction. A typical objective in colour reproduction is image proofing, which is sometimes described as the *re-targeting* of an image, where the image colours reproduced on one device are to be simulated on another. In this scenario, where colours are being checked, the aim is to provide the closest match possible between source and destination colours. Colorimetric rendering intents are generally most suitable for this type of application. The other major goal in colour reproduction is termed *re-purposing*, where colour that has been rendered to one intermediate or output colour coding is rendered to provide optimal colour reproduction on a different medium. The non-colorimetric rendering intents are intended for re-purposing and modifying the colorimetric

values to take into account image appearance variables such as differences between source and output devices, media and viewing conditions.

Two colorimetric rendering intents are specified. Both operate on colorimetric values measured under the D50 illuminant, or are chromatically adapted to D50 if an alternative illuminant is used. The colorimetric intents accurately preserve the relationships between in-gamut colours, making them suitable for proofing applications, but this is at the expense of out-of-gamut colours, which are clipped to the gamut boundary for both of the intents (see Figure 26.5). The impact of this will of course depend upon how many of the colours are outside the gamut of the destination space.

The *media-relative colorimetric intent* (previously the *relative colorimetric intent* in the version 2 specification) maps the media white point to the PCS white point (i.e. by allocating the media white point to PCS CIELAB values (100,0,0)). This ensures that the white of the image retains its white appearance to the eye on the new medium, effectively taking into account the fact that we visually adapt to the white of the medium we are viewing. All other in-gamut colours (which have already been chromatically

adapted to D50) are rescaled relative to the media white point. The rescaling maintains relative differences between values, but results in some change to all colours.

In the case of the *ICC absolute colorimetric intent*, the white point of the medium is not mapped to the PCS white. Instead, the white point of the illuminant (D50, although the values may be adapted to this if another illuminant was used) is mapped to PCS LAB (100,0,0). The media white is mapped relative to this; therefore, if it had a yellow–white point then it will be reproduced as yellow–white, rather than as visually white. Effectively the image will appear as it would if our eyes did not chromatically adapt to the media white point. Information for calculating the ICC absolute colorimetric values is not included in the profile but derived from the media-relative calculated values. The profile will contain the PCS values of the media white (before allocation to the PCS white, as described above). Once media-relative values have been calculated they can be recalculated relative to the original values of the media white, and this provides absolute colorimetric values. All in-gamut colours, including white, are therefore reproduced exactly.

The *perceptual intent* is designed to produce images that are pleasing, but not colorimetrically accurate, reproductions of the source image, which may then be optimized for the output. As described in the previous section, using the perceptual intent, the images are rendered to a standard reference medium, i.e. rendering into the PCS will change the image appearance to represent the image as it will appear on the reference medium. Rendering from the PCS using the perceptual intent will take this referenced image appearance as a starting point and change it for the output medium. The standard reference medium may be considered as a subset of the PCS. Since all images are rendered to and from this medium, its gamut limits the amount of the PCS which may be used for perceptual rendering. The medium is selected to provide a gamut which is a useful intermediate between many input and output colour spaces. The intent typically includes adjustments to the tonal range to map the dynamic range of the image from source to output. The gamut is warped and compressed to bring out-of-gamut colours inside the gamut, while preserving relationships between colours. The perceptual intent is useful for general reproduction of natural images, where input and output are significantly different, and where accuracy of colorimetry is not a requirement (i.e. the aim is a pleasing reproduction). If the input and output gamuts are similar (meaning that there are fewer out-of-gamut colours), then media-relative colorimetric intent is an alternative option. The perceptual intent is vendor specific; therefore, the exact details of colour rendering will vary between vendors of profiles and CMMs. Figure 26.6 illustrates the effects of conversion using the perceptual, relative colorimetric and absolute colorimetric rendering intents on a natural image.

The *saturation intent* is also vendor specific. It preserves the saturation of image values, with possible compromise of hue and lightness. The vividness of pure colours is therefore maintained, so the intent is useful for images containing graphics objects such as charts and diagrams, but less suited to accurate reproduction of natural images.

All four rendering intents operate using transforms on data assumed to be chromatically adapted to D50. The transform used for chromatic adaptation (see Chapter 5) will be included in the profile for the media-relative colorimetric intent only. It is not a specified requirement for the non-colorimetric rendering intents.

In earlier versions of the ICC specification, the four rendering intents described above were mainly associated with printer profiles. The rendering intents assumed for input and display profiles were not identified in the profile and were one of the sources of ambiguity in the version 2 specification (ICC.1:2001-04). This has been addressed in the version 4 specification, where profiles for all four rendering intents may be created for input and display devices as well as printers.

The ICC perceptual intent reference medium and reference viewing conditions

Used for the perceptual intent only, the reference medium is defined as a print on a substrate with a density range of 2.4593 and a white with a neutral reflectance of 89%. The medium is also selected to have a black point at a realistic level, so that its dynamic range may be a suitable intermediate between images of high and low dynamic range. This ensures smooth compression of the tonal range when the source has a higher dynamic range than the destination. If the source has a limited dynamic range, then it can be expanded to that of the reference medium before rendering to output. The reference viewing conditions for the perceptual intent are specified as illuminant D50 at an illumination level of 500 lux for viewing printed media.

ICC PROFILES

Each ICC profile provides the characterization information for the colour transformations necessary to define colour from the encoded image data, defined in an open format. The transformations may be implemented as look-up tables, matrices and/or parametric curves. The available implementations will depend upon the profile type, as defined in the ICC.1 (v. 4) specification. There are several different types of profiles.

It is important to distinguish between the profile types described below and the terms *source* profile and *destination* profile, because there can be some confusion. Profiles are described as source and destination profiles temporarily in the context of a specific colour conversion; this is

Figure 26.6 Rendering intents. The image at the top was converted from the ProPhoto RGB colour space to the Euroscale coated V2 CMYK colour space using the perceptual, relative colorimetric and absolute colorimetric rendering intents (left to right, bottom row). The differences in the results are subtle. On close examination, it can be seen that the perceptual intent has caused an overall loss of lightness and saturation, as would be expected from gamut compression. The relative colorimetric intent has produced a slightly better result, by maintaining the appearance of in-gamut colours. The absolute colorimetric intent has maintained lightness and saturation in many colours, but there is a noticeable difference in the hue of the light region in the upper middle of the image, as a result of the medium white point not being mapped to the PCS white point.
'Oaxaca' image © iStockphoto.com/Jeff Morse

a description of their role in the conversion rather than the profile type. Therefore, a source profile is not necessarily an input profile. If colours are being re-rendered from one output to another, then both source and destination may be output profiles.

Device profiles fall into three broad classes: input, display and output profiles. Device profiles contain descriptions of three main variables in the colour reproduction characteristics of the device, colour gamut, dynamic range and tone reproduction, and possibly additional device and vendor-specific information.

Input profiles are used with digital cameras and scanners. Three different types of input profile are specified: these are *n*-component look-up table (LUT) based, three-component matrix based, or greyscale (see the section on *profile processing models* below). The three-component matrix based type may only be used with the PCS encoded in CIEXYZ space. For CIELAB PCS encoding the *n*-component LUT type must be used. Input profiles only require definition of colour transforms in one direction, from the input device space to the PCS space.

Display profiles are used with cathode ray tube (CRT) and liquid crystal display (LCD) displays and data projectors, and are of the same three types, with the same PCS encodings as the input profiles. These are two-way profiles, however, containing transforms from device to PCS and PCS to device, because the display acts as both input and output device.

Output profiles are used with printers and film recorders. Two types are specified: *n*-component LUTs and greyscale profiles. These are also two-way profiles, as printers act as the destination profile when images are output, but are the source profile if images are being rendered to a different medium, or are being *soft-proofed*. In this case the printed image appearance is simulated on a display device; therefore, the display profile is the destination profile.

Additionally, there are four other colour processing profile classes defined:

* *DeviceLink profiles* are a special type of device-to-device profile, which do not use the profile connection space as an intermediate. The transform contained within the

profile provides a one-way conversion directly from source to destination colour values, which cannot be reversed. The profile is therefore specific to the two devices. The four different rendering intents may be included as different transforms within the profile. This type of profile is used (although not widely) for very specific (usually high-end) applications, and allows users to add their own adjustments to the profile. The DeviceLink profile effectively implements a form of closed-loop colour management, producing a transformation which may be used for many different images.

- *Colour space conversion profiles* are used to transform values between the PCS and various colour spaces. The colour spaces may be device independent, such as CIEXYZ and CIELAB, or standard RGB colour spaces, such as Adobe RGB 98 or sRGB (described in Chapter 23). They do not represent device models, although they may be output referred to standard reference media.

- *Abstract profiles* do not represent a device model, but are used to apply specific effects to the image, for example applying the same image appearance or style to a set of images. Abstract profiles allow the transformation from PCS to PCS, defining CIEXYZ or CIELAB values for both input and output, and creating an LUT between the two to implement the mapping of the particular effect. They are not widely used, but are available in some specialist colour management applications.

- *Named colour profiles* are used with named colour systems, such as Pantone™ or vendor-specific custom colours. Such profiles are used alongside a device profile, and refer specifically to colours reproduced on that device. They contain a *Named colour2 tag* for each named colour, which provides a PCS representation of the colour and optionally a device representation. The device representation specifies the exact device coordinates for the named colours on that device, therefore ensuring that the named colours are accurately reproduced. The PCS representation can be used to estimate these values with reasonable accuracy.

USING PROFILES

Profiles have two functions within the CMS architecture. The first is *association* with an image (by *embedding* or *assigning* the profile), to allow the CMS to interpret the meaning of its colour values, by providing the information necessary to translate the values to a device-independent colour space. When converting between colour spaces (see Figure 26.3), this profile will act as the source profile. They also provide information for the *conversion* from device-independent values to values in a different colour space (which may be another device-independent colour space, such as a standard RGB colour space, or a device-dependent output colour space). In this case, the profile is behaving as the destination profile.

A profile may be associated with an image by *embedding* it in the image file. This ensures that the colour data will be correctly interpreted by the destination system when the image is transmitted, regardless of whether the profile is installed on the destination system. The ICC architecture provides specification for the embedding of profiles. All but DeviceLink and Abstract profiles may be embedded. Images with embedded profiles are called *tagged* images.

An alternative method to associate a profile with an image is by *assigning* it. The option to assign profiles is included in image-editing applications. Assigning the profile specifies the use of that profile as the source profile when the image is displayed or converted. If an image is brought into an application without an associated profile, then it must be assigned a profile to allow its values to be interpreted.

Assigning and embedding profiles do not themselves involve any conversion of colour values, simply an offered interpretation. They are therefore non-destructive. An image may be reassigned many different profiles with no degradation whatsoever. Although the image values do not change, the image appearance on screen will do to a greater or lesser extent. When an image displayed on screen with a particular associated profile has a different profile assigned to it, the displayed image appearance will change (see Figure 26.7). This is because an alternative *interpretation* has been applied to the source colour values, giving different PCS values and different output values when the image is converted for display. It is important to note, however, that this conversion for display is also non-destructive. This is because the conversion to display colour space is applied to the data as it is sent to the video card, without affecting the image itself.

Conversion of an image between colour profiles (other than to the display) by its very nature alters the image values, as they are specified by the coordinates of a different colour space. However, the aim of conversion is to reproduce image appearance as accurately as possible within the limitations imposed by the use of different source and destination colour spaces and media. Therefore, although the image values will change, the aim in conversion is for the change in image appearance to be minimal (see Figure 26.8).

An important consideration when converting images between colour spaces is the implication of data loss. Rounding errors occur as a result of conversions between integers and multiple conversions will exacerbate these errors. The PCS is usually defined at a higher precision than the bit depth of the image, which can help to reduce this loss. Working with 16-bit rather than 8-bit images also helps to minimize the colour banding that may result (see Chapter 21). As we have seen, gamut mapping may be achieved by gamut compression, warping or clipping of values, depending on the rendering intent selected.

Figure 26.7 Changes in image appearance as a result of assigning different profiles. Colours shift and in some areas appear more saturated as the image is assigned profiles with different gamuts, from left to right: sRGB, Adobe RGB 98, Kodak ProPhoto RGB. (Note that Kodak ProPhoto RGB is a version of ROMM RGB, normalized so that $Y = 1$ for the reference white; see Chapter 23 for more details on ROMM RGB.)

Out-of-gamut colours will be lost in the conversion and are usually impossible to retrieve. Finally, most profiles require some form of interpolation during conversion. This applies to tone reproduction curves stored as sets of sample points (rather than gamma values) in one-dimensional LUTs, which may be linearly interpolated and may be present in all types of profiles. Profiles in which the colour transformation is achieved using LUTs (see the Shaper/multifunctional table processing model below) will require interpolation between the values in the look-up table. The accuracy of interpolation will be increased by increasing the number of entries in the LUT, but this must be balanced against the need to limit the size of the profile.

PROFILE PROCESSING MODELS

There are several different models used for processing the colour data within a profile to or from the profile connection space. The type used will depend upon the profile class. The simplest model is the *matrix/TRC* processing model (TRC is an abbreviation for transfer curve), which uses a combination of tone reproduction curves and a 3×3 matrix for colour transformation. This model is only used for RGB and single-channel profiles for input

and display devices. The model is illustrated in Figure 26.9. When transforming into the PCS, the three colour components are first processed through the corresponding device tonal response curve to convert from non-linear RGB to linear RGB values. This is most commonly achieved using three one-dimensional LUTs, although it may be alternatively specified simply by supplying a gamma value for each colour component. The linearized values are then passed through the matrix transform to provide PCS XYZ values. The matrix values are specified by the *colorant tag* (see next section). Either the curves or the matrix may incorporate white point adaptation. The transform from PCS to device values, illustrated in Figure 26.9b, is a simple reversal of this process. The inverse tone reproduction curves and the inverse matrix are not included in the profile, but will be calculated from the forward transform by the colour management module. Matrix-based models only support the media-relative colorimetric intent (from which the absolute colorimetric intent may be derived).

Profile types other than input and display profiles rely on the use of LUTs to process colours into and out of the PCS. This is because more complex colour conversions cannot be accurately achieved using the matrix/TRC model. Models based on LUTs are more complex to implement and there can be ambiguity in interpolated values, but they

ORIGINAL

CONVERTED

Figure 26.8 Conversion between profiles. The original image on the left has an assigned ProPhoto RGB profile. The image on the right has been converted from ProPhoto RGB to the sRGB colour space. The information box below each image indicates the RGB values of a pixel at the same position (1308,798) in the centre of each image. The conversion between profiles has changed the pixel RGB values quite significantly as a result of the different gamuts of the two colour spaces, with minimal change in image appearance.

are very flexible, providing reasonable accuracy for many devices. There are four possible models of implementations of LUT models identified in the ICC profile version 4 specification. These vary in complexity. Two of the alternatives for PCS to device, known as 'LutBtoA type', are illustrated in Figure 26.10. These models may contain up to five different elements, and any or all of them may be used. As well as the one-dimensional LUTs, which may implement various transfer functions, the models may also

include a matrix and a multi-dimensional look-up table, the CLUT, which combines the colour components. The LUTs may be of 8- or 16-bit precision. The contents of the LUTs and the matrices are not defined in the ICC specification and are therefore vendor specific. Because the matrix/TRC processing model can only be used with CIEXYZ as the PCS, all profiles requiring a CIELAB PCS must use LUT models. It should be noted that input and display profiles are not limited to the matrix/TRC

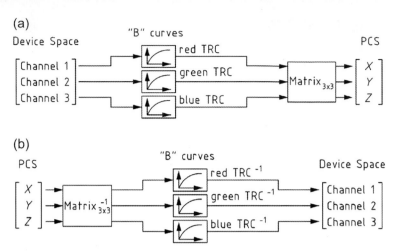

Figure 26.9 Matrix/TRC profile processing model. (a) Device to PCS. (b) PCS to device (from ICC version 4 Specification ICC.1:2004-10, profile version 4.2.0.0).

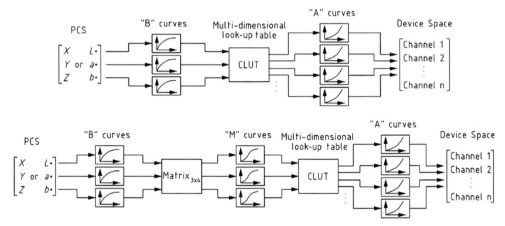

Figure 26.10 Examples of two of the models implementing LutBtoA type tables, from the ICC version 4 profile specification (ICC.1:2004-10, profile version 4.2.0.0).

processing model, but may also use models based upon LUTs.

The processing model used has implications for the profile size. Profiles containing matrix-based models are small, as they only store numbers for a 3 × 3 matrix and the tone reproduction curves will be represented by a single gamma value or a limited number of sample points, rather than the huge numbers stored for an LUT. Additionally they only support a single rendering intent, and do not require the inverse transform to be included. Profiles based upon LUTs and CLUTs provide values transformed in one direction; a further LUT is required to transform the other way. Output profiles tend to be the largest, requiring tables in both directions for each of the supported rendering intents; the numbers of values in the tables will be defined by the vendor.

PROFILE STRUCTURE

ICC profiles are tag-based data files, which have three main components, as shown in Figure 26.11.

The *profile header* is a fixed length (128 bytes) and provides the information necessary for systems to sort and search for the profile. There are 18 fields included in the header, although they are not all used for some of the profile types. The header includes key information about the profile and where it has come from, such as its size, creator, a unique identification number, and date and time that the file was created. It also includes information about the data it contains, for example the profile class or type, the manufacturer and the model of the device for which it was

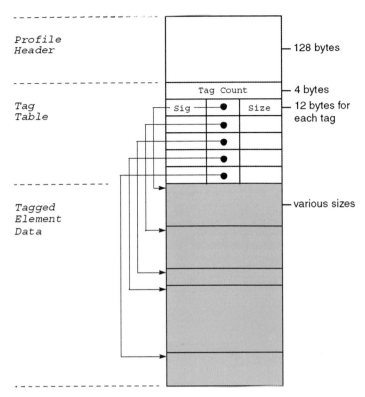

Figure 26.11 ICC profile structure.

created, vendor-specific device attributes, data colour space, PCS colour space, and preferred colour management module to be used. A rendering intent may also be specified.

The data describing the colour characteristics of the device and the process of conversion to and from the PCS are contained within a series of *tag elements*, some of which are requirements of all profiles and some that are specific to the profile class. The tag data are preceded by a *tag table*, which immediately follows the header and provides an index into the tag data. The tag table specifies the number of tag elements, and for each element a tag keyword description, byte offset from the beginning of the file, and length of data. The tag elements will include relevant matrices and LUT data depending upon the processing model. As well as the tags required for each profile, there are some optional tags, which allow the addition of extra functionality to the profile. Developers may also add proprietary information in a number of private tags, while still providing the profile in a standard and predominantly open format.

All profiles (except the DeviceLink profile) require tags for profile description, copyright, media white point and chromatic adaptation (when an illuminant other than D50 has been used to calculate the measurement data). The main tags required for colour conversion are listed in Table 26.1.

Structure of device profiles

A display profile based on a 3×3 matrix model and opened in the ICC profile inspector software is shown in Figure 26.12. On the left-hand side of the window is the profile header information and on the right the tag table showing the list of tag element data contained within the profile. The 'cprt', 'desc' and 'wtpt' terms correspond to the essential copyright, description and white point tags. The rest of the table contains tags relating to the colour transformation. Note the inclusion of a kTRC tag, which is the greyscale tone reproduction curve.

The structure of a display profile will depend upon which profile processing model is being used. The profiling process results in a set of tags for each profile type. These are detailed in Table 26.2 for each model.

The colour processing tags for input and output profiles are listed in Tables 26.3 and 26.4. The information contained within Tables 26.2–26.4 is based on information from ICC.1:2004-10 profile version 4.2.0.0 (see Bibliography). Note that there are also monochrome versions of all the device profiles. All monochrome profiles, regardless of the device, require only the Grey TRC tag in addition to the required tags for description, white point, chromatic adaptation and copyright.

Table 26.1 Profile tags used for colour transformation

TAG	DESCRIPTION
Red/green/blue TRC tag	Tone reproduction curves for the three channels. These may be defined as gamma values, or as sets of sample points which are linearly interpolated to create the curve
Red/green/blue matrix column tag	These provide values for the first, second and third columns respectively in the 3 × 3 matrix used in the matrix/TRC processing model. They are multiplied by linearized RGB values
Grey TRC tag	Grey tone reproduction curve, providing the information necessary to convert between a single channel and the PCS XYZ or CIELAB values
AtoB0 tag	Device-to-PCS look-up table, which for most profile classes achieves perceptual rendering. The LUT may be defined with 8- or 16-bit precision (lut8 type and lut16 type). It may also be of lutAtoB type, which is a colour transformation structure comprising up to five elements, including sets of one-dimensional curves, a 3 × 3 matrix and a multi-dimensional LUT
AtoB1 tag	Device-to-PCS look-up table, achieving colorimetric (media-relative) rendering for most profile classes. It has the same type options as the AtoB0 tag
AtoB2 tag	Device-to-PCS look-up table, achieving saturation rendering for most profile classes. It has the same type options as the AtoB0 tag
BtoA0 tag	PCS-to-device look-up table, achieving perceptual rendering for most profile classes, with the same type options as above
BtoA1 tag	PCS-to-device look-up table, achieving colorimetric rendering for most profile classes, with the same type options as above
DtoB0 tag	Device-to-PCS colour transformation achieving perceptual rendering. This transformation supports a 32-bit floating-point encoded input range, output range and transform, allowing a big improvement on accuracy. It is implemented using 'multi-processing elements' (a sequence of processing elements contained within a structure — the elements included in the sequence are flexible; currently, 1D curves, a matrix and a CLUT are supported). This tag provides a means for overriding the AtoB0 tag (which also implements perceptual rendering)
DtoB1 tag	Transformation and processing mechanism as for DtoB0, but achieving colorimetric rendering and with a means for overriding the AtoB1
DtoB2 tag	Transformation and processing mechanism as for DtoB0, but achieving colorimetric rendering and with a means for overriding the AtoB2
BtoD0 tag	PCS-to-device colour transformation achieving perceptual rendering, using 'multi-processing elements'. This tag also provides a means for overriding the BtoA0 tag
BtoD1 tag	Transformation and mechanism as for BtoD0, but achieving colorimetric rendering and with a means for overriding the BtoA1
BtoD2 tag	Transformation and processing mechanism as for BtoD0, but achieving saturation rendering and with a means for overriding the BtoA2
Gamut tag	An out-of-gamut tag, providing a table which specifies colours input as PCS values as in or out of gamut
Colorant table tag	Identifies the colorants used in the profile by their XYZ or CIELAB values, and a unique name
Named colour 2 tag	PCS and optional device representation for a list of named colours

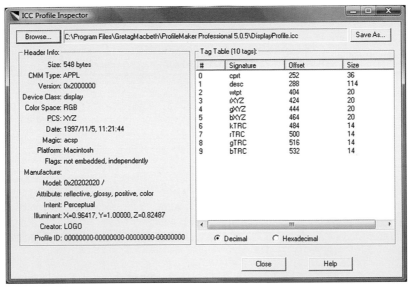

Figure 26.12 3 × 3 matrix-based display profile opened using the ICC profile inspector software.

Table 26.2 Colour processing tags for display profiles

TAG NAME	THREE-COMPONENT MATRIX BASED	N-COMPONENT LUT BASED	NOTES
Profile description	•	•	
Red/green/blue TRC	•		Transfer curves after media-relative scaling
Red/green/blue matrix column	•		
AtoB0		•	
BtoA0		•	
Media white point	•	•	XYZ values of media white point (D50 for display profiles)
Chromatic adaptation	•	•	Required if white point is different to D50, converts XYZ of colours measured under actual white point to what they would be under the PCS white point
Copyright	•	•	

Structure of colour space conversion profiles

Colour space conversion profiles convert between the PCS and non-device colour spaces; therefore they do not relate to any device. They are based on the shaper/MFT table profile processing model. They have the same basic structure as output profiles, although only the AtoB0 and BtoA0 tags (which are the look-up tables transforming data to and from the PCS using the perceptual rendering intent) are required (as well as the four essential tags required for all profiles). However, the tags for the colour transforms using the other rendering intents may optionally be included. The gamut tag may also be included and performs the same function as it does in output profiles.

Table 26.3 Colour processing tags for input profiles

TAG NAME	3 × 3 MATRIX BASED	N-COMPONENT LUT BASED	NOTES
Profile description	•	•	
Red/green/blue TRC	•		
Red/green/blue matrix column	•		
AtoB0		•	
Media white point	•	•	XYZ values of media white point
Chromatic adaptation	•	•	Required if white point is different to D50, see Table 26.2
Copyright	•	•	

Table 26.4 Colour processing tags for output profiles

TAG NAME	N-COMPONENT LUT BASED
Profile description	•
AtoB0	•
AtoB1	•
AtoB2	•
BtoA0	•
BtoA1	•
BtoA2	•
Gamut	•
Media white point	•
Chromatic adaptation	•
Copyright	•

CREATING CUSTOM DEVICE PROFILES

Although manufacturers supply *generic* ICC profiles with colour devices, these are created on the basis of the average behaviour of the device model, and therefore do not take into account the variability in behaviour displayed by individual devices. Their usefulness depends upon the stability of the device. Generic inkjet printer profiles, for example, may provide reasonable results, although they will not be as good as those obtained from a custom profile. The majority of devices, however, do display variation from the average behaviour, which may be present when they leave the factory, or colour reproduction may drift over time. Additionally, if any of the settings for the device is changed from the factory calibrated state, then the generic profile will no longer be accurate.

A good colour management workflow will therefore rely on custom profiles for at least some, if not all, of the devices. Custom profiles are generated by sending a target image or set of target colours containing known values, which have been colorimetrically defined in a reference file, to the device and measuring the reproduced values. The reproduced values are then compared to the reference values and a relationship between them is constructed, resulting in the colour transformation matrices or LUTs which are stored as tag elements in the profile. Once the profile is created, it will be accurate for the conditions under which it was created.

Some of the sources of variability in devices, such as drift over time as a result of components ageing, cannot be controlled. Under these circumstances, it will be necessary to recalibrate and re-profile the device to provide a profile updated to the new conditions. Other sources of variability are controlled by the user, in software and hardware settings. If these are changed, a new profile will be required, so the user should endeavour to restrict such changes. A specific source of variability in output devices is the use of different media and colorants. Each media/colorant combination will need its own profile.

Display profiles

A calibrated display with an accurate profile is one of the most fundamental requirements in a colour-managed workflow. As images are adjusted and soft-proofed on displays, it is vital that they provide an accurate representation of the image colours. Generic profiles may produce

reasonable results for input and output devices, but display devices exhibit significant variability and therefore require custom profiles and regular calibration.

In general, the process of creating a display profile is combined with calibration by the majority of profiling tools available. There are currently limited numbers of self-calibrating display device models available, in which the calibration software and measuring device is bundled with the monitor. These tend to be expensive and are therefore used mainly in very high-end workflows and scientific applications. More commonly, standalone profiling devices and software are bundled together. The more expensive measuring devices may be instruments which are extended to allow the profiling of several different types of device. However, there is a greater need by the consumer for display profiling instruments than for instruments for profiling input and output devices; therefore, there are several cheaper models for profiling displays only. The profiling instrument may be a colorimeter or a spectrophotometer, and measures values from the surface of the screen produced by the display of a number of known reference colours (see Figure 26.13).

A necessary step prior to calibration is the setting of white and black point luminance to adjust the dynamic range of the display. This step may be performed within the calibration software. The calibration itself involves the adjustment of the display transfer function (gamma) and white point to target values set by the user. These adjustments are applied by the software to the video card colour look-up table (CLUT). The CLUT then alters pixel values

'on the fly' as they are sent to the screen, effectively changing the behaviour of the display as if it had these values. The guidelines for gamma and white point vary depending upon the technology, the native white point of the display, the degree of control afforded the user and the output requirements of the imaging workflow. It is important that the monitor is allowed to warm up before calibration. CRT displays require a minimum warm-up of 30 minutes to allow them to stabilize. LCDs are quicker to stabilize. Other display technologies may vary.

Once calibration is complete, the software displays a series of reference colour patches and measurements are taken from the display faceplate using the profiling device. The colours are displayed sequentially, often in random order. The profile is constructed by defining the relationship between the measured values and the reference values. The profile should be saved in the correct location on the operating system. This will normally be identified automatically by the profiling software.

An important consideration when creating and using display profiles is the viewing environment. The background of the desktop should be set to a mid-grey and the screen saver turned off. Ambient illumination levels and coloured objects in the environment which may reflect on the screen can significantly alter image appearance. For the profile to be accurate, viewing conditions at the point of creation and when the profile is used to view an image should be the same. Ambient illumination levels should be relatively subdued, daylight balanced and should not change. Ideally, the room should not be lit by natural light. In some cases, where displays are being set up to a defined standard colour space, such as sRGB, the ideal viewing conditions may be specified (see Chapter 23).

After the profile has been created and saved, it must be associated with the display. This is achieved by selecting it as the default profile for the device in the device properties and may be done automatically by the profiling application, but it is important to check this. Device properties are found in the control panel, and the default profile is set under the colour management tab in the advanced settings.

Input profiles

The main variables affecting the colour reproduction of input devices are the light source used during capture, the sensor spectral sensitivities (see Chapter 23) and software settings. Clearly, because scanners have fixed light sources, the only factors over which the user has any influence are the software settings. For cameras the lighting conditions are a much bigger issue, affecting the uniformity of illumination, the dynamic range and the colour temperature. This leads to a fundamental problem in the use of a camera profile. A good profile will work well for images captured under similar lighting conditions, which may be controlled in a studio, but less well if the lighting conditions change.

Figure 26.13 Display profiling. The profiling instrument, in this case a colorimeter, measures values from the surface of the screen.
i1 Display 2 measurement device image © X-rite™

This subject is covered in more detail in the section below, 'Using camera profiles'. Nevertheless, the creation of camera profiles is useful and necessary for some applications, hence its inclusion.

The construction of input profiles involves the scanning or digital capture of test targets. The RGB values of the captured images are then compared with original measured XYZ or CIELAB values. There are a number of standard targets used for input profiling and these are supplied with a target description file. The accuracy of the values in the target description file will depend upon the target and how it has been manufactured. More expensive targets are manufactured in smaller batches and individually measured, whereas cheaper ones will provide target measurements based on the average of a batch of targets. The main requirements are therefore suitable targets and profiling software. No hardware is necessary, although more accurate target measurements can be taken by hand using a colorimeter or spectrophotometer, but this is not a requirement for profile creation. Input profiling software may be standalone, or may be bundled with measuring devices and software for profiling other devices.

The most commonly used scanner targets are the standard IT8.7/1 transmission target (see Figure 23.11) and the IT8.7/2 reflection standard targets; the transmissive version is available on various different film stocks. The majority of camera profiling packages use the standard Macbeth colour checker chart, or the Gretag Macbeth colour checker SG, which is shown in Figure 23.11.

Scanner profiling

The aim when profiling a scanner is to obtain an image of the target under conditions that are repeatable. Scanner software often has a number of automatic settings applied by default. These may include automatic setting of black and white points to optimize the dynamic range of the image, auto colour balance and sharpening. It is important that these are all turned off, so that the response of the scanner without image-specific corrections can be characterized. The scan should be captured at a reasonable resolution and saved in an uncompressed file format, such as TIFF. The profiling software will then prompt for the scanned target and the target description file, from which it will construct the profile. The software should automatically save the profile in the appropriate location (this will vary depending upon operating system). As for displays, it must be selected as the default profile for the scanner in the device properties.

Digital camera profiling

The process of profiling a digital camera differs from creating a scanner profile, because the user must control the camera response in terms of exposure and white balance. The majority of digital single-lens reflex (SLR) and higher-end cameras now allow RAW capture as well as the capture of files that have been colour rendered and compressed (typically as JPEG files). Optional RAW capture is also becoming a feature of some cameras aimed at consumers, both the 'prosumer' type and digital compact cameras.

If the camera can only output compressed files, then there is very limited use in creating an input profile. Cameras outputting JPEG files, for example, will in the majority of cases encode the images in a standard sRGB encoding and an input profile will not be appropriate in this case. The reasons for this are described in the next section. Furthermore, lossy compression algorithms are very scene dependent and may result in colour distortions in the image. Therefore, a colour transform created from a captured and compressed test chart is unlikely to be accurate for a compressed image from a natural scene.

In profile creation, therefore, the image should be captured as a RAW file or in an alternative uncompressed format, such as a TIFF file. The profiling software should define required conditions at capture, and further processing. The test target should be evenly illuminated, parallel to the focal plane and should be large within the frame. Whether profiling using TIFF or RAW, a (manual) custom white balance should be performed using a neutral area within the frame, rather than using an automatic white balance. Any other automatically applied controls of contrast or colour should also be turned off, to allow the default behaviour of the camera to be profiled.

The image should be opened from within the profiling software, which will then guide the process of profile generation. Camera profiling software often provides options for various settings, such as how much of the captured image of the target is used to create the profile, or options in the profile itself, to allow certain corrections to be applied. The amount of this type of control is vendor specific.

As with all device profiles the profile is only accurate for the imaging conditions under which the test chart was captured, so images captured under those same conditions can be usefully associated with it. Other imaging conditions will require a different profile. The colour temperature of the illuminant in particular will affect the accuracy of colour reproduction. Therefore, it is good practice to create profiles for both daylight and tungsten, as the most commonly used illuminants.

Using camera profiles

It is important to note that two different types of ICC profiles may be applied to images captured with a digital camera. These are input profiles, as described above, or colour space profiles for standard RGB colour space encodings, such as sRGB, Adobe RGB 98 or ROMM RGB (see Chapter 23 for descriptions of the characteristics of these colour spaces).

The majority of digital cameras perform colour rendering of the data from the sensor to produce an image which is

output referred to a standard reference medium, i.e. to one of the standard colour space encodings. As illustrated in Figure 23.2, the data will be captured in a sensor image state and will then possibly (but not compulsorily) be processed to a scene-referred image state. However, neither sensor-referred nor scene-referred data are viewable as an image. The image is therefore colour rendered before output to an output-referred state. If the image is being captured to a format other than RAW, then colour rendering will be performed automatically by the camera. Images captured and output as RAW files defer the colour rendering until RAW conversion, during which the user selects the required output colour space. Whether the camera is capturing RAW or JPEG, if it is outputting images to a standard colour space, then an input profile created as described in the previous section will not be suitable. In this case the correct ICC profile to be applied to the image is the required colour space profile for which the image is output referred.

Custom camera profiles are only really useful for scene-referred image data. The number of cameras capable of doing this is limited; they are usually medium-format or larger, high-end professional cameras. The Adobe DNG conversion software may also output scene-referred images. In these cases a custom-made profile representing the scene in the PCS may be used. If this type of camera is being used for images where the requirement is for colour matching of the scene, then the colorimetric rendering intent should be used. More general imaging, where the aim is to produce pleasing images rather than accurate colour matches, requires the use of the perceptual rendering intent.

Therefore, in the majority of imaging workflows, it is not necessary to create a custom camera profile and the focus should be on capture using the appropriate colour encoding for the predicted output medium of the image. There is also a brief discussion on this subject in Chapter 25.

Output profiles

The measurement of output profiles requires the use of a dedicated measuring device; this may be a reflection colorimeter or a reflection spectrophotometer. A test target in electronic form is sent to the printer and the printed version is then used to compare to the reference file and generate an LUT-based profile. The target should be printed without colour correction applied by the printer driver, as it is the default behaviour of the printer that is being characterized.

The calibration of printers varies depending upon the type of technology. Calibrating a printing press may involve many different calibration adjustments at different stages, whereas many desktop printers do not have controls to allow calibration of the printer itself. The aim of calibration, as for all devices, is to set the printer conditions to a state that is repeatable. Defining the ink/paper

combination is part of the calibration process; different combinations require separate profiles.

Many profiling packages include a *CIELAB linearization* stage as part of the calibration. This step is necessary because CMYK is perceptually non-linear, meaning that linear increments in CMYK space will be non-linear in CIELAB. This is illustrated in Figure 26.14, which shows the IT8/7.3 CMYK test target. Consecutive target patches have CMYK values changing by linear amounts, but these values produce non-linear increments in their corresponding CIELAB values.

To correct for this, a pre-profiling linearization chart is printed (an example is shown in Figure 26.15), which contains linear CMYK scales. These are measured and the profiling software reallocates the CMYK values to linearly spaced CIELAB values. Although these new CMYK values are non linear in CMYK space, they are linear in CIELAB space. The profiling test target is then printed with these new adjusted CMYK values replacing the original ones. Because the resulting LUT is generated from values at regular intervals in CIELAB, the required interpolations to obtain intermediate values will be more accurate, and the profile more uniform.

Once linearization has been performed, the profiling target must be opened and printed. There are a wide range of printer targets available. Although the IT8.7/3 is generally supported, it has a number of shortcomings, in particular when profiling desktop printers, therefore various alternatives have superseded it as recommended by vendors. As an example, the ECI 2002 CMYK chart, illustrated in Figure 26.16, contains more patches, to improve the representation of device behaviour. Both RGB and CMYK charts are available for output devices. RGB charts are used for output devices that use only three channels to control colour, such as the Fuji Pictrography. Many inkjet printers should also be considered as RGB devices. Because of the move towards RGB workflow (see later in this chapter), images are sent to these printers in an RGB colour space and the conversion to CMYK is performed by the printer driver. Dye-sublimation printers may also function as RGB devices. It is therefore important to check which type of test chart is suitable for the particular printing technology and device model before profiling.

The number of patches required for measurement varies, depending upon the profiling package, but a minimum of a few hundred is usually required. It should be noted that the number of measurements taken does not correspond to the number of entries in the resulting table. The values measured are interpolated down to provide a more manageable set of data in the LUT (and will then be interpolated up to provide colour values when the profile is used). From printer to printer the number necessary to obtain a good profile will depend upon how 'well behaved' it is — in other words, how close it is to being linear and grey balanced (where values from neutral measurement patches are reproduced as neutral without a colour cast) in

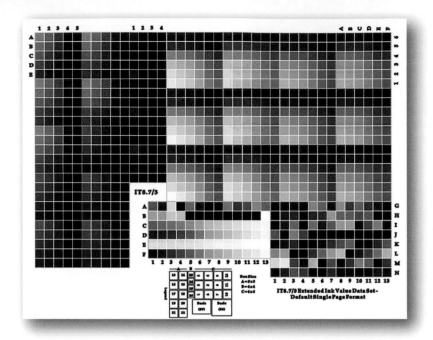

patch	1	2	3	4	5	6	7	8	9	10	11	12	13
CMY	0	0	0	0	0	0	0	0	0	0	0	0	0
K	90	80	70	60	50	40	30	25	20	15	10	7	3
L*	23	34	44	54	63	71	80	83	87	91	94	96	98

Figure 26.14 LAB values versus CMYK: the IT8/7.3 CMYK target. The table below the illustration shows values for the set of greyscale patches from the centre bottom of the target, row F, 1—13 for CMYK and LAB space. Patches 1 and 2 have a change in *K* of 10 (*K* = 90 and *K* = 80), with a corresponding change in *L** of 11 (*L** = 23 and *L** = 34). At the other end of the scale, the change between patches 9 and 11, also a change of 10 in *K*, produces a difference of only 7 in the corresponding *L** values.

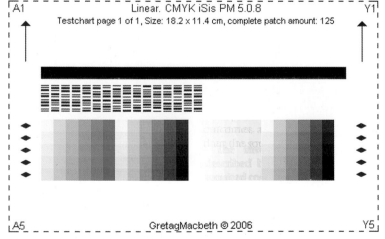

Figure 26.15 CMYK iSis linearization target from Gretag Macbeth.
© X-Rite™ (www.xritephoto.com)

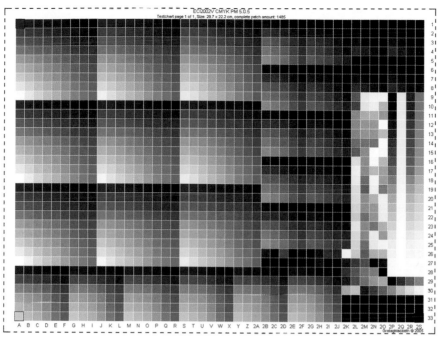

Figure 26.16 "ECI 2002" CMYK target.
© *European Color Initiative (ECI, www.eci.org)*

its default behaviour. A printer that exhibits colour casts or significant non-linearity will require more patches to obtain an accurate profile.

Often, profiling software will allow the option of printing from within the application. The alternative is to save the chart and print it from an external application such as Adobe Photoshop. If Photoshop is used, then it is important that a profile is not assigned to the image when it is opened. The colour management policies in the Photoshop colour settings should be set to 'ask when opening' for images with missing profiles. When the image is opened, a missing profile window will open up. This should be set to 'Leave as is (don't color manage)'. When the chart is printed, the source space should be set to 'document' and the Print space to 'same as source'. This process ensures that the chart is unchanged.

It is important to ensure that the print has dried and that the profiling device has been calibrated before measurement. The calibration involves setting the zero point by measuring a white calibration tile, which will be included with the device. The profiling package will usually indicate the order in which patches should be read, to ensure that the measured values are matched to the corresponding reference values.

Once the measurements have been taken the software will generate the profile; however, there are a number of settings that the user may be prompted to select before the profile is created. Some packages allow the user to choose a profile quality, which is based upon the number of entries

in the resulting LUT. The need for high quality must be balanced against file size requirements. Another commonly encountered option is black generation setting. This involves defining grey component replacement (GCR) and under colour removal (UCR). In simple terms, these processes specify the combination and amounts of the different colorants used to create colours. For example, colours may be created as a combination of amounts of only cyan, magenta and yellow inks. However, it is also possible to remove a certain amount of the CMY inks and replace them with an amount of black ink that produces the same tone as the three inks combined, the remaining amounts of CMY inks producing the actual colour. In other words, the black ink is used to contribute to the lightness of the colour, while the amounts of the other three inks define its hue and saturation.

The details for generating profiles for the many different types of printing technology available are too numerous to be covered in this text, but may be found in some of the references at the end of the chapter. The ICC website is also an extremely useful source of information.

COLOUR MANAGEMENT WORKFLOW

There are various factors that require consideration in designing colour management workflow. The devices used, the predicted output media, the need for flexibility, the

purpose of the image as it moves through the imaging chain, and the ultimate reproduction aims will all define when and how an image will be converted between colour spaces. Guiding principles for practical implementation of colour-managed workflow are dealt with in Chapter 25, and details of image states, colour encoding methods and standard colour spaces are covered in Chapter 23. This section deals with some of the conceptual issues governing the process and provides some examples of workflows for different imaging tasks.

Colour rendering options

As described earlier, colour rendering is the mapping of image data from a scene to output-referred image data. The colour rendering process begins with captured values from an original scene. The values may be scene referred, for example if they have been transformed to the RIMM RGB colour encoding (see Chapter 23), or in a sensor state. The colour rendering transform performs several functions: the mapping of the dynamic range and gamut of the image to those of the output medium, appearance adaptation to take into account different viewing conditions at input and output, and adjustments to colours to accommodate human observer preferences.

There are two commonly implemented approaches to colour rendering: rendering to an *intermediate reproduction description* or *deferred colour rendering*. In the first approach, the input image is rendered to an intermediate standardized real or virtual reference medium and, during conversion to output, it is re-rendered from the intermediate to the output medium. Deferred colour rendering encodes the source data (which may be scene-referred colorimetry or colour filter array (CFA) raw data, and therefore device dependent) with input metadata, and defers color rendering until output. When the output medium is defined, the data is rendered directly from source to output. If the data is CFA raw data, the data may be demosaiced to become raw RGB data, before rendering, or the demosaicing process may be combined with colour rendering.

The ICC rendering intents support both approaches; the perceptual intent, which uses a reference print medium, is a form of intermediate reproduction description. The colorimetric intents enable deferred colour rendering.

As described in the section on using camera profiles, the intermediate reproduction description dominates for digital capture, with most cameras encoding images directly into a standard output-referred colour space such as sRGB. However, the use of camera RAW capture is becoming more widespread, and is supported by the majority of digital SLRs and some compacts. RAW capture may be considered as a form of deferred colour rendering, in which the required colour rendering is decided by the user in RAW conversion software after capture. It should be noted that the majority of RAW conversion software renders the image to a standard output-referred colour

space, and the image will then be re-rendered to an alternative real output if required.

Early-binding versus late-binding workflow

An important issue in determining workflow concerns the point at which conversion to the final output colour space will occur. It is relevant for workflow using all types of colour space, but has a particular influence if the output is to a CMYK colour space. In nearly all cases, the input will be captured in an RGB colour space; therefore, the conversion may well be from a larger to a smaller gamut, and the gamuts may have significant areas of mismatch.

In an *early-binding* scenario, the conversion occurs as early as possible in the workflow. Early-binding workflows were traditionally used for the delivery of CMYK files, although the concept applies equally when the output is in an RGB colour space. Because the gamut will be limited early on to that of the output, there will not be problems with out-of-gamut colours further down the imaging chain. Image adjustments will be performed within the constraints of the gamut and because all users involved in the workflow work in the same colour space, there will be no ambiguity in terms of how colours should be interpreted. However, the simplicity of the approach means that it is inflexible. All stages of the imaging chain will be optimized for the specified output, but will not be optimum for other outputs, should they be required. Any out-of-gamut colours in the original will effectively be lost early on and cannot be retrieved.

A *late-binding* workflow (see Figure 26.17) delays the conversion for as long as possible, maintaining the original gamut. This is therefore much more flexible if multiple outputs are required, or the output is unknown, allowing the image to be repurposed for outputs with very different characteristics. This approach can be complex, however, and there is the need for the correct use of colour management by all involved in the workflow. Because the output is not explicit, there may be problems if the correct profiles are not used or are ignored at some stage in the chain. Additionally, without the constraints of a known output gamut earlier on in the process, image adjustments may result in more out-of-gamut colours when the image is finally converted for output.

RGB and CMYK workflows

The definition of an RGB workflow is one where the original RGB encoding is retained and exchanged. The encoding may be *input referred* if an input profile is being used, or an output-referred colour encoding such as sRGB if an intermediate reproduction description is used for colour rendering. The former case is a late-binding workflow as

Figure 26.17 Late-binding RGB workflow. The image is retained with source RGB profile assigned to it until output. This allows conversions to multiple outputs from the source profile.

conversion happens at output. The latter case is also late binding, although in the special case of the output-referred colour encoding being the same as the required output, no conversion is necessary.

A CMYK workflow is one where a CMYK encoding is retained and exchanged. The CMYK encoding may be an intermediate reproduction description from an RGB capture, which may be viewed as an early-binding workflow. Alternatively it may originate from a CMYK capture (some drum scanners scan images to CMYK values, although the sensors are RGB). This is more typical of early closed-loop systems which scanned for a particular output, but may also be a late-binding workflow, if it is necessary to convert to a different CMYK space.

The workflow illustrated in Figure 26.17 is an RGB workflow, where the image is retained with the scanner profile throughout the imaging chain. Inkjet printers, as described previously, may be considered to be RGB devices in most cases, as they accept RGB images and the conversion to the printer CMYK colour space is performed by the printer driver at output.

Using an intermediate colour space

An alternative to early or late binding is to use an intermediate colour space, between the input and output colour spaces (see Figure 26.18). This is not to be confused with the intermediate reproduction description, described above, which refers specifically to colour rendering, although the working space may be the same as that of the intermediate reproduction description. The image is converted to the intermediate space early in the workflow (unless it has been encoded at capture into the same colour space), and all editing is performed in this space before the image is converted to output.

The requirements of a useful intermediate space are that it is perceptually uniform, grey balanced and has a gamut large enough to be suitable for conversion to any likely output gamuts. CIELAB may be used, but it is also not particularly intuitive for image editing. More commonly, device-independent RGB colour spaces (for example, sRGB or Adobe RGB 98) may be used, which are perceptually uniform and grey balanced, but have more limited gamuts. The choice of particular intermediate space will depend mainly upon anticipated output gamuts. This subject is covered in Chapter 25.

The intermediate colour space is termed the *working space* in many image-editing applications. As well as being an intermediate between input and output profiles, it has an additional function as a default colour space for images brought into the workflow (from another imaging chain, for example) without profiles. In this case, the image may be initially assigned the working space to be viewed. The working space profile acts as the source profile in the conversion to display and the image may then be assigned an alternative working space if more appropriate.

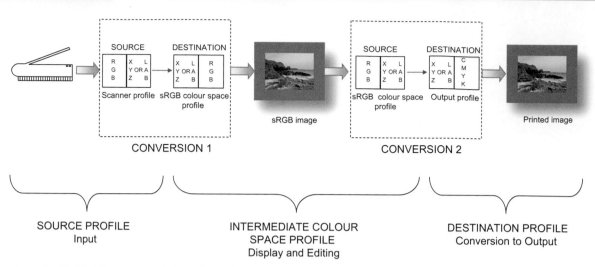

Figure 26.18 Workflow using an intermediate colour space.

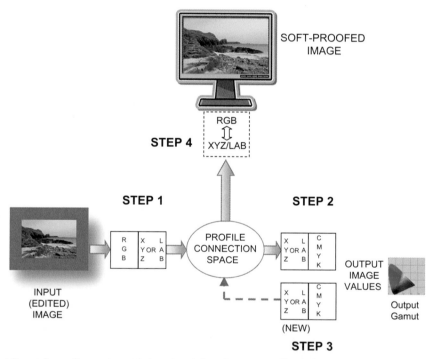

Figure 26.19 Workflow soft-proofing an image to be printed. Step 1: source profile used to convert image RGB values to PCS values. Step 2: image PCS values converted to printer CMYK. Gamut mapping/compression is likely to occur at this point. Step 3: inverse process converts CMYK values back into PCS values (note: these will be new PCS values, limited by the combination of the printer gamut and the rendering intent). Step 4: new PCS values converted to display RGB (note: conversion on values sent to video card, not on original data).

Proofing and soft-proofing images

The process of *proofing* an image is a re-targeting operation, as described in the earlier section on rendering intents. The aim of proofing is to check the final colour reproduction to ensure that it has the desired colour appearance. A *proofer* is a device used to simulate the appearance of an image on another device. Traditional proofing involves printing a simulation of the final print appearance on a proofing printer, whereas soft-proofing simulates the

print appearance on a display. The basic process is the same. The relevant PCS-to-device transform is first used to convert the image to the output colour space. This conversion may use the perceptual intent or the media-relative colorimetric intent depending upon the colour reproduction goal. The result is then converted back to the PCS, before being converted to the proofer (printer or display) using the proofer profile and one of the colorimetric intents. The choice of colorimetric intent is important if the media white points for the proofer and the output device are very different. In this case the media-relative colorimetric intent will produce an image in which the white point is adapted, but will be less accurate for the majority of colours than the absolute colorimetric intent. The absolute colorimetric intent may produce a colour cast in the image whites as a result of simulating the different white point. Figure 26.19 illustrates soft-proofing workflow.

BIBLIOGRAPHY

Fraser, B., Murphy, C., Bunting, F., 2005. Real World Color Management, second ed. Peachpit Press, Berkeley, CA, USA.

Green, P., MacDonald, L., 2002. Colour Engineering: Achieving Device Independent Colour. Wiley, Chichester, UK.

Sharma, A., 2004. Understanding Color Management. Delmar Learning, Thomson Learning, New York, USA.

Sharma, G. (Ed.), 2003. Color Imaging Handbook. CRC Press LLC, New York.

Wallner, D. Building ICC Profiles — The Mechanics and Engineering. Available to download from www.color.org

Standards and specifications

International Color Consortium, 2001. Specification ICC.1:2001-04. File Format for Color Profiles. Available online from the International Color Consortium website. www.color.org.

International Color Consortium 2004. Specification ICC.1:2004-10 (profile version 4.2.0.0). Image Technology Colour Management — architecture, profile format, and data structure available online from the International Color Consortium website, www.color.org

International Standards Organization 2004. ISO 22028 1:2004. Photography and Graphic Technology — Extended Colour Encodings for Digital Image Storage, Manipulation and Interchange, Part 1: Architecture and Requirements. Available online from www.ISO.org

White papers

ICC white paper 4 2004. Color Management — Conceptual Overview, Evolution, Structure and Color Rendering Options.

ICC white paper 6 2004. ICC Version 2 and Version 4 Display Profile Differences.

ICC white paper 7 2004. The Role of ICC Profiles in a Colour Reproduction System.

ICC white paper 9 2005. Common Color Management Workflows and Rendering Intent Usage.

ICC white paper 17 2005. Using ICC Profiles with Digital Camera Images.

ICC white paper 20 2005. Digital Photography Color Management Basics.

ICC white paper 23 2008. RGB Color Managed Workflow Example.

All the above are available to download from www.color.org

Spatial image processing

Elizabeth Allen

All images © Elizabeth Allen unless indicated.

INTRODUCTION

One of the most powerful motivations for the processing of digital images is image *enhancement*, either to improve their visual appearance and make them more pleasing to the human observer, or to improve the results obtained if the images are to be further analysed in computer vision applications. Enhancements typically involve: the reduction of unwanted elements, such as noise, introduced at the point of capture or by the imaging system; the correction of distortions, introduced by a poor choice of camera angle, less than optimum imaging conditions, or by the imaging optics; the modification of tone and colour reproduction; and the improvement of the important elements in the scene, such as edges. Image enhancement operations may be broadly categorized by the *domain* in which they are performed: *spatial-domain operations* refer to processes that operate on the image plane, on the pixels themselves, while *frequency-domain operations* are carried out by manipulation of a frequency-domain representation of the image, obtained using a transform, typically the Fourier transform (see Chapter 7). In many cases there are equivalent processes in both domains, although one may be preferable to another, depending upon the required result, ease and efficiency of application. It is the former class of operations with which this chapter is concerned. Frequency-domain processing operations are dealt with in the next chapter.

The importance of operations in the spatial domain lies in their simplicity, as they are often very basic arithmetic operations, and are easy to implement. These processes are a good illustration of one of the huge advantages of digital imaging over silver halide systems. When an image is reduced to a simple array of numbers, processes that require time, equipment and technical skills in the darkroom become the mere application of an algorithm. These can be written easily in suitable software by anyone with fairly basic programming skills. Furthermore, they produce immediate results and most importantly are repeatable and in many cases, depending upon the operation itself or the use of 'history' in an image editing application, they are reversible.

The points of application of spatial processes and the variations in their implementation at different stages in the imaging chain depend upon the hardware and software being used as well as the overall workflow. These issues are dealt with in detail in Chapter 25. This chapter aims to look at the 'nuts and bolts' of some of the most commonly used operations and their effects on the image. The Bibliography at the end of the chapter contains some classic texts on digital image processing for more in-depth coverage of the subject.

BACKGROUND

Structure of the digital image

As introduced in Chapter 1, the digital image is a discrete representation of a continuous scene, consisting of an array of non-overlapping pixels. In a two-dimensional image, each pixel may be described by a set of variables describing its spatial coordinates in relation to the origin of the image and values representing its intensity per colour channel, the nature of which will depend upon the colour space in which the image is encoded. In image-processing literature, a pixel is usually described as $p(i, j)$, where i and j represent row and column numbers respectively and p the pixel value. The image will consist of M rows and N columns (see Figure 27.1). These conventions will be used in this chapter.

Figure 27.1 Coordinate representation of digital images. *Inspired by Gonzalez and Woods (2002)*

Implementation of spatial domain processes

As we are generally dealing with input and output images of the same size, we may view the implementation of a spatial process in terms of an input image, $f(i, j)$, a spatial

operation, H, and an output image $g(i, j)$. The general form of a spatial domain process may be written as:

$$g(i, j) = H[f(i, j)] \qquad (27.1)$$

Generally, spatial processes may be categorized according to the number of input pixels used to produce an output pixel value. *Point processes* are those where the output pixel value is based only on the value of the input pixel at the same position, and some operator. This process is illustrated in Figure 27.2a. Point processes are therefore mapping operations between input and output. Examples include changes to tonal range, such as the overall exposure of the image, contrast or dynamic range, which all involve mappings of intensity, or greyscale, values. Additionally colour corrections are applied using the same types of mappings to individual colour channels. They are often implemented using look-up tables (LUTs), which are created by applying various transformation functions to the input—output transfer curve (the digital transfer curve is the equivalent of the silver halide characteristic curve described in Chapter 8 — see Chapter 21), or using the image statistics, by manipulating the image histogram. In image-editing applications such as Adobe Photoshop or Image J, they may also be applied using the histogram (by making levels adjustments) or by altering the input—output curve of the image (using curves adjustments).

A special type of point process uses multiple images at input. The pixel values at the same coordinate position

Figure 27.2 (a) Point processing operations (using a 1 × 1 neighbourhood). (b) Point processing operations, multiple images. (c) Neighbourhood processing operations.

from all the input images are combined in some way to produce the output pixel value (Figure 27.2b). These methods tend to use either arithmetic operations or logical operations to calculate the output value.

The other major types of spatial domain process are *neighbourhood processing* operations. As the name suggests, these methods involve the calculation of an output pixel value based on a neighbourhood of input values, which is selected using some kind of mask or kernel, depicted in Figure 27.2c. These are more commonly known as filtering methods. The two main classes of spatial filters are either linear or non-linear. The differences in implementation and properties of each are described later in the chapter.

Linear systems theory

The idea of a linear, spatially invariant system was introduced in Chapter 7 in the context of the Fourier theory of image formation. Linear operators are used extensively in image processing and an understanding of the properties of linear systems is important, hence an elaboration of the subject here. Linear systems possess two key properties:

1. *Additivity*. If f and g are input into the same linear system, H, the sum of their outputs will be the same as if the inputs had been added together before going through the system. This can be summarized in the following expression:

$$H[f + g] = H[f] + H[g] \qquad (27.2)$$

2. *Homogeneity*. If an input, f, is multiplied by a scalar value, a, before being input into a linear system, H, then the output will be the same as if the output of the system from input f had been multiplied by the scalar:

$$H[af] = aH[f] \qquad (27.3)$$

Note that f and g may be image functions or single pixel values.

In spatial processing, linear filters produce very predictable results compared to their non-linear counterparts. An additional and extremely important property of linear filters is that they have a frequency-domain equivalent, based upon the *convolution theorem*, which is described in Chapter 7.

DISCRETE CONVOLUTION

Convolution is important in digital image processing as the basis of linear spatial filtering, but is applied as a discrete operation. Continuous convolution was introduced in Chapter 7. The integral in continuous convolution (Eqn 7.30) is replaced by multiplication and summation in discrete convolution, which is much simpler to understand

and implement. Two-dimensional discrete convolution is given by the expression:

$$f(i, j) \otimes h(i, j) = \sum_{m=-\infty}^{\infty} \sum_{n=-\infty}^{\infty} h(m, n) f(i - m, j - n)$$

$$(27.4)$$

This describes the process of one discrete function being rotated and passed over the other. At each point of displacement, the values in the underlying function are multiplied by the values in the corresponding position in the convolving function. The multiplied results for the range are summed and this becomes the output value at this point. In filtering operations the two functions are finite and in general the convolving function is tiny compared to the image, often a mask containing 3×3 or 5×5 values. The extension of the above expression for finite functions and an illustration of this process are given in the later section on digital filtering.

POINT PROCESSING OPERATIONS: INTENSITY TRANSFORMATIONS

Often called grey-level transformations, as they are most commonly applied to greyscale images, they may also be applied to individual colour channels; colour corrections are frequently implemented using the same approach.

Brightness and contrast changes using linear transformation functions

The graph in Figure 27.3a represents a simple mapping between input and output. Max may be the maximum pixel value ($L - 1$, where number of levels $= L$) or 1.0, when pixel values are normalized. The function contains values across the full range of grey levels which are rising monotonically. The dynamic range, which is the ratio between the smallest and largest values and is indicated by distances X_1 and X_2 on the graph, remains the same from input to output. This particular function represents no change to the image; all input values and output values are equal. This function may be described by the expression:

$$g(i, j) = mf(i, j) + c \qquad (27.5)$$

This is an equation of a straight line of the form $y = mx + c$, where the constants m and c (the gradient and y-intercept) are 1 and 0 respectively. By changing the values of the constants, global changes to contrast and brightness may be achieved.

Changing the value of c to a negative value will result in a reduction in the overall brightness of the image, producing the function in Figure 27.3b, while a positive value will

Figure 27.3 Brightness changes using linear functions. (a) The identity function (no change between input and output). (b) Reduction in global brightness (clipping in the shadows). (c) Increase in global brightness (clipping in the highlights). (d) Conversion of image from positive to negative.

cause the opposite effect (Figure 27.3c). Note that in the former case a large number of the lower output values will be set to 0 and in the latter the higher output values will be set to the maximum value, representing clipping in the shadows and highlights respectively. This is the type of function which is applied when a brightness change is applied using a slider. Both functions also indicate the reduction in the dynamic range of the output image, as a result of the clipped values. The same result may be achieved using a *histogram slide*, where values are added or subtracted to the histogram values. The results of applying the functions in Figure 27.3b and c to an image are illustrated with their histograms in Figure 27.4.

The reversal of an image from positive to negative (illustrated by the function in Figure 27.3d) is obtained from Eqn 27.5 with values of $m = -1$ and $c = 1$ (assuming the function is normalized). This may be generalized to non-normalized images using the expression:

$$g(i, j) = f_{max} - f(i, j) \qquad (27.6)$$

where f_{max} is the maximum pixel value contained within f.

Any deviation in the gradient of the function will represent a change in the contrast of the image (Figure 27.5): a steeper slope ($m > 1$, $c < 0$) indicates an increase in contrast of the values affected; $m < 1$, $c > 0$ results in contrast reduction (also known as tonal compression). These functions are rotated versions of the identity function around the middle grey level. In the case of contrast increase, the separation between the mid-tones will increase, with their dynamic range expanded to match the dynamic range of the input image, resulting in clipping in both highlights and shadows.

Piecewise linear functions

The functions in Figure 27.6a and b illustrate changes in contrast using linear functions which are applied in segments across the tonal range. They are used in situations where the aim is to enhance the contrast of one or several

subjects which comprise grey levels in a specific narrow range. They are known as *piecewise linear contrast enhancements*. These functions are characterized by the fact that the gradient is altered linearly between defined control points, P_1 and P_2. In Figure 27.6a, the contrast of the grey levels between the two points has been increased by applying a gradient of 1.5. Below P_1 and above P_2 the slope has been decreased, which maintains the overall dynamic range of the image without clipping any values. The shadow and highlight tonal ranges (above and below the control points) have been compressed, while the contrast of the mid-tones has been increased. In Figure 27.6b, the contrast of the mid-tones between the two control points has been reduced by applying a gradient of 0.5. Above and below the control points the gradient has been maintained at 1, therefore maintaining tonal separation for the shadows and highlights. The result of the tonal compression in the mid-tones, however, is that the overall dynamic range of the image is reduced.

Although linear functions are easy to implement, they are restricted in that all input values (of the image, or of a range within the image) will be altered in the same way. An alternative to piecewise linear functions is to use a sigmoidal function (Figure 27.6c), which has the advantage of altering values smoothly, with much less clipping at either end of the tonal range.

Image thresholding and quantization

The conversion from a greyscale to a binary image is achieved using a *thresholding* operation. This is a special case of piecewise linear contrast enhancement, in which the input values for control points P_1 and P_2 are equal and represent the image threshold. In this case, all values below this point are set to 0 at output and all values above are set to the maximum value (before being converted to 1 in a binary representation of the image). The position of the threshold will depend upon the application. Figure 27.7 illustrates

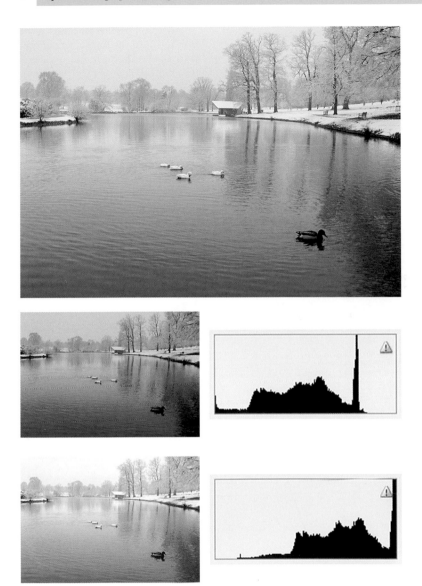

Figure 27.4 The results of applying the functions in Figure 27.3b and c to an image (middle and bottom images and histograms respectively). The spikes at the end of each histogram indicate clipped values in the shadows or highlights.

the function for an 8-bit image thresholded at a value of 128. Thresholding is used widely in image segmentation. The threshold may be set automatically or interactively based on inspection of the image and its histogram.

A further extension of thresholding is illustrated in Figure 27.8, which is a function used to quantize an image, in this case from 255 levels in an 8-bit image, down to four levels in a 2-bit image. Quantization functions may be applied at multiple points in the imaging chain: examples include image capture using a scanner, which will often capture at 10 or 12 bits per pixel (per channel) and then down-sample the luminance signal, quantizing the output to 8 bits; digital cameras of course involve quantization in the

analogue-to-digital conversion (see Chapters 9 and 14), and today it is quite common to work with 16-bit images throughout the imaging chain until the completion of editing and then convert them to 8-bit images once finalized.

Power-law transformations: gamma correction

The process of gamma correction (detailed in Chapter 21) involves the correction of the input signal to alter the output response of a device. This may be to correct for non-linearities in the device's native transfer function. Alternatively, it may also be applied to the device to compensate

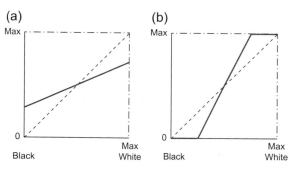

Figure 27.5 Changes in contrast. (a) Contrast decrease ($m < 1$). (b) Contrast increase ($m > 1$) with clipping in shadows and highlights.

for the non-linearities of other devices that have preceded or follow it in the imaging chain. In reality, many devices exhibit a non-linear response following a power law. The power-law transformation function takes the form:

$$g(i, j) = cf(i, j)^{\gamma} \qquad (27.7)$$

where c and γ are both constants. Figure 27.9 illustrates this function with $c = 1$ for two different values of gamma, above and below 1. Gamma values of greater than 1 result in tonal compression (a decrease in contrast) in the shadow areas and tonal separation in the highlights. This type of function is typical of the voltage response of a display based on cathode ray tube (CRT) technology (see Chapters

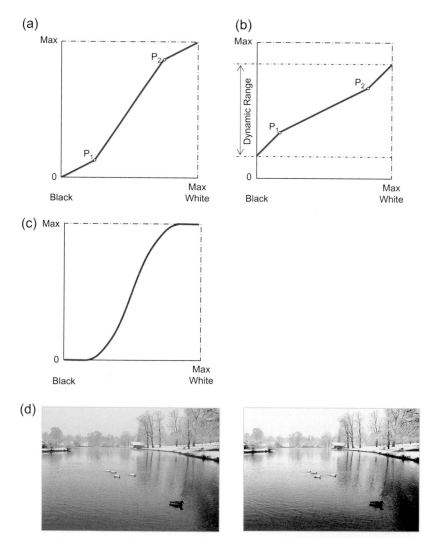

Figure 27.6 Contrast enhancement. (a) Piecewise linear enhancement — contrast increase. (b) Piecewise linear enhancement — contrast decrease. (c) Contrast enhancement using a sigmoid function. (d) Original low-contrast image and image enhanced using the sigmoid function from (c). Mid-tone contrast is enhanced, at the expense of lost detail in shadows and highlights, due to clipping.

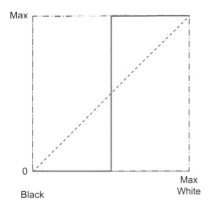

Figure 27.7 Image thresholding. Thresholding function for an 8-bit image, threshold = 128.

15 and 21). The correction of such a response is achieved by applying the transformation function in expression 27.7 using $1/\gamma$ as the exponent. The functions for gamma correction in the imaging chain, although based on this type of gamma model, tend to be significantly more complex (see Chapter 21 for more details).

Power-law functions may also be used for contrast enhancement, in images where the requirement is that either shadow or highlight contrast is increased.

POINT PROCESSING: MULTIPLE IMAGE OPERATIONS

Point processes may be used with multiple images as a method of combining or comparing pixel values within the images. They may be summarized by the following expression:

$$g(i, j) = f_1(i, j)[\text{operator}] f_2(i, j)[\text{operator}] f_3(i, j) \cdots f_n(i, j) \tag{27.8}$$

This means that each pixel position (i, j) in the output image is a combination on a pixel-by-pixel basis, using [operator] of all the pixels in the same position from all the input images.

Some of the most common examples of point processing operations using multiple images are given below.

Enhancement using arithmetic operations

There are a range of techniques using addition, subtraction or multiplication of image values. One of the simplest is *image averaging*, which computes the pixel-by-pixel average for each pixel coordinate from a set of input images of the same dimensions. This operation has particular application in low-light-level imaging, mainly astrophotography,

where multiple images may be captured of a static or almost static subject. The long, low-intensity exposures produce high levels of photon noise, which appears as a random noise pattern on each frame, differing between frames. The average of a set of sequential frames captured at short time intervals retains the unvarying image information, but cancels out varying random information, such as noise (Figure 27.10). This is a very powerful method of noise removal without the disadvantages of the blurring of edges produced by filtering methods (see later), as long as the images are exactly in register.

Subtracting one image from another enhances their differences. An example of its application is in the evaluation of the errors caused by a lossy compression algorithm, where the compressed image is subtracted pixel by pixel from the original. The difference image can then be used to derive objective measures of distortion, such as peak signal-to-noise ratio (PSNR) — see Chapter 29 for details of distortion measures.

Image subtraction can also be used to subtract a background from an image to enhance features of interest. This is achieved by capturing an image of the object on its background, followed by an image of the background alone and then subtracting the latter, isolating the object on an area of flat tone. The operation removes unwanted background elements, or gradients caused by non-uniform illumination, and it is used in computer vision applications to improve the recognition and segmentation of objects. Multiplication may be used between greyscale images to implement greyscale masks, used in some cases to blend layers in image-editing applications.

Enhancement using logic operations

Multiple images may also be combined using *logic operations*. Logic operations such as AND, OR and NOT examine single (in the case of NOT) or multiple values and return a 1 or 0 result depending on certain criteria. They are used in image masking, where the binary mask is combined with the image using an AND or OR operation. Logical operations tend to be used in image *compositing* to mask and combine particular elements from different images. They are the basis of some of the masking and blending methods used in image layers in applications such as Adobe Photoshop.

POINT PROCESSING: STATISTICAL OPERATIONS

The image histogram

Image pixel values may be considered as a random variable taking values between 0 and the maximum value

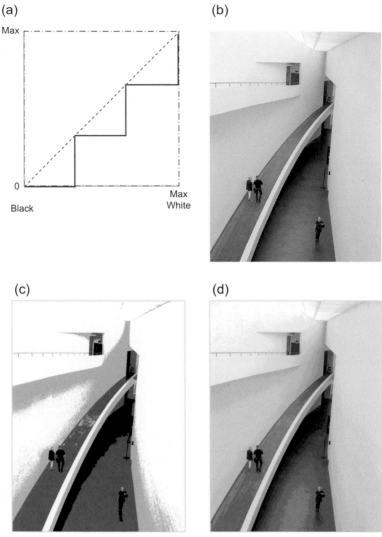

Figure 27.8 Quantization function. (a) A function producing four output levels (a 2-bit image). (b) Original image. (c) Image quantized to four output levels. (d) Image quantized to 16 output levels.

(255 for an 8-bit image). A *histogram* is a statistical (discrete) bar graph of a frequency distribution, in which the x-axis represents the range of values of the data and the y-axis the frequency of occurrence. The image histogram is an important tool, allowing us to evaluate the intensity range within the image (Figure 27.11). Let us denote the histogram $h(f)$, and each individual value in the histogram is:

$$h(f_k) = n_k \qquad (27.9)$$

where f_k is the kth grey level in image function $f(i, j)$ and n_k is the number of pixels at that level.

Probability density function and probability distribution function

The *probability density function* (PDF) of the image is a plot $p(f)$ of the probabilities of a pixel taking each grey level. It can be estimated by normalizing the histogram:

$$p(f_k) \approx \frac{n_k}{N} \qquad (27.10)$$

where N is the total number of pixels in the image.

Another distribution related to a random variable is the *probability distribution function*, or *cumulative distribution function*, where $P(f_k)$ is the probability that $f \leq f_k$. In images

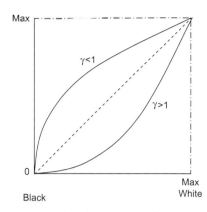

Figure 27.9 Power-law intensity transformation. The two functions illustrate $c = 1$, $\gamma > 1$ and $c = 1$, $\gamma < 1$. Each gamma function corrects the other.

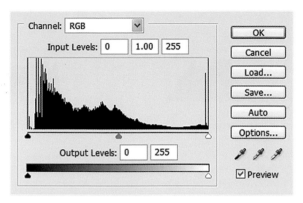

Figure 27.11 The image histogram.

it is a plot of cumulative probabilities against pixel values, with each distribution value corresponding to the probability that a pixel will have a value less than or equal to it. Because the distribution is cumulative it is always a monotonically increasing function, and its range is $0 \le P(f) \le 1$ (because the probability that a pixel will take a value less than or equal to the maximum pixel value is 1).

The probability distribution function is the integral of the probability density function and therefore:

$$p(f) = \frac{dP(f)}{df} \qquad (27.11)$$

As described in Chapter 25, using the histogram at image capture is an accurate method for assessing exposure. The appearance of the histogram provides useful information about the image, such as overall exposure and contrast, dominant tones within the image, and importantly

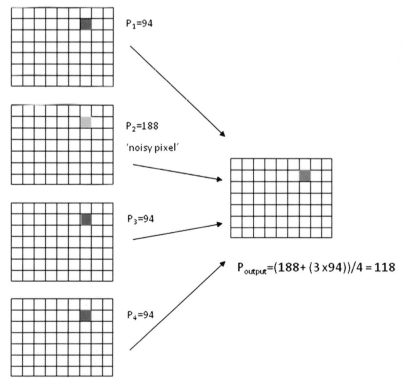

Figure 27.10 The removal of noise using image averaging. The output pixel value is computed as an average of the pixel values in the same position from the four input images. The single high pixel value in the second input image is effectively removed.

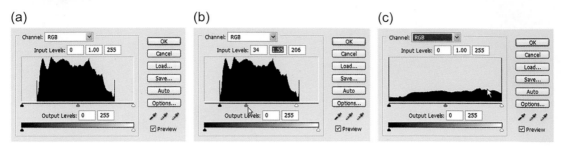

(a) **(b)** **(c)**

Figure 27.12 Histogram sliding and stretching using levels adjustments. (a) Original histogram does not use full range of values. (b) Moving the shadow and highlight sliders to the edges of the image histogram values applies a histogram stretch to the values. Sliding the mid-tone value performs a histogram slide. (c) Final histogram covering full range of values.

whether the exposure has clipped either highlights or shadows and is in need of adjustment. Adjustments to the histogram are known as statistical operations.

Histogram slide and stretch

The simplest histogram enhancement operations involve sliding all the values in one direction or another, or stretching them out to more fully cover the available range of pixel values. A histogram slide is performed by adding or subtracting a constant to all pixel values in the histogram, which shifts all the values laterally along the horizontal intensity axis. This achieves a change in the overall exposure of the image and may result in a compression in dynamic range and clipping of values. A histogram stretch is performed by multiplying all pixel values by a constant which, if greater than 1, stretches out the values. A histogram stretch will generally result in posterization of the values. A posterized histogram has a comb-like appearance as a result of gaps between levels, indicating that some pixel values will not appear in the image and this can result in visual contours in areas of smoothly graduating tone; therefore, it should be used with care. To maintain the darkest values within the image, a histogram slide may be performed to 'peg' the lowest value at zero before the histogram stretch. 'Levels' adjustments in applications such as Adobe Photoshop involve combinations of these operations (Figure 27.12).

Histogram equalization

A more complex method of histogram enhancement, histogram equalization is an automatic process, producing a transformation function for the image from the distribution of values themselves. It is based upon the assumption that important information in the image is contained in areas of high PDF (the peaks within the histogram). By stretching out the histogram values selectively, the contrast can be improved in the high PDF areas, while compressing the areas of low PDF, which contain fewer values.

The principle behind the method can be understood by referring to Figure 27.13.

The aim of histogram equalization is to convert the input image PDF $p_f(f)$ to a flat function such as $p_g(g)$, in which all values are equally probable, as a result of selective stretching and compressing of values. Because both functions are normalized, the number of pixels in the grey level interval Δf is equal to the number of pixels in Δg, i.e.

$$p_f(f)\Delta f = p_g(g)\Delta g \qquad (27.12)$$

so that:

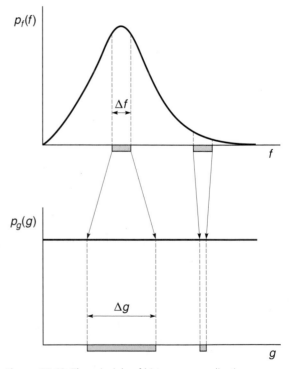

Figure 27.13 The principle of histogram equalization.

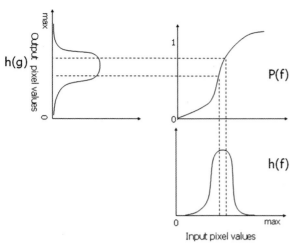

$$p_g(g) = p_f(f)\frac{df}{dg} = \text{constant} \qquad (27.14)$$

Letting the constant $= k$:

$$\frac{dg}{df} = kp_f(f) \qquad (27.15)$$

Integrating both sides with respect to f gives:

$$g = k\int_0^f p_f(x)\,dx \qquad (27.16)$$

where x is a dummy variable of integration. Remembering that the probability distribution function is the integral of the PDF:

$$g = kP_f(f) \qquad (27.17)$$

Hence the required intensity transformation to obtain g is a scaled version of the probability distribution function of the input image. The scaling factor is the maximum value $L - 1$.

In practice the pixel values are integers and the integral is estimated by taking a running sum from the histogram. Since the output image must also be quantized into

Figure 27.14 The probability distribution function is used as the transformation function to produce the equalized histogram.

$$p_g(g) = p_f(f)\frac{\Delta f}{\Delta g} \qquad (27.13)$$

which as Δf and Δg tend to zero yields:

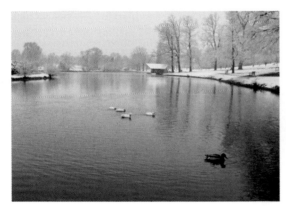
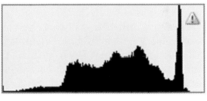

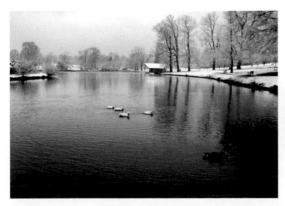
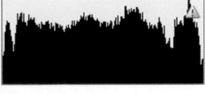

Figure 27.15 The image from Figure 27.4 and its histogram before and after histogram equalization.

integers, the histogram is not flat as depicted in Figure 27.13. It is stretched and compressed to maintain a constant local integral, but the quantization means that some pixel values are not used and gaps appear in the histogram. The process using the probability distribution function is illustrated in Figure 27.14 and an example using an 8-bit greyscale image in Figure 27.15.

It is important to note that histogram equalization is an automatic process, which always produces the same result on a particular image. It is only useful if the important information is contained in the most frequently occurring pixel values. In other circumstances, one of the interactive methods already described, or an alternative method directly editing the transformation function, as in a curves adjustment, would be more suitable.

POINT PROCESSING: GEOMETRIC TRANSFORMATIONS

There is some crossover between operations performed to enhance images and those applied for image restoration. Although some of the methods described here correct for image defects, they should be distinguished from the more formal approach used in image restoration, which is covered in Chapter 28. In general, *image corrections* applied in the spatial domain tend to require user input, the results being judged subjectively before further processing is applied. By contrast, the methods applied in *image restoration*, which may also correct for degradation (such as blur, for example) introduced by the imaging system or conditions, produce an objective model of the degradation and restore the image using this model. As shown in Chapter 28, such methods are usually applied in the frequency domain.

The correction of geometric distortion, such as barrel or pincushion distortion, is often performed interactively using *geometric transformations*, also called *spatial transformations*, which are based on sampling processes. They are also used when parts of images are selected and moved around an image. They are mapping operations which alter the position of image pixel values, using matrix transformations on the pixel coordinates. They may be applied as forward or inverse transformations, i.e. the pixel position in the original image is transformed to a new position in the output image, or the pixel position in the output image is mapped back to find its value according to its position in the original image (see Figure 25.2). Whichever method is used generally involves two stages, the spatial transformation itself and a grey level (or colour) interpolation. The exception is when the image is being translated by whole numbers of pixels or when it is being rotated by 90° or multiples thereof. In these cases, each pixel coordinate position will map exactly to another pixel position and no

interpolation is necessary. In most cases, however, the mapping process produces spatial coordinates which fall between pixels in output or original image (depending on direction of the mapping). If the mapping is into a position between pixels in the output image, then the mapped pixel value must be averaged in some way between the pixel positions closest to it. If the mapping is backwards to the original image and falls between pixels, then the output value will be interpolated from the pixels closest to its position at input. The use of interpolation will of course degrade the image quality, resulting in various artefacts, such as the blurring of edges. Interpolation methods are discussed in detail in Chapter 25.

The simplest spatial transformations are linear transformations, such as translation, scaling and rotation, which can be cascaded or combined into a single transformation matrix, reducing the amount of interpolation. Lines that are straight and parallel in the input image will remain so in the output image. For image correction, however, non-linear transformations are more commonly used, which may be considered as processes of two-dimensional curve fitting. The image is fitted on to a non-linear sampling grid to remove the distortions.

NEIGHBOURHOOD PROCESSING: SPATIAL FILTERING TECHNIQUES

The methods described so far have been processes based upon an operator being applied to individual pixels, each of which may be considered to be a 1×1 neighbourhood. The approach discussed in this section, more commonly known as spatial filtering, involves the calculation of each output pixel value based upon some calculation from the neighbourhood surrounding the input pixel at the same position. There are two classes of spatial filters, which are distinguished by the approach used to process the neighbourhood.

LINEAR FILTERING

Convolution is important in digital image processing as the basis of linear spatial filtering, but is applied as a discrete operation. Continuous convolution was introduced in Chapter 7. The integral in continuous convolution (Eqn 7.30) is replaced by summation in discrete convolution, which is much simpler to understand and implement. Again, the convolving function is rotated and slid over the static function. This was described earlier for two dimensions in Eqn 27.4.

The convolving function in linear spatial filtering is a filter *mask* or *kernel*, which is an array of numbers (usually

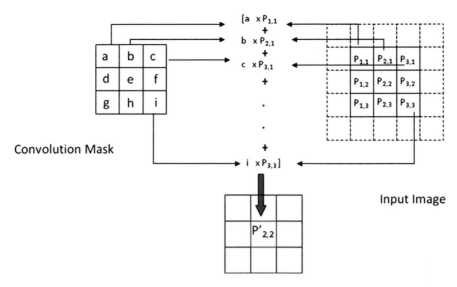

Convolution Mask

Input Image

Figure 27.16 Convolution filtering. (a–i) Values in the mask used to multiply image values before summation to produce an output. The pixel subscripts refer to the corresponding position in the mask.

square), the values of which will determine the effects of the filter on the image. The mask is generally small compared to the image and of odd dimensions, typically 3×3 or 5×5. At each pixel position in the image, the mask is centred over the pixel and its values are multiplied with the image pixel values in the corresponding neighbourhood, as illustrated in Figure 27.16. The resulting values are then summed to produce an output value. This is summarized by:

$$g(i,j) = f \otimes h = \sum_{m=-a}^{a} \sum_{n=-b}^{b} h(m,n)f(i-m, j-n)$$

$$(27.18)$$

where the image is f, the filter h, size is $M \times M$ and $a = b = (M-1)/2$. Note the similarity to Eqn 27.4: the difference is in the limits of the summation, a and b, which simply define the neighbourhood as half the filter's width from the central pixel on either side and above and below. The output, $h(i, j)$ is the value of the convolution at position (i, j) and becomes the pixel value in this position in the output image. The mask is then centred over the next input pixel, and the process is repeated across rows and down columns until all pixel values have been processed.

A problem in implementation arises at the image borders, as the filter overhangs when it is centred over the pixels at the very edge of the image, with some mask values having no corresponding pixel values in the image. There are a number of solutions to this problem:

1. Keep the filter within the image boundaries, which means that the edge pixels will not be processed and the output image will be smaller. To retain the same

image size, the input pixel values for these rows and columns can be kept in the output image, but are likely to be visibly different from the rest.

2. Change the size and shape of the filter at the corners and edges of the image, so that only real image values are used in the calculation. The errors in output values are unlikely to be as visible as in the method above, although this can be complicated to implement.

3. Pad the image edges with zeroes, or another constant grey level, providing 'false' values for the calculations. The output image will be the same size as the input, but the false values will skew the calculated values and will become more visible as the filter size increases.

4. Assume that the image extends beyond its borders, either as a periodic function, where the first rows and columns are repeated after the last ones, or by mirroring edge values at the borders. Use the extra values for the calculations but return an image of the same size as the original.

Properties of linear filters

There are a number of properties of convolution. They are summarized here because they are important in image processing. The first is *commutativity*, defined by the following rule:

$$f \otimes g = g \otimes f \qquad (27.19)$$

The second is that convolution is *associative*, i.e.

$$f \otimes g \otimes h = (f \otimes g) \otimes h = f \otimes (g \otimes h) \qquad (27.20)$$

513

Linear filters have a number of important properties based upon the properties of convolution:

1. If two or more linear filters are applied sequentially to an image, they will produce the same result regardless of the order in which they are applied.
2. When two or more filters are convolved together and the result is applied to the image, it produces the same result as if the filters were applied separately.

Linear filters may be applied in the spatial or the frequency domain, using the *convolution theorem* (explained in Chapter 7), i.e. any spatial linear filter has a frequency-domain equivalent.

TYPES OF LINEAR FILTERS AND THEIR APPLICATIONS

Linear filters fall broadly into two categories, although there are many adaptations for specific purposes. In general, *smoothing spatial filters*, as their name suggests, blur the image by removing fine detail while maintaining large structures within the image. Their main application is noise removal, although there are a number of non-linear filters which may do a better job, albeit with less predictable results. The other main type of filter has the opposite effect, i.e. enhancing fine detail. These are known as *edge detection* or *sharpening* filters, depending on how they are applied and for what purpose.

As described in Chapter 7, image content may be considered in terms of *spatial frequencies*. Areas of smoothly graduating changes in intensity may be classed as low frequencies, while sudden intensity changes such as edges contain high frequencies. The effects of the two different classes of filter can also be considered in terms of their effects on the frequencies within the image: smoothing filters will reduce values which change rapidly, i.e. the high frequencies, but leave smoothly changing areas largely unaffected. Hence they are sometimes referred to as *low-pass filters* (they *pass* low frequencies). By the same token, edge detection filters enhance or pass high frequencies. Hence they are known as *high-pass filters*. Strictly speaking, these names refer to the frequency-domain equivalents of the spatial filters, but are used interchangeably in some texts.

As one of the main applications of linear filters is to produce a weighted average of the neighbourhood, some implementations include a final step, in which the value from the convolution is divided by the *weight* of the mask to average out the pixel values in the input image. A simpler approach is to include the division in the mask values, meaning that it is automatically carried out by the convolution process. Some filters have a weight of zero, because they contain both positive and negative values. An example is the *Laplacian filter*, a type of high-pass filter. In such cases the division step must be omitted.

Smoothing spatial filters

These filters contain only positive coefficients in the mask and are used to compute an average of the neighbourhood, hence they are alternatively called *averaging filters*. The result of averaging is to remove or reduce sudden changes in intensity values, while maintaining values in homogeneous regions. The filter kernel for the simplest type of 3×3 averaging filter is shown in Figure 27.17a. As discussed earlier, the average may be computed by using a mask of ones to select the neighbourhood and dividing by the weight of the mask after multiplying and summing the neighbourhood. Alternatively it may be calculated by including the weight within the mask values, as described above, which means that all the mask values in Figure 27.17a become 1/9.

Applying such a filter to an image has the effect of blurring the image; its main purpose is to reduce random image noise. Random noise appears as sudden fluctuations in pixel values compared to their neighbours and is most visible in uniform areas of the image. By averaging the pixel values, these sudden discontinuities are reduced, becoming closer to the values of their neighbours. The effect of applying the filter in Figure 27.17a to an image is shown in Figure 27.18b. After application of the filter it is clear that the noise has been reduced but at the expense of image sharpness. A better result may be obtained using the filter in Figure 27.17b. This 'centre-weighted average' filter has a higher value at the centre of the mask, meaning that the original pixel value will be weighted more highly than its neighbours. More of the original image features will be retained, thus reducing the unwanted blurring of edges within the image (centre, Figure 27.18b). The output from this filter is divided by 16, the weight of the mask.

A larger neighbourhood increases the degree of blurring of the image, as a larger number of values are used in computing the average (the last image in Figure 27.18). In practice, larger neighbourhoods are only used in specialized applications such as image segmentation, where the aim is to remove objects of a specific size and are usually combined with other spatial processing techniques to further enhance the required remaining objects and counteract the blurring of object edges.

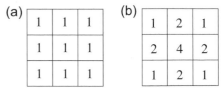

Figure 27.17 Averaging filters: (a) 3×3 averaging filter; (b) 3×3 centre-weighted averaging filter.

(a)

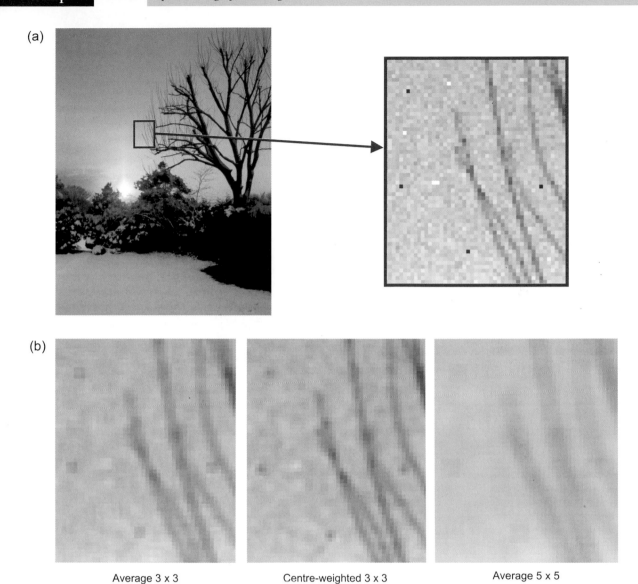

(b)

Average 3 x 3 Centre-weighted 3 x 3 Average 5 x 5

Figure 27.18 (a) Original image and close-up. Note the odd noisy pixels. (b) A comparison of the results obtained. From left to right: a simple 3 × 3 averaging filter, a centre-weighted smoothing filter and a 5 × 5 averaging filter.

Edge detection and sharpening spatial filters

These types of filters contain both positive and negative values in the filter mask and, in the majority of cases, the mask values cancel each other out. Thus, the mask weight is zero. The simplest form of edge detection filter is a *first-derivative filter*, which takes differences between adjacent pixels in any given direction as an approximation of the first derivative. These types of filters consist of sets of

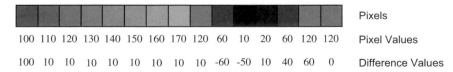

														Pixels	
Pixel Values	100	110	120	130	140	150	160	170	120	60	10	20	60	120	120
Difference Values	100	10	10	10	10	10	10	10	10	-60	-50	10	40	60	0

Figure 27.19 First derivative of a row of pixels.

515

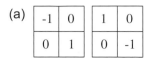

(a)

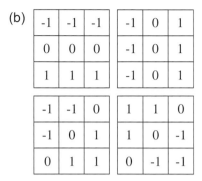

(b)

Figure 27.20 (a) Roberts filter masks. (b) Prewitt filter masks.

directional masks, employed for the identification of edges of different orientations. They are often used in image segmentation applications.

Consider the row of pixel values in Figure 27.19. The differences are obtained by subtracting the previous value from each pixel value. The first block of pixels is representative of an area of smooth tone within an image, which is followed by a dark image edge. Note the results in the difference values from this simple operation. Areas of smooth tone become a low single value (as the gradient is changing by the same amount). At edges, however, the values suddenly become large, either positive or negative, depending on whether the edge is lighter or darker than the preceding values. There are a variety of first-derivative filters. They tend to have a 3 × 3 neighbourhood as a minimum, because masks smaller than this are difficult to apply. One exception is the *Roberts operator*, which consists of two masks highlighting edges at +45° and −45°. Figure 27.20 illustrates the Roberts operator and the 3 × 3 *Prewitt filter* masks for horizontal, vertical and diagonal edges. Usually the masks are combined, using either all four or more commonly just the horizontal and vertical masks. The final image is produced by taking the magnitude of the gradient at each point, which is approximated using:

$$\text{Magnitude} = \left[\left(G_x\right)^2 + \left(G_y\right)^2\right]^{1/2} \approx |G_x| + |G_y| \quad (27.21)$$

Because there is a gradient change leading into and out of the edge, first-derivative filters produce thick edges, hence they tend to be used more in the detection of edges than in image sharpening. *Second-derivative filters* are more commonly used in image enhancement, specifically sharpening, as they detect edges in all directions using a single mask and tend to produce finer edges than first derivatives. The second derivative is approximated by taking the difference between the difference values derived

from the first derivative. It is implemented using the Laplacian filter, a form of high-pass filter, two versions of which are illustrated in Figure 27.21. In these cases, the value at the centre is positive and all other values negative. However, the masks may alternatively have a negative central value and positive surrounding values.

Because of the high (positive or negative) value at the centre of the Laplacian filter, surrounded by small values of the opposite sign, the effect on the image is more pronounced than that produced by first-derivative operators. The filter dramatically emphasizes sudden changes over a localized area, producing high values, while low frequencies are effectively set to a zero frequency appearing as a flat grey or black tone. The image in Figure 27.21b illustrates the property of the Laplacian to produce fine edges, but in some cases double edges, and its tendency to emphasize noise. An issue of implementation arises as a result of the range of values produced, which may include negative and very high positive values. If such an image is displayed on an 8-bit monitor, then negative values will be clipped to black and high positive values to white. Some method of intensity scaling must be applied to the image before display to correctly interpret the results, as illustrated in Figure 27.21c.

The output images from high-pass filters so far illustrated consists of only the enhanced edges within the image, since all other information has been set to a flat 'background' value. This process may be viewed in terms of the subtraction of the low-frequency information (which is the output from a low-pass filter) from the original image:

$$\text{High pass} = \text{Original} - \text{Low pass} \quad (27.22)$$

A widely used darkroom method, developed in the 1930s, to increase the appearance of sharpness of photographic images is known as *unsharp masking*. It has inspired the development of various digital equivalents for sharpening images. The photographic unsharp mask is a slightly blurred positive obtained by contact printing a negative on to another low-contrast piece of film, which is then sandwiched with the image negative to produce a sharpened image. When the two are sandwiched together and light is shone through them, the positive partially (because of its lower contrast) subtracts some of the low-frequency information from the negative. Although the two images are in register, the edges do not quite match; therefore, less information is cancelled out in edge areas. The effect is an increase in the local contrast at the edges compared to that of the overall image. Sandwiching the two reduces the dynamic range of the enlarged image, which is therefore printed on to a high-contrast paper to counteract this, but the enhancement of edge contrast remains. The higher edge-contrast compared to the rest of the image results in an overshoot and undershoot in the densities on either side of the edge. The combination of these *edge effects* is often termed a *Mackie line*.

(a)

-1	-1	-1
-1	8	-1
-1	-1	-1

0	-1	0
-1	4	-1
0	-1	0

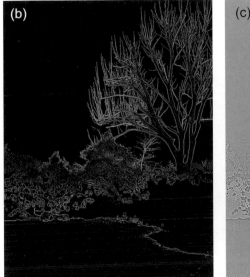

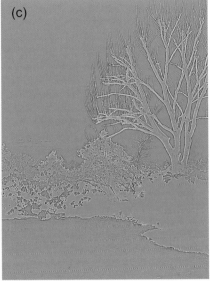

Figure 27.21 (a) Laplacian filter masks. (b) Laplacian filtered image. (c) Scaled Laplacian filtered image.

Digital image sharpening using high-pass filters employs the same principles as unsharp masking, using a combination of the filter output with the original image; the edges are effectively added back into the image. The simplest case adds (or subtracts, depending on whether the central coefficient of the Laplacian is positive or negative) the Laplacian filtered image to the original image. However, a better result may be obtained using a variation of this method, known as *high-boost* filtering, which is a digital adaptation of unsharp masking. The unsharp masking method described above is not simply the subtraction described by Eqn 27.22. The image contrast is increased to take into account the reduction in dynamic range as a result of the sandwiching of the positive and negative. In high-boost filtering this is achieved by multiplying the image by a constant A greater than 1:

$$\text{High boost} = A(\text{Original}) - \text{Low pass} \qquad (27.23)$$

This is equivalent to:

$$\text{High boost} = (A - 1)(\text{Original}) + \text{Original} - \text{Low pass} \qquad (27.24)$$

And substituting Eqn 27.22 into Eqn 27.24 leads to:

$$\text{High boost} = (A - 1)(\text{Original}) + \text{High pass} \qquad (27.25)$$

When A is equal to 1, then this is the simple addition of the Laplacian image described previously. This may be achieved in one operation by slightly adapting the mask as in Figure 27.22. Digital image sharpening should be used with care, as oversharpening can produce unwanted artefacts in the image, such as the enhancement of noise and a characteristic *halo artefact*, visible in Figure 27.22, which appears close to sharpened edges. It is an exaggeration of the overshoot and undershoot effects described above, appearing as a light or dark halo around edges, which appears as a light region around dark edges (or vice versa).

Mention should be given here to the unsharp mask filters commonly available in image-editing software. These are usually adaptive filters, using the same principle as traditional unsharp masking in that they employ a blurred version of the image as a mask (rather than the high-pass filter used in high-boost filtering). The blurred version is compared to the original and, using a 'threshold' value, only pixel values where the difference is greater than the threshold are changed. This reduces the problem of noise enhancement, meaning that the filter only enhances edges, but means that the process is no longer linear.

(a)

-1	-1	-1
-1	9	-1
-1	-1	-1

(b)

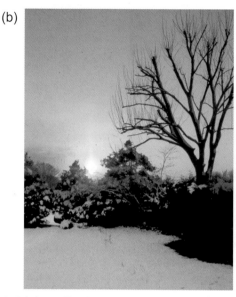

Figure 27.22 (a) High-boost filter kernel. (b) Image sharpened using the high-boost filter. Notice the halo artefacts around the tree branches in the sharpened version.

NON-LINEAR SPATIAL FILTERING

Non-linear filtering methods, unlike linear methods, do not involve a combination of the image with mask values. The mask is simply used to select the neighbourhood pixel is values. The pixel values are ordered in terms of their intensity (hence these are also known as *order statistic* or *ranking* filters) and an output value for the central pixel is determined based upon the statistics of the neighbourhood and the required effect. The mask is then stepped along to the next pixel, along rows and down columns. Non-linear filters are not information preserving: it isn't possible to get back to the original image once it has been filtered. Additionally and most importantly, because they are not based on convolution and linear systems theory, there is no frequency-domain equivalent. They can be extremely useful in image enhancement, however, often producing better results than equivalent operations using linear filters.

Median filters

Probably the most widely used non-linear filter, the median filter simply selects the median value of the neighbourhood. This is an effective way to remove extreme values, which often correspond to noisy pixels and are particularly characteristic of certain types of digital noise. A key advantage of noise removal using the median filter rather than smoothing linear filters is the fact that it retains more of the local contrast and the position and localization of edges. Figure 27.23 compares the results from a 3×3 centre-weighted linear filter and a 3×3 median filter applied singly and over a number of iterations. It is clear that the edges are much less softened by the median filter. Repeated application of the smoothing filter would result in the edges being further blurred and pixel values moving closer to the average value.

The close-up section of the image in Figure 27.23e illustrates one of the problems with the median filter which can make it less suitable for the enhancement of pictorial images. Median filtered images will begin to display *posterization artefacts*, which appear as blocks of tone, where many values have moved towards the same median values. However, this may not be a problem in image analysis applications where noise removal is required, but edge sharpness and position must be maintained.

The non-linear nature of the median means that the results obtained are not always predictable, particularly if the median is applied to colour images. The medians in the

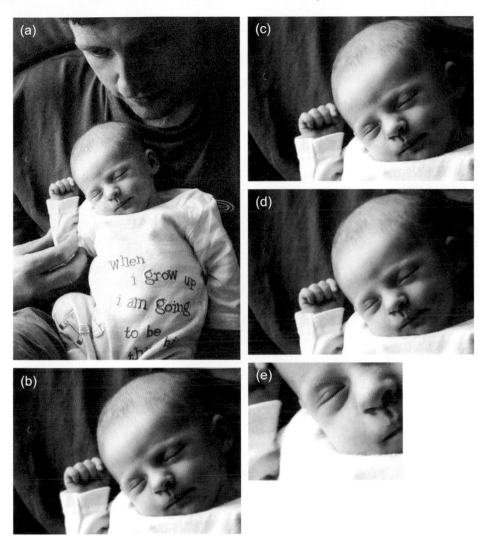

Figure 27.23 Noise removal. (a) Original image with dust and scratches. (b) 3 × 3 centre-weighted linear smoothing filter. (c) 3 × 3 median filter, one application. (d) 3 × 3 median filter, five applications. (e) Close-up of section from (d), illustrating artefacts from the median filter.

red, green and blue channels may be very different, and a combination of the three may not produce a colour in any way related to the colours in the original neighbourhood. This can be resolved by converting the image to $L^*a^*b^*$ mode and filtering only the lightness (L^*) channel. As the values associated with image noise are often of a different lightness to their neighbours, then noise removal may be achieved without affecting the hue of the original pixel.

A further disadvantage of order statistic filters is that the process of sorting each neighbourhood can be slow. The number of values to be sorted may be reduced by using a *partial* neighbourhood, achieved by changing the shape of the neighbourhood but keeping the extent of pixels that it encompasses. An example of this is the *hybrid median filter*,

Figure 27.24 The hybrid median filter. The output value is obtained from:
Hybrid median = Median{Median(A), Median(B), C}.

depicted in Figure 27.24. The neighbourhood is divided into three sub-neighbourhoods, indicated in the figure; A is the set of pixels horizontal and vertical in line with the central pixel, B the pixels diagonally in line with the central pixel and C the central pixel. The medians of A and B are taken, and then the median of the set of these two values and C is the final output value. The hybrid median is also known as the *edge-preserving median*, as it preserves fine lines and does not round corners, characteristic of the standard median filter.

Another alternative is the *truncated median filter*, which aims to shift the calculated median value closer to the *mode* of the distribution of values. It is not possible to calculate the mode for small neighbourhoods which may have no value occurring more than once. The truncated median filter estimates the mode by calculating the mean of the neighbourhood and discarding the value or values furthest away from it, then calculating the median of the remaining pixels.

Minimum and maximum filters

Outputting the minimum and maximum values in a neighbourhood can be useful. Extracting minimum values removes odd high values from a neighbourhood. As a minimum filter passes from a dark area to a light area, values at the edge of the light area will be set to dark values, effectively eroding the edges. Hence this filter is sometimes known as an *erosion* filter. Erosion is a type of *morphological operation*. These are processes which examine or extract structures from an image. The maximum or *dilation* filter has the opposite effect, removing odd high values and dilating edges of light areas within the image.

Figure 27.25 Pseudomedian filter.

These filters are useful for more general imaging purposes when combined to provide an adaptive noise removal filter, the *pseudomedian filter*, commonly known as the *degraining filter*. This filter is designed to remove dark and light spots in a neighbourhood, particularly characteristic of image noise. The partial 5 × 5 neighbourhood, consisting of only nine pixels including the central one, is divided into sets of three consecutive pixels: [(a, b, c), (b, c, d), (c, d, e) … (c, h, i)] (Figure 27.25). Two operations are then applied; the first is the *maximin* operation, selecting the maximum value from the set of all neighbourhood minima:

$$\text{Maximin} = \text{Max}[\min(a, b, c), \min(b, c, d), \quad\quad \min(c, d, e) \ldots \min(c, h, i)] \quad (27.26)$$

which removes bright spots from the neighbourhood, followed by the minimax operator:

$$\text{Minimax} = \text{Min}[\max(a, b, c), \max(b, c, d), \quad\quad \max(c, d, e) \ldots \max(c, h, i)] \quad (27.27)$$

which removes dark spots in the neighbourhood.

BIBLIOGRAPHY

Burdick, H.E., 1997. Digital Imaging: Theory and Applications. McGraw-Hill, New York, USA.

Castelman, K.R., 1996. Digital Image Processing. Prentice-Hall International, London, UK.

Davies, R., 1997. Machine Vision: Theory, Algorithms, Practicalities, second ed. Academic Press, London, UK.

Gonzalez, R.C., Woods, R.E., 2002. Digital Image Processing. Pearson Education, Prentice Hall, USA.

Gonzalez, R.C., Woods, R.E., 2004. Digital Image Processing Using

MATLAB. Pearson Education, Prentice Hall, USA.

Jacobson, R.E.J., Ray, S.F.R., Attridge, G.G., Axford, N.R., 2000. The Manual of Photography, ninth ed. Focal Press, Oxford, UK.

Keelan, B.W., 2002. Handbook of Image Quality: Characterization and Prediction. Marcel Decker, New York, USA.

Pratt, W.K., 1991. Digital Image Processing, second ed. Wiley, New York, USA.

Russ, J.C., 2002. The Image Processing Handbook, fourth ed. CRC Press, Boca Raton, Florida, USA.

Sanz, J.L.C. (Ed.), 1996. Image Technology: Advances in Image Processing, Multimedia and Machine Vision. Springer.

Sonka, M., Hlavac, V., Boyle, R., 1993. Image Processing, Analysis and Machine Vision. Chapman & Hall Computing, London, UK.

Weeks, A.R., 1996. Fundamentals of Electronic Image Processing. SPIE Optical Engineering Press, Bellingham, WA, USA.

Chapter | 28 |

Digital image processing in the frequency domain

Robin Jenkin

All images © Robin Jenkin unless indicated.

INTRODUCTION

We have seen in various chapters that a digital image is a rectangular array of numbers representing the luminance and colour at discrete positions in a scene. The image can be thought of as a matrix of pixels, each pixel carrying three numerical values (i.e. one per colour channel). The pixel position identifies a spatial coordinate and each pixel value represents the intensity of the colour channel at that position. The three values of a pixel depend on the colour model employed. For example, they may represent primary colour components of red, green and blue (e.g. RGB), or they may represent luminance and two normalized chromaticity values (e.g. YCC) — see Chapter 23.

Other chapters have clearly demonstrated that the power of digital image processing and manipulation lies in the simple fact that with modern computers it is very easy to process numbers. The majority of techniques described previously have concentrated on processing image data presented in the above form. The processing may be applied as an operation to individual pixels, known as a *point process*, where each output pixel value is the result of an operator being applied to an input pixel in the same position, e.g. the application of a greyscale transformation function to alter tonal values and contrast. Alternatively, it may rely on the relationship of the position of two or more pixels and their values, known as *neighbourhood processing*, e.g. the difference in or averaging of neighbouring pixel values. Applying digital image-processing techniques in this manner to the image data as above is termed 'working in the spatial domain' or 'spatial image processing'.

Chapter 7 introduced the concept of spatial frequency and the Fourier transform. Rather than consider signals in terms of the value represented at each point, we may alternatively imagine the signal as composed of differing amounts of various frequencies (Figure 28.1). The idea presented by the mathematician Fourier is conceptually simple, but has far-reaching consequences in many areas of science and technology. Fourier demonstrated that all functions (signals) may be represented by the addition of a number of sine and cosine waves of various frequencies and phase. The number of sine and cosine waves in some instances may approach infinity. He further proved that for each unique signal there is a unique set of waves to represent that signal.

Analysing imaging systems by examining their frequency content (i.e. looking at the amount of each sine and cosine wave) we may arrive at the modulation transfer function (MTF) and the Fourier theory of image formation among many others (see Chapters 7 and 24). It is possible to transform between spatial frequencies and the original signal represented in the spatial domain via the application of the Fourier transform (see later).

The principles of the majority of frequency processing operations may be understood by concentrating on

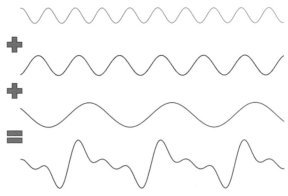

Figure 28.1 The construction of a signal by the addition of sine waves.

monochrome images. It should be noted that, because of the difference between the performance of the human eye to chrominance and luminance signals, in particular the poor resolution of the chrominance response (see Chapters 4 and 5), it is common for different processing to be applied to each image channel. Unless specified, for the remainder of this chapter we will work on greyscale (or single-channel) images.

It has been seen in Chapter 27 that one of the major tools in image processing is digital filtering. There are two basic classes of spatial digital filter: linear and non-linear. In general terms only linear spatial filters have a direct equivalent Fourier (or frequency-domain) implementation. This is because linear filters are applied in a manner consistent with linear systems theory (a linear spatial filter is applied by convolution of a mask with the image) – see Chapter 7. They may also be combined and their effects largely reversed within the limitations of the integer representations used for digital images. As we will see later, whilst non-linear filters may be combined, their effects, once applied to an image, cannot be undone. This is an important consideration when designing workflows to process images and contemplating appropriate points to record or back up images.

As an important tool for transforming between the spatial and frequency domains, the Fourier transform will be briefly reviewed before developing its discrete implementation. Convolution will be reintroduced and its implementation in frequency space discussed. Later in the chapter, image restoration and further image space transformations, the *discrete cosine* and *wavelet* transforms, will be introduced.

FOURIER SERIES AND TRANSFORM REVISITED

Briefly, summarized from Chapter 7, it has been shown that the addition of enough sine and cosine waves will enable the reproduction of any signal desired. The addition of three sine waves may be represented by:

$$f(x) = a_1 \sin (ux) + a_2 \sin (2ux) + a_3 \sin (3ux) \quad (28.1)$$

where u is spatial frequency and a is the coefficient for each sine wave. This notation is inefficient, however, for large numbers of sine waves and a more compact form is given by:

$$f(x) = \sum_{n=1}^{\infty} a_n \sin (nux) \quad (28.2)$$

To add a phase change and a constant offset we may rewrite the above as:

$$f(x) = a_0 + \sum_{n=1}^{\infty} a_n \cos (nux) + b_n \sin (nux) \quad (28.3)$$

This is the Fourier series. Euler's formula is a classical result in trigonometry and states that:

$$e^{i\theta} = \cos \theta + i \sin \theta \quad (28.4)$$

Using Euler's formula, Eqn 28.3 may be rewritten as:

$$f(x) = \sum_{n=-\infty}^{\infty} c_n e^{inux} \quad (28.5)$$

where c_n is a coefficient related to a_n and b_n via: $a_n = c_n + c - n$ and $b_n = i(c_n - c - n)$. For a non-periodic function $f(x)$, the Fourier transform $F(u)$ is defined as:

$$F(u) = \int_{-\infty}^{\infty} f(x) e^{-2\pi ux} dx \quad (28.6)$$

The complex function $F(u)$ represents the amount of frequency u present in the non-periodic $f(x)$. The total amplitude of the signal at frequency u is given by the modulus of $F(u)$. The inverse Fourier transform may be derived using a similar approach and converts signals represented in the frequency domain into the spatial domain:

$$f(x) = \int_{-\infty}^{\infty} F(u) e^{2\pi ux} du \quad (28.7)$$

Using the Fourier transform and its inverse it is possible to move into and out of frequency space efficiently. Some common results for the Fourier transform are given in Chapter 7.

Signals that have been digitized are a finite number of discrete samples, i.e. they are not continuous or infinitely long. This means that it is not possible to use the continuous formulation of the Fourier transform to process our discretely sampled images. The one dimensional discrete Fourier transform (DFT) may be written as:

$$F(u) = \frac{1}{M} \sum_{x=0}^{M-1} f(x) e^{-2\pi i \frac{ux}{M}} \quad (28.8)$$

where M is the number of discrete samples (number of data points).

The inverse transform is given by:

$$f(x) = \frac{1}{M} \sum_{u=0}^{M-1} F(u) e^{2\pi i \frac{ux}{M}} \quad (28.9)$$

For most practical purposes the DFT closely approximates the Fourier transform, save for the introduction of aliasing and a bandwidth limitation. If n samples are spaced at δx, frequency samples will be spaced at $\delta u = 2W_{Max}n$, which is equivalent to $1/\delta x \cdot n$, where the maximum spatial frequency contained in the output, $W_{Max} = 1/2\delta x$. Frequencies above this are not rejected but

aliased about the Nyquist frequency and contaminate the spatial frequencies in the output.

The Fourier transform and the DFT may be extended to two dimensions, where:

$$F(u,v) = \int\limits_{-\infty}^{+\infty}\int f(x,y)e^{-2\pi i(ux+vy)}\,dxdy \qquad (28.10)$$

is the two-dimensional Fourier transform and

$$F(u,v) = \frac{1}{MN}\sum_{x=0}^{M-1}\sum_{y=0}^{N-1} f(x,y)e^{-2\pi i\left(\frac{ux}{M}+\frac{vy}{N}\right)} \qquad (28.11)$$

the two-dimensional DFT where M and N are the number of data points in each dimension.

The inverse transforms are given by:

$$f(x,y) = \int\limits_{-\infty}^{+\infty}\int F(u,v)e^{2\pi i(ux+vy)}\,dudv \qquad (28.12)$$

and

$$f(x,y) = \frac{1}{MN}\sum_{u=0}^{M-1}\sum_{v=0}^{N-1} F(u,v)e^{-2\pi i\left(\frac{ux}{M}+\frac{vy}{N}\right)} \qquad (28.13)$$

for the two-dimensional continuous and discrete cases respectively.

Equation 28.11 is separable and thus it may be rewritten:

$$F(u,v) = \frac{1}{N}\sum_{x=0}^{N-1} e^{-2\pi i\frac{ux}{N}}\sum_{y=0}^{N-1} f(x,y)e^{-2\pi i\frac{vy}{N}} \qquad (28.14)$$

This is an important result as it shows that the two-dimensional DFT may be implemented by computing the one-dimensional DFT of each column and then the one-dimensional DFT of each row of that result. The importance of this will become apparent as we discuss the fast Fourier transform.

FAST FOURIER TRANSFORM (FFT)

The FFT is a method to efficiently compute a one-dimensional DFT, generally reducing the approximate number of operations required from N^2 to $N\log N$, where N is the number of data points and the logarithm is to base 2. The most common FFT is the Cooley–Tukey algorithm, which iteratively splits the N data points into two transforms of length $N/2$. One transform is of the odd data points and the other of the even data points. The algorithm may be applied recursively until N transforms of data length 1 are required. Once the transforms are performed the completed DFT may be reconstructed. As mentioned later in this chapter, it is for the reason of recursive splitting that data lengths of 2^n are preferred.

IMAGING EQUATION REVISITED

As discussed in Chapter 7, provided that a system is linear and stationary, an image may be considered to be formed from the addition of overlapping, scaled point spread functions (PSFs) in the x and y directions. The input scene may be denoted as $Q(x_p, y_p)$, the output image as $Q'(x_p, y_p)$ and the PSF as $I(x, y)$. Mathematically, the relationship between them is given by *the imaging equation*:

$$Q'(x_p, y_p) = \int\limits_{-\infty}^{\infty}\int\limits_{-\infty}^{\infty} Q(x,y)I(x_p - x, y_p - y)\,dxdy \qquad (28.15)$$

This is a two-dimensional *convolution integral*. It represents the previously described process of adding up the scaled PSFs over the surface of the image. The integrals represent the summation process when the individual PSFs are infinitesimally close together.

It is often written as:

$$Q'(x,y) = Q(x,y) \otimes I(x,y) \qquad (28.16)$$

or even just:

$$Q' = Q \otimes I \qquad (28.17)$$

where \otimes denotes convolution as previously.

LINEAR SPATIAL FILTERING (CONVOLUTION)

It was seen in Chapter 27 that a convolution kernel may be created to generate a particular effect in an image. The desired result is controlled by the size of and the values given to the kernel. The convolution process was described in Chapter 7 when dealing with image formation. Here we review a discrete digital implementation. The formula for digital convolution is:

$$g(i,j) = \sum_{m=\frac{M-1}{2}}^{\frac{M-1}{2}}\sum_{n=\frac{M-1}{2}}^{\frac{M-1}{2}} h(m,n)f(i-m,j-n) \qquad (28.18)$$

i.e.

$$g = h \otimes f \qquad (28.19)$$

In these two equations, f represents the original image and h is the filter array of size $M \times M$ where M is an odd number (typically 3 or 5). The output of the convolution, g, is the required processed image.

Figure 28.2 illustrates the process of convolution (this was also previously illustrated in Figure 27.16). The array of numbers is a portion of a digital image, f, under convolution with a 3×3 filter array, h. The convolution kernel is positioned above f, in position (i, j) and

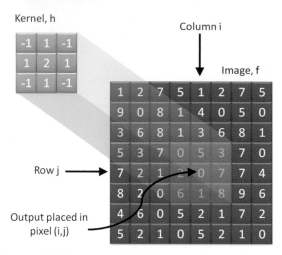

Kernel, h

Column i

Image, f

Row j

Output placed in pixel (i,j)

Figure 28.2 Digital convolution.

multiplied with the image values. The nine products are summed and the result placed in the position (i, j). This is then repeated for all values of (i, j). As previously discussed in Chapter 27, care must be taken to account for values at the boundaries of the image. It should be noted that the results from convolution are identical to the results from the equivalent frequency-domain implementation when the image is considered to be periodic in real space. It should also be noted that as with all calculations based on integer output, there will be some rounding errors associated with the application of each kernel. Further, clipping will occur if the output value cannot be represented using the specified bit depth of the image because it is either too large or too small. These effects can be minimized by combining convolution kernels that perform several processes into a single operation.

FREQUENCY-DOMAIN FILTERING

The convolution theorem, introduced in Chapter 7, implies that linear spatial filtering can be implemented by multiplication in the frequency domain. Specifically, the convolution of Eqn 28.19 can be implemented by the relationship:

$$G = H \times F \qquad (28.20)$$

where F is the Fourier transform of the original image f, H is the Fourier transform of the filter h and G is the Fourier transform of the processed image g. A digital image represented in the spatial domain is processed by taking its Fourier transform, multiplying that transform by a frequency space filter, and then taking the inverse Fourier transform to revert the resulting image back to the spatial domain. For the reasons mentioned previously, FFT

algorithms require that the image is square, with the number of pixels on a dimension being a power of 2 (128, 256, 512, 1024, etc.).

The number of operations for the FFT is approximately $N\log N$. Therefore, to perform a convolution in frequency space on an image of size $N \times N$ requires:

- $N\log N$ (base 2) operations to FFT each row $= N^2 \log N$ operations to FFT the image in a single direction.
- An additional $N^2 \log N$ to FFT the result to create the two-dimensional (2D) DFT for the image, totalling $2N^2 \log N$.
- An additional $2N^2 \log N$ operations to perform the 2D DFT on the kernel. Note that the kernel has to be the same size as in the image in frequency space to be able to multiply each point in the 2D DFTs.
- N^2 multiplications to multiply the 2D DFTs.
- An additional $2N^2 \log N$ operations to convert the image back into the spatial domain.

The total number of operations to perform convolution in the frequency domain is therefore of the approximate order $6N^2 \log N + N^2$. To perform convolution in the spatial domain on the same $N \times N$ pixel image with an $M \times M$ kernel assuming the image is treated as periodic, we require approximately:

- M^2 operations to multiply the kernel with the image at a single location.
- $M^2 - 1$ additions to sum the results at that location.
- One divide to scale the result, totalling $2M^2$ operations at each pixel location.
- Repeat the above at each image location, or N^2 times.

The total number of operations to perform convolution in the spatial domain is therefore approximately $2M^2N^2$. Figure 28.3 illustrates that for small kernel sizes on a 1024×1024 pixel image there is little advantage in

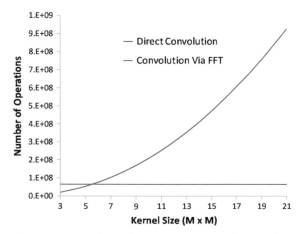

Figure 28.3 Number of operations required to perform convolution in the spatial and frequency domains on a 1024×1024 pixel image versus kernel size.

performing the calculation in frequency space. As the kernel size increases, however, the advantages of performing the calculation in frequency space are readily apparent. Further advantage may be gained when applying the filter to a series of images, or a movie sequence. The 2D FFT of the kernel only needs to be computed once and thus the number of calculations for each additional frame is reduced to $4N^2 \log N + N^2$. It should be noted that the above is a generalized approximation and there are many techniques to reduce the number of calculations further in both cases, such as storage of results for reuse, etc.

Frequency space filters are often developed from a consideration of the frequency content of the image and the required modification to that frequency content, rather than an alternative route to a real space convolution operation. A simple analogy is that of a sound system. If

a set of speakers has particularly poor treble or bass response, it is possible to overcome this limitation by boosting those frequencies using a graphic equalizer. Conversely, if the music has too much treble or bass the graphic equalizer is used to reduce those frequencies.

Figure 28.4 illustrates such a filter approach. The Fourier transform in Figure 28.4b shows strong vertical and horizontal components. By attenuating the horizontal high frequencies (Figure 28.4c), it is possible to suppress the vertical edges (Figure 28.4d). The same effect could be achieved by operating directly on the appropriate pixel values in the original image, but this would require considerable care to produce a seamless result.

As seen in Chapter 27, linear filters have two important properties:

1. Two or more filters can be applied sequentially in any order to an image. The total effect is the same.

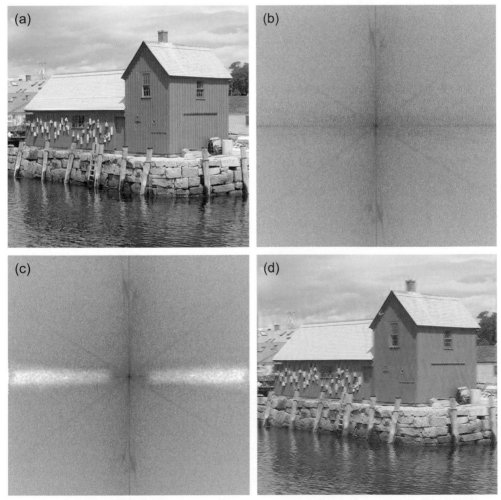

Figure 28.4 (a) Original image. (b) The Fourier transform of (a). (c) The Fourier transform of (b) with frequencies attenuated as indicated by the pale areas. (d) The resultant processed image.

2. Two or more filters can be combined by convolution to yield a single filter. Applying this filter to an image will give the same result as the separate filters applied sequentially.

The properties above are readily apparent when considering convolution in the frequency domain. Since convolution in the spatial domain is represented by multiplication in the frequency domain, the application of many filters can occur in any order without affecting the result. Further, the filter frequencies can be multiplied together before application to the image.

Low-pass filtering

A filter that removes all frequencies above a selected limit is known as a low-pass filter (Figure 28.5a). It may be defined as:

$$H(u,v) = 1 \quad \text{for } u^2 + v^2 \leq W_0^2$$
$$= 0 \quad \text{else} \tag{28.21}$$

where u and v are spatial frequencies measured in two orthogonal directions (usually the horizontal and vertical).

W_0 is the selected limit. Figure 28.6 illustrates the effect of such a *top-hat* filter, also sometimes termed an *ideal filter*. As well as 'blurring' the image and smoothing the noise, this simple filter tends to produce 'ringing' artefacts at boundaries. This can be understood by considering the equivalent operation in real space. The Fourier transform (or inverse Fourier transform) of the top-hat function is a Bessel function (similar to a two-dimensional sinc function — see Chapters 2 and 7). When this is convoluted with an edge, the edge profile is made less abrupt (blurred) and the oscillating wings of the Bessel function create the ripples in the image alongside the edge. To avoid these unwanted ripple artefacts, the filter is usually modified by *windowing* the abrupt transition at W_0 with a gradual transition from 1 to 0 over a small range of frequencies centred at W_0. Gaussian, Hamming and triangular are examples of windows of this type (see Figure 28.7).

High-pass filtering

If a low-pass filter is reversed, we obtain a high-pass filter (Figure 28.5b):

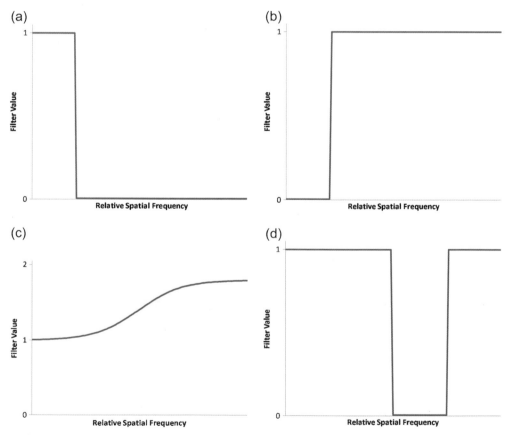

Figure 28.5 The transfer functions for low-pass (a), high-pass (b), high-boost (c) and band-stop (d) filters.

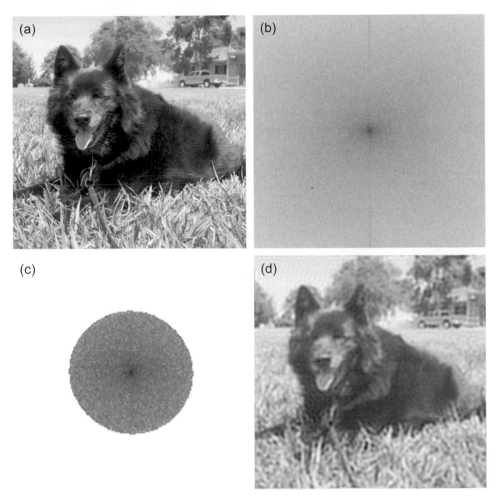

Figure 28.6 (a) Original image. (b) The Fourier transform of (a). (c) The Fourier transform from (b) with frequencies attenuated by a low-pass filter as in Eqn 28.21. (d) The resultant processed image.

$$H(u,v) = 0 \quad \text{for } u^2 + v^2 \leq W_0^2$$
$$= 1 \quad \text{else} \tag{28.22}$$

This filter removes all low spatial frequencies below W_0 and passes all spatial frequencies above W_0. Ringing is again a problem with this filter and windowing is required. Figure 28.8 illustrates the result of a Gaussian-type high-pass filter.

High-boost filter

Selectively increasing high spatial frequencies it is possible to create a high-boost filter (Figure 28.5c):

$$H(u,v) = 1 \quad \text{for } u^2 + v^2 \leq W_0^2$$
$$\geq 1 \quad \text{else} \tag{28.23}$$

In regions where the filter is greater than unity a windowing function may be used. As edges are predominantly associated with high spatial frequencies, it is possible to create the illusion that the image is sharpened. This can, however, cause 'tell-tale' over- and undershoot when edge profiles are plotted. Further, due to the shape of typical MTF curves (see Chapter 24), high spatial frequencies are usually associated with low signal-to-noise ratio and thus over-amplifying the frequencies in this region can increase the effect of noise. Figure 28.9 illustrates the result of a high-boost filter.

BAND-PASS AND BAND-STOP FILTERS

Bass-pass and band-stop filters are similar to high-pass and low-pass filters except a specific range of frequencies is

(a)

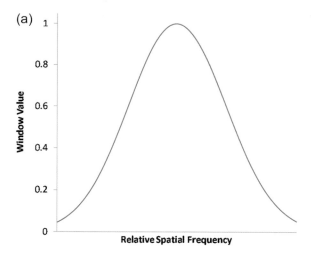

(b)

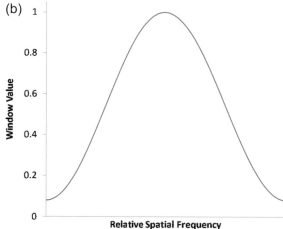

(c)

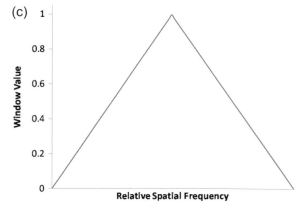

Figure 28.7 Examples of Gaussian (a), Hamming (b) and triangular (c) windowing functions.

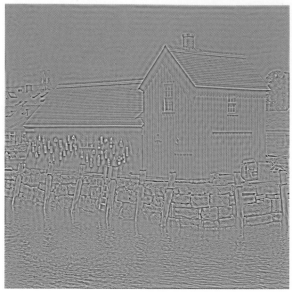

Figure 28.8 The result of applying a high-pass filter to the image of Figure 28.4a.

either attenuated or transmitted by the filter (Figure 28.5d). A band-pass filter may be defined as:

$$H(u, v) = 1 \quad \text{for} \quad W_0^2 \leq u^2 + v^2 \leq W_1^2 \atop = 0 \quad \text{else} \tag{28.24}$$

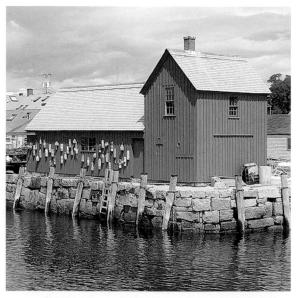

Figure 28.9 Result of applying a high-boost filter to the image of Figure 28.4a.

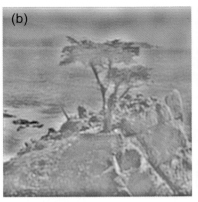

(a)
(b)
(c)

Figure 28.10 (a) Original image. (b) The result of applying a band-pass filter to (a). (c) The result of applying a band-stop filter to (a).

where W_0 to W_1 represents the range of frequencies to pass. A band-stop filter is defined as:

$$H(u,v) = 0 \quad \text{for} \quad W_0^2 \le u^2 + v^2 \le W_1^2$$
$$= 1 \quad \text{else} \qquad (28.25)$$

These types of filters can be particularly useful for removing or enhancing periodic patterns. Figure 28.10a–c illustrates the effects of applying band-pass and band-stop filters to an image.

IMAGE RESTORATION

In very general terms, two degradation processes always affect an image when it is captured, or subsequently reproduced: the image is blurred and noise is added. The process of recovering an image that has been degraded, using some knowledge of the degradation phenomenon, is known as image restoration. The degradation function may be measured directly if the image system used to record the images is available, *a priori* information, or in certain cases such as astrophotography, it may be estimated from the image itself, *a posteriori* information.

Those image-processing techniques chosen to manipulate an image to improve it for some subsequent visual or machine-based decision are usually termed enhancement procedures. Image restoration requires that we have a model of the degradation, which can be reversed and applied as a filter. The procedure is illustrated in Figure 28.11.

We assume linearity so that the degradation function can be regarded as a convolution with a PSF together with the addition of noise, i.e.

$$f(x,y) = g(x,y) \otimes h(x,y) + n(x,y) \qquad (28.26)$$

where $f(x, y)$ is the recorded image, $g(x, y)$ is the original ('ideal') image, $h(x, y)$ is the system PSF and $n(x, y)$ is the noise.

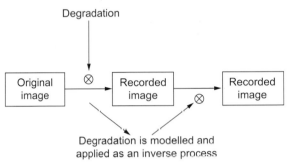

Figure 28.11 A simple model for image recovery from degradation.

We need to find a correction process $C\{\}$ to apply to $f(x, y)$ with the intention of recovering $g(x, y)$, i.e. $C\{f(x, y)\} \to g(x, y)$ (or at least something close). Ideally the correction process should be a simple operation, such as a convolution.

Inverse filtering

This is the simplest form of image restoration. It attempts to remove the effect of the PSF by creating and applying an inverse filter. Writing the Fourier space equivalent of Eqn 28.26 we obtain:

$$F(u,v) = G(u,v) \cdot H(u,v) + N(u,v) \qquad (28.27)$$

where F, G, H, and N represent the Fourier transforms of f, g, h and n respectively; u and v are the spatial frequency variables in the x and y directions.

An estimate for the recovered image, $G_{est}(u, v)$ can be obtained using:

$$G_{est}(u,v) = \frac{F(u,v)}{H(u,v)} = G(u,v) + \frac{N(u,v)}{H(u,v)} \qquad (28.28)$$

529

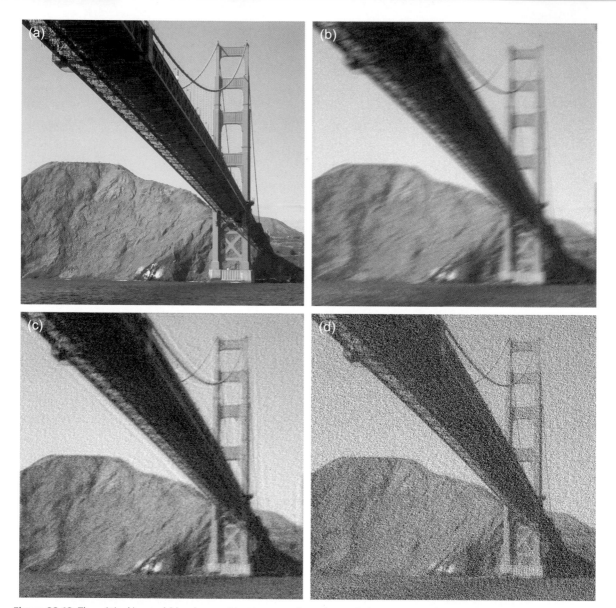

Figure 28.12 The original image (a) has been subject to a complicated convolution process at the capture stage involving movement (b). A Wiener filter correction yields (c). Simple inverse filtering yields the noisy result in (d).

If there is no noise, $N(u, v) = 0$ and if $H(u, v)$ contains no zero values we get a perfect reconstruction. Generally noise is present and $N(u, v) \neq 0$. Often it has a constant value for all significant frequencies. Since, for most degradations, $H(u, v)$ tends to be zero for large values of u and v, the term

$$\frac{N(u, v)}{H(u, v)} \qquad (28.29)$$

will become very large at high spatial frequencies. The reconstructed image will therefore often be unusable because of the high noise level introduced.

This problem can be illustrated very easily using a simple sharpening filter. Although a specific degradation process is not involved in the derivation of the filter, some typical form for $h(x, y)$ is implied. The effect of such a filter is broadly equivalent to the application of Eqn 28.28 followed by an inverse Fourier transform. Figure 28.12 shows an example.

Despite the problems described above, it is often very much easier to work in the frequency domain when attempting to deconvolve an image. The PSF of an imaging system is typically small with respect to the size

of an image. Because of this, small changes in the estimated PSF cause large changes in the deconvolved image. The relationship can be understood further by considering the Fourier transform of a Gaussian function, as given in Chapter 7, Eqn 7.21. The Fourier transform of a Gaussian is another Gaussian of changed width. As it becomes narrower in real space it grows wider in frequency space. Therefore, if we imagine the line spread function (LSF) of a system as a Gaussian function we can clearly see that a small LSF will yield an extensive MTF. As the MTF extends over a large range of frequencies, it will be less sensitive to small changes if used to deconvolve the image.

Optimal or Wiener filtering

A better approach to image restoration is to modify the inverse filtering process to take into account information about the noise level. The Wiener filter is derived for this purpose. It attempts to reconstruct the image by finding not the 'ideal' or the 'true' image version, but an optimal image that is statistically the best reconstruction that can be formed. The optimal image is defined as that image which has the minimum least-squared error from the 'ideal' image. In practice we do not know what the 'ideal' image is, the problem is expressed like this to simply allow the mathematical derivation to continue.

Consider a reconstruction $g_{est}(x, y)$ of the 'ideal' image $g(x, y)$. We wish to minimize the least square difference, i.e. we require

$$\left\langle |g_{est}(x, y) - g(x, y)|^2 \right\rangle \qquad (28.30)$$

to be a minimum. The $< >$ brackets denote an average over all values of x and y. It would also be useful to do this by convolution. In other words we want to find a filter $y(x, y)$, say, such that:

$$g_{est}(x, y) = f(x, y) \otimes y(x, y) \qquad (28.31)$$

and the above minimum condition applies.

In Fourier space, Eqn 28.31 can be written as:

$$G_{est}(u, v) = F(u, v) \cdot Y(u, v) \qquad (28.32)$$

where $Y(u, v)$ is the Fourier transform of $y(x,y)$. Using Eqn 28.27, this result becomes:

$$G_{est}(u, v) = G(u, v) \cdot H(u, v) \cdot Y(u, v) + Y(u, v) \cdot N(u, v) \qquad (28.33)$$

The minimization condition may be rewritten in the frequency domain:

$$\left\langle |G_{est}(u, v) - G(u, v)|^2 \right\rangle \qquad (28.34)$$

This minimization takes place with respect to the filter $Y(u, v)$ and is written as:

$$\frac{\delta}{\delta Y} \left\langle |G_{est} - G|^2 \right\rangle = 0 \qquad (28.35)$$

where the subscripts u and v are omitted for clarity. Equation 28.35 becomes:

$$\frac{\delta}{\delta Y} \left\langle |GHY + NY - G|^2 \right\rangle = 0 \qquad (28.36)$$

If we assume the noise $n(x, y)$ has a zero mean and is independent of the signal, it follows that all terms of the form $<N(u, v)>$ will be zero and can be ignored. If the squared term in Eqn 28.36 is expanded and simplified, the minimization condition can be solved to yield:

$$Y(u, v) = \frac{H^*(u, v)}{|H(u, v)|^2 + \frac{|N(u,v)|^2}{|G(u,v)|^2}} \qquad (28.37)$$

where $H^*(u, v)$ is the complex conjugate of $H(u, v)$. This is because of notation from complex mathematics and arises because the general function $H(u, v)$ has separate real and imaginary terms to allow for an asymmetric spread function $h(x, y)$. The result above is the classical Wiener filter. If we assume the degrading spread function is symmetrical, Eqn 28.37 reduces to:

$$Y(u, v) = \frac{H(u, v)}{|H^2(u, v)|^2 + \frac{|N(u,v)|^2}{|G(u,v)|^2}} \qquad (28.38)$$

Note that in the noise-free case, where $N(u, v) = 0$, Eqn 28.38 reduces to:

$$Y(u, v) = \frac{1}{H(u, v)} \qquad (28.39)$$

which is just the ideal inverse filter. The term

$$\frac{|N(u, v)|^2}{|G(u, v)|^2} \qquad (28.40)$$

in Eqn 28.38 can be approximated by the reciprocal of the squared signal-to-noise ratio as defined in Eqn 24.12 of Chapter 24. Therefore, Eqn 28.38 above can be approximated by:

$$Y(u, v) = \frac{H(u, v)}{H^2(u, v) + \frac{\sigma_N^2}{(\sigma_T^2 - \sigma_N^2)}} \qquad (28.41)$$

Equation 28.41 offers a useful means of devising a frequency space filter to combat a known degradation (e.g. uniform motion blur) when the image is noisy.

Maximum entropy reconstruction

In common with other reconstruction techniques, this aims to find the smoothest reconstruction of an image, given a noisy degraded version. It does so by considering the pixel values of an image to be probabilities, from which the entropy of an image can be defined. The entropy of the reconstructed image, formed in the absence of any

constraints, will be a maximum when all the probabilities are equal. In other words it will comprise white noise. When constraints are applied by using the information in the original degraded image, an optimum reconstruction for that image is formed. The process involves iteration (repeated approximations) and will include the deconvolution of a known or estimated PSF. The technique is computationally expensive and care is required to avoid divergent or oscillatory effects. It is used widely for the reconstruction of noisy astronomical images where information as to the limits of resolution and detectability is sought.

Interactive restoration

In many applications of digital image processing the operator will have the opportunity to react to the outcome of a particular process. It then becomes advantageous to utilize the intuition of an experienced observer for the interactive restoration of images. Given the uncertain nature of noise measures and degradation processes, most restoration procedures will benefit from this flexibility. For example, the noise-to-signal power term of Eqn 28.41 may be replaced by an operator-determined constant, chosen by trial and error to yield the most appropriate correction.

Extended depth of field (EDOF)

Image restoration is employed in some modern cameras to attempt to increase the apparent depth of field. By modifying the PSF of the lens to be consistent (though not necessarily as good over a larger depth of field), it is possible to subsequently recover the lost sharpness using image restoration. The resultant effect is that the lens has an apparently larger depth of field. The technique can eliminate the need for autofocus, thereby reducing the number of mechanical parts and increasing the reliability of a system. The cost of the procedure, however, is increased image-processing complexity and possible noise. As noise is prone to change depending on exposure conditions, a noise model of the sensor needs to be included internally to the imaging system to optimize the reconstruction. Further, variation of the PSF across the field of view needs to be accounted for. A modern mobile phone sensor, for which EDOF is particularly desirable, can deconvolve an image in real time.

WAVELET TRANSFORM

Despite the importance of the Fourier transform in imaging, there are many other transformations which prove useful for various applications. Of great utility in modern image compression is the wavelet transform. A transform is simply a method for converting a signal from one form to another. The form to which it is converted depends upon its *basis function*. In the case of the Fourier transform the basis for the conversion is a sine wave and, as we have seen, the phase at each frequency is changed by adding a proportion of a cosine wave of the same frequency. These waves are thought of as extending infinitely in space.

A limitation of the Fourier transform is that whilst it reveals which spatial frequencies are contained in the image as a total, it does not tell us *where* those frequencies occur in the image. It is not localized spatially. A wavelet is limited in space and may be thought of as a pulse of energy. Figure 28.13 shows a typical wavelet, though it should be noted that there are many different types, of various shapes. The wavelet is used as the basis function for the wavelet transform.

The continuous wavelet transform (CWT) may be written as:

$$F(\tau, s) = \frac{1}{\sqrt{|s|}} \int f(x) \cdot \psi^* \left(\frac{x - \tau}{s} \right) dx \qquad (28.42)$$

where $\psi(x)$ is the wavelet, $f(x)$ the function to be transformed, τ a translation variable and s a scaling variable. The wavelet may be thought of as being convoluted with the input signal. It is shifted through the signal as τ is changed. The wavelet is effectively scaled using s, which changes the scale of details with which it is concerned, i.e. the set of spatial frequencies it is analysing.

Interpreting this in a less mathematical manner, we may imagine the convolution form of the equation to be similar

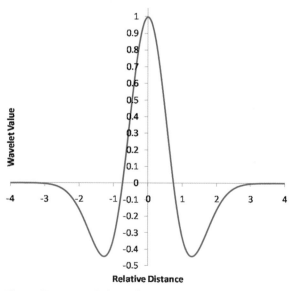

Figure 28.13 A typical wavelet used in the continuous wavelet transform, the Mexican hat wavelet.

to matched filtering or correlation (see Chapter 27), and the wavelet as being resized. For a given *'size'* (scale) of the wavelet, the wavelet transform is finding out how much of the wavelet there is at each point in the image. The transform then repeats this for many *'sizes'* (scales) of the wavelet. When the wavelet is scaled to be small it analyses small or high-resolution information and conversely, when it is large, low-resolution or large structure.

Discrete wavelet transform

The discrete wavelet transform (DWT) is not simply a discrete version of the above CWT as is the case for the Fourier transform. The DWT operates via a method known as *sub-band coding* and iteratively decomposes the signal into ever-decreasing bands of spatial frequencies. At the heart of its operation, a pair of quadrature mirror filters (QMFs) are created. The QMFs consist of a high-pass and low-pass filter whose impulse response is closely related by:

$$h_H[n] = (-1)^n h_L[n] \qquad (28.43)$$

where h_H is the high-frequency impulse response and h_L the low-frequency response. Application of both filters to the signal results in two outputs, one of which contains higher spatial frequencies and one of lower spatial frequencies, hence the name sub-band coding. We denote the higher spatial frequencies *detail information*,

the lower spatial frequencies *approximation information*. The filters are applied in a convolution-type operation as previously:

$$F_L[n] = \sum_{k=-\infty}^{\infty} f[n] h_L[2n - k] \qquad (28.44)$$

and

$$F_H[n] = \sum_{k=-\infty}^{\infty} f[n] h_H[2n - k] \qquad (28.45)$$

where f is the original discrete signal, F is the filtered signal and h the filter. The subscripts L and H indicate low- and high-frequency respectively. Because the signal has been filtered to contain half the number of spatial frequencies, it follows from the Nyquist theorem (see Chapter 7) that half of the samples may be removed without changing the information contained in each result. One of the goals of efficient QMF filter pair design is to generate filter pairs that can reconstruct the original signal after the removal of the redundant samples effectively.

The DWT proceeds by iteratively applying the low- and high-pass filters, also known as the scaling and wavelet filters, successively to the signal, then subsampling to remove redundant information (Figure 28.14). This creates a *filter bank* or *decomposition tree*. The information from the wavelet filter yields the DWT coefficients at each

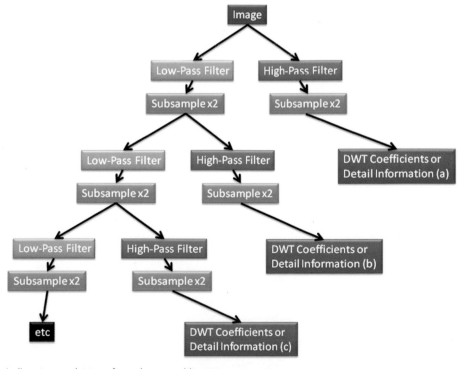

Figure 28.14 A discrete wavelet transform decomposition tree.

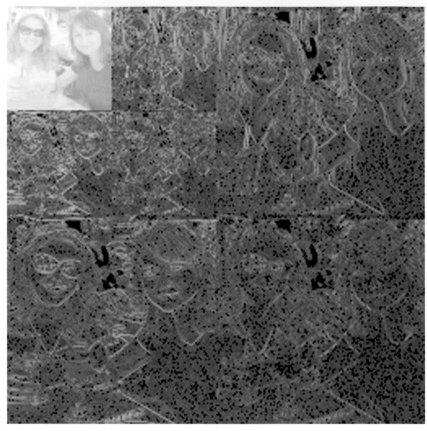

Figure 28.15 The application of the Haar wavelet transform to an image.

decomposition level and that from the scaling filter is processed again to yield coefficients for the subsequent level.

Reconstruction of the signal is performed by up-sampling the result at each decomposition level and passing it through a reconstruction filter. The reconstruction filter is exactly the same as the analysis filter except it is reversed spatially. The benefit of the DWT to imaging is in the area of image compression, as explained in Chapter 29. By quantization or removal of the coefficients that represent the highest spatial frequencies in the image, information can be removed with a minimum of visual impact (Figure 28.15).

BIBLIOGRAPHY

Bracewell, R.N., 1999. The Fourier Transform and its Applications, third ed. McGraw-Hill, New York, USA.

Brigham, E.O., 1988. The Fast Fourier Transform and its Applications. Prentice-Hall, New York, USA.

Castleman, K.R., 1996. Digital Image Processing. Prentice-Hall, Englewood Cliffs, NJ, USA.

Gleason, A. (translator), et al., 1995. Who Is Fourier? A Mathematical Adventure. Transnational College of LEX/Blackwell Science, Oxford, UK.

Gonzalez, R.C., Woods, R.E., Eddins, S.L., 2004. Digital Image Processing Using MATLAB. Pearson Prentice-Hall, Englewood Cliffs, NJ, USA.

Goodman, J.W., 1996. Introduction to Fourier Optics (Electrical and Computer Engineering), second ed. McGraw-Hill, New York, USA.

Jacobson, R.E., Ray, S.F., Attridge, G.G., Axford, N.R., 2000. The Manual of Photography, ninth ed. Focal Press, Oxford, UK.

'Scion Image', www.scioncorp.com. A free image-processing package capable of performing fast Fourier transforms and processing on images.

Chapter | 29 |

Image compression

Elizabeth Allen

All images © Elizabeth Allen unless indicated.

INTRODUCTION

The growth in global use of the Internet, coupled with improvements in methods of transmitting digital data, such as the widespread adoption of broadband and wireless networking, mean that an ever greater range of information is represented using digital imagery. Improvements in digital image sensor technology enable the production of larger digital images at acquisition. Advances in areas such as 3D imaging, multispectral imaging and high-dynamic-range imaging all add to the already huge requirements in terms of storage and transmission of the data produced. The cost of permanent storage continues to drop, but the need to find novel and efficient methods of data compression prior to storage remains a relevant issue.

Much work has been carried out, over many decades, in the fields of communications and signal processing to determine methods of reducing data, without significantly affecting the information conveyed. More recently there has been a focus on developing and adapting these methods to deal specifically with data representing images.

In many cases the unique attributes of images (compared to those of other types of data representation), for example their spatial and statistical structures, and the typical characteristics of natural images in the frequency domain are exploited to reduce file size. Additionally, the limitations of the human visual system, in terms of resolution, the contrast sensitivity function (see Chapter 4), tone and colour discrimination, are used in clever ways to produce significant compression of images which can appear virtually indistinguishable from uncompressed originals.

UNCOMPRESSED IMAGE FILE SIZES

The uncompressed image file size is the size of the image data alone, without including space taken up by other aspects of a file stored in a particular format, such as the file header and metadata. It is calculated on the basis that the same number of binary digits (or length of code) is assigned to every pixel. The image file size stored on disc (accessed through the file properties) may vary significantly from this calculated size, particularly if there is extra information embedded in the file, or if the file has been compressed in some way. The uncompressed file size (in bits) is calculated using:

$$F = \text{Number of pixels} \times \text{Number of channels}$$
$$\times \text{Number of bits per channel} \qquad (29.1)$$

More commonly file sizes are expressed in kilobytes (kb) or megabytes (Mb), which are obtained by dividing the number of bits by (8×1024) or $(8 \times 1024 \times 1024)$ respectively. Some examples of uncompressed file sizes for common media formats are given in Table 29.1.

IMAGE DATA AND INFORMATION

The conversion of an original scene (or continuous-tone image) into a digital image involves the spatial sampling of the intensity distribution, followed by quantization. Although the user sees the image represented as an array of coloured pixels, the numbers representing each pixel are at a fundamental level a stream of *binary digits*, which allow it

DOI: 10.1016/B978-0-240-52037-7.10029-8

535

Table 29.1 File sizes for some typical media formats

MEDIA	DIMENSIONS		RESOLUTION	BIT DEPTH	UNCOMPRESSED FILE SIZE (Mb)
	H	V			
Scan of 35 mm film (RGB)	36 mm	24 mm	2400 ppi	24 bits per pixel	22.1
Image from 10.1 megapixel sensor (RGB)	10.1 million active pixels at native resolution			24 bits per pixel	28.1
Image from medium-format digital back (RGB)	49.1 mm	36.8 mm	7416 × 5412 = 40,135,492 active pixels	16 bits per channel × 3 channels = 48 bits per pixel	223.1[†]
10 × 8 in. print (CMYK)	10 in.	8 in.	300 dpi	32 bits per pixel	27.5
Image displayed at three-quarters of the size of an XGA monitor	764 pixels	576 pixels	Displayed at 72 ppi	24 bits per pixel	1.3

[†]Image file from a camera back of this type will normally be a losslessly compressed RAW file, significantly smaller than this calculated value.

to be read and stored by a computer. All the information within the computer will at some point be represented by binary data and therefore image data represent one of many different types of information that may be compressed. Many of the methods used to compress images have their basis in techniques developed to compress these other types of information.

It is important at this point to define *data* and *information*, as these are core concepts behind image compression. At its most fundamental, information is knowledge about something and is an inherent quality of an image. In communication terms, information is contained in any *message* transmitted between a *source* and a *receiver*. Data are the means by which the message is transmitted and are a collection of organized information. In a digital image, the information is contained in the arrangement of pixel values, but the data are the set of binary digits that represent it when it is transmitted or stored.

Information theory is a branch of applied mathematics providing a framework allowing the quantification of the information generated or transmitted through a communication channel (see Chapter 24). This framework can be applied to many types of signal. In image compression the digital image is the signal, and is being transmitted through a number of communication channels as it moves through the digital imaging chain. The process of compression involves reduction in the data representing the information or a reduction in the information content itself. Data reduction is generally achieved by finding more efficient methods to represent (encode) the information.

In an image containing a certain number of pixels, each pixel may be considered as an information source. The *information content* of the image relates to the probabilities

of each pixel taking on one of *n* possible values. The range of possible values, as we have already seen in Chapter 24, is related to the bit depth of the image.

The process of gaining information is equivalent to the removal of uncertainty. Therefore, information content may be regarded as a measure of predictability: an image containing pixels which all have the same pixel value has a high level of predictability and therefore an individual pixel does not give us much information. It is this idea upon which much of the theory of compression is based. Where a set of outcomes are highly predictable, then the information source is said to contain *redundancy*.

The amount of redundancy in a dataset can be quantified using *relative data redundancy* (R_d), which relates the number of bits of information in an uncompressed dataset to that in a compressed dataset representing the same information as follows:

$$R_d = 1 - \frac{N_{compressed}}{N_{original}} \quad (29.2)$$

Note that the fraction in this expression is the reciprocal of the *compression ratio* for these two datasets, which we will discuss later on.

BASIS OF COMPRESSION

Compression methods exploit the redundancies within sets of data. By removing some of the redundancy, they reduce the size of the dataset necessary without (preferably) altering the underlying message. The degree to which

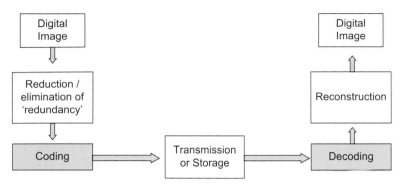

Figure 29.1 Image compression algorithms consist of two processes: the compression process which occurs when the file is saved and a corresponding decompression process when the compressed file is reopened. \hat{f} indicates that the output is an approximation to the input and may not be identical.

redundancy can be removed depends on various factors, such as the type of signal being compressed. For example, text, still images, moving images and audio all have different types of redundancies present and different requirements in terms of their reconstruction.

When describing compression methods we are actually considering two processes: the compression process and a corresponding decompression (see Figure 29.1). The aim is that the decompressed version of the dataset is as close to the original as possible. However, it is important to note that compression may be *lossless* or *lossy*.

Lossless compression methods, as the name suggests, compress data without removing any information, meaning that after decompression the reconstruction will be identical to the original. However, the amount of compression achieved will be limited. Certain types of information require perfect reconstruction, and therefore only lossless methods are applicable.

Lossy compression methods remove redundancy in both data and information, incurring some losses in the reconstructed version. Lossy compression is possible in cases where there is some tolerance for loss and depends on the type of information being represented. An example of such a situation is one where some of the information is beyond the capabilities of the receiver. This process is sometimes described as the removal of *irrelevancies*. In lossy methods there is always a trade-off between the level of compression achieved and the degree of quality loss in the reconstructed signal.

Types of redundancy

Mathematically, the process of compression may be seen as the removal of correlation within the image. There are a number of different areas of redundancy commonly present in typical digital images:

- *Spatial redundancy* (see Figure 29.2). This type of redundancy refers to correlation between neighbouring pixels and therefore inherent redundancy in the pixel

values (also known as *interpixel redundancy*). The correlation may consist of several consecutive pixels of the same value, in an area where there is a block of colour, for example. More commonly in natural images, however, neighbouring pixels will not be identical, but will have similar values with very small differences. In images where there are repeating patterns, there may be correlation between groups of pixels. A specific type of inter-pixel redundancy occurs between pixels in the same position in subsequent frames in a sequence of images (i.e. in video applications). This is known as *interframe redundancy*, or *temporal redundancy*; however, this chapter deals predominantly with still images, therefore the former definition of spatial redundancy is discussed here.

- *Statistical redundancy*. If an image is represented statistically (i.e. in terms of its histogram – see Figure 29.3) it will generally contain some pixel values which occur more frequently than others. Indeed, some pixel values may not be represented in the image at all and will appear as gaps in the histogram. To allocate the same length of binary code to all pixel values, regardless of their frequency, means that the code itself will contain redundancy. A significant amount of compression can be achieved using a *variable length code*, where the most frequently occurring values are given a shorter code than the less frequent values. Methods of compression exploiting statistical redundancy (also known as coding redundancy) are sometimes called *entropy coding* techniques, and have their basis in Shannon's source coding theorem (see later). Most lossy compression schemes will include a lossless entropy coding stage.

- *Psychovisual redundancy*. Because the human visual system does not have an equal sensitivity in its response to all visual information, some of the information contained within images is less visually important. Such information can be reduced or removed without producing a significant visual difference. An example is

(a)

(b)

Spatially
redundant
data

(c)

Figure 29.2 Types of spatial redundancy. (a) Runs of identical pixel values tend to occur in images containing graphics or text (e.g. fax images). (b) In natural images, consecutive pixels may have similar values, increasing or decreasing by small amounts. This image contains lots of low frequencies and therefore smooth graduation of tone. (c) Groups of pixels may be correlated in areas of repeating pattern. Although this image is very busy, the repeating patterns throughout mean that pixel values may be quite predictable.

Figure 29.3 Coding redundancy. The image histogram will often display one or several peaks, indicating that some pixel values are more probable than others.

the reduction of frequencies less important to the human visual system used in algorithms such as the JPEG (Joint Photographic Experts Group) baseline lossy compression algorithm. Additionally, in some methods, colour information is quantized by the down-sampling of chroma channels while luminance information is retained, because colour discrimination in the human visual system is less sensitive than that of luminance. Reduction of psychovisual redundancy involves the removal of information rather than just data and therefore methods involved are non-reversible and lossy.

Measuring compression rate

Lossless compression algorithms may be evaluated in a number of ways, for example in terms of their complexity; or in the time taken for compression and decompression. However, the most common and generally the most useful measures are concerned with the amount of compression achieved.

Compression ratio

The compression ratio is the ratio of the number of bits used to represent the data before compression, compared to the number of bits used in the compressed file. It may be expressed as a single number (the compression rate), but more frequently as a simple ratio, for example a compression ratio of 2:1, which indicates that the compressed file size is half that of the original.

Compression percentage

Derived from the compression ratio, the compression percentage defines the amount of compression in terms of the reduction in file size in the compressed file as a percentage of the original file size. i.e. if a compressed file is one-fifth the size of the original, then the percentage reduction will be $4/5 \times 100 = 80\%$.

Bit rate

The bit rate defines the average number of bits required to represent a single sample in the compressed image, i.e. bits per pixel. This is a very commonly used measure, but is only meaningful in comparison with the number of bits per pixel allocated in the uncompressed original. Generally the original image will be 8 or 16 bits per pixel. If an 8-bit image is compressed to a compression ratio of 2:1, then its compressed bit rate will be 4 bits per pixel.

Scene dependency and compression

Although the issue of scene dependency in image quality is covered in detail in Chapter 19, it is mentioned briefly here with respect to image compression. It is fundamental to the understanding of compression in terms of the achievable compression level in both lossless and lossy systems, as well as in terms of image quality of lossy compression.

Because all compression is based on the elimination of redundancy, and redundancies in images are directly related to image content, it follows that compression is inherently scene dependent. The degree of lossless compression achieved by exploiting these redundancies therefore varies from image to image, *meaning that two (different) images of the same uncompressed size will compress to different file sizes using the same algorithm.* Fundamentally, as we shall see, some images are easier to compress than others, and certain image compression algorithms will work on some images better than on others.

Scene dependency also exists in lossy algorithms, which as well as including an entropy coding step, quantize the image based on the reduction of psychovisual redundancy, the level of which is again the result of differing scene content. The distortions introduced by lossy algorithms will depend upon particular characteristics (such as spatial frequency characteristics) within the image, with some images being more susceptible to such artefacts than others. Therefore, images when compressed by lossy systems, as well as producing different output compression ratios, will also result in different amounts of error.

Finally, compressed image quality assessments are also scene dependent. In lossy compression the distortions will be more visible in some images, while being masked by certain image structures in others. Additionally some distortions may be more visually problematic to observers than others, meaning that the image quality loss of two images may be evaluated differently, even if the same level of objectively quantified error has been introduced.

All of these points simply serve to illustrate the fact that no one compression method is optimal for all images, whether lossless or lossy approaches are being considered.

INFORMATION THEORY

As described in Chapter 24, the transmission of information is considered in terms of an information source, containing a number of possible outcomes, and the process of gaining information results in the reduction of uncertainty about the source. In generic terms, the outcomes are *symbols* within an *alphabet* of possible symbols. In a digital image, the symbols are (usually) pixel values and the alphabet is the range of values available. Here the background to information theory is further elaborated, in the context of image compression.

The theory is grounded in the work of Claude Elwood Shannon, who was an electrical engineer working at Bell Labs and in 1948 published a now famous paper: 'A Mathematical Theory of Communication' in the *Bell System Technical Journal*. In this paper Shannon addressed the problem of transmitting information over a noisy channel. A core result from his work is the definition of *self-information*, which is a measure of the information associated with an individual outcome of a *random variable*. Self-information relates the probability of a particular outcome occurring to its information content and overall defines the level of uncertainty in an information source. The self-information contained within a particular outcome is directly dependent on the probability of its occurrence. If the probability of an event is high, then its self-information is low and vice versa.

If a source has n outcomes, and the probability associated with outcome X is $P(X)$, then the self-information, $i(X)$, associated with X is given by:

$$i(X) = \log_y \frac{1}{P(X)} = -\log_y P(X) \qquad (29.3)$$

The probabilities of course will range from 0 to 1. The use of a logarithm results in the self-information increasing as the probability decreases. Within the expression, the base of the logarithm, y, has not been specified. The unit of information specified is dependent on this base. In image compression, we are considering pixel values represented by binary digits, or bits, and therefore it is taken to be base 2, because each binary digit can only have one of two outcomes.

Where self-information relates to the amount of information gained from a particular outcome and in imaging terms from a particular pixel, we are generally more interested in the amount of information in an image,

a measurement of the overall uncertainty of the image as a source. This can be quantified using the concept of *source entropy* (also described in Chapter 24). Entropy is the *average* amount of information carried by an individual symbol from the source.

If a source has n possible outcomes, and the ith individual outcome is given as X_i, then the *average self-information* associated with the source will be:

$$H = \sum P(X_i) i(X_i) \qquad (29.4)$$

This states that the entropy associated with the source is equal to the sum of the information from all the outcomes, each multiplied by its probability. As we shall see, in a digital image this can be easily approximated from the image histogram. The average amount of information carried by a pixel tells us more about the nature of the image and can be used more generally as a comparative measure between images.

Substituting Eqn 29.3 into Eqn 29.4 and expressing the logarithm to base 2 produces the more commonly used expression, also given in Eqn 24.33, for the calculation of entropy:

$$H = \sum P(X_i) \log_2 \frac{1}{P(X_i)} \text{ bits} \qquad (29.5)$$

This may be written alternatively as:

$$H = -\sum P(X_i) \log_2 P(X_i) \text{ bits} \qquad (29.6)$$

Equations 29.5 and 29.6 define the average number of bits of information per symbol of the source and in an image this usually refers to the average number of bits per pixel. This may be further extended to blocks of symbols or pixels; the entropy is then calculated from the probabilities of such blocks of values occurring (where the probabilities of the individual symbols in the sequence are multiplied together to produce a composite probability). For a block of length b, the entropy is calculated from b times the entropy of a single symbol.

To consider the relevance of entropy to the issue of image compression, we must again look at the information capacity of an image. Information capacity, as the name suggests, considers the maximum amount of information that may be transmitted from an information source. The maximum amount of information will be conveyed if all outcomes from the information source are equally likely. In the case of an image containing n possible pixel values, if all pixel values have equal probabilities, then all $P(X_i) = 1/n$, which sum to 1 (as there are n possible outcomes) and Eqn 29.6 becomes:

$$H = \log_2(n) \text{ bits} \qquad (29.7)$$

This means that each pixel is capable of carrying $\log_2(n)$ bits of information and so we say that the information capacity is $\log_2(n)$ bits per pixel. The information capacity, C, of an image containing m pixels per unit area will then be:

$$C = m \log_2(n) \text{ bits per unit area} \qquad (29.8)$$

which is also given in Eqn 24.35.

As would be expected, if the value of m is the actual number of pixels in the image, then this expression is equivalent to the one given at the beginning of the chapter to calculate uncompressed file size.

It is assumed in this expression that the pixels are independent of each other — in other words, there is no correlation between them. In reality of course, there is usually some inter-pixel correlation, meaning that the information content for the typical image will be less than the information capacity. It is this difference between the information content and the information capacity that defines the amount of spatial redundancy within the image.

Entropy and image structure

Although two images of the same spatial resolution and bit depth will have equal information capacity, their information content will be different because it is predominantly determined by the spatial structure, or arrangement of pixels within each image. Equation 29.7 defines entropy for the situation where all outcomes of a random variable are equally probable. In such a case entropy is at a maximum and equal to information capacity. The opposite case occurs when a single outcome is certain. In this case, $P(X_i)$ for most values will be 0 and for one value will be 1. Since $\log(1) = 0$, entropy in this case will be 0.

In imaging terms, an image of random noise is an example of one, in which all values might be equally probable whereas an image in which a single value is certain will be a uniform patch of that value. Hence an image containing only random noise has maximum entropy and the uniform patch has zero entropy. In less extreme cases, images with smoothly changing tones, blocks of uniform pixel values, or repeating patterns or textures will tend to have lower entropy values than those in which the values are changing rapidly and randomly in an unpredictable way. Figure 29.4 illustrates some examples of both types of image and their corresponding entropy values. The colour images were converted to 8-bit greyscale for the entropy calculation, and therefore the information capacity and maximum possible entropy values for all are 8 bits per pixel.

Because entropy is a measure of information content, it provides some correlation to the amount of statistical redundancy within the image. The predictability of pixel values within the image can therefore be an indicator of the image appearance, the entropy value and ultimately the amount of lossless compression that may be achieved when exploiting statistical redundancy alone.

Note, however, that because entropy is ultimately a statistical measure, there are special cases where the entropy value does not accurately predict image appearance or possible compression. An example is a perfect gradient or ramp, in which each consecutive pixel value is

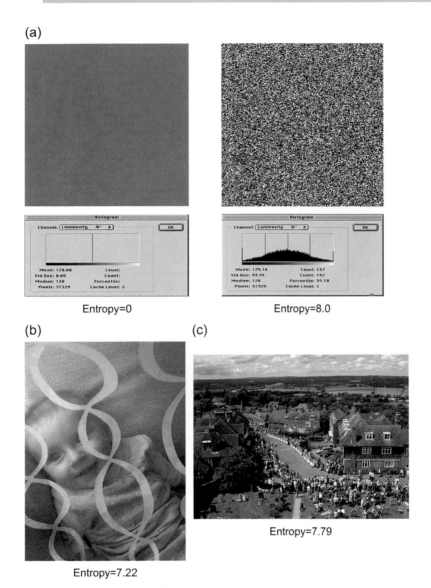

Figure 29.4 Image structure and entropy. (a) A uniform image and a maximum entropy image and their histograms. (b) A low entropy image. (c) A high entropy image. The colour images are converted to 8-bit grayscale for entropy calculation.

one greater than the previous value. In this case all pixel values are equally probable, but their values are highly predictable based on the previous one. In this case a high entropy value will be produced, but this will not reflect the structure or appearance of the image.

Shannon's theorem

The process of coding in the context of image compression involves assigning a set of binary digits to source symbols. These could be individual pixel values, sets of pixel values, or an alternative representation of image information.

Generally we talk about image *encoding* – that is, the process of converting the image information into the code. A fixed length code assigns the same number of bits to every symbol, resulting in redundancy in the code. Shannon's work looked at issues around the reduction of such redundancy.

The first part of Shannon's work involved a noise-free information channel, where the aim was to represent the information in the most efficient method possible. He considered a *zero-memory source*, where the source symbols are statistically independent: no value is more likely as a result of the value(s) that preceded it. The output from such a source is a set of symbols of length b from the

alphabet, rather than a single source symbol. Each symbol must be represented by a *codeword*, and in the case of an image a set of binary digits.

Shannon considered the minimum average codeword length to produce a code that was *uniquely decodeable*, where every symbol was assigned a unique codeword and any set of codewords could be decoded into only one sequence of original symbols. It was therefore completely unambiguous. This minimum average length defines the level of compression that can be achieved by reducing coding redundancy alone, without reducing any of the other redundancies that may also be present in the image.

Let f_k be a variable in the interval $[0,1]$ representing the grey levels in the image, L the total number of grey levels and $P(f_k)$ the probability of f_k occurring. The number of bits required to represent each individual f_k is $n(f_k)$ and the average length of code is then:

$$L_{ave} = \sum_{k=0}^{L-1} P(f_k)n(f_k) \qquad (29.9)$$

Shannon's first theorem defines the upper and lower boundaries for the average length of code if the code is optimal, i.e. coding redundancy has been reduced or removed. It relates the average code length to the entropy of the source as follows:

$$H \leq L_{ave} \leq H + 1 \qquad (29.10)$$

This states that the minimum average length of code in an optimal code will be between entropy and entropy + 1.

IMAGE COMPRESSION MODELS

As illustrated in Figure 29.1, the process of image compression involves two algorithms: the compression algorithm, which originates in an array of pixels and results in an encoded stream of bytes; and the decompression algorithm, which reverses the process to again produce an array of pixel values. The latter may or may not be identical to the original set of values. Each of these algorithms usually consists of several stages. A model of the possible stages in a compression algorithm is illustrated in Figure 29.5.

Although there are three stages in this model, not every compression system will include all three. In particular, if the system results in lossless compression there will be no quantization stage. The three stages correspond to the reduction of the three types of redundancy:

- *Pre-processing* involves the reduction of inter-pixel redundancy, usually mapping original pixel data into an alternative representation. Examples include the coding of sequences of repeating values (*runs* of values) in *run-length encoding*, production of strings of difference values in *differential encoding*, or the transformation of the data into an array of frequency coefficients by a frequency transformation such as the *discrete cosine transform* (DCT) used in JPEG compression. Colour transformations from an RGB colour space to a luminance–chrominance colour space may also be performed at this stage. All of these methods are invertible and therefore lossless. However, some systems may use non-invertible transformations (e.g. the JPEG 2000 compression standard has the option of using a non-invertible *discrete wavelet transform* at this stage).
- The *quantization* stage, used in lossy algorithms only, is the point at which information, rather than data, is discarded. This is most commonly performed on the frequency coefficients which are the output from the pre-processing stage but may also be performed on chrominance channels. The amount and method of quantization will be defined according to the image quality requirements specified by the application and the user. The quantization stage works to reduce psychovisual redundancy and is therefore defined and limited by the capabilities of the human visual system.
- The *encoding* stage is present in all systems. It involves the production of, most commonly, a variable-length binary code using one of many entropy coding techniques, hence reducing statistical redundancy.

Although the entropy coding stage may be used on the original pixel values, in lossless systems it is more frequently used on the output of a mapping operation, while in lossy systems it is used on the output from the quantization stage.

There is, of course, an equivalent decompression model. It is important to note, however, that the quantization stage is non-invertible. Therefore, decompression will only ever involve two stages whether the compression is lossless or lossy: the decoding of the binary input values followed by an inverse mapping procedure to produce the reconstructed image values.

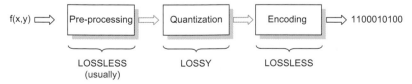

Figure 29.5 Generalized model of the possible stages in an image compression algorithm.

The following sections deal with the specifics of compression methods. The section on lossless compression illustrates some individual methods used in the different lossless stages of the model given above and the section on lossy compression places these in a broader context of an overall compression system.

LOSSLESS COMPRESSION

Lossless compression methods

Lossless compression methods exploit the redundancies in image data (spatial and coding redundancies) without altering the underlying information. The simplest approaches, such as *run-length encoding*, deal with spatial redundancy alone, with limited success in terms of the level of compression achieved. More complex techniques, which are more commonly used in the compression of continuous-tone images (either alone or as a single stage of a multi-stage algorithm), reduce coding redundancies alone to produce a variable-length code (e.g. *Huffman coding*). Methods such as *arithmetic coding*, which are more complex still, deal with both spatial and coding redundancy. Finally, there are a number of adaptive *dictionary techniques*, which build a table of codes to represent repeated sequences of values in the original. Although the approaches described in the following sections are lossless, in some cases there are equivalent lossy versions based upon the same fundamental principles. Additionally, a number of these techniques are used in one or more lossless stages in lossy compression schemes such as JPEG.

Reducing spatial redundancy

1. Run-length encoding

In images where there are many identical adjacent pixels, a simple approach to removing this type of spatial redundancy involves encoding runs of values (i.e. a number to represent the value and a number representing how many times the value is repeated — Figure 29.6). Runs of the same value are less likely to occur in natural images, more commonly occurring in images containing text or graphics.

Run-length encoding (RLE) was originally developed for the encoding of facsimile (FAX) images (which consist of only black or white values) and is of limited use for encoding the actual pixel values of continuous-tone

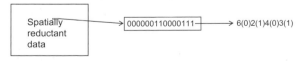

Figure 29.6 Run-length coding.

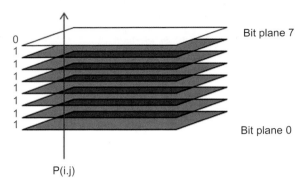

Figure 29.7 Bit-plane representation of an 8-bit image.

images. However, it does have application within continuous-tone image compression when used in combination with other compression methods. For example, in algorithms where *bit planes* are encoded individually (see below), each bit plane is effectively a binary image and runs of values are more likely to occur. Additionally, it may be used as a final stage in transform-based lossy compression schemes (see the later section on JPEG compression).

2. Bit-plane coding and gray code

The pixel values in an 8-bit uncompressed image will each be represented by an 8-bit *binary code*, i.e. a string of ones and zeros. It is possible to consider the image as a set of *bit planes*. In Figure 29.7, the binary codes for a sequence of pixel values are represented as a stack of binary digits. If these stacks are sliced horizontally, each level represents a separate bit plane, i.e. at each level pixel values are represented by a single bit. Each individual bit plane is actually a binary image. A number of compression methods apply *bit-plane decomposition*, compressing each binary image separately.

The top level in the stack, corresponding to the first binary digit of each code, is known as the *most significant bit* and the bottom level the *least significant bit*. The majority of the image structure is represented in the most significant bit plane, while the least significant bit plane appears as random noise. This is as a result of the way that binary code is distributed. The first digit in an 8-bit binary code is 0 for all values below 128 and 1 for all values at 128 and above, whereas the last digit changes for every other value as pixel values increase. Because consecutive pixel values tend to be similar as a result of spatial redundancy, it is quite likely that there will be many runs of values in the most significant bit planes. Methods that work on individual bit planes will often employ various forms of run-length encoding to these bit planes and achieve some level of compression.

A further improvement in levels of compression may be achieved by using a gray code prior to bit plane coding, which reorganizes the binary code so that in consecutive pixel values, only 1 bit changes.

543

(a)

Original Sequence	54	55	55	56	57	59	58	59	60	61
Difference Values	54	1	0	1	1	2	-1	1	1	1

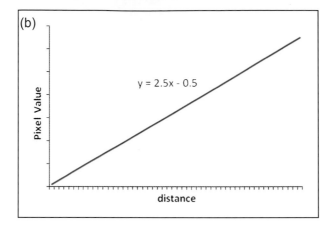

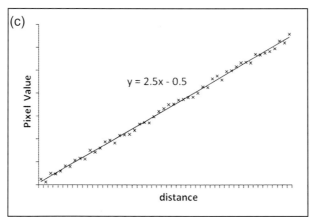

Figure 29.8 Differential coding. (a) Original sequence and alternative sequence of difference values. (b) Data following a simple rule. (c) Model plus residual.

For example, the values 127 and 128 in an 8-bit binary code, as described above, are [01111111] and [10000000] respectively. An 8-bit gray code for these same two values is [01000000] and [11000000]. Where binary code means that runs of values dominate only in the most significant bit planes, a change to gray code for all pixel values also results in many more runs of values in the least significant bit planes.

3. Differential coding

Although runs of identical values do not occur often in natural images, consecutive pixel values are frequently very close in value, particular in low-frequency image areas. In such cases it may be more appropriate to encode the small differences between the values, rather than the values themselves. An example of such a sequence of values and an alternative representation of the values is illustrated in Figure 29.8a. Because most of the values in the second sequence are small, they require fewer bits of storage and therefore some compression can be achieved while maintaining perfect reconstruction.

Some differential methods, known as *predictive coding* methods, attempt to describe the changes in the data using a simple rule or model. A simple example of such data and the associated rule is shown graphically in Figure 29.8b. It is unlikely that the image data will perfectly follow such a rule, in which case there will be a sequence of deviations from the rule, known as the *residual* (Figure 29.8c). Rather than expressing the image pixel values explicitly, the model

and the residual values can be stored instead, as long as the first value in the sequence is known. Again, because the residuals are likely to be very small, they will require fewer bits than the original values would. Some predictive methods, rather than defining a rule for the whole dataset, will predict values based on a number of previous pixels.

Differential coding methods may be lossless or lossy (in cases where the predicted values are not exact). *Delta modulation, a form of differential pulse code modulation* (DPCM) is an example of a lossy predictive coding scheme.

Reducing coding redundancy: variable-length coding

The number and complexity of the various compression methods exploiting coding redundancy (and in some cases inter-pixel redundancy) limits their inclusion in this text; therefore, we will concentrate on one of the most commonly used methods, Huffman coding, as an illustration of variable-length coding. Information upon other commonly used methods such as arithmetic coding can be found in the sources listed at the end of this chapter.

As already discussed, in most natural images there will be some more frequently occurring pixel values which, if all encoded with the same length codewords, will result in a high level of redundancy in the resulting binary code. Variable-length coding methods attempt to reduce this redundancy, producing the shortest possible average length of code (Eqn 29.9) per symbol while producing a code that is uniquely decodeable. The fundamental principle behind such methods is the production of an efficient code, i.e. one in which the most commonly occurring values are assigned the shortest number of bits. Variable-length coding methods are sometimes called entropy coding techniques, as they aim to produce optimal codes according to Shannon's first theorem, i.e. the average length of code is related to the entropy of the source according to Eqn 29.10.

1. Huffman coding

Huffman coding is one of the most commonly used variable-length coding methods. It works by first evaluating the set of symbols according to their probabilities and then constructing a *probability tree*, from which the binary codes for the symbols are derived.

Table 29.2 Example source values used for constructing a Huffman code

SOURCE SYMBOL (R_K)	FREQUENCY (H_K)	PROBABILITY (H_K/N)
r_1	40	0.1
r_2	180	0.45
r_3	70	0.175
r_4	10	0.025
r_5	100	0.25
$N = 400$		

In Table 29.2 a set of five possible source symbols, r_1-r_5, are listed. These are simply a set of values, but for simplicity consider them to be a set of possible grey levels in a digital image. The second column in the table indicates the frequency of occurrence of each grey level. These values are the equivalent to those displayed in an image histogram. The probabilities of each grey level occurring may be approximated from the image histogram by:

$$P(r_k) \approx \frac{H_k}{N} \qquad (29.11)$$

where $P(r_k)$ is the normalized histogram and is the probability of value r_k occurring, H_k is the number of values of r_k in the histogram and N is the total number of number of image pixels. These values are listed in the third column of the table.

The Huffman code is created by constructing a probability 'tree', whereby the probabilities are reordered from largest to smallest. At the first *source reduction,* the bottom two probabilities are merged by adding them together. The resulting probabilities are then reordered from largest to smallest and the process is repeated until only two probabilities remain. The process of source reduction for the values and their probabilities in Table 29.2 is illustrated in Figure 29.9. Following this process the values are coded by allocating 1 and 0 to the bottom two branches of the tree (the ones that are merged) at each stage of the source reduction (Figure 29.10). The order of the two values does not matter, as long as it is the same throughout. The path of the probability for each symbol is traced from the reduced source

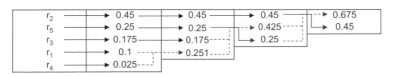

Figure 29.9 Source reduction in Huffman coding.

CODES READ IN THIS DIRECTION

r_2	0.45	0.45	0.45	0.675 **1**
r_5	0.25	0.25	0.425 **1**	0.45 **0**
r_3	0.175	0.175 **1**	0.25 **0**	
r_1	0.1 **1**	0.125 **0**		
r_4	0.025 **0**			

Resulting Codes
0
10
111
1101
1100

Figure 29.10 Code construction in Huffman coding.

back to the original (right to left in Figure 29.10), with binary digits being added as they are encountered, resulting in the codes in the last column in Figure 29.10.

2. Dictionary techniques — LZW compression

Lempel-Ziv-Welch (LZW) coding is a dictionary-based lossless compression algorithm developed in 1984 as an improvement on the LZ78 algorithm.

The algorithm works by building a table (or dictionary) of values from the image, encoding strings of symbols as it encounters them. At the initialization stage, for an 8-bit monochrome image, the first 256 values in the dictionary are assigned to pixel values 0–255. Following this, the encoder examines the image in terms of groups of pixels. The first pair of pixel values encountered is assigned to the next available space in the dictionary (i.e. 257). This process is repeated whenever a new pair is encountered.

For example, in the sequence of pixel values in Figure 29.11, position 257 in the dictionary represents the sequence 10-10 and so on. The next time a sequence of pixels already in the dictionary are encountered, the next pixel is also examined and added to the recognized sequence, becoming a new dictionary entry. In the example, the sequence 10-10-20 will now become dictionary position 261. This process is repeated until the dictionary is full. The entry in the dictionary will consist of the number that represented the previous sequence plus

the new pixel value, but it will be encoded as a single number. The size of this number will depend upon the size of the dictionary. For a 9-bit dictionary, 512 sequences can be stored. As a result, a group of n pixels, rather than being represented by n times the number of bits per pixel, will be represented by the 9 bits encoding the dictionary position number of the group. The dictionary must of course be stored with the compressed image data, but in an image containing many repeating groups of pixels, significant compression may be achieved. Hence LZW compression exploits both coding and inter-pixel redundancy, but as with all image compression methods, it is very *scene dependent*, as illustrated by the images in Figure 29.12.

LZW is a patented method, and has been integrated into a variety of file formats, forming the basis of compression in Graphic Interchange Format (GIF) files, as an option in Tagged Image File Format (TIFF) files and also incorporated in Portable Document Format (PDF) files (see Chapter 17 for information on these file formats).

LOSSY COMPRESSION

The previous sections have illustrated various approaches to compression that provide a perfectly reconstructed signal. However, according to Shannon's first theorem, the degree of lossless compression that may be achieved is fundamentally limited by the entropy of the image. For

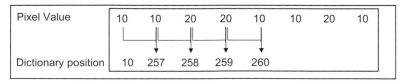

Figure 29.11 Encoding of a sequence of pixels in LZW coding.

Compression rate: 1:1.5

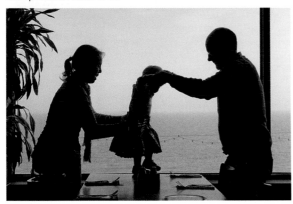

Compression rate: 1:2.1

Figure 29.12 The performance of LZW compression depends on the scene content as illustrated by these images, which are 8-bit RGB images of the same uncompressed size. The bottom image contains much less detail, hence the higher compression rate. LZW compression rates are detailed below each image.

many imaging applications, in particular in the transmission of images over the Internet, this level of compression is not adequate to match the demands for fast processing and small file sizes. This has led to the development of a number of lossy compression systems. These methods are of course only appropriate in situations where quality loss may be tolerated. Images for web use, for example, are usually intended for viewing at the relatively low resolution of a computer display and not for printed output. Additionally these images and those used in multimedia applications are often viewed quickly and in multiples. Nevertheless, one of the requirements of a good

lossy compression system must be to provide the best possible *perceived* image quality for a particular level of compression or required file size. As we shall see, this is achieved by exploiting the properties and limitations of the human visual system, reducing psychovisually redundant information and, in some cases, enhancing more visually important information.

EVALUATING LOSSY COMPRESSION

Measuring the performance of lossy compression schemes is a complex issue. Where lossless schemes are generally only evaluated in terms of compression rate, some quantification of the degree of loss must also be considered in determining the usefulness of a lossy system. Performance measures are vital in the design of these systems; information loss must be balanced against compression rate.

In lossless compression, where perfect reconstruction is no longer a criterion, the compression rate is not an adequate measure, because it is possible to discard all data and achieve a maximum compression rate. *Rate distortion theory*, also derived from Shannon's work on information theory, defines a relationship between compression rate and some measure of distortion. The theory provides a theoretical bound for the level of lossy compression achievable, based upon minimal entropy, without exceeding a particular level of distortion. The relationship is often defined in a *rate distortion function*. Many lossy compression systems use rate distortion theory as a basis for optimizing their performance.

Distortion metrics

The simplest methods for measuring the loss incurred by a system involve measuring the differences between original and reconstructed image values. So-called *distortion metrics* quantify the total difference between the images or the average differences per pixel and are often used as performance measures in lossy systems. The following are examples of such distortion metrics:

1. Mean absolute error (MAE)

This method compares the difference between the original pixel value and the reconstructed value and then finds the average across the whole image:

$$\text{MAE} = \frac{1}{N} \sum_{n=1}^{N} |x_n - \widehat{x}_n| \qquad (29.12)$$

where N = total number of pixels in the image, x_n = value of pixel n in the original image and \widehat{x}_n = value of pixel n in the compressed image.

547

2. Mean squared error (MSE)

This method compares the difference between the original pixel value and the reconstructed value, and squares it before finding the average value across the whole image:

$$\text{MAE} = \frac{1}{N} \sum_{n=1}^{N} (x_n - \widehat{x}_n)^2 \qquad (29.13)$$

3. Signal-to-noise ratio (SNR)

The SNR compares the power of the original signal with the mean squared error (MSE) as calculated above:

$$\text{Power of the original signal, } P = \frac{1}{N} \sum_{n=1}^{N} (x_n)^2 \quad (29.14)$$

$$\text{SNR} = \frac{P}{\text{MSE}} \qquad (29.15)$$

This is then converted to decibels by:

$$\text{SNR (dB)} = 10\log_{10}(\text{SNR}) \qquad (29.16)$$

4. Peak signal-to-noise ratio (PSNR)

The PSNR defines the ratio between the maximum possible power of the signal and the noise in terms of MSE defined above. It is expressed in decibels as follows:

$$\text{PSNR (dB)} = 20.\log_{10}\left(\frac{\text{max}}{\sqrt{\text{MSE}}}\right) \qquad (29.17)$$

where 'max' is the maximum possible pixel value in the image, defined by the bit depth.

The problem with these approaches is that the values obtained often do not correlate well with the perceived loss in image quality. For example, a simple translation of the entire image by one pixel will cause significant increases in all pixel values, without altering the image appearance.

Alternative assessment methods

Other methods of assessment may be used, such as the measurement of image *fidelity* or assessment of image *quality*. Distortion, fidelity and image quality are all discussed in Chapter 19; therefore they are briefly introduced here in the context of their use in assessment of compressed images.

The *fidelity* of the reconstructed image with respect to the original may be measured. This is achieved either by employing subjective fidelity assessments or by attempting to mathematically model the response of the human visual system and using it to process the images before numerical comparison. In subjective fidelity assessments observers are asked to compare the original image with compressed versions across a range of compression rates and evaluate the point in the range at which they notice a difference (just-noticeable difference). Both approaches are complicated: the first by the practicalities of carrying out large numbers of tests for huge numbers of images, the second because of the difficulties in designing a model that accurately reflects human visual processes.

More complex still is the evaluation of compressed *image quality*, which attempts not only to quantify the degree of loss or fidelity between original and compressed images, but also how acceptable or bothersome such loss is to the human observer. The types of errors or artefacts introduced by various systems are different and produce different effects visually. Some distortions are more problematic visually than others. In fact, at lower compression ratios, some distortions can actually result in a slight improvement in perceived image quality (an example is the *ringing* artefact in JPEG, which can result in images appearing sharpened at low compression rates). Image quality measures can take into account such unexpected results, therefore providing a more accurate evaluation of the effects of the algorithm than either distortion or fidelity measures. Image quality assessment may be performed objectively or subjectively, with the same practical complications as those in fidelity assessments.

More details on the basis of quantification of lossy compression are given in Chapter 19. The study of perception remains an important ongoing area of research and is fundamental in both evaluation and design of successful lossy compression systems.

LOSSY COMPRESSION METHODS

There are a number of different approaches to the lossy compression of images. They fall broadly into two categories: *lossy predictive* (or *differential*) *encoding* methods and methods which encode the frequencies within the image. In the latter, the most widely used are *transform-based compression* methods such as JPEG. *Wavelet compression* methods also come under this category.

Like their lossless counterparts, predictive methods use previous samples (and in the case of compression of moving images, subsequent decoded samples), sometimes with a model of the data to predict values. The residuals, i.e. differences from predicted values, are additionally encoded with the prediction model. The difference between these and lossless methods is the inclusion of a quantizer step. Where lossless methods encode the exact difference values resulting in perfect reconstruction, in lossy systems the difference values are quantized. The actual differences from the model may contain fractional components. In a lossy system, these may be rounded to the nearest integer.

The second category of lossy compression, instead of compressing the image pixel values directly, uses some form of linear transform of the image pixel values to produce a set of transform coefficients (of the same number as the number of pixel values). These are then quantized and encoded instead. The transform decorrelates the image data, providing most commonly a frequency space representation of the image. These methods work on the premise that a large amount of the image power is concentrated in a few (lower) frequencies, meaning that higher frequency coefficients may be zero or close to zero. The frequency response of the human visual system, defined by the *contrast sensitivity function* (Chapters 4 and 5), indicates that we have more sensitivity to some frequencies than others, with certain very high frequencies being beyond our visual capabilities. Exploiting this psychovisual redundancy means that some frequencies may be attenuated with little visual impact. The frequency coefficients are rearranged to concentrate higher magnitude coefficients together. After quantization the array of coefficients can be compressed using a combination of variable-length coding and run-length encoding. Figure 29.13 illustrates a typical block of reordered transform coefficients after output from a DCT of a block of pixel values of the same size.

The details of wavelet representations are introduced in Chapter 28; therefore only a brief summary of their properties is provided here. Where most transform-based compression systems use a frequency representation based upon sinusoidal basis functions (such as the DCT in JPEG), wavelet transforms are based on compact and localized 'small waves' of varying frequency.

Generally they are implemented using a *sub-band filter bank* (see Figure 28.14). Filter banks consist at each stage of a *scaling filter*, which uses some form of low-pass filtering and down-sampling to produce a reduced resolution version of the image. In addition, at each stage a *wavelet filter*, which may be considered as a form of high-pass filter, produces the high-frequency output at the same resolution in different image orientations (vertical, horizontal, diagonal).

Wavelets implemented in this way provide a form of *multiresolution analysis*, decomposing the image into a series of two-dimensional *sub-bands*. Each of these consists of one down-sampled image, one-quarter of the size of the previous sub-band, and three quarter-size images representing high frequencies in the horizontal, vertical and diagonal directions. Each down-sampled image may then be further decomposed into another set of four smaller sub-bands and so on. Figure 28.15 illustrates an image decomposed using a *discrete wavelet transform*. Large areas of the resulting representation consist of details or edge information on a background of zeros — as might be expected from the output of a high-pass filter. This representation can be compressed much more easily than the original pixel values and provides the added advantage of encoding the image at multiple resolutions. The latter enhances the capabilities of a standardized compression scheme using wavelets, JPEG 2000, described later in this chapter.

Quantization

All lossy compression schemes use some form of quantization. The simplest approach uses *scalar quantization*, in which the range of values at input (whether pixel values or the output of some pre-processing method) are mapped to a smaller range of output values. Scalar quantization may be *uniform*, dividing the range into equally spaced intervals, or *non-uniform*, where the interval spacing varies across the range. *Entropy-coded quantizer* methods optimize quantization by minimizing entropy for a given distortion level. Quantization may be further improved by grouping source outputs together as a single block and quantizing the range of blocks. This approach is known as *vector quantization*, and can provide lower distortion for a given compression rate than scalar quantization methods.

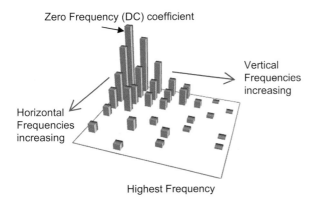

Zero Frequency (DC) coefficient

Vertical Frequencies increasing

Horizontal Frequencies increasing

Highest Frequency

Figure 29.13 Three-dimensional representation of typical layout of coefficient magnitudes from a discrete cosine transform after reordering. The zero frequency component at the top left has the highest magnitude and is surrounded by low-frequency coefficients. The frequencies increase in a diagonal zig-zag, to the highest frequency component in the bottom right. The highest frequency components are of very small or zero magnitudes.

LOSSY COMPRESSION STANDARDS

Joint Photographic Experts Group (JPEG) standard

The JPEG standard was the first international digital image compression standard developed for continuous-tone still images (both greyscale and colour). It was developed in response to advances in digital technology and the need for

a reduction in image file sizes for storage and transmission with minimum loss of visual quality. Although developed with a number of different modes of operation, including a lossless mode based upon predictive coding and a lossy progressive encoding mode, it is the lossy baseline sequential mode that has proved to be the most widely used. The following is a brief summary of the main stages in the algorithm:

Pre-processing

1. In colour images, image data can be reduced by converting to a luminance—chrominance colour space such as YC_bC_r (see Chapter 24) and down-sampling the chroma channels. This takes advantage of the fact that the human visual system is less sensitive to colour discrepancies than to changes in tone.
2. The image is divided into 8×8 pixel sub-images. Each block is then processed individually using the following steps.
3. The block is transformed into frequency coefficients using the two-dimensional discrete cosine transform, resulting in 64 coefficients representing magnitudes of different frequencies for the block.

Quantization

4. The DCT coefficients are reordered using a zig-zag sequence through each block. Frequency coefficients from each block are quantized using visually weighted quantization tables, the selection of which is based upon a quality level defined by user input, resulting in the highest frequency components and lowest magnitude components being reduced or removed.

Entropy coding

5. Differential pulse code modulation (DPCM) of *DC coefficients* of all blocks. The DC coefficient is the zero frequency coefficient and represents the average pixel value of the block.
6. Modified run-length/Huffman coding of each block of *AC coefficients* (all remaining).

The decompression of the algorithm produces a reconstructed and viewable image. Each of the stages of the compression algorithm is reversed apart from the quantization stage (which is irreversible).

The JPEG algorithm is capable of achieving compression ratios of up to 100:1 with an associated loss of image quality. It is, however, considered to be *perceptually lossless* at compression ratios of 20:1 or less (Figure 29.14), meaning that the artefacts introduced by the algorithm are imperceptible in most images to most observers.

The artefacts produced by JPEG are distinctive and recognizable (Figures 29.14d and 29.15). The output from

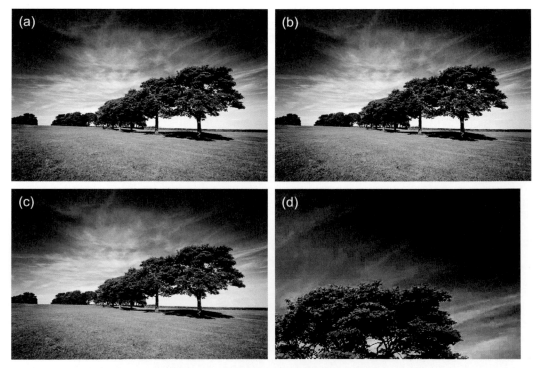

Figure 29.14 Perceptually lossless compression. (a) Original image. (b) JPEG compression at 20:1. (c) JPEG compression at 50:1. (d) Part of (c) magnified.
Summer Landscape © iStockphoto/duncan1890

Figure 29.15 Artefacts in JPEG compression: Further magnification of Figure 29.14c illustrates the 'blocking' artefact throughout the image, although it is somewhat masked in areas of detail. 'Ringing' artefacts and colour bleeding artefacts are visible around the edges of the trees.

Summer Landscape © iStockphoto/duncan1890

the DCT stage results in blocks of 64 coefficients spatially arranged so that they relate to the magnitudes of frequencies in the *same spatial region* in the original image. At higher levels of compression this can result in *blocking artefacts*, which arise due to coarse quantization in individual blocks of pixels, meaning that the edges of the blocks become visible. JPEG images also suffer from *ringing* artefacts. These are a result of abrupt truncation of high-frequency coefficients which affects the appearance of edges in particular and is evident as oscillations or 'ripples' around high-contrast edges. This is particularly problematic in images containing text, which tends to be very poorly reproduced in JPEG images. Finally, in colour images, colour distortions may be visible in areas of neutral tone, as a result of the down-sampling of chroma channels at the pre-processing.

Despite these characteristic artefacts, JPEG is probably the most widely used compressed image format globally and JPEG images are standard output for many digital cameras, particularly consumer formats.

JPEG 2000 standard

The growing requirements of technologies and applications producing and using digital imagery, in particular the expansion of the Internet and multimedia applications, prompted the development of a new standard to address areas in which JPEG and other image standards had failed to deliver. JPEG 2000 Part 1 was standardized in 2001 with the following features:

- Superior rate distortion and subjective image quality performance at low bit rates to that of existing standards, a key requirement of network image transmission and remote sensing applications.

- The ability to compress bi-level, grey scale, colour and multi-component images, allowing the compression of documents containing both images and text.
- The ability to encode images with different characteristics, for example natural images, images from scientific and medical applications, images containing text or computer graphics.
- Lossless and lossy encoding, allowing the use of JPEG 2000 by applications such as medical imaging, where lossless reconstruction is required. Progressive lossy to lossless decompression means that an image may be compressed losslessly, but then decompressed to required lossy compression levels or quality levels. Effectively, a single compressed version of the image may be used in multiple contexts.
- Progressive transmission by pixel accuracy or spatial resolution, particularly important for image archives and web-browsing applications.
- Robustness to bit errors for transmission over wireless communication channels.
- Special features to improve flexibility, such as region-of-interest coding and protective image security.

The operation of the algorithm is considerably more complex than JPEG. However, a brief summary is provided here for comparison:

Pre-processing

1. An optional image 'tiling' stage — the division of large images into non-overlapping image tiles.
2. An optional reversible or irreversible colour transformation may be applied.
3. A reversible or irreversible discrete wavelet transform (for lossless or lossy compression respectively). The image or image tile is decomposed into a number of 'sub-bands'. Each sub-band consists of coefficients describing horizontal and vertical frequency components at a particular resolution (see Figure 28.15).

Quantization

4. Sub-bands of coefficients are quantized separately using a uniform scalar quantizer with the option of different quantizer step sizes for different sub-bands, based upon the dynamic range of the sub-band. Quantization step size will be 1 if lossless compression is required.

Entropy coding

5. Sub-bands are divided into precincts and code blocks (see Figure 29.16). Each code block is input independently in raster order into the entropy coder.
6. Code blocks are coded by individual bit plane, using three passes of an arithmetic coder.

JPEG 2000 images do not suffer from blocking artefacts unless the image has been tiled. Because the quantization step size is different in different sub-bands the errors will build up in a very different way, being much less uniform over a spatial location by comparison with JPEG blocks.

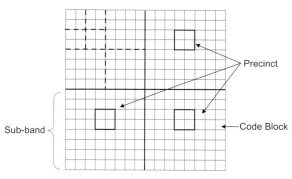

Figure 29.16 Diagram illustrating the partition of a tile or image component into code blocks and precincts.
Based on a diagram by Skodras et al. (2001)

Figure 29.17 Image illustrating smoothing artefacts typical of JPEG 2000.
Summer Landscape © iStockphoto/duncan1890

'Smoothing' or 'smudging' artefacts appear, however, at higher levels of compression. These appear as a blurring of small regions within the image, as shown in Figure 29.17. The visual effects of ringing are also present in JPEG 2000, but they are reduced compared to JPEG because of the arrangement of sub-bands, meaning that they are less localized and the errors are distributed across the image. They tend, therefore, to be less noticeable than the smoothing artefact.

JPEG 2000 is yet to be widely adopted, particularly in commercial imaging applications, which have moved towards RAW image format workflows. However, it is anticipated that it will find application in scientific imaging (it is already in use in forensic imaging in the UK) and archiving, and much research is being conducted into its use in these areas.

BIBLIOGRAPHY

Adams, M.D., Manz, H., Kossentiniy, F., Ebrahimi, T. JPEG 2000: The Next Generation Still Image Compression Standard. Available at the time of writing from www.jpeg.org

Allen, E., Triantaphillidou, S., Jacobson, R.E., 2007. Image quality comparison between JPEG and JPEG 2000 — I. Psychophysical investigation. J. Imag. Sci. Technol. 51 (3), 248(11).

Ford, A., 1997. Relationships between Image Quality and Image Compression. Ph.D. thesis, University of Westminster, London, UK.

Gonzalez, R.C., Woods, R.E., 2002. Digital Image Processing. Pearson Education, Prentice Hall, USA.

Jacobson, R.E., Ray, S.F.R., Attridge, G.G., Axford, N.R., 2000. The Manual of Photography, ninth ed. Focal Press, Oxford, UK.

Russ, J.C., 1995. The Image Processing Handbook, second ed. CRC Press, Boca Raton, Florida, USA.

Sayood, K., 1996. Introduction to Data Compression. Morgan-Kaufmann, San Francisco, CA, USA.

Skodras, A., Christopoulos, C., Ebrahimi, T., 2001. The JPEG 2000 still image compression standard. IEEE

Signal Processing Magazine, September.

Sonka, M., Hlavac, V., Boyle, R., 1993. Image Processing, Analysis and Machine Vision. Chapman & Hall Computing, London, UK.

Triantaphillidou, S., Allen, E., Jacobson, R.E., 2007. Image quality comparison between JPEG and JPEG 2000 — II. Scene dependency, scene analysis and classification. J. Imag. Sci. Technol. 51 (3), 259(12).

Wallace, G.K., 1992. The JPEG still picture compression standard. IEEE Trans. on Consumer Electronics 38 (1), 18–34.

Appendix A

Table with definitions of variables, units and mathematical expressions associated with harmonic waves			
SYMBOL	**DEFINITION**	**UNITS**	**EXPRESSION**
V	Velocity (speed)	$\mathrm{m\,s^{-1}}$	$V = x/t$ (distance/time) $V = \nu\lambda$
c	Speed of light	$\mathrm{m\,s^{-1}}$	$V \approx 2.99792 \times 10^8$, $c = \lambda\nu$
λ	Wavelength (spatial period)	m μm, nm, Å	$\lambda = 1/f$, $\lambda = VT$ $\lambda = c/$ (for light waves in vacuum)
f	Spatial frequency	$\mathrm{m^{-1}}$, $\mu\mathrm{m^{-1}}$, $\mathrm{nm^{-1}}$	$f = 1/\lambda$
T	Temporal period	s	$T = 1/\nu$, $T = \lambda/V$ $T = \lambda/c$ (for light waves in vacuum)
ν	Temporal frequency (or just frequency)	$\mathrm{s^{-1}}$ or Hz	$\nu = 1/T$, $\nu = V/\lambda$ $\nu = c/\lambda$ (for light waves in vacuum)
ω	Angular temporal frequency	$\mathrm{rad\,s^{-1}}$	$\omega = 2\pi/T$, $\omega = 2\pi\nu$
k	Wave propagation number	$\mathrm{rad\,m^{-1}}$	$k = 2\pi/\lambda$, $\kappa = 2\pi f$
ϕ	Phase	rad	$\phi = kx - \omega t$, $\phi = kx + \omega t$
v	Phase velocity	$\mathrm{m\,s^{-1}}$	$v = \omega/k$
ε	Phase difference	rad	$\varepsilon = \Delta\phi$

Appendix B

The CIEDE2000 colour difference formula was published by the CIE in 2001 and is based on CIELAB colour space (see Chapter 5). It was developed to improve on the predictions of the CIELAB and further the CIE94 colour difference formulae, published by the CIE in 1976 and 1995 respectively. It includes lightness, chroma and hue weighting functions, and an interactive term between chroma and hue differences for improving the performance for blue colours, as well as a scaling factor for CIELAB a^* scale for improving the performance in neutral regions.

Given two colour samples specified in CIELAB, the following steps are computed to derive the metric derived from the CIEDE2000 formula, ΔE_{00}:

Step 1. Calculate CIELAB L^*, a^*, b^* and C^* for both samples (described also in Chapter 5):

$$L^* = 116f(Y/Y_n) - 16 \qquad (B.1)$$

$$a^* = 500\left[f(X/X_n) - f(Y/Y_n)\right] \qquad (B.2)$$

$$b^* = 200\left[f(Y/Y_n) - f(Z/Z_n)\right] \qquad (B.3)$$

$$C^*_{ab} = \sqrt{a^2 + b^2} \qquad (B.4)$$

where $f(x)$ is defined differently for very low and for normal and high ratios:

$$\text{for} \quad x > 0.008856 \quad f(x) = (x)^{1/3} \qquad (B.5)$$

$$\text{for} \quad x \le 0.008856 \quad f(x) = 7.7871(x) + 16/116. \qquad (B.6)$$

Step 2. Calculate L', a', b', C' and h' for both samples:

$$L' = L^* \qquad (B.7)$$

$$a' = (1 + G)a^* \qquad (B.8)$$

$$b' = b^* \qquad (B.9)$$

$$C' = \sqrt{a'^2 + b'^2} \qquad (B.10)$$

$$h' = \tan^{-1}(b'/a') \qquad (B.11)$$

where

$$G = 0.5\left(1 - \sqrt{\frac{\overline{C^*_{ab}}^7}{\overline{C^*_{ab}}^7 + 25^7}}\right) \qquad (B.12)$$

where $\overline{C^*_{ab}}$ is the arithmetic mean of the C^*_{ab} values for the pair of samples.

Step 3. Calculate $\Delta L'$, $\Delta C'$ and $\Delta H'$, where b and s refer to the test (batch) and standard colour samples respectively:

$$\Delta L' = L'_b - L'_s \qquad (B.13)$$

$$\Delta C' = C'_b - C'_s \qquad (B.14)$$

$$\Delta H' = 2\sqrt{C'_b C'_s}\,\sin\left(\frac{\Delta h'}{2}\right) \qquad (B.15)$$

where

$$\Delta h' = h'_b - h'_s \qquad (B.16)$$

Step 4. Calculate ΔE_{00}:

$$\Delta E_{00} = \sqrt{\left(\frac{\Delta L'}{k_L S_L}\right)^2 + \left(\frac{\Delta C'}{k_C S_C}\right)^2 + \left(\frac{\Delta H'}{k_H S_H}\right)^2 + R_T\left(\frac{\Delta C'}{k_C S_C}\right)\left(\frac{\Delta H'}{k_H S_H}\right)} \quad (B.17)$$

where

$$S_L = 1 + \frac{0.015(\overline{L'} - 50)^2}{\sqrt{20 + (\overline{L'} - 50)^2}} \quad (B.18)$$

$$S_C = 1 + 0.045\overline{C'} \quad (B.19)$$

$$S_H = 1 + 0.015\overline{C'}T \quad (B.20)$$

with

$$T = 1 - 0.17\cos(\overline{h'} - 30°) + 0.24\cos(2\overline{h'})$$
$$+ 0.32\cos(3\overline{h'} + 6°) - 0.20\cos(4\overline{h'} - 63°) \quad (B.21)$$

$$R_T = -\sin(2\Delta\theta)R_C \quad (B.22)$$

and

$$\Delta\theta = 30\exp\left\{-\left[\left(\overline{h'} - 275°\right)/25\right]^2\right\} \quad (B.23)$$

$$R_C = 2\sqrt{\frac{\overline{C'}^7}{\overline{C'}^7 + 25^7}} \quad (B.24)$$

The parametric factors k_L, k_C and k_H in Eqn B.17 are used to adjust the relative weighting of the lightness, chroma and hue components for various viewing conditions. In most imaging applications they are set equal to 1.0 — see Bibliography for more explanations.

$\overline{L'}$, $\overline{C'}$ and $\overline{h'}$ are the arithmetic means of the L', C' and h' values for the pair of samples. For calculating $\overline{h'}$ caution needs to be taken for colours having hue angles in different quadrants. For example, a standard and a sample with hue angles of 90° and 300° would have a mean value of 195°, which is wrong. The correct $\overline{h'}$ value is 15°. It is obtained by:

1. Calculating the absolute difference between the two hue angles. In the given example this is equal to 210.
2. If the difference is less than 180°, the arithmetic mean should be used. In the given example the difference is more than 180°.
3. If the difference is more than 180°, 360° should be subtracted from the larger angle, followed by calculating the arithmetic mean between the resulting value and the smaller angle. This gives 300° − 360° = −60° for the sample and a mean of (90° − 60°)/2 = 15°.

BIBLIOGRAPHY

CIE Technical Report, 2001. Improvement to Industrial Colour-Difference Evaluation. CIE Pub. No. 142-2001. Central Bureau of the CIE, Vienna.

Luo, M.R., Cui, G., Ring, B., 2001. The development of the CIE 2000 colour-difference formula: CIEDE2000. Color Research and Application 26 (5), 340−350.

Index